ART AND MANKIND

LAROUSSE ENCYCLOPEDIA OF RENAISSANCE AND BAROQUE ART

GERMAN. *Putto. Detail from the altar of St Bernard (1775) in the abbey church at Birnau, by Josef Anton Feuchtmayer.*
Photo: Toni Schneiders - Coleman and Hayward.

Frontispiece. ITALIAN. FLORENTINE. MICHELANGELO (1475-1564). *The Creation of Man. Detail, ceiling, Sistine Chapel, Vatican. Fresco. 1508-1512.*
Photo: Joseph Ziolo - André Held.

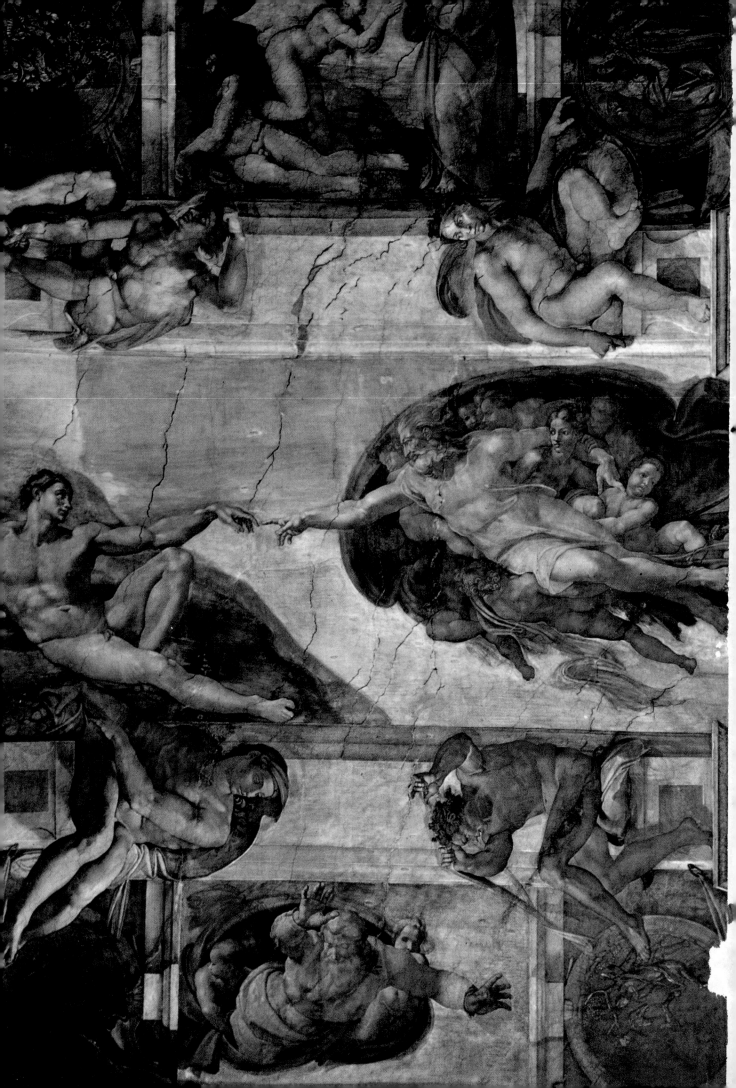

ART AND MANKIND

LAROUSSE ENCYCLOPEDIA OF
RENAISSANCE
AND BAROQUE ART

General Editor RENÉ HUYGHE

Member of the Academie Française *Honorary Chief Curator of the Louvre*

Professor in the Collège de France

PAUL HAMLYN

English text prepared by Emily Evershed, Hugh Newbury,
Ralph de Saram and Katherine Watson from the French original

L'ART ET L'HOMME

© 1958 and 1961 Augé, Gillon, Hollier-Larousse, Moreau et Cie
(Librairie Larousse, Paris)
First edition © 1964 The Hamlyn Publishing Group Ltd,
Hamlyn House, The Centre, Feltham, Middlesex
Reprinted 1967 (paperback), 1968 (paperback)
Printed by Toppan Printing Co. (H.K.) Ltd, Hong Kong

CONTENTS

4 BAROQUE ART

CONTRIBUTORS

GIULIO CARLO ARGAN, *Professor of the History of Art, University of Palermo*

JOSÉ CAMÓN AZNAR, *Professor in the University of Madrid, Director of the Museo de la Fundación Lázaro Galdiano, Madrid*

JEAN BABELON, *Chief Curator of the Cabinet des Médailles, Bibliothèque Nationale, Paris*

EUGENIO BATTISTI, *Docente Libero at the University of Rome*

GERMAIN BAZIN, *Chief Curator of the Louvre*

MARCEL BRION

ENZO CARLI, *Superintendent of the Monuments and Museums of Siena*

JACQUES COMBE

The late PAUL FIERENS, *Chief Curator of the Belgian Musées Royaux des Beaux-Arts*

ADELINE HULFTEGGER, *Curator at the Louvre, Professor at the Ecole du Louvre*

RODOLFO PALLUCHINI, *Professor of the History of Art, University of Bologna*

PIERRE PRADEL, *Chief Curator of the Louvre, Professor at the Ecole du Louvre*

CHARLES STERLING, *Curator at the Louvre, Professor at the Ecole du Louvre*
JACQUES VANUXEM

The late LIONELLO VENTURI, *Professor of the History of Art, University of Rome*

Sylvie Béguin, Liliane Brion-Guerry, Emily Evershed, Adeline Hulftegger, Lydie Huyghe, Evelyn King, the late Jean Charles Moreux and Gisèle Polaillon-Kerven wrote the Historical Summaries

COLOUR PLATES

INTRODUCTION

The four hundred years spanned by this volume begin and end with a return to classical ideals. In Italy the idea of a rebirth of letters and the arts, a return to the classical based on the rejection of the Middle Ages, had been gaining ground since the time of Giotto. It was in Florence, with its economic power and stability, that the break with the International Gothic came in the first decades of the 15th century with Brunelleschi, Donatello and Masaccio. The result was not a rebirth of antiquity but the birth of modern man and a search for the conquest of the visible world, with the aid of perspective and anatomy. Outside Florence the most important pioneers were Alberti at Rimini and Mantua, Piero della Francesca at Urbino and Arezzo, Mantegna at Padua and Giovanni Bellini at Venice. In Florence in the 1480s the neo-Platonic ideals of Lorenzo de' Medici and his humanist circle were poignantly evoked in Botticelli's mythologies.

In the north, where classical antiquity was not part of the national inheritance, architecture in the 15th century retained a Gothic form (Flamboyant, Perpendicular). The new realistic vision first appeared in Burgundy in the sculpture of Sluter and the paintings of Robert Campin and Jan van Eyck. The illusion of reality was achieved empirically, through heightened observation of the particular. The perfection of the oil medium contributed to the achievement of space through luminosity. The most influential artist was Rogier van der Weyden, whose realism was tempered by emotion and pathos. It was transmuted into expressive intensity by Hugo van der Goes in the *Portinari Altarpiece*. In Germany and Bohemia the International Gothic style lingered, but there was an influential development of woodcuts and line engravings by Master E. S. and Martin Schongauer.

Soon after 1500 the centre of patronage in Italy shifted from Florence to Rome and the High Renaissance developed there under Popes Julius II (1503–1513) and Leo X (1513–1521). The new ideals included a humanist belief in the potential dignity of man and in beauty as the harmony of all parts. First embodied in Leonardo's *Last Supper* at Milan, these ideals crystallised in Bramante's designs for the new St Peter's, Raphael's frescoes in the Vatican Stanze and Michelangelo's ceiling in the Sistine chapel. This short-lived harmony and serenity was shattered in 1527 by the sack of Rome; only Venice retained its prosperous independence and with Titian and Veronese achieved its own ideals of mood and colour.

The High Renaissance in the north was equally short-lived and accompanied by the spiritual upheaval of the Reformation. Germany saw the sudden flowering in a single generation of Dürer, Grünewald, Holbein, Altdorfer and Cranach. With his deep religious beliefs, his serious humanism, his wide curiosity, Dürer is the key to the whole era in his attempt to reconcile northern introspection and Mediterranean formal ideas. His greatest influence was through his woodcuts and engravings, the main channel through which Renaissance ideals were introduced into the north. Holbein, driven from Basle to England by the Reformation, was one of the most penetratingly realist portraitists the north ever produced; Grünewald, in his *Isenheim Altarpiece*, one of its greatest expressionists.

In the second half of the 16th century the Reformation in the north and Counter Reformation in Italy, coupled with a revolt against the rationalism and harmony of the High Renaissance, produced the international, subjective style of Mannerism, anticlassical in its use of space, antihumanist in its view of mankind. Represented in Italy by late Michelangelo, Pontormo, Parmigianino, Romano, Tintoretto and Vignola, in France by the school of Fontainebleau, its opposite extremes of spirituality and realism are embodied in El Greco and Bruegel.

The 17th century found Europe a less integrated entity, with the universal faith superseded by a new philosophy based on experimental science. The beginning of the century saw an upsurge of spiritual confidence, coupled

with a new approach to classical art which culminated in the Baroque. Foreshadowed in the first decade in Rome by Caravaggio and Annibale Carracci, the greatest exponent of the high Baroque was Bernini. In his work for Popes Urban VIII and Alexander VII, especially at St Peter's, he achieved the Baroque ideal of the union of architecture, painting and sculpture — a blending of illusionism, light, colour and movement inviting the emotional participation of the spectator. His contemporary, Borromini, was even more influential for later Baroque architecture in the north. Bernini's counterpart at Antwerp was Rubens, the first northerner to achieve, during his years in Italy, a mature understanding of classical and Renaissance ideals. His vast European reputation is implicit in commissions such as the Marie de' Medici series for the Luxembourg palace, the ceiling of the Banqueting House, Whitehall, and the series of late mythologies for Philip IV.

From the middle of the century France succeeded Rome as the leading political and cultural power. Under the dictatorship of Le Brun, Versailles, with its modified Baroque style, set the standard for the official art of the whole of Europe. The two greatest French painters, resident in Rome, Poussin and Claude, reflected the triumph of French *raison* and the new importance of landscape. Spain, though a waning power politically, produced a flourishing native school at Seville with Zurbarán and Murillo and one genius in Velasquez, court painter to Philip IV at Madrid for almost forty years.

As a medium for the triumphant Counter Reformation and absolutism, the Baroque was suspect in England and Holland. In England architecture achieved its own rational compromise in the work of Inigo Jones and Sir Christopher Wren. Wren's influence was felt in 18th-century American architecture, largely through the work of his followers in England. Even more important in the American colonies was the influence of James Gibbs, particularly in church architecture. Painting in England was dominated by a succession of foreign portraitists, from van Dyck through Lely to Kneller. In the later 18th century, the leading American painters studied in England. In Holland, victory in the war with Spain resulted in dependence on middle class patronage. The demand for familiar subjects and detailed finish resulted in specialisation, overproduction and a low level of quality. Exceptions were the achievements in landscape of Ruisdael and Cuyp, in genre of Vermeer and de Hooch, in portraiture of Hals. The one universal genius was Rembrandt, whose deep humanity suffused all his work, especially his religious themes, reinterpreted in Bible terms.

After the death of Louis XIV in 1715 a reaction against the Grand Manner resulted in a return from Versailles to Paris and the evolution of Rococo as a style of interior decoration. Essentially an aristocratic art, it is at its finest in furniture, porcelain, silversmiths' ware and the frescoes of G. B. Tiepolo, the last great Venetian decorator. In Germany and Austria, a belated flowering after the religious wars produced an outburst of church building, especially in Catholic Bavaria with the Asams, Zimmermanns and J. M. Fischer.

In 18th-century England the most influential achievement was the creation of the landscape garden. In architecture Palladianism, developed by Burlington and Kent, was superseded in the 1760s by the new style, compounded of Pompeian and High Renaissance motifs, evolved by Robert Adam. In painting, Hogarth, Reynolds and Gainsborough all broke with the narrow demands of portrait painting. Gainsborough's 'fancy' pictures reflected the change from an age of reason to one of feeling; on the one hand the rise of sentiment, pioneered by Rousseau; on the other a new archaeological approach to past history, leading to Neoclassicism. Originating in Rome, with Winckelmann and Mengs, increased knowledge of the antique, through the excavation of Herculaneum and Pompeii and the publications of Stuart and Revett, Wood and Adam, brought with it for the first time the danger of conscious imitation. David and Canova, in their approach to classical art, could not hope to recapture the freedom of Brunelleschi and Donatello in 15th-century Florence.

EVELYN KING

1. FLEMISH. PETRUS CHRISTUS
(active from 1444 – d. 1472/73).
St Eligius weighing the Wedding Rings of a
Betrothed Couple. 1449. Painting commissioned by the
goldsmiths' guild of Antwerp.
Lehman Collection, Metropolitan Museum of Art.

*No work is more representative than this of the
influence of commerce with its preoccupation with the material
value of things — an influence which led artists to
concern themselves with the rendering of substances.*

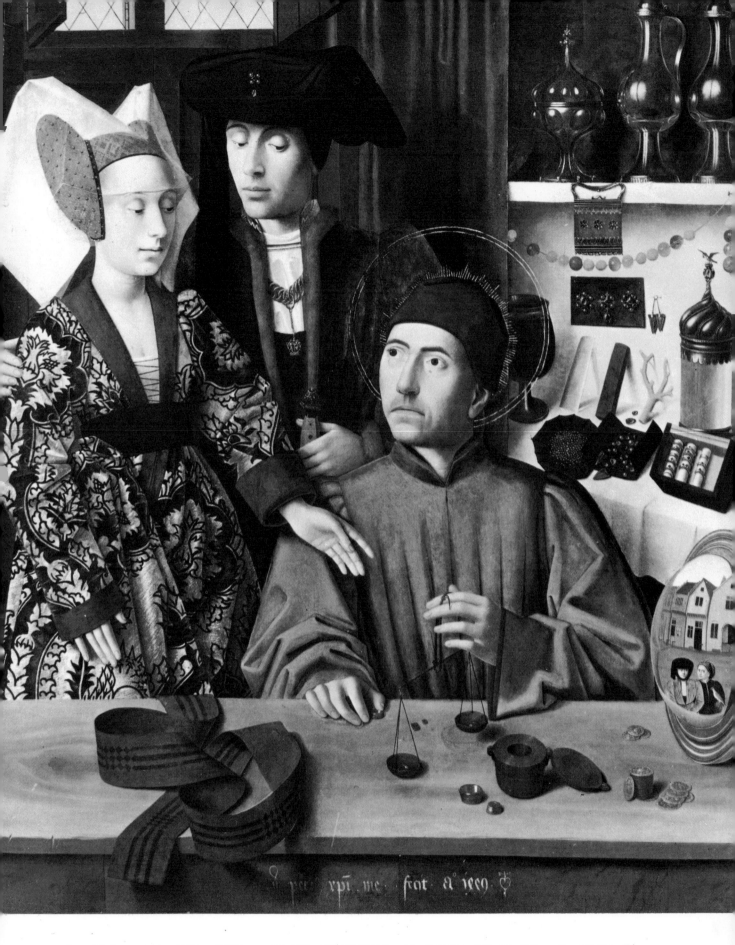

1 THE END OF THE MIDDLE AGES
AND THE GROWTH OF REALISM

ART FORMS AND SOCIETY *René Huyghe*

The 15th century witnessed the end of the Middle Ages and the beginning of modern times. A civilisation which had seen the establishment of Christian Europe died out; another, which is only now being revaluated, came into being with the Renaissance.

From this point in history the study of the West becomes more complex; religious, intellectual and social life were enriched by new experiences and possibilities and were beset by internal conflicts. The threads of this ever-widening pattern of existence are closely interwoven; the world and the art which expresses it become difficult to decipher. A greater effort than ever before is needed in order to pick out from this detailed background those trends whose effects will be significant.

In the 13th century it is possible to speak of a Gothic art which was French both in origin and in character. As the Middle Ages advanced, national Gothic schools developed which were much more clearly defined than the provincial Romanesque schools had been and which eventually gave rise 3 to individual styles: Perpendicular in England, Flamboyant in 6, 8 France, Isabelline in Spain, Manueline in Portugal and Hanseatic in the countries around the North Sea and the Baltic.

In the 13th century Paris, the seat of the court and of the university with its scholars and students of all nationalities, was the undisputed hub of medieval civilisation. In the 14th century the centres were more dispersed. The prestige of a court such as that at Prague, where Charles IV (a nephew of Charles V of France), who had been brought up in Paris, reigned, or of a papal town such as Avignon, the increasing power of 60 commercial cities such as Pisa, Florence, Siena and Venice in Italy and Bruges and Ghent in Flanders, and the growing new universities such as Prague, Cracow, Vienna and Heidelberg, and, at the beginning of the 15th century, Louvain, bear witness to a kind of efflorescence of the Gothic spirit.

In the 15th century, particularly after Agincourt in 1415, Paris suffered an eclipse. The leadership passed to the commercial and middle class centres of the Duchy of Burgundy from Dijon to Flanders, of the Hanseatic League in the north and of Italy in the south.

But the 15th century was marked by more than a dispersal of influence; it was based on contradiction. It served as a link between two concepts of the world. During its course we see three centuries of human thought and feeling finally expend themselves and end in scepticism and anxiety. On the other hand we witness the inauguration of three centuries of progress and of new beliefs. In going from one system to another we pass a neutral point mentally, a ground level at which the given facts are most easily imposed on the now receptive mind. So, whether we consider the 15th century in the light of what it ended or in the light of what it began, it was realism which dominated it, a realism which adapted itself to the various trends which kept this era in a state of flux. The signs of its advent had been apparent from the 13th century.

The course followed by medieval civilisation

Every civilisation eventually begins to break up and finally disintegrates. What is a civilisation if not one of the phases in which man, perpetually seeking to better adapt himself to his world so that he may find therein security and peace of mind, thinks he has reached his goal? To do this he needs to understand the universe, that is, to form for himself a concept of it, an explanation of it which he calls truth, and at the same time to be sure he has the means to protect himself against it and to cope with it. Anxiety accompanies his efforts, and the

menacing presence of forces beyond his comprehension and control, which can crush him at any moment, fills him with terror. At the same time he experiences faith in himself, in the part he is to play, in his reason for living and in his future.

Every civilisation has entered the lists; it has stated and defined the body of beliefs which characterise and constitute it. It has progressed in the process of striving to affirm and systematise its ideas. It has reached its peak, that is its classical phase, when the picture thus built up appears to coincide with the experience of reality and gives it that authoritative certainty produced by harmony of the means with the ends and by an inner peace arising from material and spiritual security. When this optimum point is reached there comes a sclerosis of the system — which becomes hard and mechanical — followed by a recourse to extremes in order to recapture a distinctive quality which has departed. Then there is a period of surrender to chance, of despair for the future, when each man strives only to safeguard his immediate and selfish interests. We are familiar with this last phase, since it is the fate of the 20th century to live it over again.

In the course of a few centuries the Middle Ages followed this almost inevitable sequence — search for identity, finding of it and loss of it — and its art reflected these stages faithfully. After studying this chain of events it is possible to forge the links into a whole. The 11th century, when a feudal society born of the anarchy of the 9th century established itself definitively, was the century of struggle and conquest; Christianity and Europe were solidly welded together, uniting the spiritual power of Rome and the temporal power of the north. Monasticism, relying from the 10th century on the Cluniac Order with its vast organisation, ensured an intellectual, cultural and artistic unity. Groups which had threatened from without — the Magyars, Vikings and Slavs — became converted; others, like the Arabs, were in retreat. From the end of the century the crusades in the Holy Land took the offensive. Everything perceived, every aspect of life, pointed to the presence of God and could be explained by it; every undertaking or achievement tended to make this presence more manifest and tangible. As a symbol of the times part of the abbey church at Cluny was dedicated by the Pope in 1095, and the earliest cross-ribbed vault was erected at Durham. The latter foreshadowed a constructive system which was called for by the increasing size of churches and which, going beyond the mere restoration of ancient principles of construction, dared to try out radically new solutions. A century later it was to be carried to completion at Chartres.

Thus, in the 12th and 13th centuries, the zenith of the curve was reached. The verticality of architecture expressed the inflexible upward thrust of the vital impulse and its lyrical tension, at the same time that the great rose windows combined the ethereal light of the stained glass windows with an absolute yet elastic centralisation — a radiation which was both a diffusion and a concentration of the spirit. The universe appeared whole and clear, in an intimate union with God who was Himself its clarity and order. The *Speculum* of Vincent of Beauvais and the *Summa* of Thomas Aquinas speak of the encyclopedic confidence of knowledge, as do the cathedrals, which became in their iconography a mirror of the world and of religion. The universities, from Chartres and Paris to Oxford, strove to show through scholasticism the harmony between faith and reason. Another bond was that between God, the universe and man. St Bernard at the beginning of the 12th 12 century and St Francis at the beginning of the 13th introduced

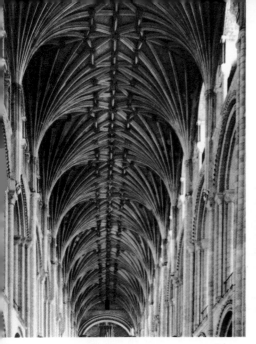

2. ENGLAND. GOTHIC.
View of the 15th-century vaulting in the nave, Norwich cathedral.

3. FRANCE. Detail of the west portal of the abbey church of La Trinité at Vendôme. 14th century.

4. SPAIN. SIMON OF COLOGNE.
Chapel of the Constable, Burgos cathedral. 1482–1494.

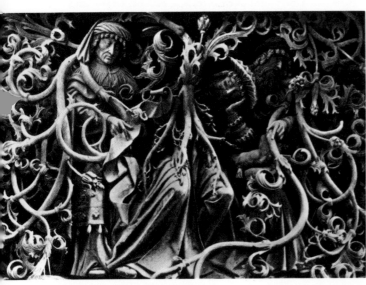

THE DISINTEGRATION OF THE GOTHIC STYLE

During the 15th century Gothic art entered a late phase, a phase in which, as often happens, the disintegration of the style was accompanied by a concentration of its extreme forms. A style expresses a unified concept of the world, to which its methods of expression correspond. However, at the end of the Middle Ages France had ceased to be the focal point for Gothic art, and national tendencies had a free rein [2–8]. At the same time, and this was also the case in France [3], the discipline imposed by reason and logic progressively lost ground to the previously pent-up forces of life, which were expressed in an unrestrained profusion of plant decoration [5].

5. GERMAN. HEINRICH DOUVERMANN.
Tree of Jesse. Detail from the Altar of the Virgin of the Seven Sorrows. 1521. *St Nicholas, Kalkar.*

6. PORTUGAL. MANUELINE.
Window of the chapter house in the monastery of the Knights of Christ at Thomar. c. 1450.

7. FLANDERS. MATHIEU DE LAYENS. Town hall, Louvain. 1448–1463.

8. GERMAN. BERNT NOTKE.
St George and the Dragon. Polychrome sculpture. 1488. *Stockholm Cathedral.*

the theme of love, a theme which recurred in the songs of the troubadours. The material world was only the transparent veil of God, who was so clearly visible through it that there was no longer any need to draw it aside. Life was truth, joy, certainty and fulfilment.

After this classical period of far-reaching harmony between inner life and external reality came the decline of the 14th century. The world was torn asunder. As a result of the bitter rivalry between the Pope and the Emperor which started at the close of the 11th century and ended with the triumph of Innocent III, the dream of an alliance between the spiritual and temporal powers ended — the dream to which, in the 13th century, St Louis had given an ideal form. As early as 1303 his grandson Philip the Fair arrested Pope Boniface VIII. The Church was split internally; the exile of the popes to Avignon was followed in 1378 by the Great Schism. On the temporal side France and England began a fratricidal struggle (the Plantagenets were from Anjou and Edward III was the grandson of Philip the Fair) which was to last for a whole century. On the social level the same brutal conflicts occurred; the dominant class, the knights, whose resources were exhausted by the crusades in which they had played a leading role, suffered disaster after disaster, beginning with the defeat of the cavalry of Philip the Fair at Courtrai in 1302 by the Flemish weavers' infantry and ending, after Crécy and Poitiers, with Agincourt in 1415.

At the same time the middle class was gaining the ascendancy, and its position was firmly established after the meeting in 1355 of the States General (first assembled in 1308). The social transformation was underscored by the brief triumph of Etienne Marcel, the provost of the merchants of Paris. Similarly, in 1378 a wool-carder took control of Florence. The populace rose up in their turn after the rich merchants — but with more violence — in France (the Jacquerie in 1358), Italy, Flanders and England (the Peasants' Revolt of 1381). In the words of Froissart, ' It was feared that all nobility had perished. ' The enormous deathrate caused by epidemics in the towns brought about a compensating influx of people from the country and with it a drop in the cultural level. Millard Meiss has shown that this situation had been paralleled in Italy after the terrible plagues of 1340, 1348, 1363 and 1374.

It could be said indeed that natural forces, from now on ill-controlled, were once again becoming aggressive. The devastation wrought by deadly weapons was increased with the introduction of gunpowder from the East. Disease wrought unbelievable havoc; the disastrous Black Death appeared in Italy in 1347 and spread as far as to England. Siena saw the number of its inhabitants shrink from 100,000 to 13,000; in Limoges in 1435 no more than five inhabitants were to be counted. A long period of misery and affliction followed; as late as the 15th century the diary of a citizen of Paris recorded that in 1439 wolves had entered the city and eaten fourteen people.

The whole of Christendom was now weakened by a wave of doubt. Christianity's efforts to expand ceased with the eighth crusade in 1270; a complete reversal took place which in the 15th century would be fully confirmed by the Turkish attack on the Venetian power in the Levant and by the fall of the enfeebled Eastern Empire of Byzantium in 1453.

Inevitably the very foundations of spiritual feeling were shaken, and the result was that a deep rift appeared. Faith and reason were no longer united; moving farther and farther apart, they tried to regain a jealous and sometimes hostile independence. Under the auspices of the Oxford Franciscan William of Occam nominalism ensured the posthumous revenge of Abelard, the unfortunate adversary of St Bernard. The concept of God and His attributes, since it was not demonstrable

and could not be an object of direct knowledge, relied solely on faith. Men were therefore led to conceive of nature as a separate entity and to explore and understand it on grounds other than divine explanation. Just as God was an object of faith, so nature was an object of reason comprehensible through the experiences of the senses. The universities, which dominated intellectual life to a greater and greater degree, lent their authority to this conception. This was especially the case with Oxford, a centre of increasing attraction, to the detriment of Paris which remained faithful to traditional doctrines.

Touching more nearly the mass of the people, the monastic circles served as a kind of counterbalance and gave themselves zealously and completely to their belief in the God they felt had been threatened. So uncompromising was this attitude that it ruled out the natural world together with the senses which experienced it and the reason which examined it. These men dreamed of obtaining direct access to God. The impassioned Rhenish mystics Meister Eckhart, Heinrich Suso and Johann Tauler, and the Fleming Jan van Ruysbroeck, all men of the 14th century, opposed reason with love, to which they surrendered themselves completely in order to give themselves to God. This attitude found its direct echo in the paintings of the school of Cologne, whereas elsewhere a realistic outlook, tinged with nominalism, emerged.

But contradictions gave rise to scepticism. To triumphant nominalism ideas were only words; everything was reduced to experience. Certain people came to distrust thought when it was not supported by the evidence of the senses. For John of Jandun neither the creation of the world nor the immortality of the soul was capable of proof. Nicolas of Autrecourt posed the problem of whether knowledge of the external world could be proved.

Never were the lines of de Vigny more completely apt:

Evil and Doubt ... there's the accusation
Which weighs o'er all of this creation.

With this double malediction the 15th century began.

Social revolution

As is often the case, these upheavals were the corollaries of a profound social transformation. Around the 12th century the Church had begun to discipline the uncontrolled and sometimes brutal power of feudalism which, in its mature phase, sought to establish a code of values. The spirituality of the Middle Ages depended on heroic chivalry and on its link with the Church and its ideal of courtliness. The new era would be founded on the commercial middle classes, whose interests were completely material. The date 1270 symbolically unites the eighth and last crusade, when St Louis, the very epitome of chivalry, died, with the completion of the second part of the *Roman de la Rose*, in which Jean de Meung brought to the ideal of chivalry a biting materialism and a contempt of woman. The new practical, positive spirit had imposed itself even on the crusades and had perverted their meaning and filled them with the most calculating greed. It levelled its new weapon, mockery, at that chivalry whose ideals it considered hollow in the same way that the nominalists considered universal concepts to be mere symbols lacking reality. The *Roman de Renart* served in the 14th century as a satirical parody of the early epic poems, while the *Trois Dames de Paris* mocked courtly love. In the 15th century *Petit Jehan de Saintré* completed the discrediting by ridicule of the chivalric ideal, which became obsolete and was only partially revived during the Renaissance through the way of life of the Italian nobility and its influences in France.

The middle class, with its trade, business enterprises and banking, extended its sphere of activity, imposing everywhere the reign of money and transforming the economic structure. The cult of power through riches was substituted for that of

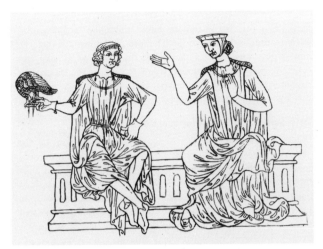

9. FRENCH. Couple conversing.
Drawing from the notebook of Villard de Honnecourt.

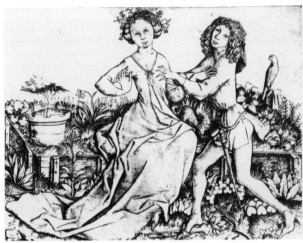

10. GERMAN. UPPER RHINE. MASTER E.S. Lovers seated in a Garden. Engraving. 15th century.

FROM ABSTRACTION TO MATERIALISM

The stern rationality of the scholastic theologians was gradually modified by warmth of feeling and emotion. St Bernard [12], like St Francis, taught men to approach God not only through the mind but through the emotions; this new attitude gave rise to the need for a physical and material representation. In art both human beings and things were portrayed with increasing realism and materialism. In 13th-century art, lovers seem to be engrossed in reasoning [9]; in 14th-century representations, they are portrayed exchanging shy caresses [11]; in 15th-century art they have become far more intimate [10]. Increasingly the artist places lovers in a setting of nature — of gardens and flowers — which he delights in painting with precision [13]. In Flanders he abandons a poetic interpretation for a more positive version in which money counts and even makes the repulsive acceptable [14]. Thus in two centuries art moved from abstraction to realism and then to materialism.

11. FRENCH. The Springtime of Life.
Figures on the west front of Lyon cathedral.

12. GERMAN. MASTER OF THE ST AUGUSTINE ALTARPIECE. The Vision of St Bernard.
Detail from the St Augustine Altarpiece. 1487.
German National Museum, Nuremberg.

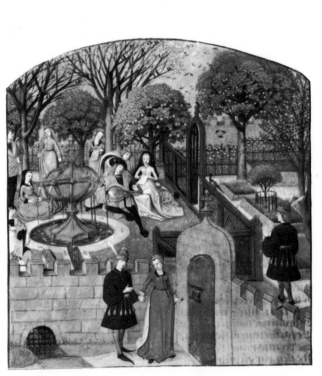

13. FRENCH. Lover brought to the Garden of Delight by Idleness. Roman de la Rose. 15th century. *British Museum.*

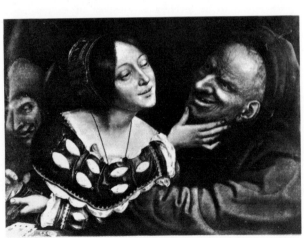

14. FLEMISH. QUENTIN METSYS (1465/66 – 1530).
The Woman and the Old Man. *Private Collection.*

power through courage. At this time the middle class gained close access to the king himself, furnishing him with counsellors, financiers and jurists. As early as the end of the 13th century Philip the Fair depended on them when he inaugurated his political innovations; at the same time he borrowed from the bankers of Florence and Siena. The power of these men became extensive; at the time of his arrest in 1451 Jacques Coeur, court banker to Charles VII, possessed a million gold crowns, lead and copper mines and thirty castellanies. But in the case of Charles VII's son Louis XI it was the king himself who, more concerned with practical reality than with outward prestige, affected the manner and dress of the middle class. There were complaints as early as the 14th century that in the papal palace at Avignon money matters threatened to take precedence over the holy offices.

While the power of certain princes — for example the dukes of Burgundy — rested on the most extensive draper's business of the time, in Italy, in Genoa in the 15th century, the leading credit enterprise, the Florentine bank, was founded. This became the basis of the growing wealth of the Church and aided the rise of a family destined to become princes — the Medici. Money was beyond price; in Italy in the 13th and 14th centuries the interest on loans rose from twelve to twenty and even to thirty-five per cent.

Mathematics, the accuracy of measures and calculation, played a most important role and helped to bring about astonishing progress, and business accounting, in common use first in Italy, had become an imperative necessity. The first wheel clock appeared in the middle of the 14th century. The search for qualitative values, in which till now the Church and chivalry had taken the lead, was opposed by the ceaseless and more threatening competition of purely quantitative standards, which would finally surpass itself in the scientific civilisation of the 19th century. Then the 'middle class cycle' would be completed. The following simplification might almost be allowed: the middle class gave precedence in all spheres to the concrete and the precise, hence to quantity rather than quality which had inspired medieval man, and this priority was to last until the 19th century, when individuality came to the fore, opening new adventures to modern man. A faithful reflection of these events is to be seen in art.

In the political and social structure it was the economic and practical which dominated, and philosophic and even religious thought, whether it was a matter of science or 'piety', was proceeding along more and more positive lines. Indeed, realism (in the new sense, in which it dealt with reality and was to be from now on synonymous with material evidence) showed all the signs of the times which were being ushered in. Henceforth it was to be involved in questions of an apparently contradictory nature. When the artists of a reawakening Italy tried to rise above simple factual representation by devoting themselves to the cult of the beautiful, they did so by introducing into their work the spirit of exactitude through research on calculable proportions. At the end of the 15th century the mathematician Fra Luca di Pacioli, in his famous *De Divina Proportione*, written after 1497, tried to reveal the secret of beauty through a measurable proportion — the Golden Section (the division of a line so that the shorter part is to the longer, as the longer is to the whole). In this work he took up again the ideas of Piero della Francesca. He attracted the intense interest of painters such as Leonardo da Vinci and Dürer, whose 15 *Melencolia* meditates among scattered instruments of calculation and geometry. Still, Pacioli was not purely an aesthetician, for he also published his *Summa de Arithmetica, Geometria, Proportione*, in which this former teacher of the children of a rich Venetian merchant gave considerable space to the science of bookkeeping, the method of double entry, etc. Let us not forget that the first arithmetic book, published in 1478, dealt with commercial calculation. The practical positivism of the new society was so deeply ingrained that it found its way into even the most idealised examples of the art of the succeeding centuries, not in order to escape from realism, now accepted as a basic fact, but simply to go beyond it and to sublimate it.

Aristocratic and popular realism

While realism became the irresistible ruling passion of the 15th century, it assumed different forms according to the social milieu and the country in which it manifested itself. In Italy the new impetus which · came with the Renaissance made it above all a point of departure for the search for beauty. In Flanders, on the other hand, it often remained impregnated 101 with, and sustained by, what still existed of the now disintegrating medieval religious spirit. Another factor intervened; each social class, as far as it influenced art, sought to give visible expression to its conception of life—a life which allowed it to develop its gifts and satisfy its desires. Each class demanded that art give image to its aspirations. The aristocracy, the common people and the middle class took their own stand with regard to realism.

The aristocracy had the most difficulty in adapting itself to the new attitude. It remained true to the ideals of the times which had seen its formation. The appearance of the *Chanson de Roland* in 1065 had marked the point at which literature, till then exclusively religious, was opened up to chivalric poetry. In the castles, around the 'noble ladies', a courtly life grew up, patronising and augmenting a culture previously monopolised by the monasteries. Chivalry, like all organised aristocracies, was founded on an impossibly high standard of values and a sense of 'honour' which demanded perfection in human courage and love. This was fundamentally a reflection of the neo-Platonic tradition, which at an earlier time had influenced the religious thought of St Augustine. 'Aristocracy' and 'aristocrat' are derived from the Greek *aristos*, which is a superlative meaning 'best'. Thus the aristocracy must inevitably have been opposed to materialism. Even when it did not apply the code of values — self-sacrifice, purity and heroism — on which it was built (and which Don Quixote continued to practise, but as a madness unrelated to the commonsense world of Sancho) the aristocracy did not dare openly to betray it but made a show of adhering to it.

Shortly before the beginning of the 15th century the nobility, swamped by the claims of the middle classes who were supplanting them politically and socially, ill-adjusted even in military matters to new techniques and showing thereby their inefficacy and, in addition, conscious of the ultimate decline of their class, sought refuge in a ritual observance of the outward forms. Wherever they remained the patrons, as with the mural paintings in the castles, the illuminated pages of manuscripts, the tapestries and the luxury goods such as jewel boxes, mirrors and combs, they preserved an iconography in which the images of life as they dreamed of it were displayed. The theme of valiant knights of legend and of their combats, common in wall paintings (which have mostly been destroyed), maintained the heroic illusion. Scenes of dalliance and of leisurely pursuits — walking, fishing and hunting — set in gardens and other natural surroundings, as in the Tour de la Garde-Robe in the Palace of the Popes at Avignon, perpetuated an illusion of refined hedonism. But an insidious decline was soon perceptible; on miniatures, ivories, etc., the 13th-century devices — such as woven garlands of flowers — which suggested amorous desires gave way a century later to bolder, less abstract motifs. At the 10, 11 same time, the middle class was responsible for the introduction of 'drolleries'.

Platonic indifference to material possessions combined with

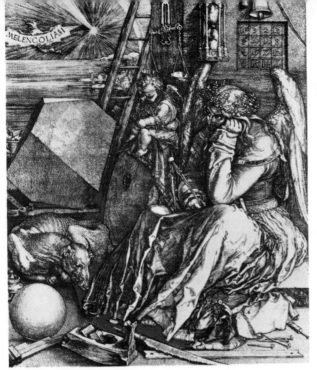

15. GERMAN. ALBRECHT DÜRER (1471–1528).
Melencolia. Copper-plate engraving. 1514.

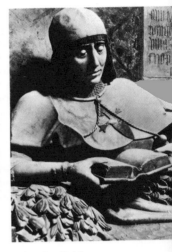

16. FRENCH. Detail from the tomb of Philip the Bold
(d. 1285). 1298–1307. Designed by Pierre de Chelles.
Abbey Church of St Denis.

17. SPANISH. Tomb of Vazquez de Arce (d. 1406).
15th century. *Siguenza Cathedral.*

DEATH AND THE DEVIL

*The abandoning of the intellectual system belonging to a
culture implies a return to nature and to an
emotional and instinctive realism; it also gives rise to
uncertainty, malaise and anxiety. Faced with the enigma of life
and of the world, man no longer felt protected by a
body of ' accepted truths '. Dürer's* Melencolia
[15] *evokes the drama of this meeting between a
consciousness stripped of its old beliefs and the new sense of
the mystery of the world. Thrown back on his own
resources, each individual feared for his destiny, in which
two threats loomed large. One of these was death,
which evoked an atmosphere first ideally serene [16], then
realistic [17], then haunted [19] and even hideous physically
[18]. Man's other threat was evil and the punishment of
it, which made the Devil far more terrifying and
horrific [21] than he had ever been before [20].*

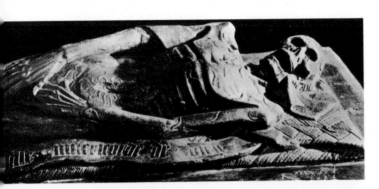

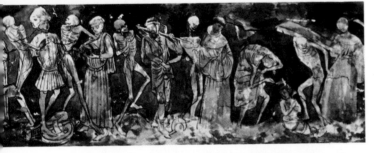

20. ENGLISH. Demons carrying St Guthlac. Drawing from
the Scroll of Guthlac. 12th century. *British Museum.*

18. *Above left*. FRENCH. Tomb of Guillaume le François. 1456.
Formerly in St Barthélemy at Béthune. *Arras Museum.*

19. *Left*. FRENCH. Detail of the Dance of Death.
Wall painting. *c.* 1460–1470. *Church of La Chaise Dieu.*

21. GERMAN. MARTIN SCHONGAUER (d. 1491).
The Temptation of St Anthony. Engraving.

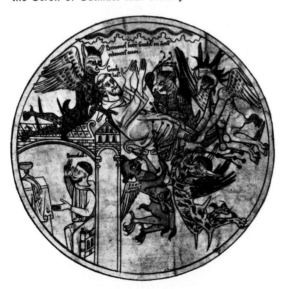

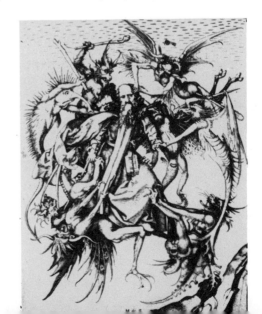

techniques suited to miniatures had favoured an art which ignored mass and volume and concerned itself with a graphic elegance that grew increasingly manneristic. The middle class, on the other hand, loved easel paintings, articles of furniture and objects which were privately owned, and the technique of oil painting, hitherto unexploited, would enable the material world to be portrayed with astonishing realism.

Thus the cosmopolitanism of the princely courts, both those in which the past lived on and those in Italy which were created in imitation of them (as we shall see in Chapter 2), was to spread throughout Europe an art which, yielding to the march of time, succumbed increasingly to realism — but to a realism that was narrative and literary rather than visual and sensory. Conventions continued to rule it. The line, now arbitrary to the point of preciosity, was used to express all things. The artist confined himself to carefully rendering the details of costume and fashion and to studying domestic or wild animals, especially those which were connected with hunting. It has perhaps not been sufficiently noted how far Cranach's characters with their affected poses, his precious linearity and his hunting scenes are those of a court artist. But this art, profane by inclination, was easily applied to religious subjects. The Virgin in Rhenish art, as in the *Madonna of the Rose Garden* by Stefano da Zevio, sits amid roses and greenery — a setting also given to lovers. Lulled by the music of small angels, she sits enveloped in an affectionate and chaste tenderness; such works passed on a lingering echo of courtly love to the Sienese Madonnas of the 15th century.

The popular mood was less remote than one would suppose from the aristocratic trend. The mendicant Orders imbued their faith with the spirit of love introduced by St Francis. Moreover, this new force, the populace — which expressed its desire for emancipation in frequently bloody upheavals and about which Nicolas of Cusa prophesied in 1433: ' Just as the princes devour the Empire, so the people will devour the princes ' — was much less opposed to aristocratic art than was the middle class. The common people had no formulated code of values; they were impulsive and instinctive, hence sentimental. They were fond of story-telling and of nature; their taste ran to clear outlines and pure colours rather than to clever trompe l'oeil, therefore they preferred the art that stemmed from the miniatures in manuscripts. They loved to be carried away with adoration for the Virgin or with pathos. (In Byzantium the cult of the Virgin and the representation of the Passion had ranked first in the iconography under the popular influence of the monks, as witness the *Khludov Psalter*, which developed this double cycle.) Undoubtedly this sensibility, reinforced by the influx of people from the country into cities whose populations had been decimated by plagues, coloured the early form of realism which developed in the cities of Italy (Siena in particular) and Bohemia and in the Rhenish and Hanseatic towns. This realism, which could be called mystical, was distinct from the aristocratic realism of the court circles, although it was often seen in combination with it because of their common sense of the all-pervasive sweetness of love, religious in the first, profane in the second. It spread from Prague to the North Sea and the Baltic and was carried along one of its sources, the Rhine, which was both the ' monks' way ' and a great commercial artery. This early realism facilitated the transition from medieval aristocratic art to the middle class art of the 15th century, which had its origins in the rich and purely commercial atmosphere of Flanders. This middle class art developed late, breaking every link with the mystical movement to which it was indebted and giving to realism its definitive materialist and modern aspect.

In doing this the middle class, its origins in the common people, gave a more developed and concrete form to these realist tendencies, which emerged in the popular taste for the theatre. Previously art had expressed in pictures what had been conceived in the realm of thought; the theatre learned to present in a tangible form episodes which were true to life. Through this intermediary the vital scenes from the sacred books became objects of sensory experience, of visual perception. Henceforth one saw and almost touched what formerly one merely knew intellectually; one participated in it. This was far removed from the liturgical drama of the 10th century, in which (only during the important Church festivals, such as Christmas and Easter) representations of relevant episodes from the Holy Scripture were included in the service. In the 13th century, the century which witnessed both the development of realism and the rise of the middle class, dramatic action evolved, particularly in the already more materialistic north, with Jean Bodel, Adam de la Halle and the Arras group and with Rutebeuf, author of the first important early miracle play about the Virgin. But the staging, scenery, acting and costume, and the choosing of the liveliest and the most moving episodes, only reached their peak in the mystery plays of the 15th century, when these works, which had begun as liturgical dramas presented only during religious festivals, attained mature technical development and even employed ingenious stage effects and various machines to help portray battles, fires, etc.

Religion was involved in yet another way with this vogue for dramatic representation. The popular preachers, especially St Francis, yielded to the necessity to mime and illustrate; the theme of the Dance of Death (*Danse Macabre*) may owe its form in part to the ' representations ' with which the Friars Minor liked to illustrate their sermons.

In 1223 St Francis (who, it must be remembered, was the son of a rich merchant) ' staged ' the mystery of the Incarnation at the Christmas Mass at Greccio. His sermon went so far as to imitate the bleating of a lamb, and his gift of creating an illusion was such that his congregation actually saw the Christ Child in his arms. The following year he went even further; he produced on his own flesh, even to the wounds and the blood, the Stigmata of the Crucified. In a similar way, in the following century the Rhenish monk Suso relived the Passion at night in his cloister, acting out the stages from pillar to pillar. Thus the highest kind of mystic love, so close to the hearts of the people, sought to assume the most concrete shape in preference to the abstract form given it by the intellectuals.

Still, these same intellectuals, from the 13th century and particularly under the influence of the Oxford Franciscans, had begun to abandon purely scholastic problems and to concern themselves with sensory experience; visual experience was one of the problems which preoccupied them from the outset.

Middle class realism

The inevitable rise of the middle class was the principal factor in this development; wherever this class held undisputed sway art turned towards a fairly extreme realism. The two principal centres of this were Italy, where communities had begun to evolve from the first third of the 11th century, and Flanders, where their development followed several years later. In the 15th century the commercial cities experienced their greatest flowering to date. But while in Italy, as we shall see, the new trends had to include the traditions of ancient classical art and of Byzantine intellectualism, Flanders had only to adapt these trends to a waning medieval religious fervour. Still experienced by the greatest of her primitives, this fervour soon sank into a comfortable piety which the *devotio moderna* spread in the north, where a moral code took the place of spontaneous love and earthly life was conceived with a view to salvation in the life to come. In 1441 the *Imitation of Christ*, the major religious book of the time, attributed to Thomas à Kempis, opened with ' Admonitions *useful* for a Spiritual Life '. Useful!

22. FRENCH. The Death of the Virgin. Tympanum of the left-hand door, south portal, Strasbourg cathedral. c. 1230.

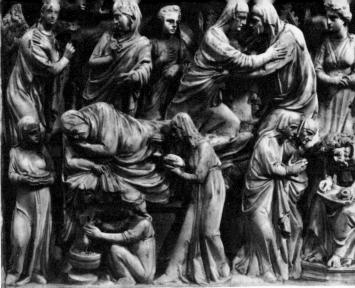

23. ITALIAN. GIOVANNI PISANO (c. 1245 – c. 1320). The Birth of St John the Baptist. Detail from the pulpit in Pisa cathedral. 1302–1310.

THE TRANSITION FROM GOTHIC TO RENAISSANCE ART

The desire for clarity can bring about excessive simplification; it is tempting to contrast the Middle Ages and the Renaissance, to see in the latter period a reaction — especially in Italy — against the former with its French affinities. In reality there was no break, only a transition. And it was the example of French statuary which influenced the Italian sculptors (the Lombard sculptors in the 13th century [26–29] and the Pisan sculptors in the 14th century [22–25], who were the first craftsmen of the new art). The attempt to reproduce forms from the real world was inspired originally by the first Gothic artists. The Italian Renaissance brought this quest to a successful completion by drawing directly on the examples of antiquity, that is, by going back to the very sources of sculptural art.

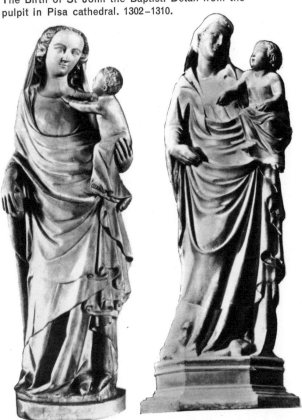

24. GOTHIC. Virgin and Child. Alabaster. 14th century. *Musée de Cluny, Paris.*

25. ITALIAN. NINO PISANO (d. before 1368). Madonna and Child. 14th century. *Sta Maria Novella, Florence.*

26. *Below left.* FRENCH. GOTHIC. The Month of August. Detail from the portal of the Virgin, west front of Notre Dame, Paris. Beginning of the 13th century.

27. *Below right.* ITALIAN GOTHIC. The Month of August. From Ferrara cathedral. School of Benedetto Antelami. 13th century.

28. *Below left.* FRENCH. GOTHIC. The Month of September (Harvest). Quatrefoil on the St Firmin porch, Amiens cathedral. Beginning of the 13th century.

29. *Below right.* ITALIAN GOTHIC. The Month of September. From Ferrara cathedral. School of Benedetto Antelami. 13th century.

That was on a par with an extension of the cult of the saints, invaders of the iconography, who as intercessors were nearer, more human and reputedly more efficacious than God and offered a comfortable halting place which obviated the urge to reach God directly.

1 Worldly preoccupations were soon to be asserted without disguise. Petrus Christus had painted a goldsmith's shop under the pretence of glorifying St Eligius, but in the 16th century Metsys with his *Moneylender and his Wife* and Marinus van Reymerswaele with his studies of money-changers introduced an iconography which for a long while featured the banker, the tax collector and the usurer. Among the sacred themes that of Christ driving the traders from the Temple took on a new reality. The social problem of the rich and the poor was brought up by van Hemessen and portrayed symbolically by Bruegel. The power of money was illustrated by numerous 14 pictures of amorous old people — men and women — buying the favours they lust after; courtly love had vanished.

However, this decline of spiritual feeling was compensated by one of the greatest victories of painting; the visible appearance 94-96 of things was reproduced with complete optical veracity, with a balanced rendering of matter and of the light which surrounds it. The eye was king; one could almost touch the object rendered. On the other hand the idea of form, which was becoming so important in Italy, appeared to be secondary because it was more a mental than a sensory approach to the visual world. The painter, having mastered the technique of oils, succeeded, through the controlled play of light on his opaque impastos and transparent glazes, in reproducing visually with matt or shiny surfaces, and with density or clarity, a world of perception so intense it can almost be tasted. It rested with the middle class — which by its very position had to assess and appreciate (from the Latin *ad pretium*, meaning to put 'at its price') the textures of merchandise — to establish this new contact with the substance of reality, the latest stage in its conquest. Thus the painters seized on the 'substance' of the atmosphere to represent space, instead of trying to render space by means of the geometrical, as was done in Italian perspective.

At the end of the 13th century Jean de Meung, author of the last part of the *Roman de la Rose* — in which the new positivism was introduced — prophetically traced the development of the artist:

> To kneel is to be at nature's feet...
> To copy her is to overreach,
> To mimic her like monkeys.

This conception of art coincided with the reign of the middle class from the time of van Eyck in whom it was new and heroic to the time of Meissonier who stifled it in uninspired mechanical work. Its true end has been marked by two world wars which have heralded a new stage of history.

So everywhere art turned to nature. Italy, reviving the still not completely buried tradition of antiquity, regained the faith in visible reality which the mind demanded. The expiring aristocratic Middle Ages strove to retain the tradition of the elegant and arbitrary graphic style of the manuscript miniature, but this, too, ended in mundane description. It was the emerging middle class that assured the future fortune of realism through the cult of the material world.

Death and the Devil

Religious inspiration did not so much dissipate as slip back into the devoutness of former times, when it was preoccupied with the salvation of the soul and the perils surrounding the future life, perils made more formidable by realism because more tangible. St Thomas Aquinas stated as early as the 13th century: 'The worms which gnaw the damned must be interpreted in a figurative sense and signify the pangs of conscience,'

and in the 15th century Villon could have his mother say:

> In my parish church I see
> A painted paradise with harps and lutes,
> And a hell where the damned are boiled...

The tortures of the damned, which the mystery plays had already begun to portray, were represented in great detail by the Flemish painters, from Bouts to Bosch. This subject grew in importance; it met the pessimism with which the 15th century opposed the enthusiasm that had aided the early Gothic world to idealise the universe until it became etherealised. Materialism was an open door to pessimism, because it was strictly speaking a devaluation of the world. It reduced the world to what it appeared to be and nothing more. It mocked at the idealism which had given it meaning and importance. Nature was no longer a book to be read; it was merely something from which spiritual life had retreated and in which ugliness and cruelty were revealed in turn, underscored by the ills of the time. 'The 15th century was a time of terrible depression and fearful pessimism,' concluded J. Huizinga, who stressed 'the continual state of anxiety in which this century lived, constantly under the threat of injustice and violence, with the fear of hell and the Last Judgment, of plague, fires and famine and devils and witches.'

Materialism and pessimism together produced a self-centred attitude. Forced to rely more and more on his own resources, alone and faced with a universe devoid of spiritual presence, man thought primarily of his own personal fate. Religion reminded him of the crucial problems: in this world, death; in the next, eternal torment.

Iconography became more and more evocative of this. From the 13th century the *Dict des Trois Morts et des Trois Vifs* (*Tale of the Three Living and the Three Dead*), and from the 14th century the Dance of Death, presented the living man confronted 19 by the dead body. In the 15th century it was death itself, an obsessive skeleton, that became the allegorical figure. Vast compositions, in Italy in particular (in the Campo Santo in Pisa and the Palazzo Scláfani in Palermo, for example), commemorated its triumph.

In France the poor, with their strong sense of inequality, loved to stress the great levelling of the future, evoked by Villon:

> I know that rich and poor...
> Nobles, peasants, princes and misers...
> Death seizes without exception.

The Germanic countries displayed an even more uneasy penchant for the macabre and concern with annihilation. Inevitably these grew stronger as the religious struggle accentuated the break with Rome, and therefore with the Latin spirit, and encouraged a return to the medieval past which was considered a national tradition. In the 16th century Dürer, Baldung Grien and Urs Graf were to continue and develop the colloquies between the living and the dead.

The invention of printing in the middle of the 15th century and the increasing number of books illustrated with woodcuts spread the illustrations of the *Ars Moriendi* (*Art of Dying*) — the most famous edition of which was Antoine Vérard's *Art de Bien Mourir* (*Art of Dying Well*); here everyone could study for himself the means of securing his salvation. Printed books illustrated with woodcuts were responsible, also, for the spread of the Dance of Death theme — the most famous edition of which was the *Danse Macabre* of Guy Marchand in 1485.

In this materialistic century preoccupation with the body was added to that with the soul and its destiny. In the beginning the medieval tomb was no more than an emblem, and in the 13th century it was merely a conventional portrait of the 16 deceased at the age of thirty-three — Christ's age at His death. In the 14th century the personal portrait became widespread, 17

and later in the century all the horror of the corpse was exposed. Merely shown as shrunken and withered on the tombs of Guillaume de Harcigny (1393) and Cardinal Lagrange (1402) (the inscription warns: 'Thou shalt soon be like me a mouldering corpse, food for the worms'), the corpse was portrayed by the end of the 15th century as rotting, bursting, and torn open with the skeleton exposed. One need only follow Emile Mâle's interpretation of the iconographical evolution to judge how quickly the waning Middle Ages had turned to materialism and to its own termination.

The next stage was the preoccupation with evil. After turning the world from the spiritual and to the material, evil passed from neutrality to the point where it became a positive force for ill. Already, in his Last Judgments — a theme which had become so expressive of the times — Hieronymus Bosch ignored heaven and seemed absorbed in analysing hell with its horrors and monstrosities. More and more the Devil occupied the foreground. It was his menacing presence that haunted the dying in the *Ars Moriendi*.

As soon as the strong unity evolved by civilisation and protecting man from doubt and anxiety broke up and dispersed, instability, incoherence and multiplicity emerged — problems which puzzle us in the same way, placed as we are in the centre of a similar period of disruption.

Since he could not aspire to the heights, man submitted to the attraction of the depths — of regression. Caricature, exaggeration of the human face, is often found. Flemish and German art (particularly the latter) gave it pride of place. In cultivating it Bosch echoed Leonardo da Vinci, his exacting contemporary, in whom so many medieval characteristics met.

Soon there followed a preoccupation with those dark places in man where his animal nature breaks through. Bosch — of whom José de Siguenza wrote as early as the beginning of the 17th century: 'The others generally portray men as they appear on the outside, but he alone has the audacity to paint them as they are on the inside' — penetrated the darkness of the unconscious and had the intuition to render it symbolically through fantastic images and through the monsters which, together with woman, tempted St Anthony.

But the Germanic countries, whose insufficient Latin tradition left them closer to the sources of instinct, were responsible for the most striking developments in this desire to portray the world of darkness. In this art we find the theme of savage, hairy, bestial man, armed with his club and back in his forests and sometimes attacking the unicorn, symbol of purity, or the Christian angel; he was one day to become the bear still popular in Swiss folklore. The most common figures in German art of this time were the Devil (companion of the knight in the famous Dürer engraving), the hideous naked witches with flowing hair, often portrayed by Baldung Grien, and the Beast itself with many monstrous heads, which Dürer, in a little known woodcut, took from the Apocalypse for man, kneeling and terrified, to worship.

The Beast and the Devil merged into one another more and more. The demon, merely a 'dark angel' at first, acquired its bestial aspect proportionately as it became less an intellectual concept than a reflection of unconscious fears. As early as the 12th century, after the severe Cistercian reforms, the monks felt themselves to be 'besieged by devils' in their monastery which they saw as a 'fortified camp'. Repressed desires had helped bring about the representation of the Evil One in animal form in Romanesque art. However, in the same period John of Salisbury — faithful to the ideas of the primitive Church which, at the council of Prague in 563, laid curses on those who believed in 'the magical creations of the Devil' — observed that there were those who mistook the creations of their imagination and their senses for the real and the external. This observation, of profound psychological import, was in keeping with the refusal of the papacy in the 13th century to add a campaign against witchcraft to the burden of the struggle with heresy. This former campaign was not undertaken until the 14th century and gained momentum in the 15th, in conformity with the general trend of thought. And it was in the last years of the Middle Ages, and in those areas in which the medieval outlook lingered late, that the demon took on his most phantasmagoric and terrifying appearance, from Schongauer to Grünewald. Baltrusaïtis has shown how exotic influences from Asia, that opposite pole to classical antiquity, made their appearance. When, however, classical culture, brought to life again by the Renaissance, regained its prestige these uneasy emotions found an outlet in the person of Saturn, who haunted the Germans from Baldung Grien to Dürer (whose *Melencolia*, according to Panofsky, symbolises the Saturnian temperament). But even in Italy, in Marsilio Ficino's circle and with Pico della Mirandola and others, similar preoccupations could be found.

The inspiration which medieval man had received from faith now faded away; man felt himself alone and abandoned, surrounded and possessed by powerful forces. *Melencolia*, brooding on the enigmas of the world, echoed the Christian theme, at that time often treated in the same way, of Jesus forsaken on the Mount of Olives. 'Evil and Doubt,' de Vigny was to say.

However, at the same time a new concept of the world was emerging which in this context can be given the name of Renaissance, though it is sometimes considered fashionable to disagree with this title. But this concept marked the dawn of a new phase of civilisation, of which we, in our turn, are the twilight.

30. CENTRAL EUROPEAN. VEIT STOSS (probably of German origin; *c.* 1447–1533). Detail from the panel of the Magi. Altarpiece of the Virgin. 1486. *St Mary's, Cracow.*

THE REVIVAL OF REALISM
IN MEDIEVAL ITALY *Enzo Carli*

*By the beginning of the 15th century the waning Middle Ages
were giving way to new forces. We must look to Italy,
fundamentally hostile to the Gothic spirit, for the germination
of trends which, over a long period of time,
had been preparing the way for future developments.
The ever-present memory of antiquity — less and less fettered by
the influence of declining Byzantium — together with
economic and social progress, favoured not only a revival of
interest in the real world but an increased awareness of
the Western tradition.*

It is difficult to find a formula for describing on the historical
level the course of Italian art from about the middle of the 11th
century to the dawn of what we call the Renaissance. It is
preferable to speak of 'background facts' profoundly differ-
entiated, although not isolated, from the body of experiences
which, during the same period was accumulating in the rest
of Europe. For the first time since the decline of classical art
an artistic tradition was able to form in Italy which in some
way could be called national, although politically Italy was
still far from aspiring to the rank of state.

Were we to say (as is often said) that the progressive split
with the often secular Byzantine tradition began at that time
and that a fundamentally naturalistic inspiration, tempered by
the intellect because of the classical tradition, grew in strength,
we would be only partially correct. It would be better to try
to find the way in which Italian art confirms what Erwin
Rosenthal, speaking of the medieval spirit, aptly defined as the
'process of individualisation' common to all the West. This
was partly the emergence and development of what is usually
called naturalism, but was also a growing admission of the
supernatural into human life. This process of individualisation
originated in France about the middle of the 12th century
where it appeared in the poetry of the troubadours even earlier
than in the sculpture of Provence. It culminated in Italy at the
end of the 13th century in the poetry of Dante, the philosophy
of St Thomas Aquinas, the sculpture of the Pisano family and
the paintings of Giotto. The political and social conditions of
medieval Italy supplied the atmosphere most favourable to its
development.

The rise of the communes

The new individualism was reflected first of all in the radical
change, both psychological and spiritual, brought about by the
new freedoms in the rising communes (virtual city-states).
Recalling the democratic customs of republican Rome to the
extent of reviving its constitutional elements (such as the consuls,
who appeared in Pisa in 1081, and a short time afterwards in
nearly all the Italian cities), the new civic consciousness was
in opposition both to the feudal outlook of Germanic origin
and to the despotism inherited from Byzantium, more suitable
to the organisation of the papacy. The new social consciousness
inevitably influenced art, either by suggesting new themes and
new aims or (and this was the more important and decisive
point) by acting directly on the imagination and sensibility of
the artists, who were subject to the demands of the new society.
Springing not from a political doctrine but from a movement
revolutionary in origin — the rebellion against the abuses of
the clergy and the feudal elements in the Empire — the new
outlook was expressed in a variety of ways according to place

and circumstances. The vigorous spirit of independence which
characterised the communes from the first and which brought
about the decentralisation of political and economic life gave
rise to a diversity of intellectual trends and an eclecticism of
artistic styles unparalleled elsewhere.

The most immediate result in art of the new social situation
in Italy was the building, from the second half of the 11th
century, of the great Romanesque cathedrals and, from the
13th century, of the town hall (or palazzo pubblico). The grow-
ing participation of the people in politics in the course of the
evolution of the communes necessitated the creation of meeting
places which could accommodate vast assemblies. The cathe-
drals were built under secular enterprise at the expense of the
communes and by means of public subscription. They replaced
the earlier churches, property of the bishops or the lords, which
were often the object of scandalous transactions because of the
revenues, prebends and privileges attached to them. Party chiefs
and political agitators made these buildings ring for the first
time with an oratory which was no longer the flawless and
highflown Latin of the courtiers (that Latin which, according
to Otto of Freising, irritated Frederick Barbarossa) but which
had not yet become the Italian of Dante and Boccaccio; it was
a sort of dialect, full of impurities and differing from town to
town; lively and colourful, it reached the people easily and
could convince and rouse them. In the same way the sculptures
and paintings in the churches, in order effectively to teach the
illiterate faithful, had to rediscover a human measure and make
use of forms which had an obvious connection with the real
world. We do not know in just what rough patois Arnold of
Brescia incited the people of Rome to revolt, but we find this
dialect reflected in art in the primitive and tentative sculpture
of 11th-century northern Italy. There is for example in the
Civic Museum at Turin a capital showing St Peter grasping
the arm of a pious man who shambles along behind a woman;
between the saint and the man is a big key which symbolises
the entry into paradise. It is a work of poor quality from the
point of view of form and style. However, the anonymous
stonemason has succeeded in conveying the meaning of the
story in an extraordinarily direct fashion and so well that the
entry into paradise of this timid married couple takes on the
true savour and vivid effectiveness of a popular tale. This native
attempt to 'express something sincere and first hand' was the
earliest leaven of the renascence of Italian figurative art, which
rejected both the flat, decorative stylisation of the earlier Middle
Ages and the abstruse symbolism of the Byzantine tradition and
sought above all to represent everyday and domestic life, in
which there were certain legendary elements which were still
alive in the popular imagination.

THE REVIVAL OF SCULPTURE

The 'transition from concern with the terrible problems of
death and immortality to the less disturbing problems of the
world and its creatures, from great symbols and metaphysical
concepts to the representation of the immediate and living,
the individual and the tangible,' which, according to Arnold
Hauser, constituted the great turning point of the Western
outlook in the Gothic period, had its earliest beginnings in the
humble and anonymous works of the Lombard stonemasons;
these early works yet aspire to the dignity of art. And since
sculpture seems better able than any other art form to give

immediate significance to reality, it was logical that sculpture should open the way to the other arts, notably to painting, which for a long time had been stuck fast in the Byzantine style.

The Lombard stonemasons and the beginnings of realism

Centred in the 11th century in the region of the Po, between Modena, Parma, Como, Pavia and Milan, Italian Romanesque sculpture had at the outset the basic objective of rediscovering sculptural form and consequently of mastering movement as a means of expressing life. It acquired dignity and severity of style in the work of Guglielmo (or Wiligelmus), who carved the sculptures on the façade of Modena cathedral (beginning of the 12th century), including the bas-reliefs of scenes from Genesis, and whose name is inscribed on that same façade. Although Guglielmo was not unaware of contemporary French sculpture, his work is distinguished from those fantastic almost mannered creations by its profound gravity and archaic simplicity. The movements of the *Prophet Isaiah* at Souillac, and the *Prophet Jeremiah* at Moissac are 'portrayed with a dancing rhythm' according to Henri Focillon. The figures in the bas-reliefs at Modena on the other hand, composed of a few vigorous rigid planes, stand out from the smooth background with massive power, adapting themselves to their architectural framework, and show a vivid and popular narrative directness. Far from observing the organic co-ordination of all the parts of the body, the artist has freely accentuated the elements of it which best suit the needs of the story; the characters are very

31

31. ITALIAN. GUGLIELMO OF MODENA.
The Creation of Adam and Eve. Relief from the façade, Modena cathedral. Beginning of the 12th century.

much alive because of the clarity and simplicity of their gestures and are more intense in their effect because they are carved in massive solid forms. These sculptures of Guglielmo show not only a definite acquaintance with French Romanesque sculpture but also, and above all, the strong influence of Roman classical art. There are for example small figures of Eros, leaning on reversed torches, which could be the descendants of similar funerary figures from a sarcophagus of the Imperial period.

This nostalgia for ancient Rome is one of the most characteristic features of Italian sculpture, and in the Middle Ages it ranged from the revival of pagan themes to attempts at exact imitation of drapery.

The art of Benedetto Antelami — the leading Romanesque sculptor of his time in the region of the Po (he worked in Parma in the second half of the 12th century) — seems to have stemmed from both classical antiquity and Byzantium. Calm and grave with firm solid masses, but animated with delicate sensibility by the treatment of the drapery folds and the hair

32

32. ITALIAN. BENEDETTO ANTELAMI.
The Deposition. From Parma cathedral. 1178.

and by fine rendering of the features, this art also recalls the contemporary sculpture of Provence. Related to Guglielmo in the pure Lombard character of his style, Antelami appears the more skilled at suggesting subtle shades of feeling and intense spiritual and physical drives. The solemnity of restrained gestures, communicating a feeling of fear and respect, appears in the *Presentation in the Temple*, one of the inner tympana of the baptistery at Parma (begun 1196) which contains Antelami's most important sculptural cycle; in the group of *Solomon and the Queen of Sheba* in the same baptistery, the expressive note rises from the static poses of the two characters — their heads turned towards each other — which remind us of two columns. But the faces are imbued with an inner life, which reminds one of the great Gothic statuary of the Ile-de-France. The equestrian statue of Oldrado da Tresseno (1233) on the Palazzo della Ragione in Milan is attributed to Antelami; although this attribution is contested today this famous sculpture, based on the reliefs at Parma, still illustrates the rapid spread of Antelami's style throughout northern Italy. Together with the contemporary group of *St Martin and the Beggar*, on the façade of Lucca cathedral, the Tresseno statue is the beginning of a trend leading up to the equestrian statues of the Scaliger 45 tombs at Verona (14th century).

Pupils of Antelami were probably responsible for the beautiful series of high reliefs of the *Labours of the Months* from 27, 29 Ferrara cathedral. The principle of adapting the figure and the background to each other, which is characteristic of French Romanesque sculpture, is clearly made use of here and is carried to the point where the proportions of figures and objects are freely altered or 'distorted'.

The spread of naturalism in Venetia and Tuscany

Even Venice and Venetia, stronghold of Byzantine art in Italy, where valuable sculptures and marble paving-stones had been brought directly from the East to decorate St Mark's, did not remain insensible to the new Lombard naturalism; and while in Verona two followers of Guglielmo of Modena — Niccolò, and Guglielmo of Verona — collaborated on the biblical scenes on either side of the main portal of the church of S. Zeno (*c.* 1140), the influence of Antelami shows up strongly in Venice itself in the very richly decorated central portal of St Mark's. In the allegories of the *Earth* and the *Ocean* and in the *Labours of the Months*, the fresh vitality of 34 the Lombard school combines particularly with the idealised classicism of the Second Golden Age of Byzantine art and inaugurates an extremely refined taste which reaches its height in this portal in the reliefs showing the Venetian *Trades* (*c.* 1275), 33 in which signs of the Gothic style can already be detected.

The penetration of the naturalistic Lombard style into Tuscany took place in an unusual way. Florence — the chief centre of 53

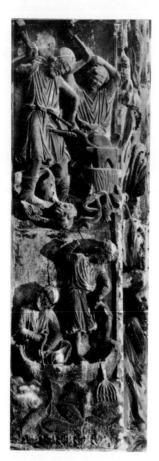

33. ITALIAN. Details from the Trades: the Smithy; Fishermen. Main portal, St Mark's, Venice. c. 1275.

34. ITALIAN. Details from the Labours of the Months: November (Bird-hunting); December (Butcher killing a pig). Main portal, St Mark's, Venice. c. 1275.

the region, where at a later date Giotto was to inaugurate a new art — was as yet untouched by it; in other centres on the other hand it spread in forms very similar to those which were adopted in the Po valley, for instance at Arezzo (*Labours of the Months* on the archivolt of the main portal of Sta Maria della Pieve). Then again it served both as a tonic and a source of discipline to the centres of culture and refinement but at the same time was more frivolous and inclined to degenerate into a preoccupation with the decorative which was a little precious and superficial, as at Lucca and Pisa. In Pisa, centre of a highly evolved figurative art of both classical and Byzantine derivation, sculpture had up till then developed essentially on ornamental forms, incorporating into capitals, cornices and architraves classical elements so faithfully imitated that it is sometimes difficult to decide whether or not certain decorative details in 12th-century buildings are re-used parts of ancient monuments of the Imperial period. About the same time, the vividly colourful architectural style created by Buschetto, the first builder of Pisa cathedral, brought about the introduction of ornamental motifs borrowed from Eastern fabrics and inlays (intarsia). It was in this refined cosmopolitan atmosphere, characteristic of the republic which up to the defeat at Meloria in 1284 was one of the greatest Mediterranean powers, that the exceedingly complicated style of Guglielmo of Pisa, the author in 1162 of the pulpit formerly in the cathedral (transferred at the beginning of the 14th century to the cathedral at Cagliari), was formed. If indeed the power of the reliefs on the panels of Guglielmo of Pisa's pulpit recalls the vigorous

plastic sense of the sculptors of the Po valley, then by contrast the backgrounds, finely incised and inlaid with black stucco, certain iconographical ideas and above all the acute sense of the rhythm of the compositions are undoubtedly derived from Byzantine art. In addition in the figures, with their drapery pleated in delicate folds in obvious imitation of classical drapery, the modelling seems to show an attempt to suggest movement and evidences subtle pictorial effects, the only equivalents of which can be found in contemporary Provençal sculpture. The work of Guglielmo of Pisa, the principal founder of an important school of sculpture which flourished up to the middle of the 14th century, is especially significant in that his pulpit is some twenty years earlier than the first documented work of Antelami, the *Deposition* at Parma cathedral, dated 1178. 32

Another great Pisan sculptor of this time, Bonannus, made in 1186 the bronze doors of the cathedral of Monreale in Sicily, and — undoubtedly later (though this is contrary to general opinion) — the bronze doors of the side portal of Pisa cathedral, facing the campanile. The figurative art of Bonannus — which integrates elements of the art of Guglielmo and whose sources reveal classical and Byzantine influences as well as the influence of contemporary Rhenish bronzes — welds its various elements in the fire of an extremely personal, candid and passionate inspiration. 35

The influence of Frederick II

In the first half of the 13th century another kind of classicism, which was particularly sensitive to political events and which was most evident in southern Italy, especially in Apulia and Campania, was added to the natural and so to speak ancestral fluid classicism which reappeared fairly openly throughout the course of Italian Romanesque sculpture. Indeed in the south Frederick II's ideal of the restoration of the Empire favoured a return to classicism, or more precisely to imitation of Roman sculpture, which gave rise to works of considerable formal refinement but of academic inspiration as, for example, certain 36

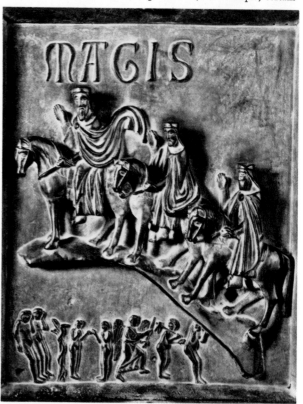

35. ITALIAN. BONANNUS OF PISA. The Magi. Detail from the bronze doors at Pisa cathedral. After 1187.

36. ITALIAN. Bust of Frederick II (1194–1250),
king of Sicily and Germany and Emperor of the West.
13th century. *Staatliche Museen, Berlin.*

37. ITALIAN. NICCOLÒ DI BARTOLOMEO
DA FOGGIA. Bust of a crowned
woman, doubtless an allegory of the Church.
Detail from the pulpit of Ravello cathedral. 1272.

busts from the Castello delle Torri on the Volturno (today in the Capua museum) imitating the busts of the later Roman Empire but roughly transformed into a Romanesque idiom. Through the imitation of classical models the Apulian sculptors achieved a deeper and nobler concept of individuality and the dignity of man. So the classical formulas which these sculptors resurrected acquired a naturalistic power of suggestion, in accord with the solemn, gravely pathetic spirit of southern Romanesque sculpture (for example the wonderful panels of the bronze doors of Benevento cathedral).

These 'classicistic' aspirations did not remain limited to the highly cultured circles of the Hohenstaufen court; in 1272, twenty-two years after the death of Frederick II, a sculptor from Apulia, Niccolò di Bartolomeo da Foggia, came to Campania and carved on the pulpit of Ravello cathedral (a pulpit resplendent with precious marbles inlaid with mosaic in the 37 manner of the Cosmati) a bust of a crowned woman (probably an allegory of the Church rather than a portrait of Sigilgaita Rufolo) whose magnificently regular features are animated by a subtle play of light and shadow. Also in close keeping with this return to antiquity, the styles borrowed directly from north of the Alps were penetrating deeply, especially in Campania and Apulia under the rule of Frederick II; in his desire to strengthen the unity of the realm and his own authority he brought about an intense building activity, constructing, in the place of the former baronial fortresses, castles, palaces and hunting lodges. These Imperial buildings, the most perfect example of which is Castel del Monte near Andria, reflected the new French Gothic style, not only in structure but also in decorative details.

The classicism of Nicola Pisano

It was at this extraordinarily complex stage in the development of Italian representational art of the middle of the 13th century that the art of Nicola Pisano (*c.* 1220 – before 1284)

suddenly appeared on the scene. Indeed the pulpit in the bap- 38, 39
tistery at Pisa (1260) — the first authenticated work of the sculptor (preceded probably by two reliefs on the portal of Lucca cathedral, which though undocumented have recently been attributed to him) — emerges not only as the expression of a great creative personality but also as an admirable synthesis of the aspirations of a whole period. This was so true that the much disputed question of the place where Nicola was born and where he had his training (the scanty documentary evidence points sometimes to Pisa and sometimes to Apulia) becomes of secondary importance. Although the obvious classicism of his style makes it probable that the artist had at some time been in direct contact with the artists working for Frederick II, his immediate models were the Graeco-Roman antiquities in which Pisa was very rich, and he was influenced even more by the growing interest in the classical world than Guglielmo of Pisa had been. Moreover, although numerous structural and decorative elements of this pulpit seem copied from the French features of Frederick II's castles, the strong sculptural sense recalls the Lombard school. Finally, the exceptional mastery of Nicola Pisano's style lends colour to the theory that as a young man he frequented Byzantine or Byzantine-influenced studios, which were skilled in highly refined working of ivory and marble (many examples of this work can be found in Pisa — in the decoration of the portals of the baptistery, for example). But Nicola combined all these elements into an essentially new style, animated by a deeper and more ideal humanity. A monumental rhythm previously unknown dominates the composition of the reliefs which decorate the panels of the Pisa pulpit, in which the basic themes of Christian iconography are revived: the *Nativity*, the *Adoration of the Magi*, 38
the *Presentation in the Temple*, the *Crucifixion* and the *Last Judgment*. These themes, together with others, appear on the pulpit of Siena cathedral, which Nicola did in collaboration with his son Giovanni and with Arnolfo di Cambio. In this

38. ITALIAN. NICOLA PISANO. Adoration of the Magi. Detail from the pulpit in the baptistery, Pisa.

39. ITALIAN. NICOLA PISANO (c. 1220 – before 1284). Pulpit in the baptistery, Pisa. Nicola's first authenticated work. 1260.

Here antique, Byzantine and Romanesque elements are intermingled with Gothic arches and trefoils.

second, greater, masterpiece Nicola's technical knowledge and expressive powers appear to have gained in stature and his whole spiritual attitude seems to have been profoundly renewed. The tendency towards massive geometrical forms in the first pulpit disappears in the second, which employs nervous and restless forms and an interplay of light and shadow. Also the nostalgia for the ancient world no longer manifests itself in rhetorical and solemn forms but appears to be sustained by a more living, animated and ardent awareness of humanity and of history. In fact in his version of the childhood and the Passion of Christ Nicola succeeded in combining the earthly and the celestial and the real and the ideal with such poetic simplicity that one can say that he, even before Giotto, must be given the credit for having created the first examples in figurative art of the new spirituality which had been awakened in the heart of Italy in the 13th century by the example of St Francis of Assisi.

Nicola's last great work was the fountain in the square in Perugia, completed in 1278. Like the Siena pulpit this work, in which a realistic note is introduced through an increasing Gothic influence, was executed in close collaboration with his son Giovanni and with Arnolfo di Cambio.

Realism in Pisa after Nicola Pisano

The lesson of the great master could not have been interpreted in a more different, one might even say contradictory, manner than by these two artistic personalities. Arnolfo, who was to become the principal architect of Florence cathedral, always favoured squared forms with heavy, clearly defined masses, so much so that his sculpture seems in some indefinable way to recapture the powerful quality of ancient Etruscan realism. With Giovanni Pisano, however, the Gothic idiom definitely appeared and became established in Italian sculpture. A visit to France by Giovanni — in which he would have become familiar with the Gothic style — has been postulated but is not too likely; in any case, however, ivories from the Ile-de-France were by that time found throughout the peninsula. To these Giovanni gave an original interpretation. Giovanni's individuality manifested itself as a dominant feature from the first work he executed independently of his father — the imposing series of over life-size statues of prophets, philosophers and sibyls carved between 1284 and 1296 for the façade of Siena cathedral. This individuality is especially evident in the extraordinary variety of sculptural solutions found in the treatment

40. ITALIAN. GIOVANNI PISANO (c. 1245 – c. 1320). A sibyl. Detail from the pulpit at S. Andrea, Pistoia. Completed 1301.

46

41. ITALIAN. GIOVANNI PISANO. Adoration of the Magi.
Detail from the pulpit at Pisa cathedral. 1302–1310.

of the single statue, solutions free of the formulas so common in northern sculpture. His dramatic pathos is stressed again in his later works. The flowing linear quality, reminiscent of Gothic, gives way to a harsh, exaggerated modelling which is emphasised through the play of light and shadow. The two 40 pulpits executed by him — the first for the church of S. Andrea 41 at Pistoia (completed 1301) and the second for Pisa cathedral (1302–1310) — superficially reflect Nicola's great examples, but the spirit and the style are completely different. The vitality of the sculptures springs from the discordant contrast of masses with deeply undercut spaces, which produces a terse narrative style of extraordinary emotional strength, in which one finds oval compositions and powerful foreshortenings. A few years later we see a change in Giovanni's style which ultimately tended to a kind of negation of sculptural form, the energy that had gone into it now finding its outlet in powerful brief linear notation and sharp streaks of light. Although the whole of Italian 14th-century sculpture is more or less directly influ-

enced by the teachings of Giovanni, no sculptor ventured further than he did in his last works towards denying the traditional sculptural values by means of a violent illusionistic or pictorial expressionism which was ultimately derived from Gothic realism.

On the contrary, the general tendency was towards a material and structural approach which went hand in hand with the search for a more agreeable and a simpler realism. And this was the particular contribution of the Sienese school. This applies to Tino di Camaino, whose development reflected the influence of Arnolfo's style and whose figures of emperors, courtiers, prelates and saints were static in posture with grave, pensive expressions. The same is also true of Gano da Siena, author of an impressive example of 14th-century portraiture, *Ranieri del Porrina*, the statue at Casole d'Elsa, and of Goro di Gregorio and Agostino di Giovanni, charming narrative artists. Also, in the reliefs of biblical scenes and of the *Last Judgment* on the façade of Orvieto cathedral, Ramo di Paganello and Lorenzo Maitani expressed a fine Sienese sensitivity 44 in sculpture in fairly light relief and of a refined rhythmic and linear style.

In Florence on the other hand Andrea Pisano, in his bronze reliefs of scenes from the life of John the Baptist (1336), on the earliest pair of doors of the baptistery, regained a simplicity and dignity which were basically classical, in which the influence of Giotto can be seen. Andrea's admirable relief panels representing the *Arts* and *Sciences*, on the lower part of the campanile of Florence cathedral, were based on drawings by 43 Giotto. One of Andrea's sons, Nino Pisano, rivalled in his finely carved graceful Madonnas the most delicate linear elegance 42 in French Gothic statuary. Thanks to Nino Pisano and Giovanni di Balduccio (also Pisan) the new Tuscan style spread throughout northern Italy where there had previously been no great sculptors apart perhaps from the unknown sculptor from Verona (free of Tuscan influence) whose equestrian statue of Can Grande della Scala (Verona museum) represents one of 45 the most perfect embodiments of the chivalric, realist spirit of the north. It is a work full of crude popular vitality, but it is at the same time superbly feudal in character.

42. ITALIAN. NINO PISANO (d. before 1368).
Madonna and Child. Second half of the 14th century.
Sta Maria Novella, Florence.

43. ITALIAN. ANDREA PISANO (d. 1348).
Agricultural work. Relief on the campanile, Florence.
Between 1337 and 1343.

44. ITALIAN. LORENZO MAITANI (c. 1275–1330).
Head of Christ. Detail from a crucifix.
First quarter of the 14th century. *S. Francesco, Orvieto.*

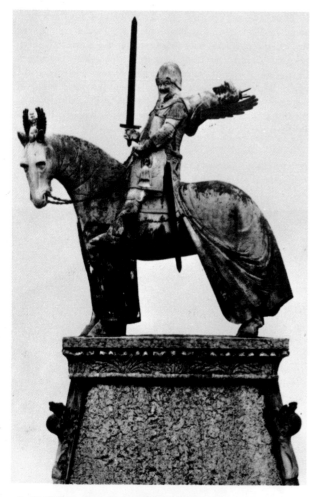

45. ITALIAN. Equestrian statue of the
Governor of Verona, Can Grande della Scala,
friend of Dante (d. 1329). *Verona Museum.*

THE NEW PICTORIAL LANGUAGE

In painting the break with the Byzantine tradition and the creation of a new naturalistic style came about far less easily and considerably later than in sculpture. A few great creative personalities in the second half of the 13th century were the inaugurators. It would be incorrect however to say that up to that time Italy had been, in painting, a mere province of ancient declining Byzantium. Although Byzantine trends, given new vigour by the neo-Hellenistic revival, continued to spread throughout the peninsula from Venice to Sicily during the whole of the 13th century, it is not unusual to find here and there the beginnings of a renascence which drew readily on classical and Early Christian painting. This can be seen in the frescoes in the lower church of S. Clemente in Rome (*c.* 1080), 48 where it has been claimed that the first examples of an 'Italian style' in painting can be found. However, the most imposing ensemble of work in the Byzantine style in Italy, the mosaic decoration in St Mark's in Venice, in which local masters and craftsmen from the East collaborated, is equally distinguishable from Eastern models through the persistence of strong Early Christian characteristics and in the assimilation of Romanesque and pre-Romanesque elements. The Venetian cycle of mosaics is freer and is especially rich in the ethnic and historical motifs added to the principal theological and liturgical themes. It can be said that Western themes, nearer to the *speculum mundi* of a cathedral, are expressed in the language of Byzantium. During the same period in Rome the impressive mosaic compo- 47 sition in the apse of Sta Maria in Trastevere (*c.* 1145), with its regal, stately yet human figures was, despite its Byzantine characteristics, the prelude to the noble and monumental pictorial style which Pietro Cavallini used in the following century. 49

The earliest examples: Lucca, Pisa and Rome

The region destined to excel in the new pictorial language by the combination of the most varied cultural trends was Tuscany. From the first decades of the 13th century four quite distinct local traditions took shape, two of which, the Florentine school and the Sienese school, were to reach their greatest heights during the first half of the 14th century and to dominate the whole of Italian painting throughout the century.

The schools of Lucca and Pisa, however, were more limited in development. There are examples of the former school dating from the end of the 12th century. These consist of a few painted crucifixes in which, with a completely Romanesque simplicity and vitality, the Western theme of the living Christ was revived. They resemble the treatment given the subject by a certain Guglielmo in a painted crucifix in Sarzana cathedral, signed and dated 1138. From the beginning of the 13th century the Berlinghieri, a family of painters, were working in Lucca; 50 they were influenced by the new wave of Byzantinism which reached the peninsula after the capture of Constantinople by the crusaders. This courtly refined style had its first and greatest centre of expansion in Pisa. This was owing to the very strong links between this maritime republic and the East, and also to several remarkable artists such as Giunta Pisano, Enrico and Ugolini di Tedice and the anonymous painter now known as the 'Master of S. Martino'. The element of pathos in the Byzantine style was given its most extreme expression in the crucifixes of Giunta. The one painted in 1236 (which is now lost) for Elias of Cortona, the founder of the basilica of S. Francesco at Assisi, was inspired, like all Giunta's other crucifixes, by the Eastern iconography of the *Christus patiens*, that is, the Brother of Man in His suffering. Under the influence of the Franciscans this interpretation was definitively substituted for the heroic Christ, impassive, triumphing over death.

At this time, when in Florence in the great mosaic in the

46. ITALIAN. ARNOLFO DI CAMBIO (*c.* 1232 – *c.* 1301).
Pope Boniface VIII. Detail. *Opera del Duomo, Siena.*

47. ITALIAN. BYZANTINE. Christ, the Virgin and
St Peter. Detail from a mosaic in the apse of
Sta Maria in Trastevere, Rome. *c.* 1145.

48. ITALIAN. Mass of St Clement. Detail from a
fresco in the lower church of S. Clemente, Rome. *c.* 1080.

baptistery 'Greek masters' (as Vasari called them) who came
from Venice and local artists were pushing Byzantine mannerism
to the limits of expressionism, Coppo di Marcovaldo succeeded
in giving new artistic validity to the abstract linearism of that
from now on degenerate and meaningless style. It was no longer
a case of creating a new language, but of attempting, though
tentatively at first, to establish a more direct link between the
artist and the world as experienced through the senses.

Following the example of Coppo di Marcovaldo, Cimabue
gave new force to the archaic harshly outlined figures of the
Christi patientes and disciplined the creative energy inherent in
such powerful individuality. After he had painted the monu-
mental crucifix in S. Domenico at Arezzo, he was in Rome
in 1272, where the contacts with the classical world, with the
moving, linear style of belated Latinism and with Early Christian
and Romanesque painting, ultimately freed him from the
formulas, both graphic and intellectual, of the Byzantine tradi-
tion; and, about ten years after Nicola Pisano's first pulpit,
he, too, rediscovered a more profound, ancient 'truth'. This was
the period of the *Madonna and Child* in the Louvre, formerly
in Pisa, which seems to be derived from ancient marbles and in
its formal relief recalls Nicola's sculpture. There is also the
54 famous *Madonna and Child* in the Uffizi (formerly in Sta Trinità
in Florence), in which the old Byzantine rigidity has changed
to a lively and sculptural grandeur, and in which the drawing
has become swift and incisive, giving the figures an intense
vitality. The frescoes in the transept of the upper church of
S. Francesco at Assisi show an unusual power of invention.
The figures have the serene and strong aspect of Romanesque
sculpture. The conventional dramatic force of Byzantine forms
which had served as a point of departure is sublimated in a
tragic and visionary violence in which the formal rhythmic
canons of the Byzantine East and the dramatic expressionism
of the Romanesque West combine in an impressive synthesis
— the end of the medieval figurative world. At the same time,
because of the predominance of drawing and relief over purely
chromatic values, it became the basis of Giotto's idiom.

Another great painter, Pietro Cavallini, appeared in Rome
towards the end of the 13th century. By taking the essence of
the local trends, which still contained influences of Early Christian
art (and, through this, of classical art), Cavallini infused a calm,
majestic beauty into a noble and cultured painting style. The
mosaics in the apse of Sta Maria in Trastevere (1291) already
show evidence, under the Byzantine conventions, of a new
material preoccupation — in the search for realism in the
rendering of the perspective of the buildings in the background
and in the calm and easy rhythm with which the figures are
placed against them. In the great fragmentary fresco of the
Last Judgment in Sta Cecilia in Trastevere (*c.* 1293) the serried 49
ranks of apostles and angels gathered round Christ are portrayed
with an extraordinary richness of coloured impasto, and each
figure gives the same suggestion of impassive grandeur. The
work of Cavallini had a profound influence on Roman and
Neapolitan painting towards the end of the 13th century and
in the first decades of the 14th century. But it was at Assisi
that this new trend, stamped with the classical spirit and inspired
by a Rome which was slowly awakening from a centuries-old
lethargy, met and mingled with the Florentine style of Cimabue
and his followers. And it was at Assisi — centre of the new
Italian religious spirit stemming from St Francis — that the
new trend in Italian painting would become firmly established.

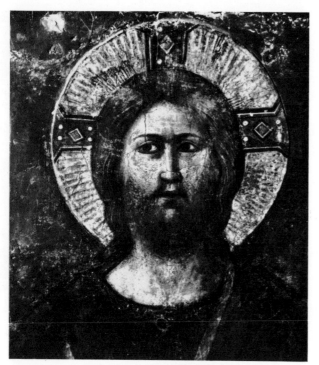

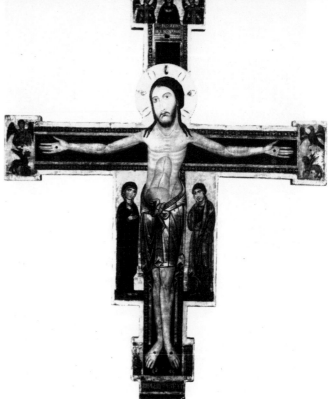

49. ITALIAN. ROMAN. PIETRO CAVALLINI
(before 1250 – c. 1330). Head of Christ.
Detail from the fresco of the Last Judgment. c. 1293.
Sta Cecilia in Trastevere, Rome.

50. ITALIAN. LUCCA. BERLINGHIERO.
Crucifix. 1228. *Pinacoteca, Lucca.*

51. ITALIAN. FLORENTINE. GIOTTO (1266/67 – 1337).
The Kiss of Judas. Detail from a fresco in the
Arena Chapel, Padua. c. 1305 – 1309.

Giotto and the new era

56 The scenes from the life of St Francis painted by Giotto and
his assistants in the nave of the upper church of S. Francesco
at Assisi mark the beginning of a decisive stage in the progress
of the whole of Western civilisation. It was, indeed, the first
time that a theme of sacred character was interpreted with so
much human warmth; it was far above mere narrative illus-
tration. Giotto's fresco cycle gives expression to the truly lasting
significance of the life of St Francis by putting it into the realm of
human sensibility. The expression of the feelings of the characters
is in fact restricted to eloquent gestures. By the simplicity and
naturalness of their emotions the figures acquire that physical
reality which endows them with a compelling force and that
accent of profound 'truth' which on the other hand is closely
linked with the continued effort to translate volumes into dense
plastic form (the famous 'tactile values' of Berenson). Now,
through a new interpretation, the landscape and other elements
of the background are no longer stylised in an abstract manner
nor are they used symbolically; they are drawn from reality
and not from conventional concepts.

51, 52 In the cycle of frescoes in the Arena Chapel in Padua, which
includes among other subjects scenes from the lives of the
Virgin and Christ and from the story of Joachim and Anna,
Giotto's style is even more highly developed and more concise,
and greater synthesis has been achieved in the handling of
composition. In this work of Giotto's the human figure has
finally become of central importance — a clear foreshadowing
of the essential character of Tuscan art of the Renaissance.

 To maintain an accurate historical perspective, however, we
should point out that there remains something basic in Giotto's
figures which makes us feel that they are not conscious parti-
cipants but are the instruments of a divine will which assigns
to each one of them a fixed function and place which he must
maintain for ever. It is in the light of this concept that Giotto's
'realism' must be interpreted. The faces of the most indivi-

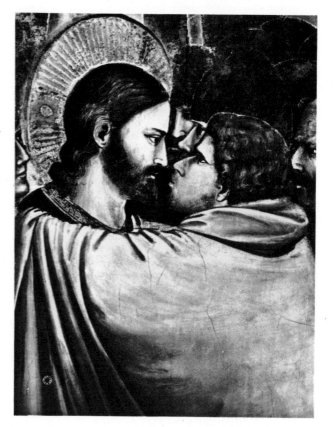

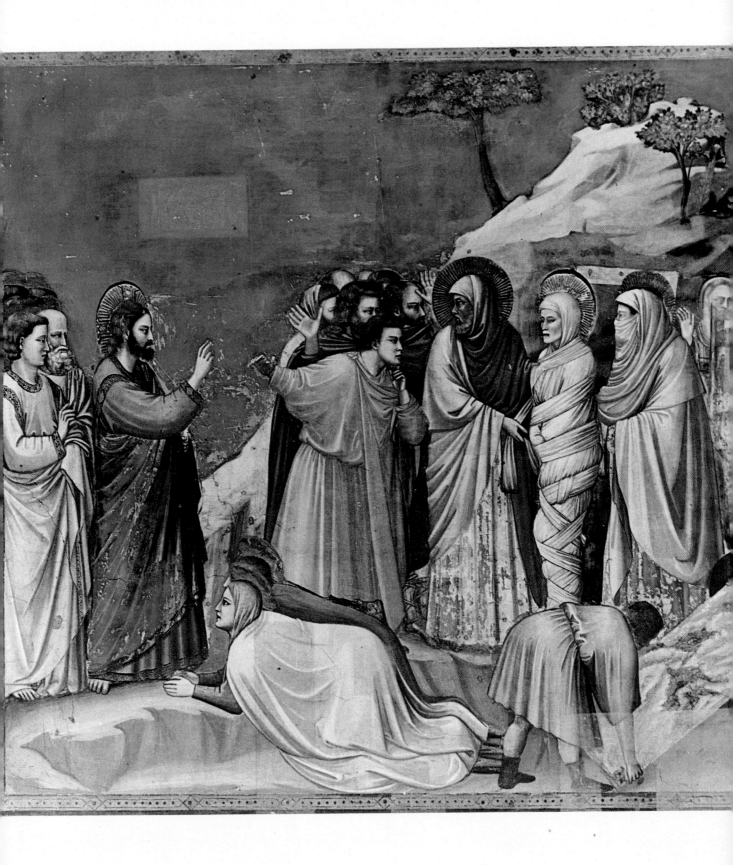

ITALIAN. FLORENTINE. GIOTTO (1266/67–1337).
The Raising of Lazarus. Fresco. *c.* 1305–1309.
Arena Chapel, Padua. *Photo: Scala, Florence.*

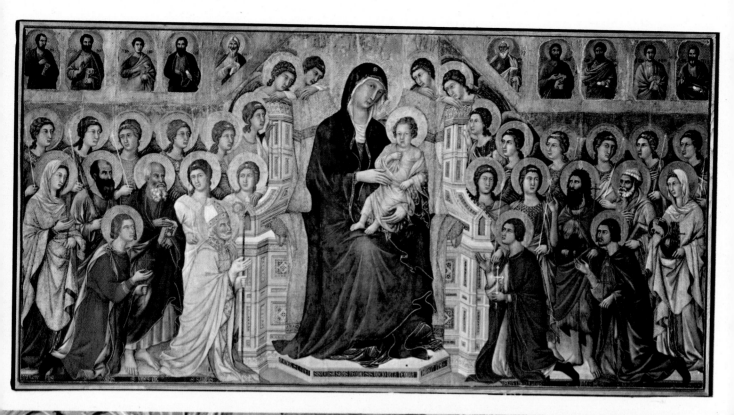

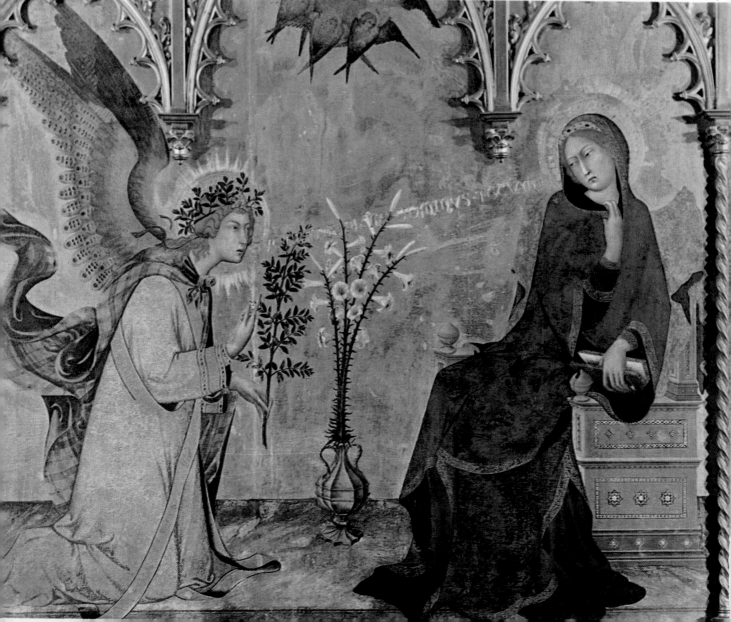

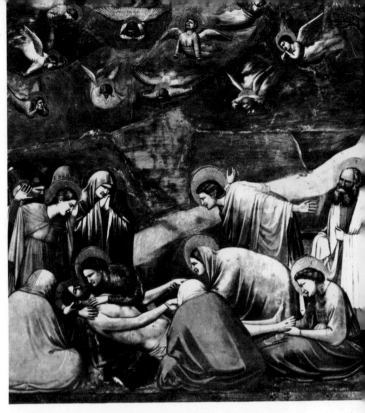

51 dualised characters in the Padua frescoes tend to assume the fixity of a mask and — although they offer a very wide range of individual expressions — like the inanimate objects, the buildings and the landscape, each one retains a 'conventional value' which is appropriate to it. In this Giotto, who was the first to succeed in the 'Greek manner' and who thus paved the way for the whole of modern art, remains fundamentally medieval and, like Dante, belongs to the spiritual climate of the Gothic and the scholastic world. He seems indeed to admit man and nature to the 'universal heaven' by the very fact of having discovered them, and he invariably attributes the human drama to divine omnipotence.

Siena's contribution

The new Sienese school of painting, of which Duccio di Buoninsegna was the founder and head, was established in a very different manner from the Florentine school with Giotto. Duccio did not change 'the art of painting from Greek (in the Byzantine sense) to Latin' (as the theoretician Cennino Cennini wrote in reference to Giotto). In a certain sense he continued to 'speak Greek'. He was not, because of this, less 'modern' than the great Florentine. The scenes from the life of

57, 58 Christ on the famous *Maestà* (the Madonna Enthroned) painted for Siena cathedral, which represent the painter's most important contribution, show that Duccio rarely renounced the iconographic formulas of centuries of Byzantine tradition. But he revitalised them through an extremely lucid consciousness of the nature of style and of the artistic function of each element of which these formulas were composed. The result of such a process of refinement was something more than an exquisite elegance of form. The great distinction of the figures themselves and their perfect harmony with the setting and surroundings give Duccio's works a refined, lyrical quality which was quite different, if not completely opposite, to the character of Giotto's work. Duccio can produce a gesture, a character or an episode evocative in a mysterious way that transcends mere illustration. Like Giotto's, his characters seem genuinely to participate in events, but they seem to be suspended in a magical, dreamlike and timeless world.

Duccio was in advance of his time in assimilating a purely Western element of style into the refined and aristocratic Eastern cosmopolitanism which had become an important influence in Sienese art during the second half of the 13th century. Before the advent of Duccio this tendency had been especially marked in the work of Guido da Siena and his followers. The Sienese painters could have borrowed this purely Western characteristic, the emphasis on a flexible, sinuous linear style coming from Gothic influence, as much from the lively, decorative calligraphy of the illustrations in French manuscripts as from the rhythmic flowing lines of Giovanni Pisano's sculpture. Henceforth preoccupation with line would in general be characteristic of Sienese painting.

59 For Simone Martini, the second of the great Sienese masters, this was in fact a vital source of inspiration. Line was truly the basic element of his style; he never let it become decorative in a superficial and facile way despite the extraordinary richness and elegance with which it was developed and modulated. In all his work Simone Martini gave a vivid, authentic and humble interpretation to the life and times and the people of 14th-century Siena. We see it in the *Maestà* (1315) — a fresco com-

52. ITALIAN. FLORENTINE. GIOTTO. The Deposition. Fresco in the Arena Chapel, Padua. *c.* 1305–1309.

53. ITALIAN. FLORENTINE. GIOTTO.
The Death of St Francis. Detail. Fresco in the Bardi chapel, Sta Croce, Florence. *c.* 1317–1324.

ITALIAN. SIENESE. DUCCIO (*c.* 1255–1319).
Maestà. 1308–1311. Opera del Duomo, Siena.
Photo: Scala, Florence.

ITALIAN. SIENESE. SIMONE MARTINI (*c.* 1284–1344).
The Annunciation (centre panel). 1333. Uffizi.
Photo: Scala, Florence.

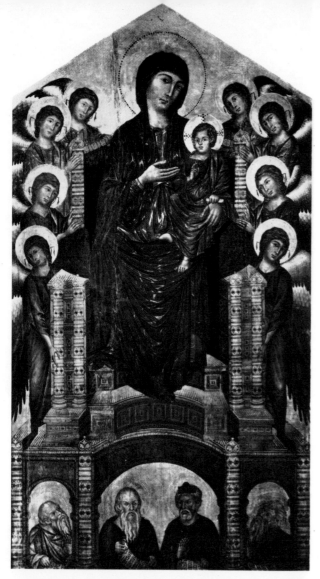

54. ITALIAN. FLORENTINE. CIMABUE (c. 1240 – c. 1302). Madonna and Child. *Uffizi.*

56. ITALIAN. FLORENTINE. GIOTTO.
The Christmas Mass at Greccio. Fresco in the upper church of S. Francesco at Assisi. c. 1288–1296.

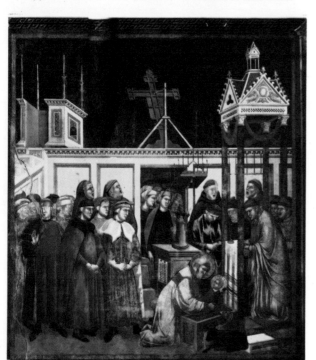

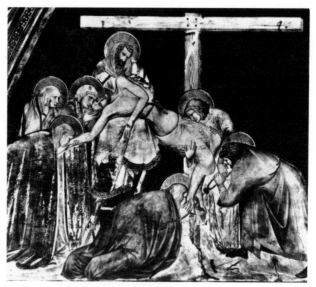

55. ITALIAN. SIENESE. PIETRO LORENZETTI (d. 1348). The Deposition. Fresco in the lower church of S. Francesco at Assisi. Between 1320 and 1330.

The composition centres round the body of Christ, and the figure recalls the emaciated figures of the crucified Christ by Giovanni Pisano.

missioned by the Sienese magistrates to occupy the place of honour in the Palazzo Pubblico — where he had to express a reviving secular and civic fervour, and we see it also in the famous polyptych of 1320 (now in the Pisa museum), where he had to revive traditional iconographic forms. It is also evident when, as in the altarpiece of *St Louis of Toulouse Crowning Robert of Anjou* (1317, Naples museum), he had to exalt the virtues of a saint of royal blood for one of the most cultured courts of Europe. Simone's work, the most agreeable and refined in its serene beauty of all 14th-century painting, is also one of the richest expressions of an earthy realism. The rough soldiers and the fat, ranting clerics and monks who appear in the scenes from the life of St Martin — Simone's fresco cycle in the lower church of S. Francesco at Assisi — are an example.

Florentine painting, despite the strength it had drawn from Giotto's realism, seems in comparison with these paintings to remain in a restricted court circle. But the realism of the Sienese school always retains a certain poetic atmosphere because of the rigorous choice of stylistic elements — line and colour — and because, too, this realism had at its origins a feeling of receptivity to the world and to its physical phenomena. It was a religious feeling, as can be seen from the formula which the Sienese painters employed to define themselves at the beginning of their *Brève* or guild statutes in 1355: ' We are, by the Grace of God, those who show to ignorant men, who cannot read, the miracles wrought through virtue, and by virtue of the holy faith,' which can be compared with the famous saying of Thomas Aquinas: ' God rejoices in all things, because each one of them is in harmony with His Being.' It is also the key to the so-called ' particularism ' of Sienese painting, in other words the tendency to portray the humble objects of everyday life with a lively and elegant grace, a tendency which began with the innumerable details of Duccio's *Maestà* and was well established in the paintings of Simone Martini and the Lorenzetti brothers, Ambrogio and Pietro.

This realism was not emphasised only when it was a case of giving greater persuasive force to religious themes such as episodes from the lives of Christ, the Virgin and the saints. It reinforced the piety of the faithful by attributing to sacred

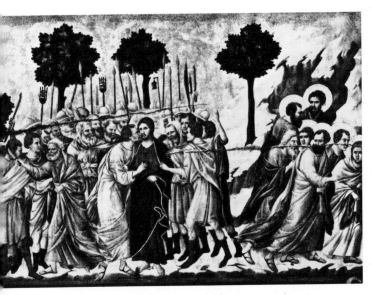

57. ITALIAN. SIENESE. DUCCIO. The Taking of
Christ. Back of the Maestà. *Opera del Duomo, Siena.*

*Several panels from the back of this altarpiece have been lost;
others are to be found in London, in
Washington and in the Frick Collection, New York.*

58. ITALIAN. SIENESE. DUCCIO (*c.* 1255 – *c.* 1319).
St Agnes. Detail from the Maestà. 1308–1311.
Opera del Duomo, Siena.

59. ITALIAN. SIENESE. SIMONE MARTINI (*c.* 1284–1344).
Guidoriccio da Fogliano. Detail. 1328. *Palazzo Pubblico, Siena.*

60. ITALIAN. SIENESE. AMBROGIO LORENZETTI
(d. 1348). Detail from the Effects of Good and
Bad Government. 1337–1339. *Palazzo Pubblico, Siena.*

characters human emotions and feelings; we can see this in
the psychological intensity and sensitivity with which the maternal
sweetness of the Virgin (chosen as the 'protectress of and
intercessor for' the city after the victory over the Florentines
at Montaperti in 1260) is expressed. In his famous fresco cycle
60 of the *Effects of Good and Bad Government* (Palazzo Pubblico,
Siena), Ambrogio Lorenzetti would no doubt not have produced
so living a picture of the life of his city if he had not been very
much a part of that world both as an artist and as a man and a
citizen. Moreover, the moral philosophy and the political and
civic advice which he propounded in the form of allegorical
images (the series is ethical and didactic in intent) aimed actually
at fitting the fresh impressions gained by the painter through
a new outlook on the world around him into an intellectual
climate which drew inspiration from classical thought.

55, 60 The painting of Ambrogio and Pietro Lorenzetti, the last great
masters of the 14th century in Tuscany, represented the climax
of medieval Italian realism — a realism which throughout its
course (as we have seen) harked back to the classical world
and was animated by a deep ethical and religious ideal. It had,
therefore, very little in common either with the courtly, aristo-
cratic realism of France and Bohemia, stamped with the spirit
of chivalry and of the troubadours, or with the middle class
realism of Burgundy and Flanders. Although the complex
trends of Italian painting in the 14th century were not all
offshoots of the Florentine and Sienese schools, these two schools
brought about a revival of painting which reached the farthest
regions of Italy. Only a few decades at the beginning of the
14th century — those of Giotto, Duccio, Simone Martini and
the Lorenzetti — sufficed to determine the character of Italian
painting for a whole century.

The language which those masters were the first to speak,
their 'vernacular', which was that of the Pisani in sculpture
(in literature it corresponded to that of Dante, Petrarch and
Boccaccio), was so in tune with their spiritual grandeur and
their strong individuality that when it was used by others it
was reduced to a mere patois. Only a few great figures such as
Masaccio, Piero and Donatello would be able, a century later,
to carry their legitimate heritage to its greatest heights.

Sculpture. By the beginning of the 13th century Frederick II [36] had begun his attempts to reintroduce the realism and monumentality of antiquity into the sculpture of southern Italy. However, the first great school of Italian sculpture was at Pisa. The Pisan sculptors were the first to abandon Byzantine models, having assimilated the lessons of antiquity and of contemporary French sculpture.

Nicola Pisano (c. 1220 – before 1284) was the first great innovator, with the following works: pulpit in the baptistery at Pisa (1260) [38, 39]; pulpit in Siena cathedral (c. 1265–1268); fountain at Perugia (completed 1278), in which he was assisted by his son Giovanni and his pupil Arnolfo di Cambio.

Giovanni Pisano (c. 1245 – c. 1320), Nicola's son, added an expressive, taut beauty to the calm grandeur of his father's style. His chief works are the pulpit in S. Andrea at Pistoia (completed 1301) and the pulpit in Pisa cathedral (1302–1310) [40, 41].

Nicola's followers, who carried Pisan art to other parts of Italy, included the following: Fra Guglielmo (1240 – c. 1313), who worked on the tomb of the saint in S. Domenico at Bologna; Arnolfo di Cambio (1232 – c. 1301) in Rome, who worked as an architect in Florence after 1285 (Tino di Camaino worked in Florence in 1321); Andrea Pisano (d. 1348), who did the reliefs on the first doors of the baptistery at Florence and also worked on the campanile from drawings by Giotto [43]; Andrea Orcagna (d. 1368), sculptor, painter, architect and goldsmith, whose masterpiece is the Tabernacle in Or S. Michele, Florence (1349–1359). Nino Pisano (d. before 1368), Andrea Pisano's son, developed in Pisa a graceful and elegant style closely related to French ivories [25, 42]. In Siena under Nicola and Giovanni Pisano an important school of sculptors was formed, the best known being Tino di Camaino (d. 1339), Agostino di Giovanni (d. c. 1350; tomb of Bishop Guido Tarlati in the cathedral of Arezzo, 1330), Gano da Siena (d. 1318?), Goro di Gregorio (reliquary of S. Cerbone, 1324, in the cathedral of Massa Maríttima) and Lorenzo Maitani [44] (c. 1275–1330), who worked on the reliefs on the façade of Orvieto cathedral. Under the influence of Tino di Camaino and others a local style developed at Naples.

In Lombardy the Pisan style was introduced by Giovanni di Balduccio (tomb of St Augustine, c. 1362, in S. Pietro in Ciel d'Oro at Pavia).

In Venice Nino Pisano's work influenced the dalle Masegne brothers (active 1383 – after 1400) and Andriolo de Sanctis. At a later date Giovanni and Bartolomeo Buon (active late 14th century – first half of the 15th century), together with various Venetian and Tuscan artists, decorated St Mark's and the Doges' palace.

Painting. *13th century.* In the 13th century Italian painting was still Byzantine in tradition and was influenced by mosaicists who came from the East to southern Italy and to Venice.

In Rome the style of the Byzantine artists brought from Venice by the popes prevailed (chapel of S. Silvestro, Rome; Anagni cathedral; portrait of St Francis in the Sacro Speco at Subiaco), but frescoes in S. Lorenzo fuori le Mura (c. 1216–1217) showed a pronounced classical influence. Pietro Cavallini (before 1250 – c. 1330) brought new life to Roman painting through his feeling for volume and the majestic beauty of the faces of his characters. Examples of his work are: mosaics in Sta Maria in Trastevere (1291), Rome; frescoes in Sta Cecilia in Trastevere (c. 1293) [49]; frescoes in S. Giorgio in Velabro, Rome (c. 1296). Jacopo Torriti (mosaics in S. Giovanni in Laterano, c. 1291; *Coronation of the Virgin,* mosaic in Sta Maria Maggiore, 1295) worked at Assisi. Cimabue (1272) and Arnolfo di Cambio worked temporarily in Rome.

Pisa and Lucca played an important part in the 13th century in the initial stage of Tuscan painting. Crucifixes and icons, although still Byzantine in style, became more 'Western' in treatment. The work of Giunta Pisano, who was active from 1229 to c. 1254 (crucifix in Sta Maria degli Angeli, Assisi), foreshadowed Cimabue and Cavallini. The so-called 'Master of S. Martino', a Pisan, who painted the *Maestà* in the Pisa museum (c. 1260–1270), was a forerunner of Duccio. In Lucca the work of the Berlinghieri (Berlinghiero and his sons Barone and Bonaventura [50]) illustrates the same transitional phase.

The workshops of Assisi were a meeting place in the 13th century for Roman and Tuscan mural painters. Duccio may even have worked there.

In Florence Cimabue (c. 1240– c. 1302), the most important painter before Giotto, was trained in the Byzantine tradition in the workshops of the baptistery. He worked in the basilica of S. Francesco at Assisi (*Madonna with Angels* and *St Francis* in the lower church; *Crucifixion* in the upper church). Cimabue visited Rome in 1272, and he later worked in Pisa (figure of St John in the apse mosaic in Pisa cathedral, 1302). His last works (*Madonna and Child,* Louvre) foreshadow the art of Giotto [54].

In Siena, Guido da Siena was the principal painter in the earlier years of the 13th century. The real founder, however, of the Sienese school was Duccio di Buoninsegna. In his work the grace and humanity and the power of emotional expression of the figures dominated the hieratic style of the Byzantine tradition. His masterpiece — and the only work which can be attributed to him with certainty — is the great altarpiece of the *Maestà* (1308–1311) [57, 58; see colour plate p. 36], painted for Siena cathedral and now in the Opera del Duomo, Siena (parts of it are also in the National Gallery, London, the Frick Collection, New York, and the National Gallery, Washington). The *Rucellai Madonna,* formerly attributed to Cimabue but now considered Duccio's work, shows Florentine influence.

14th century. The true founder of the Florentine school was Giotto (Giotto di Bondone, 1266/67–1337 [51, 56; see colour plate p. 37]). His ability to render three-dimensional form and space, the simplicity of his compositions and his effective portrayal of human emotions make his works the first modern paintings. He was influenced earlier in his career by Rome, where he painted the *Navicella* in St Peter's (c. 1298); before this he had painted the frescoes depicting the life of St Francis (upper church at Assisi, c. 1288-1296). His greatest work is in the Arena Chapel at Padua (c. 1305–1309) [52], in the frescoes depicting the lives of Christ and the Virgin, which also include a *Last Judgment,* and the *Virtues* and *Vices.* From about 1317 to 1324 he worked on a fresco cycle in the Bardi chapel in Sta Croce, Florence, of scenes from the life of St Francis [53]. He also worked in Naples for Robert of Anjou (1329–1332) but returned to Florence in 1334 to direct the work on the cathedral. His impact on Florentine painters was enormous, resulting in a sort of Giottesque academicism. Artists influenced by him were: Taddeo and Agnolo Gaddi, Bernardo Daddi (also influenced by Sienese painting), Maso di Banco, Giottino and Nardo di Cione. Giotto's influence is also noticeable in the work of Andrea Orcagna (d. 1368), Andrea da Firenze, Spinello Aretino and the painters of the frescoes at the Campo Santo, Pisa.

Siena, a Ghibelline stronghold having close ties with Naples, Milan and France (Avignon), became in the 14th century a centre of the refined, intellectual, courtly trend of which the art of Simone Martini (c. 1284–1344) is a typical example. Simone's first work was the *Maestà* in the Palazzo Pubblico, Siena (1315). His equestrian

portrait of Guidoriccio da Fogliano (1328) [59] recalls the epic poems of chivalry. Between 1320 and 1330 he painted frescoes in the chapel of St Martin in the lower church of S. Francesco at Assisi; in Naples he painted *St Louis of Toulouse Crowning Robert of Anjou* (1317); in 1339 he went to Avignon where he died in 1344. His finest work is perhaps the *Annunciation* in the Uffizi, Florence (1333) [see colour plate p. 38]. His last works, such as the *Annunciation* in the Musée Royal des Beaux Arts, Antwerp (after 1339), were more dramatic and emotional and had an even more refined linearity. His chief follower was Lippo Memmi (active by 1317; d. *c.* 1356).

Pietro Lorenzetti (d. 1348) and more particularly his brother Ambrogio Lorenzetti (d. 1348) brought Giotto's influence to Sienese painting. Many of Pietro's powerful paintings show the influence of Duccio and of Simone Martini, for example: altarpiece in the church of Sta Maria della Pieve, Arezzo (1320); *Carmine Altarpiece* (1329, Pinacoteca, Siena); *Birth of the Virgin* (1341, Opera del Duomo, Siena) [55]. While working on the frescoes in the lower church at Assisi (including scenes from the Passion of Christ) he came under the influence of Giotto. Ambrogio Lorenzetti's best works are his frescoes of the *Effects of Good and Bad Government* (1337–1339, Palazzo Pubblico, Siena [60]), which represent the zenith of naturalism in 14th-century Italian painting. The last notable 14th-century Sienese painter was Barna (active middle of the 14th century).

In Pisa apart from the *Allegory of the Three Living and the Three Dead* in the Campo Santo, attributed to Francesco Traini (active 1321 – after 1345), the most remarkable work was the fresco of the *Triumph of Death* (middle of the 14th century; destroyed in 1944), also in the Campo Santo, which showed both Tuscan and Bolognese influence.

Giotto's style was transmitted to northern Italy by way of Emilia and the Marche, and Ravenna and Rimini, through such painters as Giovanni Baronzio (active middle of the 14th century in Rimini), Pietro da Rimini and later (about 1415) by Jacopo and Lorenzo Salimbeni who worked at Urbino in a Gothic style.

In Bologna, which was an intellectual centre of international character, the influence of early 14th-century manuscript miniatures of French style could be seen in some very original frescoes which were free of Tuscan influence, such as those of Vitale da Bologna (active *c.* 1330 – after 1359) and Tommaso da Modena (*c.* 1325–1379), who worked at Treviso (frescoes of eminent Dominicans, in the church of S. Niccolò) and in Venetia.

In Lombardy at the fashionable court of the Visconti a more direct French

61. ITALIAN. SIENESE. SIMONE MARTINI (*c.* 1284–1344). Miniature from Virgil. Detail. *c.* 1340. *Ambrosiana Library, Milan.*

and Rhenish influence was responsible for manuscript miniatures of a linear character (Giovannino de' Grassi, d. 1398; Michelino da Besozzo). The most outstanding Lombard painter of the period was Giovanni da Milano (active *c.* 1350–1369) [62].

The founder of the local school in Padua and Verona was Altichiero (*c.* 1330 – *c.* 1395); born near Verona, he worked in Padua where he was influenced by Giotto's frescoes. The Bolognese and Lombard miniaturists also contributed to his style. In the work of his follower Stefano da Zevio (*c.* 1375 – *c.* 1450) the delicate beauty of the colour and the graceful linear Gothic style point to the influence of French and Rhenish miniatures (*Madonna of the Rose Garden* [71]) and foreshadow the work of Gentile da Fabriano and Pisanello.

Guariento (active 1338 – before 1378), a Paduan, also worked in Venice. Paolo Veneziano (active *c.* 1333 – *c.* 1362) gave the emergent Venetian school a style presenting a mixture of Byzantine and Gothic elements with a marked feeling for colour (verso of the Pala d'Oro in St Mark's). The paintings executed for the Doges' palace by Guariento and Gentile da Fabriano (from *c.* 1408) brought the International Gothic style to Venice.

62. ITALIAN. GIOVANNI DA MILANO (active *c.* 1350–1369). Detail from the Crucifixion. Fresco. *Brera, Milan.*

41

THE INTERNATIONAL GOTHIC STYLE

Charles Sterling

*While towards its close the Middle Ages seemed,
especially in architecture and sculpture, to have reached the
peak of its evolution and to have arrived at its 'baroque' phase,
it was also coming under the influence of the growing realism.
Painting, which remained a less rigid medium,
lent itself better to these new and worldly influences, even in the
aristocratic circles which were nostalgically attached to the past.
Despite its refined mannerism painting made increasing
concessions to the search for visible reality.*

More than half a century ago art historians — the first of whom
was Louis Courajod (1892) — noticed that a large number of
paintings dating from about 1375 to 1425 bear a surprisingly
strong resemblance to one another. These made their appearance
throughout Europe, from England to Bohemia and from the
Low Countries to Spain and Sicily; many were painted in the
kingdom of France and the Duchy of Burgundy. Whether the
subject matter is religious or profane, frescoes, miniatures from
manuscripts, stained glass, tapestries, embroidery and enamels
frequently reflect the style of contemporary paintings. The
relationship between these works is so marked that a number
of them have been attributed by the greatest experts to a group
of successive schools. Intrigued researchers have accumulated
information which justifies the art historian's recognition of the
existence of a trend in painting which is called, by common
consent, the International Gothic style. The most obvious
characteristic of this trend is a stylisation which subordinates
all forms — from the human figure to trees and rocks — to
the rhythm of a fluid, curvilinear style obviously based on
Gothic aestheticism. This linear style is of the greatest refine-
ment; human beings and animals are treated with the same
grace and elegance — qualities almost equally apparent in the
delineation of rustic characters and everyday objects. Religious
subjects, too, despite a mysticism which sometimes achieves a
lyrical fervour, take on a worldly appeal. The painter has
attempted to cover his canvas with a multitude of narrative
episodes in which the objects, clothes and manners of the times
are reproduced. In this way religious art has been profoundly
humanised. This secularising is accompanied by an increasing
use of profane subjects — hunting, farming and scenes of
urban life.

In order to study the origin of this movement, how it took
shape and the way in which it spread throughout Europe, it
is necessary to follow the history of the Gothic style in medieval
painting in profane art, and more particularly in the court
art of the period.

The origins of profane art

There was a large output of profane art in the period of clas-
sical antiquity — landscapes, genre scenes, still lifes, historical
subjects, battles, etc. An extremely evolved style corresponded
to this zest for life which was sharpened by the townsman's
nostalgia for nature. The painter aimed at a completely natu-
ralistic illusionism; he evoked the illusion of true relief and of
spatial recession through the use of light and shadow and
thereby achieved trompe l'oeil. The barbarians stamped out
this tradition. In Europe the new Christian religion with its
transcendental spirit was not concerned with profane subjects.
However, historical painting did not die out. Employed to
uphold the Imperial power, in the West as well as in Byzantium,

63. ITALIAN. GENTILE DA FABRIANO (*c.* 1370–1427).
One of the Magi. Detail from the Adoration of the
Magi. 1423. *Uffizi.*

it extolled the past and the present prestige of the dynasties.
In this painting the desire for naturalism persisted as a powerful
undercurrent. It took on new life in the Byzantine workshops
and the Carolingian monasteries at the same time that Christian
theology, continually struggling against the latent heritage of
classical thought, undermined the value of the material world.
There were many 'renaissances' in Byzantine art and in Charle-
magne's vast empire, partly because of his deliberate cultural
efforts and partly because of the then little known but cosmo-
politan activity of the monasteries, especially in Italy; it is
significant that the recently discovered frescoes in Castelseprio
are so classical in feeling that they could be ascribed as easily
to the 10th century as to the 8th.

Nothing remains of the profane decorations of the Carolingian
palaces, but descriptions of them carry an echo of the magni-
ficent scenes of war of Aachen and Ingelheim. In the Roman-
esque period, when chivalric literature and the poetry of the
troubadours glorified feudal life, it is fairly certain that the
paintings in the castles, either frescoes or textiles, had to represent
scenes of battle and of the hunt. The Bayeux Tapestry (about
1080), directly foreshadowed in English miniatures, could not
have been an isolated work. Its vivid narrative style and its
comprehensive interest in all aspects of contemporary life —
men and their various activities, animals, and buildings and
other objects — illustrate the extent and depth of curiosity
about the real world. Such a conception, presented in this
free style, carried on the ancient heritage as interpreted in the
Carolingian idiom of the astonishing *Utrecht Psalter*. There is
every reason to believe that by cultivating it England assured
the survival of realism in painting in north-western Europe up
to the beginning of the Gothic period.

Then, towards the end of the 12th century, a breath of life
was infused into the abstract linear patterns of Romanesque
sculpture and painting; the ideas of Bernard of Clairvaux and
the critical rationalism of Abelard helped to prepare the way
for this. The Alsatian miniatures of the *Hortus Deliciarum* were

64. FRANCO-FLEMISH. BOUCICAUT MASTER.
Charles VI and Pierre Salmon. Miniature from the
Dialogues of Pierre Salmon. *c.* 1411. *Geneva Library*.

65. FRANCO-FLEMISH. JACQUEMART DE HESDIN
(d. *c.* 1410). Christ carrying the Cross.
Miniature from the Très Belles Heures of the Duke of Berry.
Royal Library, Brussels.

the equivalent on the continent of those English miniatures
which were preoccupied with scenes of everyday life. This
trend seemed to reappear in the pictorial art of Ottonian Ger-
many, in which the Carolingian tradition was fused with a
Byzantine neoclassicism and, as in the English works, a strain
of the antique tradition was evident.

After a time the ideas of St Francis of Assisi and St Thomas
Aquinas brought the world of nature to Christianity. First
sculpture then painting showed a preoccupation with worldly
themes. In English illumination (beginning of the 13th century)
and then in French (end of the 13th century) the margins of
manuscripts displayed, with a tireless satirical verve, a universe
of men and beasts, the equivalent of the fabliaux and of the
Roman de Renart in literature. Both this pictorial expression
and this literary expression arose, it would seem, from the
fusion of the French and the Germanic traditions in the melting-
pots of Norman England, Picardy, Flanders and the Rhine-
land. Their dominant characteristic was a vigour and freedom
of imagination which was very nearly of the people. But at
the same period there appeared another form of profane paint-
ing in Europe — a notable innovation which was to have a
long and fertile existence — the court style, which arose in
France.

The court style in 13th-century France

In any civilisation the life of the court, conceived in terms
of an ideal, cannot do without rules and formulas and conse-
quently tends to conform to a pattern. The French monarchy,
which maintained a surprising number of Carolingian traditions,
was always ready for an ostentatious and politically useful outlay.
This happened under St Louis in the middle of the 13th century;
the *Gospels of the Sainte Chapelle* and the *Psalter of St Louis*
reveal a new unprecedented form of art, in striking contrast

to Romanesque art, in which a spirit of refined luxury and
controlled vitality betray the exigencies of the court. For the
first time in the West since antiquity a new canon is set up for
the depiction of the human form. The body, elongated, graceful
and flexible, and definitely modelled, although this modelling
is barely indicated, is both articulated and solid beneath its
clothes and is treated with a completely new sensuality. The
gestures are true to life and by a subtle art they are also
harmonious, blending with the composition and the architec-
tural setting. The supple slimness of the human figure corre-
sponds closely to Gothic aestheticism — to the vertical thrust
of the column and the pinnacle. Colour remains purely deco-
rative. The result is a perfect balance between the ideal and the
real — a balance between style and a feeling for life. But it
is a restricted life, as the exclusive taste of the courtier shows
when it condemns all spontaneous expression which might
destroy conventional elegance.

The rest of Europe was quick to adopt the new trend, which
was first taken up by the countries north of the Alps. Thus
the French court style formed the basis of the International
style in Gothic painting and bequeathed most of its charac-
teristics to the art of the late 14th and early 15th centuries.

This court style was accompanied by the spread of worldly
themes in the painted decoration in castles. Only a few frag-
ments of these paintings remain to us, such as the *Tournament
at Cindré*. But in the poetic descriptions we can sense the
enthusiasm of a rapidly growing new art. The *Roman de la
Rose*, the last parts of which date from the time of the death
of St Louis (1270), speaks of the art of painting and lists its
diverse subjects. It mentions the ' knights armed for battle, on
fine chargers covered with caparisons in heraldic blues, yellows
and greens '. It describes subjects depicted only in French ivories
and in a few paintings of the following century: various pas-

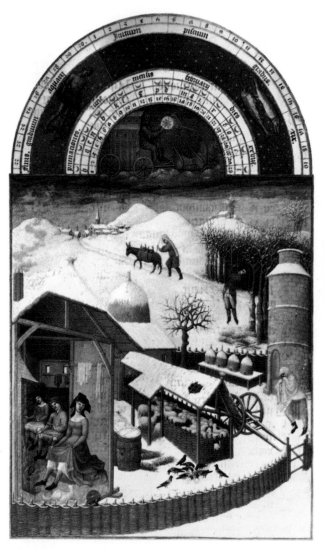

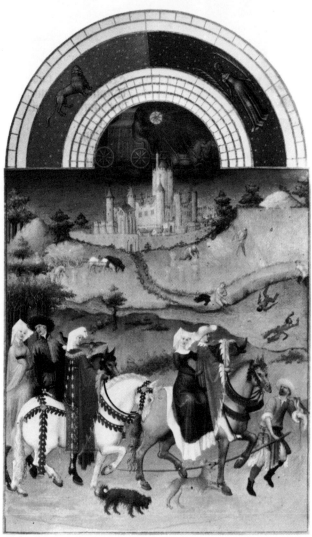

66. FRANCO-FLEMISH. BROTHERS LIMBOURG.
The Month of February. Miniature from the
Très Riches Heures of the Duke of Berry. 1411–1416.
Musée Condé, Chantilly.

67. FRANCO-FLEMISH. BROTHERS LIMBOURG.
The Month of August. Miniature from the
Très Riches Heures of the Duke of Berry. 1411–1416.
Musée Condé, Chantilly.

times, dances and rounds in which beautiful ladies in fine clothes take part. Nor does it forget the trees, flowers, animals and birds. According to the *Roman de la Rose* the frescoes, panels and sculptures show

 Beautiful little birds in green thickets,
 Fish in all the streams and pools,
 And all the wild animals
 Which graze in these woods;
 All the plants and all the flowers
 That maids and youths·
 Come to gather in the woods in spring;
 Tame birds, domestic animals ...

This is indisputable evidence (and it appears to precede the earliest Italian examples) of profane themes and the depiction of nature in literature as well as in painting. Indeed, at about the same time Brunetto Latini states that Italy does not know the luxury of painted rooms. The oldest examples still extant of the painted battle scenes in Italy come after the *Tournament at Cindré*; they date from no earlier than the end of the 13th century, and it is significant that they are found in the vicinity of Siena, the Italian city which was then undoubtedly the best acquainted with French civilisation. Young people picking fruit and ladies dancing rounds amid rich greenery can be seen in France in the Tour de la Garde-Robe in the Palace of the Popes at Avignon (*c.* 1343; attributed to an Italian artist) and at Sorgues (*c.* 1380; by French painters), and in Italy in the

Spanish Chapel in Sta Maria Novella, Florence. We can therefore conclude that in the middle of the 13th century France not only produced the court style but introduced worldly themes generally, notably those themes of aristocratic life with a bucolic tone. The foundation of what was to become International Gothic painting was thus laid.

Naturalism in 14th-century Italy

From the beginning of the 14th century Italian painting, thanks to Giotto, made an unparalleled advance towards naturalism. South of the Alps profane subjects rapidly assumed a convincing air of truth and a new authority. One has only to look at the scenes of town and country life in Ambrogio Lorenzetti's frescoes in the Palazzo Pubblico in Siena (1337–1339). These subjects, although first depicted in France in the 13th century, take on a new Italian form in the following century. Indeed, the famous foliage background in the Tour de la Garde-Robe in Avignon, which is in appearance so like the background of French tapestries (of a later date however), seems to come from Italy. It is found again, according to Otto Pächt, in Italian miniatures of the first half of the century — at which time it was unknown in French miniatures — and also in the frescoes in the Palazzo Davanzati in Florence, in which the trees alternating with columns and vases of flowers remind one of Hellenistic decoration (as can be seen from recent excavations at Pompeii).

51, 52
53, 56

60

68. *Top*. FRANCO-FLEMISH. MELCHIOR BROEDERLAM (active *c*. 1381–1409). The Presentation in the Temple and the Flight into Egypt. Wing of an altarpiece painted for the Chartreuse of Champmol. After 1392. *Dijon Museum*.

69. Detail of the Flight into Egypt.

It was at this time that the naturalism of Giotto and Duccio made Italian artists aware of the sculpture (the Pisani) and painting of antiquity, many examples of which could still be found in the ruins. In 1295 in Sta Maria Maggiore in Rome Jacopo Torriti, in his mosaics, represented *Earth* and *Water* in landscapes that were purely classical in spirit. Giotto, who was working at the same church at the same time, devoted two compartments in his Arena Chapel frescoes to a painting of a vault from which there hangs a chandelier — a trompe l'oeil motif comparable to those in Hellenistic decoration. His *Allegories* in grisaille (grey monochrome) portray little scenes in stereoscopic relief which foreshadow the painted friezes at the bottom of the pages in the *Turin Hours*; but they recall as well those minute scenes, also in grisaille, which are to be seen in the panels of the 3rd Pompeian style. Dating from about 1330–1340 at Rimini, where Giotto's influence is very marked, is a fresco showing a direct borrowing from classical painting; in one scene of the antique world, the *Earthquake at Ephesus*, we see on a stele a painting of an interior which is treated as trompe l'oeil according to Hellenistic rules of perspective.

There were the same Hellenistic influences in Sienese art from the time of Duccio and Simone Martini. Duccio always characterised the poor shepherd by his torn clothes, in which he followed Byzantine iconography; but at the same time this characterisation was the forerunner of the striking portrayals of common people which we see in International Gothic art. And Simone's handling of antique subjects recaptures all the bucolic flavour of the paintings of the late Roman Empire; an example is his miniature in the Virgil in the Ambrosiana Library, Milan, 61 painted about 1340 for his friend Petrarch, then at Avignon. His hirsute peasants, who symbolise the *Georgics* and the *Eclogues*, are the descendants of those who in a Roman mosaic in North Africa illustrate the course of the four seasons in the country (Bardo Museum, Tunis). His Aeneas, a strong, earthy warrior, seems to come straight from the *Joshua Roll* despite his belt, his hair and the Gothic folds of his mantle.

All of Simone is in that page, and he has infused into it all that his cultured background contained of the heritage of ancient Italy together with what he had absorbed from the Gothic world. In his youth he had acquired the French style, with its rhythmic folds and its curving sharply defined silhouettes, in Siena and in Naples at the court of Robert of Anjou. This style made his art more acceptable in the kingdom of France and in Burgundy than that of any other Italian painter. This work of Simone's was the first stage in the development of International Gothic art and the forerunner of the *Très Riches Heures* painted for the Duke of Berry. Simone fused 66, 67 the stylisation of French court art with the new Italian realism. By making Franco–Italian art the ' modern ' art of the century, he made the second stage towards the development of International Gothic possible.

However we must guard against an error which has been widespread, namely that of regarding Simone's work and the artistic activity of the south of France in general (not only that of Avignon but also that of Béziers, Narbonne and Montpellier) as the exclusive vehicles of the Italian influence in France. From the very beginning of the century this influence had penetrated to the heart of the kingdom of France. Italian painters had been working in France since the time of Philip the Fair; Italian paintings were being sold in Paris as early as 1328. The evidence of painting supports the evidence of literature. Not only did Jean Pucelle profit from Italian iconography, but his Italianate temple-like buildings were unrelated to those painted in French illumination in the 13th century and followed Giotto's and Duccio's methods of rendering perspective. It is possible, as Erwin Panofsky suggests, that the strong relief in which his figures are rendered, and which appeared to be unknown in

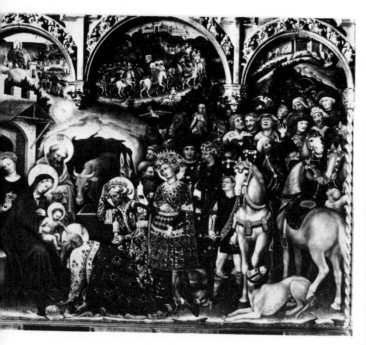

70. ITALIAN. GENTILE DA FABRIANO (c. 1370–1427).
The Adoration of the Magi. 1423. *Uffizi*.

71. ITALIAN. STEFANO DA ZEVIO (c. 1375–1451).
The Madonna of the Rose Garden. Beginning of the 15th
century. *Castelvecchio Museum, Verona*.

France even if we compare it with the distinct modelling of
Master Honoré, comes from the same source.

Nevertheless, Pucelle remained fundamentally Gothic and
French; his vision is flat, and the ethereal and vibrant world
that his art suggests adapts itself perfectly to a linear arabesque
— a combination worthy of Hokusai. In this Pucelle is behind-
hand when compared to the Italians; but he opposes their
massive and static art with an art of fascinating movement and
elegance. At the end of the 14th century, in the studios working
for the Duke of Berry, his work gained a new and powerful
65 prestige. Jacquemart de Hesdin (so-called) copied him, and the
direct tradition of his style can be recognised in the style of
66, 67 the Limbourg brothers. It is therefore impossible not to credit
Pucelle with an important role in the formation of the Inter-
national style — that of having injected new life into the tradi-
tional French style and of having bequeathed it to the gene-
ration of artists who were working about 1400.

Franco-Flemish art and its links with Italy

The Flemish painters, on the other hand, had no national tra-
dition to keep them from following the lesson of Italian art.
They accepted it at a very early date owing to the relationship
between their middle class society and that of the Italian cities
and owing in particular to their innate feeling for realism. Their
success with French patrons from the first half of the century
was due to their modern realism, inspired by Italy. However,
their Gothic background and the taste of their patrons kept
them within the aesthetic sphere of French art. The Flemish
artists who lived in France — and they included the best —
became truly Franco-Flemish artists. Jean de Bruges, in the
cartoons for the tapestry of the *Apocalypse of Angers* (c. 1375),
places an elegantly painted St John, completely French and
aristocratic in feeling, side by side with thickset virile-looking
men of the people of typical Netherlandish appearance. In the
Psalter of the Duke of Berry (c. 1385) André Beauneveu painted
the mantles of the Apostles and prophets in the French style,
but he modelled their heads with a light free touch which evokes
a suggestion of truly Flemish sensuality. Jacquemart de Hesdin,
working for the same patron, took up the Italian style with
enthusiasm; he was, however, thoroughly familiar with the
refinements of the French style and in his use of it he copied

Pucelle. It would seem that the artists working for the Duke
of Berry laid the true foundation for International Gothic in
the uniting of the traditional French style with Italian realism
as interpreted and developed by the keen and sensitive observation
of the Flemish artists. At this juncture the masterpieces of a
composite yet original art appeared in France — the miniatures
by the Boucicaut Master and those by the Limbourg brothers. 64, 66
From this time onwards Franco-Flemish art would largely
determine the course of the International style.

The record of the growth of this style would, however, not
be complete if we were to ignore yet another new factor coming
from Italy. As early as 1340 the Sienese and Florentine painters,
stimulated perhaps by the examples of antique painting, made
what amounted to a discovery of the world around them and
were on the point of rediscovering the various categories of
profane painting — still life, landscape and genre scenes. Taddeo
Gaddi painted a religious still life (Sta Croce, Florence, c. 1337),
and at the same period Simone Martini painted his very Hellen-
istic illustration for the Virgil, while the frescoes of Ambrogio 61
Lorenzetti in the Palazzo Pubblico show a picture of Siena 60
and the surrounding countryside which has an extraordinary
breadth of realism; all the activities of town and country are
represented in it. It is important to stress the influence that
these frescoes, situated in a public place in one of the most
important cities of Italy, must have exerted over the various
paintings of scenes from the calendar which preceded and led
up to the Limbourg brothers' *Très Riches Heures*. The Loren-
zetti frescoes are by far the most important example of 14th-
century profane art, and their essential realism surpasses all
that the most advanced work north of the Alps had accomplished
in this direction; this includes the miniatures of Jacquemart de 65
Hesdin and the famous *Flight into Egypt* of Melchior Broederlam. 69
The reason for this was that Lorenzetti wished to capture the
very essence of reality by eschewing the abstract stylisation of

Gothic art and treating every aspect of his paintings with this realist-approach. But Broederlam, while making his St Joseph into an authentic Flemish peasant, places his figure in front of rhythmically stylised calligraphic rocks and among ridiculously small trees — in short, in an unlikely natural setting adapted to the aristocratic dream that he serves. In this Broederlam is the perfect representative of the International court style.

The logical realism of Lorenzetti found a following in the painting of northern Italy in Lombardy, Emilia and Venetia. In 1377 a Lombard miniaturist painted rustic scenes of surprising realism. Tommaso da Modena (active from the middle of the 14th century) was the first to paint cast shadows. Vitale da 62 Bologna and Giovanni da Milano developed the sculptural treatment of the human figure. Finally, in the work of Altichiero and Jacopo Avanzo in the oratory of S. Giorgio, Padua (last quarter of the 14th century), this trend culminates in scenes having a realistic perspective and a palpable life surpassing any European painting before Robert Campin and the van Eycks. 175 Giovannino de' Grassi and Michelino da Besozza did some remarkable animal studies. Such works were precursors of the work of the Limbourg brothers and their great Flemish successors with their new visual concept of the world around them. 64 The interiors and landscapes of the Boucicaut Master, and to an even greater degree those of the Limbourgs, surpass those of the Lombard painters in the rendering of perspective and of atmospheric qualities, at any rate within the framework of contemporary knowledge. But in the preceding generation (about 1390) there was nothing in Europe which could equal the convincing impression of reality reached in the successful achievements of the Lombards (such as the dimly lit shops of the *Tacuinum Sanitatis*).

The Limbourgs (or one of them) most certainly went to Italy; there are too many indications for it to be doubted; while in the work of the Boucicaut Master (whether or not he is the Jacques Coene who was in Milan for a while) the monumental figures, like those of the Italianised Jacquemart de Hesdin, betray their foreign affiliation. We are thus justified in speculating, as does Otto Pächt, on the possibility that the sudden great flowering of Franco-Flemish painting in about 1400 was due to a link with Lombardy. The inventories of French collections mention pieces of 'Lombard work', and there were close family and political ties between the Visconti and the French princes. The artistic ties were no less well established. When Valentina of Milan came to Paris to marry Louis Duke of Orléans she brought many illuminated manuscripts with her. Jean d'Arbois, painter to Philip the Bold, Duke of Burgundy, returned from Lombardy as early as 1373. Giovanni Alcherio of Milan crossed the Alps several times to compare the secret techniques of various workshops. In this way Lombardy at the end of the 14th century, together with Franco-Flemish France, became the formative source of the International style. There as in Siena half a century earlier the realist tendencies were encouraged to develop.

By assimilating, in exchange, the Franco-Flemish influence, Lombardy became an even more effective melting-pot. Through its contact with northern art, painting in Milan and Verona underwent a profound change towards 1400. It is no mere chance that Jean d'Arbois is grouped with the most famous artists in northern Italy — with such personalities as Michelino 63, 70 da Besozza and Gentile da Fabriano. The things the Italians admired in the works of the northern painters were the curvilinear style, the bearded old men, the slim Virgins, the sumptuous 63 'Burgundian' dress and the polished elegance — in short, all the bizarre, brilliantly coloured world which appeared so perfectly Gothic and lyrically exotic south of the Alps. This attraction was comparable to that which the German and Flemish engravers were to exercise at the beginning of the

72. ITALIAN. PISANELLO (c. 1395–1455). St George and the Princess. Detail. Fresco in Sta Anastasia, Verona. c. 1435.

16th century for the first Mannerists, Pontormo and Rosso, and this is one of the connections between the International Gothic style and Mannerism. This also explains the extraordinary fondness of the northern Italian painters for linear pattern and pictorial narrative. Michelino is more Gothic, more of a caricaturist, than Broederlam, and Stefano da Zevio is more 68, 71 pliant and sinuous in style than are the painters working in France between the time of Pucelle and that of the Limbourgs. It was in northern Italy that the International style was to reach its peak, its most flamboyant and ornate development, and this stage was to continue for a long time — especially with Pisanello, who died in 1455. Owing to the artists' continued preoccupation 72 with flat surfaces and with linear pattern, the painting of this region was, despite its realism of detail, to be behindhand in an Italy in which Masaccio and Uccello were at work; but in spite of this it continued to flourish in the princely courts of the provinces, where the prestige of the courts of the dukes of Berry and of Burgundy was still very much alive.

47

The spread of the Franco-Flemish style

The courts of the dukes of Berry and Burgundy and that of King Charles VI were, it would seem, the centres from which the Franco-Flemish style spread to the rest of Europe around 1390. The characteristics of this style were clearly developed at that time in France. Its principal workshops were located in the following towns: Mehun sur Yèvre, where John Duke of Berry put André Beauneveu in charge of painting and sculpture; Bourges, where John of Berry maintained a studio of illuminated manuscripts (and where Jacquemart de Hesdin worked); Dijon, at the Chartreuse of Champmol, founded by Philip the Bold, where his painter Jean de Beaumetz (whose works had just begun to appear) was active and where Broederlam installed the altar panels he had painted at Ypres; finally Paris, where painters with purely French names were organised into a professional body but where Flemish artists of the first rank worked as well. (However it was only after 1400 that Parisian miniatures came into their own with the work of the Boucicaut Master.)

In each European country the Franco-Flemish style was interpreted according to the national idiom. We have mentioned northern Italy where the art of Giovannino de' Grassi (d. 1398) already bore the Gothic imprint. At the same time, and perhaps a little earlier, this influence appeared in Bohemia. This country witnessed an astonishing pictorial activity, the most advanced north of the Alps in the middle of the 14th century. Here the new Italian trends blended with the Germanic influences and with the established Gothic style (the paintings at Vyšší Brod). The Master of Třeboň was one of the most original painters of the International style at the end of the century. His *Třeboň Altarpiece*, which cannot easily be dated before 1390, is striking in its colour and dramatic expression. The rhythm of the outlines and of the drapery folds is clearly French; the characters are Franco-Flemish but are interpreted according to the Bohemian tradition; the chiaroscuro, the use of foreshortening and the fine rendering of the animals could well have been inspired by northern Italy. Later on the painters of Bohemia, where court

art was predominant, concerned themselves with formal harmonies and with gently curving lines. These were to dominate the style in the first quarter of the 15th century.

In Austria the patrons were the bishoprics and monasteries rather than the courts, that of Vienna excepted; also the International style was less widespread. The Master of Heiligenkreuz (*c.* 1400) interpreted the elegance of the Franco-Flemish style with Germanic exaggeration; the gestures of the figures are angular and the pointed fingers are of almost monstrous length; the deep colour, of an almost metallic brilliance, is not without its attraction. In the capital the Master of the Presentation in the Temple and the Master of the St Lambert Altarpiece (*c.* 1420) show a greater balance, and their softened modelling is reminiscent of the subtle chiaroscuro of Bohemia.

While we cannot say precisely how the Franco-Flemish style entered Bohemia and Austria (the relationship between the courts no doubt played a large part in this), its presence along the Rhine can be more easily explained. As neighbours of the Low Countries and France, these regions were early introduced to the new influences coming from western Europe. The aristocracy and the powerful middle class confraternities were quick to imitate the fashion of the princely courts, whose influence was spreading rapidly from the important artistic centre of Dijon. Here as in the Italian cities panel painting was beginning to supplant illumination. It was in the altarpieces and the small panels on domestic altars that the Franco-Flemish style came into its own at the beginning of the 15th century. We can see this in Hamburg — a Hanseatic town and therefore open to new influences — in Master Francke's altarpiece, one of the most refined and characteristic examples of the way in which courtly French grace and mannerism were translated into middle class and Germanic exaggeration. Konrad of Soest had a deeper sensitivity and was able to interpret the lyrical character of the German mystics with a gentle and graceful vivacity. With the Rhenish artists the elegance of International Gothic was fused with the fluid, gentle manner of the so-called 'soft' style

74. BOHEMIAN. MASTER OF TŘEBOŇ.
The Resurrection. Panel from the Třeboň Altarpiece. *c.* 1390. *National Gallery, Prague.*

73. FRANCO-FLEMISH. JEAN DE BEAUMETZ
(active 1370–1396). Calvary with Carthusian Donor. 1391–1395.

48

75. GERMAN. MASTER OF THE UPPER RHINE.
The Garden of Paradise. *c.* 1410–1420.
Städelsches Kunstinstitut, Frankfurt.

76. GERMAN. WESTPHALIAN. KONRAD OF SOEST
(end of the 14th century – beginning of the 15th century).
Fragment of the panel of the Death of the Virgin.
Altarpiece in the Church of Our Lady, Dortmund. *c.* 1420.
Dortmund Museum.

(*der weiche Stil*), the earliest examples of which would appear to be those from Bohemia. This delicacy of style enabled them to create exquisite dreamlike works. One of these Rhenish artists was the Veronica Master in Cologne (early 15th century); another was the Master of the Upper Rhine, painter of the famous *Garden of Paradise* in Frankfurt. Stylistically similar works were produced in large numbers in the Rhineland, some of a courtly blandness such as the *Ortenberg Altarpiece* at Darmstadt (in which the types of people and the draped figures are not unconnected with those of northern Italy) and some showing a sharper touch as in the *Crucifixion* in Colmar. In the German Rhineland the *Crucifixion* at Pähl and the panels at Bregenz are examples of a rare delicacy in painting.

In England, where there was a remarkable dearth of panel paintings, the *Wilton Diptych* (*c.* 1396), one of the most controversial of paintings, stands out as a work of exceptional quality (see colour plate p. 53). The author of this masterpiece of the court style, though influenced undoubtedly by Parisian art, shows an English taste in his figures and in his feeling for elegance. There is the same Franco-Flemish inspiration in the best English manuscripts — the Oxford *Marco Polo*, the *Beaufort Hours*, the Cambridge *Chaucer*; they have the delightful, stimulating charm of Persian manuscripts. The miniaturists Johannes Siferwas and Herman Scheerre introduced a Germanic and Flemish flavour into the International style in England.

The artists of the Low Countries, retarded by a provincialism full of robust if somewhat barbarous vigour, knew the refinements of the Flemish artists in France only through repercussions coming from there, and within the shadow of their princely courts. This was the case in Gelderland, where Mary of Harcourt tried to recreate a Parisian atmosphere, and also in Liége and in Maastricht, where the exquisite small triptych in the van Beuningen Collection (*c.* 1415) represents a synthesis of Franco-Flemish and Rhenish elements. This is the final stage of the Netherlandish International style and foreshadows the art of the van Eycks. At this time also the painters of the middle class centres of Utrecht (the *Mirror of the Virgins*, 1415), Bruges (the *Calvary* of the Tanners' Guild) and Ghent (*Hours of Baltimore*, MS. No. 170) were using the French style with no difficulty.

From the end of the 14th century the influence of the Franco-Flemish style can be seen in Spain. Catalonia was closely related

77. GERMAN. HAMBURG. MASTER FRANCKE (active first quarter of the 15th century). Group of Holy Women. Fragment of the Crucifixion, the only existing panel of the Altarpiece of St Thomas. 1424. *Kunsthalle, Hamburg.*

to France through dynastic links, and the paintings of Jaime and Pedro Serra already contain Gothic elements, transmitted perhaps through the influence of Avignon. But Luis Borrassá 81 was probably the first to introduce into Barcelona the repertoire of worldly painting and the animated narrative style of the northern miniaturists. He was followed shortly after by the Master of Roussillon in Perpignan, which was at that time Spanish. There was similar activity in Tarragona in the studio of Ramón de Mur, and in Lérida in that of Jaime Ferrer the Elder, whose works have only recently been identified. Bernardo Martorell despite his superbly realist character still shows a 82 dependence on the International style in the archaism of his landscapes and backgrounds and in the slenderness of his figures. In Aragon Juan de Levi and the Master of Arguis (*Altarpiece of the Legend of St Michael*, now in the Prado) were established; in Valencia Marzal de Sax, probably from Saxony as his name and Germanic expressionist style would indicate, and his collaborator Pedro Nicolau painted numerous and often quite large altarpieces, very crowded and executed in a style reminiscent of miniatures, whose colours display surprising harmonies and clear subtle tones — pale greens, mauves, pinks and blacks —

78. GERMAN. COLOGNE. VERONICA MASTER.
St Veronica holding the Miraculous Cloth.
c. 1420. *Pinakothek, Munich.*

80. ENGLISH. View of Venice. Detail of a miniature from Marco Polo. *c.* 1400. *Bodleian Library, Oxford.*

79. SPANISH. CATALAN. FERRER BASSA
(active 1324–1348). Head of an Angel.
Detail from a fresco in the church of S. Miguel in the monastery of Sta Maria de Pedralbes, Barcelona. *c.* 1345.

81. SPANISH. CATALAN. LUIS BORRASSÁ
(active 1380–1424). St Dominic saving the
Shipwrecked Mariners. Fragment of the Altarpiece of
Sta Clara. 1415. *Episcopal Museum, Vich*.

82. SPANISH. CATALAN. BERNARDO MARTORELL
(d. 1452). St George and the Dragon. c. 1438.
Art Institute, Chicago.

unknown elsewhere in Europe. Like northern Italy, Spain prolonged the International Gothic style into the middle of the 15th century.

A network of commercial routes across the Mediterranean linked Barcelona and Valencia with Marseille, Genoa, Naples, Palermo and Venice. They formed a circuit in which artistic trends as well as merchandise were exchanged. This accounts for the similarity between the painting of southern Italy and that of Spain at this time. The Aragon dynasty contributed to this unity in the course of extending its possessions. Naples was connected in a comparable way to Lombardy and its branch of International Gothic; Leonardo da Besozza, son of Michelino da Besozza, was one of the links in this chain.

The International style still flourished in nearly all of these countries at a time when it was dying out in France itself, where the Hundred Years' War had a disastrous effect on
83 painting. However, the Rohan Master was to carry this art to an exceptionally high level. He knew how to express through his arabesques a powerful mysticism which would seem to be incompatible with such stylisation. His position in the history of International Gothic is similar to that of El Greco at the end of Mannerism. His flashes of insight gave spiritual depth and human intensity to an art which had appeared to be limited to the lighter, worldly emotions.

The art of the cosmopolitan aristocracy

Why, and how, did this art spread from France to the rest of

Europe? and how was it propagated? France and Burgundy were situated on the route which directly connected the two centres having the highest economic development in Europe — northern Italy and the Low Countries. France offered the intellectual authority — secular even at this date — of the university of Paris, and Burgundy the example of a truly Franco-Flemish civilisation which profited from the empirical spirit of the middle class Netherlands. As a result of its complexity Franco-Flemish art could be understood equally by the Latin and by the Germanic peoples. The former appreciated its fine stylisation which reduced nature to a disciplined formula, the latter, the realist trend and the mystic sentiment. Also France and Burgundy possessed brilliant courts. At the end of the 14th century aristocratic society was completely cosmopolitan. It formed a single family with branches throughout Europe. Artists, a large number of whom had freed themselves from the bonds of the confraternities by entering into the service of the princes, went from court to court. This led inevitably to a homogeneous art. In this way France, from which Gothic architecture, Provençal literature and, in music, the *ars nova* of Philippe de Vitry and Guillaume de Machaut had spread, gave to chivalry a long-awaited art — court painting.

In its decline at the end of the 14th century chivalry began to take stock of its own concept of life. Temporarily reassured when at the cost of an alliance with the middle class it had controlled the revolts of the people, it continued to feel

51

83. FRENCH. ROHAN MASTER. The Flight into Egypt. Miniature from the Hours of Rohan. *c. 1435. Bibliothèque Nationale, Paris.*

84. FRENCH. PARISIAN. Left-hand panel of the Parement de Narbonne, showing the Taking of Christ, the Flagellation and Christ carrying the Cross. Brush and Chinese ink on white silk. *c. 1373–1378. Louvre.*

the menacing pressures of economic and social forces. However, finding its immediate practical problems insoluble chivalry steeped itself in its traditions, prejudices and conventions. There was a withdrawal into the realm of imagination in poetry, music and painting; these arts could be used to glorify the chivalrous way of life.

Together with painting, the new polyphony of the *ars nova*, brilliantly employed by Guillaume de Machaut, became the most eloquent expression of these ideas. It was not until the time of Alain Chartier and Charles Duke of Orléans that poetry acquired the sophistication and the freshness of sentiment (if somewhat precious) of the other arts. The musician, poet and painter fulfilled in their work the desires of the nobles.

They also fulfilled the dreams of the ladies of the castles, brought up on the trouvères' tales and seeing life only from their towers. It is difficult today to appreciate the influence which women exercised on medieval society — on the imagination, emotions and ideals of men — at least as far as the nobility was concerned. Women had charge of the boys until the latter reached the age of fourteen. From the 11th century on, three-quarters of the profane poetry and music had been composed for women. So, now, was profane painting.

The taste for the ' pastoral ' — for the rustic simplicity which goes hand in hand with extreme luxury and which exudes eroticism — is not the only way in which the society and art of the 14th century resemble those of the 18th century. Both periods succumbed to the sympathetic magic of the stylised and affected. Both were mannerist.

14th-century mannerism

We have learned to consider mannerism not merely as an academicism which has reached degeneracy nor as the last expression of a dying style but as a definite style which is complete in itself. It can be seen in a number of civilisations; through continued research we will no doubt find it in every evolved civilisation — together with narrative realism, classicism and lyric realism (the baroque or the romantic). Mannerism comes to the fore in the art of an ageing select society at times of spiritual crises.

The elongated figures and sinuous lines which carry the eye away from the aspect of form, as well as the other exaggerations — exquisite and at the same time shocking — are merely signs that reality has once again been abandoned for the dream — a victory of the imagination over the natural world. This was the essential nature of many periods in art: of the International style; of the art of the church of Kahriyeh Djami in Constantinople at the beginning of the 14th century, when the Empire was menaced by threats from without; of the art of Italy at the time of the fall of Rome and the failure of humanist philosophy; of the painting of the school of Fontainebleau at the time of the Wars of Religion (it is significant that Mannerism did not disappear in France until after internal peace had been assured by Henry IV); of the art of the Regency and of the reign of Louis XV in France, when revolutionary unrest was increasing; of the art of our century of disillusionment and anxiety, from Picasso's Blue Period to Surrealism. These last are the things that have made us ' discover ' 16th-century Mannerism. The escape into fantasy and the preoccupation with an absorbing, compensatory play with artistic forms is common to all mannerist periods. The expression of powerful feelings, on the other hand, is exceptional and arises from a spiritual source — usually a mystic revelation. This was the case with the Rohan Master and El Greco.

ANGLO-FRENCH. Richard II with Patron Saints. Left-hand panel of the Wilton Diptych. *c. 1396. National Gallery, London. Photo: Michael Holford.*

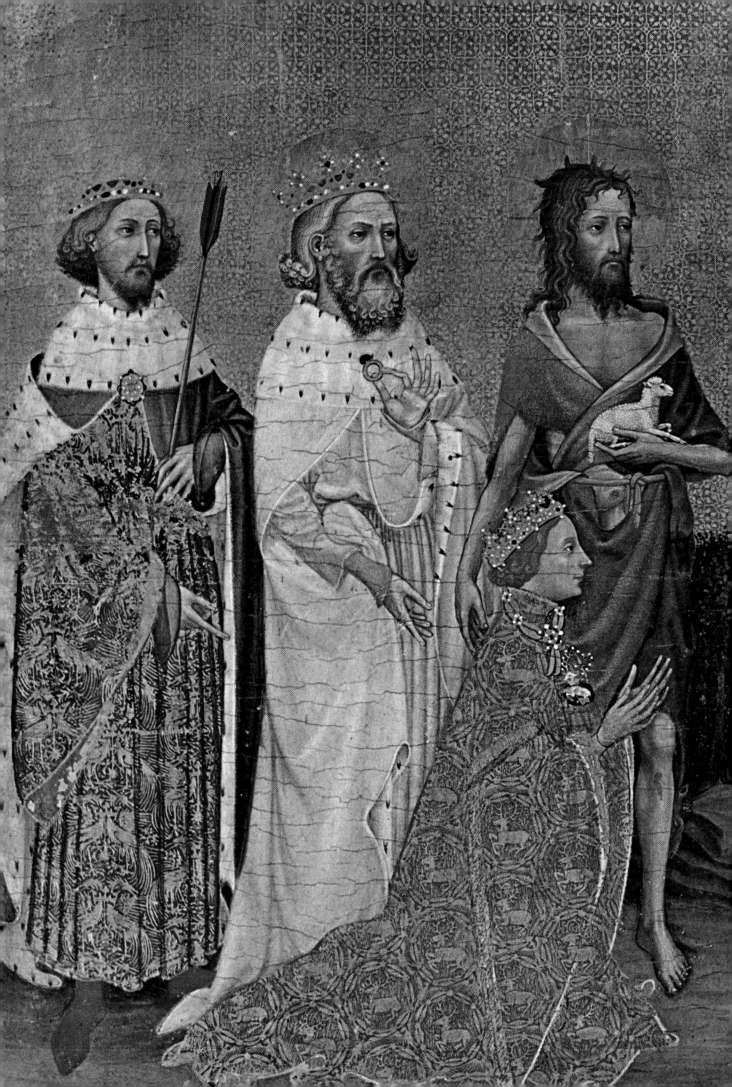

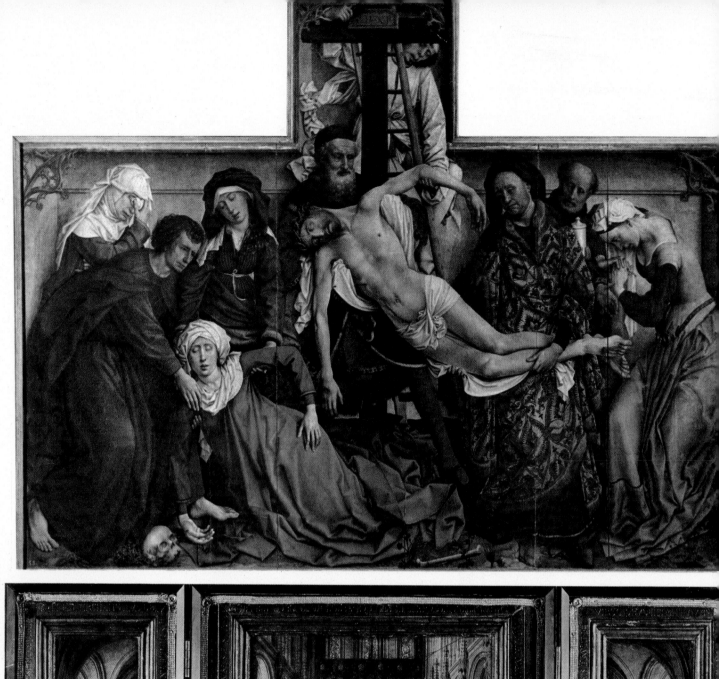

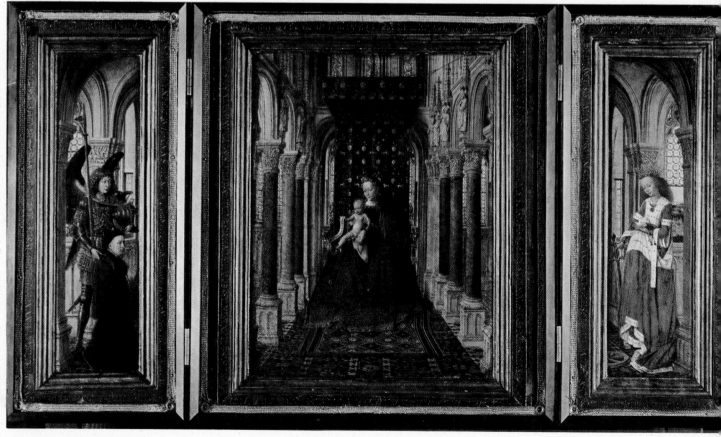

85. FRENCH. NORTHERN. Virgin and Child.
Carved and painted stone. Last quarter of the
15th century. *Louvre.*

86. BURGUNDIAN. KLAUS SLUTER
(active *c.* 1380 – d. 1406). Virgin and Child. Statue from the
portal of the Chartreuse of Champmol, Dijon. *c.* 1393.

87. FRENCH. PARISIAN. Portrait of John the
Good, king of France. (Before restoration.) *c.* 1360. *Louvre.*

*This is the oldest surviving portrait, in the true sense of the
word, painted north of the Alps. It is painted on canvas covered
with thin plaster and stuck on to a wood panel. This
technique was used from the 13th century in France and Italy.*

Mannerism is an anti-natural art but not an anti-naturalistic one; it excludes neither the reality of the subjective nor that of the external world. It accepts all realistic innovations provided they represent unusual and striking — even revolutionary — aspects of life. The 16th-century Mannerists made every use of the innovations of the times — still life, landscape, genre scenes, animal paintings, artificial lighting — paralleling the Franco-Flemish miniaturists who painted nobles and peasants, the countryside, animals and everyday objects, and who also portrayed the first night scenes. By reacting against the serenity and idealisation which had preceded them — against the classicism of Raphael or against the majestic balance of the 13th century as the case might be — both groups of painters stressed motifs which before their time had been merely subsidiary ones.

However, it is necessary to evaluate this realism correctly. It has often been set up as the principal feature of the International style. This is because it has been considered in its historic role, for the realist elements contained in the International style incontestably herald the integral realism of the van Eycks. But considered in itself this style is the exact opposite of an art which aims at reproducing an objective view of the world. The real aim is to evoke a vision of the world which is in fact magical, though made to appear feasible by the introduction of familiar properties. A dream can fill us with terror; it can also show us the joys of a real world which has been so idealised

90-97

FLEMISH. ROGIER VAN DER WEYDEN (1400–1464).
Deposition. *c.* 1435. Prado.
Photo: Scala, Florence.

FLEMISH. JAN VAN EYCK (*c.* 1390–1441).
Madonna with Saints and Donor. Triptych. 1437.
Gemäldegalerie, Dresden. *Photo: Giraudon, Paris.*

88. GERMAN. Madonna from the Altar of the Last Judgment. Formerly in the church of St Nicolas, Stralsund. Wood. Second third of the 15th century. *Stralsund Museum.*

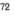

89. BURGUNDIAN. KLAUS SLUTER. The Well of Moses. 1397–1402. *Chartreuse of Champmol, Dijon.*

that it has a kind of hallucinatory perfection. And in these paintings, as in a dream, the nobles with their long scalloped sleeves and the peasants in breeches, the chargers and the oxen, the cloth of gold and the farm implements, drawn and painted with precise accuracy, seem suspended in a strange atmosphere and present a picture of the world which is unreal.

Needless to say, it was not only in painting that stylistic convention, which corresponds to the view of life seen by the imaginative dreamer, continued to dominate 14th-century society as a whole. The precious calligraphic style of miniatures and other pictures was on a par with the over-refined rhetorical poetry of the time, with the music, in which the isorhythmic arabesque was cultivated for its own sake, and with scholasticism, which was reduced to tenuous ideological links and a passionate didacticism. The periods which codify ideas in order to teach are ordinarily those which love ideas for their own sake and not for the way in which they are related to life. In the military field chivalry, which was abstract and formal, treated war as a game encumbered with rules of honour; so chivalry was defeated by forces which obeyed other rules, such as the popular armies and the Turks. But here again (as in the *Très Riches Heures*) a realistic note is incongruously associated with noble but pointless gestures. When the Duke of Lancaster besieged Rennes he could not subdue it, but he had sworn to plant his standard on the walls; the defenders respected his honour as a knight and they allowed his standard to fly for a few moments, whereupon the siege was lifted. However, ' to rid the Duke of any regrets' they received him armed to the teeth, among the empty casks and sacks on which however were placed in tiny quantities the last provisions of the town. Good-natured popular farce is here allied to the romanticism of the troubadours.

The aristocracy of Europe neither understood nor controlled this reality any longer, but they could still find it in the arts where it was transformed in accordance with their dreams. That was the social role of International Gothic, the reason for its independent style, and its particular poetry. The miniatures

66, 67

of the Limbourg brothers and the paintings of Pisanello — those most perfect products of the feudal West, which combine the essence of the Latin and the Germanic nations — never cease to fascinate. In their jewel-like colours, their golds, their linear harmony and their visionary character we can sense the nostalgic moment when an entire civilisation is about to disintegrate. For us these pictures are the ones which best evoke the medieval fable and stir our imagination. This is so because their authors, on the threshold of the Renaissance, expressed in them with a technique of supreme refinement their naïve desires.

72

If we place our emphasis on painting it is because of all the visual arts painting best expresses the essence of International Gothic. Architecture, while following the structural principles of the 13th century, betrayed at this time a preoccupation with sinuous decoration which corresponded to the graphic mannerism of painting. The Flamboyant style in France, derived from the Curvilinear style in England, appeared towards the end of the 14th century and spread rapidly throughout Europe. Its expansion paralleled that of International Gothic painting; thus, for example, in Italy the Flamboyant style became established in the north and in Naples. In addition to their rich decoration the churches, chapels and castles, regardless of their size, adopted the proportions and the chased silhouettes of shrines and reliquaries. This was the tyranny of the objet d'art, which is a fundamental feature of courtly civilisation.

Sculpture paralleled painting more closely at this time than did architecture. Detached from the architectural background, statues were adorned with abundant, articulated and fluid drapery. The hipshot silhouette resembling the curve of a capital S bears the stamp of a delicate worldly mannerism. In France still dedicated to a static monumental style, and in Flanders still fundamentally realistic, the decorative and expressive play of exaggerated gestures and extremely linear drapery folds was not pushed as far as in central Europe. It was in Germany and Bohemia that the ' beautiful' Madonnas (*die schönen Madonnen*) embodied to perfection the aspirations of the court style in sculpture.

MIDDLE CLASS REALISM IN THE FIFTEENTH CENTURY

I. FLEMISH REALISM AND ITS EXPANSION *Charles Sterling*

*In the 15th century realism was approaching its definitive form.
This form was fully expressed in Flanders, where the
middle class, whose positive outlook fostered this development,
was predominant. The chief outlet for this realism
was painting, which had occupied a secondary place during the
Middle Ages and which was now virtually a new art,
more suitable than any other for interpreting a naturalistic view of
the world. From Flanders this realism spread throughout Europe.*

About 1420 one of the greatest revolutions in European painting took place; the religious emotion evoked by the beauty of the world, together with the idea that the Godhead is incarnate in the smallest particle of nature, urged the painter to reproduce faithfully and in its entirety the spectacle of life around him. Thus by way of Christian spirituality the West returned to the obsession with illusionism of the pagan world of Hellenistic and Roman times. A long period of searching preceded this change in outlook and this preliminary period gave rise to new techniques and forms; the new trend was taken up simultaneously in Flanders in the north and in Florence in Italy.

The first great European movement in painting, the International Gothic style, contributed very important ideas to realism. Certain Lombard miniatures showing merchants in their booths surrounded by familiar objects, certain pages of the *Très Riches Heures* at Chantilly and certain similar paintings by Pisanello were the first works to faithfully reflect the spectacle of life itself. Plants, animals, human faces and figures, and costumes were observed therein with great acuteness and with a fine rendering of detail. But a closer examination discloses some incongruities: sometimes the proportion of the figures in relation to the architecture or landscape remains arbitrary; sometimes buildings jut forth too abruptly from the distant hills; the different planes of the landscape are almost always built upwards one above the other instead of being made to recede progressively. The astonishing sowing scene (*October*) from the *Très Riches Heures* is the most accurate rendering of a real landscape antedating the landscapes painted at the bottom of the pages of the *Turin Hours* and those of Jan van Eyck. However, despite the continuity of the landscape, the sporadic cast shadows and the reflections in the water, this view of Paris from the *Très Riches Heures* lacks a convincing and truly organic unity; the air which bathes it is rarefied because it is empty of light. Like the Lombards and Pisanello, the Limbourg brothers were vitally preoccupied with reality, but although they made it tangible the effect was merely that of an enchanted microcosm having an unreal sense of life.

The discovery of the real world

A fanciful concept of the world and an aristocratic religious lyricism were not sufficient for the generation which was reaching maturity at the beginning of the 15th century. A new unrest and a new curiosity pervaded its outlook, driving it to investigate perception and the external world. Nominalist philosophy encouraged detailed observation of the world. A broader conception of the universe was coming into being. Among the various treatises by Pierre d'Ailly written about 1410, the *Imago Mundi* inspired Christopher Columbus and the *Meteora* Amerigo Vespucci. The writings of John Gerson

brought mysticism down to earth and away from the realm of the visionary. It was the spirit of the *Imitation of Christ* and of the communal brotherhoods. The result was a new attitude; for the Christian, man and the entire real world were now worthy of his attention and even his admiration because their beauty and their riches were of divine essence.

Sculpture and painting were the first to express this. Literature voiced it somewhat later; to find the direct and sympathetic expression of a Sluter or a Campin (the Master of Flémalle) we must wait for François Villon and Philippe de Commynes. In music however an almost Eyckian breadth and depth is seen in the work of another Fleming, Guillaume Dufay. Just as the *ars nova* of Philippe de Vitry and Guillaume de Machaut was comparable to the mannered style of painting in France from Jean Pucelle to the Rohan Master, so Dufay's new polyphony in its thematic unity corresponded to the lyrical unity of luminous space in the *Madonna with Chancellor Rolin*. 83

Sculpture was in advance of painting. Just as Nicola and Giovanni Pisano foreshadowed Giotto and Duccio in their feeling for volume and for dramatic movement, so Klaus Sluter, Jacopo della Quercia and Donatello gave the painters of their time a new powerful and emotional image of man. Sluter (active *c.* 1380–d. 1406), who came from the northern Netherlands and worked at one time in Flanders, did his most important work in Burgundy in the Franco-Flemish atmosphere of Dijon. 86, 89 His expressive realism, of Germanic inspiration (his precursors were the sculptors of Naumburg and Peter Parler), freed the statue definitively from the domination of architecture and gave it an impressive life of its own. His animated and eloquent figures, painted with bright colours, were the first real examples of trompe l'oeil that the West had known since Roman portraiture. As a result their influence was compelling. It was dominant in Burgundy and it spread rapidly to the countries receptive to the lyrical quality of Sluter's sculpture — to the south of France and to Germany, Spain and Portugal. Compared with Sluter's work a large part of European sculpture in the 15th century was pathetic and theatrical. The elongated supple French Gothic canon gave way to a thickset plebeian style in which drapery played as important a part as the face and the pose; the impact of this new style was felt by the great revolutionaries of northern painting, Campin and van Eyck.

The sculpture which escaped the influence of Sluter was sometimes archaistic in its strict adherence to Gothic stylisation and sometimes anecdotal with a chronicler's realism. This was the case in Flanders and Spain. But in Germany, in accordance with the national genius, the rhythm of the Gothic drapery folds was used to enhance a tense expressionism which sometimes gave the works a visionary quality. German sculpture was only partially realistic and often fell victim to an arbitrary mannerism. French sculpture remained free of the theatrical strain; Gothic stylisation gradually disappeared, and about 1500 a calm and naturalistic sculpture was receptive to the Renaissance.

As court painting spread on either side of the Alps it became subject to certain changes which were common to both the north and Italy. It concerned itself with abolishing the arbitrary in the image of the world and with portraying a heavier, more solidly rendered and more emotionally involved humanity — in short, with capturing more closely both visible and subjective

57

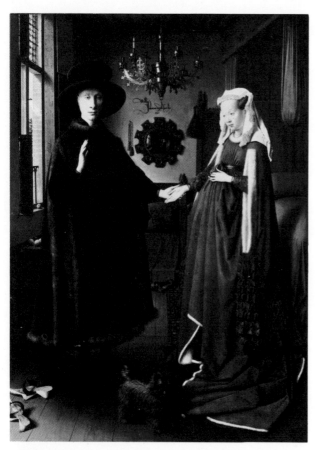

90. FLEMISH. JAN VAN EYCK (c. 1390–1441).
John Arnolfini and his Wife. 1434. *National Gallery, London.*

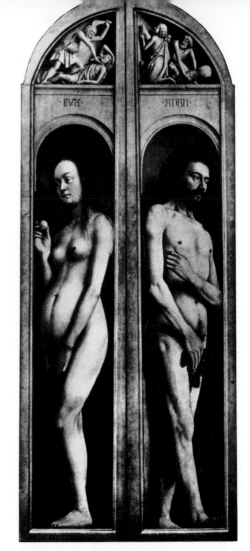

91. HUBERT? AND JAN VAN EYCK.
Adam and Eve. Panels from the Ghent Altarpiece.
Completed 1432. *Cathedral of St Bavon, Ghent.*

92. JAN VAN EYCK. Madonna
with Chancellor Rolin. c. 1434. *Louvre.*

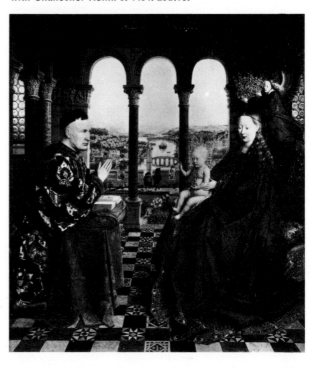

reality. But this could not be achieved everywhere in the same way. In Florence the principal revolutionary, the young Masaccio, resolved to 'remodel Giotto after nature' (to paraphrase Cézanne's dictum about Poussin). In his return to reality he was recreating, not obeying, its dictates. Masaccio was followed by a group of artists and intellectuals among whom sculptors and architects were predominant, and from their common efforts a style of painting emerged which resembled nature only remotely, through a sort of pictorial illusionism, despite the fact that the human body was rendered in accordance with the laws of anatomy and space was depicted through the use of scientific perspective. It was realism, but a purely intellectual

211 realism. A painting by Uccello is enchanting not because it resembles life but because it differs from it.

At exactly the same period Robert Campin and the van Eycks were depicting a world which was no less poetic. But it is almost a dream world, charged with an intense and emotional realism of a deeply spiritual nature. The Flemish artists' way of accurately rendering nature on the flat surface of a painting was through patient acute observation. They did not construct the world; they registered it through the senses. They reproduced the visible and tangible surface of it, not the hidden structure. They saw the volume of a body as a surface modelled by the effects of light. Space to them was an infinity in which light and shade circulated freely. In Italian paintings cast shadows are short and are firmly attached to the figures, so much so that between the figures there is a sort of void in aerial space. Flemish painters diffused cast shadows, and Jan van Eyck discovered that truth which the Hellenistic painters had glimpsed but which had since been lost — that shadow is everywhere,

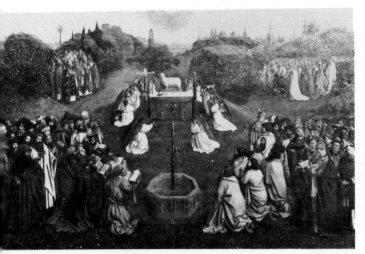

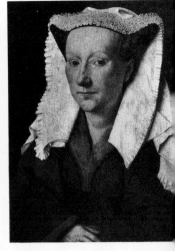

93. HUBERT? AND JAN VAN EYCK.
The Adoration of the Lamb. Detail. Central panel of the
Ghent Altarpiece. Completed 1432. *Cathedral of
St Bavon, Ghent.*

94. JAN VAN EYCK. Man in a Turban.
1433. *National Gallery, London.*

95. JAN VAN EYCK. Margaret van Eyck. 1439.
Bruges Museum.

even in brightness, and that light is everywhere, even in shadow.

Although in the past we have been led to believe that the spiritual is represented in art only by forms which rebel against the accurate depiction of nature, we know now that van Eyck's paintings are infinitely more than prodigious diminishing mirrors in which the natural world is reflected; they are religious hymns. They are furnished with inscriptions and filled with symbols which van Eyck's cultured contemporaries deciphered with delight. We know that if the least blade of grass shines under his brush with the freshness of the day of Creation, it is a reminder of God's handiwork, that the quality, source and direction of earthly light are allusions to grace, revelation and redemption, and that in the chamber of the Annunciation the humble pitcher pierced by the ray of light but remaining intact is the image of Mary's virginity. Man in the 15th century was no doubt able to distinguish the symbols within the purely familiar details, for not all the objects in these paintings had a symbolic meaning. Symbols in fact were inextricably mingled with earthly life, and this mysterious confusion endowed the image of life with a divine character.

Trompe l'oeil painting and polychrome statuary

Italian realism, which was humanist and scientific, was to a great extent free of this medieval spirituality and had little understanding of the humble tribute paid by the Netherlandish painters to the sensual beauties of nature. However it was Italy which was influenced by the north and not the north which was influenced by Italy. In 1437, during the lifetime of Campin and van Eyck, evidence of this was given by Filippo Lippi in his *Tarquinia Madonna*. In the middle of the century the travels of various painters (the only ones that we are certain of are those of Fouquet, Rogier van der Weyden and Justus of Alla-magna, but there were no doubt others) and the importing of pictures brought the Italians into contact with the northern aestheticism, which stirred their admiration. This influence could not but increase. What were the reasons for it?

In the first place there were the improvements made by the van Eycks in the technique of oil painting. Also no doubt at the end of the 15th century, when there was a reaction against humanistic paganism in Italy, the Christian piety of Flemish art acquired an increased prestige. But the principal reason lay in the sensual and positive character of Flemish realism which gave expression to the aesthetic feeling of the middle classes.

Throughout Europe at that time the middle classes were the patrons of panel painting. The great Italian bankers, the Arnol-fini, Portinari and Medici, patronised the Flemish painters. 90

The patricians and the merchants were not the only groups to commission the majority of 15th-century painting of which we know the history; the clergy and the ruling houses shared more or less consciously the taste of the middle classes. René of Anjou, the king of Sicily, liked only Flemish painting; Philip the Good, Duke of Burgundy, who was proud of his subjects the van Eycks and van der Weyden, never commis-sioned Italian painters; Alphonso V of Aragon and Isabella of Castile also showed a great interest in Netherlandish painting. The realist middle class spirit also spread to the Italian intel-lectuals and artists. Antonio Filarete and others justified their admiration for the paintings of van Eyck and Fouquet by the simple assertion that they faithfully resembled nature. But among the humanists this summary criterion was also encouraged by the fact that it was that of writers of antiquity such as Pliny and Philostratus. In the eyes of the Italian intellectuals van Eyck appeared to be the first to equal Apelles and Zeuxis, those masters of trompe l'oeil. Van Eyck himself, whose broad literary culture was highly praised by the Italians, was perhaps conscious of this flattering rivalry.

In the north as in Italy the new pictorial trends soon culminated in trompe l'oeil. Some portraits by van Eyck and some figures by Castagno and Uccello are set in a simulated frame out of which hands, feet or a head protrude. In the portrait of a Carthusian (1446) by Petrus Christus a fly is walking on a stone ledge in the foreground, and one longs to chase it away by thrusting one's hand into the painting. In many Flemish interiors a convex mirror reflects in miniature the objects in the foreground of the painting. These tricks tend to persuade us that the space in which we live is the same as the illusion of space portrayed in painting; this confusion causes us to take the picture for a fragment of reality.

From the beginning of the new realist trend Robert Campin and the van Eycks did paintings of stone statues of a striking solidity and so animated that they almost seem to be living beings. At the same time the Florentines were painting human figures having the solidity and volume of statues. Nothing better reveals the difference between the sensitive approach which takes a work of art and humanises it and the intellectual approach which stylises man in a work of art. But in both

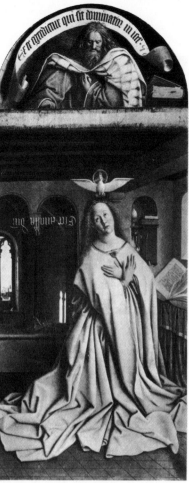
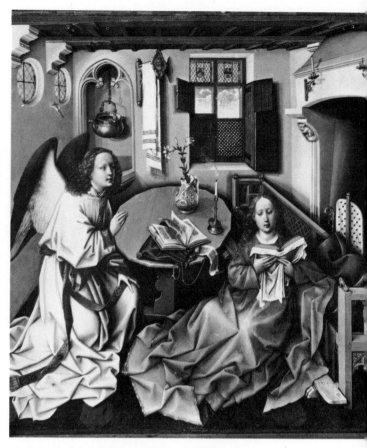

96, 97. FLEMISH. JAN VAN EYCK. The Angel of the Annunciation and the Virgin. Two wings of the Ghent Altarpiece. Completed 1432. *Cathedral of St Bavon, Ghent.*

98. FLEMISH. ROBERT CAMPIN (MASTER OF FLÉMALLE; *c.* 1378–1444). The Annunciation. Central panel of the Mérode Altarpiece. *Cloisters Museum, Metropolitan Museum of Art.*

cases there is the same intentional confusion between object and being; the trompe l'oeil which deals with form parallels that which deals with space.

This lively interest in sculpture sheds light on the origin of trompe l'oeil in painting. The two arts were very close to one another at the beginning of the century; for while painting emphasised the three-dimensional quality of figures and while sculpture in the round and in relief became pictorial, they both concealed the internal structure of solid forms under a richly modelled surface and depended on the purely optical effects of light and shade. On the other hand scenes on receding planes had appeared in bas-reliefs from the 13th century — that is, well before they had appeared in painting. Sculpture was thus in a position to influence painting. This influence was transmitted in the simplest way (a way, however, which has not yet been sufficiently emphasised) — through the use of polychromy.

Throughout Europe the medieval painters, even the most famous of them, were commissioned to cover sculpture with lifelike colours. This practice enabled them to see the connection between colour and relief. Painters could study daily the changes in a tone as it filled a hollow or covered a projection, the reflections in the shadows, in fact all the reactions of flat colour placed on a three-dimensional object and affected by the play of light and shadow. When they had to reproduce these reactions on the flat surface of a picture they drew on this experience.

It is true that polychromy had been used throughout the Middle Ages without producing such an effect on painting. But a technique does not in itself determine any artistic attitude or any style; there were periods when miniatures were monu-
83, 104 mental in style (the Rohan Master; Fouquet) and others when
60, 72 frescoes became as linear as illuminations (Lorenzetti; Pisa-

nello). The improvement in the technique of oil painting was not the cause of van Eyck's realism but the principal means of amplifying it. It was only when the Flemish painters, anxious to achieve greater realism, concentrated every effort on suggesting mass that polychrome sculpture became for them a source from which they might draw useful lessons.

Around 1400, painted sculpture became a sort of trompe l'oeil. The costumes of the prophets in the *Well of Moses* by **89** Sluter were coloured down to the smallest detail; Jeremiah wore the metal rims of spectacles on his nose. For the New Year in 1411 the Limbourg brothers fooled their patron the Duke of Berry, a passionate book-lover, by making him a present of a book carved in wood and carefully painted to imitate a real manuscript. This was a feat of dexterity which explains the pre-eminently stereoscopic character of the objects and the painted architecture in the *Très Riches Heures*. And **66** the first among the Flemish artists working in the new style, Robert Campin, strikes us precisely by the tangible bulk of his **99** figures; his own technique becomes more understandable when we realise that he worked in Tournai — then a centre for outstanding tomb sculpture.

Differences between Campin and van Eyck

It is obvious today that the paintings of Robert Campin **98, 99** (very probably the author of the works grouped under the name of the Master of Flémalle) are more archaic than those of the van Eycks and antedate everything that can be attributed to them with certainty. The triptych of the *Entombment* (collection of Count Seilern, London), known since 1942, appears indeed to date from 1415 to 1420. Campin's style draws heavily on the art of the Flemish and Franco-Flemish miniaturists. But

99. FLEMISH. ROBERT CAMPIN
(MASTER OF FLÉMALLE). Crucified Thief.
Städelsches Kunstinstitut, Frankfurt.

100. FLEMISH. ROGIER VAN DER WEYDEN (1400–1464).
Francesco d'Este. c. 1460. *Metropolitan Museum of Art.*

it is characterised by the influence of sculpture and this influence, which became increasingly strong in his work, is not particularly evident in van Eyck's work. Despite Jan van Eyck's habit in his painting of depicting realistic statues, or voluminous draperies inspired by those of Sluter, his style is not essentially sculptural; it is characterised by subtle pictorial modulations, a heritage from the art of the miniature. The dynamic sculpturesque style of Campin differs completely from van Eyck's softly rounded serene style. Campin outlines his figures and objects with incisive contours and makes them stand out vividly from the background by means of strong cast shadows; he makes frequent use of aggressive foreshortenings — hands pointing towards us and many drapery folds which extend towards the foreground. There is the same essential difference from van Eyck in the conception of space. Campin builds it up laboriously, using an exaggerated recession of the lines of an interior or a landscape; the distant backgrounds are stepped upwards and the horizon line is raised. The sharply receding lines and the layers of forms give his pictures a decorative rhythm. Van Eyck, while seeking to render the illusion of depth, is not at all concerned with a sculptural arrangement of the picture plane. He never stresses linear perspective but evokes the illusion of depth primarily through gradations of light in the atmosphere. If he is the author of the rustic scenes at the bottom of the pages of the *Turin Hours* we owe him credit for landscapes of an extraordinary modernity, with thin bands of countryside under an extensive sky, such as are usually seen only in 17th-century Dutch paintings. Finally the two artists differ in their treatment of light. Campin tackles the most difficult kinds of problems: the contrast between the half-light of a domestic interior and the full light of day; cast shadows which vary in

treatment according to the objects on which they lie; the blazing light of a fireplace. These, however, are only isolated effects of light and stand apart from the ensemble of a scene. Van Eyck concentrates only on a single overall effect — the flood of light which penetrates the whole of nature, linking all parts smoothly and uniting all substances, such as the skin of a face, fabrics, metal and glass, in an organic harmony (see colour plate p. 54).

The above represents not only two different approaches in the development of realism but the contrast between two temperaments — one dynamic to the point of violence, seeking ever to express emotion, the other balanced, serene and self-contained, having a feeling for symmetry and suggesting an inner life in a less obvious way. Van Eyck's was a classical, humanist intellect, closer in spirit to that of the Italians than to the mystical sensibility of the north. In spite of his original contributions to religious painting, his interest was not confined to it. He painted profane subjects which must be among the first real genre pictures (studies of women bathing, an otter hunt, a banker and his assistant, etc.). But in spite of such themes he remained, like the Limbourgs, a court painter in the service of the dukes; all his works have an air of distinction and depict brocades, jewels and marbles. Campin was basically middle class, as much in the strictly familiar setting of his scenes as in the nature of his observation which takes in the crack in a wall, the knot in a board and the nail and its tiny shadow.

It is important to contrast these founders of Flemish realism, both of whom were of vital significance in the evolution of painting. In the middle of the century van Eyck's influence was less general than that of Campin. This was because the *Ghent Altarpiece* (completed 1432) and the *Madonna with Chancellor Rolin* (c. 1434) were advanced in style for their time. His all-

61

101. FLEMISH. ROGIER VAN DER WEYDEN (1400–1464). Detail from the Deposition. *c.* 1435. *Prado.*

102. GERMAN. COLOGNE. MASTER OF THE ST BARTHOLOMEW ALTARPIECE (active in Cologne 1480–*c.* 1510). The Deposition. *Louvre.*

embracing realism seemed too miraculous and his light too subtle for painters brought up on the principles of International Gothic. Campin, on the other hand, whose chief work, the triptych of the *Descent from the Cross*, is known to us only through a fragment and an old copy, was much easier to understand. His composition retained the decorative character of the earlier period. His patient efforts to suggest solidity and space were easily understood. His middle class setting suited the preponderant taste in Europe. Finally — and this is perhaps the most important point — his emotional religious quality was closer to the ardent piety of Gothic Europe than was van Eyck's calmer, more contemplative expression of religious feeling.

But both influences, that of van Eyck and that of Campin, were combined in the majority of those painters who because of these two Flemish artists abandoned the court style. The two founders must have been regarded by their contemporaries as two sources of enlightenment of equal and complementary value, rather as Giotto and Duccio had previously been in Italy. Those who turned to them chose what suited their own temperaments.

In the Low Countries the major tradition which prevailed for half a century sprang from the art of Campin. We might call it 'Tournaism', because it was further developed by his pupil, the third great Flemish artist, Rogier van der Weyden, who was born at Tournai. Rogier's memorable *Deposition* (*c.* 1435) in the Prado, Madrid, exploits the essence of Campin's art — the sculptural solidity of the figures and the sense of pathos which they express (see colour plate p. 54). But to this he adds an element of prime importance — a majestic linear rhythm in the outlines, poses and drapery folds. Rogier revitalised the secular tradition of the linear Gothic arabesque which had inspired the French sculptors and miniaturists of the 13th century. By combining this tradition with realism he created a new Gothic painting which flourished north of the Alps.

Rogier was one of those geniuses whose role in the history of art is due as much to his eclecticism as to his personality. A short time after he had painted the *Deposition* he added to his art by blending the breadth and intimacy of van Eyck with the qualities he had inherited from Campin. He succeeded in retaining a hieratic quality while adding an increasing anecdotal charm to his interiors and landscapes. His *Last Judgment* at Beaune (*c.* 1446) is one of the most majestic of medieval polyptychs, as rich and as filled with interest as a cathedral. It is comparable to the *Ghent Altarpiece*. Rogier was also one of the greatest portrayers of human types and inventors of iconographic motifs. Examples of his Christs, Virgins and saints were found

throughout the century in all countries except Italy. The deep but restrained emotional content of his pictures, spontaneous and majestic at the same time, was imitated everywhere without ever being equalled — either in the Low Countries or elsewhere.

Flemish influence in German art

The Germans were the first to profit from the great lessons of Campin and the van Eycks. The influence first took root in the cosmopolitan centres — the Hanseatic towns and the regions of the upper Rhine and Lake Constance. At Lüneburg the Master of Heiligenthal produced a composition dated 1438 in the style of Campin. But in the south a closely knit group of painters abolished more or less brutally the International Gothic tradition. As early as 1431, before the *Ghent Altarpiece* was completed, Lucas Moser (*Altarpiece of the Magdalen*) was in

103. DIRCK BOUTS (*c.* 1415–1475). Portrait of a Man. 1462. *National Gallery, London.*

104. JEAN FOUQUET (*c.* 1420 – *c.* 1481). Portrait of Juvénal des Ursins. *c.* 1460. *Louvre.*

105. MASTER OF THE LIFE OF MARY (active 1460–1480). The Virgin and St Bernard. *Wallraf-Richartz Museum, Cologne.*

106. HANS MEMLING (*c.* 1433–1494). Virgin and Child. *c.* 1485. *Lisbon Museum.*

107. NICOLAS FROMENT (active *c.* 1450–1490). Mary in the Burning Bush. Central panel of the Triptych of the Burning Bush. 1476. *Cathedral of St Sauveur, Aix en Provence.*

108. MARTIN SCHONGAUER (*c.* 1435–1491). The Holy Family. *c.* 1475–1480. *Kunsthistorisches Museum, Vienna.*

109. HUGO VAN DER GOES (*c.* 1440–1482). Young Girl. Detail from the Portinari Altarpiece. *c.* 1475–1477. *Uffizi.*

110. MASTER OF MOULINS (active *c.* 1480–1500). Young Princess. Detail. *c.* 1490. *Lehman Collection, New York.*

111. MICHAEL PACHER (*c.* 1435–1498). Miracle of St Wolfgang. Panel from the Altarpiece of the Fathers of the Church. *c.* 1483. *Pinakothek, Munich.*

THE NORTHERN SCHOOLS AND THEIR SUCCESSIVE STYLES

THE LOW COUNTRIES

FRANCE

GERMANY

Middle of the 15th century

103

104

105

Second half of the 15th century

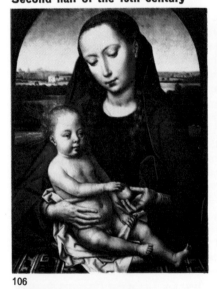

106

107

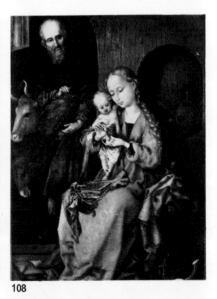

108

End of the 15th century

109

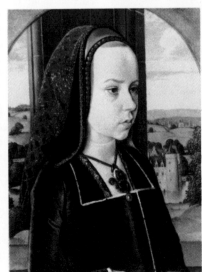

110

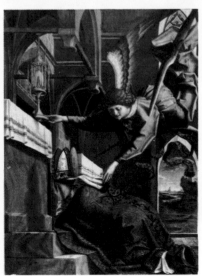

111

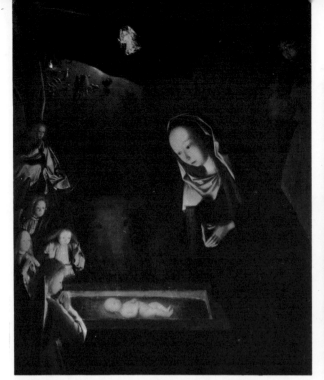

112. NETHERLANDISH. GEERTGEN TOT SINT JANS
(c. 1460 – c. 1495). Nativity at Night. *National Gallery, London*.

*The painting of night scenes lit by a flame or supernatural glow
appears to have originated north of the Alps.*

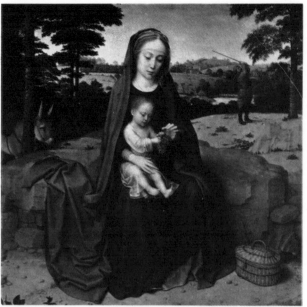

113. FLEMISH. GERARD DAVID (c. 1460–1523).
The Rest on the Flight into Egypt. c. 1509?
National Gallery, Washington.

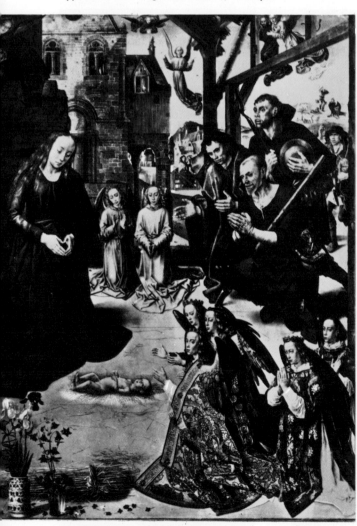

114. FLEMISH. HUGO VAN DER GOES (c. 1440–1482).
The Adoration of the Shepherds. Detail. Central
panel of the Portinari Altarpiece. c. 1475–1477. *Uffizi*.

touch not only with the advanced art of the *Très Riches Heures*
and the *Turin Hours*, but also with that of Campin. A few
years later the influence of the miniature was superseded by the
dynamic art of Tournai, combined at times with van Eyck's
influence. We find this in Konrad Witz (*Heilspiegel Altarpiece*,
1435; *St Peter Altarpiece*, 1444), in the Austrian master who
painted the *Altarpiece of King Albert* (1438), in Gabriel Angler
(the *Polling Altarpieces*, 1440 and 1444), in the Master of the
Tucher Altarpiece (c. 1445) and in the Munich Master of the 105, 128
Life of Mary (c. 1450). It should, however, be noted that all
these artists interpreted the new trends with originality.

The style of Konrad Witz is characterised chiefly by sharply
faceted forms and by thickset figures which have the awkward 183
majesty of peasants. The sculpturesque quality, clear luminosity
and advanced perspective suggest Campin's style, but all is seen
with an admirable freshness. Witz used this style to help him
study the real world which surrounded him, and he painted the
shores of Lake Léman in Geneva. This was not, as has been
claimed, the first identifiable landscape in Western painting.
The haymaking scene from the *Très Riches Heures* presented as
early as about 1415 a view of Paris that the Duke of Berry
would have seen from his windows, and it is quite probable
that there were realistic landscapes in Flemish painting before
1444. However, Witz depicted the first modern landscape we
have in panel painting in this view of the lake bathed in light.

True realism in German painting dated only from the second
part of the 15th century, when artists such as the Master of
the Housebook and Schongauer succeeded in assimilating the 108, 129
calm Flemish interpretation of the world. What is realism but
the vision of the world as it appears to us day by day, with
its disorder without chaos, its beauty and ugliness in equal parts,
its force and its gentleness, its similarities and its differences —
all of which make it typical? It is the world of Campin, van
Eyck and van der Weyden — but not of certain German works
such as those which were attributed to Multscher; here we see 115
ugliness and brutality, and scenes from the Passion which are
all poignant tumult. In such scenes the world consists entirely
of an interplay of moral and physical forces, where the tangible
expression of these forces is all that matters. The choice of the
elements of reality is such that it results in a hallucinatory,

visionary spectacle. The vocation and greatness of German painting lies precisely in this expressionism, this transgression of realism. For many generations German artists strove to overcome this, seeking first the aid of the Flemish artists, then that of the Italian Renaissance painters. Nevertheless this expressionism represents the culmination of what was most representative in German painting up to Grünewald and Altdorfer.

There was however another current in German painting in which sensibility was closer to that of Western Europe. It appeared in the middle Rhine, a Latinised region having direct links with the Low Countries. Here the artists understood the subtle light effects of van Eyck and were not attracted by Campin's linear and massive style. Although the figures of the Master of the Darmstadt Passion are modelled with prismatic clarity, the scenes take place in a tenuous chiaroscuro which is like a grey veil, and the colour has a subdued harmony of rare distinction. In Cologne Stephan Lochner preserved the many coloured, delicate quality of court miniatures but gave his compositions depth and breadth and his figures a feeling of solidity; a light which envelops the various objects is diffused through his paintings. He has been compared quite justifiably with Fra Angelico; he holds an analogous position in the history of art for his lucid attempt to combine mysticism with a calm interpretation of the real world. Although Lochner's art was middle class, it was nevertheless of great refinement; it was the art of the great Rhenish patrons.

The new style in Iberian painting

Despite Jan van Eyck's stay in Portugal and Spain and despite an enormous importation of Flemish paintings, Iberian art did not produce a generation capable at the outset of adopting the new trend in painting, as was the case in Germany. It was only in the second half of the century that the Flemish aestheticism took root in Spain and Portugal.

However, several precursors of the great Hispano-Flemish movement appeared from the middle of the century in Catalonia, 82 Castile and Andalusia, and in Valencia. Bernardo Martorell, a Catalan painter of great ability, shows the influence of International Gothic and also of van Eyck. Luis Dalmau, who worked in Barcelona, was a great admirer of the *Ghent Altarpiece*, and his *Virgin of the Counsellors* seems to be an awkward pastiche of the art of van Eyck; he reproduced van Eyck's forms but without van Eyck's modelling. The new lesson in naturalism was still too difficult for the Catalans and was foreign to their taste for the decorative. The leaders of the school of Valencia, Joan Reixach and Jacomart, tried hard to reconcile this taste with Flemish illusionism. The Netherlandish influence on which Jacomart drew probably came from Naples; here Colantonio, Antonello da Messina's master, successfully interpreted the art of van Eyck with a Latin clarity of line that appealed to the Spanish artists. It was probably in this same atmosphere of 124 Naples that Bartolommé Bermejo, one of the greatest Spanish painters of the century, was trained, at least to judge by a *Descent from the Cross* only recently discovered (private collection, Italy), which could be a work of his youth and was painted about 1450–1460, and which shows curious similarities to 183 Konrad Witz's work in its thickset style and ' cubic ' modelling. The influence of Campin was predominant in Castile in the *Santillana Altarpiece* by Jorge Inglés (*c.* 1450) and in Andalusia in the charming *Annunciation* by Pedro de Cordova (*c.* 1475).

Spanish painters gave their own interpretation to Flemish aestheticism. Their centuries-old familiarity with Arab art, that is to say with a flat and graphic background, influenced their artistic vision. The linear dramatic style of Campin and Rogier suited them much better than the art of van Eyck. The Spanish artists portrayed modelled figures and objects, but they placed them in interiors and landscapes which were built up vertically

and were not elements of space but were mere settings — or they arranged them against rich gold backgrounds. They created in this way unusual harmonies between tangible human figures and abstract surfaces. Out of this there followed a tension between the real and the imaginary and the sacred and the profane — the secret of Jaime Huguet's originality. 123

A large number of altarpieces were painted in Spain in the 15th century — all filled with lively narrative and covered with a network of broken drapery folds and metallic reflections. This southern country was thus an outpost of the Gothic spirit. In the Mediterranean ports painting showed a variety of influences but retained a certain homogeneity. It perpetuated a Gothic aestheticism of Flemish inspiration well into Renaissance times.

Flemish art in the later 15th century

Rogier van der Weyden established a code for Flemish art which remained at a standstill for a time. His contribution had been considerable as regards both content and form and it needed at least another generation to absorb it. Many artists took as their point of departure the types, iconographical motifs and stylisation of Rogier van der Weyden. Among these the northern Netherlandish artists played an important part. From the 15th century they showed the duality of temperament which was to be so evident in Rembrandt's time. Some treated religious subjects calmly in an everyday setting; others treated them in a visionary setting. Albert van Ouwater and Dirck Bouts belonged to the first group. They evoked religious feeling with restraint; Bouts interpreted the Bible in an almost Protestant spirit; nowhere, perhaps, does northern Gothic man appear so 103 vulnerable before God as in his portraits. Landscape in northern Netherlandish painting was already becoming richer under an increasingly lively sky; it was a truer and more intimate landscape than Rogier's and was simplified by an overall stylisation. In Geertgen tot Sint Jans' painting we first find the characteristic static forms — sleek and rounded and modelled by a purer light than that used by the Flemish artists — and the colours with the sheen of enamel which were to constitute the essential elements of Vermeer's poetic art.

But at the same time a disturbing quality appears in Geertgen's painting which heralds the eruptive art of Bosch. He explores the effects of light at night (the *Nativity at Night*, 112 National Gallery, London); he suspends the Virgin, like a lamp in the bosom of the shadows, in the middle of a shadowy swarm of angel musicians; he paints a *Man of Sorrows* who is rising abruptly from the tomb, bleeding and torn — the first northern Netherlandish expressionist painting. In the paintings of the Master of the Virgo inter Virgines we see deformed 117 figures in a troubled twilight, and only their bewildered faces are important. It is clear that the feverish restlessness which heralded the Reformation demanded an increasingly free technique and a subjective approach.

In the great Flemish centres only Justus of Ghent and Hugo van der Goes were able to contribute to Rogier's influence. They stressed emotion and were less addicted to aristocratic stylisation. Hugo rivalled Rogier in the invention of types. In 114 his work the Virgin and the angels assume a new gravity and the Apostles a new solemnity; his shepherds are half savage and smell of the stable and the fields. The powerful light, rounded figures and the precision of objects recall Campin. He had a more pronounced feeling for the monumental than had Rogier; this, together with his emotional religious spirit and his realism, explains the admiration the Italians felt for his *Portinari Altarpiece*, 109, 114 which was set up in a church in Florence.

But the heritage of Rogier can best be seen in a host of less important painters, of whom Memling is the most appealing. 106 His rare profound portraits are not sufficient to raise him to the rank of leader of a school. He accentuated all that was

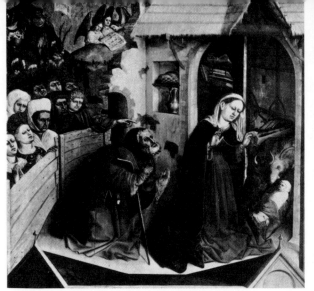

115. GERMAN. SWABIAN. WORKSHOP OF
HANS MULTSCHER. The Nativity. 1437.
Staatliche Museen, Berlin.

116. FRENCH. PROVENÇAL. ENGUERRAND
CHARONTON (*c.* 1410 – *c.* 1461). The Coronation of the
Virgin. Detail. 1453. *Hospice of Villeneuve lès Avignon.*

117. NETHERLANDISH. MASTER OF THE
VIRGO INTER VIRGINES. The Annunciation. Detail.
Van Beuningen Collection, Vierhouten.

tender in Rogier and combined all Rogier's stylistic formulas
in a sort of pleasant academicism. The rich middle class, who
considered Memling's art to be the perfection of the austere
grandeur of Rogier and Hugo, favoured his cheerful piety and
the charm of his interiors and landscapes. Embellishments
appealed to Memling; in his later pictures he added the putti
and garlands of the Italians to his Gothic interiors as a recent
worldly innovation.

In this eclecticism we can sense a dying art. Fifty years of
Gothic stylisation imposed by Rogier provoked a profound
reaction towards the end of the century. The religious malaise
caused men to look back to the security of Christian beliefs.
A generation of artists, adhering to the past, attempted to revive
the Middle Ages. Gerard David turned to van Eyck, as did
Quentin Metsys with his famous *Moneylender and his Wife* in
the Louvre. Colijn de Coter imitated Campin; Hieronymus
Bosch drew on the fantasy and mysticism of the 14th-century
miniaturists. From that time onwards the reaction against
Rogier brought with it a new appreciation of van Eyck's
113 serenity and of his use of light. This enabled Gerard David
to evolve a new outlook. His outlines become simpler and
calmer; his landscapes recede through dark shadow towards
lowered horizons; his composition gains in density with the

help of a full, rich colour like that of van Eyck. The Gothic
severity of line and angle disappears.

This almost classical harmony was the final achievement of
15th-century Flemish art. It brought the younger Flemish
artists closer to the harmony of Renaissance art.

France and the Flemish influence

Situated between Italy and Flanders (from which during the
15th century there came a constant flow of new pictorial forms),
France was often considered by historians as a land of compro-
mise. A more correct definition would be that it was a land
where different trends met, and what compromise there was
was spontaneous; in other words the French conception of paint-
ing naturally contained both Flemish and Italian traits. From
Fouquet to Cézanne French painting was concerned with the
world, but a real world subject to modification by rules. So
in the 15th century French realism was sensual, that is, compa-
rable to Flemish, and stylised, that is, related to Italian.

The Hundred Years' War paralysed artistic activity in Paris,
the great centre of the International style, and it moved to the
outlying regions such as prosperous Provence. The art of the
court emigrated with the king to Bourges and to the châteaux
of the Loire. In the north and east — which were near the Low
Countries or were bound to them politically under the dukes
of Burgundy — the Flemish spirit reigned. There were three
very distinct regions, despite the peregrinations of artists and
the patronage of King René which between them united Anjou
and Provence. Each region produced masters: the south, the
unknown painter of the *Pietà of Villeneuve lès Avignon*; the 119
Loire, Jean Fouquet; the north, Simon Marmion. So the artistic 118, 165
geography of France resembled that of all the other European
countries in which there were regional schools, and it is contrary
to history to regard 15th-century French painting, as has been
done recently, as an amorphous series of pictures arranged
simply in chronological order.

In France the Flemish influence made itself felt from about
1435 onwards. It was natural that this took place first in the
north and in Burgundy. The only productions, however, were
provincial works which were awkward interpretations of the
art of van Eyck or of Campin. On the other hand important
works directly inspired by Flemish art appeared in the heart
of France, in Angers and also in Provence, domains of King
René of Anjou, the most lavish of patrons and an ardent
admirer of the aestheticism of the Netherlands.

Two great painters appeared in his entourage — the Master
of the Aix Annunciation, and the Master of King René. The 182
first, who had no doubt been in direct contact with Campin

and van Eyck and had been strongly influenced by Burgundian sculpture, gives in his powerful *Aix Annunciation* (painted in Aix about 1445) a monumental example of the French style. He influenced local painters — the authors of the *Boulbon Altarpiece* (1457) and of the *Tarascon Pietà* (1457). These southern artists transformed the ductile Flemish style into a harsh and moving one. The Master of King René, who about 1460 illustrated the manuscripts of the *Coeur d'Amour Epris* and the *Théséide*, seems to have been influenced directly by the Master of the Aix Annunciation and indirectly by Campin. It was from the Aix Master that he drew his robust types and the formal drapery; but it was from Campin that he derived his experiments with light — the effects of the glow from a fireplace and the transparency of shadows on grass damp with dew. In his time he had no equal in the whole of Europe in the poetic interpretation of light. And in spite of his Flemish background, his ample forms and pleasing realism are reminiscent of Fouquet, who worked in Tours, not far from Angers; this relationship enables us to consider him a French artist. In Bourges where the king lived certain works of high quality and a decided French character show the impact of Flemish innovations and of a spirit similar to that of the Aix Master. The works in question are the magnificent window showing the *Annunciation* (1445–1450), and the paintings of angels in the house of Jacques Coeur (before 1453), both commissioned by Coeur. In France, as in Italy, the rich middle classes were turning towards the painting inspired by the Netherlands.

The schools of the Loire and of Provence

Jean Fouquet, probably trained in Bourges and Paris at some time between 1435 and 1445, was certainly familiar with Flemish art. The miniatures he painted before his journey to Italy (about 1445) have not yet been identified. However, as I have tried to show, there is nothing to prove that his portrait *Charles VII* was not painted on the eve of this journey. Although his work shows a knowledge of the portraits of van Eyck and Rogier van der Weyden, he does not seem to have derived anything essential from the Flemish style. It was to

118. FRENCH. JEAN FOUQUET
(c. 1420–c. 1481). Virgin and Child. Right part of the Melun Diptych. c. 1450. *Museum of Fine Arts, Antwerp.*

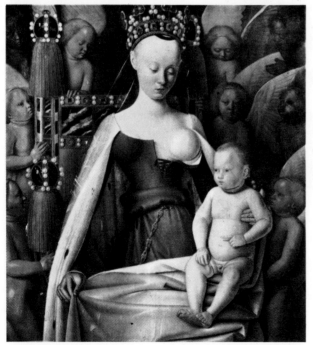

119. FRENCH. PROVENÇAL. Pietà of Villeneuve lès Avignon. Before 1457. *Louvre.*

the Italian artists that he was chiefly indebted; from them he acquired his knowledge of perspective and his radiant light. But his shadows which seem to move, his intimate feeling for town or country landscape and his taste for heavy Gothic drapery are no more Italian than Flemish.

The art of Fouquet has nothing in common with Flemish art unless it is the direct sensual perception of reality characteristic of the northern painters. What is original in his work comes **118** exclusively from French sources, from the miniatures of the Limbourgs and of the Parisian studios of about 1430 and from the monumental statuary (an essential point) which Henri Focillon has commented on. If the portrait *Juvénal des Ursins* **104** (c. 1460) occupies a position midway between Italian and Flemish art (in that it seems almost alive yet has the durable look of a statue), this is because it is French in conception. The world which Fouquet represents is that of a peaceful and confident France — a world of hale and tranquil men and of superb animals established in a simple, smiling countryside in which one senses the continuity of earth and sky and in which the light is that of spring and the shadows are transparent. It is his Olympian calm and not his painting of ornaments and marbles that links Fouquet to the Italian Quattrocento. But just as Campin's naturalism made it possible for Konrad Witz to see and portray the beauty of the lake at Geneva, so the Italian innovations influenced Fouquet's ennobled image of France.

Fouquet founded a tradition in the valley of the Loire — a **120** tradition, however, which did not retain his essential qualities such as the plenitude of forms, the organic depth of space and the seriousness of feeling. This was because Fouquet, like van Eyck, was ahead of his time. He was the first Renaissance painter north of the Alps — fifty years before Dürer. The *Loches Triptych* (1485) still reflected the style of Fouquet, but this style was considerably diluted and adapted to the taste of the court in the author of this triptych, Jean Bourdichon.

A contemporary of Fouquet (and no less eminent and no less French) painted the famous *Pietà of Villeneuve lès Avignon* **119** (before 1457). In all likelihood he can be identified with Enguerrand Charonton (or Quarton), who painted the *Madonna of Mercy* (1452) and the *Coronation of the Virgin* (1453). These **116** three paintings are identical in style; the drawing is Gothic in style but the modelling is southern, in definite almost 'cubistic' planes. Charonton came to Provence from the diocese of Laon and must have been trained in the north. The type of the Virgin of the *Coronation* is that found in the sculpture of Champagne and Picardy, and although it is difficult to detect in Charonton any borrowing from Rogier van der Weyden it seems certain that he was familiar with his art; but he must have come to Provence when he was young enough to evolve there a clearcut sculptural style very much in contrast with the Flemish

style, and a style such as only the dry atmosphere and blazing sun of the south of France could inspire. His style is in fact paralleled only in Spain. Charonton was in every sense an artist; he gave great variety to his Madonnas, and was able to infuse his characters with nobility and at the same time to people a strikingly realistic Provençal landscape with witty small figures. His compositions are always dominated by broad arabesque forms. But, as in Fouquet's work, this amplitude goes hand in hand with the delicacy of the miniature.

The clear-cut Provençal style and the emphasis on a vertical composition gave a French character to the work of a number of painters brought up in the Flemish tradition. This applied 107 to Nicolas Froment in his *Triptych of the Burning Bush* (1476), 122 to the young Ludovico Brea (*Pietà*, 1475), to the Master of St Sebastian and finally to the painter of the impressive *St Peter* (1490–1500) which was formerly in the Cook Collection. This last painter may be identical with Jean Changenet, who came to Avignon from Burgundy and became the head of a school. And when in 1477 Burgundy passed from the control of the dukes to the crown of France and was thus cut off from Flemish influence, it was Provençal art which replaced that influence and which stamped the superb portrait of Hugues de Rabutin (*c.* 1480) with its own character.

The second Franco-Flemish style

The distinctively French quality in painting was much less pronounced in the north, where the influence of the Low Countries prevailed. It can be seen however in provincial works (*Altarpiece of St Anthony*, 1451, in New York; *Altarpiece of Thuison lès Abbeville*, *c.* 1480); in these works slender linear forms and modelling in clear-cut planes give stylisation to types which are Flemish in origin, and illustrate the very French 165 reluctance to adopt trompe l'oeil. Simon Marmion, one of the greatest miniaturists of the century (who worked for a time at Valenciennes), was fully steeped in the art of Rogier and Bouts; his work shows a more delicate, less mannered grace than does that of Memling (*St Bertin Altarpiece*, *c.* 1455).

The patronage of the court in Paris was an important factor at the end of the century. The court favoured the Flemish style. At that time the most important painter in France was the Master of Moulins, whose identity has still not been established. He was a court painter in the service of the king and the Duke of Bourbon, and he travelled between the capital and Burgundy. In spite of his Flemish training and the influence of Hugo van der Goes, his style is French; this is particularly evident in his use of ample forms of a clear-cut and elegant modelling and in his aristocratic quality. A composition such as his *Moulins Triptych* (1498–1499) — inspired by stained glass windows and strictly architectonic — would not have been found in Flemish painting (see colour plate p. 71). The Master of St Giles, who also worked for royalty and had a Flemish training, resembled Marmion in his depiction of faces with regular features and figures in calm poses in the French taste. The art of the court portrait painters was similar in style.

In this way a kind of Franco-Flemish school was formed about 1500 which was comparable to that which had flourished about 1400, although it was less important historically. In spite of the charm of his work the Master of Moulins does not represent 15th-century French painting at its best — that is, with the purity and strength with which Fouquet and Charonton endowed it. In France as in Flanders and Germany it was the first generation of artists to discover the beauties of the natural world whose enthusiasm produced the greatest works in their own national style.

Outside Italy the chief arts in the 15th century were sculpture and painting. Elsewhere in Europe the output of religious architecture was considerably reduced. Such architecture was now characterised by ornate dynamic decoration, but beneath this magic robe the structure remained functional and grew more massive and solid. The spirit of realism was even more evident in the comfortable and attractive domestic architecture — evidence of a prosperous middle class.

In town houses and palaces and castles the medieval vertical forms were slowly replaced by horizontal divisions and square proportions; this was the beginning of a search for an ordered balance which heralded a return to a classical taste.

120. FRENCH. WORKSHOP OF JEAN FOUQUET.
Head of the Virgin. Detail from a Pietà.
c. 1470–1475. *Church of Nouans les Fontaines.*

121. FRENCH. MASTER OF MOULINS (active *c.* 1480 –
c. 1500). Head of the Virgin. Detail from the Nativity with
Cardinal Jean Rolin. *c.* 1480. *Autun Museum.*

122. FRENCH. LUDOVICO BREA (*c.* 1443–1523).
Head of the Virgin. Detail from the
Altarpiece of the Annunciation. *Church of Lieuche.*

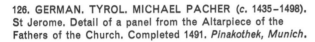

123. SPANISH. CATALAN. JAIME HUGUET
(1414? – after 1489). St Sebastian. Detail from the Altarpiece
of the Constable. 1464–1465. *Private Collection.*

124. SPANISH. BARTOLOMMÉ BERMEJO
(active 1474–1498). St Michael. Panel of an altar from
Tous. *Wernher Collection, Luton.*

125. ITALIAN. FERRARA. COSIMO TURA
(before 1431–1495). St Anthony of Padua, from a wing of a
polyptych. *Louvre.*

THE INFLUENCE OF SCULPTURE ON PAINTING AFTER 1450

*Medieval sculpture profoundly influenced painting in the
15th century, giving it a feeling of volume, and the
purely pictorial discovery of how to portray substances through
the technique of oil painting forged another link
between painting and sculpture in the
middle of the century. Through an exaggerated
imitation the most solid substances, even the figures, with their
extreme trompe l'oeil treatment, seem cut from
hard stone or fashioned of metal. This style, whose
sculptural quality comes from its modelling in hard, clear-cut
planes [127] and from its extreme 'tactile values',
was found throughout Europe.*

126. GERMAN. TYROL. MICHAEL PACHER (c. 1435–1498).
St Jerome. Detail of a panel from the Altarpiece of the
Fathers of the Church. Completed 1491. *Pinakothek, Munich.*

127. PORTUGUESE. NUNO GONÇALVES
(active 1450–1472). Head of a Man. Detail from the St
Vincent Polyptych. c. 1465. *Lisbon Museum.*

II. THE LATER FIFTEENTH CENTURY IN GERMANY AND THE IBERIAN PENINSULA *Adeline Hulftegger*

The Flemish artists provided the formula for realism in the north; indeed, their influence spread throughout Europe and was counteracted only by the influence of Italian art.
However — and this was especially so in the second half of the 15th century — different countries tended to interpret these influences in their own way. Germany, still dedicated to the medieval spirit, was dominated by its own expressionist genius; Spain tried to find a middle way between the extravagant late Middle Ages and the emergent Renaissance. Portuguese art evinced a restlessness and malaise which foreshadowed more modern times.

Realism and expressionism in Germany

Divided in art as she was politically, Germany finally found a certain unity in the second half of the century in the adoption of Flemish aestheticism by most of the schools. The ever increasing traffic between Germany's commercial centres and the cities of the west brought the realist trend to this country of artisans and of merchants whose importance socially is confirmed in the many civic buildings — town halls and guildhalls with gables and tall belfries — and hall churches (churches having a nave and two aisles all of equal height), the walls of which bore inscriptions indicative of class pride.

To satisfy the tastes of a merchant aristocracy who sought all that was splendid and who were the first to acclaim the superiority of the Flemish style, the painters renounced those influences which had shaped their predecessors and deliberately cultivated the style of van der Weyden and Bouts, which had already influenced certain artists in Cologne. For many of these painters a stay in the Low Countries became a necessary part of the tour prescribed for journeymen by the rules of the guild as a preliminary to becoming master painters. At that time Rogier

100, 101 van der Weyden was the painter they most admired. They emulated his sculptural manner and his striking compositional effects; they also sought to reproduce his pathos; but they never attained his grandeur and the assured rhythm of his composition, and still less did they achieve that elegance of style which betrays his connection with the aristocratic tradition of the beginning of the century.

103 It was rather through Bouts, more middle class and therefore closer to them, that the German painters established contact with Flemish art. They never completely grasped the secret of its subtle perfection; their technique remained far less rich and less refined than that of the Flemish painters. This new pictorial style, which was spread even to the far north of Germany by the Hanseatic League, was modified in the various regions which adopted it. It was harmonious and charming in the work of

105, 128 the Master of the Life of Mary, in Cologne, and these qualities were even evident in Hans Pleydenwurff's work in Nuremberg. It had a still more marked regional flavour in the work of Friedrich Herlin in Nördlingen and of Hans Schüchlin in Ulm. Only certain of the painters and engravers of the upper Rhine,

10 such as Kaspar Isenmann and Master E.S., were successful in amalgamating the new style with that bequeathed to them by

183 Konrad Witz.

While the northern studios succumbed increasingly to the Flemish style, at the risk of reproducing a pale copy of it, the southern studios were drawing new vigour through the practice of sculpture and the graphic arts. They gained their individuality and paved the way for an authentic national style, which

manifested itself in the best works in the late Gothic style which was then at the height of its luxuriant splendour. The architectural forms of the Flamboyant style have a decorative lyricism verging on the baroque; this is equally evident in the work of the Rhenish, Swabian and Franconian sculptors — the heirs of the tradition of Sluter — and in the work of the painters, most of whom were also engravers or entrepreneurs for enormous carved and painted altarpieces. The limits of realism were transcended. Angular contorted figures, tortured lines, tumultuous drapery with broken turbulent folds, extreme naturalism, exaggerated gestures and facial expressions, excess of vigour or gracefulness, violent colour contrasts — all these were indications of the powerful expressionism already present in certain painters and about to emerge in the work of Jan Polack, a Bavarian painter of Polish origin. This strong expressionist tendency is also seen in the work of the sculptor Veit Stoss 131 (active in both Nuremberg and Cracow). The art of Stoss, with its feverishly compelling reliefs, and (though to a lesser degree) the virtuoso art of his Franconian colleague Adam 147 Krafft, offer the best parallels with the vehemence and decorative exuberance of the early woodcut series of the *Apocalypse*, executed by the young Dürer at the very end of the century, which was a last example of the medieval spirit. (The painstaking Wolgemut, however, could not have passed on to his 142 pupil Dürer anything more than the rudiments of an honest but uninspired trade.)

The decisive stimulus came from Colmar, where Schongauer, 21, 108 a painter and engraver of rare quality, successfully assimilated 129 the art of van der Weyden and translated Rhenish mysticism and northern fantasy into the flowering profusion of German Gothic. His engravings supplied first Germany and then the rest of Europe with an inexhaustible repertory. The early tenseness of his line was soon moderated by an almost Latin preoccupation with proportion and balance; the linear quality gave way to graceful arabesques and curving forms. In his small panels, although the subject matter is treated in great detail, the landscape backgrounds have a transparent, ethereal quality that enhances the intimacy of his poetic scenes. The influence of his style is to be found throughout the Rhine valley — behind the mannerism of the Master of the Housebook and in Cologne in the preciosity of the Master of the St Bartholomew Altar- 102 piece, who was also influenced by the Netherlandish mannerism to which other artists from Cologne succumbed. It can be seen later in Switzerland, in Austria and in Swabia, notably in Augsburg in the art of Hans Holbein the Elder and of Hans 343 Burgkmair before they came under the influence of the Lombard and Venetian Renaissance. Schongauer's work, in which the excesses of the ' fin de siècle ' style were moderated, represented for them as for Dürer a decisive stage in their search for an ideal 15 of beauty, the secret of which only Italian art could reveal; inversely its excessive sensibility unleashed in Grünewald the 333 dark forces of instinct of the German Middle Ages.

In Austria — the natural route of Italian influence into central Europe — the Tyrolean painter Michael Pacher, influenced by 111 Paduan and Venetian art, employed a sculptural rendering of form and a deep rendering of perspective which were monumental in style. Although the *St Wolfgang Altarpiece* shows a 132

FRENCH. MASTER OF MOULINS (active c. 1480–1500).
The Moulins Triptych (centre panel). 1498–1499.
Moulins cathedral. *Photo: Giraudon, Paris.*

HEC EST ILLA DEQVA SACRA CANVNT EVLOGIA SOLE AMICTA
IN NAM HABENS SVB PEDIBZ STELIS MERVIT CORONARI DVODENIS

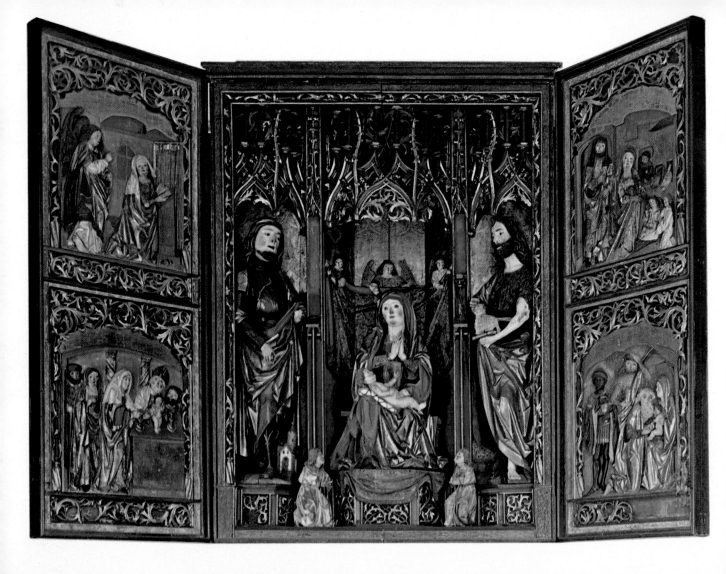

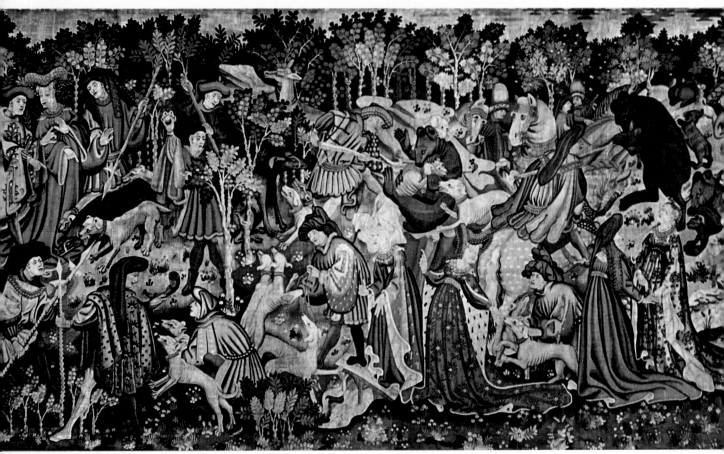

purely German emotionalism, the richness of the brocades, the attention given to the structure of the bodies and the landscape, the bold foreshortenings and viewpoints and finally the complete mastery of the use of light, show the influence exerted on Pacher's work by the school of Mantegna and of Giovanni Bellini. This new understanding of one of the essential problems of Renaissance painting, namely composition in depth rendered by means of linear and aerial perspective, must have been in the nature of a revelation to the German school, which had ignored the achievement of Witz. It was Pacher, together with Rueland Frueauf the Younger of Salzburg, with their great perception of the charms of the rural setting, who paved the way for the 'landscapists' of the Danube school whose work influenced the still expressionistic Cranach at the beginning of the 16th century.

143, 228

346

The later 15th century in Spain

Spain, on the eve of becoming a European power and at the mercy of various political and economic pressures, slowly evolved from the many influences present an art which in each centre of activity reflected local preferences and tastes.

Although the realist concept was current everywhere, the Flemish trend came into contact in the east with that of Italy — with which the opulent cities of the Levant had already become familiar. Reinforced towards the middle of the century when Alphonso V united the thrones of Aragon, Sicily and Naples, this adherence to Mediterranean aestheticism was, to begin with, modified by the tastes for a monumental style and for rich decoration — tendencies which were not always compatible. Nevertheless in many respects the painting of the Valencian Jacomart (Jaime Baço), who was a very determined eclectic, and that of the Catalan Jaime Huguet, who had a more individual style, exhibited a nostalgic longing for the refinements of International Gothic; their clear, brilliant colours and their realism with its strong popular flavour were due rather to this style than to the middle class art of the north.

123

Deeply rooted in local tradition and combining in a very Iberian way a strict naturalism with a decorative richness which was Arabic in origin, the work of the Vergós family sealed the fate of the Catalan school of painting, whose work soon degenerated into mere formula. As the commercial importance of Barcelona declined so it lost its position as a centre of art. Reacting from this backward-looking attitude, two painters, not natives of the city, aimed at a more evolved style; like their fellow painters in Provence, Liguria, Naples and Sicily — with whom they may have been in contact at some time — they succeeded in reconciling the Flemish taste for realism with the Italian feeling for amplitude and monumentality.

This duality is indeed apparent in Bartolommé Bermejo of Cordova, who also worked in Aragon; his sculptural style was derived from van der Weyden, and his composition had a true grandeur. At the same time his sensibility — filled with a southern melancholy and a forceful but suppressed emotion — his colour and the Oriental magnificence of his costumes and ornament betrayed the fundamentally ethnic quality of his work. In a similar way the Master of the Martyrdom of St Medin (no doubt a German living in Spain) combined the intense emotionalism common to the German and Spanish temperaments with naturalism — the latter latent as yet in his

124

GERMAN. Carved and painted altarpiece.
Late 15th century. Victoria and Albert Museum.
Photo: Michael Holford.

FLEMISH. Tapestry showing boar and
bear hunting. Detail. 1425–1450. Victoria and Albert Museum.
Photo: Michael Holford.

128. GERMAN. COLOGNE. MASTER OF THE LIFE OF MARY (active 1460–1480). The Birth of the Virgin. *c. 1460–1470. Pinakothek, Munich.*

This artist was influenced by Flemish painting, particularly by Dirck Bouts. He owes his name to a series of pictures devoted to the life of the Virgin.

129. GERMAN. UPPER RHINE. MARTIN SCHONGAUER (c. 1435–1491). The Madonna of the Rosehedge. 1473. *St Martin, Colmar.*

adopted country. In a striking antithesis he countered an evocative cruelty with a serenity of form and colour — a foreshadowing of the Renaissance. The influence of Renaissance Italy had already reached Valencia where Rodrigo de Osona contributed to the monumental trend by exploiting the influence of Paduan painting and of van der Goes; he was also influenced by Portuguese art, to which this presumably Andalusian painter perhaps owed his melancholy and a discreet sense of colour which was rare in the local products.

Castile was more open to influences from the north, which were in harmony with its energetic and austere character. The court and the aristocracy welcomed architects, sculptors and goldsmiths from the north and imported paintings from Flanders and prints from Germany; Queen Isabella herself bought paintings from the Low Countries. Juan de Flandes, a follower of Gerard David, and other painters from the studios of the Netherlands and Germany, also emigrated to Castile. The Castilian masters were soon converted to the new style; their allegiance was such that their works are called 'Hispano-Flemish'.

Architecture, which was under royal patronage, showed a greater originality than painting. Following the example of the Andalusian school — and with as prolific a decoration — the masters who came from Germany, France and the Low Countries achieved an extraordinary synthesis of the elements borrowed from Flamboyant Gothic and Mudejar art, the latter a survival of the Moorish occupation. The church of S. Juan de los Reyes
149 in Toledo, the Infantado palace in Guadalajara and the college
148 of S. Gregorio in Valladolid, all of which are in this purely Iberian hybrid style, belong to the reign of Isabella; certain motifs were even now of Italian origin. The proliferation of ornament characteristic of this art was also found in sculpture, not only in the work of local artists but also in that of French, Flemish and German artists who were influenced by Hispano-Moorish art. The altarpieces carved in an exuberant style by
135 Gil de Siloe and by Hans and Simon of Cologne, arbitrarily partitioned and overflowing with figures, lacy canopies and pinnacles, lose in sculptural value what they gain in sumptuousness through the brilliance of their execution. In the huge monstrances of heavy chased silver by the goldsmith Enrique de Arfe of Cologne a Germanic tendency towards the ornate and towards virtuosity is seen.

Ostentatious decoration is less evident in the painters, whose austere style, carried to the point of harshness, was inspired by van der Weyden and Bouts. A distinctive drawing and modelling, sober and sometimes hard colours, an insistence on realism and a certain solemnity of tone give the works of Fernando Gallegos (*Altarpiece of S. Ildefonso*, Zamora cathedral) an essentially Spanish character. The impact of Schongauer's engravings together with Flemish influences can be seen in the work of the Master of Ávila and even more directly in Toledo in the work of the Master of the Sisla. At the end of the century with the coming of the Renaissance, the influence of Italian art joined that of northern art in Spain in the late sculpture of Gil
133 de Siloe and in the painting of Pedro Berruguete. The superb praying figures on the tombs in the cathedral and in the Carthusian monastery of Miraflores at Burgos, freed from their still exuberant background, are evidence of this conversion to the art of the Italian Quattrocento. Pedro Berruguete, who may have worked in Naples and who probably worked in Urbino with Italian and Flemish painters, had learned the secrets of composition and of the most advanced technique. Back in his own country he interpreted the spiritual fervour of Spain in evocative scenes of the life of the times in which the dual vocation — mystic and realistic — of the national school may be detected.

Andalusia, where the memory of the Moorish occupation was even stronger than in Castile, was to have a brilliant

130. GERMAN. SCHOOL OF SCHONGAUER.
Young Man smelling a Flower.
Engraving. *E. de Rothschild Collection, Louvre.*

131. CENTRAL EUROPEAN. VEIT STOSS (c. 1447–1533).
Head of an Apostle. Detail from the Altarpiece of the
Virgin. 1486. *St Mary's, Cracow.*

economic future and manifested in architecture as well as in sculpture and the minor arts a tendency towards the rich, colourful style of the artists from the north. The painters Juan Sanchez de Castro (who worked in Seville) and Pedro de Cordoba followed, somewhat tardily, the Flemish aestheticism, which they invested with Oriental splendour. As the Andalusian-born Bermejo had moved to Aragon early in his career, the art of Andalusia lacked an important representative until the 16th century when Alejo Fernandez was active in Seville. He seems to have been trained in northern Italy and to have come under the Portuguese-Flemish influence; his aristocratic gentleness gave a personal flavour to an art in which grace and delicacy of composition were combined with grandeur.

132. GERMAN. TYROL. MICHAEL PACHER
(c. 1435–1498). The Coronation of the Virgin.
Carved central shrine of the St Wolfgang Altarpiece.
c. 1481. *Church of St Wolfgang.*

133. SPANISH. CASTILE. PEDRO BERRUGUETE
(active 1483–1503). The Trial by Fire. Episode
from the life of St Dominic. Panel of an altarpiece
from the church of Sto Tomás at Ávila. *Prado*.

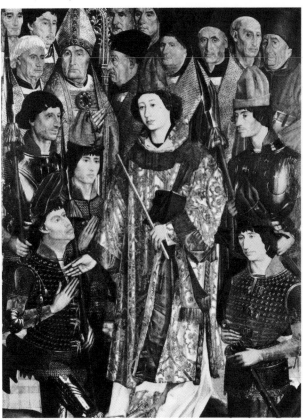

134. PORTUGUESE. NUNO GONCALVES
(active 1450–1472). Panel of the Archbishop. Detail.
Central panel of the St Vincent Polyptych. *c.* 1465.
Lisbon Museum.

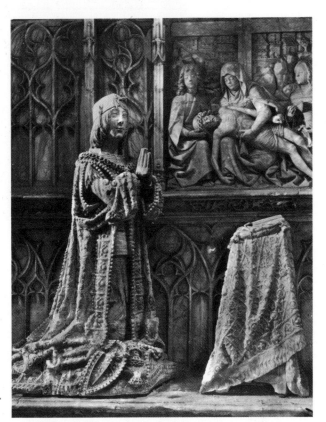

135. SPANISH. GIL DE SILOE (of northern
European origin; active in Burgos in 1486). Detail
from the tomb of Juan de Padilla, page to Queen
Isabella, killed in 1491. *Burgos Museum*.

The 15th century in Portugal

Although very much preoccupied with the expansion of her
trade and her maritime network, Portugal did not restrict her
initiative to the exploration of seas and unknown lands alone.
We must, it is true, wait until the 16th century to see the full
flowering of architecture and sculpture, when an exuberant and
decorative style was evolved at Belem, Batalha and Thomar 6
which equalled and even surpassed that of Spain under Isabella.
On the other hand in the third quarter of the 15th century the
genius of one man placed Portuguese painting in the foremost
rank in art.

Although we do not know the exact origins of his style,
we know that Nuno Gonçalves was directly influenced by
Flemish realism, which had reached Portugal with van Eyck's
journey to Lisbon in 1428. Nuno's mastery of sculptural form
and of monumental composition, combined with a rare deco-
rative sense rooted in the tradition of tapestry, as well as the
beauty of his warm rich colouring enhanced by contrasting
cool tones, would have sufficed to assign him an important
position in painting even without the addition of the rare
talent of the portrait painter who penetrates beyond the out-
ward appearance. The strongly characterised figures in the
St Vincent Polyptych (Lisbon), which are vibrant with an inner 127, 134
life and are tinged with a racial sadness, reveal the new impor-
tance which was attached to the individual. In that as in the
broad treatment and the freedom of composition — absolutely
without equal until modern times — the work of Nuno Gon-
çalves reaches far beyond the confines of medieval art. When
in King Manuel's time, under the aegis of the Antwerp painters,
Portuguese painting became more brilliant and its colours more
refined, it was still imbued with this same subtle melancholy
and at times with this same human warmth.

History. In its beginnings the formation of modern Europe was aided by the rise of a nationalist spirit. In France Joan of Arc (*c.* 1412–1431), who hastened the end of the Hundred Years' War (1453), was the incarnation of it. While the power of Burgundy (which died with Charles the Bold in 1477) was waning that of Spain became established with the final expulsion of the Arabs (1492). In the east Ivan III, Grand Duke of Moscow (1440–1505), liberated his country from the Mongols, preparing the way for the rise of the Russian empire.

A parallel movement of independence in the national churches opened the way to the beginnings of the Reformation, represented in England by John Wycliffe (d. 1384) and his followers the Lollards, in Bohemia by John Huss (burnt alive in 1415), in France by the rise of Gallicanism, marked by the Pragmatic Sanction of Bourges (1438), and in Germany by the Concordat of Vienna (1448).

Europe, where the importance of the towns (except in Italy) was passing to the nations, was threatened in the East by the Turks, who conquered first the Serbs (battle of Kossovo, 1389) and then Byzantium (1453). The Slavs triumphed over the Teutonic Knights in the battle of Tannenberg (1410).

But Europe was discovering new horizons (Portuguese voyages to Africa; discovery of America by Christopher Columbus in 1492; discovery of the route to the Indies by Vasco da Gama in 1498).

THE LOW COUNTRIES

History. The 15th century witnessed the ascendancy of Bruges, whose wealth was founded on the cloth industry and on links with the Baltic and the Mediterranean. In 1460 the first European stock exchange was established in Antwerp. The Duke of Burgundy, Philip the Good (1419–1467), abandoned Dijon for Bruges. In 1428 he inherited Hainaut, Holland and Zeeland. Charles the Bold was Duke of Burgundy from 1467 to 1477 (in 1468 he married Margaret of York in Bruges). In 1477 Mary of Burgundy (d. 1482) married Maximilian of Austria. The Low Countries passed to the Habsburgs. Philip of Austria married Joanna the Mad of Castile, heir to the throne of Spain, in 1496.

Religion was imbued with a spirit of practical common sense. Thomas à Kempis (d. 1471) wrote the *Imitation of Christ*; Alain de la Roche (d. 1475), a Breton Dominican, introduced the use of the rosary.

Intellectual life was rich; the university of Louvain was founded in 1426; it was a time of court chroniclers and rhetoricians (Georges Chastellain; O. de la Marche; Jean Molinet) and of humanism (Rodolphus Agricola, d. 1485). Printing may have developed in Haarlem (1423, where Laurens Koster perhaps used movable type), Antwerp (1472), Alost and Utrecht (1473), Bruges (1475), Louvain, etc.

A generation of polyphonic composers of Franco–Anglo–Italian origin appeared in the south. Court musicians were Guillaume Dufay (1400–1474), Gilles de Binchois (d. 1460) and Pierre de la Rue (d. 1518). These were contemporaries of Joannes Ockeghem and Josquin des Prés in France.

Architecture. The Gothic spirit persisted up to the 16th century, especially in secular buildings such as markets, belfries and town halls (Brussels, 1402; Middelburg in Holland).

Sculpture. The production of gilded and painted carved altars was the most original contribution of the Brabant school. After 1480 these became an industry and were exported to France, Germany and Sweden (altars by the Bormans, father and son, who were in Brussels at the end of the 15th century; altar in Notre Dame at Tongeren, a work from Antwerp, *c.* 1500). The decorative skill of the Flemish wood-carvers was evident also in ecclesiastical furnishings (choir stalls, choir screens and pulpits). Two makers of tombs from Brussels, Jacques de Gérines (before 1392–1464) and Pieter de Beckere, gave artistic value to the casting of metal, which became an industry in Dinant, Tournai and Mechelen (tomb of Mary of Burgundy, *c.* 1500, Bruges). At various times the artists from the northern Netherlands expressed their tranquil realism in decorative sculpture (Amsterdam; Breda; 's Hertogenbosch; Utrecht), wooden and stone statuary and funerary monuments (Breda; Utrecht).

Painting. Developing from the art of the miniature and based on a detailed observation of reality, Flemish painting attained a technical superiority which ensured its prestige throughout Europe. Robert Campin (*c.* 1378–1444), from Tournai, and the van Eycks, from Bruges, were the founders of the school. Dispensing with gold backgrounds they created the modern form of panel painting.

The work of Hubert, the elder van Eyck brother (d. 1426), remains hypothetical; he may have worked on the *Ghent Altarpiece.*

Jan (*c.* 1390–1441), born in the vicinity of Maastricht, was perhaps connected *c.* 1415–1417 with the *Turin*

136. ENGLAND. View of Lavenham church, Suffolk.

137. ENGLAND. Detail of the roof at March, Cambridgeshire. *c.* 1500.

138. Page from the Breviarium
Grimani, illustrated by Flemish artists.
Beginning of the 16th century.
St Mark's Library, Venice.

139. ATTAVANTE (1452–1517).
Illumination showing Tommaso Sardi.
Corsiniana Library, Rome.

140. Roman Ruin. Woodcut from the
Dream of Polyphilus by
Francesco Colonna. Published
Venice, Aldus, 1499.

Hours for William of Bavaria. In 1422–1424 he was working for John of Bavaria at The Hague. As court painter to Philip the Good he established himself in Lille in 1425. Commissions in Aragon (1426) and in Lisbon (1428) took him to Spain and Portugal. In 1430 he settled in Bruges. Although not the inventor of the technique of oil painting, Jan van Eyck improved it greatly. In this medium he developed a hitherto unknown almost illusionistic treatment of the real world, and he used a marvellously transparent colouring. Some famous works by van Eyck are: *c.* 1425, *Virgin in a Church* (Berlin); completed 1432, *Ghent Altarpiece*, St Bavon, Ghent [91, 93]; 1433, *Man in a Turban* (National Gallery, London [94]); 1434, *John Arnolfini and his Wife* (National Gallery, London [90]); *c.* 1434, *Madonna with Chancellor Rolin* (Louvre [92]); 1436, *Madonna of Canon van der Paele* (Bruges); 1437, *St Barbara*; 1439, *Madonna of the Fountain* (Antwerp); 1439, *Margaret van Eyck* (Bruges [95]) [see colour plate p. 54].

Van Eyck's position as a pioneer was challenged only by Robert Campin (usually identified with the so-called Master of Flémalle), the painter of three altarpiece wings at Frankfurt, wrongly supposed to have come from Flémalle; other attributed works include the *Mérode Altarpiece* (Metropolitan Museum of Art [98]) and the *Madonna and Child* (National Gallery, London), both in a style slightly earlier than van Eyck's but as revolutionary in its realism [99].

Rogier van der Weyden (1400–1464)

studied under Campin in 1427–1432. He may have visited Italy in 1450. His works include: *c.* 1435, the *Deposition* (Prado [101]; see colour plate p. 54); 1436, *Town Painter* (Brussels); *c.* 1446, *Last Judgment* (Hospice at Beaune); *c.* 1452, *Bladelin Triptych* (Berlin); *c.* 1460, *Francesco d'Este* (Metropolitan Museum of Art [100]). The influence of his emotional style extended into Germany and Italy. Dirck Bouts (born *c.* 1415), after influence from van der Weyden at Brussels, settled at Louvain by 1448. His qualities of colour and landscape powerfully influenced German painting. His works include: *Altarpiece of the Sacrament* (St Pierre at Louvain, 1464–1468); *Justice of Emperor Otho* (Brussels, 1474–1475); *Portrait of a Man* (National Gallery, London, 1462 [103]).

The Bruges school was represented by Petrus Christus (d. 1472/73) [1], who was influenced by van Eyck, and by the eclectic artist Hans Memling (*c.* 1433–1494) [106]. In Ghent Justus of Ghent, who later moved to Urbino, and Hugo van der Goes (*c.* 1440–1482), who painted the famous *Portinari Altarpiece* (Uffizi), chose more monumental, livelier forms [109, 114].

The northern school was formed first in Haarlem with an imitator of van Eyck, Albert van Ouwater, and his pupil Geertgen tot Sint Jans (*c.* 1460–*c.* 1495) [112], then in Delft with the Master of the Virgo inter Virgines [117], and finally with the brilliant and original painter Hieronymus Bosch (*c.* 1450–1516). His family came from Aachen, but he was born, and he worked, in 's Hertogenbosch. His

masterpieces were painted between 1480 and 1505 and include: the *Hay Wain* (Prado); the *Ship of Fools* (Louvre); the *Temptation of St Anthony* (Lisbon [326]); *St Jerome* (Venice); *St John on Patmos* (Berlin); the *Garden of Earthly Delights* (Prado). Paintings done between 1505 and 1516 include: the *Adoration of the Magi* (Prado); the *Crowning with Thorns* (Escorial, Madrid); the *Prodigal Son* (Rotterdam).

Gerard David (*c.* 1460–1523) [113], from Haarlem, brought the taste for landscape to Bruges at the turn of the century (*Baptism of Christ*). After him, Jan Provost of Mons (d. 1529), trained at Valenciennes by Simon Marmion, yielded to the influence of the school of Antwerp which was to eclipse Bruges. Two other pupils of David, A. Isenbrandt and A. Benson (of Lombard origin), continued in his manner until 1550.

Miniatures. Much favoured by Philip the Good and Charles the Bold, manuscript miniatures were still flourishing from about 1480 to 1530 with the Ghent-Bruges school, the masterpiece of which is the *Breviarium Grimani* (beginning of the 16th century, St Mark's Library, Venice [138]).

Tapestry. Tournai, the rival of Arras from 1390, was the principal centre about 1450 (Stories of Trajan and Herkenbald, after van der Weyden; tapestry of the *Knight with the Swan*). From 1475 on, Brussels, using a more refined technique (use of silk, gold and silver threads), chose the pictorial style. In addition to works conceived in the

141. LOW COUNTRIES. ALAERT
DU HAMEEL (c. 1449–1495).
The Bronze Serpent of Moses.
Engraving after Hieronymus Bosch.
National Library, Vienna.

142. GERMAN. MICHAEL
WOLGEMUT (1434–1519). Adam and
Eve. Illustration from the
World Chronicle of Hartmann Schedel.
Published Nuremberg, 1493.

143. ITALIAN. PADUAN.
ANDREA MANTEGNA (1431–1506).
Battle of two Tritons (detail).
Engraving.
Petit Palais, Paris.

style of narrative paintings (*Adoration of the Magi* in Sens cathedral), tapestries of monumental and symbolic character were woven there (*Credo*; *Passion*) [see colour plate p. 72].

The graphic arts. Woodcuts appeared at an early date (plates in the *Ars Moriendi* attributed to a follower of van der Weyden). Anonymous engravings are attributed to the Low Countries: Master of the Gardens of Love; Master F.V.B., etc. In his prints, Alaert du Hameel reflected Bosch's satirical spirit [141].

The minor arts. The most significant works in brass were the baptismal fonts of Hal (1464) and the enormous paschal candlestick of Léau (1482–1483) by Renier van Thienen.

The decoration of monstrances and chalices of gold and silver continued to be inspired by architecture. The silver bust-reliquary of St Lambert (1505–1512, Liége cathedral) carried on the Gothic tradition.

ENGLAND

History. The reign of Henry IV (1421–1471), who married Margaret, daughter of René of Anjou, was marked by defeats in France and the loss of the markets of Guyenne and Flanders. At the beginning of the 15th century royal patronage declined. A grave political crisis, the Wars of the Roses (1455–1485), ruined the aristocracy and strengthened the power of the throne. With the Tudors (Henry

VII, 1485–1509) commercial and industrial development began.

John Lydgate (c. 1370 – c. 1450) adapted Boccaccio. Printing was established in the second half of the 15th century.

John Dunstable (1370–1453), mathematician, astronomer and musician of great melodic invention and clever counterpoint, a disciple of the Italian composers of madrigals, was to have a great influence.

Architecture. The remodelling of the choir (1337–1350) and south transept (1331–1337) of Gloucester cathedral foreshadowed the Perpendicular style, with its desire for spatial unity, its aesthetic basis in the denial of the arch-line as a conditioning motif and its replacement of curves by a horizontal and vertical grid (nave and tower, Canterbury; nave vault, Norwich [2]). The proliferation of ribs culminated in the fan vault, where the conception of a structural rib was abandoned for a traceried conoid: cloisters, Gloucester cathedral (from 1370); Sherborne abbey choir (rebuilt 1436–1459); King's College chapel, Cambridge (1446–1515); Henry VII's chapel, Westminster abbey (dating from 1502).

It was an era of magnificent parish churches (Lavenham, Suffolk [136]). There was a wealth of wood-carved furnishings in the roofs at: Needham Market (c. 1460); March, Cambridgeshire (c. 1500) [137]. There were fine screens at Cullompton, Plymtree and Atherington, all in Devon.

Sculpture. English sculpture, realist by inclination and also because of Flemish influence, nearly always favoured juxtaposed statues in niches, sometimes placed in rows at several levels (façades; choir screens). Friezes composed of the head and shoulders of angels, surmounting a parapet, are typical of the Perpendicular style. The tomb with mourners of Richard Beauchamp (1439, Warwick), by John Massingham, illustrates the vigour of funerary art. Macabre subjects were more realistic than in France (tomb of Thomas Hardy, d. 1424, York). The tomb used as a chantry chapel is frequently found, for example: tomb of Henry IV (1443, Canterbury); bishops' chantries at Lincoln, Hereford and Ely. At the beginning of the 16th century Henry VII's chapel in Westminster abbey was given a lively statuary, perhaps by R. Bellamy, while in the rich heraldic decoration of King's College chapel, Cambridge, the human figure had a modest place. The carved wooden stalls of the early 16th century at Windsor, Ripon, Manchester, and in the Henry VII chapel were inspired by Dutch or Flemish models.

Sculpture in alabaster was developed on the scale of an industry. Ready-made panels were used to compose sarcophagi, tombs and altars. These stereotyped works, gilded and polychrome, whose style seldom varied, were destined for an English clientèle as well as for the foreign market [144].

Painting. Those works, of unequal merit, which have escaped the hand of

time and the iconoclasts (wall paintings; panels decorating choir stalls; choir screens; altars) bear witness to Flemish influence. In the Eton College chapel the frescoes of the miracles of the Virgin (c. 1480–1488), by William Baker are reminiscent of van der Weyden and Bouts. Royal iconography was enriched by portraits of various sovereigns [see colour plate p. 53].

Stained glass. The most individual characteristics of 15th-century glass were its light colours, due to the universal use of silver stain, and the popularity of quarries for heraldic designs. Surviving glass is seen in the largest quantities in parish churches (All Saints, York; St Peter Mancroft, Norwich; Fairford, Gloucestershire; Great Malvern, Worcestershire; St Lawrence, Ludlow).

The minor arts. Much ecclesiastical metalwork was destroyed at the time of the Reformation; secular silversmiths' work bears witness to the originality of local production (cups with lids; salts, sometimes in animal form; treasures of the Oxford and Cambridge colleges).

GERMANY AND CENTRAL EUROPE (1425–1515)

History. The supremacy of the middle classes went hand in hand with the economic prosperity of the towns. The imperial dynasty of the Habsburgs was founded in 1437. Frederick III (1440–1493) lost Bohemia-Hungary to Matthias Corvinus (1458–1490); Maximilian I (d. 1519), who married Mary of Burgundy in 1478, organised the Empire on an aristocratic and federal basis in 1495. In 1499 Switzerland broke away from the domination of Austria. In 1495–1517 there were wars with Italy.

The attempt to make Prague the capital of the Empire miscarried. In the 15th century Cologne was the largest city in Germany, and its archbishop was the most powerful Elector. The council which met in Basle in 1431–1449 contributed to intellectual and artistic activity in the region of the upper Rhine.

Writers of the period were: Nicolas of Cusa (d. 1464), author of *De Concordantia Catholica*; J. Geiler von Kaisersberg (d. 1510), a disciple of John Gerson, who preached in Strasbourg; S. Brandt (the *Ship of Fools*, 1494; popular songs or *Volkslieder*; Passion plays). Philosophers such as Regiomontanus (d. 1476), humanist and astronomer, expressed the religious and cultural upheaval in Germany.

Printing began with Johann Gutenberg (d. c. 1468). The earliest ventures were in Strasbourg. Printing soon spread throughout Germany and central Europe (Cologne, 1464; Basle and Augs-

burg, 1468; Nuremberg and Vienna, 1470; Budapest, 1473; Cracow, 1474), opening up the way to humanism.

Music theorists of the period included K. Paulmann (1410–1473), organist in Munich, and Heinrich Finck (1445–1527), who spent some time in Poland.

Architecture. In addition to the many churches, the towns, which were growing rich, contained fine public buildings, squares and middle class houses.

Sculpture. The influence of Sluter, already evident in Ulm in the work of Hans Multscher, spread to the Rhineland, Swabia, Franconia and even Austria through the influence of Nikolas Gerhaert von Leyden (d. 1473) and his pupils. Profusion of decoration, a distinctive characteristic of the very late Gothic style, prevented a monumental effect in sculpture in stone.

Sculpture in wood, used for ecclesiastical furnishings (stalls), and often associated with painting in altarpieces [see colour plate p. 72], became one of the favourite media of German artists. The best representatives were: Jörg Syrlin, father and son (Ulm); Gregor Erhart (Ulm and Augsburg; *La Belle Allemande*, Louvre — a figure of Mary Magdalen); Veit Stoss (Nuremberg, c. 1440–1533; *Altarpiece of the Virgin*, church of St Mary at Cracow, 1486 [131]); Nikolas von Hagenau (Strasbourg). With the great Bernt Notke of Lübeck, who worked in Sweden (*St George*, 1488 [8], in Stockholm), the Hanseatic school competed with the exports from Antwerp, from which it remained in many respects derivative. In Nuremberg Adam Krafft (d. 1509) translated into stone the technical skill and exuberance of wood-carving (tabernacle in the church of St Lawrence, Nuremberg, 1493–1496) [147].

Painting. The independent character of German painting emerged. Production was extensive, particularly of carved and painted altarpieces. In certain regions up to about 1500 paintings were on a gold background, sometimes embossed. After Lucas Moser, who was a product of the International Gothic style (*Altarpiece of the Magdalen* at Tiefenbronn, 1431), strong personalities came to the fore who were devoted to realism in the manner of Sluter or Campin. Among them were: Konrad Witz [183] (Basle, d. c. 1445; the *Miraculous Draught of Fishes*). The Master of the Tucher Altarpiece (Nuremberg) and K. Laib (Salzburg) illustrate a taste for sculptural effects, with which the Master of the Tegernsee Altarpiece (Bavaria), the Master of the Altarpiece of the Regulars, in the Canons' Church at Erfurt, and Hans Hirtz (Strasbourg)

144. ENGLISH. Head of St John. Polychrome alabaster. *c.* 1440–1450. *Victoria and Albert Museum.*

145. FRENCH. BURGUNDIAN. ANTOINE LE MOITURIER. The tomb of Philippe Pot. *c.* 1480. *Louvre.*

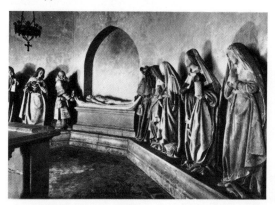

146. FRENCH. The Entombment. 1490. *Chapel of the Hospital of Monestiés sur Céron.*

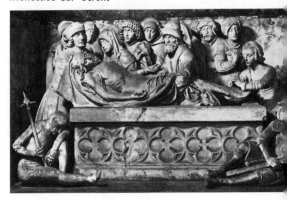

147. GERMAN. ADAM KRAFFT (d. 1509). Entombment. Sandstone. 1507–1508. *Holzschuher Kapelle, Nuremberg.*

combined the growing preoccupation with expression. The Master of the Darmstadt Passion (middle Rhine) and the major master of the Cologne International Gothic style, Stephan Lochner (d. 1451; *Adoration of the Magi*), show the finest sense of colour. The German schools, under Flemish influence from the middle of the century (the Master of the Life of Mary, Cologne [105, 128]; Kaspar Isenmann, Colmar; Hans Pleydenwurff, Nuremberg; Friedrich Herlin and Hans Schüchlin, Swabia), regained artistic independence at the end of the century — except for Cologne, which still adhered to the Flemish style.

The best representatives of expressive German art were: two painter-engravers, Martin Schongauer (Colmar, [108]; *Madonna of the Rosehedge* [129], the prints of which assured a very wide sphere of influence) and the enigmatic Master of the Housebook (middle Rhine, *c.* 1480); Michael Pacher (Tyrol, d. 1498), as great a sculptor as he was a painter (*St Wolfgang Altarpiece, c.* 1481) [111, 126, 132]; Jan Polak (Bavaria); finally, Rueland Frueauf the Younger (Salzburg). With Michael Wolgemut (Nuremberg) and B. Zeitblom the production of carved and painted altarpieces [see colour plate p. 72] became an industry. In Cologne the Master of the St Bartholomew Altarpiece [102], the Master of the Legend of St Ursula and the Master of St Severin reflect the manneristic tendencies of the last Gothic painters of the Low Countries.

Stained glass. Alsace remained the leading centre (Sélestat; Strasbourg). Peter von Andlau (stained glass at Walburg, 1461) worked as far afield as Austria. The influence of Alsace was felt in Switzerland (Berne). From 1460 onwards in the Germanic cantons armorial windows (often found in Germany) became widespread. After 1500 two Cologne painters produced cartoons for stained glass windows for Cologne cathedral (Master of the Holy Kindred), for Altenberg abbey (Master of St Severin) and also for private houses.

The graphic arts. The techniques of wood blocks and of metal engraving assumed considerable importance in Germany. In the form of single plates or in collections (*Blockbücher*), woodcuts had at first a popular character. Printing and publishing in Mainz, Augsburg and Ulm made such progress that they extended to include book illustration. About 1490 Nuremberg took the lead thanks to Wolgemut (*World Chronicle* of Hartmann Schedel, Latin ed. 1493, German ed. 1494 [142]). Basle and Strasbourg became in their turn centres of publishing. Deriving from gold and silver work, engraving on metal was the favourite medium of the Rhenish artists; after the Master of the Playing Cards, a contemporary of Witz, Master E. S. (d. after 1467) [10] perfected its technique which was carried to the highest point of refinement by Schongauer [21, 130] whose influence was all-important. The very rare prints by the Master of the Housebook on secular subjects were probably executed in dry-point on a metal softer than copper.

The minor arts. Tapestries of modest size depicting religious, legendary and secular subjects, which are found in Switzerland (Basle), Alsace (Strasbourg; in the vicinity of Saverne) and Germany (Nuremberg; Regensburg; Halberstadt), seem to be of local provenance.

In gold- and silversmiths' work in Germany (especially in Cologne and on the lower Rhine), Switzerland and Austria-Hungary the Gothic formulas were preserved. Realism was evident in bust-reliquaries and in statuettes with complicated drapery. Backgrounds became richer. Secular silver ware was popular (cups and goblets with niello and enamel work).

HUNGARY

In Hungary, after the brief visit in 1427 of the Florentine painter Masolino, the humanist sovereign Matthias Corvinus encouraged work in Italian styles. The son-in-law of Ferdinand of Aragon, king of Naples, he commissioned Florentine artists. Manuscript

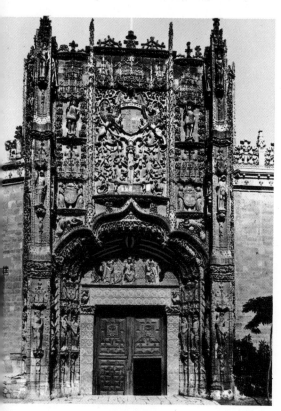

148. SPAIN. Detail of the façade of the college of S. Gregorio, Valladolid, conceived in the manner of an altarpiece. 1488–1496.

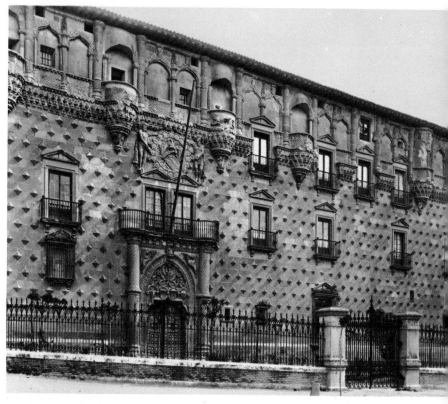

149. SPAIN. ISABELLINE. The Infantado palace at Guadalajara. 1483. Destroyed 1936.

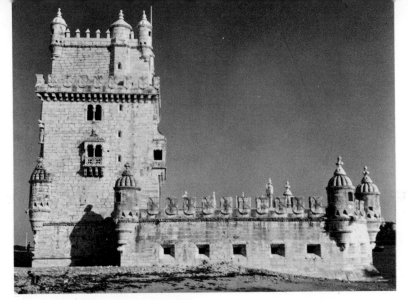

150. PORTUGAL. The tower of Belem from the west. Completed 1520.

illuminations carried out by artists established at the court workshop followed the style of northern Italy (*Codex Cassianus* by G. A. Cattaneo, National Library, Budapest). The Hungarian painter Michele Ongaro, called Pannonio (d. 1464), settled in Ferrara.

FRANCE (1425–1515)

History. The kingdom was liberated and unified during this time. In the reign of Charles VII (1422–1461) the Hundred Years' War ended. The reign of Louis XI (d. 1483) witnessed the struggle with the house of Burgundy. In 1482 Picardy and Burgundy came under the crown. On the death of René of Anjou, Anjou, Maine and Provence were annexed. Charles VIII (d. 1498; expedition to Italy 1494–1495) was married to Anne of Brittany

(d. 1514). After Charles' death she married Louis XII (d. 1515; wars with Italy 1499–1513).

A religious revival heralded the Reformation. In 1482 St Francis of Paula, an Italian monk, founded a new Order, the Minims. The theatre took on a new importance (*c.* 1425–1450, mystery plays by Eustache Marcade and Arnoul Gréban). Leading poets were: Charles, Duke of Orléans (*Ballades*, *c.* 1450); René of Anjou (the *Coeur d'Amour Epris*, composed in 1457); François Villon (*Testament*; *Ballade des Pendus* [*Villon's Epitaph*], *c.* 1462). Story writers (Antoine de la Sale, d. after 1469) and court writers (Philippe de Commynes, d. 1511; Jean Le Maire, d. 1525) were linked with such artists as J. Perreal and M. Colombe. Printers worked in Avignon (Waldvoghel of Prague), Paris (in the Sor-

bonne) and Lyon; in 1504 H. Estienne founded his printing house in Paris. The Greek Jean Lascaris, in France from 1494 to 1503, worked with Guillaume Budé to organise the Royal Library. The Flemish musician Joannes Ockeghem (d. *c.* 1496) was in the service of Charles VII, Louis XI and Charles VIII. Josquin des Prés (d. 1521), who worked for Louis XII, after having been with the Sforza family, the Pope and the Este family in Italy, was the greatest French polyphonic composer.

Architecture. In the 15th century political events had repercussions in art and the role of Paris and the Ile-de-France became less important. As a result Flamboyant architecture was stamped with the vigour of growing provincial trends. Structural parts of buildings were overloaded with decorative curvilinear forms. Complicated architectural elements increased; liernes (ridge ribs) and tiercerons (intermediary ribs) proliferated in vaulting in which the ribs no longer had any structural significance. The towers and belfries of the 15th and 16th centuries were typical (Butter Tower of Rouen cathedral).

In Paris the porches of St Germain l'Auxerrois, St Gervais and St Etienne du Mont, like the hôtel de Cluny and the hôtel de Sens, bear witness to the vitality of the Gothic style. Normandy (porch of St Maclou at Rouen; Notre Dame at Louviers; Notre Dame at Alençon) and eastern France (Champagne, Bresse and Lorraine) were the provinces where the Flamboyant style flourished. The house of Jacques Coeur at Bourges was the most magnificent 15th-century home in France.

151. ITALIAN. Faience plate. *Louvre.*

152. FRENCH. Medal of Anne of Brittany, by Nicolas Leclerc, Jean de Saint-Priest and Jean Lepère. 1499. *Bibliothèque Nationale, Paris.*

153. SPANISH. Faience vase with lustre decoration, from Valencia. *c.* 1465. *Godman Collection, Horsham.*

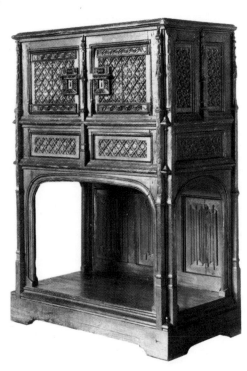

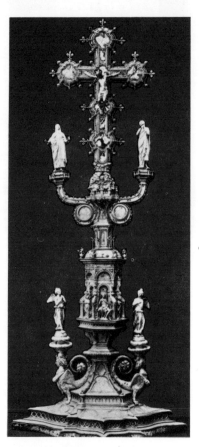

154. FRENCH. Dresser. Carved oak.
End of the 15th century.
Musée des Arts Décoratifs, Paris.

155, 156. SPANISH. Tiles (*azulejos*)
in glazed brick. 15th century.

157. ITALIAN. Silver Cross.
15th century. *Cathedral
Museum, Florence.*

The late Gothic style continued into the 16th century, as witness the famous town hall at Rouen.

Sculpture. Sculpture developed in the provincial centres after the decline of the Paris workshops, which were ruined by the Hundred Years' War. The influence of Sluter, which was very widespread, was felt first in Dijon and Burgundy in funerary sculpture (tomb of John the Fearless, by Juan de la Huerta of Aragon and Antoine Le Moiturier of Avignon, at Dijon, 1440–1470; tomb of Philippe Pot, *c.* 1480, Louvre [145]) and in statuary (Madonnas at St Jean de Losne and at Auxonne; *Buliot Virgin,* Musée Rolin, Autun; *St James of Semur,* Louvre). Sluter's influence was also seen in productions of a more discreet realism (tomb of John, Duke of Berry, carved in Bourges under the direction of Jean de Cambrai) and in statues of the Virgin and Child and of saints, works of tender expression and worldly grace (*Virgin of the Marthuret, c.* 1450, Riom; *Virgin and Saints,* 1464–1468, Chateaudun; *Virgin of the Celestines,* Avignon). The cult of saints inspired many works commissioned by brotherhoods and corporations. The feeling for pathos was expressed in monumental groups of the Entombment [146].

The school of Troyes left some moving examples of the Virgin of Sorrows (Bayel and Mussy sur Seine), another favourite theme. The Gothic tradition persisted up to about 1530 in Troyes, a centre of middle class art (*St Martha,* church of La Madeleine; *Visitation,* church of St Jean du Marché).

The decorative exuberance of Flamboyant Gothic showed itself as much in the stone sculpture of the south (choir screen, Albi cathedral, 1473–1502) as in the wood-carving of the north (stalls at Amiens, 1508–1522). However, the Italian influence reached France about 1470–1500 with the sculptors summoned by René of Anjou (Francesco Laurana; Pietro da Milano) and by Charles VIII (G. Mazzoni). The Italian influence was also seen in the work of the masters of the Loire school in the adaptation of forms and the adoption of Italian motifs in decoration; the Solesmes sepulchre (1496) and the marble sculpture of Michel Colombe (*c.* 1430–1515) on the tomb of Francis II of Brittany, in Nantes (1502–1517), are examples of this (see Chapter 2). But in the first quarter of the 16th century the sculptor of the statues commissioned by Anne of Beaujeu for the château of Chantelle (Louvre) still remained faithful to the medieval spirit.

Painting. The political situation and the installation of the Duke of Burgundy in his northern provinces brought about a shift in the centres of art. Production grew after 1450. The workshops of Amiens and Valenciennes, whose principal representative was Simon Marmion (*St Bertin Altarpiece, c.* 1455 [165]), and those of Dijon and Bourges, were connected with the Flemish school whose influence had spread as far as Provence. The Master of the Aix Annunciation [182], who according to the most recent hypothesis may be Guillaume Dombet, Enguerrand Charonton (*Coronation of the Virgin,* 1453 [116], Villeneuve lès Avignon), the master who painted the *Pietà of Villeneuve lès Avignon* (before 1457) [119], and later Nicolas Froment (active *c.* 1450–1490) [107] who was painter to René of Anjou, the Master of St Sebastian and Ludovico Brea of Nice [122] assured a privileged place to the school of Provence, which encompassed both northern and Mediterranean traditions. In the region of the Loire two great miniaturists, the Master of King René in Angers (miniatures in the *Coeur d'Amour Epris,* 1460–1465, Vienna Library) and Jean Fouquet in Tours, gave a poetic note to French realism. Jean Fouquet (*c.* 1420–*c.* 1481) made a journey to Rome

158. ITALIAN. Part of the
'Studiolo' of Duke Federigo da
Montefeltro of Urbino, with
its marquetry panelling.
1475. *Ducal Palace, Urbino.*

159. *Below.* FLEMISH. Reliquary of
St Ursula, by Memling.
1489. *Hôpital St Jean, Bruges.*

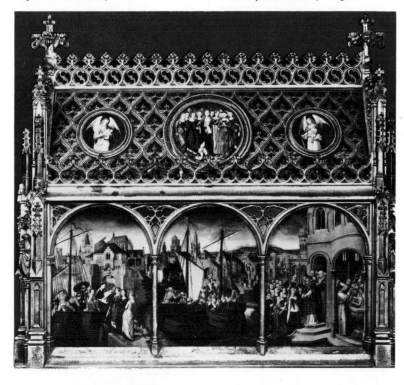

160. FRENCH. Self-portrait of
Jean Fouquet. Painted enamel.*c.*1450.
Louvre.

161. ITALIAN. Medal of
Malatesta Novello, by Pisanello.
c. 1445. *Museo Nazionale, Florence.*

early in his career. About 1445 he was
working for Charles VII and his circle.
In 1475 he was court painter to the
king. He was both a portraitist and a
painter of religious subjects; his master-
pieces are: before 1445, his portrait of
Charles VII (Louvre); *c.* 1450, *Virgin
and Child* (Antwerp) [**118**] and *St
Stephen with Etienne Chevalier* (two
halves of the *Melun Diptych*); *c.* 1460,
Juvénal des Ursins [**104**]; miniatures of
the *Hours of Etienne Chevalier* [**168**];
c. 1470, *Les Antiquités Judaïques.*

Jean Bourdichon, illuminator and
painter (*c.* 1457–1521), was affiliated
with the school of Tours; together
with Bourdichon, the Master of
Moulins [**110, 121**; see colour plate
p. 71], active in the Bourbonnais
(*Moulins Triptych* in Moulins cathedral,
1498–1499), and the Flemish trained
Master of St Giles (active *c.* 1500; two
scenes from the life of St Giles, National
Gallery, London) settled in Paris,
where they were representatives of
the court art which flourished anew
under Charles VIII and Louis XII. At
Douai the work of Jean Bellegambe
(d. 1534), a follower of Marmion, was
influenced by Antwerp (*Anchin Altar-
piece*, 1511–1520, Douai [**166**]).

Stained glass. The window of
the Annunciation (1445–1450) in the
Jacques Coeur chapel in Bourges
cathedral, the windows at Riom, those
in Moulins cathedral and those in
St Ouen at Rouen (*c.* 1495) are the
important works. Their energetic style
reveals tendencies similar to those of
the painters.

The graphic arts. The first printed
books appeared about 1460. Paris and
Lyon were the principal centres of
publishing (Paris: *Danse Macabre* print-
ed by Guy Marchand in 1485; *Calen-
drier des Bergiers*, also printed by
Marchand, 1491: Antoine Vérard and
later Simon Vostre printed Books of
Hours with woodcuts). In Lyon the
Comedies of Terence were published
in 1493.

The minor arts. Sculptural bust-
reliquaries in silver and bronze were
made in the provinces. Under Parisian
influence magnificent pieces in gold
decorated with enamel and jewels
were made about 1425–1475 in the
Duchy of Burgundy (treasures of the
dukes and the Golden Fleece vest-
ments, Vienna).

After 1450 the Parisian workshops
were again very active (reliquaries of
the Holy Thorn and of the Resurrection,
c. 1450–1460; the St Ursula Nef,
c. 1500 — remodelled in the 16th
century — in Reims cathedral; mon-
strance of the Order of the Holy
Spirit, Louvre). Jean Fouquet intro-
duced the medaillon in painted enamel
(*Self-portrait*, Louvre [**160**]), a technique
practised about 1470–1500 in Limoges.

Medals were introduced into France by Italians (Pietro da Milano; Francesco Laurana). Artists from Lyon and Tours worked as medallists under Charles VIII and Louis XII [152].

Until 1477 the centres for tapestry were Arras (lives of Clovis [162] and of St Peter, c. 1460) and the Duchy of Burgundy (*Tapestry of Chancellor Rolin*, Beaune; three *Coronations* in Sens, c. 1480; *Life of the Virgin*, Beaune, c. 1474–1500). Schools, probably itinerant, were active about 1500 in the valley of the Loire. They were responsible for tapestries with backgrounds of red or blue flowers, for example: the *Lady and the Unicorn* (Musée de Cluny, Paris [164]); various rural scenes and scenes of courtly life [163]. At Aubusson tapestries, with a decoration of flowers and animals, called *mille fleurs* were produced.

In furniture carved decoration became richer, especially after 1450. In addition to fenestration and other elements borrowed from architecture (colonnettes; carved panels; leaf decoration), the most widespread motif was linenfold panelling. Under Louis XII Italianate ornaments (pilasters; foliage) appeared. The canopied four-poster bed took on the character of a work of art.

ITALY
(See *Historical Summary*, p. 40.)

SPAIN AND PORTUGAL
(1425–1515)

History. Spain embarked on its great policy of expansion. The kings of Aragon, who ruled the Balearics, Sardinia and Sicily and traded with the Levant, re-established under Alphonso V, who added Naples in 1442, the greatest kingdom in Italy, that of the Two Sicilies (which had been ruled by the house of Anjou ever since St Louis' brother Charles had received it from the Pope in 1266). Sicily seceded from this kingdom in 1458 at the death of Alphonso; but in 1504 after the war with Naples Ferdinand of Aragon made the two countries one Spanish possession. The links between Spain and Italy were strengthened through the popes of the Borgia (Borja) family, Calixtus III (1455–1458) and his nephew Alexander VI (1492–1503).

At this time also Castile and Aragon, two rival kingdoms, united as a result of the marriage in 1479 of Isabella of Castile and Ferdinand of Aragon. These rulers completed in 1492 the reconquest which had started seven centuries earlier with the capture of Granada. They restored the authority of the king and created in 1480 the Holy Office of the Inquisition to support them. The Infanta Joanna the Mad of Castile married in 1496 Philip the Handsome, son of the Emperor Maximilian I of Austria, thus preparing the way for the vast future empire of their son Charles V.

Portugal turned towards the Atlantic; Prince Henry the Navigator, son of John I, began, from 1415, his voyages of discovery which took him to the Canaries, the Azores and West Africa. In the reign of John II, Bartholomeu Diaz discovered the Cape of Good Hope (1488); Vasco da Gama reached India in 1498. Dom Francisco de

162. FRANCO-FLEMISH. ARRAS. Scenes from the life of Clovis. Detail. Tapestry. c. 1460. *Reims Museum.*

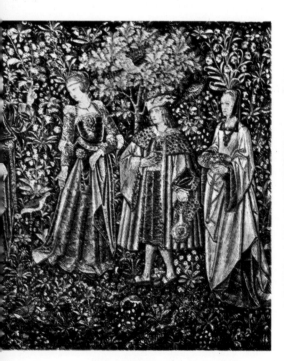

163. FRENCH. The Promenade. Detail. Mille fleurs tapestry. c. 1500. *Musée de Cluny, Paris.*

164. FRENCH. Episode from the Lady and the Unicorn. Tapestry. c. 1509–1513? *Musée de Cluny, Paris.*

Almeida (d. 1510) was Viceroy of India. In 1500 the Portuguese explorer Pedro Alvares Cabral reached the South American mainland (Brazil).

Under the auspices of Spain Christopher Columbus, from Genoa, discovered America in 1492, in 1497 Amerigo Vespucci reputedly discovered the American mainland. A literary coterie existed round John II of Castile (the Marqués de Santillana, d. 1458, poet and patron of the arts). In 1450 the university of Barcelona was founded.

Printing had its beginnings in Valencia and Barcelona in 1474 and in Lisbon in 1489.

Architecture. In Spain during the 15th century Gothic architecture, long indebted to France, developed a rich exuberant decoration corresponding to the French Flamboyant style but having (especially after the reconquest) Moorish elements, which had first made their appearance at the end of the 12th century (the Mudejar style).

While in the north the builders were occupied with the completion of works begun in the 14th century, in southern Spain, especially in Andalusia, which was particularly sensitive to Moorish influence in decoration, the new style flourished. Seville cathedral, begun in 1405, had a nave and four aisles lightly stepped up towards the centre and had a dome over the crossing. The towers or *amborios* of the transepts, and the raised sanctuaries, were, together with a preference for a broad aisleless nave, the most remarkable characteristics. Secular buildings were also erected (the Audiencia in Barcelona; the Lonja de la Seda, Valencia; the Lonja, Palma, etc.).

In the middle of the century the interest in lavish decoration led to an efflorescence of the Mudejar style. Elements from Italian Renaissance art were introduced into the decoration, which acquired the richness of gold- and silversmiths' work, whence the name Plateresque (*platero*, silversmith).

Foreign architects played a great part in the evolution of this style, which flourished in Toledo, Avila, Valladolid [**148**], Burgos (where Hans of Cologne [Juan de Colonia] built the Carthusian monastery of Miraflores, completed by his son Simon who built the Chapel of the Constable in Burgos cathedral [**4**]) and Segovia (where Juan Gallego built, after 1460, the church for the Parral monastery).

The Spanish rulers gave such active and enthusiastic support to art that the style of the end of the century, in which Gothic, Mudejar and Italian elements mingled, was called Isabelline. Its principal representative was Juan Guas (d. 1496) who worked in Toledo (cathedral; church of S. Juan de Los Reyes) and in Guadalajara (Infantado palace, *c.* 1483 [**149**]). Moorish influence

165. FRANCO-FLEMISH. SIMON MARMION (active 1449 – d. 1489). St Bertin conversing with a bishop and tempted by a woman with a cloven hoof. Detail from the St Bertin Altarpiece. *c.* 1455. *Staatliche Museen, Berlin.*

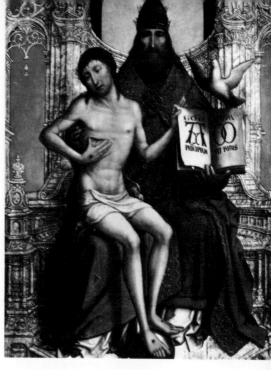

166. FRANCO-FLEMISH. JEAN BELLEGAMBE (d. 1534). Detail of the central panel of the Anchin Altarpiece. 1511–1520. *Douai Museum.*

persisted — perhaps because of the number of Moslem craftsmen — in the frequent repetition of certain elements of decoration such as stucco facing and stalactite ceilings.

Enrique de Egas, successor to Guas and one of the builders of Toledo cathedral, began the Hospital Real at Santiago de Compostela in 1501 and, in 1506, the Capilla Real at Granada, the burial chapel of the rulers Ferdinand and Isabella.

The façade of Salamanca university, dating from the beginning of the 16th century, marked the triumph of Italian themes and of Renaissance architecture.

In Portugal the Gothic style, which was at first Cistercian, was perpetuated with great individuality at Batalha monastery, begun by King John I in 1385. At the end of the century the influence of the Flamboyant style could be seen in the Manueline style (which owed its name to Manuel I, 1495–1521), a style that resembled the Isabelline but also showed Islamic influence which had come via Morocco and the voyages of discovery. This powerfully original Manueline style experienced its greatest flowering at the beginning of the 16th century (tower of Belem, completed 1520 [**150**]; completion of the monasteries of Batalha [cloisters *c.* 1509] by Boytac, the Fernandes and others, and of Alcobaça and Thomar, *c.* 1510, by João de Castilho, who succeeded Boytac at the Jeronymite monastery in Belem [**378**], where his masterpiece, the cloisters, is evidence of the increasing influence of Italy).

Sculpture. In Spain the majority of sculptors were of foreign origin, except in Catalonia and Aragon where local masters such as Padre Joan revealed original qualities in the decoration of civic buildings (*St George*, Casa de la Diputación in Barcelona) and in the monumental altars in marble or alabaster (Sta Tecla altar, 1426, Tarragona cathedral). French, German and Flemish stonemasons and carvers introduced into Castile and León the dynamic style of the Sluter school with the decorative repertory of Flamboyant Gothic, which was enriched by elements borrowed from Mudejar art. The originality of the sculptors showed itself in Castile in the choir terminations and in the monumental altars and stalls in both churches and cathedrals (stalls and altar in Seville cathedral, by Master Dancart of Lille, 1482–1492; lower stalls in Toledo cathedral, before 1495; stalls in Plasencia cathedral, 1497, and in the cathedral at Ciudad Rodrigo by Rodrigo Alemán; stone altar in S. Nicolás, Burgos, by Francisco de Colonia). Together with Juan Guas, who represents the opulent decorative Isabelline style, the greatest sculptor in the service of the court was Gil de Siloe, who worked in Burgos but had trained in Flanders or in Germany (altar and tombs in the church of the Carthusian monastery of Miraflores, completed 1499). With this sculptor and his followers in Castile, richness of composition and abundance of detail were carried to extremes [**135**].

In Portugal sculpture was almost exclusively decorative. The sculpture of the first phase of the Manueline

167. FRENCH. PROVENÇAL. MASTER OF ST SEBASTIAN (active 1493–1505). St Sebastian destroying the Idols. *Johnson Collection, Philadelphia.*

168. FRENCH. JEAN FOUQUET (c. 1420–c. 1481). St Margaret and Olibrius. Miniature from the Hours of Etienne Chevalier. Parchment. c. 1450–1460. *Louvre.*

style (c. 1495–1515) was influenced by Moorish art. It was the equivalent of the Mudejar style evident from the end of the 14th century and used at Evora under John II. Geometric and naturalistic motifs, treated in high relief (ropes, tackle, instruments of navigation, seaweed, coral, etc.), lent an exotic aura to the ornamental art of this country of sailors and explorers (cloisters of Batalha and Belem; north portal of the Thomar monastery, c. 1510; tower of Belem, 1520 [**150**]). Flemish and Spanish sculptors carved altars and stalls in wood (cathedral and church of Sta Cruz at Coimbra).

Painting. In Spain the use of the gold background, which had gradually been abandoned in all the other western European schools (except in Germany), persisted until about 1500. In Aragon

and Catalonia the high relief of the plaster decoration gave the enormous altarpieces an almost Oriental richness. The many works of the Spanish painters of this period reflect various influences.

In the east, under Alphonso V of Aragon and his successors, Italian and Flemish influences were blended. While the Master of Arguis and Bernardo Martorell (panels of *St George*, Louvre and Art Institute of Chicago [**82**]) prolonged the International Gothic style to about 1450, Luis Dalmau (Valencia and Barcelona) imitated the work of van Eyck (*Virgin of the Counsellors*, 1445, Barcelona). Jacomart (Jaime Baço) from Valencia (d. 1461) and his pupil Joan Reixach were influenced by Italian art and Flemish painting (*St Martin Altar*, Segorbe), as was Rodrigo de Osona (active 1476–1484), whose style was more evolved. In its final stage the Catalan tradition was represented by Jaime Huguet (d. after 1489) [**123**] and the Vergós family. Still working in Barcelona at the turn of the century were Bartolommé Bermejo of Cordova (active 1474–1498 [**124**]; *St Dominic of Silos*, Prado) and the Master of the Martyrdom of St Medin, who perhaps trained in Naples.

In Castile, where the style of the Italian painter Nicolás Florentino (fresco in Salamanca cathedral, c. 1445) was not echoed in local painting, the Flemish influence was predominant. Pictures imported from the Low Countries by the court and by other patrons of art, and Flemish works sold in the fairs of Medina del Campo, helped, as did German prints, to spread the taste for northern art, to which the local workshops now adapted themselves. Jorge Inglés (active 1450) and later Fernando Gallegos (Salamanca) and his numerous followers (Master of St Ildefonso, Valladolid) were the most representative of these Hispano-Flemish artists, among whom were the Master of Avila and the Master of the Sisla, influenced, like Gallego, by Schongauer. Pedro Berruguete, who was originally influenced by Flemish artists but later followed the Italian style, was the dominant personality in Castile at the end of the Middle Ages (scenes from the lives of St Dominic and St Peter, Prado [**133, 345**]). In Andalusia the Hispano-Flemish tendency had as its principal representatives Juan Sanchez de Castro and Juan Nuñez in Seville and, in Cordova, Pedro de Cordova.

In Portugal little remains of the output of the workshops and schools of painting. (Jan van Eyck visited Portugal

during the winter of 1428–1429). The portrait of John I (Vienna) and the curious *Ecce Homo* with closed eyes (copy in Lisbon) were influenced by Flemish art, which also inspired the works of Nuno Gonçalves, painter to King Alphonso V in Lisbon in 1450 and one of the greatest masters of the Middle Ages. He painted the *St Vincent Polyptych* and numerous portraits [**127, 134**]. He was painter to the city in 1471 and also did cartoons for tapestries (*Taking of Arzila*; *Occupation of Tangiers*).

The minor arts. In Spanish gold- and silversmiths' work Flemish and German influences can be seen in the architectural forms and in the decoration, often heavily overloaded, of monstrances, processional Crosses and ciboria, to which may be added those typically Spanish items the custodias (polygonal towers of several storeys in which the monstrance was placed on Corpus Christi). The earliest custodias were made in Catalonia about 1400–1450 for the cathedrals of Vich, Barcelona and Gerona.

Enrique de Arfe, originally from Cologne, made, at the beginning of the 16th century, the enormous custodia for the monastery of Sahagún and for the cathedrals of Cordova and Toledo. Examples of secular gold- and silversmiths' work are more rare (in the cathedrals of Saragossa and Toledo).

Portuguese gold- and silversmiths' work was also influenced by Germany (Belem Monstrance, 1506, by Gil Vicente, made of the first gold brought from India by Vasco da Gama).

In ceramics Spanish craftsmen borrowed from Moorish art and were concerned with the technique of tin-glazed earthenware with lustre decoration which shone like metal [**153**]. Even before the conquest of Malaga and Granada, centres of Hispano-Moorish production, the Mudejar potters were working in Majorca (from which comes the name majolica, given in Italy to pottery which was in imitation of that which had been brought from Spain on the boats from Majorca), in Valencia and the surrounding districts and in Seville. They produced glazed tiles (*azulejos*) [**155, 156**], vases, and dishes with lustre decoration, either in the Moorish manner or ornamented with armorial bearings, inscriptions in Gothic lettering or religious emblems.

Adeline Hulftegger and Jean Charles Moreux

169. ITALIAN. FLORENTINE. MICHELANGELO (1475–1564). Head of Dawn, from the tomb of Lorenzo de' Medici. 1524–1531. *Medici Chapel, S. Lorenzo, Florence.*

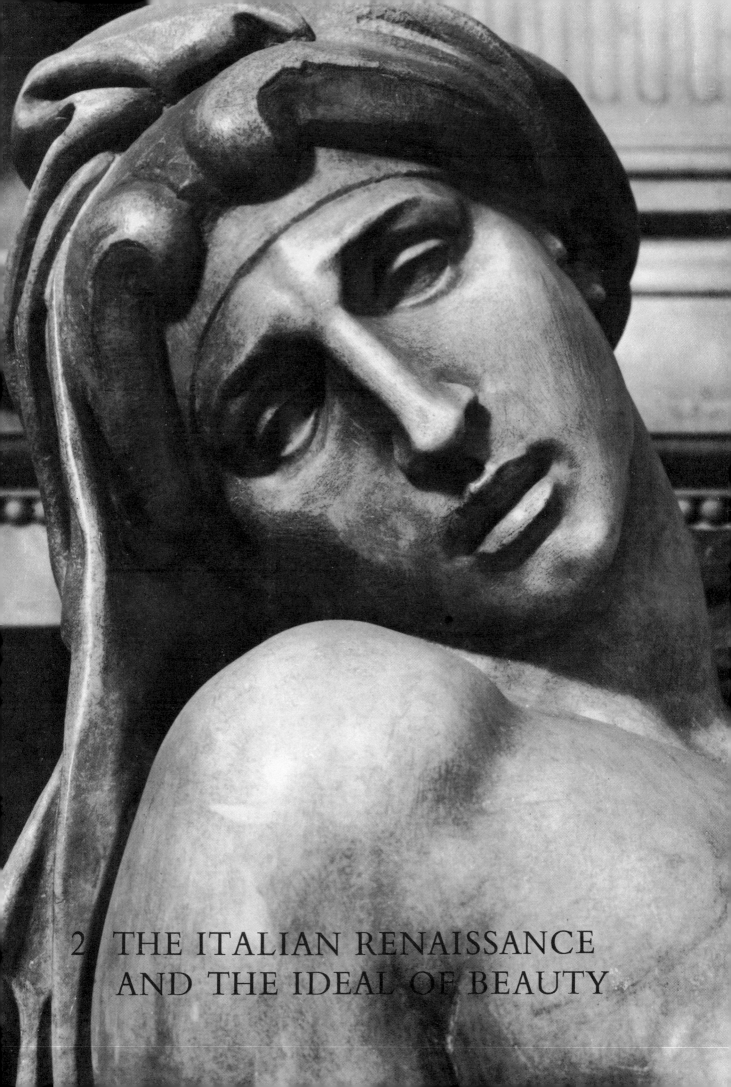

2 THE ITALIAN RENAISSANCE
AND THE IDEAL OF BEAUTY

ART FORMS AND SOCIETY *René Huyghe*

The more one studies the 15th century in the northern countries where the firmly established medieval spirit was making its last stand, the more agonised it appears. But once we turn to Italy the perspective changes and shifts; there civilisation was very much older; far from being founded by the Middle Ages, as was northern civilisation, it had been compromised and sometimes nearly destroyed by them. In Italy regret for the lost splendours of antiquity brought a constant urge to revive them.

Traces of the medieval spirit did, it is true, survive longer in the peninsula than might have been expected since, in spite of some reserve, Italy, too, had been impregnated; perhaps it was not extinguished until 1455, the year when Fra Angelico, in whom an intense religious spirituality persisted, and Pisanello, who embodied International Gothic and the court style, both died. And yet, by that time, the second half of the 15th century had already arrived, which is identified with the ' first Renaissance ', the origins of which date back at least to the end of the 13th century, to Giotto.

If one wished to show more succinctly how artificial are the traditional divisions of history, it would suffice to note the extent to which the 16th century, the century of Julius II and Leo X, which has been labelled the High Renaissance, spills over from the confines of this title; the first of the two popes died in 1513, the second in 1521, and it can be said that as early as 1527 the sack of Rome sounded the knell of this Renaissance which was to be succeeded by a series of styles, from Mannerism to the Baroque, marking the stages of a totally different age.

Italy and the role of form

Middle class realism was the most immediate and natural form of expression in Flanders where its first tentative appearance dates from the Gothic, and it remained the basis of Western art until the end of the 19th century. At best the middle class which continued under the aegis of the Church — as had previously the aristocracy — put this positive vision in the service of a piety which progressively declined in fervour but which still maintained a high quality in the work of van Eyck and of van der Weyden, until it grew insipid in that of Memling. Nothing remained but this reproduction of the appearance of reality, of complete truth, which still dominated the Dutch school of the 17th century.

In Italy, also, the social scene was revolutionised by the triumph of the middle class, and yet the art arising out of the same growth of realism was completely different. A calm notation of visual reality never had a chance against the supremacy, or even tyranny, of the intellect, which required appearances to be sternly subjected to philosophical categories. From the beginning, Italian realism was a formal, not a visual, realism. The great theorist of the 15th century, L. B. Alberti, inspired by Aristotle, observed of form and matter: ' The one is a product of the mind, the other borrowed from nature.'

Moreover it is to this reconquest of form, which, with classical Greek thought, became the main phenomenon, that the first efforts of Italian art were directed after contact with the Gothic realistic trend. It differed from Byzantine art in this rediscovery of form and mass and disengaged itself from Byzantine domination. The comparison in Chapter 1 of the research undertaken in different regions at the same moment has already shown that Italian realism has its own particular logic. Transported to a new milieu, thrust into a different situation, the upheaval which was transforming the Gothic was practically unrecognisable in Italy, but the principle of it remained the same. But in Byzantine-influenced Italy, to recover contact with reality meant, above all, to break away from the two-dimensional interpretation and the immaterialism of Christian art of the previous centuries; it meant reintroducing the concrete reality of things through mass and form. This was the meaning of the antique heritage which, buried under a thin layer of foreign importations, aspired to impose itself everywhere in Italy. And it now becomes important to view the art of the peninsula through the perspective of tradition and autochthonous evolution rather than through the Middle Ages. With Cavallini, drawing was already taking account of relief, in order to restore to painting the illusion of full, solid mass. When the realist impulse showed itself precociously in Italy, artists borrowed the abandoned methods of antiquity and reanimated them. They were much more interested in reproducing structure and relief than concrete substance — stone, flesh, wood or material — which preoccupied the northern middle class artists, whose art was guided by no previous culture.

At the end of the 13th century Cimabue in Florence and Cavallini in Rome, striving for faithful representation, turned towards sculptural art. That is why the initial impetus came from the sculptors — the ones who in the 13th century worked for Frederick II of Hohenstaufen, basing their style on antiquity, and the ones who, in Pisa, beginning with Nicola Pisano, founded the new school, by adding to the Roman style that of the French Gothic. This introductory role played by sculpture already shows that the Italian inspiration was going to be, above all, and in the true sense of the word, sculptural. When Giotto, through his genius, brought the research that had been inaugurated to fruition he created a sculptural style of painting. It was the settling of an old account between East and West. Ghiberti realised this when, at the beginning of the 15th century, he said in homage to Giotto that he ' discovered a whole doctrine which had been buried for six hundred years '. So much light is thereby thrown on the history of art that we must pause for a moment to consider it.

Linear art and three-dimensional art

There are, indeed, two fundamental possibilities for art, which coexisted from prehistoric times until after the emergence of Greece, as distinct from the Oriental world, when they separated and opposed one another. One respects the flat surface and its two dimensions; the other represents mass and attempts to give a true representation of real form and its three dimensions. The first demands the use of drawing in its linear form, transforming everything into a linear design; the most frequent result is to produce flat surfaces suitable for colour. The second, by means of the illusion of trompe l'oeil in painting, expresses itself as volume, the drawing of which is confined to defining the contours.

Whereas Egypt had cultivated not only the flat surface in her paintings or bas-reliefs (which were sometimes combined) but also the high relief in her statues which were conceived as ' doubles ', and Mesopotamia, like Crete, had shown a marked preference for the first form of expression, Greece and then Rome were pre-eminent in the second form of art. Their painting, which was, by definition, the art of the flat surface, attempted by means of shading and modelling which ' rounded ' the surface to infringe the two-dimensional rule and create the illusion of a third dimension, and therefore of relief and depth.

It must already be apparent that where the line predominates it suggests a dynamism by the vivacity of its drawing, or provides a representation of movement. Volume, on the other hand,

49

54

38

171

90

101, 106

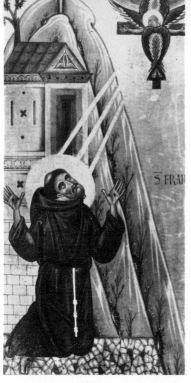

170. ITALIAN. FLORENTINE. SCHOOL OF
BONAVENTURA BERLINGHIERI (13th century).
St Francis Receiving the Stigmata. *Uffizi.*

171. ITALIAN. FLORENTINE. GIOTTO
(c. 1266–1337). St Francis Receiving the Stigmata.
Upper church of S. Francesco, Assisi.

172. *Right.* ITALIAN. BENEDETTO DA MAIANO (1442–1497).
St Francis Receiving the Stigmata.
Relief from the History of St Francis. *Sta Croce, Florence.*

173. ITALIAN. SIENESE. SASSETTA
(documented 1423–1450). The Stigmatisation of St Francis.
One of the panels of the altarpiece painted for
Borgo S. Sepolcro. 1437–1444. *National Gallery, London.*

*The other panels are dispersed between the
Berenson Collection and Chantilly.*

THE EVOLUTION OF REALISM

*St Francis contributed a great deal to the value of
positive vision by teaching the love of God through His
concrete, tangible creation. If the significant
theme of the stigmatisation, in which the saint physically
experiences the wounds of Christ, is examined, the various ways
in which the subject is treated reveal the increase in the use of
realism at the end of the Middle Ages. In the 13th
century, which was still influenced by
Byzantine intellectualism, nature was represented as flat and
ordered by a strong geometrical and symmetrical
sense [170]. In the 14th century, the Florentine Giotto drew
closer to visible reality, but still interpreted it with a
sculptural simplification of mass and clarity of
exposition [171]. In the 15th century, the optical approach
became all-important, to the extent that in Florence even
sculpture became pictorial [172]; Siena, more sensitive,
discovered the gentle modulations of lighting [173];
but Flanders saw the triumph of interpretation by the
senses, with the exact reproduction of matter and
of microscopic detail [174].*

174. FLEMISH. JAN VAN EYCK (1385/90–1441).
The Stigmatisation of St Francis. *Turin Museum.*

only exists in relation to a static centre, that of its mass; it invokes an effective ponderance and balance; it immobilises. While in Greece vase painting, which retained its linear formula, contrasted with ancient statuary or mural painting in its use of scenes of movement, sculpture, apart from the ambitious attempts of Myron and the final excesses of the Hellenistic phase, found its ideal in balanced, harmonious stability. In all Western art, it was discovered that statuary only becomes animated if it tends to go beyond its own limitations, that is, in its mannerist or baroque periods.

Drawing, at times, seems to strive for free dynamic expansion, ignoring all formal restraint and allowing itself to be carried away by its own possibilities; barbarian decoration and, taken to the extreme, Irish miniatures are examples of this. Generally it confines itself to an animated play of lines, it tends towards calligraphy, it becomes arabesque. This was the solution of the Gothic miniature. This tendency to yield to the impulse of the hand, to the ease of gesture, flourishes in the sculptor's and goldsmith's craft. When the draughtsman is not confronted by the necessity of rendering volume, he gives full play to linear rhythm. For example, Rubens overcomes the discipline of classical form in order to allow the enthusiasm of his creative gesture to live in his style, in the form of undulations; Rembrandt, still more independent, makes his canvas vibrate with sparkling brush strokes.

On the other hand, while line in its vital continuity spontaneously depended on rhythm, high relief, establishing fixed relationships between elements which could be isolated and were only constructed together, called for proportion, the only means of binding them together intimately. This can be demonstrated in the art of classical antiquity, and it will again be demonstrated in Italian art. Finally, when line, in painting for example, is used to create the illusion of volume, it is of necessity restricted to the outline and must suppress its potential 230 dynamism in order to concentrate on the form it encloses. It soon has to revert to geometric figures which define form. In order to define the mass for which it is responsible, drawing must become static and loses its natural flexibility. It ceases to be gesture and becomes form; it becomes petrified. This is the law which regulates classical art, from the Italians to Jacques Louis David.

Mediterranean art from the days of ancient Greece was three-dimensional; Persian art, on the other hand, was two-dimensional. From antiquity, therefore, an antithesis was established which was continued through the centuries with mass predominating in the West, and the two-dimensional plane in the East. The antique capital carved in the round lived on in Byzantine art, carved in the flat with the ornament sketchily outlined; the drill producing pierced decoration replaced the chisel which models. Byzantium 'de-Westernised' the classical heritage, and shifted towards the East. As soon as ancient tradition declined, art favoured a flat surface design, and Byzantine mosaics assured its success. The moment this tradition revived, three-dimensional art reasserted itself; once Italian art had reverted to its sources, its main objective was to represent form in three-dimensional space.

The technique of fresco painting, which requires even, matt colours and simple, firm contours due to the fact that some of the lines have to determine the area that must be finished before the plaster dries, could only encourage an arrangement in broad 171 masses. Giotto used this to reintroduce three-dimensional form into Italian art, the tradition of which had been submerged beneath the double offensive of the barbarians and Byzantium. That was Italy's true vocation. If Gothic sculpture had helped to establish it anew, Gothic painting on the other hand was going to endanger this reconquest. Illumination and stained glass did indeed oppose it, for they express everything in flat colours, the outlines of which are drawn by the illuminator

with arabesque-like flexibility. This style had been diffused by the Parisian studios, from the end of the 13th century by Master Honoré, and from the 14th century by Jean Pucelle.

Italian art and the arabesque

Thus the Italian school, in its progress towards the Renaissance, found itself faced with two possibilities — and hesitated. Giotto had committed it forcefully to the path of the first, and his example had great influence. In 1339, two years after Giotto died, the leading master of the Sienese school, Simone Martini, established himself in Avignon, where he spent the rest of his life. His native town had maintained continuous commercial and financial relations with the papal city from the time of Benedict XII. As early as the end of the 13th century Duccio, though he retained the Sienese adaptation of Byzantine flatness, modified its linear rigidity by simple elegant drawing, the 177 example for which had perhaps been provided by French miniatures. Siena was prepared to welcome the French pictorial style, dominated by the miniature; Simone had already come 178 in contact with it at the time of his stay in Naples, at the court of the princes of Anjou, whose kingdom occupied the whole of the southern half of Italy and thus constituted a centre for the spread of the French style. This was further assured by books containing illuminations whose influence, already so noticeable in Siena, was profound in Bologna, where the university prompted a great output of manuscripts. As a result the Gothic style was disseminated again by the Bolognese illuminators who derived their inspiration from it. It maintained its position consistently in this way, in the face of Tuscan influence depending on the enormous prestige of Giotto. In the middle of the 14th century, in the work of the Lorenzetti, for example, the two 60 influences are intermingled, and a balance was sought, in which volume and arabesque would be equally satisfied.

In northern Italy, the 'work of Lombardy', deriving from the miniaturist tradition which could be called 'Franco-Bolognese', maintained with greater integrity the Gothic style and its drawing, the importance of which, at the end of the 14th century, is demonstrated by the art of Giovannino de' Grassi. 175 It was soon to find support in the social evolution.

Indeed, the social situation, in Italy as in Flanders, evolved towards a triumph of the middle class, but Italy profited from a certain initial advantage. The patriciate, which in the Low Countries had confined itself to forming a new ruling class, here went a stage further; its powers ended by being concentrated in the hands of a family, or a prince who was often a military chief, a *condottiere*. The first of these lords, the Scaliger in Verona and the Visconti in Milan, the exact centre of Lombardy, established themselves in the 13th century. Only Venice remained fiercely hostile to this evolution and clung to the same patrician stage as that in Flanders. Perhaps that is one of the reasons why her artists preferred sensuous realism rather than too much intellectual elaboration, as did the northern artists. On the other hand, the princes, whether they were of noble birth or were newcomers like the Medici, the bankers of Florence, had more aristocratic aims. They soon formed around themselves real courts, which either from inclination or in order to strengthen themselves, were intended to revive the medieval courts. Thus, as has been seen in Chapter 1, a chain stretched across Europe linking the last centres of a dying society; it ran from London, so imbued with French culture, to Prague, where the Luxemburgs were reigning; moreover the daughter of the Emperor Charles IV of Bohemia married Richard II of England in 1383. The father of Charles IV, John of Luxemburg, and John II the Good of France had both throughout their lives felt a longing for the golden age of chivalry. They were symbols of a past world; the former was killed at Crécy in 1346, while the latter was taken prisoner at Poitiers in 1356.

175. ITALIAN. LOMBARD. GIOVANNINO DE' GRASSI (d. *c.* 1398). Initial of the Magnificat in the Book of Hours of Gian Galeazzo Visconti. *c.* 1385. *Library of Duke Visconti di Modrone, Milan.*

THE GOTHIC ARABESQUE IN ITALIAN ART

With the continuation of the Middle Ages and of their aristocratic traditions the refined draughtsmanship, arbitrary to the point of Mannerism, which had been cultivated by French miniaturists, faded out in the ' International Gothic ' style of the last princely courts. It passed to Italian miniatures, due mainly to the university of Bologna, and influenced the art of Lombardy in the 14th century, where the work on Milan cathedral attracted a crowd of international artists; it may be seen in such manuscripts as the Tacuina Sanitatis, in the work of Giovannino de' Grassi [175], then in the pictures of Michelino da Besozzo [176], whose arrival in Venice brought this style to Gentile da Fabriano, Pisanello, etc. Siena, too, from the beginning of the 14th century [177] underwent the influence of the French arabesque, strengthened by the visits of Simone Martini [178] to the Anjou family in Naples and to the papal court at Avignon. Even in Florence, where the sculptural sense of volume had dominated since Giotto, the graphic techniques of engraving [179] and the decoration of goldsmith's work assured the continuation and sometimes the supremacy of the arabesque and its graceful curves [181], even affecting sculpture [180].

176. ITALIAN. LOMBARD. MICHELINO DA BESOZZO. The Mystic Marriage of St Catherine. Beginning of the 15th century. *Pinacoteca, Siena.*

177. *Above, centre.* ITALIAN. SIENESE. DUCCIO (documented 1278–1319). Madonna of the Franciscans. *Academy, Siena.*

178. *Above, right.* ITALIAN. SIENESE. SIMONE MARTINI (*c.* 1284–1344). Virgin of the Annunciation. After 1339. *Royal Museum of Fine Arts, Antwerp.*

179. ITALIAN. Arabesque with a griffon. Niello of the 14th century attributed to Peregrino. *Edmond de Rothschild Collection, Louvre.*

180. *Below, centre.* ITALIAN. AGOSTINO DI DUCCIO (1418–1481). Agriculture. Relief in the Tempio Malatestiano in Rimini.

181. *Below, right.* ITALIAN. FLORENTINE. BOTTICELLI (1444/45–1510). The Primavera (detail). *c.* 1478. *Uffizi.*

To begin with, the 15th century appears to sound the knell for the centres of Gothic culture. The French court seemed the worst hit; driven from Paris, which was dealt a terrible blow by the defeat at Agincourt in 1415, the court vegetated in Bourges. But, to tell the truth, it had already been divided up for half a century between Bourges itself, which the Duke of Berry, son of John the Good and nephew of Charles IV of Bohemia, had already made his capital, Dijon, whence the power of the dukes of Burgundy erupted, Moulins, the Loire, Anjou and Provence, which had become the centres of the French artistic schools, and Avignon, from which the Pope had withdrawn the court in 1378, but where he had left a legate. There the old medieval traditions shed their last radiance but they came to terms with the new trends and especially with the visual realism of the Flemish bourgeoisie.

As for the Italian courts, although they evolved out of the new world then being formed, they were intended to follow in the footsteps of the medieval aristocracy, to equal it in luxury and brilliance. So court art had to be made more vigorous.

The International Gothic grew out of this combination and, as we have seen in Chapter 1, spread from London to Prague a courtly vision, evolving under the pressure of the realist trend. Some of its centres were in Italy where, especially in the north, it helped to sustain the fashion for the linear style, hostile to volume and spatial recession. Milan, under the aegis of the Visconti, with the combination of Lombard illuminators, trained by French examples, and the re-establishment of a life of aristocratic luxury, represented an almost opposite pole to Florence: work on the cathedral, attracting many different artists, contributed to the expansion of this style, which found in Verona, the seat of the Scaliger, another stronghold. It spread

70 to the Marche, where it was represented by Gentile da Fabriano, through whom it reached Florence. Under Gentile's influence

71, 72 and that of Stefano da Zevio of Verona, Pisanello carried it to Rome with great brilliance, to Venice, and from court to court, to the Visconti, the Gonzaga, the Este, the Malatesta and the Aragona, until the middle of the 15th century. In the same generation, the Sienese tradition of Dom Lorenzo Monaco, who was as much a miniaturist as a painter, was also passed on to Florence through the art of his pupil Fra Angelico. Moreover the tradition of the arabesques spreading over a flat surface found some support in the capital of Tuscany among the gold-smith-carvers, and the effects of it can be traced as far as the second half of the 15th century in the sculpture of Agostino de

180, 181 Duccio and in the painting of Baldovinetti, Botticelli and Filippino Lippi. But it then became absorbed in the opposing three-dimensional tradition.

The re-establishment of form

At the beginning of the century, there was to be found in Florence a second Giotto who, in spite of his short life (1401–

201, 207 1428), re-established the sculptural style; this was Masaccio. With him, realism expressed itself again through the feeling for mass, suggested by space in three dimensions. It was helped by the impetus given at that time to sculpture by the stonemasons of the cathedral, under the direction of Ghiberti. The compe-

203 tition of 1401 for the second doors of the baptistery had sparked it off. Masaccio had the good fortune to be the contemporary of Donatello, his elder by fifteen years, and also of Leone Battista Alberti, born in 1404, who, with his complete clarity of thought, was establishing the doctrinaire framework which would confirm

194 definitively the return to the classical Mediterranean heritage. The Gothic 'deviation' was over, apart from a few survivals. Florence once again asserted itself as the centre of the revival.

Italian art, however, was to be exposed to another temptation coming from the north, the subject this time of the latest research, that of blending the representation of reality with that of matter.

The commercial links between the cloth-trading cities of Italy and Flanders were more active than ever and were doubled by the network of banks maintained mostly by the Italians. The influx of northern artists is a measure of the knowledge of and the interest in their art and the high esteem in which it was held. The connection between the Arnolfini and van Eyck 90 in Bruges is well known, and so is that of the Portinari and van der Goes in Florence, and the visits of van der Weyden and Fouquet. The introduction of oil painting into Italy, attributed to Antonello da Messina, demanded quite different studies for panel painting from those needed for fresco; they would be especially valued in northern Italy, from Venice to Mantua, where the links with the northern countries, Germany and Flanders, were the most direct.

But a remarkable phenomenon took place in Venice, Mantua, Padua, Verona and Ferrara, for the most part under the impetus of Mantegna's genius. In the second half of the 15th century oil painting was used to imitate the sharpest metal, and the 125 hardest and most compact stone, and to give them a sort of excess of definition which confers a trenchant and, in some respects, exaggerated appearance to form. A hard world of steel and flint eliminates everything whose softness or fluidity might weaken the dominance of forms.

It is curious to see that this contamination is reciprocal; while, towards the middle of the 15th century, Italy is exposed to the temptation of a material style, northern painting, which had brought it to Italy, seems for its part to be suddenly obsessed by the sculptural style, that is, by the suggestion of the isolation and relief of bodies in space. This suggestion is more or less implied in the whole search for realism, hence the trompe l'oeil; the Flemish artists were aware of it, and the grisaille figures which they often painted on the reverse sides of polyptychs were imitations of statues. The combination of sculpture and painting on the altarpieces must have contributed to this substitution; the close connection between Rogier van der Weyden and the sculptors of Tournai has already been emphasised.

But towards the middle of the century the Italian example exercised in its turn a strong influence on the northern artists. By abandoning the uninterrupted contours, lessening contrasts and eliminating half-tones, the illusion was created of a body cut in stone or wood. The prestige of Klaus Sluter and the school 184 of Burgundy must have counted for a lot in this new trend. It was revived in the German schools, where it swept away the remnants of the Parisian arabesque; the founders about the second third of the century were Multscher, who was a sculptor 115 and perhaps a painter, and Konrad Witz, whose father had 183 actually worked at the court of Burgundy. It triumphed after 1450 with Michael Pacher, who was obsessed with volume and 132 space, it passed to the school of Avignon, where the *Pietà* seems to be carved from hard wood, and perhaps the influence of Witz was in some way responsible. It was to be found again in Spain with Jaime Huguet, Bartolommé Bermejo and Fernando 124 Gallegos, and in Portugal with Nuno Gonçalves. In Flanders it 127 was van der Goes who was most sensitive to it, and in France Jean Fouquet who, less harsh, preferred smooth, solid roundness to sharp, brittle, flat drawing. It was the time when Andrea del Castagno was producing in Italy what were really adaptations 186 of Donatello, though actually in fresco, his imitation statues 187 perched in imitation niches in Sta Apollonia, Florence.

It is perhaps in the admirable frescoes in the Schifanoia palace in Ferrara, by Tura, Cossa and Ercole de' Roberti working in association, that we find the most complex picture of the art of that time torn between these different influences. The intensity of execution is as violent in the relief of the forms as in the substance of the material; but this realism, at once asserted and modified, is used to depict the old courtly themes of noble life with which the new learned humanism is mingled.

182. FRENCH. MASTER OF THE
AIX ANNUNCIATION
(15th century). The Prophet Isaiah.
Van Beuningen Collection.

183. GERMAN. KONRAD WITZ
(d. *c.* 1445/46). St Bartholomew.
c. 1435. *Museum of Fine Arts, Basle.*

184. FRENCH. KLAUS SLUTER
(recorded 1380–1406). Mourning
monk. One of the weepers from the
tomb of Philip the Bold, Dijon.
1410. *Musée de Cluny, Paris.*

FORM AND MATTER

*The realism of volume, enhanced by the Florentine passion for
form, and the realism of matter, in which Flemish
positivism flourished, led to a singular union of painting and
sculpture in the middle of the 15th century. While
sculptors were sometimes attracted by pictorial effects [172],
painters, pushing their desire for trompe l'oeil to
excess, carried the representation of solidity and relief to the
point of imitating statuary, in Flanders [102],
Germany [126 and 183], in Italy and the Iberian peninsula
[123, 124, 127]. Sometimes the same artist translated a
similar theme in both techniques. Indifferent to the
softer effect of a painted picture, some painters like Mantegna
[185] or the artists of Ferrara [125]
imitated sculpture to an extraordinary degree.*

187. *Below, right.* ITALIAN. FLORENTINE. DONATELLO
(1386–1466). St George. From the niche of the Guild of
Armourers on the façade of Or S. Michele. *c.* 1415.
Bargello, Florence.

185. *Above.* ITALIAN. MANTUAN. MANTEGNA
(1431–1506). Esther and Mordecai. *c.* 1495.
Cincinnati Art Museum.

186. *Right.* ITALIAN. FLORENTINE. ANDREA DEL
CASTAGNO (1423–1457). The Florentine captain
Pippo Spano. *Sta Apollonia, Florence.*

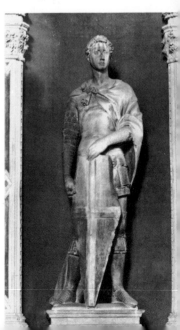

The intellectuals and aesthetic theory

The fact is that a new class, the intellectuals, which had begun to form ever since the development of a ' middle ' class between the peasants and the aristocracy, reached maturity with the Renaissance. This was to have a great effect on the evolution of culture; the intellectuals were, at that time, above all humanists. Henceforth, the inevitable parallel between philosophy and art, often unconscious until then, was to be strengthened by the lucid intellectual thought which the artist brought to his task. He was no longer an executant, a craftsman, but a responsible person, conscious of his mission. Alberti stated this; the precepts he formulated ' are drawn directly from philosophy, and appropriate to the regulating and defining of the means and method of art '. They no longer have anything in common with the studio recipes taken from ancient treatises, from the monk Theophilus to Cennino Cennini.

The roots of the new intellectualism go back a long way. At the end of the 11th century, St Anselm had written of faith in search of reason (*fides quaerens intellectum*). At the beginning of the 13th century, the popes themselves helped the universities to free themselves from the authority of the bishops. Certain others, especially those of northern Italy where law was taught, and the most ancient (Bologna founded in 1158, and Padua in 1228) even threw off the control of the Pope. The rise of the bourgeoisie had added the legislative spirit of the jurist to the positive spirit of the businessman. The pursuit of logic and argument succeeded the quest for the contemporary ideal — and the ' ideals ' — of chivalry. No doubt this evolution counted for a great deal in the development of scholasticism at the heart of religious thought and in the increasingly important position of ' lawyers ' at the courts of sovereigns such as Philip the Fair and in social life. Man learns to reason for himself, to propose problems and resolve them. Once art no longer has a solely religious function and tends to isolate itself like philosophy, to ' think for itself ', the time is ripe for research into the rules of beauty.

195 Alberti, the great theorist of the Renaissance, belonged to the famous family of wool merchants and bankers (one of his ancestors was described at his death as ' the richest man in terms of money in the last two hundred years ') and had studied law, and then mathematics, at Bologna. If we add that among his fellows students was Francesco Filelfo, who had returned from Constantinople, then we have all the elements to explain the aesthetics of the Renaissance. The mind formed by the study of law and mathematics was employed in the exalted resurrection of ancient philosophy preserved by the Greeks of Byzantium. Greek immigration was increasing with the Turkish threat to the old capital of the Empire, soon besieged, captured and devastated by Mohammed II in 1453. The influence of Constantinople had begun well before the final act; in the middle of the 14th century, the philosopher Barlaam had accepted a mission to the West and had been in contact with Petrarch; he was followed by Leonzio Pilato. The exchanges had been favoured by the negotiations for obtaining the help of the West, and also for reconciling the two churches. Emperor Manuel II Comnenos had begun in Europe in 1399 a series of *démarches* which led him as far as Paris and London; he was not to return permanently until 1404. A few years later, he sent the famous humanist Manuel Chrysoloras on a mission to Italy. His grandson John VIII in his turn made the journey in 1437 and stayed in Florence for the council; he was accompanied by, among others, the illustrious Cardinal Bessarion. A medal by Pisanello and the fresco of the *Procession*

130 *of the Magi* by Benozzo Gozzoli perpetuated the memory of the Emperor. Just as the Palaeologues had restored a great final brilliance to the Byzantine culture, these journeys and exchanges brought a considerable impetus to the revival of classical antiquity. It was not only the philosophers, some of whom were

masters of great repute, who came, but the original Greek texts became known. As Poggio had just done in Italy, Guarino, a disciple of Chrysoloras, collected manuscripts alone in Greece (238 of them, it is said) and brought them back from his journey. Spurred on in this way, Italian philosophers eagerly resumed contact with the literature and philosophy of antiquity, drawing on the genuine sources; at the same time, following the example of this old Byzantine civilisation, the position of the intellectual became established and assumed very much greater importance.

Thus the opposing traditions of Plato and Aristotle were given new life, but in a more authentic form. The philosophy of Aristotle had acquired, during the last centuries of the Middle Ages, a considerable following. Under the influence especially of the nominalists, it had advocated increasing preoccupation with positive reality which should be approached henceforth with the only human weapons — the senses to observe it and the reason to understand it. This philosophy was solidly established in the university of Padua, which the patronage of Venice had freed in 1405 from the control of the Church. This Aristotelian philosophy which was brought from the university of Paris by Pietro d'Albano at the beginning of the 14th century, and which two centuries later, with Pomponazzi, dared to deny the immortality of the soul, was involved in the scientific trend because of its close attachment to the Averroism of the 13th century. But the nominalism of Paris and Occam had also penetrated into Italy. Freed from the out-of-date dynamism of Aristotle, it had opened up the way for modern mechanics by admitting that motion would be perpetual if it were not braked by friction; from this arose in part the philosophy of Leonardo da Vinci who owed much to Albert of Saxony and Nicolas Oresme. But Leonardo was also influenced by the ' technological' spirit of Archimedes who, in ancient times, had indicated the way which modern science was to take. For Leonardo, art was inseparable from science and philosophy. He showed how to observe phenomena by training the perception; then he called upon reason to deduce their laws, and thus discover the secrets of nature. See in order to know, but know in order to have power — this is the link which unites the artist and the man of science.

Even when it adapted itself to this experimental discipline, the Italian genius did not abandon its intellectualism. While the northern painter, committed to this same path, was content to perceive appearances as faithfully and precisely as possible, the Italian painter did not stop until he had defined the laws which explain and control them. Whereas the Flemish artist confined himself to reproducing depth by the most subtle optical notations of the atmosphere, the substance of space, the 174 Italian aimed to push on to a complete, intelligible and rational doctrine of depth, basing it on mathematics and geometry. This 191, 192 is perspective, which provides the means to reproduce reality by means of pure theory, that is, the aspect which reality *ought* to have. The whole of the 15th century in Italy was to be absorbed in this enthusiastic study. L. Venturi has stated it excellently: ' After substituting nature for God as the goal of art (that is the stage where the northern artists stopped), human intelligence is substituted for God as the origin of art.'

The neo-Platonic reaction against positivism

God and reason had been separated, and now reason could do without Him. But medieval fervour was still so close that serious doubts were unavoidable. For many Christian consciences this break was a catastrophe; it led to Savonarola's violent counter-attack on intelligence in its battle with faith, which dragged art, with its independence and paganism, into disrepute; it shattered Michelangelo whose poems reflect the thirst to find God again.

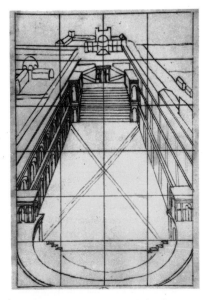

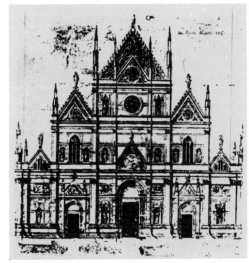

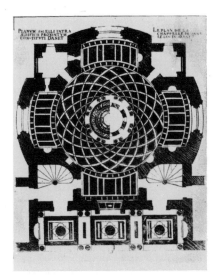

188. ITALY. Bramante's Belvedere court. Drawing by Dosio. *Uffizi.*

189. ITALY. 14th-century design for the façade of S. Petronio, Florence. *S. Petronio Museum.*

190. FRANCE. Plan of the chapel, château d'Anet, by Philibert de l'Orme. After du Cerceau.

191. ITALIAN. FLORENTINE. LEONARDO DA VINCI (1452–1519). Perspective study for the background of the Adoration of the Magi. Drawing. 1481. *Uffizi.*

THE RULE OF THE INTELLECT

The intellectualism of the Italian Renaissance soon took hold of sensual realism. Architecture, in which there is an absolute triumph of the intellect over matter, figured as a major art; the greatest theorist of the new aesthetic was an architect, Alberti [195]. Geometry and its scientific combinations of forms, rhythms and proportions controlled space, either in elevation [189], plan [190] or perspective [188]. Platonism was born again.
Painting itself was concerned less with impressionism than with applying to form [192] and space, governed by perspective [191], abstract laws in which the artist often revealed himself as very close to the geometrician and mathematician.
Everything, even beauty and harmony, seemed compelled to reveal their secrets. These could be calculated, in the Golden Section, for example, which became the subject of treatises, and whose application was to be seen in painting from Piero della Francesca to Raphael [194].
It even affected the German masters, such as Dürer [193].

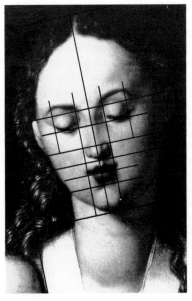

192. ITALIAN. FLORENTINE. PAOLO UCCELLO (1397–1475). Geometrical model in perspective.

193. GERMAN. ALBRECHT DÜRER (1471–1528). Head of the Madonna in the Uffizi, showing the proportions. After Justi.

194. *Far right.* ITALIAN. FLORENTINE. RAPHAEL (1483–1520). Head of the Madonna del Granduca, showing the proportions. *Pitti Palace, Florence.*

95

The opposing doctrine of the neo-Platonists, on the other hand, permitted the avoidance of naturalism, the gratification of this nostalgia for the divine, the reconciliation of the pagan lesson of pure beauty with religious scruples, since beauty was a means of approaching God. In the 14th century the Rhenish mystics who revived what remained of neo-Platonism in religious thought had already made use of their enthusiasm over and above the senses and reason to oppose the triumphant doctrine of Occam. The 15th century in Italy was to find a more direct contact with the restored Platonic philosophy. It was an illustrious cardinal, Nicolaus Cusanus, born near Trier in 1401, thus in the same Rhenish area, who was to commit the 15th century in this direction. In spite of his Occamist training acquired in Heidelberg, he soon became an adherent of neo-Platonism. He wanted to renounce the down-to-earth doctrine of positivism; he opposed it by a doctrine that transcended the normal apprehension of reality. Over and above knowledge through reason and the senses, it was necessary to reach knowledge through the intellect whereby endless multiplicity of the particular is superseded by the revelation of its unity. This is God: it is also beauty.

His Italian contemporary, Leone Battista Alberti, who made famous ' the unrestrained desire to contemplate infinite beauty ', 193 was to apply this doctrine to art; the doctrine did indeed establish 194 the ideal and almost mystic character of beauty, its power and duty to confer unity on initial diversity by means of harmony. For four hundred years European art hardly ever swerved from this conviction which had become fundamental.

Neo-Platonism in Germany belonged particularly to conventual, and therefore popular, circles; they reacted against the intellectualism of the universities, and therefore they had very little contact with art. In Italy the opposite took place; her success was assured by the intellectuals, the humanists who were dissatisfied with 14th-century positivism and, under the impact of genuine antique philosophy, perceived how Platonism and its resulting doctrines justified the ancient masterpieces which they admired, and the same time permitted an escape from the dead end of materialism. Moreover in Italy the humanists did not live in close proximity, as they did in university circles; thanks to their patrons they formed part of the aristocratic society, and shared their taste for lavishness and refinement. Beauty, considered as a means of rising above everyday reality, brought the desired scale of values, all the more so since at the same time it allowed richness and luxury to expand.

So, in the struggle which was taking place between the Aristotelian and Platonic philosophies, it was the second doctrine that gained the victory, so completely, in fact, that it became a keystone of the Renaissance. In the middle of the 15th century the philosophy of Aristotle, which extended and renewed the trend of the preceding century, was spread with great brilliance in Florence by Donato Acciajuoli and by John Argyropulus who came from Byzantium; Cosimo de' Medici was the first to patronise it. Platonism, however, which was taught by Manuel Chrysoloras, had from the outset found a great following, to such an extent that Petrarch had championed it against Aristotelianism. The master of Chrysoloras, Gemistus Pletho, one of the greatest philosophers of dying Byzantium, came to Ferrara and Florence in 1438, during the council, and gave a definitive impetus in favour of Plato, of whom he was a devoted follower. In a vigorous attack on Gennadius, and later on George of Trebizond, he published in 1440 a pamphlet against Aristotle; but it was his disciple Cardinal Bessarion who, while respecting Aristotle, assured the final victory in his *In Calumniatorem Platonis*. In 1459 Cosimo took Marsilio Ficino into his household where he became the teacher and friend of Lorenzo de' Medici. While in 1471 Argyropulus gave up his position and retired,

Ficino founded his Platonic Academy, gathering together patrons such as Federigo da Montefeltro, whose court at Urbino was to have so much influence on the destiny of the Renaissance, and humanists like Pico della Mirandola and Landino in a common cult of Platonism. He translated Plato in 1484 and Plotinus in 1492. The Academy spread this cult throughout Europe because of its contacts with the greatest minds of the period.

The new doctrine in fact not only dominated Italy, but in Germany captivated Dürer who came to study in Italy and was, in his turn, the author of several theoretical treatises. In Flanders it influenced Erasmus, whose *In Praise of Folly*, published in Paris in 1511, was to have enormous repercussions; in it he states that truth cannot be reached through matter, which is concerned with the body and makes the soul blind. At the same time the shifting of the economic emphasis from Bruges to Antwerp made the break with the past easy and started a new preoccupation with beauty, often clumsy, of which the chief exponent was Quentin Metsys. The king of France, François I, reacted 14 against Louis XI's drift towards the middle class and took as models the Italian patron princes. He reinstated the aristocratic aesthetics at his court; introducing the Collège de France, in opposition to the Aristotelianism of the Sorbonne, he directed national art towards the ideal of beauty by inaugurating the school of Fontainebleau. The moment this ' Rome of the north ' became a real centre of the Renaissance, the northern countries were won over.

The apotheosis of beauty

The Middle Ages were definitely over. From now on, Italy led the new research; she quite naturally sought beauty in form, according to her sculptural tradition never completely interrupted since antique times, and in the human form, since henceforth the object of action lay no longer in God alone, as in medieval thought, but increasingly in man himself, intoxicated with his ever-widening powers.

Just as in the civilisation of classical antiquity, man took his place in the centre of creation; it appeared intelligible to him, made to suit him and amenable to his wishes. He was impatient to exercise and extend the boundless power of his philosophy on things.

Francis Bacon was soon to sum up the ambitions which science in particular would develop in the centuries to come — the search for ' the very power of human genius and its rule over the universality of things ', so as to establish this reign of man over creatures. A little later Descartes, too, proclaimed the ambition of our species to ' become the master and possessor of nature '.

Art is one of the means to this mastery. It captures appearances; but, more than that, it adapts them to our system of thought, which is a revival and extension of the classical dream. Vitruvius, who was to become an indispensable authority, extolled *eurythmia*, the repetition of parts, and *symmetria*, putting them in proportion. This regulating spirit, eminently architectural, communicated itself to painting, in which composition played a principal part. Alberti was preoccupied with the organisation of both the whole and the parts, as well as their interrelationship, in order to attain an immediately perceptible unity, a unity of such importance that it conferred pre-eminence henceforth on the circle, the most centralised of all geometric forms.

Humanism is inseparable from the scientific impetus on which its philosophy is based. So geometry and mathematics were called upon, as they were in Greece, to help in defining this ideal beauty of form. Marsilio Ficino stressed ' how necessary mathematics are to the arts '. Plato would have agreed with him. It was from him and his theory of the ' five perfect Platonic solids ' that the revelation of the eternal secret was sought; Piero della Francesca was the most famous researcher

in this field and inspired the *De Divina Proportione* by Fra Luca di Pacioli, in which, as we saw in Chapter 1, this almost magic, but calculable, formula for beauty was perceived in a perfect proportion called the Golden Section. The passionate interest brought to the problem by such painters as Leonardo and Dürer, whose *Melencolia* meditates among scattered instruments of measurement and geometry, is well known.

The same scientific spirit, obsessed with 'rule and compasses', was applied to more practical questions of perspective, the solution to which was ecstatically sought by Paolo Uccello. His exclamation has remained famous: '*O! che dolce cosa è questa prospettiva!*' ('What a lovely thing this perspective is!'). A painting becomes a problem to solve.

In someone like Leonardo, who possessed this experimental spirit, it can be seen how he becomes increasingly absorbed in the search for the ideal of beauty. But it was without doubt Raphael who was to provide a complete, sometimes sublime, expression of the perfect union between the religious spirit and the profane, in the heart of a search for God half-perceived in the transcendence of beauty. Beauty is sought for in a unity achieved in form by proportion and in the work as a whole by composition; composition is a resultant of geometry and rhythm added to convergent perspective, which contributes also to the realism of space.

With Raphael the spirit of the Renaissance is triumphant. It took root in Rome in the heart of Christianity; it enjoyed the patronage of the popes. It dominated the different arts, architecture, sculpture and painting, so related by the unity of their principles that the greatest geniuses, from Leonardo to Michelangelo, could practise them all in turn.

In the Renaissance, humanity lived through one of those highest periods of balance and fullness, which seem, at the time, so securely established that they are considered permanent. This balance is born of the perfect equation of what is seen and understood of the world and the means which are used to represent and translate it. It seemed that all problems were solved or were about to be solved.

However, a shrewd observer would have already noticed the first beginnings of a movement which was going to undermine this certainty; a new set of doubts was to ensure the development of new forms of expression. The eternal adventure of art would continue on its course.

WESTERN EUROPE DURING THE RENAISSANCE

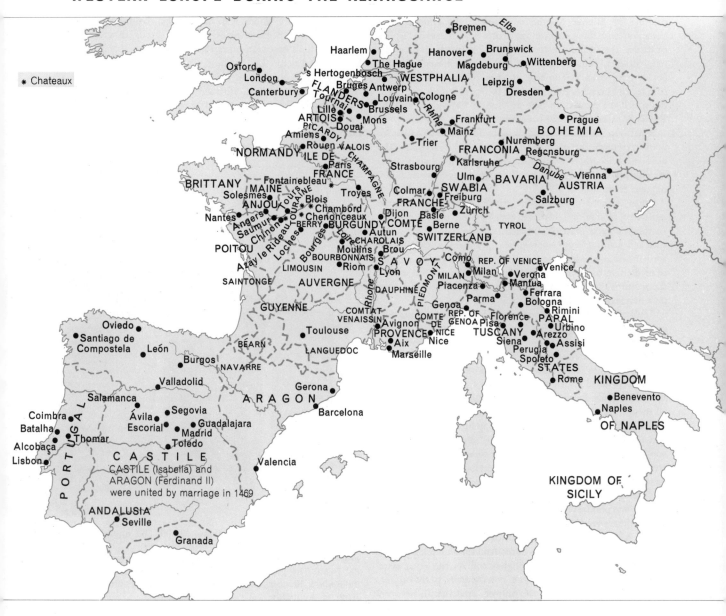

* Chateaux

THE QUATTROCENTO *Eugenio Battisti*

*During the 15th century medieval civilisation, originally
centred in France, ended up in particularism and excess. At the
same time the new civilisation was seeking its centres of
gravity; realism, still uncertain in its forms and
given impetus by the middle class, especially in the north,
provided this civilisation with one centre. The other, the quest for
beauty, was to be imposed by Italy, which was trustee of the
classical heritage and which, for this reason, was called upon to
dominate the new phase.*

From the beginning of the Quattrocento (15th century), Florence deliberately opposed the Gothic, creating a tradition of its own which was to have resounding consequences for the whole of modern art.

The formation of the Florentine Renaissance

At this time, artists, men of letters and intellectuals, as well as politicians and churchmen, were probably more closely and coherently linked than at any other time in Europe. That in itself was a powerful reason for opposing the Gothic. In a painting by Simone Martini or Pisanello the refinement of execution and the extraordinary sensitivity to certain aspects of nature, the amorous seductiveness of the image, even of the religious one, and the taste for the most ordinary everyday details created an atmosphere of pure aestheticism in which culture, and even religion, succumb to this courtly love poetry, for which the treatise on love by Andrea Cappellano and the *Roman de la Rose* were the basic texts.

What is so surprising, in any work by Donatello or Masaccio, is the extraordinary sense of the concrete, of materiality. The deliberate rejection of all elegance, even a certain aggressiveness in presentation, demonstrate a conception of art radically opposed to the Gothic.

When Ghiberti wrote that the painter must know grammar, geometry, philosophy, medicine, astrology, perspective, history, anatomy, theory, drawing and arithmetic, or stated that ' sculpture and painting are sciences formed by many disciplines and varied teachings, which are complemented by a certain amount of meditation based on a combination of matter and reasoning ', the accent is not so much on the universality of the artist as on the complexity of art.

Aesthetics in the Renaissance was absorbed by culture, or rather it was the concrete manifestation of it. Beauty is not one of life's luxuries: it is the visible appearance of civilisation.

Indeed, the characteristics of the style at the beginning of the Quattrocento in Florence correspond perfectly to the moral qualities esteemed at that time; Poggio (Gian Francesco Poggio Bracciolini), for example, wrote that ' nature, the mother of all things, has given to the human race intelligence and reasoning to act as guides for a good and happy life and they are such that nothing could be adjudged better.' Similarly, intelligence and reason create the laws of proportion which govern an architectural structure and the laws of perspective which govern pictorial vision.

Florence was obsessed by the consciousness of the rationality of the universe and its principles. Religious fervour and civic pride helped these investigations along. Study, research and creation were a complete human education, of which civic life was the conclusion and perfection. To understand the link joining these ideas on the one hand with religion and on the other with classicism, it is necessary to go back two centuries, to the origins, then already perceptible, of this culture. Frederick II, between

1234 and 1239, had himself portrayed seated and in Roman costume side by side with two judges in togas above a gigantic bust of Imperial justice on the gateway at Capua. The gate not only symbolised defence; it was a political programme; it set up in opposition to the Church the secular system founded on rational ideas whose principles were those of the Imperial laws. The style of architecture and sculpture was a tangible symbol of the return to a classical morality and jurisdiction.

Boniface VIII was the first pope to recognise the political significance of art as propaganda. He had himself portrayed in S. Giovanni in Laterano with the insignia of the last Roman Emperors, to show his direct descent from Constantine. He also commissioned Giotto to execute the famous mosaic of the *Navicella* with the Apostles succoured by Christ, to support the precept that the Pope alone could steer the world through the storm. What linked Frederick II so firmly with the Renaissance was the completely new concept of the love of glory, of the ambition to dominate and of civic pride, in which St Augustine saw the worst vices of the Roman Emperors. And it was no accident that the main theme of religious life was a discussion on poverty; the *Testament* of St Francis forbidding monks to possess earthly goods was annulled by the Pope. Giotto himself wrote a poem in praise of riches, that is, of an active life which finds its sources on earth and its reward in civilisation. In Poggio's dialogue *De Avaritia* (1428–1429) St Francis' ideal of poverty is quite frankly an object of satire; and moreover, he continues, ' all splendour, all beauty, all ornaments and decoration would disappear from our cities; no more temples or cathedrals, no more monuments, no more art ... Our whole life and even the life of the state would be upset if every man

195. ITALY. Tempio Malatestiano, Rimini. Old church of S. Francesco reconstructed in 1446–1455, by order of Sigismondo Malatesta, by L. B. Alberti and Matteo de' Pasti. The façade, the upper part of which is unfinished, is composed of three arches modelled on the Arch of Augustus.

only set out to obtain the necessities of life.' Architecture therefore, since it was closely connected with civic activity, had to take the lead. This was due not so much to the need for municipal organisation (the outward appearance of Florence in the 14th century was already remarkable) as to the importance of architecture in the life of the town (one has only to remember the discussions of, and enthusiasm for, the great dome of the cathedral), and to the contemporary predisposition of architects to rationalise forms and reduce them to questions of number and proportion, which the painters of the time were not doing.

New problems of architecture and sculpture

The direct line between the classicism of Frederick II, the building enthusiasm of Boniface VIII who had statues of himself erected in the conquered cities, and Florence's attempt to proclaim herself a legitimate daughter of Rome, that is, a city independent of all exterior power, explain why Brunelleschi, creator of the new architecture, went back further than the Gothic to link up with the Romanesque style of S. Miniato and the Church of the Holy Apostles in Florence, buildings which were recognisably princely and built at a time when classical civilisation was being revived.

By comparing the works of Brunelleschi and his predecessors, the difference in quality between the Renaissance and the medieval revivals may be seen. First of all, the artists of the Renaissance acquired exceptional theoretical knowledge; in the second place, their art was no longer produced for a special purpose, nor exclusively religious, but based on a very broad cultural penetration and on a modern attitude sharpened by business practice, that is, on precise calculation. Thus Brunelleschi gave the architect a primarily theoretical and directing role (Argan). Conceptual questions, proportion and perspective, were made predominant. S. Lorenzo or the Pazzi chapel have no substantial connection at all with Brunelleschi's classical studies in Rome. Only the external details were borrowed from classical antiquity. There were two absolutely new characteristics: the rhythm of space was obtained by means of geometry and not by intuition, and the proportions of the different parts of the building were calculated on an organic overall basis. Perspective, symmetry and proportion thus became visual laws, the means whereby art can pass from experience to science, from things to ideas. There was in Brunelleschi a mystique of forms which anticipated the neo-Platonism of Ficino. The Pazzi chapel in Florence, the effect of which is to make it one of the most enclosed spaces ever designed, was built in accordance with rules influenced by astrology; the use of light walls, and the more harmonious and serene distribution of lights is in conscious contrast to the empirical distribution of didactic or devotional paintings customary in the Italian Gothic churches. This solemnity and clarity are perhaps the greatest triumph of the Renaissance. From contemporary sources we know that the aim of such a distribution of light was to 'give worshippers some idea of the glory of God'.

In Pienza cathedral, built by Rossellino, 'so much light enters with the glory of the sun that those who are in the church feel it is not walls but a house of glass that encloses them.' And Alberti believed that 'although God does not hold in high esteem these contemptible things which men prize so much, He will, nevertheless, be moved by the purity of these splendid things.' There were threats of punishment for whoever 'violates the purity of walls and columns', or 'makes paintings, hangs pictures, adds chapels or altars'. This is a devotion which is philosophical and even of classical origin. Alberti adds: 'Cicero, who shares the opinion of Plato, considers it good to establish legally that one should renounce all kinds and all subtleties of ornamentation and contrive above all to make work clear and pure. Purity and simplicity of colour especially please God, just as the pure life pleases Him.' Owing to the

240

196. ITALIAN. FLORENTINE. DONATELLO (1386–1466). David. Bronze. *Bargello, Florence.*

197. ITALIAN. FLORENTINE. DONATELLO (1386–1466). St Mary Magdalen. c. 1457. *Baptistery, Florence.*

198. ITALIAN. FLORENTINE. DONATELLO (1386–1466). Feast of Herod. 1427. Bas-relief of the baptismal font. *Baptistery, Siena.*

199. ITALIAN. FLORENTINE. DONATELLO (1386–1466). External pulpit (detail). 1439. In collaboration with Michelozzo. *Prato Cathedral.*

success of his dome, Brunelleschi obtained not only fame and richés, but the possibility of fulfilling his poetic style in the most coherent manner. He made the first practical applications of perspective to painting, and in this connection was also a theorist.

In sculpture the problem was full relief, and here it was even more imperative to come to terms with antiquity. The humanist readers of the *Nicomachean Ethics* (in which Aristotle states that virtue consists of the exercise of reason and the domination of the senses) and imitators of the famous men of antiquity were bound to wish for the translation of sacred iconography into equally rational terms. The artist who tried this experiment, apart from the brilliant and dramatic work by Brunelleschi for the doors of the baptistery, was certainly Nanni di Banco; the *Quattro Santi Coronati* (*Four Crowned Saints*) on the flank of Or S. Michele, as solemn as senators, were a sort of programme of the new sculptural style. The quest for monumental and sculptural effects is clearly evident — for example, in the *St Luke* on the façade of the cathedral who pauses in his reading to contemplate; Nanni di Banco here shows himself more sure in execution than the young Donatello. However, his ideas were not followed up, not so much because he died at the beginning of the century, in 1421 (after returning, moreover, to a more Gothic style), but because the classical aspect of his figures contrasted too much with the spiritual asceticism of the first years of the 15th century.

Sculpture was bound to set itself many difficult problems. The architectural revolution of Brunelleschi had respected two essential characters of the local Gothic — the rigorous simplicity of the structure and the tension of the single architectural members especially noticeable in the church of S. Lorenzo. Nanni di Banco, on the other hand, wanted to make a cleaner break with tradition; he came into conflict with essential qualities like the naturalism of Ghiberti on the first doors of the baptistery, where sacred history is also expressed sentimentally, and with the elegance of Jacopo della Quercia, and his famous tomb of Ilaria del Carretto of 1406 in the cathedral at Lucca. 200 Like Nanni, Ghiberti and Jacopo had experience of classical sculpture, but with them the knowledge was not inflexible.

Donatello between the Gothic style and antiquity

It was an arduous task to find a new path between the two poles of antiquity and the Gothic style; it was a task which fell to Donatello, perhaps the most complex artistic personality 196-199 in Italy. According to Lanji, he was the first to define precisely in terms of art the fundamental problem of the modern age — to find again a message of morality through aesthetics.

Alberti affirmed him with his genius 'equal to any classical artist whatsoever'. Modest and temperate in his life, Donatello could proudly affirm his own value; he replied to the patriarch of Venice: 'I am a patriarch in my art as you are in yours.' In his contempt for the life of luxury Donatello anticipated certain aspects of the late phase of the Renaissance, expressed in the idea of the genius as a 'melancholy man'. To bring his genius to maturity the artist must withdraw into himself and achieve an interior sublimation, which produces unsociability and the ascetic life of self-denial.

In spite of this accentuated form of intellectualism, Donatello was basically a manual worker. He placed technique first and foremost. The same passion for inquiry is to be found in his culture. Ragghianti observed that Donatello rediscovered the Gothic, and used it again with so much fervour that he translated it into a completely new sculptural style. To understand the significance of this research one must examine it from the new conception of the artist as creator and inventor, characterised from the time of Brunelleschi by an industrious, refined intelligence. But Donatello is apart from it by reason of his

200. ITALIAN. SIENESE. JACOPO DELLA QUERCIA
(1374–1438). Detail of the tomb of Ilaria del Carretto.
Marble. 1406/07. *Lucca Cathedral.*

technique. While in Brunelleschi the subject dominates the
execution, Donatello was led by his temperament to search
and to realise his art in concrete matter. A marvellous harmony
is thus achieved between the conception of the work and its
187 material. In the *St George* of Or S. Michele, for example, the
figure of the saint is treated in very clearly formed full relief,
totally different from the picturesque allusive subjects of the
predella. Donatello imposes his personality on his material in
an almost dramatic fashion; he bends it, complicates it, gives
it elegance, monumentality and humility, enhances its light
values and its possibilities of expression, spatial or constructive.
The source of the distortions in his art seems to well up from
within the material itself. In short, between Aristotelianism and
Platonism, he chooses the philosophy of Aristotle; between
isolation and action, he chooses action. To him, technique was
the instrument not of knowledge but of creation. These are
problems that were debated during the first years of the 15th
century by C. Salutati and the Dominicans. Donatello deliber-
ately puts artistic creation on a moral level. There is a tradition
that refers to a crucifix by Brunelleschi and one by Donatello.
Donatello, faced with an idealised image by the architect, is
said to have exclaimed: ' To you it is given to make Christs,
to me peasants.' Architecture was enabled to achieve religious
feeling through a purification, and idealisation of space (Ghi-
berti saw in it a return to the purity of the primitive Church);
but sculpture had to face up to concrete humanity. In Donatello
a single line explains his inner development, that of dramatic
expression. The *Entombment* in Padua and the pulpits in S. Lo-
renzo, together with the paintings of Masaccio and the Ronda-
271 nini *Pietà* by Michelangelo, are the peak of the spirituality of
the Renaissance.

Masaccio and the evolution of religious painting

For Masaccio, father of the new painting, the central problem,
212 too, is a religious one. In the 15th century the subject weighed
very heavily on the style, and the painter who might have to

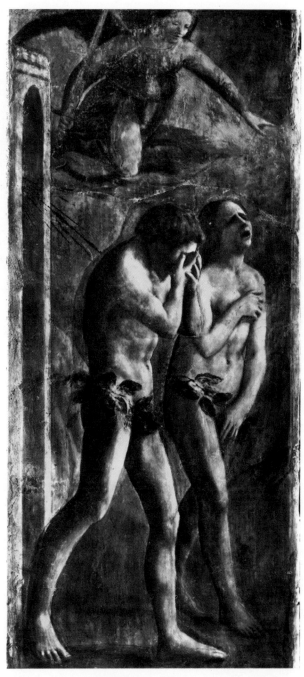

201. ITALIAN. FLORENTINE. MASACCIO (1401–1428).
The Expulsion of Adam and Eve. Fresco. 1426–1428.
Brancacci chapel, Sta Maria del Carmine, Florence.

decorate a chapel or paint a votive picture was steeped in the
mystic symbolism. During the first part of the Quattrocento
profane art is almost unknown. We must wait for the intro-
duction by Botticelli of mythological themes or, slightly earlier,
the illustrated fables by Pesellino and other decorators of cassoni
(marriage chests).

Gradually, however, there was less preoccupation with the
final aims of existence than with the free functioning of civic
life. Nevertheless it was accompanied, especially in Florence, by
an almost mystic exaltation of secular virtues. Frederick II
considered that the state should be founded on justice, regarded
as a supreme virtue; government became almost a religion.
This political conception, in some ways heretical in the eyes of
Rome, was revived in Florence. Moreover, artists such as Bru-
nelleschi, Donatello and Masaccio were not normal products of

FLORENTINE ART IN THE 15TH CENTURY (I)

ARCHITECTURE **SCULPTURE** **PAINTING**

Born c. 1370–1380

202

203

204

Born c. 1380–1405

205

206

207

Born c. 1405–1420

208

209

210

society: they represented on the contrary its internal crisis. The first decades of the 15th century are not a period of natural optimism, even politically. Society founded on reason, which succeeded the anxiety and moral crises of the 14th century, is an official stronghold in which, in spite of the increasing penetration of courtly elegance (the *Adoration of the Magi* by Gentile da Fabriano, painted for the merchant Palla Strozzi, is a prodigy of religious insensitivity), the spectres of sin and what is beyond the grave continue to terrorise the conscience.

The comparison between the frescoes of Masaccio in Sta Maria del Carmine and the works of Lorenzo Monaco (perhaps the most sensitive representative of the 'piety' of the end of the 14th century) shows that religious obsession was quite as strong, but the two masters have a completely contrasting lyricism. Thus Lorenzo Monaco, in the admirable drawing in Berlin of the *Three Kings* who follow the star, set the three riders, who are larger than the cities and ships, in a fantastic landscape; the rhythm of the composition is so violent in its linear distortions that the scene becomes an apocalyptic cavalcade. In the same way he bestows abstraction and solemnity on his altarpieces by resorting to the conventional and schematic. In Masaccio a certain lack of stylisation is the first thing that strikes us. It is only afterwards that one discovers the skilful perspective foreshortenings and the rhythmic interplay of heads and expressions. The psychological harshness and the violent simplifications which were immediately evident give way on closer examination to the sense of reality, of nature, of humanity, which appears here for the first time in the world of art.

Masaccio and Masolino, who were close collaborators, had in common a lively interest in nature which went beyond schematic forms and were eager investigators of human life. But their aims in this investigation were different. Masolino idealised reality by embellishing it, by stressing the elegance of everyday life. Masaccio brought it back to its proper level by showing its morality. To his characters, absorbed in their inner life, virtue is not a tangible emotion but the habit of self-mastery. Beggars and people cured by miracles in the narrow streets retain so much dignity that the miracle appears completely logical and natural. The order of the world reflects the divine. For Masolino, on the other hand, everything is miraculous, from the visual order of perspective to those magnificent textiles which founded the wealth of Florence. The final proof of

Masaccio's 'naturalness' can be obtained by following the evolution of the donor figures. In the predella with the *Adoration of the Magi* in Berlin they appear alongside the kings; in the amazing *Crucifixion* in Sta Maria Novella they are as big as 212 the holy personages: although husband and wife are outside the painted chapel, Mary's pose and her sorrow are so human that there is no separation between earthly life and eternity. The skeleton under the altar, like the violent expressionistic colours which restoration has revealed, and the rhythm of the perspective, show how vexed a question religion was for the Florentines at that time.

The generation of Cosimo de' Medici

When Cosimo de' Medici came to power in 1434, the great administrative undertakings were not interrupted. But the arts experienced the impact of this masked dictatorship, which created a sort of official taste: the famous Ghiberti worked on 203 the second doors of the baptistery, and with them came the official acceptance of perspective; Fra Angelico, who, like everybody else, had studied Masaccio, profited from this study to purge religious painting of all sensual attraction and to give to his images, which were otherwise so gentle, a more rational fascination founded on the proportions of forms, on the visual arrangement and on a static reflective composition (see p. 106).

Filippo Lippi is not so afraid of the flesh: he is warm and 249 impetuous, and prepares the way for the sentimental subtlety of such artists as Botticelli. In the chapel of the Medici palace Benozzo Gozzoli makes of the procession of the Magi a grand 210 parade. The most showy manifestations of popular devotion were in fact the *sacre rappresentazioni* in the squares, representations of scenes which made use of the different arts. They were so popular that five years before, in 1454, 'three Magi with a cavalry of more than two hundred magnificently decorated horses were dedicated to the new-born Christ.'

But to understand the artificiality of this culture it is enough to note how little it referred to nature, even on the part of such artists as Fra Angelico who could on occasion use their eyes to discover new pictorial horizons.

Even if the artistic quality does not depend directly on social factors, it is connected with them, adopting the principal poetic and moral themes of each generation.

Under Cosimo art lost its religious and civil associations but acquired extraordinary dignity as a science. All the treatises, from Alberti's on painting to the *Commentaries* by Ghiberti, the *De Prospectiva Pingendi* by P. della Francesca, and the *De Divina Proportione* by Luca di Pacioli, which are connected, agree in giving priority to the mathematical and geometrical aspect of design, which was then held to be the basis of all artistic activity. Naturally it is not a matter of perfecting technique; perspective, that is, the geometrical aspect of painting, becomes a means of seeing with which to conquer space and volume. It means the rediscovery of nature under a new, entrancing and mysterious aspect. But in this way the accent shifts from the subject to the style, from expression to vision. So much so that, while artists acquire economic and social dignity as opposed to the mere craftsman, their task loses the solemn function that it had previously had in the city; it becomes profane. Two great personalities in the world of painting, Paolo Uccello and Andrea del Castagno, bear witness to this. 211, 213 Vasari describes Uccello as 'solitary, strange, melancholy, poor ... always alert for the most difficult and impossible aspects of art ... staying at home for weeks and months without seeing anyone'. To characterise the new taste by comparison with that of the first generation of the 15th century, Vasari praises the inventions in perspective of Paolo Uccello, and then criticises 192 them through Donatello. Donatello, the great friend of Uccello, while showing him bowls with seventy-two facets like a diamond

202. BRUNELLESCHI (1377–1446). Sacristy of S. Lorenzo, Florence. Sculptured decoration by Donatello.

203. GHIBERTI (1378–1455). Paradise Door (detail). 1425. *Baptistery, Florence.*

204. LORENZO MONACO (before 1372 – before 1425). Nativity (detail). c. 1405–1410. *Lehman Collection, New York.*

205. L. B. ALBERTI (1404–1472). Palazzo Rucellai, Florence. 1446–1451. Executed by Rossellino.

206. DONATELLO (1386–1466). Detail from the tomb of Martin V. *S. Giovanni in Laterano, Rome.*

207. MASACCIO (1401–1428). St Peter healing the Sick with his Shadow. 1427. *Brancacci chapel, Sta Maria del Carmine, Florence.*

208. DUCCIO (1418–1481). Façade of S. Bernardino, Perugia. 1461.

209. DUCCIO (1418–1481). Madonna and Child surrounded by Angels. *Louvre.*

210. GOZZOLI (c. 1420–1497). Procession of the Three Kings (detail). 1459. *Chapel of the Palazzo Riccardi, Florence.*

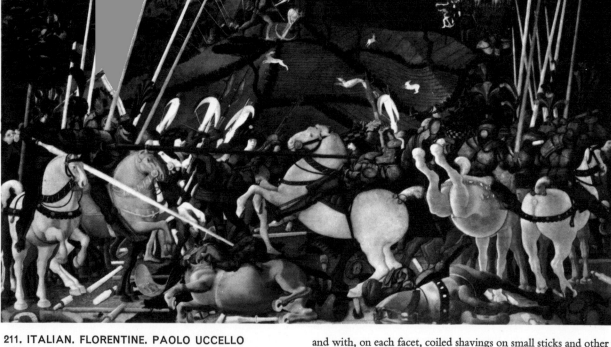

211. ITALIAN. FLORENTINE. PAOLO UCCELLO (1397–1475). The Battle of S. Romano. *c.* 1454. *Uffizi, Florence.*

This picture is one of three panels illustrating this battle. The other two are in the National Gallery, London, and the Louvre. They decorated the Medici palace. The battle of S. Romano was won by the Florentines over the Sienese in 1432.

212. ITALIAN. FLORENTINE. MASACCIO (1401–1428). The Trinity. Fresco. *Sta Maria Novella, Florence.*

Masaccio, the friend of Ghiberti and Donatello, was influenced by sculpture, and studied three-dimensional form. Important restorations have recently revealed new portions, such as the skeleton on the base.

and with, on each facet, coiled shavings on small sticks and other oddities on which he spent his time, said to him: 'Paolo, your blessed perspective is making you abandon the certain for the uncertain; what good are things which can only be used by those who do marquetry?' In fact, the great compositions of Uccello seem to be geometric forms fitted into each other, made still more abstract by infallible perspective. This applies to the three pictures of the *Battle of S. Romano*, which may 211 date from 1454, in which every horse has its own particular foreshortening without any perspective relationship with the others. Only the rhythm of the intense, dramatic colour succeeds in organising them into a complete entity. Weapons, armour, trumpets, horses, insignia, everything is represented from an improbable point of view, as if for an exercise in foreshortening. The battle with its tumult misses being historical as it misses being emotional, and becomes absolutely motiveless. Andrea del Castagno, on the other hand, tried by every means to re-establish the relationship between art and content, whether 186 historical or religious. He accentuates line and volume aggressively; Cristoforo Landino described him thus: 'A great draughtsman with a great feeling for solidity, who loved difficulties and foreshortening.' His *Crucifixion* and his *Last Supper* in Sta Apollonia reveal a passionate intensity and descriptive talent, though his characters, especially the famous men who form a sort of moral programme of the Renaissance, do not reveal any real inner life.

Uccello and A. del Castagno, like Donatello, worked in Venetia. Donatello made Padua a centre for the spread of Tuscan ideas in central Italy, where they developed and gained more lightness and warmth. Naturally, perspective was still the battlecry. In studying the expansion of the Tuscan style the reaction of International Gothic has been perhaps underestimated, which had at that time a revolutionary and renovating force as great as the Florentine Renaissance. Examples of this are the monumental frescoes, often of profane subjects, in Lombardy, Trentino, Piedmont, the Marche, Umbria and even

ITALIAN. FLORENTINE. MASACCIO (1401 – *c.* 1428). The Rendering of the Tribute Money (detail). Fresco. *c.* 1425–1428. Brancacci chapel, Sta Maria del Carmine, Florence. *Photo: Scala, Florence.*

ITALIAN. UMBRIAN. PIERO DELLA FRANCESCA (*c.* 1416–1492). The Queen of Sheba adoring the Bridge made of the Wood of the True Cross (detail). Scene from the Story of the True Cross. Fresco. 1452–1459. S. Francesco, Arezzo. *Photo: Scala, Florence.*

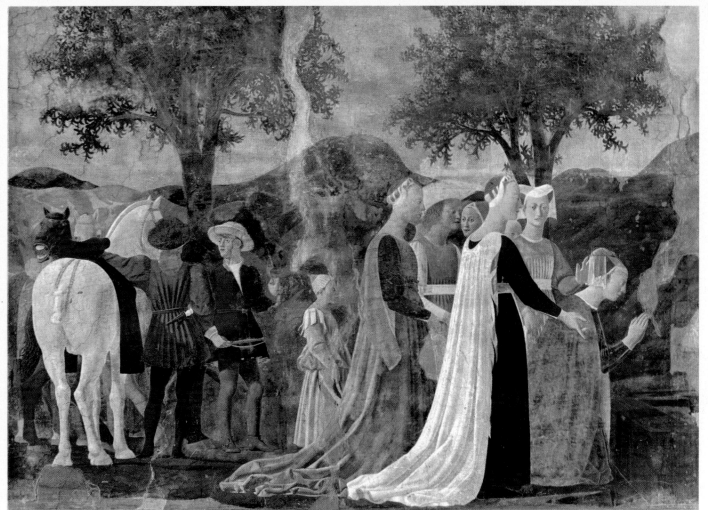

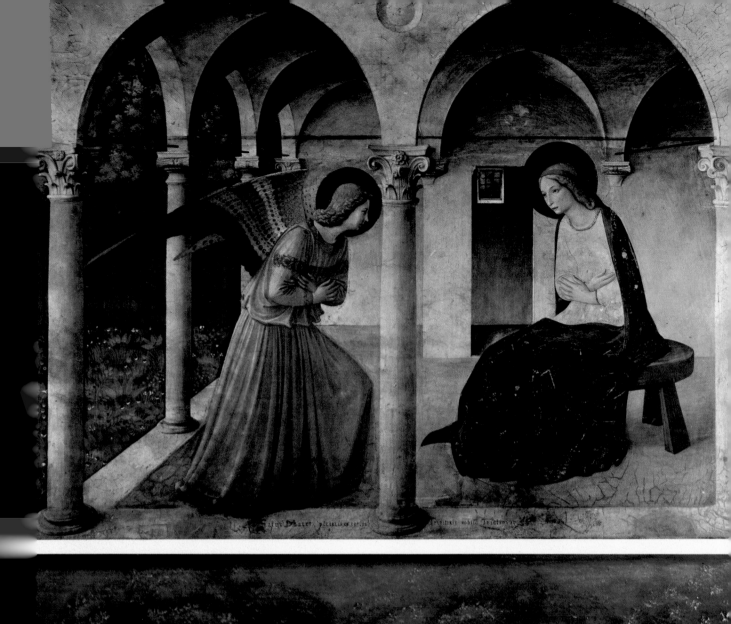

Sicily, unparalleled elsewhere. On the other hand, during the whole of the 15th century, the cultural exchanges between the Mediterranean and the Flemish world were very extensive. Sienese painters, such as Sassetta and Giovanni di Paolo, appeared to discover and enhance the authentic characteristics of religious mysticism and poetry, but set the narrative in a space that seems more logical and natural.

In Padua, Mantegna, who could take advantage of a local classicism which flourished from the Trecento on, aimed, even in his early period, at giving a lesson in archaeology; he made use of Squarcione's collection of Roman and Greek copies, set out to investigate inscriptions and abstracts, and tried to reimpose a heroic and idealised antiquity, and to enrich the decorative repertoire with innumerable new themes.

In Ferrara an excellent school, from which Tura, Cossa and Ercole de' Roberti emerged, tried to re-establish the Gothic world and even its symbolic side, by imposing on it an inflexible unity. Spontaneous rhythm and stylistic distortion became aggressive linearity and expressive emphasis. As opposed to Mantegna's insistence on analytical description, the artists from Ferrara emphasised the rhythm of composition with trenchant ferocity.

225
227

Art, science and poetry

The credit for transforming the Florentine style, which at the beginning was of little more than local importance, into an Italian style, and for establishing fully the ideal of balance, clarity and logic, while retaining the emotional force of the Gothic, belongs to Piero della Francesca and Leone Battista Alberti. Piero went to Florence, where he could study Masaccio, but he was also much influenced by the freshness of colour and the innate sensitivity of Domenico Veneziano, the first great link between the Gothic and the Renaissance. He assimilated perspective and absorbed its geometric quality so thoroughly that he was able to simplify and regulate its forms to an extent never again achieved. But he was also one of the first in Italy to make use of *velatura*, very delicate glazing, under Flemish influence. His rivers, in which trees and banks are reflected, his backgrounds which evoke with the greatest precision the valleys of the Apennines, especially those of the Tiber and Sava, and his architecture which rivals the splendour of Urbino, demonstrate a profound analysis of the external world. Man and nature live in magical harmony, in a cosmos purified but not made sterile by sentiment.

230

In fact, in the geometric rigidity of Piero, there is always an expressive aim which is revealed in the faintest of irregularities, in the knitting of the brow, the lowering of the eyes, or even the deepening of a shadow. His humanity is taciturn, his sentiments indefinable. He raises the heroes who appear in the series of the legend of the True Cross, in Arezzo, out of fable into symbolism. Ficino was to write: 'In our time we are no longer satisfied with the miracle; we must have a rational, philosophic explanation.' Piero believed in a perfect union between wisdom and religion. Isolation from the world and Aristotelian contemplation which characterised his figures correspond on the other hand to the serene tranquillity of the soul in which all anxiety and tumult were appeased, in the sense in which it was conceived by Francesco Filelfo during

213. ITALIAN. FLORENTINE. ANDREA DEL CASTAGNO (1423–1457). An Angel. Detail from the Scenes of the Passion. Fresco. *c.* 1445–1450.
Monastery of Sta Apollonia, Florence.

214. ITALIAN. SIENESE. GIOVANNI DI PAOLO (*c.* 1399–1482). St John in the Desert. *c.* 1450.
Ryerson Collection, Art Institute, Chicago.

This painting is part of a series of panels from the life of St John the Baptist in the Art Institute, Chicago, the Landesmuseum in Münster, and the Lehman Collection, New York.

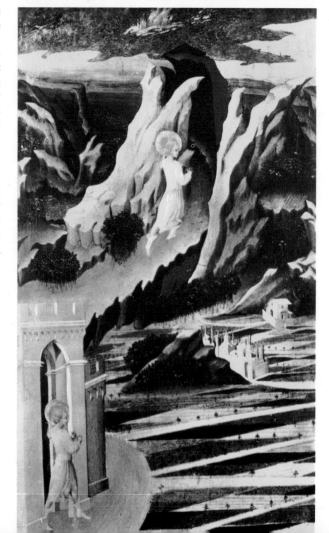

ITALIAN. FLORENTINE. FRA ANGELICO (*c.* 1387–1455).
The Annunciation. Fresco. *c.* 1437.
Monastery of S. Marco, Florence. *Photo: Scala, Florence.*

ITALIAN. FLORENTINE. PAOLO UCCELLO
(1397–1475). Hunt by Night (detail). *c.* 1465–1469.
Ashmolean Museum, Oxford. *Museum photograph.*

FLORENTINE ART IN THE 15TH CENTURY (II)

ARCHITECTURE **SCULPTURE** **PAINTING**

Born c. 1430

215

216

217

Born c. 1450

218

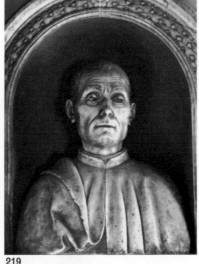

219

220

Born c. 1470

221

222

223

224. ITALIAN. VENETIAN. ANDREA MANTEGNA
(1431–1506). The Return of Federigo Gonzaga
from Exile. Fresco. *Palazzo Ducale, Mantua.*

these same years. Alberti explained this balance as a reconstituted
harmony, that is, as a rediscovered link with the music of the
universe.

Although the theories of Alberti differed from the poetic
ideas of Piero della Francesca, they sometimes throw light upon
them — for example, when Alberti defines beauty as the
'harmonious combination of the different parts in a consistent
whole, in which no part can be withdrawn, diminished or
modified without the whole suffering.' In this both artists
agree: Alberti, in his famous town planning — the origin
perhaps of the modern city — coordinated religious, cultural,
political, social and astrological demands in a very sensitive
aesthetic rigidity; Piero made his mark as much on heraldry
as on popular devotion. His taste for the particular is equal to
his capacity for synthesis.

Thus the culture of Piero may be explained, but not his
poetic quality, so delicate and subtle, and full of light. In his
panel paintings and frescoes it becomes evident that it is really
light which gives the final touch to the beauty. Marsilio Ficino
defined it as 'the smile of heaven which comes from the joy
of celestial beings', 'reality which is spiritual rather than cor-

215. BENEDETTO DA MAIANO (1442–1497).
The Palazzo Strozzi, Florence. 1489.

216. VERROCCHIO (1435–1488). Christ.
Detail from the Resurrection. *Bargello, Florence.*

217. POLLAIUOLO (1432–1498).
Hercules killing the Hydra. *Uffizi.*

218. GIULIANO DA SAN GALLO (1445–1516).
Villa at Poggia a Caiano, from a 17th-century view.

219. BENEDETTO DA MAIANO (1442–1497).
Bust of Onofrio Vanni. *Cathedral Museum, S. Gimignano.*

220. BOTTICELLI (1444–1510). Birth of Venus (detail).
c. 1485. *Uffizi.*

221. MICHELANGELO (1475–1564). The dome of
St Peter's, Rome (433 ft. high).

222. ANDREA SANSOVINO (1470–1529).
Virgin and Child (detail). *S. Lorenzo, Genoa.*

223. FRA BARTOLOMMEO (1472–1517).
The Mystic Marriage of St Catherine of Siena. *Louvre.*

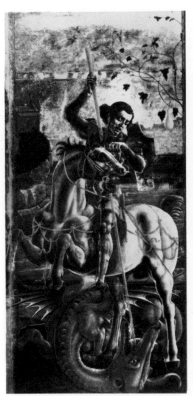

225. ITALIAN. FERRARESE. COSIMO TURA
(before 1431–1495). St George and the Dragon.
Cathedral Museum, Ferrara.

226. ITALIAN. SICILIAN. ANTONELLO DA MESSINA
(c. 1430–1479). The Martyrdom of St Sebastian. 1476.
Dresden Art Gallery.

*This work is marked by the painter's visit to Venice
(1475–1476), where he came under the influence of Bellini.*

227. ITALIAN. FERRARESE. FRANCESCO DEL COSSA
(c. 1436 — c. 1478). The Triumph of Minerva. Detail from the
Month of March. Fresco. 1467–1470. *Schifanoia Palace, Ferrara.*

*Cosimo Tura and Ercole de' Roberti also painted
decorations for the rooms of this palace.*

229. ITALIAN. VENETIAN. GIOVANNI BELLINI
(1430–1516). Pietà. c. 1470. *Brera, Milan.*

228. ITALIAN. VENETIAN. GIOVANNI BELLINI
(1430–1516). The Madonna of the Meadow. c. 1500.
National Gallery, London.

*The group of the Virgin and Child is seen by
Bellini from a ground-level viewpoint. Various genre
scenes give life to the landscape, like the
peasant woman leading her cows to the watering place.*

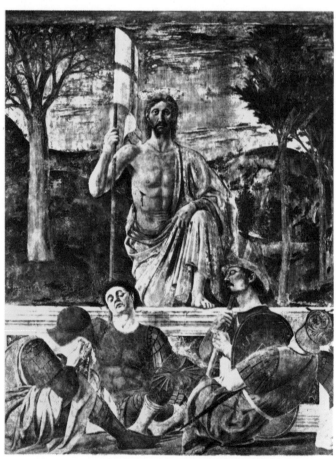

230. ITALIAN. UMBRIAN. PIERO DELLA FRANCESCA
(c. 1410/20–1492). Virgin and Child with two Angels.
Urbino Gallery.

231. ITALIAN. UMBRIAN. PIERO DELLA FRANCESCA
(c. 1410/20–1492). Resurrection. Fresco. c. 1459.
Palazzo Comunale, Borgo S. Sepolcro.

232. ITALIAN. UMBRIAN. LUCA SIGNORELLI
(1444/50–1523). Pan as God of Music (detail).
Formerly in the Staatliche Museen, Berlin, destroyed 1945.

233. ITALIAN. NEAPOLITAN. FRANCESCO LAURANA
(documented 1458–1502). Bas-relief on the Arch of
Alphonso of Aragon in Naples. 1458.

234. ITALIAN. FLORENTINE. Attributed to BOTTICELLI
(1444–1510). Pietà. After 1500. *Pinakothek, Munich.*

*Considered by van Marle and Berenson as a studio work, and
by Bell and Bode as an original painting, this* Pietà *is
none the less highly characteristic of the deep religious
crisis which Botticelli experienced at the end of his life.*

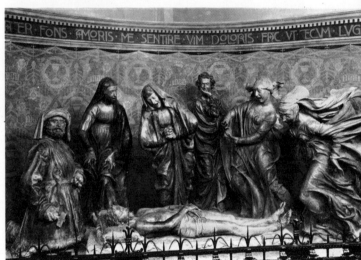

235. ITALIAN. BOLOGNESE. NICCOLO DELL' ARCA
(documented 1440–1490). Pietà.
Sta Maria della Vita, Bologna.

poreal'. Castiglione, who with Raphael inherited the poetic
style of Piero and the culture of Urbino, likewise compared
beauty to ' an influx of divine goodness, which impregnates all
created things like sunlight '. While considering the symbolism
and mysticism of love which developed in all neo-Platonic
literature, we can identify this light and grace with love itself
— the power which ' wakes things that sleep, lights the dark-
ness, gives life to dead things, form to the formless and perfection
to the imperfect ' (Ficino) and which, according to Bembo,
should bring back the golden age.

It is thus a gentle sensuality that should be perceived in the
226 serene faces by Piero; and this is the example he gave to Anto-
228 nello da Messina and Bellini, who were certainly conversant
with his ideas — not only a new sense of form, very different

from the draughtsmanship of Mantegna or the Flemish artists,
but also a new enthusiasm for light and colour.

From then on, and with the birth of true Venetian painting,
colour, opposing rationalism as well as volume, was to become
the immediate means of representing emotion born of nature;
at the same time it served that religious feeling mixed with
melancholy which, under Flemish influence, was to take the
place of the harsh mournful presentation of sacred pictures
throughout Italy.

The second age of the Renaissance, which under the influence
of Piero and Alberti profoundly inspired our art, had its Par-
nassus, so to speak, in Urbino, in the scenes which decorate
the Sala della Jole, where Hercules, fascinated by his loved
one, forgets his heroic duty.

236. ITALIAN. MILANESE. AMADEO (1447–c. 1522).
The Annunciation. Medallion. *Louvre.*

237. ITALIAN. FLORENTINE. DESIDERIO DA
SETTIGNANO (d. 1464). Tomb of Carlo Marsuppini.
c. 1453. *Sta Croce, Florence.*

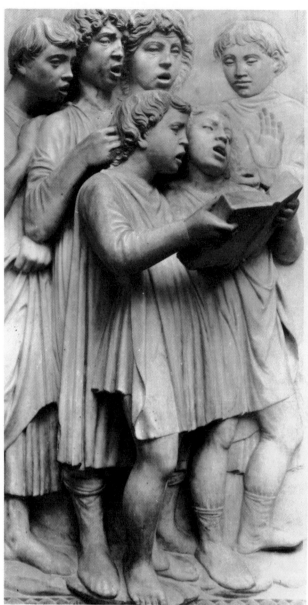

238. ITALIAN. FLORENTINE. LUCA DELLA ROBBIA
(1399–1482). Cantoria for Florence cathedral. Marble. 1432–1438.
Opera del Duomo, Florence.

The third period, almost contemporary with Lorenzo de'
Medici, witnessed the return of Tuscan predominance and was
symbolised in the painting, now destroyed, of Signorelli in
232 Berlin, the *Pan as God of Music*. It not only alludes to the return
of Plato on earth, but it solemnises the union between religion,
myth, literature and the art it represents.

Poetry and painting inspired by each other

181 In Botticelli's *Venus* and *Primavera*, in the heroic nudes of
Signorelli interpreting the writings of Valla, in the story of
Hercules by Pollaiuolo, which seems to illustrate a myth by
Landino — in all these painted narratives, full of allusions to the
mysteries of a fashionable philosophy, there is a sort of excess
of refinement, a frustrated esoteric quality. Yet — and here
lies one of the paradoxes of history — they are among the
most popular paintings today. In order to evaluate their artificial
taste, it is necessary to compare them to the solid ability of
Ghirlandaio, a disillusioned portrait painter, or to the decorative
virtuosity of Verrocchio, tied to the difficulties of technique.

In this movement of art towards poetry, more ascetic and
sensitive than the preceding identification of art with knowledge,
there is a shade of regret and decadence, which can be sensed
in Florence in the decoration of Sto Spirito, executed at the
end of the century. In spite of the nudes glorifying the grandeur
and divinity of man, Marsilio Ficino writes: ' Let it be, O
Lord, that this is a dream; that tomorrow, as we awaken to
life, we realise that up to now we were lost in an abyss, where
everything was darkened by fear; that, like the fish of the sea,
we were creatures imprisoned in water, haunted by evil spirits.'
The abyss and the prison are the houses, cities, arts, sciences
and the inventions glorified by Manetti; the evil spirit is the
Renaissance itself. The myth of man was reduced to ashes in
the fire of Valhalla and, as Garin says, there arose in its place
' the feeling of the fundamental emptiness of things, the feeling
that we live in an ephemeral world of shadows and illusions,
the feeling that we live on the surface of a reality whose meaning
escapes us'. When Botticelli painted the London *Nativity*, he
thought he saw Satan unleashed upon the earth.

History. Six great states predominated — the republics of Venice and Florence (the Medici in power, 1434–1494), the duchies of Milan (the Sforza from 1450 onwards), of Ferrara and of Savoy and the kingdom of Naples. But the minor principalities (Urbino, Mantua, Rimini) had great artistic importance. Economic prosperity was being established (banking in Florence, Genoa, Venice). Alphonso of Aragon, in 1442, turned René of Anjou out of Naples and Sicily. In 1492 the death of Lorenzo de' Medici marked the end of the golden age of Florentine civilisation. In 1494 Charles VIII of France was in Italy; in 1499 Milan was captured by Louis XII, who also conquered and then lost Naples (1500–1504).

Councils at Ferrara in 1438, at Florence in 1439–1444 (the Greek Emperor John Palaeologos and Cardinal Bessarion were present). Preachers swayed the masses: St Bernardino of Siena (d. 1444); Savonarola, who from 1495 to 1497 exercised a moral dictatorship in Florence before being burned at the stake (1498). The spread of classical culture by the Greek philosophers before and after the fall of Constantinople (1453), research into ancient writings (Poggio), archaeological investigations (Cyriac of Ancona), collections of antiques (the Pope, the Medici) encouraged humanism. The centres of humanist studies were Florence (L. Bruni, N. Niccoli; the Medici; the Platonic Academy of Marsilio Ficino, C. Landini, Pico della Mirandola); Rome (Nicholas V, Pius II and Sixtus IV collected ancient manuscripts; Vatican library; the academy of ancient studies of Pomponius Laetus); Naples (B. Fazio, L. Valla); Ferrara (Guarino da Verona); Venice (the library of St Mark's, 1423, endowed by Petrarch and augmented by the gifts of Cardinal Bessarion in 1460; E. Barbaro; Aldus Manutius established his printing-house in 1490, then the Accademia della Fama); Padua (Pomponazzi and Alexandrianism).

Printing started in Subiaco (1465), Rome (1476), Milan and Venice (1469), Ferrara, Naples, Florence (1471), etc. Among the poets were Lorenzo de' Medici (*Canzoni*), Politian (*La Giostra*, 1475–1478), Pulci (*Morgante*, 1483), Boiardo (*Orlando Innamorato*, 1476–1484). Writers of philosophical prose: F. Barbieri (*Treatise on Sybils and Prophets*, 1481), Colonna (*The Dream of Polyphilus*, 1499). Writers of theoretical works: L. B. Alberti, treatises on painting (1435), sculpture and architecture (1460–1472); L. Ghiberti, *Commentaries*, about 1450–1455; treatises on architecture by F. di Giorgio, A. Filarete; Piero della Francesca's *Perspective*

(about 1480); Baldovinetti's *Memoirs* (1449–1491).

The great patrons were: in Florence, the Medici, Cosimo the Elder (1389–1464), Lorenzo the Magnificent (1448–1492) and his brother Julius, the Strozzi, Pitti, Tornabuoni, Sassetti, etc.; in Rome, the Popes Martin V (1417–1431), Eugenio IV, Nicholas V, Pius II, Paul II, Sixtus IV, Alexander VI Borgia (1492–1503); in Milan, Filippo Maria Visconti (1412–1447), Francesco Sforza (1450–1466), Ludovico il Moro (1451–1508); in Rimini, Sigismondo Malatesta (1417–1468); in Naples, Alfonso V of Aragon (1442–1458), Ferdinand I of Aragon; in Ferrara, the Este family, Lionello (1422–1450), Borso, Ercole I. In Mantua, the Gonzaga, Lodovico III (1444–1478), Giovanni Francesco III, married Isabella d'Este (d. 1539). In Urbino, the Montefeltro, Federigo (1444–1482) married Battista Sforza, Guidobaldo married Elizabeth Gonzaga. In Venice, the Grimani, Foscari, Trevisani, Vendramin, Mocenigo, etc.

Architecture. For the theorists of the Renaissance who abandoned the Gothic spirit, which had only penetrated very superficially into Italy, the eurhythmics of a building was comparable to a microcosm, to an ideal human body in which ' all the proportions are related to a dominant theme and recurrent rhythms combined with a study of Platonic bodies '. Serlio, F. Sansovino, Labacco, Vignola, Palladio, Rusconi and Scamozzi wrote, between 1485 and 1590, architectural treatises, not counting numerous translations of Vitruvius.

What are the architectural characteristics of the Renaissance? Very often the walls are of brick and faced in marble decorated with rusticated stones, diamond points, etc. Vaults and domes of bricks and mortar were in common use; sometimes the roof of Roman tiles was disguised by an attic or balustrade and took on the appearance of a terrace. The Orders borrowed from antiquity were an innovation and appeared in the composition of façades and the decoration of interiors. At the beginning of the Renaissance, Brunelleschi applied them in the Pazzi chapel, Alberti superimposed them in the Rucellai palace [**205**]; he brought coupled columns and pilasters back into repute in the ' temple ' of Rimini. Bays, at the beginning of the Renaissance, were composed of a semicircular arch within which an ogival arch is contained, often subdivided by a little column. Very soon, the façades of palaces were surmounted by a heavy cornice and frieze. In religious buildings, pediments supported on consoles

were in common use. Staircases developed as an interior feature. Finally, palaces and churches were decorated with colourful frescoes or paintings enhanced by marble and stucco surrounds.

In Florence the work on the cathedral symbolised the advent of the new style. Filippo Brunelleschi (1377–1446), goldsmith and sculptor [**202**, **240**], offered a design for the dome, in 1420, which simplified that of Arnolfo di Cambio; he combined knowledge of Roman art with that of the Romanesque of the 11th and 12th centuries which inspired the simple, harmonious arrangement of the Foundlings' Hospital (1419), and of the old sacristy of S. Lorenzo (1420) with a dome over a square plan. For his church of S. Lorenzo he reintroduced the plan of the nave and two aisles of the Latin basilica, and the sense of space achieved the utmost harmony in the church of Sto Spirito; finally his Pazzi chapel in Sta Croce (1430–1440) combined grace with a forcefulness emphasised by the pilasters in the interior. The most massive Florentine palace, the Pitti (about 1440), heavily rusticated, was executed by Luca Fancelli and finished by Ammannati (1511–1592), from the design by Brunelleschi. It inspired Michelozzo Michelozzi (1396–1472) for his Palazzo Medici, later the Palazzo Riccardi (about 1440).

Leone Battista Alberti (1404–1472), architect, writer and theorist (*De Re Aedificatoria*, about 1450), based his ideas on Vitruvius. His designs were executed by Bernardo Rossellino (1409–1464); Palazzo Rucellai (about 1446–1451) [**205**] by Matteo de' Pasti; Malatesta temple in Rimini [**195**], the unfinished façade of which recalls the Roman triumphal arch. His most influential works were the façade of S. Maria Novella (rebuilt to his design 1456–1470) and S. Andrea, Mantua (begun 1472): the interior, combining aisleless nave and dome, foreshadows the Baroque.

Agostino di Duccio (1418–1481), who helped Alberti in Rimini, revealed the influence of his work in Rimini on the façade of the Oratory of S. Bernardino in Perugia [**208**].

Rossellino, who was also well known as a sculptor, may have been the architect of the Palazzo Venezia (1455) in Rome. It was thanks to the patronage of Pius II that he had the opportunity of designing a square in Pienza in the purest Renaissance style. The brothers Benedetto (1442–1497) and Giuliano (1432–1490) da Maiano [**215**] worked in Naples (Porta Capuana) and in the collegiate church of S. Gimignano. From 1489 onwards Benedetto, with Simone Pollaiuolo called Cronaca

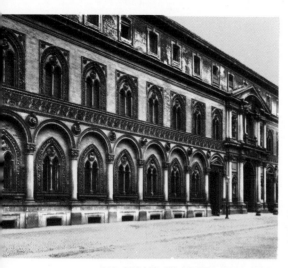

239. ITALY. FILARETE (1400–1469). Façade of the Ospedale Maggiore, Milan, with terra-cotta decoration. 1456.

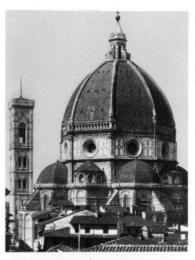

240. ITALY. BRUNELLESCHI (1377–1446). Dome of Florence cathedral. Project 1420.

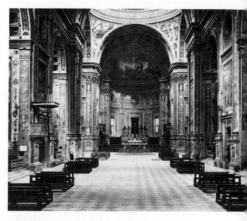

241. ITALY. ALBERTI (1404–1472). Interior of S. Andrea, Mantua. Begun 1472.

(1457–1508), built the most beautiful of all the Florentine palaces, the Palazzo Strozzi.

The 15th century in Tuscany ended with the San Gallo family. Giuliano Giamberti, principally a military architect (1445–1516) [218] (fortifications of Borgo S. Sepolcro, 1502, villa at Poggio a Caiano, 1488), heralded Palladio in the façade of Sta Maria delle Carceri in Prato (1485); Antonio, called 'il Vecchio' (1455–1534), already showed the influence of Bramante in S. Biagio at Montepulciano (1518).

At Urbino the famous ducal palace was partly rebuilt by Luciano Laurana (1420–1479) with three superimposed loggias and a courtyard with Corinthian columns. Francesco di Giorgio (1439–1502), architect, sculptor and painter, wrote a treatise on architecture. Giacomo Cozzarelli (1455–1515) designed the dome of the Church of the Observance in Siena.

In Milan the Gothic style persisted but the influence of Michelozzo was felt, for example, in the Castello Sforzesco by Antonio Averlino, called Filarete (1400–1469), author of a treatise on architecture [239]. Milan was the starting point for Donato Bramante (1444–1514) who was trained in Urbino [262]. For Sta Maria presso S. Satiro, and for the choir of StaMaria delle Grazie (1492–1499), he reverted to an Early Christian style. The masterpiece of this revival of Early Christian style was the Church of the Incoronata at Lodi (1488–1494) designed by Giovanni Battagio.

In Bologna some of the most beautiful palaces of the Renaissance were erected (Bevilacqua). In Ferrara there are the Schifanoia palace (1391–1471) and the Diamond palace by Biagio Rossetti (d. 1516) [242], creator of the Loggia del Consiglio in Padua.

In Naples and Sicily, alongside the Gothic-Islamic influence (Palazzo Sto Stefano, Taormina) we find a classical influence which Matteo Carnelivari helped to introduce.

In Venice, the famous Ca d'Oro (begun in 1421) [297] represents another late Gothic triumph. Giovanni (d. 1442) and Bartolomeo Buon (d. 1464) [298], architects and sculptors, worked on the Doges' Palace, as did Antonio Rizzo (1430 – about 1500), designer of the Scala dei Giganti, finished by Pietro Lombardo (about 1450–1515) [303]. Helped by his sons, Antonio and Tullio, Lombardo created in Sta Maria dei Miracoli precious veneers of coloured marble. Mention must also be made of the Palazzi Dario and Vendramin Calergi, of the façade of S. Zaccaria (1483), of Sta Maria Formosa, and of the façade of the Scuola di S. Marco (1485–1495), which blends the Venetian temperament with the principles of Alberti — the aim of Mauro Coducci (1440–1504 [300]).

In Verona, Palazzo del Consiglio by Fra Gioconda (1435–1515), one of the greatest architects of the century.

Sculpture. Sculpture came to the fore in 1401, especially in Florence (the competition for the second doorway of the baptistery). The leading master was Donatello (1386–1466) [196-199]; he executed works for Or S. Michele: *St Mark* (1413), *St George* (1416); for the campanile: *Jeremiah* (1423–1426), *Habakkuk* (1427–1436); in the baptistery; the tomb of the anti-Pope John XXIII, in collaboration with Michelozzo; for Cosimo de' Medici: *David* (about 1430). From 1432 to 1433 he was in Rome. On his return, he created the musicians' gallery for the cathedral (1433–1439); later, in Padua, the equestrian statue of Gattamelata (1444–1447) [245], and the reliefs and statues for the high altar of the basilica of S. Antonio. In 1452 he returned to Florence again: *Mary Magdalen* (baptistery); *Judith* (Piazza della Signoria). Pulpits, S. Lorenzo (1460–1466), completed by Bertoldo. (See p. 123.)

Lorenzo Ghiberti (1378–1455), goldsmith by training, won the competition for the second baptistery bronze doors (1403–1424); third bronze doors (Porta del Paradiso, 1425–1452). His large workshop was the principal training ground for the next generation. Other sculptors, such as Nanni di Banco (d. 1421), also worked on public buildings (cathedral, Or S. Michele) and for private patrons (portraits, funerary monuments at Sta Croce, la Badia, S. Miniato); so did Bernardo Rossellino (d. 1464) and his brother Antonio (d. 1470), Desiderio da Settignano (d. 1464), pupil of Donatello, Mino da Fiesole (d. 1484), follower of Ghiberti, the eclectic artist Benedetto da Maiano (d. 1497) [172, 219], all sculptors in marble. Their decorative compositions, of classical inspiration, are derived from the architectural models of Brunelleschi, Michelozzo and Alberti, who had as collaborator, in S. Francesco at Rimini, Agostino di Duccio (d. 1481), imitator of Donatello in his very low relief (stiacciato). Luca della Robbia (1399–1482) [238], creator of the second musicians' gallery in Florence cathedral, and his workshop introduced sculpture in tin-glazed terra cotta, destined to be very successful (Foundlings' Hospital, Florence). In imitation of Ghiberti and especially of Donatello, whose successor was Verrocchio (1453–1488) (*David*, Bargello; *Colleoni*, Venice [244]), Antonio Pollaiuolo (1429–1498) [217] and Bertoldo (d. 1491) displayed their mastery as bronze workers in small statuettes or funerary sculpture (tombs of Popes Sixtus IV and Innocent VIII, by A. Pollaiuolo in St Peter's, Rome).

The only eminent sculptor outside

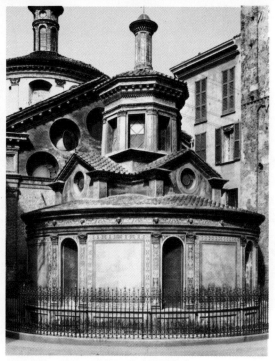

242. ITALY. B. ROSSETTI (d. 1516).
Palazzo dei Diamanti, Ferrara.
Begun 1492, finished 1565.

243. ITALY. BRAMANTE (1444–1514).
Rotonda, Sta Maria
presso S. Satiro, Milan. c. 1482–1494.

Florence was Jacopo della Quercia of Siena (1374–1438) who took part in the 1401 competition for the baptistery doors. Earliest work, fragmentary tomb of Ilaria del Carretto (c. 1406, Lucca cathedral) [**200**]; Fonte Gaia, Siena (1414–1419); his most influential sculptures are the reliefs of the Old Testament on the façade of S. Petronio, Bologna (1425–1438).

The prestige of the Florentine school spread throughout the peninsula, to Rome and Naples and to Urbino, Venetia and Milan where the best representatives worked. A few masters are distinctive: at Lucca, Matteo Civitali; at Siena, L. Vecchietta and Francesco di Giorgio Martini (1439–1502); in Naples and Urbino, Francesco Laurana [**233**]; in Venice, Antonio Rizzo [**301**] and Pietro Lombardo [**304**]. A special place must be assigned to Guido Mazzoni of Modena (d. 1518) and Niccolo da Bari, called dell'Arca, the sculptors of monumental groups in coloured wood or terra cotta, inspired by a feeling for the picturesque. The decorative sculpture of the Lombard style, in high repute in northern Italy, contrasts in its highly coloured and rather excessive richness with the classical character of the Tuscan style which Michelozzo and Filarete, followers of Brunelleschi, did not succeed in imposing on Milan. The works of Giovanni Antonio Amadeo (1477–1522) [**236**] in Bergamo (Colleoni chapel) or in Pavia (cloister and façade of the Certosa, 1491–1498), in collaboration with B. Briosco, had successors in Spain and the northern countries, where funerary sculpture was also to be inspired by the mausoleum of Gian Galeazzo Sforza in the Certosa in Pavia (1493–1497), by Cristoforo Romano and Briosco, completed in 1562.

Painting. In the first quarter of the century Florentine painting experienced the influence of the International Gothic through the Sienese Lorenzo Monaco (c. 1370–1422/25): *Coronation of the Virgin* (Uffizi, 1414); Gentile da Fabriano (c. 1370–1427), *Adoration of the Magi*, 'Strozzi' altarpiece (Uffizi, 1423) [**70**]; and Masolino da Panicale (c. 1383–1447) who worked in the Brancacci chapel, Carmine (1425–1427) before going to Hungary, 1427; 1430, Rome: c. 1435, Castiglione d'Olona [**246**]. In opposition was the austere and heroic style of Masaccio (1401–1428), friend and disciple of Brunelleschi and Donatello: fragments of Pisa polyptych (*Madonna and Child*, National Gallery, London; *Crucifixion*, Naples; predella, Berlin, 1426). 1426–1428, major surviving work, frescoes in the Brancacci chapel of the Carmine: *Expulsion* and life of St Peter, completed by Filippino Lippi c. 1484. 1427/28, *Trinity with Donors* (Sta Maria Novella).

His older contemporaries included Uccello and Fra Angelico. Paolo Uccello (1397–1475) was famous for his study of perspective, used for non-naturalistic ends; 1425–1431 Venice, 1445 Padua. His most famous work was *The Deluge* (Chiostro Verde, Sta Maria Novella, c. 1445). The three battle scenes for the Medici Palace (Louvre, Uffizi, National Gallery, London, 1454–1457) reveal the increasingly decorative aspect of his late work. Fra Angelico (Fra Giovanni da Fiesole, c. 1387–1455), a Dominican monk at Fiesole and S. Marco, Florence, evolved a simple, direct style used for didactic purposes: *Annunciation* (Cortona, c. 1430); Linaiuoli *Madonna* (1433), S. Marco *Madonna* (1438–1440) at S. Marco, where there is a series of fifty frescoes (done with assistants, 1438–1450), the majority in cells. 1447–1449, Orvieto and Rome: frescoes from the lives of St Stephen and St Lawrence, chapel of Nicholas V, Vatican. His qualities of serenity and beauty of colour are shared by Domenico Veneziano (*St Lucy Altarpiece*, Uffizi) and Alesso Baldovinetti (c. 1426–1499). Donatello's influence is strong in the works of Andrea del Castagno (1423–1457): frescoes of the *Passion* and *Last Supper* in Sta Apollonia, where also nine frescoes of famous men and women (from Villa, Legnaia) [**186**]. In Fra Filippo Lippi (c. 1406–1469) the early influence of Masaccio (relaxation of Carmelite Rule, c. 1432) is superseded by Donatello and Flemish painting: *Barbadori Altarpiece* (Louvre, 1437–1443) [**249**]; *Coronation of the Virgin* (Uffizi); frescoes in Prato cathedral (1452–1464) when master of Botticelli. Decorative charm coupled with Flemish portrait realism is intensified in Benozzo Gozzoli (c. 1421–1497): *Journey of the Magi*, chapel, Medici palace (1459), and Domenico Ghirlandaio (1449–1494), master of Michelangelo, whose prosaic naturalism is visible in his fresco cycles in Sta Trinità (c. 1485) and Sta Maria Novella (c. 1490) [**248**].

The scientific, realistic works of Verrocchio and Pollaiuolo, goldsmiths and sculptors as well as painters, reflect one aspect of Florentine painting in the late 15th century. The other, the neo-Platonism of Lorenzo de' Medici and his humanist circle is personified in the mythological creations of Sandro Botticelli (1444–1510): *Primavera* (c. 1478); *Birth of Venus* (c. 1485, Uffizi), both for Lorenzo di Pierfrancesco, Lorenzo's cousin. His dependence on outline as a means of emo-

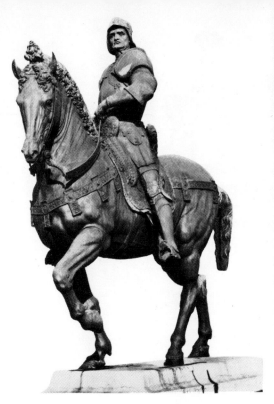

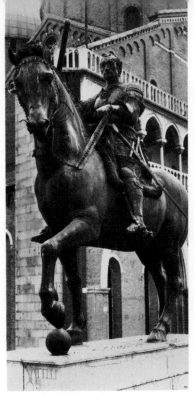

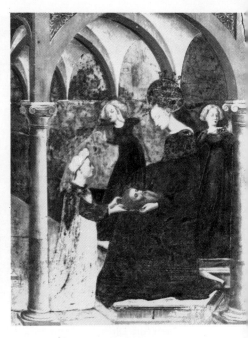

244. ITALIAN. VERROCCHIO (1435–1488). Equestrian statue of the Condottiero Colleoni, Venice. Finished by Leopardi.

245. ITALIAN. DONATELLO (1386–1466). Equestrian statue of the Condottiero Gattamelata, Padua. 1444–1447.

246. ITALIAN. FLORENTINE. MASOLINO (1383 – c. 1447). Salome bringing Herodias the Head of John the Baptist. Fresco. c. 1435. Baptistery of the Collegiate Church of Castiglione d'Olona.

tional expression is intensified in his late works, perhaps influenced by Savonarola: *Mystic Nativity* (National Gallery, London, 1500; *Pietà* (Munich) [181, 220, 234]. Lorenzo di Credi, Filippino Lippi (son of Filippo Lippi) and Piero di Cosimo mark the transition to the Cinquecento.

The school of Siena, which had fallen behind, was faithful to its past: awareness of new trends, but used for non-realistic ends. The two leading painters were Sassetta (Stefano di Giovanni, 1392–1450): *St Francis Altarpiece* for Borgo S. Sepolcro (Settignano, National Gallery, London, Chantilly, 1437–1444) and Giovanni di Paolo (1403–1483): panels of the life of John the Baptist (Chicago, Münster, Lehman Collection, New York) [214]. Matteo di Giovanni (1435–1495) and Francesco di Giorgio (1439–1501), architect, sculptor and painter, were more affected by Florentine influences.

The other schools followed the lead of Florence, while imposing their own characteristics on their works. In central Italy the virtuoso of spatial composition, Piero della Francesca (c. 1416–1492) [230, 231], follower of Masaccio who worked with D. Veneziano, worked before 1440 in Florence, then at Borgo S. Sepolcro, Rimini, Arezzo, Ferrara and Urbino. Frescoes: 1452–1459, cycle of the legend of the True Cross, Arezzo, S. Francesco; *Resurrection*, Borgo S. Sepolcro. Pictures: *Baptism of Christ*; *Flagellation*; 1465, portraits of the Duke of Urbino and his wife; about 1475, *Madonna of*

Sinigallia. He wrote a treatise on perspective (c. 1480). He created a great tradition of mural painting which his pupils Melozzo da Forlì (1438–1494), Luca Signorelli of Cortona (1450–1523) continued: Orvieto cathedral, frescoes in the S. Brizio chapel, 1499–1504 [232, colour plate p. 105]. In Umbria Perugino (1445–1523), the master of Raphael, heralds the space composition of the High Renaissance in his finest works: *Crucifixion with Saints*, Sta Maria Maddalena de' Pazzi, (Florence, 1496) [267]. Pinturicchio (c. 1454–1513) illustrates the Umbrian tendency to narrative detail: Borgia apartments, Vatican (1492–1495); Piccolomini Library, Siena (1503–1508). In Naples and Sicily where artistic cosmopolitanism favoured a mixture of the most diverse trends, Colantonio and Antonello da Messina (c. 1430–1479) [226] became adept in the Flemish style. About 1475 Antonello introduced it in Venetia, where at the beginning of the century two other travelling painters, Gentile da Fabriano (c. 1360–1427) [70] and Antonio Pisanello of Verona (c. 1395–1450), had already brought in court realism in its northern aspect; but it was the arrival of Florentine sculptors and painters that determined the evolution of Venetian painting. Antonio Vivarini (c. 1415–1480) and Jacopo Bellini (c. 1400–1470) were the chiefs of the two dynasties of painters in Murano and Venice.

The tendencies were defined about 1450. The one became more descriptive; the chief representatives were

Gentile Bellini (d. 1507) and Carpaccio (c. 1455–1526) [247] (*Legend of St Ursula*, Venice). Under the leadership of Mantegna (1431–1506), head of the Paduan school and son-in-law of Jacopo Bellini (altar panels of S. Zeno, 1457–1459, Verona, Louvre, Tours) [185], the second — with Bartolomeo Vivarini (d. 1499) and Carlo Crivelli (1430–1495) [302] — moved in the direction of sculptural formality, which Giovanni Bellini, who imitated Antonello, tempered by soft colours; to this group belonged Alvise Vivarini, Cima da Conegliano [305], Marco Basaiti and, in Vicenza, Bartolomeo Montagna.

Giovanni Bellini (c. 1430–1516), the real founder of the Venetian school, had the largest and most important workshop in Venice and trained most of the younger generation: Giorgione, Titian, Palma, Sebastiano del Piombo. His early works were strongly influenced by his brother-in-law Mantegna: *Agony in the Garden* (National Gallery, London, c. 1460): *Pietà* (Brera, c. 1470); *Pesaro Altarpiece* (c. 1475). The influence of Antonello da Messina's visit of 1475 is visible in the *Transfiguration* (Naples, 1480–1485), the Frari triptych (1488) and in the development of the Sacra Conversazione type of altarpiece: SS. Giovanni e Paolo (c. 1475, destroyed); S. Giobbe (c. 1483–1485); S. Zaccaria (1505). Late works include *Doge Loredano* (National Gallery, London, c. 1501); *Feast of the Gods* (Washington, 1514).

At Padua, Andrea Mantegna (1431–

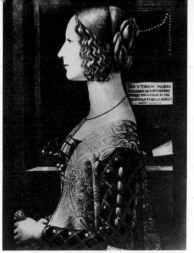

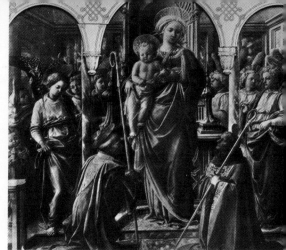

247. ITALIAN. VENETIAN. CARPACCIO (c. 1455 — c. 1526). The Vision of St Ursula. 1490–1496. *Academy, Venice.*

248. ITALIAN. FLORENTINE. DOMENICO GHIRLANDAIO (1449–1494). Giovanna Albizzi Tornabuoni. 1488. *Edsel Ford Collection, Detroit.*

249. ITALIAN. FLORENTINE. FRA FILIPPO LIPPI (1406–1469). The Virgin and Child between SS. Frediano and Augustine. 1437–1443. *Louvre.*

1506) is strongly influenced in his early works by Donatello and classical sculpture: frescoes in Ovetari chapel, Eremitani (1448–1459, destroyed 1944): *St Zeno Altarpiece* (Verona, Louvre, Tours, 1457–1459). 1460, Mantua, as court painter to the Gonzaga: frescoes, Camera degli Sposi (Castello, 1474), the ceiling being the first sotto in sù (foreshortening in a ceiling painting, designed to give the spectator below a convincing illusion of figures in space) of the Renaissance: *Triumph of Caesar* (Hampton Court, c. 1486–1494); *Madonna della Vittoria* (Louvre, 1495/96).

The painters of Ferrara, Cosimo Tura (before 1431–1495) [125, 225], Francesco Cossa (d. 1478) and Ercole de' Roberti (d. 1496) owed much to Mantegna; Lorenzo Costa (d. 1535) chose the Umbrian gentleness, which F. Francia (d. 1517) from Bologna made popular in the north. In Lombardy, Vincenzo Foppa (1427–1515) and Borgognone (d. 1523) did not repudiate their connections with Padua and Ferrara. The influence of Foppa was felt in Genoa where he worked and where he had followers (Braccesco, Massone).

Miniatures. After 1450 Italian illumination was distinguished by richness of decoration and brilliance of colouring. The principal centres were Ferrara, with Taddeo Crivelli (Bible of Borso d'Este, 1455–1462); Verona, with Liverale, whose style was continued by Girolamo dai Libri; Florence, with Francesco d'Antonio and especially with Attavante (1425–1517) [139], who was admired by Italian and foreign bibliophiles; Perugia and Urbino.

Stained glass. In Perugia (S. Domenico), in Florence (cathedral, Sta Croce, Sta Maria Novella), in Lucca (cathedral), in Venice (SS. Giovanni e Paolo), windows in powerful colouring were most often made from the cartoons of leading masters (in Florence: Ghiberti, Donatello, Uccello, Lippi).

Marquetry. Decoration in marquetry (intarsia) was used in ecclesiastical woodwork in conjunction with sculpture, and in domestic cabinet making: in Florence (baptistery), in Modena (cathedral), in Urbino (studiolo of the ducal palace, 1475) [158], in Pavia (certosa), in Venice (Sta Elena). Besides geometrical motifs, the usual repertory included still life in trompe l'oeil, landscapes or figures (tarsia pittorica), and competed favourably with painting.

Tapestry. French or Flemish artists controlled the workshops established in Milan (after 1419), Venice (1421), Rome (1447–1455) and Ferrara (c. 1450–1460).

Engraving. Woodcuts, a technique imported into Venice by German craftsmen, were used to illustrate books, a factor which helped the humanist publisher Aldus Manutius to produce the *Dream of Polyphilus* (1499), the most beautiful work of the Quattrocento [140]. In Florence the printers sometimes had recourse to copper engraving for illustrations (plates by Baccio Baldini, after Botticelli, for the *Divine Comedy*, 1481). The goldsmith Maso Finiguerra (d. 1464) contributed with his niellos towards spreading the technique of intaglio engraving, though he did not invent it. Another goldsmith, A. Pollaiuolo, instigated the broad manner (*Battle of the Naked Men*), which C. Robetta afterwards adopted. In northern Italy Mantegna [142] imposed a vigorous, severe style, amplified by his followers Giovanni da Brescia, Zoan Andrea, and B. Montagna, and afterwards made more tractable by Domenico Campagnola and Jacopo de' Barbari.

The minor arts. Many sculptors (Ghiberti) and painters were first trained as goldsmiths. The great silver altar in the baptistery of Florence was finished about 1451–1459 by the architect-sculptor Michelozzo and by goldsmith-sculptors including Verrocchio and A. Pollaiuolo with the collaboration of Betto di Geri for the cross. The masterpiece of Italian goldsmiths' work is the base of the gold cross, enamelled and jewelled, called the Mount of Calvary, created before 1490 for Mathias Corvinus, king of Hungary (Gran cathedral). In addition to translucid enamel on relief, the technique of painted enamel, translucid or opaque, developed in northern Italy.

The painter Pisanello revived the art of portrait medals cast in bronze [161]. He worked for the courts of northern Italy, then for Alphonso of Aragon, king of Naples, and he gave real artistic distinction to this technique. His disciples, Matteo de' Pasti and Sperandio were masters of this art form, as were Pietro da Milano and F. Laurana (who later entered the service of René of Anjou). To these may be added Niccolò Fiorentino and Giovanni Candida, who moved to the court of Burgundy, and the Mantuans Cristoforo Geremia and Lysippe, medallist to the Pope.

Ceramics, which were to become very decorative, were inspired by painting or engraving. Majolica with tin-oxide glaze, copied from Hispano-Moorish pottery was replaced about 1450 with lead-glazed earthenware decorated with sgraffito (design obtained by scratching through the glaze), practised in northern Italy [151].

Often enhanced with marquetry or gilded gesso and painting (cassoni, chests) [158], domestic furniture was inspired by antique styles (seats in the shape of an X, tables in the Roman manner). Cabinets (chests with drawers) were usually decorated *alla certosina* (marquetry); in Ferrara and Venice they were decorated with stamped and gilded leather: in Florence they were inlaid with gems (stipi).

Adeline Hulftegger and Jean Charles Moreux

117

THE ITALIAN CINQUECENTO
AND IDEALISM *Giulio Carlo Argan*

*The search for reality, that is, for truth, and the search for beauty,
at first carried on more or less empirically,
came increasingly to be conducted by means of the intellect.
These two lines of research, hardly differentiated at first,
as can be seen in Leonardo da Vinci, ended far apart, the one as
science, the other as aesthetics. The latter even
claimed kinship with a philosophy, that of Plato.
So in the 15th century in Italy, above all in Florence, the
Renaissance laid down the aims and the means of art.*

The idea that art can be a means to knowledge, a positive
and constructive experience of nature and history, had found
230 its most sublime expression and also its fulfilment in Piero
della Francesca.

The search for beauty

The attitude of artists in Florence during the last decades of
the 15th century was a product of neo-Platonist teaching,
namely that the supreme purpose of human existence is the
attainment of a state of pure spirituality. The same must therefore
be true of all human experience, whether in history or in nature.
181 Botticelli's painting is a typical example of this: movement is
220 pure rhythm, action is suspended in gesture, forms are no longer
related to a consistent space. Just as formal construction and
spacial relationships evaporate in this way, so does the sense of
250 history lose its precision. For Piero di Cosimo, the ancient
251 world was merely a poetic myth, while Filippino Lippi exercises
his exact and almost Flemish powers of observation in order
to explore the very limits of fantasy in the capriccio.

Since the aim of art was no longer truth but beauty, and since
' beauty ' — like any abstract idea — evades a positive definition
of form or theoretical fomulas, all that derives from the tech-
nique, or from the skill, of the craftsman acquires increased value.
And since beauty is in itself inaccessible, art tries to glorify it
rather than to realise it. Already, in the paintings of Botticelli,
decoration plays an essential part, because it comes into the
ritual of this new cult of beauty. Similarly, in the poetry of
Lorenzo the Magnificent, Politian and Pulci, it has a profound
metaphorical significance; thus a young girl may be adorned
with jewels and flowers, clad in diaphanous drapery so as to
show clearly that her eyes shine like precious stones, that her
lips have the colour and perfume of roses, her movements have
the lightness of drapes blown by the wind. The theory of art
considered as poetry is henceforth consciously opposed to that
of art considered as the knowledge of nature and history, a
clear and constructive vision of time and space.

But the attitude of the Platonic Academy in Florence goes
further than that. The revelation of immaterial beauty, which
in itself is nothing but a perfect harmony of proportions in
decoration, is also a characteristic of Florentine architecture of
219 the second half of the century, of Benedetto da Maiano or
218 Giuliano da San Gallo, a characteristic, too, of the sculpture of
253 Antonio Rossellino or Mino da Fiesole, of the ornate codices
adorned with miniatures by Francesco d'Antonio, Gherardo
and Monte d'Attavante. This same skilful, even literary, group
of artists, through their reference to the themes, forms and
techniques of classicism, made the so-called ' minor arts '
flourish — small bronzes and medallions, gold and silver work,
carved gems, furniture, materials, embroidery. At every princely
court a centre of humanist culture and a school of artisans

were established; the greatest artists themselves were often
required to design properties for festivals and plays. Thus they
became the stage managers of a gorgeous refined social life.

Two very great artists, Leonardo da Vinci and Michelangelo,
seemed to react against this encroaching aestheticism, although
from different motives; the one opposed it by penetrating and
feverish scientific research, the other by a very severe moral
attitude. In reality Leonardo and Michelangelo represent the
final crisis of humanist culture, but only in the sense that they
present the problem of beauty and art in new terms, that is,
in terms other than the more or less skilful imitation of antiquity.

Leonardo and the value of experiment

When the variety and complexity of Leonardo's artistic and
scientific activities are considered, it is generally admitted that
the outstanding characteristic of his genius lies in his categorical
rejection of all ' principles of authority ', and in his assertion of
the exclusive value of experiment. This indeed is the dominant
characteristic not only of Leonardo's personality, but also of
his art; Leonardo rejects every *a priori* system or conception of
nature, every system or theory of space, so much so that he
deliberately ignores the examples of antiquity, that is, he does
not recognise the authority of history. He opposes the geometric
construction of space and linear perspective by ' aerial ' per-
spective, with an empirical and experimental foundation. To
the historical or heroic concept of human personality he opposes
the direct study of the ' phenomenon ' that is man. But can
we really maintain that Leonardo, the man of science, brings
to art the spirit of inquiry which belongs to his scientific acti-
vity? A profound coherence does, it is true, exist between the
many different activities of Leonardo's genius, but we believe
that this unity is due rather to the tendency to separate problems
than to his tendency to unify them. This variety of Leonardo's
mental activities seems to be more the final sublimation than
the triumph of this union of art, science and ethics which cha-
racterised the first great personalities of the Renaissance such as
Alberti. C. Luporini noted that ' Leonardo represents not only
the artist-philosopher according to the glorious tradition of the
Quattrocento; there is also in him a new factor, the artist and
philosopher beginning to separate, who already, to a certain
extent, contradict each other, now dialectic and prolific, now
rigid and opposed to established precepts, with different kinds
of feeling, and with different methods of working which
eventually also become separate on the social level.' It is true
that his contemporaries did not know, or did not appreciate at
their true worth, the scientific researches of Leonardo; but it is
equally significant that in his work as a painter they saw parti-
cularly the search for a new type of beauty, a purpose which
is exclusively part of the aim proper to art and not to science.
Even though, in his studies as a philosopher, Leonardo makes
extensive use of drawing, and he applied his scientific observations
and experiments to his paintings to the exclusion of the traditional
methods, the two activities remain completely distinct. The
link which connects them is solely this: the visual appearance
is considered as a proof of the validity of the experiment.
Leonardo's beauty is always a visible beauty, in contrast to the
ethereal character of the beauty of the neo-Platonists and Botti-
celli. The aim of the artist is specifically the search for beauty
and is not limited to the representation of visible things; the
proof of this is that the exact opposite is found in ' ugliness ',
which Leonardo sought to define in his caricatures. Now beauty

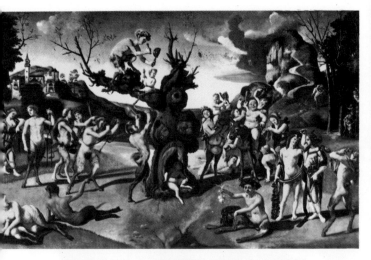

250. ITALIAN. FLORENTINE. PIERO DI COSIMO
(1462–1521). The Discovery of Honey.
Worcester Art Museum, Massachusetts.

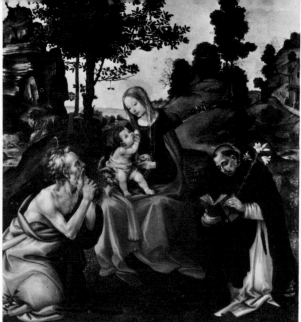

251. ITALIAN. FLORENTINE. FILIPPINO LIPPI
(*c.* 1457–1504). Virgin and Child between SS. Jerome and
Dominic. *National Gallery, London.*

and ugliness are both visible appearances; however, they are valid not through the representation of reality, but through the fact that they make visible qualities which are not visible, such as the effect of passions or the continually changing aspects of nature. Certainly, for Leonardo also, brought up in the neo-Platonic ambience of Florence, *pulchritudo est aliquid incorporeum*, 'beauty is an ethereal thing', but it is no longer revealed in apologies and metaphors as in Botticelli, but through a direct visual image; it is demonstrated by the sfumato (soft blending of light and shade), which, it is true, involves the scientific theory of the dense transparency of air, but which is not entirely explained by it. Sfumato is the unity of people with nature;

252. ITALIAN. FLORENTINE. MINO DA FIESOLE
(*c.* 1431–1484). Bust of Dietisalvi Neroni.
Marble. 1464. *Louvre.*

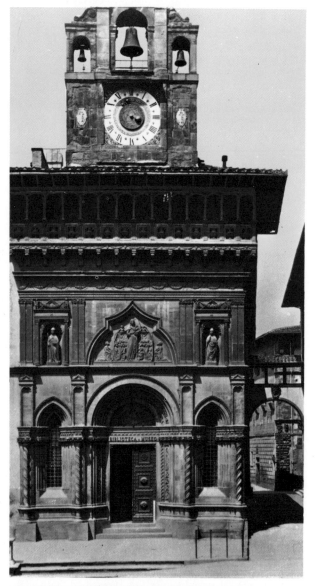

253. ITALY. FLORENTINE. Palazzo della Fraternità,
Florence. Begun in Gothic style, finished in
Renaissance style. Lunette by Bernardo Rossellino (1409–1464).

when it is achieved this unity expresses a profound combination, or 'sympathy', between human and cosmic nature; this conception of form, which by fusing and vibrating eliminates its dryness and severity, is the opposite of beauty. It stems from Leonardo's training with Verrocchio, who only suggests the internal structure of the form through a tight series of light, quick and intangible brush strokes. It must not be forgotten that the only artist quoted many times by Leonardo in a polemical spirit is Botticelli. Sfumato, at first a simple atmospheric vibration, may be considered the antithesis of the linear rhythms of Botticelli. Discussions of Leonardo's writings on the connection between painting and poetry go back to the experiments in Florence of the neo-Platonist circles. Leonardo admits the basic analogy between the two arts, but he asserts the pre-eminence of painting, because it can be seen. The unfinished work which 191 brought to an end the Florentine period (1481), the *Adoration of the Magi*, takes up Botticelli's favourite theme, but treats it in a diametrically opposed fashion. The rhythmic composition of Botticelli and his clear colours graded in the contours make way for a vortex of dynamic masses of light and shade; figures are no longer defined by a determining gesture, the continuity of movement is assured by the union of figures and space in a single vision. What in Botticelli had been the supreme abstraction of the spirit became in Leonardo a feverish application to reality, the participation of man in the constant evolution of the cosmos. His *St Jerome* is a typical example in its acutely perceived anatomy, less in order to set the pose than to reveal, by the raging tension of nerves and tendons, a state of internal agitation.

Leonardo's concept of painting and of beauty

In 1483 Leonardo left Florence for Milan. Far from the centre of neo-Platonism, he sought in all directions and in a number of specific cases to verify experiment. In art, he felt the necessity henceforth to distinguish between the different techniques of painting, sculpture and architecture which he defined as intel-257 lectual rather than manual. *The Virgin of the Rocks* (1483) can be considered the first document of a very definite poetic conception, capable of expressing itself uniquely in painting. Neo-Platonism and the physical interpretation of emotions become of secondary importance. Leonardo's efforts are henceforth completely concentrated on the solution of every problem of form and space in relation to light and shade. The grotto is in twilight; the characters are as if suspended between the light which filters from the background and the light from the outside, the limits of light and shade, and they are affected by each other. The lessening of vibration in the passages defining the continuity of the contours, and the subtlety with which the planes turn, the caressing softness of the chiaroscuro, are the ingredients of both pictorial sfumato and the grace of pose and expression; herein lies the 'gentleness' — *dolcezza* — which for his contemporaries was Leonardo's particular contribution to the definition of pictorial beauty. This ideal of beauty no longer expresses the sovereignty of the human personality over the world, but is its intimate, profound 'naturalisation' in the heart of reality; it is no longer portrayed in heroic actions, but in the naturalness of sentiments. The *Last Supper* (1495–1498) shows how Leonardo directed his activity progressively towards the sphere of morality. There, for the first time, the artist represents a story no longer of great decisions or human actions, but of fluid secrets of movement, of hidden impulses and the profound aspirations of the soul. The picture shows the moment when Christ says that one of those present will betray Him, and the attitudes and faces of the Apostles express stupor, incredulity, bewilderment and horror. Judas himself is not isolated; only the tormented expression on his face betrays the consciousness of his sin. Leonardo, who is generally considered a sceptic

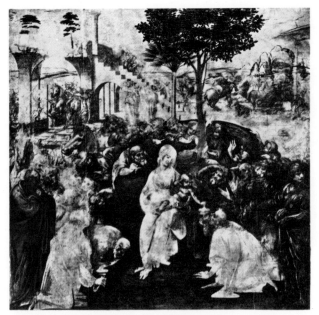

254. ITALIAN. FLORENTINE. LEONARDO DA VINCI (1452–1519). Adoration of the Magi (unfinished). *Uffizi.*

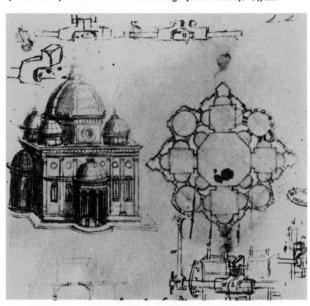

255. ITALIAN. FLORENTINE. LEONARDO DA VINCI (1452–1519). Sketch and architectural plan. Pen drawing. *c.* 1511. *Institut de France.*

or indifferent as far as morality and faith are concerned, brings to them not only a philosopher's objectivity but also a more vast and fundamental knowledge of human nature in all its complexity.

In Florence, in the first years of the 16th century, he painted, in competition with Michelangelo, the *Battle of Anghiari*; in this work, known only from drawings, Leonardo presented not so much a definite action as a whirlpool of men and horses in clouds of smoke and dust, almost a hurricane of unchained human and natural forces. To Michelangelo's theory of the greatness of the Idea, he opposes that of the greatness of the 'phenomenon'. The face of the *Gioconda* and the group of the 259 *Virgin with St Anne*, are equally 'phenomenal'. In this last composition, which was to play such a great part in the development of Raphael, Leonardo defines clearly his ideal of beauty, a complete union of all the different 'phenomena' in one form embracing them all, in an image which resumes and

MASTERPIECES OF LEONARDO DA VINCI
(1452–1519)

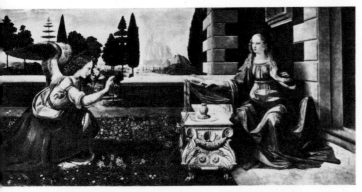

256. The Annunciation (detail). 1472–1473. *Uffizi.*

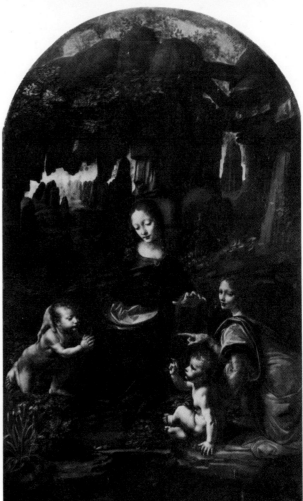

257. The Virgin of the Rocks. 1483. *Louvre.*

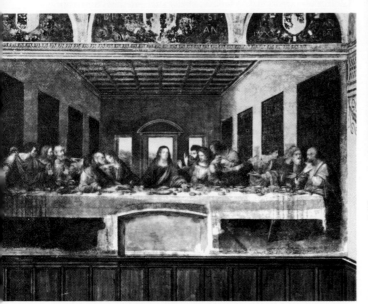

258. The Last Supper. 1495–1498.
Refectory, Sta Maria delle Grazie, Milan.

absorbs the infinite variety of natural images. So beauty is no longer an *a priori* idea or category which, in artistic expression, could only be contaminated by contact with any particular reality; it is a condition of internal completeness and harmony which is attained after varied and complicated experiments resulting in this final vision, this supreme ' phenomenon ' which is the work of art. That is why it can be stated that, if the mission of painting is to achieve beauty, and in this way to be distinguished from the sciences, art is nevertheless the highest activity, one which combines the results of different researches in a universal synthesis and, by presenting them in perceptible form, makes them immediately accessible to human consciousness.

In art, as in science, Leonardo's great contribution is to oppose method, supple, agile, always contributing to the direct experience of reality, to rigid and authoritative system. In this way the traditional distinction between theory and practice, between invention and execution, disappears. Beauty is no longer an abstract principle which the hand of the artist can portray only imperfectly; it is a value or quality which is attained by means of creation of both an intellectual and a manual character. Technique, with its practical prosaic materialism, can no longer be isolated from ' poetry '. It is to this anxious quest for ' intel-

259. The Mona Lisa, called La Gioconda. 1503. *Louvre.*

260. ITALIAN. FLORENTINE. Horse and rider.
Bronze. Attributed to Leonardo da Vinci. *c.* 1506–1508.
Budapest Museum.

261. ITALIAN. FLORENTINE. LEONARDO DA VINCI
(1452–1519). Sheet of studies for the
Trivulzio monument. *c.* 1511. *Royal Library, Windsor*.

lectual' technique that we owe the unfortunate loss of many of Leonardo's works; a few years after it was painted the *Last Supper* was almost indecipherable, and the *Battle of Anghiari* fell to pieces even before it was finished. But the principle that art does not reproduce beauty, but produces it, was henceforth and for ever established.

Bramante and architectural beauty

The great creator of architectural beauty, Donato Bramante, was in contact with Leonardo in Milan during the last years of the 15th century; in 1499, he settled in Rome, where his work as an architect developed on a parallel with Raphael's work in painting. He is therefore a key figure.

In Milan, Leonardo was also preoccupied with architecture, as proved by the drawings in which he particularly studied the theme of the central plan, which was to be Bramante's basic theme. Moreover, Bramante was much more interested in obtaining grandiose results than in solving concrete architectural problems and his constructive technique strangely resembles Leonardo's intellectual technique, even in its sometimes disastrous results. But Bramante does not, as Leonardo does, ignore the lessons of antiquity, and his culture draws deeply on the humanism of Alberti and Piero della Francesca. In one of his first works in Milan, the church of Sta Maria presso S. Satiro, where he was unable to develop space effectively in depth, he substituted for it the visual illusion of space, thanks to a clever trick of perspective. The aim is not the construction of space, but the effect of depth; for Leonardo, too, space was empirically conceived: it is a void inhabited by the atmosphere and in which the effects of light and shade are produced. Since space can only be evaluated in relation to fullness, there is a search for balance between the fluid mass of the atmosphere and the solid mass of the masonry. Balance is sought between these effects, and is no longer sought in the abstract calculation of proportions. This is the basic theory of the 'monumentality' of Bramante. In the little church of S. Satiro, built on the foundations of a 9th-century building, a complicated construction of squared shapes is placed on a low cylindrical shape, broken up by niches; the whole is dominated by an octagonal drum with a lantern which marks the central axis around which all the solid masses of the building unite. The porch of the presbytery of Sto Ambrogio is dominated by an arch; an arch spans the entire width of the façade of the cathedral of Abbiategrasso, enveloping it in aerial space. In the gallery of Sta Maria delle Grazie, Milan, the great masses of the apses are absorbed into the ornate polygonal dome articulated by an airy gallery. Furthermore, on these great masses of stonework the artist put a small detailed ornament, a sort of delicate linear arabesque, which gives the surfaces a chance to vibrate in light and in the atmosphere. This method of creating a union between form and space applies equally to Leonardo's researches.

When Bramante arrived in Rome, the first-hand view of the ruins caused him to revert to his first humanist training, to Alberti and to Laurana. He set himself the task of defining in a system of precise relationships the empirical and almost pictorial balance of the effects of space and fullness; the cloister of Sta Maria della Pace is the first attempt to do this.

But what is space for Bramante? Certainly not perspective or geometry or the pure intersection of planes of Brunelleschi, but the 'ideal form' of nature, conceived in the manner of Leonardo, as a balance of forces in opposition. Sculptural

ITALIAN. FLORENTINE. DONATELLO (1386–1466).
The Healing of the Wrathful Son.
Bronze relief for the high altar, S. Antonio, Padua.
c. 1443–1450. *Photo: Scala, Florence*.

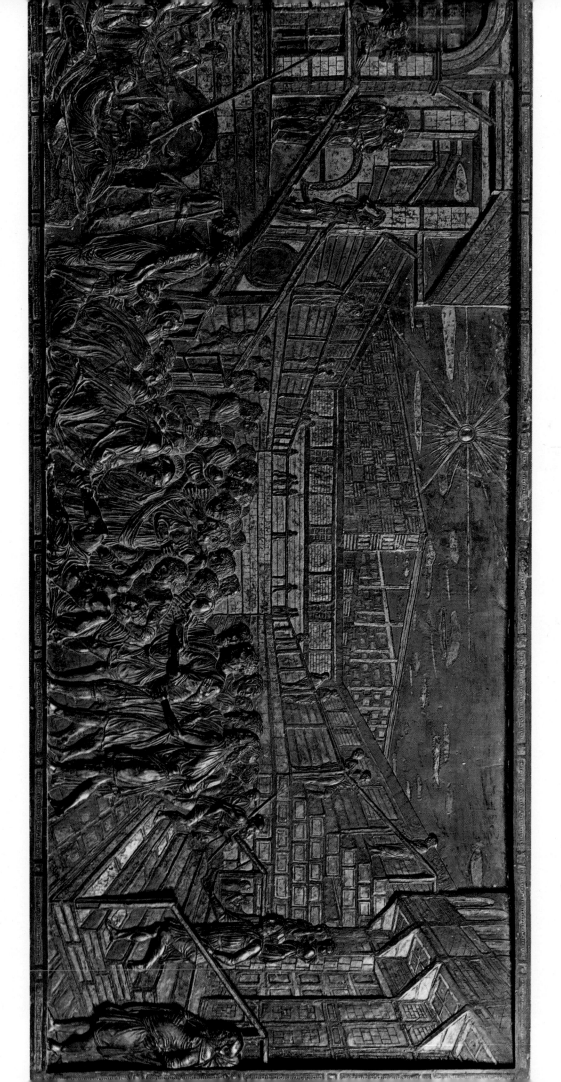

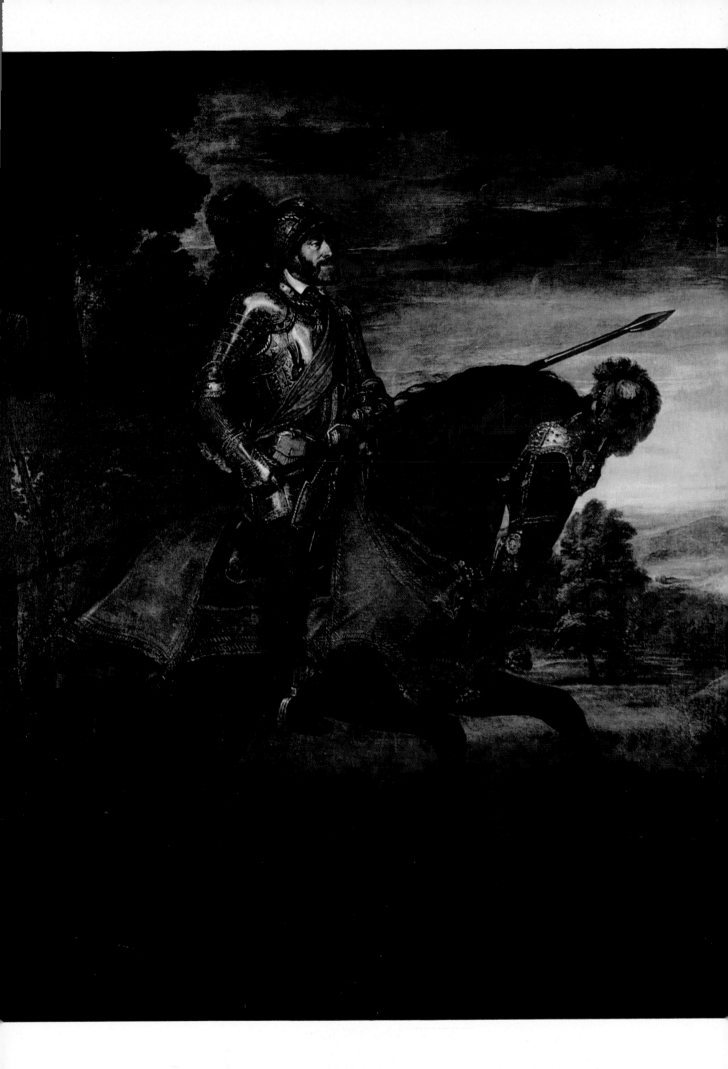

balance is the expression of great physical laws, of gravity.

It is a significant fact that one of Bramante's first buildings in
262 Rome, the little tempietto near S. Pietro in Montorio, was
valued as a model and canon of architectural beauty. But the
artist was no longer searching for a geometric construction of
space, but was trying to invent for it a form, even an 'object'
which almost became its symbol.

The tempietto, indeed, does not present any new structural
problem, and is only vaguely derivative of classic examples and
the norms of Vitruvius. But for the first time architectural
creation is presented as a problem of composition and not of
construction. The point of departure is the Vitruvian principle
of 'modular' composition, but here the module is no longer
a measure, but the cylindrical form of the columns which is
developed in the roundness of the oratory and balustrade, and
culminates in the semicircular cap of the dome. The whole is
noteworthy for its chiaroscuro effect. A contemporary, Sebas-
tiano Serlio, had already noted that to achieve his sculptural
effect the artist had to exploit the twilight of the atmosphere
and to create an illusion of space. The principle of composition
consists of establishing the laws of equilibrium, derived from
antiquity and from Vitruvius, which allow forms, already
beautiful in themselves, to be combined in a harmonious whole,
and which Bramante tried to make stand out in this undefined
atmospheric space by loosening the ties of perspective and
structure.

This is the 'monumentality', the breadth of spatial effects,
which Bramante was striving to attain when, between 1506
and 1514, he took a hand in the reconstruction of St Peter's.
His plan is a Greek cross, with a great dome at the intersection
of the arms, and smaller domes between the arms. It is still a
modular composition, based on the repetition on various scales
of the same basic element; its effect had to be founded on the
balanced orientation of the four great empty spaces of the arms
around the hollow of the dome; these atmospheric voids play
around the pure sculptural forms of the pillars. Bramante's
188 architecture culminated in the enormous court of the Belvedere,
which is reminiscent of the great arch of Abbiategrasso, but
emphasises its 'monumentality'. This is indeed a pure 'spatial
form'; an enormous hollow in the background plays an important
part pictorially through the gradation of light and shade. The
same image of space can be seen again in the paintings of
Raphael's mature years; but it is the supreme development of
the conception which Leonardo had of form.

Raphael, the height of humanism

Raphael aimed at defining pictorial beauty as Bramante did
architectural beauty. Like Bramante, Raphael was born in
Urbino, and was the pupil of Perugino. In Florence, between
1505 and 1508, he noted and sought to reconcile the antithesis
of the ideologies of Leonardo and Michelangelo; then he worked
in Rome up to his death (1520). Reynolds cites him as the
supreme example of the artist who does not abandon himself
to the heat of inspiration, but forms his own particular style
through the study and critical appreciation, both personally
and as imitator, of his masters. In reality, Raphael's painting
does not offer a new conception of man and the world, but is
a definitive representative of a culture, the perfect expression
of a society which believed it had found its equilibrium and
established its values. His search for perfect form is in fact a
search for absolute 'value'; for him, form has the value not of
what it represents, but of its essentials, a full and total represen-

ITALIAN. VENETIAN. TITIAN (c. 1487/90–1576).
Charles V on Horseback. 1548. Prado.
Photo: Joseph Ziolo — André Held.

262. ITALY. BRAMANTE (1444–1514).
The Tempietto of S. Pietro in Montorio, Rome. 1503.

tation of reality. From his first works, *The Dream of the Knight*,
The Three Graces (about 1499), or in 1504, *The Marriage of
the Virgin*, every description of action and every dramatic 264
emphasis is rigorously excluded; his form is henceforth that of
a world which placed every contrast and every tension in perfect
equilibrium, and in which, as Schopenhauer would say, the
will is nothing, and the 'representation' is all. Every line
becomes a connection, a development of restful curves; volumes
alternate with open spaces, just as in Bramante's architecture
solids alternate with voids. The colours themselves take on a
new intensity and depth which depend not so much on an
emotional or acute vision of the truth as on the search for a
purer, surer 'value'. Beauty itself already exists in nature and
the artist can reveal it merely by choosing what is perfect and
by composing with this choice of particular beauties the universal
beauty which belongs to art; this formal beauty, in its universa-
lity, is at once both ancient and modern, outside time and expe-
rience. The aesthetic ideal of Raphael is both religious (and
specifically Catholic) and profane; just as reality, in the truth
revealed by the Scriptures and affirmed by the Church, is within
reach of all consciences, so form, beauty, would have no value
if it were not equally 'representative' for everyone, if it did
not constitute the immediately obvious and tangible form of
revealed truth. That is why it can be said that the art of Raphael
is at the same time philosophical and popular; like religious
ritual it must also have its spectacular character. The total
representative capacity of form also eliminates the duality of
theory and practice, since if the idea can become form only
through experience, experience is only of value if it is directed
by the idea; it is only in this way that the artist can select from
nature the particular beauties and reveal them in the universal
beauty of art. The authority of antiquity counts for little if it
is not related to present experience and surrounded by it, thus

MASTERPIECES OF RAPHAEL (1483–1520)

263. Pope Julius II. 1511–1512. *Uffizi.*

264. The Marriage of the Virgin (Lo Sposalizio). 1504. *Brera, Milan.*

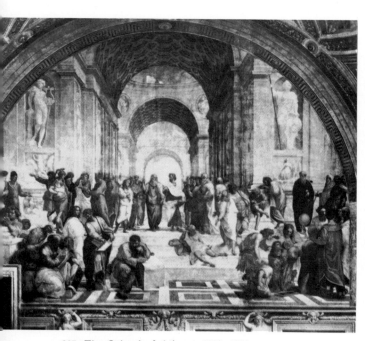

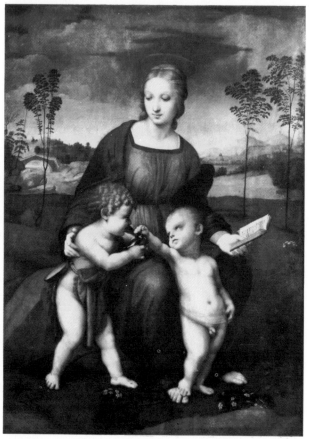

265. The School of Athens. 1509–1511. Fresco in the Stanza della Segnatura. *Vatican.*

266. Madonna with a Goldfinch. 1505–1506. *Uffizi.*

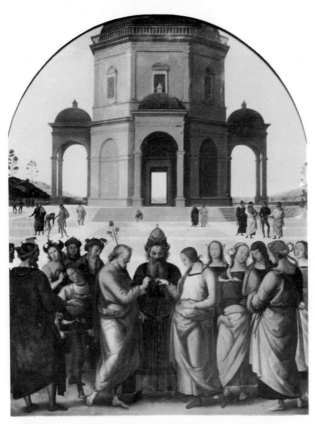

267. ITALIAN. UMBRIAN. PERUGINO (c. 1445–1523).
The Marriage of the Virgin. *Caen Museum.*

If, as is thought, the Sposalizio *of Caen was completed in 1504, one can return to the traditional view that this work was the model for Raphael.*

268. *Above, right.* ITALIAN. FLORENTINE. RAPHAEL (1483–1520). The Liberation of St Peter. 1511–1514. Fresco in the Stanza d'Eliodoro. *Vatican.*

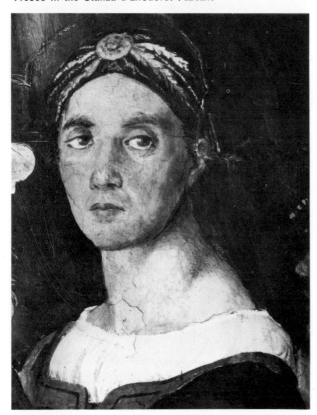

269. ITALIAN. FLORENTINE. RAPHAEL (1483–1520). The Mass at Bolsena (detail). 1511–1514. Fresco in the Stanza d'Eliodoro. *Vatican.*

demonstrating the eternity and universality of the beauty of nature. In one of the *Virgins* of the Florentine period, the *Madonna with the Goldfinch,* the will to realise beauty according 266 to Leonardo's theory clearly appears in the profound harmony of people and nature, in a gentleness of gesture and expression revealing the absolute naturalness of feeling. But Raphael, sensitive equally to the moral ideal of Michelangelo, wanted to show the ethical and religious significance of this unity, and that is why he emphasises the pyramidal composition which gives the group a monumental character; he makes it stand out from the open landscape as far as the horizon, and yet unites it with this background by means of ample curves and contours, which rule both the sculptural quality of the figures and the depth of space.

Raphael as the synthesis of antiquity and Christianity

It was in the decoration of the Vatican Stanze that he stated his great theory more explicitly — the unbroken continuity between the 'philosophy of nature' of the ancients and the Catholic dogma, the possibility of religious synthesis between the tradition of Plato and that of Aristotle. A little before this, in 1507, his *Deposition* had already shown how a profound continuity of ideal could exist between the classical myths and the Christian drama by progressively adding, from Christian experience, moral meaning around a poetic core of classical myths. But now, in the great compositions of the *Parnassus,* the *School of Athens* and the *Disputà,* this exalted philosophy of 265 the unity and continuity of human experience and its providential character finds its expression in a truly universal conception of time and space, in the search for a form which, far from limiting human experience, expresses clearly its universality. That is why the *School of Athens* is framed in a style of architecture which, like that in Bramante's mature work, is an attempt to evoke the limitless scope of natural space, of the horizon which unites earth and sky in a single entity; the *Disputà* is at the same time rite and ceremony, miracle and history, and is situated in space which is both empyrean and terrestrial, so as to make quite clear the unity between dogma and philosophy, great intellects and blessed souls.

Raphael and creative freedom

Raphael's colour acquired the depth of tone and sensitivity to light which is evident in the *Mass at Bolsena* not only because of the influence of Sebastiano del Piombo; it is the conception of an artist whose constant aim is to broaden his vision, to suggest space ever wider and more luminous, and to intensify and dramatise facts and episodes. Almost as if he had a presentiment of the imminent crisis of the Reformation, and the attack on the 'representative' character of the Church and its art, Raphael seems to want to confirm more precisely that beauty is in nature, in human feelings and affections which the artist sees with a judgment which is also an act of creation. This is the theory of the creator's choice of spiritual freedom in the homage rendered to great values. In this, at the beginning of the 16th century, Raphael took up a position very like that of Erasmus. The trend of his art brings it close to polyphony, to the orchestration of different themes and motifs in a single form combining them all. The *Fire in the Borgo* or the *Expulsion of Heliodorus from the Temple* or the more intense passages in the decoration of the Loggias of the Vatican must not be interpreted as the sign of the beginning of a crisis, but rather as the 'crescendo' and 'fortissimo', which a profound law of harmony gives ideally to the more sweet and melodic passages. That is the confirmation of the truth and complexity of experience and history in which every feeling and action is foreseen and calculated, to such an extent that nothing can ever destroy their unity or the eternity of their form. This faith in the universality of experience led Raphael to transfer what he·had acquired in painting to the other arts, and especially to architecture. So when he succeeded Bramante as architect of St Peter's, he broke up the balance of his predecessor's central plan so as to obtain an effect of space or illusion of perspective similar to that in *Heliodorus*, but he added to it a more subtle study of the beauty of detail. In literary terms he seems to search for the etymology and the more exact meaning of the phrases in the language of architecture. It is really from him, rather than from Bramante, that this new search for perfection in formal details stems and for their combination in a harmonious whole, which gave rise to the most perfect works of Mannerism by Giulio Romano, Antonio de San Gallo the Younger, and especially Baldassare Peruzzi. Giulio Romano aimed at reducing as far as possible the structural links, at dissolving the building in natural space, and at emphasising form by elegant 'artifice', sometimes by the brilliant 'caprice' of a decoration full of refined invention. Peruzzi was almost a goldsmith of architecture, completely preoccupied as he was with uniting, in subtle and complex rhythms, forms as pure as gems. Although San Gallo was more preoccupied with the grandeur of space and mass than Bramante, he was also above all a 'composer'. It is also clear that this search for the beautiful form for its own sake necessarily led to a rich skilful decoration inspired to a great extent by antique 'grotesque' motifs introduced significantly enough by Raphael. His pupils, Giovanni da Udine and Perino del Vaga, were to develop them with mannered refinement in their clear stuccoes, while in woodwork the marquetry of the 15th century was replaced by carving, and medals stamped, this method allowing more depth than does engraving; and the same classical motifs are found in tapestries and textiles, and in the figured ceramics of Pesaro, Gubbio and Urbino.

292
367

Michelangelo and the return to the Idea

Michelangelo did not like the paintings of Leonardo or Raphael, nor the architecture of Bramante or San Gallo. Leonardo had stressed the necessity of experiment or practice, Raphael had achieved a balance with theory; Michelangelo himself in the first half of the 16th century affirmed once again with

270. ITALIAN. FLORENTINE. MICHELANGELO (1475–1564). Pietà. *c.* 1499. *St Peter's, Rome.*

271. ITALIAN. FLORENTINE. MICHELANGELO (1475–1564). Pietà, called the Rondanini Pietà. *Castello Sforzesco, Milan.*

The work remains in a state of rough modelling, and the artist was probably working on it on 12th February 1564, a few days before his death.

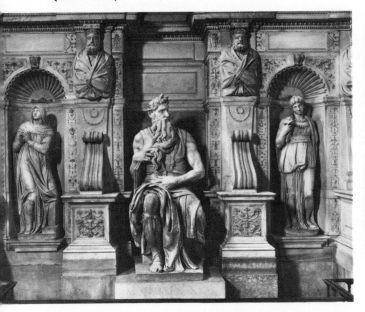

272. The tomb of Julius II (lower part) is an unfinished work. Only the *Moses*, 1513–1516, and parts of the statues of *Rachel* and *Leah* (from left to right) 1542–1545, are by Michelangelo. *S. Pietro in Vincoli, Rome.*

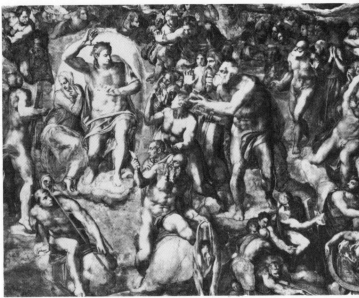

273. The Last Judgment. 1533–1541. Fresco. *Sistine Chapel, Vatican.*

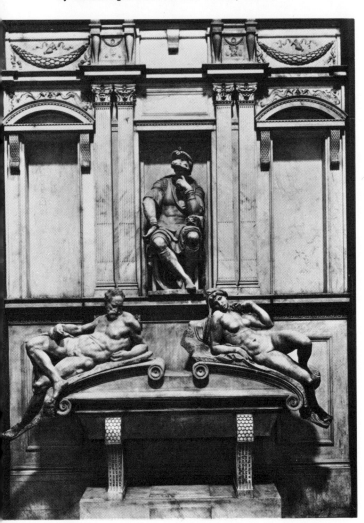

274. The tomb of Lorenzo de' Medici. One of the tombs in the Medici chapel, executed between 1520 and 1534. *S. Lorenzo, Florence.*

uncompromising severity the Platonic theory of the Idea. But his idea of 'beauty', pure spirituality to be reached through a struggle against all that is material, was from now on inseparable from an aspiration to moral perfection and from a profound sense of tragedy. To the critics of the 18th century, who argued at length about the superiority of Raphael or Michelangelo, the first was the example of natural beauty, the second of sublime beauty, that is, of moral beauty; and the sublime surpasses both nature and history. It is not to underestimate the art of Michelangelo to state that it is fundamentally intellectual. To a world opening up to experiment, Michelangelo firmly opposed the theory of the futility of experiment and of the exclusive value of the Idea; but his art reflects only the eternal value of the Idea — the crisis. He is in revolt against circumstances; when he exalts antiquity as a unique source of beauty, it is not because he detests the present. He also excludes history, bound to human actions, and he unites in a desperate synthesis the first origin and the last destiny of humanity, the *Genesis* and the *Last Judgment*, as in the frescoes of the Sistine **273** chapel. His religious feeling is very deep, but filled with a desperate tension; it is Platonic and Christian, but as far removed from the Catholic historical Christianity of Raphael as from historical antiquity.

Michelangelo was sculptor, painter, architect and poet, not because of the versatility of his genius, but because of the conviction that all the arts can be reduced to an ideal form. For figurative art, this ideal form is drawing, the common foundation of all the arts. This was the theory of the first artists of the 15th century, to whom Michelangelo reverted almost in a controversial spirit, to rediscover the most pure sources of Florentine neo-Platonism; but his attitude was profoundly different. It is true that he maintained that drawing is strictly line or outline, that is, the most non-material of forms; but he afterwards went on to assert that the more painting resembles sculpture the better it is, and when he worked as an architect, he still sought to realise therein the tension and plastic unity of sculpture. The *Holy Family* (1503) really was conceived as a piece of sculpture; the three figures form a compact group, their spiral composition tends to enclose the whole space in

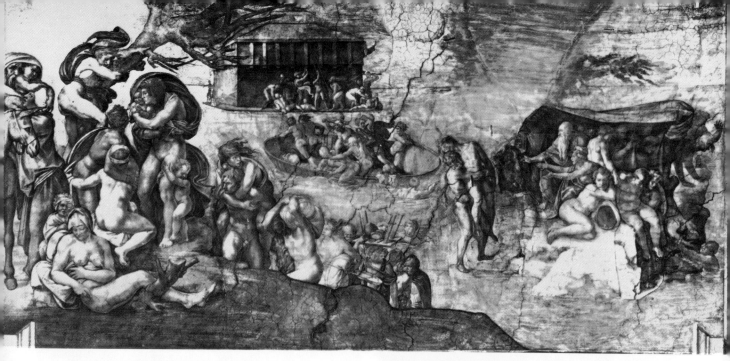

275. ITALIAN. FLORENTINE. MICHELANGELO (1475–1564).
The Flood. Fresco. 1508–1512. Detail from the ceiling.
Sistine Chapel, Vatican.

276. ITALIAN. FLORENTINE. MICHELANGELO
(1475–1564). Preliminary sketch for the
Libyan Sibyl, Sistine Chapel. Drawing. 1511–1512.
Beruete Collection, Madrid.

sculptural form, the cold colours make each form stand out separately, and accentuate the brightness of the picture. This striking sculptural quality recurs in the frescoes on the ceiling of the Sistine chapel (1508–1512) and in the *Last Judgment* (1533–1541); but in his architecture, too, the windows inserted between powerful ribs in the New Sacristy of S. Lorenzo (1520–1530) and the coupled columns against the wall in the vestibule of the Laurentian Library (1521–1526) evoke the dramatic motif of the *Slave*, and the dome of St Peter's (1564), with its sides bulging like distended muscles, is conceived almost as a colossal architectural nude.

273, 275

Michelangelo and the drama of excess

Sculpture more than any other art is tied to matter. Sculpture, said Michelangelo, is an art which is practised by 'taking away', that is, by the physical removal of matter, so much so that the image 'increases to the same extent that stone disappears'. The process of art consists of this liberation of the image, of the spirit, from the weight of unyielding matter. So he accentuated the volume and mass of his figures, and the weight and strength of architectural ribs. He was no longer content, like Alberti, to conceive the formal idea, leaving the execution of it to others; on the contrary, he refused the help of collaborators, painted his enormous frescoes alone, and attacked the block of marble with the chisel. The execution, which for Leonardo was mental technique, and for Raphael an experience inseparable from the idea, becomes for Michelangelo a stubborn struggle against the opposite conception, a moral engagement. The 'Idea' is not truth *a priori*, but has a degree of choice which is reached through the moral drama of life. So art is 'difficult', and this theory passed to the art of the Tuscan Mannerists; the artist's worth lies in surmounting difficulties. In frescoes the flat surface must be forced to assume a strong relief; on the ceiling of the Sistine chapel the artist began by creating a powerful architecture of transverse arches, close together, in order to fix the limits between which the figures, fitted in with difficulty, would appear more important. At the bases of the arches he placed great nude figures which

impose the dramatic strength of their contortions on the architectural features. But for sculpture, since form is the expression of a will to excel, it is necessary to go beyond sculptural relief. As early as the sculpture for the tomb of Julius II (the *Prisoners* and the *Slaves*) the will to violate the limits of form appears clearly. In the *Prisoners* (1513–1516) the attitude of the weighty trunk, turning round on the uncertain support of the legs, expresses a strength which prevents a harmony of masses. In the Medici tomb (1520–1534) the allegorical figures of *Day*, 169 *Night*, *Dawn* and *Dusk* seem to be sliding from the broken pediment of the sarcophagi and only keep a tenuous balance by means of the supporting elbows, bent legs and exaggerated contortions of the bodies.

In order to render the transformation from matter to form more noticeable, certain parts have obviously been left roughly hewn; but in the coarse chisel marks the light produces a vibration which suddenly gives life to the mass, and makes

it pulsate in space. It is through this immaterial light, without source or beam and almost invoked by the working of the material, that the medium becomes exalted, loses its inertia and becomes as spiritual as pure drawing.

273 In painting too, in the *Last Judgment* and in his last frescoes in the Pauline chapel, the lack of ' finish ', that is, the light which is produced by the unfinished material, shows how Michelangelo's form tends to go beyond its limits. In the *Last Judgment*, the composition is opposed to the traditional rules; the groups, more widely spaced at the bottom, become closer together and heavier towards the top. But precisely because of this inversion of perspective, this aggravated ' crescendo ', the intensified movement of the figures at the top dramatises the contrast between the masses of shadow and the light which culminated in the glowing halo surrounding Christ the Judge. The powerful writhings of the body and the full force of the gesture form the pivot of the composition, emphasising the double movement of the blessed drawn up to heaven and the damned descending to hell; this continuous haunting rhythm seems destined to last for ever, just as the conflict between good and evil will last for ever in the conscience of man.

 The four *Pietàs* carved by Michelangelo, for St Peter's (1499),
271 the one in Florence cathedral (1553–1555), the Palestrina one, and the Rondanini *Pietà*, translate into painfully human terms the drama which in all such works is expressed in universal terms.
270 If in the *Pietà* in St Peter's, the body of Christ retains the classical beauty of a Bacchus, and if the classical myth becomes humanised, as in the last works by Botticelli, by the spiritual sadness of the Christian story, in the Palestrina *Pietà* the drama is established in the contrast between the great body of Christ, a fallen giant, and the figures of the Virgin and Mary Magdalen scarcely even roughly sketched in, softened by an immaterial light which dematerialises the form. In the group in Florence, conceived as an enclosed block, the articulations at an acute angle and the convergence of masses on the essential axes introduce a dramatic contrast of weight and upward thrust, of cadences and impulses. The Rondanini *Pietà*, unfinished because of the death of the master, marks the culmination of his long tragedy, the final sublimation of masses in a movement which is at the same time a fall and an ascent, like the last spurt of a flame about to go out. At the end of his bitter effort to rise to pure spirituality, which was to be the connecting link between the moral experience of Christianity and the classic idea, Michelangelo discovered that this synthesis is only possible in the supreme annihilation of man in death.

After the great masters

If it is true that the historic phase of the Renaissance ended inevitably with the great tragedy of Michelangelo, then the theory which made Michelangelo the ' father of the Baroque ' is completely outmoded. Although the Platonism of Michelangelo is the fundamental basis of the whole Mannerist aesthetic, he remained in fact a great solitary figure. Vignola, who, after him, was the greatest architect of the 16th century in Rome, was closer to the tradition of Bramante, Raphael and San Gallo, because he tended more towards great architectural composition than to the plastic unity and architecture-sculpture of Michelangelo. This is what produced the great flights of steps and staircases which link the pentagonal mass of the Villa Farnese at Caprarola to the landscape, the taste for curved surfaces, which embrace the maximum of surrounding space, as in the courtyard of the Villa Giulia, and the spectacular grandeur of the interior of Il Gesù, which takes up again with a broader rhetoric the classical theory of Alberti. It is thus clear that by continually enlarging space and structural relationships Vignola had to refine the form of each element not in architectural but in literary terms. These form, as it were, an ornamental

treatise and Vignola himself established the canon of their beauty in his book on the five Orders of architecture which represents for architecture what the *Dictionary of the Crusca* (the Florentine Academy of Letters) represents for literature. Bartolommeo Ammannati and Giorgio Vasari followed in Florence the precept of Michelangelo, and it is obvious that, far from developing it towards the Baroque, they aimed especially at achieving ' inventions ' of the most subtle Mannerist elegance, either in the sculptural quality of particular forms or in their composition.

 It would seem that from the beginning of the century the figurative arts in Tuscany moved away from great problems and towards a refined formalism. The cartoons of Leonardo and Michelangelo were, as Benvenuto Cellini said, the ' school of the whole world ', and with these examples Fra Bartolommeo modified his early style in which were mingled the austere, sacred eloquence of Signorelli and Perugino, and the Florentine severity of Filippino Lippi and Piero di Cosimo. He sought a harmony between the Leonardesque vision that sought the experience of the immediate present and that of Michelangelo entirely absorbed in the contemplation of history, and he attained it in a sober, severe grandeur, full of gentleness and gravity, two things which certainly served to guide the young Raphael in his early period. The problem of chiaroscuro to enhance sculptural qualities and pictorial sfumato, the problem of space dominated by the figure, or of space which, on the other hand, absorbs the figure in its depths, and the problem of the example of history or anecdote remained the basis for the painting of Bugiardini, Franciabigio and Bacchiacca, and led them to ingenious and sometimes capricious solutions. They are also to be found in the first works of Andrea del Sarto in the cloister of the Annunziata (1509–1510); they led him afterwards, in the frescoes of the Scalzo cloisters and in his altarpieces to expand still further the spatial arrangement of Fra Bartolommeo, to break up and shape the form so that it could absorb atmospheric half-light without in any way losing its projecting force, to increase the range of colours and blend them in new and often bold relationships so that the dispersal in space does not diminish the play of forms. Thus the way was opened for the acute formalism, profound, sometimes disturbing and mournful, of Tuscan Mannerism as seen in the art of Bronzino, Pontormo, Rosso and Beccafumi. It was to have a repercussion on all forms of applied art, from furniture to tapestry and jewellery, spreading the cult of antiquity which from then on, deprived of historical foundation, was bound to end in arbitrariness and caprice.

Correggio, initiator of expressive beauty

The ultimate source of the Bolognese school of the 17th century, which was to form the greatest cultural centre of the first Baroque style must be sought in the development which the humanist culture underwent in northern Italy. The so-called eclecticism of the Carracci had its great historical source in the painting of Correggio; and contact with Mantegna in Mantua 277-282 was an essential part of Correggio's development. Very early on, he showed himself to be wide open to influences from the complicated culture elaborated at Ferrara in Emilia. But the soft chiaroscuro dear to Costa in his later works, the echo of the edifying devout eloquence of Perugino, and the graceful lines of Francia soften the heavy, truly Aristotelian logic of the pictorial expression of Mantegna; they prepare him to receive the reflection of the Venetian use of colour, transmitted by the fantastic, almost pagan fervour of Dosso Dossi. An altarpiece like the *Madonna of St Francis* (1514–1515) is still conceived according to the monumental plan of the *Madonna of Victory* by Mantegna, but the space recedes into the distance so that the figures stand out in the clear atmosphere which

277. Danae. c. 1526. *Borghese Gallery, Rome.*

278. The Virgin with St Jerome (Day).
c. 1527. *Pinacoteca, Parma.*

279. Nativity (Night). c. 1530. *Gemäldegalerie, Dresden.*

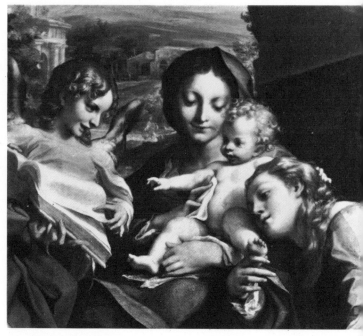

280. Detail from 278.

surrounds them, while rapid suggestions of movement add to this symmetrical composition a flowing rhythm which has repercussions in the modulation of colour. In the *Adoration of the Magi* (1513–1514) the rapidly receding perspective of steps and columns directly connects the foreground with the distant landscape which is plunged into a vibrant shower of light. The foreshortenings do not suggest the development of the figure, but synthesise its gesture in a brief rhythmic phrase; they are far more expressive of cadence and rhythm than of the idea or story that is illustrated.

Correggio was, therefore, the first to appear less preoccupied with form or space than with the image as a clear-cut vision, rapid and instantaneous. Such is *La Zingarella* which may show

281. ITALIAN. PARMA. CORREGGIO (before 1489–1534).
Fresco in the dome of
S. Giovanni Evangelista, Parma. 1520–1523.

282. ITALIAN. PARMA. CORREGGIO (before 1489–1534).
St John the Baptist. 1523–1530. One of the
frescoes in the dome of Parma cathedral.

a Madonna or a nymph of the woods or a chance encounter, a luminous figure in the dense half-light of the woods. Painting, once again more preoccupied with the image than with form, no longer owes anything to the experience of reality nor to any preconceived theory of beauty.

The formal motifs of his early Mantegnesque development were not effaced but progressively enriched by subsequent experiments, in the heart of which they maintained accents and shades as sensitive and changing as the colours which enveloped them. Classical and religious themes were fused together, but no longer in Raphael's syncretism. On the contrary the classical motifs, with their vague erotic feeling, as well as religious motifs with their accent on devotion, so easily assimilated and interchanged, were imprinted with ease in the mobility of the picture, and were materialised in the supple flow of the lines, in the slender brilliance of the forms and in the tender luminosity of the colours. Under this often too obvious sensitivity lies a depth of poetic scepticism which is connected with Leonardo's profound, methodical scepticism. It is really to Correggio that we owe the interpretation of Leonardo's art which stood until the 18th century, and he, neglecting the profound problems, only saw in it a new type of beauty, in which movement and grace are substituted for the solidity of form.

Correggio must have studied especially the Leonardo of the second Florentine period and the interpretation of him which Raphael had already given. The *Rest on the Flight into Egypt* (1515–1516) shows clearly that the sfumato of Leonardo, which for Correggio lost all naturalistic justification of atmospheric effect, just as the golden colouring of the Venetians lost for him all meaning in the representation of space, became the substance of the pictorial image.

In the frescoes on the ceiling in the Camera di S. Paolo in the monastery in Parma, Correggio combines the style of Mantegna in the openings of the alcoves against the background of sky with Leonardo's style in the Sale delle Assi in Milan; at the same time mythological themes, in the hollow shells at the base, show his preoccupation at that time (1518) with the formal purity of Raphael. Higher up, lovers chasing each other pass rapidly by, showing themselves for only an instant. Movement is no longer gesture or action, but attitude and rhythm, a brief, intense musical phrase.

A little later (1520–1523) in the frescoes in the dome of S. Giovanni Evangelista, Parma, Correggio was influenced by Michelangelo. The *Apostles* are evocative of the powerful contorted masses with strong outlines of the nudes in the Sistine chapel; but the rapid movements unite them in a rhythm continually broken and taken up again; back lighting alternates with the white of the clouds, space is now only a whirlpool of brightness with at its summit the luminous image of John the Evangelist, raised up to heaven. And the same solution occurs again, more complicated and articulated, in the frescoes in the dome of Parma cathedral (1523–1530) in which there are again surprising foreshortenings. The light does not originate in the atmosphere, which is only a fluid enveloping forms, making them float in a space without depth or structure; the colours themselves have neither shade nor tone, but they fade, dissolve and melt into one another. Light, atmosphere and movements are not any more natural than are the figures whose movement could only be sensed but not defined.

So, although Correggio's painting had its roots in the iron logic of Mantegna, it became a poetic treatise, easy, fluent, rhythmic. His painting suggests rather than persuades; it communicates directly rather than illustrates. The beauty it seeks is no longer based on fixed definition, but on the continuous internal mutability of form.

Art is no longer the creation of a pictorial language, the building of a system of expressive, symbolic signs of reality, but rather the manner in which language is used to communicate its own feelings and express the inner nature. Beauty, as a constant unchangeable form, is succeeded by the idea of quality which refers not to contents which can be known nor to the perfection of form, but to the mode of pictorial expression. To be more exact, in the history of the conception of beauty in the first half of the Cinquecento, Correggio marks the end of the beauty founded on the authority of the past or on the eternity of nature, and the dawn of a beauty born of the soul of man, and justifiable only by moral or sensuous qualities. It is the end of classic or antique beauty, and the beginning of what Stendhal called 'the ideal of modern beauty'.

281

282

THE CINQUECENTO IN VENICE *Rodolfo Palluchini*

At the heart of the Italian Renaissance, Venice represented an opposite pole to Florence. While Florence was dominated by intellectual research, Venice was absorbed by the senses which subsequently allowed individualism to find its expression and to succeed humanism, after competing with it for a long time. Venice discovered the pictorial as distinct from the sculptural style, the effects of colour as opposed to the effects of line, the feelings of the soul counterbalancing the products of the intellect.

Venetian art of the Cinquecento was so essentially pictorial that this characteristic was even imposed on architecture and sculpture: thus it forms the transition between the civilisation of the Renaissance, which Florence prides itself on having created, and modern civilisation, with a new artistic concept, a concept which was accepted in Spain and Flanders by Velasquez and Rubens. This transition is not due solely to the mastery of an expressive technique, but to the change in spiritual perspective.

Whereas, in the first half of the Cinquecento, Venice accepted the ideal of the Renaissance, and her conception of beauty was of classical character, since it was based on a relationship with reality in the concrete Aristotelian sense, later on she saw this balance upset under the attacks of the Mannerist aesthetic: fantasy predominated, to the extent of ousting serene, classically objective vision.

Boschini, the great 17th-century critic of Venetian painting, sensed this change intuitively when he warned that the painters of the Cinquecento could not be understood unless a different theoretical point of view was accepted from that of the Renaissance in Tuscany. He maintained, in fact, that the Venetians, who upset the theory of imitation so deeply rooted in the Renaissance, had gone beyond purely naturalistic research by abandoning themselves to the lively and sometimes adventurous realm of fantasy.

The revolution of Giorgione

Bellini and Carpaccio, the greatest representatives of Venetian painting in the 15th century, were still fully active at the beginning of the following century. Giorgione had, before 1510, determined the course of its art. The critics may argue about the number and attribution of his works, but the innovations of his art appear decisive. During his formation in the circle

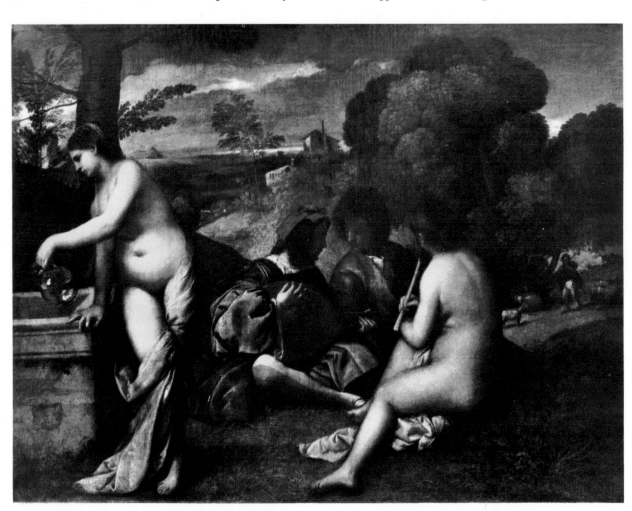

283. ITALIAN. VENETIAN. GIORGIONE (1477/78–1510). Fête Champêtre. *Louvre.*

It has sometimes been thought that the Fête Champêtre *could have been completed by Titian, or even painted by him in his youth and under the influence of Giorgione.*

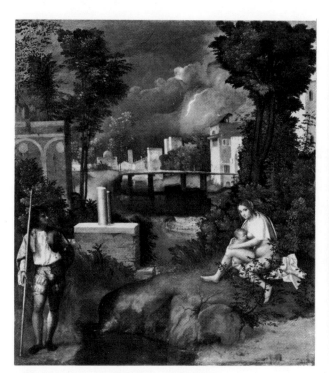

284. ITALIAN. VENETIAN. GIORGIONE (1477/78–1510). The Tempest. 1503. *Academy, Venice.*

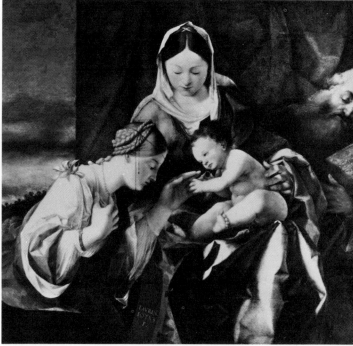

285. ITALIAN. VENETIAN. LORENZO LOTTO (c. 1480–1566). The Mystic Marriage of St Catherine. *Pinakothek, Munich.*

of Bellini Giorgione created a new expressive concept and artistic vision, which revolutionised Venetian painting. In his first manner, completely Hellenic in its purity, he retains severity of style; but he achieves a powerful luminosity of colour that absorbs the drawing and is just as much in evidence in the monumental phase of the frescoes of the Fondaco dei Tedeschi as in his later period, when the tonal values acquired a new richness. For the linear perspective of the Quattrocento he substitutes progressively aerial perspective. From the analytical vision of each element he attains a synthetic vision in which everything is subordinated to a principle of unity. The colour perceived in the tonality presupposes a unifying and profound vision of nature, to which the division into separate forms would constitute an obstacle; it suggests the participation of man in surrounding space, and hence in the life of the universe. This new vision gives Giorgione the feeling that man is only one aspect of the cosmos. Not only does he allot to the human figure proportions which relate it to the ideal of Romano-Tuscan classicism; he gives it a self-absorption that was hitherto unknown. It is banal to say that Giorgione's figures are lost 312 in a dream; they seem to remove themselves from everyday reality, and yet they are surrounded by it to the point of living a spiritual life of intense lyrical power. Man is put in such close touch with nature that nature is sometimes transformed into a protagonist. The revolution of Giorgione was not only a transformation of subjects, but a total renewal of figural sensitivity; the power of colour becomes a means of expression, a basic style for the subsequent development of Venetian painting, the course of which was to be thereby transformed.

286-290 Titian understood Giorgione; his first training took place within the orbit of Giorgione's influence and of his tonal revelations. He made of them not a passive cultural element but a potential new interpretation which reaches full independence in the admirable frescoes in the Scuola del Santo in Padua (1511). He adopted the tonalities of Giorgione, but he put them to the service of his more powerful dramatic sensitivity. From the beginning his was a more spontaneous realist inspi-

ration. The conquest of reality is not separated for Titian from the association of space and perspective. By means of brilliant colouring, growing ever richer and more sensuous in quality, which he uses to suggest the reality of space Titian restored the conception of harmonious beauty, pagan and serene, which had seemed to belong only to the Greece of Phidias. This chromatic classicism was identified for at least twenty-five years with a total faith in the human values of existence, in a spiritual reality nourished on the vitality of the sensations. His robust, warm colour became his docile instrument in the mastery of reality, envisaged either in the lyrical aspect of human events, or in that of nature and landscapes.

The painters influenced by Giorgione, such as Palma Vecchio, Paris Bordone, Cariani, etc., expressed in the same period, although with less intensity, the same psychological and poetic mood. There is, however, one artist who at the beginning of the 16th century remained aloof from the revolution of Giorgione. Solitary and capricious Lorenzo Lotto preferred to 285 work apart, at Bergamo in the Marche. Reacting against the chromaticism of Giorgione, he reinforced the value of his cold colours by means of vigorous form, made crystalline by light. During his period at Bergamo, when his genius was revealed, it is probable that he came under the influence of Altdorfer and Grünewald, through the Swiss painters who came down to Lombardy with the mercenaries, painters such as Niklaus Manuel (Deutsch), Urs Graf and Hans Leu; but in Venice Lotto had already studied Dürer closely. So the art of Lotto, sustained by a deeper feeling for pathos, endowed form with rhythms free of all connection with the Renaissance. He did not have the classical balance between reason and sensitivity which inspired Titian and Raphael, but rather the hallucinatory fantasy of medieval man, portraying in his figures a passionate, romantic sensitivity. His spiritual unrest is shown particularly in his work as a portrait painter, which Berenson justifiably described as 'modern'.

Jacopo Tatti, called Sansovino, a Florentine by birth, sculptor and architect, had the ability to combine the formal classicism

MASTERPIECES OF TITIAN
(c. 1488/90–1576)

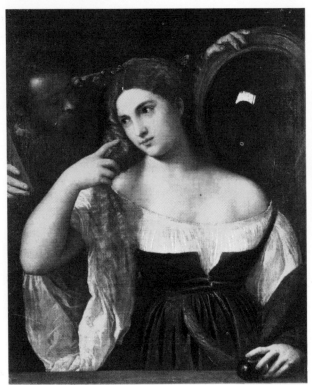

286. Young Woman at her Toilet. *c.* 1515. *Louvre.*

287. The Man with the Glove. *c.* 1510–1520. *Louvre.*

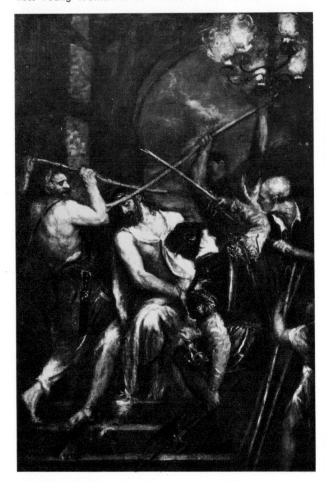

288. The Crowning with Thorns. *c.* 1573–1575.
Pinakothek, Munich.

289. Bacchus and Ariadne. 1519–1523.
National Gallery, London.

290. The Vendramin Family. *National Gallery, London.*

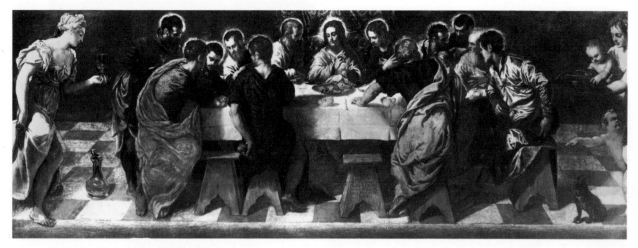

291. ITALIAN. VENETIAN. TINTORETTO
(1518/19–1576). The Last Supper. *Sta Marcuola, Venice.*

of the Renaissance with the spirit and tradition of Venice. He was already interested in a pictorial sense of form, and when he arrived in Venice after the sack of Rome (1527), he adapted himself easily to Venetian taste, and there became aware of his own inclinations. In the solemn rhythm of the arches, skilfully emphasising planes and reliefs, the Libreria with its well developed chiaroscuro is a sumptuous painterly creation. If Palladio reminds one of Veronese, Sansovino makes one think of Titian.

The entire secular and religious output of Sansovino dates between 1530 and 1550, before the Mannerist influence made itself felt. As a sculptor Sansovino did not change his artistic conception; his pictorial vision was sensuous, his feeling for form serene, with a vital compelling rhythm. From Giorgione to Sansovino, from Palma Vecchio to the young Titian, the artistic culture of Venice shows a coherent unity of inspiration.

The reaction against the style of Giorgione

However, between 1530 and 1540 a reaction set in against the style of Giorgione, both as regards colour which once again divided the surface into sections, though with neo-Byzantine brilliance, and in the lack of vigour in the psychological scope of his imitators. The elements of a new Mannerist culture, different from that which had developed in Rome after Michelangelo, were prevalent in Venice and artists regarded the problems of formal construction and sculptural dynamism as the most pressing ones of the day, thus giving a new impetus to the narrative style that Giorgione had discarded. The spirit of classical serenity was also dissipated in Venice under the onslaught of Mannerism, the critical point of which was overcome by the genius of Titian, Tintoretto, Veronese and Bassano. In Mannerism were sought the means of expression and a way past classicism which had reached its saturation point and was of no significance when faced by the anxieties of the new times.

Titian was not indifferent to the challenge of Mannerism; it encouraged him to go beyond the classical and humanist vision which confined itself to extolling natural forms. It led him to a concept of reality which was both more profound and more lyrical. Without the 'moral unrest' which it evoked in him, his detachment from a naturalism, of which between 1530 and 1540 he had given the most categorical proof, would be incomprehensible. Titian's experiments in Mannerism constitute the least happy aspects of his work, but they enabled him to modify his vision systematically. Titian had no need to revise his themes; since he had very little inventive imagination, he used them again and again, but he revised them

from a completely fresh point of view. It was not the new 'colour alchemy' of which Lomazzo speaks which transformed his subjects; it was his new spiritual vision which necessitated his new method of chromatic expression. By renouncing complete adherence to exterior reality in the last period of his work, interrupted by his death in 1576, Titian created a magical world of appearances of a peculiarly lyrical and dramatic richness, due to the dissolution of colour in light. In response to the tragic aspect of his time, he took refuge in an interior world, which was increasingly visionary, and sometimes tortured. The final proof of Titian's expressive imagination rests in his ability to find the means of giving a full poetic interpretation to our own deep-rooted inner fears. Young men such as Tintoretto, Veronese and Bassano took part in the critical development of Mannerism between 1530 and 1550. Ridolfi has spoken of Jacopo Tintoretto's brief period of apprenticeship with Titian; it is more probable that he drew from the tradition of Bonifazio, which was very close to him. But in the Mannerist style and in the study of statuary Tintoretto acquired a vigorous sculpturesque feeling which enabled him to revitalise the colour abandoned by the followers of Giorgione. In this way he discovered the expressive value of the play of light and shade in the scope of colour. His presumed visit to Rome between

292. ITALIAN. FLORENTINE. GIULIO ROMANO
(c. 1499–1546). Part of the Hall of the Giants.
Fresco. 1530–1535. *Palazzo del Tè, Mantua.*

MASTERPIECES OF TINTORETTO
(1518/19–1576)

293. The Mystic Marriage of St Catherine (with the portrait of the Doge Donato). *Doges' Palace, Venice*.

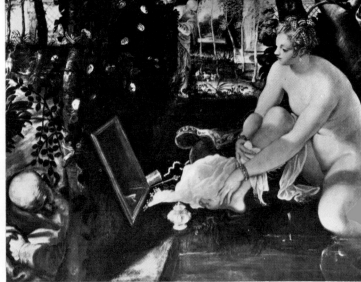

294. Susanna and the Elders. *c.* 1560. *Kunsthistorisches Museum, Vienna*.

296. Detail from 294.

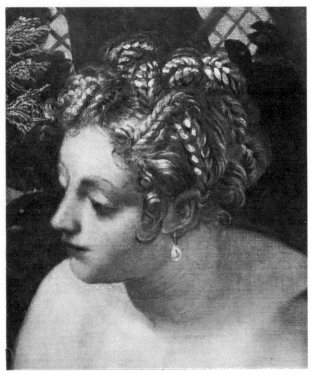

295. The Flight into Egypt. 1585–1587. *Scuola di S. Rocco, Venice*.

297. BARTOLOMEO BUON (d. 1464). The Ca d'Oro, Venice (late Gothic). 1421–1440.

298. BARTOLOMEO BUON (d. 1464). Doorway, Scuola della Misericordia, Venice.

299. ANTONIO VIVARINI (1415–1476/85). The Holy Family. After 1450. *Strasbourg Museum*.

300. MORO CODUCCI (1440–1504). The Palazzo Vendramin Calergi, Venice. Completed in 1509.

301. ANTONIO RIZZO (documented 1465–1498). Eve. *Doges' Palace, Venice*.

302. CARLO CRIVELLI (1430/35–1493/95). Virgin and Child. *Palazzo Bianco, Genoa*.

303. PIETRO LOMBARDO (*c.* 1450–1515). Sta Maria dei Miracoli, Venice. Completed in 1489.

304. PIETRO LOMBARDO (*c.* 1450–1515). Tomb of the Doge Mocenigo. 1476. *SS. Giovanni e Paolo, Venice*.

305. CIMA DA CONEGLIANO (*c.* 1459 – *c.* 1517). The Virgin and Child with St John the Baptist and Mary Magdalen. *Louvre*.

1545 and 1546 may explain the new sudden change of stylistic direction, characterised by a dramatic narrative enthusiasm.

In Rome his colour lost the brilliant richness of the Venetian tradition, because he sacrificed the principle of tone to the pre-eminence of light. Because of their sinuous, opposed movements, the figures are grouped according to compositional patterns calculated to create complex space, sometimes of a scenic character. For Tintoretto the need for a theme became pressing; the subject for him was no longer an occasional argument, but an immanent reality of his mind. Therein lies his difference from other Venetian artists of the 16th century. His approach to the subject was dynamic; he felt it as a dramatic moment of action. An anonymous crowd, drawn from the

THE RENAISSANCE IN VENICE (I)

ARCHITECTURE

SCULPTURE

PAINTING

Born c. 1410–1430

297

298

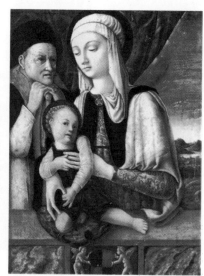

299

Born c. 1430–1450

300

301

302

Born c. 1450–1460

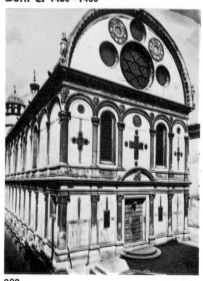

303

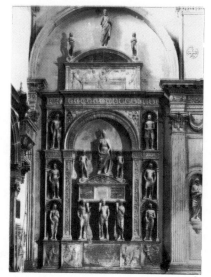

304

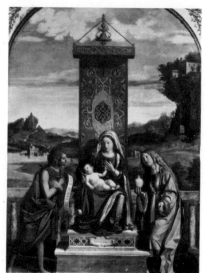

305

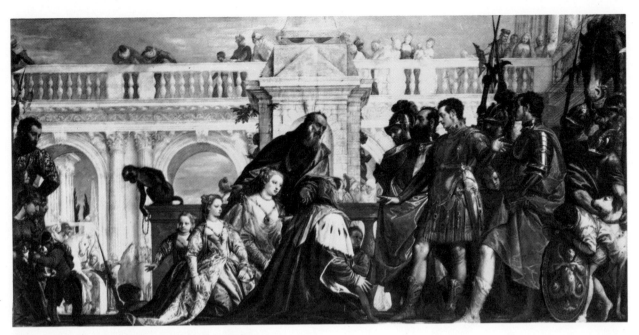

306. ITALIAN. VENETIAN. PAOLO VERONESE
(1528–1588). The Family of Darius before Alexander.
National Gallery, London.

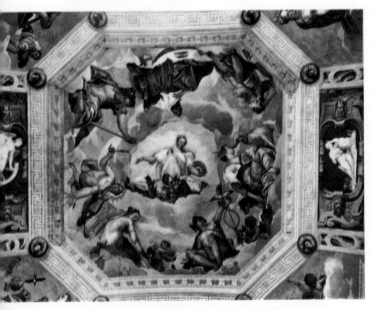

307. ITALIAN. VENETIAN. PAOLO VERONESE
(1528–1588). Ceiling of the Sala dell'Olimpico. Fresco.
Villa Giacomelli, Maser.

squares and back streets of Venice, was transformed in his
mind's eye into a theatrical scene, subjected to his violent,
impetuous stage management, full of a romantic 'pathos',
which captivates us and plunges us into his visionary world.

290 While in Titian's portraits the figure is proudly conscious of
its own individuality in the human and social aspects, in the
293 portraits of Tintoretto the descriptive element is neglected;
the entire interest is concentrated on the inner awareness of
the model; in this sense El Greco may be considered the only
true disciple of Tintoretto.

The profound harmony which was the essence of the Renais-
sance was disrupted; at this time 'man seems to be oppressed
by the cosmic forces of nature, fearful of the hostile elements
of life... and he seeks salvation in himself' (Vipper).

Tintoretto's form is broken up and dislocated by the impact

of light and shade. The all-powerful chiaroscuro, which forms
the basis of his dynamic inspiration, becomes identified with
his agile pictorial form and staggering brush work which,
particularly in the backgrounds, create magical, fabulous effects.
As early as the 18th century, Cochin stated that 'that master
is most admirable when he is least finished, and gives himself
up completely to his inspiration' — this 'famous enthu-
siasm' as Antonio Maria Zanetti described it.

Imitators pounced on Tintoretto's art, changing what was
skilful in the means of expression into mere dexterity. Thus
the 16th century in Venice came to an inglorious end in the
failure of a painting that was superficially derived from Tinto-
retto's themes, but complied with the demands of political and
ecclesiastical pageantry.

Paolo Veronese was a genius of quite a different order. His
306-308
initial development took place in the atmosphere of the pro-
vincial tradition of Verona, characterised by precise colours,
isolated in a way that was unacceptable to those formed by
the Venetian style. In Verona, Paolo had every opportunity of
seeing the Mannerist style which had spread through central
Italy and Emilia; in Mantua, he studied the 'Romanism' of
Giulio Romano, so characteristic of the great decorative works,
and came into contact with the Correggesque manner in the
Mannerist interpretations of Parmigianino and Primaticcio, but
he also took an interest in Raphael and Michelangelo.

From all this he created a personal style increasingly removed
from that of Titian and Tintoretto, and attuned to a classicism,
not archaeological but modern and alive, paralleling the archi-
tecture of Palladio. As a result of his first training, however,
he threw off the shackles of naturalism by inventing that
exquisite colour as an immediate means of lyrical expression.

In 1553 Paolo triumphed in Venice. Through foreshortening
and the calculated play of movement in the figures, he succeeded
in defining clearly his diaphanous luminous tints, inventing
that transparent half-light in which they shine out like gems.
For the colourist tradition of Titian, founded on a scale of

ITALIAN. FLORENTINE. LEONARDO DA VINCI
(1452–1519). Madonna and Child with
St Anne. *c.* 1507–*c.* 1510. Louvre. *Photo: Giraudon, Paris.*

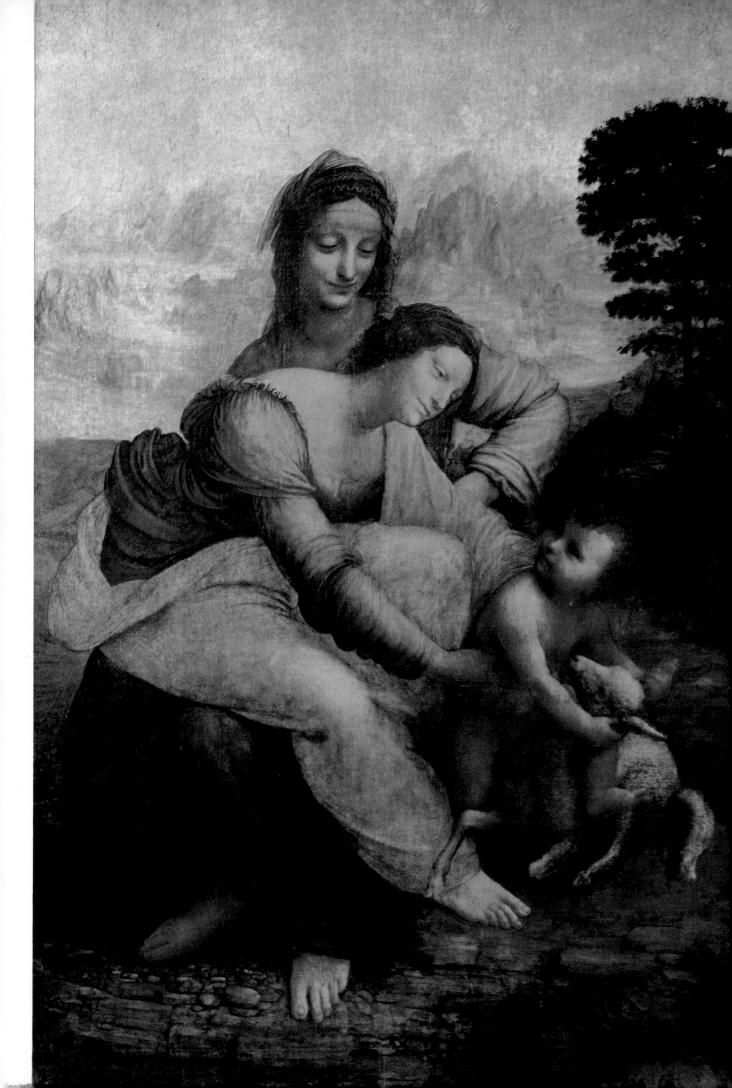

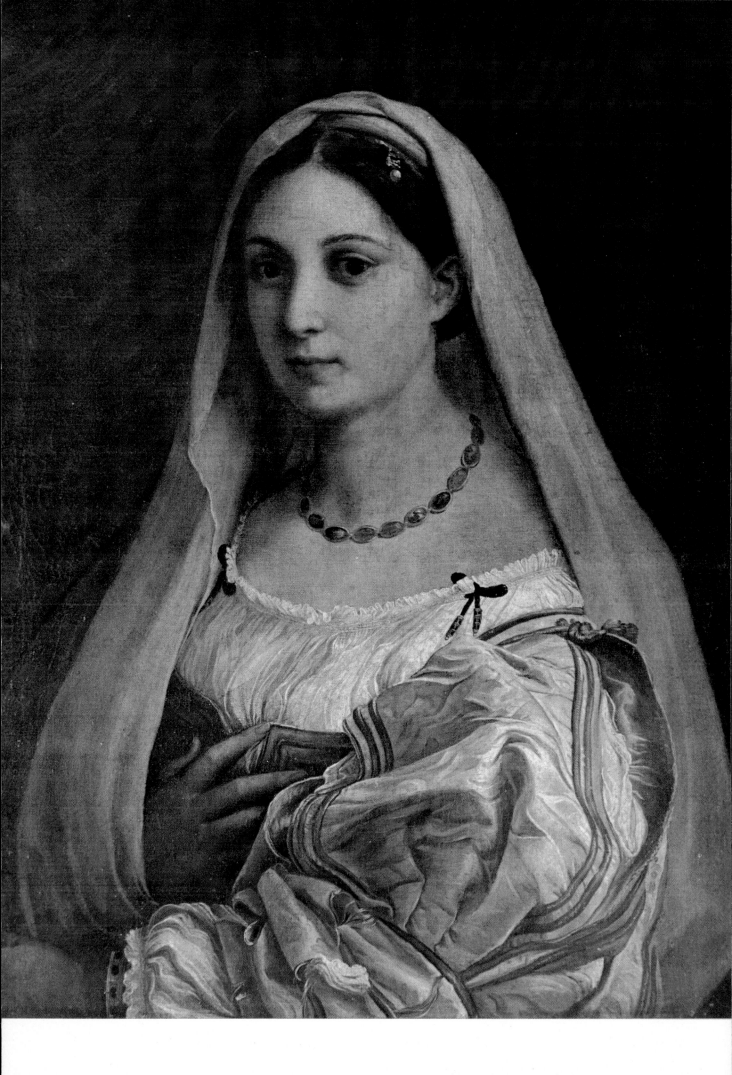

warm tones, in impasto or glazed, he substituted a world of architectural forms with a crystalline structure, unfolding in a rarefied atmosphere, clear and limpid.

About 1560 Veronese's Mannerism was definitely superseded. He probably visited Rome in 1560, and this will have given him the chance to become more closely acquainted with classicism. The frescoes in the Villa Maser are the triumph of an admirable perfection of forms created luminously in space and exalted by colour. An uninterrupted series of masterpieces followed, characterised by monumental forms constructed in a splendid afternoon light. About 1570 his colour tended to become colder and more leaden. Instead of softening the timbre of his colour, as Tintoretto did, he exalted it in a more minute research into exquisite tones. His serenity was clouded by melancholy and he abandoned his pomp and splendour for a more lyrical expression.

This was the last great manifestation of the Venetian and Italian Renaissance: Veronese's classicism avoided academicism through his admirable power to idealise every element of reality in an imaginative harmony controlled by the blazing rhythm of colour. Even in the 17th century Ridolfi (1648) and Boschini (1660) both understood the power to idealise of the art of Veronese, and Ridolfi writes that Paolo 'created things seen solely in his imagination' and that, wishing to imitate nature, 'he paints it as more beautiful'; Boschini observes that 'every one of Paolo's figures has something celestial in it'. Certainly Mannerism was the basis of this neo-Platonism of Veronese.

Sansovino reminds one of Titian; Palladio is evocative of Veronese, as Argan observed. It is symptomatic that Veronese should have painted the frescoes of the Villa Maser, built by
319 Palladio, in such harmony with it. The critics, until recently, considered Palladio 'a pure classic artist, a true reviver, theore-
316 tically and practically, of the classic form' (Becherucci). It was not noticed that he made use of the classical repertoire to create a living style, the quite different aim of which was a coloured vision of a purity which parallels Veronese's colour.

Palladio was not a youthful prodigy; in 1537 he was still working at the Villa Cricoli, designed by Trissino. But his development was helped by the work of Falconetto of Verona, who between 1524 and 1534 in the district of Padua was the first to introduce the Renaissance into Venetian architecture in a pure and unified form and in a happy relationship of architecture with its surroundings. In Rome Palladio studied the antique monuments and contemporary architecture (Bramante, Michelangelo); he particularly appreciated the Mannerist inter-
354 pretation of Giulio Romano in the Palazzo del Tè, Mantua. He owed a whole conception of Mannerism to Serlio; the architectural tradition of Venice left an indelible impression on him through the play of empty spaces and masses, in the chiaroscuro of the façades. Palladio gave it a special character and transformed it into one of the most personal visions in the history of art. His starting point was the practical requirements of homes, palaces, churches, etc., and he elaborated his concept of highly coloured space. He adopted a classical repertoire, and erected buildings of increasing purity and complexity, related to the surrounding space in such a way that man, the centre of the microcosm, is in a constant relationship with nature.
319 In this sense, perhaps, the Palladian villa, which arose out of a specifically Venetian social need, constitutes the freest aspect of Venetian art. Each one is a new, unexpected solution. The main characteristics of Palladio's style are clean surfaces broken up by alcoves, little towers rhythmically limiting the intervening space,

ITALIAN. FLORENTINE. RAPHAEL (1483–1520). La Donna Velata. Pitti Palace, Florence.
Photo: Joseph Ziolo - André Held.

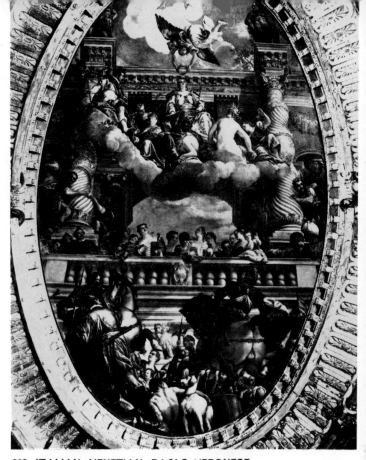

308. ITALIAN. VENETIAN. PAOLO VERONESE (1528–1588). Venice crowned Queen of the Sea. Fresco. *Sala del Gran Consiglio, Doges' Palace, Venice.*

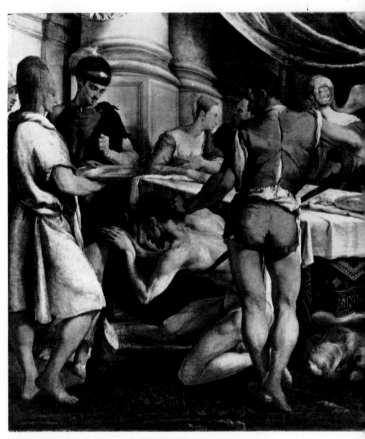

309. ITALIAN. VENETIAN. JACOPO BASSANO (c. 1518–1592). The Beheading of St John the Baptist. c. 1550. *Copenhagen Museum.*

THE RENAISSANCE IN VENICE (II)

ARCHITECTURE **SCULPTURE** **PAINTING**

Born c. 1460–1480

310

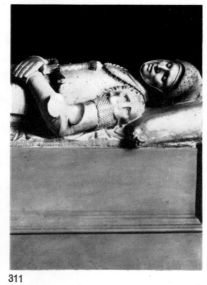

311

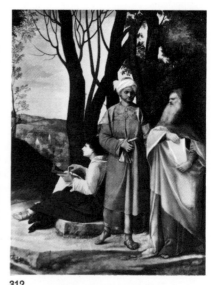

312

Born c. 1480–1510

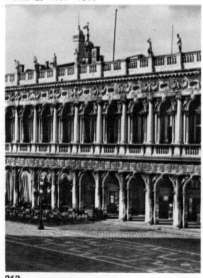

313

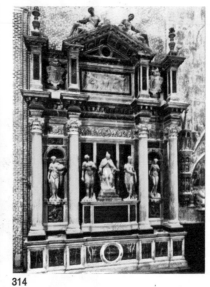

314

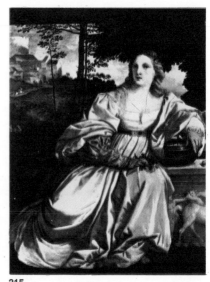

315

Born c. 1510–1525

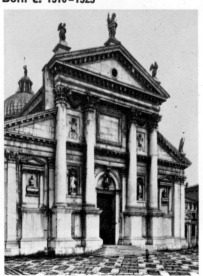

316

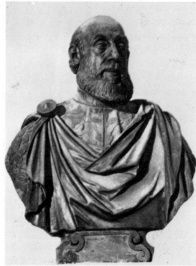

317

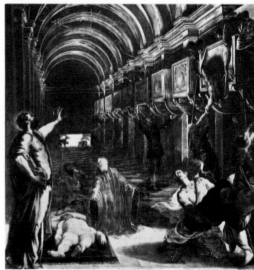

318

and porticos opening out at the sides. Not only do the galleries which cover the whole façade make it airy and light, but they extend it, projecting outwards, and capture space everywhere to give it rhythm and broaden it into a symphonic movement, as in his masterpiece, the Rotonda in Vicenza.

In the town palazzo he could not use the surrounding space so freely. The predominance of empty spaces over masses, the use of brick, the emphasised contrast between shadows and the luminous shafts of columns and pilasters make of the façades a 'pictorial' version of space. The heroic Order, which in Michelangelo was oppressive with a sense of doom, becomes lighter and its vigorous rhythm gives a feeling of serene joy.

Palladio was particularly concerned with the interior of the churches built in Venice and with their spatial harmony. He imprinted all the classical canons with his style. In his work one can see how the Orders embrace the entire façade, in which his buildings differ from those of antiquity; the windows open out of the white façades, without cornices, simple splashes of shadow, the architraves are broken up, and the columns deviate from the rule of Vitruvius.

Palladian classicism, as it appears now that it has been freed from the academic misconceptions, is one of the greatest creations of the 16th century in Venice.

Modern critics, abandoning the prejudices of the 19th century, restored Jacopo Bassano to a place of honour in the Venice of the 16th century, as Ridolfi (1648) and Boschini (1660) had already proclaimed in the 17th century. While Titian, Veronese and Tintoretto were predominant in Venice, Bassano worked in the provinces, conscientiously carrying on the experiments of Venetian painting, and sometimes anticipating them.

About 1534, he entered the studio of Bonifazio de' Pitati. He underwent the same Mannerist influences as Tintoretto; the elegance of Parmigianino liberated him from his provincialism. The freedom he derived from it enabled him to give free rein to his pictorial style in which the cold tones counterbalance the warm tones in a 'fabulous marquetry'.

His feeling for the countryside, strengthened by the northern masters, in particular Pieter Aertsen, led him to characterise the figures to such an extent that he anticipated the realism of the 17th-century Spaniards. After 1560 he made his tones colder and thus darkened the general atmosphere of the picture. In his last period nocturnal poetry was predominant. At the same time he broke up the continuity of the forms by means of a clear spirited touch. He created a new rustic poetry, based on the melancholy of twilight in the countryside, and on the mysterious, intense life of nature. This rural style ignored the romantic dramas of Tintoretto and the aristocratic nonchalance of Veronese; even his religious compositions assume a rustic aspect, but this simplicity and indifference to the subject enabled him to give full expression to his strong feeling for colour. His instinctive way of working drove him to seek a luminosity less lyrical than Titian's and less vaporous than Tintoretto's, but well adapted to portray the luminosity of space, and anticipating in a certain sense modern Impressionism. The elaborate pictorial matter of his final period was the basis of 17th-century development.

Alessandro Vittoria of Trento, sculptor, architect and medallist, arrived in Venice in 1543 and trained in the school of Sansovino, 'whose experience was essential to him, especially for his pictorial tendencies' (Moschini). He concentrated on portraits, in which he was influenced by those of the Tuscan sculptor Danese Cattaneo, who had worked in Venetia. After a period of development, at the end of the century he opposed the Mannerist vision of Cattaneo with a more delicate and supple concept of mass, in which the light is glorified in the continuous undulation of sculptural form. While in his best busts he seems to rediscover a classical grandeur animated by Venetian colour, he elaborated the structure of his statues according to Mannerist principles so as to show the play of light on them, creating a new link between sculptural mass and luminous space. His style, transmitted through Camillo Mariani, came to fruition in Rome and stimulated the development of Bernini.

The artistic development of El Greco would be incomprehensible without the lesson of Venice. When he arrived there from Crete about 1566, he painted like a 'maker of Madonnas'. In his subsequent attempts to free himself from the old style and from the Byzantine canons, and being attracted by the vaporous Mannerism of Tintoretto, he succeeded in becoming a part of the contemporary movement. During his two stays in Venice, interrupted by a visit to Rome, he established his pictorial style, characterised by the exalted and ardent atmosphere of colour defined by an agitated linearism. His style was henceforth associated with Western culture, as Dvořák noted, but it avoided the naturalist principle of the Italian Renaissance. After finding in Venice a modern culture which, especially in Tintoretto and the mature Titian, freed him from the yoke of naturalism, his atavistic mysticism found full expression in the solitude of Toledo.

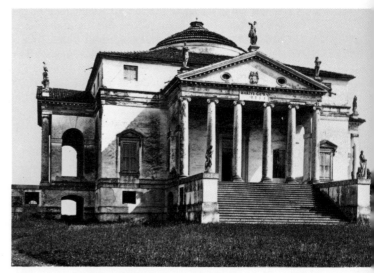

THE BEGINNINGS OF THE RENAISSANCE OUTSIDE ITALY

I. FRANCE, FLANDERS AND ENGLAND *Pierre Pradel*

*On the threshold of the Renaissance, European art,
unified in the Middle Ages, found itself split by two
opposing concepts. In the northern countries the accent was on
visual realism; in Italy it was on intellectual concepts.
Italian prestige was predominant. But the first attempts to bridge the
gap between these two spirits, or rather to link the
attachment to truth of the north with the idealism of the
peninsula, were hesitant and were resisted.*

Beginning of Italianism in France

The barrier of mountains had not shielded the French Gothic
world from the wind of change from Italy. There existed in
Avignon, controlled by the Pope, a sort of embassy of the art
of the Trecento. Lyon, the key to the Rhône valley, was a
halfway stage between the northern and Mediterranean spirits.
From Florence and Siena hints of the new style spread to the
Parisian miniaturists.

The patrons of the 15th century helped to spread it. Italian
art had a place in the eclectic tastes of King René. Francesco
233 Laurana of Dalmatia came from Naples to execute in the
south of France sculpture of mixed style, in which the decla-
matory realism associated badly with an antiquated decoration.
The revived art of the medallist was imported into Provence
as well as to the court of Burgundy.

However, the pressure of the details of Italian art upon the
Gothic style did not make itself felt immediately after the
Hundred Years' War. The decorative backgrounds with foliage
and putti, and a broader feeling of space, which characterised
the work of Fouquet after his journey to Rome in 1443, are
168 exceptional, as indeed was the artist's entire work. On the other
hand, what can be noted is the subtle affinity with Tuscan
elegance, distinguished in the school of French sculpture by a
relaxation which is not entirely explained by the reaction against
the vehement lyricism of Sluter. From Bourges, the refuge of
323 artists during the troubled times, came Michel Colombe, who
revived the noble naturalism of the sculptors in Fouquet's valley
of the Loire as a sort of harbinger of the coming spring.

This was when a king of France aged twenty-four set out
to conquer Naples. Whatever may have been the consequences
of Charles VIII's escapade, one thing is certain: Gothic art was
condemned by ardent young men, and Italianism, supported by
politics, began its prodigious ascent.

Following instinctively the order of preference of French
taste, Charles VIII neglected painting and brought back in
particular decorators of buildings — constructors of gardens or
'hewers of masonry in the antique style'. Ornament, an
ubiquitous element, was brought in its Florentine or Veronese
forms to decorate the royal buildings among the Flamboyant
exuberance without, however, affecting the actual architecture.
As for Italian statuary, it had only a sorry ambassador in the
person of Guido Mazzoni.

Under Louis XII the pace increased. The foreign ornamen-
tation which the French craftsmen copied was soon used to
replace the Gothic motifs, and then demanded a new linear
order. In the façades of domestic buildings — for religious
architects still retained a lofty reserve — classical art reappeared,
helping to give a more regular arrangement in which experiments
with entablatures and friezes counteracted the vertical Gothic

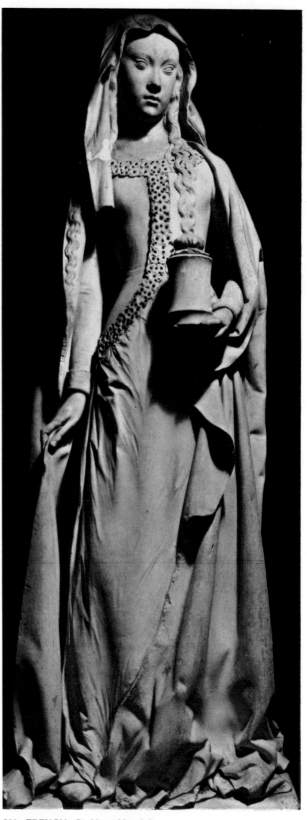

320. FRENCH. St Mary Magdalen.
End of the 15th century. *St Pierre, Montluçon.*

146

style. This was a short period of transition which preceded the purer style of the castles of the Loire where French master 322 masons, such as Sourdeau and Trinqueau, combined classical rhythm with the luxuriousness of Milanese ornament.

The Juste, Florentine sculptors, established themselves at Tours alongside the ageing Michel Colombe and his nephew Regnault, but scarcely managed to influence them, except on the technical level, by teaching them the use of terra cotta. Tombs, which were essential monuments for the sculptors, became Italianised in their form and ornamentation, and then in their accessory figures. But the traditional style with the recumbent figure remained the heritage of the French who surrounded it with a new serenity even when they reconciled the macabre realism of the 15th century with the newly acquired science of anatomy, and represented a naked corpse. At that time the true spirit of the Renaissance revealed itself to greater advantage in the faintly idealised marbles of Regnault than in the heavy nude statues imitated from foreign art. Even in Champagne there was a revival of religious imagery, middle class and fervent, in which the only concession to the new age was a slight affectedness of the drapery but which otherwise maintained the Gothic feeling during the whole of the first half of the century.

Painting, too, remained aloof, with the exception of the southern schools, especially in Provence, which, as was natural, allowed themselves to be won over by the sweeter conventions 385 of the Lombard school. Bourdichon, the official painter of the French court, was perhaps more advanced than the Master of 110, 121 Moulins, who, in the service of the last feudal princes, remained completely Gothic; but in fact he carried on Fouquet's formula 363 without originality. The arrival of Andrea Solario brought some reflection of the art of da Vinci; but not even the arrival of da Vinci himself, followed by Andrea del Sarto, upset the course of French painting; and the establishment at Tours of the first of the Clouet, who came from Flanders, strengthened the positive tendency of portrait painting despite experiments with Italian formalism. The only painter who appears to have been eager for a new style was Jean Perréal of Lyon, whose work is almost completely unknown. It is probable that from his journeys to Italy and his discussions with Leonardo he brought back something more than superficial forms. In any case, he proclaimed his curiosity about everything, his knowledge of Italy, and his desire to distinguish the artist from the artisan. But little remained of all that. The innovations came from other sources. The mysterious Perréal was perhaps still alive when Rosso arrived in 1531.

Penetration of the new art into the northern countries

French art thus reacted with moderation, within the limits of official patronage, and especially in the field of architecture.

In the north a different picture emerges, one which shows no sign of an Italianism spreading throughout Europe.

To begin with, there was a painter who, although certainly knowing nothing of the Renaissance in Italy, nevertheless foreshadowed the coming of the new age by departing equally from the Gothic trend. This painter was Hieronymus Bosch, 325, 326 who retained something of vigorous Dutch boldness which he transformed into a disconcerting mixture of fantasy and implacable reality. Tragic human caricatures associated with traditional religious themes, and spectres and hybrid phantoms charged with a hermetic symbolism shed the enchanted clarity of their colours against a limpid nature which the northern landscape painters were to remember.

With the exception of this meteoric genius, we can follow the inevitable course of Flemish painting, noting certain contradictions, such as Justus of Ghent who in 1472 was called to the court of the Montefeltro in Urbino and was progressively converted to the Italian taste, and, the exact opposite of Justus,

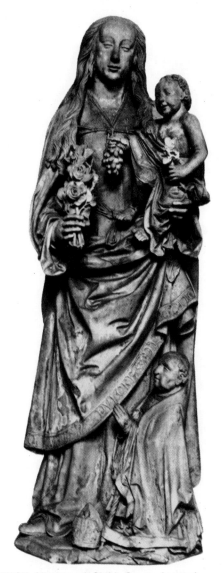

321. FRENCH. Virgin and Child. Group donated between 1508 and 1512 by Nicolas Forjot, abbot of St Loup at Troyes, who is portrayed kneeling at the feet of the Virgin. *Hôtel Dieu, Troyes.*

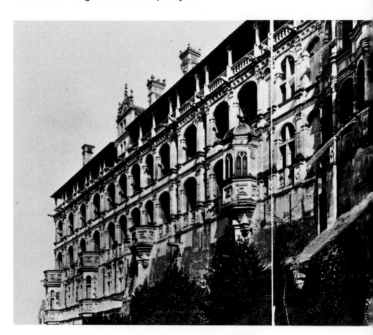

322. FRANCE. North-west façade with the Loggias, château de Blois. *c.* 1515–1525. Work of Jacques Sourdeau, probably in collaboration with an Italian.

147

323. MICHEL COLOMBE (documented 1430–1512).
Fortitude. Detail of one of the Cardinal Virtues on the
tomb of François II of Brittany and Marguerite de Foix,
executed 1502–1507 from the design of Jean Perréal.
Nantes Cathedral.

324. FRANCE. Façade of the château de Gaillon. Built
1500–1510 by Cardinal d'Amboise, minister of Louis XII.

325. DUTCH. HIERONYMUS BOSCH
(*c*. 1450–1516). St John the Baptist in the Desert.
Museo Lázaro Galdiano, Madrid.

326. DUTCH. HIERONYMUS BOSCH (*c*. 1450–1516).
The Temptation of St Anthony.
Central panel of the triptych. *c*. 1500. *Lisbon Museum.*

Colijn de Coter who died at over ninety years of age in Brussels in 1538 without in any way losing his Gothic mentality. The great school of Bruges continued an unspectacular supremacy with the art of Memling, who in his late works adapted the Renaissance motif of the swag, popularised by della Robbia, without upsetting the balance of the composition. Later Gerard David was welcomed there; he came from the school of Haarlem, was a follower of Geertgen tot Sint Jans and, impregnated with the two primitive northern trends, began a discreet evolution — perhaps precipitated by a journey to Italy — towards the grace, facility and poetic fullness of the landscape. His successors, Isenbrant and Jan Provost, were scarcely more Italianate but Christian serenity and the brilliance of middle class painting became clouded over, while at the same time Bruges, the great centre of the medieval corporations, began to give way to Antwerp, created by the new European economy. Gerard David was the first to submit to the art centre of the Scheldt which was already shining around Quentin Metsys.

Moreover, Metsys was an offshoot of the school of Bruges which was wide open to new inspiration; with him Flemish religious painting was transformed by the new compositional ideas and by a discreet sensitivity which created faces more moving and gently shadowed, and more delicate tones on softer drapery. But the most important innovations were without doubt the images of picturesque or bitter reality and portraits. Here, Metsys revealed himself as the interpreter of humanist philosophy when, without in any way abandoning the traditional attention to detail, he created in the human being such a complete synthesis of his expression, attitude and surroundings that he invalidates the declaration of his friend Erasmus: ' My best portrait you will find in my books. '

Alongside this intellectualised art we find the Walloon painter Joachim Patenier, a lover of nature and the inventor of landscapes at once grandiose and contemplative, which seem to include the oddities and the harmonies of the universe.

In direct contrast to these Antwerp pioneers of the Renaissance, who had little to inspire them but echoes of the art of da Vinci, was the first ' Romanist ', Jan Gossart (Mabuse) who opposed them with virtuosity. A pilgrimage to the classical ruins, and also to the Rome of Michelangelo, aroused his interest in the mythological or paradisiacal world of the *Ignudi* (nude figures): and the sculptural modelling which he adopted to sustain the generous amplitude of human forms is also applied to his striking portraits. Travelling to and fro in Flanders, in the service of the last patrons of the house of Burgundy, Mabuse took his message as far as the northern Netherlands, which retained an ascetic

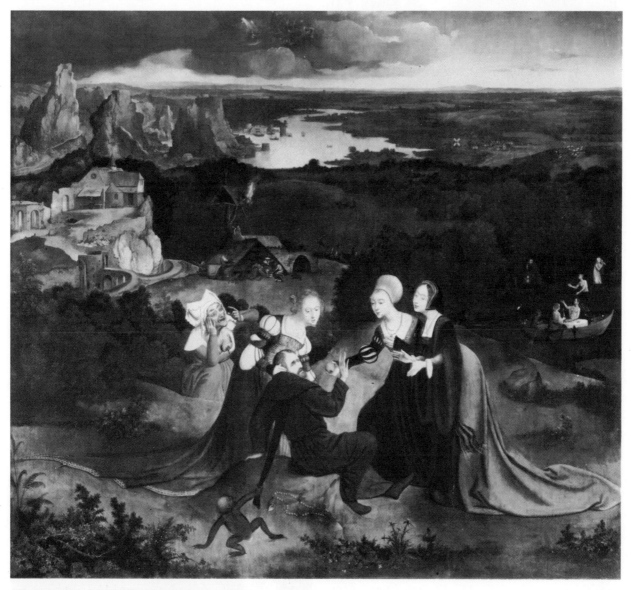

327. FLEMISH. JOACHIM PATENIER (d. 1524).
The Temptation of St Anthony. Figures painted by
Metsys. *Prado.*

328. FLEMISH. MABUSE (c. 1478–1533/36).
Jean Carondelet. Wing of the Jean Carondelet
diptych. 1517. *Louvre.*

329. DUTCH. LUCAS VAN LEYDEN (1494–1533).
Portrait of a Woman. *Van Beuningen Collection.*

architecture of the southern Netherlands foreshadowed earlier
than the other arts the approaching split between Flanders and
Holland and the link with Flemish art, to the detriment of the
classical phase, between the beginning of the Renaissance and
the Baroque.

If England is mentioned here, it is to record cultural trends
rather than masterpieces. Submerged in the Gothic convention
of the Tudor style, the island received only spasmodic impor-
tations of the Renaissance, coming mainly from France or
Flanders at the demand of court circles, to supplement the
deficiencies of its native schools of sculpture and painting.

Henry VIII approached Mazzoni for a design for a tomb;
Cardinal Wolsey attempted to rejuvenate architecture with
Milanese or Florentine ornamentation; for his part, Sir Thomas
More favoured the style of the Erasmus circle at Antwerp.
Finally, a few Italians went there, the most famous being the
itinerant Florentine sculptor Torrigiano, who readily adapted
himself in his funerary statues to the aridity of the English style.

330. FLEMISH. JOOS VAN CLEVE
(c. 1485–before 1541). Portrait of a Man. c. 1540.
Strasbourg Museum.

reticence with the affectations of a Jacob Cornelisz of Amsterdam,
or the febrility of a Cornelius Engelbrechtsz of Leyden. Lucas
329, 384 van Leyden, a disciple of Engelbrechtsz, a painter and particularly
skilful engraver, torn by opposing trends, combined pagan
Italianism with hints of Bosch and Dürer.

It is not always the very individualised movements which
decide the fate of art. The uncertainties and unrest which
accompanied the end of the Gothic world generally led to a
surfeit of easy Mannerism. Antwerp encouraged the commercial
production of wooden altarpieces on which painters and sculptors
alike depicted the gospels to satiety with the exuberant pageantry
330 of the theatre. The Rhenish painter, Joos van Cleve, was
captivated by the pathos of this art, despite his elegance as a
391 portrait painter, while Barent van Orley from Brussels gave
himself to it with skilful eclecticism, which the monumental
383 richness of his tapestries, after the revelation of Raphael's cartoons,
finally redeemed.

The name of Margaret of Austria is connected with this rise
of the Brussels studios, and it is right to recognise the part
played by Charles V's aunt in the concentration of these scattered
artistic trends. Under her patronage an international pre-Renais-
sance style flourished with a traditionalist painter like Jan
Mostaert, who came from Haarlem, with the sculptor Conrad
Meyt from Worms, the architect Guyot de Beaugrant from
Bresse, who favoured the French style, the Germanised Venetian
Jacopo de' Barbari — and it must be remembered that the
princess had also approached Pietro Torrigiano, Perréal, and
Michel Colombe. It is from the artistic centre of which Mechelen
was the focus that came the principal works of architecture
and sculpture, which introduced the Italo-Gothic style to the
Netherlands. Altarpieces, tombs, elaborate fireplaces, façades
with columns under ogee pediments were built, suitable for
the prolific ornamentation of Lancelot Blondeel, but stifling the
392 more gentle sculpture produced by Jean Mone following his
visits to Provence, Italy and Spain. While the northern provinces
were content to build middle class brick monuments, the

II. GERMANY BETWEEN THE MIDDLE AGES AND THE RENAISSANCE *Adeline Hulftegger*

In spite of many concessions to the new spirit which was spreading across Europe at that time, Germany in the 16th century did not break with the medieval tradition. The native tendencies, given free play in the late Gothic style, were an excess of naturalism, sculptural dynamism and the thirst for expression, which were in complete contrast to the idealism, the sense of balance and the taste for harmony extolled by the neo-Platonists of the Renaissance. In many aspects, particularly architecture, Germany therefore remained faithful to the aesthetics and philosophy of the Middle Ages.

Significant in this respect was the attitude of the first of the Habsburgs to whom the Empire owed the revival of the old Germanic dream of universal monarchy. Maximilian, who was too impecunious to establish in stone the evidence of his glory, left to the engravers the task of celebrating his glorious deeds and illustrating his allegorical writing, completely imbued with past chivalry; his love of heroic chronicles permeates, too, the proud statues of the legendary kings Theodoric the Goth **331** and Arthur of Britain, figures cast in bronze by Vischer the Elder in the Venetian manner, during the Emperor's lifetime, to mount guard with his ancestors around his tomb at Innsbruck. Nevertheless, as in the preceding century, it was among the bourgeoisie, always more opulent, that promoters of the new trends must be sought — in Cologne, where Italianism penetrated in the form given to it by the Antwerp school; in Nuremberg and Augsburg, where economic relations with Venice and Lombardy put them in direct contact with Mediterranean civilisation. Eminent patricians were no longer content merely to enlarge their fortunes founded on international trade or banking; they enriched their spirit through the study of classical literature, and discovered, with many of their less cultured compatriots, that the business of the arts was the surest guarantee of individual prestige. In Augsburg itself, the Fuggers were the first to favour the Renaissance, and they had their funerary chapel in the church of St Anna built in the resplendent Venetian style with Daucher's decorative sculptures.

Nuremberg and the other centres of printing, Mainz, Strasbourg and Basle, played at that time an essential part in the dissemination of classical philosophy. From Basle there spread through the whole of Europe the subtle spirit of Erasmus who, more than any other perhaps, helped to put man back in the centre of nature, freed from links with scholasticism. But in the north humanism did not result, as in Italy, in a happy combination of classical philosophy and Christian mysticism; on the contrary, and although their authors had certainly not foreseen it, the social satires of Sebastian Brandt and Erasmus opened up the way for the Reformation, a ferment of religious and political discord. Efforts at reconciliation remained in vain; the pamphlets of Ulrich von Hutten, Luther's break with the Catholic Church and the place reserved by him for the national language in sacred literature demonstrate the willingness of Germany to escape from the control of Rome by creating a form of Christianity which was more favourable to its aspirations. So, after favouring the growth of individualism and urging a greater liberty in the expression of thought, humanism ended up by contributing towards a stiffening of the German tradition by adopting a hostile attitude towards the Graeco-Latin culture, the ideas of which were never truly assimilated. Germany was torn between the need to ensure her spiritual autonomy and the temptation to yield to the attraction of formal beauty, the image of which was offered to her by a Platonic Italy.

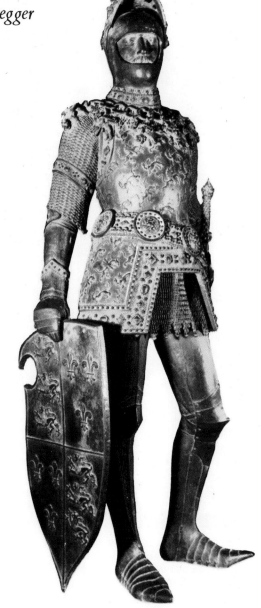

331. GERMAN. PETER VISCHER THE ELDER. King Arthur. Statue for the tomb of Maximilian. c. 1513. *Franciscan Church, Innsbruck.*

The echo of this conflict is to be found in the majority of works by painters, sculptors and engravers during the course of the first third of the century, the golden age of German representational art. The early signs of the religious and social crisis which was at first latent, the agitation and spiritual unrest of which the productions of Dürer in his youth, of Cranach **346** and of Grünewald bear the mark, far from paralysing Germany's creative instinct, seem to have been a sort of leaven to her natural expressionism. The easing of tension, introduced by Schongauer **108** and encouraged by the penetration of the Italian style, flourished at Augsburg, because of the placidity inherent in the Swabian character, and a too obvious search for nobility in forms, for sumptuous decoration and rich colours bear witness there in the works of Holbein the Elder, and especially Burgkmair, to **343, 387** an unreserved but awkward rallying to the concepts of the Venetian and Lombard Renaissance. Yet, on the other hand, the faithful adherence to the late Gothic spirit in its most

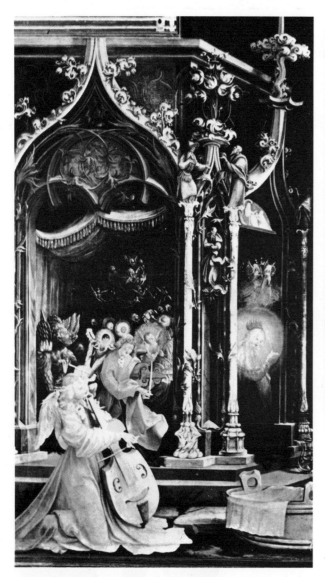

332. GERMAN. MATTHIAS GRÜNEWALD (1470/80–1528).
The Concert of Angels (detail from the
Christmas picture). Panel from the Isenheim Altarpiece.
c. 1510/15. *Colmar Museum.*

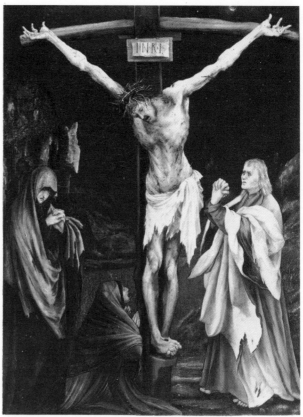

333. GERMAN. MATTHIAS GRÜNEWALD (1470/80–1528).
Crucifixion (The Small Crucifixion). *Samuel H. Kress
Collection, National Gallery of Art, Washington.*

uncontrolled form triumphed in many respects in Matthias
333 Neithardt, known as Grünewald, the most brilliant German
colourist. Established in the region of Mainz and for a short
time in Alsace, but a native of Würzburg, he reconciled the
violence of the Franconian temperament with the most ethereal
flights of Rhenish mysticism, while yielding to the call of the
restless universe of the northern phantasmagoria. Still medieval
in the nature of its inspiration and even in its expression, the
332 *Isenheim Altarpiece* nevertheless brings an originality of vision,
a fullness of form, an evocative power, a virtuosity and boldness
of execution which spring from the new times. The need to
go beyond the limits imposed by tradition and craftsmanship
was henceforth recognised by every artist anxious to assert his
personality. Nobody understood this better than Dürer.

Dürer between German tradition and the new ideas

Probably Dürer never dreamed of disowning his double
apprenticeship as a goldsmith in his father's studio, and as a
142 painter-engraver with Wolgemut. Moreover, alongside works
147 such as the *Stations of the Cross* carved by Adam Krafft which
is related to Dürer's series of the *Great Passion*, and the *Shrine
of St Sebaldus* decorated by the Vischers in the style of Sansovino,

Dürer's own works show the imprint of the artistic centre of
Nuremberg in which he grew up and lived, an austere centre,
less pervious than that of Augsburg to the attractions of luxury.
But Dürer did not neglect any means of widening his know-
ledge; a journey to the upper Rhine initiated him to the art
of engraving and made his style more supple through the study
of Schongauer's engravings. More fruitful still were the expe-
riences of Venice and the discovery of the works of Mantegna
and Bellini; they helped him to widen his vision, and to a
certain extent restrained his leanings towards expressionism.
Won over to scientific ideas, he gave himself up to theoretical
writings on perspective and the human body; he experimented
with the representation of the nude, the supreme means of the
masters of the Renaissance to attain harmony. But in spite of,
and even because of, his efforts, the ideal of beauty escaped him,
and for him the only source of art was still nature. He studied
it indefatigably; many sheets of studies testify to his rigorous
analysis of it; here is revealed his destiny as a draughtsman-
engraver, and as such he recovered all his freedom of expression
and also his flowing, decorative style which he inherited from
the Gothic. More than in painting, where his weakness as a
colourist and his minutely detailed manner prejudiced the
greatness of the inspiration — with the exception of the *Four
Apostles*, of truly monumental character, and the incomparable
series of portraits — it is in the graphic arts that Dürer displays
the full scope of his powerful, keen genius. He mastered the
problems of form and the representation of space, used light
in a bewitching manner to enhance the spirituality and in his
most famous prints, the *Knight, Death and the Devil, Melencolia,* 15
St Jerome in his Cell, revealed both an amazing technical profi-
ciency and the full powers of his mind, tormented by the corrod-
ing pessimism of his race and purified by the humanist flame
and the indestructible faith of the Christian.

MASTERPIECES OF DÜRER (1471–1528)

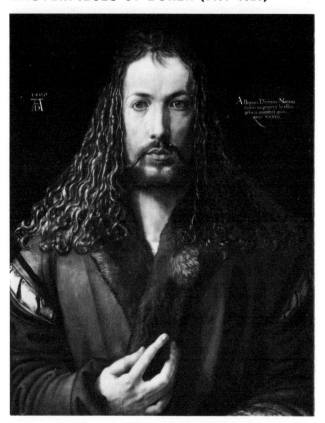

334. Self-portrait. 1500. *Pinakothek, Munich.*

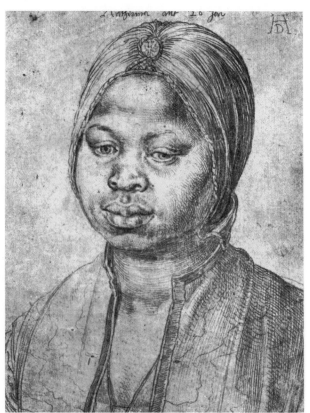

335. The Negress Catherine. Drawing. 1521. *Uffizi.*

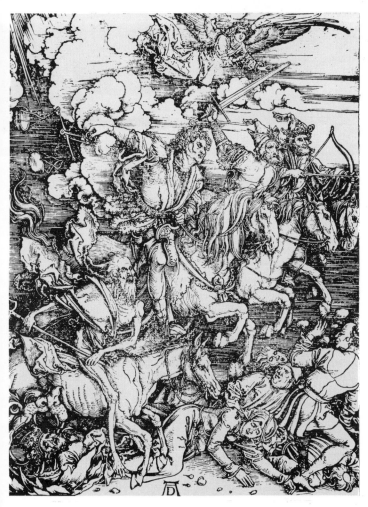

336. The Four Horsemen of the Apocalypse. 1498.

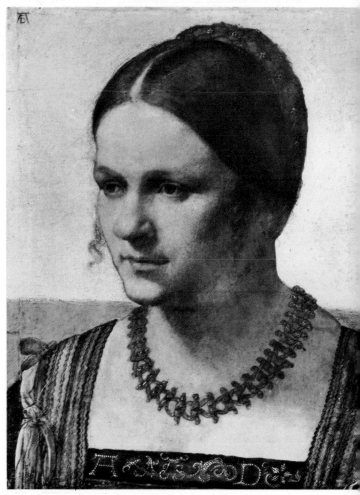

337. Portrait of a Lady. 1506. *Staatliche Museen, Berlin.*

MASTERPIECES OF HANS HOLBEIN THE YOUNGER (1497/98–1543)

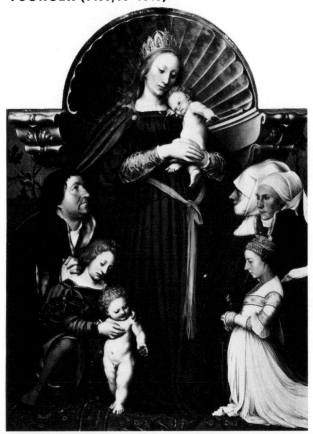

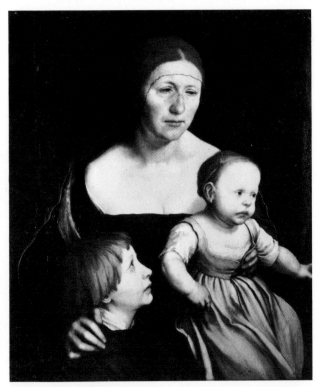

338. Madonna of the Meyer Family. 1528–1529. *Darmstadt Museum.*

339. The Artist's Wife and Sons. 1528–1529. *Basle Museum.*

340. The Dead Christ in the Tomb. 1521. *Basle Museum.*

The message of Dürer, of universal significance, went far beyond the limits of his time and country. His influence, which became European through his engravings, exerted itself on the indigenous school all the more successfully in that his style offered the German masters the means of adhering to the spirit of the Renaissance without completely renouncing the formula of the late Middle Ages. His art was continued in Nuremberg itself by his disciples and afterwards by the Little Masters and the ornamentalists such as Flötner and the Jamnitzer, whose fertile decorative style inspired legions of goldsmiths, armourers and cabinet makers, and it spread with equally beneficial results to the upper Rhine and Switzerland. It can be seen, mixed with the style of Grünewald, in Hans Baldung Grien, a first-class draughtsman and colourist, whose contact with the humanists did not curb his strange imagination, and it is to be found again in Urs Graf, Niklaus Manuel and Hans Leu, representatives of the Landsknecht school, whose expressionism, with all its odd details, seems to reflect the tumultuous life led in the mercenary camps in northern Italy.

With a more sentimental note and an intuitive science of light and colouring, the masters of the Danube school, Altdorfer and Huber, gave free rein to their lyricism in scintillating mythologies and religious scenes, in which the landscape acquires an importance never before equalled, and vibrates with a com-

pletely personal communion with nature. At first Cranach's work had similar trends; later his enthusiasm cooled, and he became the painter to the Electors of Saxony and one of the most fervent followers of Luther, whose beliefs are reflected in Cranach's paintings. Although he chose the profane subjects of the Renaissance, in which the nude figure played an important 346 part and which he painted with an ambiguous charm, his predilection for delicate figures and for exaggerated ornamental rhythms and the affectation of his sensuous drawing suffice to place him among the inveterate partisans of the Gothic style. His portraits, which are less dominated by decorative qualities and are often incisive, are in themselves sufficient to justify his reputation.

The contribution of Hans Holbein, one of the greatest portrait 338-341 painters of all time, is of quite a different quality. The son of Holbein the Elder, and younger than Dürer, he seems to have freed himself quite easily from the tradition of the craftsman, and his work shows no trace of the restlessness or strain revealed in his predecessors. Born and trained at Augsburg, and established first at Basle and then in London, a painter of the middle class and the humanists and later of the English court, he had a cosmopolitan talent, eminently representative of that intellectual Europe which, with all frontiers abolished, found its true home in the realm of literature and the arts. He combined the objec-

341. GERMAN. HANS HOLBEIN THE YOUNGER
(1497/98–1543). Boniface Amerbach. 1519. *Basle Museum.*

342. GERMAN. HANS HOLBEIN THE YOUNGER
(1497/98–1543). Die Edelfraw (The Noble Lady).
Engraving for the Dance of Death.

tivity of the north with a harmonious sense of form deriving from Italian art, and he appears to be the least Germanic of the German masters; the compulsion to analyse and the infallible precision of his brush strokes alone betray his origin. As a painter, engraver and miniaturist, he tried his hand successfully in various branches of the arts, but the practice of portrait painting raised him immediately to a higher plane. A born psychologist, he was not satisfied with an absolute fidelity to the model; he caught the most fleeting, but also the most revealing indications of the individual in the face.

342

After the disappearance of the great creative geniuses of the German school, and with the religious schism which divided the country into two opposing parties, the impoverishment of art in the last two-thirds of the century was compensated by an apparent triumph of the Renaissance, either by direct importation as in the south of the Empire, where the Italian decorative architects and Italianised masters (Friedrich Sustris, Pieter de Witte, known as Candido) were much used, or by adherence to the Flemish style, as in the northern and western districts, for example the Ottheinrich wing of Heidelberg Schloss, the most remarkable architectural creation of the century. Works of this type, with borrowed decorative themes, seldom well adjusted, had no successors. The Swiss painter, Tobias Stimmer, a worthy emulator of Holbein, was the only one to escape the general stagnation; his robust decorative talent seems to form a natural transition from the late Gothic to the Baroque.

It is always important to note that under the aegis of the Emperor Rudolph II, a keen scholar, a knowledgeable collector and patron of philosophers, musicians and artists, the court of Prague became the last great rallying point of the adepts of the international Mannerism. Followers of the artists from Parma, Bologna and Venice set the tone, for instance the Antwerp painter Bartholomaeus Spranger, the German Hans von Aachen, the Swiss Joseph Heintz, who were joined in 1601 by the Dutch sculptor Adriaen de Vries. Their works, with their strangeness, with their affected style and with their undoubted originality of form and expression, guarantee to this ephemeral centre of art in Prague an important position in the history of the Mannerist movement.

The transition in the Iberian peninsula

Spain was equally disinclined to welcome the lessons of the Renaissance, but she found the means for compromise more easily, because she had not as yet a clear consciousness of her artistic needs. As a Mediterranean country, longstanding relations with Italy made her familiar with the Latin civilisation, and the very force of her religious convictions was an intellectual weapon strong enough to combat humanist thought with all the ardour of an unassailable spirituality. The prosperity of the kingdom, helped by the influx of riches from the New World and by Spain's political unity, had a direct effect on artistic activity, which was very great up to about 1570.

The Italian manner, which had already been adopted for certain works dating from the time of Queen Isabella, became widespread. There are imitations of the Lombard style in such buildings as the university of Salamanca and the monastery of 379 S. Marcos in León; grotesque and other elements of Renaissance decoration followed easily on from Gothic or Mudejar motifs. All the fantastic ornamentation of the previous age was retained, but the plenitude of form gave way to a manner of carving inspired by silversmiths' work (platería), whence the name 'Plateresque' style. In spite of more frequent recourse to classical forms, this decoration is almost a veneer imposed on a structure which remained Gothic, and it was only at the instigation of Charles V that the spirit of the High Renaissance appeared in Granada, in the Alhambra, a splendid building in the Roman 381 style, while the construction of the Alcazar of Toledo and Granada cathedral began a purist reaction against the excesses of the Plateresque.

Italianism, introduced by Florentine sculptors, also dominated the sculpture of their followers Vasco de la Zarza and Ordoñez, and that of Biguerny or of the sculptor Forment who, in order to serve the Renaissance more fully, even claimed to rival Phidias and Praxiteles. The spirit of submission is complete in the painters of Valencia, F. de los Llanos and F. Yañez, disciples of Leonardo and at times of Giorgione, as it was in V. Macip and his son Juan de Juanes, dull emulators of the Lombards and Raphael. The northern manner always maintained its influence in Castile, visited by Benson and Anthonis Mor, called

COMPARISON OF THE NORTHERN SCHOOLS
AND SPAIN IN THE 16TH CENTURY

GERMANY **LOW COUNTRIES** **SPAIN**

FIRST GENERATION

SECOND GENERATION

THIRD GENERATION

Antonio Moro, portrait painter to Philip II. Other painters from the Netherlands, such as Kempeneer, introduced Romanism in Seville; after a visit to Italy Luis de Vargas contributed a frankly academic note. Without any real link with the indigenous art, this style, which was confined to sacred subjects and portraits, is mainly remarkable for a total lack of originality.

353 Because of a much more personal assimilation, the sculptures of a Hispanised Frenchman, Juan de Juni, and those of Alonso
352 Berruguete, a son of the painter, reveal sculptural qualities and a power of inspiration the source of which might appear to dry up. These polychrome sculptures, full of fire and passion, precursors of the art of El Greco and Gregorio Hernandez, seem to embody the divine ecstasy of St Theresa of Avila and St John of the Cross. Another pure figure of this Spain of
351 mysticism, fervour and truth was Luis de Morales, a solitary figure, who settled in Badajoz, in the province of Extremadura, on the borders of Portugal. Perhaps it was from the painting of Portugal that he received the influence of the school of Antwerp; he must also have seen Lombard pictures from which he borrowed his delicate sfumato. His mannerist drawing, with its expressive distortions in the spirit of the late Gothic style, the play of light and shade and a poetic sense of colour lend a fascinating power to his works steeped in melancholy and burning with contemplative devotion, which were well calculated to move the souls of the people.

In Portugal, under the influence of French sculptors, the Manueline style also underwent a Renaissance phase; the
378 Lombard style of decoration was assimilated in Belem in a manner very close to the Plateresque. Classicism was accepted more completely here than in Spain, as can be seen in the buildings in a very pure style, inspired by Serlio or Bramante, in Tomar and Évora. In Lisbon and Viseu Portuguese painting furnished brilliant examples of its vitality, revived by the work of Metsys and the Antwerp immigrants who popularised the new aesthetic. The luxuriant decorative settings are related in a curious manner to the school of Augsburg. In addition to Cristovão de Figueiredo, Gregorio Lopes, and Vasco Fernandes, who set the tone for this court art with real distinction in the colouring, the best representatives were portrait painters — Sanches Coelho, a disciple of Moro who later moved to Madrid, Cristovão de Morais and that spiritual son of the great Gonçalves, the Master of the Portrait of the Lady with the Coral Rosary, the enigmatic precursor of Velasquez.

343. HANS HOLBEIN THE ELDER (c. 1465–1524). The Annunciation. Panel from the Kaisheim Altarpiece. 1502. *Pinakothek, Munich.*

344. GERARD DAVID (c. 1460–1523). Virgin with the Bowl of Milk. *Brussels Museum.*

345. PEDRO BERRUGUETE (d. before 1504). The Martyrdom of St Peter. *Prado.*

346. LUCAS CRANACH THE ELDER (1472–1553). Venus in a Landscape. 1529. *Louvre.*

347. QUENTIN METSYS (1465/66–1530). St John the Evangelist in the Boiling Oil. Right wing of the Altarpiece of the Joiners' Guild. *Antwerp Museum.*

348. ALEJO FERNANDEZ (c. 1480–1543). Virgin with the Rose. *Church of St Anne, Triana.*

349. HANS HOLBEIN THE YOUNGER (1497/98–1543). The Merchant Georg Gisze of Danzig. 1532. *Staatliche Museen, Berlin.*

350. JAN VAN SCOREL (1495–1562). Portrait of a Young Boy. 1531. *Boymans Museum, Rotterdam.*

351. LUIS DE MORALES (d. 1586). Virgin and Child. *Prado.*

352. SPANISH. ALONSO BERRUGUETE (1486/90–1561). St Sebastian. 1529/32. *S. Gregorio Museum, Valladolid.*

353. SPANISH. JUAN DE JUNI (d. 1577). Joseph of Arimathaea. Detail from Christ in the Tomb. *S. Gregorio Museum, Valladolid.*

HISTORICAL SUMMARY: 16th-century art

ITALY (1500-1570)

History. Political instability was widespread. Wars of Milan, Naples, Venice. Italy was a battlefield disputed by France and Austria. The French occupied Milan in 1500–1512 and in 1515–1522. In Florence, P. Soderini was governor (1502–1512), then the Medici regained power. 1527–1530, unrest in Florence, taken by the Empire: Alessandro de' Medici became the hereditary duke. In 1529 northern Italy came under French influence. In 1530 Charles V was crowned Emperor at Bologna. Milan came under Spanish domination in 1535. Parma became a hereditary duchy in 1545 (the Farnese family).

Following the magnificence of Popes Julius II and Leo X, the papal see declined after the sack of Rome by the Empire in 1527. The Church created new Orders (1524, Theatins; 1528, Capuchins; 1533, Barnabites; 1540, Brothers of Mercy). It was hard pressed by the struggle against the Reformation (council of Trent, 1540–1563), and it was supported in Spain by St Ignatius Loyola (d. 1556, founder of the Jesuits, first General of the Order in 1541) and by St Charles Borromeo, archbishop of Milan (1538–1584), the two champions of the Counter Reformation led by Paul III, Paul IV and Pius IV.

Culture. Humanist cliques existed in Venice, Ferrara, Mantua, Rome (around the popes, Cardinal Bibbiena, Agostino Chigi, Baltasar Castiglione, Paolo Giovio; Cardinal Bembo and Aretino in Venice after 1527). Archaeological excavations continued in Rome; the *Laocoön* was identified by Michelangelo and G. da San Gallo (1506). About 1510–1520, discovery of Roman remains (tombs, via Latina; the Baths of Titus; Golden House of Nero). Collections of antiques were started (Belvedere court, about 1505–1550).

Among the writers were Sannazaro, *Arcadia*, 1504; P. Bembo, *Asolanes*, 1505; Ariosto, *Orlando Furioso*, 1506–1516; Machiavelli, *The Prince*, 1513; Bibbiena, *La Calandria*, comedy, 1514; B. Castiglione, *The Courtier*, about 1508–1518; di Giorgio, *Harmony of the World*, 1525; sonnets by Vittoria Colonna and Michelangelo. In science, A. Vesale, *Anatomy*, 1543.

The writers on art were numerous: Fra Luca di Pacioli, *De Divina Proportione*, 1509; Leonardo da Vinci, *Treatise on Painting* (compiled in the 16th century, from his manuscripts); Fra Giocondo da Verona published and annotated Vitruvius. Treatises on architecture by Serlio (1537), Palladio (1570), Vignola (about 1530, edited in 1582). Cellini published a treatise on the art of the goldsmith and his memoirs, Vasari his *Lives of the Artists* (1550).

The Florentine Academy of Literature was created in 1541, the Academy of Drawing in Florence in 1562. The Medici library was opened to the public, 1548.

In music, Venice was influenced by Flemish musicians: Villaert (d. 1562), choirmaster of St Mark's; Cypriano da Rora moved to Parma (d. 1565); the Cabrieli, organists. In Rome Palestrina triumphed (Giovanni Pierluigi, 1526–1593: the Mass of Pope Marcellus, 1555); the Flemish musicians Orlando Lasso and Filippo di Monte were in Naples and Rome about 1550–1554.

The principal patrons were, in Rome, the popes: Julius II (1503–1513); Leo X (son of Lorenzo the Magnificent), d. 1521; Clement VII (son of Giuliano de' Medici, 1523–1534); Paul III Farnese (d. 1549); the Cardinals Hippolyto d'Este, Alessandro Farnese, etc., the banker Chigi (d. 1520).

In Florence, the Medici: Cosimo I, Grand Duke of Tuscany (d. 1574). In Ferrara, the Este: Alphonso I (d. 1534) married Lucrezia Borgia; Ercolo II (d. 1558) married Renée of France, thus pleasing the Calvinists; his brother Cardinal Hippolyto; Alphonso II (d. 1597). In Mantua, the Gonzaga: Giovanni Francesco III (d. 1519), his wife Isabella d'Este, and their son Federigo II, first Duke of Mantua (d. 1540). In Parma, the Farnese: Ottavio (d. 1586), married to Margaret of Austria; his brother Cardinal Alessandro. In Urbino: Guidobaldo da Montefeltro (d. 1508) and Isabella Gonzaga; Francesco Maria della Rovere (d. 1538), nephew of Pope Julius II. In Venice the great patrician families already quoted in the 15th century (see p. 113).

Architecture. Rome had an overwhelming importance in the 16th century. Bramante (1444–1514) expanded classical culture and was inspired by antique buildings as in the tempietto of S. Pietro in Montorio (1503) [262] and the little cloister of Sta Maria della Pace (1504). From 1503 he planned to link the Belvedere to the Vatican in a majestic scheme including the Cortile of S. Damaso, with its three-storeyed loggias, and the Cortile della Pigna, with its enormous semicircular niche. In St Peter's, Rome, Bramante designed the plan of the new basilica (the first stone was laid on 18th April 1506); in the form of a Greek cross, with projecting apses, with four small domes flanking the great central dome and the façade decorated with two campaniles. On the death of Bramante in 1514, the work was so little advanced that Raphael and G. da San Gallo were able to change the plan of St Peter's into a Latin cross, finally adopted by Michelangelo (see p. 161). But Michelangelo only had time to build the drum of the dome; the dome itself was finally erected by Giacomo della Porta. After 1607, Maderna extended the nave by additional bays and lateral chapels which convert the plan into a Latin cross; he built the new façade which was to be still further transformed by the campaniles of Bernini.

Bramante designed the church of the Sta Casa in Loreto (1510), the severity of which was modified by the sculptors, and the church of Sta Maria della Consolazione, at Todi, carried out by Cola da Caparola (1508).

Bramante's style dominated the 16th century. In Rome Baldassare Peruzzi (1481–1537) of Siena, painter [367], decorator and designer of stage sets, built his masterpieces, the Villa Farnesina, built for Agostino Chigi, (1508–1511) and the Palazzo Massimi alle Colonne (1532). His disciple, Sebastiano Serlio (1475–1544), famous for his treatise on architecture, worked in Venice between 1531 and 1540 and also in France.

Raphael (Raffaello Sanzio, 1483–1520) revealed his delicate genius as an architect inspired by the classical style in the Chigi chapel of Sta Maria del Popolo (1520), and in the Villa Madama. Nero's Domus Aurea (Golden House) was revived in the decoration of the Villa Madama and the Vatican Loggias. Giulio Romano (Giulio Pippi, c. 1499–1546) was influenced by Raphael and Bramante; he was particularly famous for the Palazzo del Tè, Mantua, a massive square building, with rooms decorated with stucco and paintings [354, 355]. Antonio da San Gallo the Younger (1485–1546), nephew and disciple of Giuliano da San Gallo, specialised in military architecture (Perugia: Rocca Paolina, 1540). He built the Palazzo Farnese in Rome, of which Michelangelo was to make the impressive cornice and the interior of

GERMAN. HANS HOLBEIN THE YOUNGER (1497/98–1543). Erasmus. 1523. Louvre.
Photo: Jacqueline Hyde.

158

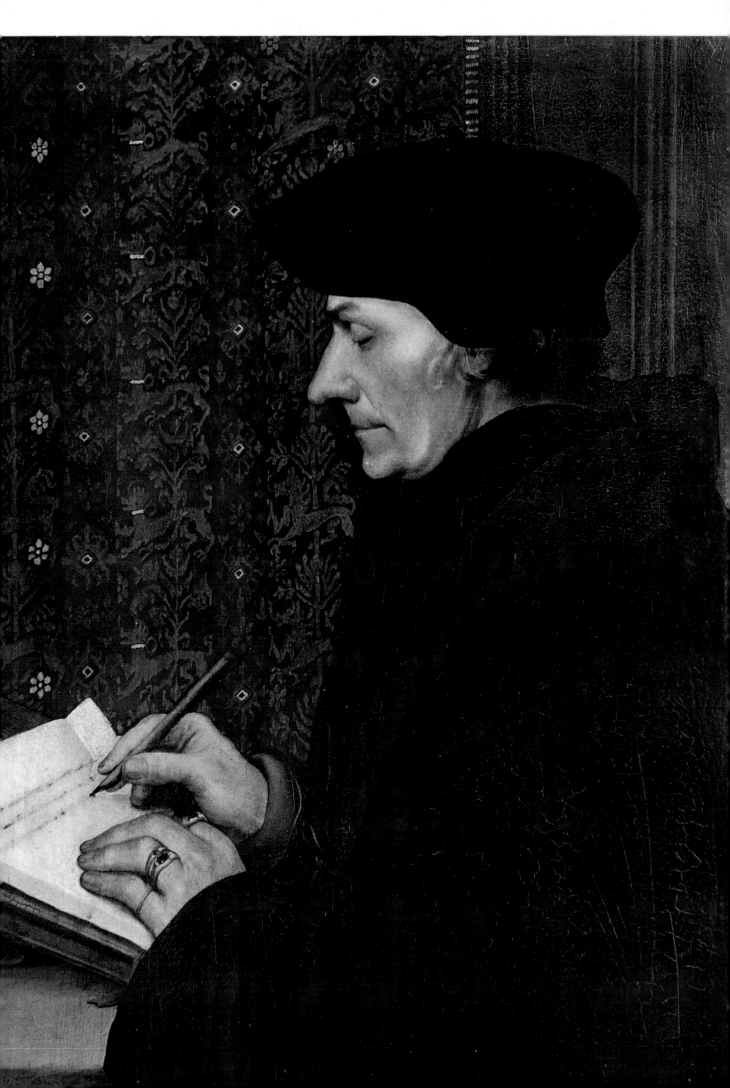

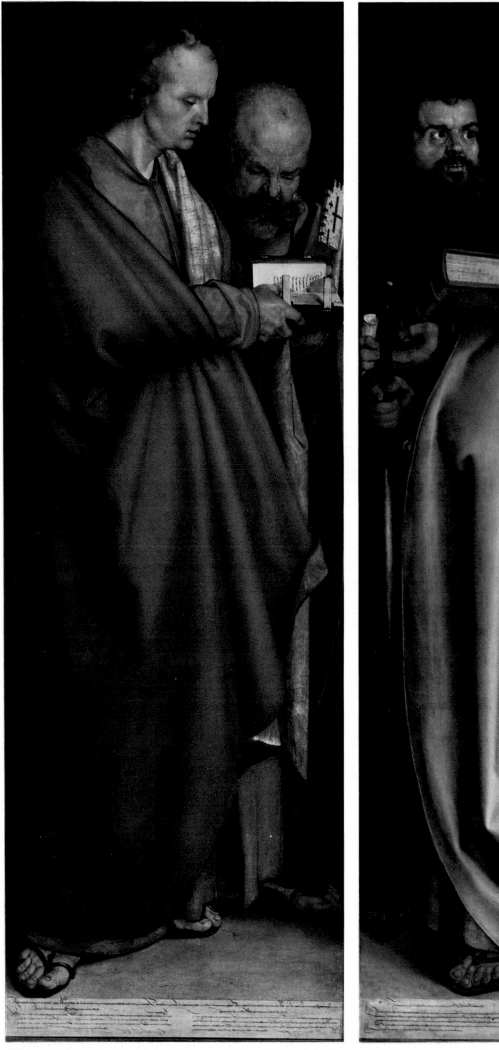
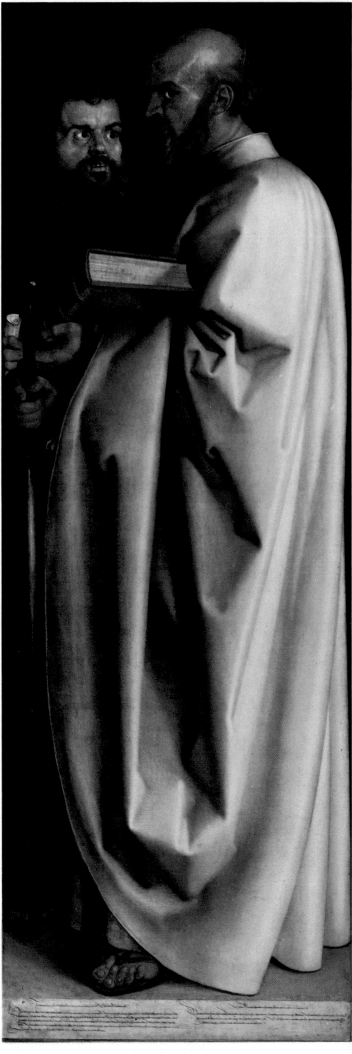

the third floor. Giacomo della Porta completed it with the grand loggia opening on to the Tiber.

Michelangelo (Michelangelo Buonarroti, 1475–1564) contrasted the harmonious serenity of Bramante and Raphael with a vehement restless style. In 1515 Leo X commissioned him to design the façade of S. Lorenzo, which was never carried out, but three designs for it show how the classical plan was kept in which solids are more important than voids. For Giuliano de' Medici, later Pope Clement VII, he began the sacristy of S. Lorenzo, the mausoleum of the Medici. From 1524 he worked on the Medici library in S. Lorenzo, completed by Vasari and Ammannati after his designs. The grand disposition of the piazza in front of the Capitol and the transformation of the tepidarium of the Baths of Diocletian into a church (Sta Maria degli Angeli, 1560–1561) are by him (see *Sculpture*).

Vignola (Jacopo Barozzi da Vignola, 1507–1573) reacted against the dramatic style of Michelangelo. His two famous written works (*Rule of the Five Orders of Architecture*, 1562; *Treatise on Perspective*, published posthumously in 1587) became the standard works on classical architecture. His severe style, very close to the austerity recommended by the council of Trent, was expressed in the church of Il Gesù, 1568 (façade by Giacomo della Porta), in the pentagonal Palazzo Farnese, Caprarola (from 1559), started by A. da San Gallo, and in the Villa Giulia, where Vasari, Ammannati, Fontana and Ligorio also worked. Pirro Ligorio (1510–1583) erected the Villa Pia in the Vatican (1560), the porticoed casino of the Villa Medici and the famous Villa d'Este at Tivoli (1550).

In Florence the example of Michelangelo influenced most of the architects. Giorgio Vasari (1511–1574) rebuilt and rearranged the interior of the Palazzo Vecchio from 1540. Bernardo Buontalenti (1536–1608) worked on the façade of Sta Trinità (1593), decorated with fantasy several villas (Villa Fratolino), and designed the admirable gardens of the Boboli, Pratolino and Castello. Bartolommeo Ammannati (1511–1593) worked in Venice, Padua and Rome before returning to Florence. His masterpieces are the interior court of the Pitti and the Sta Trinità bridge (1567–1569).

In Genoa Galeazzo Alessi (1512–1572), originally from Perugia, and an admirer of Michelangelo, created luxurious palaces (Cambiaso, Spinola, Doria, the latter perhaps remodelled by Giovanni Angele Montorsoli) and

adapted in miniature, in the church of Sta Maria di Carignano (1522), the plan by Bramante and Michelangelo for St Peter's.

In Venice classical architecture found its best representative in Jacopo Tatti, called Sansovino (1486–1570), who was a Florentine by birth, but Roman by training and by his admiration for Bramante, and who went to Venice in 1527 after the sack of Rome. Between 1534 and 1554, he worked on the Libreria which Scamozzi completed [313], on the Zecca (1537–1545) and on the Loggetta at the base of the Campanile (1537–1540). Sansovino is more severe in the Palazzo Corner (1532) and the Palazzo Dolfini. Vincenzo Scamozzi (1552–1616) worked in Vicenza, Genoa and Rome; he was inspired by Sansovino in the Procurazie Nuove in the Piazza S. Marco.

Michele San Micheli (1484–1559) of Verona, the famous military architect (in Verona, Porta Nuova, Porta Stuppa) erected the Palazzo Grimani in Venice. But the most important architect was Andrea Palladio (Andrea di Pietro della Gondola, 1508–1580), friend of the humanist Trissino, influenced by his journeys to Rome, by his study of antiquity and the new edition of Vitruvius (1556). His treatise of *The Four Books of Architecture* (1570), like the façade of S. Francesco della Vigna (1562), S. Giorgio Maggiore (1560–1580) [316] and Il Redentore (1577–1580), reflected his cult of classicism. The same classical elements appear in his villas (Pisani, Cornaro, Giacomelli at Maser), the most Roman of which is known as the Rotonda (Villa Capra) near Vicenza [319]. In Vicenza itself, his influential town houses reflect a growing Mannerism: Palazzo della Ragione (1549); Palazzo Chiericati (1551–1554); Palazzo Porto-Colleoni (1552); Palazzo Valmarana (begun 1566); Palazzo Comunale (Loggia del Capitano, 1571). His last work, the celebrated Teatro Olimpico, with its permanent set, was begun in 1580 and completed by Scamozzi [508].

Gardens. The new theories of landscape gardening in Italy brought architecture into harmony with nature. Thus the garden itself became a branch of architecture. Not only in the letter but even more in the spirit, it evoked the gardens of classical times described by Seneca and Pliny and lauded by the humanist poets. Four types of gardens: 1. geometrical gardens cut out of the sides of hills and made of a series of terraces with monumental stairways decorated with rows of stat-

ues, often classical (Belvedere gardens in the Vatican, by Bramante, 1503; those of the Villa Madama by Raphael, 1519); 2. landscaped gardens where terraces and ornamental water (canals, little waterfalls, pools, fountains, water organs and automatic fountains) blend with disciplined shrubberies and grottoes peopled with classical divinities (gardens of the Villa d'Este by Pirro Ligorio, and those at Frascati, Aldobrandini, and Boboli by Tribolo, 1540) [357]; 3. iconographical gardens where the lay-out is punctuated by trimmed trees and statues illustrating mythological themes (garden of Cosimo de' Medici at Castello, by Tribolo); 4. educational gardens with an artistic character (botanical gardens) laid out according to geometrical plans and always ornamented with statues of Dioscorides, Aesculapius, Pliny, etc. (those of Ferrara, 1540, Padua, 1546, and Pisa are the most remarkable in Italy).

Sculpture. The personality of Michelangelo dominated Italian sculpture of the Renaissance and assured the fame of the Florentine school. Michelangelo Buonarroti (1475–1564) [270-276] was a pupil of Bertoldo in Florence. In 1494 he was in Venice and Bologna, in 1496 in Rome (*Pietà* in St Peter's, 1498-1499), in 1501–1505 in Florence (*David*, *St Mark*, the Pitti *Madonna*). In 1505–1520 in Rome he made the plan for the tomb of Julius II, of which statues executed are *Moses*, *Leah* and *Rachel* (S. Pietro in Vincoli, Rome) [272]; two *Slaves* in the Louvre; four unfinished statues in the Florence Academy; from 1520 to 1534 he worked on the Medici chapel of S. Lorenzo; tombs of the dukes Giuliano and Lorenzo (*Il Penseroso*) [274] with recumbent figures, *Night* and *Day*, *Dawn* [169] and *Dusk*; statue of the *Virgin and Child*. In 1534–1564 in Rome: three *Pietàs* (Florence, cathedral and Academy; Milan, Castello Sforzesco).

Andrea Contucci, known as Sansovino (d. 1529), introduced the new Florentine style [222] followed by Benedetto da Rovezzano, G. F. Rustici, and by Tribolo and Bandinelli, influenced by Michelangelo. The Mannerist trend was represented in Florence by Benvenuto Cellini (1500–1571) [382], sculptor, goldsmith and author of the famous *Autobiography* (1558–1562). In France 1537 and 1540–1545: gold Salt for François I (Vienna) (1540–1543) [382]; *Nymph* of Fontainebleau (1543–1544). Influence of Michelangelo in bronze *Perseus* (Loggia dei Lanzi,

GERMAN. ALBRECHT DÜRER (1471–1528).
The Four Apostles (St John and St Peter, St Paul and St Mark). 1520–1526. Pinakothek, Munich.
Photo: Joachim Blauel.

354. ITALY. Palazzo del Tè, Mantua (east façade) by Giulio Romano. 1524–1534.

355. ITALY. Plan of the Palazzo del Tè, Mantua.

356. ITALY. The Palazzo Farnese, Rome. Begun by A. da San Gallo the Younger in 1514, completed by Michelangelo.

Florence, 1545–1554). Also influenced by Michelangelo were V. Danti (1530–1576) of Perugia: *Beheading of the Baptist* (baptistery); and B. Ammannati (1511–1592): Neptune fountain (1536–1576) [**433**]. Giovanni Bologna (1529–1608), born at Douai, trained in Flanders, was the most famous sculptor in Florence after the death of Michelangelo: *Rape of the Sabines* (Loggia dei Lanzi, 1579–1583); *Mercury* (1564); small bronze replicas produced in large quantities in workshop [**439**].

The art of the bronze statuette in which the studios of Florence and Padua, disciples of Donatello and the Pollaiuolo, excelled, was practised with particular skill by Andrea Riccio (Padua, d. 1532). Trained in Florence, his native city, Jacopo Sansovino (1486–1570) produced brilliant work in Venice: decoration of the Loggetta of the Campanile (1537–1540). Cattaneo [**314**] was also brilliant. Alessandro Vittoria (1525–1608), a true Venetian [**317**], was distinguished by his talents as a decorator and portrait painter. Leone Leoni, the Tuscan bronze worker, who was trained in Venice and Milan, belongs to Spanish sculpture, because he moved in 1550 into the service of Charles V, and later of Philip II.

Painting. The principal centres of painting at the time of the classical Renaissance were: Florence, which was declining; Rome, whose brilliance was short lived but of immense prestige; finally, Venice with its dependants. Florence first saw the genius of the three great masters who gave to the painting of the 16th century its noblest expression: Leonardo da Vinci, Raphael and Michelangelo.

Leonardo da Vinci (1452–1519), one of the greatest of the *universali uomini* produced by the Renaissance; intellectual powers diffused over such a range of interests that he finished hardly any major enterprise; thousands of notes and drawings but few completed paintings. 1469–1478, pupil and

assistant of Verrocchio, Florence. 1481–1482, *Adoration of the Magi*, unfinished [**191**]. At Milan 1483–1499 he was in the service of Ludovico il Moro; *Virgin of the Rocks* [**257**], Louvre and National Gallery, London (1483–1506); model for bronze equestrian monument to Francesco Sforza; the *Last Supper*, fresco in the refectory of Sta Maria delle Grazie [**258**]; 1498, decoration of the Sale delle Asse in the Castello Sforzesco, restored in the 19th century; scientific studies. In 1500 he went to Mantua (cartoon for the portrait of Isabella d'Este) and to Venice. 1500–1505, he was in Florence; theme of the *Virgin and Child with St Anne*: cartoon (National Gallery, London, c. 1498), unfinished painting (Louvre, from 1506). 1503–1505, cartoon for the *Battle of Anghiari* in the Palazzo Vecchio (lost). Portrait of Mona Lisa del Giocondo (the *Gioconda*), Louvre [**259**]. 1507–1513, in Milan, he was the 'painter and engineer to Louis XII'. 1513–1515, stay in Rome (Vatican). In the autumn of 1516, he left for France, settled at Cloux, near Amboise, in the service of François I. He died there in 1519. His manuscript notebooks and drawings bequeathed to his pupil Melzi are kept in the Ambrosiana Library, Milan (*Codex Atlanticus*), in the Institut de France, and the Royal Library, Windsor. Other drawings are in the British Museum, the Uffizi, the Louvre, etc. [**255, 261**] (see colour plate p. 141).

Raphael Sanzio (1483–1520), born in Urbino, son of the painter Giovanni Santi. Pupil of Perugino in Perugia, 1500–1504; the *Dream of the Knight*, National Gallery, London; 1504, *Sposalizio* in the Brera [**264**]. 1504–1508, in Florence: *Madonna with the Goldfinch*, Uffizi [**266**]; *La Belle Jardinière*, Louvre; portraits of Angelo and Maddalena Doni in the Pitti. In 1508 he was in Rome; there he painted in the Vatican the frescoes in the Stanza della Segnatura, 1509–1511 (the *Disputà*, the *School of Athens* [**265**], *Parnassus*, etc.), for the Stanza d'Eliodoro, 1511–1514

(the *Expulsion of Heliodorus from the Temple*, the *Liberation of St Peter*, the *Mass at Bolsena*, etc.); after 1514, drawings for the Stanza dell'Incendio and the Loggias, decorations carried out by pupils under the direction of Giulio Romano. 1515–1516, cartoons for the tapestries on the Acts of the Apostles (seven cartoons in London, Royal Collection on loan to the Victoria and Albert Museum) [**383**]. Frescoes in the Farnesina (1514, *Galatea*); 1518, drawings for the *Story of Cupid and Psyche*. Pictures: *Madonna di Foligno*, Rome; *Madonna della Sedia*, Florence; the *Sistine Madonna*, Dresden; portrait of a Cardinal, Prado; portrait of Baldassare Castiglione, Louvre; *La Donna Velata* and the portrait of Leo X, Pitti (see colour plate p. 142).

Michelangelo (see also *Sculpture*), pupil of Ghirlandaio, in Florence. 1503, *Holy Family*, tondo, Uffizi. Cartoon for the *Battle of Cascina* in the Palazzo Vecchio (lost). His masterpieces are in Rome: frescoes for the ceiling of the Sistine chapel in the Vatican (1508–1512, 13 subjects from the Old Testament, 12 sibyls and Prophets and various figures [**275** and frontispiece]); on the wall behind the altar in the same chapel, the *Last Judgment* (1533–1541) [**273**]. Last works: the frescoes in the Pauline chapel: *Conversion of St Paul*, *Martyrdom of St Peter* (1542–1550).

359. FRANCE. Château de Chambord.
c. 1519–1533.
Built by Jacques Sourdeau, then by
Pierre Neveu and Denis Sourdeau,
from a model by Domenico da Cortona.

357. ITALY. Garden of the Villa
d'Este, Tivoli. Built from 1555 by
Pirro Ligorio.

358. FRANCE. Hôtel d'Assézat,
Toulouse. 1555–1558.

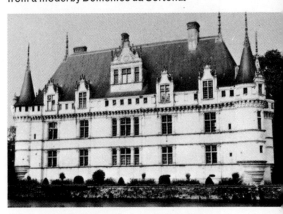

360. FRANCE. Château d'Azay
le Rideau. 1518–1527.

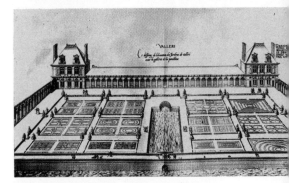

361. FRANCE. Vallery gardens in the
16th century. From an
engraving by du Cerceau.

In Florence the influence of the art of Leonardo, Raphael and Michelangelo is reflected in the work of Fra Bartolommeo (d. 1517) [223], Albertinelli (d. 1515) and Andrea del Sarto (1486–1531), painter of frescoes (Annunziata, Florence) and of portraits. The influence of Leonardo was also felt in Milan and Lombardy, where Boltraffio [362], Andrea Solario [363] and Bernardino Luini (d. 1532) were his best followers.

In Rome alongside Raphael were his main collaborators, Giulio Romano (c. 1499–1546) [292], chief assistant who executed much of the work, Francesco Penni, Perino del Vaga, Giovanni da Udine; they helped to create a decorative style which they popularised (in Mantua, Genoa, etc.). Raphael's followers include Sienese artists, by birth or adoption: the decorator B. Peruzzi [367] and his friend Bazzi, known as Il Sodoma (d. 1549) [365], who was also influenced by Leonardo. In the orbit of the lone genius Michelangelo was Jacopo del Indaco (d. 1526), the Florentine Bugiardini (d. 1554) and the Venetian Sebastiano del Piombo, a follower of Giorgione and influenced at first by Raphael [366].

In Venice the decisive innovator in the early years of the 16th century was the short-lived Giorgione (1477/78–1510) who introduced a new type of small easel picture, mysterious and evocative in subject, lyrical and romantic in mood: *Castelfranco Madonna*; *Tempest* (Academy, Venice); *Three Philosophers* (Vienna). He influenced the early work of his friend and collaborator Titian (Tiziano Vecelli, 1488/90–1576), the greatest Venetian: *Sacred and Profane Love* [315] (Borghese, Rome, c. 1515); *Man with Glove* (Louvre). The *Assunta* (Frari, Venice, 1518) heralded the High Renaissance in Venice. Fully developed style in the *Pesaro Madonna* (Frari, 1519–1526); the *Bacchanals* for the Duke of Ferrara (Prado, National Gallery, London, 1516–1523); *Venus of Urbino* (Uffizi, 1538). 1533, painter to Charles V and later Philip II; at Augsburg 1548–1549; 1550–1551,

Charles V at Mühlberg; *Philip II* (Prado), type of official portrait developed by Rubens and van Dyck. 1545, Rome, *Paul III* (Naples). In late works, including a series of mythologies for Philip II, vision and freedom of handling anticipating Impressionism: *Education of Cupid* (Borghese, c. 1565–1568); *Jacopo da Strada* (Vienna, 1567); *Nymph and Shepherd* (Vienna, c. 1570); *Christ crowned with Thorns* (Munich, 1570); *Pietà* (Academy, Venice, 1573–1575, completed by Palma Giovane) [286–290, p. 124].

After Giorgione and Titian, Palma Vecchio (d. 1528), Sebastiano del Piombo (d. 1547) [366], Cariani, Bonifazio de' Pitati, Paris Bordone (d. 1571) showed themselves to be colourists of great merit. Lorenzo Lotto (c. 1480–1556) [285, 368] spread far and wide the lessons of Venice, to which he gave a highly original interpretation (predella on the altarpiece of S. Bartolomeo, 1516, Bergamo). In the Venetian orbit were Savoldo and the fresco painters Romanino and Moretto of Brescia; G. B. Moroni [369], the solid portrait painter of Bergamo; Dosso Dossi of Ferrara [370].

The last two representatives of the Venetian school of the 16th century, Tintoretto and Veronese, were virtuosi of mural decoration, affected by the Mannerist trend, which Pordenone (1483–1539) and Schiavone (c. 1510–1563) continued in Venetia.

Tintoretto (Jacopo Robusti), 1518/19–1594 [291, 293–296, 318], pupil of Titian, P. Bordone and Pordenone. About 1545 he visited Rome, then worked in Venice. *Freeing the Slave* (1548); about 1550, the cycle in Sta Maria dell' Orto (*Presentation in the Temple*). *Susanna and the Elders* (Vienna); *Marriage at Cana* in the Salute (1561); three *Miracles of St Mark* (1562–1566). Cycles in the Scuola di S. Rocco: *The Road to Calvary*, *Crucifixion*, *Jesus before Pilate*, *Nativity* (1564–1587), *Flight into Egypt*, *St Mary Magdalen* and *St Mary the Egyptian* (1585–1587). Decorations in the Doges' palace: ante-rooms to the Assembly

rooms (1578, four mythological subjects), in the Assembly rooms (*Mystic Marriage of St Catherine*), in the Senate (1581–1584, *St Mark* and the *Doge Loredano*), in the Grand Council Chamber (1588–1590, *Paradise*, sketches in the Louvre and the Prado). The *Last Supper* in S. Giorgio Maggiore (1594). Numerous portraits: *Alvise Barbaro*, *J. Soranzo*, *S. Venier*, etc.

Paolo Caliari, known as Veronese (1528–1588) [306 - 308], born in Verona, was the pupil of A. Badile. In 1552 he was in Mantua, in 1553 in Venice, where about 1555 he worked in the church of S. Sebastiano (ceiling and several paintings). 1560, Rome. His masterpieces include the *Marriage at Cana* (Louvre, 1563); *Feast in the House of Levi* (Academy, Venice, 1573); *Family of Darius before Alexander*

362. GIOVANNI A. BOLTRAFFIO
(1467–1516). Ludovico il Moro.
Brera, Milan.

363. ANDREA SOLARIO
(c. 1460 – c. 1520). Virgin with the
Green Cushion. *Louvre.*

364. BERNARDINO LUINI
(c. 1475–1532). Virgin and Child with
St John. *National Gallery, London.*

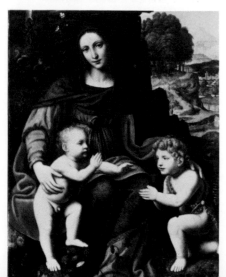

(National Gallery, London, c. 1565–1570); *Finding of Moses* (Prado) and the frescoes of the Villa Giacomelli, Maser (1560s). Decorations in the Doges' palace (1575–1578): ante-rooms, the *Rape of Europa* (1576); ceiling of the Assembly rooms, allegorical subjects; ceiling of the Grand Council Chamber, *Triumph of Venice.*

Deriving from Titian and Tintoretto, the Bassano family were the forerunners of the naturalism and lighting effects of Caravaggio; the head of the studio was Jacopo da Ponte, known as Bassano (c. 1518–1592).

In Parma in the first third of the century, Antonio Allegri, known as Correggio (before 1489–1534) [277-282] seemed to combine the aspirations of the best contemporary painters, and to foreshadow the aims of the Baroque period. Probably a disciple of Mantegna and Costa in Mantua, his early works reveal a knowledge of Leonardo: *Madonna with St Francis* (Dresden, 1514–1515); vault of convent of S. Paolo, Parma (1518–1519). Possible visit to Rome before 1520, since strong influence of Michelangelo and Raphael in the *Ascension*, dome of S. Giovanni Evangelista, Parma (1520–1523) and *Assumption*, dome of Parma cathedral (1526–1530). In their illusionistic effect these domes anticipate the Baroque. Pictures: *La Zingarella* (Naples, about 1520), *Mystic Marriage of St Catherine* and *Antiope* (Louvre, about 1525); *Nativity* (Night), Dresden; *Madonna with the Magdalen and Jerome* (Day), Parma; *Ganymede, Jupiter and Io*, in Vienna; *Danae*, in Rome; *Leda* (Berlin, about 1530).

Mannerism, an essentially subjective and emotional style, resulting partly from the Reformation and the invasions of Italy, led to the abandonment of the serenity of the High Renaissance, the flouting of rational perspective and, under the overwhelming influence of Michelangelo, insistence on the primacy of the human figure, often exaggerated or elongated for emotional or decorative effect. Rosso and Pontormo in Florence, Giulio Romano at Mantua and Parmigianino at Parma were the outstanding figures of the first generation. G. B. Rosso (1495–1540), pupil of Sarto: *Moses and the Daughters of Jethro* (Uffizi, 1523) [448], was in Rome 1523–1527. 1530 to France, where he was one of the founders of the first school of Fontainebleau: Gallery of François I (1531–1539, see *France*). Jacopo Pontormo (Carucci) (1494–1556) was co-pupil of Rosso under del Sarto c. 1512. Fresco *Vertumnus and Pomona* (Villa Poggio a Caiano, 1521); religious intensity in Passion cycle, Certosa di Val d'Ema (c. 1522–1525) and *Deposition* (Sta Felicità, Florence, c. 1525) [447]. Increasing personal contact with Michelangelo visible in frescoes in S. Lorenzo (1546–1556, destroyed).

In Emilia one of the most influential of early Mannerists was Parmigianino (Francesco Mazzola, 1503–1540). Influence of Correggio in early frescoes at Fontanellato, Rocca (c. 1523). 1523–1527, Rome: *Self-portrait in Convex Mirror* (Vienna, 1524) [454]. *Vision of St Jerome* (National Gallery, London, 1527) [462]. Last years in Parma: *Madonna with the Long Neck* (Pitti, c. 1535). Frescoes in the vault of Sta Maria della Steccata (1531–1539). One of the chief centres for the diffusion of Mannerism was Mantua, where Giulio Romano had settled in 1524. Frescoes in the Sala di Troja, Sala di Psyche, Hall of the Giants, Palazzo del Tè (1532–1534). His chief assistant, the Bolognese Francesco Primaticcio (1504–1570), joined Rosso at Fontainebleau in 1532: Ulysses Gallery (1552–1571) with Niccolò dell'Abbate (c. 1512–1571) who introduced the Mannerist landscape to France. In Siena the most important Mannerist painter was Domenico Beccafumi (1485–1551); highly personal style with intensity of emotion and use of shot colour: *Birth of the Virgin* (Siena) [458].

The scholar Vasari (1511–1574) and his pupils evolved towards academicism: decorations in the Palazzo Vecchio in Florence. The same occurred in Rome with D. da Volterra, a close follower of Michelangelo (d. 1566), Jacopo del Conte, Taddeo Zuccaro (1529–1566), grandiose decorator of the Farnese palace, Caprarola. After working in Genoa and Bologna, their followers Luca Cambiaso and P. Tibaldi went to Spain (1577) with Federico Zuccaro, brother of Taddeo.

Illumination. In Rome Giulio Clovio (d. 1578), friend of El Greco and Bruegel, reduced the creations of Michelangelo and Raphael to the scale of miniatures.

Stained glass. Stained glass windows with arabesques by Giovanni da Udine (Florence, S. Lorenzo Library) are the only surviving works of the school of Raphael. The majestic windows in Arezzo cathedral (about 1520), are the work of a French monk, Guillaume de Marcillat, who settled first in Rome (1506) where he worked in the Vatican and in Sta Maria del Popolo.

Tapestry. The set of tapestries of the Acts of the Apostles, after designs by Raphael (Vatican), were woven in Brussels. Flemish craftsmen were summoned to Italy to direct the tapestry workshops; about 1530–1560 Karcher and his colleagues worked in Mantua for the Gonzaga, in Ferrara for the Este (using cartoons by Giulio Romano and B. Dosso; the *Metamorphoses*). In Florence, under Cosimo I, Karcher established a workshop under the direction of the Netherlands artist Jan Røst (cartoons provided by Bronzino;

365. SODOMA (Sienese, d. 1549). St Catherine Fainting. 1526. *S. Domenico, Siena.*

366. SEBASTIANO DEL PIOMBO (Venetian, *c.* 1485–1547). Salome. *National Gallery, London.*

367. BALDASSARE PERUZZI (Sienese, 1481–1536). The Coronation of the Virgin. Fresco. *S. Pietro in Montorio, Rome.*

the story of Joseph; Salviati, Pontormo, etc.: the Months, and the Grotesques).

Engraving. Marcantonio Raimondi (1475–1534) of Bologna, who forged Dürers and was a follower of Lucas van Leyden, worked in Rome with Raphael [386], whose drawings and compositions he engraved on copper. He influenced A. Veneziano and G. J. Caraglio. The Mannerists Parmigianino and Schiavone chose etching, while in Venice Ugo da Carpi executed woodcuts with chiaroscuro.

The minor arts. In Venetia A. Riccio, a follower of Donatello, was the best exponent of bronze plaques with mythological subjects. Practised by sculptors (B. Cellini, Leone Leoni) and by a Sienese glass painter, Pastorino, the art of the medallion lost in seriousness what it gained in finesse.

Gold- and silversmiths were numerous and often travelled from place to place. The best known, B. Cellini, worked at the court of François I (gold Salt, about 1540–1545, Vienna) [382], then in Florence for Cosimo I (see *Sculpture*). There were also objects decorated with painted enamel (osculatories, Louvre); the Italian school produced liturgical pieces in the classical style and numerous profane objects: ewers, bowls, plates; dishes and vases in hard stone or rock crystal minutely worked, with settings of enamelled and jewelled gold and silver; lastly, jewels with subjects enamelled in gold with Baroque pearls and precious stones.

Production of majolica work increased in numerous centres. Apart from the studios of Faenza, followers of German and Italian engraving of historical scenes, the most active were those at Caffagiolo, suppliers to the Medici, and at Siena, Pesaro, Deruta, and Gubbio, where Maestro Giorgio (d. about 1540) obtained a brilliant lustrous glaze, specialised in pottery with a metallic sheen. These centres

were all eclipsed by Castel Durante, then after 1530 by Urbino, which imposed its style of fastidious decoration on all Italian ceramics. Venice and Florence (B. Buontalenti) tried to imitate Chinese porcelain.

The most important works of marquetry were by Fra Giovanni da Verona (Sta Maria in Organo, Verona, and Monte Oliveto, 1502–1505) and Giovanni Barili (Stanza della Segnatura, Rome, 1514–1521).

In furniture, sculpture was substituted for painting and stucco relief in the decoration of cassoni (chests). The cabinet, a piece of furniture in two sections, carved and decorated with marquetry, imitated architectural forms. In Naples and Milan cabinets of oak inlaid with engraved ivory were made; Florence was distinguished for inlays of mother-of-pearl, ivory, tortoiseshell and semi-precious stones (B. Buontalenti, Porfirio da Leccio).

FRANCE

History. The reigns of François I (1515–1547), patron of the arts and literature, and of Henry II (d. 1559). 1560–1598, religious wars tore the country apart under Charles IX (d. 1574), Henry III (d. 1589). Henry IV (d. 1610), who had to reconquer his kingdom, restored prosperity to France through industry and the arts. Religious life was upset by the Reformation. The Edict of Nantes (1598) permitted the practice of the reformed religion.

Culture developed; humanism was predominant (Guillaume Budé) favoured by François I, who founded the Collège de France (1530) and the Royal Library at Fontainebleau. Poetry triumphed at court under Marguerite of Navarre (d. 1519), and in the Platonic circles of Lyon. The Pleiades (1549), a movement inspired by antiquity in the rules it gave to French poetry, was represented by Du Bellay and Ronsard (1524–1585). Prose: Rabelais went to Rome (1533–1548) where he studied the ruins; Montaigne (1533–

1592). The theatre lost its religious character; mystery plays were forbidden (1548). The Italian players were in Paris in 1572.

Archaeology was born in France. The High Constable Montmorency bought antiques in Italy about 1550 and had the Romano–Gallic remains in Languedoc preserved. Artistic scholarship: J. Martin and Jean Goujon, first French editions of Vitruvius (1547). Treatises on architecture by P. Delorme (1561 and 1567), J. Bullant (1564), du Cerceàu (1559 and 1576–1579).

The academy of poetry and music (under Henry III: Académie du Palais, at the Louvre) was founded in 1570.

Architecture. At the beginning of the 16th century the Orders were only incorporated decoratively and without rules, still in the Gothic manner which remained traditional in France until about 1530.

The role of the decorative designers was therefore predominant in the first Renaissance. Very few Italian architects came to France (Fra Giocondo [1435–1515] about 1479) but a number of decorators: Gérôme Pacherot, Bernardino da Brescia, Domenico da Cortona, brought arabesque motifs (candelabras, putti, mingled with classical elements, ova, sunbursts, beading, scrolls). The Orders did not follow the modular rules until in the time of Henry II P. Chambiges and P. Delorme invented pilasters and drum columns, and P. Lescot garlands of foliage. Windows, in contrast to the Italian principles, were superimposed in vertical rows (with decorated jambs) and continued up to the dormer windows with pediments often flanked with stone candelabras. These dormer windows divided by cruciform mullions are, with the chimney shafts, the decorative attributes of the high roofs of the 16th century. The Orders emphasised the storeys, and were distributed between the ground floor and the roof thus: Tuscan, Doric, Ionic, Corinthian and Composite. Sometimes a major or

368. LORENZO LOTTO (c.1480–1556).
Portrait of a Man. *Academy, Venice.*

369. GIAMBATTISTA MORONI
(1520–1578). The Tailor.
National Gallery, London.

370. DOSSO DOSSI (c. 1479–1542).
Circe. *Borghese Gallery, Rome.*

colossal Order extended from the ground to the cornice, thus encompassing several storeys. The favourite form for staircases was spiral round a filled or empty centre.

In the châteaux of the Loire, about 1495, the new decorative style appeared in the tower of the Minims of Amboise. At Blois, especially in the François I wing (1515–1525) [322], the new style asserted itself. In Azay le Rideau (1518–1524) [360] the Gothic character decreased, and the decorations were simplified. Chenonceaux and especially Chambord (1526–1536) [359] were important for the use of decoration in the true architectural sense; but the structure remained medieval under the Italian veneer. The influence of the Loire châteaux spread quickly: at Oiron, where the gallery is reminiscent of the Louis XII wing at Blois, at La Rochefoucauld, at Gaillon [324], the scattered fragments of which (Louvre, Ecole des Beaux-Arts, St Denis, Cluny) again showed the intervention of Italian workmanship coming from Amboise.

In the Ile-de-France, from 1525 onwards, the princely residences were concentrated (Madrid, St Germain, la Muette, Palluau, Fontainebleau, Villers-Cotterêts). The château de Madrid shows a new trend. Known from the engraving of du Cerceau and from the description of Tevelyn (1650), it was a building with loggias and had terracotta decorations by Girolamo della Robbia. At St Germain, where Pierre Chambiges worked, and which was altered by Louis XIV, the windows in Venetian style, about 1500, have led to the suggestion that Serlio had a hand in it. Between 1528 and 1558 the great works at Fontainebleau were carried out, almost entirely by Italian artists: the oval courtyards, the François I Gallery decorated by Rosso, the Ulysses Gallery by Primaticcio and N. dell' Abbate, etc.

The school of Fontainebleau consisted of French, Italian and sometimes Flemish artists. Primaticcio and Rosso were its representatives, while Serlio (1475–1554) was its instructor. To Serlio are attributed the hôtels of Ferrara and Montpensier, later Ancy le Franc. Primaticcio, the architect, was first influenced by Giulio Romano (about 1545, grotto in the Jardin des Pins; about 1555, the Meudon grotto: after 1561, the gates to the courtyard of the Cheval Blanc), then by Vignola (1568, he built the cold but beautiful wing, the Belle Cheminée). He probably furnished the plan of the Valois chapel at St Denis, where he also designed the mausoleum carved by Germain Pilon. From 1540 onwards, after the return of Primaticcio and Vignola from Rome and the arrival in France of Serlio and Philibert de l'Orme, the Italian trend was emphasised which combined the cult of Bra-

371. MORETTO (c. 1498–1555).
SS. Bonaventura and Anthony of Padua. *Louvre.*

mante with that of Peruzzi, Sansovino and Vitruvius.

The classical Orders became general (Villandry 1532, Valençay about 1540); in Normandy (the hôtel d'Ecouville at Caen, about 1535–1538, the north wing of the Fontaine Henri, about 1537–1544). In the churches classical decoration was superimposed on a Gothic framework (in St Eustache, 1532, the plan of which is very close to that of Notre Dame; the Gothic structure was combined with classical pilasters in St Pierre at Caen), or on a Romanesque one (Angers cathedral). The transition from the arabesque style to classical decoration is very clear in the façade of St Denis at Dijon (1535–1550).

From 1550 onwards, the exterior and interior architectural composition were based on geometrical and arithmetical plans (the Golden Mean). Proof of this is the first book on architecture by P. de l'Orme (1567) and the *Rules of Architecture* by Bullant as well as the important work by Serlio which was translated over and over again. The High Renaissance was contemporary with Henry II, and was marked by P. Lescot (1515–1578) who worked on the Louvre from 1546 onwards and designed the Cour Carrée executed under Louis XIII and Louis XIV, built the hôtel de Ligneris (Carnavalet) and worked on the Fountain of the Innocents (1547–1549). It was also marked by P. de l'Orme (1510/15–1570) who built the châteaux of St Maur (1541), of Anet (1547–1552), perhaps the masterpiece of the period, and began the Tuileries which was to demonstrate the creation of a completely French type of decoration (1564). At the same time J. Bullant (1520/25–1578) was the architect of Ecouen, of the little

château de Chantilly (c. 1561) and of the hôtel de Soissons (1572). Philender (c. 1505–1565), a pupil of Serlio (Rodez cathedral), worked in the antique manner. N. Bachelier created the masterpiece of Languedoc, the hôtel d'Assézat at Toulouse (1555). Jacques Androuet du Cerceau, the Elder, who came from a family of architects, a famous engraver [361] and an architectural theorist, created about 1570 an anticlassical style in which decoration played a part full of fantasy (châteaux of Verneuil and Charleval).

Gardens. The French garden broadly kept the design and principles which composed the medieval *hortus conclusus*: walks, thickets cut in squares, fountains with a centre basin, everything was disposed in the same plan. In this way, at Blois, the three adjacent gardens, on three different levels, kept their individuality. Gradually there was a change from tiles to parquet, recalling Italian marquetry (intarsia). Later came statues and small pavilions in the Italian style or made by Italians (the gardens of Cardinal d'Amboise at Gaillon provide numerous examples). Grottoes and concealed porticoes, very much in favour from 1550 onwards, were occasionally decorated with people and animals which were sometimes lively, rising from the middle of fountains or stream of water: Bastie d'Urfé, grottoes of the Tuileries and Ecouen by B. Palissy. From then onwards, gardens built by architects were linked according to Italian principles with the building to which they belonged. Ornamental water, introduced into the decoration, formed lake-gardens. Anet and St Maur were designed by P. de l'Orme, Verneuil and Charleval by J. Androuet du Cerceau, St Germain en Laye by Dupérac in 1594, and were the triumph of the geometric and landscape Italian style, and the prototype of classical gardens.

Sculpture. The first third of the century was a period of adaptation to the ornamental grammar and to the fuller, calmer forms of the Renaissance, introduced by the Italians in the service of the king in Touraine (Amboise, Blois) and afterwards employed by the Cardinal d'Amboise (d. 1510) at Gaillon. To this direct action may be added that of the works in Genoese marble imported about 1505–1510. Teams of Franco-Italian decorators deriving from Gaillon made the first two great mausoleums of the French Renaissance: the wall tomb of the Cardinals d'Amboise (Rouen cathedral, 1518–1525) after a design by Rolland Leroux, the architect of the cathedral, and the monumental sepulchre of Louis XII (St Denis, 1517–1531), the work of the Juste, naturalised Florentines. Italian influence can be discerned in other sculptures in marble created

372. FRENCH. GERMAIN PILON (1535–1590). Medal of René de Birague. Bronze, gilded and chased.

in the workshops of Tours, works of serene grandeur (tomb of the Poncher, 1521, Louvre, by Guillaume Regnault, nephew of Colombe; *Virgins* of Ecouen and of Olivet, Louvre; *Virgin* of St Galmier, with more studied grace). From 1527 the arrival of the Florentines, attracted by François I, confirmed the success of the Italian manner. When they arrived in 1530 the most eminent of them, Rosso (d. 1540) and Primaticcio of Bologna, combined painting and sculpture in the decoration of Fontainebleau (stuccoes in full and low relief; the François I Gallery, 1531–1539). Primaticcio (d. 1570) who became the head of the school of Fontainebleau in 1541, and created the new canon of form, more elongated, which was subsequently adopted by French artists (room of the Duchesse d'Etampes). Bronzes cast from antique moulds which Primaticcio had gone to Italy to fetch (1540) allowed French artists to absorb Graeco-Roman statuary. B. Cellini's stay in France (1540–1545) does not seem to have had any profound effect. Henry II favoured French artists over Italian decorators, whose lessons the Frenchmen had assimilated. Paris, a centre of humanism, became the artistic capital and, alongside the Ile-de-France, was the centre of the French Renaissance. In his low reliefs Jean Goujon from Normandy (about 1510–about 1566) combined the nobility of the purest classic style with the sinuous elegance of Mannerism: nymphs in the Fountain of the Innocents, in Paris, 1549. Bontemps (1507–about 1570), Primaticcio's assistant at Fontainebleau, rediscovered intuitively the virility of Gothic sculptors: bas-reliefs on the tomb of François I at St Denis. The effigies and religious sculptures of Germain Pilon (1535–1590), a pupil of Bontemps and the favourite sculptor of Catherine de' Medici (monument for the heart of Henry II, Louvre), formed the connection between the art of the Gothic masters and that of the Baroque period: *Virgin of Pity, Chancellor Birague* (Louvre). In Paris, under

373. FRENCH. Ewer. Ste Porchaire (3rd period). 1555–1570. *Rothschild Collection.*

Henry IV, B. Prieur and Biard represented the classicising tendency of the second Mannerist school, represented in Italy by Giovanni Bologna and his collaborator Pietro Francavilla.

Painting. The stay of the Lombard painter Andrea Solario at Gaillon (about 1505–1507), the activity in Albi of a group of Italian fresco painters (1513), the arrival at Amboise of Leonardo da Vinci with his pupils (1516–1517) followed by Andrea del Sarto's brief stay at court, did not influence French painting until after 1530, when François I and Henry II began their patronage of Fontainebleau. Under the direction of Rosso from Florence and Primaticcio of Bologna with whom was associated in 1552 his follower Niccolò dell' Abbate (d. 1571; ballroom, 1556), Italian, Flemish and local painters, the most eminent of whom was Antoine Caron (c. 1520–1599), formed the first school of Fontainebleau, making it one of the centres of international Mannerism. In Paris, masters who derived from local traditions, Jean Cousin the Elder (d. about 1560) and his son (d. about 1594) and the painter of the *Ladies in a Bath* (Louvre), followed the aesthetic of the Renaissance though they also retained personal qualities. Under Henry III and Henry IV, a new generation of painter-decorators constituted the second Fontainebleau school; Toussaint-Dubreuil (1561–1602), Jacob Bunel, the naturalised Flemish artist Amboise Dubois, and Martin Fréminet

(1567–1619) were its leaders. With them and the Netherlands artists Jean de Joey, grandson of Lucas van Leyden, Jérôme Franck, influenced by Floris, the Mannerist style became ponderous, while in Nancy, Jacques Bellange (d. 1616) successfully preserved its elegance. Portrait painting, very much in fashion during the Valois period, retained northern realism under Jean Clouet (about 1485–1541), his son François (about 1516–1572), a brilliant draughtsman, and Corneille de Lyon (d. after 1574). The Quesnel, the Dumonstier and Lagneau extended into the 17th century the art of the portrait-drawing in three colours. The Antwerp painter Frans Pourbus II (d. 1622), painter to Marie de' Medici, gave a more official character to his portraits.

Stained glass. This followed painting more and more closely, developed a highly skilled technique and continued to flourish. The stained glass windows of Auch, of St Etienne, Beauvais (by Leprince), of St Vincent at Rouen, of Notre Dame at Châlons sur Marne, of Brou (executed by craftsmen from Lyon), of Bourges cathedral (by J. Lecuyer), of St Gervais in Paris and of the Sainte Chapelle at Vincennes (sometimes attributed to Jean Cousin) represent the finest examples. After 1570 stained glass declined, marked particularly by the lack of colour and feeble composition of the works.

Tapestry. The Gothic tradition persisted in tapestry (tapestries from Le Mans, Reims and Beauvais). But in 1530 François I founded the royal factory at Fontainebleau, and from that time on, French and Flemish weavers worked there in the style of Rosso and Primaticcio or were inspired by du Cerceau (tapestries with grotesque decoration). Paris, in the workshop of the Trinité, created in 1551 by Henry II, continued the same style (story of Diana, cartoons attributed to J. Cousin). A new impetus was given in 1601, when Henry IV installed Flemish weavers in the suburb of St Marcel, who took up designs by Caron and Lerambert (tapestries of Artemis and Coriolanus) and worked from designs by Toussaint-Dubreuil (story of Diana).

Engraving. G. Reverdy of Lyon, Jean de Gourmont and Jean Duvet, a very close emulator of Dürer (Apocalypse, about 1550), were the best copperplate engravers. Numerous etchers, including E. Delaune, du Cerceau [**361**], and P. Woeriot, spread the style of the school of Fontainebleau, which Bellange of Lorraine continued in an original manner at the beginning of the 17th century. E. du Pérac, in a series of etchings, presented views of Rome (1575). Paris and Lyon were centres of book production. Woodcut

illustrations by Geoffroy Tory, Jean Goujon (Vitruvius, 1547) and Jean Cousin (*Book of Perspective*, 1560), published in Paris, and those of Bernard Salomon, in Lyon, are the most remarkable.

The minor arts. After a period of stagnation medals were restored to fame by Etienne Delaune under Henry II, and in the following reigns by Germain Pilon [**372**] and Guillaume Dupré.

The most beautiful pieces of gold- and silverwork still extant are the chalice of St Jean du Doigt (Finistère), the shield and morion of Charles IX in enamelled gold and the silver objects, gilded and chased, forming the 'plate' of the Order of the Holy Ghost (Louvre).

The technique of painted enamel was developed in Limoges by the Pénicaud family, who were inspired by the prints of Dürer and Marcantonio. Their successors were to have greater recourse to Italian models (Niccolò dell' Abbate) or French ones (du Cerceau, Delaune). The greatest master was Léonard Limousin (d. 1575–1577), enamel worker to Henry II, to whom we also owe some beautiful portraits (*High Constable of Montmorency*, Louvre) [**376**].

In addition to glazed pottery (Saintonge) and stoneware (Beauvais), tin-glazed earthenware in the Italian style was made at Rouen (paving tiles). Italian potters established themselves at Lyon (about 1550) and at Nevers (1584). Between 1525 and 1560 very individual, fine faience was produced at Ste Porchaire (Poitou) [**373**]. Bernard Palissy (about 1510–1590) invented pottery with naturalistic reliefs; he was established at Saintes, later became the 'king's potter', and worked at Ecouen for the High Constable Montmorency, and in Paris for Catherine de' Medici.

Under François I, the very rich decoration on furniture was Italianate. Under Henry II, designs were inspired by classical models and decoration provided by the architects and by the collections of engravings (du Cerceau, H. Sambin). Walnut was preferred to oak. Inlays of wood and marble appeared, then plaques of ebony. The double cupboard took the place of the sideboard. Chairs became more varied (armchairs, conversation seats). In the Ile-de-France the style was more refined than at Lyon or in Burgundy, where the decoration was opulent (H. Sambin).

SPAIN AND PORTUGAL

History. The unified kingdom of Spain, enriched by overseas possessions, saw the decline of the Mediterranean port of Barcelona; Seville and Cadiz became the gateways to the New

World. Naples and Sicily passed to Spain. Philip of Habsburg, the regent of Castile, died in 1506, Ferdinand V of Aragon, king of Spain, died in 1516. Then Charles V, king of Spain, emperor of Germany in 1519 (d. 1558), was the most powerful monarch in Europe. In 1556, Philip II became king. The court, which was at first in Toledo, was established in Madrid (1560).

1492, Columbus landed in the Caribbean. 1509–1510, Cardinal Ximenes in Morocco; 1519–1522, Magellan sailed round the world; 1519–1535, F. Cortez in Mexico; 1527, Pizarro in Peru. 1530s, Spaniards in La Plata and Chile; 1541, at the Amazon; 1565, in the Philippines.

The Portuguese kingdom prospered after the organisation of the colonial empire. Commercial relations were established in Lisbon with Antwerp and the merchants of Augsburg (Welser). The monarchy was at its peak under Manuel I (1495–1521) and John III (d. 1577). The decline; Sebastian (d. 1578). The disaster of Alcacer-Kibir (Morocco, 1578) marked the end of the power of Portugal. 1580, vice-regency of Spain.

1503–1515, Albuquerque in the Indies, Malaya, New Guinea; Portuguese explorers went to China, 1517–1520; banks were established in Japan and China, 1542.

Religious life was dominated by the power of the Inquisition. The Jesuit Order was founded by St Ignatius Loyola, 1491–1556 (St Francesco Borgia, 1510–1572; St Francis Xavier in India, 1542–1548, died in Japan in 1552). St John of the Cross founded the Order of Barefoot Friars in 1568. In 1551, the military Orders of Romar, Crato and Aviz supported the king of Portugal. The mystics (Luis de Granada, St Peter of Alcántara, St Theresa [1515–1582]).

Humanism was encouraged by the Catholic kings and Cardinal Ximenes (d. 1517), the founder of Alcalá university (1499). D. Hurtado de Mendoza collected ancient manuscripts and medals, wrote the *Life of Lazarillo de Tormes* (1535). The theatre: *autos pastoriles* by Juan del Encina (d. 1529) and Gil Vicente (d. 1536). Poetry: Garcilaso de la Vega (1503–1536), now regarded as the founder of modern Spanish poetry; Boscan (d. 1543); in Portugal particularly the school of Coimbra with Sa de Miranda; Camoëns and his *Lusiadas*, 1572; the pastorale (Montemayor, d. 1561). Writings on the arts: E. Diego de Sagredo, *Medidas del Romano*, illustrated by Biguerny (1526); C. de Villalón, *Ingeniosa Comparación* (1539); the Portuguese F. de Holanda, *Dialogues with Michelangelo* and *The Eagles* (1549).

Music in Spain: Juan del Encina, poet and musician; A. Cabezón (1510–1566) and his organ school; in Portugal, the *a cappella* choir, the school of Évora

(Cosimo Delgado), the school of Coimbra (the monks of Santa Cruz) are especially notable.

Architecture. In the second half of the 15th century Flemish and German artists flocked to Spain and their influence combined with the Mudejar style which still persisted (palace of the Aljageria near Saragossa). Juan Guas (d. 1495) created a typically Spanish style, sometimes called the Isabelline after Queen Isabella (Infantado palace, 1483) [149]. Surviving monuments by Enrique Egas are of the style known as Plateresque, a name suggested by the resemblance to gold- and silversmiths' work (Salamanca university [379], hospital of the Holy Cross, Toledo). A number of monastic churches (Sto Tomás of Avila, S. Juan de Los Reyes, S. Jerónimo in Madrid) have an aisleless nave, and enormous galleries above the entrance. The cimborios (lantern towers) are decorated with Mudejar motifs inspired by Spanish lace (Burgos cathedral).

Under Charles V, Italian influence began to eclipse the Mudejar style, in spite of the persistence of certain Gothic features (new cathedral at Salamanca). Alonso de Covarrubias (1488–1570), architect to Charles V in 1537 (rebuilt the Alcazar of Toledo; Grand College, known as the ' Archbishop's College ', in Salamanca), was Italianate in style and this style spread to Granada, Málaga and Jaén, especially to the work of Pedro Machuca (d. 1550), and triumphed under Philip II. The Escorial (designed by Juan Bautista de Toledo [1563], completed by Juan de Herrera [1530–1597]) was the most typical monument of the Spanish Renaissance, at once austere and grandiose. Herrera completed the Alcazar of Toledo and began Valladolid cathedral. He influenced Juan Gomez de Mora (1580–1648; Plaza Mayor of Madrid), Martin Diaz Novarro (Chancillería of Granada, 1585).

In Portugal Manueline art flourished in the 15th and 16th centuries and continued in the great Portuguese abbeys (Batalha, Jeronymite monastery, Belem) [373]. Boytac (d. 1522: Batalha and Belem), Diogo Arruda (d. about 1531: Convento do Cristo in Tomar), his brother Francisco (tower of Belem), Juão de Castilho (Jeronymite monastery) who modified the Manueline decoration under Italian influence, were the principal architects. The Moorish tradition persisted until the 18th century, in the decoration of the walls of the churches in faience.

Sculpture. Under Ferdinand V and Charles V, Italianism became popular in Spain owing to the import of marbles from Genoa to Catalonia, and the immigration to Castile, Andalusia and Aragon of numerous Florentine artists (D. Fancelli, imitator of Mino da

Fiesole to Avila and Granada; P. Torrigiano, fellow-student of Michelangelo, to Seville; Francesco and Jacopo del Indaco to Murcia and Granada; Giovanni Moreto to Saragossa). The first Spanish sculptors who supported the aesthetic of the Renaissance, Vasco de la Zarza (d. 1524) and B. Ordoñez (d. 1520) stem from Fancelli. Whilst showing their predilection for the most ostentatious forms in church furnishings — altars, stalls, choir screens (trascoro) — the artists gradually adapted themselves to the new taste in arrangement and decoration; for example, Philippe Biguerny of Burgundy (1498–1543, at Burgos, Toledo, Granada); the Valencian alabaster sculptor Damian Forment (at Saragossa, where he must have known G. Moreto); the woodcarver from Picardy, Gabriel Joly at Saragossa and Teruel. Local characteristics were more obvious in Guillén de Holanda (about 1521–1540), Guyot de Beaugrant (about 1530–1550) and Juan de Ayala. Diego de Siloe (d. 1563), the son of Gil, who was known principally as an architect of classical tendency, profited by Italian examples in funerary sculpture (tomb of A. de Fonseca, Salamanca). The greatest Castilian sculptor of that time, Alonso Berruguete (1486–1561), son of the painter Pedro, was also trained in Florence and Rome, where he knew Michelangelo (sculptures in Valladolid museum, Toledo) [352]. Like those of the Spanish-naturalised Frenchman Juan de Juni (d. 1577), author of polychrome groups (Valladolid Museum) [353], his Mannerist works are typically Spanish in feeling.

In a parallel evolution in Portugal, the decorative sculpture of the Manueline style became Italianised and lost some of its opulence (Belem monastery, 1517). Three Norman artists, trained at Gaillon and Rouen, Nicolas Chatranez (worked about 1516–1517), Jean de Rouen and Felipe Udarte, introduced into Coimbra [377] the composite style of the first French Renaissance (convent of Santa Cruz: doorway, tombs, pulpit). Chatranez first worked at Belem and contributed to the spread of the new trends in art.

Painting. In Valencia the aesthetic of the Renaissance, spread from about 1472–1481 onwards by the Italians (Francesco Pagano, Pablo de San Leocadio), was adopted about 1505 by Fernando Yañez and Fernando de los Llanos, who visited Florence and perhaps Venice (triptych in Valencia cathedral, 1507). Vicente Macip (d. before 1550) and his son Juan de Juanes (d. 1579) imitated Leonardo and Raphael in their numerous devotional images.

In Castile Flemish art maintained its position in the first quarter of the century, thanks to the masters who

374. SCHOOL OF FONTAINEBLEAU. ANTOINE CARON (1520–1598). Triumph of Winter. *Ehrmann Collection.*

came from the Low Countries; Juan de Flandes, former painter to Queen Isabella (d. 1519 at Palencia), Juan de Holanda, Francisco de Amberes and A. Benson, pupil of Gerard David. About the middle of the century the Netherlands portrait painter Anthonis Mor, known as Antonio Moro, worked for the court of Spain and prepared the way for A. Sanchez Coello (about 1531–1588), painter to Philip II and founder of the school of Madrid (after 1555). However, Italianism was shortly to establish itself at Toledo with the Spanish-naturalised Frenchman Juan de Borgoña (d. 1554) who continued the style of P. Berruguete in Avila, and was a follower of Ghirlandaio, in the frescoes painted for Cardinal Ximenes (the Moorish-Arab chapel of Toledo cathedral).

In Andalusia two Italians painted frescoes in the Raphaelesque style in the Alhambra at Granada. Alejo Fernandez (d. about 1545) remained faithful to the medieval spirit while choosing Italianate forms. In addition to the Romanists from the Netherlands F. Sturm and F. Frutet, Peter de Kempeneer of Brussels (Pedro de Campaña) helped to introduce the Mannerist style in Seville (*Descent from the Cross*, 1547–1548, in the cathedral); Luis de Vargas (1502–1568) adopted it after a visit to Italy, where he studied Raphael, Correggio and S. del Piombo (Nativity altar, Seville cathedral). Luis de Morales (1500–1588) [351], influenced by artists from Lombardy and Antwerp from the beginning of the century, gave to Mannerism a truly Spanish flavour (*Virgin and Child*, *Ecce Homo*, etc., in Madrid, Prado and S. Fernando Academy).

In the reigns of Manuel I and John III, Portuguese painting entered its golden age. Relations between Lisbon and Antwerp assured the predominance of Flemish influence (import of works from Bruges and Antwerp), reinforced by the activity of masters from the Low Countries, such as Francisco Henriques (about 1500–1518)

375. FRENCH. PIERRE FRANCHE-VILLE (1548–1615).
Slaves from the pedestal of a statue of Henri IV. 1618.
The statue (now destroyed) was set up by Marie de' Medici on the Pont Neuf, Paris. *Louvre.*

376. LÉONARD LIMOSIN (d. between 1575–1577). The High Constable Anne, Duke of Montmorency. 1556. *Louvre.*

or of Flemish descent, like the monk of Evora, Frei Carlos (the *Good Shepherd*, about 1530, Lisbon Museum). Under these auspices, an original style developed in Lisbon with Jorge Affonso (d. 1540), painter to the king, and his pupils Gregorio Lopes, Garcia Fernandes, Cristovão de Figueiredo (Santa Cruz retable, 1522–1530, at Coimbra; *Entombment*, about 1530, Lisbon Museum). Numerous anonymous artists, the Masters of Sta Auta, of Santiago, of Setubal, and of São Bento joined this group (works in Lisbon Museum). Another important centre was established in the north, at Viseu, where Vasco Fernandes worked, who had seen prints by Dürer (about 1480–1543; *St Peter*, Viseu Museum), and Gaspar Vaz (d. 1568), both pupils of Affonso. After 1550, Cristovão Lopes, son of Gregorio, Cristovão de Morais (*King Sebastian*, 1570, Lisbon Museum) and A. Sanches Coelho (Sanchez Coello in Spain), pupil of

Antonio Moro — who himself visited the court of Lisbon in 1550 — distinguished themselves as portrait painters.

The minor arts. The last works in gold and silver of Enrico de Arfe were in the Italianate style (reliquary in León cathedral). His son Antonio made custodias in the new style (at Santiago de Compostela, and at Medina de Ríoseco). Another family of goldsmiths, the Becerril, worked in Cuenca (osculatory in the cathedral of Ciudad Real, 1565, by Francisco Becerril). Spanish influence was exerted in Portugal (chalices, ewers); certain pieces are of Indo-Portuguese workmanship (altar screen-reliquary, Lisbon Museum) or of Eastern inspiration (silver-gilt jug, Lisbon Museum).

The Italian Niculoso de Pisa painted majolica tiles for the Alcazar in Seville (1504). Numerous workshops established at Talavera and Puente del Arzobispo on the Tagus.

Portugal imported large quantities of porcelain from China, which were later disseminated throughout Europe. From the end of the century, native craftsmen imitated it.

The bureau (escritorio) decorated with leather is the acme of Spanish furniture. Precious woods imported from the colonies were enriched with marquetry and inlaid with ivory, mother-of-pearl and silver.

LOW COUNTRIES

History. Economic prosperity came with industry. Antwerp was the principal port of the Low Countries; Bruges was declining; Amsterdam was developing. 1506–1555, Charles of Austria, the future Charles V, born and brought up at Ghent, was the ruler, his aunt Margaret of Austria was regent (d. 1530), followed by Mary of Hungary (d. 1558). In 1548–1549, the Federation of the Seventeen Provinces was established with Brussels as the capital. 1555–1598, Philip II of Spain was the ruler, 1559–1567, his sister Margaret of Parma the regent. A movement of emancipation was connected with the religious crisis (1563, the Revolt of the 'Gueux'); 1567–1573, repression by the Duke of Alba; 1576, the sack of Antwerp. In 1584–1585, a split occurred between the 10 provinces of the south (Flanders) which remained Spanish, and the Republic of the United Provinces of the north (Holland) which was henceforth autonomous.

Religious struggles were grave. Calvinism increased (1535–1585); Cardinal Granvelle called upon the Inquisition (1559); destruction of the churches, 1566–1572; iconoclasm, especially in Holland. Flanders, faithful to the Roman Church, broke away from Protestant Holland (Utrecht, centre of resistance to Catholicism).

Culture and humanism spread. Jean le Maire was at the court of Mechelen about 1500–1512. Under the aegis of Erasmus of Rotterdam (1467–1536) humanist coteries were created: at Louvain (Buysleden, d. 1517, founder of the College of Three Languages; L. Vives; Alard of Amsterdam; 1512–1529, Martens press; J. Lipsius); at Antwerp (P. Aegidius, C. Plantin started printing, 1550); at Deventer, centre of publishing; at Utrecht (round Philip of Burgundy, bishop, d. 1524, and de Bourgogne, admiral of Flanders, d. 1540); at Leyden (university, 1575, whose brightest stars were J. Lipsius from 1579 to 1592 and J. Scaliger; L. Elsevier of Louvain founded his library there, 1580).

Schools of rhetoric flourished. Poetry of the Gueux water-beggars, H. Marnix (1538–1598). The greatest scholars were geographers: 1569, projection by G. Mercator; 1570, the first geographical atlas by A. Ortelius (d. 1598). Writings on art were important: treatises on architecture by P. Coecke van Aelst, 1539; H. Vredeman de Vries, 1577; *Lives of the Painters* by Carel van Mander (Haarlem, 1604).

Music of the north spread to Italy and the European courts (Orlando Lasso, etc.), J. P. Sweelinck (1562–1621) organist at Amsterdam.

Architecture. The Italian Renaissance was introduced into Flanders in the decoration. That is why decorators like Hans Vredeman de Vries played a big part. The Gothic style persisted in the structure. About 1540, a reaction set in against the excesses of the decorative style. The earliest monument of the Renaissance is the palace of Margaret of Austria at Mechelen (1517), part Gothic, part French Renaissance. At the same period were built the Maison du Saumon (Mechelen), the Maison des Bateliers (Ghent), the town hall of Audenarde. In Bruges, Lancelot Blondeel decorated the façade of the Ancien Greffe, but the Greffe du Franc by Jean Mone is newer with its superimposed fluted and twisted columns. In Liége, the palace of the Prince Bishops (1526) is of a composite style (court with arcades, Gothic windows). In Antwerp, the town hall (1561–1565) by Cornelis de Vriendt, called 'Floris' (1514–1575), is an interesting synthesis of Italian and Flemish elements (rusticated base with arcades in the Florentine manner, high roof with dormer windows, gables in the Flemish). It inspired the town hall of Flushing (destroyed) and the Palais de Justice of Furnes (1628).

In Holland the Renaissance came later. The town hall of The Hague (1564) was influenced by the one at Antwerp; the town hall of Leyden dates from the end of the century (1597). It was not until 1602 that the beautiful Vleeschhall (Butchers' Hall) in Haarlem

ARCHITECTURE IN THE IBERIAN PENINSULA

377. PORTUGAL. MANUELINE. Coimbra university. 16th century.

378. PORTUGAL. MANUELINE. The cloister of the Jeronymite monastery, Belem. Beginning of the 16th century.

379. SPAIN. PLATERESQUE. Main doorway of the old university of Salamanca. Beginning of the 16th century. Attributed to Enrique Egas.

380. SPAIN. Patio of the Casa de las Conchas, Salamanca. 1512.

381. *Right.* SPAIN. Façade of the palace of Charles V, Granada. 1526–1528. Unfinished work by Pedro and Luis de Machuca.

was built. Hendrik van Keyser (1567–1621) built many civil and religious buildings in Amsterdam (Zuider and Westerkerk) adopting for these last the central plan which suited the exigencies of the Reformation (Norderkerk).

Gardens. Dutch gardens, laid out on flat ground, were surrounded and divided up by paths roofed with trellis work, or walls with carved wooden balustrades from which one could contemplate single flowers, selected and rare, enclosed in geometrically laid-out flowerbeds in concentric circles or sometimes in a star shape.

Sculpture. The Gothic style persisted for a long time in the exuberant decoration; but the motifs, and later the forms, were Italianised. The tombs of Brou (Ain) executed from the designs of L. van Boghem of Brabanz (d. about 1522) and then under the direction of the German Conrad Meit (d. about 1531) reflected the taste of the court of Mechelen, the first centre of the Flemish Renaissance, under the aegis of Margaret of Austria. At Bruges, where the *Madonna* by Michelangelo, commissioned by Flemish merchants, arrived in 1506, similar tendencies inspired Lancelot Blondeel and his contemporaries (chimneypiece in the Greffe du Franc, 1528–1531), then Guillaume Aerts (the Greffe du Franc, 1535). Italianism was more easily assimilated by two official sculptors: Jean Mone, born in Metz (d. 1548) [392], who adapted funerary sculpture to the new style, and especially the Romanist Jacques Dubroeucq (about 1500/10–1584), sculptor of the *Virtues* and low reliefs of the rood-screen of St Waudru in Mons, in whose workshop Giovanni Bologna was trained. With Cornelis Floris, Antwerp accepted Mannerism: decoration of the town hall, 1561–1565. The consciously archaic decorative style of Floris, very much in

fashion and popularised by collections of prints, spread to Germany and Scandinavia. Alexander Colyn of Mechelen (1526–1612) spread the Flemish style to central Europe.

In a more leisurely manner, Netherlands sculpture followed a parallel evolution, but later. The work of Vincidor of Bologna, the decoration of the tomb of Engelbert of Nassau at Breda (about 1530), combined Burgundian and Italian elements; Jan Terwens (d. 1589) was influenced by them (stalls at Dordrecht). Colyn de Nole (d. 1554–1558) born in Cambrai, introduced into Utrecht an ornamental style very similar to that of Floris, but more elegant (chimneypiece, town hall, Kampen). Two Dutch bronze workers, Hubert Gerhard and Adriaen de Vries, first trained by Giovanni Bologna in Florence, had successful careers in Germany and Prague.

Painting. Antwerp became the principal centre of the Flemish school which was gradually won over to Italianism. Quentin Metsys (1465/66–1530) [347] and the 'landscape painter' J. Patenier (d. 1524) [327] were the first representatives. With the painters of the Dutch school, Jacob Cornelisz of Amsterdam, C. Engelbrechtsz (d. 1533) and his pupil L. van Leyden (1494–1533) [329], who admired Dürer, they bring about the transition from Gothic Mannerism to the Renaissance. The latter, as an evolution of northern humanism, prospered first in court circles: in the south, at Mechelen and in Brussels with B. van Orley (about 1488–1541), J. Gossart, called Mabuse (1478–1533/36) [328], the Dutchman Jan Mostaert, then M. Coxie, a follower of Raphael; in the north, at Utrecht and Middelburg where Gossart also worked, who joined J. van Scorel (1495–1562) [350], the best of the Dutch Romanists. Blondeel of Bruges expressed in painting the decorative fantasy of the Flemish Renaissance architecture, and features among the Mannerists with Jan Metsys of Antwerp (d. 1575), who represented the

382. ITALIAN. BENVENUTO CELLINI. Salt made for François I. *c.* 1540. *Kunsthistorisches Museum, Vienna.*

383. ITALIAN. RAPHAEL. St Paul preaching in Athens. One of the cartoons for the tapestries of the Acts of the Apostles. 1515–1516. *Crown copyright reserved. On permanent loan from H.M. the Queen to the Victoria and Albert Museum.*

school of Fontainebleau. Lambert Sustris of Amsterdam worked with Titian in Venice. The Romanising taste engendered a scholarly Mannerism, the exponents of which were: at Haarlem, M. van Heemskerck (d. 1574), pupil of Scorel; at Liége, Lambert Sustris (d. 1566), a follower of Gossart; at Antwerp, Frans Floris (1516–1570), brother of the decorative sculptor. In the last third of the century, the best pupils of Floris, Marten de Vos and Ambrosius Franken, Otto Venius and painters from Haarlem and Utrecht (C. Cornelisz, H. Goltzius, A. Bloemaert, J. Uytewael), became eclectic, a trend which itinerant Netherlands artists of international culture helped to establish: F. Sustris, son of Lambert, and B. Spranger.

Portrait painting was practised by the majority of the masters and by specialists such as the Flemish Willem and Adriaen Key, Pieter and Frans Pourbus the Elder, and the Netherlanders Dirk Jacobsz, Dirk Barentsz and Cornelis Ketel (who invented the Doelenstukken or company pieces, collective portraits of civil guards); they were all eclipsed by Anthonis Mor, *c.* 1519–1576, of Utrecht, court painter to the Spanish Netherlands. His amalgam of Titianesque grandeur and Dutch sense of character profoundly affected the development of the court portrait: *Queen Mary* (Prado) [486].

In the great tradition of northern realism was Pieter Bruegel the Elder (about 1525/30–1569), the most important satirist in the Netherlands and one of the greatest landscape painters, who was trained at Antwerp and travelled to Italy (Rome, Messina?) [1552], where he associated with G. Clovio; linked with the humanists Ortelius the geographer and Plantin the publisher, he worked at Antwerp, then (1563) in Brussels: *Fall of Icarus* (Brussels, *c.* 1558) [497]; *Children's Games* (1560); *Triumph of Death* (1562); *Tower of Babel* (1563); *Dulle Griet* (1564); *Hunters in the Snow* (1565); *Harvest, Peasant Wedding* and *Peasant Dance* (1566); *The Land of Cockaigne* (1567); *The Magpie on the Gallows*; *The Blind Men.* His son Pieter (about 1564–1638) known as Hell Bruegel and his grandson Pieter III (1589–?) imitated his style.

A number of genre painters were produced by the school of Antwerp: M. van Roymerswaele, J. van Hemessen (d. about 1563), established in Haarlem, Pieter Aertsen of Amsterdam (1508–1575) and his nephew Beuckelaer. Landscape painting was characteristically Flemish, with Herimet de Bles and J. Grimmer; afterwards the Valckenborgh and G. van Coninxloo, who moved to Frankfurt; the Brill and Velvet Bruegel (Jan Bruegel the Elder), who worked in Rome; J. de Momper and Rubens' first master, T. Verhaecht. Following H. Bol and G. van Coninxloo, their compatriots D. Vinckeboons and R. Savery introduced landscape painting in Amsterdam and Utrecht.

Stained glass. The most beautiful examples of the Flemish Renaissance were made by B. van Orley (windows in the transept of St Gudule, Brussels, 1537). He and Michael Coxie designed the stained glass windows in the chapel of the Holy Sacrament in the same church.

Tapestry. The fame of Brussels deservedly surpassed that of other centres (Tournai, active up to about 1550; Enghien, Audenarde specialised in ' verdures '). The traditional style (story of Herkenbald, legend of Notre Dame du Sablon) became modified after 1516 (weaving of the Acts of the Apostles tapestries, designed by Raphael). Under the influence of van Orley and Pieter Coecke van Aelst, the clarity of Italian composition was combined with Flemish richness and precision in the great creations of the weavers of Brussels about 1530–1560, whose decorative genius was displayed in superb borders (*Hunt of Maximilian,* designed by van Orley [389]; *Vertumnus and Pomona;* the *Conquest of Tunis,* designed by J. Vermeyen). After 1550 Flemish tapestry weavers emigrated to France, Italy and Spain; one of them, Frans Spiering of Antwerp, settled at Delft in 1591.

Engraving. The great century of engraving was the 16th. The Dutch painter-etcher Lucan van Leyden surpassed in delicacy Dürer who influenced him [384]. In Flanders, Cornelis Metsys and D. Vellert practised copperplate engraving, as did J. Cock, publisher of the drawings of P. Bruegel, also reproduced by P. Huys, P. Galle and Jean Wierix. Wierix in collaboration with his brothers produced copperplate engraved illustrations for the great printing house of Plantin (Antwerp); with the prints of the Sadeler and Spranger, their plates contributed to the spread throughout Europe of the Mannerist style from which sprang the fine engraver Hendrik Goltzius (Haarlem); like G. van Coninxloo and Brill, he engraved landscapes. The collections of the decorators P. van Aelst, Cornelis Floris and Vredeman de Vries served as models for many decorators.

The minor arts. The art of the medallist, which was high in favour among the humanists and archaeologists, who sometimes tried their hand at it (Jean Second), was practised in the manner of Leone Leoni by Jacques Jonghelinck of Antwerp and Steven van Herwijk of Utrecht.

In Flemish gold- and silverwork P. van Aelst and Vredeman de Vries were the dominant figures. The Charles V ewer (1558–1569, Louvre) is the masterpiece of this art. The best Dutch silversmith, Paulus van Vianen of Utrecht, worked in Munich, and later in Prague.

Italian potters from Castel Durante settled in Antwerp; Flemish ceramics specialised in facing and paving tiles, and also produced vases and dishes in majolica. Emigrants from Antwerp introduced their technique to Middelburg (1564), Haarlem (1572) and Amsterdam (1587).

The fashion for tables and chairs with turned legs seems to have originated in Spain. At the end of the century big dressers in two sections, with the table surface supported by caryatids, became popular. The decoration was inspired by engraved designs by Cornelis Floris and Vredeman de Vries.

ENGLAND

History. Absolutism of the monarchy triumphed with Henry VIII, 1509–1547; Edward VI, died 1553; Mary Tudor, died 1558 (married Philip II of Spain; loss of Calais, 1558); Elizabeth, died 1603. Maritime power developed (voyages of Drake, 1577; of Walter Raleigh, 1586 and 1595; annihilation of the enormous Spanish Armada, 1588).

The religious problems determined politics. Henry VIII broke away from Catholicism, 1535. By the Act of Supremacy, the king became head of the Church of England. The monasteries were suppressed (1536–1539). Catholicism, restored under Mary, unleashed a persecution of the Protestants. Humanism was very much alive around Henry VIII; Cardinal Wolsey (d. 1530), Thomas More (d. 1535) were friends of Erasmus who visited England between 1495 and 1514 (*In Praise of Folly*, 1509) as did Luis Vives (about 1522–1530). The poets Thomas Wyatt and Henry Howard wrote sonnets in the Italian manner. The Elizabethan period was the golden age of English literature (Spenser, Philip Sidney, the 'poets of love') with Christopher Marlowe and the genius Shakespeare. Music held a high place; Henry VIII was a composer. The school of virginals and madrigals was important; W. Byrd (1543–1623) was the organist of the Chapel Royal.

Architecture. Period of experiment out of which emerged, in the 17th century, the art of Inigo Jones. Activity centred round architecture, since the Reformation eliminated all religious art.

In England Renaissance architecture was introduced initially as a mode of decoration. Great houses continued the collegiate tradition of the courtyard plan, with an emphasis on the gatehouse and a new predilection for symmetry: the Long Gallery made its appearance, though the Hall remained the principal element in lay-out: Suffolk Place (1521–1527); Hengrave Hall (from *c.* 1525); Hampton Court for Cardinal Wolsey (from 1515; completed by Henry VIII as a royal palace; Great Hall, 1531–1536). Similarly Wolsey's York Place became Whitehall Palace and additions to the west front (1530–1536) included two gatehouses, the Holbein Gate and the King St. Gate, the latter with classical detail of French character. The most ambitious creation of Henry VIII was Nonsuch Palace (begun 1538; demolished 1670), its extrovert character emulating Chambord, its lavish decorative work, that of the school of Fontainebleau.

The mid-Tudor Renaissance (1540s and 1550s) emanated from a group connected with Protector Somerset and including Sir William Sharington (Sharington's Tower, Lacock, 1540–1549) and Sir John Rhynne (d. 1580): Somerset House (1547–1552), the first attempt in England to build a classically disciplined house; the gateway and loggia recalled Ecouen.

In Elizabeth's reign, the cult of sovereignty played its part in the erection of 'prodigy' country houses: all show a gradual contraction into a single pile, either on an H-plan: Wimbledon House (begun 1588, de-

stroyed 18th century); Montacute (finished *c.* 1599); or as a solid mass: Longleat [**512**] (rebuilt 1568–1575 after fire), the greatest monument of Elizabethan architecture. It is associated with Robert Smythson (*c.* 1536–1614) who also designed Wollaton (1580–1588) on a square plan derived from Serlio, with a two-storeyed hall, and Hardwick [**505**] (1590–1597), where for the first time the hall is on the axis of the main entrance. In Northamptonshire is a group showing marked French influence: Kirby (1570–1575); Burghley [**506**] (1577–1585).

Between the reigns of Elizabeth and James I, architectural continuity is apparent (Hatfield House, 1611). In Bolsover castle (Derbyshire), designed by John Smythson, the construction remains square and massive. Town houses were rare before 1580; examples are at Shrewsbury (1570–1580); Sherar's Mansion is the finest.

Gardens. The English increased the number of game preserves which adjoined rectangular spinneys and regular flowerbeds with shrubs shaped in the manner of Roman topiary.

Sculpture. Italian sculptors, summoned by Henry VIII and Cardinal Wolsey, introduced about 1512–1520 the art of the Renaissance (tombs of Dr Young [1512], of Henry VII and Elizabeth of York [1512–1519] in Westminster abbey, works by P. Torrigiano, in the Florentine manner; medallions of polychrome terra cotta by Giovanni da Majano, and the ceiling of Cardinal Wolsey's Closet, after 1521, in Hampton Court). English sculptors adapted themselves with varying degrees of success to the Italian style in funerary art (tombs of the Fitzwilliams, about 1525, at Tickhill; of Sir Anthony and Lady Browne, about 1540–1548, at Battle).

In purely decorative work they used foliage, arabesques and other motifs in the style of the Renaissance (ceilings in Hampton Court, rood screen and carved wooden stalls in King's College chapel, Cambridge, 1532–1536) but the real spirit of this art remained foreign to them. First the abolition of the monasteries, then, under Edward VI, the ban on images in the sanctuaries restrained the activities of sculptors, who confined themselves to decoration and to funerary art. In the time of Elizabeth, the work of German and Netherlands decorators spread Italianism in the northern manner. This more overloaded style appeared in monumental chimneypieces (Knole, Longford, Hatfield). The form of the tombs became classical; the statuary adorning them was generally stiff, sometimes awkward: tombs of the Fetiplaces in Swenecombe (1562), of Sir Richard Pecksall (1571), Westminster.

Painting. Limited to portraits and allegorical scenes — other subjects being banned after 1533 in Protestant aristocratic England — painting was almost entirely in the hands of foreigners. Of the various painters employed by Henry VIII, Holbein was the only one who did honour to the sovereign's choice. It was in London, in fact, where he died (1543), that he created some of his finest portraits. His best follower was John Bettes. Under Mary and Elizabeth, royal preference was for Dutch artists and Flemish Calvinists. Anthonis Mor (portrait of Mary Tudor, 1554), Hans Eworth of Antwerp (d. 1574), in England from 1549: *Sir John Luttrell* (1550); *Capt. Thomas Wyndham* (1550); *Lord Darnley and his Brother* (1563); *Queen Elizabeth with Juno, Minerva and Venus* (1569). Other visiting artists included Lucas de Heere of Ghent, Cornelis Ketel of Gouda, Marc Gheeraerts the Elder, of Bruges and Federico Zuccaro. Portraits of Queen Elizabeth tended to be cult images: 'Ermine' portrait (Hatfield): 'Ditchley' portrait (National Portrait Gallery, London).

In the Elizabethan period, the English school was represented by painters of miniature portraits, a speciality which remained in fashion for three centuries. Nicholas Hilliard (about 1547–1619) was influenced by Holbein, who had himself painted miniatures: *Mrs Pemberton* (Victoria and Albert Museum, London); but he differed from Holbein in the rather precious gracefulness, more delicate colouring and scientific approach which he enlarged upon in his treatise *The Arte of Limning* (*c.* 1600): *Man against background of Flames*; *Youth among Briars* [**490**]; *George Clifford, Earl of Cumberland*. His pupil, Isaac Oliver (before 1568–1617), son of Huguenot refugees from Rouen, was his chief rival by 1595: *Sir Arundel Talbot* (1596); self-portrait (Earl of Derby); executed with astonishing precision small full-length portraits, for which he used the same manner of presentation as for life-sized effigies: *Richard Sackville, Earl of Dorset* (1616), *Sir Philip Sidney*.

The minor arts. The finest ensemble of Renaissance stained glass is in King's College chapel, Cambridge, where Flemish influences are to be seen. After the Reformation stained glass workshops disappeared. Secular windows with coats-of-arms and heraldic subjects were of Flemish importation.

Like Germany and Scandinavia, England dealt with Flanders for tapestries. About 1560 William Sheldon set up a manufactory on his estates at Barcheston under the direction of Richard Hickes (d. 1621): topographical maps of counties (Bodleian); *Four Seasons* (Hatfield, 1611) from engravings by Martin de Vos.

In gold- and silverwork, in addition

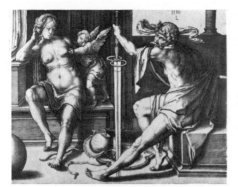

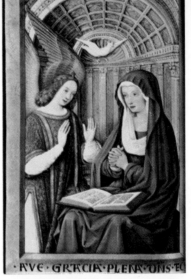

384. *Top, left.* DUTCH. LUCAS VAN LEYDEN (1494–1533). Mars and Venus. Engraving. 1530.

385. *Top, centre.* FRENCH. JEAN BOURDICHON (1457 – c. 1521). The Annunciation. A page from the Hours of Anne of Brittany. About 1508.

386. *Top, right.* ITALIAN. MARCANTONIO RAIMONDI (1475–1534). Massacre of the Innocents. Engraving after Raphael.

387. *Far left.* GERMAN. HANS BURGKMAIR (1473–1531). Death and the Lovers. Woodcut. 1510.

388. *Left.* FRENCH. ETIENNE DELAUNE (c. 1519–1583). Architecture. Probably 1561–1582.

to Holbein, who designed a number of models, German and Flemish masters (John of Antwerp) set the tone.

Furniture of the Elizabethan period, which was similar to Dutch examples, was rather massive.

GERMANY AND CENTRAL EUROPE

History. The prominence of Nuremberg and Augsburg (trade with Venice, Antwerp, Lisbon and the Americas), the development of the capitalist economy (the Fuggers and the Welsers, merchant-bankers of Augsburg), the decline of the Hanseatic League which brought about the rise of German economic prosperity; 1501, Basle entered the Swiss Confederation, Imperial prestige, restored by the Habsburgs, triumphed with Charles V (1519–1556); war with France. Religious crisis and social troubles succeeded each other; 1522, Rebellion of the 'Poor Barons'; 1524–1525, peasants' revolt; emancipation of the princes (Houses of Saxony, Bavaria and the Palatinate); 1546–1547, religious war; 1555, Peace of Augsburg, choice of confession left to the princes. Ferdinand I, Emperor (1556–1564), king of Bohemia-Hungary from 1526, and Rudolph II (1576–1612) made

Prague their favourite residence.

The Reformation, 1520–1555: Luther (1483–1546); P. Melanchthon drew up the Confession of Augsburg (1530), charter of the Lutheran faith. About 1520–1540, iconoclasm in Germany, Alsace and Switzerland. The Lutheran rulers in the north and west confiscated ecclesiastical goods. But the Catholics reacted: William IV of Bavaria called upon the Jesuits (1542).

In literature and science, Emperor Maximilian, *Weiskunig*, 1512, *Teuerdank*, 1517; Ulrich von Hutten, pamphlets, 1514–1520; Luther, the Bible in German, 1522–1541. The Meistersinger (Hans Sachs, 1515–1558). Humanism developed (Erasmus in Basle, 1515–1529); C. Celtes, Reuchlin, Melanchthon; C. Peutinger, etc. The great publishing centres were Basle (Froben), Strasbourg (Grüninger, Knobloch), Nuremberg (Koberger). Theoretical works: Dürer, *Book of Proportion*, 1525; W. Dietterlin, *Treatise on the Five Orders*, 1598. Historical and scientific studies (Wimpfeling, Aventinus, Paracelsus, Agricola, C. Gessner) were numerous; publication in Nuremberg of the *Treatise on Astronomy* by the Pole Copernicus in 1543; in Basle, the *Treatise on Cosmography* by S. Münster in 1544. Tycho Brahe in Prague, 1597, was astronomer to Rudolph II; Kepler

succeeded him in 1610: *Astronomy*, 1609.

Music was the international art. The court musicians, often Flemish, introduced Franco-Flemish and Italian influences, for example, in Munich, Orlando Lasso from Mons (about 1532–1594), precentor to Albert V and William V of Bavaria. The Lutheran chorale (J. Walther, friend of Luther, 1496–1570; H. L. Hassler and J. Eccard) galvanised Germanic musical feeling which awoke to its real genius.

Architecture. Architecture in Germany and Switzerland was a compromise between the Gothic and the new style. Domestic architecture was all-important. The arcaded ground floors, the oriel windows, the gables, pointed and pierced like lace, gave to middle class dwellings and public buildings their particular characteristics. The Renaissance came earlier to southern Germany, especially to Augsburg: Fugger chapel, St Anna (1509–1518). Early in the 17th century, Palladian motifs were introduced by Elias Holl into the town hall (1615–1620). The city of Nuremberg kept its medieval character with motifs borrowed from France (Tucher Haus, 1533) and from Italy (Peller Haus, 1605). At Heidelberg, the Palatine Elector, Ottheinrich had built a clas-

sical façade, in which Italian and Flemish influences combined, for his palace which was partially destroyed in 1698. At Munich, the most important Counter Reformation church, St Michael's (1583–1597) by Wolfgang Miller, derives from Il Gesù (1583–1597). The only Protestant churches of the 16th century, at Bückeburg and Wolfenbüttel are a mixture of Gothic and Renaissance.

In northern Germany, the Italian influence penetrated into Silesia and Saxony (castle of the Piastes in Brieg; in Saxony, Hartenfels). The castle of Wismar, in Mecklenburg, with its terra-cotta decoration was inspired by Pavia. In the whole of coastal Germany, from Emden to Danzig, the influence of the Low Countries was predominant as far as Cologne (town hall, loggia, 1569–1573). Architecture in wood, highly original, persisted in the north (Hildesheim).

Sculpture. Attachment to the forms and expression of the late Gothic was evident not only in the enigmatic Veit Stoss [131], who died in Nuremberg in 1533 (Bamberg altarpiece, 1523), and Master H. L. (*Breisach Altarpiece*, about 1523–1526), but also in Hans Backofen (Mainz, d. 1519), who distinguished himself in funerary sculpture. In spite of an easing of tension discernible in certain of their works, the Germans had difficulty in adapting themselves to the balanced forms of the Renaissance. Apart from Konrad Meit of Worms, who worked abroad, the true adepts of the new art were: in Augsburg, Adolf Daucher, also called Dauer (d. 1524); in Nuremberg, Peter Vischer and his sons (shrine of St Sebaldus, 1508–1519) whose workshop, active up to 1549, specialised in the casting of funerary monuments in bronze: tomb of Maximilian at Innsbruck (some were exported to Hungary and Poland). In the same way Peter Vischer the Younger (1487–1528) and the goldsmith and decorator P. Flötner (d. 1546) took up small-scale sculpture; his delicate decoration of patrician houses in Nuremberg was inspired by the Lombardo-Venetian style, which prints helped to spread to Germany. Alexander Colyn of Mechelen (d. 1612), a pupil of Meit, brought the decorative manner of the Flemish Renaissance to Heidelberg: the Ottheinrich wing, 1558. In the second half of the century and the beginning of the following, Augsburg and Munich were centres of Italianism. Netherlands artists trained in Italy: Hubert Gerhard, Adriaen de Vries (d. 1626), and the Germans Hans Krumper (pupil of Gerhard and son-in-law of the painter F. Sustris), Hans Reichle (trained by Giovanni Bologna), worked for the Fuggers and the dukes of Bavaria; they bestowed a Germanic flavour on the last international Man-

nerism and inaugurated the Bavarian art of the Counter Reformation.

Painting. In the first third of the century German painting went through its most glorious period. Dürer, Grünewald and Holbein raised it to the level of the greatest schools.

Albrecht Dürer (1471–1528) [334 - 337], born in Nuremberg, son of a goldsmith and a pupil of Wolgemut, was the main channel through which Renaissance forms and ideas were introduced into the north. 1490–1494, travels in Germany (Colmar, Strasbourg, Basle): self-portrait (Louvre, 1493). 1494–1495, Venice (landscape watercolours, British Museum, London; Ashmolean Museum, Oxford). 1495–1506, reputation at Nuremberg as painter and engraver. Self-portraits (Prado, 1498; Munich, 1500). *Oswald Krell* (1499, Munich). *Paumgärtner Altarpiece* (Munich, 1502–1504). 1505–1507, second visit to Venice: *Feast of the Rosegarlands* (Prague, 1506); *Portrait of a Lady* (Berlin); after return intensified humanistic studies in mathematics, perspective, treatises on measurements (1525), fortifications (1527), artistic theory (1528). 1512, court painter to Emperor Maximilian: portrait (Vienna, 1519). 1520–1521, journey to the Netherlands (Antwerp, Brussels, Cologne, Bruges, Ghent). In last years deeply affected by spiritual conflicts of the Reformation: *Four Apostles* (presented to city 1526, Munich) [p. 160]. *Hieronymus Holzschuher* (Berlin, 1526). Dürer's greatest achievement lay in his graphic work, in woodcut series such as the Apocalypse (1498); the *Great Passion* (1498–1510); the *Little Passion* (1509–1511); the *Life of the Virgin* (1501–1511), and in engravings such as the *Sea Monster* (c. 1498); *St Eustace* (1501); *Nemesis* (1501–1502); *Adam and Eve* (1504); *Knight, Death and the Devil* (1513); *St Jerome* (1514); *Melencolia I* (1514) [15]; *Pirckheimer* (1524); *Melanchthon* (1526). From Nuremberg, where he trained Hans von Kulmbach and H. L. Schäufelein, Dürer's influence extended throughout Germany and Europe in the course of the century.

Matthias Grünewald (about 1470/80–1528) [322, 323] whose real name was Matthias Gothardt-Neithardt of Würzburg (Franconia), worked at Seligenstadt (about 1503–1519), at Aschaffenburg (Lower Main), in Alsace, and as painter to Archbishop Albert of Brandenburg at Mainz until 1525, then at Frankfurt and Halle (Saxony), where he died. His principal work was the large folding altarpiece (central panel dated 1515) for the monastery of the Antonites of Isenheim (Alsace): *Crucifixion*, the Christmas picture, *Resurrection*, two scenes from the life of St Anthony (Unterlinden Museum at Colmar). Other paintings: *Crucifixions* at Basle, Washington, Karlsruhe; the *Mocking of Christ*, Munich; *Madonna*,

1519, Stuppach church, near Mergenthenn, Bavaria; *SS. Erasmus and Maurice*, about 1520–1522, Munich. Grünewald had no artistic followers; but echoes of his art are nevertheless found in the work of Jorg Ratgeb of Stuttgart (d. 1526), in that of Dürer's pupil from Alsace, Hans Baldung Grien (d. 1545; altarpiece in the cathedral of Freiburg im Breisgau); with these are connected the Swiss painters, Urs Graf, Niklaus Manuel Deutsch (d. 1530) and H. Leu.

Augsburg, the native town of the Holbein family (Hans Holbein the Elder, d. 1524) [343], was, with Nuremberg, the true home of the Renaissance in Germany. Hans Burgkmair (1473–1531) was one of the first to adopt the new aesthetic but he had no more success than his contemporaries in assimilating its fundamental conceptions: triptych of the Crucifixion, Munich. Ulrich Apt, J. Breu and L. Beck were similarly inspired by the examples of Venice and Antwerp. To the Swabian school were also attached B. Strigel (d. 1528) of Memmingen, Hans Maler and M. Schaffner of Ulm, able portrait painters. Lucas Cranach the Elder (1472–1553), court painter to the Electors of Saxony at Wittenberg and close friend of Luther: *Henry the Pious* (Dresden, 1514); evolved new type of erotic female nude: *Sleeping Nymph* (Leipzig, 1518) [346]. *Judgment of Paris* (Metropolitan Museum of Art, 1529). Large workshop with sons Hans (d. 1537) and Lucas II (1515–1586). Early religious works in Vienna 1500–1503, in which landscape played a great part, linked with the ideals of the Danube school, fusing emotional sympathy, landscape and human action. Chief exponents were Wolf Huber (c. 1490–1553) at Passau and Albrecht Altdorfer (c. 1480–1538) at Regensburg; his paintings and etchings of the Danube valley make him one of the principal landscape painters of the early 16th century: *St George* (Munich, 1510). Other works include the St Florian altar (1518); *Alexander's Battle* (Munich, 1529).

Hans Holbein the Younger (Augsburg, 1497/98 – London, 1543), son and pupil of Hans Holbein the Elder, settled in Basle about 1515–1516: *Burgomaster Meyer and his Wife* (Basle, 1516). In 1517–1519, he was in Lucerne (and possibly in northern Italy). 1519, portrait of B. Amerbach; 1521, *Dead Christ*, Basle; 1523, portrait of Erasmus, Louvre. 1524, journey to France. 1526, *Madonna of the Burgomaster Meyer*, at Darmstadt. 1526–1528 he was in England, stayed with Sir Thomas More: series of drawings in black and coloured chalks for the portrait of the More family, Windsor; 1528, *N. Kratzer*, Louvre. In the summer of 1528, he was in Basle (1528–1529, the *Wife and Children of the Painter*, Basle); in 1532, in London (*G. Gisze*,

389. SWISS. B. KOCH.
Vessel in the form of an owl.
Silver. 1590. *Basle Museum.*

390. ENGLISH. Chalice of
Thomas à Becket. Ivory and silver.
1525–1526. *Victoria and Albert Museum.*

391. FLEMISH. The Meet (detail).
A scene from the Hunts of
Maximilian. *c.* 1535.
From designs by B. van Orley. *Louvre.*

392. FLEMISH. JEAN MONE.
Detail from the high altar of
Notre Dame, Hal. 1533.

Berlin; 1533, the *Ambassadors*, London).
In 1536, he was appointed painter
to Henry VIII: *Jane Seymour*, Vienna;
1538, the *Duke of Norfolk*, Windsor;
fresco, Whitehall palace; portraits of
Henry VIII, his parents Henry VII and
Elizabeth of York, and wife Jane
Seymour (burnt 1698; part of cartoon
in National Portrait Gallery, London).
In 1538–1539, he was on an official
mission to the continent; portraits of
the Duchess of Milan, Anne of Cleves
(National Gallery, London, and Lou-
vre). Numerous drawings for portraits
[479] (important series at Windsor),
designs for decorative works, stained
glass windows, gold and silver work,
etc. (at Basle, in the Louvre), woodcut
illustrations: series from the Old
Testament, the *Dance of Death* were
evidence of his enormous activity [342].
He was the last great representative of
the German school [338–341, p. 159].

After 1530, this school started to
decline. A member of the Cologne
school, closely attached to Flemish art,
was Barthel Bruyn (1493–1555) who
emulated the Dutch Romanists. The
Italian influence imposed itself at
Nuremberg on the pupils of Dürer,
Barthel Beham and Pencz; at Augsburg
where Titian, Bordone and Sustris
stayed in 1548, C. Amberger (d. 1561)
modelled himself on the Venetians.
The Swiss, Tobias Stimmer (1539–
1584), also dependent on Italy, pre-
served more successfully his native
characteristics (double portrait, 1564,
Basle). In the second half of the
century and the beginning of the 17th,
the patronage of the Fuggers and the
dukes of Bavaria at Augsburg, Landshut
and Munich (Antiquarium) favoured
production by international teams of
decorators, led by Friedrich Sustris
and Pieter Candido, pupils of Vasari.

Stained glass. Numerous German,
Alsatian and Swiss drawings prove that
the painter-engravers often provided
the models. After the Reformation,
armorial windows and windows with
profane subjects were very widespread.
In Switzerland, where Holbein played
a decisive part in the formation of the
style, Basle, Berne, and later Zürich
were centres where small round or
rectangular windows, with heraldic
decoration, sometimes with figures of
soldiers, were made.

Tapestry. Tapestries were generally
commissioned from Brussels. From
1540 onwards Flemish weavers worked
in Bavaria for Ottheinrich of Neuberg,
the future Elector Palatine (d. 1559);
they specialised in genealogical trees.
Under his successor Frederick II
(d. 1576) other Flemish weavers were

established at Frankenthal. Not until
1603 was a high-loom workshop
established at Munich.

Engraving. As the national art,
engraving was practised in Germany
by the greatest painters. Dürer, the
unquestioned master of the technique
of engraving and woodcuts, exploited
it in the most expressive manner [15].
His influence, which was considerable,
was felt by the specialists in woodcuts
(Schäufelein, Burgkmair, L. Beck,
Cranach, Baldung, the Swiss Urs Graf,
Hans Leu); the most famous were
Holbein and Wolf Huber, the latter
one of the most original. Some of
these graphic artists, such as Waecht-
lin, Baldung, Burgkmair [387] and
Cranach, sometimes adopted the process
of camaieu or chiaroscuro woodcuts
(impression in white and colour using
two or more blocks). Altdorfer, an
excellent engraver, etched his remark-
able series of landscapes, afterwards
imitated at Nuremberg and Vienna by
Hirschvogel and Lautensack. Among
the engravers who were disciples of
Dürer, the Westphalian Aldgrever, the
Beham and G. Pencz of Nuremberg
formed a group apart, that of the
'Little Masters' (by reason of their
predilection for small-scale works);
they were not free from Italian in-
fluence. They, too, like the decorators
P. Flötner, Virgile Solis, W. Jamnitzer,
contributed to the spread of new deco-
rative motifs, to which, towards the
end of the century at Strasbourg, the
theorist W. Dietterlin, author of a
collection of architectural plates, and
the illustrator T. Stimmer gave an
opulence which foreshadowed the
Baroque style.

The minor arts. A few medallions
bearing the monogram of Dürer,
numerous medallions and plaques exe-
cuted at Nuremberg (by P. Vischer
the Younger, P. Flötner, Valentin
Maler, son-in-law of W. Jamnitzer), at
Augsburg and in Saxony bear witness
to the fashion for this art, practised
also in Austria and Switzerland. Some
models in box-wood survive; certain
deep-cut plaques are of wood (for
example, those of the Master I. P.) or
of soft stone (*Speckstein*). The Refor-
mation brought about the decline of
ecclesiastical gold- and silversmiths'
work in some of the Germanic coun-
tries. Among the secular pieces, the
favourite model was the stemmed
goblet with a lid (*Pokal*) the structure
and decoration of which remained
Gothic for a long time. After 1550,
the forms of the Renaissance became
more general, but adapted to the
German taste. The most famous gold-
smiths were: at Nuremberg, Wenzel
Jamnitzer (1508–1585), head of a
family of craftsmen and the creator
of pieces of ceremonial plate covered
with arabesques and naturalistic mo-

tifs (animals, plants) in enamel, then Christoph Jamnitzer (1563–1618), his grandson, and Hans Petzolt; at Augsburg, Paul Hübner; at Munich, Hans Reimer; at Strasbourg, G. Kobenhaupt; at Paderborn, Anton Eisenholt.

Hard faience was used for monumental stoves in Germany, as in Austria and Switzerland, where dishes in enamelled faience were also made. The national pottery of Germany was stoneware, the speciality of the Rhine area; Siegburg, Westerwald, Frechen and Raeren made an export industry of it to the Low Countries. The decoration was borrowed from German or Netherlands prints.

In furniture northern Germany was inspired by Dutch models. In imitation of Italian prototypes, cupboards with wood marquetry or ebony inlaid with mother-of-pearl, ivory and tortoiseshell, were made at Nuremberg and Augsburg, and afterwards exported to France and Spain at the beginning of the 17th century.

AUSTRIA AND BOHEMIA

Architecture. Austria kept the Germanic tradition, but the Habsburgs called Italians to Prague to build the Belvedere palace (1536) and the Summer Gallery of the Waldstein palace (1629). In Hungary, where we know that Laurana, Benedetto da Maiano, Pellegrino di Formo, etc. had worked for the court at Buda, Italian influence was felt for a long time in local architecture.

Sculpture and painting. In Vienna the sculptor Anton Pilgram continued the tradition of Sluter, which he combined with the ornamental exubérance of the late Gothic: pulpit in the cathedral, 1513–1515. In the reign of Ferdinand I, whose court portrait painter was the Austrian J. Seisenegger, Italian decorators introduced into Prague the style of the Renaissance: Belvedere. Subsequently, Archduke Ferdinand of Tyrol (d. 1595), a great lover of portraits and objets d'art (Ambras collection, for the most part in the Vienna museum) and his nephew Emperor Rudolph II called upon Italianate Netherlands artists: A. Colyn (tombs of P. Welser, d. 1580, and of the archduke at Innsbruck; tomb of Ferdinand I in Prague cathedral, 1589) and Adriaen de Vries (*Rudolph II*, bust, Vienna museum).

About 1575–1610, the Prague court was also the rallying point of the last Mannerists; under the aegis of B. Spranger of Antwerp, working with the Flemish landscape painter Roelandt Savery, Germanic painters trained in Italy were to be found: Hans von Aachen (d. 1615), Joseph Heintz (d. 1609).

The minor arts. In Prague, Rudolph II

employed a Dutch goldsmith, Paulus van Vianen, who had worked for the Bavarian court.

SCANDINAVIA

Architecture and sculpture. In Denmark architecture in brick and stone is characteristic. The royal castle of Kronberg (1574–1585) shows that the Renaissance had very little effect.

In Roeskilde cathedral the tombs of the kings of Denmark were often the work of foreigners (tomb of Christian III by Cornelis van Vriendt).

In Sweden the major inspiration in architecture came from the Low Countries. The buildings are castles: Gripsholm (1537), Wadstena (1545), Uppsala (1549), Kalmar (about 1570).

Painting and engraving. In Denmark the few painters were German portrait painters (J. Binck of Cologne, d. 1569) or Flemish ones (H. Knieper of Antwerp, d. 1587). The national contribution came from the court painter Melchior Lorichs (1527–about 1590) trained in Italy and Mannerist in style.

Swedish painting includes a few portrait painters: about 1580, Anders Larsson (d. 1586) and Master Knut; about 1600, J. H. Elbfaas.

POLAND

History. Poland was an aristocratic republic, ruled by an elected king: the last Jagellon up to 1572; Alexander I, Sigismundo I, Sigismundo II Augustus; then Henry de Valois (1573–1574), Etienne Bathory (1576–1586) and Sigismundo III Vasa. Poland gradually declined and allowed Prussia to become consolidated in 1525, and Russia and Austria to expand. Italian influence was predominant under Sigismundo I (1506–1548), husband of one of the Sforza. But the Renaissance was only a superficial trend, a fashionable art.

Architecture. At Cracow the Sigismundo chapel in the cathedral (1519–1530) and Wavel castle were the work of Italians (Francesco della Lora and Bartolomeo Berecci). The Cloth Hall, more adapted to the Polish tradition, was by Gian Maria Padovano.

Sculpture. It was Italian sculptors who decorated Wavel castle at Cracow, the Sigismundo chapel in the cathedral and created the royal mausoleums: tombs of Sigismundo Augustus and Anna Jagellonka, after 1578; of Etienne Bathory, d. 1586. Polish sculptors, such as Jean Michalowicz, revealed themselves as excellent adepts of the Renaissance: tomb of Bishop Izbienski, d. 1553 (Poznan cathedral).

Painting. Germanic influence persisted in painting (visit to Cracow, 1514–1518, of Hans von Kulmbach,

pupil of Dürer, pictures in Notre Dame and in St Florian; Hans Dürer, brother of Albrecht, was court painter 1525–1538; other Germans succeeded him). The local school was especially distinguished for illumination: *Codex Behem* (1505), *Pontifical of Erasmus Ciolek* by Simon of Cracow, the *Szydlowiecki Genealogy* (1531), the *Tomicki Gospels* (1534), attributed to Stanislas of Mogila, a Cistercian monk.

The minor arts. Engraving was by no means negligible, thanks to Jan Ziarnko. Cracow goldsmiths' work is very beautiful. The most significant examples were made by Erasmus Kamyn of Poznan.

RUSSIA

History. Ivan III (1462–1505), prince of Moscow, enlarged his territories at the expense of Lithuania, refused to pay tribute to the Tartars, married a member of the Palaeologue dynasty, the niece of the last Emperor of Byzantium, and made use of the mystic idea of Holy Russia to become an autocratic sovereign. Basil III, then Ivan IV, called the Terrible (1533–1584), continued his policy, creating the Russian state dominated by its Tsar, an absolute sovereign, since Russia had achieved political and religious freedom.

Architecture. Ivan III brought architects from northern Italy (Alevisio from Milan) to the Kremlin; they succeeded one another from 1475 to 1525, and gave to the Kremlin, which was at the same time a sanctuary and a citadel, that curious character, the result of a mixture of Milanese and indigenous elements. Renaissance decoration was sometimes combined with Russian elements.

The influence of the Castello Sforzesco in Milan is reflected in the fortified walls.

But, although the Italians brought Western techniques and decoration to Russia, the structure of the churches remained Byzantine. However, from the middle of the 16th century true Russian architecture was created by using wood instead of stone as building material, an original art (Kolomenskoe palace, known from a wooden model made for Catherine II) and characteristic of northern Russia, decorated with brilliant paintings.

Painting. The painting of icons in Moscow was, in the 16th century and the beginning of the 17th, more national than that of the school of Novgorod, which was very Byzantine, but it remained popular and without any great aesthetic value.

Adeline Hulftegger, Jean Charles Moreux and Evelyn King

3 THE LATER RENAISSANCE

ART FORMS AND SOCIETY *René Huyghe*

With the Renaissance a new phase of civilisation supplanted the Gothic of the Middle Ages. It is not so much that a new ' age ' was superimposed on an old one, making a kind of chronological stratification, as over-simplified textbooks might lead one to believe: the Gothic style of the Middle Ages was in fact still very much alive in northern Europe where it flourished most. On the other hand, the Renaissance style predominated in places where the Gothic style had never really become established. This was the case in Italy mainly, whence the new movement spread to all the formerly Gothic countries. But the Renaissance style was often badly assimilated or sometimes completely falsified, so that it became nothing more than a superficial veneer. For this reason Germany and Spain passed from late Gothic to Baroque without any real break in continuity, the Renaissance style appearing only occasionally between the two phases.

The breakdown of a system

The life and death of the Renaissance may best be observed in Italy, just as Gothic is best studied in northern Europe. In this way, their common destiny becomes apparent, and we get a clear idea of the characteristics and the evolutionary rhythm of civilisations, or rather of the various phases of civilisation. Faced by the task of living, man is obliged by the exigencies of life, and enabled by his intelligence, to organise himself. To understand the world and his relationship with it, to act on it, man must have an effective representation or concept of it; he must give it form. This form is at once mental, visual and social. It is embodied mentally by religion and philosophy in an ideological system, visually by art in a style of representation, and socially by a constitution which organises the community. The more one tries to grasp the essential structure that conditions any given age, the more one realises that this structure, though variously applied, is embodied in all aspects of that age.

The Renaissance was centred on man. From him flowed all explanations and creations. The anthropomorphic concepts of the ancients were resuscitated and adopted. The cult of antiquity was often an archaeological one, for Renaissance man was delighted to find that others had anticipated his own problems and the kind of solutions he wished for them. For anthropomorphists these solutions could only be founded on reason, on a method that tries to find clear and distinct definitions of both thought and image. The resulting elements were synthesised 212 to form a logical whole, in an attempt to escape from the 202 confusion and the infinite multiplicity of brute nature as seen by the uninitiated. The Mediterranean countryside, without nuances, mists or proliferating plant life, lent itself to such clear and precise organisation, unlike the hazy light and damp fecundity of northern Europe. The emphasis on clear-cut forms, both mental and visual, was as spontaneous in Renaissance Italy as it had been in ancient Greece.

265 In the *School of Athens* and the *Disputà* Raphael provided the perfect image of such a balanced and co-ordinated universe. Perfection is given to appearances by a combination of contour, perspective and composition, and to human experience by the reconciliation and harmonising of the conflicting ideas of Plato and Aristotle, of paganism and Christianity. Harmony, this universal concord that could even be perceived and enjoyed 194 aesthetically, became the supreme law. The 13th century had also devised a perfect system. Focused on God and based on love alone, this system went further towards realising the intimate unity that the men of the more intellectualised Renaissance hoped to find in their concept of harmony.

All this was suddenly disrupted; and the process of disintegration was more rapid than in the Middle Ages, perhaps because this perfect organisation had only been adopted by an aristocratic élite at first, till it became more and more concentrated round the Pope in Rome. Now Italy, the chosen land of the Renaissance, was tied to the yoke of servitude. As early as 1494 the invasion by Charles VIII started off the Italian wars. In 1527 Rome was taken and laid waste by the Imperial army. For many of these Protestant conquerors, Rome had come to mean the city of the Anti-Christ, and the symbol of an enemy to be exterminated. Even her art was questioned. Was it not in order to build and decorate her monuments that the papacy had put pressure on the Catholics and increased its revenues? They attacked in particular the famous Indulgences that had provoked Luther's angry denunciation of St Peter's as having been ' built with the flesh, skin and bones of her flock '. It is significant, too, that a Medici, Leo X, was succeeded by a monk from Utrecht, Adrian VI, who despised humanism and the arts. As for Florence, the collapse of her last republic in 1530 spelt her end. All that was left was the independent power of Venice, source of the first germs of the disintegration of the aesthetic system established by the Renaissance. Little remained in 1530. Raphael had been dead for ten years, Leonardo for eleven years. Michelangelo alone was to survive for any length of time, only to be torn apart by inner conflict.

The growth of the 15th century was, as we have seen, marked by scission. The 16th century saw Catholicism, which had remained the unquestioned basis of society, severely shaken by a complete rupture. The course of events set in motion by Luther had unforeseen results. The failure of the Church to make any bona fide effort to reform, when she herself realised the need for reform, led to Protestantism and the Reformation. As early as 1436 at the council of Basle, Cardinal Cesarini had informed the Pope of the urgent need ' to reform the Head and all the Members of the Church '. Luther, an Augustinian, had posted up his 95 Theses at Wittenberg ten years before the sack of Rome, and in 1530 propounded his doctrine at the Diet of Augsburg. Four years later Calvin published his *Institutes of the Christian Religion*, which started off the second Protestant movement. From then on the process of disintegration became more rapid. First Germany and then Italy became battlefields. The opposition between Protestants and Catholics was further complicated by the numerous and conflicting Protestant sects. Social grievances were coupled to the religious ones. To add to these religious conflicts, the warring princes had social problems to deal with such as the rebellion of the ' Poor Barons ' in 1522–1523, and the Peasants' Revolt the following year. The Renaissance dream of unity was completely shattered before the end of the 1530s, and man was once more plunged in doubt.

The spirit of reform in art

The premonitory signs of disquiet were already discernible at the end of the 15th century. Erwin Panofsky and André Chastel have rightly pointed out the extensive occurrence of ' melancholy '. Melancholy, as part of the current analysis of temperament, was placed under the malefic sign of Saturn by men like Ficino, and was thought to be caused by a predominance of imagination over reason: madness was but an extreme case of the same thing. 16th-century Germans such as Dürer were particularly prone to melancholy. Unable to adapt themselves to classical form, they found in such new anxieties a prolongation of their persistent medieval tradition. Even in Florence the neo-

393. FRENCH. NICOLAS POUSSIN (1594–1665). The Holy Family on the Steps (detail). *Samuel H. Kress Collection, National Gallery of Art, Washington.*

370 Platonic doctrines revived the old leanings towards magic that
had been handed down from ancient Alexandria. This yearning
250 for the mysterious, already noticeable in Botticelli or Piero di
181 Cosimo, prepared the way for Mannerism, which stemmed
from the development of neo-Platonism and was the first break
from the Renaissance style.

From the very beginning of the 16th century, Dürer in
Germany and Michelangelo in Italy revealed the general concern
that was felt for the problems arising out of the Reformation.
Michelangelo was, after all, born in Florence where Savonarola
had stirred up the first reform movement. In Rome he was on
intimate terms with Vittoria Colonna's circle which was trying
to rediscover religious authenticity by means of reform. Of the
problems under debate, Michelangelo was most concerned with
the question of salvation and the possibility of direct commu-
nication between the individual and God. These were the very
questions posed by Protestantism, and the Inquisition did in
fact suspect him of being a Lutheran. Michelangelo was very
much a man of his time, acutely aware of contemporary
273 anxieties. In his *Last Judgment* the God of Wrath looming
menacingly over man echoes the relentless Calvinist doctrine
of predestination.

Although Dürer was a precursor of the new movement, he
was not yet free of the old. Medievalism survived in Germany
until well into the 16th century, when it merged effortlessly
with movements, such as the Baroque, that supplanted the
Renaissance. Luther's revolt against the Catholicism of the
Renaissance, his sceptical humanism, his insistence on the salva-
tion of the individual and his struggles with the Devil were
really the dying reflexes of the Middle Ages. Moreover, Luther
harks back to the 14th-century Rhenish mystics, just as Grüne-
333 wald moved directly from them to Anabaptism, that extreme
form of Protestantism, as though unaware of the Renaissance.
Luther said of Johann Tauler that ' he had never read, either
in Latin or in any other language, a theology so sound and so
consistent with the Gospels ' — in other words, further from
' all the metaphysics of an Aristotle '. Dürer, however, far from
being hostile to the new ideas, was influenced by them during
his two visits to Italy. He wanted to get away from the medieval
concept of art as a practical craft, and to make of it a conscious
intellectual quest for beauty. His theoretical works, such as the
193, 195 treatises on geometry and perspective (1525) and on human
230 proportion (1528), rank him, along with Alberti and Piero,
among the initiators of a ' rational ' art, the *Kunst*. But this did
not prevent him from feeling an affinity with Luther, ' this
true Christian who has helped me and freed me from a great
anxiety, ' as he wrote in 1514; and when Luther died he uttered
a cry of despair. Like Goethe, Dürer would have liked to have
access to the serene certitude of the Latin peoples, but the
depths of the old Germanic soul are too bound up with the
unseen forces that reason can never appease. After years of
striving towards the classical concept of beauty, Dürer confessed
15 that it was only a relative idea. The *Melencolia I* of 1514 marked
the climax of his doubts. He had a foreboding that what was
most opposed to a universal and almost scientific definition of
beauty was the unpredictable individual factor, the creative
force of genius that is something irrational. The term he uses
is significant — ' *Gewalt* ', that is, power or violence. It evokes
Michelangelo's ' *terribilità* ', the irresistible passion that breaks
through from his classical forms.

Reason was thought to have an answer to everything. Reli-
gious problems were resolved by the structure of the Church,
spiritual life was clarified by intellectual discipline, the visible
world represented logically by three-dimensional form. But the
unsatisfied forces of the spirit, its very substance, revolted
against the sovereignty of form. The humanists of antiquity
had claimed that the best instrument for understanding was the

form inherent in human thought. For Plato the creative act
consisted in the application of this form to matter. For Aristotle,
thought informs and organises matter. Even the Aristotelians of
the Renaissance, whose faith in sensory experience favoured
realism, maintained this emphasis on form. They agreed that
matter was nothing in itself, but that the true essence of things
was to be found in form which obeys the laws of reason and
is immutable. This was all the more so for the Platonists.

But ritual forms are no answer to the problems of man faced
by his eternal destiny. Intellectual forms or ideas cannot express
what the individual feels deep down inside himself. Three-
dimensional form allowed the vital force that gives it breath
and warmth to elude its grip. Leonardo had already sensed this.
Shunning the Platonism of his ' learned ' contemporaries, he
fostered and developed the medieval tradition. The *Mona Lisa* 259
is an example of his exceptional awareness of the uncanny
presence and mystery of inner life. Realising that strict form
cannot recreate the continuous unfolding of existence and the
intimate relationship that exists between man and nature, he
developed the sfumato technique. He endeavoured to penetrate,
bring out and confront the enigma of things as they are, rather
than substitute a coherent logical pattern based on theory.
Leonardo was linked with the school of Milan, and he spent
the end of his life in France. He was, therefore, very much a
part of northern Italy where, in close contact with northern
Europe, there grew up in Venice and Parma an expanding
movement of innovation that was outside the main Renaissance
current of Florence and Rome.

The apogee of Venice and Parma

Venice was open to the influence of Byzantium, the gateway
to the East, thanks to her navy and her trading empire. The
Brenner pass opened to her the Germanic world where the
ebbing forces of the Middle Ages seemed to be concentrated.
Consequently Venice anticipated the influences that were to
divert Italian art from the classical tendency of the Renaissance.
She had remained a patrician city of merchants and bankers
who were opposed to princely rule and to the establishment
of a court because of the ideas they implied. This city of the
Doges was obstinately opposed to any system of ideal values,
being more given to a sensual appreciation of concrete realities.
The university of Padua, which was dependent on Venice, had
been an Aristotelian stronghold. Art theorists such as Titian's
friend the writer Pietro Aretino, the painter Paolo Pino and
Ludovico Dolce published, in about the middle of the 16th
century, works contrary to those of Ghiberti or Alberti. They
admitted their scepticism and their dislike of doctrinaire prin-
ciples. Form and proportion seemed to them to be restrictive
rather than stimulating. Their gospel was colour. The ambi-
guity, the dazzling warmth, the irrational evocative quality of
colour would enable painting to become the highest form of art.
Architecture and sculpture had prime importance for Floren-
tines and Romans because they were obsessed by their notion
of strict form. Colour, on the other hand, endows painting
with the moving sonority of music that was so dear to Vene- 401-404
tians and was the subject of so many paintings from the 15th
century onwards. Inversely, painting was soon to imbue sculp-
ture and architecture with the resonance of chiaroscuro effects. 408
But Michelangelo had already attempted to liberate sculpture
from static forms. His twisted shapes have all the movement
and vitality of real life. His Titans, straining every muscle
against the bonds that tie them, symbolise the need to break
out of the limits of the material world. In his last *Pietàs* Michel-
angelo evolved a rough unfinished kind of form which he
modelled by an ambiguous play of shadows. 271

This mode of expression was adopted definitively by Gior- 399
gione, and there is no doubt that he was influenced by Leonardo.

394. ITALIAN. FLORENTINE. LEONARDO DA VINCI
(1452–1519). Waves and Whirlpools.
Drawing. c. 1514–1516. *Windsor Castle Library.*
Reproduced by gracious permission of H.M. the Queen.

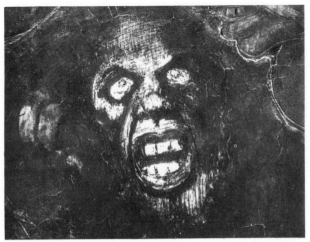

395. ITALIAN. FLORENTINE. MICHELANGELO (1475–1564).
One of the damned. Detail from
the Last Judgment. 1533–1541. *Sistine Chapel, Vatican.*

SIGNS OF UNEASINESS

*At the very moment when the triumph of the Renaissance
with its aesthetic theory of pure, rational,
hedonistic and serene beauty seemed complete, certain
unexpected and contrary aspirations can be detected.
The greatest geniuses have strange obsessions.
Leonardo da Vinci meditated on the return to nothingness,
an 'aspiration' which he saw as 'a law of nature',
on uncontrolled forces, on the Flood [394]. Michelangelo was
tormented by the thought that God could
abandon man [395]. Even the divine Raphael seemed to have a
surprising knowledge of the monsters and fires [396]
of Hieronymus Bosch (whose work was already in Venice),
and the engravings of some of his followers suggest
oneiric and apocalyptic visions,
drawn, it would seem, from the unconscious [397, 398].*

396. ITALIAN. FLORENTINE. RAPHAEL (1483–1520).
St Michael slaying the Dragon. c. 1502. *Louvre.*

397. ITALIAN. The Skeleton (detail). 1518.
Engraving by Agostino dei Musi (A. Veneziano).
Bibliothèque Nationale, Paris.

398. ITALIAN. Raphael's Dream or Michelangelo's
Melancholy. Engraving by Giorgio Ghisi
(c. 1540–1578) after Penni. *Bibliothèque Nationale, Paris.*

The latter once posed the question: 'Which is more difficult, the contours or the highlights and shadows?' Giorgione tried to escape from strict form. Intellectual forms he avoided by replacing all definite subjects by vague dream-like themes that allow the mind to flow beyond the confines of fact and concept. Plastic forms he avoided by replacing the specific delimitations of contour by a more evocative use of colour, and by creating an atmosphere of light and shade that makes each object part of the universal life that surrounds it. Heinrich Wölfflin has

232 pointed out this transition from 'tactile' values (which, as Bernard Berenson noted, played an essential role during the

295 Renaissance) to visual values. Instead of objects being distinguished separately by their surface outline, they were seen together with their surroundings as part of a whole. This asser-

410 tion of the purely visual established painting as a medium of its own, entirely independent of sculpture; and it revealed the limitless possibilities that were to be explored by modern art.

But form, which is the solid and positive basis of universality, tends to be an expression of the general. When, on the other hand, impression takes the place of definition, reverie, atmos-

284 phere and the sonority of colour open up the world of suggestion, which alone can hint at the inexpressible element of each individual. A new language was being shaped just at the time when the claims of the individual against the general framework of society were becoming so acute. It was no longer the application of universal aesthetic laws that mattered, so much as the expression of what is unique in the artist's soul. Here again the ground was prepared for modern art.

288, 409 Titian was to go further in developing the possibilities inherent in his friend Giorgione's art, and his work was to stimulate

406 and inspire 17th-century painters like El Greco and Velasquez, Rubens and Rembrandt. They were to use this new art form as a kind of impressionism to fix the most fleeting appearances, or else as an expressionist form for emotional impulses and spiritual intimations. The individual was no longer walled up in his inner world, but could communicate his most personal feelings and aspirations.

280 At Parma, Correggio was also reacting against the restrictions imposed by form. His evasion of strict form did not express ideas so much as evince a dreamy kind of sensuality, a 'morbidity' as Vasari called it. For this, he derived from Leonardo's

259 sfumato a suave technique for handling the blurred transitions of light. Correggio's humble origins are significant. He was not interested in an art and culture that implied an elaborate system of intellectual and plastic formulas, but tried to produce a spontaneous impact that would appeal to the emotions. More so than the Mannerists (of whom he, together with Michelangelo, was the spiritual father) Correggio was, as Alois Riegl pointed out, the initiator of the Baroque, that art of mass persuasion. He prepared the way for the new movement and created a style for it by his treatment of forms — his volumes shaped by gradations of colour and suggested by a luminous atmosphere, his strained and animated shapes that seem to be part of the bustling activity of life, his forms in movement that become movement itself. The subjects he chose for his

279 frescoes at Parma, in S. Giovanni Evangelista and in the cathedral (these last were completed by 1530), show an obsessional desire to break out of all material confines and to soar into

268 space and light. These works, the *Ascension* and the *Assumption of the Virgin*, reach upwards with a vertical movement that El Greco was to employ in a more exaggerated and tragic way.

The Mannerist betrayal of the Renaissance ideal

Such were the tentative attacks aimed at the established Renaissance system by the isolated efforts of genius. It was only later that there was any general movement systematically to destroy that system. This came with the Mannerists, who

in fact acknowledged Michelangelo or Correggio as their master, according to whether they came from Florence or Parma. The Mannerists contented themselves at first with modifying their treatment of form, so as to obtain refined and subtle effects that could not be achieved by harmony alone.

462, 439 Painters like Parmigianino and sculptors like Giovanni Bologna elongated their forms or set them in motion by introducing a touch of instability. Sometimes on the other hand smoothly rounded volumes were deliberately broken up into flat planes in a kind of pre-Cubist style. Dürer had already employed the

455 latter in some of his drawings. It was now adopted by Cambiaso, and Rosso even used it in his painting. Cambiaso also used artificial lighting effects such as a candle whose light, instead of

457 providing a background or atmosphere for form, actually cut

458 into the objects. In this, Cambiaso, together with Beccafumi,

523-526 prepared the way for Caravaggio. What is more, these forms were taken out of their true spatial context, and perspective was eliminated in favour of space as defined by the surface of the canvas. Whereas the Renaissance artists had endeavoured to give a standardised and clear representation of nature, the Mannerists broke away from actual appearances, ignored and forgot about them. The Mannerists were more interested in the invention of refined and original effects than in the expression of any factual or ideal truth. Such an exaggerated concern for aesthetic effects led to the distortion of form, and the search for rarity resulted in the abnormal and the bizarre. It would seem that the intellect had become so blasé about natural subjects that it tried to create synthetic sensations of its own. The young Parmi-

454 gianino, for example, painted a portrait of himself as he appeared in a convex mirror, and he did so for the sake of the extraordinary optical transformations.

This refined art was naturally the vogue in aristocratic and court circles, in the same way as Gothic mannerism had been before. It flourished particularly, under the influence of Rosso and Primaticcio, in the school of Fontainebleau. This school was dedicated to the glory of the 'second Rome', and did much to spread the 'Renaissance' in northern Europe (which shows how careful one must be in using the term 'Renaissance', for from then on it lost its original meaning). It is true that the cold sensuality of the Mannerists that was induced by a cerebral exaltation of the emotions found a new equilibrium in France. There this intellectual game was to be based uniquely on the appreciation of female forms. The sensuality of the school of Fontainebleau was so delicate as to be hardly carnal. But it was indeed genuine, and it brought Mannerism out of the domain of the purely synthetic. In this sense, the school of Fontainebleau harked back to a more vital source, to Botticelli, whose grace and delicacy it seemed to embody.

The same approach, combined with a fresh appreciation of nature, was to be found again in England. Here the Elizabethan sensibility that revealed itself mostly in literature and music was finely expressed by two miniaturists, Isaac Oliver and,

490 above all, Nicholas Hilliard.

Just as the courtly version of Gothic had been specially favoured in Prague, so Mannerism attained its most frenzied form there, at the court of Charles V's grandson, Rudolph II. On succeeding his father Emperor Maximilian II, Rudolph added Austria to his kingdom of Hungary and Bohemia. Under this odd prince who had a passion for alchemy and astrology, Prague again became an artistic centre. Many painters were drawn to

514 it, among them the extraordinary Arcimboldo who was a master at creating confused forms in his picture-metamorphoses. Then there were northern painters to whom the Emperor felt drawn on account of his Flemish descent — Roelandt Savery, the landscape painter, Johann Rottenhammer, and Bartholo-

494 maeus Spranger who died at his court in 1627. There, in Prague, the Mannerist cult of the bizarre reached the borders of madness,

399. ITALIAN. VENETIAN. The Concert.
Palazzo Pitti, Florence.

This painting, attributed to either Giorgione or Titian, has been thought to be a work of the former that was completed, on his death, by the latter. But the latest research seems to show Titian as the sole author.

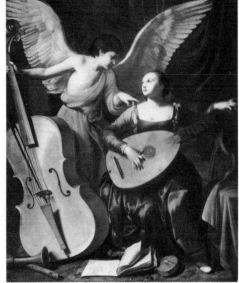

400. ITALIAN. ROMAN. SARACENI
(recorded 1580–1620). St Cecilia and the Angel. *c.* 1610. *Palazzo Barberini, Rome.*

MUSICAL INSPIRATION

The classical genius of the Renaissance seems, by its harmonious and logical clarity, to be essentially architectural. Yet subtle moods of sadness were not dispelled, but aroused, by the constant invocation of reverie and music. Venice had become the centre of such musical inspiration through the school of Bellini [402] and through Giorgione's evocation of the poetry of dreams [399]. In a famous quintet, Veronese depicts the great Venetian masters cast as instrumentalists [401]. Posterity was left a tradition of musical themes, such as concerts and soloists, whose song gives life to solitude. From Giorgione to Watteau, this tradition continued unbroken, carrying with it the seeds of Romanticism [403-405].

401. ITALIAN. VENETIAN. PAOLO VERONESE (1528–1588). The Marriage at Cana (detail). 1563. *Louvre.*

The central group of musicians contains portraits of Veronese, Palladio, Jacopo Bassano, Tintoretto, Titian.

402. *Above, centre.* ITALIAN. VENETIAN. CIMA DA CONEGLIANO (*c.* 1459–1517/18). Orpheus. Drawing. *Uffizi.*

403. *Above, right.* ITALIAN. MARCANTONIO RAIMONDI (1475–1534). Guitarist. Engraving, perhaps after Francia. *Dutuit Collection.*

404. *Right.* ITALIAN. EMILIAN. DONATO CRETI (1671–1749) Fête Champêtre. *Palazzo Venezia, Rome.*

405. *Far right.* FRENCH. ANTOINE WATTEAU (1684–1721). Mezzetin. *Metropolitan Museum of Art.*

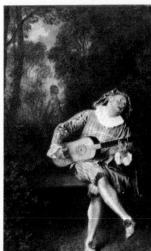

where Rudolph himself seemed to be precariously balanced.

Although the Mannerist movement hastened the end of the Renaissance, it was in fact no more than a development of tendencies inherent in the Renaissance. The same had been true of the Flamboyant Gothic style. Chastel was right in seeing it as the result of Ficino's neo-Platonic movement which first began to draw a distinction between nature and reason. This meant opposing the classical aesthetic that had considered nature and reason as one. Ficino added a taste for the esoteric and a weakness for the magical. There was even a touch of Orientalism. Gemistus Pletho had stayed at Sultan Bayezid's court at Adrianople, and he had links with Persian thought and the Zoroastrian cult. Ficino himself had looked into the *Corpus Hermeticum* of Hermes Trismegistus, into demonology, and even into the Chaldean oracles.

In this way we can trace the taste for the strange and mysterious that was carried over from the Middle Ages to upset the norms of the Renaissance. In the Germanic countries neo-Platonism was handed down by the Rhenish mystics and enriched by Cabbalism. Those countries therefore had no difficulty in banishing the rationalism of the Latin peoples and sliding into a symbolic conception of the universe. Paracelsus (c. 1490–1541) opened the way for Jakob Boehme (1575–1624). Together they gave back the sense of mystery to the world, and to reason all its instability. The combination of this tendency and Italian neo-Platonism explains the excesses of Rudolph II's court.

Even the Renaissance in Italy had a hidden streak of the fantastic. Some contemporary engravings are proof of this. **397, 398** In the *Skeleton*, the *Dream*, etc., there are echoes of Hieronymus Bosch, of Giorgione, and of Raphael, who invented the weird **396** monsters and the fire in his small picture of *St Michael*. It was thus from an underlying stratum of Rome that there arose the stale aroma of irrational Orientalism, brought over in ancient times from Alexandria. A. von Salis has recalled that the vestiges of Alexandrian decoration in Nero's Golden House were discovered as early as the end of the 15th century. Their style was made fashionable by Pietro Luzzi, whom Vasari referred to as one of the sombre 'melancholics' who prepared the ground for the Mannerists. It was Luzzi who invented the 'grotesques'. So it was that the minor art of decoration produced, about 1500, **411, 413** the host of strange monsters that are found in profusion in foliated scrolls, as in the Middle Ages, and are combined so oddly with human, animal and plant motifs. This strange world **412** was adapted by Raphael and Giovanni da Udine in the Vatican Loggias (1517–1519), taken up with relish by the Mannerists, **417** and popularised by engravers. It passed to Fontainebleau, whence **416** it was handed down, through Berain, Audran and Watteau, to modern times.

Faith versus 'humanist' arrogance

Despite certain divergencies, Mannerism kept within the mainstream of the Renaissance. And it remained humanist in the sense that it was still based largely on the human figure — portraits in which, however, the expression is empty, fixed or haggard, and nudes for which the female figure was preferred as it lent itself to the play of gracefully curved lines. Man was still on the pedestal he had made for himself, content with the sensation of a contrived vertigo; he was ready for the fall. The Reformation made scathing attacks on man's pride in an attempt to humble him before God, as in the Middle Ages. In doing so, it was to open the way, as we shall see, to individualism. But at this stage it only made the individual acutely aware of his overwhelming and solitary insignificance in the face of the Creator and the God of Judgment.

At the end of the 15th century Ficino said of man: 'To him the sky does not seem too high, nor the centre of the earth too deep. Time and space do not prevent him from going anywhere at any moment... On all sides he strives to dominate, to be praised, to be eternal like God.' If Leonardo belongs to **254-261** the Renaissance, it is because of the enormous impetus he gave to this awareness of man's greatness and power. How different were Calvin's words some years later: ' The Scriptures show us what we are in order to reduce us to nothing. It is true that men will intoxicate themselves all the more, deluding themselves with the belief in their great dignity. They may well think highly of themselves, for God, in the meantime, knows them to be only a lot of stinking refuse ...' It was not until Pascal that these two conceptions of man, the grandiose and the abject, were reconciled. For the moment the revelations of man's insignificance vis-à-vis the universe was a rude awakening from the arrogant dream of the Renaissance. From Patenier (who died in 1524) up to the *Seasons* by Bruegel (born about 1528), there was in northern Europe a sudden spate of cosmic visions. In these, man, whose actions are only significant to himself, has no more importance than an insect in the infinitude of space. In Bruegel's *Fall of Icarus* Icarus passes unnoticed by **497** the peasants working near by. A generation earlier Altdorfer had depicted St George and Alexander's entire army swallowed up in the vastness of the cosmos.

Humanism had been created by the new class, the intellectuals, and had affirmed the autonomy of human genius. Similarly the artists, who had emerged from the ranks of the craftsmen, wished henceforth to depend on nothing outside their art. But Christian fervour was checked in its flow and remained unsatisfied. Separated from God by the irresistible growth of his achievements and by his confidence in himself, man found himself clinging to a pinnacle of his own making, alone and afraid. Very soon those spiritual aspirations that had been so triumphant, and were now so frustrated, began to reassert themselves alongside the current intellectualism. The spiritual trend may be due to the fact that neo-Platonism was steadily gaining ground over Aristotelianism. The influence of the latter created a tradition, from as early as the 13th century, that leads up to modern science and positivism. Ficino's neo-Platonism, which was in some ways the acme of the Renaissance, showed signs of unconscious religious and quasi-mystical leanings. The demands of faith came to a head with Savonarola in Florence, at the very heart of the Renaissance movement. It is significant that someone like Botticelli was affected by this. Botticelli's **220, 234** early painting was the direct outcome of contemporary neo-Platonism which led him to the very threshold of Mannerism. Then suddenly he burnt his paintings of Venus as a sacrifice and threw himself into the extremes of Christian anguish.

El Greco was soon to be a striking example of the same phenomenon. Brought up in Crete, in a society steeped in the medieval faith, he matured in Italy where he absorbed the various Venetian influences and the style of the Mannerists. **433** Then without transition he transformed this Mannerism effortlessly into a paroxysm of mystical fervour. El Greco expressed man's need to escape from his physical condition, to stretch form to its limits, to heighten colour to a pitch where it explodes **548-551** like light, to transcend himself in order to reach up to God again. El Greco only achieved this when he settled down in Toledo, the burning core of Spain, whose golden hour was approaching. Spain had remained intact since the Middle Ages. She had borrowed from the Renaissance only certain decorative elements that were rapidly absorbed by the Mudejar and Gothic **148** tradition to form the Plateresque style. She also readily absorbed, **379** in her literature especially, the Mannerist and Baroque styles, those offshoots of the Renaissance. Charles V previously had only really appreciated Venice, and it was Venetian art that formed El Greco for Philip II. The new art only became acceptable to Spain once it negated the conceit of humanism and began

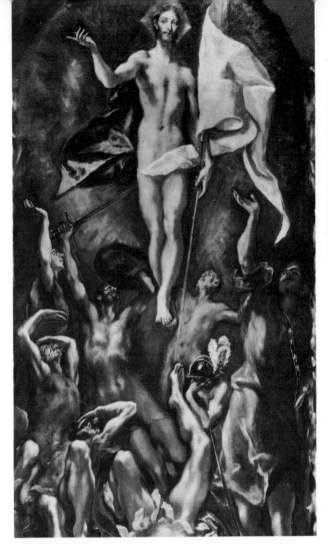

406. SPANISH. EL GRECO (1541–1614).
The Resurrection (detail). *c.* 1600. *Prado.*

407. ITALY. BRAMANTE (1444–1514).
Cloister of Sta Maria della Pace, Rome.

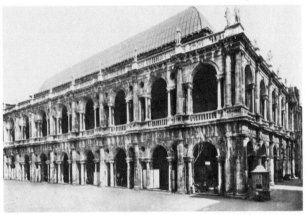

408. ITALY. PALLADIO (1508–1580).
The Basilica (Palazzo della Ragione), Vicenza. 1549–1614.

DISAPPEARANCE OF FORM

*The emphasis on strict form appeared to be the
intangible basis of Italian art. Here again, it was Venice that
seemed to hasten the evolution towards a different
kind of expression. Architecture had been especially concerned
with the geometric play of clear-cut lines and surfaces.
Starting with Sansovino, it became a play of
light and shade, of relief and hollows. The comparison of
two versions of a very similar idea, Bramante's [407]
and Palladio's [408], brings out the contrast. In painting
particularly there was a marked change.*
*Linear structure gave way to a much freer treatment of paint
and outline. Some late Titians set a bold example in
breaking up surfaces and volumes by strongly
contrasted brushwork [409]. Tintoretto was a pastmaster of
this style [410]. Strict sculptural qualities were replaced by
essentially pictorial features in these daring
interpretations that have elements of both impressionism and
expressionism. El Greco, who was a pupil of the
Venetians, developed these tendencies to extremes in
Spain [406], and prepared the way for Velasquez.*

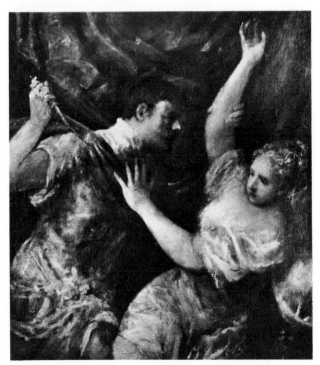

409. ITALIAN. VENETIAN. TITIAN (1488/90–1576).
Tarquinius and Lucretia. 1570.
Kunsthistorisches Museum, Vienna.

410. ITALIAN. VENETIAN. TINTORETTO (1518/19–1594).
Adoration of the Magi (detail). *Scuola di S. Rocco, Venice.*

to treat man and his complacency with severity. A great archi-
534 tectural style then evolved. Dominated by Herrera, it was
accepted by the morose Philip II in the Escorial. The strict
austerity of the *desnudo* style was typical of the tendency towards
simplification that followed the Renaissance, once the latter was
condemned by the Counter Reformation.

Counter Reformation and the 'populist' movement

The term 'Counter Reformation' is ambiguous. It started
as an attempt to make long-needed reforms. But the Protestants
outstripped it, and their radicalism made the Counter Refor-
mation seem heretical. When the Church became aware of the
gravity of the situation and undertook to pull herself together,
it was Spain that was chosen as the instrument of this difficult
task. For Spain had never forsaken the faith of the Middle
Ages and the spirit of Christian humility (of humility towards
God if not towards other men). The Society of Jesus, founded
by Ignatius Loyola in 1537 and subjected to a rigorous disci-
pline, provided the Church with a veritable army. It was from
Spain, too, that St Francis Xavier, a friend of Ignatius, set out
to carry the new passion for Christian expansion as far as Japan.
Finally the Inquisition, the most brutal attempt to restore Cath-
olic discipline, was most fully developed in Spain. It was a
country that had not experienced the luxury and pleasure of
life centring round many small princely courts. Nor were there
any intellectuals who could transform the aristocracy into a
class dedicated to intellectual and aesthetic pleasures. Loyal to
the medieval tradition, Spain had only had dealings with sover-
eigns, vicars of God and the Church. The very idea of an
élite, which was the basis of the Renaissance movement, was
foreign to Spain. There civil authorities provided a link rather
than a barrier between God and the people.

A revival of such an attitude was sought when between 1545
and 1563 the council of Trent planned a reaction to the Renais-
sance. The outcome was the Baroque. The Baroque style was
used at first, in Rome and Spain (by the Jesuits particularly),
as a means of emotional persuasion and religious propaganda.
Henceforth art no longer aimed at the sensitive appreciation
of an élite, but was created for the broad masses of the faithful.
Mannerism, on the contrary, had taken to extremes the purely
aesthetic (and therefore aristocratic) function that the Renais-
sance had imputed to art. But Protestantism had denounced
Rome, with her popes and clerical princes, as a monstrous
system designed to drain the resources of Christendom in order
to pay for all her luxuries, of which art was the most costly.
So it was desirable to remove the grounds of such accusations.
Art was to be restored to its proper function — as a means
for influencing the great majority of the faithful. As part of
the new policy, the erection of a central monument to the
papacy was abandoned. Instead, there was a wide campaign,
unprecedented since medieval times, to build churches.

The change in the social implications of art soon resulted in
a movement to portray the everyday life of ordinary people.
This 'populist' movement had already been engendered by
422 Jacopo Bassano, who had been freed of classical preconceptions
thanks to Venetian influences, and whose rural origins inclined
him to the observation of humble life. The same trend was
followed by Todeschini, Niccolò Frangipane and Campi, and
419 popularised by Villamena's engravings. It led to Caravaggio,
523-526 who at the end of the 16th century gave the movement a revo-
lutionary aspect. All these last artists were from the north of
Italy, from Venice or Lombardy. Caravaggio was the son of
a plasterer, so it may be that his social background accounts
for his leanings. But it should also be remembered that he
came from the region of Milan, the home-country of Ceruti
and Cifrondi who prolonged this populist trend right up to
the 18th century. Now the province of Milan belonged to

Spain from 1535 to 1714; so did that other stronghold of natu-
ralism, the kingdom of Naples, where Caravaggio ended his
short life, and where Ribera worked. The Aragonese had 552
established themselves there in Naples from 1442, and in 1504
they handed over the power to the Spanish crown.

There was another source of populism that was to be devel-
oped in Rome by the 'bambocciata' or rustic-life painters,
and in France by the le Nain. This came from northern Europe, 680-683
where the Reformation had done more than the Counter
Reformation to oppose the aristocratic flavour of the Renais-
sance. Protestantism, which, in spite of resistance from Luther,
was committed to opposing the ruling princes, and which in
1525 inveighed against the 'gangs of killers and robbers of
the peasantry', was considered by the people as an instrument
of freedom. Furthermore, Protestantism was immediately accom-
panied by social movements, revolts and peasant uprisings that
were ruthlessly suppressed by the barons. What is more, man
was placed face to face with the Word of God as it is revealed
in the Bible; faith, the faith even of the humblest individual,
was considered more important than good works; the hierarchy
of the Church and all the doctrinaire 'middlemen' from the
Pope down to the priests were swept away. In this way, Protes-
tantism placed the simple uncultivated being, who was igno-
rant of all the doctrinal subtleties, on the same footing as the
élite. These new ideas were soon spread about by Illuminism
and the Pietists, and, above all, by the Anabaptist movement
which was to stir up Hussite memories as far afield as in Bohemia.
In Germany, and even at Lyon in France, social and religious
aspirations were sometimes merged in the general effort to
shake free from authority and regulation.

A similar thing happened on the Catholic side. The Rhenish
mystics, in opposition to doctrinaires and their acquired know-
ledge, claimed that the soul had access to God by religious
zeal alone, and so prepared the common people for Protes-
tantism. The fact that a cardinal like Nicolas of Cusa should
suggest that even a simple person could understand God and
nature indicates the extent of Protestant influence. But just when
the struggle against Protestantism began, there grew up in
Rome a 'new piety' that was much closer to the people, and
was poorly received at first by the pontifical court. St Philip
Neri, however, gave it all his support, and contributed to its
success by founding the new Order of Oratorians in 1575.
Caravaggio is rightly said to have been influenced by the Ora-
torians. He worked for them, and his *Descent from the Cross*
was painted for their church in Rome, now the Chiesa Nuova.

The influx of north European artists to Rome created a
veritable colony, the *Bent*, which helped to fuse the two tend-
encies stemming from northern Europe and Rome respectively.
These artists imported new and more plebeian tastes. George
Isarlov has shown how Bosch and then Quentin Metsys were 14
stimulated by Leonardo's caricatures and became interested in
the expressive truculence of boorish characters, and how Quentin
Metsys painted the interior of a peasant's house in as early
as 1549. Bruegel, who was then at the beginning of his career,
paid considerable attention to this populist trend in spite of
his trip to Italy in 1552–1553, and created a wide public for
it. Plebeian themes were to have a great success in Italy and
then all over Europe, thanks to Caravaggio. But like all move-
ments from then on, its success owed much to the growing
popularity of engravings, which had become essential as a 419
means of widespread diffusion.

The new trend was so universally predominant that it is
even found in works by the Carracci, who are normally consid-
ered in opposition to Caravaggian realism. The 1956 exhibition
in Bologna has justified the 17th-century admiration for the
Carracci. Annibale Carracci was as firmly against aristocratic
Mannerism as Caravaggio was, and he created a populist realism

411. ROMAN. Foliated scroll with plants and animals. Flavian period. *Uffizi.*

412. ITALIAN. GIOVANNI DA UDINE (1487–1564). Foliated scroll. Pilaster, Raphael's Loggias. 1517–1520. Vatican.

413. SPANISH. Detail from the church stalls of the monastery of S. Benito, Valladolid. 15th–16th centuries.

414. ITALIAN. UMBRIAN. PINTURICCHIO (1454–1513). The Cumean Sibyl. Detail from the decoration of the nave of Sta Maria del Popolo, Rome. 1505.

415. ITALIAN. Imaginary vase, decorated in the grotesque manner and presented as of antique inspiration. Engraving by Aeneas Vico. Mid 16th century.

416. FRENCH. The Mountebanks. Sketch for a decorative composition of arabesques. Drawing by Claude III Audran (1658–1734). *National Museum, Stockholm.*

GROTESQUES

Even in the decorative arts a new tendency arose. Although conceived during the Renaissance it went against current ideas, based, as it was, on the irrational and the fantastic. The ' grotesques' were so named after the grottoes found among ruins where remnants of Alexandrian decoration were discovered. This fantasy and irrationality, of Oriental inspiration, had at one time shocked ancient Romans like Vitruvius. It should be remarked that the Venetian artists, who conformed but little to the strictest classical style, played their part in discovering and popularising grotesques: Pietro Luzzi da Feltro was the first, followed by Giovanni da Udine, who must have stimulated the interest of his master Raphael [412]. Giorgione's poetic revelations made a deep impression on them both, for he collaborated with Pietro Luzzi and taught Giovanni da Udine. Giovanni da Udine copied classical designs [411], mixing medieval foliage motifs with human and animal ones that intertwined in extraordinary combinations [414]. The ancient Oriental tradition had been handed down by the Romans or the barbarians to the Middle Ages. This tradition, taken up again from its classical sources, diffused by engravings [417], and mixed, paradoxically, with the classical style [415], continued unbroken [413] up to the 18th-century ' arabesques' [416].

417. ITALIAN. ' Grotesques ' (fragment). Engraving by Aeneas Vico. 1541.

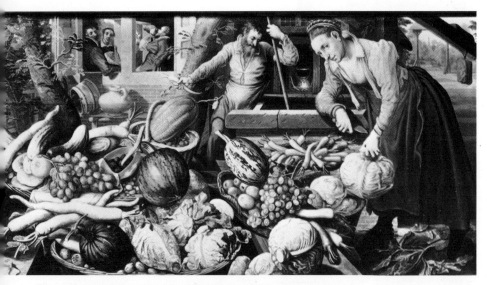

418. FLEMISH. PIETER AERTSEN (1507/08–1575). Fruit and Vegetable Vendor. 1562. *Hallwylska Museum, Stockholm.*

419. ITALIAN. FRANCESCO VILLA-MENA (1566–1626). Peasant. Engraving.

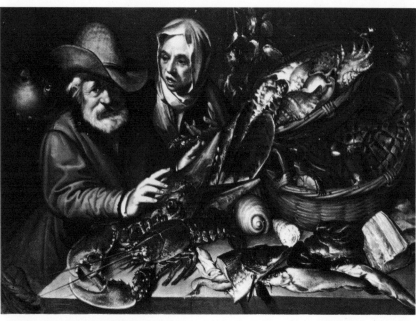

421. DUTCH. REMBRANDT (1606–1669). Beggar Couple with a Dog. *c.* 1628/29. Pen drawing. *Cassirer Collection, Amsterdam.*

420. ITALIAN. BOLOGNESE. BARTOLOMEO PASSAROTTI (1520/30–1592). The Fishmongers. *Palazzo Barberini, Rome.*

424. FRENCH. MATHIEU LE NAIN (c. 1607–1677).
Venus in Vulcan's Forge. *Reims Museum.*

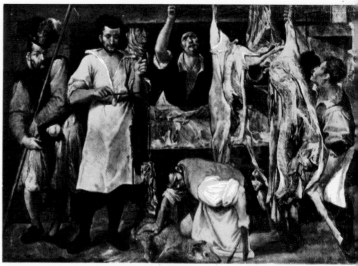

425. ITALIAN. BOLOGNESE. ANNIBALE CARRACCI
(1560–1609). The Butcher's Shop. *Christ Church, Oxford.*

'POPULIST' ART

*Renaissance art became official in character,
particularly when it was stiffened by the French classical
movement in the 17th century, and ideas that were
incompatible with its conception of beauty were avoided.
Nevertheless, a realist tendency, whose everyday subjects did not
fit the idealisation process and which stemmed from the
Middle Ages, had continued to flourish in the
north, from Bruegel to Aertsen [418] and his disciple
Beuckelaer. Their still lifes enlivened by figures
had a considerable influence, the result of which may
be seen in Italy [420] and in the Spanish bodegones,
especially those of the young Velasquez. Even in Italy, the
protagonists of the Counter Reformation,
anxious to appeal to the people, encouraged this movement.
The genius of Bassano, pioneer of the rustic genre,
gave it impetus [422], and the forceful ruggedness of
Caravaggio made it widely known. Even Annibale Carracci
created a surprisingly sturdy version of it, which contrasts with
the oversimplified idea of him as an 'academic'
painter [425].
Engravings, which often had to be of obvious inspiration
to appeal to a wider and more modest public,
made much of the picturesque tramp motif in the north [421]
and in France [423], Spain and Italy [419].
Realistic interpretations of certain mythological themes show
that the two tendencies, the classical and the popular,
were not only concurrent but intermingled [426]: this is
true of both the academic [427] and the realist painters [424].*

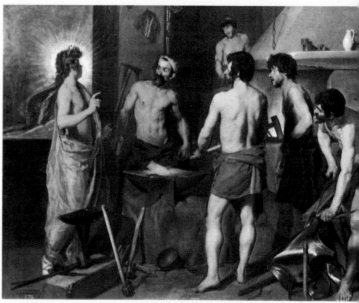

426. SPANISH. DIEGO VELASQUEZ (1599–1660).
The Forge of Vulcan. *c.* 1630. *Prado.*

422. *Far left.* ITALIAN. VENETIAN. JACOPO BASSANO
(c. 1518–1592). The Grape Harvest. *Doria Pamphili Gallery,
Rome.*

423. *Left.* FRENCH. JACQUES CALLOT (1592–1635).
Captain of the Beggars. Engraving from the
'Beggars' series.

427. *Right.* FRENCH. LOUIS BOULOGNE THE ELDER
(1609–1674). Venus in the Forge. *Formerly Vuyk Collection.*

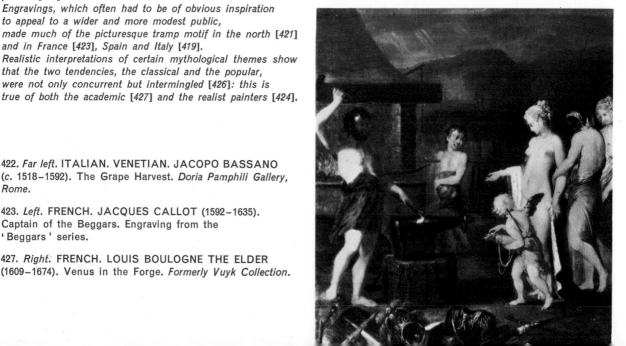

which he treated in a rough instinctive technique that sometimes anticipates Manet or Cézanne. Carracci's drawings of the ordinary people of Rome were popularised by engravings, and he inaugurated a long iconographic tradition. His paintings of rough characters caught in the activity of everyday life, such as the *Bean-eaters* and the *Butcher's Shop*, show that he, too, was eager to, and indeed capable of, sweeping away formal conventions both in his choice of subjects and in his treatment of them. Carracci's evolution led him towards classicism. But prior to the Farnese palace paintings, which had a far-reaching influence, his work was full of a sturdy and wholesome strength. This quality has often been ignored, thanks to the blind prejudices of the 19th century, but there is no doubt that it helped Rubens to find himself while he was studying in Italy from 1600.

Caravaggio and the new art

Caravaggio's position was more decisive and drastic. The Renaissance had been formalist in the widest sense of the word: it was based essentially on form, intellectual and artistic form. This was what Caravaggio attacked. On the spiritual plane the Renaissance had set about creating a scale of values, starting from crude matter and working up progressively to ideal beauty. Such a refining process, whereby reality and appearances were elevated to a higher and purer state, was well suited to an aristocratic society which was itself based on a hierarchical system with, at its summit, the accomplished gentleman, the courtier as defined by Raphael's friend and model Baldassare Castiglione. We have seen how that attitude led to the overrefined and arbitrary formalism of the Mannerists.

Caravaggio brought about a return to reality. He ostentatiously selected subjects that were unspoilt by any social or moral refinement, and vindicated populist art in a revolutionary way, bringing religious themes down to earth and setting them in ordinary, everyday surroundings. He also dealt equally severely with the sculptural forms that had been modelled on the purity of antique sculpture during the Renaissance. He systematically used the lighting effects devised by Mannerists like Beccafumi and Cambiaso. Classical painters had employed luminous areas of light as a background or atmosphere surrounding the contours and shaded volumes. Caravaggio used direct lighting effects, cutting arbitrarily into dark areas with a beam of light so as to make the reliefs it chanced upon stand out in a violent and unexpected way. Thus he replaced normal, and skilfully elaborated, forms by pools of light that spring out from an area of darkness. There is none of the regularity that comes from contour and tonal gradation. Forms are so cut, dislocated and disjointed that traditional sculptural values disappear altogether. Form, which the Venetians had merely recast in colour, and which the Mannerists had manipulated and exaggerated, was now evoked by an aggressive use of light.

What is more, Caravaggio's painting no longer presupposed an educated spectator of taste and discernment. It has a direct impact on the nerves and senses and makes an immediate impres-

428. SPANISH. ZURBARÁN (1598–1664).
St Francis of Assisi. 1640/45. *Lyon Museum.*

433. *Right.* SPANISH. EL GRECO (1541–1614).
St Francis Receiving the Stigmata. *Women's Hospital, Cadiz.*

429. *Right.* FRENCH. GEORGES DE LA TOUR (1593–1652).
St Francis in Ecstasy. *Le Mans Museum.*

This picture may be a replica of a lost original.

434. *Centre.* FRENCH. PHILIPPE DE CHAMPAIGNE
(1602–1674). Mother Catherine Agnès Arnauld and Sister Catherine Ste Suzanne, daughter of the artist. 1662. *Louvre.*

435. *Far right.* FRENCH. JOUVENET (1644–1717).
St Bruno Praying. *Lyon Museum.*

425

190

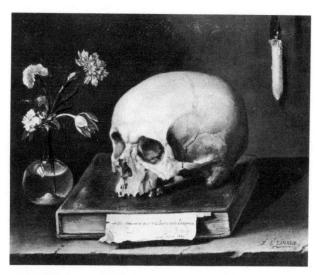

430. *Above, left*. FRENCH. LA HYRE (1606–1656).
Pope Nicholas V opening the tomb of St Francis of Assisi
(detail). 1630. *Louvre*.

431. *Above, right*. SPANISH. PEDRO DE MENA (1628–1688).
St Francis of Assisi. 1663. *Toledo Cathedral*.

432. FRENCH. JACQUES LINARD (1600–1645).
Memento Mori. 1644. The scrap of paper reads:
'This is how all our beautiful days end.' *Private collection*.

SPIRITUAL THEMES

*The habitual classifications of history are often too
radical. It is true that the Renaissance established an
intellectual system that broke with the Middle Ages. For this
system was humanist rather than religious,
idealist rather than mystic, rational rather than
emotional; and it did in fact lead to the classical discipline of the
17th century that glorified thought and was so sure of
its foundations, its means, and its aristocracy.
But the spirit of the Middle Ages lived on in the
realistic attitude of the Church which was given new impetus
by the religious conflicts. This spirit found its expression in
a Protestant country through Rembrandt.
In Catholic countries it avoided the rhetorical Baroque
to extol severe asceticism [428, 430, 431], deep meditation [435]
(on death, particularly, which was evoked by the
physical presence of a skull [432, 429]) and it aimed at revealing
supernatural light [433, 434] and even mystic ecstasy [429].
Characteristic of this is the new interpretation of the
already familiar figure, the kind and tender St Francis (see p. 89).*

sion. El Greco, whose figures are seen as if dislocated in a flash of lightning, has the same violent, instantaneous and intensified effect. Caravaggio, who is less intense and heavier, cultivated clashing moral and physical effects. The immediate impression of his *Conversion of St Paul* is that of a rustic scene rather than anything else: all we see at first is the enormous rump of a horse that blocks out the rest and takes all the light.

He enjoyed being provocative when he was young, but he was more than that. The mature Caravaggio disclosed the significance of his aims. The exhibitions at Milan in 1951 and at Bordeaux in 1955 have revealed his last works which were preserved in Malta and Sicily. These paintings have a profound spiritual quality; and some of them have such an inner concentration, particularly in the shadowed areas, that they could be compared with Rembrandt. Recent Italian criticism is thus confirmed. Caravaggio was a religious painter who tried to re-establish contact with the reality of biblical stories as well as with the minds of his spectators. To do so he endeavoured to give his work a living and active presence. He expressed the religious tendencies of the Counter Reformation, of St Philip Neri with whom he linked himself, and of Ignatius Loyola. In the *Spiritual Exercises* the impact of naked reality, such as the sight or touch of a skull, is considered by Loyola as a source of profound meditation.

Even the mystics, especially the Spanish mystics, St John of the Cross and St Theresa, did not turn their backs on the physical world, but often looked to concrete objects for an initial jumping-off point for mystic experience and revelation. In place of such authentic intensity, the Baroque painters employed a rhetorical and histrionic style, so that sincerity was often sacrificed to technique. It is true that Caravaggio was and intended to be spectacular, but it would be unfair to associate him with the Baroque movement which he preceded and which did not possess his pungent veracity.

The century of spirituality

We come now to the Baroque. The Counter Reformation and classicism were indeed associated closely with this movement, and they will have to be discussed again in the next chapter. Yet it would be wrong to regard this period in the light of these movements alone, as one has been all too inclined to do in recent years. 17th-century art can by no means be explained simply as being Baroque.

The 17th century marked, above all, a return to spiritual values in reaction to the excessive intellectuality of the Renaissance. An effort was made to grasp the essential substance of the soul, which was sought, naturally enough, within the framework of the reinstated religious tradition. This ardent desire for sincerity, which had previously been at the root of the Reformation, was in distinct contrast with the imperious attitude of the Renaissance and the artificial effects sought in the Baroque. Spain, with her fervent and strong-willed mystics, her theologians (at Salamanca especially) and her new religious Orders, led a religious revival. This culminated in the spiritual awakening of France under men like Pierre de Bérulle, Jean Jacques Olier, St François de Sales, St Vincent de Paul, and the proud triumph of Jansenism which the Jesuits had such difficulty in crushing.

It is sometimes difficult to see the unity of this spiritual revival since it took on varying forms in different regions. Caravaggio's followers tended to use dramatic effects of violently contrasted light and shade; painters like Zurbarán in Spain and Georges de La Tour or Nicolas Tournier in France, who were associated with the asceticism of the Counter Reformation, immobilised interior violence by their extreme intensity. But as the Counter Reformation became more concerned with the persuasion rather than the renovation of souls, painting also shifted

554
666, 677

to persuasive methods. With the development of the Baroque style, painting took on the aspect of a stirring visual sermon, and became more warmly communicative and expansive. Severity gave way to an inspiring superfluity. Flanders, which was the avant-garde of the war against Protestantism and was, therefore, more concerned with effective action than with introspection, provides the best example of this kind of painting in the lyrical and sensual exuberance of Rubens. 571

The spirituality of the French, on the other hand, was more introspective, and their Gallic decisiveness gave it an almost Spanish intensity. French painting varied from the Caravaggesque of Georges de La Tour or Tournier, to the restrained realism of Philippe de Champaigne, for example, a realism that 434 was rather Flemish, but Jansenist (Cornelius Jansen was himself from Ypres), or to Le Sueur's kind of fervour that is softened 695 by tenderness.

In Protestant countries the last traces of Flemish verve soon died out. It was still alive, and stamped with a Caravaggesque truculence, in the school of Utrecht. It became more and more inward-looking with Frans Hals, and was then absorbed into 634 the deep and rather melancholy world of Ruisdael, the poet of 642 solitude, and Rembrandt, the magician of the soul. Rembrandt 643-651 gave this Flemish zest an evangelical bent, so that it shines out in brotherly warmth and love for all men and for all times. Vermeer, meanwhile, infused familiar objects with a crystal 657-660 clarity that is intellectual. The French, with their reserved inward-looking approach to meditation, were not so different from the Dutch. But whereas the former, as Catholics, interpreted the views of the Church as a whole, the Dutch, as Protestants, concentrated more on the individual's experience of life and his personal vision of religious themes.

It was all part of the same yearning of the soul to subsist, to expand, to waste away and, as it were, to justify itself. Art was but a votive testimony of this yearning: ' Lord, here is the best proof we can give of our dignity. ' It was a dignity nourished by faith and sincerity. This testimony took on different forms, according to various sects, schools or individuals. In this first half of the 17th century the importance of the particular was affirmed. The individualism outlined by Montaigne fought its first battle. Differing beliefs, religions and ambitions caused a restless anarchy in society that lasted from the religious wars till the Fronde, when disbelief was first admitted by the free-thinkers. The Anabaptists, for their part, denied the possibility of an established religion since faith was considered a personal gift of the Holy Spirit. Civilisation has seldom seemed so rich and at the same time so incoherent. The Renaissance attempt to co-ordinate and harmonise the world appeared, towards the middle of the century, to have come to nothing. There was instead a multiplicity of fervent souls wearing themselves out in bitter rivalries or in the struggle for independence. Italy, Germany, the Spanish empire and even France after Richelieu's death seemed to be on the verge of annihilation.

The return to rational order

To combat the threat of chaos, classical concepts were resuscitated. There had been a precedent for this in Italy at the end of the 16th century. Since the end of the 15th century criticism had been centred on the lives of artists, and its high-water mark was Vasari's work. Then, for the first time, criticism had begun to grasp the characteristics that are peculiar to each artist and that do not conform to general rules. The notion of ' manner ' soon became the current way of characterising the particular

SPANISH. EL GRECO (1541–1614).
The Burial of Count Orgaz. 1586. Sto Tomé, Toledo.
Photo: Michael Holford.

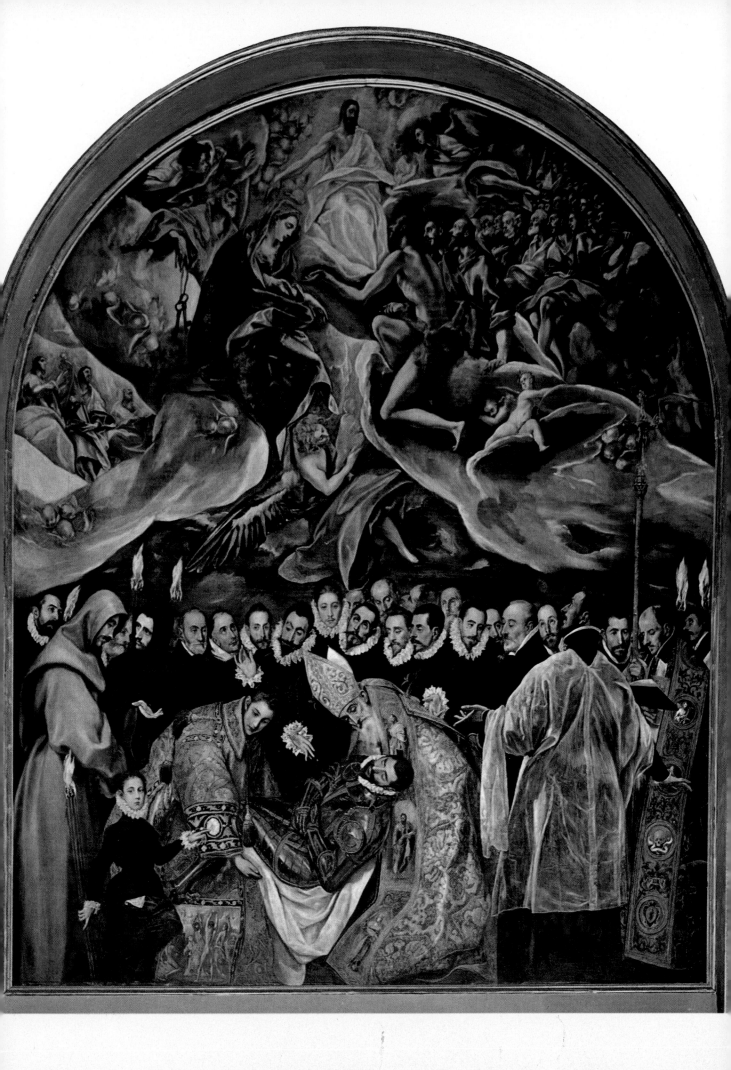

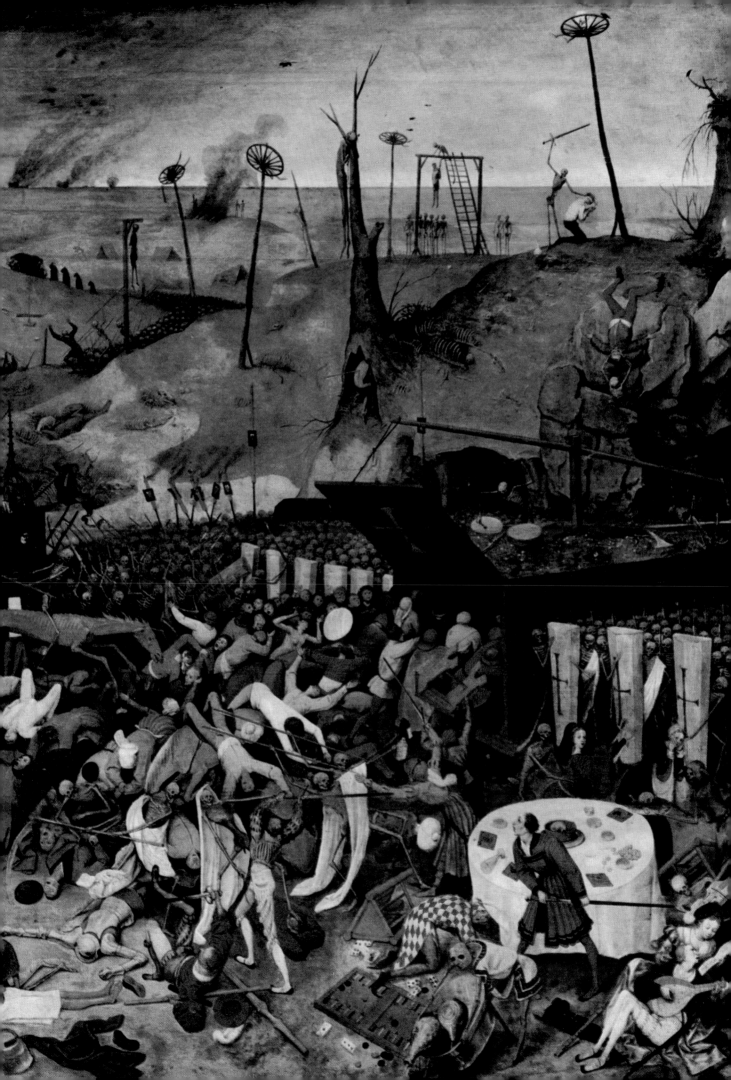

genius of a great master. The unity of art was no longer sought in general principles but in the totality of particular contributions. One dreamed of an art that would synthesise all the best results which each artist had achieved at the price of his defects. This eclectic conception is attributed, in simplified terms, to the Carracci and their academy.

As the 17th century wore on, however, the need was felt to find some basis for universality, for Europe was henceforth deprived of any unifying religious principle, and her countries even were divided. But faced with such a variety of sects, ideas and artistic styles, it was difficult to find any such unity. The problem was not only intellectual but social. In France the young Louis XIV, who had been marked for life by the memory of the anxious beginning of his reign when he fled to St Germain during the Fronde, set himself resolutely to find the solution.

Already at the end of the 16th century certain Protestants, such as the Socinians, were horrified by all the variations within the Church that Jacques Bénigne Bossuet was to denounce, and they called for a return to reason and the rejection of all doctrines that could not be justified by reason. The Catholics for their part stressed the need for stronger discipline, which as far as they were concerned had been restored by the Jesuits, along military lines.

As for the philosophers, they tended to brush aside appraisal by the individual, basing their ideas on the quantitative and measurable, and avoiding anything that could be the object of variable or subjective valuation. Thanks to them science ceased to be what it had been for Leonardo — an inquiry by an intelligent observer, little different from artistic experiment. Science now became rational, and it was based on dispassionate objective knowledge. Bacon's *Novum Organum* in 1620 and Galileo's *Dialogue* in 1632 followed these lines. In his *Regulae* Bacon affirmed that ' only the intellect can perceive the truth ', which he distinguished from ' the variable testimony of the senses and the misleading judgment of the imagination '. Thus England took the lead in the positivist movement whose triumph was to be assured by Newton (born in 1642). It was discovered that, outside the domain of variable emotions, reason supported by experiment could be the object of universal and incontestable agreement. All that was required was a method, and this was provided by Descartes, the mathematician, geometrician and physicist, in his *Discourse on Method* in 1637. So it was that philosophy achieved by rationalism the unity that religion could no longer provide. In a Protestant country as well, in Amsterdam, the Portuguese Jew Spinoza took up Descartes' ideas and developed an unprecedented discipline for the study and formulation of ' true ideas ' and the laws of ' fixed and eternal things... which cause and determine all particular things '. Reason claimed to apprehend reality as ' a particular form of eternity ', and to make the individual conscious of the universal laws on which he depends. If Spinoza clung so tightly to determinism, it was only in order to oppose individualism and the ' free will ' theory.

In France Louis XIV wished to establish the state itself on a rational, hierarchical and centralised basis, so as to ensure stability. The king was to become an absolute monarch, which means, etymologically, the unique source of power. France headed the quest for a universally valid system, as her art and literature show. The classical movement she founded was to serve as a model to all Europe which aspired to this same solution. 689, 692 Poussin and Claude le Lorrain, who represent the acme of

this style, prove, since both were born well before Louis XIV, that the Roi Soleil merely acknowledged a movement that had already mastered its aims and technique. Both these painters had been formed in Rome where they were influenced by the Carracci and their school. But they remained typically French with a spiritual seriousness that is ever conscious of the presence of the soul, but which, in spite of their deep individual force, they subjugated entirely to the laws of reason. This individual power was lost during Louis XIV's reign, and painting began to dry up with the codifying rigidity of the Academy whose first director was Le Brun. Architecture, an essential art 719 for the king because of its prestige value, reached a kind of classical perfection, at Versailles in particular, thanks to Le Vau and J. H. Mansart. Even the natural surroundings were submitted to the classical ideal by Le Nôtre's gardens in the French style. 436 Versailles was the very symbol of monarchic and absolute power, and its triumphant style was to be adopted by all the kings of Europe.

Thus, if 17th-century French art did not escape entirely from the Baroque movement, it nevertheless stood unyieldingly apart. And it reaffirmed in a new form the ambition of classical times and of the Italian Renaissance to promote an aesthetic ideal conceived by the intellect according to natural laws.

436. FRENCH. Ornamental flowerbeds at Champs seen from the balcony of the château. Flowerbeds reconstructed from contemporary documents (1718).

FLEMISH. PIETER BRUEGEL THE ELDER (c. 1525/30 – 1569). The Triumph of Death (detail). Prado. *Photo: Giraudon, Paris.*

437. ITALIAN. FLORENTINE.
MICHELANGELO (1475–1564).
David. 1501–1504.
Galleria dell' Accademia, Florence.

538. ITALIAN. FLORENTINE.
AMMANNATI (1511–1592).
Neptune. Detail from the fountain.
1563–1576. Piazza della Signoria,
Florence.

439. ITALIAN. FLORENTINE.
GIOVANNI BOLOGNA (1529–1608).
Neptune. Detail from the
Bologna fountain. 1563.

THE FIRST MANNERISTS

*Though the Mannerists were the first to move away from the
Renaissance, and even in a certain sense inaugurated the
Baroque, they only prided themselves on creating
a refined version of the Renaissance style, and they were
in fact influenced by some of the Renaissance masters.
Leonardo da Vinci's subtle sfumato prepared the
way for a certain softness and delicacy [440-442];
Michelangelo's energy verged on excess [437-439]; there is
already an element of disintegrating form in the sensual
mellowness of Correggio or Andrea del Sarto [443-445].*

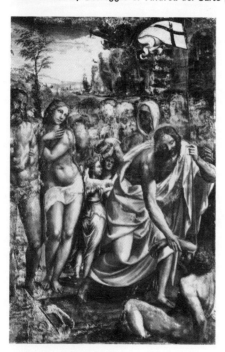

440. ITALIAN. ROMAN. SODOMA
(d. 1549). Christ in Limbo. Fresco.
Palazzo Pubblico, Siena.

441. ITALIAN. FLORENTINE.
GIOVANNI BOLOGNA (1529–1608).
Astronomy. Bronze gilt.
Kunsthistorisches Museum, Vienna.

442. ITALIAN. FLORENTINE. After
LEONARDO DA VINCI (1452–1519).
Leda and the Swan (detail).
Formerly Spiridon Collection.

MANNERISM IN THE SIXTEENTH CENTURY

I. THE FIRST ITALIAN MANNERISM AND THE NEW CONCEPTION OF REALITY *Rodolfo Palluchini*

The Renaissance showed the first signs of weariness in Italy itself with the rise of a new movement, Mannerism.
In appearance this was a refinement of the same aesthetic of pure beauty. But in trying to find new meaning in an ideal that had worn thin, Mannerism strayed from that ideal.
Harmony, moderation and serenity gave way to distortion, excess and anxiety. The way was thus prepared for the Baroque.

The word 'Mannerism' had, originally, a pejorative sense like the terms 'Gothic' and 'Baroque'. But in the last few years it has acquired a positive value: it stands for a particular vision, a way of looking at things, a new sensibility that found a mode of expression. Mannerism used to be thought of as a period of transition between the Renaissance and the Baroque. Nowadays it is regarded as a movement in its own right, an artistic vision that was well defined in spite of its varying facets. Whereas the Renaissance was an essentially Italian phenomenon, Mannerism, though it originated in Tuscany, soon spread all over Europe with a momentum only matched by the Gothic movement.

But in regarding Mannerism as a European movement, beginning in Tuscany in 1510 and ending in Toledo on the death of El Greco, one might think of it as a generic whole. In fact the movement was divided into various currents: the Mannerism of Tuscany was different from that of Emilia, just as the movement at Fontainebleau was different from that at the court of Rudolph in Prague. Our task will be to discuss the first phase of Italian Mannerism.

At the beginning of the 16th century Leonardo and Michelangelo, who represent the peak of the second phase of the Tuscan Renaissance, already showed symptoms of new anti-Renaissance ideas — Michelangelo in his violent treatment of form, and Leonardo in his preoccupation with the problem of

443. ITALIAN. FLORENTINE. Portrait of a woman. A 16th-century Mannerist painting influenced by Andrea del Sarto. *Uffizi.*

444. ITALIAN. FLORENTINE. ANDREA DEL SARTO (1486–1531). The Artist's Wife. *Prado.*

445. ITALIAN. FLORENTINE. BRONZINO (1503–1572). Lucrezia Panciatichi. *Uffizi.*

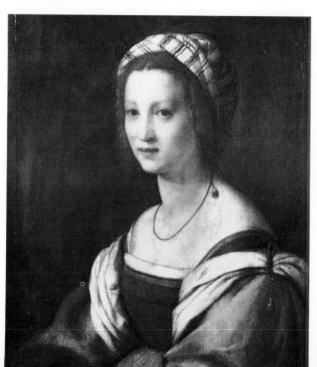

446. ITALIAN. TUSCAN. DANIELE DA VOLTERRA (d. 1566). Descent from the Cross. 1541. *Sta Trinità dei Monti, Rome.*

447. ITALIAN. TUSCAN. JACOPO PONTORMO (1494–1556/57). Descent from the Cross. *c.* 1530. *Sta Felicità, Florence.*

light. While Leonardo's teachings were developed by Fra Barto-

444 lommeo, Raphael (during his stay in Florence) and Andrea del Sarto along essentially classical lines, Michelangelo's works were the source of Pontormo's and Rosso's frankly anticlassical reforms. In Florence and Rome classicism reached its climax between 1510 and 1530: then the balance established by the Renaissance between emotion and reason, imagination and reality, was upset by the innovations of Pontormo and Rosso.

Form, space, colour and light were so many problems to be discussed and resolved in an original way. The Renaissance concept of harmony gave way to a freer and more imaginative rhythm. An acute spiritual disquiet expressed itself in tortured experiments with form that went so far as to distort reality.

447,448 Besides Pontormo and Rosso in Florence, Beccafumi in Siena
458 contributed to the general stir caused by Mannerist tendencies in Tuscany between 1512 and 1517.

Jacopo Pontormo broke away from Andrea del Sarto to devote himself to the deeper study of Michelangelo. Just as
368 north European influences in Venice had cast Lotto on to the fringe of official culture, so Pontormo underwent a violent
447 crisis as a result of contact with Dürer. Pontormo had abandoned
444 the rational moderation of the Andrea del Sarto tradition, and his forms were almost lost in their interior and diaphanous luminosity. Under the influence of Dürer, his figures took on more nervous and vibrant contours and lost their solidity. A new restlessness, a sudden desire for introspection, lent his artistic imagination a hallucinatory power of expression.

In the frescoes of the lunette at Poggio a Caiano depicting Vertumnus and Pomona, Pontormo was inspired by a rustic purity. The Passion illustrated in the four frescoes in the main cloister of the Certosa di Val d'Ema (1522–1525) reveals, on the contrary, as Miss Becherucci has put it, ' a pause, outside time and beyond the exigencies of narrative, in a smooth flow, as though it were suspended in the rhythm '. Pontormo created some of the most pathetic compositions of 16th-century Italy, working them out with an unreal use of space that had no firm perspective basis. His profound melancholy seemed to find an outlet in an imaginative invention that was without precedent.

Colours flare up in a shadowless luminosity and combine with forms that throb with a hallucinating rhythm. Light

makes transparent, like crystals of a truly Platonic purity, the figures in the *Deposition* (Sta Felicità, Florence), whose dramatic 447 tension is unforgettable.

Pontormo, who at the height of maturity was still untouched by the troubles of his last years, proved himself a great poet. More strange and unstable was Rosso's imagination that was tied to a more intellectual and specious treatment. He did not renounce Michelangelo's sculptural feeling for form; on the contrary, he reinforced it with all the dynamism of his tense and dramatic effects. Vasari tells us that one of Rosso's altar panels was refused with horror on account of ' the cruel and despairing aspect of the figures ': these were ' fantastic geo-metrical forms in crystal and hard stone gleaming in an intense light '. Thus Rosso affirmed the Mannerist process of transposing realistic subjects, anatomy for example, into a purely imaginative composition, as in *Moses defending the Daughters of* 448 *Jethro.* After a visit to Rome, in 1530 perhaps, Rosso was invited to France by François I. The ' Italian manner ' thus kindled a fire that was to burn all Europe.

Round about 1530, Angelo Bronzino broke away from Pontormo with whom he had collaborated in Sta Felicità. Bronzino lent Pontormo's style a more classical character by bringing out the abstract nature of form with a glossy marble-like sense of purity that only Ingres was to recapture some three centuries later. In his magnificent series of portraits the supreme 445 elegance of form is never separated from a more and more abstract idealisation of the model. These portraits seem to be of archetypes that have never had the solidity of concrete reality.

In Siena, Domenico Beccafumi's characteristics were quite 458 different from those of Pontormo and Rosso. Although unable to benefit from the Sienese culture that was dominated at the beginning of the century by the Leonardesque manner of Sodoma, Beccafumi adopted Raphael's and Michelangelo's inno- 440 vations during his stay in Rome between 1510 and 1512. But he reacted, perhaps under the influence of Rosso, and his forms disintegrated into a chromatic fluidity.

Beccafumi did not renounce the use of elements borrowed 458 from the Renaissance, and, above all, from classical rationalism: rather he subjected them to his confused imagination. The transfiguring effect of light seemed to deprive him of any power of co-ordination and composition in the Renaissance

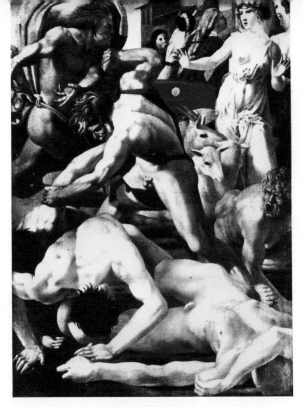

448. ITALIAN. FLORENTINE. ROSSO (1494-1540).
Moses Defending the Daughters of Jethro. c. 1523. *Uffizi.*

449. ITALIAN. FLORENTINE. BENVENUTO CELLINI
(1500-1571). Perseus. 1553. *Loggia dei Lanzi, Florence.*

450. Detail of 449, showing the back of the helmet.

sense. Some of his religious paintings, such as the *St Michael* of Sta Maria del Carmine, Siena, and the *Fall of the Angels* in the Pinacoteca, Siena, combine composition with a characteristically absurd and illogical luminosity that is reminiscent of Grünewald's sensibility.

After 1530 Beccafumi's style aimed at a certain elegance that once more gave his form a more substantial appearance, before, in his final period, his power of imagination seemed to dry up.

Francesco Salviati, a Florentine who died in Rome, was the link between Tuscan and Roman Mannerism. Sebastiano del Piombo had already provided examples of the latter. Salviati, Daniele da Volterra, Giorgio Vasari and Jacopo del Conte created, among Michelangelo's followers in Rome, a trend of ' reform ', as critics have defined it. The second phase of Mannerism headed by Vasari was less satisfactory and its eclectic cleverness led to a falling off in quality.

In Tuscany, sculpture, unlike painting, became Mannerist later on, towards the middle of the century.

Leonardo and Michelangelo had exhausted certain aspects of the formal problem of the Renaissance. Michelangelo ended up by sacrificing form completely to a purely interior vision in his last masterpiece, the *Rondanini Pietà*. During all the first half of the century his influence was decisive, but stifling.

Baccio Bandinelli (1488-1560) never managed to solve the problem of following Michelangelo. But Bartolomeo Ammannati (1511-1592), Bandinelli's pupil who worked in Venice and Rome, had more vitality and more elegant taste. Ammannati's masterpiece is the Neptune fountain in the Piazza della Signoria in Florence; it was executed with his followers Giovanni Bologna, Vincenzo de' Rossi, Vincenzio Danti, etc.

Benvenuto Cellini (1500-1571) was of the same generation. The stucco work of Primaticcio and Giovanni Battista Rosso was a revelation to him while at Fontainebleau (1540-1545) where the new Mannerist canon of neo-Platonic beauty was a departure from all the classical proportions. In the *Nymph* as in the Salt executed for François I, Cellini put himself in tune with the subtly enchanting tone of Fontainebleau, and this same tone he breathed into his masterpiece, *Perseus*.

Giovanni Bologna, from Douai in Flanders and a pupil of Jacques Dubroeucq, came to Rome in 1555 before settling down in Florence. Bologna achieved the miracle of reuniting the classical tradition of Rome with the new Mannerist culture of Florence, by giving play to his northern sensitivity to subtle textural effects. Continuing the work of Cellini he knew how to create a dynamic vision of space. Bologna was undoubtedly the most important figure in Mannerist sculpture; and it was he who, at the end of the Cinquecento, ensured the future of European sculpture, for, as Miss Becherucci has written, with him ' the contrivances of the Mannerist style led up to the fantasy of the Baroque.'

The outburst of Mannerism in Emilia was of no less importance.

Besides the Apollo-like figure of Correggio, whose art rallied the practically exhausted spirit of the Renaissance and retains a harmonious equilibrium between reason and fantasy, there was Parmigianino who approached the problem of expression in an entirely personal way, in a highly refined and precious imaginative style. When Michelangelo Anselmi moved from Siena to Parma, he probably took with him certain elements of Beccafumi's Mannerist style that caused Parmigianino to react against the Olympian world of Correggio. By modulating his forms with a refined elegance, Parmigianino transformed aspects of reality into an imaginative creation of almost morbid subtlety.

He became the pioneer in Emilia of a new concept of beauty. This was no longer based on classical canons, but on new and highly stylised forms, in which the neo-Platonic concept was kept alive by melancholy. Like Pontormo, he had his moment of surrender to the ' rustic idyll ' in the Fontanellato frescoes, in which there is an echo of Correggio's voluptuous charm. Parmigianino's stay in Rome strengthened his power of expression, adding ' to the impressionism of Raphael and Michelangelo the disturbing presence of Rosso '. In the *Vision of St Jerome* (1527), *St Roch with a Donor*, the *Madonna of the Rose* (1530) and in the *Madonna with the Long Neck*, he created a preciously modulated world of fantasy. The logic of space became absurd, losing the certitude it had had in the three-dimensional approach of the Renaissance. Figures were elongated inordinately to conform to the sinuous rhythm. Elements borrowed from reality were transformed into the fantastic, while certain details of striking minutiae and veracity remain intact. Correggio's sensuality is here lost in a hallucinating and almost magical morbidity.

199

454. ITALIAN. PARMA.
PARMIGIANINO (1503–1540).
Self-portrait in a Convex Mirror.
Kunsthistorisches Museum, Vienna.

451. *Above, left*. ITALIAN. PARMA. PARMIGIANINO
(1503–1540). Primavera. Drawing. *Louvre.*

452. *Above, centre*. SCHOOL OF FONTAINEBLEAU.
PRIMATICCIO (1504–1570). Stucco figure. Detail from the
decoration of the former bedroom of the
Duchess of Etampes. 1541/43. *Château de Fontainebleau.*

453. *Above, right*. SCHOOL OF FONTAINEBLEAU.
FRANÇOIS CLOUET (c. 1516–1572).
Diana's Bath (detail). 1550/55. *Private collection.*

ANGULAR MANNERISM

455. *Below, left*. ITALIAN. GENOESE. LUCA CAMBIASO
(1527–1585). Group of figures. Drawing. *Uffizi.*

There is another version in the Frankfurt Institute.

456. *Below, right*. ITALIAN. BOLOGNESE. BARTOLOMEO
SCHEDONE (1578–1615). The Entombment. *Parma Gallery.*

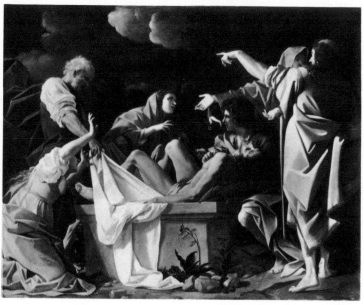

457. ITALIAN. GENOESE. LUCA CAMBIASO (1527–1585). Madonna with a Candle. *Palazzo Bianco, Genoa.*

458. ITALIAN. TUSCAN. DOMENICO BECCAFUMI (1486–1551). The Birth of the Virgin. *Academy, Siena.*

MANNERISM OF THE FANTASTIC

459. DUTCH. MICHAEL VAN CONINXLOO (c. 1500–1558). The Virgin Enthroned. *Dr Pietri Collection, Caracas.*

VARIOUS FORMS OF MANNERISM

The Mannerists radically modified classical style to give it a new flavour. Forms were elongated [451–453], or the traditional modelling of volume was replaced by synthesised planes [455, 456]. Unexpected lighting effects were used [457, 458], preparing the way for Caravaggio. The search for realism was pursued to the point where it lost its habitual appearance and took on an air of strangeness [454, 459, 460].

460. DUTCH. The Spirit of God carried on the Water. From a work by Goltzius (1558–1617). Engraving by his pupil Jan Muller.

461. ITALIAN. FLORENTINE. GIOVANNI BOLOGNA (1529–1608). The Euphrates. 1572/75. Detail from the Ocean fountain (1567–1575). *Boboli Gardens, Florence.*

462. ITALIAN. PARMA. PARMIGIANINO (1503–1540). St Jerome's Vision. 1527. *National Gallery, London.*

In this, Parmigianino was the inventor of a subtle, fascinating beauty that was to be taken up by Baroque and Rococo artists.

Imitation of Parmigianino appeared easy to his contemporaries who confused what was exterior, obvious, affected and sometimes mundanely superficial in him with the very substance of his idealistic vision. Only Girolamo Mazzola Bedoli, of Parma, understood the essence of his surrealist universe. He was to Parmigianino what Bronzino was to Pontormo.

Mantua, meanwhile, had become a Mannerist centre thanks
354 to Giulio Romano. A painter, architect and decorator, he was formed under the direct influence of Raphael, that is to say in a highly classical atmosphere. But his personality matured in the north of Italy outside the sphere of classical influence. On the invitation of Federigo Gonzaga, he spent the autumn of 1524 in Mantua, where he enlarged the ducal palace and built
355 the Palazzo del Tè, the country residence of the court.

In architecture as well as in painting, Romano invented a new rhythm of such unparalleled violence that it has been called 'barbarous'. In painting, his style was heavy to the point of bad taste, when he did not fall consciously into the grotesque. He did, however, invent new decorative themes, in an imaginary perspective that Primaticcio was to develop with more elegance at Fontainebleau. But in architecture Romano's vision was freer and more personal. Forcing classical elements into a concentration of effects, he produced a new architectural vision, based no longer on a closed form but on an open rhythm. Effects of chiaroscuro and atmosphere were obtained by the use of natural reliefs, niches and half columns. The incorporation of rough material into a constructive organism was very characteristic of Mannerist poetics: in painting precise concrete details were often inserted into an unreal composition. The aim in the Palazzo del Tè was to blend the construction with its natural surroundings. The example of Giulio Romano in Mantua was

studied and developed by Palladio. If, at Ferrara, after Dosso's outburst of Venetian and northern fantasy and Benvenuto da Garofalo's classicism, Girolamo da Carpi enriched the local tradition with echoes of Michelangelo, it is certain that the personalities of Primaticcio from Bologna and of Niccolò dell' Abbate from Modena transcended all geographical boundaries to incorporate themselves authoritatively in the formation of the school of Fontainebleau. Primaticcio started his education in the shade of the classical and 'barbarous' Mannerism of Giulio Romano, with whom he worked on the Palazzo del Tè. But, with the subtle elegance of Parma, he poured out the impulsive violence of his master into decorative designs, combining them with the perspective schemas that Mantegna had already made fashionable in northern Italy. In 1531 Primaticcio was at Fontainebleau, and on the death of Rosso in 1540, he took charge of the works. In this auspicious environment, his taste matured to a full expression of enchanting refinement.

Niccolò dell' Abbate of Modena formed himself after the example of Rosso and Parmigianino. Blending the dazzling chromaticism of the one with the elegance of the other, he was able to create his own world, with forms suited to his chivalrous and adventurous imagination. In the frescoes of the Palazzo Scandiano and the Palazzo Zucchini-Solimei in Bologna, he has a zest for narrative and an imaginative verve which, at its best, borders on the epic poetry of Ariosto. In 1552, Niccolò also settled down at Fontainebleau, to be followed two years later by Francesco Salviati.

There grew up at the court of François I a remarkable and complex artistic culture that was alive and rich in new ideas. Fontainebleau was the cradle of the French art of the next two centuries; and it was there that began the second phase of Mannerism which was to spread from Prague to Amsterdam and from Munich to Rome.

II. MANNERISM IN NORTHERN EUROPE AND THE
SCHOOL OF FONTAINEBLEAU *Jean Babelon*

*Radiating from Italy with all the prestige of her highly developed
civilisation, the Renaissance had spread like a new fashion.
Grafted rather superficially on to a tradition that had remained
medieval, the Renaissance consisted above all in
a repertoire of decorative forms.
On the other hand Mannerism, which was heir to the same
pre-eminence, appealed by its very irregularity to a number of
stubborn instincts, who found at last in Mannerism a lawful outlet.
It was also in the misleading guise of Mannerism
that the Renaissance often found a hearing in Europe. In this way
it eased the transition between the outmoded Middle Ages
and the Baroque to come.*

Considered retrospectively with the eye of a historian, the
Renaissance, that simple concept of Burckhardt and Walter
Pater, of an earlier generation, dissolves into a balance of con-
tradictions — a return to antiquity that had never really been
forgotten, a pagan revival when so many artists, who were far
from being mystic, were engaged in building or decorating
churches, the development of modern languages as a means of
artistic expression when Latin, Greek and even Hebrew were
the subjects of more authoritarian study, the birth of rival
nations just when medieval ecumenicity gave way to European
civilisation.

The precepts that had been formulated by Dante remained
valid: 'To translate into action all the powers that exist poten-
tially in the mind.' Art acquired a new prestige and was rated
so high as a mental activity that erudite thinkers became inter-
ested in artistic creation. What had been a purely practical
craft now came under the influence of a philosophy, that of
the Platonic academy. A critical method was developed by men
like Leone Battista Alberti, and then Leonardo da Vinci, Erasmus,
Juan Luis Vives of Valencia, Guillaume Budé in Paris, Sir
Thomas More in London, all Europeans, who wove a coherent
network of ideas across the world.

The difference in attitude between Erasmus and Martin Luther
throws light on another aspect of a period of violent philoso-
phical controversy. They reveal the incompatibility between the
Latin way of thinking, which was backed by the Holy See,
and the Germanic temperament, that conflict whose solution
Goethe was to propose to us in Faust's meeting with Helen.
The matter of the Indulgences and the questions of dogma held

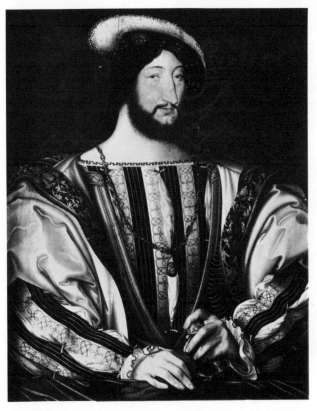

464. FRENCH. JEAN CLOUET (d. 1540).
Portrait of François I. *c. 1528. Louvre.*

*It is possible that François Clouet collaborated on
this picture, the lower part of which
suggests the help of an Italian Mannerist.*

465. FRENCH. FRANÇOIS CLOUET (c. 1516–1572).
François I on Horseback. *c. 1545. Uffizi.*

*There are two other equestrian portraits of
François I, in the Louvre and at Chantilly.*

463. ITALIAN. EMILIAN. NICCOLÒ DELL' ABBATE
(c. 1512–1571). Card Game. Fresco. *Palazzo Zamboni, Bologna.*

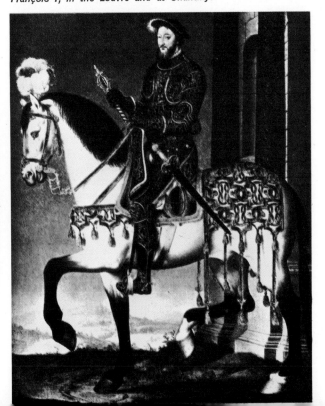

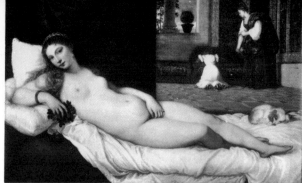

467. ITALIAN. VENETIAN. TITIAN (*c.* 1488/90–1576). The Venus of Urbino. *c.* 1538. *Uffizi.*

466. SCHOOL OF FONTAINEBLEAU. PRIMATICCIO (1504–1570). Stucco decoration in the former bedroom of the Duchess of Etampes. 1541/43. *Château de Fontainebleau.*

468. ITALIAN. BOLOGNESE. PRIMATICCIO (1504–1570). Reclining Woman with Child. Drawing. *Louvre.*

the foreground, but what Luther really objected to was the sovereignty of Rome and the ceremony and display of the papacy. Erasmus remained loyal to Catholicism because he discerned among all the obvious vices the humanism inherited by the popes; he consented to Julius II being called Jupiter and brandishing thunderbolts, because he realised it was the price of his *Enchiridion Militis Christiani*, that handbook of the Christian knight, perhaps the inspiration for Dürer's knight.

While certain amateurs were highly delighted by Neptunes and Amphitrites, and royal huntsmen were flattered to see their exploits sublimated in the adventures of Actaeon, there was still a large public who expected painters and sculptors to illustrate the Catholic dogma and who scoured hagiographic treatises in search of exalting subjects that were, nevertheless, pious and orthodox. It is not enough to associate the speculations of philosophers or the admiration of the faithful with an artistic boom, nor can one talk of the Italian Renaissance merely in terms of Ariosto and of Pico della Mirandola's neo-Platonism. At a time when a method was sought for the coherent interpretation of nature, and when political technique had been developed, economics also became a technical matter. This development, together with a parallel evolution of the fine arts, led to a convergence of minds that might almost be called 'European'.

To understand the historical movement as a whole, one must take into account the importance of the silk craft in the history of Florence and Bruges, the fact that Antwerp contributed to the rise of capitalism, and the growth of banking at Augsburg with the Fuggers. Erasmus, who played a vital part in spreading a certain way of thinking at the time of the Reformation, was in some ways an economist.

François I, a Renaissance prince

After the triumphant battle of Marignan and the catastrophic battle of Pavia the school of Fontainebleau came into being. The spiritual attitude of the ruling dynasty provides us with, as it were, a centre of gravity during a period of artistic confusion. One single family, the Valois, occupied the throne for almost an entire century, and their influence was firm and durable enough to control and channel the various artistic and intellectual movements.

The French Renaissance was marked by a dazzling clarity and by an unrestrained *joie de vivre*. And yet this zest remained an obstacle rather than a source of freedom. Emulation was to become a discipline that had to be rejected in order to return to the sources, in order to recover the freshness and charm of a past that was thought to have been lost for ever. French art thus lost and then found itself. It lost itself in the maze of the Baroque, as though in one of those enchanted gardens, inspired by poets and subtly planned to bewilder lovers, who enjoy the anxiety of being abandoned and the fear of being isolated in a seemingly virgin forest. French art was as sham as Bernard Palissy's grottoes. Emotions were as counterfeit as those mountains and forests peopled with bejewelled gods of a purely romantic mythology.

Rabelais, whose verbal power and fiery truculence give the reader an almost physical shock, was the spokesman of the French Renaissance. It is not simply our belated historical judgment that associates this period with a *joie de vivre*, but rather the belief or illusion of the people of the time — Ulrich von Hutten, for example, when he exclaimed: 'O century, literature flourishes, minds awaken, it is a joy to be alive.' Clément Marot expressed this same exuberance in another form: 'The

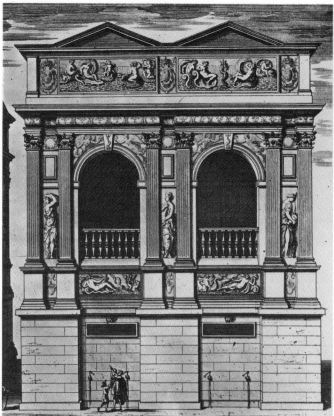

469. SCHOOL OF FONTAINEBLEAU.
JEAN COUSIN (1490–1560). Eva Prima Pandora.
c. 1548. *Louvre*.

470. GERMAN. LUCAS CRANACH THE ELDER (1472–1553).
Reclining Water Nymph. After 1537. *Besançon Museum*.

471. FRENCH. JEAN GOUJON (c. 1510–c. 1564/68).
Detail from a 17th-century engraving illustrating the
Fountain of the Innocents, Paris.

world laughs at the world, for the world is young.'

François I led the way. When one thinks of his sumptuous
court, his desire for glory, his lavish generosity, his role as a
Maecenas and the ambitious drive of his imagination, Louis XII
at the opening of the century seems, in comparison, like a
bourgeois still steeped in the neurotic parsimony of Louis XI,
in the niggling and cheese-paring austerity of the Middle Ages.
The Italian enthusiasm for the fine arts had reached the throne
of France, and the king exchanged the traditional title of 'His
Highness' for 'His Majesty', which smacked of the Imperial
title he failed to win at the Frankfurt election.

Unlike his predecessors, François I was vigorous and hearty,
with a sensuality that revealed itself in his clothes as in his
appearance. Louis XI was mean and sly; François I was tall
and broad, with features which Leonardo da Vinci might have
caricatured to resemble those of a faun or Bacchic goat. The
humanism he absorbed was that of the ancient doctrines as
rethought by Gargantua. It was not that he did not take humanism
seriously, for soon after its appearance in 1517 he negotiated
with Erasmus over the preparations for the foundation of the
Collège de France. In 1520, the office of the King's Reader
was set up. 'He is on earth what the sun is in the sky,' his
fond sister Marguérite de Valois was to say of him, thus
preparing the ground for the application of the same symbolism
to Louis XIV. It is only too true that all eyes were to be fixed
on France for a long time to come. François I was the very
epitome of this period, which witnessed the grafting of an
Italian branch on to the French tradition. Earthy Frenchman
though he was, he alone acquired the Italian concept of what a
prince should be, after the manner of Lorenzo de' Medici,
Isabella d'Este, Leo X or Julius II — organisers of splendid

472. FRENCH. JEAN GOUJON (c. 1510–c. 1564/68).
One of the nymphs from the Fountain of the
Innocents, Paris, constructed in about 1550.

473. FRENCH. GERMAIN PILON (1537–1590).
Recumbent statues of Henry II and Catherine de' Medici.
Detail from their tomb. 1560–1570. *St Denis*.

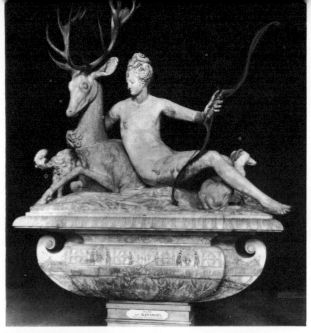

474. Effigy of François I (detail of 475).

475. Monument of François I, of Claude de France and their children. 1549–1558. Designed by Philibert de l'Orme and carved (1556/58) by François Marchand and Pierre Bontemps (c. 1507–1566/72). *St Denis.*

476. SCHOOL OF FONTAINEBLEAU. The Diana of Anet. This piece has long been attributed to Jean Goujon. *Louvre.*

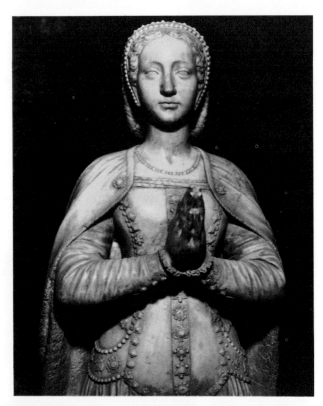

477. Praying figure of Claude de France (detail of 475).

478. FRENCH. PIERRE BONTEMPS (c. 1507–1566/72). Battle scene. 1556/58. Relief from the tomb of François I. *St Denis.*

symphonic ensembles in which architecture, painting, sculpture and even goldsmiths' work have their place. The fanatical Benvenuto Cellini made no mistake in visiting France; the king, whose character and magnificent ways he admired, who dreamed of splendid artistic works, was to grant a goldsmith (an exceptional one, it is true) a salary similar to the one he paid Leonardo da Vinci. 382, 449 450

At first painting presented a problem. There was then no Frenchman with imagination of sufficient scope to envisage the entire decoration of all the palaces that began to spring up, of all those houses where the king took his nomadic court, and where he expected to find, at each stopping-place, both visual and intellectual pleasure. The best painter of the preceding generation was Jean Fouquet. But he only excelled in small-scale works. The enlargement of details from illuminations, those exquisite landscapes of Touraine that illustrate the Books of Hours, merely resemble the pages of a manuscript, and not a fresco on a wall. The art of the fresco, which had been confined to churches, was hardly able to meet the prodigious demands of a royal commission. 104, 118

If the cream of French society which had been to Italy with Charles VIII had had the leisure to reflect after their return, they might have remarked what an abyss there was between their dazzling but already fading illusions, the mirage of epic poems and crusading songs, and the actual splendours that were commonplace in republics which hired the *condottieri*, splendours that were more fantastic and at the same time more disciplined. There was, in fact, more than a difference in character between Italy and what she called the barbarians; there was a difference of period. Ariosto bridged the gap in his *Orlando Furioso* by giving a modern twist to the far-off fantasies that had provided another age with a means for glorifying its heroism. The school of Fontainebleau eased the transition. The artists who embellished the reign of the Valois came from Italy. But their art was so far ahead of the appreciation of the French people that almost a century elapsed without those masters Rosso, Primaticcio, Niccolò dell' Abbate, Luca Penni who fostered a new law of human forms in France, finding local followers competent to carry on their work. When Leonardo da Vinci died at the château of Cloux near Amboise in 1519, he had had no influence on the artistic development of France. *St John the Baptist*, his last work for which he meditated at such length, was too disconcerting in its resemblance to a half-pagan hermaphrodite to bring him any pupils; and the smile of the *Mona* 448 446, 463 254–261

480. GERMAN. CONRAD MEIT (early 16th century).
Bust of Charles V. Painted wood. 1519. *Bruges Museum*.

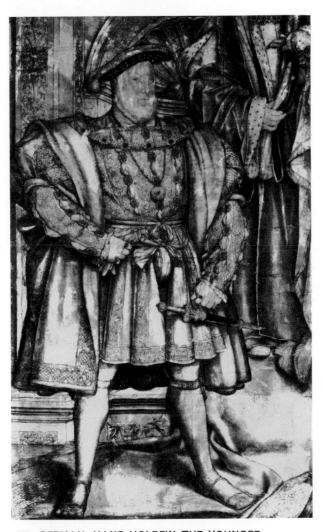

479. GERMAN. HANS HOLBEIN THE YOUNGER
(1497/98–1543). Henry VIII.
Drawing for the Whitehall fresco.
National Portrait Gallery, London.

482. ENGLISH. Queen Elizabeth (the 'ermine portrait').
Hatfield House.

481. FRENCH. JEAN CLOUET (d. 1540).
Aimée Motier de La Fayette, 'baillive' of Caen.
Drawing. *c.* 1530. *Musée Condé, Chantilly*.

483. FRENCH. Portrait bust of Dieudonné de Montal. 1527.
Château de Montal.

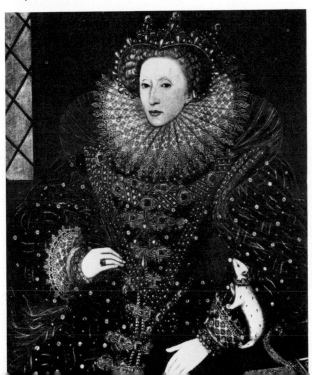

484. FRENCH. 16th century. Portrait of a man, attributed to Corneille de Lyon (active 1541–1574). *Montpellier Museum.*

485. FLEMISH. 16th century. Le Duc d'Alençon (later Henry III) and Louise de Lorraine. Detail of a tapestry made from a cartoon after Caron, the portraits inspired perhaps by François Quesnel. *c.* 1580/85. *Uffizi.*

486. DUTCH. ANTONIO MORO (*c.* 1519–1576/77). Jean Gallus. *Kassel Museum.*

488. DUTCH. JAN VAN SCOREL (1495–1562). Five Members of the Brotherhood of the Jerusalem Pilgrims, Utrecht. After 1541. *Central Museum, Utrecht.*

487. FLEMISH. FRANS FLORIS (1516–1570). Old Woman with Dog. 1558. *Caen Museum.*

489. FRENCH. GERMAIN PILON (1537–1590). Medal representing Catherine de' Medici.

490. ENGLISH. NICHOLAS HILLIARD (*c.* 1547–1619). Youth among Briars. Miniature. *Victoria and Albert Museum.*

491. FLEMISH. FRANS FLORIS (1516–1570).
Hercules Fighting the Hydra. Engraving by C. David.

492. SCHOOL OF FONTAINEBLEAU. AMBROISE DUBOIS
(1543–1614). Sophonisba before Aladin (Jerusalem Liberated).
Wash drawing. *Ecole des Beaux-Arts, Paris.*

493. FLEMISH. MARTEN DE VOS (1531/32–1603).
St Luke painting the Virgin (detail). *Antwerp Museum.*

Lisa remained a hieroglyph. But it was in splendid isolation in France that Leonardo wrote his *Treatise on Painting,* which was a kind of testament. On the other hand, the fact of living in the French countryside and of breathing the air there modified the native qualities of the Italian painters in the pay of François I, and their temperaments, however pronounced, underwent a change. This was all the more so since they had to have recourse to labour and to pupils recruited on the spot.

The first school of Fontainebleau

The Italian masters of Fontainebleau had Flemish as well as French pupils. This accounts for the composite nature of the school of Fontainebleau — sensuality and a taste for decoration, elongated forms, mythological paintings with voluptuously simpering nudes, and arabesques, but also a realism that resulted in a more tightly controlled composition and draughtsmanship. **453, 464** To this the Clouet added the strict discipline of portraiture, **481** from the sumptuous portrait of the king to the homely portrait of Pierre Quthe. Thus the simple Flemish anecdote was not abandoned in the face of Michelangelo's gods, the nymphs of Diana and the dryads. The *Story of Psyche,* the *Toilet of Venus* and the *Tepidarium* are as naturalistic as still lifes; they are very **466** different in tone from the decoration of Madame d'Etampes' **269** chamber, and from the frescoes in the Vatican Loggias or the **275** Sistine chapel, which had much grander pretensions. Meanwhile, the most important ladies-in-waiting vied shamelessly for the honour of being recognised in the goddesses in amorous and revealing postures. This decadence fell far short of the **480, 290** frank and more robust sensuality of Titian's compositions that Charles V or Philip II were to commission. And there was nothing at Fontainebleau to compare with Venetian religious painting, with its grave sonority enriched by intense and radiant colours. What is more, it can hardly be denied that the decorators of the royal palaces never rose to the heights of the

erudite and powerful orchestrations that Veronese created for **308** the glory of the Venetian republic. The rather laboured allegories of the ballroom are nothing like as exciting as the goddesses of the Doges' palace.

This does not mean, however, that the school of Fontainebleau was a failure, certainly not to the same extent as the school of the Escorial which, on account of the obvious poverty of the painters invited to the Spanish court, sank into oblivion. The Escorial is merely a picture gallery, often of the first order; **548** Fontainebleau, on the other hand, offers a decorative ensemble which merits considered attention even if one does not immediately take to it.

It has to be admitted that the Valois were better served by architects than they were by painters. The art of building and sculpture during this dynasty showed, compared with Italy, a liberty that was not to be found in painting. It is to the credit of the French kings and their good fortune that they employed men like Pierre Lescot, Philibert de l'Orme, Pierre Bontemps, **765, 510** Germain Pilon and Jean Goujon, whose success in this field is **475, 473** incontestable. This was, no doubt, due to the fact that the archi- **472** tectural and sculptural traditions in France were strong and vigorous enough to produce majestic works. Henry II's Louvre **765** is one of the most admirable monuments erected on French soil. Nevertheless, compared to François I, Henry II at Anet is more like a gentleman offering his mistress a beautiful château, for it was an elegant ornament rather than a seat of sovereignty. **476**

In spite of adverse criticism based on some rather poor reconstructions, Fontainebleau was in fact a school, and its prestige was considerable. It was, anyway, the best that 16th-century France could offer as an object of study for the art historian. Rubens had a keen admiration for Primaticcio's Ulysses Gallery, which Louis XV condemned to destruction. Poussin said that he knew 'nothing more fitting than the subjects of the Ulysses Gallery for the formation of a painter and the stimulus of his

494. FLEMISH. BARTHOLOMAEUS SPRANGER (1546–1627). Painting, Sculpture and Architecture. *Grenoble Museum.*

495. FLEMISH. PIETER BRUEGEL THE ELDER (c. 1525–1569). The Birdsnester. 1568. *Kunsthistorisches Museum, Vienna.*

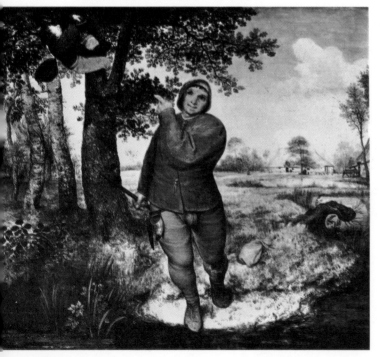

genius '. Pierre Mignard was of the same opinion. ' I remember, ' said Marietta, ' accompanying the famous François Lemoine through the Ulysses Gallery, and I was a witness of the endless praise he felt obliged to give a work which he considered to be the finest thing he knew. '

The second school of Fontainebleau and Flemish humanism

In the long run, Fontainebleau made itself felt, first in France during the second generation, that of Toussaint-Dubreuil and of Ambroise Dubois. The latter was of Flemish origin, and 492 from this moment we can see the pre-eminence of Flemish painters during this period of evolution. In the second half of the century, the activities of the Flemish painters sometimes gives a misleading idea of their authentic mastery, above all the portrait painters, Gillis Congnet, Abraham de Ryckere, the elder Frans Pourbus, and then masters of such scope as Anthonis Mor. The attraction of Fontainebleau, which had previously drawn so many artists, was transferred to Italy, and a trans-Alpine trip was now considered essential training. The result of this was the appearance in the Netherlands of a flourishing ' Roman-ist ' school whose artists streamed to Rome to study under the guidance of Federico Zuccaro, Pomarancio, Cavaliere 513 d'Arpino, Barocci and Tempesta. 519

Historical painters, though they remained loyal to the Italian-ate manner, endeavoured to safeguard their own personalities by illustrating episodes drawn from the Bible or the legends of the saints. But at first they only managed with difficulty: for they lacked a sense of the dramatic and that sensitivity, born of conviction that cannot exist with too much rhetoric. Marten de Vos may well have studied Tintoretto in Venice, 493 but he never managed to go beyond insipid pastel colours, and 291 his characters were lifeless and made-up like actors. Ambrosius Francken of Antwerp was no less artificial, and his agitated style never achieved true pathos. The best master of this period was Denys Calvaert, who settled in Bologna in 1560, and whom the Italians adopted by the name of Dionisio Fiammingo. He had Guido Reni and Albani as pupils. 746

It was to France that Bartholomaeus Spranger went first of 494 all to learn his craft, before visiting Rome and Prague. Otto van Veen tried to find a source of renewal in a more naturalistic kind of art. A pupil of Federico Zuccaro, he was painter to 513 Alessandro Farnese before going into the service of the governors of the Netherlands, Archduke Albert and Isabella. Van Veen's innumerable paintings illustrate world history, treated in a way different from the humanists of the preceding generation, to whom Marten Pepyn of Antwerp still remained faithful; he had a richness and verve that anticipate Rubens. Rubens in 571 fact admitted his debt to van Veen, and Abraham Janssens was also a precursor of Rubens.

In the second school of Fontainebleau there seemed to be hardly enough talent for the work in hand. An artist such as Frans Floris, whose best pupil was Ambrosius Francken, and who 487, 491 did pastiches of Michelangelo with gusto, was not a master on whom one could confidently depend; nor was Michael Coxie or Lambert Lombard. All they had retained of their admi-ration for the Italians was the ambition to cover vast surfaces with subjects suggested by a traditional repertoire, for they had none of the poetic imagination of those who, in the old days, ' used to read Homer's *Iliad* in three days '.

This northern Romanism, fostered by Fontainebleau, result-ed in some respects from van Eyck's landscapes, from van 93, 101

ITALIAN. ROMAN. CARAVAGGIO (1573–1610). The Flagellation of Christ. 1606–1610. S. Domenico, Naples. *Photo: Joseph Ziolo — André Held.*

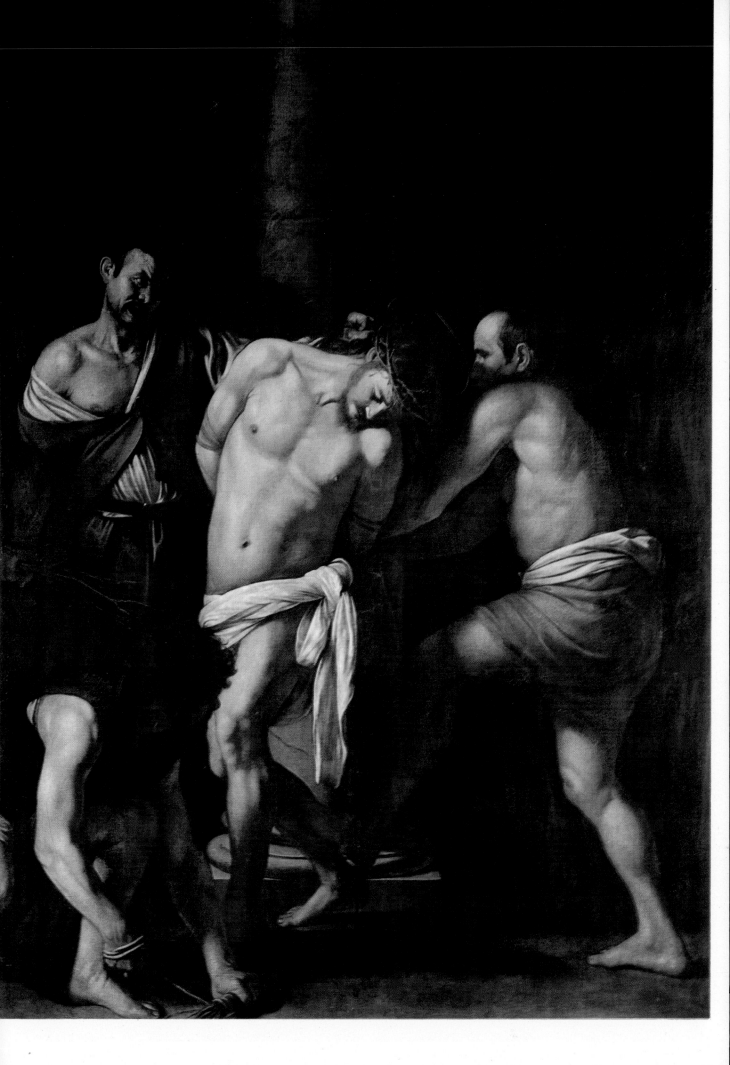

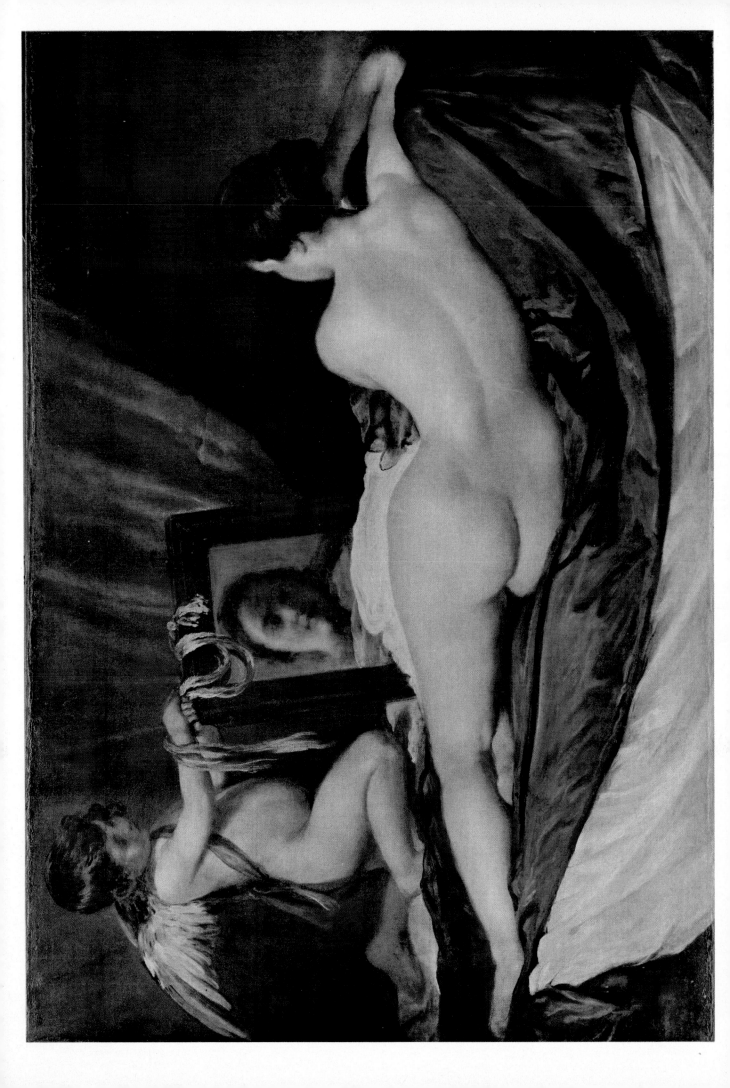

106 der Weyden's linearism, from the 'verdures' or brocade-like
328 backgrounds against which Quentin Metsys set *Mary Magdalen*,
and from the portraits of Memling, Mabuse or van Orley.
It is easy to follow the transition beginning with the portraits
of celebrities by Justus of Ghent on the walls of Federigo da
Montefeltro's library, through the great nude figures in sculp-
tural rhythms by Lucas van Leyden, which owed almost every-
thing to Italy. The transition continued with the banquets of
the gods and the myths painted by Gillis Mostaert for Margaret
of Austria, and the courtly art with which the Spanish embel-
lished their elaborate ceremonies in the Netherlands. Princes
and dukes, kings and the Emperor became accustomed to an
ambiguous world that was both terrestrial and Olympian, and
to finding, without undue surprise, Diana with her retinue in
the forests where they hunted game.

Through this contact with Roman humanism, which was
somewhat modified by the time it reached the banks of the
Loire, the Flemish painters were in danger of losing the austerity
that was their great asset. The bold crispness of their draughts-
manship and the restraint in sculptural form ran the risk of
being swamped by a different sense of harmony and enveloped
in chiaroscuro and the silky vibrations of flesh and cloth.

495 There was, however, one man of genius, Bruegel, who, more
by instinct than by deliberate intention, opposed Italian human-
ism with the humanism of the north, which was inherited from
Erasmus. Bruegel is best known as a painter of scenes of low
598, 326 life that anticipate Teniers; he is also Hieronymus Bosch's rival,
a painter of diabolical sorceries; he is the illustrator of proverbs,
the man who enjoyed vulgar jokes and village fairs, who loved
the fantastic world of which the *Dulle Griet* provides a grotesque
and sinister example.

But Bruegel must be taken more seriously than that. His
498 country bumpkins and his hovels are ample proof of his ability
to imitate and interpret living nature. Yet robustness and rusti-
city are inadequate terms with which to define a temperament
that reached the very core of things and went beyond their
outward appearance. He was a visionary who recreated the
world in his own way, a way quite different from that of the
Italian masters: one has only to compare his landscapes with
Titian's. Bruegel did, however, go to Italy, as far as Naples
and Sicily. In spite of this, his personal vision led him into a
world of the imagination that only he could traverse. He was
obsessed by the vertigo of aerial space. The *Numbering at Beth-
lehem*, the *Haymaking*, the *Children's Games* and the *Tower of
Babel* are seen from above, as if one were plunging down
towards them. His paintings were all done from memory, free
from the restrictions of reality. There is, instead, a new feeling,
which is already romantic — the *Stimmung*, which one can
render as ' mood ', the quintessence of time and place. Such
was the rapid growth of a northern humanism — confined at
first to the contemplation of man seen from close up in his
hovel, and then placing him, on an infinitely reduced scale, in
497 the vastness of the cosmos.

So Bruegel bridged the gulf between, on the one hand,
327 Hieronymus Bosch, Quentin Metsys, Patenier, van Scorel and,
on the other hand, Marten de Vos, Ambrosius Francken, Otto
van Veen, Adam van Noort, those who were there when
Rubens returned from Italy in 1609. For Rubens was to liberate
sensuous form and, with his genius for orchestration, by taking
up again the programmes, if not the themes of Fontainebleau,
he found a form of expression for the Baroque of the Counter
Reformation.

SPANISH. DIEGO VELASQUEZ (1599-1660).
The Toilet of Venus (The Rokeby Venus).
1648-1651. National Gallery, London.
Photo: Paul Hamlyn Photographic Library.

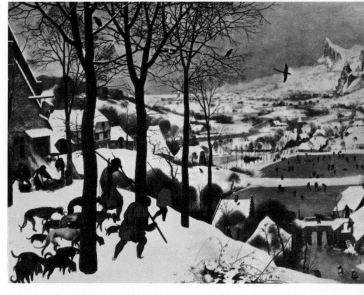

496. FLEMISH. PIETER BRUEGEL THE ELDER (*c.* 1525-1569).
Hunters in the Snow. 1565. One of the series of
the Seasons. *Kunsthistorisches Museum, Vienna.*

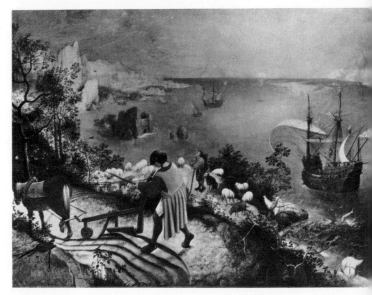

497. FLEMISH. PIETER BRUEGEL THE ELDER (*c.* 1525-1569).
The Fall of Icarus (detail). *c.* 1558. *Brussels Museum.*
*For Bruegel, man is lost in the universe. Even Icarus
falls unnoticed (in the bottom right-hand corner of the picture).*

498. FLEMISH. PIETER BRUEGEL THE ELDER
(*c.* 1525-1569). Painter and Art Lover. Drawing. *c.* 1565.
Albertina, Vienna.

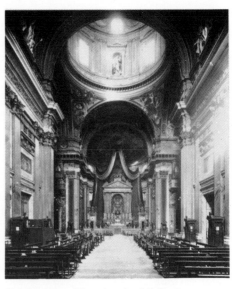

499. ITALY. Church of Il Gesù, Rome. Started by Vignola (1507–1573) in 1568. Completed in 1575 with the façade by Giacomo della Porta (1540–1602).

500. Plan of the church of Il Gesù, inspired by Alberti and the classical style.

501. Interior of the church of Il Gesù. The decoration is 17th century.

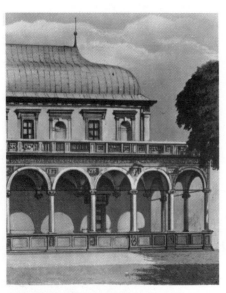

502. BOHEMIA. The Belvedere, Prague. Commissioned by Ferdinand I for Queen Anna. Built by G. Spatio and J. M. del Pambio. 1535–1560.

503. GERMANY. Augsburg town hall, by Elias Holl. 1615–1620.

504. FLANDERS. Antwerp town hall. 1561. Built by Cornelis Floris (1516–1570). This stately building marks the turning of Flemish architecture towards Italy.

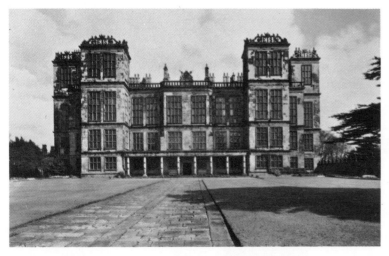

507. ITALY. Villa Giulia, Rome, built for Pope Julius III by various architects. Started in 1553.
The main facade is almost entirely by Vignola.

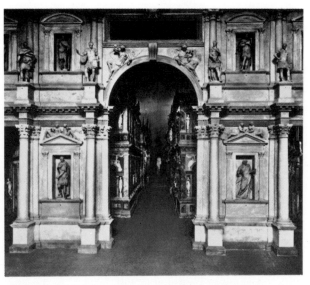

508. ITALY. Scena of the Teatro Olimpico, Vicenza. Palladio's last work (1580) completed in 1585 by Scamozzi.

509. FRANCE. Portico, said to be by Serlio, in the Oval Court, Fontainebleau. François I period.

510. FRANCE. PHILIBERT DE L'ORME (1510–1570). Façade of the chapel, château d'Anet. 1549.

511. FRANCE. Internal façade of the château d'Ecouen. Jean Bullant (c. 1510–1578) worked on it after 1556.

512. *Left*. ENGLAND. Longleat. Rebuilt 1568–1575, probably by Robert Smythson (c. 1536–1614).

LATE RENAISSANCE ARCHITECTURE

505. *Far left*. ENGLAND. ROBERT SMYTHSON (c. 1536–1614). Hardwick Hall. 1590–1597.

506. *Centre*. ENGLAND. Inner courtyard, Burghley House. 1577–1587.

512. *Left*. ENGLAND. Longleat. Rebuilt 1568–1575, probably by Robert Smythson (c. 1536–1614).

III. THE DEVELOPMENT OF ITALIAN MANNERISM AFTER 1550 *Lionello Venturi*

The Mannerist attempt to renew the Renaissance
came to a dead end in the second half of the 16th century.
The over-refinements that verged on a taste for the bizarre seem
calculated to satisfy intellectuals and aristocrats.
Its international character is reminiscent of the courtly
art that brought the Middle Ages to a close.
Like the latter, it has the air of being, even in Italy,
a last bid rather than an advance towards the future.

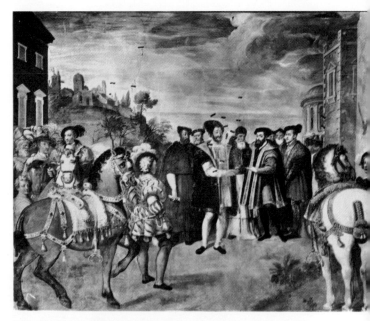

513. ITALIAN. ROMAN. FEDERICO ZUCCARO (1542–1609).
The Truce of Nice, made between François I
and Charles V in the presence of Paul III.
Council of Trent Chamber, Palazzo Farnese, Caprarola.

The problem of 'Mannerism' has gradually been elucidated. This phase of artistic development, that had been so long despised, now receives its rightful measure of attention, thanks to an exhibition in Amsterdam in 1956 called 'The Triumph of European Mannerism'.

After 1550 Mannerism became international, and Italy, which had suggested the classical and Mannerist ideas to the rest of Europe, began to incorporate other elements into her tradition. The decoration of Cosimo I's studiolo in the Palazzo Vecchio in Florence is proof of this. The centre of taste was no longer in Florence but in Rome. Taddeo Zuccaro and his brother
513 Federico became the models of a style which had decorative
265 qualities, and which was inspired as much by Raphael and
273 classical art as by Michelangelo. There was already an abundant and facile eclecticism, which became academic whenever the subject depicted required the least moral conviction on the part of the painter. The virtuoso gained ground over the artist. Painters escaped from academicism by weird contrivances of northern origin, for example, Raffaellino da Reggio in Rome,
514 and especially Arcimboldo in Milan whose human figures composed of flowers and fruit are as amusing as modern Surrealism.

A kind of Mannerist reform was envisaged by Federico
519 Barocci, who had a very acute sense of beauty, of colour gradation and of religious feeling, but he lacked boldness and creative freedom. The end of Roman Mannerism, which continued into the 17th century with Cavaliere d'Arpino, was absolutely deplorable.

In the north of Italy, where they had the splendid example of the Venetians and some knowledge of Flemish and German art, it is understandable that contrasts of light and shade could express the Mannerist feeling perfectly, for instance in the work of Luca Cambiaso in Genoa, of the Procaccini in Milan, and
515 above all of the Campi at Cremona. They can indeed be considered as the precursors of Caravaggio.

The sculptors were less free compared with Michelangelo, except for two Lombard artists of great scope, Pompeo Leoni
516 and Guglielmo della Porta, who used Mannerist forms to achieve an objective realism.

In the architecture of Michelangelo's imitators repeated elements are arranged in a small space to force man in a certain direction, as Nikolaus Pevsner puts it. Outside Venetia, the typical masterpieces of Mannerist architecture are the Uffizi
507 palace in Florence, built by Giorgio Vasari, Julius III's villa in
499 Rome by Vignola and, above all, Vignola's Church of Il Gesù in Rome. Vignola's immense reputation is due either to the fact that the mother church of the Jesuits was the model for innumerable religious buildings, or to the *Rule of the Five Orders of Architecture* (1562), a small book, written in a very clear style for schools, which became the law for all architecture and is still in use today.

Prints, as a means of circulating the works of the masters

514. ITALIAN. LOMBARD. GIUSEPPE ARCIMBOLDO
(c. 1527–1593). Allegory of Winter.
The ingenious arrangement of objects, a tree trunk,
ivy, etc., is made to resemble an old man.
Kunsthistorisches Museum, Vienna.

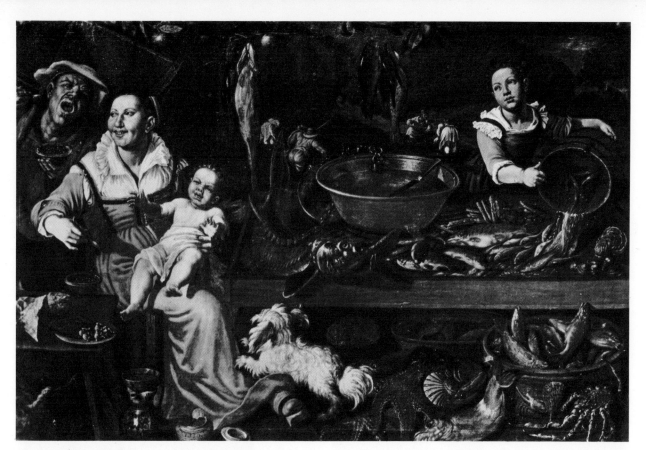

515. ITALIAN. CREMONA. VINCENZO CAMPI (d. 1591).
Fisherwoman. *Brera, Milan.*

abroad, were highly developed during this period of Mannerism.
518 Some of them, such as the chiaroscuro works of Ugo da Carpi
or of Antonio da Trento, are, moreover, of high artistic quality.
382 Goldsmiths' work continued to flourish after Benvenuto Cel-
lini, for the nobility had Mannerist tastes that especially favoured
that kind of work. In Florence and Milan particularly jewellery,
cameos, precious stones and rock crystal were wrought in
Michelangelesque forms, but without losing the special charac-
teristics of the natural materials. The artistic production of the
second half of the 16th century was bound up with the prevail-
ing social conditions — on the one hand the economic crisis,
and on the other the patronage of popes, princes and nobles.
The nobility was enriched by the economic crisis, while the
people became poorer. It was the favourite practice of patricians
to show off their greatness by employing artists.

 The council of Trent played an essential part in conditioning
Italian art during the second half of the 16th century. There
has been much argument on whether it was Mannerism or the
Baroque that was the established representative of the Counter
Reformation. The latter seems to have influenced both Manner-
ism and Baroque in turn. One can see in Mannerism that aspect
of the council of Trent that stood for law, order and the control
of creative liberty. But the mysticism, the militant determination
and desire for renewal that were introduced by the Counter
Reformation were beyond the Mannerists who were too scep-
tical and too intent on working for the nobility. It was not
until the beginning of the 17th century that realists and clas-
sical artists were able to respond, in different ways, to the new
moral demands.

 Mannerist theory had been expressed mainly by Vasari, Bor-
ghini, Lomazzo, Armenini and the Zuccari. Vasari's *bella
maniera* contrasted the 16th century, the century of perfection,

with the 15th century, which for him, had been too ' realist '.
' Manner ' is what we would call the individual style of an
artist, by which a true artist stands out from the mass of painters
who copy nature. For Vasari, therefore, ' manner ' is to be
found in classical as well as Mannerist painting. But the Manner-
ists had a greater freedom, a richer and more arresting com-
position, a whimsicality and, above all, an awareness of the
difference between manual technique and the intellectual work
of the artist. This difference, already sensed by Leonardo, was
taken to extremes by Mannerist theoreticians. Federico Zuccaro 513
emphasised the difference between the inner design or creative
idea, and the exterior design or execution of the idea. Moreover
the idea, according to St Thomas Aquinas, comes from God;
this was an attempt on the part of the Mannerists to get back
to the Middle Ages. They rejected the mathematical laws on
which Renaissance theory was based, but they accepted the
rules of decorum from which painters occasionally lapsed; and
churchmen and writers searched enthusiastically for these
' lapses ', particularly where prudery was concerned. For Lomaz-
zo, who was influenced by Plato, beauty lies in the revealing
of an idea in form by means of matter. From this grew the
belief that certain forms are beautiful in themselves — for
example, the serpentina or S-form, which is attributed to 271
Michelangelo. Technical difficulties too, foreshortenings and
illusionistic perspectives, served as proof of the *terribilità* seen
in Michelangelo's work.

 Finally, Lomazzo considered the various ' manners ' of artists
in terms of abstract categories — form, colour, movement,
light, etc. He no longer saw them as technical tools, as they
had been thought of in Renaissance treatises, but as an analytical
table for critical interpretation. Lomazzo was, in this way,
the precursor of art as a science.

516. ITALIAN. LOMBARD. GUGLIELMO DELLA PORTA
(c. 1510–c. 1577). Paul III's monument.
In the foreground, Prudence and Wisdom. *St Peter's, Rome.*

517. ITALY. GIORGIO VASARI (1511–1574).
Portico of the Uffizi Palace, Florence. The statues in the niches are modern.

518. ITALIAN. VENETIAN. UGO DA CARPI (c. 1460–1523).
Hercules driving Envy out of the Temple of the Muses.
Engraving. *Bibliothèque Nationale, Paris.*

519. ITALIAN. URBINO. FEDERICO BAROCCI
(1528/35–1612). The Manger. *Prado.*

REALISM AND THE FIRST CLASSICAL AND BAROQUE TRENDS

I. REALISM AND CLASSICISM IN ITALY *Lionello Venturi*

*As a result of the Counter Reformation Italian artists
were once more made aware of their religious responsibilities,
so that they reacted against the aesthetic of Mannerism.
Their new concern for truth either led them to a popular realism,
headed by Caravaggio, or else they followed the
principles and techniques developed by the Carracci which
resulted in a kind of classicism. But Italian art was soon carried
away by eloquent effects calculated to persuade the public:
it was this development that launched Italy into the
Baroque movement.*

The realist revolution and Caravaggio

455
513 A number of Mannerists, Bronzino in particular, but also
Barocci and Federico Zuccaro, painted excellent portraits which
were often their best works. The Mannerists possessed a perfect
mastery of draughtsmanship, which they used dispassionately
and sometimes without conviction. When they painted por-
traits, however, the living presence of a model obliged them
to modify their academic style, and their work took on a
vitality that is lacking in their other paintings. Further, the
Venetians had shown how colour could achieve realistic effects
that were lacking in linear representation, and they suggested
effects of light and shade, which, as we have seen, were used
455, 515 by Cambiaso and the Campi. What is more, the increasing
number of Dutch and German painters, who were often in
Italy, popularised the taste for landscapes and other genres
that had to be treated realistically.

At the end of the 16th century a reform in art was felt neces-
520 sary. This was brought about in Rome by Michelangelo Merisi,
425 known as Caravaggio, and by Annibale Carracci. The former,
from Lombardy, arrived in Rome in about 1593, and the
latter, from Bologna, in about 1595. As is well known, Cara-
vaggio was the founder of the ' realism ' that influenced Flemish,
Dutch, Spanish and certain French painters for a century, not
to mention many Italians, especially in Genoa and Naples.
Annibale Carracci, meanwhile, was the founder of the ' clas-
sicism ' that influenced the majority of Italian painters and the
688, 692 greatest French masters, such as Poussin and Claude le Lorrain.
It was Rome, therefore, that was from about 1600 the most
important source of European taste for a century and a half
to come.

Caravaggio and the Carracci used to be regarded as Baroque
painters. Nowadays, we have a more distinct notion of the
Baroque. In architecture and sculpture the transition from Man-
906, 875 nerism to Baroque was immediate. Bernini and Borromini
were the most conspicuous exponents of that Baroque. The
only sculptor that can be called realist would be Francesco
Mochi, who did the equestrian statues of the Farnese at Pia-
cenza. In painting, on the other hand, realism and classicism
were developed before the Baroque, properly speaking, of
522 Pietro da Cortona revealed itself in large-scale decoration.

Realism and classicism, which originated in Rome, were
naturally bound up with the most important movement of the
times, the Counter Reformation. But it must be remembered
that after 1570 the strict and limited nature of a Counter Refor-
mation under Spanish influence began to change under Sixtus V

and Clement VIII, whose policies were favourable to France.
The lower clergy, whose greatest representative was St Philip
Neri, wanted, on the contrary, to return to the Christian life
as described in the Gospels, the life of poverty and humility,
and they equated religious feeling with moral action. This branch
of the Church responded to that need for truth and freedom
of thought which was the best outcome of the Renaissance;
and it produced at the time of Caravaggio those heroes of
humanity, Giordano Bruno, Galileo Galilei and Tommaso
Campanella. The upper clergy reacted very strongly against
St Philip Neri, accusing him of vulgarity. Caravaggio's life **520, 521**
was a continual revolt, first against his family, and then against **523-526**
Roman society. Towards the end of his short life, when he
developed a persecution mania, he had frequent and serious
skirmishes with the law. It is, therefore, easy to see why some
of his pictures were refused as altarpieces. In so adopting the
role of a libertine, he suffered many misfortunes, but his style
spread all the more readily in Protestant countries.

Realism has been adopted by most periods, but in response
to very different needs. Caravaggio needed to get away from,
and to fight constantly against, Mannerism, against classical
culture, against the classical statues that were considered as
models of art, against the ideal of beauty as represented by
Raphael and against the sublime heroism embodied by Michel-
angelo. Moreover, in his first Roman period, between 1592
and 1598, Caravaggio accepted the technique of the Manner-
ists, with their precise contours, their sculptural sense and their
bright colours. Yet, even then, there is a moral awareness that
comes through in his paintings, but which is lacking in Man-
nerist works. His *Magdalen* is a poor lost girl, who, having
cast her jewellery and scents on the ground, meditates on her
sin, in a room so forlorn and bare that it resembles a prison.
The Renaissance had envisaged Mary Magdalen as the Christian
Venus, and Titian had given her all the sensual charms that
his imagination and colour sense could invent. Caravaggio, on
the other hand, saw Mary Magdalen in the street, in everyday
life; he set the saint of the Gospel within his social conscience.

The self-esteem of painters had increased inordinately since
the beginning of the 16th century. Biographies were written
about them, their culture was appreciated, they founded acad-
emies so as to be on a par with poets, they were to become
' professors '. They considered only historical painting to be
worthy of their talents, and to show how clever and rich they
were in imagination they filled their canvases with a crowd
of bustling people. But Caravaggio was convinced that an
apple is as difficult to paint as a Madonna, and he proved his
point by transforming a small basket of fruit into a masterpiece.
At a time when everyone was busy showing off, a poor and
ill-considered young man had the humility to devote himself
to studying the roundness of an apple, the foreshortening of a
leaf or the transparency of a grape. His feeling for the poetry
of such objects made all the painters in Europe aspire to this
same awareness.

Caravaggio's art, however, only attained perfect cohesion
when he subjected the representation of images to effects of
light and shade. His light is neither daylight nor night light,
so it is not at all realistic. It is, rather, a stylistic element, an **523**
abstract force, a spiritual quality, which comes from outside

520. ITALIAN. ROMAN. CARAVAGGIO
(1573–1610). Martyrdom of St Matthew. 1597–1601.
S. Luigi dei Francesi, Rome.

521. X-ray detail of 520.
Close study of this picture, together with the X-ray,
reveals the original figure, replaced by the two figures on
the extreme right.

the picture and which has no natural origin. It throws one
object into relief, conceals another, creates an atmosphere. It is
this light that makes Caravaggio's images more forceful and
arresting than reality itself. In the *Calling of St Matthew* (S.
Luigi dei Francesi, Rome) light comes in with Christ to disclose
Matthew's mission; in the *Conversion of St Paul* (in Sta Maria
del Popolo, Rome) it is light that awakens the spirit of Saul,
who opens his arms to receive the divine light.

Caravaggio is a strange realist. His *Death of the Virgin* (Louvre)
is perhaps the most religious of all 17th-century Italian paintings.
And yet everyone, from his own time down to the present day,
has regarded him as a realist because he refused to idealise nature,
refused to choose models who had aristocratic beauty, because
he preferred to reveal the inner spiritual beauty of the humble
lives of simple people and of everyday objects.

Although Caravaggio did not have a regular school, he
influenced the young painters who went to Rome during the
first decade of the 17th century. But they saw only the technical,
rather than the spiritual, side of his light and shade contrasts;
they preferred natural models to the idealised forms of Raphael
and classical art, and were for that reason accused of being
vulgar and tenebrist.

745 One of them, however, Orazio Gentileschi, benefited wisely
from Caravaggio's style. He was summoned to the courts of
France, England and Spain, and so spread abroad the work of
Caravaggio. His draughtsmanship is meticulous and his colour-
ing delightful.

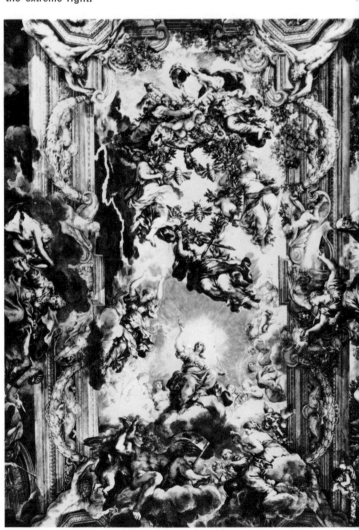

522. ITALIAN. ROMAN. PIETRO DA CORTONA
(1590–1669). Ceiling fresco glorifying the Barberini family.
1640. *Palazzo Barberini, Rome.*

523. ITALIAN. ROMAN. CARAVAGGIO (1573–1610).
The Beheading of St John the Baptist.
Valletta Cathedral, Malta.

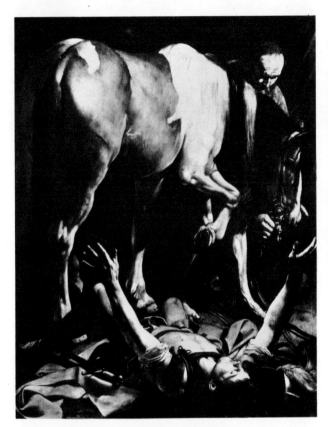

524. The Conversion of St Paul. 1600–1601.
Sta Maria del Popolo, Rome.

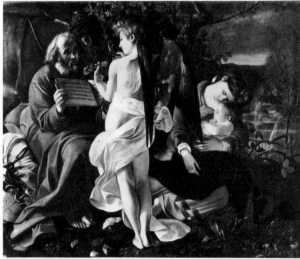

525. The Rest on the Flight into Egypt. *Palazzo Doria, Rome.*

When, in about 1630, Caravaggio's pupils were heard of no more in Rome, the bambocciata painters sprang up under the impact of the Dutch painter van Laer. They prided themselves **632** on depicting poverty, and won great success with the aristocracy by describing the ridiculous vulgarity of common life. Michelangelo Cerquozzi was the best of the Italian bambocciata painters.

The classical reform of the Carracci

To destroy Mannerism Caravaggio had carried out a veritable revolution. But the upper clergy, and literary people in general, had the impression that the ideal was missing in his realism. They hailed with enthusiasm, therefore, the Mannerist reform which the Carracci accomplished without losing sight of the ideal.

The Carracci were from Bologna; their family came from Cremona in Lombardy. They studied Correggio and the Venetians, Titian, Tintoretto and Veronese; and they worked together on the decorations for various Bolognese palaces, exploiting light and shade effects to escape from Mannerist line. At the beginning of his career, Ludovico, the eldest of the Carracci and the head of the team, had a similar style to Caravaggio; in fact his reform was based above all on a closer regard for objective reality. But the prolonged study of great Renaissance masters left its mark on the work of the Carracci. The various qualities of the masters, the classical draughtsmanship of Raphael and Michelangelo, the colouring of Venetian and Lombard painters, all this had to be assimilated and harmonised: it was the beginning of eclecticism. It is true that all the Mannerists had been more or less eclectic without giving up their individual styles. But the Carracci, in borrowing from the same sources as their predecessors, were able to harmonise them more skilfully and lucidly. They were considered eclectic painters par excellence, which was a compliment at the time, but which became a reproach in the 19th century.

Ludovico Carracci stayed at Bologna to supervise that school of painting which was so successful and which was honoured with the title of 'academy'. In about 1595 Annibale Carracci, **425, 527** the most brilliant of the three, was summoned to Rome to **528, 530** decorate the Farnese palace. He realised that he had to give his drawing the polish of ancient statues and of Raphael, so

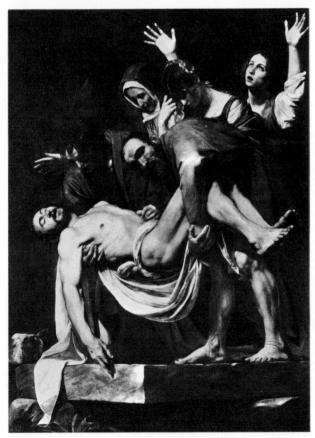

526. The Entombment. 1602–1604. *Vatican.*

MASTERPIECES OF ANNIBALE CARRACCI
(1560–1609)

527. Nude Study. *Louvre.*

528. Portrait of a man. *S. H. Kress Foundation, Philbrook Art Centre, Tulsa, Oklahoma.*

530. Caryatids and decorative figures from the fresco in the Farnese Gallery. 1597–1604. *Palazzo Farnese, Rome.*

529. ITALIAN. BOLOGNESE. GUERCINO (1591–1666). Aurora. 1621. Fresco. *Villa Ludovisi, Rome.*

as to carry on the Roman Renaissance. His decoration of the Farnese gallery was to make him famous, and it served as an example to more than one generation of that literary and decorous style of Baroque known as classicism. He was in fact influenced by classical art, without, however, losing that freedom of expression which came so easily to his brush. He knowingly represented objective reality, suggesting at the same time the classical ideal of beauty.

Annibale Carracci was an authentic artist, and his true nature is not to be found in the Farnese palace. Two small paintings, the *Flight into Egypt* in the Doria Gallery in Rome and *Christ and the Good Samaritan* in Vienna, are his masterpieces. They reveal his delicate nature — the dreams of love and melancholy, associating light and landscape with his feelings. It was Annibale Carracci who in fact launched the 'classical' landscape. It is true that Flemish and German painters had already done landscapes in Rome, but following Annibale Carracci and Domenichino the classical landscape had a world-wide success: one 692 has only to think of Claude le Lorrain.

The style of the Carracci and their pupils answered the demands of contemporary society so well that Bologna was called the Athens of Italy, and the Bolognese school became the most sought after and the most admired for two centuries.

Domenico Zampieri, called Domenichino, was the most 531 classicising of the Carracci's pupils. His draughtsmanship is precise, his expression lively and sincere, and though his colouring is poor in general, his forms have beauty and grace and are full of naïve charm. His aspiration to become the Raphael of his time and his belief in classical form are perhaps best revealed in his frescoes depicting the story of St Cecilia (S. Luigi dei Francesi). Domenichino was the best theoretician of the school. He suggested to Cardinal Agucchi a treatise (some fragments of which have recently been discovered) which was the first doctrine of classicism — reality and the ideal synthesised in the Idea. The doctrine was developed and codified later by Bellori.

The most brilliant and the most independent of Carracci's pupils was probably Guido Reni. He was famous all over Europe and was regarded as a second Raphael. The French, who called him 'the Guide', drew inspiration from his gracefulness even in the 18th century, and Goethe praised him as a 'divine' genius. He was later despised, but he enjoys renewed interest at the present day. He felt that the classical ideal represented a need for perfection in a world invented and elevated above all reality. He succeeded in expressing his taste for perfection with extraordinary ease and with a highly refined sense of colour. But his perfection, which made him so successful, limited his art. Perfection spells death, and his art often lacks vitality. His masterpiece is, perhaps, the portrait of his mother

(in Bologna) in which he expresses his ideal without losing sight of real life. His most famous work is *Aurora*, on the ceiling of the Palazzo Rospigliosi in Rome, in which all foreshortenings are suppressed so as not to impair the harmony of the contours: the fresco consists of a procession of beautiful people.

His religious scenes, which to us are very conventional, were believed by his contemporaries to have been painted by angels. Reni was a good Christian, but without much depth of feeling. If he was the idol of his time, it was because he had the qualities and weaknesses of his time: he carried to extremes the refinements of a great tradition and thought the rules of decorum more important than the eternal sources of life.

Giovanni Francesco Barbieri, known as Guercino, was a great colourist in his youth; his effects of light and shade had the mark of a creative genius of surprising force and he was much freer than his colleagues of the same school. He was a very talented painter but rather a superficial artist, and he never developed beyond his *St William of Aquitaine*. Summoned to Rome by Pope Gregory XV in 1621, he was dazzled by classicism which was new to him. He painted the fine *Aurora* fresco in the Villa Ludovisi in Rome, better painted than, though not as beautiful as, Guido Reni's *Aurora*. Guercino's landscapes are especially fantastic. But Cardinal Agucchi's theories and the example of Domenichino and Reni gave him the idea of softening the contrasts of light and shade and of giving his forms a nobler aspect. As he said in a letter, in following the classical fashion so as to please his clients, he destroyed his creative force.

For nearly three generations classicism had a vigour that prevented it from becoming academic.

Andrea Sacchi had been Francesco Albani's pupil; he enriched his colouring by studying Titian, from whom he drew a new vitality. Sacchi's masterpiece, and perhaps the best of all Italian classicist paintings, is his *Vision of St Romuald* in the Vatican

Museum. This painting asserts the ideal of peace and wisdom, of the dignity of life, of meditation. The synthesis of beauty and spiritual grandeur is truly Platonic. With this picture classicism died a beautiful death. It was the time of Poussin's success. From this Rome that he loved so much and where he lived most of the time, Poussin inherited the classicism which he passed on to France, and which was to survive there for so long.

Whereas Mannerism had its theoreticians, critics and art historians, realism, on the other hand, was not and could not be analysed methodically — not until Boschini, who with his enthusiasm for Baroque art elucidated the realist elements in the Baroque. Classicism, which corresponded so well to the culture of the time, was often explained by various writers. However, the best theory of classicism and its place in the history of art was written by Gian Pietro Bellori in his *Lives of the Modern Painters, Sculptors and Architects* (1672). He was against the Mannerists, whose bastard works were not born of nature, and he was against the naturalists who scorned reason and truth in art. For him the Mannerists were represented by Cavaliere d'Arpino, the naturalists by Caravaggio. Just as the truth lies beyond the two errors, so Annibale Carracci went beyond those two painters. The truth is the Idea, the artist's idea. The Mannerists, too, had talked of the Platonic or neo-Platonic Idea, rooted in metaphysics. But the Renaissance had already found the Idea in nature. For Bellori, the Idea must come from nature, but it outstrips its origins by becoming an artistic idea. It must, therefore, go beyond nature, while at the same time expressing nature: a balance must be kept between the ideal and nature. So it was that Bellori saw this Renaissance ideal fully embodied in the works of Annibale Carracci and Poussin. This ideal was passed on from Mengs to Winckelmann, who handed it down to modern idealist aesthetics.

It was, moreover, in the very nature of classicism, steeped as it was in culture, to find its apotheosis in a theory.

II. THE GOLDEN AGE OF SPAIN, PORTUGAL AND THE AMERICAS *José Camón Aznar*

*In a strongly Catholic country like Spain the Renaissance
was interpreted in a reformist spirit that was severely classical.
But after trying to satisfy their intense temperament with
a rigorous austerity, the Spanish soon returned to a violent and
exuberant lyricism that had its roots in the Arab and medieval past.
The characteristics of the Counter Reformation became more
powerful, taking the form of either a realism reminiscent of
Caravaggio, and intended to make a forceful impression
on the faithful, or, on the other hand, a spirituality that tended to
break away from the material. In the visual field of
painting, this intensity awakened a sensory acuteness which,
thanks to Velasquez in particular, anticipated the
modern Impressionists.*

Architecture from classical austerity to Baroque lyricism

The second half of the 16th century saw the most profound
change in the entire history of Spanish architecture.

As from 1560, the Plateresque style, the Spanish version of
the Renaissance (medieval structures with Italian decoration),
gave way to an architecture that was completely free of Gothic
543-546 elements. With the Escorial Spain committed herself even more
radically than Italy to Michelangelo's theories, by concentrating
the aesthetic interest of the building in the essential harmony
of the masses and in the very strict proportions of all the archi-
tectural elements. In the Escorial architectural rationalism is
taken to its extreme limits. It is designed with compasses and
setsquare, without the least concession to the spectator's sensi-
bility. It is bare, pure, mathematical: the groins are severe, the
Doric columns engaged, the architraves uniform, the niches
empty; all the power lies in the chiaroscuro effect.

With the Escorial the Gothic rib vault disappears from
Spanish art. Domes and barrel vaults curve solemnly over
wide spaces. The revived Platonism was realised to the full in
this building, and the wholehearted application of Roman
theory achieved a purity that is not to be found even in
St Peter's, Rome, where Michelangelo's architectural concepts
are distorted by the surrounding Baroque elements.

The Spanish character of the Escorial is accentuated by the
grandiose sweep of the ensemble — the tombs, the palace and
the monastery. The Escorial was to be the model for church
interiors, and it created the tradition of buildings with corner
towers. Architecture, which in other countries was character-
ised by dynamism, rich ornamentation, and whimsical variations
of classical purity, produced in Spain, paradoxically, the Esco-
rial — the most austere and geometrical building of the time,
stripped of all decorative elements. It was on these intangible
foundations that 17th-century Spanish architecture was to be
built up.

544 The first architect to break away from the austerity of Herrera,
who, together with Juan Bautista de Toledo, had designed the
537 Escorial, was Juan Gomez de Mora. A nephew of Francisco de
Mora and Herrera's successor, he designed the most important
buildings at the beginning of the 17th century. He was the
founder of the Baroque architecture of Madrid, a style which
lasted throughout the 17th century and continued into the
Rococo period. Juan Gomez de Mora's work is so much in
character with the genius of his race that it seems impersonal.
The general structure of his buildings remains grave and solemn
even when swathed in Baroque decoration. He designed the
Plaza Mayor in Madrid, which must have been completed

before 1621 as there was a *corrida* there that year. He also built
the Clerecía in Salamanca, that architectural masterpiece of the 537
time of Philip III: its construction lasted throughout the century,
and it bears the imposing and monumental stamp of the
great master.

As for Juan Gomez de Mora's municipal buildings, we have
a valuable example of them in the old Carcel de la Corte (the
Court Prison) in Madrid, which is now the Ministry of Foreign
Affairs; it was built between 1614 and 1624. Although it has
been attributed to the Italian Crescenzi, there is no doubt that
it is the work of Gomez de Mora.

From the beginning of the 17th century the Herrera manner
lost its almost universal characteristics, to become more popular
and at the same time more Spanish. So it was that, little by
little, Spanish sentimentality introduced the broken-up interior
spaces and the sumptuous complicated ornamentation of which
it has always been so fond. Further, an architecture that had
tended to be horizontal turned to vertical form. As the Baroque
continued to develop, so the towers of the new style rose up
higher and prouder in Salamanca, Barcelona, Saragossa and
Santiago de Compostela. Even at the end of the Baroque period
Spanish architecture seemed to be quickened by an upward-
moving impulse.

Francisco Bautista, who built the churches of S. Isidro, Madrid, 540
and S. Juan Bautista at Toledo, where he used the Palladian 316
Orders on a gigantic scale, preserved the sober and monumental 319
characteristics of the Escorial tradition in his interiors.

A new architectural idea appeared in the middle of the 17th
century in circular or elliptical churches, such as the Bernardas
church at Alcalá de Henares, probably built by Juan Bautista
Monegro, under the influence perhaps of El Greco who was
also an architect. In these circular churches the domes are deco-
rated with murals.

Spanish architecture changed in the second half of the 17th
century. The Baroque excesses that covered the façades and
doorways, and the fantastic ornaments in heavy relief, were in
strong contrast with the purity and the architectural frigidity

534. JUAN BAUTISTA DE HERRERA (1530–1597).
S. Lorenzo del Escorial.

535. ESTEBAN JORDAN (1534–1600). Two saints.
The Church of the Magdalen, Valladolid.

536. JUAN DE JUANES (1523–1579).
The Stoning of St Stephen. *Prado.*

537. JUAN GOMEZ DE MORA (1586–1648).
Façade of the Clerecía, Salamanca.

538. JUAN MARTINEZ MONTAÑÉS (1568–1649).
St Bruno in Meditation. *St Sebastian's Chapel, Cadiz Cathedral.*

539. FRANCISCO RIBALTA (1565–1628).
Vision of St Francis of Assisi. *Prado.*

540. HERMANO F. BAUTISTA (1622–1665).
S. Isidro el Real Cathedral, Madrid. Completed in 1661.

541. ALONSO CANO (1601–1667). St John of God.
Archaeological Museum, Granada.

542. ALONSO CANO (1601–1667). Death of a Franciscan.
S. Fernando Academy, Madrid.

SPANISH ART IN THE 16TH AND 17TH CENTURIES

ARCHITECTURE **SCULPTURE** **PAINTING**

Born in the first half of the 16th century

534

535

536

Born in the second half of the 16th century

537

538

539

Born in the first half of the 17th century

540

541

542

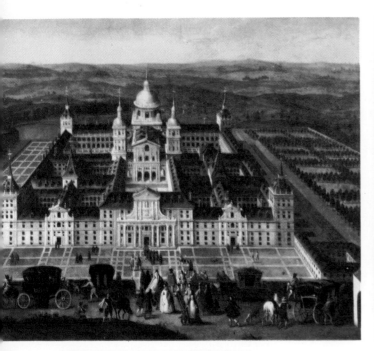

543. General view of the Escorial,
after a 17th-century Spanish painting. *Louvre*.

544. Monastery of S. Lorenzo del Escorial.
South façade and the kitchen-garden lake.
Built between 1563 and 1584 by Juan Bautista de Toledo and
Juan de Herrera.

545. Mausoleum of Charles V (detail). Bronze gilt.
The king, wearing the imperial mantle, is surrounded
by members of his family. *Capilla Mayor, Escorial*.

546. The lower cloister (north gallery)
with frescoes by Pellegrini, Tibaldi and Luca Cambiaso.

of the interiors. A taste for colour, together with the rich textures and polychromy of plaster or stone reliefs, overhanging cornices supported by highly decorated corbels, high domes — all these characteristics of Madrilenian Baroque marked the style that was inaugurated by the church of S. Andrés in Madrid.

Ever since the discovery of America the Spanish kings had been busy having churches and palaces built there, as can be seen in the Archivo de Indias in Seville, which is full of building projects.

During the first half of the 16th century the Spanish buildings in the Americas — the church at Acolman and Santo Domingo cathedral — are similar to the Plateresque style in Spain, and the influence of pre-Columbian decorative art is negligible. In the second half of the 16th century the influence of the Spanish Renaissance, particularly in its Andalusian form, is noticeable. The most important architect of this period was the Spaniard Francisco Becerra, whose Plateresque art follows the tradition of Diego de Siloe, architect of Granada cathedral. He worked on Puebla cathedral, and built various churches in
822 Mexico and Quito. The Spanish viceroys also commissioned him to build the cathedrals in Lima and Cuzco.

Portuguese architecture at the end of the 16th century developed along similar lines to Spanish art in the monuments built by the Italian Filippo Terzi, Master of Royal Works to Philip II. He was the moving spirit of a Portuguese movement parallel to that of Herrera. In his great monument to São Vicente de Fora, in Lisbon, he proved the weaker. With Terzi there began the generation of Baroque architects, such as the Tinoco family. The monumental plan of Sta Engracia, in Lisbon, we owe to João Nunes Tinoco.

Portuguese Baroque became austere with the Turriano brothers. But Baltasar Álvares, at the very beginning of the 17th century, created in the Jesuit church at Oporto known as the Grilos some very dynamic forms, which were the origin of that heavily ornamented Baroque that marked the opening of the 18th century.

Sculpture from the Renaissance to Baroque naturalism

It is in sculpture in particular that the lack of coordination between the various arts in 16th-century Spain becomes apparent. During the Renaissance the Castilian school of
352, 353 Berruguete and Juni was characterised by a sculptural fury, a Baroque restlessness, a convulsive kind of expression, that carried feelings as far as they could go within the possibilities of representation. The use of polychrome wood no doubt helped to accentuate this sense of the dramatic, and made it possible to create figures in dynamic attitudes with passion-twisted faces. The decoration of the Escorial changed the course of Spanish sculpture. The change was imposed by two Italians, Leone Leoni and Pompeo Leoni. Their portraits of the Spanish court and the high altar of the Escorial are in accordance with the strictest Renaissance aesthetics. They avoided the turmoil of a Michelangelo, and sought for forms of lofty and noble severity: it was a sculpture of restrained emotions, classical rhythms and relaxed attitudes. It is perhaps only in their way of treating space that we see signs of a modernism that went beyond the Renaissance — for instance, the effects of perspective in the distribution of the statues on the tombs of Charles V and Philip II.

We also find classical characteristics in Andalusian sculpture. There the normal evolution of the Plateresque style of the High Renaissance replaced the sinuous and emotional forms of mid 16th-century statuary by fuller and more Romanist forms. This evolution, which was consolidated by Siloe's disciples, was stimulated by that great sculptor J. B. Vazquez, whose style, moreover, has much in common with that of Sansovino. In
222 his Sevillian works, Vazquez mastered large forms with all the

547. SPANISH. GREGORIO FERNANDEZ (c. 1576–1636). Recumbent Christ (detail). *National Sculpture Museum, Valladolid.*

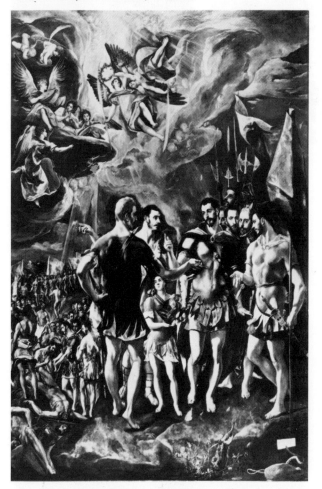

548. SPANISH. EL GRECO (1541–1614). Martyrdom of St Maurice and the Theban Legion. Commissioned in 1580 by Philip II for the Escorial.

227

549. SPANISH. EL GRECO (1541–1614). View of Toledo. *H. O. Havemeyer Collection, Metropolitan Museum of Art.*

550. SPANISH. EL GRECO (1541–1614). The Assumption of the Virgin (detail). 1608/13. *S. Vicente Museum, Toledo.*

551. SPANISH. EL GRECO (1541–1614). Fray Hortensio Paravicino. *Museum of Fine Arts, Boston.*

552. SPANISH. RIBERA (1591–1652). Jacob's Dream. *c.* 1646. *Prado.*

grave elegance of a Florentine. Michelangelo's influence, noticeable in north Spain, lasted till about 1650. Juan de Ancheta was such a brilliant imitator that he can be said to have filled the gap in European sculpture between Michelangelo and Bernini. Ancheta borrowed all his vigour and his feeling for massive and twisted forms from Michelangelo. He added, however, a sombre note of pessimism and imbued his figures with a surly vindictive expression. Della Quercia's influence is **200** equally noticeable in Ancheta. Finally, to complete this summary, we might mention El Greco's sculptures, with their elongated forms and their surfaces that are smooth and undulating for all their plastic force.

Let us now see how Spanish art set about eliminating the Renaissance style in order to develop the naturalism of Baroque.

In Castile the powerful originality of Gregorio Fernandez appears to reflect certain antagonisms. On the one hand, his recumbent *Christs* are in line with an essentially Spanish tra- **547** dition: the harmony of the bodies, which evoke classical sculpture, are the most perfect in all Spanish art, and the bloody traces of martyrdom are concentrated in the faces. On the other hand, the rigid, not to say metallic, folds of the clothes of his figures indicate the influence of Burgundian Gothic. These angular creases prevent the rhythmic development of the cloaks in the manner of Italian or French Baroque painters. Fernandez enjoyed emphasising individual gestures, and he was cruelly realistic with lower class types. These qualities made him the perfect sculptor of the processional *pasos*. These *pasos*, designed to be carried in the streets, have always been very popular, and they represent a particular genre of Spanish sculpture. Themes from the Passion are interpreted by means of scenic ensembles. Their pungent realism and essentially descriptive character are conditioned by their function.

In Andalusia the genius of Martinez Montañés laid down the specific forms of Sevillian sculpture. It was at his instigation that the school of Seville concentrated on psychological interpretation and avoided exaggerated postures and wild contortions. Though Martinez Montañés preserved the balance of the **538** classical Renaissance style, the intense humanity of his *Christs* expresses the passion of the Baroque: the dramatic features of a *Christ* appear to imbue the whole body with grandeur and serenity.

The evolution of Sevillian sculpture after Martinez Montañés only accentuated even further the importance of the features, giving them a more anguished and tragic expression.

Alonso Cano and his followers of the school of Granada **541** represent another aspect of Andalusian sculpture. Cano was highly original; he was concerned with beauty rather than forcefulness, and his pictures have a quiet intimate charm, an ideal gentleness.

Among his Granada followers, Mena to begin with, and later Mora, transformed this delicate touch into a more passionate inner expression. Yet their apparently violent and dramatic figures reveal, paradoxically, in their features a shallow sentimentality. This school of Granada had a weakness for small sculptures, and some of them, such as the *St Francis* in Toledo **431** cathedral, are extremely ascetic. Andalusian sculptors used wood, and their colours tended to be realistic.

Apart from the Portuguese sculptor Pereyra, who lived in Spain and whose elegant work is less realistic, sculpture in Castile and Aragon began to decline, consisting mainly of pompous altarpieces and carvings with excessive decoration.

El Greco and foreign influences in painting

In the second half of the 16th century there were a great variety of pictorial styles which were not related to the different regional schools, nor to the chronological development of the great European movements. It was precisely this strangely

553. SPANISH. FRAY JUAN SANCHEZ COTÁN
(1561–1627). Bodegón (Still life). *San Diego Museum, U.S.A.*

554. SPANISH. ZURBARÁN (1598–1664).
The Vision of St Peter Nolasco. 1629. *Prado.*

555. SPANISH. PEDRO DE CAMPAÑA (1503–1580).
Group of donors. One of the two panels
flanking the Mariscal retable. *Seville Cathedral.*

independent quality that produced such extremely intense works, like those of El Greco and Morales. The overall view of Spanish painting, in this period, is highly complex. The Renaissance manner did, however, provide a certain continuity in Valencia, where the Juan de Juanes tradition was kept alive until the end of the 16th century. There is a hidden Gothic influence, a medieval feeling, in the forms used by Morales, who was deeply religious. His forms, drawn out and sharpened by his emotionalism, are reinforced by Italian Mannerism, by the elegant elongations of a Parmigianino, whom Morales resembles in so many ways and who so obviously influenced him. Morales' paintings of *Ecce Homo* and of Madonnas have a passionate mysticism that earned him the nickname of *El Divino.*

El Greco's work, from the time he arrived in Spain, was

536

462

much more complex. His first Spanish paintings show a reaction against the spirited and brilliant manner of his Venetian period. But his big canvases in Sto Domingo el Antiguo in Toledo are in the Roman tradition: their full generous forms have a serenity that is not to be found in any of his other works. Later, after his failure with Philip II, his means of expression became entirely personal, and it is difficult to relate him to his contemporaries. To grasp his real worth, El Greco must be looked at from various angles. His Byzantine training in Crete, first of all, and then in Venice, reveals itself in the colouring of his first works and is even noticeable after 1590. The enamel-like quality of many of his Italian paintings, and the lines broken up into short strokes, appear to be of Greek origin. Byzantine aesthetics may also explain the repetition of certain characters and postures, which were to acquire an archetypal significance.

548–551

The undulating rhythms of some of his works, the frequent lack of perspective depth, and the colouring and the symbolism of his figures are all characteristic of Byzantine art. From 1575 to 1580, without any apparent effort on his part to renounce the Byzantine aspect of his personality, Roman forms predominated in his work. But from 1590 onwards El Greco reverted to Byzantine forms. How else, in fact, can one account for the elongations and the dislocated line of his last works, if not by this ' renewal of his temperament, the call of his Greek blood '? El Greco was in Italy just when post-Michelangelesque aesthetics were at their height. The famous elongations thus coincided with those of Pontormo's, Schiavone's and Parmigianino's figures; but the art of El Greco, with its frenzied sense of movement, is radically different from the art of those Italians. He was also different in that his figures are haunted by a kind of unrest that gives them a mobility, accentuated by his ' impressionistic ' technique. Was El Greco a Baroque painter? He did not employ the same light and shade contrasts as in Baroque works. Above all, the light which fills his pictures is not natural, but is intended to be ' metaphysical ', for El Greco was not in the least concerned with the realism that was the basis of the Baroque. It is no doubt the passionate movement of his figures that has caused El Greco's paintings to be classed as Baroque. But his is an interior dynamism essential to the reality of the figures, and not merely a stylistic dynamism

409

MASTERPIECES OF VELASQUEZ (1599–1660)

*There is in the work of Velasquez the greatest
technical versatility. At first, as a disciple of Caravaggio, he
used powerful chiaroscuro, plastic modelling and
illusionist projection. Then he went further and showed a new
awareness of aerial space, and gave new value to
surface strata in depth, in some ways anticipating Cézanne.
In his later pictures he achieved
greater limpidity and an amazing lightness of touch.
His range of subject matter is quite considerable: religious,
historical and mythological pictures;
landscape, still life and genre painting; animals and
hunting scenes; character studies and court portraiture.
Like many painters of the time Velasquez also made a stand
against the Renaissance conception of beauty and
saw the attraction of ugliness, but he never laid any undue
emphasis on it. Even to the portrayal of the
most idiotic court dwarf, he imparted something of his
own proud reserve. Tactful restraint and skilful objectivity were
invariable characteristics. He even remained aloof from
the stirring expressionism of the mature Rembrandt.
What is to be most admired in Velasquez is his unerring
instinct for proportion. Everything in his work is necessary;
there is neither too much nor too little, and
always there is harmony in the whole manner, composition,
colouring and expression. His art is as great
in its simplicity as in its richness.
Some of his composure and reserve may well be
a Spanish trait inherited from the Moors or due in part to
his own noble birth, but it is also individual, and
his individualism went beyond national boundaries. But till the
end of his days this aristocratic artist sought
contact with every aspect of the life of the people and never
gave up painting them. His own sense of democracy
enabled him to see the personal worth and
equality of any peasant or beggar.
Velasquez, as a consummate artist, with his own
convincing view of the world, transfigured what he painted and
fixed the classic form of the Baroque. His work will remain
a yardstick for great artists to measure their own achievements.*

August L. Mayer (*Velasquez*, 1924)

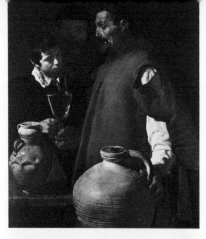

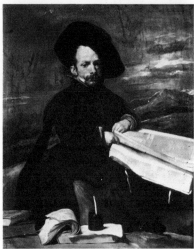

556. The Water-carrier of Seville.
c. 1619–1621. *Apsley House, London.*

557. The Court Jester Don Diego
de Acedo (El Primo). 1644. *Prado.*

558. The Surrender of Breda (Las Lanzas).
1634–1635. *Prado.*

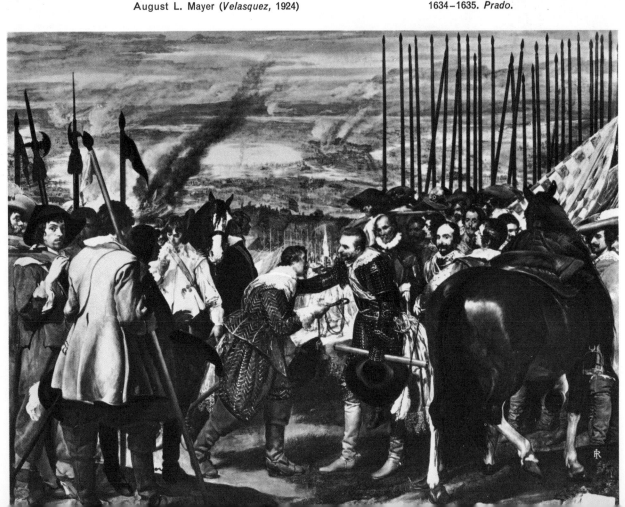

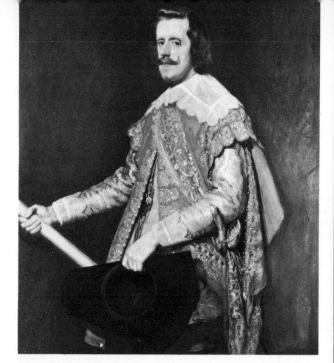

559. Philip IV of Spain at Fraga. 1644.
Frick Collection, New York.

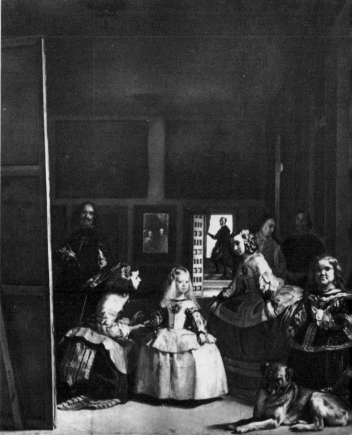

560. The Maids of Honour (Las Meninas).
1656–1660. The Infanta Margarita is in the centre,
with her entourage. The mirror in the background
reflects the king and queen. *Prado.*

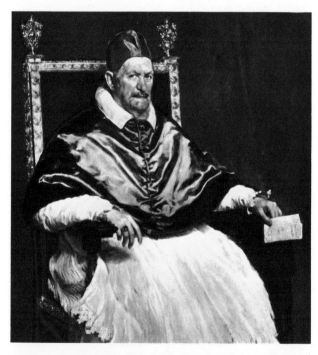

561. Pope Innocent X. 1650. *Doria Pamphili Gallery, Rome.*

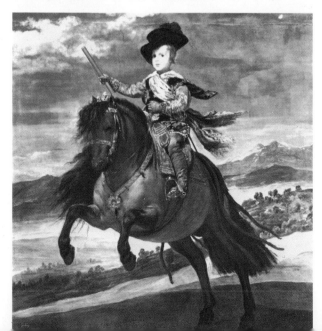

562. Prince Baltasar Carlos on Horseback. *Prado.*

imposed from outside. The movement of his figures expresses, rather, ' a destiny of eternal migration ', which was the basis of their intimate structure.

Philip II, who preferred the Roman style, sent for Italian artists to decorate the Escorial. The representatives of Roman art, Cambiaso, Zuccaro, Tibaldi, Romulo Cincinnato, were conscientious artists who understood the classical and Michelangelesque formulas, but they were mannered and lacked genius. They made no impact on Spanish painting, for their art was the very negation of Iberian sensibility.

A group of Iberian painters (among them Fernandez de Navarrete) who had a better artistic sense interpreted this foreign style *à l'espagnole*. There was another style that found a wider public: this was the school of northern painters, whose renascent Mannerism succeeded in expressing the Spanish sense of religious tragedy. Pedro de Campaña, Sturm and Frutet in Seville, and Eschepers in Aragon, worked with elongated forms, and took a delight in passionate subjects. Some of these masters — Campaña, for instance — painted so well in the popular Spanish style that their works were the beginning of the great Baroque movement of the 17th century. Meanwhile, other painters, such as Céspedes and Becerra, continued to work in the Roman style. At court the most illustrious of the school of portraiture founded by Antonio Moro was Sanchez Coello. This cold objective school, which produced aristocratic and distinguished effects by the use of greys, was to influence Velasquez's palette.

Spanish tenebrism

In the transition between the 16th and 17th centuries there was a spate of tenebrism that produced some of the most characteristic works of the golden age of Spanish painting.

231

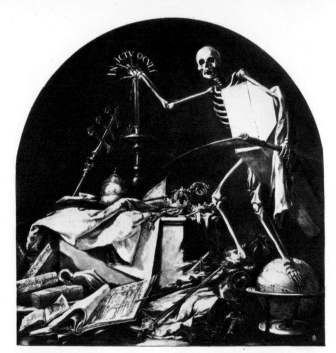

563. SPANISH. JUAN VALDÉS LEAL (1622–1690). Las Postrimerias de la Vida (In Ictu Oculi). c. 1672. This allegory of 'last moments' shows death extinguishing life's flame. *Hospital de la Caridad, Seville.*

It is hard to determine whether this tenebrism stemmed from Caravaggio, or sprang spontaneously and autonomously from some indigenous source. Caravaggio's influence is evident in Ribera, who could not have learnt his chiaroscuro technique from Ribalta; for this technique was developed in Ribalta's studios after he, Ribera, was supposed to have worked there.

Francisco Ribalta is traditionally regarded as the first master of Spanish Baroque painting, and as the creator of forms placed on vast surfaces with violently contrasted lights and shadows. It was not Caravaggio, however, whom Ribalta thus imitated, but Sebastiano del Piombo, some of whose works he copied. Ribalta's chiaroscuro accentuated the highlights of his figures which not only gave them greater sculptural relief but a strong expressive character. His son, Juan, returned from Italy with a Caravaggesque style that was more rugged and Iberian than Ribera's: this was no doubt responsible for the more violent chiaroscuro in Ribalta's last works.

One of the promoters of the Spanish tenebrism was Fernandez de Navarrete in the 16th century. Contemporary writers stressed the vigour and relief of his work, as opposed to the *vagueza* or haziness of the Italians. Another source of this tenebrism was perhaps a tendency — very characteristic of the Spanish artistic tradition — to reproduce simple concrete objects in a realistic way. With Ribera, the tenebrism attained a kind of expressionism, whose poetic quality has been so well described by L. Gillet: 'For Ribera night is a trafficker in anxiety and passion... the painting of a dramatist, which, in black and white, summons forth a host of violent and stirring emotions.'

Naturalistic painting took the form of strong contrasts, and emphasised the 'tactile values' of objects. Tenebrism was also successfully allied to still life painting: the school of Toledo, in particular, profited from this alliance. Sanchez Cotán belonged to this school, and his still lifes with their forceful treatment of masses are of unquestionable beauty. This naturalistic tendency was also, no doubt, the origin of Luis Tristán's tenebrism. Orrente, too, employed strong contrasts of light for realistic purposes.

No less original was the tenebrism of the Seville school, which was based on a realist impulse that does not seem to have anything to do with Caravaggio. The seeds of the Sevillian

tenebrism must be looked for in Pedro de Campaña, whose sense of the dramatic led him to deepen the shadows so as to give his pictures a more tragic aspect. But it was mainly Pacheco who inspired the great tenebrist movement of the Andalusian school. He gave his figures relief by effects of light and by using ochre, brown and yellowy white, colours which were later to be the basis of Zurbarán's and Velasquez's chromatic art. The solidity and tactile quality of Velasquez's forms during his early period are due to his following closely the example of his father-in-law Pacheco. Pacheco himself said of his works that Velasquez 'found in them the true imitation of nature'.

One could say much the same of Zurbarán, although this other great artist was not trained in Pacheco's studio. His chiaroscuro which makes the volumes stand out so clearly is to be found, without any essential differences, in all his work, from the *Virgin* (1616) to the end of his life. This was the fundamental difference between the techniques of these two great painters. Zurbarán never went beyond the tenebrist manner, and in all his works, apart from a few variations, there is the same contrast between the light surfaces and the equally well defined dark masses. Palomino used to say of Zurbarán's works that they were so similar to Caravaggio's that they could easily deceive anyone who did not know their origin. 'But Zurbarán's work is exclusively religious... Zurbarán, faced with a miracle, is full of ingenuousness, a child-like candour... He has the unspoilt mind of the inventors of myths...' So he was described by L. Gillet, who regarded him as 'the true poet of Spanish painting'.

Velasquez and impressionistic painting

Spanish painting was dominated by tenebrism until in 1630 artists began to shake free of it, thanks to a kind of impressionistic technique that became an essential element of their conception of art. Detached brush strokes were used to obtain an instantaneous impression and to capture the fleeting effects of light. It was a technique well suited to the passionate and impulsive Spanish temperament. El Greco was the first to use

564. SPANISH. MURILLO (1617–1682). The Immaculate Conception (the 'Large' Conception). *Seville Museum.*

551 this technique. Fray Hortensio de Paravicino, whose portrait El Greco painted twice, tells us: ' You will notice that while painting he stands back from time to time to see the effects of the painting; he is satisfied with a brush stroke he has just made only after he has studied it from a distance ...'

This way of painting with separate brush strokes was severely criticised by Pacheco. Quevedo used to speak of ' juxtaposed dabs ' in referring to Velasquez's technique.

Velasquez's chiaroscuro period ended in 1627, when he began to employ freer brushwork to build up the composition. ' He first of all made sure that he understood all about form; he then devoted several years of his life to the study of line and volume. It was only then, when he was certain of his technique, that he gradually built up his style and developed his simplified manner of painting ' (August Mayer). Velasquez's evolution was nothing more than a continual advance towards a more radical form of impressionism. Thanks to his genius and his delicate and supple technique, he was to have no difficulty in tackling the problems involved in interpreting light in terms of paint. In his last works the endless repetition, the profusion of separate, little brush strokes, enabled him to transpose the play of light and to render form in terms of reflections.

564 Velasquez was not the only one to master this impressionistic technique. In Murillo's best paintings, too, everything is in movement, everything seems to be made up of innumerable luminous particles. In his backgrounds especially the light touch of his superimposed and transparent brush strokes produces effects that resemble 19th-century Impressionist works.

Juan Valdés Leal employed the impressionist technique in a personal way, with a nervous intensity that gives his work
563 the character of a brilliant sketch. Palomino, who visited Valdés in Seville, described his impressionistic way of working: '... I have seen him painting several times: normally he paints standing up, for he likes to move away from the canvas periodically, so as to come back to it suddenly to add a few touches, and then move away again. This was his way of painting, with a restlessness and vivacity that were part of his nature... '

565 Early Sevillian masters like Herrera the Elder, whose brush-work was already rather impressionistic, had indeed prepared the way for this technique. Palomino said in praise of Herrera that he worked ' with such skill that his paintings appear to have been painted with a housepainter's brush '. His son, Herrera the Younger, used the same technique.

It is commonly said of Spanish painting that it is austere and reserved, and that its qualities are characterised by a predilection for easel painting. Mural painting did, however, exist as well. One could even say that if the 17th-century Baroque attained such grandiloquence it was thanks to the decorative ability of a number of Spanish painters. In this sense the painter who revitalised 17th-century painting was the Spaniard Francisco Rizi. A mediocre painter himself, Rizi was the associate or teacher of some of the greatest Baroque masters. In his capacity as a fresco painter, he placed the Spanish school in line with the general movement of European Baroque. It is nevertheless true that his lighting and perspective never attained the grandeur of Italian frescoes; there is always something earthbound and heavy in his works. Rizi, in collaboration with Juan Carreño de Miranda, painted frescoes in Toledo cathedral. Carreño
812 de Miranda, with his melancholy and intense pictures of Anne of Austria and Charles II, belonged to the great school of court
817 portraitists. Claudio Coello, a follower of Rizi, combined the decorative exuberance of the grand Baroque style with an extreme realism. It was an unfortunate coincidence that just when the grand manner in painting disappeared Spanish drama also died out, on account of Father Nithard's prohibitions. Nothing more resembles Calderón's writings than Coello's paintings of allegorical and religious scenes. The most striking

characteristic of his painting is his ironic interpretation of mythology. In the hands of Velasquez the classical gods look anything but Greek. This caricatural view of Olympus corresponded to the general attitude of the 17th century; from Góngora onwards there was a flow of poems and romances burlesquing mythology. As a result there were no nudes or pagan themes in Spanish Baroque painting, with the exception of Velasquez's *Venus* (National Gallery; see colour plate p. 212). Only the ceilings of palaces and royal residences were decorated with mythological subjects.

The Spanish school had a considerable influence on Latin American painting, which can be said to have developed along the lines of Andalusian art.

Zurbarán and Murillo were the most frequently imitated and it was the Sevillian school that supplied almost all the paintings for Latin American churches, so much so that Andalusian art, from Martinez Montañés' sculptures to Zurbarán's *apostolados*, was created with an eye on the American market. Other artists, like the Colombian painter Gregorio Vazquez Ceballos in Bogotá, underwent a mixture of different influences, for they worked after prints and drawings. This accounts for the Venetian and Flemish echoes to be found in their work.

Quito was another artistic centre. The chief painter of this school, Miguel de Santiago, was eclectic, but his style was basically Sevillian. El Greco and Morales had an obvious influence on the artists of Peru; but there, as in the other viceroyalties, the predominant influences were those of Zurbarán and Murillo, from whose studios a number of paintings were sent to Lima. Cuzco painting, with its primitive realist style and popular appeal, was the most original. The descriptive and ingenuous quality of the Cuzco school has been compared to medieval painting in the West.

565. SPANISH. HERRERA THE ELDER (c. 1590–1656). The Apotheosis of St Hermengild. *Prado.*

233

III. CATHOLIC AND BAROQUE FLANDERS *Paul Fierens*

The religious split in the Netherlands set up between the two halves an opposition that was as clear-cut in art as it was in the field of religious faith or politics. Flanders became the stronghold of the Counter Reformation. Everything there was mobilised as a means of Catholic propaganda against the Protestant reforms. The national temperament, the Jesuit movement and the genius of Rubens were so many ingredients of the first fully expressed Baroque.

The signing, in 1609, of a twelve-year truce between the north and south Netherlands confirmed the separation of two artistic spheres — the Dutch and the Flemish. Rembrandt had only just been born. Rubens, who had returned from Italy, was appointed court painter to Albert and Isabella, whose reign was to witness the flowering of a new style in Flanders. By superimposing the general characteristics of the Counter Reformation and of the Baroque on to the northern tradition, this style was to express a vibrant sensibility, a warmth of feeling, a free and proud fluency that was heralded by Rubens.

Flemish vitality and the Catholic revival

After the long political and religious conflicts of the 16th century, Flanders sprang to life again, and the relaxation of tension that followed brought a period of feverish activity. The Archduke Albert, one of Emperor Maximilian II's nine sons, and his wife the Infanta Isabella, daughter of Philip II, ruled the Netherlands as 'sovereign princes' under the strict supervision of Spain. A descendant of Charles V and the dukes of Burgundy, a model of domestic virtue and adviser to her husband, Isabella rapidly became popular. On the death of Albert in 1621, she adopted the habit of a nun, as we see in many of van Dyck's portraits, and dedicated herself to pious and charitable works, continuing all the while to administer the affairs of state under the tutelage of Madrid.

Although the fashions, behaviour and etiquette were copied from the Spanish court, the court of Brussels was, according to Cardinal Bentivoglio, 'gayer and more agreeable on account of the greater liberty of the country and the mixture of nationalities to be met there'. The activity of the court of Brussels reached its culminating point between 1631 and 1638 on the arrival of those refugees from Richelieu's hostility, Marie de' Medici and her household, Gaston d'Orléans, Louis XIII's brother, and his followers, Charles de Lorraine and his family. They all emigrated to Brussels which became an 'inn for the French nobility'. Gaston d'Orléans in particular, and his circle, were 'great enemies of melancholia', so that there were many more balls, concerts and plays. Many a Flemish gentleman, once he had doffed his armour, showed himself to be well-read, a brilliant conversationalist, a skilful sonneteer, a good lutenist, a collector and art-lover.

The middle classes, for their part, and even the lower classes enjoyed a prosperity unknown since the time of Charles V. Industry flourished, supported by large-scale trade, with products exported far and wide. The towns maintained their monopolies and privileges, and they had their guilds and corporations. An individualistic spirit that was conservative and more and more capitalistic presided over the organisation and growth of an economic life whose main centre was still Antwerp. The reopening of hostilities in 1621, at the end of the truce, was not immediately fatal to the Flemish industrialists and merchants, and it needed the wars of Louis XIV to provoke a new crisis.

The large number of *Chambres de Rhétorique* was deceptive,

566. FLEMISH. THEODOOR VAN THULDEN (1606–1676). Triumph of Galatea (detail). *Potsdam Museum.*

567. FLANDERS. Façade of St Charles Borromeo, Antwerp. Built from 1613 to 1635 by Brother Huyssens (1577–1637).

for Flemish letters were on the decline. French, the language of government, the civil service and the aristocracy, strengthened its prestige and spread its influence. Every educated person knew Latin. Scientific research was carried on with distinction, as Taine noted, adding: 'Mercator, Ortelius, van Helmont, Hans Jansen, Justus Lipsius are all Flemish and of this period. The *Description of Flanders* by Sanderus, a huge work completed at the cost of so much trouble, is a monument of national zeal and patriotic pride.'

What contributed more than anything else to give 18th-century Flanders her characteristic atmosphere, and to revitalise her art, was the Catholic revival which affected all sections of the people during the reign of the Archdukes. 'The entire society,' wrote Henri Pirenne, 'was worked on, and so to speak moulded, by religion.' It was a triumph of orthodoxy, an outburst of faith, not to say mysticism. The pilgrimages to Hal and Montaigu drew immense crowds; an army of Capuchins and other Franciscan friars dedicated themselves to the popular apostleship begun in the Middle Ages by the Friars Minor; the convents of Carmelites, Brigittines, Clarisses, Annonciades, Ursulines, etc., as well as the Béguinages, filled up. The Society of Jesus, whose work was identified with the Counter Reformation itself, led the movement. The Jesuits, who had arrived in the Netherlands in the middle of the 16th century, immediately had a great success at Louvain university, but they were coldly treated by the Duke of Alba, and had to overcome a lot of suspicion and resistance. Their merit as preachers made them indispensable, and the Archdukes had complete confidence in them. The Order became so big that in 1612 the Belgian province had to be divided into two regions — Flemish Belgium and Gallo-Belgium. Thanks to the excellence of their teaching, which adapted humanism to the new needs, the Jesuits shaped generations of solid, well balanced Christians, well versed in ancient Greek and Roman culture. Their ex-pupils banded into confraternities, and Rubens was secretary of the one in Antwerp. The Society included in its ranks not only eminent theologians, but mathematicians like Aiguillon, philologists like André Schott, scholars like Bolland, painters like Daniel Seghers, architects like Pieter Huyssens and Willem Hesius.

567
568

The arts benefited from the very favourable climate of this wisely governed country which, although supported politically by Madrid and spiritually by Rome, was as if intoxicated by a relative independence, an independence which was not, however, to survive the death of Isabella in 1633. The national feeling which, at the time of Bruegel, had asserted itself in Italianate, Mannerist and Romanist works, was able to express itself in its own individual forms. The Flemish artists worked not only with a modern concern for the universal, creating a heroic humanity which they infused with a prodigious vitality, but with a traditional concern for national prestige and the ambition to see their 'school' ranked among the greatest. They first of all made sure that they had mastered all the mediums of expression provided for them by Italian art. But the Counter Reformation, as did the Renaissance, took a particular turn in Flanders. There the Baroque followed on, not from classical art, but rather from a late Gothic, the Flamboyant, style whose intricate refinements corresponded with the Flemish ideal of dynamic multiplicity and decorative profusion.

496

Taine's formula ('Following the Italian tradition, art turned out to be Catholic and pagan at the same time') is inadequate to describe 17th-century Flemish art, for this paganism was only superficial. What we find in the Rubens manner is a mystical fervour and a realism which were inherited from the Middle Ages and from the 15th century, and which the Renaissance had not stifled. The national temperament manifested itself with perfect ease in classical forms which had been com-

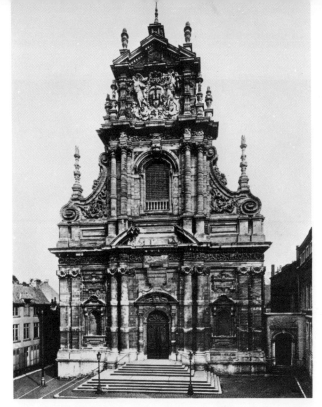

568. FLANDERS. Façade of St Michel, Louvain, by Father Willem van Hees, called Hesius (1601–1690), chief architect to the church.

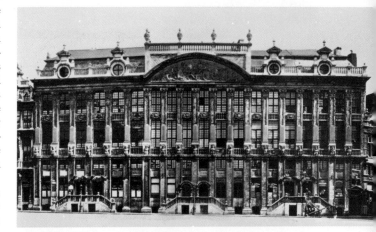

569. FLANDERS. House of the dukes of Brabant, rebuilt after the 1695 bombardment, by Willem de Bruyn (d. 1719). *Grand' Place, Brussels.*

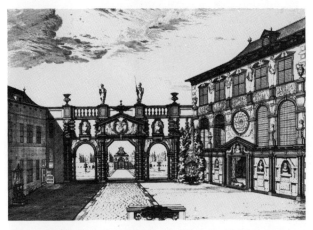

570. Rubens' house at Antwerp, built by himself in 1611. He died there on 30th May 1640.
View showing portico. Engraving by J. van Croes. 1684. *Cabinet des Estampes, Brussels.*

235

571. FLEMISH. PETER PAUL RUBENS (1577–1640).
Hélène Fourment and her Children. *c.* 1636/37. *Louvre.*

572. FLEMISH. RUBENS (1577–1640).
Self-portrait with Isabella Brandt. *Pinakothek, Munich.*

pletely mastered. Religion enters into and inspires art, gives it back the enthusiasm, the generosity, the creative impetus which has been its perquisite in the greatest periods of faith, unity and unanimity. The individual was unable to resist the current that carried the masses, nor could he stand apart from the aesthetics of the time: Jordaens, a sincere and militant Calvinist, **593** painted in the language of his century and worked for Catholic churches.

But from the 16th century man claimed an active and preponderant role in the universe. While recognising his dependence on God, he aspired to know more about himself, to know more about the world he lived in. He acquired a taste for portraits, landscapes and still lifes. All his aspirations and curiosity were to be reflected in humanism — a Catholic humanism that was open-minded, did not despise the evidence of the senses, concrete objects, and that rose naturally to the lyrical mood, a humanism that found its style, its dimensions and its radiance in art.

Architecture from the Gothic to the Baroque

The term 'Jesuit style' which has been used in architecture has been dropped, for the Jesuits merely employed and diffused a style which they had not invented themselves. In Flanders they were in fact the last to work in the Gothic style. Two Jesuits, Father Hoeimaker and Jean du Block, in their seminary and novitiate churches in Tournai, and also in Luxembourg, Maubeuge and St Omer, used Gothic fan vaulting, and all they borrowed from Vignola's style were decorative elements that became less and less discreet. The Maastricht college church, completed in 1614 by Brother Pieter Huyssens, is the first characteristic example of Flemish Baroque.

At about the same period, Jacob Francart, architect to the Archduke Albert, built a more important church in Brussels, the Jesuit church, 'a Gothic building clad in Baroque', which was demolished in 1812. The church of the Béguinage at **576** Mechelen, also by Francart, has a spatial composition, a layout and a use of ribs in the vaults that keep within the established conventions. But it has a fresh appearance with its bright and harmonious robustness. The main originality of 17th-century Flemish architecture lies in this wrapping of a basically Gothic structure in Baroque decoration. The Italians proved to be more daring and original in their plans and in the wide

573. CORNELIS FLORIS (1514–1575).
Central part of the rood-screen in Tournai Cathedral. 1568/75.

574. JACQUES DUBROEUCQ (1500/10–1584).
Strength. Detail from the rood-screen of Ste Waudru, Mons.

575. PETER POURBUS THE ELDER (1523–1584).
Portrait of a young woman. *Van Beuningen Collection.*

576. JACQUES FRANCART (*c.* 1582–1651).
Interior of the Béguinage church at Mechelen. 1627/47.

577. FRANÇOIS DU QUESNOY (1594–1642).
St Susanna. *S. Maria di Loreto, Rome.*

578. RUBENS (1577–1640). Self-portrait (detail). 1638/40.
Kunsthistorisches Museum, Vienna.

579. LUCAS FAYDHERBE (1617–1697).
Façade of Notre Dame de Hanswyck, Mechelen.

580. ARTUS QUELLIN THE ELDER (1609–1668).
Judgment of Solomon. Relief.
Dam Palace (the old town hall), *Amsterdam.*

581. DAVID TENIERS (1610–1690).
St Anthony Tempted by Drunkenness. *Louvre.*

FLEMISH ART IN THE 16TH AND 17TH CENTURIES

ARCHITECTURE **SCULPTURE** **PAINTING**

Born in the first quarter of the 16th century

573

574

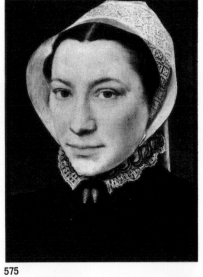

575

Born in the last quarter of the 16th century

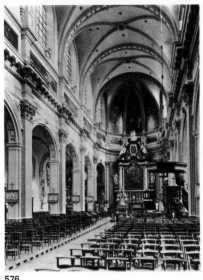

576

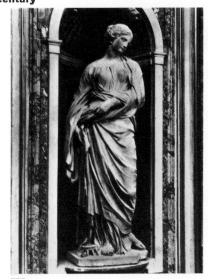

577

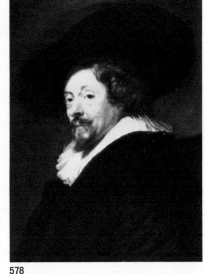

578

Born in the first quarter of the 17th century

579

580

581

582. FLEMISH. RUBENS (1577–1640).
The Artist's Son Nicholas. Chalk drawing. *Albertina, Vienna.*

583. FLEMISH. RUBENS (1577–1640).
Le Chapeau de Paille. *National Gallery, London.*

spread of their façades. The Flemish were more decorative, and normally kept to the basilica structure which they embellished with brilliant variations of the new architectural style: their naves, façades, towers and the general vertical movement reveal the persistence of the medieval tradition.

The Holy Trinity church in Brussels, whose severity conforms to the purest Counter Reformation style, is by Jacob Francart; St Augustine's in Antwerp is by Wenceslas Cobergher, as is the round church of Notre Dame at Montaigu, the first example in the Netherlands of a domed church, though it was probably inspired by some project by Serlio; the Jesuit church of St Charles Borromeo in Antwerp, finally, was Pieter Huyssens' masterpiece. It is not quite true that Rubens collaborated in the construction of this last church: he in fact painted, with his pupils, the thirty-nine ceilings which were destroyed in 1718 when the church caught fire. Even so, his influence seems to have animated the whole of this rich building: the façade, like an immense painting flanked by turrets, has as its centrepiece a cartouche with a monogram of Christ surrounded by angels; the magnificence of the interior, according to a contemporary comment, 'makes one think of the celestial dwelling-place'; and the beautiful tower is built on to the chevet. One can almost speak of it as Rubensian architecture.

Huyssens built Ste Walburgis in Bruges and St Loup in Namur. In the latter the vaulting, with its network of ribs in relief, is as if embroidered in stone, and the interior contains the most beautiful marble in the country, blacks, whites, browns and reds. The lay-out was set: elevation with three naves, semicircular choir, façade detached from the building at the top, with the orthodox vertical arrangement of the Orders. The invention of any style results, inevitably perhaps, in a

certain stereotyped rigidity: in any case, this is what happened to Flemish Baroque from 1650 onwards.

A superb flight of imaginative virtuosity, the façade of St Michel at Louvain is remarkable for its frankly vertical movement. Victor Hugo admired it at a time when everyone was sarcastic about Baroque art. The first architect of this church was Father Willem Hesius.

The architect of the church of the Brussels Béguinage is unknown. The façade of this church suggests a retable or a triptych, and the decoration is notable for its vigour. Italian decoration is perhaps nobler and French decoration more delicate. Flemish decoration, on the other hand, is characterised by a homely simplicity, a tendency to redundancy and truculence typical of the national temperament; it is heavy and 'pictorial', as in Lucas Faydherbe's Notre Dame at Mechelen, whose strange octagonal dome is so obviously lacking in gracefulness.

The Premonstratensians vied with the Jesuits in zeal and wealth. Their great abbeys of Parc, near Louvain, Grimberghen, near Brussels, Averbode, etc., each have a princely and rather classic appearance, with ample living quarters and communal buildings and a vast sumptuous church. Grimberghen abbey, although incomplete, is on a colossal scale with extremely fine decoration. During the 18th century churches, notably St Pieter's at Ghent, continued to be built in the 17th-century style, until French influence took the place of Italian influence. There was a reaction from the abuses and excesses of the Baroque, and the wave of the rather overdone Rubensian style was checked.

In secular architecture as well, Baroque ornamentation was usually superimposed on Gothic structures. Even at the very end of the 17th century the guild houses in the Grand' Place in Brussels reproduced the traditional rhythm of narrow gabled houses with lattice windows. The general effect, however, is one of a gay extravagant fantasy which reveals a certain earthiness. Willem de Bruyn, who was in charge of the reconstruction of the Grand' Place after the French bombardment in 1695, was an admirer of Palladio, but he could not resist the temptation to overload his work. His Brewers' Hall and the House of the dukes of Brabant did impose a kind of classical restraint on the whims and redundancies of Brabant decoration. Willem de Bruyn was eclectic, and allowed the construction in the Grand' Place (which shows up to advantage the flamboyant 15th-century town hall) of De Zwaan (the House of the Swan) in the Louis XIV style with a truncated dome. This French influence blends well with the brilliant Italo-Flemish Gothic-Baroque architecture.

Rubens, focal point of the century

Rubens dominated not only painting, but all forms of art. His influence, moreover, spread well beyond the bounds of his country. After his death, he continued to influence 17th-century Flanders. One of the most complete geniuses Europe has produced, and a child of the Renaissance, he paved the way for the innovations of the 18th century and the achievements of the 19th century, and heralded the Counter Reformation and the Baroque in northern Europe. Rubens had all the Flemish painter's feeling for colour, and was able to combine the 'grand manner' of Italy with the temperament and instinct of his country. 'I consider the whole world to be my native land,' he wrote to Valavez. This diplomatic statement could also have served as his artistic motto. Rubens' painting is like a confluence of rivers, where the tendencies of north and south Europe are merged and amalgamated. And his nature strengthened and elevated itself by competing with the great masters. He created a style of his own, a northern form of the Baroque, whose rhythms have something triumphant, majestic, rhetorical, which tends to do violence to reasonableness, but which appeals strongly

568

579

569

316

571, 572
582–587
578, 601

567

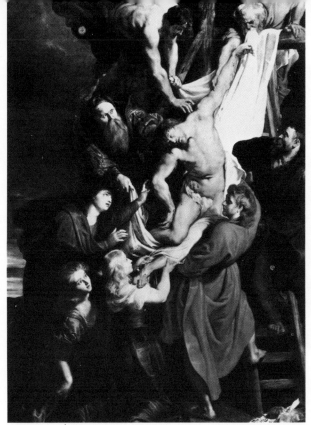

585. Descent from the Cross. 1612. *Antwerp Cathedral.*

584. Coronation of Marie de' Medici as Regent at St Denis, 13th May 1610 (detail). Painted for the Medici Gallery of the Luxembourg palace. 1622–1625. *Louvre.*

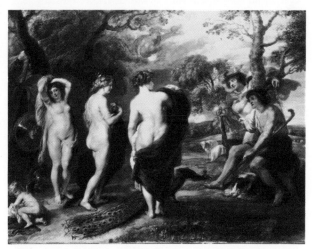

587. The Kermesse. *c.* 1635/38. *Louvre.*

586. Judgment of Paris. 1638. *National Gallery, London.*

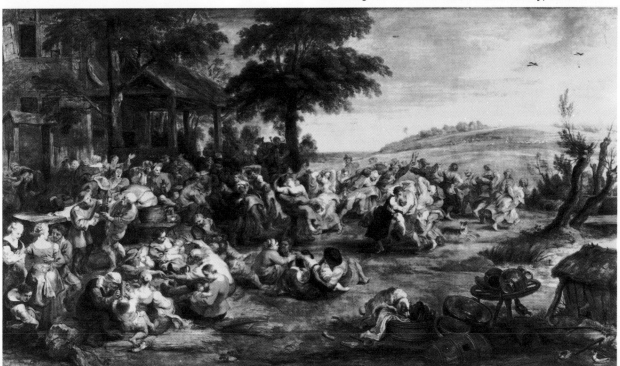

588. FLEMISH. GERARD DE LAIRESSE (1640–1711).
Autumn. Engraving.

589. FLEMISH. CORNELIS DE VOS (c. 1585–1651).
The Artist's Children. *Staatliche Museen, Berlin.*

to the emotions. Inevitably this style was to become systematic and sometimes commonplace. Rubens himself was never a slave to his own inventions but was capable of breaking loose to surprise us by his flights of imagination, his vivacity, the lightness of his touch, the pungency of his malice. What is most remarkable, pure, rare and unique in Rubens is that he never made concessions to the current tastes.

There is thus a Rubens to suit everybody — a Rubens for the public at large, and a Rubens for the more discerning. There is the eloquent rhetorical Rubens, whose subtle sonorities enchanted Watteau and Fragonard, Renoir and Delacroix. There is a Rubens who was too much part of the 17th century to move us as he moved his contemporary public of kings and archdukes, Jesuits and bourgeois. There is also a Rubens who is above the contingencies of time, who, one has reason to believe, will remain ' modern ' so long as there are eyes to see. Eugène Delacroix, who never tired of discussing Rubens in his *Journal*, made a most penetrating judgment in admitting that he ' disapproved of his bulky forms, and of his lack of experiment and elegance '. But he hastened to add: ' How superior he is to all the trivial qualities that are the stock-in-trade of other painters ! He at least has the courage to be himself. ' Moreover, Delacroix, who realised that he was in some ways heir to Rubens, praised him in these terms: ' Glory to the Homer of painting, to the father of the warmth and enthusiasm of that style with which he eclipses everything, not merely by the perfection he gave to any particular part, but by that secret force and that deep inner life he gave everything. '

With his third teacher, Otto van Veen, a cultivated man and a true Romanist, Rubens educated himself intellectually, preparing himself for the trip he made to Italy in 1600. He went straight to Venice where Titian's work seduced him. At Mantua, in the service of Vincenzo Gonzaga, he copied Mantegna and started his collection of antiques. In Rome he was very taken by Michelangelo, Caravaggio and the Carracci brothers, by the *Aldobrandini Marriage* and by the view of the Palatine. After so many influences and eight years spent in Italy, his own style was not yet completely formed.

Back in Antwerp in 1608, his personal style began to take shape in the *Raising of the Cross* (1610) and the *Descent from the Cross* (1612) painted for the cathedral. These two triptychs left far behind them all that Flemish art had, up till then, taken from the Sistine chapel and the Scuola di S. Rocco. The *Descent*

585

590. FLEMISH. VAN DYCK (1599–1641).
Marchesa Geronima Brignole Sale and her Daughter.
Palazzo Rosso, Genoa.

591. FLEMISH. VAN DYCK (1599–1641). Charles I.
In a bill drawn up by the artist and paid in 1638,
this painting is referred to as *The King Hunting. Louvre.*

592. FLEMISH. VAN DYCK (1599–1641).
St Martin dividing his Cloak. Before 1621.
Saventhem Church, Belgium.

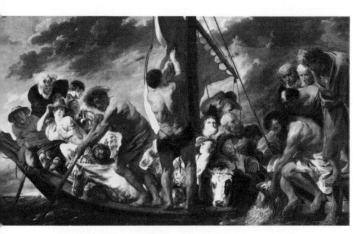

593. FLEMISH. JACOB JORDAENS (1593–1678).
The Antwerp Ferry (St Peter finding the Stater).
c. 1635/40. *Copenhagen Museum.*

from the Cross was the first masterpiece painted in straightforward
colours and with clearly defined contours. This tragic picture
painted in a fine easy style, sublime and as moving as a 15th-
century *Pietà*, provided a meeting ground for the up and
coming Renaissance (that rejuvenated Renaissance style, the
Baroque) and traditional Flanders. Rubens tackled all subjects,
all genres, and renewed them: to north European realism he
added a dramatic note and an epic flavour which were his
own. He was immensely popular, and, unable to meet demands,
surrounded himself with collaborators. From his sketches or
projects they executed his compositions on panels or canvas,
which he finished himself, giving them the final unity of touch,
light and movement. It is true that the output of his 'workshop'
is uneven, but the hunting scenes do throb with an extraor-
dinary physical and animal ardour, and what movement there
is in his *Last Judgments*! His *Last Communion of St Francis*, inspired
by Agostino Carracci, went further than Bolognese art and
almost attained the emotional power of a Rembrandt. In paint-
ing the *Miracles of St Ignatius* for the Jesuit church in Antwerp
and the *Miracles of St Francis Xavier* (Vienna) Rubens rendered
the very spirit of the Counter Reformation, and preached
according to the norms of the council of Trent.

He aimed at the broadest public, and made the Christian
miracles convincing, rather in the style of an oratorio. A softer
style began in about 1616 with the *Adoration of the Magi*
(Brussels); luminous effects were added to the rounded flesh
and the multicoloured garments; and the colours, instead of
being juxtaposed, were blended into each other. Mythology
and ancient history were treated and transformed in the same
way as were the lives of the saints and the Gospels. In his
Fragment on Classical Times, published by Roger de Piles, Rubens
wrote: 'Let us study the ancients in order to recover their
heroic spirit.' He rediscovered this spirit in the six episodes of
the story of Decius Mus, in the cartoons for the life of Constan-
tine and in the sketches for the legend of Achilles.

In less than four years, from 1622 to 1625, Rubens executed,
for the gallery of the Luxembourg palace in Paris, the twenty-
one gigantic compositions of the history of Marie de' Medici 584
(Louvre), which, according to Théophile Gautier, are the
masterpiece of official painting. Reality, allegory and myth are
amalgamated in an imaginative, and sometimes comic, way.
The rhetorical aspect can be forgotten when one is confronted
with such details as the sirens in the *Disembarkation at Marseille*
and the portraits in the *Coronation*. The Medici gallery was,
in the 18th century, like a classroom for French painters.

Henceforward Rubens played the part of a European artist.

594. OSIAS BEERT (active 1596–1625).
Still Life. *Brussels Museum.*

595. FRANS SNYDERS (1579–1657).
Fishmonger's Display. *Brussels Museum.*

596. JAN FYT (1611–1661). Mushrooms.
Brussels Museum.

Charged with diplomatic missions, he was in Madrid in 1628, where he copied Philip IV's Titians and made friends with Velasquez; the following year he was in London, where he was knighted by Charles I. He negotiated the peace between England and Spain. In 1630, having lost his first wife and being in his fifties, he married Hélène Fourment, who was not yet twenty, and who was to be the model for all his heroines thereafter — Venus, the Magdalen, the Madonna. In the *Education of the Virgin* (Antwerp) she is a child; in the full-length portrait with a fur coat in Vienna she is half-naked, robust and well-set; in the Louvre masterpiece in which she is accompanied by her two sons she is serene and fresh. The last works show an improvement in his style and especially in his colouring. All the tones are subdued, all the elements integrated in the overall effect. The sketches, notably those which inspired his *Metamorphoses* of Ovid, are of unequalled fluency. His *Gardens of Love* paved the way for Watteau's *Fêtes Galantes*; these aristocratic reveries contrast with the savage passion of the *Country Dance* (Prado) and the *Kermesse* (Louvre), in which the spirit of Bruegel 587 comes to life again in a whirlwind of Baroque.

Rubens was the best painter in all the genres in 17th-century Flanders. As a portrait painter, he proved himself equal, if not superior, to van Dyck, in the portraits of Gevartius of Antwerp and the *Mattheus Yrsselius* of Copenhagen. As a landscape painter, though he may owe something to the Carracci, he 601 expressed the profound oneness of nature, lending it his ardour which never died out though it sometimes abated. He spent his last summers at the château de Steen near Mechelen, and as he did not have a studio, he painted the fields, the trees and the clouds. His enormous output provides us with one of the most comprehensive and exciting visions of the world. To make sure that reproductions of his works reached a wide public, Rubens from very early on set about looking for copperplate engravers able to submerge themselves in his style and to reproduce the effects of his brushwork. As Cornelis Galle's style was rather dry, Rubens turned to the engravers of the Goltzius school, Pieter Soutman, Willem Swanenburgh, Egbert van Panderen, Andries Stock and Jacob Matham. He supervised their work and directed the commercial exploitation of the business himself. The plates were usually made from monochromes specially prepared by him or his collaborators. If, as Louis Dimier has remarked 'the colouring reduced to black and white upsets the luminous disposition of the paintings' and if the plates are not exact replicas of the works reproduced, one can say that engraving became, under the influence of Rubens, essentially pictorial.

Lucas Vorsterman engraved about fourteen prints which represent the acme of Rubensian art in black and white. But at the end of two years, Rubens quarrelled with Vorsterman who even went so far as to threaten to kill him. Vorsterman was succeeded by his pupil Paulus Pontius, who accentuated the colourist tendency of his craft. Meanwhile, the Netherlander Boetius Bolswert emphasised the chiaroscuro aspect, and his younger brother, Schelte, devoted himself to the landscapes.

It is somewhat difficult to distinguish, among the horde of emulators and imitators, the individuals who were gifted with any independence. The influence of Rubens overlaid that of Caravaggio which had swept over north European painting since before 1600. Abraham Janssens, an Italianate painter of merit, included among his pupils Gerhard Seghers and Theodoor Rombouts, who hesitated between Caravaggio and Rubens. 599 The direct disciples of Rubens and the most loyal to the practices of his studio, were Cornelis Schut, Erasmus Quellinus, Theodoor van Thulden, Boeyermans, etc. Certain regional centres 824 preserved a comparative freedom from Rubens' influence: Bruges was ruled by the van Oost family; Caspar de Crayer 823 was the accredited painter for the churches of Brabant and

597. FLEMISH. JAN (VELVET) BRUEGEL (1568–1625).
The Earth or the Earthly Paradise. *Louvre*.

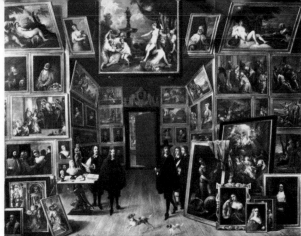

598. FLEMISH. DAVID TENIERS (1610–1690).
The Picture Gallery of Archduke Leopold Wilhelm. *Prado*.

599. FLEMISH. THEODOOR ROMBOUTS (1597–1637).
Card Players. *Antwerp Museum*.

600. FLEMISH. ADRIAEN BROUWER (c. 1605–1638).
Peasants Smoking. *Prado*.

Ghent; Theodoor van Loon, whose masterpieces adorn the altars of Montaigu, escaped the Rubensian influence and resembles Domenichino; a small group of painters in Liége — Gerard Douffet, Bartholomé Flémalle, J. W. Carlier, Gerard de Lairesse — formed a 'school' in the true sense of the word, and 588 their Poussin-like style ended up in distinct opposition to the Flemish Rubensian style.

Van Dyck and the triumph of portraiture

The Flemish are known, traditionally, for the accuracy of
589 their portraits. Those by Cornelis de Vos have something of
575 the vigour and sincerity of a Pourbus. Justus Sustermans, a pupil of Frans Pourbus in Paris, settled down in Florence, where he did a number of solemn portraits of the last members of the Medici family. J. F. Voet, meanwhile, worked in France, where his painting has often been confused with Laurent Fauchier's.

The prince of Flemish — and European — portrait painters
590–592 was van Dyck, who applied the best Venetian methods of Titian and Tintoretto in Flanders, while at the same time giving his work, after his stay in Genoa, a more human and individual verisimilitude. His portraits, particularly those of women, disclose a subtle and complex concept of intimate emotional life, very different from the physical view of life to be found in Rubens' portraits. Although van Dyck was always himself in the melancholy dreamy mood of his work, he was also Genoese while in Genoa, and English while at the court of Charles I. From 1617 to 1621 van Dyck was the star of Rubens' workshop. He certainly played a considerable part in executing on canvas Rubens' sketches for the story of Decius Mus; and he no doubt had a hand in the *Miraculous Draught of Fishes* (Meche-

len), the *Coup de Lance* and the *Bacchanal* (Berlin). The *Heads of Negroes* (Brussels) and other paintings by Rubens have been attributed to him. At twenty-one he was more than just Rubensian. But he kept Rubens' taste for theatrical effects; he was religious in his own way, full of the mysticism of the times, on occasion rather similar to Bernini, and in the 18th century his works apparently 'inspired a profound devotion'. He travelled all over Italy. In Rome he was the guest of Cardinal Bentivoglio, of whom he painted a magnificent portrait (Pitti Palace); he was impressed by the Bolognese painters and was to remember Guido Reni's expressive heads and Albani's female figures; for Palermo he painted a *Madonna with the Rosary*, which followed the composition of the Rubens *Assumption*. But it was in Genoa that he had his first opportunity to paint not merely individuals, but an entire society. Profoundly sensitive to the charm of this proud and decadent aristocracy, he established himself as the confessor and impresario of many families including the Spinola, the Pallavicini, and the Durazzo.

In 1632 van Dyck settled in London, in the service of Charles I, where he pandered to the tastes and snobberies of his new public. He appeared to be the first of the masters of the British school. The aspirations of a period, as revealed in its fashions, were endowed with a style by van Dyck. He played, in the court of Charles I, the role that Nattier was to assume in the following century in the entourage of Louis XV. His whole concept of art is to be found in his *Charles I with Groom and* 591 *Horse* (Louvre), and with it, the art of Reynolds and Gainsborough as well — the association between the landscape and the figure, the emphasis on the heroic pose rather than on the features, the eloquence which is taken for poetry.

FLEMISH LANDSCAPE

601. RUBENS (1577–1640). Landscape. c. 1636.
Van Beuningen Collection.

602. JOOS DE MOMPER (1564–1655).
The Ravine. *Private collection.*

603. PAUL BRILL (1554–1628). Landscape.
Musée des Beaux-Arts, Algiers.

Like the English, the French and even the Spanish, the Flemish portrait painters of the 17th and 18th centuries were bewitched by van Dyck. Cornelis de Vos ended by imitating him, as did Caspar de Crayer, Pieter Franchois, Victor Bouquet, and Pieter van Meert. This is not the place to mention Philippe de Champaigne, who was also influenced by van Dyck, but who belongs to the French school. After 1650 Gonzales Coques was very successful in Antwerp: he did some charming small-scale family groups, treated as genre paintings. 823 434

Some original portraits were done by engravers — van Dyck, to begin with, whose *Iconography of Famous Men* is justly famous. Portraitists were normally content to etch the head and hands for the plates, the rest being engraved by a collaborator. There is hardly a single follower of Rubens who did not do etchings. Finally, Antwerp was the birthplace of Gerhard Edelinck, who was appointed engraver to the French king in Paris, where he did portraits of Pascal, Descartes, Racine and La Fontaine. The French school of engraving stemmed from the Rubens school. 828

Flemish naturalism

Jacob Jordaens was more or less untouched by the influence of Rubens. He was influenced rather by van Noort, and although he hardly ever left his birthplace, Antwerp, he must have been particularly interested in two Italian or Italianate tendencies — that of Caravaggio and the Caravaggesques, and in the work of Jacopo Bassano and his family. Like these painters, he stooped with pleasure to ordinary everyday life which had been scorned by the Renaissance, but which had so much success in Flanders with Pieter Aertsen and Bruegel. His early works glow with a spicy rustic quality, heightened by a violent chiaroscuro that was most fully expressed in his admirable allegory of the *Fertility of the Earth*. After 1630, he resembled Rubens, replacing his clear and intense tones with thin layers of rather diffused shades; then, towards the end of his long career, he made excessive use of browny reds and leaden shadows.

His religious paintings lack enthusiasm but not forcefulness; as a decorator, he has not the ease of Rubens; but his true hero was the common Flemish man. His *St Peter finding the Stater* (Copenhagen), sometimes called the *Antwerp Ferry*, shows the zeal of his ' populism '; naturalism has rarely achieved such an intensity in every detail, such a transfiguration of the whole. The *King Drinking* is the title of a noisy gathering of people, a translation into Flemish, into a sonorous Flemish that defies politeness, of the Caravaggesque theme of intimate gatherings or ' conversation pieces '. The tavern has become a middle class diningroom. Jordaens could have been the portraitist of that well fed, and rather heavy, middle class. Certain exceptional works of this kind (Louvre, Budapest) combine psychological depth with extremely restrained colouring. But in general he did not like painting portraits. 593

A realist painter, Jordaens collaborated more than once with the great animal painters and still life specialists. The most prolific of these was Frans Snyders, who painted enormous piles of food. He excelled in suggesting the substance and consistency of joints of meat, vegetables and fish, and gave to this essentially static genre of painting some of the dynamism of the Baroque. His pupil and brother-in-law, Paul de Vos, painted beautifully rhythmic hunting scenes, while Jan Fyt, with his finer more subtle technique, is the only Flemish painter who reminds one sometimes of Chardin. The Dutch painter Jan Davidsz de Heem arrived in Antwerp in 1636 and brought to still life painting a more simplified sense of composition 595 596

FLEMISH. PETER PAUL RUBENS (1577–1640). Thomas, Earl of Arundel. National Gallery, London.
Photo: Paul Hamlyn Photographic Library.

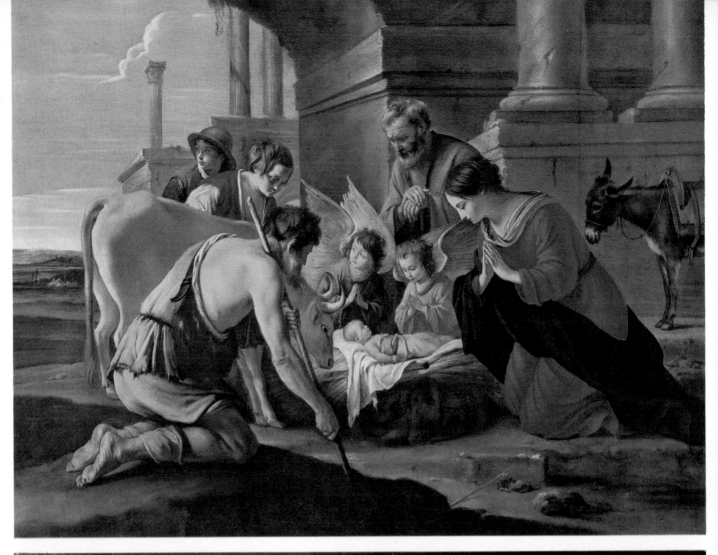

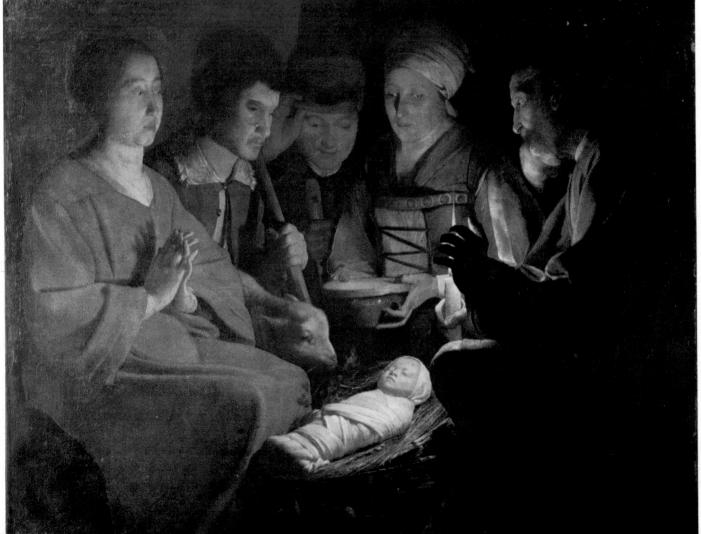

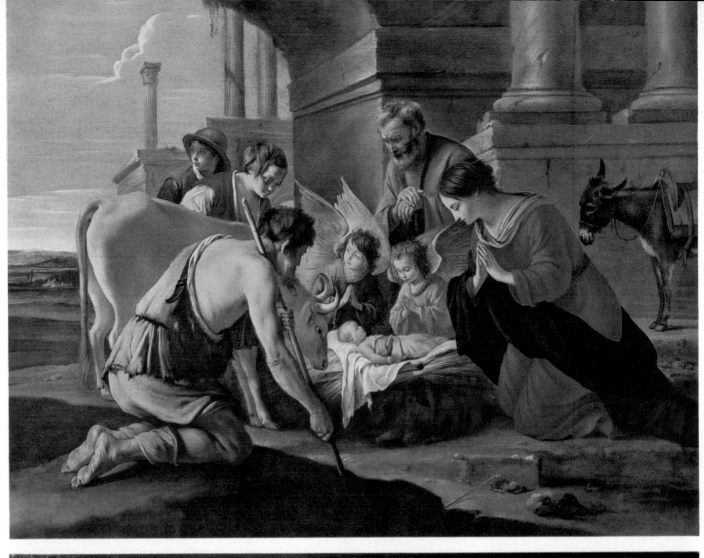

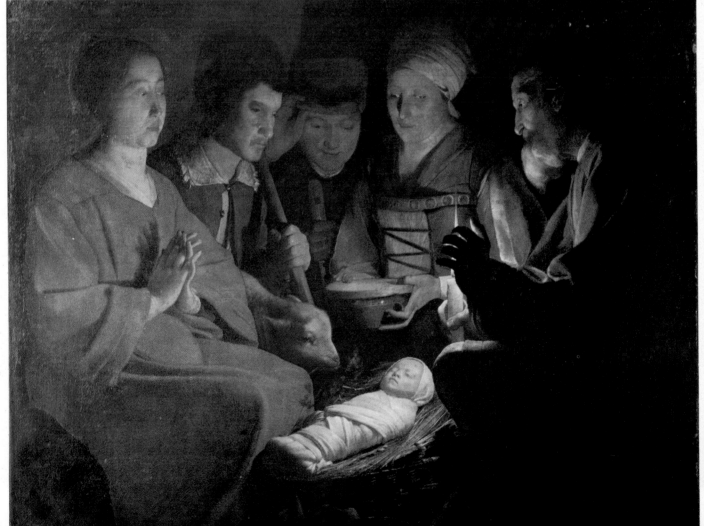

and a more intimate atmosphere. But this intimate quality had, ever since the beginning of the century, seeped into the work 594 of severe painters like Osias Beert, Jacob van Es and those 597 young painters, emulators or disciples of Velvet Bruegel — Ambrosius Bosschaert, Daniel Seghers, Jan van Kessel, etc., whose botanical precision resembles the fine work of a limner.

The taverns and smoky rooms of Caraveggesque artists like 599 Rombouts were not in the least Flemish. But the ' genre ' was to be inspired by local customs, and was to be amply justified 600 by the excellent works by Adriaen Brouwer. His early paintings, in which the picturesque quality of drinking bouts and tavern brawls is overlaid with a dramatic sense of human life and a 495 feeling for the peasant world, resemble Bruegel. In Holland, under the influence of Frans Hals, his style became freer and more supple. In Antwerp, finally, Brouwer painted his last masterpieces, including some twilight landscapes, which are at the same time poetic and familiar, and which rank among the most moving we know.

581, 600 Compared with the rascally Brouwer, David Teniers seems a very respectable painter. He observed the life and ways of his rustic models with malice, and ridiculed their antics to please an upper class public. The first director of the Antwerp Academy, agent and curator of the gallery established in Brussels by the 598 Archduke Leopold Wilhelm, Teniers did not only portray ugly characters in order to annoy Louis XIV, nor did he only paint Flemish *Kermesses*. He excelled in certain worldly paintings in which he is almost like Gonzales Coques. Of all his immense production, his masterpieces are, for us, certain exceptional paintings like the still life in Brussels and two or three landscapes that are sometimes attributed to Brouwer. Sebastian Vranx, with his more archaic style and enchanting precision of details, depicts military scenes and horse markets. Pieter Snayers distinguished himself in his panoramic battle scenes, a genre that 676 was perfected by his disciple Adam Frans van der Meulen, historiographer to Louis XIV.

The three best landscape painters, Rubens, Brouwer and Teniers, were not wanting in emulators and disciples. Although 601 Rubens determined, in the evolution of the cosmic concept of art, a Baroque phase that was already almost a concept of art, a Baroque phase that was already almost Romantic, he very often called upon Jan Wildens and Lucas van Uden to paint the backgrounds for his works. They both had a feeling for wide horizons and an instinct for decorative colour. Jacques Fouquières, who had worked with Rubens, installed himself in Paris, as did his compatriot van Plattenberg.

Denis van Alsloot has sometimes been considered as the founder of the Brussels school of landscape painters. Another precursor of that school was Lodewijk de Vadder. The latter was struck by Brouwer's brilliant improvisations, and some of his works have a lively touch that seems to anticipate the style of the minor masters of the Norwich school. But the great landscape artist of 17th-century Brussels was Jacques d'Arthois, who painted the Soignes forest. His grand, generous and rather heavy style represents one of the noblest expressions of Baroque and Rubensian landscape art. At the end of the century landscape painting was mostly influenced by the French: this was particularly so in the case of Francisque Millet.

606 Jan Siberechts, with his peaceful evocations of rural life, his

FRENCH. LOUIS LE NAIN (*c.* 1593–1648).
Adoration of the Shepherds. 1640. National Gallery, London.
Photo: Michael Holford.

FRENCH. GEORGES DE LA TOUR (1593–1652).
Adoration of the Shepherds. Louvre.
Photo: Giraudon, Paris.

604. FLEMISH. VERVOORT THE ELDER (1667–1737).
Pulpit. Wood. 1723. *Mechelen Cathedral.*

605. FLEMISH. LUCAS FAYDHERBE (1617–1697).
Tomb of Bishop Andreas Cruesen. 1669.
Mechelen Cathedral.

606. FLEMISH. JAN SIBERECHTS (1627–1703). The Ford.
Landesgalerie, Hanover.

farmyards and fords, must be ranked among the landscape artists rather than among the genre painters. His early works, which are vaguely Italianate, can almost be confused with those of Claes Berchem. Siberechts then broke away from all convention, but he lacked imagination and poetry; his work was quite different from the Rubensian tendencies, and was more like Louis Le Nain. In England, from 1672, Siberechts became an ' architectural ' painter, without, however, equalling those 17th-century masters of this genre, Hendrik van Steenwijck and Pieter Neefs.

685

Flemish sculpture influenced by Rome and Paris

Catholic by inspiration, dynamic and pictorial, Flemish 17th-century sculpture seems all the more Baroque as it was decorative rather than statuary. Rubens and Bernini set the tone for the other sculptors. The most individualistic of the Brussels school was François du Quesnoy, whose masterpieces have, exceptionally, an almost classical appearance. He established himself early on in Rome, where he made friends with Nicolas Poussin, studied the ancient statues, specialised in the representation of children, and was nicknamed *Fattore di putti*. He worked for Pope Urban VIII and collaborated in the execution of the bronze baldachino of St Peter's. For the same cathedral, he created the heroic and slightly rhetorical *St Andrew* which, in one of the four niches under the dome, forms the pendant to Bernini's *St Longinus*. A more harmonious work is his *St Susanna* in Sta Maria di Loreto, Rome, with its serene draperies and soft dreamy expression: Burckhardt considered it ' perhaps the best 17th-century statue '. Richelieu appealed to du Quesnoy to found an academy of sculpture: so Poussin's friend set off for France but he had to stop at Leghorn, where he died. His influence was considerable in the field of ivory carving (crucifixes, children's games): all sculptors up to Bouchardon owe something to this master.

901

577

738

Artus Quellin the Elder, who decorated the churches of Antwerp, was trained in Rome in du Quesnoy's studio. Sent to Amsterdam, he decorated the exterior and interior of the town hall there with pediments, bas reliefs and forceful caryatids. He carved busts after the style of Bernini, and passed on his talents to his cousin Artus Quellin the Younger. The latter created religious monuments, suave and mannered figures, and the beautiful communion rails which are preserved in the cathedral at Mechelen.

580

The star of Mechelen was Lucas Faydherbe, who had been an apprentice in Rubens' studio. His monument to Bishop

Andreas Cruesen in the cathedral, has more movement and eloquence than the Bishop Anton Triest monument (Ghent cathedral) by Hieronymus du Quesnoy, François' brother. In his big works, Faydherbe aimed to produce a pictorial illusion: for the dome of Notre Dame at Mechelen, which he had constructed, he executed two high reliefs in stone, a *Nativity* and a *Christ carrying the Cross*, in a laboured realist style, full of heavy emotionalism. They are rather like a sculptural version of a painting by Rubens or Jordaens.

605

579

Like the Quellins, the Verbruggen family came from Antwerp. The great man of the family was Hendrik Frans, who created the Ste Gudule pulpit in Brussels and the confessionals of Grimberghen abbey. These preaching pulpits, which were sermons in themselves — the ones in the Antwerp and Mechelen cathedrals are by Michel Vervoort the Elder — and these confessionals covered with statues, which have lost all resemblance to furniture, may scandalise purists. To us they represent the most characteristic and the most convincing product of the inventive imagination of northern Baroque: there is nothing else like it outside Belgium.

604

At Liége the most fertile sculptor of the 17th century was Jean Delcour. He spent nine years in Rome where he acquired a taste for wind-blown draperies; and he filled the churches and streets of Liége with restless figures and graceful fountains. Jean Varin, also from Liége, spent his life in France, where he executed busts of Louis XIII, Richelieu and Louis XIV, and became the main medallist of the latter: he was French in the way that Philippe de Champaigne was. The numerous Flemish artists working at Versailles (Philippe de Buyster, Martin van den Bogaert, Sébastien Slodtz) conformed naturally to the disciplines of Le Nôtre and Girardon.

803

718, 712

Historians who count the battles fought on Belgian soil during the 17th century and who enumerate the disastrous political and economic consequences of the treaties of Münster (1648), of Aachen (1668) and of Nijmegen (1678) consider that for Flanders the 17th century was a century of misfortune. Art historians judge it differently. The century of Rubens was, for man, a century of faith, of physical and mental equilibrium and sanity, of spiritual prosperity. These victories were more durable than those brought about by force of arms. The art of this century was energetic, full of joy and light, burning with the life of man's whole being. God and the most banal realities both had their place. The earth and the sky, the flesh and the soul were united in a world in which man held his prominent position without feeling isolated.

IV. REALISM IN THE PROTESTANT AND BOURGEOIS COUNTRIES *Marcel Brion*

*Holland, clinging tenaciously to her independence and her
Protestantism, dominated the other northern European schools.
She opposed the Counter Reformation with a simplified concept of
art, which eliminated traditions, conventions and
contrivances in an attempt to face up to reality and God.
The more superficial artists only achieved an accurate
reproduction of familiar objects; but the more profound ones,
such as Rembrandt, Vermeer and Ruisdael, brought into play the
revelations of the soul. In this way they prepared the
ground for the individualistic conception of modern art.*

The triumph of the Reformation in northern Europe, the advent
of religious and political ideas bound up with the success of
Protestantism, the development of a philosophy bent on affirm-
ing the prestige of reason and the growth of science as an
objective study of natural phenomena, determined, in the regions
removed from the direct influence of Catholic thought, the
aesthetic, psychological and social changes that are evinced in
the art of the time. This art, which was secular and no longer
religious, civic rather than monarchical, was based on obser-
vation, individualism and free thought, and gave the human
element the precedence formerly reserved for the divine. It took
into account the profound changes that had taken place in
individuals as in social groups. It became the ambition of artists
to represent objects and bring in all their immediate and con-
crete reality rather than to idealise them according to a certain
model of spiritual and supranatural beauty. Artists were inspired
and guided by the terrestrial, the everyday presence of truth
and simplicity. The transcendental Baroque of the southern
Catholic countries gave way to the objective and concrete
immanence of the Protestant countries, bringing about a similar
revolution in the field of ideas and in the world of forms.

The creation of a Protestant architecture

After the union of Protestant states at Utrecht in 1579, Holland
had become one of the richest, the most economically active
and the most learned countries of Europe. The Netherlands
were in close contact with classical culture, thanks to humanism,
and they made classicism their own by preserving their national
characteristics even when interpreting structures and motifs
408, 499 borrowed from Palladio or Vignola. The network of canals
favoured the development of towns and created a system of
town planning which is best exemplified in Haarlem. To con-
trast with the flatness of the country, an architecture with
vertical emphasis was invented, with stepped gables, high
rhythmical windows, and pilasters so disposed as to break up
the flat surface into a series of vertical undulations in slight but
clearly accentuated relief. The scarcity of stone, which was
reserved for door and window frames, leaves free play to the
warm tones of the bricks and encouraged combinations of
different colours, producing a kind of mosaic in brick and stone.

The Amsterdam town hall, completed in 1655 by Jakob van
Kampen, is the best example of this Dutch neoclassicism, which
was as supple in its organisation as it was strictly defined in
its general appearance. Kampen was aided in this work by the
sculptor Symon Bosboom, author of a book on the Orders
of the columns, by the architect Pieter Post who had accom-
panied Prince John Maurice to Brazil and who had created a
colonial classicism at Pernambuco, and by Hendrik de Keyser
and his son Thomas.

Hendrik de Keyser, author of the *Architectura Moderna* pub-

lished in 1631 by Salomon de Bray, launched a religious archi-
tecture that conformed to Protestant aspirations and to the
needs of the Reformed Church. He considered the circular
ground plan the most suitable and did away with the chancel.
He built many such churches of which the North Church in
Amsterdam (1620–1623) is the best example of all. In the
same spirit and according to the same principles Adriaan Dors-
mann built the Lutheran chapel, the Singel, in Amsterdam in
1668, and in Leyden Arent van 's Gravensande built the first
Dutch church with a dome supported by round columns.

The weigh-house in Groningen, with its relieving arches in
the form of a shell (Lieven de Key, 1635), the country houses
with pilasters and gables by Philip Vingboons, and enlivened
with Baroque cartouches by Crispin van der Passe, show a
rejection of rigid classicism and an attempt to adapt architecture
to the character, atmosphere, contours and tones of the coun-
tryside. Architects were still influenced by Italy, but in the
middle of the 17th century they profited from the example
of Versailles.

In the same way, classicism developed in England during the
decline of religious architecture. English classicism was essen-
tially original, ranging from symbolic forms, like Longford
castle, near Salisbury, built in 1560 on a triangular plan 'in
honour of the Holy Trinity', to the theatrical Baroque of John
Vanbrugh, who was a playwright as well as an architect (Castle
Howard, 1702, Blenheim palace, 1715). The late Gothic style
lingered on at St John's in Leeds (1633), with its two naves
divided by a Gothic arcade, at Christ Church, Oxford (stair-
case, 1640), at Wadham College (1613), while it combined
harmoniously with Renaissance forms in the chapel of Brase-
nose College (1666).

Introduced by Giovanni da Padova, who collaborated with
Smythson at Longleat (Wiltshire) from 1568 to 1575, Italian
classicism found an English form of expression in the Palladian
and Vignolan style of Inigo Jones. Only once yielding to the

607. DUTCH. JAN VAN DER HEYDEN (1637–1712).
View of the old town hall, Amsterdam. 1665/68. *Louvre.*

608. ENGLAND. The Banqueting House, Whitehall, London. Rebuilt 1619 by Inigo Jones (1573–1652).

609. HOLLAND. Meat market, Haarlem. Built by Lieven de Key (c. 1560–1627) in 1602/03.

Gothic tradition (Lincoln's Inn chapel, 1623), Inigo Jones adapted classicism in a masterly way in his projects for Whitehall **846** and the Queen's House, Greenwich; if Whitehall had been realised, it would have been the largest palace in the world. **608** Whitehall Banqueting House and St Paul's, Covent Garden, remain his master works, though the latter was destroyed and the present building is a copy. His successor to the title of Surveyor-General of the King's Works was Wren, who had been formed in France instead of Italy, and who had the good **610** fortune to rebuild St Paul's and fifty-one of the London churches destroyed by the Great Fire in 1666. He adopted the compact lay-out typical of Reform churches, which brought the altar, pulpit and organ as close together as possible, unlike the symbolic plan of Catholic churches, which kept them apart according to a metaphysical idea. The rather frigid majesty of St Paul's corresponds with his aim to create a Protestant St Peter's in London that would rival Rome. While the interior planning of Wren's churches conformed to their liturgical function, which demanded simplicity and utility, the variety and fantasy of his **849–852** steeples are proof of a rich imagination.

The circular plan and compact lay-out also governed the religious architecture in Reformed Germany, where poverty and severity were the keynotes, as laid down by Leonhard Cristoph Sturm in his treatise on architecture published at the end of the 17th century. The Catholic churches were built by Italianised Germans or by Italians living in Germany (St Michael's in Munich, 1573–1597; Jesuit style at Innsbruck, Neuburg, St Andrew's in Düsseldorf). Scamozzi was in Salzburg, Lurago in Prague and Passau, Carnevali in Vienna, Zuccali and Viscardi in Munich, Petrini in Franconia, Chieze in Berlin, Pozzo in Bamberg; but Pozzo and Petrini had studied and assimilated Dietterlin, which gave the nascent Baroque a Germanic flavour.

Traces of medievalism, in what has been called the ' posthumous Gothic style ', are to be found in Catholic churches like the Trinity in Molsheim (1614–1619) and the Jesuit church in Cologne (1618–1627), both built by Christopher Wamser of Aschaffenburg. Medieval elements are combined with classical structures in these churches (Doric columns in the Wallfahrtskirche at Dettelbach am Main, 1608–1613); we find them again in Lutheran churches (Bückeburg, 1613–1615, by an unknown architect, has Gothic arches supported by Corinthian columns, and the exterior has caryatid pilasters and Baroque ornaments). But at the same time a new and original sense of space animated the ancient and foreign concepts, and their combination produced a style of singular personality.

The civic buildings are often the works of Flemish or Dutch architects — Emden town hall (1577, by Laurens van Steenwinkel of Antwerp), Danzig town hall (Anton van Obbergen of Mechelen), Bremen town hall (1611–1614, by Luder van Bentheim). But those built by German architects achieve a perfect cohesion in their fusion of Renaissance or Baroque elements with the Germanic creative impulse — for instance, the Weinhaus in Münster, Westphalia (1615, by Johann von Bocholt), Gewandhaus in Brunswick (1591, Balthasar Kircher), Zeughaus in Danzig (1600, Hans von Strackowsky), Hochzeithaus at Hameln (1610), town hall, Nuremberg (1616–1622, Jakob Wolff the Younger). Private houses in south Germany also incorporated details borrowed from Italy; in north Germany Dutch characteristics were incorporated, for the country was divided into two zones of influence, in spite of the originality of its art.

This originality is obvious in the ' Neue Bau ' of the Stuttgart palace (1600–1609) and in Freudenstadt (1600), a town built on a geometric plan in the Black Forest to house Protestant refugees from Austria; both works are by Heinrich Schickhardt. Original again are the Lutheran university of Helmstedt (1592–1597) by Paul Franke, and the Beckenhaus in Augsburg (1602) by Elias Holl. An obvious example of the variations of style is the Heidelberg Schloss, the construction and decoration of which

610. ENGLAND. St Paul's, London.
Built by Sir Christopher Wren (1632–1723) after the
Great Fire (1673–1710).

611. DENMARK. Frederiksborg palace, near Copenhagen.
Built by Christian IV 1602–1620 on three islands of a small lake.

612. ENGLAND. St Paul's, London.
Isometric drawing by R. B. Brook-Greaves and
W. Godfrey Allen. 1923–1928.

evolved from the Renaissance wing of Friedrich (1601–1617) by Hans Scoch, to the Palladian part completed in 1615.

The revocation of the Edict of Nantes brought a number of French architects to Germany — Charles Philippe Dieussart, Paul Dury, Jean Baptiste Broebes, who shared the favour of kings and princes with the Netherlanders Johann Georg Memhardt, Rudger van Langerveld and Matthis Smidts. In the second half of the 17th century German realist classicism triumphed over outside influences by reconciling the Baroque tendencies with her national traditions, whose most eminent exponents were Johann Arnold Nering, Johann Georg Starcke, Martin Grünberg and Georg Ditzenhofer.

Architecture in the Scandinavian countries, Denmark and Sweden (Norway remaining faithful to wooden constructions inspired by the old Stave churches), was above all a courtly art, inspired by the great royal building patrons — Frederick II and Christian IV (who has lent his name to a certain style) in Denmark, and in Sweden Eric XIV, who studied Vitruvius, and Johann III, who used to say: 'Building is our greatest pleasure.' It was usually foreign architects, Dutch, German and French, who restored and extended old castles or built new ones, in particular Obbergen from Mechelen and the two Steenwinkel from Antwerp. It was only at the beginning of the 18th century that there appeared a generation of native architects. Till then, the influence of the Dutch builders Vredeman de Vries and Dietterlin remained unshaken.

In Sweden Christian IV encouraged an enormous amount of building. The *Suecia Antiqua et Hodierna* by Dahlberg, an essential source of knowledge about the buildings of this period, many of which have disappeared or else have been rebuilt and disfigured, enumerates and describes more than fifty castles built during the second quarter of the 17th century alone. Later on, the two Nikodemus Tessin (the Elder and the Younger), the Frenchman Simon de la Vallée and his son Jean, were to give Swedish classicism a new impetus.

613. DUTCH. ADRIAEN DE VRIES (1560–after 1603).
Mercury and Psyche. *Louvre.*

The limitations of sculpture

The Reformation had almost completely silenced religion as a source of inspiration by proscribing images of saints, and it put an end to church and monastic commissions. All there was in the way of ecclesiastical sculpture was the decoration of church furniture, choir stalls, pulpits, etc. These were often of exuberant ornamentation, but were limited to floral decoration or to abstract motifs, in which the northern imagination revelled — scrolls and coiling lines, full of vigorous and varied dynamism, which were particularly successful in Germany. Sculptors were therefore almost exclusively engaged in decorating civic buildings and in making portraits and funeral monuments.

Fountains in the Renaissance tradition, vast combinations of bas-reliefs and statues still influenced by the allegorical and mythological spirit, were often decorated with themes taken from picturesque aspects of everyday life: for example, the 'Gänsemänchen' fountain ('man with geese') by Pankraz 614 Labenwolf, in Nuremberg. The pride of the people, conscious of their own importance, their independence and their wealth, reveals itself especially in the ornamental reliefs on the town halls, hospitals, guild houses, etc.

The allegorical spirit, regarded by men of the Reformation with almost as much suspicion as sacred images, did, nevertheless, inspire the bas-reliefs of Artus Quellin the Elder and his assistants Bosboom, Willem de Keyser and Verhulst, who cooperated on the Amsterdam town hall, making it such an 607 object of glory and wonder that it was regarded by contemporaries as 'the eighth wonder of the world'. But in general allegory was shunned as being contrary to the love of real and everyday things, and was replaced by naturalistic and anecdotal scenes that were directly connected with the nature and function of the municipal or corporative building. The descriptions of the lives of soldiers (military hospital, Amsterdam), of tailors 615 (the Tailors' Guild, Horn), by anonymous artists, seem to be taken straight from real life. The butter market and the weigh-house in Leyden, the Amsterdam prison (Hendrik de Keyser) were based on the same aesthetic principles, as were the bas-reliefs commemorating the exploits of the dead, on the monuments of Admiral van Tromp in Delft (by Rombout Verhulst) and of Admiral de Witte in Rotterdam.

The cult of great men revealed itself in statues. It is important to note how many scientists, literary figures and philosophers benefited from this idolatry which was transferred from saints and mythological characters to living contemporaries. The statue of Erasmus (1621) in Rotterdam is the first example of 617 the homage paid to humanists. Such statues were never idealised, but tended to be accurate reproductions of the physical characteristics of the sitter. The innumerable busts often sacrificed beauty and dignity in an attempt to render the exact appearance and expression of the model. Man was shown at his 616 most personal, and the general composition was determined by picturesque or psychological details. To achieve such effects painted terra cotta was used by Hendrik de Keyser; the Danish sculptor Caius Gabriel Cibber, who worked in England, modelled from nature the heads of madmen that decorated the doors of Bedlam, while Bernt von Münster executed the funeral statue of Duke Magnus (at Vadstena, Sweden) in polychrome limestone. Even when a bust has an air of grandeur suitable to the personality (*Jan de Witte* by Artus Quellin, *Jacob van Reygersberg* by Rombout Verhulst) the naturalistic element is by no means diminished or concealed, the realistic likeness being in itself part of the grandeur and dignity.

This naturalism was also employed in funerary monuments commemorating kings and famous people, even when they took the form of large structures remarkable for their architecture as much as for their decoration. These monuments, built along church walls, were so magnificent that in 1576 the Danish

614. GERMAN. PANKRAZ LABENWOLF (1492–1563). Gänsemänchen Fountain (Man with Geese). 1556. *Nuremberg.*

615. DUTCH. Military Life. Relief. 1587. From the old military hospital, Amsterdam. *Rijksmuseum, Amsterdam.*

616. DUTCH. ROMBOUT VERHULST (born at Mechelen in 1624, lived in Holland 1654–1696). Admiral van Ghert. Terra cotta. *The Hague Museum.*

nobility were forbidden by Frederick II to build tombs comparable to the royal ones.

Scandinavian funerary sculpture was normally the work of Netherlandish artists like Cornelis Floris, Adriaen de Vries and Willem Boyens, or of Frenchmen like Abraham Lamoureux, Nicolas Cordier, Jean Baptiste Dieussart. We find again the same Flemish and Dutch artists, with in addition Colyn de Nole and Anton van Zerroen, in Germany. There, as in the rest of northern Europe, most of the sculpture of this period was directly or indirectly influenced by the Netherlandish style. In England these sculptors were associated with Italians (Fanelli, who was the king's sculptor from 1610 to 1642), and with Frenchmen (Hubert Le Sueur). But essentially English characteristics developed at the same time with the picturesque Francis Bird, with John Bushnell, who portrayed General Mordaunt dressed as a Roman Imperator, with Nicholas Stone, who represented John Donne wrapped in a shroud, and with Grinling Gibbons, who excelled in decorative wood-carving which is stamped with an entirely original form of English naturalism. 618 848

However solemn and majestic funerary monuments may have been in northern Europe, the principal element was always the statue of the deceased, executed with the most direct and expressive realism. The personality lives, or at any rate reclines as if asleep (*Adriaan Clant* by Rombout Verhulst). Familiar postures were preferred to the heroic attitudes of the Baroque. This desire for simplicity, for austerity even, eradicated all traces of the Baroque, to return to the fundamental principles of the Reformation. At the same time, bas-relief portraits gained in naturalistic intensity with the disappearance of the accessories, baldachinos, thrones, etc., that accompanied statues in high relief.

There was also a late Gothic survival in Germany, in the altars of carved wood, lavishly overdecorated (St Afra at Augsburg by Degler), and in the taste, so common among German sculptors, for small-scale works in wood, ivory, boxwood, coconutwood and coral. This aspect of German art should not be neglected, for it produced some masterpieces, as well as the table centres in precious metals by Melchior Dinglinger and Christopher Jamnitzer. Some of the most famous artists, such as Melchior Barthel, Leonard Kern (who took naturalism to horrible and repulsive extremes in his bas-relief in wood of the *Famine*), Matthias Rauchmüller, who did the statue of St John Nepomuk for the Charles bridge in Prague, and above all, Peter Flötner, did not scorn these unusual materials.

Romanist painters and the advent of realism

It was in painting, and in Holland particularly, that the characteristics peculiar to northern realism revealed themselves in their most obvious and brilliant form, characteristics resulting from the Reformation, the liberation of the Netherlands, and the clear-cut division between the Catholic world of Flanders and the Protestant atmosphere of Holland. The discovery of objective nature, the love of objects in themselves and their humble everyday setting, the inquiry into reality here and now, a sensitivity, finally, for the modest wonders of the material world, brought Dutch painters into happy communion with everyday life, without the desire to go beyond or escape from it by pursuing an ideal other than this reality in itself.

These characteristics were so deeply ingrained that even those Dutch painters who had been marked by southern countries like Italy and France transposed foreign influences into powerful and entirely original works which were in the spirit of local aesthetics and sensibilities. In speaking of 'Romanists', that is to say, artists who had learnt their craft and formulated their concept of structure and sculptural form in Italy, one should distinguish their different cultural backgrounds: in the Catholic and Jansenist town of Utrecht the Caravaggian tendency inclined towards the full-blown sensuality of Hendrick Terbrugghen 631

and the theatrical fantasy of Gerard van Honthorst; in the strictly Protestant and fiercely independent Haarlem we find the eclecticism of Hendrick Goltzius (who prided himself on imitating and amalgamating the styles of Raphael, Parmigianino, Dürer and Lucas van Leyden) and the lively and picturesque 632 Pieter van Laer (the widely practised genre of bambocciata painting was so called after his nickname Bamboccio). From these tendencies Haarlem produced that syncretic concept of art which resulted in group portraits, genre paintings and landscapes.

Whether they were classical, Mannerist or Baroque, concerned with religious or mythological scenes, the Romanists like Abraham Bloemaert, Joachim Uytewael, Nikolaus Knüpfer, Cornelis Cornelisz of Haarlem or Jan Gerritsz van Bronckhorst in no way retarded the evolution of Dutch painting towards the triumph of realism. They aided this evolution rather, by developing a more supple sense of objectivity. They enriched the meticulous, contemplative temperament of Dutch artists, who were shy of their feelings and reserved in the expression of their passions, with a more open and poetic sensitivity to the beauties of the countryside, such as they had discovered in

Italian landscapes. So it was that Utrecht so open to southern influences, Haarlem so wrapped up in her Dutch particularism, and Amsterdam so cosmopolitan thanks to her wealth and genius for business, thrived on the harmonious fusion of national characteristics with ideas acquired abroad. Their art, which was so well defined as a whole and so strongly individualistic in its parts, and which raised the genius of the country to such heights, became the most complete and the most significant expression of this period.

The individual and the group in portraiture

One can refer, without being paradoxical, to the collective individuality of the group portraits, which became one of the main features of Dutch painting. The group portrait was not merely a collection of individual portraits (except in the *Night Watch* by Rembrandt, the outcome and negation of this genre), 644 but the creation of a composite and unified personality, representing the importance that was given to civic and guild life in the Netherlands. The assembly rooms of the governors of these institutions were no longer hung with religious paintings, as in the Italian *scuole*, but with pictures of the administrators; 634 the same goes for archers' companies (successors to the old 636 militia companies), medical schools and learned academies. In response to the desire to fix and perpetuate an action achieved in common, whether a pilgrimage to Jerusalem (Jan van Scorel) 488 or a ceremonial banquet of the civil guard, the group portrait seems, ever since the first archers' company piece painted by Cornelis in 1583, to have been one of the characteristics of Dutch social life. This company piece marks an important date in the history of Dutch painting, because it was the first painting that was not merely a collection of separate personalities, as were the works of Cornelis Teunissen and Dirck Jacobsz in the first half of the 16th century. The first painting of governors (1599) and the first *Anatomy Lesson* (1603) by Aert Pietersz mark equally decisive stages. Gradually the group portrait, which was to end up with free dynamism and diagonal grouping of masses by Frans Hals, broke away from the linear and horizontal compositions that lingered in Cornelis Ketel's work in 1588, and from the parallelism of two horizontally grouped and immobile volumes which we find like some archaic survival in the works of Cornelis van der Voort. Werner van der Valckert's *Archers*, in 1625, nine years after the *Officers of the Company of Archers of St George* by Frans Hals, is already a masterpiece of natural rhythms, supple and spontaneous movement and lively freedom. As it has been described by Riegl and Six, the history of group portraits summarises one of the

617. DUTCH. HENDRIK DE KEYSER (1565–1621). Erasmus. 1621. *Rotterdam.*

618. ENGLISH. NICHOLAS STONE (1586–1647). Funerary statue of John Donne. *St Paul's, London.*

619. JAN VAN GOYEN (1596–1656). The Blasted Oak. 1653. *Bordeaux Museum.*

620. THOMAS DE KEYSER (1597–1667). A Musician and his Daughter. *Formerly Osborn Kling Collection, Stockholm.*

621. JUDITH LEYSTER (1609–1660). Gallant Proposal. *Mauritshuis, The Hague.*

622. ALAERT VAN EVERDINGEN (1621–1675). Waterfall in Norway.

623. BARTHOLOMEUS VAN DER HELST (1613–1671). Self-portrait. *Formerly Mensing Collection.*

624. GERARD TER BORCH (1617–1681). Lady Drinking Wine. *Atheneum Art Gallery, Helsinki.*

625. MEINDERT HOBBEMA (1638–1709) The Water Mill. 1692. *Louvre.*

626. CASPAR NETSCHER (1639–1684). Portrait of a Lady and her Daughter. 1679. *National Gallery, London.*

627. FRANS VAN MIERIS (1635–1681). The Frailty of Life. *Rijksmuseum, Amsterdam.*

DUTCH PAINTING IN THE 17TH CENTURY

LANDSCAPES **PORTRAITS** **GENRE PAINTING**

Born between 1595 and 1610

619

620

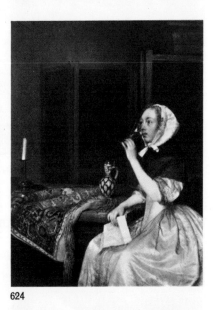

621

Born between 1610 and 1625

622

623

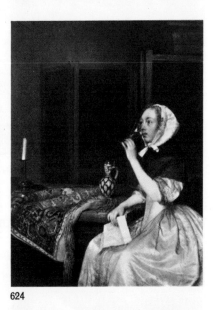

624

Born between 1625 and 1640

625

626

627

THE BEGINNINGS OF THE 17TH CENTURY

Emerging from the Italianate Mannerist style inspired by the school of Fontainebleau, Dutch painting was diverted from southern influences by political circumstances, and developed a realist style that became more and more restrained and severe in its means of expression.

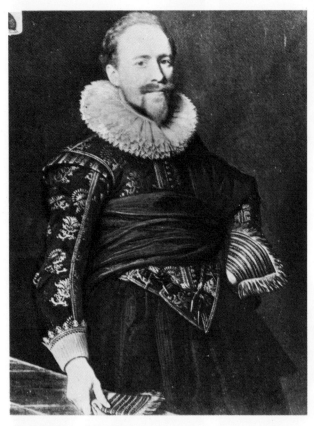

628. DUTCH. MIEREVELD (1567–1641). Portrait of a Man. *Formerly Cottreau Collection.*

629. DUTCH. GERARD VAN HONTHORST (1590–1656). Adoration of the Shepherds (detail). *Uffizi.*

630. GERMAN. ADAM ELSHEIMER (1578–1610). The Flight into Egypt. *Gemäldegalerie, Dresden.*

631. DUTCH. HENDRICK TERBRUGGHEN (1588–1629). The Lute Player. *Bordeaux Museum.*

most important sociological and aesthetic aspects of Dutch life after the establishment of the United Provinces. Taking the place of religious, mythological and allegorical pictures, the group portrait became the usual form of decoration in buildings designed for the collective life of the city, and it represented a kind of mirror in which the city could see and recognise herself as a multiple but uniform entity. This explains the disappointment and discontent provoked by the *Night Watch*, in which **644** there was no longer any uniformity. It lacked that sculptural homogeneity and that spirit of unanimity which we find in Frans Hals in spite of his powerful individuality, in Thomas de **620** Keyser and van der Helst in spite of their taste for elegance, **623** and in Nicolaes Eliasz, in spite of his rather theatrical imagination.

The capricious, impulsive and touchy character of Frans Hals, with regard to anything that threatened his independence drove him to break away from the set formulas and to destroy the old structures of group portraits. He was a pupil of Karel van Mander, who was a knowledgeable theoretician of painting and drawing, and who, together with the Romanists Goltzius and Cornelis, had founded an academy in Haarlem for the study of the nude. Frans Hals rebelled against classicism and Catholicism. He was every inch a Netherlander, with that mixture of seriousness and humour, enthusiasm and melancholy, Puritan pessimism and candid sensuality. Though his world was limited to the visual, he certainly knew how to look at things, and with what a seeing eye! Substance throbs and bursts out of its contours; an overpowering appetite for sensual and organic

632. DUTCH. PIETER VAN LAER, called BAMBOCCIO (c. 1592–after 1642). Game of Morra. *Corsini Gallery, Rome.*

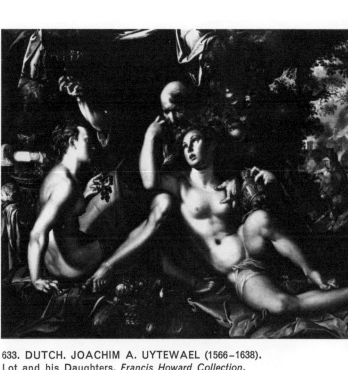

633. DUTCH. JOACHIM A. UYTEWAEL (1566–1638). Lot and his Daughters. *Francis Howard Collection.*

634. DUTCH. FRANS HALS (1580/85–1666). Governors of the Old Men's Almshouse in Haarlem.

635. Detail of 634. The free and bold technique of this late work by Frans Hals shows him as a precursor of Impressionism.

life thrusts its way through the fiery supple rhythms of his individual and group portraits. Towards the end of his life his misanthropy left him lucid, bitter, unsatisfied, disenchanted, and old age and ugliness took on the force of a *memento mori*. Till then Hals had had a passion for the substance of which man is 635 made, if not for man himself, and for the thick paint with which he would model a heavy hunched-up body clad in black with a hat ridiculously askew. Black cloth, lace and swollen blotchy faces were for him just as real and inspiring as a well shaped and seductive body. He had no preferences, but would paint with the same free and intense application the play of light on a cheek and the reflections on a felt hat.

With Hals Dutch naturalism attained a supreme and almost sacred exclusiveness. This Netherlandish naturalism, which was Protestant, democratic, revolutionary but disciplined, transformed in Hals all that is romantic in Rembrandt — the chiaroscuro, the mysterious shadows, the subtle transitions — into the simple existence of everyday reality. And according to whether his pupils adopted the romantic or trivial aspect of his interpretation of society, they turned to aristocratic groups of refined gentlemen (Jacob Duck, Pieter Codde and Antonie Palamedes), or to destitute villagers, in a jeering way with 637, 600 Adriaen van Ostade and Adriaen Brouwer, with a happy lyricism in the case of Jan Steen, a lyricism that was theatrical 639 rather than naturalistic in its obvious concern for spectacular and scenic burlesque.

The extreme individuality of man was more important to Frans Hals than social man; so there is always in his group portraits a certain dissociation which favours the most striking character in the picture. In general, Dutch portrait painters strove to reconcile such exigencies, which are not necessarily antagonistic, the individual often being the result of social man's conditioning by his particular background. Thomas de Keyser, van der Helst, Santvoort and Ravesteyn, even when representing a person as an individual, never detached him completely from his social context. The merchant, the shipowner, the scholar, all preserve something of their class and profession in their attitudes, and even in their expressions. This tends to make them types belonging to certain groups and representatives of certain social functions, so that they stand for different ways of

257

636. DUTCH. FRANS HALS (1580/85–1666).
Assembly of Officers and Subalterns of St Adrian at Haarlem.
1633. *Frans Hals Museum, Haarlem.*

637. DUTCH. ADRIAEN VAN OSTADE (1610–1685).
Rustic Interior. *Formerly Mensing Collection.*

638. DUTCH. PAULUS POTTER (1625–1654).
Cattle in a Stormy Landscape. *National Gallery, London.*

639. DUTCH. JAN STEEN (1626–1679).
Revelry by Moonlight. *National Gallery, Prague.*

feeling and thinking. Realism, in fact, could be complete only by taking into account the collective idea of the individual which is an essential aspect of democratic and plutocratic societies — societies such as the one Keyser and van der Helst so obediently mirrored and which Frans Hals smashed into fragments, thus breaking up society into an infinite multiplicity and diversity of individuals, whose desire to be different amounted almost to anarchy.

The genre and bambocciata painters, Steen, van Ostade, Brouwer and van Laer, pretended that their scruffy peasants were meant as a defiance of bourgeois hypocrisy. The delight they took in describing the licentious and vulgar pleasures of the lower classes was a defensive reaction against conformity, the tyranny of which oppressed Hals and Rembrandt so painfully. The polemical aims of this genre are confirmed by the exag-

gerated vulgarity that was sought. The nobility of Le Nain and the gentleness of Teniers are absent in these paintings 'of ruffians, in which Louis XIV, with the instinct of an absolute monarch, sensed the revolutionary message. In the drinking scenes set in wretched village taverns, the beggars, in spite of their good-natured joviality, suggest the atmosphere of a class war, whose cause is not so much social inequality, but a conflict between peasant liberalism and town conformity, a revolt against the moralising townsman, dressed in black, and submitting with such docility to the laws of sects and cities.

Landscape as a communion with nature

This element of dissension, that cuts across portraiture and genre painting, disappears in the communion with nature which

685

was felt by all Netherlanders alike. Though the first landscape painters on their return from Italy evoked the Roman countryside with nostalgia (Cornelis Poelenburgh, Jan Both, Berchem), direct communion with nature and sketching (in pencil, ink, walnut stain) made it possible to work out the composition, perspectives and highlights on the spot, so that there soon developed an entirely autonomous aesthetic concept of the Dutch countryside and the Dutch skies. For classical painters the landscape was only a setting for human action, an orchestral accompaniment for the central theme which was man. To make the landscape the actual subject of a painting was a daring innovation, almost an anticlassical provocation. Contrary to the heroic pastorals of the Italians, Dutch landscapes could only show the beauty of natural forms and colours, so that they acquired the same characteristics as the portraits, that is, the absolute individuality of a particular place, and — what could not be done in a portrait, which represents the accumulation of time in a man — of a unique moment. Situated at the meeting place of time and space, the Dutch landscape represents an instant and a place, a living being, a portrait of a particular piece of nature that had to be as naturalistically true and as intensely alive as the portrait of a man.

Those aspects of the country that were most immediately felt and most intimately associated with Dutch life, the sea, the meadows, the vast sky with passing clouds — which were often the main subject of a picture — the shimmer of light on grass or water, became favourite themes. While the seascapes were rarely concerned with the pure contemplation of the sea, the interest being mainly centred on the shipping, sometimes peaceful and sometimes involved in a battle, the landscapes were contemplated and enjoyed for their own sake. The seascapes were dramatic, while the landscapes were idyllic, evoking walks along lanes bordered with hedges, fragrant meadows with grazing cattle, or the calm activity of the canals where heavy barges are being towed. A new, more subtle, more sensitive sense of space was developed by Pieter Molyn and Jan Wynants. The picturesque skaters who animated Hendrik Avercamp's winter scenes disappeared. Compositions were determined by nature alone, and no longer by human action. The seasons with their changing colours, sunsets and moonlight (Rafel Camphuysen) were life enough, and Jan van Goyen, with his rich and delicate monochromes, did not need colour to express the intense and mysterious life of the elements.

Exceptionally, painters such as Alaert van Everdingen went to Sweden or Norway in search of romantic scenes of mountains, foaming waterfalls and dense pine forests that were not to be found in their native country. Occasionally a Herkules Seghers, the most romantic of the realists, inspired perhaps by the Chinese landscapes he might have studied in one of the private collections of Oriental art, invented soaring far-away perspectives full of disturbing mystery. Albert Cuyp was content to paint the magic of an everyday sunset, Hobbema created space in depth by drawing out his avenues of slender trees, Paulus Potter gave a silvery gleam to his clayey fens, and the Ruisdaels reiterated with invariable success, and without getting stale or mechanical, the reality of everyday life.

The time came, however, when this local realism was transformed into a cosmic realism, when the love of nature developed into an absolute value. From the expression of the finite there grew the desire to express the infinite. After describing objects with a mere suggestion of their innate spirit, artists dared to attempt the portrayal of the cosmic soul. The transition from realism to the romanticism of the *Jewish Cemetery*, which won Jacob van Ruisdael the title of 'poet' in the eyes of Goethe, suggests that the landscape was being intensified by a spiritual concept, no longer conceived as an objective reality but as a reflection of the emotional state of the artist. The idealised

(marginal reference numbers: 640, 619, 622, 840, 641, 625, 638, 648, 642)

640. DUTCH. CLAES BERCHEM (1620–1683). Italian Harbour. *Formerly Steegracht Gallery.*

641. DUTCH. ALBERT CUYP (1620–1691). Moonlight. *Wallraf-Richartz Museum, Cologne.*

642. DUTCH. JACOB VAN RUISDAEL (1628/29–1682). Jewish Cemetery. *Gemäldegalerie, Dresden.*

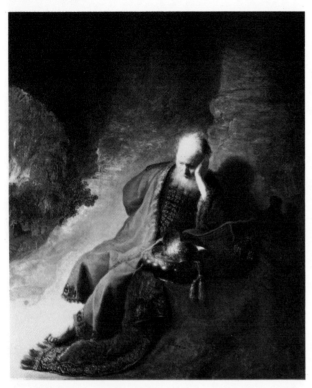

643. Jeremiah mourning the Destruction of Jerusalem. 1630. *Rijksmuseum, Amsterdam.*

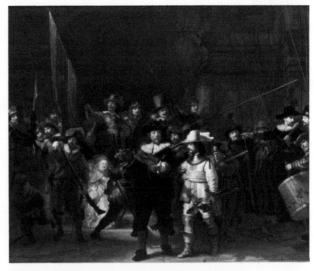

644. The Company of Captain Banning Cocq (The Night Watch). 1642. *Rijksmuseum, Amsterdam.*

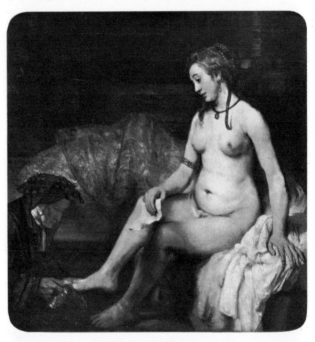

645. Bathsheba. Hendrickje Stoffels as model. 1654. *Louvre.*

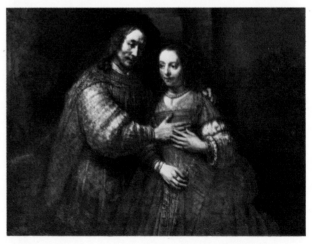

646. The Jewish Bride. 1668. *Rijksmuseum, Amsterdam.*

nature of the Italianate landscape evolved towards the expression of reality that was not idealised but individualised by the sublimation of its component parts; then it evolved towards an evocation of nature that was more spiritual and less concerned with the particular. From the composed landscape of Jacob van Ruisdael to Rembrandt's invented landscapes (purely lyrical, poetic and romantic, no less real, but living in a reality of the second degree) the transition was smooth and effortless.

Rembrandt, the summit of Dutch art

643–647
649–651
All the elements typical of Baroque art appear in Rembrandt, and its themes were developed in his work — portraits showing not only the character but the destiny of the person; a highly individualistic realism which rejected stylised beauty; the drama of death and night; the strangeness of man as revealed in everyday life. But Rembrandt was essentially anti-Baroque in his way of interpreting religious, mythological and historical themes, which lend themselves to emotional gestures. When he treated such subjects, it was with the northern spirit of revolt against the aesthetics of the south, with the attitude of a Reformation man against the secret purpose of the Baroque art of the Counter Reformation.

In some of his works Rembrandt appears to be a pure painter in the way that Velasquez and Renoir were; but in others he leads us on beyond image and form, and makes us consider an implied philosophy which is disconcerting in its range and depth. His metaphysical preoccupations have often been explained by the contact he is known to have had with Dutch and Jewish scholars, and by his possible contact with Spinoza (some claim that the latter was portrayed in *Saul* in The Hague). It is more reasonable to believe that Rembrandt, who liked meditating in solitude, spontaneously encountered the great problems that disturb the minds of all men. Rembrandt's work was the outcome and conclusion of Dutch painting, which he transfigured

260

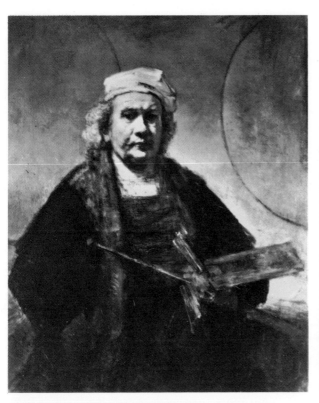

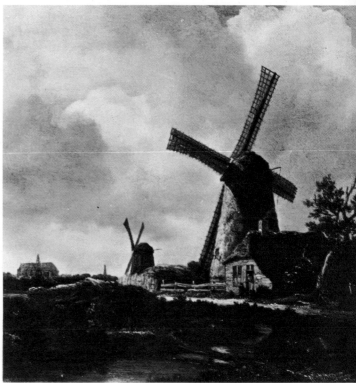

647. DUTCH. REMBRANDT (1606–1669). Self-portrait.
c. 1663. *The Iveagh Bequest, Kenwood, Hampstead*.

648. DUTCH. JACOB VAN RUISDAEL (1628/29–1682).
Landscape with Windmills. *Dulwich College Picture Gallery*.

649. DUTCH. REMBRANDT (1606–1669).
The Denial of St Peter. 1660. *Rijksmuseum, Amsterdam*.

and realised in its most intense form. He magnified and subli-mated the elemental, revealing and deepening its mystery. In the world of Rembrandt's painting, objects take very little space, for they are consumed and transcended in that almost monochrome substance in which the mystic gold of an alche-mist infuses and vitalises the brown silt of the earth's origins.

Few still lifes are to be found in Rembrandt's work, for here again the objects he liked had to have a strange, exotic, enigmatic beauty. Tormented by the problem of man's destiny, by his presence on earth and his transcendence, he infused concrete forms with an incandescent soul which destroyed all that is not quintessential. Whether he had to do with portraits or landscapes, profane or religious, naturalistic or mythological pictures, he was haunted by the problem of the divine in man and the flesh of the angel. In the flame of his inspiration the uncertain and perishable were annihilated, so that the gold of his significant transmutations might shimmer at the bottom of the crucible. He was admired for talents that were only a trivial part of his genius, and misunderstood by his contemporaries because he had a different notion of the 'real'. He has been reproached for decomposing the flesh when it interfered with the soul as if the latter were not the supreme reality and ultimate end of artistic creation. His religious anxiety was condemned as spiritual anarchy, and his artistic freedom as a perversion of form. His contemporaries were hardly able to realise that no one was more concerned with reality than he was, for they preferred skin-deep naturalism and the superficial, almost photo-graphic accuracy of reproduction; nor could they understand that it was necessary to go through the smelting process in order to achieve a higher state of reality. Based on a misunder-standing, his fame was obliterated by misinterpretation and lack of appreciation. Yet if Dutch art in general developed along such daring lines, it was because of Rembrandt's supreme achievements. His greatest achievement, which was at the very

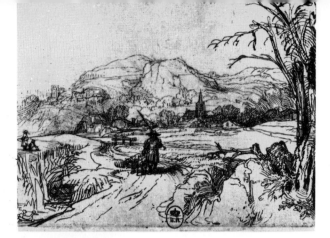

650. DUTCH. REMBRANDT (1606–1669). The Huntsman.
Engraving. *c.* 1653. *Bibliothèque Nationale, Paris.*

651. DUTCH. REMBRANDT (1606–1669).
The Polish Rider. *c.* 1655. *Frick Collection, New York.*

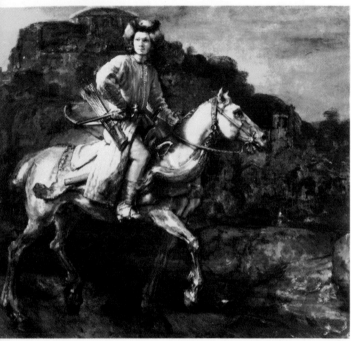

centre of the formal and mystic venture, is that he fused into
one substance the natural and the supernatural. Rembrandt's
two marriages, if one can call his concubinage with Hendrickje
645 Stoffels a marriage; his fame and decline; his unhappy father-
hood, for the destiny of Titus was involved with his father's
destiny; his extravagances and miseries, even his moving from
house to house and his descent from his beautiful and fashionable
house in St Antonie Breestraat in Amsterdam to the dingy
lodgings in the street where the Jewish pedlars lived — all this
is part of Rembrandt's biography, in which each incident is
important. The worries of a needy painter, his success with the
rich and cultivated middle classes, then solitude and an independ-
ence which became more and more costly, and finally the wiles
of a bankrupt tradesman — such was the epic life that has its
place blazoned in Dutch history. He had to be born in obscurity
and die in obscurity, so that Dutch painting could complete
its full circle, the complete sacrifice and sanctification of man's
destiny.

Vermeer and the glorification of material substance

Born of the philosophy of 'vanitas' (like the *autos sacra-
mentales* or allegorical religious plays of Spain and Portugal
born, at the same period, of the 'victory of death'), Dutch
still life painters did not hold with the pessimistic morality of
'dying well' nor with the hedonistic attitude of 'good living'.

The visual and tactile sensuality, the opposition to monastic
asceticism, the natural inclination of a society richly acquainted
and satiated with the pleasures of wealth and refinement (so
that greed for 'acceptable' satisfactions compensated for what
was refused to sexual appetites) so brought it about that tempting
still lifes played the same role in the Netherlands as nudes did
in Catholic and pagan Italy — the glorification of material
substance. There was no question of gluttony; Willem Kalf
and Claesz Heda orchestrated their sensual compositions with 653
subtle harmonies in which the touch, the eye and the palate
(with even a suggestion of sound in the glass, which would
ring if touched) revel, without scruple or uneasiness, in the joy
that aesthetic perfection adds to sensual pleasure. Dutch still life
was no longer the *memento mori* it had been originally; painters
no longer regretted the transience of pleasure, nor questioned
its morality or value. The full intensity of the moment, the
immediacy of the senses, finds its echo in memory; and if the
moment is prolonged and immortalised, it is because an object,
like the body, like nature herself, has a spirit which is augmented,
rather than diminished or destroyed, by time.

Dutch artists had a way of living intimately with time, in
the very fibre of time, and their delight and greatness was in
the sense of time as a being, a becoming. The pregnancy of
each instant creates a voluptuous intimate immobility which is,
at the same time, action. Expectant, meditative, contemplative,
listening to exterior sounds and an interior voice, relishing each
drop of time as perfect bliss, the humanity of Pieter de Hooch 656
or Johannes Vermeer was not transformed into fire, as in Rem- 655
brandt, but into mother-of-pearl, pearl and precious stones.
The act of pouring milk into a jug, reading a letter, fingering a
necklace, looking at the sky or a flower, or listening to foot-
falls in the street became symbolical of the happiness of intensely
lived moments, as if the finite had attained all the possibilities
of the infinite. Pieter de Hooch's painting, with its loving and
contemplative vision of the depths of reality, suggests an unrip-
pled submarine peace, where even the torpor remains watchful.
Joy is silence and stillness. All substance is given dignity by this
calm intimacy of things. The painter participates in the divine
emotions of creation as he fashions in pearl-like or slightly
rough pigments a genesis of his own making. The calm assured
way that people and objects in Vermeer's paintings have of 657–660
being there is proof of the harmony that reigns between the
individual and the universe, the stability of space, the regularity
of time, the agreement between the will of man and the laws
of the universe. How moving is this modest, peaceful perfection,
withdrawn into itself, where it weaves its eternity, without
haste, without anxiety! The spirituality of temporal moments
which we admire in Pieter de Hooch, and which move us in
Vermeer, was not, of course, equalled by those 'minor masters'
Gerard Dou, Gabriel Metsu, Nicolas Maes and Gerard ter Borch,
but they did participate in this gentle celebration of senses and
emotions. With the rather common taste for anecdote, bright-
ened by music (the resonant solitude of a harpsichord in a ter
Borch, an old woman praying in a Dou, the person waiting
by a window in a Maes), and the rather uneasy, aristocratic
decadent restlessness of Pieter Janssen, these painters missed all
the mystery of Vermeer, and could only produce a shallow
echo of his disturbing magic. Belonging to the same family
were the architectural landscape artists, Job Berckheyde and
Pieter Saenredam, who were fond of clear white Reform chur- 661
ches, deserted streets in sunlight, and green canals in the shade
of spreading trees. Like them, too, were the painters of farmyard

DUTCH. REMBRANDT (1606–1669).
Self-portrait. Uffizi. *Photo: Paul Hamlyn Photographic Library.*

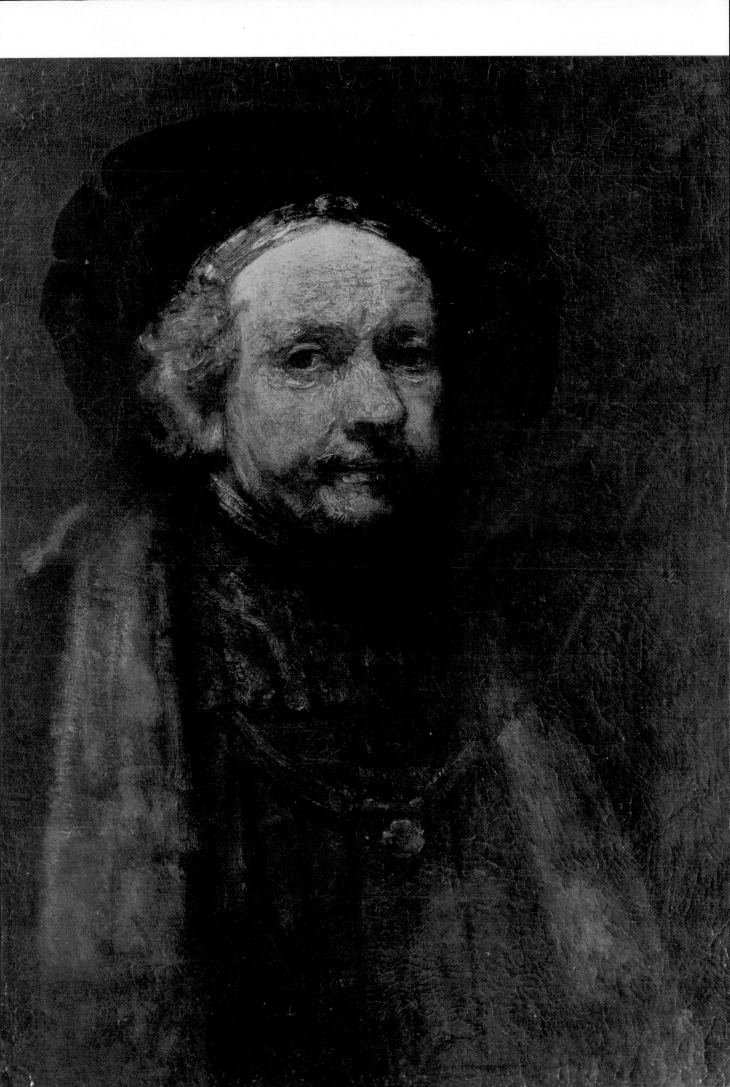

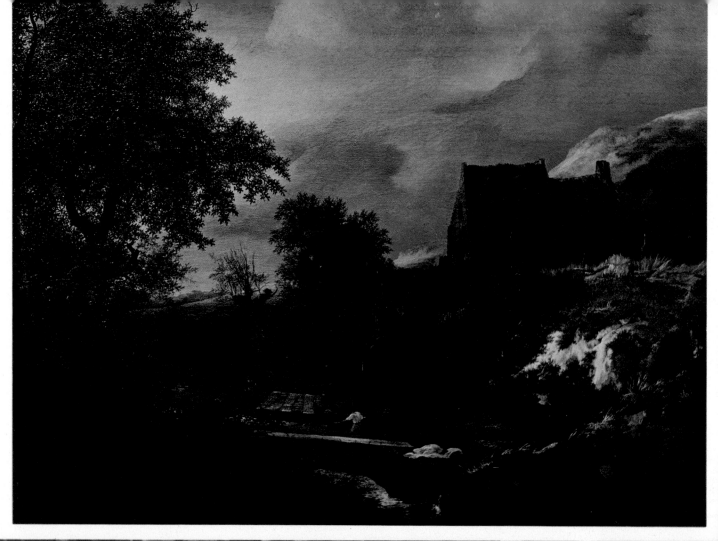

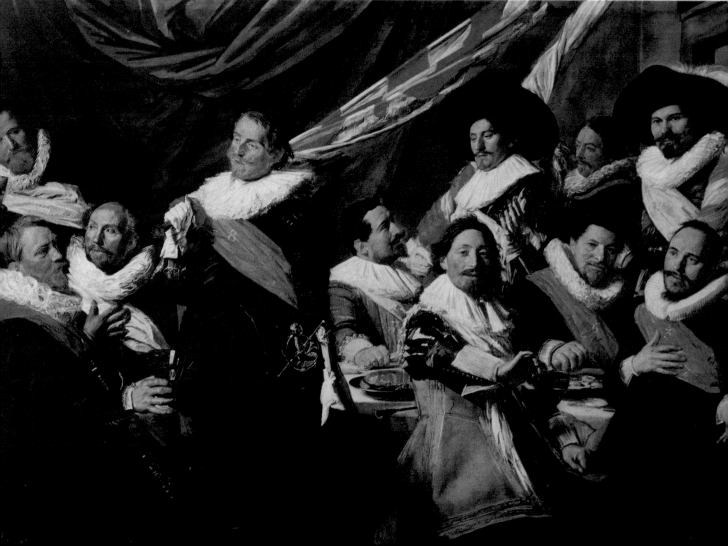

(Hondecoeter) or of flowers (Jan Davidsz de Heem) for whom reality was never vulgar, since it was without original sin.

From England to Scandinavia

Equally prone to poetic invention and realistic objectivity, the English greeted Holbein and van Dyck with equal favour, receiving from these masters new aesthetic tendencies just when the religious reform was questioning artistic values and metaphysical ideas. Englishmen have always been inclined to regard the world as a 'practical dream', in the words of Berkeley, that is to say, as an amalgam of perception and imagination. They also transposed the cult of truth practised by Holbein into a dynamic and lyrical treatment of the portrait, such as we find in Gilbert Jackson, George Gower and Sir Nathaniel

490 Bacon, a relation of Francis Bacon. But in Nicholas Hilliard and his pupil Isaac Oliver we discern an association with nature similar to that conceived by the school of Fontainebleau, only more phantasmagoric and with an emotional restiveness in the portraits which is reminiscent of Shakespeare's plays. Gardens and forests were no longer a décor, but a visual reflection of an interior world, almost a vegetable reflection of the person represented. When he recommended the painting of portraits in the open air, so as to avoid shadows, Hilliard revealed his desire for luminosity, transparence and poetic simplicity. The miniaturists Peter Oliver, son of Isaac Oliver, John Hoskins and Samuel Cooper reconstructed the lines of a face with scrupulous delicacy, so that the subtle workings of the soul appear in the liquid finesse of an imponderable substance.

Foreign influences diverted English art from its individual destiny. Zuccaro and Verrio from Italy, Lagrenée from France, Kneller from Lübeck and Francis Cleyn from Rostock in Germany, Decritz, Peter Lely and Cornelis Ketel among others from Flanders and the Netherlands, all profited from the invasion triumphantly led by Rubens and van Dyck. Some of them were ennobled and anglicised in their conception of art and linked the Elizabethan England of Hilliard with the Romantic

662 movement of the 18th century: Sir Peter Lely and Sir Godfrey Kneller completed the fusion between society and the court for which they worked, and then in their turn they inclined the tastes of the country of their adoption towards a rather heavy and rhetorical solemnity that was foreign to the English tradition. As far as technique was concerned, Rubens and van Dyck had prepared the materials necessary for the development of Romantic painting, but the spirit of romanticism, its inner mystery and intimate communion with nature, died out in the exaggerated compositions of the Rubensian school. The art of the Elizabethan miniaturists had corresponded with the fragile music of the madrigalists Dowland and Orlando Gibbons. The fresh natural charm of their work, which had all the delicacy of lawns and spring flowers, was lost when paintings were heavily glazed in imitation of van Dyck's technique, and was only revived with the great 18th-century watercolours of Girtin, Cozens and Turner. The artificiality of the vast historical and decorative canvases by Sir James Thornhill, Isaac Fuller and Robert Streeter was scarcely compensated for by Robert Walker's grave portraits or by the sensitive and agitated seascapes of Peter Monamy.

In Germany the Romanists fulfilled the demand for a court

DUTCH. JACOB VAN RUISDAEL (1628/29–1682). The Bleaching-ground. National Gallery, London. *Photo: Michael Holford.*

DUTCH. FRANS HALS (c. 1580–1666). Banquet of the Officers of the Civic Guard of St George, Haarlem (The Archers of St George). 1627. Frans Hals Museum, Haarlem. *Museum photograph.*

STILL LIFE

652. FLEMISH. AMBROSIUS BOSSCHAERT THE ELDER (c. 1568–1621). Flowers and Shells. *Stockholm Museum.*

653. DUTCH. W. CLAESZ HEDA (c. 1594–1680/82). Dessert. 1637. *Louvre.*

654. DUTCH. ABRAHAM VAN BEIJEREN (1620/21–1675). Still Life. *Formerly Mensing Collection.*

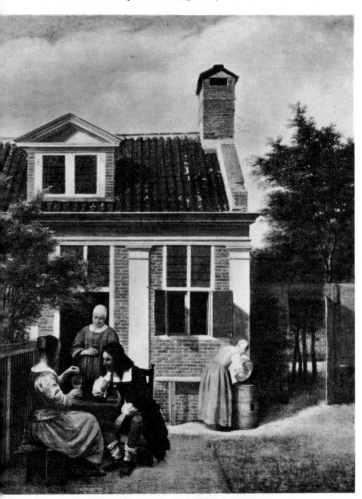

655. DUTCH. JOHANNES VERMEER (1632–1675).
The Guitar Player. *The Iveagh Bequest, Kenwood, Hampstead.*

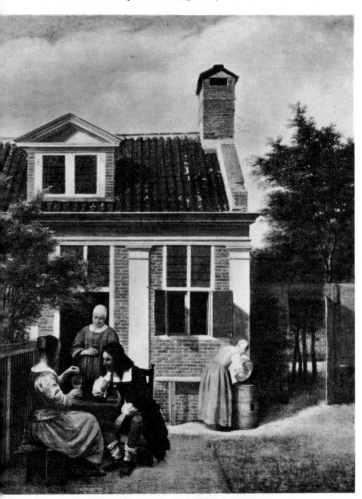

656. DUTCH. PIETER DE HOOCH (1629 – c. 1684).
A Country House. *Rijksmuseum, Amsterdam.*

MASTERPIECES OF JOHANNES VERMEER
(1632–1675)

657. The Courtesan. 1656. *Gemäldegalerie, Dresden.*

658. Young Girl in a Turban. *Mauritshuis, The Hague.*

659. View of Delft. *Mauritshuis, The Hague.*

660. Allegory of Painting (The Painter in his Studio).
Kunsthistorisches Museum, Vienna.

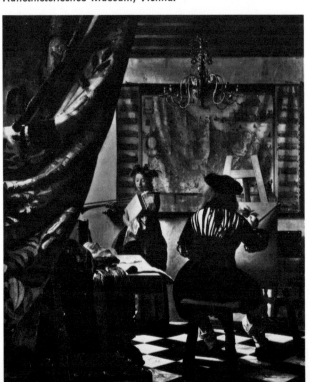

art, which benefited from the decline of the town leagues and from the general tendency towards absolute monarchies. Moreover, the observation of, and feeling for, reality was never without a certain poetic element, idyllic or dramatic, which was closely associated with the very essence of that reality; thus Italianate artists such as Johann von Aachen, Bartholomaeus Spranger, Hans Donauer and Rottenhammer developed a composite style of idealisation and mannerism. The influence of the imaginative and fanciful king, Rudolph II, and of the various academies (the first school of art was founded in Berlin in 1697, the first Austrian one in Vienna in 1692, the first German academy in Nuremberg in 1662) encouraged historical, religious and mythological painters' preference for the technique and manner learnt in Italy. One solitary and forceful genius, Adam Elsheimer, whose formation went back through Uffenbach and Grimmer to Matthias Grünewald, and who, through the intermediary of Lastman, was to influence Rembrandt and even Claude le Lorrain, launched a grand epic and naturalistic style. With him, German painting regained its independence and the strictly original character of its heroic pastoral scenes. Nocturnal illusions and complex fanciful lighting effects lend Elsheimer's landscapes that mysterious dream-like intensity, which does not idealise nature, but brings out from the visible all the forces of the invisible world. He thus added to perceptible reality that expanding surreality, which German artists were to look for in everyday objects and which was for them the very soul of things.

The Netherlands and Germany exchanged artists so readily that one forgets that Flinck was from Cleve, Netscher from Heidelberg and Bakhuyzen from Emden, so much were they all influenced by Dutch aesthetics. The eclecticism of style and the amalgamation of techniques indicate, in Germany more than anywhere else, the constant exchanges that occurred in this period between the important artistic centres of Europe. But it was incapable of producing a really original form of art.

The best exponents of the German realist portrait, with all its traditional objectivity and robust sincerity, are to be found mainly in Switzerland: the most representative are Jost Amman, Tobias Stimmer and Hans Asper, with their plebeian truculence and their deep roots in the everyday life of village and city. There also developed in Switzerland an art of realistic stained glass, destined no longer for churches but for private houses, small stained glass windows suggestive of the opulence and pride of a middle class whose success was summed up in the display of their coats-of-arms. This popularisation of an ancient craft that had been reserved for churches was due to the Reformation which confined stained glass to this modest function. It was also due to the rise of the middle class. Industrious, cultivated, but with simple tastes — which prevented them from playing the lavish Maecenas, like the Fuggers or the Medici — this middle class retained the predilections of a mountain people, attached to the earth and to the faithful representation of people and things.

In the first national collection of Scandinavia, that of Gustavus Vasa in his castle at Gripsholm, national painters were not represented. Germany and the Netherlands used to export their artists and works of art to the north. The only painter referred to as a master was Anders Larsson of Stockholm, but we now have no work definitely known to be by him. Holger Hansson, who worked at the Stockholm palace between 1586 and 1619, is hardly better known. It was only at the beginning of the 18th century that a national aesthetic was developed by Michael Dahl, Carl Gustav Pilo and Olof Arenius.

Diffusion of art through engravings

The art of engraving was one of the most active means of spreading the Reformation. The transport and exchange facilities helped to develop that stylistic unity characteristic of the 17th

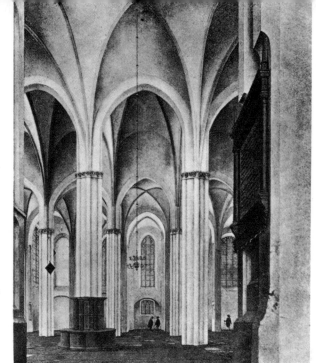

661. DUTCH. PIETER SAENREDAM (1597–1665). Utrecht Parish Church. *Six Foundation, Amsterdam.*

662. ENGLISH. SIR PETER LELY (1618–1680). Two Ladies of the Lake Family. *c.* 1660. *Tate Gallery.*

century. Ever since the second half of the 16th century, collections of engravings, the *Neuen Biblischen Figuren* (1564), *Römische Historie* (1570), *Neuw Thierbuch* (1569), popularised this means of expression, which Joachim von Sandrart, the 'German Vasari', author of the *Teutsche Akademie*, was to use in order to circulate reproductions of paintings. While etchings remained, in the Netherlands, the perfect method of rendering the subtleties of light and shade, Bloteling and Ludwig van Siegen were especially fond of the technique known as mezzotint and Herkules Seghers, that remarkable restless genius who was so full of new ideas, made bold experiments and tried colouring the finished engravings — which are, except for the ancient woodcuts, the first of their kind.

An art in its own right, engraving was during this period an enrichment of visual perception and sensitivity, a means of pursuing new spatial realms in monochrome; it offered the artist a new medium for his imagination and a means of experiencing all the lyrical possibilities of chiaroscuro. Rembrandt is the most spectacular example of these painters who found, in the biting effects of acid and in the cutting line of a burin, new artistic possibilities. The construction and animation of forms, in which the authenticity and eloquence of a line, its movement and intensity, were materialised in the preparation of a copper plate, created an expressive language that was hitherto unknown.

FRENCH CLASSICISM AND ITS PROLONGATION *Jacques Combe*

*From the time of the Counter Reformation, there had appeared,
in Italy in particular, a tendency towards a traditional form
of art based on certain predetermined laws.
This tendency came to a head in France. The French school,
after having hesitated during the reign of Louis XIII
between all the new possibilities offered by Italy, Spain and Flanders,
opted for classicism. This classicism, best exemplified
by Poussin, stemmed from Italian sources, and was based on a
rational lucidity similar to the Cartesian method.
Under Louis XIV it became the official form of art, which,
in spite of the rival Baroque movement in the 18th century, was
kept up in architecture, and was given new life,
especially in official painting, by David and Ingres.*

The term 'classical' has so many shades of meaning that it is
somewhat ambiguous. Yet for the French it signifies a familiar
and essential idea. Apart from specific doctrines, a certain kind
of classicism corresponds to a very marked tendency of the
French turn of mind. The literary, philosophical and artistic
expression of this classicism during the 17th century made a
deep and lasting impression on a people particularly apt, by
their very nature, to receive such an impression.

I. HIATUS AND EXPERIMENT UNDER LOUIS XIII

In the course of the 16th century the new ideas and tastes that
came from Italy were crystallised in France in a spirit of
moderation and strict order, in comparison, at least, with the
French art of the preceding century. These ideas took shape
round about 1600, when the country quietened down somewhat
after so many disturbances and catastrophes. But the years from
1610 to 1715, covering the reigns of Louis XIII and Louis XIV,
form a period that has nothing to do with the arbitrary limits
associated with the idea of a century. The death of Henry IV
in 1610 brought the French Renaissance to an end, both on the
historical and intellectual planes — Malherbe, Salomon de
Brosse, Métezeau and Jacques du Cerceau the Younger were
artists of a classicism that was as exclusive, perhaps, if not as
complete as that of the masters during the mature Louis XIV
period, and Henry II's ideas on town planning were already
rather Cartesian. But this classicism was somewhat abstract, with
that awkward stiffness which is often the mark — and the
charm — of something new. Compared with classical art and
Renaissance Italy, it still lacked that freedom of interpretation
and transposition essential for the development of any great
independent form of art.

It was only after the Louis XIII period and the early Louis XIV
period, so full of new ideas, experiments, aspirations and often
contradictory passions, those intense, fruitful years of useful
study and comparison, that French classicism was able to express
itself in any important works. It was only after these years of
distillation that France could produce a Racine, a La Fontaine,
a Jules Hardouin Mansart.

During the period from about 1600 to 1620 there was in
the development of French art a kind of silence, an absence,
especially noticeable in painting, in which the new followed
the old almost without transition. But, reduced to a pause or
a hesitation, the same phenomenon also took place in other
fields. Although the works of Lemercier, Le Muet, François

Mansart even, and then Le Vau, followed on with such apparent
ease from the works of Salomon de Brosse, the development
of French classical architecture felt its way among very dissimilar
experiments, among accumulated temptations and enticing
reasons for hesitating. From the end of the Renaissance to the
end of Louis XIV's reign there was in French architecture on
the whole a remarkable continuity, but one gets the impression
that during the first half of the 17th century it might have
developed in a different direction. The choice made then by
certain great masters, which accorded with the most profound
aspirations of both architects and their clients, determined the
lines along which French architecture was to develop.

Hiatus in architecture

Thus, as in literature, there appeared a kind of architectural
romanticism born of a taste for the rare, strange and irrational.
Isolated works in this romantic style developed along lines
parallel to the fleeting appearance of a French Baroque style,
which, though it derived from Italian Baroque, had distinct
characteristics of its own. The imaginative picturesque quality
was, moreover, intimately combined with a classicism that
clashed with it. Salomon de Brosse was, after all, responsible
for the Medici fountain, which is scarcely less extraordinary
than the later fountain (1636) of the château of Wideville.
François Mansart himself, the main craftsman of French clas-
sical architecture, had at the beginning of his career designed a
very unorthodox façade and dome for the Chapel of the Visit-
ation; and at Maisons he planned to exaggerate the normal 698
module to obtain trick effects of perspective, setting the body
of the château well back in an illusionary distance. This duality,
which was short-lived in François Mansart, is characteristic of
much of Louis Le Vau's work up to the beginning of
Louis XIV's personal rule. At Vaux le Vicomte (1656–1660) the 664
heaviness of the dome, the contradiction between the colossal,
rather ostentatious Order, and the high roofs with their archaic
interplay of sharp angles, the variations produced by the oval
plan of the central room, the disposition of a completely Palla-
dian façade in front of the dense mass of the dome, the placing
of statues whose disproportion makes them seem gigantic on
the ramps of the pediment, and, on the courtyard side, the
complex interplay of the joint-grooves and the beringed columns
— all these make of Vaux a hybrid building in which classical
elements seem to be distorted by some sort of romantic nostalgia.
The first Versailles palace (which we know from the detailed paint-
ing by Patel in the Versailles museum) by Le Vau (1661–1665)
seems to have been characterised by a picturesque and lively
polychromy rather than the serene classicism that the same
architect was to create a few years later on the garden side,
that new façade from which grew the Versailles of Jules Har-
douin Mansart.

Other architects, on the other hand, devoted as they were
to these tendencies, only retained the minor characteristics of
classicism. Antoine Le Pautre is perhaps the best example of 671
this. His Port Royal chapel, his hôtel de Beauvais with its oval
colonnade and highly imaginative decoration, and especially
the projects in his *Oeuvre d'Architecture* (1652) illustrate the
deliberately unexpected aspect of the architecture of the time.
But such intentions, however, had much more effect on archi-
tectural projects than on the buildings actually constructed.
This is proved by Marot's engravings, by Cottard's or Léonor
Houdin's projects for the Louvre, and by the temporary con-

663. FRANCE. Luxembourg palace, Paris (1615–1625).
Built for Marie de' Medici by Salomon de Brosse
(1565–1628) on the model of the Palazzo Pitti.
Engraving by Aveline.

structions built in light materials for special public occasions. The colonnade of the Louvre (by Perrault probably) is only so perfectly classical because the whole series of ornaments which appear in the projects was abandoned in the course of construction. The architectural profession and the taste and sensibility of the times in France were in favour of the budding classicism.

But that imaginative impulse, that tendency to create dreams out of stone, has left us some surprising works — the château of Raray with its double portico surmounted by a sculptured hunting scene; the château of Harfleur with its accumulation of polychromy, bosses, cartouches, projecting strips, breaks, the unexpected alternation of columns and pilasters which are both fluted and ringed; and then the numerous religious buildings, including the fantastic bell tower of the church at St Amand, whose strangeness cannot be explained merely by the influence of northern European Baroque.

In decoration this tendency was expressed with the greatest of freedom and perseverance. Apart from those weird grotto-like rooms which were the fashion for a long time and in which a variety of materials produced a dreamy effect totally opposed to classical art, decoration in the Louis XIII and early Louis XIV periods was imbued with a strong picturesque quality which was to have far-reaching results. This tendency has never completely disappeared from French decoration; with a hundred variations the Rococo arabesques and the floral naturalism which give Louis XVI woodwork its charm conserve something of the Louis XIII romanticism, of those garlands of fruit and flowers and those richly decorated ceilings that were more naturalistic than Baroque.

Hiatus in painting

The tendency to create within a tight circle of apparent contradictions a new classical form of expression, contrary to and against everything else, occurs also in the painting of the

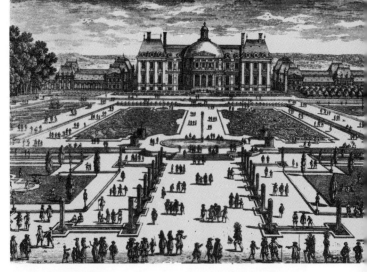

664. FRANCE. Château of Vaux le Vicomte (1656–1660).
Built for Fouquet by Le Vau (1612–1670).
The interior decoration and gardens in collaboration with
Le Brun and Le Nôtre. Engraving by Pérelle.

665. FRANCE. Luxembourg palace, Paris,
seen from the gardens.

666. FRENCH. GEORGES DE LA TOUR (1593–1652).
Irene Mourning St Sebastian. *Staatliche Museen, Berlin.*

667. FRENCH. GEORGES DE LA TOUR (1593–1652).
Hurdy-Gurdy Player. *Nantes Museum.*

Louis XIII and early Louis XIV periods. But here the actions and reactions, which were more complex and dispersed, are all the more revealing of the deep significance of French art in this period.

The pause in France during the years 1600–1620 was more like a gap as regards painting. There was at this time no ' grand old man ' of French painting; after the last products of the Mannerist Renaissance, the new generation had to start all over again. The artists who were most representative of the spirit of this first half of the century were almost of the same age as those who were to remain the great classical craftsmen, champions of a spirit that was to find a more general expression only with the apogee of Louis XIV. Vouet was born in 1590, Valentin in 1591, Callot in 1592, Vignon in 1593, Georges de La Tour and Louis Le Nain at about the same time, while Poussin was born in 1594, Claude le Lorrain in 1600, Philippe de Champaigne in 1602. These dates reveal the isolation of Poussin and Claude le Lorrain; like Descartes, born in 1596, and François Mansart, born in 1598, those two great minds were in advance of their time: La Fontaine was only born in 1621, Molière in 1622, Racine in 1639, and Jules Hardouin Mansart in 1646. Nothing is more eloquent than these dates. They show the importance, in this century, of certain exceptional men, great enough to go straight to the heart of their preoccupations, in order clearly to recognise an end which, even for their more talented contemporaries, remained vague and far off.

Yet how many tempting ideas and motifs there were to be found elsewhere. Almost everyone went to Rome or at least to Italy which was athrob with the Caravaggesque crisis, and which was full, too, of north European influences. But they drew on Caravaggio for his full static treatment of mass rather **139** than for his urgent problems of space. What is more surprising is that when Rubens was in Paris, painting the important Medici cycle for the Luxembourg palace, of extraordinary originality **584** at the time (1622–1625), which in favourable circumstances could have influenced an entire school, French painters learnt nothing from him. It was as if they did not know of his existence.

Whatever contact Georges de La Tour may have had with Caravaggio's work, it is quite clear that he is one of the most classical of the Caravaggesque painters. Though his lighting arrangements are in accordance with the formula of that school, the effects he produces with them are highly personal. He used light not to break up forms, but to produce an evenness, even more so than the Utrecht masters; the body of *St Sebastian* in **666**

668. PIERRE LE MUET (1591–1669).
Façade of the hôtel Tubeuf, Paris. 1635/41.

669. JACQUES SARRAZIN (c. 1588–1660).
Detail of the monument to Henri de Bourbon,
Prince de Condé (d. 1646). *Chapel, Château de Chantilly.*

670. CLAUDE VIGNON (1593–1670).
Croesus presenting his Treasure to Solon. *Private collection.*

671. ANTOINE LE PAUTRE (c. 1621–1691).
Hôtel de Beauvais, Paris. 1655.

672. PIERRE PUGET (1620–1694).
The Head of Medusa. *Louvre.*

673. SÉBASTIEN BOURDON (1616–1671).
Self-portrait. *Stockholm Museum.*

674. LIBÉRAL BRUANT (c. 1635–1697).
Les Invalides, Paris. 1670/76. Main entrance gate.

675. JEAN BAPTISTE TUBY (c. 1630–1700).
The Saône (detail). 1683. *Parterre d'eau, Versailles.*

676. VAN DER MEULEN (1632–1690).
Louis XIV on Horseback. *Dijon Museum.*

17TH-CENTURY FRENCH ART

ARCHITECTURE

SCULPTURE

PAINTING

Born about 1590

668

669

670

Born about 1620

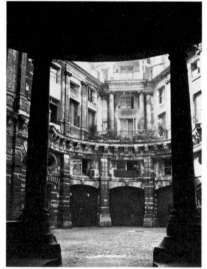

671

672

673

Born about 1630

674

675

676

677. FRENCH. ROBERT TOURNIER (1604–c. 1670).
Descent from the Cross. *Musée des Augustins, Toulouse.*

678. FRENCH. JACQUES BELLANGE (documented at Nancy
between 1600 and 1617). The Three Marys
at the Sepulchre. Engraving. *British Museum.*

679. FRENCH. JACQUES CALLOT (1592–1635).
St John on Patmos. Engraving.

Berlin and certain faces and dresses are arranged as large monumental surfaces in which the light brings out an abstract quality that almost suggests Ingres. There is even in his work (*Job and his Wife*, Epinal museum) a far-off echo of Masaccio and the great 15th-century classics. That is perhaps the reason why, after centuries of oblivion, his work is so well received today. Behind the Caravaggian surface, La Tour in fact continues a classicism of ancient and noble standing — the tradition of 429 Piero della Francesca and Fouquet. In this, his work is a particularly good example of the most profoundly revealing advances of French thought.

Among the other French Caravaggesque painters there were some, like Valentin, who came so close to the master that they 778 were perfectly in place among their Italian contemporaries, French characteristics being confined to certain details. On the other hand, Tournier, who was, moreover, a pupil of Valentin 677 in Rome, counteracted the Baroque use of light with a very personal and static way of handling figures with a serene evenness of movement, a certain harmonious moderation in the relations between gesture, expression and sentiment, whose equilibrium, which might almost be called classical, is similar to the harmony of Gothic statuary. In Tournier and in La Tour, though along different lines, the temptation of a modernism that was fascinating then, but difficult for the French to assimilate, resulted in a secret act of faith in the essential values of French art. La Tour lived at Lunéville, while Tournier was from Toulouse: the provinces contributed largely to the formulation of a new tradition and style.

An unexpected note was added in Lorraine where Callot, Deruet and Bellange slipped through Mannerism into the 777, 678 bizarre, the fantastic and the picturesque, in the same way, as we have seen, as contemporary architects.

In Rome and particularly in Florence Callot (who died in

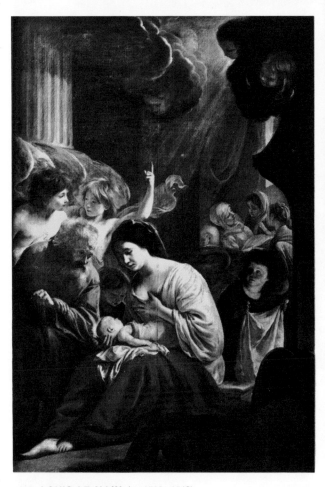

681. LOUIS LE NAIN (*c.* 1593–1648).
Peasants' Meal. 1642. *Louvre*.

680. LOUIS LE NAIN (*c.* 1593–1648).
The Holy Family tended by Angels. *St Etienne du Mont, Paris*.

682. *Right*. MATHIEU LE NAIN (*c.* 1607–1677).
The Dancing Lesson. 1655–1660.
Maurice Bérard Collection, Paris.

683. ANTOINE LE NAIN (1588–1648). Young Musicians.
Private collection.

684. FRENCH. CLAUDE VIGNON (1593–1670).
Christ among the Doctors. 1623. *Grenoble Museum.*

685. FRENCH. LOUIS LE NAIN (c. 1593–1648).
Peasant Family. *Louvre.*

686. FRENCH. SIMON VOUET (1590–1649).
Ceres. *National Gallery, London.*

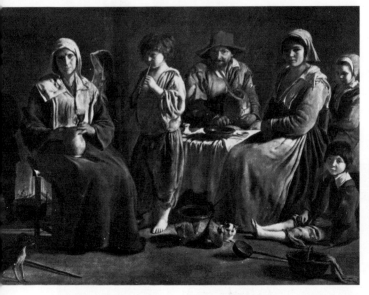

679 1635) found in the last Mannerist works a starting point for the development of that fantasy, that sharp linear imagination, that rich iconographic invention which made him one of the main exponents of Louis XIII romanticism — a romanticism that found its essential form of expression in literature. The taste for 'bambocciate', 'caprices', fleeting images, ceremonies, feasts and fairs, all these reflect the lure of the fantastic; Callot was to go so far as to revive the old medieval theme of the temptation of St Anthony, which Bosch, above all an artist of the fantastic, had interpreted.

777 One can range alongside Callot the weird refinements of the allegories painted by Claude Deruet, and also, no doubt, those twilight cities, those petrifications of history in which Monsu Desiderio projects his imagination on to ancient Rome (if, as now seems to be agreed, this mysterious name was a cover for two French painters from Lorraine).

The work of Louis Le Nain is of quite different historical importance and of quite different spiritual significance. The Le Nain brothers, who also came from the provinces, were strongly marked by their Laonnais background, and tied to very local and immediate subjects. They were able, thanks to the genius of Louis, to develop one of the most subtle and essential elements of French art. While the youngest of the three, Mathieu, who 682 had something in common with Dutch art, pursued an elegant career right up to the height of the Versailles period, Antoine 683 and Louis belong to the first half of the century. Louis' art echoes the experiments and problems, which often seem contradictory, of the years 1620–1650. 'Antoine and Louis Le Nain,' Mariette, author of *Abécédario*, tells us, 'painted bambocciate in the French taste.' The similarities between Louis and the northern Romanist bambocciata painters are obvious. Though his religious paintings remind one of Gentileschi, and

MASTERPIECES OF NICOLAS POUSSIN
(1594–1665)

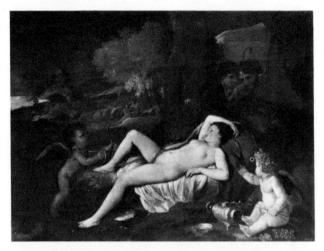

687. Venus Asleep. c. 1630. *Gemäldegalerie, Dresden.*

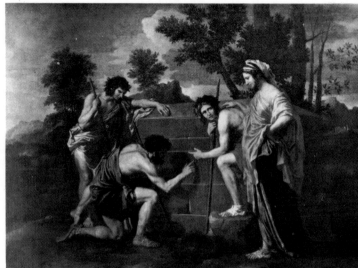

688. Arcadian Shepherds. 1638–1639. *Louvre.*

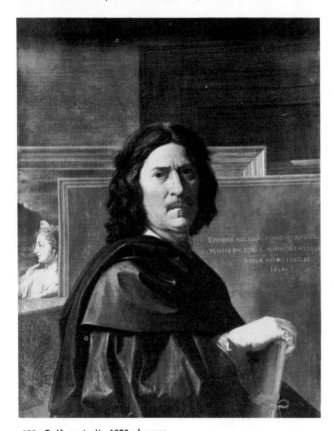

689. Self-portrait. 1650. *Louvre.*

690. Blind Orion in Search of the Rising Sun. 1658.
Metropolitan Museum of Art (Fletcher Fund. 1924).

his *Forge* resembles Velasquez, he was very far from Caravag- 426
gianism in spirit. His relationship with objects that he saw
was very different from that of his contemporaries, both from
the north and from the south. The light which bathes the
Waggon (1641) or the *Peasants' Meal* (1642) tends towards a 681
serene, even effect, as in the architectural Orders and mould-
ings of François Mansart: it tends towards a classical effect in
'the French taste'. Similarly, in his transcription of faces or
sites, each detail is uniquely inscribed among the neighbouring
details: each wrinkle, each detail of the ground brings out
with reserve the response of a spontaneously disciplined sensi-
bility to the appeal of the subject. Far from the analytical
reasoning of a Poussin and indifferent to the canons of antique
statuary, Louis Le Nain, with solid meditation, gives the horse
in the *Halte du Cavalier*, and the dogs that sit attentively at
the feet of his peasant families, that sense of eternal suspense 685
which moves us in the best of Poussin's work.

Thus the yearning towards a French classicism, often expressed
in a surprisingly roundabout way, was deep-rooted and irre-
sistible. Italian art certainly supplied a number of hints, but
the movement was based on an inner necessity, which some-
times even opposed its own surface tendency. So it seems wise
to forget the unreasonable significance that has been generally
attributed to Vouet's return from Italy in 1627. There is no
doubt that this enchanting artist brought back a certain famil-
iarity with a number of novelties and skills, not to say conven-
tions, and that these found a deeper echo in the Paris of the
time than did the fleeting and discreet passage of Rubens at
the Luxembourg palace. Yet there is no question here of a
violent Italianisation as has sometimes been thought; and, more-
over, however Italianate Vouet may be, he was never really 686
Baroque. When he yielded to the charm of the Venetians, as
in the beautiful *Allegory of the Arts* (in the National Gallery in
Rome) painted at the beginning of his new manner in a clear,
rather academic style, his straightforward decorative brush- 783
work is more like David in the *Oath of the Horatii* than
Titian or, closer to him, Francesco Mola. In France his easy
progress was blazed with elegant decorations, which did not
run counter to the Parisian work of Romanelli and which
anticipated Le Brun.

Moreover, one must take into account, in a painting done
in those years of lively individualism, the Rembrandt-like
romanticism of Vignon, the abstract nature of the still lifes by 670
Baugin, and the personal note added by so many minor pro- 781
vincial masters.

II. THE RISE OF CLASSICISM

Nicolas Poussin

687–691 It must not be forgotten that in the course of those same years Nicolas Poussin was in Rome, meditating and painting. Born near Les Andelys, he went very early to Paris, where he studied, Félibien tells us, the engravings of Raphael and Giulio Romano. Of these years we know next to nothing. In 1624 he went to Rome, where he spent all his life, except for an unhappy stay in France, from the end of 1640 to 1642, at the request of the king. In the Baroque and cosmopolitan Rome of the years 1625–1650 Poussin was to construct methodically an art that corresponded with the views and demands of his lucid mind, and, fully conscious of his ends, he was to achieve the most classical form of expression in French art. Poussin had a profound love of ancient sculpture, not merely the verbal and academic taste which was the fashion, but a lucid passion. Just as Cézanne later wanted to 'recreate Poussin after nature', so Poussin wanted to recreate classical art after nature. An extract from one of his letters to his friend Chantelou throws light on his concept of art: 'The beautiful girls you have seen in Nîmes would not, I am sure, have visually delighted your mind any less than the beautiful columns of the Maison Carrée ... The latter are merely old copies of the former.'

691 He made drawings of antique works of art, but, Félibien emphasises, when he went out, 'he observed all the movements of the people he saw.' His sketches and wash drawings, in the Baroque manner, in which life is captured in such a cursive way that one sees them to be the instantaneous response of the eye, are proof of the freshness of his vision. But in the finished, painted work, each brush stroke is placed with deliberate intention. It often happens, particularly in the last years of his life, that a breath of abstraction freezes his figures, holding them in abruptly suspended movement. But, thanks to the invariably sensitive draughtsmanship and modelling, the figures remain charged with a life which is all the more explosive as the reserved expression restrains it within stronger limits. In the same way Racine was able to express the most violent psychological movements in the relentless rhythm of Alexandrines and in the strict vocabulary allowed by the rules of a rigid convention.

Apart from antiquity, Poussin liked those modern artists who had the most feeling for the classical spirit — especially Raphael (for instance, in Poussin's *Parnassus* in the Prado), his pupils and Domenichino, but also those who, like Titian or the Carracci, were able to respond to suggestions of light and colour without abandoning style. What exactly did he know about classical painting? We know that he copied the *Aldobrandini Marriage*. He seems in any case to have felt intuitively more than he actually knew about it. The evolution of his art up to his brief return to France does not follow a very definite curve, and one notes in his work a repetition, deepening and enrichment of his themes. Sometimes an analytical tendency draws everything towards abstraction (the *Triumph of David*, Dulwich, c. 1626; *Chasses de Méléagre*, Prado, c. 1632–1636); sometimes sensibility and even sensuality tend to elevate the tone (*Triumph of Flora*, Louvre, c. 1630; the series of Bacchanals; *Inspiration of the Poet*, Louvre, c. 1636). After his return to Rome, he seemed to explore more and more methodically the spatial concepts derived from the classics of the Renaissance. We know that he applied Alberti's ideas. Figures, architecture and landscapes all obeyed the same laws of reasonable and structural expression. His compositions were loaded with more and more intentions and ideas. He conceived each class of subject as if it had to be treated in a way comparable to architectural Orders or musical modes.

693 In his last years he painted large allegorical scenes in which

687

195

691. FRENCH. NICOLAS POUSSIN (1594–1665). Landscape. Wash drawing. *Louvre.*

692. FRENCH. CLAUDE LE LORRAIN (1600–1682). The Expulsion of Hagar (Morning Landscape). *Pinakothek, Munich.*

693. FRENCH. NICOLAS POUSSIN (1594–1665).
Landscape with a Snake. *National Gallery, London*.

minute figures are set in vast landscapes, in which man is related to mountains and trees with a dignity and serenity worthy of classical Greek art. Here, as in *Berenice*, is to be found the ultimate expression of French classicism.

Claude le Lorrain

692, 694 The life of Claude Gellée reflects, but on a more restricted intellectual scale, that of Poussin. Born in 1600 in a village in Lorraine, of very modest origins, Claude left for Italy while quite young. There he seems to have begun to paint along with Agostino Tassi and an obscure Neapolitan. From 1625

777 to 1627 he stayed at Nancy with Claude Deruet, whose influence is probably reflected in the drawn-out module and precious ornamentation of his architectural pieces. He never left Rome again, but died there in 1682. We know almost nothing about him before 1630, when he began to acquire his ever widening reputation. Claude had little culture, and did not share the intellectual preoccupations of Poussin. While Poussin acquired his understanding of the ancient spirit by examining the masterpieces of statuary, Claude arrived at the same spirit by a sensitive response to the beauty of the Roman countryside, littered with the remains of antique grandeur.

By the exactness of their tonal values, Claude's sepias are proof of his spontaneous reaction to the light of the south. He found his style by keeping as close as possible to the natural effects of light. Of course he composed the volumes and spaces in his landscapes, but in this respect he had greater pictorial ease than had Poussin. He sometimes adopted the reasoned sculptural concepts of Domenichino and Poussin; but usually he tended towards the manner of those northern painters who

603, 630 had been his first models, Brill, Elsheimer, Tassi, adding in all kinds of picturesque detail. The veritable harmony and classicism of his paintings owe more to his deep feeling for light than to the strictness of his composition. The figures, which he did not always do himself, are reduced to the function of punctuation. The areas of vegetation, the ruins and the architectural features, in his very personal and crystalline style, are well organised according to a definable harmony, but the

694. FRENCH. CLAUDE LE LORRAIN (1600–1682).
Landscape: Hagar and the Angel.
National Gallery, London.

695. FRENCH. EUSTACHE LE SUEUR (1616–1655).
Plan of the Carthusian Monastery, Paris (detail). One of the
22 paintings of the Life of St Bruno, done between
1645 and 1648. *Louvre*.

696. FRENCH. LAURENT DE LA HYRE (1606–1656).
Allegory of Music. *Metropolitan Museum of Art
(Charles B. Curtis Fund, 1950)*.

697. FRENCH. PHILIPPE DE CHAMPAIGNE (1602–1674).
Jacques Lemercier. 1644. Lemercier was architect
of Val de Grâce. *Versailles Museum*.

predominating element is the light which is equally important
in the structure of the work: it is this that was original. A
Claude landscape is essentially a construction of light correctly
illuminating ground surfaces, trees, stones, intangible mists, all
these being mainly a pretext and support for the composition
of light rays. In about the years 1640–1655 this luminous
aspect reached its zenith; it was then that he painted his har-
bours, in which a rising or setting sun is seen directly from the
front, with its concentrated beams fixed in a magnificent net-
work on columns, mouldings, waves and rigging. This was
the period, in about 1648, of the two versions of the *Mill* (one
is in Rome, the other in London), and also probably of *Apollo's
Temple* (Doria Pamphili Gallery, Rome), the most Poussinesque
of his works. The landscapes with increasingly atmospheric
horizons painted at the end of his long life were illuminated
by evening light which expressed a questioning melancholy, a
mystery, an anxiety (the *Enchanted Castle*, 1664, English collec-
tion; *Evening*, 1672, Hermitage), and which coincided with a
new tendency towards a certain asymmetry (*Morning*, 1677,
Hermitage; *Noli me tangere*, 1681, Frankfurt), and even a certain
fantastic element in landscapes (*Acis and Galatea*, 1657, Dresden;
Perseus and Medusa, 1674, English collection) or in architectural
pieces (*The Expulsion of Hagar*, 1668, Munich). Even the most
strictly classical artists gave way readily, in spite of themselves,
to the voice of dreams.

Besides these two great artists, Poussin and Claude le Lor-
rain, some other painters were won over to the new classicism.
La Hyre had studied the Fontainebleau decorations, so neglected 696
at that time, and when he adopted Poussin's ideas there was
in his rather distant classicism a faint echo of the elegant Manner- 430
ist arabesque. Le Sueur, who was younger (born in 1616), did 695
not know Italy either, but was to find the Italian spirit in
Raphael's prints and tapestries which made him forget the lesson
of Vouet. He then met Poussin during his stay in Paris. Formed
by these two influences, Le Sueur developed a frankly classical
style, which, like Raphael's, could express a primeval freshness
(*The Muses*, 1647–1649; *Mass of St Martin*, Louvre) as well
as a visionary abstraction (*St Bruno distributing his Worldly Goods*,
Louvre).

698. FRANCE. Château of Maisons Laffitte
(façade facing the Seine). Built between 1642 and 1650 by
François Mansart (1598–1666).

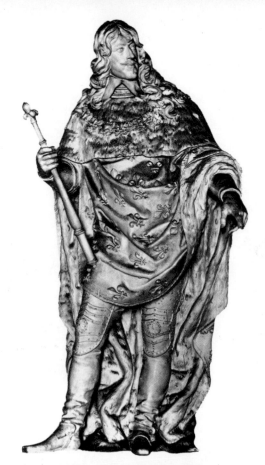

699. FRENCH. SIMON GUILLAIN (1581–1658).
Louis XIII. Bronze. From the monument set up
in 1647 at the entry to the Pont au Change, Paris. *Louvre.*

Philippe de Champaigne (1602–1674) testifies to the attraction of this growing classicism, for this Flemish painter was able to conceive a portraiture that was more classical than that of any of his contemporaries. His scorn for pictorial effects, his austere analysis, his rejection of the temptations of colour, firmly restricted to local tones, and above all his constant adherence to the model, giving equal importance to each line of the face and hands — by all these means he avoided any accent that might destroy the meditative continuity. In this way, the series of Jansenist portraits by this Flemish artist is one of the most purely French events in the history of portraiture.

Foreshadowing the Louis XIV style in sculpture and architecture

The sculpture of the preceding period was a long way behind painting and architecture. The development of a new style in sculpture was much slower and was not fully formed until the time of Louis XIV. Guillain, Varin and the Anguier brothers remained minor artists. Only Jacques Sarrazin's work is important, the more so as most of the sculptors of the following generation were to work in his studio. In Rome (about 1610–1627) he seemed, like Poussin, to have found only the encouragement of a strict discipline, and he absorbed nothing of the early Baroque. His great merit was to have maintained in the decoration of the château of Maisons an exceptionally fresh sensibility in the deliberately abstract lines which are in perfect keeping with the spirit of François Mansart. This Mansart-Sarrazin understanding was particularly valuable. For it was especially in the joint work of architects, sculptors and decorators that art under Louis XIV reached such heights: Maisons foreshadowed this. Though Lemercier, Le Muet and others played an important part in the development of a French classical architecture, the decisive part was played by the great architect François Mansart. In his principal works, the Blois and Maisons châteaux, Mansart did not reject any of the traditions of the previous century (he had worked under Salomon de Brosse); but by a subtle choice of proportions, by the strict moderation of the relief accorded to each element, and by the calculated arrangement of a sober and restrained decoration, he created

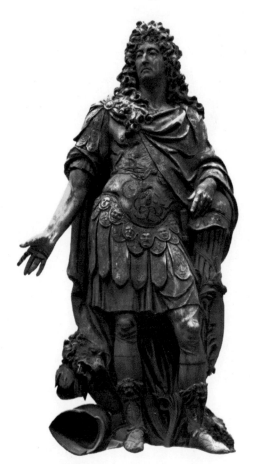

700. FRENCH. ANTOINE COYSEVOX (1640–1720).
Louis XIV. Erected in 1689 at the town hall, Paris. Bronze.
Carnavalet Museum, Paris.

VERSAILLES

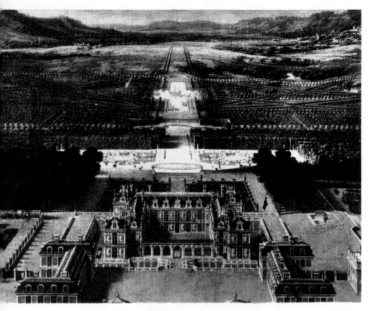

701. FRENCH. PIERRE PATEL (1648–1707).
The château and the gardens (detail). c. 1668.
Versailles Museum.

702. FRENCH. View of the château on the garden side,
with the first arrangement of the parterre d'eau. 17th century.

703. The 'Hundred Steps'.

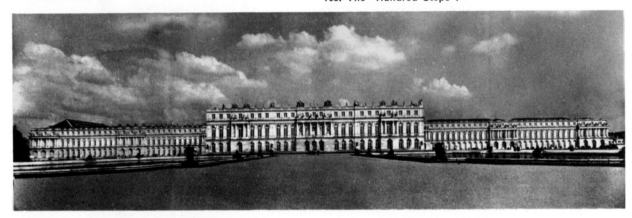

705. The central gallery of the Orangery. 1681/86.
Built by Jules Hardouin Mansart. It is lit by
thirteen arched windows set in recesses built in the vaulting.

704. The château from the gardens.
The central part was built by Louis Le Vau (1668/78);
the north wing (left) by Jules Hardouin Mansart (1684/89);
the top of the theatre at the end by Jacques Ange Gabriel
(1770); the south or princes' wing (right) by
Jules Hardouin Mansart (1678/82).

706. FRENCH. ANTOINE COYSEVOX (1640–1720).
Urn (called Vase de la Guerre). Marble.
1684. Terrace looking towards the north parterre.

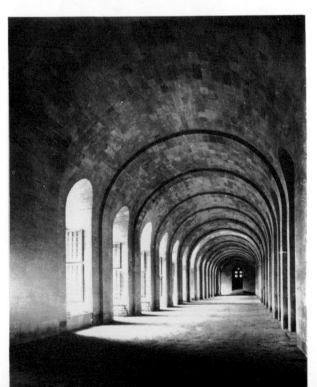

707. FRENCH. GASPARD MARSY (c. 1626–1681).
The Horses of the Sun. One of three sculptured groups,
originally in the Thetis grotto (demolished
to make way for the north wing) and now in the grotto of les
Bains d'Apollon (see 708).

708. FRENCH. HUBERT ROBERT (1733–1808). Grotto of les
Bains d'Apollon, with the group by Girardon (see 723).
This grotto, designed by H. Robert, was completed in 1781.
Versailles Museum.

709. ITALIAN. BERNINI (1598–1680). Louis XIV.
Commissioned for the Orangery.
The king did not like it, so it was placed at the end of the
Swiss Lake and given the name of Marcus Curtius.

710. The rose-coloured marble peristyle
on the garden side of the Grand Trianon (1687–1688)
from designs by J. H. Mansart.

711. The entrance of the Grand Trianon. Built on the site
of a former little château known as the 'Trianon
de Porcelaine', the new palace was called the 'Trianon
de Marbre' until the 'Petit Trianon' was built by Gabriel
for Louis XV. In the course of construction, which was
remarkably quick, Louis XIV had the original plans altered
by Robert de Cotte.

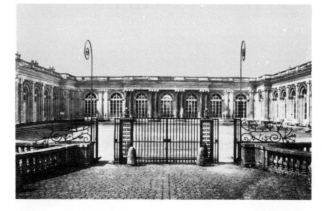

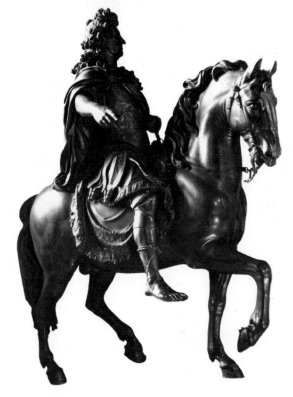

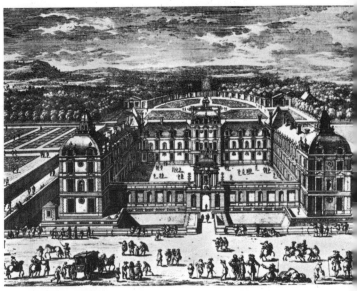

713. FRANCE. Richelieu's château in Poitou (entrance side). Built between 1625 and 1635 by Jacques Lemercier (1585–1654). Engraving by Pérelle.

712. *Above, left.* FRENCH. FRANÇOIS GIRARDON (1628–1715). Louis XIV in Roman Costume. A bronze model of the statue put up in 1699 in the Place Louis le Grand, Paris, and destroyed in 1792. *Louvre.*

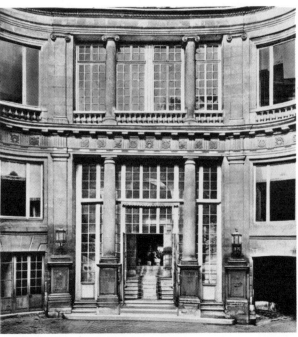

714. FRANCE. Courtyard of the hôtel Lambert, Paris. Built in 1640 from plans by Louis Le Vau (1612–1670) for President Lambert de Thorigny.

715. FRANCE. The Petit Trianon at Versailles (façade overlooking the French garden). Built by Jacques Ange Gabriel (1698–1782) between 1762 and 1764.

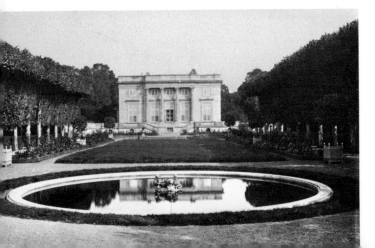

a style. Not only was the architecture at the height of the reign modelled and influenced by him, but certain aspects of Blois (the windows on the garden) and Maisons (the staircase) foreshadowed the art of the Louis XIV period. More than anyone else, Mansart contributed towards the development of that golden rule of French classicism, which was stronger and more efficient than all the decrees of the Academy — the evenness, the suppression of any emphasis on a single element at the expense of the adjoining elements. In building as in literature, this method produced the most subtle variations and highly expressive inflections. Openings, pilasters, columns, entablatures, and those beautiful slabs of stone with which he liked to break up the solid parts of a building where there were no intervening Orders — all these elements are linked by the delicate interplay of slight projections, low bossages and fine mouldings that cast restrained shadows.

Louis Le Vau was fourteen years younger. More open to the temptations of a restless imagination than was Mansart — as we have seen — his most classical works have a more calculated, abstract quality. One often senses — which was an 664 exception in France, particularly in this period — a direct echo of Palladio: this is the case in the central salon of the château of Vaux le Vicomte which is in such strong contrast to the exterior of the building, or again in the elevations of the hôtel Lambert, or in the extraordinary façades of the châ- 714 teau (now destroyed) of St Sépulcre. This duality followed Le Vau right through his career. Shortly after his designs for the Collège des Quatre Nations in Paris (now the Institut de France), one of the buildings most closely related to the Baroque that has ever been built in France, his last work was the Ver- sailles façades (the ones on the garden side). So he left, as a 704 kind of testament, a work from which grew the architectural style, that classical style par excellence, of the Louis XIV period — a style symbolised in the names of Jules Hardouin Mansart and Robert de Cotte.

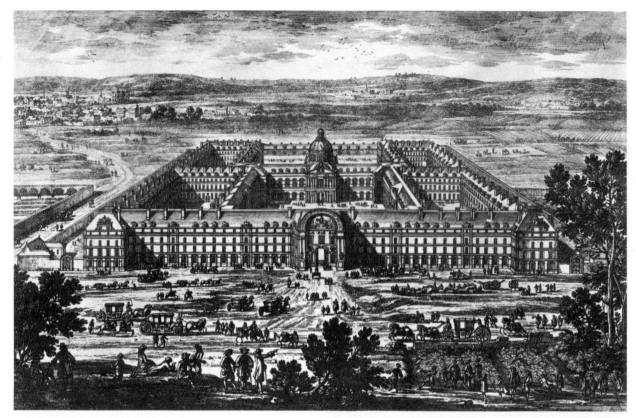

716. FRANCE. Les Invalides, Paris. Engraving by Pérelle.

III. THE ART OF VERSAILLES

The regular façade, with its strictly geometric volumes, the
terraced roof replacing the multiple contour of the roofs with
701 a clear-cut sky-line, the whole subdivided into equal sections
705 by the rows of regular openings, and varied only by slightly
projecting parts and by the setting back of the central terrace
— in all this, Versailles represents the culmination of classical
architecture in about 1668.

Louis XIV and architecture

This essential building was to remain in its pure form for
only a few years. From 1678 the extent of the king's projects
obliged the young architect, Jules Hardouin, to make important
changes. This entire evolution had been determined by the
ideas of certain men who were intimately connected by their
family attachments and their professional training — François
Mansart, trained under Salomon de Brosse's team, Jules Hardouin
Mansart, François Mansart's nephew, and Robert de Cotte,
Jules Mansart's son-in-law. One might say that this style was
born of the association, during a few decades, of certain excep-
tional men. All the doctrinal side, embodied in the Academy
(founded in 1671) and in a few essayists who represented the
criticism of the time, was hardly more than so much talk that
had no decisive influence.

The real creators found a more effective support in the intel-
lectual and technical attainments of their collaborators and in
the strong inclinations of their clients from the king down-
wards. François Blondel, an architect of great merit, had no
greater say despite his *Cours d'Architecture* than had Boileau
with his *Art Poétique*. It was, in a certain sense, against theoretical
717 teachings that the Invalides chapel was to be built and that
Molière's and Racine's plays were written. The central doc-
trine of the imitation of classical antiquity remained but a
pious lie.

717. FRANCE. Church of the Invalides, Paris.
Begun in 1679 by Jules Hardouin Mansart, completed after
1708 by Robert de Cotte.

718. Plan of the gardens of the château of Clagny built by
Jules Hardouin Mansart (1646-1708) for
Madame de Montespan, from 1674 to 1678: demolished in 1769.
Gardens designed by A. Le Nôtre (1613-1700).
Engraving by Pérelle.

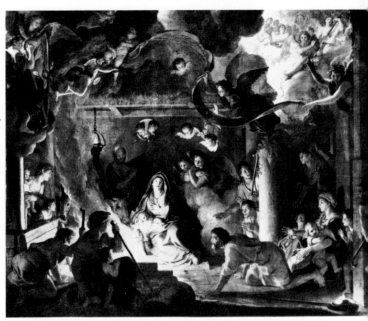

719. FRENCH. CHARLES LE BRUN (1619-1690).
Adoration of the Shepherds. 1688. *Louvre.*

720. FRENCH. ANTOINE COYPEL (1661-1722).
Democrites. 1692. *Louvre.*

In 1678, at the age of thirty-two, Jules Hardouin Mansart took over the work of Le Vau. He already had behind him several buildings which revealed his style: a particular suppleness in the handling of classical forms which was to make his work an important source of the architectural style known as 'Louis XV' (the châteaux of Le Val, 1674, and of Clagny, **718** 1676, both destroyed). But it was at Versailles that he proved his worth in transforming Le Vau's façades on the garden side. He suppressed the central terrace, and so made room for the **704** Hall of Mirrors which he designed in collaboration with Le **731** Brun. He replaced the rectangular windows of the first floor with arched windows decorated with grotesque masks on the keystones, which completely change the elevation, giving it a pleasant freedom. It was a very revealing modification for it throws light on the evolution of the years 1680 to 1710.

After building the wings, which in a set-back position re-echo the same uniform rhythms, Mansart contributed, in the work on the Grand Commun, a decisive element of the classical concept of the town house as being neither palace nor hôtel; this concept of the town house lasted throughout the 18th century and into the 19th. Then came that unusual masterpiece, the Orangery, in which the wide bays and the strong module of the columns are maintained in the grand classical manner by the choice of the Doric Order, by the delicate moulding of the cornice and, above all, by the device of the long horizontal slits whose unbroken parallel lines follow the entire length of the façade, giving the whole a sustained evenness. The interior is of even greater originality and simplicity — a long, generous and bare semicircular barrel vault, marked **705** only by transverse arches in low relief and without ornament, base or moulding. The effect is produced only by the proportions, the sweep of the bays and the subtle bonding of the beautiful white stone. It is one of the most important works of French art and recalls some of the best of Romanesque art. One of the purest aspects of classicism, it has an almost ethereal evenness.

All these works were part of a vast overall plan, which made the entire site obey the laws of reason. Around the king's bed,

721. FRENCH. CHARLES DE LA FOSSE (1636–1716).
Sunrise. Sketch for the ceiling of the
Apollo Gallery at Versailles which was completed in 1681.
Rouen Museum.

722. FRENCH. PIERRE PUGET (1620–1694).
Perseus and Andromeda. 1684. Commissioned for the
gardens of Versailles. *Louvre.*

which was the quasi-mystic centre of the whole, around the king's bedroom and his quarters, there grew up an immense scale model of the state, in which every detail was determined by the architect; lodgings for princes of the blood and courtiers, offices for the secretaries of state, service rooms, cult rooms, reception rooms, walks and amusements, vistas opening on the horizon — everything conformed to the strict laws of a general composition.

718 Le Nôtre, who planned the gardens, was one of the most eminent creators of this new concept of art. At Vaux le Vicomte the abstract purity of his work brought out the hybrid character of Le Vau's creation. At Versailles the harmony between the building and the gardens is perfect. By means of enormous excavations, the entire park was made to play its part in the

701 overall effect. The lay-out of the grounds, beginning with the vast ornamental water garden, the slope of the alleys and vistas, the arrangement of trees and plants, the sculptures and fountains, all these express the most intellectual kind of art; a walk in these gardens is so much like a ritual that the king took care to lay down a certain itinerary to be followed in this abstract park, so that its beauty could best be appreciated.

To this successful understanding between Mansart and Le Nôtre, Marly added a complementary variant: with its numerous cube-like pavilions setting off the royal pavilion, an extremely abstract architecture gave rhythm, and not simply axes, to the severely measured planning of the site. Only Le Brun's contribution (exterior façades painted with trompe l'oeil decoration) added a Baroque touch to the general composition. There is much to be said concerning the part played by Le Brun in the decoration of the time. Theoretically classical, he was in fact a

719 Baroque painter and designer, whose intended and, one might say, affected reasoning resulted more often than not in effects that were far from his pretended strictness. If the tapestries made at the Gobelins under his directorship are so representative of Louis XIV classicism, it is due not so much to his cartoons as to the tapestry weavers who, in choosing their wools and in marking out each coloured surface, invariably controlled and even counteracted the style of the painter. In the same way, in

723. FRENCH. FRANCOIS GIRARDON (1628–1715)
and THOMAS RENAUDIN (1622–1706).
Apollo Tended by the Nymphs. 1666/75. Originally in the grotto of Thetis at Versailles, it is now in the grotto of les Bains d'Apollon (see 708).

724. FRENCH. ANTOINE COYSEVOX (1640–1720). Prince de Condé. Bronze. *Louvre.*

725. FRANCE. Hôtel de Peyrenc de Moras (hôtel Biron), now the Rodin Museum. Built between 1728 and 1731 by Jacques Gabriel (1667–1742).

726. FRANCE. Grand Staircase of the Grand Théâtre, Bordeaux. Built between 1773 and 1780 by Victor Louis (1735–1807).

the Grande Galerie at Versailles the ceiling decorations add a 731 Baroque touch which is deadened by the restrained naturalism of the sculptures, so as not to break the subtle evenness obtained by the large surfaces of mirror, which give the blind wall as much light as the façade wall.

After the period 1678–1685, which saw the transformations of Versailles, Mansart's career was to be marked by three important monuments, apart from his town planning work in Paris (Place des Victoires, Place Vendôme). These were, first of all, the 776 Grand Trianon (1688) in which, developing the idea of the 710 château of Le Val, particularly in the wing known as the Trianon sous Bois, he anticipated the inventions of the following century. Finally, the masterpieces of his late years, both completed by Robert de Cotte, were the chapel of the Invalides and the 717 chapel of Versailles. These two buildings, of exactly the same period (1698–1710) and built by the same team of assistants and decorators, throw light on the two aspects of J. H. Mansart's genius: while the chapel of Versailles, through its decoration, looked towards the future, the Invalides chapel is the outcome of the classical concepts worked out fifty years before by François Mansart. Jules Hardouin in fact took the overall idea, the proportions and the general lines of this work from an elaborate project designed by François Mansart in 1665 for a proposed funerary chapel at St Denis; and, as a homage to that great master, he treated the idea in a style that recalls François. The exterior of this chapel, built at the turn of the 17th century, is like an exemplary résumé of the aims of French classical architects. It is enough to think of Italian Baroque while looking at this chapel to appreciate the essential differences between the two styles. The lesson is even more complete when one sees Mansart's dome rise above the harsh elevations of the hôtel des Invalides, by Libéral Bruant. This is one of the finest examples 674 of that austere architecture, whose soberness expressed strength and stability more than abstract clarity, and which was the achievement of a whole series of technicians who were half engineer, half architect. For military, administrative or religious purposes, these men constructed solid dignified buildings, which were usually stripped of all the charms of ornamentation, but were well suited to their site and function — the fortifications and gates by Vauban, convents and chapels by Jesuit architects.

The official doctrine and its decline

The poor quality of painting during the last decades of the 17th century is surprising. Just when the decorative arts found such a robust form of expression, painting languished in confusion and mediocrity. The style had been set, in its pure form, half a century before by Poussin and Claude le Lorrain. But in the absence of such strong personalities, the teachings of the Academy only spread contradictions. It ceaselessly recommended the imitation of ancient classical art, of Raphael and of Poussin, and scorned the northern masters; but behind the reiteration of such formulas was the example of Le Brun, with his feeble
719 Baroque, his indecision and his academic style. The inconsistency of the master affected his disciples, who without renouncing the basis of official teaching turned towards Rubens and the despised Flemish painters; but they did so coldbloodedly, without conviction, academically. Formula tended to take the place of inspiration, hence the failure of the vast painted decorations at Versailles and in the Invalides chapel. The Rubensian
721, 720 character of La Fosse and Antoine Coypel — which sometimes verges on imitation — was no more than an elegant exercise.
435 Jean Jouvenet alone retained up to the end of the reign some of the robustness of the 1620–1660 period.

The art of Versailles is well expressed in the sculptural deco-
672, 722 ration. But Pierre Puget, who was completely independent, was entirely ignorant of the French art of his time. In Florence and Rome from 1640 to 1643, this southern artist was influenced
272 by Michelangelo and Bernini. Up to his death in 1694 his work resolutely followed the Italian tradition and anticipated the Austrian Baroque (two statues in Sta Maria di Carignano, Genoa) rather than 18th-century French art. His *Milo of Crotona* was accepted for the Versailles gardens, but this powerful genius was only fully appreciated in the 19th century.

It was Girardon who best interpreted Le Brun's ideas. Under
723 the influence of Greek sculpture (*Apollo Tended by the Nymphs*), and also of the Bolognese Baroque (Richelieu's monument in the Sorbonne), he achieved a subtle balance between the dictates of style and a very sensitive naturalism; he did much to set the
712 general tone of the Versailles decorations. However, the most representative artist of this period was Coysevox. He was only
669 indirectly influenced by Sarrazin's teachings, whose deep significance he understood better than anyone else. Coysevox's early Versailles works reveal a strict classicism (marble vase
706 depicting *War*, 1684) but he soon adopted a grand manner,
775 which is related to antiquity in a way analogous to Hardouin Mansart's work. Despite a complete transposition, the same spiritual values were retained (water gardens with statues representing *The Garonne* and *The Dordogne*; Mazarin's tomb). In his series of busts he always maintained a close and even contact with the model; as in contemporary portraits (for instance, by Rigaud and Largillierre), one notices that the extra-temporal
724 serenity of the classical portraits gives way progressively to an expression born of the moment, thus anticipating the art of the following century.

It is in fact among the sculptors and decorators of Versailles that one can follow the genesis of the new art form that was to succeed the Louis XIV style. If, at the time of Le Brun, Berain's arabesques heralded a new movement, a new form of decoration may be seen, in about 1700, to replace the style of the 1670–1680 period. The Versailles chapel was the first big building to yield entirely to what was soon to be called the ' modern taste '. The part played by Pierre Le Pautre in the formulation of these novelties has recently been pointed out. But, though he did the designs, their success was mostly due to the team of sculptors — the same ones who had done work for the gardens — who executed them. These works in very slight relief, so subtle as to be almost tenuous, respect the limits of the surface, but animate it with a whole series of arabesques in gently fluid planes. The

727. FRANCE. Staircase of the château of Benouville. (Calvados). Constructed between 1768 and 1777 by Nicolas Ledoux (1736–1806).

728. FRANCE. NICOLAS LEDOUX (1736–1806). La Barrière de l'Etoile, now destroyed: one of the gate-houses of the Fermiers Généraux. 1785–1789. Photographed before 1860.

729. FRANCE. NICOLAS LEDOUX (1736–1806). Project for a gamekeeper's house at Maupertuis. 1780.

stone quivers, anticipating the suppleness characteristic of the ' sensitive ' art of the following century. They are also the first instances of what was soon to be the ' new manner ', the ' Rococo ', a sudden return to the ' picturesque ' in which the Academy was not so wrong in seeing a ' Gothic ' element.

IV. CONTINUANCE OF CLASSICAL ARCHITECTURE UNDER LOUIS XV AND LOUIS XVI

The Academy remained powerless in the face of this strong modern trend in decoration, but classicism was too firmly rooted in the taste of the public who had too high an idea of the dignity of architecture for the picturesque element to be

730. FRANCE. Interior of the Panthéon
(the old church of Ste Geneviève). Begun in 1764 by
Soufflot (1713–1780) and completed by his pupil Rondelet.

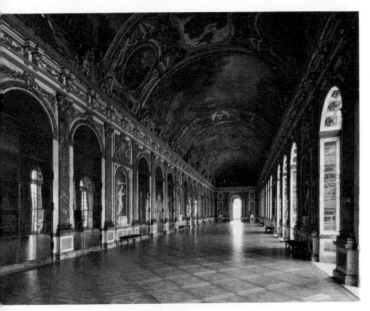

731. FRANCE. The Hall of Mirrors at Versailles. By Jules
Hardouin Mansart; ceiling by Le Brun. 1678–1684.

732. GERMANY. A replica of the Hall of Mirrors, in the
new Residenz, Stuttgart. 1746–1807.
By Pierre Louis Philippe de La Guêpière.

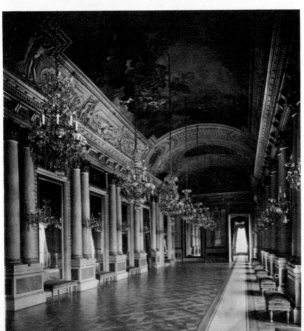

allowed to gain the upper hand. In fact, during the reigns of
Louis XV and Louis XVI, architects merely developed variants
of the classicist themes worked out in the previous century.

Until about the middle of the century, J. H. Mansart's inno-
vations were exploited, chiefly by his direct followers, starting
with Robert de Cotte, who up to his death in 1735 kept up the
style he had helped to create. He built hôtels in Paris (the Regency
had interrupted the big royal undertakings), but his activities
also extended to the provinces (hôtel de Rohan, Strasbourg), to
Germany (Schleissheim, Bonn, Poppelsdorf, Brühl, Frankfurt),
to Italy (the royal hunting lodge near Turin), in fact, to all
Europe. Another close collaborator of Mansart was Boffrand,
who, with his inquiring mind, was capable of designing not only
the robust, classical château of Lunéville, but the church of
St Jacques (Lunéville) which is nearer to the German Baroque,
and the freer imaginative projects for Malgrange. Jacques
Gabriel was the third of the great disciples and perhaps the most
faithful to Mansart's ideas. His Paris hôtels (hôtel Biron) and his 725
important works in Bordeaux are undoubtedly the offspring of
the Trianon sous Bois and the Place Vendôme. His son, Jacques 776
Ange Gabriel, was the last of the great classical architects and
he took Mansart's ideas to their ultimate conclusion. Jacques
Ange Gabriel worked with his father for a long time before
branching out on his own at the age of about fifty. It was just
at this time, in about 1750, that the king began to be interested
in building, and Gabriel was able to produce a series of master-
pieces. The wing he built at Fontainebleau already bears the
stamp of his style. If he followed the main lines of Le Vau's
work at Versailles, it was from François Mansart's work at
Blois that he took the carefully thought out subtleties of the
decoration and moulding. But he gave these borrowed subtle-
ties a delicate turn of his own. After 1757 and the Place Royal
came the Petit Trianon, in which the delicate proportions and 715
the strict control of the relief given to each decorative element
recall, with less intellectual stature perhaps but with the same
acute sensitivity, the most perfect abstractions of the great
classics of the High Renaissance.

Towards the end of his life, Gabriel reverted even more
openly to the expression of the great French classical craftsmen,
not without an obvious echo of Palladio. The façade of the 316
Ecole Militaire on the courtyard side recalls the Palladian ten-
dency of Le Vau, and the chapel adopts the colossal Order of
the church of Il Redentore, Venice; and after the more supple
evenness of Hardouin Mansart, Gabriel, with a sensitivity that
lacked nothing in power, gave stone all the flexibility of flesh.

During these same years 1750–1760, there was much talk
about a return to the more strict classical forms, but Gabriel's
example was decisive on this score. Buildings like the hôtel de
ville at Metz by J. F. Blondel, the Bagatelle by Bélanger, the
château of Le Marais by Barré and Mique's Belvédère near the
Trianon, all reveal Gabriel's influence; and it was his style again
that Vallin de la Mothe was to take to St Petersburg. The
impetus had been given, and the main architects of the following
decades were to work in the same spirit. So it was that Antoine's
Hôtel de la Monnaie reveals, behind the echo of Gabriel, an
echo of Le Vau (façade and salon) and of F. Mansart (staircase,
hall). So also, Mique's Couvent de la Reine at Versailles (now
the Lycée Hoche) mingles memories of Palladio with a sober
evenness, somewhat reminiscent of the château of Clagny which 718
Hardouin Mansart had built on the same site a century before.
In the same way, Louis' staircase in the Bordeaux theatre com- 726
bines the spirit of Gabriel with a treatment of space that recalls
that of the staircase at Blois.

But in other architects this outdated tendency was not confused
with the new movement towards antiquity. In this century
Greek art in all its variety (Greece, Sicily, the East) became
better known, and was popularised by a number of publications

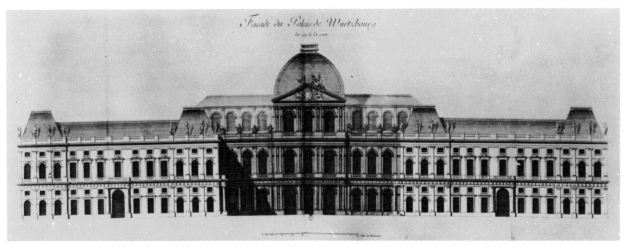

733. GERMANY. Façade of the Residenz, Würzburg.
By Balthasar Neumann, who submitted his plans to Robert
de Cotte, and to Boffrand (1667–1754)
who was also architect to the Duke of Bavaria.

734. GERMANY. Façade of the new Residenz,
Stuttgart (now destroyed), begun by the Italian Retti in 1746,
then modified and completed by Pierre Louis Philippe
de La Guêpière (c. 1715–1773) who became the
surveyor general of the Duke of Württemberg's buildings.

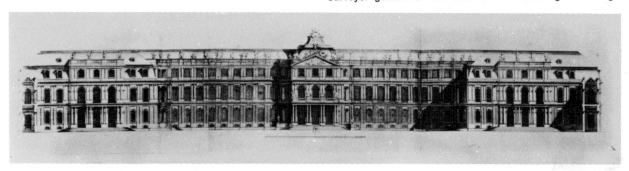

735. SPAIN. A project commissioned by
Philip V for the Buen Retiro in Madrid from
Robert de Cotte (1656–1735).

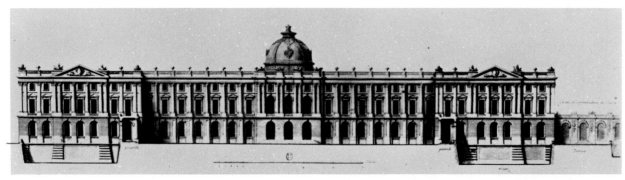

and reproductions. But the current idea of antiquity was tinged with a mysterious dream-like fantasy: Piranesi's work is an example. This tendency to confuse antiquity with a certain imaginative way of looking at things, this sober classicism as seen in an almost romantic reverie, was certainly the origin of Soufflot's gigantic undertaking, the church of Ste Geneviève (the Panthéon) in Paris. He seems to have wanted to use antique devices (peristyle, architrave, columns, large walls) to achieve the daring effects of the Gothic (vast systems of radiating arches hollowed out under the architraves). Such contradictions and the same tendency towards the colossal are to be found again in many architects of this period, such as Peyre and Ledoux. Their dreams usually took the form of immense and impossible projects, like imaginary variations on the theme of a Babylonian Rome. All they actually achieved were some small 'follies' which have mostly been destroyed, and which revealed a picturesque imagination completely lacking in restraint.

Ledoux was, however, allowed to begin realising his dreams: the propylaea in Paris, and what was built of the salt works at Arc et Senans, demonstrate a fantasy that owed more to the promptings of the unconscious than to the dictates of reason. Yet the same Ledoux had been capable, at the beginning of his career, of designing that perfect product of the pure classical spirit, the staircase of the château of Benouville (1770–1775) **727** which is a kind of résumé of the French art of building from Louis XIII to the beginning of the Revolution.

At the end of the 18th century, we again find the classical tendency reinforcing French thought, which was being subjected to the same temptations that it had already undergone at the time of Callot and Théophile de Viau.

730

727-729

HISTORICAL SUMMARY: 17th-century art

ITALY

History. Italy was dominated by Spain, by the Habsburgs who owned the provinces of Milan, Naples, Sicily and Sardinia. Spain ensured her hegemony over the peninsula by means of her fleet. France, for her part, exerted an influence over the duchies of Mantua, Montferrat, Parma, Piacenza, Modena and Piedmont.

Religion. In Rome, the importance of the papacy was considerable. The Roman Catholic Church triumphed all over Europe as a result of the Thirty Years' War, and throughout the world, thanks to missionaries. The Jesuits were all-powerful up to the middle of the 17th century; they wrote numerous treatises: on archaeology by P. Kircher (1601–1680), on architecture by P. Pozzo (1642–1709). The austerity of the previous popes eased under Paul V (1605–1621), Urban VIII

(1623–1644), Innocent X (1644–1655) and especially under Alexander VII (1655–1667).

Science and social life. The mathematician, physicist and astronomer Galileo (1564–1642) made in 1609 the first astronomical telescope. The taste for the science of life and for anatomical charts continued until the 17th century (Casserius' charts, 1627); the taste for caricature inspired exaggerated portraits (the Carracci, Bernini); finally, the Commedia dell' Arte with its famous characters was acclaimed all over Europe.

Music. Italy headed the musical movement in Europe. Claudio Monteverdi (1567–1643) already foreshadowed modern musical drama with *Orfeo* (1607). Roman opera, from 1625 to 1650, became very spectacular, with sumptuous décors. The cantata appeared in about 1620. Venetian

opera was created in 1637 by Monteverdi, Cavalli, Cesti and Stradella. Neopolitan opera became famous at the end of the 17th century with Provenzale (1610–1704).

Architecture. Rome was of unique importance, after the Counter Reformation and the council of Trent, with the popes who built churches or palaces (Paul V Borghese; Urban VIII Barberini, Innocent X Pamphili); with the prestige of the papal basilica, St Peter's [736], the work of the greatest 16th-century architects Bramante, Michelangelo and Vignola; with the famous church of Il Gesù [499] by Vignola and Giacomo della Porta, which inaugurated the Baroque style with its single nave and side chapels, façade with two storeys joined by volutes.

All the architects of Italy and Europe flocked to Rome, where the Church trained religious architects among the

EUROPE IN 1660

Jesuits, Theatines and Capuchins. 17th-century architects were also painters and sculptors, for the Baroque spirit called for a synthesis of all the arts. The first great Baroque architect was Carlo Maderna (1556–1629), nephew of Fontana. The façade of Sta Susanna (1603) was derived from Il Gesù, but is enlivened with lights and shadows by the columns, which were to have an increasing importance and were to play a more and more dynamic role (façade of S. Andrea della Valle by C. Rainaldi; SS. Vincenzo ed Anastasia by M. Longhi the Younger, c. 1650; Sta Maria in Via Lata by P. da Cortona, 1662; Sta Maria in Campitelli by Rainaldi, 1665). Maderna was commissioned by Paul V to complete St Peter's; he lengthened the nave to the west, and created the façade which was to round off the building and form the decorative setting for the ceremony of the Pope blessing *urbi et orbi* [736]. Maderna managed to preserve partially the effect of Michelangelo's dome. Maderna built the dome of S. Andrea della Valle, the largest church after St Peter's, the Palazzo Mattei (1618), and part of the Palazzo Barberini, completed by Bernini and Borromini.

The two greatest Baroque architects are Bernini and Borromini. Their stylistic innovations show the evolution of the Baroque towards movement, the accumulation of decoration and statues, and the use of brightly coloured marble.

Gian Lorenzo Bernini (1598–1680) was the key artist of the Italian Baroque [907]. Charles I, Louis XIII and Louis XIV (project for the Louvre colonnade [763, 764]) sought his services. Born in Naples of Florentine parents, he had a sculptor's training. His first work, the baldachino (1624–1633) under Michelangelo's dome in St Peter's, with its huge twisted columns, was to be much copied [738]. In the Palazzo Barberini, begun by Maderna, it is difficult to determine which part is by Bernini and which by Borromini: the main façade is traditionally attributed to Bernini [741]. After the decoration for the interior of the basilica, Bernini's major works under Alexander VII are the Scala Regia, a new ceremonial staircase linking St Peter's and the Vatican palace, and St Peter's colonnade. Around the oval piazza, 250 yards wide, with an obelisk in the centre, 284 columns in four rows, together with 88 pilasters, form a covered alley [905], the roof of which is concealed by statues: a drawing by Bernini indicates that he regarded it as a symbol of the Mother Church opening her arms to receive the faithful. Three small but influential later churches are Castelgandolfo (1658–1661), Ariccia (1662–1664) and S. Andrea al Quirinale (1658–1670), his maturest work.

His most grandiose theatrical piece of town planning is the fountain in the Piazza Navona, an allegory of the benefits of water (see under *Sculpture*, pp. 291-292).

Francesco Borromini (1599–1667), son of architect G. D. Castelli, a relation of Maderna, rival of Bernini, whose force he lacked but whom he surpassed in bold and subtle inventions, began in Milan and went (c. 1614) to Rome; worked as a stonemason at St Peter's, S. Andrea della Valle and the Palazzo Barberini. His two masterpieces were the church and convent of S. Carlo alle Quattro Fontane (1638–1641, façade 1665–1667) and S. Ivo della Sapienza (1642–1660), the Roman university church [902]. For Innocent X he worked on the reconstruction of the nave of S. Giovanni in Laterano (1646–1650) and, alternately with Carlo Rainaldi, on Sta Agnese, Piazza Navona (1653–1655). Other work included the oratory of S. Filippo Neri (1637–1650), the façade of the Collegio di Propaganda Fide (1646–1667), S. Andrea delle Frate (1655–1667) and the illusionist colonnade of the Palazzo Spada. Foreshadowing the 18th century in his flowing rhythms and his taste for white and gold, he had a widespread influence, not only in Rome, but in Turin, south Germany and even South America.

Pietro da Cortona (1596–1669) was, with Bernini, one of the founders of Roman high Baroque. Son of a stonemason at Cortona he came to Rome in 1612–1613, with A. Commodi. The patronage of Cardinal Francesco Barberini led to a share in the planning of the Palazzo Barberini, 1629. 1635-1650, reconstruction of Sta Martina e S. Luca; 1656–1657, façade of Sta Maria della Pace; 1658–1662, Sta Maria in Via Lata. His major late work was the dome of S. Carlo al Corso (1668).

Girolamo Rainaldi worked in Bologna, Parma and Modena. His son Carlo (1611–1691; Sta Maria in Campitelli) began the Piazza del Popolo and completed S. Andrea della Valle. The Bolognese Alessandro Algardi (1593–1654), Orazio Grassi (1593–1654), Martino Longhi the Younger (1602–1660), above all Carlo Fontana (1638–1714) foreshadowed 18th-century art.

Very independent, the Theatine Guarino Guarini (1624–1683) [913], born at Modena, had an encyclopedic mathematical mind and travelled widely (worked at Messina; taught philosophy in Paris, 1665). Most of his work is in Turin: his masterpiece, S. Lorenzo (1666), the extraordinary Chapel of the Sindone, the Academy of Sciences, the Palazzo Carignano with its unique and original façade. In 1686 he published *Desegni di Architettura Civile ed Ecclesiastica*.

But the provincial styles retained their individual character: in Tuscany more austere, in Emilia more academic

(anatomy theatre in Bologna by A. Levanti; Farnese theatre at Parma, ducal palace at Modena), in Lombardy and Genoa a taste for symmetry and repetition (S. Alessandro, Milan, 1602–1629, with its twin towers; Palazzo di Brera, Milan, by F. M. Ricchinio, 1583–1658; Sta Maria delle Vigne, Genoa); in Apulia, at Lecce, Sta Croce dei Celestini (1559–1697) shows the influence of the Spanish Churrigueresque, in Sicily a heavier, more lyrical character.

Venice alone created powerful original architecture, yet respected the tradition of Sansovino, Palladio and Scammozi. Baldassare Longhena (1598–1682), sculptor and architect, created the unique Sta Maria della Salute (1631–1687) with its octagonal plan and huge dome supported and joined to the church by imposing volutes [743, 744]. The Scalzi church and the Palazzo Pesaro show the range of Longhena's genius. Other architects: G. Sardi (Sta Maria del Giglio o Zobenigo) and A. Tremignon (S. Moisè).

Gardens. In the 17th century they were planned architecturally and show the triumph of man over nature. Even water was controlled and dominated so as to conform to the complicated scenic effects of ornamental fountains (Villa Aldobrandini [739] at Frascati). The fantasy of the grottoes, nympheas, mazes and hydraulic machines enlivens the over-geometric structure (staircases, long avenues) of these ostentatious and highly organised gardens.

Sculpture. Rome was dominated by the genius of Bernini, but before him the classical inspiration and the expression of movement which characterise his finest works were already found in minor artists like Cristoforo Stati, Pompeo Ferucci (c. 1566–1637) and Stephano Maderno (1576–1636; Sta Cecilia in Trastevere). Francesco Mochi (1580–1654) was linked to this movement by a classical trend in his art (the *Annunciation* at Orvieto) which yielded to an agitated form derived from Bernini (*St Veronica* in St Peter's, Rome).

Gian Lorenzo Bernini (1598–1680), son of the sculptor Pietro Bernini (1562–1629) with whom he worked (angel of the *Annunciation* in the church of St Bruno, Bordeaux), architect, sculptor and painter, held indisputable artistic supremacy under the pontificates of Urban VIII and Alexander VII. His art (interpretation of flesh, expression, movement) was inspired by Hellenistic art (*Apollo and Daphne* [908], Borghese Gallery, 1622–1625) and excelled in expressing the sensuous mysticism of the times (*St Theresa* in Sta Maria della Vittoria [906]). Admirable decorator of Rome (Fountain of the Four Rivers, Piazza Navona [901]), brilliant portraitist (*Louis XIV* [709])

ROME AND CARLO
MADERNA (1556–1629)

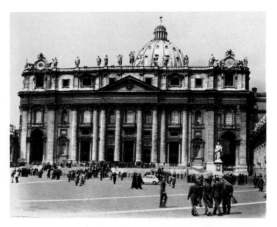

736. Façade of St Peter's (1612) by Carlo Maderna (1556–1629).

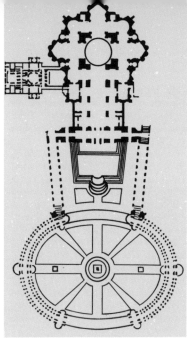

737. Plan of the basilica and the piazza with the colonnade by Bernini (1656/65).

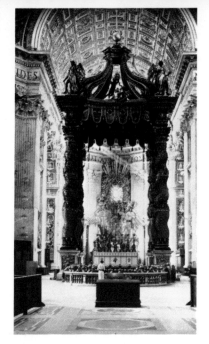

738. The interior by Michelangelo and then Maderna, with the bronze baldachino over the main altar by Bernini (1624/33).

he also created the prototype of the lavish papal tomb (monuments of Urban VIII and Alexander VII). In 1647 he finished decorating St Peter's (nave and side chapel); after 1655, the colonnade and cathedra in St Peter's. Invited to Paris by Louis XIV in 1665, he did the bust and statue of the king, as well as a project for the east façade of the Louvre [763, 764].

Among his pupils and collaborators were Antonio Raggi (1624–1686) and Giuliano Tinelli (1601–1671). Among the classicist sculptors opposed to his Baroque style were Alessandro Algardi (1595–1654), a Bolognese who has affinities with the Carracci and Domenichino (*Leo I and Attila*; tomb of Leo XI in St Peter's); Domenico Guidi (1625–1701), more eclectic [916]; Ercole Ferrata and Melchiore Caffa.

In Florence sculptors were inspired either by the tradition created by Giovanni Bologna, e.g. his pupil Pietro Tacca (1577–1640) [753] and the latter's son Ferdinando Tacca (1619–1686), or else by Bernini and Algardi, e.g. Giovanni Battista Faggini (1652–1725), Corsini chapel, Sta Maria del Carmine, Florence.

In Milan activity was concentrated on the cathedral: Dionigi Bussola (1612–1687), Giuseppe Rusnati (d. 1713) and G. B. Maestri, called Volpini.

In Genoa sculpture was marked by influence of Lombard Florentine Mannerism, and later Puget. The greatest native sculptor was Filippo Parodi (1630–1702).

In Naples the most typical works of sculpture are those of Cosimo Fanzago (1591–1678; churches in Naples; Carthusian monastery of S. Martino).

Painting. In the 17th century Italian art was diffused mainly from Rome,

the indisputable centre of the Baroque. Venice and Florence are less interesting than Genoa and Naples with their original schools of painting.

Roman Mannerism, spread abroad by the prolific work of the Zuccari (Federico Zuccaro, 1540–1609; Taddeo, 1529–1566: Palazzo Farnese, Caprarola; dome of Florence cathedral; Borghese chapel, Sta Maria Maggiore, Rome), was continued by Roncalli, called Pomarancio (1552–1626) and especially by Giuseppe Cesari, called Cavaliere d'Arpino (1568–1640), whose reputation was immense. But his decorative work (transept of S. Giovanni in Laterano; Olgiatti chapel, Sta Prassede; Conservatori palace) is less significant than that of Federico Barocci of Urbino (1528/35–1612) whose Correggesque style and colour harmonies (*Martyrdom of St Vidal*, Brera, Milan) foreshadow the Baroque [519].

The reaction against Mannerism engendered two different movements, which were sometimes linked together: one was realist with Caravaggio, the other eclectic and decorative with the Carracci.

Michelangelo Merisi da Caravaggio (1573–1610) brought about the greatest pictorial revolution of the century. His imposing compositions, deliberately simplified, are remarkable for their rigorous sense of reality and for the contrasting light falling from one side that accentuates the volumes. 1584–1588 apprenticed to S. Peterzano, at Milan; *c.* 1592, Rome; small paintings of genre and still life, clear in light and cool in colour: *Fortune Teller* (Louvre); *Music Party* (Metropolitan); *Bacchus* (Uffizi); *Rest on the Flight* (Doria). Change to harsh realism, strongly modelled volumes and dramatic light and shade in first large-scale commis-

sion: scenes from the life of St Matthew, Contarelli chapel, S. Luigi dei Francesi (1597–1601); *Conversion of St Paul*, *Martyrdom of St Peter*, Sta Maria del Popolo, 1600–1601; *Madonna di Loreto* (1603–1605); *Death of the Virgin* (1605–1606). He fled from Rome in 1606 after a brawl, and visited Naples, Malta (1607, portrait of Alof de Wignacourt, *Beheading of St John the Baptist*), Sicily in 1608 (*Burial of St Lucy*); 1608–1609 at Messina, *Raising of Lazarus*. His work, like his life, caused much scandal and excited international admiration [520, 521, 523–527].

Among the Italian disciples of Caravaggio, Orazio Borgianni (1578–1616) helped to spread the Caravaggesque style in Spain. Carlo Saraceni (1585–1620) was the only direct Venetian follower of Caravaggio [400]; Bartolommeo Manfredi (*c.* 1580–1620/21) imitated Caravaggio's genre paintings [747]; the Gentileschi (the father, Orazio, 1563–*c.* 1644 [745], and his daughter Artemisia, 1597–1651) showed a marked realism. Giovanni Serodine (*c.* 1600–1630) [749] was one of the most personal of the Caravaggesque painters; Lionello Spada (1576–1622), companion and, according to contemporaries, Caravaggio's assistant, underwent his influence, as did his biographer and enemy Giovanni Baglione (*c.* 1573–1644).

Baroque decorative art was created by the Carracci (Ludovico, 1555–1619, cousin of Agostino, 1557–1602, the elder brother of Annibale, 1560–1609 [527, 528, 530]). In 1585 they opened in Bologna an academy, a kind of art school in which technical training was based on general education. Annibale, the most famous of the Carracci, trained in Domenico Tibaldi's studio. In about 1585 he was at Parma; 1582, Bologna; 1584, he worked in the Palazzo Fava.

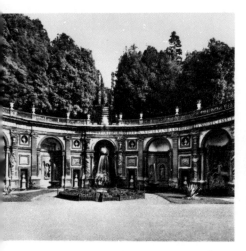

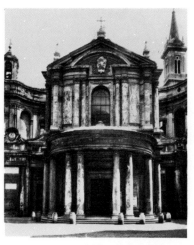

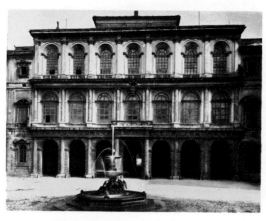

739. ITALY. The fountain court and garden of the Villa Aldobrandini, Frascati. 1598/1604. Built by G. della Porta, decorated by G. Cesari.

740. ITALY. Façade of Sta Maria della Pace, Rome (1656/57), by Pietro da Cortona.

741. ITALY. Façade of the Palazzo Barberini, Rome. 1629. By Bernini and Maderna.

1588–1591, Palazzo Magnani, *Assumption* (Dresden); *The Virgin appearing to St Luke* (Louvre); 1593, *The Resurrection* (Louvre); 1593–1594, Palazzo Zampieri. About 1595, *Fishing and Hunting* (Louvre). In 1595, he left for Rome to decorate the Farnese Gallery, an influential achievement, heralding the Baroque in its illusionism and freshness of vision. 1606, *Birth of the Virgin*. Annibale Carracci was also one of the originators of the classical landscape (Doria Gallery, Rome).

The Carracci influenced numerous followers especially at Bologna. The best of them was Guido Reni (1575–1642) [532]. In about 1594–1595 he studied at the Carracci academy. 1598, cooperated in the decoration of the façade of the Palazzo del Reggimento in honour of Clement VIII. 1600–1603, visits to Rome. 1610, decoration of the Pauline chapel at Montecavallo. 1611–1612, *Samson's Victory* (Bologna). 1613–1614, *Aurora* (Casino Rospigliosi-Pallavicini, Rome). 1614, settled in Bologna. 1617–1621, *Story of Hercules* (Louvre). Domenico Zampieri, called Domenichino (1581–1641), a prolific decorator [531] (S. Andrea della Valle, S. Luigi dei Francesi), was inspired by Agostino Carracci (*Communion of St Jerome*); *Diana Hunting* (Borghese Gallery). Francesco Barbieri, called Guercino (1591–1666), painter and engraver, was influenced by Caravaggio, then by Guido Reni [553]. His masterpiece is *Aurora* (Villa Ludovisi, Rome). Francesco Albani (1578–1660), famous for his mythological paintings (*Dance of Love*, Brera, Milan [529]).

Decorative art, after the Carracci and stimulated by them, flourished extensively. Sometimes it followed their style and that of Correggio, e.g. Giovanni Lanfranco (1582–1647), lavish

decorator of churches in Rome (S. Andrea della Valle) and Naples (S. Gennaro), who taught Giacinto Brandi (1623–1691). Sometimes the Carracci influence was combined with an admiration for Raphael, e.g. Andrea Sacchi (1599–1661) who taught Carlo Maratta (1625–1713), a fine portraitist whose religious paintings inspired a number of artists (Benedetto Lutti, 1666–1724; Giuseppe Chiari, 1654–1727). Maratta's importance as religious painter in Rome was equalled by the importance of Pietro Berrettini da Cortona (1596–1669) as a decorator. His masterpiece was the ceiling of the Gran Salone, Palazzo Barberini (1633–1639); his decorations in the Pitti Palace, Florence (1640–1647), with their combination of fresco and high relief, were influential in the formation of the Louis XIV style. They were conveyed to Paris by the heavier Giovanni Francesco Romanelli, 1610–1662 (Bibliothèque Nationale, Paris, and Louvre).

Other artists of similar style: Giacinto Gimignani (1611–1681), Pietro Testa (1611–1650), Circo Ferni (1634–1689). Cortona's illusionistic effects were taken to extremes by the religious decorators of the second half of the 17th century. The most successful were Baciccia (Giovanni Battista Gaulli, 1639–1709) in the church of Il Gesù, Rome [879], and Andrea Pozzo (1642–1709) in S. Ignazio, Rome.

Genre painting, thanks to the Caravaggesque realists and Dutch and Flemish influences, had a great success with, in particular, Pieter van Laer, called Bamboccio [632]. The best genre painters were: Michelangelo Cerquozzi (1602–1660), famous for his battles and 'bambocciate' (*Masaniello Revolt*, Spada Gallery, Rome). Painters of fruit: Pietro Paolo Bonzi, known as il

Gobbo dei Carracci (*c.* 1576–1636); and of flowers: Mario dei Fiori (Mario Nuzzi, *c.* 1603–1673).

The followers of the Carracci have already been referred to as the main representatives of Bolognese painting. We must also mention Alessandro Tiarini (1577–1668); the landscape painter Mastelletta (1575–1655); Simone Cantarini da Pesaro (1612–1648), a pupil of Reni, like Giovanni Andrea Sirani, whose daughter Elisabetta (1638–1665) was also famous. There were also the Emilian Bartolomeo Schedone (1578–1615) [456] and the painters of perspective views Agostino Mitelli (1609–1660) and Michelangelo Colonna (1600–1687).

In Florence the influence of the Zuccari lingered. Skilful decorators like Domenico Cresti di Passignano (*c.* 1560–1636) and Bernardino Poccetti (1548–1612) worked there; Lodovico Cardi, called Cigoli (1559–1613), painter and architect, was influenced by Barocci and Caravaggio.

The most original Florentine painter of the 17th century was Giovanni Mannozzi, called Giovanni da San Giovanni (1592–1636), pupil of Matteo Rosselli (1575–1650), decorator of the Sala degli Argenti in the Pitti Palace, which was completed by Francesco Furini (*c.* 1600–1646); the latter was famous for his nudes (*Hylas and the Nymphs*, Pitti). Carlo Dolci (1616–1686) is known for his suave Madonnas. Others included Cristofano Allori (1577–1621, *Judith*, Pitti); Jacopo Chimenti (*c.* 1554–1640), the *Calling of St Peter* in the Impruneta; Baldassare Franceschini, called Volterrano (1611–1689), genre painter; Lorenzo Lippi (1606–1665), decorator, illustrator of Tasso and Ariosto.

In Lombardy the transition from Mannerism to the beginning of the

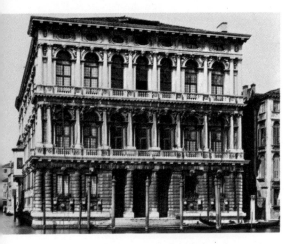

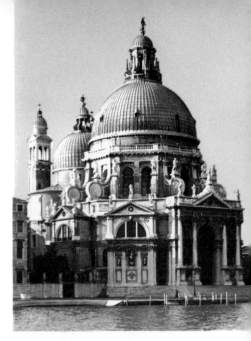

742. Palazzo Rezzonico, begun in 1680 by Longhena and completed in the 18th century by Giorgio Massari.

743. Plan of Sta Maria della Salute.

744. Sta Maria della Salute, built 1631-1687 by Longhena.

17th century was characterised by Giulio Cesare Procaccini (c. 1570–1625), member of a family of painters who also distinguished themselves in Bologna (*Mystic Marriage of St Catherine*, Brera); Giovanni Battista Crespi, called Cerano (1575–1633; *Franciscan Saints*, Berlin); Pier Francesco Mazzuchelli called Morazzone (1571–1626; *St Francis*, Milan, Castello Sforzesco); decorators of talent, they were influenced by Emilian, Sienese and Roman trends, e.g. Guglielmo Caccia, called il Moncalvo (1565/68–1625). Close to their often violently expressive manner with contrasting colours were Francesco del Clairo (1607–1665); Daniele Crespi [748] (c. 1598–1630; *The Dead Brother*, Brera); the Cremonese Carlo Francesco Nuvoloni (1609–1662) and Antonio d'Errico, called Tanzio da Varallo (1574/1580–1635).

Among the realist painters: portraitists Giovanni Paolo Cavagna (1556–1627) and Carlo Ceresa (1609–1679). Under Caravaggio's influence, Evaristo Baschenis (c. 1617–1677) inaugurated the theme of musical instruments [750], imitated by Bonaventura Bettera (1639–1700).

Genoa had an original school of painting which was to develop Flemish contacts (the de Wael brothers and visits by Rubens and van Dyck). The best painter was Bernardo Strozzi, called il Cappuccino [751] (1581–1644), of great importance also for Venice (*Berenice*, Castello Sforzesco, Milan). Giovanni Castiglione, called il Grechetto (1610–1665), took up a genre already made famous by Sinibaldo Scorza (1589–1631) with paintings of animals and still lifes under Flemish and Venetian influence (*The Purification of the Temple*, Louvre).

Domenico Fiasella (1589–1631) and Gioacchino Assereto (1600–1649) joined the Caravaggesque followers, while Valerio Castello (1625–1659), the best of a whole family of painters, was more eclectic (*Moses*, Louvre).

The decorators Domenico Piola (1627–1703) and Gregorio de Ferrari (1644–1726) worked in the churches and palaces of Genoa (Palazzo Rosso).

Venice lost her supremacy in the 17th century. Mannerism lingered on with formulas derived from Titian, Tintoretto or Veronese, with Palma Giovane (1544–1628), Pietro Malombra (1556–1618), Antonio Vassilacchi, called Aliense (1556–1629). This decadent art was revitalised by foreigners: Domenico Feti [752] (1589–1623), painter to the court of Mantua before settling in Venice, created powerful forms (*Melancholy*, Louvre), and also excelled in small-scale works (*The Lost Drachma*, Uffizi); Johann Liss (c. 1597–1629/1630), born at Oldenburg. One of the most remarkable figures of the 17th century, Venetian in his Baroque visionary imagination and his fluent touch, was Francesco Maffei (c. 1600–1660) of Vicenza, whose activities were essentially provincial (*Sacrifice of Melchizedek*). Sebastiano Mazzoni (c. 1615–1685), a Florentine, settled in Venice and carried the Baroque style to excess (*Death of Cleopatra*, Rovigo).

Caravaggio's stay in Naples and the works he did there had a decisive effect on young painters. Ribera belongs as much to Spanish art as to the Neapolitan school which started with Giovanni Battista Caracciolo, called Battistello (c. 1570–1637), a pupil of Caravaggio and fresco painter (Certosa of S. Martino, Naples). To Caravaggesque influences were added Bolognese ones, e.g. Massimo Stanzioni (1586–1656), who decorated numerous churches in Naples (story of St Bruno, Certosa of S. Martino), and Andrea

Vaccaro (1604–1670). Mattia Preti (1613–1699), who became the leader of the Naples school after Ribera, is more important. His dramatic and violent art combines echoes of Caravaggio, Guercino and Venice (*Belshazzar's Feast*, Naples [755]). Bernardo Cavallino (1616–1656) died young but left small-scale works of charm and delicacy (*St Cecilia*, Naples [754]).

Landscape painting was exemplified with sombre romantic imagination by Salvator Rosa [757] (1615–1673), who also painted battlepieces (Louvre) which were emulated by Aniello Falcone (1607–1656) and Domenico Gargiuolo (c. 1610–1675). Still lifes by Giovanni Battista Ruoppolo (1629–1670), Giuseppe Recco (1634–1695) and Andrea Belvedere (d. 1736). Among painters of architecture was 'Monsu Desiderio', whose fantastic works were by at least three different artists, including the Frenchmen Didier Barra and François Nomé.

17th-century Neapolitan painting ended with the virtuoso Luca Giordano [756] (1632–1705), sometimes called 'Fa Presto', famous decorator (1682–1683, Palazzo Riccardi, Florence). In 1692 he was in Spain, where he decorated the Escorial. He returned to Naples in 1702 (Chapel of the Relics, Certosa of S. Martino).

In Sicily Pietro Novelli, called Il Monrealese (1603–1647), was active in the first half of the century.

Miniatures and the applied arts. Giovanni Sarzoni (1600–1670), the most important miniaturist, worked in Florence, Naples and Rome.

Tapestries made in Florence in the Arazeria Medicea until 1737; the factory founded in Rome by Francesco Barberini in 1630–1635 made use of cartoons by Cortona and Romanelli.

THE FOLLOWERS OF CARAVAGGIO

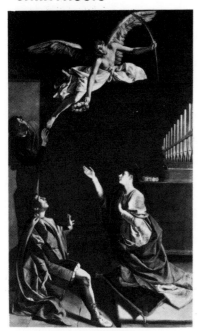

745. ITALIAN. ROMAN. ORAZIO GENTILESCHI (1563 – c. 1644). The Martyrs SS. Valerianus, Tiburtius and Cecilia. *Brera, Milan.*

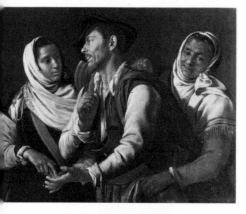

747. ITALIAN. ROMAN. BARTOLOMMEO MANFREDI (c. 1580–1620/21). The Fortune Teller. *Palazzo Barberini, Rome.*

749. ITALIAN. ROMAN. GIOVANNI SERODINE (c. 1600–1630). St Peter in Prison. *Zust Collection, Rancate.*

For carpets Italy remained dependent on the Levant and Persia.

Textiles. The predominant theme of the sumptuous fabrics picked out in gold and silver, manufactured in Genoa (velvet) and Venice, was the floral motif. Materials were embroidered, especially copes and altar frontals. Lace-making was mainly in Venice.

Engraving. A number of artists also practised engraving: the three Carracci (Annibale's masterpiece, the *Descent from the Cross*, so-called 'of Caprarola', 1597), Francesco Villamena [419], Caravaggio, Orazio Borgianni, Barocci, Guercino, Reni, Cantarini, etc. Antonio Tempesta was prolific (engravings of horses). He was imitated by Stefano della Bella (1610–1664), who was inspired by Callot and spent ten years in Paris (*View of the Pont Neuf*) [792].

Outstanding among the painter-engravers were Salvator Rosa, Solimena, Castiglione and Pietro Testa, called il Lucchesino (1611–1650). Giambattista Folda (1640/48–1678) is known for his 'views of Rome'.

The minor arts. Goldsmiths' work reveals a Germanic influence; there was a tendency to reproduce on a small scale as practical objects (especially for table use) sculptures that were in vogue (statues from the Piazza Navona).

Milanese armourers were famous for their modelling and engraving in gold and silver [760].

Ceramics was not revived in the 17th century. Faenza retained an absolute supremacy. Venice created earthenware of Baroque character.

In glass ware, painted mirrors [758], crystal [759] and glass were made exclusively in Venice (Murano factories) which produced torchères, candelabra, pendants. Small objects (glasses, bowls) too fine and fragile to suit the Baroque taste were supplanted by Bohemian glass, which imposed even on Venice its taste for the solid and heavy.

In furniture and interior decoration, chairs were characterised by profuse ornamentation in relief. Chests were replaced by chests of drawers; cabinets remained in vogue (ebony inlaid with ivory or occasionally steel). Cupboards were sometimes in bronze (in Novara cathedral). Table-tops in 'Florentine mosaic' were inlaid with pieces of marble. In Venice, console tables were supported by figures of Negroes.

FRANCE

History. On the death of Henry IV (1610) the task of restoring the monarchy was continued after Marie de' Medici's regency (1610–1617) by Richelieu (1624–1642), who rendered

746. ITALIAN. BOLOGNESE. FRANCESCO ALBANI (1578–1660). Salmacis surprising Hermaphrodite bathing. *Turin Museum.*

748. ITALIAN. LOMBARD. DANIELE CRESPI (c. 1598–1630). St Charles Borromeo's Supper. *Sta Maria della Passione, Milan.*

750. ITALIAN. BERGAMO. EVARISTO BASCHENIS (c. 1617–1677). Still Life with Musical Instruments. *Wallraf-Richartz Museum, Cologne.*

751. ITALIAN. GENOA AND VENICE.
BERNARDO STROZZI,
called IL CAPPUCCINO (1581–1644).
Berenice.
Castello Sforzesco, Milan.

752. VENETIAN.
DOMENICO FETI (1589–1623).
Parable of the Pearl.
Kunsthistorisches Museum, Vienna.

753. ITALIAN. Equestrian statue
of Philip IV (detail). Begun
by Giovanni Bologna and completed
by Pietro Tacca (1577–1640).
Plaza Mayor, Madrid.

the Protestant party powerless, intervened in the Thirty Years' War (1635), during which Lorraine was occupied, assured France's hold over Alsace, Artois and Roussillon, and made Louis XIII (1610–1643) an absolute monarch.

Mazarin (1643–1661), during the regency of Anne of Austria and the minority of Louis XIV (born in 1638), put an end to the two Frondes (1648–1652), made peace with the Treaty of the Pyrenees (1659) and negotiated the king's marriage with the Spanish Infanta.

During the personal rule of Louis XIV, from 1661 to 1685, after Le Tellier, Lionne and Fouquet, Colbert, from 1661 to 1683, played a vital part in finance, agriculture and the arts. He boosted the colonial power (Louisiana, West and East India Companies) thus opening the way for exotic influence; by protecting industry and commerce from foreign importations, he gave a new impetus to French work. Vauban invented a new system of fortifications. On the death of Philip IV of Spain, Louis XIV laid claim to the Netherlands; his army, commanded by Condé and Turenne, subjugated Lille (1667), conquered Franche-Comté (1668). The advance was stopped by the Triple Alliance which led to the Peace of Aachen (1668). Louis XIV next invaded Holland in 1672, but the first coalition, brought about by William of Orange (1673), led to the Treaties of Nijmegen (1678–1679) by which Franche-Comté and Flanders were ceded to France; Strasbourg was annexed in 1681.

But the revocation of the Edict of Nantes (1685) resulted in the exodus of an active and creative section of the population and turned the Protestant countries against Louis XIV. After the wars of the League of Augsburg (1688–1697) and of the Spanish Succession (1701–1714) French domination over western Europe weakened in favour of England.

Religion. The Jesuits returned to France (1603) where they were to have a great influence on religious art; the Catholic revival which began as early as 1616 (*Introduction à la Vie Dévote* and *Traité de l'Amour de Dieu* by St François de Sales) was in opposition to a free-thinking movement that reached a crisis in 1623–1625 and was countered by fervent men of faith like St Vincent de Paul (1576–1660) and his missionaries of the Charité. Jansenism, opposed by the Jesuits, was to be spread by St Cyran (1581–1643) and the treatise *De la Fréquente Communion*

(1643) by Antoine Arnauld (1612–1694), and upheld by Pascal (*Les Provinciales*, 1656–1657); it was wiped out in the second half of the century.

Literature. From 1600 to 1660 the classical spirit developed, in spite of active resistance, with Malherbe (1555–1628). The salons of Mme de Rambouillet, Mme de Chevreuse and Mme de Sable reigned over the literary scene, which was dominated by great men like Corneille (*Le Cid*, 1636), Descartes (*Discours de la Méthode*, 1637) and Pascal.

From 1660 Louis XIV's influence predominated, the court supplanted the literary salons, the Roi Soleil replaced the Maecenae: it was the golden age of classical masterpieces, with Molière (1622–1673), Boileau (1636–1711), Racine (1639–1699) and La Fontaine (1621–1695); and of prose writers, with Mme de Sévigné (1626–1696) and Bossuet (1627–1704).

Between 1688 and 1715 La Bruyère (1645–1694), Saint-Simon (1675–1755) and Fénelon (1651–1715), by their ideas and style, already foreshadowed the 18th century. Finally, printed newssheets were one of the most original innovations of the 17th century (*La Gazette, Le Courrier Français, Le Journal des Savants, Le Mercure Français*).

Academies were founded: Académie Française, 1635; des Inscriptions, 1664; Académies de Sculpture et Peinture, founded in 1648, reorganised in 1664; Academy of Architecture, 1665–1671; of Sciences, 1666; Académie de Rome, 1666. The Royal Library was enriched, and the Department of Prints and Medals added.

Science. Descartes (1596–1650) contributed to physics by discovering the laws of refraction and by introducing analytical geometry; he had a great influence on the sister sciences. Pascal (1623–1662) invented a calculating machine, the laws relating to the weight of air, the equilibrium of liquids, the arithmetical triangle, the law of probabilities, the hydraulic press; Mariotte (1620–1684) completed Galileo's theory; Roberval (1602–1675) gave his name to a weighing system; the Cassini drew up scientific maps of France.

Architecture. The spirit of the Renaissance lasted till about 1630–1640.

In religious architecture the Italian Baroque style was assimilated: there was to be a strong influence of St Peter's and the church of Il Gesù. A considerable part was played by those religious Orders specialising in building — Jesuits, Theatines — who had

DUTCH. JOHANNES VERMEER (1632–1675).
The Music Lesson. Reproduced by
gracious permission of Her Majesty the Queen
Photo: Crown copyright reserved.

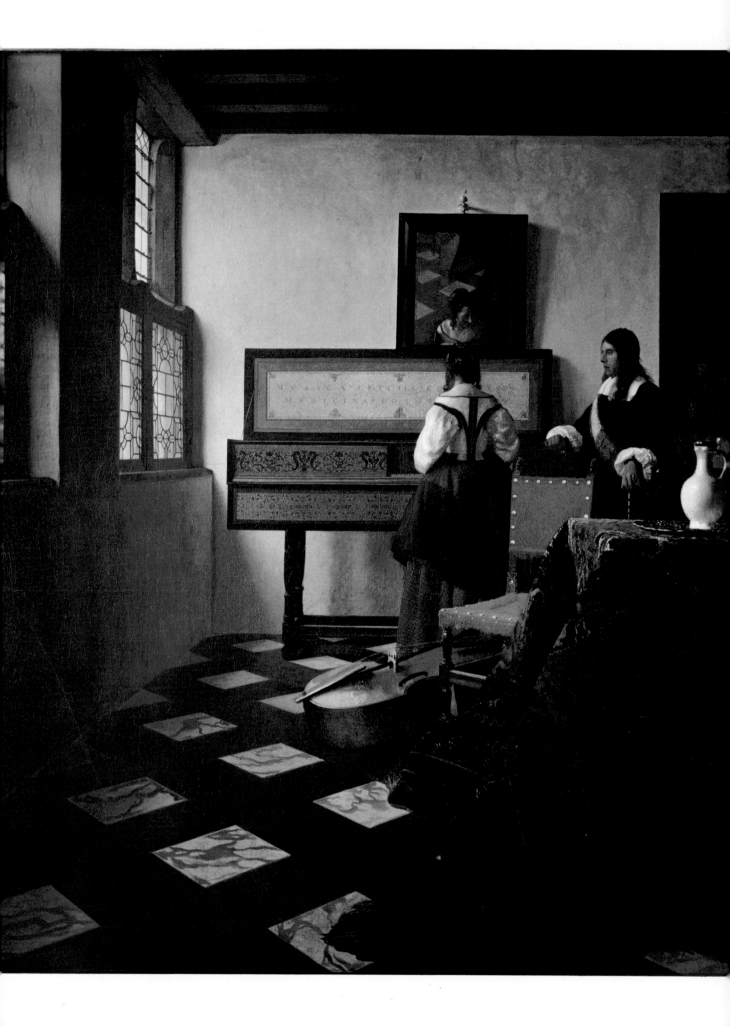

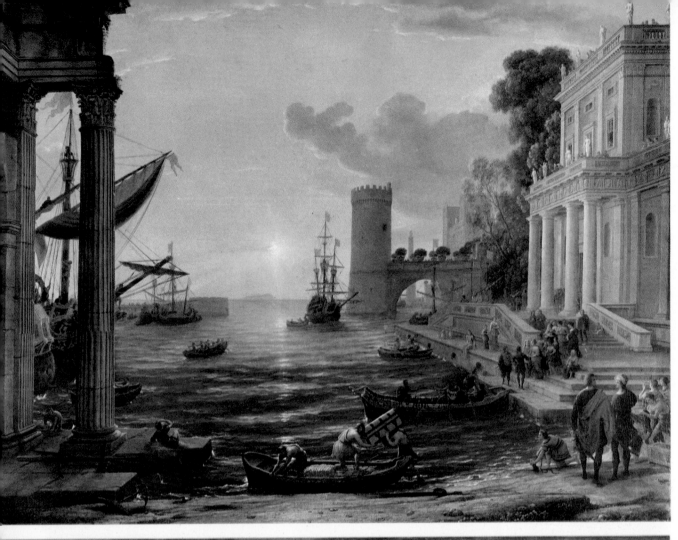

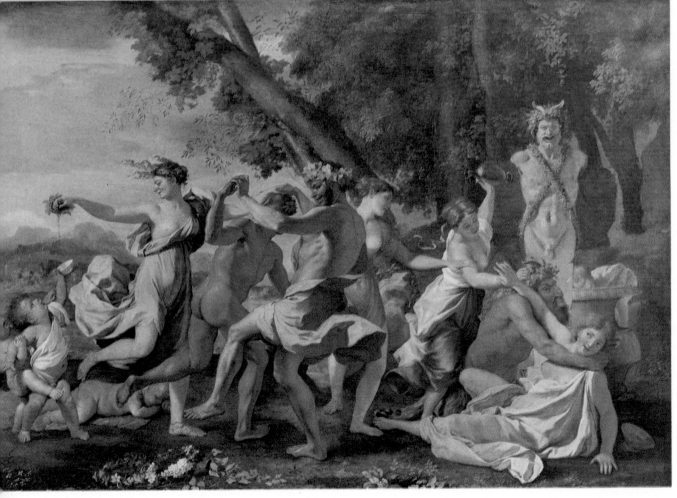

an artistic policy and employed clerical architects with dictatorial power, often trained in Rome: the Jesuit E. Martellange (1568–1641), in Rome from 1590 to 1604, supervised almost all Jesuit building, till Father Turmel took over from him.

As a result there were in France characteristics similar to those of Italian Baroque: a search for movement in façades and in interior decoration (canopies, pulpits and tabernacles) and perspectives often emphasised by light (*gloires*).

In secular architecture the Italian influence was much weaker. It is true that in 1659 Mazarin called on the Vigarini to organise the celebrations of Louis XIV's marriage and to build a theatre (the Tuileries theatre executed by Le Vau); and in 1665 Louis XIV invited the internationally famous architect Bernini to complete the east façade of the Louvre. But the Italian project for the colonnade (used by N. Tessin for the royal palace in Stockholm) was rejected and the French artists Le Vau, Le Brun, Perrault and d'Orbay triumphed [**761-764**]. With the completion of the Cour Carrée and the colonnade of the Louvre, French classical architecture came into its own.

The desire for prestige and the taste for building of Richelieu, Mazarin and Louis XIV in particular, and the vast private fortunes (Fouquet and the great financiers), gave rise to châteaux (Richelieu, by Lemercier, 1631; Maisons by Mansart [**698**]; Vaux le Vicomte by Le Vau for Fouquet [**664**]; Champs) and hôtels particuliers — town mansions — in Paris (Le Marais, Faubourg St Germain and Faubourg St Honoré), St Germain en Laye and Versailles.

The 17th-century style was evolved by the great architects of three generations: the first, in the Baroque spirit, strove for the theatrical and decorative; the second, after 1660, preferred a more functional beauty; the third was more doctrinaire, more purist, influenced by the Academy.

P. Le Muet (1591–1669), the king's architect, worked for Mazarin and in the provinces (fortifications in Picardy). The Lemercier, Pierre and Nicolas (St Eustache), and especially Jacques (1585–1654), trained in Italy at the beginning of the 17th century (the Oratoire, the Pavillon de l'Horloge at the Louvre, the Sorbonne, the Palais Royal, St Roch, work at Val de Grâce), were Richelieu's and Louis XIII's architects.

754. BERNARDO CAVALLINO (1616–1656). St Cecilia. 1645. *Naples Museum*

756. LUCA GIORDANO (1632–1705). Adoration of the Crucifix. *Prado.*

755. MATTIA PRETI (1613–1699). Belshazzar's Feast. *Naples Museum.*

757. SALVATOR ROSA (1615–1673). The Temptation of St Anthony. *Pinacoteca Rambaldi di Coldirodi, San Remo.*

The most famous of the Le Vau family is Louis (1612–1670), who worked at Versailles, at Vaux le Vicomte for Fouquet [**664**], on a project for the Collège des Quatre Nations for Mazarin. François Mansart (1598–1666), who initiated Val de Grâce, was a great planner; his nephew Jules Hardouin Mansart (1646–1708), Louis XIV's favourite and adviser, and surveyor of buildings, had a wide range of activities from Versailles to Marly and the provinces (Dijon).

Claude Perrault (1613–1688), tra-

ditional creator of the Louvre colonnade, Libéral Bruant (c. 1635–1697), who designed the hôtel des Invalides [**674**], Robert de Cotte (1656–1735) and François II d'Orbay, whom A. Laprade's research has shown to have played an essential but discreet role (in the colonnade and the Invalides) — while not being men of genius, they all contributed to the development of French architecture.

Numerous churches were built at the beginning of the 17th century — twenty from 1610 to 1660, the majority with a basilican nave. The façades were virtuoso pieces, the decoration applied without any relationship to the interior structure; they sometimes had two towers. Interior decoration no longer had figurative sculpture. The church of St Gervais et St Protais (c. 1616), attributed to Salomon de Brosse or to Métezeau, anticipated classicism with

FRENCH. CLAUDE LE LORRAIN (1600–1682).
Seaport: the Embarkation of the Queen of Sheba.
National Gallery, London. *Photo: Michael Holford.*

FRENCH. NICOLAS POUSSIN (c. 1594–1665).
Bacchanalian Revel before a Term of Pan.
National Gallery, London. *Photo: Michael Holford.*

758. ITALIAN. Rock crystal mirror in a pedimented frame of agate and sardonyx set with cameos and precious stones. A wedding gift from Venice to Marie de' Medici. 1600. *Louvre.*

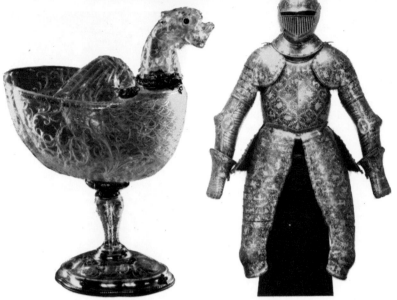

759. ITALIAN. Goblet in the form of a dragon. Rock crystal mounted in enamelled gold. *c.* 1650. *Rijksmuseum, Amsterdam.*

760. ITALIAN. A suit of armour engraved and gilded with the arms of the House of Savoy. *c.* 1625–1635. *Wallace Collection, London.*

761. *Right.* FRANCE. The Louvre. The east façade and the colonnade (1667/78) by Louis Le Vau and Claude Perrault, from drawings by François d'Orbay.

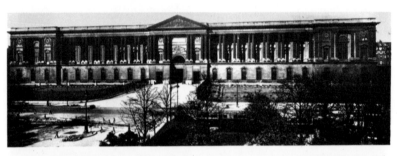

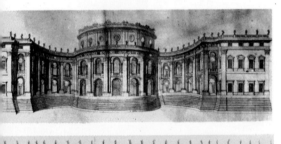

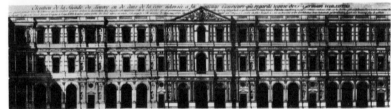

763, 764. *Above.* FRANCE. The Louvre. Bernini's first and last projects for the east façade, facing St Germain l'Auxerrois.

765. *Below.* FRANCE. The Louvre of Pierre Lescot (*c.* 1510–1578). Completed in 1551. Decorative sculpture by Jean Goujon (*c.* 1510–1566).

762. FRANCE. The Louvre. East façade of the Cour Carrée, built during the reigns of Henry II and Louis XIII, from drawings by Pierre Lescot; completed under Louis XIV by Claude Perrault who added the third Order with the balustrade.

766. FRANCE. Historical plan of the Louvre and plan of the Cour Carrée of the Louvre showing the additions made by Philippe Auguste and Charles V.

Philippe-Auguste, Charles V.

François I, Henry II, Charles IX, Henry III, Henry IV, Louis XIII.

Louis XIV (Le Vau, Perrault).

Napoleon I, Louis XVIII, Second Republic, Napoleon III, Third Republic.

Buildings destroyed during the Commune.

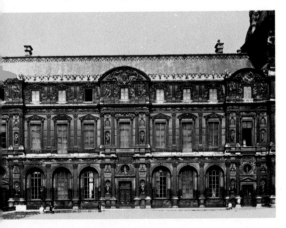

its severity and use of columns. St Paul et St Louis (aisleless nave, façade with three Orders), the most important Jesuit church in France, is by Martellange, who promoted what is called the 'Jesuit style' in France, and by P. Derand [767].

The Feuillants church by François Mansart, Ste Elisabeth (1631) and the Church of the Visitation at Avignon (1632) have façades in two Orders.

The dome took on more and more importance in relation to the façade (the court façade of the Sorbonne; the Invalides [716, 717]) and for this reason domed churches tended to be planned in the form of a Greek cross.

The church of the Sorbonne, begun for Richelieu in 1627 by J. Lemercier, is the most typical for the Louis XIII period. The Val de Grâce church, the most Italianate, begun in 1645 and worked on by J. Lemercier, P. Le Muet, G. Le Duc, can be attributed to François Mansart. The canopy by Bernini and the interior decoration by Michel Anguier accentuate its Baroque character. Conventual buildings were undertaken about 1655. St Roch, begun in 1653 by J. Lemercier, has a curious plan resulting in scenic perspectives (façade after 1736 from drawings by R. de Cotte). The hôtel des Invalides, begun in 1671 on Louis XIV's orders to house sick soldiers, was rounded off by J. Hardouin Mansart's church, his masterpiece; it was almost finished when he died in 1708, and was completed by R. de Cotte. Planned in the form of a Greek cross, it has a steeply pointed dome rising above a perfectly classical base with pediment and columns [717]. St Sulpice, the biggest Paris church after Notre Dame, begun in 1646, finished in about 1745, belongs mostly to the 18th century.

Secular architecture was dominated by the king's determination to finish or to construct palaces. At the Louvre [766]: the rearrangement of the Grande Galerie, only just completed; the closing of the Cour Carrée and the Pavillon de l'Horloge, Lescot's work being continued by J. Lemercier, then Le Vau (1661–1664), and his son-in-law d'Orbay. Louis XIV invited Bernini to Paris (1665). But the Italian projects for the exterior façade looking towards St Germain l'Auxerrois were judged inconvenient, and the colonnade was undertaken from 1668 by Perrault [761]; Le Vau designed the façade overlooking the Seine to match the colonnade.

The château of Versailles of Louis XIII [701–712], built from 1624 onwards, was on a simple plan: three blocks round the Marble Court, with an arcaded gallery that was removed by Louis XIV. The first works undertaken by Louis XIV (two pavilions, an orangery) were done by Le Vau

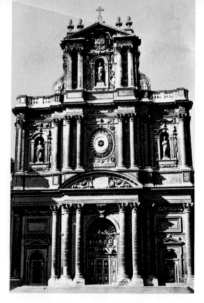

767. FRANCE. Church of St Paul et St Louis, Paris (1627–1641), copied from Il Gesù, Rome. Built under the supervision of Father Martellange (1568–1641) in collaboration with Father Derand.

769. FRENCH. MICHEL ANGUIER (1613–1686). The Nativity. Formerly in Val de Grâce. *St Roch, Paris.*

768. NEUF BRISACH. Plan of the fortified town by Vauban. 1699. The characteristic redan arrangement allows flanking fire.

770. NEUF BRISACH. Drawing of one of the gateways. 1699.

with the help of d'Orbay, and above all Le Nôtre in the gardens. From 1669 the king, who wanted to preserve Louis XIII's small château, added two wings on to the Marble Court, and orientated the central block towards the gardens. The interior decoration by Le Brun, in a sober Baroque style, makes use of trompe l'oeil (the Ambassadors' Staircase, destroyed). From 1678 and above all from 1683, with J. H. Mansart and Le Brun, Versailles evolved towards the grand classical and rational style. The ground-floor terrace giving on to the garden was destroyed and replaced by the wide level frontage without projections, articulated only by the twin columns and arched windows on the first floor of the central block; the space gained was transformed into the Hall of Mirrors [731] in between the Salon de la Paix and the Salon de la Guerre, ornamented with a symbolic 'French Order' of capitals in which a sun is flanked by lilies and cocks. The south

wing (1679–1682), the princes' wing (1684), the Orangery (1681–1686) and the Grand Trianon with its fine marble portico, which replaced the Trianon de Porcelaine — these have a striking purity that bears witness to the taste of the king and the genius of J. H. Mansart, R. de Cotte and their associates [710] (see colour plate p. 315).

The demolished château of Marly by J. H. Mansart (begun in 1679) consisted of twelve small pavilions (symbolising the twelve months) grouped round a central building (representing the sun) and a lake.

Louis XIV busied himself with public buildings, which were in a grave, severe, functional style. Town planning was developed during the 16th and 17th centuries.

Gardens. Claude Mollet (c. 1563–1650) and his son André laid down the principles for the classical royal gardens ('Keep nature at bay with the help of art') and anticipated Le Nôtre in re-

EVOLUTION OF THE FRENCH 'PLACE' IN THE 17TH AND 18TH CENTURIES

771. PARIS. The Place des Vosges (1606–1612) created by Henry IV on the site of the Palais des Tournelles.

772. NANCY. The Place Stanislas. Built in 1756 by the Nancy architect Emmanuel Héré. Wrought-iron gates by Jean Lamour.

773. MONTAUBAN. The Place Nationale. Partly constructed in 1616, it was modified after a fire in 1702 by Legendre.

776. PARIS. The Place Vendôme (formerly the Place Louis le Grand). Planned by J. H. Mansart as early as 1698; built from 1702 to 1720. The equestrian statue of Louis XIV by Girardon was destroyed in 1792, and replaced by the column cast in bronze from the 1200 cannons captured at Austerlitz.

774. FRENCH. Calvary, St Thégonnec (Finistère), decorated with scenes and figures of the Passion. 1610.

775. FRENCH. ANTOINE COYSEVOX (1640–1720). Mausoleum of the Marquis de Vaubrun. *Château de Serrant*.

777. FRENCH. CLAUDE DERUET (1588–1660). Fire (detail). This picture and three others (Earth, Water, and Air) were painted *c.* 1641/42 to decorate the Queen's Boudoir in Richelieu's château. *Orléans Museum*.

778. FRENCH. JEAN DE BOULLONGNE, called LE VALENTIN (*c.* 1594–1632). Judith. *Musée des Augustins, Toulouse*.

779. FRENCH. JACQUES LAGNEAU (born at Douai). Martyrdom of St Bartholomew. Ivory. 1638. *Toulouse Lautrec Museum, Albi*.

commending large avenues and canals, terraces, parterres, grottoes and aviaries. But it was André Le Nôtre who in his work at Versailles made nature comply with man's will for constructive planning, so creating the 'jardin à la française'.

Sculpture. Sculpture did not have the same scope as architecture and painting. At the beginning of the century, apart from Italian and Flemish influences, the tradition created by Goujon and Pilon still existed: Simon Guillain (1581–1658), son of Nicolas (d. 1639), followed this tradition. Simon's masterpieces are the bronzes for the Pont au Change monument (Louvre [**699**]). Tomb sculptors like Thomas Bourdin (*c.* 1575–1637) or Michel Bourdin (*c.* 1585–1645: *Amador de La Porte*, Louvre) took up the theme of the kneeling figure at prayer, made fashionable by Germain Pilon's school. Jean Varin (1604–1672) has less force, but he was the most brilliant medallist of the time [**803**]; in 1646, he succeeded Guillaume Dupré (1574–1642), himself a talented medallist, as head of the Mint.

With Jacques Sarrazin (*c.* 1588–1660), trained by N. Guillain and a stay in in Italy (1611–1627), French decorative style came to life (Pavillon de l'Horloge; Maisons). He is sometimes theatrical (monument to Henri de Bourbon at Chantilly [**669**]). His pupils and collaborators, Gilles Guérin [**915**] (1609–1678), Louis Lerambert (1620–1670), Thibault Poissant (1605–1668), and Flemish sculptors like van Obstal (1604–1668) and de Buyster (1595–1688) supplied the first team for Versailles. François Anguier (1604–1669) [**912**] is famous chiefly for the Montmorency tomb at Moulins, and his brother Michel Anguier (1613–1686) for his decorations for the Louvre (Anne of Austria's suite) and for Val de Grâce [**769**].

In the middle of the century, the principal role of sculptors was to decorate Versailles or the royal châteaux. Their work reveals the influence of Bernini or of antique art: e.g. François

STILL LIFE IN FRANCE

780. JEAN BAPTISTE MONNOYER (1634–1699). Flowers in a White Marble Vase on a Brocade Cloth. *Louvre*.

781. BAUGIN (worked in Paris *c.* 1630). Still Life with a Chess-board. *Louvre*.

Girardon [**712**] (1628–1715), collaborator of Le Brun, whose *Apollo and the Nymphs* was inspired by Hellenistic art [**723**], and who worked at the Louvre (Galerie d'Apollon, 1663). His style also reflects the theories of the Academy (*The Rape of Proserpine*, 1677–1699, Versailles; Richelieu's monument, 1675–1677, Sorbonne). Antoine Coysevox [**700**] (1640–1720) shone especially at Versailles [**706**] (1679, Hall of Mirrors, Ambassadors' Staircase, Salon de la Guerre); his vigorous busts (*The Grand Condé* [**724**],

782. FRANÇOIS DESPORTES (1661–1743). Peaches in a Silver Dish. *National Museum, Stockholm*.

FRENCH LANDSCAPE

784. *Above*. GABRIEL PÉRELLE (1602–1677) and his sons. Landscape with a Stormy Sky. Engraving.

785. *Above, right*. CLAUDE GELLÉE, called LE LORRAIN (1600–1682). Landscape in the Roman Campagna. Wash drawing. *Petit Palais, Paris*.

786. *Right*. GASPARD DUGHET, called GASPARD POUSSIN or LE GUASPRE (1615–1675). Landscape. *Doria Gallery, Rome*.

783. FRENCH. SIMON VOUET (1590–1649). Cupid and Psyche. *c.* 1625. *Lyon Museum*.

787. FRENCH. PIERRE MIGNARD (1612–1695). Youthful Self-portrait (presumed). *Formerly Pavel Bacher Collection, Prague.*

790. FRENCH. CLAUDE GELLÉE, called LE LORRAIN (1600–1682). Ascanius shooting the Stag. 1682. *Ashmolean Museum, Oxford.*

788. *Above, centre.* CLAUDE MELLAN (1598–1688). Raphael Menicucius.

789. *Above.* ROBERT NANTEUIL (c. 1623–1678). Anne Phelipeaux, Widow of Chavigny, 1666.

791. *Left.* ABRAHAM BOSSE (1602–1676). A Court Lady. After Saint-Igny.

792. JACQUES CALLOT (1592–1635). The Hanging of the Bandits. From the Grands Misères de la Guerre.

Le Brun, 1676; *Louis XIV*, 1680) are in contrast with the already very 18th-century style of the *Duchess of Burgundy as Diana*; Mazarin's tomb, 1689–1693, Louvre.

Pierre Puget (1620–1694) was the Baroque genius of the century [**672, 911**]. He only worked occasionally at Versailles [**722**]. Mainly trained during his stay in Rome and Florence with P. da Cortona, he also decorated ships and the town hall (1656) in Toulon. In 1659, he worked for Fouquet. *Milo of Crotona* (1671); relief of *Alexander and Diogenes* (1671–1693). He trained Bernard Toro (1671–1731), maker of decorative cartouches [**919**], and his nephew C. Veyrier (1637–1690).

Painting. Painting was gradually to free itself technically and spiritually from Italian influences which affected equally the French realist and decorative painters.

The most Italianate of Caravaggio's French followers was Jean de Boullongne, known as le Valentin [**778**] (*c.* 1594–1632), who borrowed his themes (*The Cheat*, Dresden) and his contrasted lighting. Claude Vignon (1593–1670), the decorator, was also influenced by Rembrandt [**670**] (*The Queen of Sheba*, Louvre). Lorraine, where Claude Deruet [**777**] (1598–1660) was a star, can claim Georges de La Tour (1593–1652), painter in ordinary to the king, one of the greatest artists of the century [**429**]. The clear

light of his early works: *Le Tricheur* (Landry Collection, Paris); *Le Joueur de Vielle* (Nantes); *Penitent St Jerome* (Stockholm) is superseded by an indirect candle-lighting stemming ultimately from Honthorst and the Utrecht school: *Adoration of the Shepherds* (Louvre); *Magdalen with Nightlight* (Louvre). Masses are reduced to geometric shapes, and infused with a religious sincerity inspired by the Franciscan revival in Lorraine: *Denial of St Peter* (Louvre); *St Sebastian mourned by St Irene* (Berlin); *Le Nouveau-Né* (Rennes) [**666, 667**].

To this realist trend in Paris and the provinces there belonged the Le Nain brothers, Antoine [**683**] (1588–1648), Louis [**680, 681**] (1593–1648) and Mathieu [**424, 682**] (*c.* 1607–1677), who interpreted 'à la française' the 'bam-

bocciate' that were in vogue. Antoine was more Flemish and old-fashioned (*Portrait in an Interior*, Louvre). Louis painted peasant subjects (*Peasant's Meal*, Louvre), landscapes (*The Waggon*, Louvre), religious subjects (*Supper at Emmaus*, Louvre) and mythological pictures (*Bacchus and Ariadne*). He is the greatest of the three. Mathieu, more superficial, borrowed themes from Dutch genre (*The Tric-Trac Players*, Louvre). The Le Nain were often imitated by Sébastien Bourdon (1616–1671) who was painter to Christina of Sweden (her portrait, Louvre) and by Jean Michelin (1632–1696) known for his talent as an imitator. Laurent de La Hyre [**430, 696**] (1606–1656) was a skilful but academic artist (*Nicholas V before the Body of St Francis of Assisi*, Louvre).

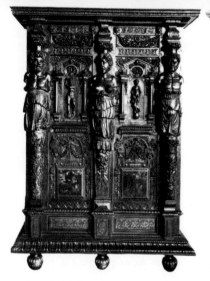

793. FRENCH. Burgundian cupboard with carvings by Hugues Sambin (d. 1600/02). *Louvre.*

794. FRENCH. Béarnese cupboard. Louis XIII period. *Château de Pau.*

795. FRENCH. Ebony cupboard inlaid with copper and tinfoil, and embellished with bronze gilt. Louis XIV period. Attributed to André Charles Boulle (1642–1732). *Louvre.*

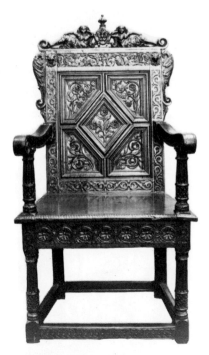

796. ENGLISH. Armchair. Early 17th century. *Victoria and Albert Museum.*

797. ENGLISH. Armchair. *c.* 1670. *Victoria and Albert Museum.*

798. ENGLISH. Chair. *c.* 1725. *Geffrye Museum, London.*

Portraiture, which was so fashionable in the 16th century, was continued in the 17th century by the Quesnel family, Foulon (*c.* 1550–1612), the Dumonstier (Daniel, 1574–1646), and Philippe de Champaigne [**434, 697**] (1602–1674), a native of Brussels. After training under Jean Bouillon, Michel de Bourdeaux and Jacques Fouquières he came to Paris in 1621. In 1621–1625 he was in the workshop of Lallemand in Paris; 1622–1626, landscapes and decoration of Luxembourg palace; 1628, painter in ordinary to Marie de' Medici and valet de chambre to the king; 1634, *The Duke of Longueville's Admission into the Order of the Holy Spirit* (Toulouse); 1635, Gallery of Famous Men at the Palais Cardinal; 1638, *Louis XIII's Vow,* Notre Dame; 1641–1644, decoration of the Sorbonne church; 1643, the portrait of St Cyran; 1648, *The*

Mayor and Aldermen of the City of Paris (Louvre); 1654, portrait of Mother Agnès Arnauld (Louvre).

Monumental painting included Eustache Le Sueur (1616–1655) who with Philippe de Champaigne was the greatest religious painter of his time; a great admirer of Raphael, who influenced his *Life of St Bruno* [**695**] (Louvre) and the *Muses* of the hôtel Lambert (Louvre), Le Sueur's restrained style contrasts with the Baroque style of his master Simon Vouet [**686, 783**] (1590–1649) whose influence was considerable. From his long stay in Italy (1612–1627) he painted the *Birth of the Virgin* (S. Francesco a Ripa, Rome, 1615–1620); 1620, *The Virgin appearing to St Bruno* (Certosa of S. Martino, Naples); back in Paris in 1627, he painted the *Presentation in the Temple* (1641, Louvre); decoration of St Ger-

main (Louvre); decorations for Anne of Austria at Fontainebleau (1643), at the Palais Royal (1643–1647), at the hôtel Séguier (1638–1649).

While decorative art was being developed in Paris, in Rome Poussin and Claude le Lorrain achieved the highest expression of French genius in historical painting and portraiture. Nicolas Poussin [**689-691, 693**] (1594–1665) lived chiefly in Rome. Pupil in 1611 of Quentin Varin, at Les Andelys, he moved in 1612 to Noël Jouvenet's studio in Rouen and worked for the queen mother at the Luxembourg palace in Paris with Champaigne; he met the poet Marino (*L'Adone*). In 1624 he left for Rome by way of Venice and worked in Domenichino's studio. 1628, *Martyrdom of St Erasmus* (Vatican), *Massacre of the Innocents* (Chantilly); *c.* 1630, influence of

Titian's Este *Bacchanals: Sleeping Venus* (Dresden) **[687]**; *Inspiration of the Poet* (Louvre); *Triumph of Flora* (Louvre); *Arcadian Shepherds* (Duke of Devonshire; Louvre); *Flora's Kingdom* (Dresden). 1636–1641, first series of *Seven Sacraments* for Cassiano del Pozzo (Duke of Rutland). 1640–1642, *Paris* for decoration of Long Gallery, Louvre. 1644–1648, second series of *Seven Sacraments* for Chantelou (Earl of Ellesmere); growing influence of Raphael and the antique in stoical themes for French patrons, Pointel, Serisier, Chambray, Passart: *Eliezer and Rebecca* (Louvre); *Landscape with Snake* (National Gallery, London, 1648); Phocion landscapes (Earl of Plymouth; Earl of Derby); *Landscapes with Diogenes* (Louvre). 1650, *Self-portrait* for Chantelou. Late works hermetic, with fundamentally different approach to landscape: *Landscape with Polyphemus* (Metropolitan, 1658). *Four Seasons* for Duc de Richelieu (1660–1664, Louvre); *Apollo and Daphne* (Louvre, 1665, unfinished). Besides Poussin: his brother-in-law Gaspard Dughet **[786]** (1615–1675), Francisque Millet (1642–1679) and Pierre Lemaire (1597–1653). Claude Gellée, known as le Lorrain (1600–1682), another Frenchman in Rome, has his sources in the romantic landscapes of the late Mannerists and the northerners Elsheimer and Brill. Pupil of Agostino Tassi, he was in Naples around 1623. In 1625–1627, at Nancy. *View of the Campo Vaccino in Rome* (1636, Louvre). By 1640, establishment of international reputation: *St Ursula* (National Gallery, London, 1641); *Queen of Sheba* (National Gallery, London, 1648); *The Mill* (Doria; National Gallery, London, 1648). Later works, increasing subtlety of light and serenity of mood: *Enchanted Castle* (H. Loyd, 1664); *Rape of Europa* (H. M. the Queen, 1655); *Origin of Coral* (Earl of Leicester, 1674); *Times of Day* (Leningrad); *Ascanius shooting Stag* (Ashmolean Museum, Oxford, 1682). Magnificent brush and wash sketches, impressionistic in sensitivity to light and freedom of handling (over 300 in the British Museum) compared to the 200 drawings of the *Liber Veritatis* (British Museum) compiled as a record against forgery **[692, 694, 785, 790]**. Besides Claude, there were the Patel: Pierre I (1620–1670), who collaborated on the decoration of the hôtel Lambert, and Pierre Antoine (1648–1708).

The personal rule of Louis XIV, Colbert's influence and the foundation of the Académie Royale led to a new style that was given weight by the genius of Charles Le Brun **[719]** (1619–1690). Historical, religious and portrait painter (*Le Chevalier Séguier*, Louvre) he was above all a decorator (cartoons for Gobelins tapestries, Louvre; Apollo Gallery, Hall of Mirrors Salons de la Paix and de la Guerre, Versailles). Formed by Perrier and

THE DECORATIVE ARTS IN FRANCE

799. Interior of the hôtel Lauzun, Paris, built by Le Vau. Detail of the State Room.

801. Detail of a tapestry from the series 'The Months' (1668–1694) by Le Brun and his workshop. September (with, in the background, the château of Chambord).
Mobilier Nationale, Paris.

804. Silver-gilt ewer with handle in the form of a leopard. 1697.
Poitiers Cathedral.

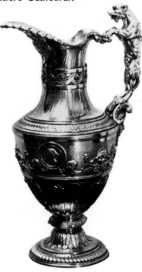

800. Chest in embossed and chased gold. Said to have belonged to Anne of Austria. Paris (?). *c.* 1645. *Louvre.*

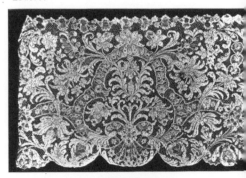

802. Alençon lace. 17th century.

803. JEAN VARIN (1604–1672). Reverse of Richelieu's Medal. France, riding in a chariot driven by Fame, is crowned by Victory. 1630.

805. Nevers faience. In the Persian style (1630–1710) with polychrome decoration. *Louvre.*

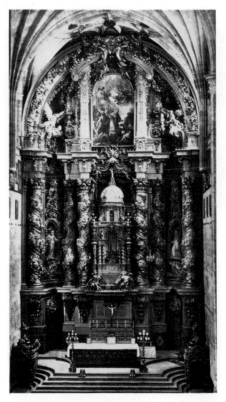

806. Savonnerie carpet, with the arms of France. Executed for the Galerie d'Apollon, Fontainebleau. Louis XIV period. *Louvre.*

807. Pendulum clock (Apollo's Chariot). Attributed to A. C. Boulle. Louis XIV period. *Fontainebleau.*

808. SPANISH. JOSÉ DE CHURRIGUERA (1665–1725). Main altar of S. Esteban, Salamanca. 1693.

809. SPANISH. ALONSO CANO (1601–1667). The Immaculate Conception. *Granada Cathedral.*

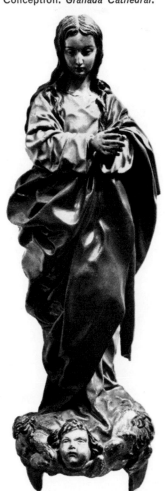

Vouet, and by his stay in Rome, painter to Fouquet and then to the king (1663), he was a veritable dictator until his downfall on Colbert's death, 1683. Pierre Mignard (1612–1695), a protégé of Louvois, took his place.

Tapestries. There was great development following the prohibition of foreign tapestries at the beginning of the 17th century and the creation of the Gobelins (1662) of which Le Brun became director in 1664 [**801**], and of the Aubusson and Beauvais (1664) factories. Among the most famous tapestries: the Old Testament and Ulysses by S. Vouet; the life of the Virgin by Philippe de Champaigne; the story of Alexander, the history of the king, the royal houses, by Le Brun; the remarkable grotesques on a yellow background by J. B. Monnoyer after Berain.

Engraving. Engraving was of the utmost importance in the 17th century. Woodcuts were almost entirely abandoned in favour of copperplate engraving. Portraiture was very fashionable: Thomas de Leu (d. 1620), Léonard Gautier (1561 – *c.* 1630) foreshadow the already more refined style of Michel Lasne (1580–1667). The craft was taken to extremes of virtuosity by Claude Mellan [**788**] (1598–1688), while Jean Morin (1609–1650) adopted 'stippling' in his portraits. Robert Nanteuil (*c.* 1623–1678) achieved perfection in

engraving as in pastel drawing [**789**].

One of the greatest etchers and draughtsmen was the Lorrain, Jacques Callot (1592–1635) [**423, 679, 792**]. His earlier works, in Florence, 1611–1621 (fairs, festivals, courtiers, beggars) are reminiscent of the Mannerist style of Jacques Bellange (1594–1638). Back at Nancy the works of the 1620s have a greater depth (*Gipsies*, 1622), culminating in the 'Grands Misères de la Guerre', a record of the savagery of the Thirty Years' War comparable to Goya's 'Desastres'. Abraham Bosse (1602–1676) is heavier, but evokes an exact picture of the middle class of the time [**791**], drawings of whom were sometimes supplied to him by Saint-Igny (1600–1650).

The minor arts. There were a number of masterpieces of goldsmiths' work, among them the famous silver ware of the king and Anne of Austria's chest carved in gold (Louvre [**800**]). Costumes were besprinkled with jewellery (tokens, trinkets, earrings, necklaces, bracelets, rings, pendants, brooches, pearls, and precious stones). Wrought-iron work produced some remarkable pieces (gates for the Wideville grotto; gates for Maisons, before 1658, Louvre).

Furniture at the end of the 16th century ceased to be transportable: its technique and function changed. Cabinets, richly ornamented, often of foreign origin or manufacture, were in ebony inlaid with ivory, metal,

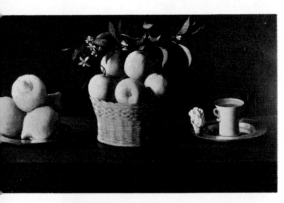

810. SPANISH. ZURBARÁN
(1598–1664). Bodegón. 1633.
Maxwell Blake Collection, Tangier.

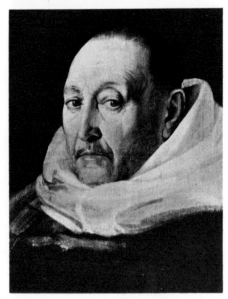

811. SPANISH. FRAY JUAN
BAUTISTA MAYNO (1578–1649).
Portrait of a Dominican.
Formerly Turner Collection, London.

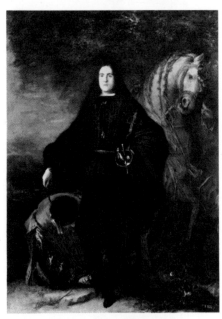

812. SPANISH. JUAN CARREÑO
DE MIRANDA (1614–1685).
The Duke of Pastrana. *Prado.*

mother-of-pearl, pewter, enamel, copper (Pierre Boulle, 1580–1635, then his grandson André Charles Boulle [**795, 807**], 1642–1732). Cupboards followed the Renaissance pattern for a long time; chests disappeared.

In 1667 the Manufacture Royale des Meubles de la Couronne at the Gobelins, for the decoration and furnishing of the royal residences, helped to spread Le Brun's style. But, in interior decoration, which developed in all fields at Versailles, ornamental painters played an important part. Interior decoration was classic in style with Jean Le Pautre (1618–1682), revived the grotesques with Jean I Berain (1640–1711) [**923**], and was already 18th-century in spirit with Claude III Audran (1658–1734).

SPAIN

History. The political power decreased under the last Habsburgs: Philip III (1598–1621), Philip IV (1621–1665) and Charles II (1665–1700) were weak rulers; the state was weakened constantly. Madrid became the royal residence, Seville remained the capital of wealth and commerce. Foreign influences and the Moorish tradition gave way to a more national inspiration which made this period the golden age.

The colonies remained stable and trade with South America flourished, the southern part of the American empire was developed (Venezuela, New Andalusia).

Religious feeling that reached intense heights existed side by side with extreme moral corruption.

In literature it was a great period of the theatre with Lope de Vega (1562–1635), Tirso de Molina (1570–1650) and Calderón (1600–1681). Poetry and the novel were immortalised by Góngora (1561–1627) and the *Don Quixote* of Cervantes (1547–1616).

In music the *zarzuelas*, *églogas* and the *comedias harmónicas* belonged to musical drama for which contemporary dramatists wrote.

Architecture. The first Baroque style showed little local variety. In Andalusia Moorish elements persisted in a late Mudejar style, the ornamental profusion in plaster and wood satisfying the people. In Aragon, the same persistence of the Mudejar (Sto Domingo del Val chapel in Saragossa cathedral). J. B. Monegro, in the Sagrario chapel of Toledo cathedral (1610) with its bronzes and sombre marble, is still Herreraesque.

The first Baroque architect was J. Gomez de Mora (1586–1648); his Jesuit college, the Clericía in Salamanca, begun in 1617, is typical of this early Spanish Baroque, which broke away from Herrera's severity [**537**]. At Toledo, the elliptical dome of the Bernardine church was built on the plan by J. Gomez de Mora. G. B. Crescenzi, painter as well as

Philip III's favourite architect, went to Italy in 1617; in his famous work, the Pantheon of the Kings at the Escorial, Spanish characteristics already appear against an Italian Mannerist background.

The Jesuit architects built according to the principles of their Order: Francisco Bautista [**540**] and Lorenzo da S. Nicolás, learned author of *De Arte y Uso de la Arquitectura*, who built several churches in Madrid in the Mora tradition.

Secular architecture produced numerous castles; these had no great external character, but were immense and housed vast collections of works of art and treasures. The only royal palace was the Buen Retiro (in Madrid) by Crescenzi and Alonso Carbonell, the favourite residence of the kings in the middle of the 17th century.

The Alcazars retained the ancient traditions (Segovia and Madrid where Mora worked). El Greco's son worked on Toledo town hall; that at Segovia is of the same type.

The Ministry of Foreign Affairs, by Crescenzi, completed in 1643, is one of the most beautiful public buildings of Philip IV's Madrid. Gomez de Mora was commissioned to do the Plaza Mayor, which was partly destroyed by fire in 1672 and rebuilt differently.

In the second half of the 17th century, Spanish Baroque became freer with more lively characteristics (importance of ceremonies, such as the entrance of Anne of Austria into Madrid in 1648, and especially the famous funeral ceremony of María Luisa of Orléans in 1689, by J. de Churriguera, which heralded a new style. The twisted columns, derived from the columns of Bernini's baldachino in St Peter's, were employed everywhere (F. J. Ricci, in his architectural treatise, even preached a 'Solomonic' style, i.e. one based on Solomon's Temple in Jerusalem). After 1650, interior decoration was characterised by enormous retables, carved and gilded, ornamented with swags of fruit, flowers and angels — e.g. Churriguera's altar in S. Esteban in Salamanca [**808**].

The great architects were at the same time sculptors and very often painters — e.g. Alonso Cano, principal master of Toledo cathedral, designer of the façade of Granada cathedral with its magnificent effects of light and shade (Lebrija altar, 1629–1631; altar in the convent of Sta Paula, Seville, 1635). He had a pupil from Madrid, S. de Herrera Barnuevo (S. Isidro chapel, S. Andrés, Madrid). F. Herrera the Younger began the church of the Virgen del Pilar in Saragossa in 1681, an immense cathedral (435 × 220 ft) typically Spanish, very Herreraesque. J. Ximenez Donoso built the house of the Panadería in the Plaza Mayor, Madrid, after the 1672 fire.

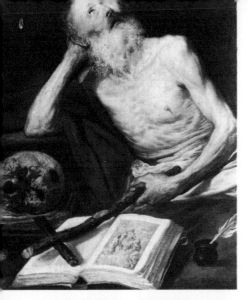

813. SPANISH. ANTONIO DE PEREDA (1608–1678). St Jerome. 1643. *Prado*.

815. SPANISH. FRAY JUAN RIZI (1600–1681). The Supper of St Benedict. *Prado*.

817. SPANISH. CLAUDIO COELLO (1642–1693). La Sagrada Forma. Commissioned in 1684 by Charles II. *Sacristy of the Escorial*.

The Castilian José de Churriguera [808] (1665–1725) is characteristic of the Spanish genius of the 17th century, when architecture was overwhelmed with decoration (see *Historical Summary* of Chapter 4, p. 403).

Architects in Galicia (Domingo Antonio de Andrade, d. 1712, supervisor of the work for Santiago de Compostela after 1676, and Peña de Toro), like the Portuguese, preserved a greater severity in the proportions. So also the Baroque Asturians, who liked a simpler style. In Catalonia, the style was lighter; the Gerona façade is the finest achievement. Valencia up to 1936 was the town with the most beautiful examples of the Baroque (tower of Sta Catalina, by J. B. Viñés).

Sculpture. Whether mystic or realist in expression, the themes of Spanish sculpture were religious. Monumental and sepulchral sculpture disappeared; the altars and especially the processional statues (*pasos*) mostly treated ecstasy or pain (the Passion). Wood was enriched with polychromy, often with the collaboration of famous painters, and created an expressive realism.

Castile, like Andalusia, was different from the other schools. At Valladolid, Gregorio Fernandez (or Hernandez, *c.* 1576–1636), sculptor of the *Recumbent Christ* (1605, Valladolid museum), was in line of succession to Berruguete and Juan de Juni, and was emotional to the point of being theatrical. He formed a school in Castile [547].

In Andalusia, Seville reached the climax of realism in Juan Martinez Montañés (1568–1649) [538] whose high altar in the church at Santiponce near Seville is one of the most beautiful works of the century. The *Immaculate Conception* (Seville cathedral) is also characteristic of the purity of his style. His dominant personality eclipsed those sculptors who in Andalusia marked the transition from classicism to realism: Gaspar Nuñez Delgado (between 1578 and 1605) in Seville, Pablo de Rojas (between 1581 and 1607) in Granada. Juan de Mesa (1583–1627) was the most original of Martinez Montañés' followers; their works were for a long time confused. He is, however, distinguishable by his emotionalism, particularly in his favourite theme, the Crucifixion (the *Cristo del Amor*, Seville, S. Salvador).

Alonso Cano (1601–1667) who was painter, sculptor and architect, dominated art in Granada [541, 542]. He also worked in Seville and Madrid. In his search for ideal types, he was classical, and his forms are full of harmony and grandeur (*Immaculate Conception*, Granada cathedral [809]). His pupil Pedro de Mena (1628–1688), who settled very early in Málaga, with a sincere and more prosaic piety, created one of the most beautiful images for public devotion, the

814. SPANISH. FRANCISCO COLLANTES (1599–1656). The Burning Bush. *Louvre*.

816. SPANISH. Detail of a vestment woven with gold thread and embroidered with pearls. Made for Cardinal Sandoval by Felipe del Corral. Early 17th century. *Toledo Cathedral*.

St Francis in Toledo cathedral [431]. Also in Granada was José de Mora (1642–1724), son of a pupil of Cano, and the most original of a family of sculptors.

At the end of the century the Seville school, following Montañés and Cano, was transformed under Bernini's influence. The last great 17th-century Sevillian sculptor was Pedro Roldán (1624–1699): altar in the Caridad hospital, Seville. His daughter, Luisa Roldán (1656–1704), was in her turn a sculptor of merit. In Granada Diego de Mora (1658–1724) continued the art of Alonso Cano (*Immaculate Conception*, collegiate church, Granada).

Painting. The 17th century is the great period of Spanish painting. During this 'golden age' Seville and Madrid were particularly active centres where there emerged a truly national style,

popular, religious and of an admirable quality, stimulated by Italian influence.

The work of El Greco [406, 433, 548–551] (Domenikos Theotokopoulos, 1541–1614) closed the 16th century and through its emphasis on form belongs to Mannerism. Born in Crete, no doubt trained by Byzantine monks, then in Italy influenced by Tintoretto, Bassano and Michelangelo, he is documented in 1577 at Toledo, where he painted the altar for the Sto Domingo el Antiguo church, and the *Espolio* (Disrobing of Christ) in Toledo cathedral. In 1580 Philip II commissioned him to paint the *Martyrdom of St Maurice and the Theban Legion* (Escorial); 1586, *Burial of Count Orgaz* (Sto Tomé, Toledo). About 1591, *Descent from the Cross*; 1597, *St Eugene, St Ildefonso* (Escorial), *St Andrew and St Francis* (Prado). In his last years: *The Visitation* (Cambridge, Massachusetts), *Opening of the Fifth Seal, View of Toledo* (Metropolitan, New York). El Greco was also a sculptor and architect.

Luis Tristán (end of the 16th century–1624) was the only one to continue El Greco's style in the 17th century. Pedro Orrente (*c.* 1570–1645) imitated the Bassani. Francisco Ribalta (*c.* 1565–1628) who worked in Valencia was strongly marked by Italian influence, but he was already able to adapt this influence to a truly national style (*Vision of St Francis*, Prado [539]). He may have been the master of José de Ribera (1591–1652), nicknamed in Italy 'il Spagnoletto' [552]. Established in Naples, he admired Caravaggio (*The Clubfoot*, Louvre; the *Martyrdom of St Bartholomew*, Prado) and himself had a notable influence on Italian painting. An exception among the Spaniards, he was an engraver and painter of mythological scenes (*Apollo and Marsyas*, Brussels). Another pupil of Ribalta in Valencia was Jerónimo Jacinto de Espinosa (1600–1667).

The Seville school, particularly brilliant, was freed from lingering Romanism by the pictorial experiments of Juan de Roelas (1558/60–1625), who taught Pablo Legote (*c.* 1598–1671), and of Francisco Herrera the Elder (*c.* 1590–1656) with his expressive violence (*St Basil dictating his Doctrine*, Louvre [565]).

Piety found an interpreter in Francisco Zurbarán [428, 554, 810] (1598–after 1664), who painted monks, and whose large compositions for monasteries have been dispersed. 1614, apprenticed to Pedro Diaz de Villanueva in Seville; also perhaps a pupil of Juan de Roelas. 1616, *Immaculate Conception*; 1625, great altar for St Peter's chapel, Seville cathedral; 1629, with Francisco Herrera, series of paintings for S. Bonaventura college; 1631, *Apotheosis of St Thomas Aquinas* for the Sto Tomás college in Seville; 1633–1639, series for the Guadalupe

convent (scenes from the life of St Jerome and the monks); 1653, *Christ bearing the Cross* (Orléans museum); 1661, *Immaculate Conception* (Budapest). Admirable portraitist (*Monks of the Order of Mercy*, Madrid, S. Fernando Academy). His stark still lifes (Contino-Bonacossi Collection, Florence) evoke the mystic feeling of the works of the Carthusian Fray Juan Sanchez Cotán (1561–1627) in Granada [553].

Another great painter of piety, but in a more popular vein, was Bartolomé Esteban Murillo (1617–1682), perfect mouthpiece of the Jesuits, who in the 'Purísima' (Immaculate Conception) created the national religious theme of Spain [564]. His varied technique evolved from Caravaggesque after a visit to Madrid towards a more fluid style with colouring inspired by Flanders and Venice. Pupil of Juan del Castillo, he painted between 1645 and 1655 *The Young Beggar* (Louvre); 1645–1646, lives of St Francis and St James (Franciscan monastery, Seville); *Angels' Kitchen* (Louvre). About 1650, *Child with Grapes* (Munich). 1655, *Birth of the Virgin* (Louvre). 1656, *Vision of St Anthony* (Seville cathedral). 1660, he founded in Seville the academy of painting of which he was the first president. 1665–1670, series of twenty-two paintings for the Church of the Capuchins. 1670, the *Holy Family* known as the *Virgin of Seville* (Louvre). 1671–1674, series for the Caridad hospital, Seville. 1682, series for the Capuchin monastery, Cadiz. His realism was continued by Nuñez de Villavicencio (1644–1700).

The most Baroque, with his sometimes morbid style and spirit, was no doubt Juan Valdés Leal (1622–1690): *Allegory of the End of the World* (Caridad hospital, Seville [563]).

In Granada worked Alonso Cano (1601–1667), remarkable less as a painter than as sculptor and architect, and Juan de Sevilla (1643–1695), so sensitive to van Dyck. At Cordova: Antonio del Castillo (1619–1668).

In Madrid, while Vincento Carducho (1576–1638) ranks mainly as a critic (*Diálogos de la Pintura*, 1633), Juan Bautista Mayno (1578–1649) followed the Caravaggesque manner (*Epiphany*, Prado) [811].

Diego Velasquez [426, 556–562] (1599-1660), pupil of F. Herrera the Elder, and of the Romanist Francisco Pacheco, whose daughter he married, but above all formed by his two trips to Italy, dominated the whole period. He started his career by painting bodegones (still lifes). In 1619, *Adoration of the Magi* (Prado). 1619–1621, *Jesus in the House of Martha and Mary*; *Water-carrier of Seville* (Apsley House, London). In 1623, he settled in Madrid in the service of Philip IV: *Don Carlos* (Prado). 1626–1628, *The Topers*. In 1628, Rubens advised him to visit

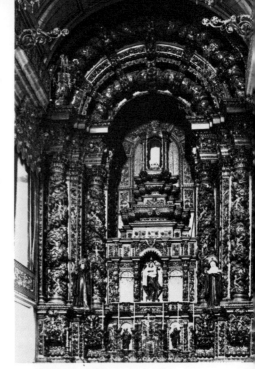

818. PORTUGUESE. Main altar of the Benedictine church of São Bento da Vitoria, Oporto. Completed before 1704.

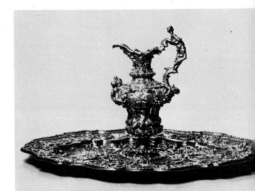

819. PORTUGUESE. Ewer and basin. Style of the second half of the 17th century. *Lisbon Museum.*

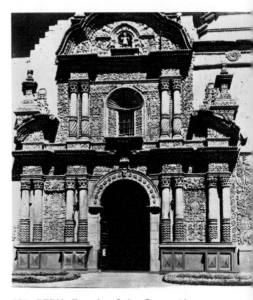

820. PERU. Façade of the Compañía, Arequipa. 1698.

Italy (1629, Venice, Ferrara, Rome). About 1630, *Forge of Vulcan*. Magnificent and relentless court portraits: *Philip IV* (London and Prado), *Don Baltasar Carlos* (Prado). 1630s, decorations for the Torre de la Parada: hunting portraits of Philip, Ferdinand, Baltasar Carlos; and for Buen Retiro: *Surrender of Breda* (1634–1635), equestrian portrait of Baltasar Carlos (Prado). Series of dwarfs, buffoons, idiots, for Alcazar: *El Primo, Sebastián de Morra, Calabacillas, Bobo de Coria*. 1640s, Catalan revolt; ' *Fraga* ' *Philip* (Frick Collection, New York, 1644); *Woman with Fan* (Wallace Collection, London). 1649–1651, second trip to Italy (Genoa, Rome); portrait of Pope Innocent X; the *Villa Medici*, the light technique of which anticipates Impressionism. 1652, appointed palace marshal. *Queen María Anna* (Louvre and Prado). 1653–1654, *Infanta Margarita* (Vienna). About 1656–1660, *Las Meninas*. His religious and mythological paintings (*Christ at the Column*, the *Rokeby Venus*, National Gallery, London [p. 212]) were rarer.

Juan Bautista del Mazo (d. 1667), Juan Carreño de Miranda (1614–1685) reflected Velasquez's manner [**812**], as did Juan Pareja (*c.* 1606–1670) and Antonio Puga.

Among Velasquez's contemporaries: Antonio de Pereda (1608–1678; *Dream of the Knight*, S. Fernando Academy, Madrid), and the Rizi brothers (Fray Juan Andrés [**815**], 1600–1681, and Francisco, 1608–1685).

In the second half of the century the two most important artists were Matteo Cerezo (*c.* 1626–1666, the *Magdalen*, The Hague) and Claudio Coello (1642–1693) whose masterpiece was the *Sagrada Forma* (sacristy of the Escorial [**817**]). Francisco Collantes (1599–1656), pupil of Francisco Rizi [**814**], as was Juan Antonio Escalante (1630–1670), was one of the few to paint landscapes.

The minor arts. Wrought iron was particularly important in the 16th century (cathedral gates at Palencia, by Francisco de Villalpando, at Pamplona and Saragossa). Wrought-iron work was continued in the 17th century by Juan Bautista Celma (cathedral gates of Burgos and Palencia). B. Rodriguez and L. de Penafiel worked at Toledo. In 1650, Puech wrought the gates of S. Pablo in Saragossa. In 1692 Sebastián Condé worked at Seville cathedral.

Armour was also wrought and skilfully engraved. Toledo excelled in the manufacture of swords and daggers.

In gold religious objects of great value were created. Among the 17th-century goldsmiths were Gaspar Arrandas of Tarragona, Rafael Gonzales of Toledo and Buenaventura Fornaguera of Barcelona. The gold and silver ware of Santiago de Compostela are famous.

Ceramics extended to great decorative ensembles (altars, church interior decoration). Talavera ceramics are justly famous (pharmaceutical jars, candelabra, vases). In Catalonia it was often popular in character.

At the beginning of the 17th century furniture was characterised by turned woodwork (of Moorish inspiration). Chairs were covered with leather, furniture ornamented with geometrical designs. Iron cabinets were damascened with gold and silver; hangings in Cordova leather became less frequent, fabrics were embroidered in gold and covered with pearls. The decorative qualities that characterise Baroque art were expressed in cabinet-making as well as in woodwork (galleys and coaches).

PORTUGAL

History. Annexed by Spain in 1580, Portugal struggled for independence during the reigns of the Duke of Braganza, John IV (1641–1646), Alphonso VI (1656–1668). Pedro II (1668–1683) gave new impetus to the kingdom, which became free again at the peace of 1668.

The colonies were conquered one by one by the Dutch (see p. 317). On the economic level Portugal became a British protectorate (Treaty of Alliance, 1661).

Literature was in the Spanish taste; it regained its originality with the Jesuit A. Vieira (1608–1698) and Manuel Bernardes (1644–1710).

Architecture. Portuguese Baroque of the 17th century is much more sober than the Italian and the Churrigueresque Baroque. It was the Italian F. Terzi who trained in Lisbon, from 1576, a generation of architects with sober tastes. Decorations in ceramic *azulejos* (sacristy of Sta Cruz, at Coimbra, by M. João, 1623 onwards). Gold and Brazilian diamonds added, at the end of the century, a note of ostentation to interiors.

The Tinoco family produced the principal architects of 17th-century Portugal: P. Nunes Tinoco (sacristy of Sta Cruz at Coimbra, 1626, decorated with ceramic tiles); his son João Nunes Tinoco (Santarém seminary, 1676, which had an influence in Brazil). The best Baroque ensemble is Aveiro (SS. Gonzalo e Carmine, 1643).

Sculpture. Mostly in terra cotta and, as in Spain, in wood, statues were polychromed and gilded, generally set in big ensembles but sometimes isolated in niches. Decorative sculpture evolved towards the Baroque in the middle of the century, particularly during the reign of Dom Pedro II. Sculptured retables, which replaced the old painted ones, at first classical, were transformed in the north (Oporto, Aveiro), then in

821. COLOMBIA. GREGORIO VAZQUEZ (1638–1711). St Catherine of Siena. *Formerly Malo de Brigard Collection.*

822. MEXICO. Cathedral, Mexico City. Consecrated in 1656. The towers were completed in 1791.

Lisbon, at Évora (fine examples at São Bento, Oporto [**818**], São Domingos at Bemfica, the side altars of São Tirso).

Side by side with minor sculptors strongly influenced by Spanish art (Fernandez or Juni), Manuel Pereyra (1588–1683) of Oporto worked in Madrid and Burgos. His work is beautifully restrained in contrast to the theatrical emotionalism of Spanish sculpture (*St Bruno*, S. Fernando Academy, Madrid).

The most characteristic and important ensemble in the Portuguese Baroque style is the Alcobaça monastery (sanctuary, 1669–1672) ornamented with large statues in terra cotta and reliquary busts in polychrome wood (high altar, 1675–1678; the damaged group of the *Death of St Bernard, c.* 1687). Mestre Frei Pedro's name is associated at least with the execution of the high altar.

Painting. Less original than the sculpture of the period, painting was dominated by Spanish art until independence was restored in 1640. André Reinoso, active from 1623 to 1641

823. FLEMISH. CASPAR DE CRAYER (1584–1669). The Miraculous Draught of Fishes. *Brussels Museum.*

824. FLEMISH. THEODOOR VAN THULDEN (1606–1676). Triumph of Galatea. *Potsdam Museum.*

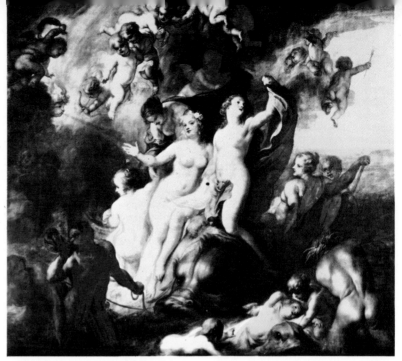

825. FLEMISH. Alexander the Great shown with a crown and keys. Tapestry. 17th century. From a cartoon after Jordaens. *Armeria Reale, Turin.*

(life of St Francis Xavier, sacristy of São Roque, Lisbon); Diego Pereira (1570–1640). Among the portraitists, Domingos da Cunha (1598–1644), pupil in Madrid of Eugenio Caxés, and especially Domingos Vieira II (active from 1627 to 1652) who sometimes anticipates Goya and recalls El Greco (portrait of Isabel de Moura, 1635, Lisbon museum) and who is the most interesting artist of 17th-century Portugal.

After the restoration of independence, more important than Avelar Rebelo, painter to King John IV, were Filipe Lobo and Antonio Pereira. The best works are often by anonymous masters like the Master of the Monk and the Master of the Braganza Family Portraits (Évora).

At the end of the century: Bento Coelho (1630–1707) of prolific and banal religious inspiration; and Josefa d'Aiala (Josefa d'Óbidos, 1634–1684) of Sevillian origin, whose still lifes in soft colours are very personal.

The minor arts. Ceramics imitated the Talavera styles, but remained Portuguese in the polychrome or blue-white mural decorations in *azulejos* in church interiors (Alcobaça monastery), palaces, or gardens.

Under Oriental influence (Chinese, Japanese and Persian motifs) there developed the so-called Luso-Oriental style in furniture, textiles, embroideries, earthenware, *azulejos*; it is remarkable for the richness and freedom of its forms. Decoration was particularly original in this period which drew its inspiration from the Orient and from an architectural style. There were two conflicting trends, one striving for simplicity, the other exuberant Baroque. Portugal's most personal contribution was less in furniture design which was subject to various influences (English, Dutch, exotic) than in goldsmiths' work which reached its apogee [819].

LATIN AMERICA

History. See under *Spain, Holland.*

Architecture. Iberian Baroque flourished in Latin America, particularly so in the 18th century, and above all in decoration, the imagination, richness and accumulation of which were stimulated by indigenous contributions.

1. After the conquest, Christianity was spread by the religious Orders, Augustinians, Franciscans, Dominicans, Carmelites. The Jesuits, great builders, had a considerable influence; they introduced the use of brick, limestone and tiles, which allowed the construction of cathedrals in place of the first crudely built wooden churches.

2. In the first Baroque period, plans were sent from Europe, sometimes from Rome itself; churches and monasteries were often fortified. But with the conquest assured, churches sprang up everywhere. Artists were called from Europe: Jerónimo Balbás built the Reyes chapel altar, Mexico cathedral, J. Martinez Montañés perhaps the one in Lima, Melchiore Cafa, a Maltese sculptor, the altar in Sta Rosa at Lima.

3. In the second period, local artists, Indian or of mixed blood, had more and more importance and were only supervised by the clergy (Compañía, Arequipa [820]). The principal building was the cathedral, which summarises all Latin American art, usually of the hall type with three doors. The façades, often with two bell towers, are very ornate. But it was in the interiors and furnishings that the Baroque richness developed, with twisted columns, leafy vines, grapes, flaming hearts, putti, scrolls and native motifs clustering on the Spanish-style altars, the stalls and organs in a flurry of gold or silver.

The most impressive cathedral is that in Mexico City, built on the site of an Aztec sun temple (consecrated in 1656, interior completed in 1667, towers finished in 1791 [822]); it follows the plan of Jaén in Andalusia, and in Mexico influenced Puebla, consecrated in 1649, Mérida, Oaxaca; in Peru, Lima (plans by J. Martinez de Arrona, 1629; completed in the 17th century; Cuzco (built on an Indian temple; plans by F. Becerra, modified; completed in 1654–1658). Worthy of note are Cajamarca in Peru (1682–1762) with severe interior and highly ornate altars, and Comayagua (Honduras), high decorated. In Argentina, Córdoba cathedral was begun

by J. Gonzalez Merguete who came from Granada in 1697, and completed by the Italians A. Blanqui and G. B. Primoli. In Colombia S. Ignacio at Bogotá is by G. B. Coluccini from Lucca.

In Guatemala the ruins of Antigua cathedral are still magnificent. The most beautiful example of the Hispano-Indian style, in which native elements (e.g. doorway of Arequipa) are grafted on to a Baroque and Churrigueresque base, is Santiago at Potoma. The splendid outburst of Baroque in Brazil was developed in the 18th century.

Secular architecture, particularly in Mexico, was influenced by Andalusian art (magnificent palaces). The Jesuit Guaranían style of the Paraguay theocracy created villages centred on a church, college and cemetery grouped round a square.

Painting. See p. 233 [**821**].

Sylvie Béguin, Lydie Huyghe and Gisèle Polaillon-Kerven

NETHERLANDS

General history. Two worlds existed in a limited space:

1. The southern provinces, with their traditional policy and religion, remained attached to Spain and were the battleground for numerous wars before being handed over to Austria in 1715. Art there reflected the pious humanism restored by the council of Trent.

2. The United Provinces of the north, recognised by Spain in 1609. The political system was federative and the new religion, Protestantism, excluded most religious art; daily life was represented with a steadfastness that seemed to ignore the difficulties of the country.

FLANDERS

History. In conferring the southern provinces on his daughter, the Infanta Isabella, and on his son-in-law Albert, Philip II gave Flanders the illusion of independence, but the country was to be ravaged by war and involved in the Spanish downfall. The Treaties of Münster (1648), the Pyrenees (1659), Aachen and Nijmegen closed the Scheldt, deprived Flanders of considerable territory; the Barrier Treaty (1715) confirmed the transfer of Flanders to Austria.

The court patronised the arts (Rubens became the official court painter) and certain national industries such as tapestry making.

Religious zeal revealed itself not only in the foundation of numerous monasteries but in the stimulus given to the arts under the influence of religious Orders, in particular of the Jesuits. Architecture, transplanted from Rome, was then an expression of the Catholic revival which triumphed in

Flanders; Rubens rallied to the cause in his preface to the *Palazzi di Genova* (1622).

Architecture. Italian elements, introduced by the Jesuits, were used for churches (St Charles Borromeo in Antwerp [**567**], works by Father Aiguillon and Father Huyssens).

The transition from the Flamboyant to the Baroque was very gradual, and the classical style had hardly any influence. In general Baroque decoration was applied to a structure that remained Gothic (houses in the Grand' Place, Brussels, 1696; Rubens' house at Antwerp). In the second half of the century, Hesius, another Jesuit, built St Michel at Louvain [**568**].

Sculpture. Pictorial in character, largely decorative, restless and congested in composition, sculpture was predominantly in wood which dissociated it from the architecture: stalls, pews, pulpits, confessionals vied in virtuosity and decorative exuberance. Certain families of artists excelled in this: the du Quesnoy, the Verbruggen, the Quellin. François du Quesnoy (1594–1642), son of Hieronymus, brother of Hieronymus II, was famous in Italy under the name of Francesco Fiammingo (decoration of the baldachino in St Peter's, Rome; portal of the Jesuit church, Brussels [**577**]). Artus Quellin the Elder (1609–1668) was called to Amsterdam to decorate the town hall [**580**] with his son Artus Quellin the Younger. Hendrik Verbruggen (1655–1724), son of Pieter, brother of Pieter II (pulpit of the cathedral in Brussels, Grimberghen confessionals). Noteworthy at Antwerp were Guillelmus Kerricx, Alexander van Papenhoven, Jan van der Steen. Lucas Faydherbe (1617–1697) of Mechelen was the most Rubensian of the Flemish sculptors: main altar and Bishop Andreas Cruesen's tomb in the cathedral, Mechelen [**604**]; high reliefs, Notre Dame de Hanswyck. He also worked in ivory. His followers were van der Veken, François Langhemans, Jean François Boeckstuyns and, in the 18th century, Theodoor Verhaegen.

The marble cutter the most sensitive to classical Italian style was Robert Henrard, of Dinant. Jean Delcour (1627–1707) of Liége was, in Italy, a follower of Bernini: bust of the Chancellor of Liverlo (1673); monument to the Bishop of Allamont in St Bavon, Ghent (his most important work, made up of a skeleton in gilt bronze, a fragile Virgin and a portrait of the prelate kneeling).

Painting. The outstanding personality of Peter Paul Rubens [**571, 572, 582, 583**] (1577–1640) dominated the century. With him Antwerp became what Venice had been in the previous

FLEMISH ENGRAVING

826. LUCAS VAN UDEN (1595–1672). The Winding Stream.

827. CHRISTOPHER JECHER (d. c. 1652). Hercules killing the Hydra. Woodcut after Rubens.

828. VAN DYCK (1599–1641). Pieter Bruegel. From the Iconography of Famous Men. Engraving.

829. FLEMISH. Goblet in silver gilt, decorated with cameos. Antwerp, c. 1625. *Rijksmuseum, Amsterdam.*

830. FLEMISH. Bobbin lace from Binche. 17th century.

century. He worked with the landscape painter Tobias Verhaecht, with van Noort and Otto van Veen. In 1600 he left for Italy where he stayed for eight years. On his return to Antwerp he married Isabella Brandt: *Self and Isabella* (Munich). Reputation established with triptychs of the *Erection of the Cross* (1610) and *Deposition* (1611–1614, Antwerp cathedral). Establishment of vast workshop; collaborators and assistants included van Dyck, F. Snyders, Jan Bruegel, Paul de Vos, Lucas van Uden. *Coup de Lance* (Antwerp, 1616); *Miraculous Draught of Fishes* (Mechelen, 1618); *Battle of the Amazons* (Munich, 1619); decorations for St Charles Borromeo, Antwerp (destroyed in 1718); 1622–1625, life of Marie de' Medici for Luxembourg palace (Louvre: modelli and bozzetti, Leningrad, Munich). In 1626 his wife died; Rubens travelled to Madrid and London as a diplomat: ceiling, Banqueting House, Whitehall (completed 1634), his only decorative work still in situ; modello (Glynde Place), sketches Louvre, Vienna, Brussels, Leningrad. 1630, marriage to Hélène Fourment: portraits as bride (Munich), *Het Pelsken* (Vienna), with two children (Louvre); series of mythologies for Philip IV: *Judgment of Paris* (Prado); *Garden of Love* (Prado). Personal late landscapes: *Château de Steen* (National Gallery, London); *Rainbow Landscape* (Wallace Collection, London); *Return from the Fields* (Pitti). Self-portrait (Vienna, 1637–1639). (See colour plate p. 245.)

The continuators and pupils of Rubens were Caspar de Crayer [823] (1584–1669): *St Augustine's Ecstasy* (Louvre), *Madonna and Saints* (Valenciennes museum); Jacob Jordaens [593] (1593–1678): *The Four Apostles* (Louvre), *The Triumph of the House of Orange* (1640, The Hague), *Fecundity* (Brussels); Pieter van Mol; Justus van Egmont; Theodoor van Thulden [824]. Among the animal painters: Frans Snyders [595] (1579–1657): *Lion and Wild Boar* (Munich), *Still Life with a Goose* (Brussels); Paul de Vos (c. 1590–1678); Jan Fyt [596] (1611–1661). Among the landscape painters: Jan Wildens (1586–1653); Lucas van Uden [826] (1595–1672); Jacques d'Arthois (1613–1686) who had as followers Ignatius van der Stock and Luc Achtschellinck. The Huysmans adopted the classical formulas: Cornelis (known as 'Huysmans of Mechelen', 1648–1727) was a pupil of Arthois; Jan Baptist (1654–1716) imitated his brother. Mention may also be made of the Peeters, of whom Bonaventura (1614–1652) specialised in seascapes and Gillis (1612–1653) painted rocky sites and delicately lit dunes.

Anthony van Dyck [578, 584–587 590–592, 601] (1599–1641) broke away from Rubens with a romantic charm which, in England, was to stimulate a whole generation of 18th-century painters. Pupil of H. van Balen, influenced by Caravaggio, he became, from 1617 to 1621, Rubens' right-hand man; he travelled to Genoa, Venice, Rome, Palermo 1621–1627; at Genoa a magnificent series of portraits of the Brignole Sale, Balbi, Doria and Spinola families (Washington, Louvre, Genoa, Edinburgh). At Antwerp from 1627 to 1632 he painted church pictures; other works include *Philippe le Roy* (Wallace Collection, London), *David Ryckaert* (Prado), *Rinaldo and Armida* (Baltimore) for Charles I, and eleven etched portraits in the *Iconography* (see *The minor arts*, p. 317). He preferred half-tones and monochromes to warm polychromes. 1632, in England as court painter to Charles I: portraits of king, Henrietta Maria and family (Louvre, National Gallery, London, Windsor, Turin) and court: family group of 4th Earl of Pembroke (Wilton, c. 1634); *Lords John and Bernard Stuart*; *Earl of Strafford*.

Cornelis de Vos (c. 1585–1651) owes very little to Rubens but belongs to the tradition of the Flemish primitives [589]. The Bosch and Bruegel tradition was handed down to Adriaen Brouwer (1606–1638): *The Surgeon* (Antwerp Museum); *Drinking Bout* (Amsterdam Museum) [600], who was followed by Jos van Craesbeeck; and to David Teniers [581, 598] (1610–1690) who married the daughter of 'Velvet' Bruegel, Bruegel the Elder's son (*Gathering of Birds*, Vienna Museum). Teniers was imitated by David Ryckaert, Willem van Herp and Mattheus van Helmont. Egidius van Tilborch (c. 1625–1678) was his pupil. Other painters: Gonzales Coques and van der Meulen (1632–1690) who immortalised Louis XIV's campaigns and was to be imitated by the Martin, by Genoels, by F. Duchatel. Denis van Alsloot and Anthonis Sallaert specialised in pageants and processions. The van Heil painted snow scenes and fires. Jan Siberechts (1627–1703) painted rustic landscapes and remained independent [606].

The end of the century saw the decline of this brilliant school of painting.

The minor arts. Audenarde was famous for the greens in its tapestries (the factory was endangered after the bombardment of the town in 1684). The workshops of Brussels were very active; the greatest painters designed cartoons for them: story of Decius Mus, of Achilles, of Constantine, *Triumph of the Eucharist* and *Forms of the Holy Sacrament*, after Rubens. Three-dimensional form was accentuated in these tapestries, figures were larger, perspective effects increased, the borders became heavier. From 1635, Jordaens designed sets (*Rustic Life*, story of Ulysses, story of Alexander [825]). Jan van der Hoecke and Justus van Egmont also did cartoons. Later the

FRENCH. CHARLES LE BRUN (1619–1690). Louis XIV visiting the Gobelins Factory. Tapestry. 1663–1675. Gobelins Museum, Paris. *Photo: Giraudon, Paris.*

FRANCE. Garden front of the château, Versailles. *Photo: Jean Roubier.*

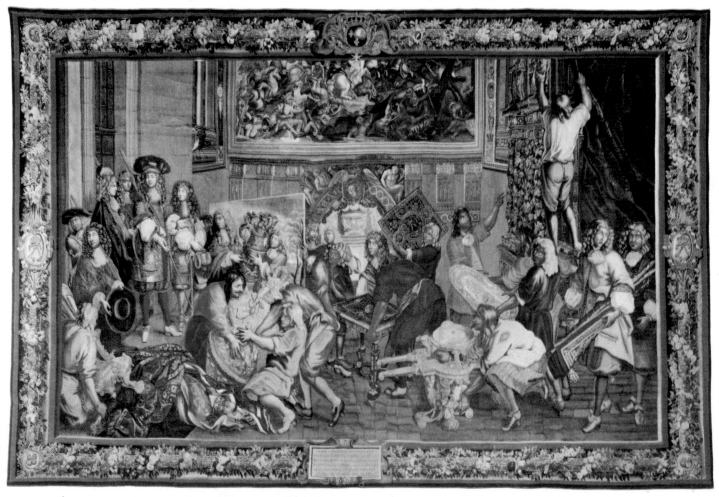

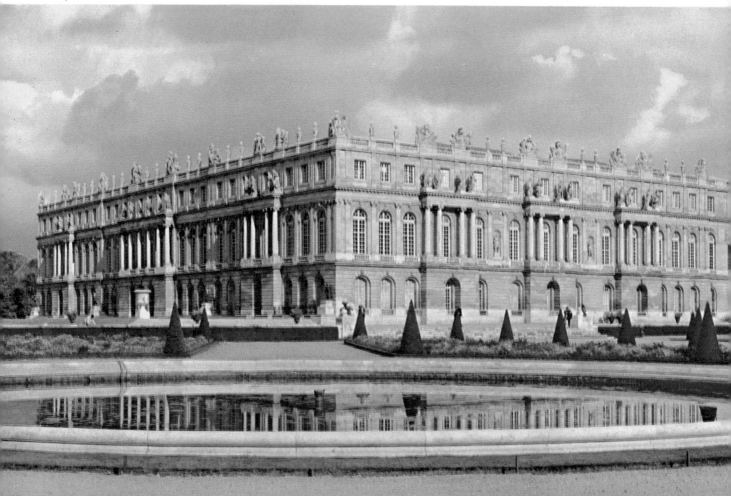

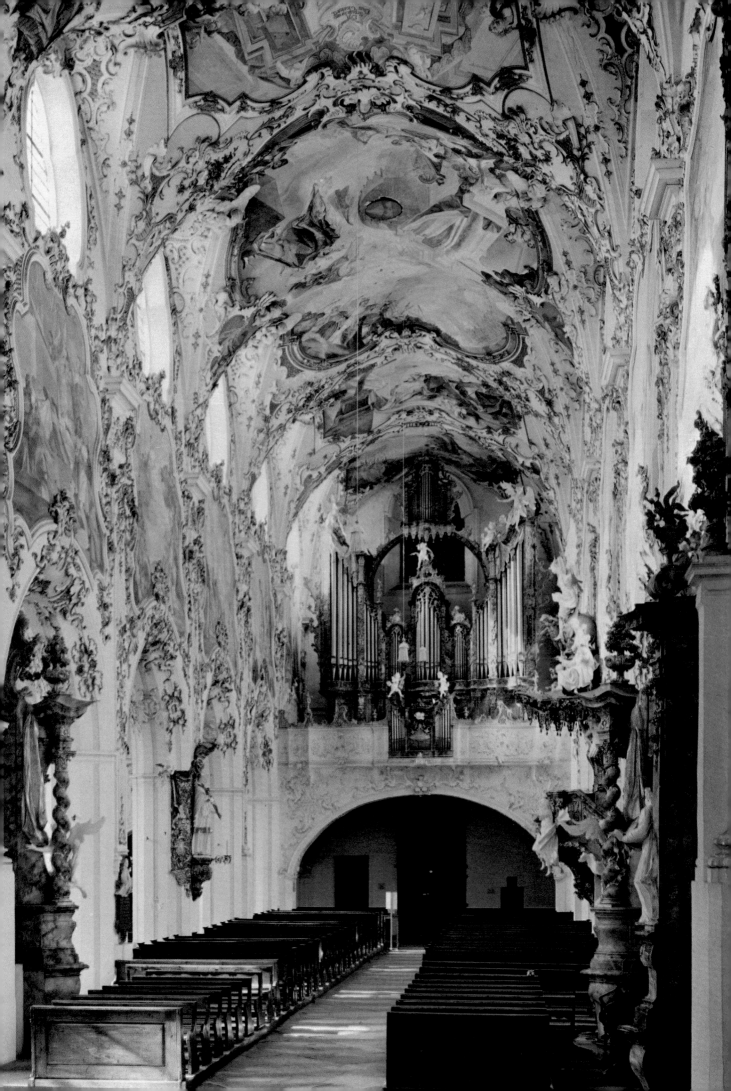

decoration became lighter and architectural or sculptural borders were abandoned. At the end of the 17th century, Ludwig van Schoor gave new importance to landscape backgrounds and was influenced by the French taste. Brussels launched the fashion for 'ténières' (tapestries with rustic subjects inspired by Teniers) which were highly favoured in the 18th century. The production of the Antwerp factories was inferior to that of Brussels. Tapestries made at Bruges and Enghien are rare but sometimes of high quality.

17th-century stained glass is far inferior to that of the 16th century. The technique was lost, and replaced by painting on glass (stained glass windows of the Chapel of the Virgin, cathedral, Brussels, designed by van Thulden, painted by J. de Labaer).

In engraving intaglio predominated, chiefly line engravings of famous paintings by Rubens, who did not himself engrave but created a school of engravers: Cornelis Galle, Pieter Soutman, Lucas Vorsterman and his pupil Paul Pontius. Reproductions also of Jordaens, Gerard Seghers and van Dyck who etched some of the plates in his celebrated *Iconography of Famous Men* [**828**].

Goldsmiths' work [**829**] and wrought iron were in the current taste: monstrances, ewers, dishes, gates and iron chimney-plates were richly decorated.

Bobbin-lace was at its height: triangular fichu of Brussels and Brabant; Flanders; Mechelen and Antwerp; Valenciennes and Binche [**830**]. The so-called ' Dutch ' and ' English ' lace originated in the southern Netherlands.

The exuberance of religious furniture complemented the massive appearance of domestic furniture, in oak or walnut, occasionally inlaid with precious woods. But great imagination went into the decoration of cabinets in ebony or rosewood, inlaid with ivory, metal, shell or small pictures. Antwerp was the main centre of such work.

REMBRANDT'S CONTEMPORARIES

831. DUTCH. FERDINAND BOL (1616–1680). An Angel appearing to Gideon. 1641.

832. DUTCH. GERARD DOU (1613–1675). Rembrandt in his Studio. *Leamington Art Gallery.*

833. DUTCH. BARENT FABRITIUS (1624–1673). Self-portrait (?). *Kunstinstitut, Frankfurt.*

834. DUTCH. NICOLAS MAES (1634–1693). The Lace-maker. *Kunsthistorisches Museum, Vienna.*

HOLLAND

History. The assembly of the States General of The Hague was permanent from 1593. The United Provinces developed individually in about 1610: in the north, Holland and Zeeland (Orange family), dominated by middle class merchants; Friesland and Groningen, rural democracy; in the south, the ancient archbishopric of Utrecht, where the clergy, middle class and nobility were in conflict; in the centre, Overijssel and Gelderland dominated by the nobility.

Holland was agitated by the political rivalry between the Republicans, middle class, peace-loving and liberal in religion and the Orangemen, centralisers, democrats and warlike, from whose ranks numerous Stadtholders were chosen: Maurice of Nassau (1567–1625), who held a veritable court in The Hague, Frederick Henry (1584–1647) and William II (1626–1672). The Republican party triumphed in 1648 with Pauw, Jacob de Witt and his son Jan (1632–1672), and opposed Louis XIV's projects. In 1672, the assassination of the de Witt brothers and the breaking

of the dykes brought back the Orange party. From 1672 to 1720, William III and the Grand Pensionaries were the preservers of liberty in Europe.

Religious differences complicated the political conflicts. The Protestants were divided. The Arminian sect (1610–1619) was opposed by the Dordrecht synod; the narrow Calvinism of the Gomarists triumphed.

Trade was prosperous, with agriculture, fishing, and the traditional industries: cloth (Leyden), linen (Haarlem), velvet (Utrecht). Amsterdam was the international market for precious metals; its bank was founded in 1609.

Colonies developed with the growth of the navy which brought Holland into contact with all parts of the world. The East India Co., started by ship-

GERMANY. BAVARIA. Parish church of Rottenbuch. 1738–1757. Decoration by Josef and Franz Xaver Schmuzer. Frescoes by Matthäus Günther. *Photo: Toni Schneiders — Coleman and Hayward.*

835. DUTCH. REMBRANDT
(1606–1669). The Goldweigher's
Field. Etching. 1651.

836. DUTCH. REMBRANDT. The
Supper at Emmaus. Engraving. 1654.

837. DUTCH. JAN VAN DE
CAPPELLE (1626–1679). Dutch Yacht
fires a Salute as a Barge pulls away.
1650. *National Gallery, London.*

838. DUTCH. REMBRANDT
(1606–1669). Arnold Tholinx.
Etching. 1656.

839. DUTCH. REMBRANDT
(1606–1669). Hendrickje Asleep.
Drawing.
British Museum.

840. DUTCH. HERKULES SEGHERS
(c. 1590–1638 or earlier). Landscape.
Engraving.
Bibliothèque Nationale, Paris.

builders, merchants and rich middle
class men, seized the Portuguese
trading posts of the Sunda Islands,
founded Batavia in Java, conquered
Ceylon and the Cape, established
relations with China and Japan. The
West India Co. exploited the Atlantic
coasts of Africa, Brazil and the Carib-
bean islands until the independence of
Portugal (1640–1661).

Architecture. Building was adapted
to the tastes and needs of the rich
middle class whom trade brought into
contact with all the countries of the
world. Great originality in the treat-
ment of Palladian or Vignolan motifs.
Predominance of brick; stone accen-
tuated door and window frames.
Ascending rhythm of stepped gables.
Influenced all Protestant Europe, espe-
cially north Germany and Scandinavia.
Lieven de Key (c. 1560–1627)
established the model for municipal
architecture at Leyden and Haarlem
[609] (Leyden town hall, 1597, Haarlem
meat market, Haarlem public weigh
house). Hendrik de Keyser (1565–
1621), author of *Architectura Moderna*
published in 1631 by Salomon de Bray,
designed a considerable number of
domestic and religious buildings in
Amsterdam, giving the town its present
appearance. He created the ideal form
of Reformed church on a central plan
(North Church, Amsterdam, 1620–
1623) which gathered all the faithful
around the pulpit.
French influence appears in the Loo
castle (1685–1688) by Daniel Marot.

Sculpture. The development of sculp-
ture was little favoured by Pro-
testantism, except for funerary sculp-
ture, pulpits and organ-lofts. Tombs
had neither allegorical nor religious
symbols, but were characterised by a
severe realism. The most important
member of the Keyser family was
Hendrik de Keyser (see *Architecture*):
tomb of William the Silent (1614);
monument to Erasmus, Market Place,

Rotterdam [617]. Rombout Verhulst
[616] (1624–1696), of Flemish origin:
tombs of Admiral Tromp in Delft,
Johannis Polyander in Leyden (1663),
Admiral Ruyter in Amsterdam (1677–
1681); and B. Egger are the most
interesting representatives of an art
that declined towards the end of the
17th century.

Painting. The middle class, with its
practical turn of mind, encouraged
painters to observe and reflect its
activities. Portraits, landscapes, still
lifes, scenes of biblical or everyday life
were the favourite subjects, while the
tradition of individual portraits con-
tinued, e.g. J. C. Verspronck (1597–
1662). Miereveld [628], van der Voort
and Ravesteyn started the fashion of
group portraits (stemming from the
16th-century company pieces) which
was developed by Frans Hals [634–
636, p. 264] (1580/85–1666), pupil of
Karel van Mander. His masterpieces
are in Haarlem. 1616, *The Company of
St George.* 1627, *Banquet of St George,
Company of St Adrian.* 1633, *Second
Banquet of the Company of St Adrian.*
1641, *Regents of St Elizabeth's Hospital.*
1664, *Regents of the Almshouses, Haarlem.*
Frans Hals' pupils, such as Hendrick
Pot (1585–1657), Judith Leyster [621]
(1609–1660) and her husband J. M. Mo-
lenaer (1610–1668), Dirck Hals, brother
of Frans (1591–1656), Pieter Codde
(c. 1599–1618), made Haarlem one of
the great centres of Dutch painting. The
portraitist Jan de Bray (c. 1627–1697)
was also from Haarlem.
Amsterdam, stronghold of the middle
class spirit, remained faithful to the
tradition of objective portraits with
Thomas de Keyser [620] (1597–1667),
Dirk van Santvoort (1610–1680), B. van
der Helst [623] (1613–1671), while
H. Avercamp (1585–1634) painted
landscapes with small figures. Rem-
brandt was too tremendous a person-
ality to be anything but isolated; but
his influence was considerable.
Rembrandt van Rijn (1606–1669)

841. Silver dish, by J. Lutma. Amsterdam. 1647. *Rijksmuseum, Amsterdam.*

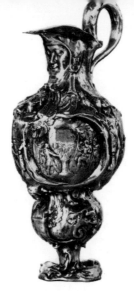

842. Silver ewer, by Adam van Vianen. Utrecht. *c.* 1620. *Rijksmuseum, Amsterdam.*

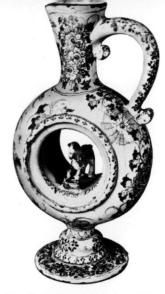

843. Ceramic jug, decorated in monochrome blue. Delft. *Rijksmuseum, Amsterdam.*

[**421**, **643–647**, **649–651**, **835–9**, p. 263] was incomparably the greatest Dutch artist; his extant output includes over 650 paintings, 300 etchings and 1500 drawings; pupils in his large teaching studio included Dou, Bol, Flinck, Koninck, Fabritius and Maes. Born at Leyden, trained there under van Swanenburg and at Amsterdam with Pieter Lastman (1624–1625), he settled at Amsterdam in 1632: *Anatomy Lesson of Dr Tulp* (The Hague). 1634, married Saskia van Uylenborch: *Self with Saskia* (Dresden); great success as portrait painter: *Jan Pellicorne and Son* (Wallace Collection, London, *c.* 1635–1637); *Marten Daey* (1634); ambitious Baroque works: *Blinding of Samson* (Frankfurt, 1636). 1642, *Night Watch* (Amsterdam); death of Saskia; one son: *Titus* (Wallace Collection, London, Vienna, etc.). 1640s, decline of reputation culminating in bankruptcy 1656: *Supper at Emmaus* (Louvre, 1648); 'the hundred guilder print' (*Christ Healing*, *c.* 1649); etchings of Clement de Jonghe, Ephraim Bonus, Jan Six, Arnold Tholinx. Etched landscapes: *Three Trees* (1643); *Six's Bridge* (1645); *Goldweigher's Field* (1651). Portraits of Hendrickje Stoffels: at window (Berlin, 1658), as Bathsheba (Louvre, 1654). Late commissioned works include *Anatomy Lesson of Dr Deyman* (fragment Amsterdam, 1656); *Conspiracy of the Batavians* for town hall (fragment Stockholm, 1661); *Syndics of the Drapers' Guild* (Amsterdam, 1662). Long series of etched, drawn, and painted self-portraits 1626–1668: Boston (1629), National Gallery, London (1640, 1659), Vienna (1652), Frick Collection, New York (*c.* 1660), Kenwood (*c.* 1663). In last works, deepening of emotional content: *Jewish Bride* (Amsterdam, 1668); *Family Group* (Brunswick, 1668/69); *Return of the Prodigal Son* (Leningrad, 1668/69).

A strong Romanist trend remained, however, thanks to which Holland remained open to European art with Pieter Lastman (1583–1633), Rem-

brandt's teacher who knew Elsheimer in Rome; the Utrecht school: A. Bloemaert (1564–1651), Hendrick Terbrugghen (1588–1629), D. Baburen (*c.* 1590–*c.* 1624), Gerard van Honthorst [**629**] (1590–1656), who was influenced by Caravaggio, and who, returning from Rome before 1625, made successful use of the famous tenebrism [**631**]. The Italian countryside inspired Claes Berchem (1620–1683), Asselyn (1616–1652) and Jan Weenix (*c.* 1650–1719).

In Amsterdam itself Rembrandt had followers in Govaert Flinck (1615–1660), Ferdinand Bol [**831**] (1616–1680), Nicolas Maes [**834**] (1634–1693), and at Dordrecht, Aert de Gelder (1645–1727).

In Haarlem Rembrandt influenced masters like Adriaen van Ostade [**637**] (1610–1685) and Gerard ter Borch (1617–1681) who visited England, Italy and Spain: *The Concert* (Berlin), *Paternal Advice* (Amsterdam) [**624**], and influenced the worldly Caspar Netscher (1639–1684) [**626**].

At Leyden, Rembrandt influenced Jan Lievens and Gerard Dou [**832**] (1613–1675): *Woman Suffering from Dropsy* (1663, Louvre), *Young Girl at the Harpsichord* (Dulwich). Dou in his turn influenced G. Metsu (1629–1667), Isaac Koedijck (1616–before 1668), the subtle Frans van Mieris (1635–1681) [**627**] and Jan Steen [**639**] (1626–1679) with his lively truculence.

At Delft interest in plein-air lighting and optics appears in the work of Carel Fabritius (1622–1654), the finest of Rembrandt's pupils and the probable master of Vermeer: *Goldfinch* (The Hague, 1654). Pieter de Hooch (1629–1684) [**656**] did his finest work at Delft (1658–1667): *Card Players* (H.M. the Queen, 1658); *Courtyard* (National Gallery, London, 1665); *Boy with Pomegranates* (Wallace Collection, London, 1664/65). Johannes Vermeer [**655**, **657–660**, p. 297] (1632–1675) reconciled the Dutch objective tradition and the poetic quality brought from Italy by the Romanists: landscapes (The Hague

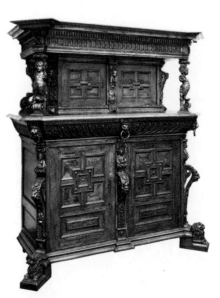

844. Walnut dresser. South Netherlands (?). 1600–1625. *Rijksmuseum, Amsterdam.*

845. Painted cabinet. North Netherlands (?). Second half of the 17th century. *Rijksmuseum, Amsterdam.*

846. ENGLAND. INIGO JONES (1573–1652). Queen's House, Greenwich. 1616–1635.

847. ENGLAND. INIGO JONES (1573–1652). The double-cube room, Wilton House. After 1647.

848. ENGLISH. GRINLING GIBBONS (born in Rotterdam; 1648–1720). Choir stalls, St Paul's, London.

and Amsterdam); *The Milkmaid* (Amsterdam); *Painter in his Studio* (Vienna); *The Lace-maker* (Louvre). Jakob Vrel, more naïve, painted street scenes, and Houckgeest (*c.* 1600–1611), van Vliet (*c.* 1611–1675), and E. de Witte (*c.* 1617–1692) painted churches.

Minor masters at Leyden: Ochtervelt (1632–*c.*1700) influenced by Metsu, and Brekelenkam (1620–1661), more simple, like Esaias Boursse (*c.* 1631–1672) in Amsterdam.

Landscapes, important at the beginning of the 17th century with Esaias van de Velde (*c.* 1590–1630), Pieter Molyn and the visionary Herkules Seghers [840] (*c.* 1590 – before 1656), flourished with Jan van Goyen [619] (1596–1656), Everdingen [622], Roeghman, van der Neer (1603–1677), specialist in night pieces, Philips de Koninck (1619–1688) with his vast horizons, and above all M. Hobbema [625] (1638–1709) and the nephew of Salomon van Ruisdael (*c.* 1600–1670), Jacob [642, 648] (1628/29–1682), for whom nature evoked a religious feeling: *View of Haarlem* (London, Berlin), *The Mill at Vijck bij Duursteede* (Amsterdam), *Coup de Soleil* (Louvre) [see p. 264].

Among the painters of architectural pieces: the subtle Pieter Saenredam [661] (1597–1665), Dirk van Delem (1605–1671), and the 'townscapists' Jan van der Heyden (1637–1712) [607], the Berckheyde brothers, Job (1630–1693) and Gerrit (1638–1698). Among the masters of landscapes with figures: P. Wouverman (1619–1668), painter of famous cavalry pieces; Isaac van Ostade, Adriaen's brother (1621–1649); Paulus Potter [638] (1625–1654), the most famous animal painter of the time — *The Bull* (Louvre), the *Meadow* (Louvre) — and Adriaen van de Velde (1636–1672). Albert Cuyp (1620–1691) of Dordrecht painted landscapes, animals, seascapes, portraits with a versatility rare in Dutch art. His poetic rendering of golden light effects strongly influenced later English landscape painting [641].

The chief marine painters, after the already outdated Hendrick Vroom (1566–1640), are Jan Porcellis, teacher of Simon Vlieger (1601–1653), his disciple Jan van de Cappelle (1626–1679), more serene than Ludolf Bakhuyzen (1631–1708), finally Willem van de Velde (1611–1693) and his son William van de Velde II (1633–1707) who settled in London in 1672.

The best still life painters: Pieter Claesz and W. Claesz Heda [653], Jan Davidsz de Heem, van Beijeren [654], Willem Kalf, Jacob Gillig.

At the end of the 17th century, French and English influences killed this pictorial vitality.

The minor arts. Frans Spiering of Antwerp established himself at Delft in 1591 and wove tapestries for the Danish court. Families of weavers settled at Gouda, Schoonhoven and Delft, but, from 1650, they had to compete with the Gobelins and died out at the end of the 17th century.

Line engraving was practised by Jonas Suyderhoef, Cornelis Visscher; etching was preferred by Jan van Goyen, Jacob van Ruisdael, Herkules Seghers [840] (the first to attempt colour prints) and above all Rembrandt [835, 836, 838], some of whose etchings are masterpieces (*The Three Trees, Dr Faust, The Three Crosses,* ' the hundred guilder print ').

Several centres worked in silver: Amsterdam, Alkmaar, Haarlem, The Hague, Utrecht and Leeuwarden (ewer by Adam van Vianen, Rijksmuseum [842]). Medal and bowl by Lutma (1585–1669), Rijksmuseum [841].

Ceramics flourished in Haarlem in the 16th century, but developed in Delft in the 17th century. In 1611, the St Luke guild was formed: the first name in it was Hermann Pietersz. First period: painted faience in blue monochrome, excessive and exuberant decoration, contours of the designs heightened with ' tek ' (brown or violet ink). Second period [843] (middle and second half of the 17th century) increasing commercialisation and large exports; inspired by the Far East and scenes by minor masters. Abraham de Coge and van Frytom (genre scenes, landscapes, seascapes); the Pynaker (blue, red and gold ' Japans '); the Fenhorn, Chinese subjects with ' Cashmere ' decoration.

Albert Magnus of Amsterdam (1642–1689) specialised in tooled book bindings.

In furniture Paul Vredeman de Vries (son of Jan) brought out in 1630 a book of furniture models. *The Carpenter's Shop* by Crispin van der Passe the Younger, published in Amsterdam 1652, was also very famous. Zeeland cupboards, oak cupboards with caryatids (called ' Dutch cupboards '), cupboards with friezes and three columns were characteristic [844]. The technique of ivory inlaid in ebony (a technique from Italy) was used not only for cabinets [845] but for cupboards, which had simple lines and well balanced proportions.

ENGLAND

History. On the death of Elizabeth I (1603), England had consolidated her economic prosperity and had won victory for Anglicanism. James I (1603–1625) compromised these results and gave precedence to Scottish interests. Charles I (1625–1649) married Henry IV's daughter, fought against Spain, sent ships to help the Huguenots at La Rochelle, quarrelled with Parliament, and was beheaded in 1649. The Commonwealth was proclaimed, the moving spirit of which was

849. St Mary le Bow.

850. St Bride, Fleet St.

851. St Vedast.

852. St Dunstan in the East.

method and sensualism, prepared the way for modern positivism and science (in 1625, Harvey discovered the circulation of blood; in 1686, Newton propounded the law of gravity).

In music Robert Jones, Campion and Rosseter wrote books of ayres (a kind of court air). Masques (allegorical or mythological entertainments) were staged at court (sumptuous décors by Inigo Jones). Theatrical music was developed by Matthew Locke (1630–1677) and especially by Purcell (1659–1695), influenced by Lully, Monteverdi and the Venetians.

Architecture. Inigo Jones (1573–1652) was a new phenomenon in England, a professional architect with an interest in the theory of his art and a profound knowledge of continental architecture. First recorded as a designer for court masques for James I, he visited Italy 1601, 1605, 1612 and made a special study of Palladio. All his most important work was for the Crown: Queen's House, Greenwich (1616–1635), initiated a complete break with tradition; Banqueting House, Whitehall (rebuilt 1619 after fire): plans for monumental new Whitehall palace (c. 1638). Other works include the lay-out, with Isaac de Caux, of Covent Garden (begun 1630) on the pattern of the Place des Vosges and a new west front for old St Paul's cathedral (begun 1633; burnt 1666). His few countryhouse buildings include south front of Wilton House (after 1647). Influence of Jones on Roger Pratt's Coleshill (from 1650; burnt 1952) and Clarendon House, London (1644–1667: demolished 1683) [**608, 846**].

With the Restoration came the influence of Dutch Palladianism with its mixture of brick and stone dressings, and its frequent use of pilasters: Eltham Lodge, Kent (1663–1664), by Hugh May. The period was dominated by Sir Christopher Wren (1632–1723) whose early interests were solely scientific; 1661, Professor of Astronomy, Oxford; 1665, Paris, meeting with Bernini. After the Great Fire, 1666, rebuilding of St Paul's cathedral and 51 city churches. In St Paul's (1673–1710) problem of combining nave and aisles with central domed space (Great Model; Warrant Design). In the city churches, evolution of a two-storeyed galleried type with vaulted nave and aisles (St Clement Danes; St James, Piccadilly); variety of steeple design (St Mary le Bow; St Bride, Fleet Street). As Surveyor-General, royal buildings include Chelsea Hospital (1682–1689); Hampton Court (from 1689; fragment of proposed scheme): Royal Naval Hospital, Greenwich (from 1694). Work at universities include at Cambridge: chapel, Emmanuel College (1669–1673); library, Trinity College (1676–1684), derived from Serlio's version of the Theatre of Marcellus; at Oxford

Cromwell (1599–1658). The Navigation Act of 1651 gave a new impetus to trade and to England's political power. The Restoration was brought about in 1660 with Charles II (1660–1685); landowners received large compensation, Parliament restored the traditional Anglican Church. The king negotiated with Spain, Louis XIV and the United Provinces, but then lapsed into an anti-Spanish and anti-Dutch policy and allied with Portugal (1662). The annexing of Tangier and Bombay hampered Dutch trade. After the war with Holland (1665–1667) the Catholic policy (1668–1673) of Charles II, who had worked for the Pope and Louis XIV, alienated the people. On his death in 1685, English opinion became definitively in favour of Holland against France. The succession crisis lasted from 1678 to 1685. James II (1685–1688), a Catholic, provoked the 1688 revolution which

finally imposed Protestantism and parliamentary authority. William of Orange profited from this; he and his wife Mary reigned over England as joint rulers and continued the struggle against France. In 1693, freedom of the press and the founding of the Bank of England.

Colonial success continued in the 17th century with the setting up of trading stations in Madras (1639), Bombay (1661), Calcutta (1686), with the Barbados (1605), the Bermuda islands (1612) and Jamaica (1655) seized from the Spanish.

In literature and science, besides her great poets (Milton, 1608–1674; Dryden, 1631–1700), England made an important contribution to the evolution of ideas in Europe with her philosophers (Francis Bacon and his essays, 1597; John Locke's *Essay concerning Human Understanding*, 1690) who, in establishing the experimental

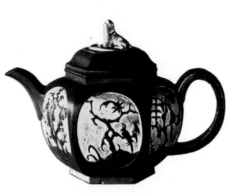

853. ENGLISH. Tea-pot by the Elers brothers. Mid 17th century. *Victoria and Albert Museum.*

855. ENGLISH. WILLIAM DOBSON (1610/11-1646). Abraham van der Doort, curator of Charles I's collection. *Hermitage, Leningrad.*

Sheldonian Theatre (1662, his first work); library, Queen's College (1693-1696) [**610, 612, 849-852**].

Sculpture. Under Elizabeth, Italian influence brought to sculpture hardly more than a repertoire of forms which were badly assimilated and soon became stagnant. At the beginning of the 17th century black and white marble tended to replace alabaster, style became purer (Elizabeth's tomb, 1606, by Colte and Critz). In Nicholas Stone, partner of Inigo Jones, there is a marked Dutch influence, and at the same time the traditional stiffness (Tanfield's tomb at Burford, Donne's in St Paul's [**618**]). His output was considerable but unequal. Hubert Le Sueur, from Paris, working mostly in bronze, did several busts and standing effigies, very carefully cast (busts of Charles I, 1631; Lady Cottington, 1633; Dr Richardson, 1635; equestrian statue of Charles I). Tombs in sheet brass, a flourishing tradition, were in decline owing to the rarity of the metal which in this troubled period was difficult to obtain from Flanders.

During the Civil War and under Cromwell, sculpture declined, only to reappear after the Restoration when it broke with tradition. After the Restoration, sculpture is more closely linked with architecture and more conscious of continental Baroque. Caius Gabriel Cibber (1630-1700), the Dane, was

854. GERMAN. ANDREAS SCHLUTER (c. 1660-1714). Frederick William, the Great Elector of Brandenburg. Cast in 1700. *Berlin.*

associated with Wren at Hampton Court (*Triumph of Hercules*, pediment of east front, 1692-1694) and St Paul's cathedral (pediment of south transept); bas-relief at base of Monument (1674). His finest works are the Sackville monument, Withyham, Sussex (1677) and the figures of *Melancholy* and *Raving Madness* for Bedlam hospital (Guildhall, c. 1680). Grinling Gibbons (1648-1720) of Rotterdam was in England by 1672. His virtuosity as a naturalistic wood-carver (choir stalls [**848**], organ case, St Paul's; archbishop's throne, Canterbury) has given him an undeserved prestige as a sculptor. His finest work is the bronze *James II* (outside National Gallery, London) in so far as it is by his own hand. Francis Bird (1667-1731) studied in Flanders and Rome. 1706-1721, statuary at St Paul's: *Conversion of St Paul*, pediment on west front; monument of Dr Busby (Westminster abbey, c. 1703).

Painting. Before the arrival of van Dyck in 1632, the best portrait painters were Paul van Somer (1576-1621) from Antwerp: *Anne of Denmark* (Windsor, 1617); Daniel Mytens (c. 1590-1642) from The Hague: *Charles I* (H.M. the Queen); *Duke of Hamilton* (1629); and Cornelius Johnson (also called Jansens, Janssen van Ceulen, 1593-1661), born in London of Flemish parents. The overwhelming influence of van Dyck during his stay (1632-1641) was felt by Robert Walker, chiefly known for his portraits of Cromwell (National Portrait Gallery, London) and the Parliamentarians (*Henry Ireton,* National Portrait Gallery, London). The most distinguished native artist before Hogarth was William Dobson (1610/11-1646) [**855**], painter of the court at Oxford during the Civil War: *Charles, Prince of Wales* (National Portrait Gallery of Scotland, 1643); *Self-portrait with Sir Charles Cotterell and Balthasier Gerbier*; *Old Stone and Son* (Duke of Northumberland): *Sir William Compton* (Castle

Ashby). At Oxford at the same time was Isaac Fuller (d. 1672). Visiting foreigners included Gerard van Honthorst and Orazio Gentileschi.

The two outstanding figures after the Restoration were the Dutchman Peter Lely and the German Godfrey Kneller. Peter Lely (van der Faes, 1618-1680), who was in England by 1647, was initially influenced by van Dyck: *Charles I and Duke of York* (Duke of Northumberland, 1647). 1661, principal painter to Charles II; large studio and vast output, in an international Baroque style: *Windsor Beauties* (Hampton Court, 1668); series of admirals (National Maritime Museum, Greenwich, 1666) [**662**]. The most conspicuous of the painters round Lely were: John Greenhill (c. 1644-1676) and Mary Beale (1633-1697); his disciples: Gerard Soest (c. 1605-1681); Jacob Huysmans (c. 1633-1696); J. M. Wright (c. 1617-1700) and John Riley (1646-1691), the leading portraitist between Lely and Kneller (*Bridget Holmes*, H.M. the Queen). Godfrey Kneller (1646-1723), born in Lübeck, trained in Holland, came to England c. 1674: *Chinese Convert* (Kensington, 1687); *Matthew Prior* (Trinity College, Cambridge, 1700); his finest works are the 42 portraits of the Kit-Cat club (National Portrait Gallery, 1702-1717).

The greatest English artist, the miniaturist Samuel Cooper (1609-1672), enjoyed a European reputation. Pupil of his uncle John Hoskins, he travelled in Italy and France 1634-1642. 1663, Limner to Charles II. Individuality of character interpretation: *Self-portrait* (National Portrait Gallery, London); *Oliver Cromwell*; *Duke of Monmouth*; *Catherine of Braganza*; *Frances Stuart, Duchess of Richmond* (all H.M. the Queen).

Decorative painting was dominated by visiting foreigners: Antonio Verrio (Windsor, Burghley, Hampton Court); Louis Laguerre (Chatsworth, Blenheim); G. A. Pellegrini (Kimbolton, Castle Howard); Sebastiano Ricci (Burlington House). The only English decorator in the grand manner was Sir James Thornhill (1675/76-1734), the father-in-law of Hogarth: dome, St Paul's cathedral (1715-1720): Greenwich Hospital, including the immense Painted Hall (1708-1727).

Tapestries. 1619, foundation of the Mortlake tapestry factory, directed by Sir Francis Crane, with French and Flemish workers. 1620-1635, quality unequalled in Europe: history of Venus and Vulcan (1620/1622) from 16th-century Flemish designs; set of twelve Months (1623-1624). The most important productions were the Acts of the Apostles (sets at Chatsworth, Boughton, Forde abbey) woven from Raphael's cartoons, bought 1623. The factory was wound up in 1703.

856. BOHEMIAN. 17th century. Engraved glass. 1605. *Prague Museum.*

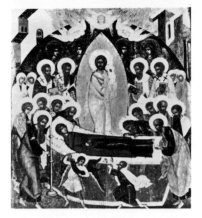

857. RUSSIAN. SIMON USHAKOV (1626–1686). The Dormition of the Virgin. 1663. *Vladimir Museum.*

Engraving. The engraver Evelyn wrote an account of the 'black manner'.

The minor arts. In the 17th century silver ware was very ornate with flowers in relief, all in embossed work; very rich pieces, but without character.

England did not take part in the great expansion of ceramics in Europe during the Renaissance. Well into the 17th century, English ceramics hung on to medieval traditions (earthenware tiles, rustic pottery by Thomas Toft in Staffordshire) and remained insular, though there was emulation of Delft pottery at Bristol, Lambeth, Liverpool. The earliest stoneware was by John Dwight of Fulham: *Daughter Lydia* (1673); *Flora* (c. 1680). Elers ceramics (late 17th century) [**853**] consist of the work of the Elers brothers (of Dutch origin) and a whole group of Staffordshire products: red stoneware imitating that of Yihing (tea-services). 1725, John Astbury at New Fenton shows the influence of Elers designs in his wares: his son Thomas introduced the cream-ware body.

1673, founding of the Savoy glasshouse by George Ravenscroft. His development of lead metal, with its combination of strength and clarity, put English glass in a leading position during the 18th century.

The evolution of furniture and decoration depended on that of architecture. Practicality was asserted and comfort sought. Decorative art was affected by the excessive naturalism made fashionable by Gibbons who accentuated details to the detriment of the general harmony. Woodwork and stucco offered a compromise between the Baroque and classicism. The Jacobean style flourished at the beginning of the 17th century (armchairs and chairs with turned legs, the seats and backs in solid wood). After 1660 forms were lighter and less severe; walnut was widely used. Indo-Portuguese furniture was imported and the fashion was for inlaid mother-of-pearl. The use of plate glass began to spread (Vauxhall factory); it was used for glass cabinets and bookcases. Samuel Pepys' *Diary* shows how interested the middle class was in interior decoration.

GERMANY AND CENTRAL EUROPE

General history. The inefficiency of Rudolph II (1576–1612) provoked a dynastic crisis in Austria. He ceded to his elder brother Mathias Hungary, Moravia (1608), Austria and Bohemia (1611). On his death, the Habsburgs of Austria no longer had any authority in their states, where there reigned a spirit of independence and religious dissension. Ferdinand II (1619–1637) reunited all the territories of the House of Austria and became the champion of Catholicism, but his ambition and the religious quarrels were to be the determining cause of the Thirty Years' War (1618–1648). The crisis began in Germany where the dispute continued between the supporters of the Reformation and those of the Counter Reformation; leagues were formed: the Evangelist Union and the Catholic League. In Bohemia opposition to the policy of Catholic restoration was extreme and the national passions between Czechs and Germans ran wild. The war, begun in Germany (1621–1625), spread into a European war. Denmark (1625), Sweden (1630) and France (1635) intervened to stop the menacing advance of the House of Austria. The Treaties of Westphalia (1648) established order in Europe. Alsace, except for Strasbourg, was acquired by France. Germany, the main seat of the war, was to take a century to recover.

The League of the Thirteen Cantons was a crossing and recruiting place during the Thirty Years' War; it was bound by alliance to Austria and to France.

Literature and science. Leibnitz (1646–1716), with Bossuet, tried in vain to fuse the Catholic and Protestant Churches; he invented the infinitesimal calculus (1675) and developed his *Monadology* (1714). Kepler (1571–1630): *Astronomia Nova* (1609), *De Harmonice Mundi* (1619).

Music. By way of the courts of Vienna, Munich and Dresden, the doors were opened to Italian music. Heinrich Schütz (1585–1672), who went to Venice, introduced the recitative. In 1678: creation of the Hamburg Opera, vitalised by Reinhard Keiser (1674–1739), composer of several operas and one of the precursors of the ' Singspiel' and the 'Lied'.

GERMANY

Architecture. Except for a brief Palladian reaction, architecture had passed imperceptibly from the Flamboyant Gothic to Italian Baroque with a preponderance of secular architecture, for the Reformation had not inspired an architectural Renaissance. The influences were complex and overlapping: Dutch in the Hanseatic towns of north Germany, French in the Protestant courts, Italian in the Catholic courts of south Germany.

In the north the structural peculiarities of wooden architecture, predominant in the Harz, are to be found in stone buildings: Gewandhaus in Brunswick (1590), Leibnitz's house in Hanover (1652). The Hanseatic towns on the North Sea and the Baltic were Dutch artistic colonies. This type of middle class architecture was well adapted to the customs and climate there: mixture of brick and stone (the latter reserved for the facings). Anton van Obbergen from Mechelen was in Danzig from 1594 to 1612 (the arsenal, 1605). Martin Arens from Delft built Emden town hall. Luder van Bentheim altered the façade of Bremen town hall (1614). The influence of the Netherlands reached as far as Hameln (Rattenfängerhaus, 1602) and Cologne.

In the west a French model by du Cerceau inspired Georg Riedinger's castle at Aschaffenburg on the Main (1605–1614). Flemish and Italian influences appear in Heidelberg castle (Englischerbau, 1615; Friedrichsbau, 1617).

South Germany was more affected by Italian influences. Elias Holl, after visiting Venice and Vicenza, built, in the Palladian style, the Augsburg arsenal (1602) and the new town hall [**503**]; Jakob Wolff the Younger: Nuremberg town hall (1616–1622). In Munich, under the principate of Maximilian I, the Residenz was rebuilt (1597–1619) by Pieter Witte, a Flemish emigrant in Florence who was called Pietro Candido. St Michael's church (Wendel Dietrich and Friedrich Sustris), copied from Il Gesù in Rome, served as a model for Jesuit churches. The Church of the Theatines (1663), by Agostino Barelli of Bologna, was inspired by S. Andrea della Valle.

Salomon de Caus designed the gardens of Heidelberg castle (Hortus Palatinus, 1620).

Sculpture. The influence of the Italians and the Dutch Romanists lasted a long time in south Germany, while

French influence gradually took root in Berlin. The fountain (1664–1680) erected by Antonio Dario in front of Salzburg cathedral and the Plague Column (1687) in Dresden, by Burnacini, are Berninesque. Balthasar Permoser, who settled in Dresden, was a pupil of Pietro da Cortona [938]. Andreas Schluter (c. 1660–1714), the greatest 17th-century sculptor, recalls the Dutch style of Artus Quellin in the bronze statue of the Elector Frederick III (1697), but was already susceptible to French influence: that of Puget in the decoration of the arsenal (masks of dying warriors); of Martin Desjardins and Girardon in the equestrian monument of the Great Elector (1698–1703) [854].

Painting. During and after the Thirty Years' War, German painters, having no more than an impoverished clientèle, had emigrated: Elsheimer [630], Carl Loth, Peter Roos to Italy; Bakhuyzen, Lingelbach to Holland; David von Krafft to Sweden; Bartholomäus Strobel to Poland. Those who remained became imitators of the Dutch or Italians. Joachim von Sandrart (1606–1688), the 'German Apelles', was more important as a historiographer than as a painter; his *Teutsche Academie* (Nuremberg, 1675) is a pendant to Vasari's *Lives* and Karel van Mander's *Schilderboeck*; he worked in Utrecht, Venice, Bologna, Rome, on the cycle of the Months for Schleissheim castle; *Company of Captain Bicker van Swieten* (1638, Amsterdam). Hamburg, escaping the ravages of war, preserved a school of painting with David Kindt, Jurian Jacobson, Mathias Scheits.

Engraving. Declined in the 17th century. Elsheimer left for Italy, and Wenceslaus Hollar, pupil of Matthäus Merian, lived mostly in England. Prince Rupert, son of the 'Winter King', who knew Ludwig von Siegen in Holland, has left a dozen famous plates executed in the 'black manner'.

Ceramics. The heyday of Cologne-Frechen stoneware was the 16th century, but it continued to be produced up to the 18th century. In the 17th century ceramic centres shifted towards the south (Westerwald stoneware, and so-called Dreussen stoneware).
Furniture. At Nuremberg and Augsburg (Philip Hainofer), as in Italy, ebony cabinets were inlaid with mother-of-pearl, ivory and shell, and exported to France and other countries.

BOHEMIA

Architecture. Under the Habsburgs Prague became a centre in which Italian influence flourished: summer gallery of the Waldstein palace, by the Milanese Giovanni Marini (1629). French influence was introduced by

the Burgundian J. B. Mathey (1630–1695) who was in Prague from 1668 to 1695; he built the Crusaders' Church, the Bucquoy palace and Troja palace, which were influenced by Borromini and Mansart and were to inspire the Viennese architect Fischer von Erlach.

Glass. The fashion for Bohemian engraved glass became so widespread in Europe that craftsmen, for lack of plain indigenous glass, engraved Venetian-produced glass, so that its origin is sometimes uncertain [856].

SWITZERLAND

Architecture. Influenced by Burgundian (Church of the Sisters of the Visitation and Church of the Ursulines at Fribourg, 1653) and Italian architecture (Wertenstein monastery, begun in 1608 by Antoine Isemann; Jesuit church, Fribourg, 1610; Lucerne church, 1630; Mariastein sanctuary, 1648–1655).

Painting and engraving. Matthäus Merian (1593–1650) was one of the first landscape painters; his pupil Conrad Meyer (1618–1689) painted historical scenes and town views. Both were engravers (*Theatrum Europeum* of Merian, 1635).

SCANDINAVIA

General history. The conflicts between France and the House of Austria weighed on the Scandinavian countries throughout the century. Sweden, opposed to the House of Austria, became the champion of Protestantism and had an indisputable hegemony over all the Baltic countries. Gustavus Adolphus II (1611–1632) transformed military tactics; Queen Christina (1632–1654) led an extravagant life. After Charles XI (1679–1697) and the victorious Charles XII (1697–1718) Sweden declined.

In science Roemer calculated the speed of light in 1676.

Architecture. Its history is one of Dutch influence (except in Norway, where wooden buildings remained traditional and untouched by the Renaissance).

In Denmark, as in Holland, the use of brick was characteristic, stone being reserved for decoration. The traditional stepped gables and volutes stayed in favour. Architecture was in the service of royalty: Frederiksborg palace (1602–1620), under Christian IV [611], by Anthonis van Obbergen and Hans van Steenwinkel (1587–1639: Kristianstad church) who also worked in Amsterdam (Rosenborg castle, 1610–1635). French influence was to increase under Frederick III (1648–1670).

In Sweden, the Scånian castles, built by the Danish aristocracy, were modelled on those built for the Vasa, great

builders (especially Eric XIV and John III). Holy Trinity at Kristianstad (1618–1628), built after plans by Hans van Steenwinkel of Copenhagen, like the Westerkerk in Amsterdam and the Marienkirche in Wolfenbüttel, is one of the most beautiful examples of the adaptation of the central plan.

Sculpture. In Denmark, at Roeskilde, old capital of the kingdom, the funerary chapel of Christian IV (1617), by van Steenwinkel, represents the finest example of the sculpture of the period.

Sweden played a very unimportant part in sculpture, dependent on Flemish and French influences. Vasa tombs in Uppsala.

Painting. In Sweden, the most representative painters were two refugees from Hamburg: Ehrenstrahl and his nephew David von Krafft, influenced by the Italians and French.

EASTERN EUROPE

POLAND

History. In about 1610, Sigismond III Vasa wanted to reconquer Sweden and seize Russia. Ladislas IV (1632–1648) remained loyal to Austria. Following the Treaties of Westphalia, Poland seemed to maintain her status. The Ukrainian question (1648–1696) laid her open to the ambitions of Sweden, Russia and Turkey.

Architecture and decoration. Buildings were under strong Italian influence. St Peter's in Cracow, by Giovanni Trevano, was modelled on Il Gesù. St Peter and St Paul's at Wilno is incredibly rich in decoration: more than 2,000 statues or bas-reliefs were executed (1668–1684) by Italian artists (Pietro Peretti, G. M. Galli). Wilanow castle, near Warsaw, built by Giuseppe Bellotti for John Sobieski, is modelled on the Villa Medici.

RUSSIA

History. The extinction of the dynastic line of the Norse Rurik in 1598 caused a fifteen-year crisis. Boris Godunov seized the crown of the tsars. The Poles occupied Moscow. In 1613 the election of Michael Romanov put an end to the troubles. Foreigners came to Moscow and established themselves in the Nemetskaia Sloboda (the German quarter); Peter the Great (1699–1725) spent his youth there and travelled to Holland (1697) and England to study shipbuilding. In 1672, production of *Esther* by J. G. Gregory. In 1703, foundation of St Petersburg.

Architecture. Predominant until the middle of the 17th century were the pyramidal churches influenced by the wooden architecture of north

858. U.S.A. Governor's Palace, Santa Fe, New Mexico. 1610–1614.

859. U.S.A. The church (with mission buildings) of S. Estevan at Ácoma, New Mexico. Completed c. 1642.

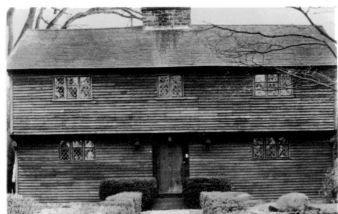

860. U.S.A. Parson Capen house, Topsfield, Massachusetts (showing overhang with pendant). 1683.

861. U.S.A. View of the Whitman house, Farmington, Connecticut, showing overhang and pendants. 1664.

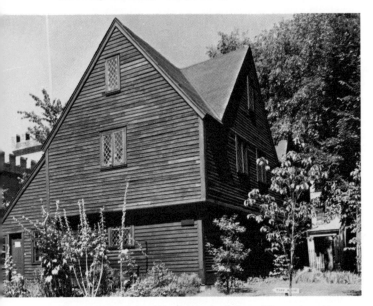

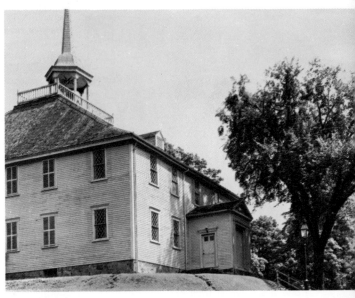

862. U.S.A. John Ward house, Salem, Massachusetts. View from the side showing lean-to and overhang. 1684.

863. U.S.A. View of the Old Ship meeting-house, Hingham, Massachusetts. 1681.

864. AMERICAN. CAPTAIN THOMAS SMITH. Self-portrait. c. 1680–1690.

865. AMERICAN. Mrs Elizabeth Freake and Baby Mary. 1674.

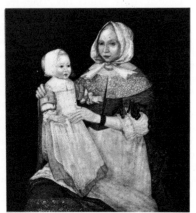

866. U.S.A. The Adam Thoroughgood house, Princess Anne County, Virginia. *c.* 1636–1640.

867. U.S.A. View from the west of Bacon's Castle, Surry County, Virginia, showing gable ends. *c.* 1655.

868. U.S.A. St Luke's, Smithfield, Isle of Wight County, Virginia, a brick Gothic church. 1682.

869. U.S.A. West front of Fort Crailo, Rensselaer, New York. 1642 (?).

870. U.S.A. Terheun house, Hackensack, New Jersey. *c.* 1709.

Russia (shatrovye khramy), very characteristic with their multiple corbels (kokoshniki) and polychrome: the Wonder of Uglitch (1628), the Putinki church in Moscow (1649–1652). In this period the clergy imposed a return to the traditional church with five domes (platiglavye). The upper Volga basin became a very important artistic centre: at Rostov, the splendid Kremlin (built under the episcopate of the Metropolitan Jonas Sysoevitch, a great builder); at Yaroslavl (which benefited from the ruin of Novgorod) the churches of the Prophet Elijah (1647), of St John Chrysostom by Korovniki (1649), of John the Baptist by Toltchkovo (1671); at Romanov-Borisoglebsk, the Cathedral of the Resurrection; at Uglitch, the monastery of the Resurrection.

Meanwhile, western Baroque architecture reached Moscow through the newly annexed Ukraine (long attached to Poland): churches of the Intercession at Fili, and of the Apparition of the Virgin at Dubrovitsy (1690–1704) built at the order of Prince Boris Golitsyn; Simonov monastery, Lavra of the Trinity St Sergius, Sukharev tower (1692). The foundation of St Petersburg (1703) and the ukase to hurry its construction (1714) brought to an abrupt end all architectural activity in the other Russian towns.

Sculpture. Owing to the prohibitions of the Orthodox Church, there was almost no religious, funerary or monumental sculpture throughout the whole century. However, through the intermediary of Catholic Poland, there appeared in the 17th century a few attempts at religious figures in polychrome wood.

Painting. The change of direction and the transition from ancient Russian painting (ikonopis) to modern painting (jivopis) took place before the foundation of St Petersburg and date from the reign of Alexis Mikhailovitch

(1645–1676), during which a number of foreign painters arrived in Moscow (the Netherlanders Jan Detterson and Daniel Wuchters, the Pole Stanislas Loputski) and revived the first Russian Academy of Art (Oruzheinaya Palata). While the indigenous fresco tradition persisted in the upper Volga towns of Kostroma, Rostov and especially Yaroslavl (cycles of St Elias and St John the Baptist), new tendencies, called the 'Frankish manner', triumphed with Simon Ushakov (1626–1686), painter to the tsar at the age of 22 (*Virgin of Vladimir*, 1652); icons of the Saviour in the Lavra of the Trinity St Sergius; *Annunciation* (1659) in the Church of the Virgin of Georgia in Moscow. Also the first Russian engraver: *The Seven Deadly Sins* (1673) [857].

Liliane Brion-Guerry,
Gisèle Polaillon-Kerven and
Evelyn King

NORTH AMERICA

History. At the close of the 16th century colonisation of North America had not begun, except in Florida where the Spanish had established the first permanent settlement at St Augustine in 1565. The next area settled by the Spanish was New Mexico (1598 by Juan de Oñate). Santa Fe was founded in 1609–1610. The Spanish were driven out of New Mexico by the Indians in 1680, but reconquered their former territory in 1692 and began colonisation in 1693.

The French, whose holdings stretched from Canada to the Gulf of Mexico, founded Quebec in 1608 and Montreal in 1611.

The English, after two unsuccessful attempts to colonise Virginia in the 1580s, made their first permanent settlement in 1607, at Jamestown, Virginia. In 1620 the English settled in Massachusetts (Plymouth). William Penn colonised Pennsylvania in 1682. In 1624 the Dutch founded New Am-

sterdam on Manhattan Island and also settled along the Hudson. Sweden sent colonists to Delaware and New Jersey in the 1630s. By 1664 all of the Atlantic seaboard between Canada and Florida belonged to England.

Cultural background. The first university (Harvard) was established in Massachusetts in 1636. Anne Bradstreet (*c.* 1612–1672), Michael Wigglesworth (1631–1705) and Edward Taylor (*c.* 1644–1729) are the best known poets of this period in New England and Cotton Mather (1663–1728) the best known prose writer.

Architecture. Spanish architectural style underwent considerable modification in New Mexico, where the Pueblo Indians, who lived in handsome adobe villages, had a centuries-old building tradition. They used a post and lintel architecture of stone, sundried brick and adobe (a wet clay mixture). Walls were thick and roofing material was supported on round logs called *vigas* which stretched across the building from wall to wall and sometimes projected on the outside. The earliest example of European building in this style — in fact the oldest surviving European building in the United States — is the Governor's Palace at Santa Fe (1610–1614) [**858**]. The only church which survives in good condition from before the Indian revolt of 1680 is the beautiful church of S. Estevan at Acoma (completed *c.* 1642) [**859**]. Simple and massive in appearance (one wall is over seven feet thick), it has sloping walls and a plain façade with a small door and window and flanked by two bell towers. Inside, the aisleless nave tapers towards its apse end (the west end in the New Mexico churches), where it forms a polygonal sanctuary. There is no transept at Acoma; decoration consists of a huge painting at the back of the sanctuary, reminiscent of the Spanish Baroque high altar, and the carved and painted corbels on which the *vigas* rest. These corbels, a typical feature, generally bore Indian motifs. Another customary feature was a concealed clerestory window which shed light on the altar (a feature reminiscent of the Spanish Baroque preoccupation with the effects of light).

The English colonists in the east followed the building styles and techniques of their village homes in England, which were still medieval in the 17th century (Renaissance architecture was as yet a court style in England and would not have reached the middle class, and humbler, settlers). Houses were of half-timber construction, most often covered with horizontal overlapping clapboards — particularly in New England where lime, necessary for mortar, was almost nonexistent. Wood, too, was a better

insulator than brick or stone and the New England climate was rigorous. The typical 17th-century New England house had two rooms on each floor, on either side of a huge central chimney. An extension called a lean-to was often added at the back for the kitchen and smaller rooms, and additional gables (dormers were rare) could be added for more upper rooms. The builders, with their medieval outlook, never aimed at exact symmetry. Steeply pitched gable roofs, a clustered chimney, overhanging second storeys (and sometimes overhanging gable ends), small casement windows and carved pendants at the corners of the overhang all pointed to the influence of medieval English building. Among the best examples are: Whipple house, Ipswich, Mass., 1639; the Scotch-Boardman house, Saugus, Mass., 1651; Whitman house, Farmington, Conn., 1664 [**861**]; Parson Capen house, Topsfield, Mass., 1683 [**860**]; John Ward house, Salem, 1684 [**862**].

The New England meeting-house, with its pulpit replacing the altar and its congregation facing the preacher, bore little resemblance to the English church. The Old Ship meeting-house at Hingham, Mass., 1681 [**863**], with its square plan and its open-timber hipped roof, is a sole surviving example of this period.

While New England society was based on the self-contained village life of virtually classless small-farming and trading communities centred round the village green and meeting-house, a very different way of life was emerging in the south, where the economy was based on one lucrative crop — tobacco. The large holdings necessary for this crop made for isolated self-contained plantations rather than villages, and for indentured and slave labour and a feudal type society. The planters built along the many navigable rivers of coastal Virginia and, via shipping, kept in close touch with England. As in New England, half-timber medieval houses were built, but with many Jacobean elements in the larger houses. While clapboard buildings were most common, brick was also often used.

The typical plan had two rooms to a floor, often with a central corridor (giving greater ventilation in a warmer climate) and sometimes with a projecting porch at the front and stair-tower at the back. The chimneys were at either end (not in the centre), sometimes projecting, sometimes flush with the wall. There were steeply pitched gable roofs, and casement windows. Kitchens were in separate buildings, as were servants' quarters. Clapboard examples have disappeared but a small early brick house remains, the Adam Thoroughgood house, Princess Anne County, Va. (*c.* 1636–1640) [**866**]. Bacon's Castle, Surry County, Va. (*c.* 1655), is a handsome brick Jacobean house, with its brick

belt course marking the line between the first and second storeys, its stepped and curved Flemish gable ends and its diagonal triple chimneys at either end [**867**]. The most complete example of a 17th-century church in Virginia is St Luke's, Smithfield, 1682 [**868**], a brick Gothic building with wall buttresses and brick tracery.

Like the English colonists, the Dutch built in the style of the mother country. New Amsterdam had fine brick town houses with an off-centre entrance, a high 'stoop' and a stepped gable end facing the street. Along the Hudson the owners of large estates lived in simple but comfortable one-and-a-half storey houses, usually of stone, with gable roofs (Senate house, Kingston, N. Y., *c.* 1676–1695. An example of a brick town house is Fort Crailo, Rensselaer, N.Y., 1642 (?) [**869**]. The Dutch built small octagonal churches, all of which have disappeared.

Flemish houses, also found in New York and New Jersey, resembled the Dutch one-and-a-half storey rural houses, but with a distinctive feature of their own — flared eaves which overhung the ground floor at the front and back. In the 17th century such houses had a gable roof, in the 18th, often a gambrel [**870**]. Later in the 18th century this overhang was extended to form a front porch [**870**]. (These Dutch and Flemish farmhouses were still being built in the 18th century.)

The Swedish settlers used log construction and introduced the log cabin (found in Sweden) into America.

Sculpture. Sculpture at this time consisted principally of wood-carvings such as ships' figureheads and some carvings on tombstones.

Painting. Family portraits were the type of painting encouraged in the latter part of the century by the prosperous Puritan and Dutch Reformed settlers. The artists were usually untrained, and we seldom know their names. The influence came largely from Dutch painting — frequently the stylistically less advanced painting of the provinces. Among the most interesting of these portraits (all late 17th-century) are the following: the child *Henry Gibbs*, 1670; *John Freake*, 1674; *Mrs Freake and Baby Mary*, 1674 [**865**]; self-portrait by Captain Thomas Smith, *c.* 1680–1690 [**864**].

The minor arts. Furniture made in the English colonies was still medieval in tradition and was heavy and simple (slat-backed chairs, trestle tables). Oak, pine and maple were used; furniture was often painted, but upholstery was rare. Towards the end of the century the drop-leaf gate-leg table came into use.

Emily Evershed

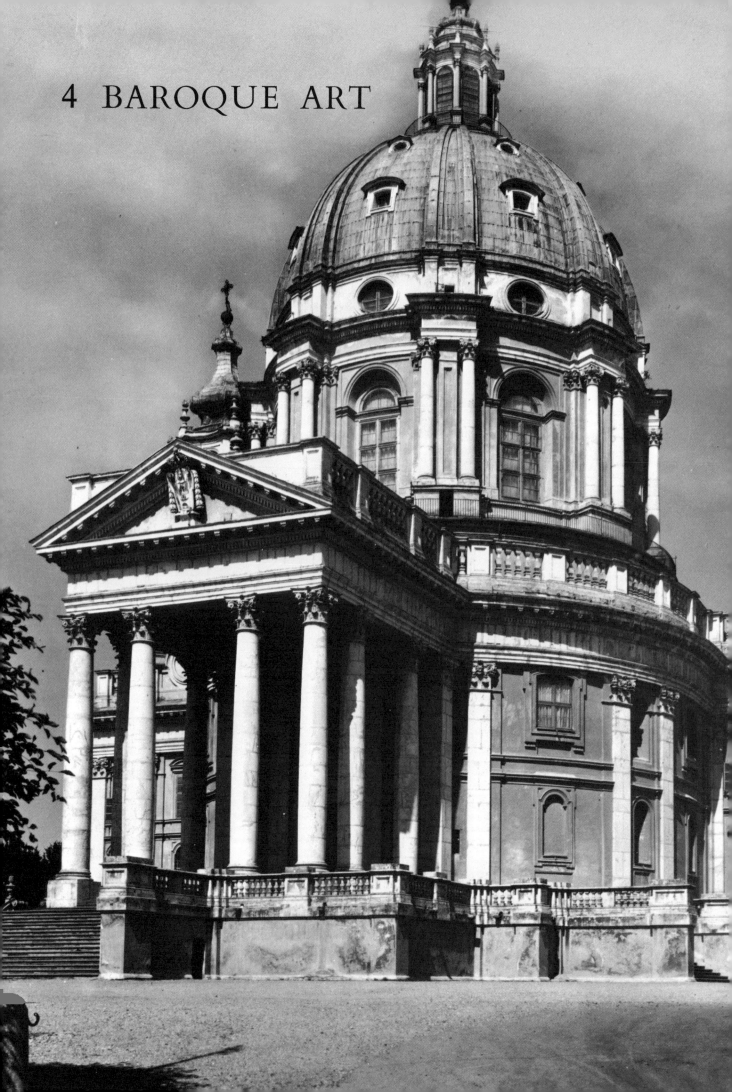

4 BAROQUE ART

ART FORMS AND SOCIETY *René Huyghe*

From its early medieval beginnings European civilisation has been constantly enriched by fresh trends and styles and the reactions which these have provoked. Nothing has been lost, however much it may have seemed at times that a trend was eclipsed. The most varied influences have continually crossed and intermingled and have been sometimes advanced and sometimes impeded by the temperaments of different nations; in the growing complexity of this culture no over-simple formula can be found which explains any period in its entirety.

This is certainly the case with the Baroque. For many years all teaching was based on the classical tradition, and the Baroque was regarded as a pariah in the history of art — a synonym for disorder and decadence. In the 20th century the decline of this classical tradition has led to a complete reversal of attitude; the Baroque was discovered, and was considered to be the antithesis of classicism and its complement. It was an intoxicating revelation, and the conception of the Baroque was extended to the point where French classicism was seen as an integral part of the Baroque — although, in fact, the two styles were totally antagonistic in spirit despite certain elements of period taste which they inevitably had in common. After years in which everything was judged in the light of classicism alone, everything was now seen in relation to the Baroque; the only effect of this attempt to reduce every problem to a single principle has been confusion.

The Baroque has thus become so important that we have thought it necessary to devote a special chapter to it, although it began as a new artistic movement before the Renaissance had ended and reached its zenith during the 17th century, which was the subject of the preceding chapter. By treating it on its own we shall be better able to define the nature of Baroque art, and we shall be able to disentangle it from the currents operating outside it, which should not be confused with it. We are now free to return to the periods we have already studied, approaching them from this new point of view, and we can trace the whole development of this very important style from its beginnings until it came to an end in the 18th century.

The Baroque in history

We cannot go far without defining what is meant by the term Baroque. Victor L. Tapié has made a clear summary of its accepted meanings. It appeared first in the 18th century; the *Dictionnaire de l'Académie* in 1718 regarded it as a synonym for irregularity. In 1797 Milizia defined it in his *Dictionnaire des Beaux-Arts* as the 'superlative of the bizarre, the excess of the ridiculous'. But a century later the great art historian Heinrich Wölfflin, in *Renaissance und Barock*, analysed it historically as the art which succeeded and reacted against the Renaissance. Marcel Raymond and later Werner Weisbach connected it more particularly with the Counter Reformation.

From the time of Michelangelo and Correggio, man was no longer content with the classical ideal of the Renaissance. New aspirations sought an outlet, all the more insistently for having been ignored in the past. Modern man was the child of the medieval world, with spiritual needs that could not be fully met by the exclusive ideal of reason and harmony, the dream of classical antiquity. We have already seen how insistently 394-398 the bizarre and the supernatural manifest themselves.

Choice of subject in itself may be a mute form of symbolism,

and perhaps it is significant that Raphael had painted the loves of gods and humans in the Villa Farnesina in Rome (and later Annibale Carracci in an avid return to classicism did the same 530 in the Farnese palace in Rome) whereas Giulio Romano, Raphael's chief assistant, drew his inspiration when he decorated the Palazzo del Tè after 1530 from the revolt of the Titans 292 against Jupiter and from the hidden physical forces which they represented. The goal of the Renaissance had been reached by the beginning of the 16th century; once the ardour of achievement had subsided it was replaced by a feeling of anticlimax. This feeling gave rise to Mannerism, a style which broke no new ground but merely refined upon and distorted the classical style in the hope of finding new possibilities in it. This very excess emphasised the deficiencies of the style and the need to make up for them (see p. 197).

Renaissance art, with its ideal of intelligence, logic and harmony, had satisfied the intellect but had thwarted life, which now claimed its turn, indeed its revenge. Life with its impulsive activity appeared to signify disorder, for any attempt to submit it to the order of artistic form cancelled life out by immobilising it. Perfect form, the ideal of the Renaissance, was by definition intangible; every change hindered the achievement of it. It 'hated movement, which displaced the line' — the line of 230 immutable beauty. It thus eschewed the active principle of life, and life repressed eventually asserted its demand for freedom.

A historical factor also intervened. About 1530, when the Renaissance having nothing more to accomplish was beginning to decline, the Reformation was gathering momentum. The Church was being attacked for its rigidity — for preferring forms, hierarchy and outward pomp to the spiritual. The Reformation brought religion back into contact with life and with the problems of the conduct of life and its eternal conclusion — salvation. The Church, confident of its immortality, was at first unaware of the danger and reacted little if at all. When almost too late it awoke to the danger, it saw the need for reform. The council of Trent, sitting between 1545 and 1563, undertook the task, and though the process was difficult it was carried through. The council's preoccupation with art resulted at first in a regression. In Spain in particular art was reduced to austerity in an attempt to combat the Reformation with its own weapon. But soon, exploiting those resources which had proved efficacious in the past and which were neglected by Protestant asceticism, art became reinstated in its social function, which was at that time religious. Renouncing what it had gained from humanism — independence and a preoccupation with its own purely aesthetic ends — it re-enlisted in the service of the Church. It became once more 'engaged' — the means of furthering a cause — and it ceased to be an object of detached contemplation and impartial enjoyment.

Art has great power to stir the emotions and to increase awareness and can thus be a means to the conquest or reconquest of souls. Protestantism, disturbed by the association of art with luxury and by its sensuous, even sensual, qualities, was hostile to art on principle; the Reformation tended to iconoclasm, rejecting art as a superfluous vanity, an aberration of the Church. Catholicism countered by using as a weapon that which was condemned by its critics as a defect. If art could seduce the soul, enchanting and disturbing it and stirring it to its irrational depths, then this could be used to further the faith! Protestantism with its dry austerity disregarded the needs of the senses. The

871. ITALY. FILIPPO JUVARRA (1676–1736).
View of the Superga, Turin. 1717–1731.

Church, on the other hand, made use of art to fulfil these needs in as many people as it could reach, using the senses to move, awaken and guide these obscure impulses of the soul to the faith. Emile Mâle has shown how iconography was transformed from this time onwards — how it exploited the emotion of love by showing the ecstasy of souls in mystical communion with God and how it exploited the emotion of fear by showing martyrs in their agony. It appealed to man's deepest responses, the ' passions ' which, since Aristotle, the theatre knew how to excite in order to move the public. It came closer to life and to the life of ordinary people, laying stress on the saints, who were accessible intermediaries to the Godhead.

But the change in style was even more important than the change in iconography. The ideal intellectual style of the Renaissance was abandoned in favour of that which would be most effective in touching no longer the élite but the masses — grandiosity and turbulent movement, and an overwhelming richness and superabundance of forms. Wishing to move the beholder in his personal life, the new art turned to life, evoking it wherever possible and filling it with animation and great excitation. Henceforth art turned its back on classicism, which it considered stark and austere and at times cold in its purity, and became Baroque, that is profuse and dynamic as well as seductive and pathetic. It was in this sense that the Baroque was principally the art of the Counter Reformation.

The Baroque in aesthetics

To bring about this change, however, the Counter Reformation only made use of potentialities which art had always possessed and had often exploited in the past. Thus critics have been tempted to look beyond the temporary phenomenon to the permanent tendency. Wölfflin spoke of two invariably antagonistic forms of art which appear throughout history — the classical and the baroque. Eugenio d'Ors sought to isolate the eternal baroque, of which that of the 16th, 17th and 18th centuries was only a localised aspect, as were the Flamboyant style of the Middle Ages and the Romantic style of modern times. Focillon, like Wölfflin and others, showed that the art of each civilisation goes through stages of both development and decline, the baroque phase being part of the latter.

There have been many debates and misunderstandings on this subject. There are people who find it difficult to think from the particular to the general and who cannot conceive of the Baroque both as a style conditioned by the Counter Reformation and as an inherent trend in art which appears periodically as the pendulum swings back from the classical attitude. Yet there is no doubt that the Baroque of the historians is merely the application of the universal baroque of the aestheticians to different sets of circumstances.

Then what, taken independently of historical context, is the Baroque? From its beginnings in prehistoric times art seems, to us, to have been a means created by man for reconciling two disparate realities: one is his own nature, founded on a unity embodied in the self and striving to bring all his inner life under the control of his sense of order and his will; the other is nature itself, the reality of the world outside himself, presented to him in the crude and disorganised multiplicity of sensations — a reality where all is unstable, transitory and constantly changing, and suggestive of infinity. Man's whole mental life from birth is an effort to organise this tumult into which he is flung and which overwhelms him with its immensity and its inexhaustible profusion. He has only one means of understanding it, living in it and influencing it, and that is to reduce it to the unity which is the principle of his own existence. His tool is his intellect, which creates mental forms and gives fixed, stable definitions to ideas; it also establishes definite discernible points and between them constructs regular links

which obey rules of logic and reason. Thus man builds an intelligible image of the universe for himself; he establishes islands of *terra firma* in the moving torrent.

The work of art is a bridge which man throws between his own nature and the natural world. The work of art to a varying degree reflects nature as man perceives it, but at the same time it embodies the laws of human nature in its representation, giving them forms and structures which satisfy the urgent need of the mind to seize hold of the entities and the intelligible and logical elements in the external world. The work of art, which is man's creation, gives a view of the external world, but it does this in order to project on to it qualities which belong to man's thought and sensibility, and so to allow him to assimilate it and make it his own. The work of art, then, connects these two extremes — the outer and the inner world — and sheds light on each of them.

But at times man is tempted to subject a greater share of nature to his own norms, and it is this that explains the opposition and regular alternation of the classical and the baroque throughout history. Man then transcribes nature into legible clear forms and joins them into a logical and fixed composition. This is a classical phase. It is to be expected that such phases will coincide with strong civilisations in which man thinks he has mastered the circumstances which have buffeted him. Nature is then seen and conceived in the light of what is eternal and immutable, and its justification lies in perfection, which excludes all possibility that it may evolve.

Eventually this authoritarian phase is found to be insufficient; certain elements in man's nature which he has tried to ignore during this classical phase persist in imposing themselves, and man has certain aspirations which he is now determined to satisfy — all the more because they have been for so long ignored. At this point art shows a tendency to return to the real, to the ever-changing and limitless complexity which objective observation reveals when the mind is freed of its preconceived notions, and to the ' immediate data of consciousness '. Art steeps itself once again in what is living and moving and breaks down the established forms as obstructions to its free exercise. It discredits the order which the mind has tried to impose on reality, regarding it as entirely arbitrary and artificial; art attempts instead to find a means of identifying itself with life in the area in which life corresponds least to the logical conception of it that existed in its classical phase; art now wishes to identify with life at its most authentic, even at the price of abandoning order and embracing anarchy.

Instead of reflecting the qualities inherent in the intellect which are its means to orderly functioning, art concerns itself with change which, keeping the intellect on the move, reveals to man how little his mental equipment is capable of apprehending the real world in which he finds himself. Reality can only be grasped by direct, blind but immediate contact, through his sensibility and intuition — through the participation of his inner life in universal life. Where the classical ideal holds to impassive rational representation and proscribes the turmoil of the ' passions ', the baroque appeals to and exalts the emotions in its desire to capture the experience of life itself. This is just as evident in the Hellenistic art which followed the art of 5th-century Greece and in the Flamboyant Gothic style which followed the 13th-century Gothic as it is in the Baroque which supplanted the Renaissance, or again, in the 19th-century Romanticism which replaced the classicism which had existed from the 17th century — first in France and later throughout Europe.

Wölfflin has given a masterly definition of the sculptural characteristics of this Baroque, which, we think, may be summarised as follows. The classical, tending to fixed definitions, is ' architectural '; the Baroque, concerned with working on the

872. ITALIAN. UMBRIAN. PERUGINO (1445–1523).
The Vision of St Bernard. 1483–1492.
Pinakothek, Munich.

CLASSICAL AND BAROQUE ART

The history of art seems to follow a kind of alternating rhythm; the desire for intellectual order and discipline, once it has been too fully satisfied, brings about a reaction — the desire to abandon oneself to life and to its impulses. Thus classical and 'baroque' tendencies compensate for each other, confirming our proposition that art responds to a tension between the infinitely complex and restless nature of the real world and the fundamental principle of unity in the human spirit. It would seem that every civilisation tends to a classical phase during its growing, ascendant, period and slips into a baroque phase when it becomes dissatisfied and seeks to renew itself. It would seem also that some groups of people show a tendency for one or the other phase and so promote its development.

In the classical work of art [872] realism submits to the laws of balance to the point of strict symmetry, and to the laws of harmony; in the Baroque work of art [873] man no longer seeks to control but luxuriates in the disorder and the rich and organic profusion. Although always in conflict with the simple, clear and geometric concepts of classicism [874], the Baroque existed in varying degrees of intensity, from a simple animated movement of lines and surfaces [875] to an exuberant and dynamic profusion [876].

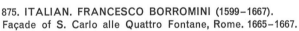

873. GERMAN. JOSEF KLAUBER (1710–1768).
The Epistles of St Peter. Illustration from Scenes from the Old and New Testaments. Engraving. 1757.

874. ITALY. Façade of the Palazzo Caffarelli (now Palazzo Vidoni), Rome. Built in 1515 from the plans of Raphael and his pupil Lorenzetto. Engraving.

876. SPAIN. IGNACIO VERGARA (1715–1776).
Portal in white alabaster of the palace of the Marqués de Dos Aguas, Valencia. From the design of the painter Hipólito Rovira Brocandel (1693–1765).

875. ITALIAN. FRANCESCO BORROMINI (1599–1667).
Façade of S. Carlo alle Quattro Fontane, Rome. 1665–1667.

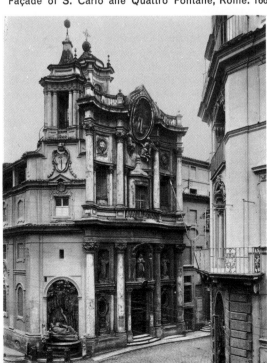

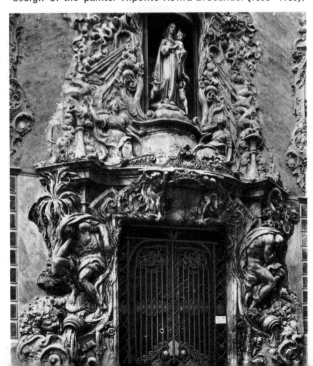

emotions of the beholder, is 'musical'. The first resorts of necessity to forms rendered exact through the importance given to contour and drawing and by the use of a continuous line. The second relies on methods of suggestion, of which colour is the most effective. The first, by virtue of its composition, aims at subordinating the whole to the principle of unity; symmetry, a centre of composition, closed form and convergent perspective are its most familiar devices. But the Baroque makes use of disunity in order to give untrammelled freedom to life and to remove all restrictions which might immobilise and so annihilate life; it employs asymmetry, space which seems to move outward because of optical illusion, open forms in which the line is less a fixed boundary than the tracing of a movement, and of course variations of light and atmosphere.

The Counter Reformation

If we accept these two definitions of the Baroque our confusion disappears. They are in no way irreconcilable but are explanations on different levels. They help to make intelligible the diversity and apparent contradictions of the Baroque, for example that it began in the very classical Renaissance and ended in the extreme form which was the 18th-century Rococo, and that it differed in spirit, though it remained similar in its forms, as it took shape in the various countries of Europe and (as Europe took root for the first time on a new continent) in the Americas.

The sequence of events can now be traced. The Baroque emerged for historical reasons from Italian art, although the rational Latin spirit might have seemed the least favourable soil for its germination. The Counter Reformation made an appeal to its persuasive powers in order to combat the increasing influence of Protestantism and to affect the masses which it seemed so nearly to have lost. The Italian artists had little inclination to abandon themselves to the extremes of sensibility but were mainly concerned with technique; they cultivated in preference an eloquence of colour and form and pursued the most theatrical and exaggerated stylistic potentialities of art. Thus Italian Baroque always had more external form than inner conviction; it was stated rather than felt, and it retained a measure and internal equilibrium which kept it free of the excesses found elsewhere.

The Counter Reformation was mainly in the hands of the Jesuits, the army of reconversion, who quickly adopted and disseminated the Baroque style. It was then that it changed character. It spread through Europe — first into Austria, Bohemia and Bavaria and ultimately to Spain and from there to America. This expansion was the work of Rome itself which, however, had always preserved the classicism of the ancient world even in face of the 'barbarian flood'. Thus the Baroque took root in lands where Latinisation had only superficially repressed deep desires which were very emotional and were contrary to the ordered classical spirit. All the buried forces which were now released could be seen emerging from the depth and becoming increasingly important. The two Baroques were brought face to face: the Baroque of historical circumstance from Italy revived the deeply vocational Baroque of the Germanic and Iberian peoples and through these latter reached the peoples of America, whose primitive vitality lay near the surface waiting to erupt.

With this outline of the development of the Baroque for two and a half centuries in mind, we can turn to a closer examination of its growth. The council of Trent ended in 1563, a short time before the death of Michelangelo whose powerful influence was preparing the way for the new artistic movement. The Church wished first to restore its own unity and that of the faithful by tightening discipline and imposing austerity. 499, 500 Vignola, who designed the Church of the Gesù in Rome

(begun 1568), and Giacomo della Porta, who was responsible for the façade ten years later, both show a sober, severe quality. In Spain this was further strengthened in reaction to the excessive profusion of the Plateresque and was carried to the extreme of severity and melancholy asceticism which we find in the Escorial (built for Philip II by Juan de Herrera) — a model of the unadorned style called *desnudo* or *desornamentado*.

The Jesuits were recognised in 1540 by Pope Paul III, the promoter of the council of Trent. They saw themselves as an army. The individual was nothing, submitting himself entirely to directives imposed in the exclusive interests of the Order for the service of the Church. At the same time art was taken in hand; its growing orientation towards individualism had been sanctioned in art criticism which, since Vasari, had allowed each painter his own manner, admitting his right to depart from the rules and accepting even deficiencies and faults if they were part of the expression of personality. Domenichino extended this notion to include groups and schools of artists. The attempts of the Carracci to mix 'manners' and combine the advantages of them all takes meaning as a contribution towards effacing this threatening individualism in the interests of the collective.

Similarly the uniformity of vision and execution of the great Baroque decorators, which has so lowered them in the estimation of modern generations, can only be understood, like the team-work of the Rubens studio, in relation to this directive 584 to annihilate the personality seeking to express itself on its own account. The first task of the Counter Reformation in its dealings with art was to provide it with an iconography, an obligatory formula for subject matter; out of this came the contemporary treatises which for a long period had the force of law, such as the *Iconologia* by the Cavaliere Cesare Ripa, which ran through many editions and had an immense influence, as was pointed out by Emile Mâle.

But in the matter of renunciation and the submission of man to God it was difficult for the Church to go further than Protestantism; the severity of Ignatius Loyola was easily equalled by that of Calvin. It was not sufficient merely to restore the sense of collective unity; it was necessary also to direct it towards the faith. Art under the tutelage of the Church was to be bent to this end. Architecture was again brought into the forefront, being eminently the social form of religious art — first drawing in the faithful, then making them partake of the sacrament and lastly sweeping them along in the current of religious feeling. 906 With these ends in view, richness of surroundings was more effective than austerity. The use of precious and dazzling materials and the lavishness with which they were distributed appealed to the ordinary people's taste for festivity and splendour and compensated for the harshness of everyday life; the people, too, were given their palaces — in the form of churches. Indeed, as Miguel de Molinos observed: 'The Church is the image of heaven on earth. How should it not be adorned with all that is most precious?' How far removed this is from St Bernard! But this power of attraction had to be made as efficacious as possible. The façade overlooking the street where the crowd passed thus became as important as the interior of the building, which in its turn had to fulfil the promise of the outside. It did not matter that the sumptuous facing no longer corresponded to the structure of the building; art was less concerned with truth than with effect. This is what shocks us today, with our modern belief in functional moderation. Yet cannot the 'function' of art be spiritual as well as practical?

This trend also bore witness to the preference for the communal. The façade was the part of the building which belonged to the public space — the chosen field of Baroque art; Baroque art was an art of the city — of the *polis* — as has already been emphasised, and hence it was concerned above all with town

877. ITALIAN. PARMA. CORREGGIO
(before 1489–1534). The Ascension. Detail from the dome of
S. Giovanni Evangelista at Parma. 1520–1524.

878. ITALIAN. ROMAN. GIULIO ROMANO
(c. 1499–1546). Dome of the Sala de' Giganti.
Fresco. 1532–1534. *Palazzo del Tè, Mantua.*

CEILINGS AND DOMES

*While classicism was based on form, which provided a clear
and fixed definition of appearances, the Baroque had by
definition to animate form, to escape from it and
even to annihilate it. Ceilings and domes, by creating an
unreal opening into the air, showed their Baroque nature at an
early date. The development can be clearly seen. In the first
half of the 16th century Correggio (who in a number of
ways can be considered among the masters of the Renaissance
as an innovator and a precursor of Mannerism and the
Baroque) was reducing the world of solid realities to
patches of light animated by moving clouds and flying
figures [877]. With Giulio Romano the scale of the figures was
reduced and their number increased, and the
effect of swarming life was accentuated [878]. The great
Baroque decorators increased the intermingling of
elements and the asymmetrical composition [879] until Tiepolo,
who seemed almost intoxicated by the vibrant
brightness of space, dissolved the last vestiges
of the solid world into a realm of immaterial light [880].*

879. *Left.* ITALIAN. ROMAN. GIOVANNI BATTISTA
GAULLI, called IL BACICCIA (1639–1709). The Glorification
of the Name of Jesus. Sketch for the vault
of the Gesù, Rome. 1672–1679. *Galeria Spada, Rome.*

880. *Above.* ITALIAN. VENETIAN. GIOVANNI BATTISTA
TIEPOLO (1696–1770). The Apotheosis of the
Pisani Family. Ceiling of the Palazzo Pisano at Strà. 1761–1767.

planning, just as Hellenistic art, that Baroque of antiquity, had been. The street and the public square with its playing fountains gave a raison d'être to the palace, which in its turn became larger with bigger reception rooms and staircases. The inside of the church was also enlarged and was opened out in plan. It was important for it to be vast and also for it to envelop the crowd and to concentrate its attention towards the altar. The altar, then, was placed in direct contact with the people by means of circular or elliptical plans; an aisleless nave was favoured. But this space was not intended to remain neutral. Not only was its splendour to attract and delight, it was to direct towards heaven. The design of these churches, with its increasingly supple lines, is subordinated more and more to an undulating movement which entwines, twists and rises aided by the multiplicity of flying figures of cherubim and angels; this movement lifts these figures up and flings them into the vortex of the central dome, carrying the eye and with the eye the soul — with the ascending gyration of clouds, draperies, holy figures, etc. — into the celestial light. Everything is drawn irresistibly to that opening into the infinite where the radiance of God is found.

901
741

Rhetoric and the theatre

Art had changed direction and its pole. For the Italian Renaissance it was an instrument of discovery, a search after truth which was not wholly separated from science; Leonardo personified the connection. It differed from science in that it devoted itself to the quest for its own truth, which was beauty. But henceforth art was not required to define this truth for itself; truth was ' revealed ', provided by the Church. The function of art was to communicate this truth and to attract people to it; art had become an instrument for persuading and convincing. The Third Congress of Humanist Studies in 1954 was devoted to the connection between the Baroque and rhetoric. If it be legitimate to define the first by the second during a certain stage of its development, this is the stage we have now reached — a phase dominated by Rome. What would not be correct would be to extend the explanation of one of its phases to the movement as a whole.

The Roman Baroque (one is tempted to call it the Jesuit Baroque, the two factors were so closely associated) is evidence, as has been shown by G. C. Argan and others, of a change of thought; no longer was the aim to prove through the compulsion of logic (as was the case with scholasticism) but to convince and to achieve unanimous participation through the use of the word. This was the purpose of the orator. Aristotle considered that rhetoric, through the establishment of reciprocal persuasion, was the very foundation of civil life. The Romans, more concerned with unanimity than were the individualist Greeks, were well aware of this; history, for Livy among others, was made by speeches (orationes). The technique of oratory was maintained by its masters Cicero and Quintilian. These authors now came to the forefront. Aristotle had been highly regarded during the period of scholasticism for his Logic, then, at the birth of modern times, for his Physics and Metaphysics, and now he was consulted for his Rhetoric.

This new orientation appeared very early in Spain, the country where Jesuit thought originated, and remained for a long time the basis of instruction because of the ascendancy of the Jesuits in the field of learning. In 1529 Nebrija published in Alcalá his De Artis Rhetoricae Compendiosa Coaptatione ex Aristotele, Cicerone et Quintiliano. The names of these three men define the new programme. In 1561 the Jesuit Father Cipriano Suarez of Coimbra set himself the same task in a work of such fundamental importance that it was translated in Venice only four years later in 1565 (De Arte Rhetorica ex Aristotele, Cicerone et Quintiliano). Together with the five books of Rhetorical

Institutions by Pedro Juan Nunez in 1595, these works show the penetration of the rhetorical point of view which is so noticeable in Giovanni Pietro Bellori, the most important art critic of the 17th century; as opposed to our modern conception of art, painting was for him a ' literary ' exposé devoted to description and to pictorial narration; drawing, form and colour, it was aptly said, were now nothing more than the means of ' pictorial discourse ' and what was more could easily become redundant. It is possible to follow the growing importance of this new point of view in the thought of the followers of Ignatius Loyola. The Ratio Studiorum of the Jesuits appeared in 1586, and in this work Renaissance Platonism was still in the ascendant. By the edition of 1599 the emphasis had shifted to the rhetoric of Aristotle. As is well known, this latter edition remains to this day an essential stage in Jesuit schooling, the high point of study before embarking on the study of philosophy.

It is thus not surprising that Baroque art, developed principally by the Jesuits centred in Rome, was dominated by rhetoric; this orientation could not fail to satisfy the liking for verbal communication and facility which is a part of the Italian temperament. But as the means were increasingly perfected so they became disproportionate to what they had to express. Investigation and innovation were almost dead; repetition brought with it a facile and empty monotony. This was reflected in art in the paintings on ceilings and domes, with their exuberant turmoil and excessive proliferation of forms, handled with great virtuosity but empty of meaning. From Pietro da Cortona and Fra Andrea Pozzo to Francesco Solimena, the great Baroque decorators have been held responsible for this tendency, often unjustly, by posterity.

878-880

As Professor Argan has shown, we can trace the change from poetical painting, founded in Venice by Giorgione and stemming from a deep and sincere sensitivity, to rhetorical painting, where only the effect counted whether or not it had been produced by artifice or trick and without the warrant of a genuine humanity.

From this, art began to evolve towards the theatre and to associate itself with it. Obsessive search for effect led to a fusion of all the elements contributing to it. Techniques were combined into hybrid forms. All the arts — painting, sculpture and the decorative arts — were brought in to contribute to the total effect of works of architecture just at a time when ballet and opera were appearing. Renaissance individualism had favoured the song accompanied by one instrument, the ' solo '. With Monteverdi's Orfeo (1607) we come to a sort of musical drama which, when taken up in Rome, became the forerunner of our modern opera. In 1637 a public opera house was opened in Venice; in 1654, under the aegis of Mazarin, the French court ballet was brought into close collaboration with Italian opera with the Nozze di Peleo e di Teti by Caprioli. Pageants and festivities were conceived almost architecturally, as a total and living whole which would set all the senses astir. These found a counterpart in the ceremonies connected with funerals, which for their part underlined the nothingness of the individual in comparison with the revelations of the faith and which showed how transitory was human reality in the perpetual flux of life, condemning all matter to the same extinction as that suffered by the individual.

882

881

883

884

The mutation of forms

Form separates and isolates individual objects through the fixed definition of a contour, whereas life joins everything together and animates the whole. Art now was concerned with the impression rather than the conception, giving preference to optical sensation received through patches of colour and light and shade rather than to the idea of a thing as suggested by form. Velasquez marks the flowering of what has been called a ' first Impressionism ', the way having been prepared by the

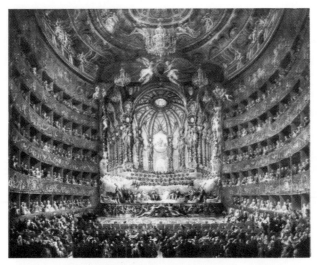

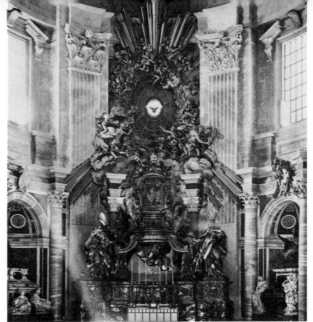

881. ITALIAN. ROMAN. GIOVANNI PAOLO PANNINI (1691–1765). Performance of the Contesa dei Numi by Leo Vinci, given on 26th November 1729 by Cardinal de Polignac in his palace in Rome. *Louvre.*

882. GIAN LORENZO BERNINI (1598–1680). The Cathedra Petri. Begun 1657. *St Peter's, Rome.*

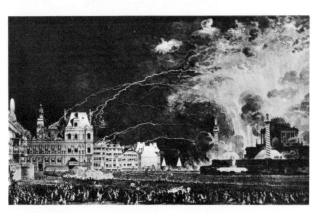

883. FRENCH. Firework display in Paris on the occasion of the birth of the Dauphin in 1782. Drawn from nature and engraved by Moreau the Younger (1741–1814).

884. FRENCH. Funeral of Elisabeth Thérèse of Lorraine, queen of Sardinia, on 22nd September 1741, in the cathedral of Notre Dame, Paris. Designed by Péro and Slodtz. Engraved by Cochin the Younger.

THEATRE AND FESTIVITIES

Historically the Baroque replaced the classical art of the Renaissance in Italy at a time when, largely under the influence of the Counter Reformation, art was becoming less a means of satisfying principles and reflecting ideas than of producing an effect on the beholder. The resort to the seductive and persuasive methods of rhetoric was made complete by an aesthetic of the theatre, of which opera was the most perfect realisation.
The imperative convergence towards a centre of light is typified in the theatre [881]; following this example the work of art brought a whole scenography into play, which was based on the combination of movement and light and the association of architectural, sculptural and pictorial techniques in a setting suggestive of music [882]. The contrasts of brilliance and night [883] and of death and pomp [884], together with the use of disguises [885], enhanced the transitory intensity of the fleeting moment.

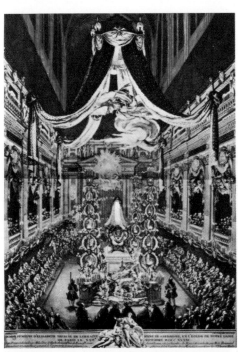

885. FRENCH. Costume for a musician playing the lute. Drawing, wash and watercolour for the Ballet de la Nuit by Lully, performed in 1653. *Bibliothèque Nationale, Paris.*

Venetians. Moreover, where it survived form was now employed to eliminate contours which evoked the fixed and abstract definitions of geometry. The artist now wished to testify to the movement of life. Rubens made the line undulate like a swelling wave; Bernini seemed to shape marble as though it were fluid. In one of those significant events which are part of the law of history, about this time William Harvey discovered the circulation of the blood, and this event may well explain the way in which Rubens rendered flesh in his paintings.

In ornamentation the straight line was supplanted by the curve — no longer the curve which surrounds a circle but rather a curve which undulates freely into rounded projections **499** or alternating volutes. It appeared first on the façades with volutes of the early Jesuit churches and soon dominated all decoration, extending its sway to the walls themselves which, **902, 903** in Borromini's work, project and recede. It swept on with the force of a wave, and in the 18th century its spiral outline was **888–891** twisted into the shape of a conch. Henceforth this last was found everywhere, both as an element of decoration and as the pattern of composition in certain pictures as, for example, in the paintings of Boucher. The much too regular circle disappeared; it was first superseded by the oval (a shape free from the law of a single centre) which was at the same time introduced into science; in astronomy it explained the orbits of the heavenly bodies, which had previously been thought to be concentric. Then it opened up, becoming the centrifugal coil of a spiral movement; Rubens in his *Virgin with Cherubim* made use even then of this open indefinite figure in place of **722** the traditional mandorla or the circle. Torsion, particularly in sculpture, added a further dimension to this movement which was now transmitted step by step into both the composition of paintings and the lines of decorative ornament. This transmission led first to fusion and then to confusion. Architecture, sculpture and painting no longer remained independent but were linked through invisible transitions into an orchestration whose total effect alone was to be felt, and primarily by the senses and the nerves.

These trends were no more than embryonic in the Roman Baroque, but through an inevitable law of growth they developed and spread rapidly and came to a full flowering as a result of two factors: on the one hand the search for effect inevitably led to the pursuit of illusion; on the other, the spread of the Baroque to the Germanic countries transplanted it to a soil where it overflowed the bounds of sweeping rhetoric and awakened and satisfied innate instincts which had been suppressed since the Middle Ages by classical culture.

Effect and illusion

From the time that effect and its result, persuasion, become more important than verification, and from the moment when the artist becomes less concerned with what he says than with his manner of saying it, illusion becomes a sort of proof of and acme of efficacy. Thus Baroque art soon succumbed to the use of illusion. In painting it was the Venetian school, more interested in creating an optical impression than in producing a logical structure, which first developed a technique based **288** on illusion; blobs of paint alone sufficed, and replaced the precise analysis of drawing. This at least was still an attempt to translate reality, if by a more suggestive method; but with **523** Caravaggio, whose search for effect revealed his adherence to the Baroque in this respect, realism resided less in exactitude than in the dramatic impression. Some people might even see a connection between Caravaggio's theatrical impact, aided by the use of exaggerated contrasts, and the pre-Impressionist technique in Venice which tended to reduce painting to blobs of colour rendered in separate strokes.

We might add that there was a precedent for this broken

technique in antique paintings (examples of which were beginning to be excavated from subterranean ruins during the 16th century) in which each contrasting colour value was given its full effect by the absence of modelling and transitions in relation to the form. Let a painter use this technique, carry it to the point at which it becomes artifice, and use it to serve a vision which aims at greater impact by resorting to the unexpected, even to macabre fantasy, and the result is the vehemence of Magnasco. His work was the final flowering of the Genoese **922** Baroque art which we have already seen in the work of Bernardo Strozzi, and later of Giovanni Battista Gaulli (called il Baciccia) who painted the ceiling (1668–1683) in the Church of the Gesù. **879**

The next link in the chain was Sebastiano Ricci from Belluno, a great traveller, who met Magnasco in Milan; Ricci carried the influence to Austria where he worked on Schönbrunn palace before visiting London and Paris and returning to Venice, where he died. The Venetians Piazzetta and Longhi, who were pupils in Bologna of Giuseppe Maria Crespi (a contemporary of Magnasco and like him a master of spectacular tenebrism), in their turn handed on this restless quest to Venice, thus preparing the way for the final effusion of the Baroque in the city of the doges, where in the 18th century Guardi and Giovanni Battista Tiepolo transmuted it with Veronese's light. Under the **880** brush of Tiepolo this light became the ethereal vibration of a sparkling void, an effect to which earlier Baroque decorators aspired. Thus the reabsorption of form and even of matter into the impalpable reached its culmination. Tiepolo was responsible for the wide diffusion of this art. In the middle of the century he worked at the Residenz at Würzburg, in the heart of the hyper-Baroque zone of southern Germany and Austria; his paintings ten years later in the royal palace at Madrid prepared the way for Goya, who was to combine the luminosity of the Venetians with the fantastic vein of the tenebrists.

The resources of illusion were most fully employed in architecture; Scamozzi in the theatre at Vicenza gave a spectacular demonstration of this with his use of hallucinatory illusionist views. But it was in the church that sham and real perspectives, sculpture which had been volatilised into movement and light and painting suggesting relief or concavity, would mingle all their resources in a whirling trompe l'oeil against which the bewildered spirit is powerless and is compelled to submit to the intoxication and let itself be carried away. All is false, but is truer than reality. Andrea Pozzo, who decorated the interior of the Church of the Gesù, says in his treatise on perspective which appeared about 1700 that these elements must ' have their intended effect ... to deceive the eye ... so true is it that the designs of great works when conducted according to the laws of architecture, painting and perspective impose themselves easily on the eye; I even remember having seen people who set out to climb a staircase, and only realised their mistake when they laid a hand upon it. '

The masterpieces of this style are to be found after the Baroque had reached its full development in the 18th century, and in the schools which, unlike Rome, were not held to a more moderate course by a formal and rational tradition.

The Baroque on its true ground

The German states, isolated from the community of European culture by the ravages of the Thirty Years' War and held back by the Reformation and the conflicts arising from it, did not join in the general cultural movement again until the eve of the 18th century. We can say that in a sense Baroque art was awaiting them and, basically, they were awaiting it. It was mere chance that conditions were favourable for Baroque to originate in Italy, where it in fact took on only the external, wholly descriptive, form which has caused it to be identified with an artificial elegance. It was capable, however, of being

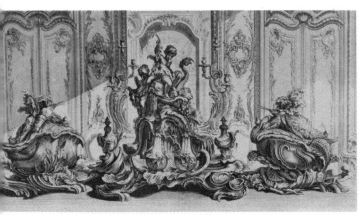

886. FRENCH. JUSTE AURÈLE MEISSONIER (1695–1750).
Project for a large table centrepiece in silver
with two tureens, for the Duke of Kingston.
Engraved by Huquier (1695–1772).

887. ITALIAN. GIOVANNI DA UDINE (1487–1564).
Detail of a pilaster with stucco decoration.
16th century. *Villa Madama, Rome.*

ROCOCO MOTIFS

In the 18th century, and especially in the Germanic countries,
the Baroque appeared in its most extreme form and,
one might say, found its own mannerism in the Rococo.
We have only to compare two decorative compositions
— both in ternary rhythm but one obeying the
dictates of the Renaissance [887] and the other giving free rein
to the unbridled agitation of the Rococo —
to see how the straight line and its division of
surfaces has been abolished and how indeed the exuberance of
the curves suggests rebounding movements reminiscent of the
rolling of waves [886].
Although Baroque art employed undulations and
marine motifs as early as the beginning of the 17th century
(Stefano della Bella [888]), we can see all that
was added by the Rococo in vehemence, fantasy and
systematic asymmetry [889]. Forms were no longer
submitted to the dictates of thought and its rules of
logic, which had reached their height in the use of contrasting
surfaces [887]; they now drew their inspiration from
life, from vegetation and from impulse. The
combination of the conch [888, 889] and the growing
tree [891] resulted in a typical Rococo form; the wavy
slanting shell whose asymmetrical outline swirls
upward into a crest seems to evoke a casual movement of the
hand rather than a preconceived shape [890].
It was a graphic decorative theme which was the basis of
composition and which imposed its upward sweep on the
structure of objects [892].

888. FRANCO-ITALIAN. STEFANO DELLA BELLA
(1610–1664). Cartouche studies with
marine motifs. Engraving.

889. FRENCH. PIERRE EDMÉ BABEL (c. 1720–1775).
Cartouche in fountain form. Engraving.

890. GERMAN. Ornament designed and
engraved by Franz Xaver Habermann (1721–1796).

891. GERMAN. PHILIPP ANDREAS KILIAN
(1714–1759). Stylised Rococo tree. Engraving.

892. GERMAN. Clock designed and engraved by
Franz Xaver Habermann.

something very different — the natural expression of those peoples who found the forces of nature overwhelming and were ill fitted by their tardy civilisation to assert their mastery over those forces by means of forms elaborated through centuries of thought; these peoples, moreover, had been little affected by Mediterranean culture. Germanic Europe was a culture in which the forces of life retained an unfulfilled impulsive energy which was more desirous of communicating with the universe than of submitting to self-discipline. The spirit was vehement rather than lucid — more eager to expand than to define with precision. Wherever Protestantism repressed this spirit with a discipline now moral rather than cultural it sought refuge in music, which would become its ideal mode of expression.

In the Catholic south, however, the Counter Reformation encouraged the release of this spirit. Prague, Vienna and Dresden were the centres of this artistic rebirth which, about the middle of the 18th century, assumed one of its most extreme forms

900 in the Southern Bavarian pilgrimage church at Wies, the masterpiece of Dominikus Zimmermann. It combines a profusion of foliage forms and a great feeling for light with the vibrant colour of the paintings by Dominikus' brother Johann Baptist. It is instructive to compare the numerous sculptural works by

947 Ignaz Günther which appeared shortly afterwards with the work

901 of Bernini. It is immediately apparent that although the lead may have come from Italy the style awakened something constant in the Germanic countries and their immediate neighbours; these excessively mannered figures are indeed much more

678 reminiscent of drawings by Bellange.

Wherever the Renaissance had taken root only superficially and had failed to obliterate the excessive and extreme style characteristic of the last phase of medieval art, the Baroque at once made contact with the past and easily grafted itself on to the local tradition. This happened in those parts of Germany which had remained Catholic and had not suffered the irremediable break imposed by Protestantism. It happened too in the Iberian peninsula which had remained basically medieval and

808 where the expansive violence of the Churrigueresque soon resumed contact, despite the period of austerity brought about by the Counter Reformation, with the lavishness of Mudejar

378 art and of the Portuguese Manueline style, as well as with the lyrical enthusiasm of Flamboyant Gothic. The tradition of

975 violently realist and polychrome sculpture lent itself to an outburst of trompe l'oeil from the time that Alonso Berruguete had absorbed and transmitted Michelangelo's quality of pathos. Spain in addition transmitted this art to her possessions in the Americas, giving the local populations a means of intensifying

960 their innate feeling for a luxuriant nature. At times the Spanish American Baroque in its exaggerated profusion and violent energy recalls certain aspects of the art of India. In Spanish America the Baroque seemed to be returning directly to that virgin nature which it symbolises in art and which it champions against the discipline imposed by the abstract forms of the human intellect.

The Gallican opposition: classicism

The Baroque did not reign unchallenged during the period in which it flourished. Although it was closely bound up with the religious revival connected with the Counter Reformation and, as we have seen, was associated with the attempt, particularly in Spain, to revive the deep faith and fervour of the Middle Ages, it departed fundamentally from its original vocation to become, mainly under Roman influence, a technique designed to impress the public — a technique more concerned with effect than with spiritual content. The original tendency towards authenticity, which was radically opposed to theatrical effects and was bent on simplicity and sincerity, had been (as we have seen in the previous chapter) the essential source of the Spanish

golden age; it had been transmitted to 17th-century France (where there is literary evidence of a strong Iberian influence) where it became less harsh but more sober in its austerity. Zurbarán, like Georges de La Tour, marks the conversion of 554, 660 the art of Caravaggio to an art of the spirit, while Magnasco, 922 conversely, represents the potentialities for Baroque latent in tenebrism.

In the same way when French art, in keeping with this inner austerity, was drawn to collaborate in the unanimous effort at religious revival brought about by the Counter Reformation, it did not follow the purely external forms of the Roman Baroque but adopted an opposite style, returning to the search for truth on a rational basis instead of exploiting the emotions. French art tried to found its quest on universal reason. This 761, 762 made France the centre of the anti-Baroque; the emotional approach, however profound it could be on occasion, was to have only limited expression. Cartesian reason would dominate the whole of Europe, affecting Spinoza and even Locke and Leibnitz although their thought developed along divergent ways.

But it would be an exaggeration to say that France remained immune to the Baroque — as gross an exaggeration as to treat the French 17th century as a manifestation of the Baroque. Although Poussin and Claude le Lorrain lived in Rome and although the former employed narrative painting and they both 690 used the scenic tableau arranged frontally in parallel receding 692 planes which seemed to consist of 'flats' as on the stage, yet they nevertheless were anti-Baroque because they turned their backs on rhetorical painting and returned to poetical painting. They prepared the way for Watteau, who at the beginning of the 18th century was able to endow his art with the magical power of expressing the spirit and the colour of his dreams. Poussin and Claude le Lorrain brought an end to the attempt in French art (an attempt which had begun with the Mannerism of the school of Fontainebleau and had lasted through the 16th and early 17th centuries with Vouet, Vignon and Bellange) to escape from classicism and to adopt a Baroque orientation.

In the generation succeeding Poussin an attitude which can be called 'Gallican' arose in resolute opposition to the Baroque. The religious situation was now stabilised in Europe which was henceforth divided between the Catholic Church and Protestantism. There was little need now for the Baroque as an organ of Church propaganda. Rubens, on the frontiers of Protestant- 585 ism, was the last great Catholic 'orator' in painting. In his pulpit in France the theologian Jacques Bénigne Bossuet, facing the last of the religious differences which had for so long troubled the country, represented an analogy with the great painter of Antwerp in the weighty abundance of his style and his forceful persuasion. Though Bossuet was Baroque in his method, he set out to give a foundation of unity and reason to truth and in this he was on the side of classicism. This mixing of the one trend with the other typifies France in the second half of the 17th century under Louis XIV. The Church was replaced by the state, and it was now the sovereign who was the undisputed rallying point. The authority of the Catholic Church was but a function of his own. Thus it was that he came to readopt Baroque techniques in certain fields; the use of display and luxury, impressive town planning and elaborate façades on 776 buildings were eloquent expressions of his power, as were various festivities, particularly those which combined the various arts, for example ballet and opera. In artistic style too he demanded a certain oratorical breadth of treatment which was spectacular rather than profound. Le Brun, who handled in his name the 719 whole range of the arts, which had been united under his direction, wholeheartedly supported this aesthetic of the theatre; even in Poussin's painting he saw nothing else. Did he not praise him for having shown 'that he was a true poet, having composed his work [the Israelites Gathering Manna] according

893. FRENCH. LOUIS TOCQUÉ (1696–1772).
Portrait of Maria Leszczynska, queen of France.
Commissioned and begun in 1738. *Louvre*.

THE DISCOVERY OF THE INDIVIDUAL

The abandonment of the primacy of logical, hence universal, rules not only brought a new repertoire of forms but facilitated the transition from humanism, in other words from a collective culture, to individualism which revealed the hidden peculiarities of the personality and of the soul. The 17th century saw the portrait above all as the expression of a function. Louis XIV as painted by Rigaud is the monarch, Bossuet, the prelate. This attitude went so deep that the face was often executed independently and stuck into the great canvas where the public personage awaited it. As late as 1738 Tocqué painted Maria Leszczynska as queen in this way [893], but La Tour, in the middle of the century, saw her only as Maria Leszczynska in a fichu [894]. In his self-portrait he does not hesitate to portray himself in careless disarray [895]. The captured gesture and momentary smile which appeared in sculpture at the same time [896] show how the permanent attitude was being replaced by the fleeting moment.
But the French portraits of the 18th century remain social portraits, since they show the ' social' person. The painters of Protestant Holland as early as the 17th century, especially with Rembrandt [898], had undertaken to explore the depths of the personality and to express it as a light rising from the shadows which have obscured it. Sometimes the probing of the individual and his inner being went beyond intimacy; it touched on the individual's strangeness, his ' incommunicability' [897].
We have passed from the public façade to the inner retreat. It is the beginning of the modern world.

894. FRENCH. MAURICE QUENTIN DE LA TOUR
(1704–1788). Portrait of Maria Leszczynska. Pastel.
Salon of 1748 (?). *Louvre*.

895. FRENCH. MAURICE QUENTIN DE LA TOUR.
Self-portrait (The Painter Laughing).
Salon of 1737. *Gift of Edward Drummond Libbey, Toledo Museum of Art, Toledo, Ohio.*

896. FRENCH. JEAN ANTOINE HOUDON (1741–1828).
Bust of Mme Houdon. Salon of 1787 (?). *Louvre*.

897. ITALIAN. BERGAMO. FRA GALGARIO
(1665–1743). Portrait of a Man in a Three-cornered Hat.
Poldi Pezzoli Museum, Milan.

898. DUTCH. REMBRANDT (1606–1669).
Portrait of Titus. *c.* 1660. *Louvre*.

339

to the rules which the art of poetry requires one to observe when *writing plays?*'

But at the same time these rules were, to Le Brun, those of French classicism and of reason. Although Louis XIV (who in fact had Italian blood in his veins) was fond of outer effect and of the impression made by the grandiose, he yet agreed with Descartes in reproving emotion which was so excessive as to be out of control and in condemning that distortion of the 'passions' on which the Baroque played. He saw the monarchic state as a centralised and therefore unifying institution, converging logically and hierarchically towards the sovereign who was an emanation of God. Behind the flattering display of pomp he desired the solid virtues of stability and immutability, in other words the rule of forms. Whether they be juridical or administrative or simply a question of protocol, these guarantee stability in the body politic; in art and literature in the same way their predominance assures permanence. The palace of Versailles may be an immense façade like all Baroque architecture; but curves are proscribed and everything on it is subject to the dry severity of the straight line. Here we can see the final conflict between the Baroque and the classical, in which the former with its sweep and movement seems bent on abolishing the resistance of form to life and, by breaking down any fixed form that would confine it, runs the risk of disintegration; the latter on the other hand strives to break down the resistance of life to the form which the mind wishes to impose on it in order to discipline it; this carries with it the opposite risk, that of desiccation. French classicism, even in the theatrical guise which it adopted through Louis XIV and which at times caused it to appear to some degree Baroque, remained independent of and even antagonistic to the Baroque.

The growing force of individualism

French classicism was not alone in escaping the ascendancy of the Baroque. The Baroque hindered the development of individualism, for all its rhetorical effort was directed at reducing autonomy, the weapon against unquestioning adherence. While classicism was centred in France, individualism prevailed principally in the northern bastions of Protestantism. It had made its appearance at the end of the Middle Ages, when Catholicism manifested, to use the words of Albert Dufourcq, the characteristics of 'individualistic disorganisation'. In a certain sense Protestantism had been an expression of this tendency, particularly before Calvin. Luther already feared that it might engender 'as many sects and creeds as there are heads'. The mind, given a choice of such diverse 'truths', was inevitably tempted to fall back on itself. This was the sceptical position of many humanists who found no certitude beyond their private experience. 'These,' said Montaigne in his *Essays*, 'are my humours and my opinions ... I am only trying here to discover myself.' Protestantism by developing reliance on the inner life and by rejecting the Baroque rhetoric of Roman Catholicism gave a new impetus to individualism. Rembrandt was both the painter who most often studied his own face and the visionary who interpreted the Scriptures in so personal a way that his biblical paintings have the intimacy of a confession. Realism itself became more intimate; the landscapes of Ruisdael are the most poignant expression of human solitude before the Romantic period.

The French 18th century was to mark in an unexpected way the progress made by the individual in reducing the Baroque to his own scale; just as the easel picture — the intimate expression of an artist painted for the solitary contemplation of an art-lover — began to replace the large scale 'public' painting and brought with it the emergence of the 'collector', so decorative art passed from the urban to the private setting. Louis XV divided up the vast saloons of Versailles so that he might have 'little apartments'. The lively, undulating forms of

Baroque art were now used for woodwork and furniture and the other objects which make up man's everyday setting. Decorators and cabinet-makers now held in the public esteem the rank which a generation ago had been accorded to architects. They spread the Rococo style; but the zealous adoption of the Baroque by such decorators as Meissonier, Oppenort and Cuvilliés is explained by their foreign origins or connections. The volutes used in the new Rococo decoration found their way into painting, and Boucher used them both in the detail of the drawing and in the composition. A little later Fragonard absorbed the vibrant and explosive forces of the imaginative works of Tiepolo and submitted them to the quick and nervous style of his brush.

Chardin, however, eschewed the established scale of values, based on the choice of subject, which placed the most histrionic subjects at the top. He brought painting back to the representation of a few apples or a pitcher of wine, his criterion being solely the extent to which he could fill his subject with the emotion he felt in contemplating it. It was the end of Baroque rhetoric. Chardin represented a new force which was to precipitate its ruin — positivism. Experimental science was developing at the same time as religion and philosophy, but was becoming increasingly independent of both. It had begun to manifest itself in the 13th century. At the end of the 16th century Francis Bacon helped to free it from attitudes which might stand in the way of its development. Science was now based solely on the controlled evidence of the senses and was subject to reason and its laws. It established the idea of a truth independent of both the revelations of faith and individual variation. It wished to be impartial. And indeed, particularly under the auspices of English thinkers, there began the development of inductive reasoning which was forearmed against the temptation of rhetoric and the logical course of deductive argument by its faith in the objective evidence of the senses. Success greeted the new psychology of the senses which saw man as a *tabula rasa* on which sensations (and their effects on the memory) are inscribed and interact and are organised. In France this psychology was championed by Etienne Condillac. While the scale of art in the 18th century tended to be reduced to that of the individual, the individual in his turn was reduced to his sensations; he was deemed to live by them alone, and the gradation of sensation ran the gamut from exact perception to sensuality (and at the end of the century to sentimentality) — the whole subject to reason. A certain restriction followed, a defensive attitude which we find in Voltaire — sharp, witty, but also barren.

Denis Diderot was the greatest art critic of the time. The diverse trends among which he worked out his theories reflected the new issues at the end of the century. The reaction against rhetoric and artifice marked the final rejection of the Baroque. Realism based on the evidence of the senses came to the fore and was reinforced by the influence from England of the psychology of the senses and by the aspirations of the middle class. This was the rising class, as it had been at the end of the Middle Ages; its ascendancy would be assured for more than a century by the Revolution of 1789. But the data of the senses do not remain objective. The individual, basically emotional, was bound to intervene before long and use these data for his own ends, demanding that they enrich his practical material life with didactic moralising and that they move him emotionally to the point of tears. At the same time the doctrine of reason, the sole authority recognised by the intellect, was being revived and, in a final reaction to the Baroque and its emphasis on illusion, was preparing the way for Neoclassicism. These complex tendencies, each of which was equally radical in its condemnation of the Baroque aesthetic, were present in full force at the beginning of the 19th century.

704
647
643
642
1052, 1065
886
926
996
1021

FROM THE ROMAN BAROQUE
TO THE GERMAN ROCOCO *Jacques Vanuxem*

*Although Baroque art was a creation of the 17th century
it was not until the 18th century that it
predominated, for in the 17th century it was held in
check by classicism, which maintained the
doctrines of the Renaissance. The traditional practice of
studying the history of art by centuries can only hinder the sense of
its continuity. The study we propose sees it as a whole.
Jacques Vanuxem first of all follows the Baroque from its
appearance in Rome to its spread in Italy,
its rather superficial manifestation in France, where it influenced the
decorative arts but left the basic forms virtually untouched,
and its eventual triumph in Germanic Europe,
where it enabled a tendency which had long been hidden to
express itself at last.*

THE 17TH CENTURY

Rome and the influence of Bernini and Borromini

The solution to much of what is problematical about the
evolution of art in the 17th and even in the 18th centuries lies
in Rome, where the prestige of the arts always remained high.
The popes and their families sought to profit from their often
transitory greatness by erecting chapels, churches, palaces and
splendid tombs. The artists who congregated there came not
only from all over Italy but from all over Europe.

899 Lavish use of materials and an abundance of decoration
characterised the Roman Baroque at the beginning of the
century. The Borghese chapel in Sta Maria Maggiore, built
1611–1612 by Flaminio Ponzio for the Borghese Pope Paul V,
is a perfect example. The frescoes are an integral part of the
whole, and it is difficult to isolate any salient characteristic
from the ensemble. The most diverse talents were assembled in
Rome at this time. Rubens had left only in 1609, having painted
a major work for Sta Maria in Vallicella. Some of Caravaggio's
most important paintings were also to be seen in Rome, and
Domenichino and Lanfranco were decorating S. Carlo ai Cati-
nari and S. Andrea della Valle with handsome compositions
in which gesticulating figures hover in the skies.

The rich and brilliantly coloured art of the Borghese chapel
suggests the line Roman art would have followed had not two
men of genius, Bernini and Borromini, altered the whole course
of its development; they were instrumental in releasing a
powerful force over western Europe which swept the whole
continent towards a new style lasting more than a century and
having an architecture full of movement, a sculpture which
utilised all possible technical resources and a painting which was
concerned with illusion and trompe l'oeil. This new art was
able to unfold in the capital of Christendom, where it had
every opportunity of becoming the cynosure of the world.
The originality of these two artists can be better understood
by comparing them with Pietro da Cortona, a complete artist
who was both a painter and an architect. His virtuosity and
his elaborate compositions continued the tradition of the Bor-
ghese chapel and of Domenichino and Lanfranco. But his
740 architectural works (Sta Maria della Pace and the more important
Sta Martina e S. Luca, both in Rome) although pleasing never
bear the stamp of genius. They found admirers in France
however, and Le Brun and Hardouin Mansart drew inspiration
from them. Borromini and Bernini were artists of a very different
stamp and of much greater achievement.

899. ITALY. FLAMINIO PONZIO (c. 1570–1615).
The Borghese chapel. Built 1611–1612 in
Sta Maria Maggiore, Rome.

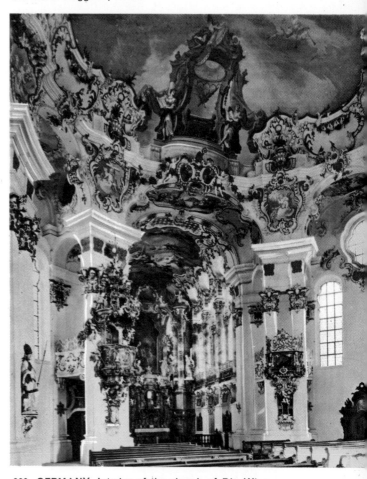

900. GERMANY. Interior of the church of Die Wies,
in Bavaria. Built c. 1749–1750 by
Dominikus Zimmermann (1685–1766) and painted by his
brother Johann Baptist Zimmermann (1680–1758).

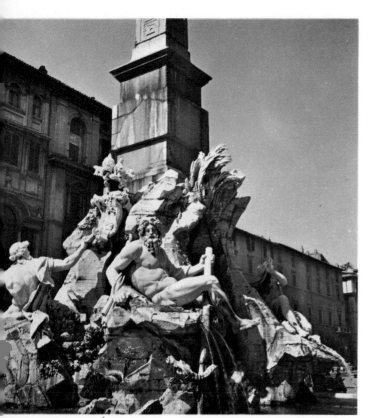

901. ITALIAN. GIAN LORENZO BERNINI (1598–1680).
Fountain of the Four Rivers, Piazza Navona, Rome.

It is often thought that the Roman Baroque was typified by the rich decoration of such churches as St Peter's and S. Giovanni in Laterano, in which Bernini and Borromini furnished the vast interiors with works of art on a scale commensurate with the building. Most often however their architecture is less ornate than the work done before they arrived on the scene, and it has a more judicious distribution of ornament.

Borromini brought about a profound revolution in architecture, and his influence was felt by Bernini despite their very bad relations. This change can be placed between 1633 and 1634, at the time that Bernini was finishing the great baldachino in St Peter's and just before Borromini began work on the little 875 church of S. Carlo alle Quattro Fontane.

Commissioned to make the principal monument for the immense interior space of St Peter's, Bernini set up a colossal 738 baldachino with magnificent twisted columns. These were inspired by pieces purported to have come from the Temple at Jerusalem. Bernini chose to substitute a movement of the actual architectural elements for the usual accumulation of ornament. The whole is conceived on a mighty scale. The four bronze columns rest on pedestals decorated simply with the arms of Urban VIII; the Baroque spirit, the quality of originality, pervades the entire work.

This restlessness of the architectural elements, an essential feature of the baldachino, is found again in S. Carlo alle Quattro Fontane, built from 1638 by Borromini. The plan of this church is a kind of oval; the exceptional interest lies in the movement of the entablature which follows all the curved lines of the building, in the setting of the engaged columns, in the disposition of the various parts of the vaulting and in the central 904 dome, which is also oval. The decoration of the church is rather sober, making little use of painting and even less of coloured

materials, and relying on the interplay of the architectural elements for its full impact.

Borromini carried his innovations still further. At S. Ivo della 902 Sapienza (begun 1642) everything is curved inwards; painting and sculpture are insignificant in the decoration, but the church is one of the most complex imaginable because of the divisions in the elevation of the dome, dictated by the ground plan which is full of curves and counter-curves. For Borromini architectural forms were elements with which the architect could play to achieve contrasts. With his inimitable knowledge of design he could evolve the most unusual plan and could make use of the curve throughout; his façades curve, the pediments and entablatures undulate and the galleries narrow and 903 taper to deceive the eye. This astonishing art was received with enthusiasm, and with its constant search for surprise and illusion it completely changed the character of architecture.

Bernini and his contemporaries

Bernini differed from Borromini in a good many respects, 907 although he too made great use of effect and illusion; the altarpieces which he carved in his youth are extremely ordered; he was a lover of the antique and an admirer of Poussin, and unlike Borromini he never broke up or twisted his architectural elements. His works are regular in conception down to the last detail. He was a Baroque architect mainly in his love of effect. In the church of S. Andrea al Quirinale, which he began in 1658, no element is irregular in itself (unlike Borromini's work), but the church is built on an oval plan which creates a variety of effects as the visitor walks about in the building. In addition, Bernini made use of sculpture to animate his work and to give it a sense of agitated motion; plaster angels and rays of glory are placed at random in S. Andrea, without regard for the lines of the architecture. Bernini avoided such effects on the outside of his buildings; there is nothing there to interrupt the lines of pilasters and columns. The fascinating colonnade of St Peter's owes its beauty to the changing aspect of the four lines of Doric columns as one moves among them; but he surmounts this colonnade, which has an extremely sophisticated simplicity, with a balustrade peopled with a row of gesticulating statues in the most varied poses. Bernini's plans, his sense of the colossal and the sculptural decoration which he added to his interiors were followed and imitated throughout Europe.

Painting at this time followed the example of the Bolognese eclectics or of Caravaggio, with his use of chiaroscuro, but vaults and domes were still decorated with scenes of apotheosis and of the heavens. However, Roman Baroque painting had not yet reached its limits, whereas it was difficult for sculpture to go beyond the bounds attained by Bernini.

In his youth Bernini produced profane works such as the 908 groups in the Villa Borghese which were natural and spontaneous in feeling, but in his maturity and during his later years he worked mainly for churches, in which work he was surrounded by assistants of distinction. He excelled particularly in figures of saints and in the depiction of mystical ecstasy — of the soul enraptured by divine love; his St Theresa, for example, engen- 906 dered a whole series of recumbent figures with billowing draperies on the bases of altars in Rome (St Anne, Sta Martina, and Sta Anastasia), carved by Bernini's followers. The admirable St Sebastian by Antonio Giorgetti, in S. Sebastiano fuori le 910 Mura, retains the beauty of his youth in his martyrdom. To carry out such works successfully the artist needed a profound feeling for the human body combined with a superlative technique. Bernini and his followers foreshadow the German Rococo plaster work in some of their slender figures with sinuous gestures, such as the group of Christ Appearing to the Magdalen or the Ecstasy of St Catherine of Siena.

Thus it was through Bernini that sculpture came to express

the heights of religious feeling. In addition to his religious works, Bernini produced excellent outdoor monuments. His 901 fountains are famous, particularly those of the Piazza Navona. There are other charming examples of Bernini's individuality in Rome, such as the elephant bearing an obelisk on its back in the Piazza della Minerva. The religious thought of this time was reflected in its art; art also reflected the current interest in symbols and emblems. The inscription engraved on the base of this obelisk on the order of Alexander VII explains that the elephant is the emblem of wisdom, and that the obelisk shows that true strength of soul should have as its base the solidity of wisdom.

Roman Baroque art was the manifestation of an elegant and fastidious attitude to the world, but it was Christian and was approved by the papacy. The most Baroque of Bernini's works, the piazza and the colonnade at St Peter's, were executed for Alexander VII. On his death-bed the Pope congratulated himself on the 'public edifices he had caused to be built and on which he had bestowed much money'.

The influence of Roman Baroque in Italy

The Roman art of Bernini and Borromini, which was the most characteristic expression of the Baroque, set a fashion for the whole of Italy and the whole of Europe. Even towns in which the artistic tradition did not favour the Baroque capitulated to Bernini's example. Florence was now no longer the town of Michelangelo. We see this when we compare the white Medici chapel in S. Lorenzo (built in the 1520s), with its remarkable sculptures, with the burial chapel of the grand dukes, built there in the early years of the 17th century and much admired at one time, which is decorated with rich marbles and mosaics. About 1680 the influence of Rome arrived when Giovanni Battista Foggini did his marble bas-reliefs and carvings of angels completely in the style of Bernini for the Corsini chapel in Sta Maria del Carmine and for SS. Annunziata. Baldassare Longhena had made Venice familiar with a Baroque having overloaded ornament but based on traditional concepts; the famous Sta Maria della Salute, the Palazzo Rezzonico and the Pesaro tomb are the best known examples of this style. The architecture is still basically classical Venetian in tradition and the new style is seen only in the very curious ornament which remains purely decorative (the voluted or scrolled buttresses on Sta Maria della Salute, and the polychrome Moors on the base of the Pesaro tomb). The façade (1668) of S. Moisè is also typical with its heavy bas-reliefs and garlands. Venetian Baroque resembles both Roman Baroque before Bernini and the Baroque of the Netherlands, being an art of the ornate rather than of movement. Bernini's emphasis on movement appeared in Venice only with the tomb of the Doge Valiero, where columns and great draperies were used to convey the unexpected and the colossal.

Apart from a few exceptions such as this, Venice retained its originality and remained one of the towns least influenced by Roman Baroque. The same applied in Venetian painting, and this independence persisted through the 18th century. The works of Tiepolo and Guardi are abundant proof of the exceptional character of Venetian art.

In northern Italy every centre reacted in a different way. Bologna, which belonged to the Papal States, was entirely Roman. The sculptor Alessandro Algardi, who was born there, did a fine high altar for S. Paolo; this work was less strikingly original than the fine bas-relief on the tomb of Pope Leo XI in St Peter's at Rome, in which Algardi rivalled Bernini.

In Genoa Roman influence was greatest in sculpture. The sanctuary of the Misericordia near Savona contains one of Bernini's finest works, the bas-relief of the *Visitation*. Between 1661 and 1667 Genoa was the scene of the prodigious activity

902. ITALY. FRANCESCO BORROMINI (1599–1667). Exterior of the church of S. Ivo della Sapienza. 1642–1650.

903. ITALY. FRANCESCO BORROMINI. Detail of the entablature in S. Ivo della Sapienza.

904. ITALY. FRANCESCO BORROMINI. Interior of the dome of the church of S. Carlo alle Quattro Fontane, Rome. 1638–1641.

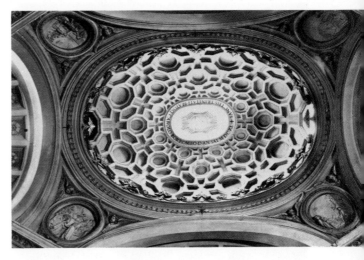

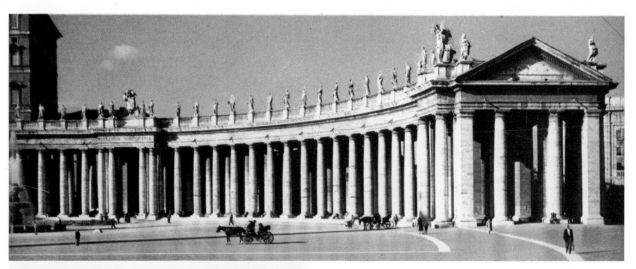

905. The colonnade of the piazza of St Peter's, Rome. 1656–1667.

906. The Ecstasy of St Theresa. 1645–1652. *Cornaro Chapel, Sta Maria della Vittoria, Rome.*

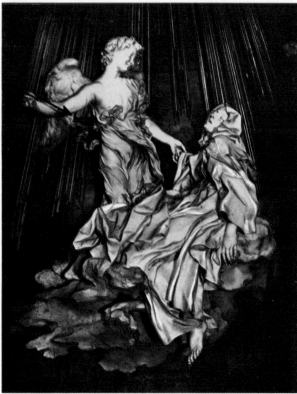

907. Self-portrait as a young man. *Borghese Gallery, Rome.*

of Pierre Puget from Marseille, who, in the nature of his talent and in his creative fertility, architectural ideas and sculptural virtuosity, most closely resembled Bernini and best understood his work, which he had known in Rome. His *St Sebastian* at 911 Genoa is justly famous.

Turin presented a somewhat different picture. The flourishing house of Savoy had contributed to the construction of some important monuments. One of the strangest aspects of the Baroque is manifest at Turin in the church of S. Lorenzo and in the Chapel of the Sindone in the cathedral. Guarino Guarini, a Theatine monk born in Modena, who had just returned from Paris, capped these two works with quite extraordinary domes 913 of Oriental appearance supported by intersecting arches, as were the domes of the mosque at Cordova. The originality of his ideas and his extensive influence put Guarini almost on a level with Borromini or Bernini. The flourishing and original 18th-century architecture of Franconia and Bohemia was particularly indebted to Guarini.

The Baroque in the Germanic countries

It was some time before the influence of Roman Baroque art took root in the Germanic lands, where the Jesuit influence was strong. At the end of the 17th century they were still drawing their inspiration from Vignola's Church of the Gesù, 499-501 with its internal buttresses and large vaults. St Michael's in Munich, built at the end of the 16th century, was so impressive a justification of this style that it was not easy to break away from its influence. In 1651 the prince-abbot of Kempten was responsible for the building of an enormous construction which was to represent all that was new and original; the result was a strange and infelicitous one — a bizarre square dome inscribed in an octagon. This attempt provoked no imitations, and the other monasteries retained the Jesuit style which was spread, especially in Swabia, by the architects of the Vorarlberg.

Sculpture in Germany was more impressive. At the beginning of the 17th century it continued in the exuberant fashion of the carved wooden altarpieces of the previous century; one of the best known examples is the altarpiece at Überlingen on 914 Lake Constance (1612). Its extremely agitated style is reminiscent of the works attributed to the Master of Brisach. The traditional taste for movement made it easier for German artists to adopt the dynamic forms of Bernini and his followers.

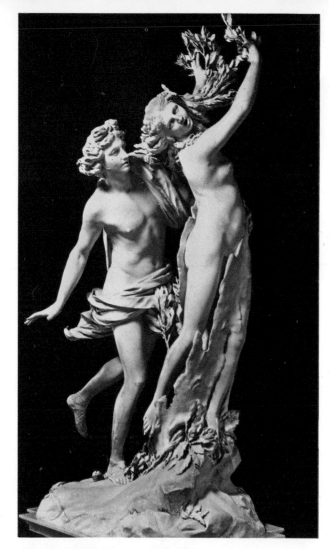

908. Apollo and Daphne. 1622–1624.
Borghese Gallery, Rome.

909. Bust of Mr Baker. *Victoria and Albert Museum.*

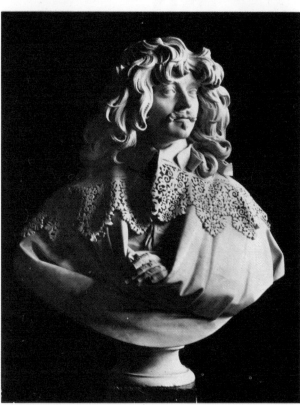

A special feature of German art was its great richness of ornament; this is particularly evident in the plaster work covering the vast churches built by the architects of the Vorarlberg after the Thirty Years' War. In Germany plaster work took the place of both painted ceilings and the coloured materials on the walls which were so popular in Italy at the beginning of the century. In churches, monasteries and castles the vaulted ceilings were covered with plaster work consisting of great swags and garlands and branches of acanthus interspersed with animals. The plaster work in the monastery of Wessobrun near Augsburg deserves mention; Wessobrun was the most famous centre in Europe of workers in plaster. These stuccoes, which date from 1685, are still in the Renaissance tradition. Repetition and accumulation of ornament were characteristic of that ornate Baroque which we find wherever the Roman Baroque style of Borromini and Bernini was absent, for example in Venice in the work of Longhena and in the Netherlands.

The Baroque in the Netherlands and in England

Historians of Baroque art tend too often to see it as one style without distinguishing the different characteristics which it developed in the various regions in which it flourished. Baroque art is generally linked with Catholicism and in the 17th century could be said to lie between two Catholic poles — Rome and Antwerp, the one represented by Bernini, the other by Rubens — which show two very different aspects of the style. The art of the Netherlands at the time of Rubens was a Baroque of excess, of heavily ornate decoration, while the art of Rome and of Bernini was a Baroque of movement.

The Catholic Netherlands in the 17th century had a completely original Baroque style and one which remained independent.

England on the other hand, although so hostile to Catholicism, was influenced by the art of Rome. When Wren built St Paul's 610 after the Great Fire of 1666 he patently aimed at rivalling St Peter's in Rome. The towers and the façades of the transepts are reminiscent of Bernini. The steeples of some of London's smaller churches were inspired by Borromini. London showed 849-852 a greater interest in the art of Rome than did Catholic Antwerp, which followed its own tradition.

The Baroque in France

Baroque art in France was not unrelated to the art of the Netherlands. In the first half of the century we find, as in the Netherlands, a heavily ornate Baroque of excess. This was true not only of northern France in such works as the Bourse at Lille and the façade of the abbey church at St Amand; both towns were then in the Netherlands. Other regions of France (apart from Provence which was influenced by Italy) also have buildings which resemble Flemish architecture in their style of decoration — for example the principal church of the Jesuits in Paris, which the purists considered too ornate. The façade of the Church of the Visitation at Nevers, famous for this reason, is comparable in aspect to Flemish façades.

Rubens himself was in Paris from 1622 painting his cycle in the Luxembourg palace of the life of Marie de' Medici, the 584 most important work undertaken at this time. Rubens had followers in Paris. Fine panels painted by Pieter van Mol can be seen in a chapel in the Carmelite church in the rue de Vaugirard; they are a good example of the rich colours and lively scenes characteristic of the influence of Rubens.

It was Flanders rather than Italy which first introduced Baroque art to France, but this situation soon changed; France began to look increasingly to Rome, and many artists and sculptors went there to study. Although their object was ostensibly to study the art of antiquity, they could not help but be influenced by contemporary art. Sculptors such as Sarrazin and painters such as Vouet returned to France bringing with them

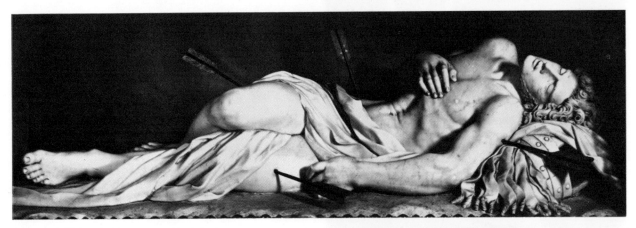

910. ITALIAN. ROMAN. Martyrdom of
St Sebastian, by Antonio Giorgetti (active 1660 – c. 1670),
a pupil of Bernini. *S. Sebastiano, Rome.*

the traditions of Roman art before Bernini. The painting of
Romanelli, who came in 1658 to work at the Louvre and at
Mazarin's palace, recaptured the competent style of Pietro
da Cortona.

Paris was becoming familiar with Baroque art. In 1641 the
sculptor Francesco Mochi, who had worked with Bernini on
the dome of St Peter's and had also carved the *St Veronica*
there, produced the very striking bust of Richelieu, now in the
Louvre, from a painting by Champaigne. The sculptors François
and Michel Anguier stayed long in Rome and worked in a
manner not unworthy of Algardi, who was Michel's teacher.
912 A statue of Cardinal de Bérulle by François, of which only the
bust survives, is particularly expressive; the completely Italian
manner in which the cardinal presses his hand to his heart
recalls funerary statues by Bernini. Michel made the famous
bronze fire-dogs called 'Algardi's fire-dogs'. Michel remained
faithful all his life to the tradition of Baroque art, especially in
his religious works.

Mazarin and his family frequently brought Italian artists to
France. In addition to Romanelli, he brought in theatrical
people such as 'the Magician' Giacomo Cavalein Torelli, whose
settings represented both movement and illusion. In 1659 Mazarin
had the famous 'salle des machines' built in the Tuileries, for
the presentation of Italian and Italian-inspired opera, by two
architects from Modena, Gaspare and Carlo Vigarani. Carlo
returned to France and his grandiose and restless style influenced
the lavish entertainments given by Louis XIV. Between 1660
and 1665 the taste for Italian Baroque grew apace. Nicolas
Fouquet, who employed Torelli, considered engaging Puget.
In 1662 the Theatines in Paris asked Guarini to design their
church. In 1663 Cardinal Barberini gave the Carmelites a
splendid statue of the Virgin, designed by Bernini and executed
by Antonio Raggi. In 1664 the Augustinian friars received a
statue of the Virgin of Mercy which had been executed in Genoa.
At this time Jean Le Pautre, who created the most flamboyant
ornament of the period, was turning out numerous designs 'in
the Roman manner' or 'in the Italian style' for both archi-
tecture and the decorative arts. His Italian-style projects for
fountains, with their accumulation of rocks, monsters and
figures among torrents of water, are equal in their tumultuous-
ness and their invention to the most grandiose fountains of
Bernini, which are their obvious inspiration.

Louis XIV and Bernini

It is hardly surprising that at this time Colbert turned to Italians
for the design for the Louvre. The most celebrated Roman

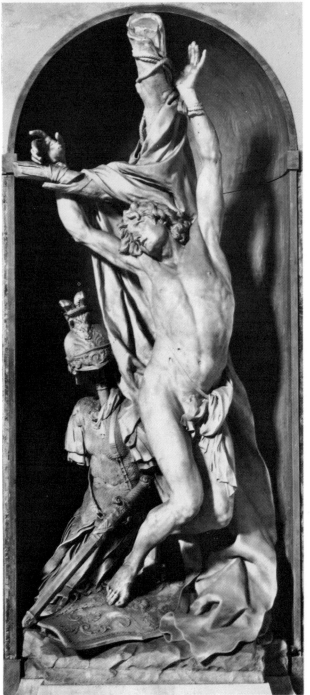

911. FRENCH. PIERRE PUGET (1620–1694).
Martyrdom of St Sebastian. *Sta Maria di Carignano, Genoa.*

architects were asked to submit designs — C. Rainaldi, Pietro da Cortona and Bernini himself. Bernini's project was chosen and gave rise to the famous journey of 1665. He planned a magnificent building supported on a stone foundation and

763, 764 topped, like the colonnade of St Peter's, by a balustrade with statues; though this was clearly a Baroque feature, the building itself was of regular and ordered design. At first the design was much praised; we see this in the engraving by Sébastien Le Clerc showing Bernini's Louvre placed above the Seven Wonders of the World.

Colbert's economic nationalism grew sensitive however, and his utilitarian theories, coupled with political intrigues, especially that of Charles Perrault and his clique, combined to defeat Bernini. He left two large works of sculpture behind him in France — a work by his son, a bas-relief of the Infant Jesus, in which he had had a hand, and the famous bust of Louis XIV, showing the king's proud and impetuous face above an extraordinary scarf blowing in the wind. The bust became known everywhere, for the king had many casts made; it gave to French artists who had never been to Rome a perfect idea of the impetuosity with which Bernini treated marble. This impetuosity was reflected in French sculpture — not at Versailles, where apart from the decorative art the team working under the iron rod of Le Brun produced only regular and balanced work, but in the decoration of churches, where artists were freer to follow the Roman style of these works left by Bernini. Gilles Guérin, who had never been to Rome, gave an example of this inspiration in two statues (deserving of wider recognition) for the high altar of the Minim church in the Place Royale —

915 a *Virgin* (now in St Thomas d'Aquin) and a *St Francis of Paula* (in the Jardin des Carmes) — which are expressive emotionally and are executed with great virtuosity, especially in the handling of the drapery folds. There is nothing in Roman sculpture to surpass them in breadth of treatment.

Louis XIV's sumptuous entertainments at Versailles were presided over by the genius of Carlo Vigarani, who returned to France in 1663. The French classics were performed against a resplendent background of Baroque scenery. An engraving by Le Pautre shows the twisted columns surrounding the production of Molière's *George Dandin*, and Félibien has left a detailed description of the marvellously rich décor for *Iphigénie*. Racine, the most classical of French authors, often had Baroque settings for his work. In 1685 for *Idylle sur la Paix* and in 1689 for *Esther* he collaborated with Jean Bérain, the most erratic and fantastic of the decorators of the period. On 2nd January 1685, when he delivered his eulogy for Corneille before the Academy, Abbé de La Chambre read a eulogy of Bernini at the same session.

The reaction against Bernini's art after he left France was not universal. The king, it is true, did not like the equestrian statue

709 sent him in 1684, but at almost the same time the bust of the king done in 1665 was accorded a place of honour in the Salon de Diane at Versailles. The entrance to the Allée Royale in the gardens at Versailles was marked by two statuary groups by

722 Puget, *Milo* and *Andromeda*, both very much in the style of Bernini. The place in the Orangery destined for Bernini's

916 equestrian statue was taken by Domenico Guidi's *Fame*, a typically Baroque work, and Louis de La Vrillière ordered a tomb in Rome for his father from this same Guidi, to be covered in sculpture.

The harmonious ensemble of the chapel of Versailles, built after 1699, showed Roman Baroque influence, and at Marly too there are works which recall the Italian Baroque, for example

917 the splendid group of *Time exalting Virtue and the Arts* (now at Bolbec), which came from Genoa in 1702. The unknown artist must certainly have been one of Genoa's finest sculptors.

Genoese sculpture drew its inspiration from Bernini and

912. FRENCH. FRANÇOIS ANGUIER (1604–1669). Bust of Cardinal de Bérulle. Fragment of a monument now destroyed. *Maison des Pères de l'Oratoire, Montsoult.*

913. ITALY. GUARINO GUARINI (1624–1683). Dome of the Chapel of the Sindone, in the chevet of the cathedral, Turin.

914. GERMAN. The Adoration of the Shepherds. Detail from the altarpiece at Überlingen, on Lake Constance. 1612.

915. FRENCH. GILLES GUÉRIN (1609–1678).
Statue of St Francis of Paula. *Jardin des Carmes, Paris*.

916. ITALIAN. DOMENICO GUIDI (1625–1701).
Fame reviving the History of Louis XIV.
Neptune Fountain, Versailles.

Puget and was wholly Baroque in spirit. The king was not alone in his admiration of it. A Genoese statue in the grand sweeping manner, representing the Virgin, stood at Le Laus, an Alpine pilgrimage church where mystical phenomena had occurred at the end of the 17th century. Both the court and popular religion found a deep appeal in this dynamic art.

Thus France first accepted the too ornate Baroque but under Louis XIV was introduced to the dynamic form of the Baroque. These two elements are curiously juxtaposed in the interior of the Chapelle du Grand Séminaire at Cambrai. The vaults are overloaded with stone ornament as at St Loup in Namur, but on the walls are great sculptural compositions showing figures in restless movement with draperies in the Roman style. Cambrai was separated from the Netherlands and annexed to France in 1677, and it was a natural meeting ground for the two aspects of the Baroque. 918

It would be wrong to assume, because of the Italian influences we have just discussed, that the dynamic Baroque in France can be written off as an imported style, brought from Italy by artists or works of art. Fantasy in ornament was a tradition stemming from antique grotesques. Jean Bérain and Claude Audran, for example, worked in a style which was full of inventions which were often charming and were derived from the theatre and the fairgrounds; grotesques, mountebanks, actors, acrobats and performing animals are seen in a gay and lively mêlée. These riotous forms, held in check in painting and sculpture by academicism, could be given a free rein in decorative art. In Paris this natural fantasy was added to the dynamic elements from Italy and gave an individual style to French Baroque. 416, 923

THE 18TH CENTURY

The influence of the theatre in Italian art

At the end of the reign of Louis XIV the ties between the art of Rome and that of France became even closer. Rome was no less active in the arts at this time than at the time of Bernini.

The Baroque continued to increase in flamboyance. Bernini had been moderate in his use of the diverse materials available to the sculptor; the effects obtainable with white marble were his greatest interest. Things had changed by the end of the century. Pierre Legros, French by birth and an admirable craftsman, used different coloured materials in his touching statue of the young St Stanislas Kotska on his death-bed. It is interesting to compare this work with the *Martyrdom of St Sebastian* in white marble by Giorgetti. 933 910

Despite his talent Legros did not reach the greatness of Bernini in his handling of large sculptural groups in the Roman manner. A humble Jesuit, Padre Andrea Pozzo, joins Borromini, Bernini and Guarini as the fourth great artist of the Baroque.

Pozzo was a master of perspective; he excelled in illusionist technique. His treatise on perspective contains a long study of theatrical décor. In his church paintings he placed his celestial scenes in illusionary architectural settings, thus extending real space by imaginary space. In the church of S. Ignazio in Rome the apotheosis of the founder saint, painted on the vaulting, is an astonishing and impressive example of his prodigious virtuosity. He used theatrical perspective to create illusion in his most serious paintings, but for certain kinds of ensembles he needed to use real and solid materials. The carved and painted altars he designed for the most famous saints of his Order, St Ignatius Loyola in the Church of the Gesù and St Aloysius (Luigi Gonzaga) in S. Ignazio, combine a sense of movement and grandeur with a polychrome richness of rare materials. Legros' dynamic sculptures found here a setting of a magnificence which was unequalled despite many imitations both in Rome and elsewhere.

In the first half of the 18th century many splendid monuments were still being built in Rome (façades of S. Giovanni in Laterano and Sta Maria Maddalena) which were further enhanced by painted or carved decoration and which successfully continued the tradition of Bernini. 1071

Two monuments of this time are curious enough to deserve mention. One is well known — the Fontana di Trevi (begun after 1732), with Neptune overlooking the turbulent waters 1070

917. ITALIAN. Time exalting Virtue and the Arts. Anonymous Genoese work from Marly. *c.* 1700. *Gardens, Bolbec.*

918. FRANCE. BROTHER BEEGRANDT. Detail of the Chapelle du Grand Séminaire, Cambrai. 1670

from his rock; the other, of a lower artistic standard but interesting for the extravagance of its conception, is the altar of St Alexis in his church, S. Alessio on the Aventine, showing the recumbent image of the saint.

Thus art in Rome as in the majority of the towns of northern Italy remained in the very Baroque and intensely devout tradition of Bernini. Churches such as the Madonna di S. Luca in Bologna and palaces in Turin and Genoa, with their galleries, vestibules and staircases, perpetuated 17th-century forms which still showed great vitality. Monumental painting still consisted of vast undertakings in the manner of Pozzo. The theatre played an important part in all the art of this period. (We have mentioned that Pozzo had linked up his knowledge of perspective with theatrical décor.) Filippo Juvarra, an architect of the first rank, is known as much for his stage designs as for his fine buildings; the most famous of the latter is the church 871 of the Superga, which overlooks Turin from a nearby hill. The extraordinary richness which we find in his imaginative decorations shows itself in all the diverse fields of his activity — for instance in his designs for table centrepieces. An entire 921 family of artists, the Bibiena, excelled in stage designs, and their activity can be traced all over Europe. Their designs were perhaps less appealing than those of Juvarra but were more widely distributed and exercised enormous influence. Often they were engraved in Germany, and they certainly contributed to giving to the buildings of the time that fascinating aspect of palaces of illusion.

The influence of the theatre was not only found in architecture and decoration; it can certainly be seen in the strange 922 painting of the Genoese artist Magnasco, who was exclusively an easel painter. His work is theatrical not only because of his subjects, which sometimes include actors, singers or clowns, but even more through the great architectural perspectives which appear in his pictures as backgrounds against which sinister and tragic scenes are enacted whose heroes are emaciated, destitute monks.

Magnasco is rightly seen today as one of the greatest painters of his time. In the 18th century however he did not enjoy so great a reputation, and it was to Venice that all eyes were turned in admiration of the one school which equalled those of the past in renown. The artists of Venice were courted by the whole of Europe. Sebastiano Ricci went to England; Antonio Pellegrini painted a ceiling for the royal bank in Paris in 1719 which called forth a salutary emulation in the young François Lemoine, who produced in his ceiling for the Salon d'Hercule in Versailles the only composition in France which can be compared with the ceiling paintings of the Venetians.

Venetian painting was no less in demand in Germany. Jacopo Amigoni worked for the Elector of Bavaria and for the abbot of Ottobeuren. Giovanni Battista Piazzetta sent his *Assumption* (now in the Louvre) to Frankfurt. The successful career of Tiepolo reached its zenith in 1750 at the court of the prince-bishop of Würzburg; he painted a masterpiece on the grand staircase of the Residenz, diverse in invention and tremendously rich in composition, showing the four corners of the earth.

In addition to Tiepolo, who was the greatest decorator of his 880 period, there were a number of painters in Venice who drew their inspiration from the beauty of the city itself, with its magnificent perspectives and its colourful festivities. Canaletto, 1017 Guardi and Bernardo Bellotto excelled at these scenes, combining 1077 subtlety of technique with exact observation. Their fame spread far beyond Venice; Bellotto was called to Dresden and to Warsaw, Canaletto to London. Their paintings of these foreign towns, particularly Bellotto's at Dresden, are as exact and as sensitive as their views of Venice. (See colour plates p. 366.)

French art and the Rococo

Unlike Germany, where Venetian art had the greatest influence, France in the first half of the 18th century drew its inspiration mainly from the Roman Baroque (despite the visits of Pellegrini and Ricci to Paris). The principal reason for this was the stay in Rome of the pupils of the French Academy. Decorators and sculptors such as Oppenort, Lambert Sigisbert Adam and 920 Michel-Ange Slodtz returned to Paris strongly influenced by

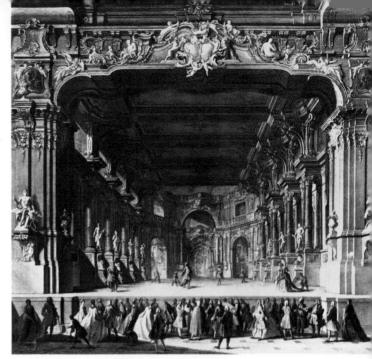

919. FRENCH. BERNARD TORO (1671–1731).
Decorative cartouche, engraved by Cochin. (Above, at the right of the cartouche, is an original drawing by Toro.) *Private Collection.*

920. FRENCH. GILLES MARIE OPPENORT (1672–1742).
Italian-style fountain. Engraving by Huquier (1695–1772). *Bibliothèque Nationale, Paris.*

921. ITALIAN. SCHOOL OF THE BIBIENA.
Interior of the Farnese Theatre. *National Gallery, London.*

922. ITALIAN. GENOESE. ALESSANDRO MAGNASCO (1667–1749). Penitence. *Private Collection.*

923. FRENCH. JEAN BÉRAIN THE ELDER (1640–1711).
Engraving of ornament. *Private Collection.*

Rome, where they had been for a number of years. Decorators such as Meissonier and painters such as Carle van Loo, who had lived in Italy, brought back ultra-dynamic forms. France was never more Baroque than at this time. Architecture alone resisted the fashion; for this reason it has been dealt with in the preceding chapter.

An apparent respect for order and symmetry had been maintained in the graphic arts; the fantasy of Jean Bérain's engravings and of the complicated arabesques and the often very strange scenes in the drawings of Claude Audran had been exercised within a balanced and ordered composition. This was now rejected. The first decorator to show the new trend was a southerner who enjoyed the patronage of Puget; Bernard Toro's work first appeared in Paris in 1716. He engraved extraordinary decorative cartouches in strange twisted shapes, in which plants are seen growing amid draperies and winged putti. This was already completely in the Rococo style, a style which was to grow and to become increasingly ornate and curving.

Oppenort's work also interested artists in these forms, but he was more dependent than was Toro on Roman Baroque art. His fountains with their twisting Tritons, which were designed about 1715 but engravings of which were not made until much later, are firmly in the tradition — established sixty years earlier — of those of Jean Le Pautre, which in their turn were derived from Bernini.

The real master of Rococo decoration was the famous Juste Aurèle Meissonier, who came from Turin. He showed great fertility of invention, and he created forms which could be used as well for silver ware and household furniture as for interior decoration or for architecture. Hardly any of his architectural projects were actually executed. His design for the façade of St Sulpice in Paris contained more curves than did any work by Borromini; this was discarded, however, in favour of a very academic design by Jean Nicolas Servandoni. Meissonier had also planned an altar for this church, surmounted by two angels carrying the Sun of the Blessed Sacrament. The composition was instinct with passionate movement. Preference however was given to a more restrained and less dynamic project by Oppenort.

Meissonier's influence was no less important for being restricted to his engravings. The charming and elaborate works of the

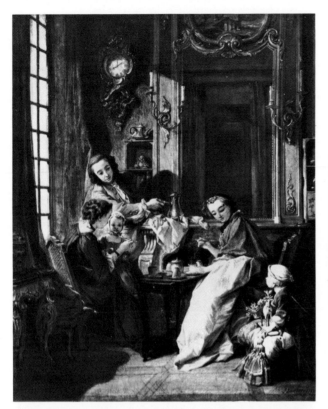

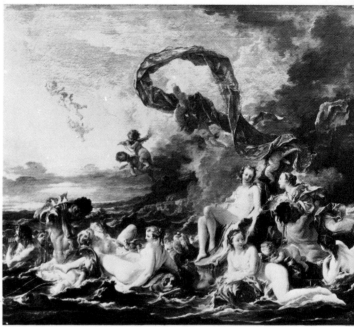

924. *Left*. Le Déjeuner. 1739. *Louvre*.

925. *Above*. The Triumph of Venus. 1740. *Stockholm Museum*.

926. *Below, left*. Decorative composition, engraved by Duflos. *Private Collection*.

Parisian goldsmiths which found their way all over the world (the best pieces of which are now in Portugal) owed much to his designs. Twisted and irregular forms were adopted in furniture design. In interiors woodwork and panelling became more animated in design; a famous example of this is the Salon Ovale in the hôtel de Soubise in Paris, where painting, materials and carved ornament combine to form a unified whole. Every craftsman no matter how obscure now followed the Rococo style in his work. Engravings of ornamental designs were there to guide him, and Meissonier's own work in this field was made use of in all branches of the crafts. In France the Rococo style was particularly effective in silversmiths' work, ceramics, furniture, iron work and interior decoration.

Painting drew its inspiration from the minor arts; the most prolific and the most charming of the painters of this period was François Boucher, who was one of the most typical masters 924–926 of the Rococo. He engraved the paintings of Watteau, and to the latter's inimitable works, which were in the tradition of Bérain and Claude Audran, Boucher added a frontispiece which recalled the asymmetrical Rococo style of Toro. Boucher was interested in the curiosities of nature — bizarre forms in shells, rocks, etc., which he worked into complex scrolls.

Boucher's painting is light, airy and translucent and is admirably suited to the mythological scenes he delighted in, where gods and goddesses appear in vivid nakedness among veritable cascades of cherubs. There is nothing more pleasing to the eye nor more alive than such pictures as *Cupid's Target* (Louvre), *Sunrise* (Wallace Collection, London) or the *Triumph of Venus* 925 (Stockholm), which is surely his masterpiece. The brilliant colour and the fine decorative sense of these works made them particularly suitable as subjects for tapestries. (See colour plate p. 365.)

Boucher had imitators who were painters and decorators like himself such as Jacques de Lajoue, in whose widely popular

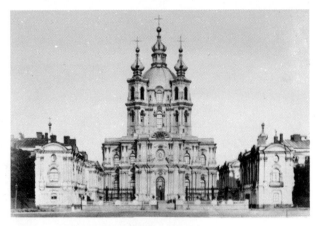

927. RUSSIA. BARTOLOMMEO RASTRELLI (1700–1771). The cathedral of the Smolny convent, Leningrad. 1748–1755.

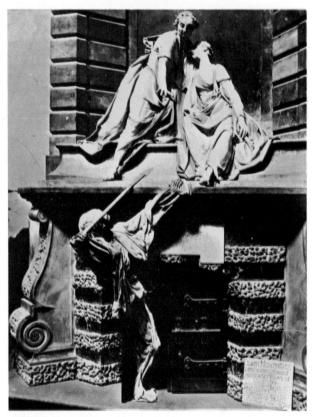

928. ANGLO-FRENCH. LOUIS FRANÇOIS ROUBILLAC (c. 1705–1762). Tomb of Lady Elizabeth Nightingale. 1731. *Westminster Abbey.*

engravings architecture and fountains often figured — as they also did in his paintings.

Sculpture was moving in the same direction. The greatest sculptors, Lambert Sigisbert Adam and Michel-Ange Slodtz, had been to Rome and had been strongly influenced by Bernini. Their art combined perfectly with the forms of Rococo, itself also deriving from Italian Baroque. The sculptors working in this style were particularly skilful at adapting their work to the general decorative scheme; the hôtel de Soubise is a standing testimony to this ability. But when given a monumental sculptural ensemble they would treat it in a splendid manner; this can be seen in the famous *Triumph of Neptune* at Versailles, the work of Adam. Neptune, among his rocks and Tritons, brooks comparison with the group of the Fontana di Trevi in Rome.

772 The finest example in this style is at Nancy. The Place Stanislas is architecturally quite restrained; the buildings have only a light carved decoration. The Rococo note comes from the leaden gods and animals on the fountains and from the

magnificent grilles by Jean Lamour. This prodigious craftsman reproduced in iron the nervous Rococo forms which had circulated so widely through the engravings of the decorators.

In this first half of the 18th century Baroque art in its Rococo phase might seem superficially to have no connection with religious art and to belong solely to profane and worldly art. In spite of the decline in religious spirit there was in fact no eclipse of religious art. Never were more churches built and decorated, more devotional pictures painted or more tombs carved. In the French provinces it is still possible to find some works which have remained intact. In the Carthusian monastery at Lyon there is a baldachino by Servandoni which has extremely effective stucco draperies hung over columns arranged on an elliptical plan; the old Jesuit church at Bordeaux has a *St Francis Xavier* (by Coustou the Younger) who is seen rising to the heavens; at the abbey of Valloires in Picardy the wrought-iron work by Veyren and the sculptures by S. G. J. Pfaff are combined in an ensemble of the highest quality.

In the Paris churches generally speaking only single pictures separated from the ensembles for which they were intended or mutilated or displaced statues survive; a few important paintings however do remain, for example the large and striking *Adoration of the Magi* by van Loo (Church of the Assumption). 934

The tomb of the curé of St Sulpice, Languet de Gergy, is sometimes regarded as excessively 'Berninesque'; in fact nearly all its ornamentation has disappeared and none of the metalwork remains. On this tomb, as in the works of Bernini, the gesticulating skeleton of Death plays a prominent role. The skeleton, sometimes alone, is often the principal subject of interest in funerary sculpture. In Westminster Abbey Death is 928 seen aiming his shaft at the dying Lady Nightingale. Nothing could be more symptomatic of the Baroque spirit than this active role played by the symbolic figure of Death.

French and Italian influences in Europe

Baroque art was much admired in England. The tombs carved

929. ARCHITECTURE. ANDREA BERGONDI. Altar of St Alexis. *S. Alessio on the Aventine, Rome.*

930. SCULPTURE. FRANCESCO QUEIROLO (1704–1762). Disillusion. *Sansevero Chapel, Naples.*

931. PAINTING. GIOVANNI BATTISTA PIAZZETTA (1683–1754). Adoration of the Shepherds. *Padua Museum.*

932. ARCHITECTURE. GABRIEL BOFFRAND (1667–1754). Towers and upper façade, St Jacques, Lunéville. 1730–1745.

933. SCULPTURE. PIERRE LEGROS THE YOUNGER (1666–1719). St Stanislas Kotska on his Death-bed. Detail. *S. Andrea al Quirinale, Rome.*

934. PAINTING. CARLE VAN LOO (1705–1765). Adoration of the Magi. *Lady Chapel, Church of the Assumption, Paris.*

935. ARCHITECTURE. GERMANY. Staircase, Schönborn palace, Pommersfelden. 1711–1718. Designed by Johann Dientzenhofer (d. 1707) and completed by Maximilian von Welsch (1671–1745). 18th-century engraving in the National Library, Vienna.

936. SCULPTURE. GERMAN. EGID QUIRIN ASAM (1692–1750). Angel in adoration. Detail from the high altar of Osterhofen monastery, Lower Bavaria.

937. PAINTING. AUSTRIAN. FRANZ ANTON MAULPERTSCH (1724–1796). The Family of the Virgin. *National Gallery, Vienna.*

THE BAROQUE IN EUROPE IN THE 18TH CENTURY

ITALY

929

930

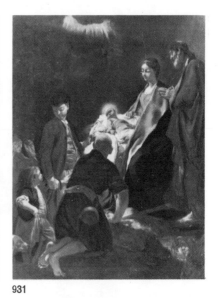

931

FRANCE

932

933

934

THE GERMANIC COUNTRIES

935

936

937

938. GERMAN. BALTHASAR PERMOSER (1651–1732).
The Apotheosis of Prince Eugene. 1721.
Osterreichische Galerie, Vienna.

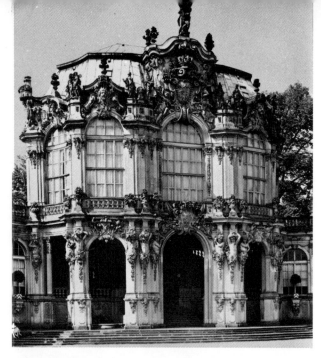

939. GERMANY. The Zwinger pavilion, Dresden.

940. Detail of Atlantes, from the Zwinger.

*Built by M. D. Pöppelmann (1662–1736) between 1711 and 1722
(commissioned by Augustus II), the Zwinger was
decorated primarily by Balthasar Permoser, who was
responsible for most of the sculpture.*

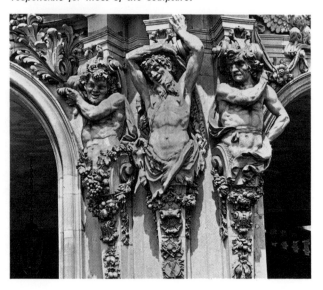

941. GERMAN. Perspective view of an
audience chamber for the Electors of the Palatinate.
Project by Paul Decker (1677–1713). Engraving by Remshard,
from *Fürstlicher Baumeister.*

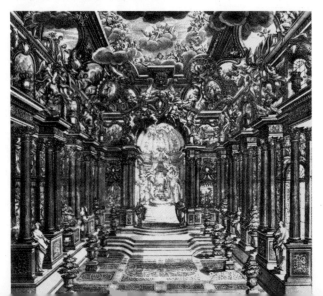

by Louis François Roubillac, in particular that of the Duke
of Argyll, are among the finest works to be found in the wake
of Bernini. Scandinavia was less responsive to the Baroque,
preferring the most academic and the least dynamic examples
of French art.

Russia showed a very different taste, and there Baroque art
found favourable ground. Nicolas Pineau, one of the best of
French decorators, was received there, and the Baroque archi-
tect Count Bartolommeo Rastrelli (1700–1771), the son of an
Italian Baroque sculptor, was given great opportunities there.
In Russia all limitations and academic restrictions could be
1144 thrown to the winds. Rastrelli built on a grand scale; the Winter
927 Palace in St Petersburg and the Smolny convent in the same
place have forms inspired by Borromini, such as broken façades
and towers placed diagonally (these crowned with onion-shaped
domes — a deliberate and intelligent link with local tradition).

But it was neither in England nor in Russia that the Baroque
reached its highest development and the Rococo its greatest
extremes; it was in the Germanic countries.

German Baroque art

German Baroque art deserves the highest admiration, and in
palaces, monasteries and towns the Germanic countries saw the
unfolding of a style worthy of the greatest periods in art. But
too many German art historians see in it the natural develop-
ment of national trends, even of certain regional styles. Without
undervaluing the German artists, who were at that time among
the greatest, it must be said that the beauty of their work was
often due to their ability to absorb and assimilate every contem-
porary trend. The architectural forms, the sculpture and the
monumental painting were Italian; the use of ornament was
French. 18th-century German art is important because it repre-
sented the high point of Baroque art of the period — in Italy,
in France and in Germany itself.

The vast area covered by the Germanic countries makes it

necessary to distinguish several centres — first Austria, the Imperial region, then Franconia, Bohemia, Bavaria and Swabia (this last includes eastern Switzerland, Lake Constance being then much more a line of communication than a frontier). In these areas, which were Catholic or where Catholicism predominated, the Baroque and its successor the Rococo were universal; but although the Protestant areas — Württemberg, Saxony and Prussia — had less opportunity for monumental religious architecture, they show a number of magnificent buildings which are completely Baroque in style. Thus Baroque art and Catholicism cannot be regarded as synonymous; Catholicism simply gave to Baroque art more opportunities for development because of the many churches and chapels to be built and decorated. The Baroque became truly popular at this time, and one might sometimes be tempted to prefer the modest chapels and pilgrimage churches hidden in the countryside to the more ambitious monuments.

It is difficult to separate 17th-century German Baroque art from its Italian origins. Italian names are everywhere, not only those of well known artists but also those of Italian craftsmen 1135 from northern Italy and the Ticino. Fischer von Erlach, the great architect of Vienna, was connected with Bernini whose work he evidently appreciated, and the whole of the capital suggests the influence of Italy. After the siege by the Turks in 1683 several magnificent palaces were erected in Vienna of 1136 which the most famous was the Belvedere, built by Hildebrandt for Prince Eugene of Savoy. Hildebrandt had lived for some time in Genoa and his style had been formed by Italian art. The painters and plasterers employed by him were for the most part Italian, but in Vienna they worked with especial enthusiasm at enriching the decoration. No Italian town can show such a host of Atlantes supporting the vaults of staircases, nor are the balustrades of such staircases ever contorted and pierced to the extent that they are in Vienna. Architecture in Vienna was certainly influenced by that of Italy but it carried the Baroque inspiration further. Andrea Pozzo came to Vienna in 1704; his style, the most extreme Baroque in Rome, seemed to fit in well in Vienna where he painted some ceilings.

In the Belvedere there is an outstanding marble group by 938 Permoser representing the *Apotheosis of Prince Eugene*. It immediately calls to mind the great Genoese marbles such as the one 722 formerly at Marly (now at Bolbec) and the *Perseus and Andromeda* by Puget. But these two groups are coherent despite the number of figures and their vigorous movement, whereas one does not know from which angle to examine Permoser's work. Although Permoser had lived in Italy and was familiar with the works which had served as models for his group, his temperament carried him beyond Italian Baroque in expression.

939 Permoser did most of the sculptures for the Zwinger in Dresden, an astonishing building which is given even greater 940 animation by its gesticulating Atlantes.

Like Vienna, Dresden illustrates Italian Baroque forms carried to extremes; the Catholic Hofkirche by Romano Chiaveri (1738) has a tower which suggests the influence of Borromini or Juvarra. The Protestant Frauenkirche (destroyed) had a completely original design and lay-out which were perhaps more reminiscent of a theatre or concert hall than of the customary lay-outs of basilican type churches. A building of this kind remained an exception. In other towns too the influence of Italy was visible everywhere. At Cassel the marble bath (1720) of the Landgrave Charles has an ensemble of sculptures in the round or in high relief by Pietro Stefano Monnot, who did the tomb of Innocent XI in St Peter's and brought some of the most striking Baroque characteristics to Germany from Rome. His many fine works on mythological subjects included themes previously treated by Bernini or Puget, such as *Apollo and Daphne* and *Perseus and Andromeda*.

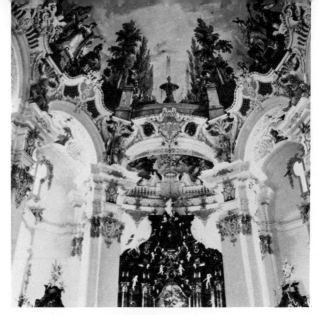

942. GERMANY. DOMINIKUS AND JOHANN BAPTIST ZIMMERMANN. Ceiling of the church of Steinhausen. Detail. After 1727.

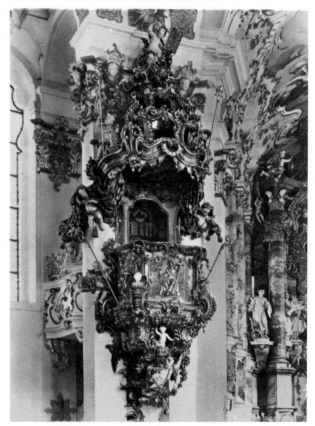

943. GERMAN. DOMINIKUS ZIMMERMANN (1685–1766). The pulpit of the church of Die Wies.

944. GERMANY. GEORG WENCESLAUS VON KNOBELSDORFF (1699–1753). Palace of Sans Souci, Potsdam. 1743–1748.

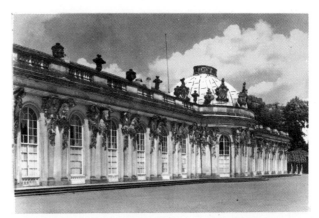

945. GERMAN. Rococo decoration. Detail of a ceiling.

946. GERMAN. JOSEF ANTON FEUCHTMAYER (1696–1770). Detail of the carved altar of the abbey church of Birnau, near Lake Constance. 1747–1749.

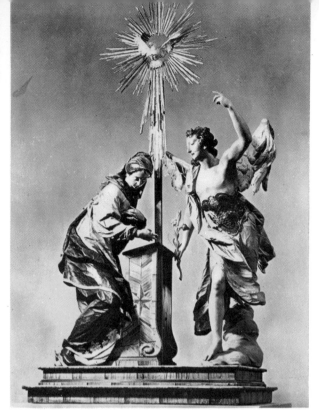

947. GERMAN. IGNAZ GÜNTHER (1725–1775). Group of the Annunciation. Sculpture executed in 1764 for the Church of the Augustinian Canons of Weyarn.

In Prague and Bohemia the most intricate forms of Italian Baroque art were perfectly assimilated. We can see the influence of Borromini in the buildings by Kilian Ignaz Dientzenhofer with their curving cornices and walls. In addition the Prague buildings show the combinations of vaults frequently used by Guarini, who had designed buildings in this area.

The numerous palaces built in Germany for the many lay and ecclesiastical princes are generally vast in size, such as those of the Electors of Bavaria, those of the prince-bishop of Bamberg in his episcopal seat, the summer palace of Pommersfelden and the palace of the dukes of Württemberg at Ludwigsburg. These buildings have vast rooms, great galleries in the Italian style and staircases with numerous statues which are closely related to the paintings on the ceilings.

But although the architecture and most of the decoration in these ensembles is Italian in derivation, another influence can be seen in the plaster work. The French ornament of Daniel Marot and Jean Bérain was very popular in Germany, so much so that in Augsburg there was a flourishing trade in counterfeits.

Perhaps the dual Italian and French influence is best seen in the imaginary palaces of the projects of Paul Decker. Below ceiling paintings of the sky and above the architectural elements are extraordinary collections of ornaments in which the whole repertory of Bérain is used with completely unrestrained exuberance.

The masters of the German Rococo

The exaggerated style and the preoccupation with vast size can be seen not only in palaces but in the great abbey churches as well. Two famous examples are Weingarten in Swabia, built after 1715, and the somewhat later Einsiedeln in Switzerland. In dignity and spaciousness Weingarten bears comparison with the finest Roman churches. Its façade thrusts forward between two towers in a sweeping typically Baroque movement; the transepts are rounded, a vast dome rises over the crossing, and the ceilings, painted by Cosmas Damian Asam, seem to open on to a heavenly scene of saints triumphant. The large altars are marbled stucco, a technique peculiar to Germany. This splendid church was to have been surrounded by large intricately curving buildings, a grandiose project only partially carried out. At Einsiedeln we can see a complete ensemble which has close connections with Weingarten, since the church was painted and decorated by the same artists, Carlone and the brothers Asam, who endeavoured to surpass their work

at Weingarten. The plan of the church at Einsiedeln is quite different however, for a miraculous chapel had to be preserved inside near the façade; behind the open space in which this chapel stands, the various parts of the building become progressively more cramped, a frequent feature of German Baroque churches.

The brothers Asam lived in Munich. After their work on these two projects they undertook some very original decoration of churches in Bavaria. The high altars in these buildings are conceived as theatre stages on which free-standing statues gesticulate in violent movement. At Weltenburg, St George on his horse is seen saving the princess and putting the dragon to death. Even more surprising in effect is the famous high altar at Rohr, where a Virgin, held by angels, seems actually to be floating in the air as she rises above gesticulating Apostles. On either side of the high altar of the very unusual church at Osterhofen — an altar which seems to derive from the richest innovations of Pozzo — the brothers Asam installed effigies of the founders, painted in naturalistic colouring, which look for all the world like the audience in a theatre box.

Two other brothers, the Zimmermanns, one the painter Johann Baptist and the other the architect and plaster worker Dominikus, became acquainted with Italian art in southern Germany. They were engaged to work on several churches at a time when many Italians were also working there. Their finest and most original work was the pilgrimage church of Steinhausen (after 1727). The very unusual stucco decoration is capped by a magnificent vault filled with balustrades, plants, draperies and valances.

Later two other famous pilgrimage churches adopted the oval plan of the ambulatory of Steinhausen. One of these was the church of Vierzehnheiligen in Franconia by Balthasar Neumann, the illustrious architect of the Würzburg Residenz, the other was the church at Wies in Bavaria, by the brothers Zimmermann. Neither church, despite greater size and complexity, achieves the perfection and charm of Steinhausen. Dominikus Zimmermann excelled in small buildings. His little chapel dedicated to St Anne (1740) in the Carthusian monastery of

935

935

941

936

942

1124, 1125

900, 943

Buxheim in Swabia is delightful. It is built on a quatrefoil plan, and the decoration shows clouds and swags of flowers descending from the heavens, together with an image of the Christ Child, through an opening in the vault, while curtains, also of stucco, seem to be drawing apart. The whole work is filled with light, clear colours — green, pink, and sky blue — and suggests sacred joy and deep religious sentiment. It is a charming example of an elegant art which was at the same time a popular art; throughout Swabia and Bavaria the small religious buildings of this time were ingenious in structure and pleasing in decoration. Among the many fine examples were the chapel of St Anthony at Partenkirchen in Bavaria (1740), with its lovely paintings by Holzer, and, near Augsburg, the church of St Anthony in Bertoldshofen (1730), its curious domes strongly reminiscent of Padua. These exquisite masterpieces are too little known.

Although the plaster decoration in these churches was very rich it was up to this time more or less symmetrical. This symmetry now vanished; the draperies, scallops, scrolls, balustrades and trellises gave way to asymmetrical cartouches (scroll-like ornaments), to plants whose tendrils or branches grew in all directions and to jagged shells. There can be no doubt that these strange, indefinable shapes were derived from the French albums of ornament, in particular those of Mondon and Lajoue which had been much imitated in Augsburg and which Cuvilliés (who worked in Munich), through both his work and his publications, made familiar to the Germans. The varied forms found in these collections of French designs were often intended only for small objects or for the temporary decorations for festivities, but the German artists raised them to the dignity of monumental and permanent ornaments.

This taste for the Rococo was general (see colour plate p. 316). It found favour both in the worldly courts and in the most devout monasteries. The interiors at Potsdam under Frederick II are in a Rococo style which is often light and charming and is a suitable frame for the French paintings of *fêtes galantes* which were purchased by the king. It is understandable that Louis XV sent two large statuary groups, *Hunting* and *Fishing* by Lambert Sigisbert Adam, to Potsdam, and that the work 944 of François Gaspard Adam was appreciated there. Potsdam was a happy synthesis of the brilliant agitated style of both Adams and the graceful curving Rococo favoured by the king of Prussia. This taste was shared by other German rulers; the Margravine of Bayreuth followed the example of her brother-in-law Frederick, and her own rooms in her palaces were overrun with a curious irregular plaster vegetation.

In the great religious buildings of the Catholic districts the Rococo was pursued with less discretion. The size of these buildings permitted an abundance of decoration; sculpture, painting and plaster work were given first place and were allowed to correct where necessary the faults of the architectural design.

Without the plaster work and the painted dome the vast rotunda of Ettal in Bavaria (completed after 1745) would be no more than a weighty mass. The paintings open up the building to the sky, where the blessed float in beatitude, and the altars, pilasters and arcades, with their lightly posed twisted vases and their irregular cartouches, do still more to relieve the whole building of its heaviness.

The plasterers also made statues. Their work could lend distinction to buildings of the most indifferent design. The church of Birnau (built between 1747 and 1749) near Lake Constance is no more than a very large light hall, but the 946 plasterer Josef Anton Feuchtmayer created a dramatic world there of haggard old people and of young people in tense, nervous poses who enliven the curious altarpieces of false marble.

Round Munich Ignaz Günther filled the cornices of buildings

with an array of saints and angels of a somewhat dubious charm, 947 with narrow faces and graceful silhouettes.

These curious figures are portrayed in distorted poses which harmonise with the contorted shapes of the decoration. In the buildings of this period in Germany the human figure is no more than an element in Rococo design; it is subordinated to the dominating movement of the whole work.

A building which synthesises all the trends of the Rococo and, thereby, all those of the Baroque, is the extraordinary abbey church of Ottobeuren in Swabia. It was begun in 1736 948 and the decoration was done between 1754 and 1767. It is of considerable size (295 feet long, 194 feet wide, 115 feet high at the vault), but its simple plan makes it appear even larger; it has an enormous choir and broad transepts with semicircular ends. As in many Baroque buildings the convex façade stands out majestically between two towers. The nave is breathtaking in the harmony of its proportions and the charm of its colour. The architect Johann Michael Fischer built a drumless dome in the centre, round which the whole building is massed. The essential elements — arcades, entablatures, etc. — are surrounded by broad white surfaces. The sumptuous decoration is found only on the backs of the altars and on the vault, the latter being covered with paintings, twisted cartouches and false perspectives which open on to the sky. Neither painter nor plasterer hesitated at introducing any freak of invention to embellish this impressive building.

This structure seems to us the supreme effort of Baroque art. Here, in contrast to so many other monuments, there is no overloading of ornament, but there is a vibrant staccato decoration which lends animation to the entire building. The Baroque here is all movement. It will go no further; it represents the synthesis of the architectural elements which came from Italy and the ornamental model which came from France into a completely original work. Let us look and enjoy it; it is the end product of a trend begun in Rome one hundred and fifty years earlier. After this the severe and rigid forms inspired by antiquity were to annihilate the impetus of the Baroque throughout Europe.

948. GERMANY. JOHANN MICHAEL FISCHER (c. 1692?–1766). Interior of the church of Ottobeuren. Begun in 1736.

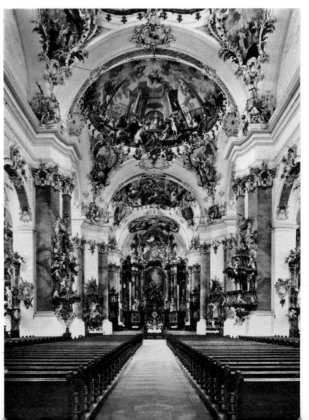

THE IBERIAN BAROQUE
AND THE NEW WORLD *Germain Bazin*

*Although despite its later success Baroque art was slow in
coming into its own in Italy, there were other
countries in which the Baroque was a latent tendency. In these
countries it seemed to follow on from very late Gothic, which
was unquestionably Baroque in spirit. This was
true of the Germanic countries; it was also the case in the Iberian
peninsula where the Baroque, introduced from Italy,
had a remarkable, seemingly inevitable, flowering; from there it
spread to Latin America where it took an unexpected turn.
In the New World the Baroque combined imitation of
its European (mainly Iberian) masters with the
unbridled expression of its own spirit. The result was an art
which has no equivalent elsewhere. Germain Bazin has,
through years of research, greatly deepened our knowledge.*

Influences from abroad

No artistic tradition has known a wider distribution than that
which came out of Spain and Portugal from the end of the
15th to the late 18th centuries.

The conquistadores spread this tradition throughout Latin
America, which could boast some of the most active centres
of Baroque art. The Portuguese for their part implanted a
Western tradition of their own in the city of Goa (a corner
of the world which was quite alien to them) which developed
into an autonomous art.

The European frontiers of Spanish Baroque art were not
confined to the peninsula. In regions which from the 15th
century had been more or less linked with Spain politically
— in Naples, Sicily and Malta — the meeting of the Iberian
tradition and the Italian produced some unusual works.

Within this universe there was a world of forms stemming
from the farthest confines of history and of the globe. Tradi-
tionally Spain had always been open to artists from all parts
of Europe. Although during the fifty years of its golden age
Spain had tended to turn inwards to its own heritage, the
subsequent decline of Spanish power loosened this constricting
attitude and aroused a feeling of curiosity regarding foreign
lands, which increased after the Treaty of Utrecht in 1714.
The Italians were in great demand as the masters of modern
art. Carlo Fontana built the Jesuit Collegium Regium at Loyola
in the Basque country (consecrated 1738). In 1735 the king
958 invited Filippo Juvarra to design his palace in Madrid and the
palace of La Granja at S. Ildefonso. This was not Juvarra's first
visit to the peninsula; much earlier he had been to Lisbon
957 to submit plans for the palace-monastery at Mafra to John V
of Portugal. The Neapolitan Luca Giordano, who was com-
missioned in 1692 to paint the vaults of the great staircase in
the Escorial, amazed the Spanish painters by his virtuosity since
they themselves were accustomed to painting saints rather than
Olympian gods. In 1762 Charles III commissioned Tiepolo to
paint the ceiling of the royal palace at Madrid; at the Spanish
court the Venetian's Rococo aesthetic clashed with the Neoclas-
sicism of Anton Raphael Mengs, a German painter who had
become Roman by adoption and was much in demand as a
talented portraitist.

The court painters in Spain were nearly all French (Michel-
Ange Houasse; Jean Ranc; Louis Michel van Loo) or Italian
(Jacopo Amigoni; Corrado Giaquinto); nor did the Spanish
scorn to use the talents of their neighbours and former enemies,
the Portuguese. Manuel Pereyra had come to Spain in the 17th

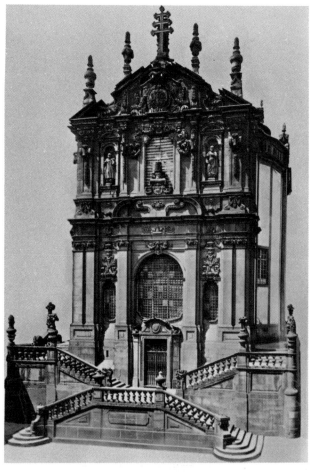

949. PORTUGAL. NICCOLÒ NASONI. Façade.
Church of São Pedro dos Clérigos, Oporto. 1732–1750.

950. INDO-PORTUGUESE. Silver Dragon.
Ewer converted into a perfume brazier. 18th century.
Marquesa Alegrete Collection, Elvas.

951. SPANISH. Detail of the porcelain closet.
Made of plaques from the Buen Retiro factory. 1765–1770.
Royal Palace, Madrid.

952. PORTUGUESE. Coach of King John V.
First half of the 18th century. *National Museum of Coaches, Lisbon.*

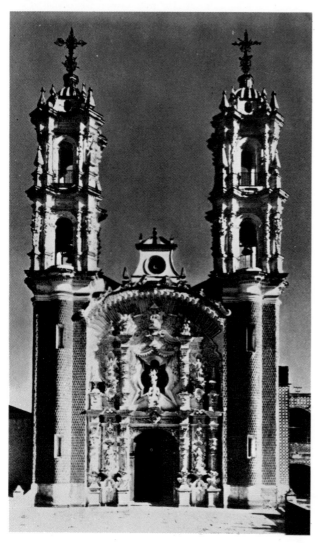

953. MEXICO. Santuario de Ocotlan, near Tlaxcala. *c.* 1745.

century to join the great school of Spanish image carvers; Cayetano da Costa designed the finest altarpieces in Seville in **959** the 18th century; and it was a Portuguese architect from Braga, Constantino de Vasconcelos, who designed S. Francisco at **961, 962** Lima, the most important monument of the Peruvian Baroque. While working on the Pilar chapel in Santiago de Compostela, Fernando de Casas y Novoa studied the monuments at Lisbon and Oporto.

Artists from northern Europe were also drawn to Spain, just as they had been drawn to it in the 15th and 16th centuries. The first builder of La Granja, Teodoro Ardemáns, was the son of a German. Konrad Rudolf, who began the façade of Valencia cathedral (1703), was also German though he had worked previously in Rome where he had been a pupil of Bernini. Jaime Bort Miliá, of Dutch descent, worked on the façade of Murcia cathedral. Spain's growing interest in making use of foreign specialised techniques attracted many craftsmen. In 1729 Jean Olerys from Provence brought Moustiers models to the new ceramic factory at Alcora, founded in 1727, and in 1748 a man from Lyon was in Talavera teaching the craftsmen to make silk. The leading gardeners of the time were French, and Etienne Boutelou was invited to work on the park at La Granja. With him came the sculptor René Carlier.

In Portugal the stages in the development of Baroque architecture were marked by the arrival of 'experts' from Italy — Filippo Terzi (1520–1597), the architect-engineer who worked for Philip II; the German architect João Frederico Ludovice (1670–1752), builder of the palace-monastery, Mafra, who had **957** worked in Rome; Niccolò Nasoni (d. 1773) who worked at **949** Oporto. A pupil of Bibiena, Giuseppe Antonio Landi, was sent to Belém do Pará in 1753 as engineer and surveyor to a commission of experts, and he built a number of admirable churches in this town — until then one of the most isolated in Brazil. In 1653 Guarino Guarini had sent drawings to Lisbon for a **913** church (Sta Maria Divina Providencia) which anticipated the Rococo style in many ways, but it was destroyed by the earthquake of 1755. In painting the influence came from France with such artists as the portraitist Jean Ranc, son-in-law of Rigaud, Pierre Antoine Quillard, a painter of genre scenes and a portraitist, and Jean Pillement, a master of decorative landscapes. The goldsmiths Thomas and François Germain, called to **1044** Lisbon by John V, gave that city the most impressive collection

954. ITALIAN. Diana and Actaeon.
One of the marble groups of the fountain in the garden of Caserta palace, by Paolo Persico, Angelo Brunelli and Pietro Solari.

955. BRAZILIAN. Ostensory in the form of a sun. 18th century. *Desterro Convent, Bahia.*

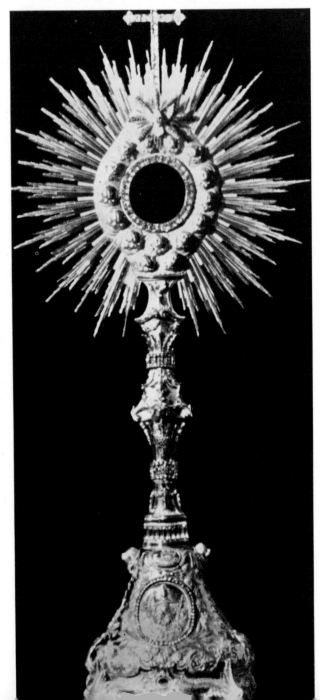

of plate ever made. Looking to France for her metalworkers, Portugal also kept in touch with developments in Dutch ceramics; the manufacturers of *azulejos* were inspired by models from Delft.

Influences from the Orient

Into this system of exchanges, whereby Lisbon and Madrid profited by artistic developments in Paris, Rome and Holland, the Middle East and the Far East brought a variety of forms which were in fact much closer to the artistic climate of the period than was the Graeco-Roman heritage in its Renaissance form, which had to be considerably and forcibly altered in its adaptation to the Baroque spirit. Chinese art with its completely different development had a powerful impact, particularly in the field of ceramics. Chinese porcelain became popular from the time the first ceramics were offered to King Manuel I of Portugal about 1500. The Iberian world, like France and like Germany, wished to make the new and fashionable taste for chinoiserie its own. In 1738 Charles III, whose wife was a princess of Saxony, founded a pottery at Capodimonte, near Naples, which soon rivalled Meissen; he was so fond of this undertaking that when he became king of Spain in 1759 he transported it to Buen Retiro. The palaces of Aranjuez and Madrid had porcelain closets which were like the one at Portici near Naples 951 (transferred in 1760 to the palace at Capodimonte), and La Granja had a lacquer closet. The influence of the Far East even reached the New World, and by direct impact and not through the intermediary of Europe. The porcelains of China and Japan were unloaded in Mexico at the port of Acapulco. These were copied at Puebla, while lacquer furniture was produced at Michoacán. In Brazil the bell tower of the Jesuit seminary church of Belém do Cachoeira in the state of Bahia was decorated with Chinese ceramics imported from the Portuguese colony of Macao. To the influence of China Portugal added that of India; the meeting ground was Goa, which had a hybrid art composed of Western Rococo, Mongol and Italian. The silver work and 950 the famous embroidered quilts (*colchas*) of Goa were much prized in the home country. The Portuguese were also interested in Persian art, and Persian tapestries were imitated at Arrayolas. As Portugal was an Atlantic country and therefore more open than Spain to the influence of foreign lands, its Baroque art drew on many sources; while Portuguese potters were looking to Delft for inspiration, Portuguese cabinet-makers borrowed two styles from England — first Chippendale and then Adam.

The importance of the minor arts

It may appear odd to reverse the usual procedure and begin a chapter with the minor arts. But the period with which we are concerned witnessed, in the Iberian peninsula as well as in France, Germany and England, a surprising flowering of those arts considered by academic standards to be of secondary importance. In the severity of the Spanish golden age the so-called 'industrial arts' were subjected to the norms of the major arts and declined considerably; the spread of the Baroque saw their magnificent revival which was in the nature of a triumph, for they even gave the lead to architecture itself. By the end of the 17th century workshops throughout Spain were producing countless examples of pottery, embroidery, wrought iron and jewellery. Religious metalwork flourished, and in Portugal, Spain and the New World splendid pieces of liturgical silver plate were produced whose brilliance was wedded to the radiance of the gilded altarpieces. One of the art objects which appeared at this time was very characteristic of the Baroque spirit; this was the ostensory (a receptacle for the Host) 955 in the form of a radiating sun, which was substituted for the custodial (a type of receptacle for relics or for the Host) in the shape of a small temple, which evolved during the Renais-

sance, itself the successor to the Gothic monstrance with its small spire. These three stages characterising this same object are analogous to the evolution of these three major styles of Western art. The 18th century witnessed the growth of domestic metalwork; though the kings of Portugal acquired their silver ware first from France and then from England, their own artists had fashioned some of the finest pieces of European metalwork of the 16th and 17th centuries. Decorative sculpture in gilded or polychrome wood (called *talla* in Spain and *talha* in Portugal) was at its peak in the years between 1680 and 1780. In addition to being used on thousands of altarpieces which can still be found all over the world, this technique was used for the decoration of everyday objects (most examples of which have now disappeared) such as ships whose poops were veritable palaces, to judge by the models which are all that remain, and state carriages, the finest of which were manufactured in Italy and France. The collection of coaches belonging to the Portuguese court, which is preserved intact at Belem near Lisbon, is all that remains to give us an idea of the unbelievable luxury of this kind of vehicle which was used during the frequent festivities such as processions, royal pageants, funerals, weddings and receptions of ambassadors.

952

There was an interchange of forms between all these arts. In the 17th century Portuguese facing-tiles imitated tapestry; these ceramics thus derived the name *azulejos de tapete*; later the potters borrowed the motif of acanthus scrolls from the ceiling painters, and the sculptors in wood in their turn took it over and passed it on to the sculptors in stone; the Lisbon *azulejos* transmitted models of the style reigning in the metropolis to the craftsmen of Brazil.

A goldsmith at this time was no 'minor artist', but stood on an equal footing with an architect; he might even become one, as was the case with Ludovice, the builder of the Mafra monastery, one of the most impressive Baroque buildings in Europe. João Frederico Ludovice (in Portuguese), a Swabian in origin, was a converted Lutheran who changed his surname in Rome from Ludwig to Ludovici; in 1701 he was in Lisbon making liturgical silver for the Jesuits. The goldsmith, the potter and the wood sculptor were all essential to the Baroque architect; he guaranteed them board and lodging so that they might practise their craft, and he himself profited from their examples. At the end of the 17th and the beginning of the 18th centuries the deeply cut relief of carved altarpieces was imitated on the façades of churches. (And does not the art of the wood-carver itself evoke the work of the goldsmith?) Some façades in Mexico are like gigantic ornate monstrances or reliquaries. If the term Plateresque or *plateresco* (silversmith-like) were not already applied to another period in Spanish art it would be much more suitable to the style than the term Churrigueresque.

957

The Baroque was essentially an art of metamorphoses; architects, goldsmiths, potters, iron workers and sculptors all borrowed ideas from one another. These ideas seem to have been governed solely by caprice. More than in any other style it is difficult to discern any derivations of forms in the polymorphic Baroque; to isolate them one has to discover the basic principle and to be guided by that kind of biological development of decoration which is the true organic law of this style.

The figure was put to the service of decoration. There was an even greater interest in human figures at this time than in the Middle Ages — in painted, carved and also scenic figures, dancing or singing. In this part of the world plaster, gilded wood, ceramics and stone were the materials. Groups of tiles such as the ones in the cloisters at S. Francisco at Lima (where the tiles came from Seville in 1620 and 1643), in the cloisters of São Francisco at Bahia, Brazil (where the tiles came from Lisbon between 1746 and 1752), in the garden of the cloisters of the Poor Clares in Naples (where the tiles were made of

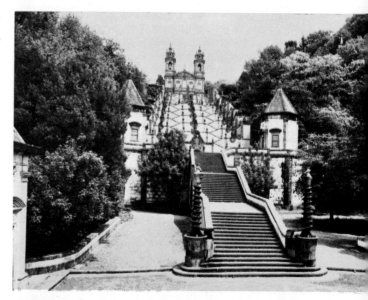

956. PORTUGAL. Stairway at the Bom Jesus shrine, Braga. *c.* 1730–1774.

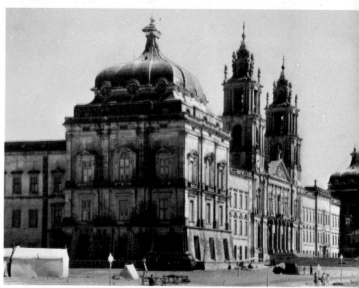

957. PORTUGAL. JOAO FREDERICO LUDOVICE (1670–1752). Palace-monastery of Mafra. Begun 1717.

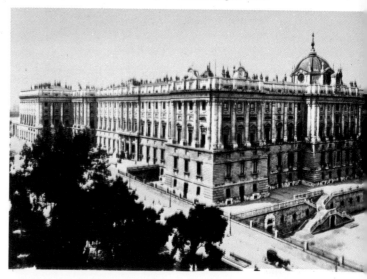

958. SPAIN. Royal palace, Madrid. Built by G. B. Sacchetti from the plans of Filippo Juvarra. 1738–1764.

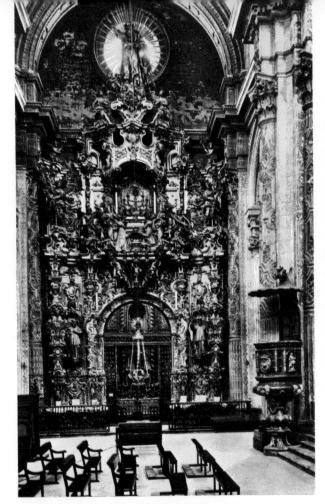

959. SPAIN. CAYETANO DA COSTA (1711–1780).
Monumental portal of the Chapel of the Holy Sacrament. 1770.
S. Salvador, Seville.

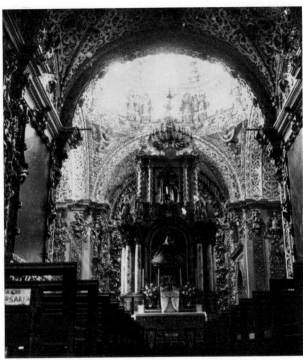

960. MEXICO. Interior of the Rosary Chapel in
Sto Domingo at Puebla. Baroque style. Sculptures in gilded
and pigmented wood. Before 1690.

Italian majolica and were laid in 1742) and in the gardens of
the palace of the Marquis of Fronteira and of the Paço de Lumiar
in Lisbon, were widely used to exhibit a complete encyclopedia
of theological, geographical, historical or purely pictorial figures.
Opera ballets had a strong influence on the statuary in the
954 gardens at La Granja and at Caserta in Italy as well, and the
same spirit now penetrated religious statuary, which was now
found outside the churches and in the open air. 18th-century
Luso-Brazilian art offers some curious examples of this. The
gardens of the episcopal palace of Castello Branco and the
956 extraordinary 'holy mountain' at the Bom Jesus shrine at
Braga (imitated in Brazil at Congonhas do Campo) are, with
their statuary, like stage productions of the old medieval theme
of the concordances of the Old and New Testaments.

Baroque art as the expression of the Iberian spirit

Perhaps no other civilisation lends itself so well as the Iberian
to the study of how an order of aesthetic and psychological
values can give rise to the various forms of art (a study which
is in accordance with the approach used by the authors of
this work). The meeting points of painting, sculpture, archi-
tecture and the minor arts, and the conflicts between them
(which were temporarily resolved only to revive with greater
intensity), dominated Spain in the 17th and 18th centuries.
The iron discipline with which the idea, so dear to the Renais-
sance, of pure architectural space was imposed on Spain during
the Counter Reformation is sufficient proof of the extent to
which this concept was unnatural there despite sporadic attempts
by predecessors of Juan de Herrera to modify the heavy
Plateresque ornament. This victory of the severely classical over
the poetic and emotional was symptomatic of a kind of renun-
ciation of the figurative arts, so that foreigners had to be called

in for sculpture (Leone and Pompeo Leoni for funerary
monuments). As for painting, the decoration of the vaulted
ceilings of the Escorial was surprisingly handed over to the
Mannerist Federico Zuccaro. This triumph was short lived,
however. The first part of the 17th century witnessed a slow
but tenacious return of the individual spirit and a somewhat
greater freedom in architecture; sculpture and painting benefited
from this. About 1660 the creative impulse in figurative art
was at a sufficiently low ebb for a new style to develop — not
now under the rod of the architect but through the re-emergence
of the true Iberian spirit (with its Islamic heritage, among
others) which uses the accumulation of the visual, of forms
in art, as a sort of curtain to mask the depth of the void. This
Baroque spirit, an essential part of Spain, produced an art
which could be integrated harmoniously into the current
Baroque style in a Europe which seemed to seek compensation
for that nostalgia engendered by the slow penetration of
rationalism by abandoning itself to the imaginary.

The palace as well as the church benefited from the richness
of the Plateresque style. Philip II achieved the fusion of regal
and ecclesiastical power in the Escorial, a monument which
is a perfect symbol of monarchy by divine right. A century
and a half later his example inspired the concept of the palace-
monastery of Mafra (begun 1717) in John V of Portugal; and 957
Philip V (although a Bourbon), in his attempt to reproduce
Versailles at the foot of the Sierra de Guadarrama, placed the
altar at La Granja at the spot where Louis XIV had put his
bedroom.

Court art and clerical art

In the Baroque period secular art suffered a decline which was
severe enough for the Bourbons to import a court art which

was developed apart from the mainstream of Spanish art by French and Italian artists, who were summoned at great expense. We can see how impersonal this royal art was by comparing the similarity of elevation of the royal palace at Madrid, designed by Filippo Juvarra in 1735, and the royal palace at Caserta, built by Vanvitelli from 1752 for the king of Naples, with the reconstruction projects for Versailles, which were begun as late as 1769 by Jacques Ange Gabriel. The Marble Palace built by Antonio Rinaldi at St Petersburg between 1768 and 1772 has the same elevation in two sections with a giant Order of pilasters for the upper section.

Thus in Spain and Portugal, and even more in Latin America, the church was the essential building, round which the other buildings were laid out (monastery, university, school, hospital and even the town itself). The urban agglomeration of Santiago de Compostela, perhaps the most beautiful Baroque city in Europe, is entirely dominated by the way in which the churches and monasteries are grouped round the cathedral (which is the famous repository of the relics of the Apostle James). In Mexico the colonisers adopted the old Aztec chequer-board plan in building their new towns, the church replacing the pyramid-temple in the central square. In Paraguay the builders of the missions developed a plan which was well suited to express the corporate and theocratic rule imposed on the Indians; the façade of the church, a symbol of its authority, dominated the groups of dwellings.

Emile Mâle made a brilliant analysis of the iconography dominating the welter of imagery in the Baroque church; it is applicable well beyond the area he studied, in fact, as far as to Latin America. To summarise briefly what lies behind this imagery, we might say that it illustrates the salvation of humanity by the Church. Never was art more clerical; at the farthest limits of the Christian world, in the lovely church at Taxco which is one of the gems of Mexican Churrigueresque, the whole series of altars was built in ten years — probably according to the plans drawn up by the son of the founder, the first priest of the parish — and dedicated to the clergy, that is, the bishops, priests, founders of Orders, fathers of the Church and finally the popes, for whom the high altar was reserved.

Ornament and decoration

The architects of the Renaissance from Alberti to Palladio wished to sing the praises of God in the music of numbers; the shrine, closed in upon itself, expressed by the purity of its architectural composition that sacred quality proper to a holy precinct, and carved ornament was subservient to the building itself. In Rome the Counter Reformation kept to this principle but allowed the use of images and decoration, which were however confined to the shadow of the chapels. There Mannerist decoration was found in inlaid marble, so little suited to the monumental character of the pictures it framed. This punctuation of the monumental interior with ornamental elements, to which the seclusion of the chapels added mystery without impairing the monumental effect, is nowadays to be seen only in a few Luso-Brazilian churches such as the cathedral of Coimbra in Portugal and that of Bahia in Brazil, where the spirit of the Counter Reformation still lived on. But in Italy, where the Baroque was becoming increasingly important, decoration invaded the whole building. Recapturing the spirit of Byzantine art, which is an art of the church rather than a religious art, Baroque art sought to apprehend the sacred through the senses by the use of decoration, music, flowers and incense. In Europe this appeal to the senses satisfied the imagination, but in the New World among the converted Indians it had a reality; the Peruvians were accustomed to seeing the Temples of the Sun lined with plaques of gold, and they did not find themselves

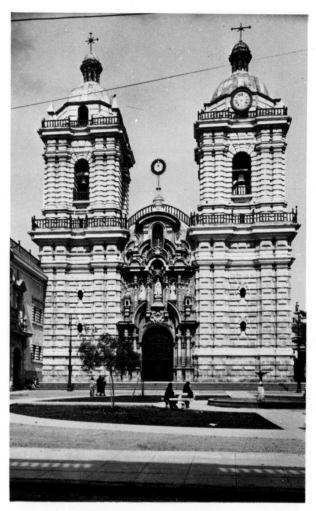

961. PERU. Church of S. Francisco at Lima. Completed c. 1674.

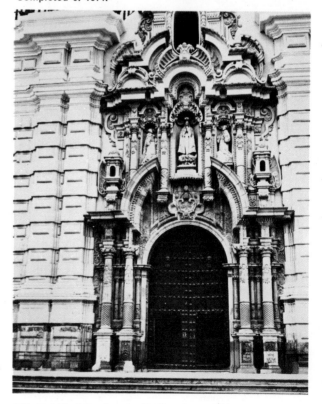

962. Detail of the façade, S. Francisco at Lima.

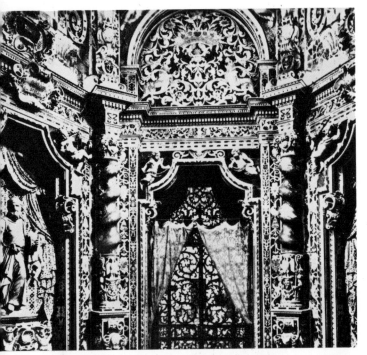

963. SICILY. Detail of the Cappella del Crocifisso. 1688. *Monreale Cathedral.*

in an entirely unfamiliar world when they entered the churches with their glittering golden altars.

In Rome there was a reaction against Mannerist decoration in favour of a monumental scale of ornament; but however rich it might be, decoration remained subservient to the laws of architectural space. In the Iberian world the decoration was valued for its own sake, like a mural tapestry. The churches of Palermo in Sicily illustrate this; in the 17th and 18th centuries the inside walls were lined with Mannerist ornament in the form of polychrome marble in the Florentine manner, which spread over the whole church a decorated covering of exquisite motifs drawn from the inexhaustible repertoire of grotesques, or fantastic subjects (although the eye can only distinguish at one time the few on which it rests). Examples can be seen at S. Salvatore, Casa Professa, S. Giuseppe dei Teatini, Madonna della Pietà, S. Domenico and S. Matteo. The Cappella del 963 Crocifisso at Monreale cathedral was decorated in the same spirit. The most beautiful of these decorative ensembles was in the Cappella per la Ciambretta at S. Gregorio in Messina (executed in 1688), which was destroyed by the earthquake of 1902. In 1711 the Menino Deus church in Lisbon was decorated in a similar way. During the 17th century there developed in Portugal a type of polychrome decoration which was applied even to the interiors of old Romanesque and Gothic churches, in the form of tile facings with designs which were at first in geometric patterns and later had motifs adapted from running scrolls inspired by the grotesques or by acanthus scrolls. A number of churches decorated in the 17th century are faced in this way. As in the marble ornament of the Sicilian churches, the scale of the design is much too small for the architectural surface it has to cover.

The *azulejos* were used by the Portuguese to magnificent effect during the 18th century, when the tiles were reduced to a monochrome blue and in fact took the place of tapestries, but the future of Iberian Baroque art lay less in such work than in plaster and gilded wood decoration. The Plateresque style had employed plaster work (the Villalpandos and their followers) only rarely, preferring the luxury of overall decoration in carved stone. Plaster work first began to spread in the form of plant motifs in the interiors of Hispanic churches roughly between the years 1660 and 1670. Vaults had been bare until this time, but from then on were covered with a decoration of panels and interlaces; the connection of this ornament with the Plateresque vocabulary is obvious and was certainly deliberate. This return to a tradition which had been interrupted by the Reformation (with which the name of Herrera is associated) was felt in architecture as well as in decoration. The elevation of S. Ildefonso at Saragossa, begun in 1661 by Domingo Zapata, is in a sense neo-Plateresque in style, with its bays with coupled galleries, its giant entablature and its panelled vaults with Mudejar interlace. The decorative repertory of Leonardo Figueroa, who was responsible for the Churrigueresque in Seville between 1680 and his death in 1730, had many elements borrowed from the Plateresque, as did most 18th-century Hispanic decoration. One of these was the *estípite* (to which the Portuguese *coartelão* corresponds), a paradoxical support, a sort of inverted pyramid with multiple projections on which are hung all manner of ornaments.

Baroque decoration also drew on an older source, which had

FRENCH. JEAN ANTOINE WATTEAU (1684–1721).
The Music Party. Wallace Collection, London.
Photo: Michael Holford.

FRENCH. FRANÇOIS BOUCHER (1703–1770).
The Birth of Venus. 1754. Wallace Collection, London.
Photo: Michael Holford.

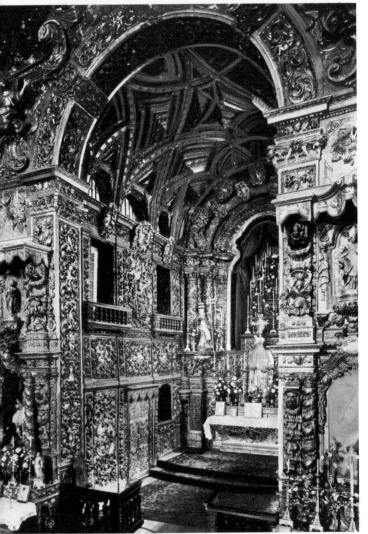

964. PORTUGAL. Interior of the chapel of São Pedro in Miragaia, Oporto. *c.* 1730–1740.

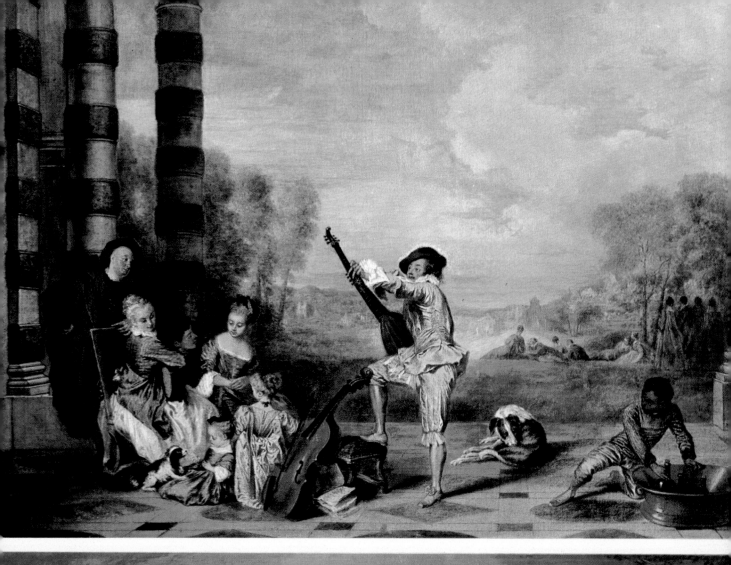

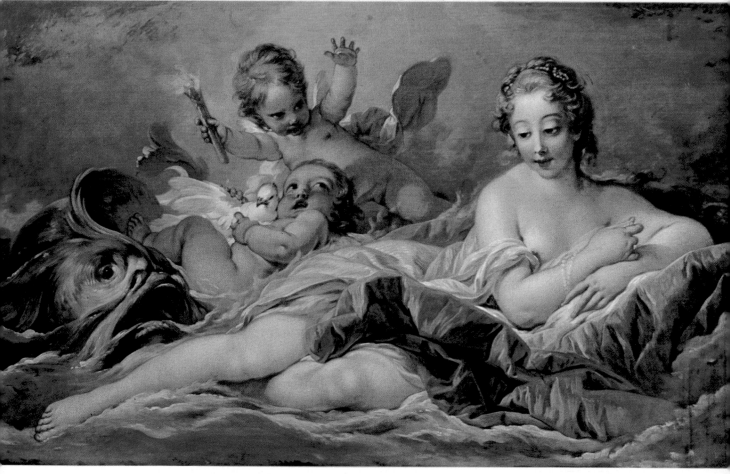

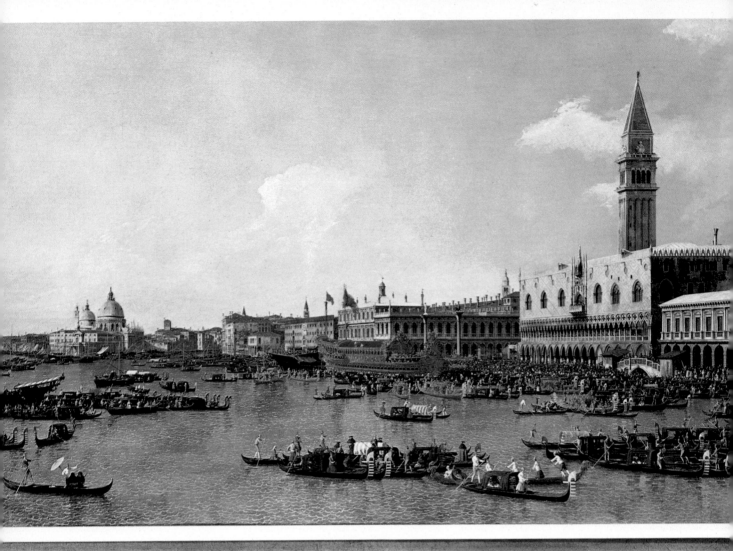

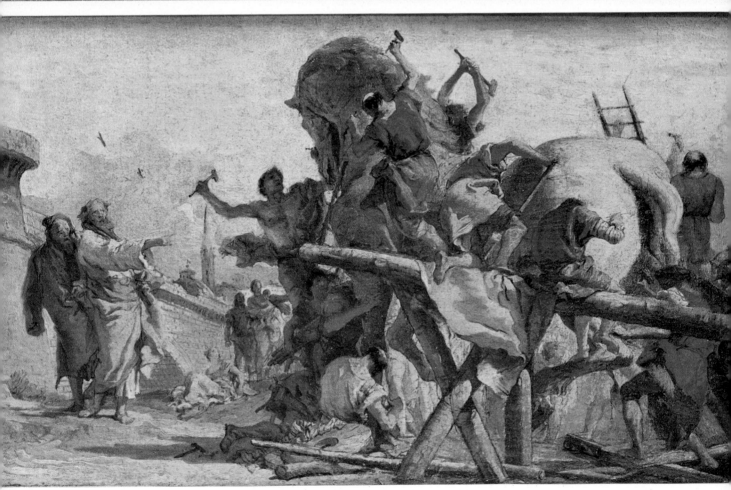

contributed to the Plateresque; this was Mudejar art which had become for Spain a kind of depository of ornamental forms. Some districts, for example Aragon, and Ecija in Andalusia, made such literal use of the Mudejar vocabulary that we can almost say that there was a renaissance of Mudejar art under the aegis of Baroque art. The Moslems had excelled in plaster work. Mudejar decorative work in wood was used into the 18th century in Spain for ceilings; the methods of the Moslem carpenters remained popular enough to form the subject of a treatise published in 1633 by Diego López de Arenas, *La Carpintería de lo Blanco*. Scalloped decoration, derived from plaques which were cut out and nailed, was the origin of the 18th-century *arquitectura de placas*, which was used exclusively by the Galicians for sculptural decoration on the outside of buildings, since their local material was granite which was unsuitable for figure carving. This gave an abstract grandeur, wholly Spanish in its harshness, to Galician architecture. Andalusia used the same motif in brick. The jerky transitions of light and shade caused by the fragmentation of the modelling in *arquitectura de placas* created a sort of rhythm which was essentially Baroque.

It was almost certainly owing to the greater liberty allowed to sculptors in the New World and to the influence of the Indian genius that the Mudejar style found even greater popularity in Mexico than in the mother country; there are many ceilings in this style from the 16th century onwards. On the *camarín* (a shrine behind the altar) in S. Martín at Tepotzotlán (1679–1688) there is a copy of a 10th-century vault in the mosque at Cordova. In the royal chapel of S. Francisco at Cholula this mosque was reproduced, paradoxically, in the Doric style. Enthusiasm for Mudejar art was so great that a Mexican architect of Andalusian origin, Fray Andrés de S. Miguel, sang the praises of its scholarly intricacies in his writings.

To this basic heritage from the Spanish mother country there was added a second one from the classical and Mannerist vocabulary of the Plateresque style; all this was then swept up in the flood of a new ornamentation based on the acanthus scroll and the twisted or Solomonic column, which made their appearance on the altarpiece.

The high altar in Iberian art

The high altar was undoubtedly the great achievement of Iberian religious art. From the Isabelline and Manueline periods — when both a Spanish and a Portuguese art emerged independent of foreign importations of the Gothic style — until the decline of this art form in the Neoclassical period, the altar went through a succession of changes which are the best illustration we have of the terms of the debate between the architect, sculptor, painter and decorator who argued about this key feature of the church. At the end of the sanctuary, which had become blind, stood this great golden cliff — on which a multitude of forms seemed to move in the semi-darkness — like a gigantic wall of faith on which the eye comes to rest and from which prayer rises. In the second half of the 17th century the Portuguese, taking their inspiration from the Romanesque portal, made of it a kind of portal into the next world. Since we can only study this important element at almost the end of its evolution, we are prevented from showing the extraordinary richness of forms in its development —

ITALIAN. VENETIAN. CANALETTO (1697–1768).
Venice: the Basin of St Mark's on
Ascension Day (The Bucentaur at the Piazzetta). *c.* 1740.
National Gallery, London. *Photo: Michael Holford.*

ITALIAN. VENETIAN. GIOVANNI BATTISTA TIEPOLO
(1696–1770). The Building of the Trojan Horse.
National Gallery, London. *Photo: Michael Holford.*

forms which were much more eloquent than the forms of architecture. About 1660 in Spain and about 1680 in Portugal the Solomonic column was introduced. The rhythm of its twisting is accompanied by the rhythm of the growth of the acanthus sprays which are executed, in their relief and their movement, on a scale commensurate with the spaces they enliven. (The height is 98 feet at the main altar of S. Esteban at Salamanca, designed by José de Churriguera.) The Solomonic columns were a Eucharistic symbol taken over from the old pagan motif of the sacred vine and were derived from the famous ' sacred columns ', Early Christian monuments which came from Old St Peter's in Rome. Bernini used them to decorate the galleries in the new basilica of St Peter's; about the end of the Middle Ages a tradition grew up that they were relics from the Temple of Solomon. 808

Important elements in Spain as elsewhere in the development of the new style of ornamentation were the temporary decorations made for the theatre and for various ceremonies, and also the purely local trends and events affecting decorators and theoreticians in different countries. José Benito de Churriguera, who gave his name to a style, became famous for a much admired catafalque he designed for the obsequies of Queen María Luisa in 1689.

The Baroque in the Iberian possessions abroad

It would be wrong to consider the overseas possessions as mere artistic dependencies of Europe. Not only did they work out their own solutions; they sometimes were in advance of the home country in their development of Baroque styles. At the beginning of the 17th century Goa used the monumental Iberian repertory with an admixture of Indian elements in the Baroque façade of São Paulo, which was half a century ahead of anything being done in Europe. Builders in Mexico may have undertaken the covering of the entire church with decorative plaster work a little before it was being done in Spain. The Puebla school of plasterers began work on the decoration of the interior of Sto Domingo at Oaxaca in 1657, and on that of the Rosary Chapel in Sto Domingo at Puebla between 1650 and 1690. 960

In Spain, it is true, Italian style plaster work was done on the ceilings of churches in Seville and Granada about 1650; this was based on the example, dating from the beginning of the century, of the cathedral at Cordova. Also, an overall decoration of acanthus scrolls was used in the church of Los Stos Juanes in Valencia at the end of the 17th century. But it is not until the 18th century that we find Baroque buildings in Spain which are as advanced as those built in Peru in the 17th century. The façades of the cathedral at Cuzco (*c.* 1657) and of the Compañía church (1651–1668), Cuzco, lead to that of S. Francisco at Lima (completed *c.* 1674), the broken pediments and overloaded decoration of which show a development quite as advanced as the portal of the Hospicio de S. Fernando in Madrid, by Pedro de Ribera (after 1722). In Brazil the development of the Rococo — which Portugal abandoned in the last quarter of the 18th century — continued and was carried yet another stage to its final form.

The Churrigueras and the Figueroas

The last phase of Spanish Baroque art in the 18th century has been called Churrigueresque after one of its creators, José Benito de Churriguera. This is a misnomer, for the art of Churriguera was only one expression of Spanish Baroque, which took various forms. A characteristic of José Benito's style is the imposition of a rhythmic unity on to the variety of forms through grandeur of proportions and precision of movement. His mastery was evident as early as 1693 in his design for the famous altar for S. Esteban at Salamanca, and he enriched 808

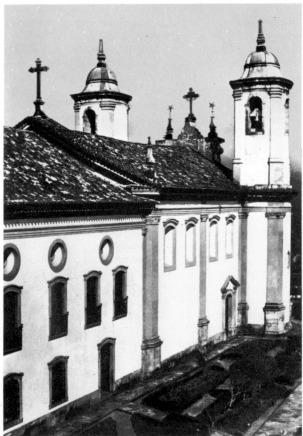

965. SPAIN. The façade, called the Obradoiro, of Santiago de Compostela. Centre portion of the façade by Fernando de Casas y Novoa. 1738–1749.

966. BRAZIL. Nossa Senhora do Carmo, at Ouro Preto. Side view. Begun 1766.

this city with many other works, in which he was assisted by his family and by other architects who carried on his style (cathedral tower; Plaza Mayor; town hall). Leonardo de Figueroa, who also had a large family, was the creator of the Baroque style of Seville, both as regards interior decoration and outside sculpture (Hospital de Venerables Sacerdotes, 1687–1697; Sta Magdalena, formerly S. Pablo, 1691–1709; Palacio de Santelmo, 1724–1734). His influence was much more important than that of José Benito, whose style was little known in Spanish America where the artists sought their inspiration mainly in Seville — the centre for the administration of the overseas territories. At Santiago de Compostela the architects achieved a powerful monumental effect from the technique of *arquitectura de placas*; under the programme of renovation of a humanist canon, José de Vega y Verdugo, the Romanesque cathedral was contained like a holy relic in a veritable shrine of stone (as was done during the same period at Sta Maria Maggiore in Rome). In 1676–1680 Domingo de Andrade built the clock tower, reviving in a Baroque guise the old Spanish form derived from the minaret; Fernando de Casas y Novoa finished the magnificent façade (called the Obradoiro) between 1738 and 1749. He was also responsible for the design of the extraordinary high altar in gilded wood in S. Martín Pinario (1730–1733).

From ornament to architecture

The true genius of the Iberian Baroque lay in the way in which it adapted the style used in decoration to architecture itself. The architect followed the carver of altarpieces. In architectural sculpture the influence of the altarpiece is first seen in the ornamental reliefs which seem to have been applied quite arbitrarily to the façades in the space between the pilasters; we see this on the Pasión façade at Valladolid (1667–1672) and on the façade of S. Cayetano at Saragossa (1681–1697), while at the Caridad in Madrid the four large *azulejos* panels on the façade are like paintings on an altar. It was perhaps in Mexico that this application of the *talla* to architecture was turned to the best account. The Sevillian *talla* was brought to Mexico by Jerónimo Balbás who made the high altar for the Sagrario of Seville cathedral, a major work which was unfortunately destroyed in the Neoclassical period and which we only know from the (one might call it sadistic) description by A. Ceán-Bermudez. Balbás introduced the *estípite* into his altar (1718–1737) for the Capilla de los Reyes (Chapel of the Kings) in Mexico City cathedral; this work had a wide influence. Lorenzo Rodriguez (c. 1704–1774) provided the Sagrario of this cathedral with a façade (1749) which was like a gigantic stone altar; the principal ornament of this façade was the *estípite*. Similar façades were on the Taxco church, at Sta María Tonantzintla near Puebla and on the Santuario de Ocotlan near Tlaxcala.

The work of Pedro de Ribera, who 'modernised' Madrid, was obviously influenced by the lavish settings created for the religious or lay ceremonies whose effect on Baroque art cannot be stressed too strongly. Ribera's portal of the Hospicio de S. Fernando (1722) and the niches on the Toledo bridge (completed 1732) — both works in Madrid — resemble catafalques or trophies; the fringed draperies on the façade of the Hospicio betray their origin plainly. With Narciso Tomé, who executed the famous Transparente chapel (1721–1732) in Toledo cathedral, architecture became completely subordinated to decoration. In this unusual monument, which defies description, architecture, sculpture and painting merge and are dissolved in the light; this

965

953

968

967

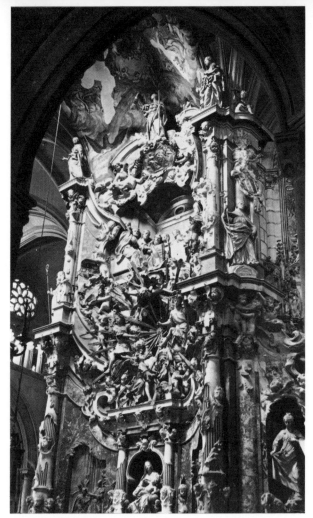

967. SPANISH. NARCISO TOMÉ.
The Transparente in Toledo cathedral. Bronze and
multicoloured marble. 1721–1732.

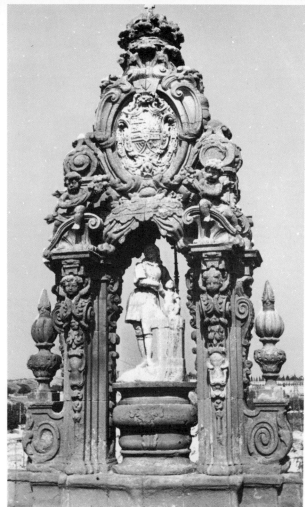

968. SPANISH. PEDRO DE RIBERA.
Niche on the Toledo bridge. 1721–1732.

969. MEXICAN. Upper part of the altar of
Sta Clara at Querétaro. c. 1730.

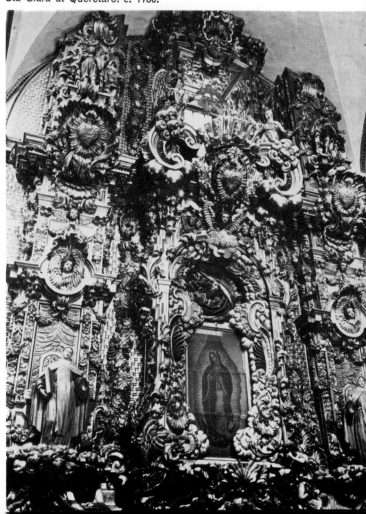

work evokes certain modern styles, in particular that of Gaudí.
The enthusiasm which greeted it is an indication of how well
it corresponded to the taste of the time. This fluid architecture
876 found a symbolic justification in the doorway of the palace of
the Marqués de Dos Aguas in Valencia, designed by Hipólito
Rovira Brocandel and carved by the sculptor Ignacio Vergara
about 1740.

The art of the Spanish colonies was infinitely complex. In
general it corresponded, according to region, to the various
styles current in the home country, although at times it was
in advance of or behind these. Mexico, where we find the finest
of the 18th-century monuments, shows clearly the two variations
of the Baroque in the New World — one which can be called
scholarly, the other popular. The churches of the former type
such as the one at Taxco might have been envied in Spain,
since they were built over so short a span of time that in both
architecture and the decoration of the altars they have a unity
which is rare in monuments of this kind. Spain with its heritage
of more than a thousand years could not offer the 18th-century
architect the opportunity that lay in the virgin soil of Mexico,
Ecuador and Peru. In churches such as Taxco (begun 1748)
and the Valenciana in Guanajuato (1765 – 1788) the interior
architecture obeyed a kind of mimesis of the *talla* in order to
adapt itself to this art form. Polychromy was often found in
Mexican churches, obtained either through the use of coloured
stones or of majolica; the latter was often used to face domes,
a procedure also employed by the Seville and Naples schools.
The Puebla decorators even went so far as to cover entire
970 façades with polychrome *azulejos* (Sta María Tonantzintla; S.
Francisco at Acatepec). The popular style of Mexican art was
an interpretation of themes imported from Spain by indigenous

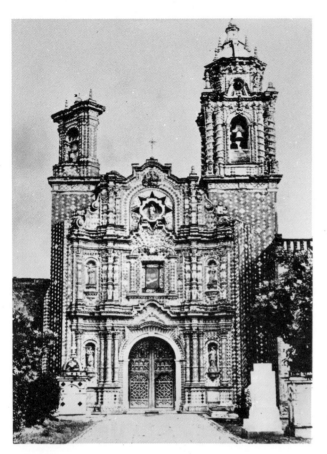

970. MEXICO. Façade of the church of S. Francisco at Acatepec (Puebla province). 1730.
The façade is entirely faced with multicoloured tiles.

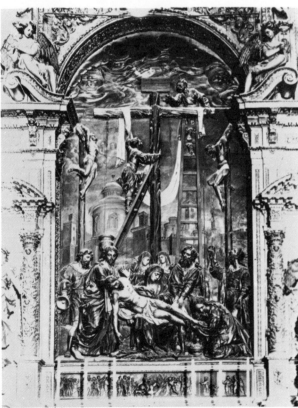

971. SPANISH. PEDRO ROLDÁN (1624-1699).
Descent from the Cross. Part of the altarpiece in the Sagrario.
Seville Cathedral.

sculptors. Although in Mexico this interpretation extended only to the actual treatment of the theme, in other regions, particularly in Bolivia (façade of S. Lorenzo at Potosí), the Baroque was enriched by the ancient local repertory of motifs borrowed from American flora and fauna; here the undercut sculpture in embroidery-like patterns, so typical of pre-Columbian times, can be seen.

Southern Italy

Despite its Spanish allegiance and its taste for heavy ornament Naples continued to be influenced by Rome, and it was Luigi 972 Vanvitelli (d. 1773) who gave the town its feeling of vast architectural space. Sicily on the other hand was caught between Italy and Spain, and this dual tradition contributed to a great richness of expression. In the 18th century Baroque art was brought to eastern Sicily after the volcanic eruption and earthquake of 1693 which necessitated the rebuilding of Catania and of a number of towns to the south of Etna. The architects of Noto, Módica and Ragusa were able to exploit the accidents 973 of the terrain to create magnificent scenic townscapes, taking as their starting point the churches and palaces, whose plans and general appearance were highly diverse. As a result these three towns, with Salzburg, rank among the finest Baroque sites in Europe. In Catania, where the ruling dynasties were the Amato and the Palazzotto, the style favoured the hypertrophic and the monstrous as at Lecce in Apulia. The taste ran to a profusion of caryatids and of brackets in the form of men or animals, under the balconies and cornices or on the window jambs. The decoration of the Villa Palagonia in Bagheria near Palermo includes a fabulous cortège along the top of the surrounding wall of grimacing gnomes, chimeras, dwarfs and puppets (which Goethe found most entertaining); no doubt the monster satisfied the desire for freedom in creation in the Baroque artist, as it had earlier lent itself to the genius for polymorphic creations of the Romanesque artist. Giovan Battista Vaccarini (1702-1768), who worked in Palermo but had trained in Rome, made a determined effort to curtail this Baroque decoration in an attempt to make the structural elements of buildings conform once more to the norms of architecture — without however resorting to the severe regulations of Neoclassicism.

If south Italian Baroque art used plethora to advantage, licence too provided it with a favourable soil. The fact that they were far from the great centres doubtless enabled Giuseppe Zimbalo and Giuseppe Cino, who built churches and palaces at Lecce, to give free rein to exuberant decoration using the vocabulary of every style including Flamboyant Gothic.

Painters and sculptors

A study of the evolution of the Spanish *talla* clearly illustrates the progressive integration of paintings and statues into the fabric of the altarpiece which was originally designed specifically to display them. The great painter of the end of the 17th century was the Neapolitan Luca Giordano, who was known in Italy 756 and Spain for the record time in which he could cover the vaults of churches and palaces with flying figures, and who could work in a number of styles. Virtuosity is of course a temptation in an art which aims at surprising more than at pleasing; in the 18th century in Naples artists such as Giuseppe Sammartino, Antonio Corradini and the Genoese sculptor Francesco Queirolo delighted in carving veiled figures or 930 figures covered by a net.

The example of Luca Giordano influenced Antonio Palomino in Spain, who in 1697 completed his painting of the *Apocalypse* on the ceiling of Los Stos Juanes at Valencia (a work unfortunately destroyed by fire during the Civil War). In the 18th century, while such a painter as Luis Egidio Melendez (or

Menendez) perpetuated the style of the preceding century in his
880 still lifes, it was the example of Tiepolo that gave rise to the
painted domes by Francisco Bayeu and by Goya in the Pilar
974 church at Saragossa. Solimena and Francesco de Mura carried
on in 18th-century Naples the practice of suspending a host
of figures in the sham space of the ceiling.

In the 17th century it was the task of the *entallador* to frame
the images produced by the sculptor or painter. In the following
century the relationship was reversed; the sculptor and painter
provided the gesticulating forms necessary to the movement
971 of the ensemble. Pedro Roldán (1624–1699) of Seville was the
last to practise sculpture in the tragic, monumental and theatrical
manner by stressing Baroque pathos in a similar way to
431 Montañés. Pedro de Mena (1628–1688) of Granada had by
this time organised the iconographic exploitation of devotional
541 images; the sculpture of his fellow citizen Alonso Cano (1601–
1667) was a forerunner of the graceful style of sculpture practised
in Granada in the following century by José Risueño (1665–1732).
In the 18th century sculpture was influenced by the style of
1082 the *presepio*, which came from Naples at the end of the 17th
century. This genre of the Neapolitan crèche which was
975 developed in Murcia by the Salzillo family (Francisco Salzillo,
1707–1783, the son of Niccolò, an Italian sculptor) from
Naples, had an influence even on large-scale statuary. This art
spread widely — to Sicily, Portugal, the Tyrol and Bavaria.
(There are reconstructions of three of these crèches in the
Museum of S. Martino in Naples, in the National Bavarian
Museum in Munich and at Caserta.) These works resemble
theatrical scenes, using hundreds of actors and bringing all the
characters from shops, fields, port and street to the Holy Family
at the centre; they are in fact the final transformation of the
bambocciata, and the Christmas figures which are made today
at various places round the Mediterranean are their heirs.

Although the artists of Naples and Spain used the details of
Rococo decoration, they ignored almost completely the Rococo
style as understood in its essential quality — the asymmetrical
division of the ornament which achieves unity of composition
by the compensation of contrapposto (twisted axis) movement.
One artist in Sicily was an exception, and he was in advance of
976 his time. The sculptor Giacomo Serpotta (1656–1732) as early
as the end of the 17th century decorated, in Palermo, a series of
small oratory chapels in stucco (oratory of Sta Cita, 1685/88–
1718; oratory of S. Lorenzo, 1699–1707; oratory of the Rosary
in S. Domenico, 1710–1717), in which the statues have a
rhythm of contrapposto movement which is a direct precursor
of the great ensembles of Swabian and Bavarian art thirty
years later. The influence of theatre art is here so obvious that
some scenes are presented in a sort of box in perspective like
a marionette theatre.

Ground plans

We have not so far discussed building plans because this purely
architectural element becomes to some extent secondary in a
monument which is conceived as decoration. The very diversity
of plans for 18th-century churches proves that there was no
further organic development; the choice of plan was no more
than a matter of pure speculation.

Thus all types of plan were used, although there was a marked
preference, especially in the New World, for the so-called
'Jesuit' plan with an aisleless nave and side chapels, a plan
which had been traditional in Spain from the 13th century;
most frequently a dome on a drum was added — a descendant
of the *cimborio* or lantern tower of the Romanesque and Gothic
periods. The Pilar church in Saragossa was a final variation
which enriched the fine plan developed in the 16th century at
Jaén and at Valladolid, which had such success in Latin America.
Houses, universities, palaces and hospitals had all found their

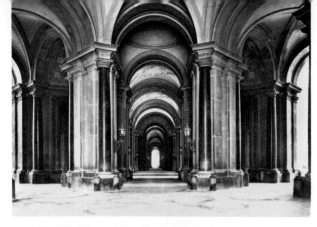

972. ITALY. View of the inner rotunda in the
palace, Caserta. Built from the plans of Luigi Vanvitelli
(1700–1773) between 1752 and 1774.

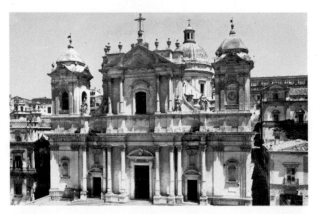

973. SICILY. The cathedral, Noto. 18th century.

974. ITALIAN. NEAPOLITAN. FRANCESCO SOLIMENA
(1657–1747). The Massacre of the Giustiniani at Scio.
Sketch. *Museo di Capodimonte, Naples.*

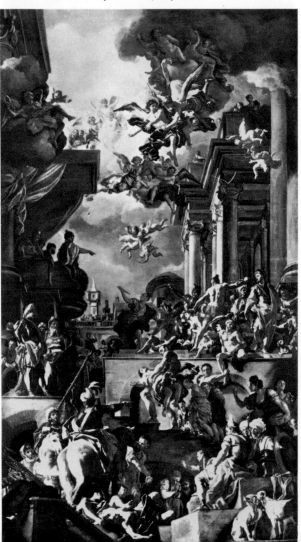

975. SPANISH. FRANCISCO SALZILLO (1707–1783). The Kiss of Judas. Detail of a paso. *Ermita de Jesús, Murcia.*

976. ITALIAN. SICILIAN. GIACOMO SERPOTTA (1656–1732). St Monica. *S. Agostino, Palermo.*

977. BRAZILIAN. ANTONIO FRANCISCO LISBOA, called ALEIJADINHO (1738–1814). Head of one of the prophets from the terrace of the prophets. 1800–1805. *Shrine of the Bom Jesus de Matozinhos, Congonhas do Campo.*

definitive plan in the Plateresque period and had retained it. Eastern Sicily saw a curious revival of the basilican plan with columns, the prototype of which was the church of S. Filippo Neri in Naples which was begun in 1592 on the plans of Giovan Antonio Dosio. The columns here are ancient ones transported at great expense from the island of Giglio which was then under Spanish rule.

The only example of functional development is provided by the Luso-Brazilian churches. The Portuguese architects of the 17th and 18th centuries reacted against the plan of the aisleless nave with side chapels, and to improve upon some of its disadvantages they were led to create a new form of religious building, the corridor church (with inner and outer walls and a corridor between). Their logical spirit then led them on to integrate into the central structure all the supplementary structures pertaining to the life of the parish (sacristies, etc.) which in other countries were left as outworks; in the second half of the 18th century however, the characteristic Baroque taste for experiment caused this plan to be modified in the interests of elegance.

The Luso-Brazilian style

Luso–Brazilian art is distinct from Spanish art and, strangely enough, comes close to German in its unreserved adoption of the Rococo. At the end of the 17th century the Portuguese church consisted above all of an interior where the gilded wood-carvings glittered over the entire surface of the walls. The gigantic undertaking at Mafra which brought many Italian artists to Portugal under the direction of Ludovice served as a workshop to which Portuguese artists came to learn the principles of Baroque form; they derived from this work a highly individual style. In the southern province of Alemtejo this style followed architectural requirements more closely; in the north at Braga and Oporto it developed into a Rococo, with the emphasis on sculpture of an overloaded, turgid and naturalistic character which seems to have been a tardy renascence of Manueline art. This tendency was reinforced in the north by the arrival of the Italian Niccolò Nasoni. In Brazil **949** the style from the home country gave rise to new forms in Bahia, Pernambuco, Rio and Belém (Pará), and resulted in the school of Minas Gerais. Portuguese Rococo reached its zenith in this last school with the Portuguese architect Manuel Francisco Lisboa (active 1728–1767) and — even more — with his son, Antonio Francisco Lisboa (1738–1814). The latter was **977** born in Brazil of a Negro slave mother. A hideous infirmity affecting his hands and feet gave him the appellation ' Aleijadinho '. He reformed the art of wood-carving, modifying its Baroque exuberance, and he brought a new purity to architecture by reverting to the concept of harmonious space. He was also the author of much excellent statuary in the pathetic style of the great Baroque works of the past. Indeed, Aleijadinho, Serpotta and Feuchtmayer were the greatest Rococo sculptors. **976, 946**

The Neoclassical reaction found a good starting point in the Madrid Academia de Bellas Artes. Foreign artists also helped the new movement — for example Raphael Mengs and G. B. Sacchetti (the successor to Juvarra on the building of the royal palace, Madrid). Ventura Rodriguez furthered this trend in architecture.

In Portugal the Lisbon earthquake and fire of 1755 caused rapid rebuilding conceived on the principle of prefabrication. This was in accordance with the taste of A. F. Pombal, who was in charge of the reconstruction. The Rococo continued for another twenty years in the northern part of the country, until it finally succumbed to the Anglomania which came via Oporto. In Brazil however the Rococo was still at its height in the state of Minas Gerais, and fine work was produced in the style even after the turn of the century.

THE QUEST FOR INDIVIDUALITY *Marcel Brion*

*By opposing the abstract and general rules of classicism with the
immediacy of life itself, Baroque art became one of the
great liberating forces of that individual expression which
Protestantism had also furthered by opposing
Catholicism with a less collectively organised religion.
But individualism itself effected a profound revolution, replacing
collective man — who was primarily an adherent of
his church — with individual man; this was the source of
19th-century Romanticism and of the modern
developments in art.*

The Baroque practice of valuing 'character' above all else, and
the psychological analysis of the intelligence and the sensibility
pursued by classicism, combined in the 18th century to form
a new concept of life. This new attitude led (if we except court
and religious art, which often remained superficial, ceremonial
and formal) to the portrayal of what is most individual in a
man or what is most specific in some aspect of nature or in
an object. The new concept found expression in the increasing
emphasis on a more intimate approach to living (intimate
apartments became more popular and smaller furniture more
usual), in the quest for pure enjoyment and in the desire to
surprise and to stir the emotions, whether complex, shallow
or troubled.

The portrait as a key to the individual

The aim was to divert and at the same time reveal that which
is most individual in each person — to accentuate the feature
which defines a personality — and to give an account of the
mysterious inner life which lies beyond this visible and material
individuality — of its psychological complexity and its many
nuances of feeling.

The new way of looking at nature, landscape and objects
favoured the creation of new relationships between external

978. FRENCH. JEAN ANTOINE HOUDON (1741–1828).
Bust of Sabine Houdon, eldest daughter of the
sculptor. 1792–1793. *Louvre.*

979. GERMAN. FRANZ XAVER MESSERSCHMIDT
(1736–1783). 'Character Head'.
Österreichische Galerie, Vienna.

980. FRENCH. JEAN ANTOINE WATTEAU (1684–1721).
Head of a Man. Drawing.
Formerly in the Georges Dormeuil Collection.

DURING THE 18TH CENTURY MAN LOST HIMSELF IN NATURE BUT DISCOVERED HIS INDIVIDUALITY

REGENCY

981

981. FRENCH. ROBERT LEVRAC DE TOURNIÈRES (1667–1752). Portrait of a Family in a Landscape. 1724. *Nantes Museum.*

982. HYACINTHE RIGAUD (1659–1743). Cardinal de Bouillon. *Perpignan Museum.*

983. JEAN LOUIS LEMOYNE (1665–1755). Bust of the Duke of Orléans. 1715. *Versailles Museum.*

984. NICOLAS DE LARGILLIERRE (1656–1746). Portrait of a Young Woman as the Huntress Diana. *Louvre.*

LOUIS XV

985

985. FRANÇOIS BOUCHER (1703–1770). Brother Philippe's Geese. Detail. Gouache on taffeta for a fan. *c.* 1734. *Besançon Museum.*

986. JEAN BAPTISTE PERRONNEAU (1715–1783). The Child with the Book. *Hermitage, Leningrad.*

987. JEAN BAPTISTE LEMOYNE (1704–1778). Bust of Montesquieu. 1760. *Bordeaux Museum.*

988. JACQUES ANDRÉ AVED (1702–1766). Portrait of Madame Crozat. *Montpellier Museum.*

LOUIS XVI

989

989. LOUIS GABRIEL MOREAU (1739–1805). View of the Bellevue Hillside. *Louvre.*

990. ANTOINE VESTIER (1740–1810). Portrait of the Artist's Son, the Architect N. A. Vestier. 1783. *Formerly in the Debladis Collection.*

991. JEAN ANTOINE HOUDON (1741–1828). Bust of Mirabeau. Marble. 1800–1801. *Versailles Museum.*

992. HENRI PIERRE DANLOUX (1753–1809). Portrait of the Countess of Cluzel. *Private Collection.*

982

983

984

986

987

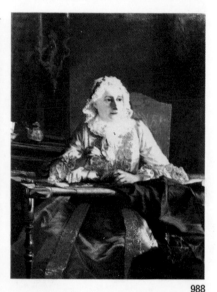

988

990

991

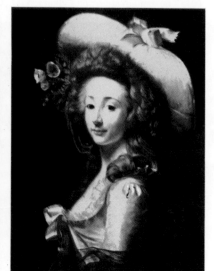

992

MASTERPIECES OF WATTEAU
(1684–1721)

993. The Fatigues of War, or Troop March. c. 1712–1715. *Hermitage, Leningrad.*

994. The Embarkation for Cythera. 1717. *Louvre.*

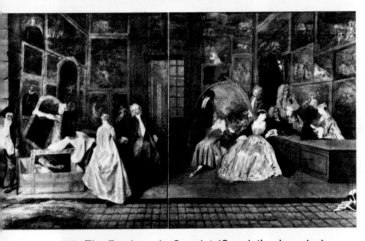

995. The Enseigne de Gersaint (Gersaint's shop sign). 1720. *Staatliche Museen, Berlin.*

forms and man's reactions to them. That passion for the strongly individual, inherited from the Baroque, was in opposition to the tendency found in classicism to fix the universal and eternal and to turn the particular into the general. It found its principal outlet in portrait sculpture, especially the portrait bust, which expresses the character and intelligence of the person. With Houdon, Pigalle, Lemoyne, Messerschmidt, Tassaert and Rou- 978, 979 billac everything which can properly be said to constitute the man was contained in the modelling of the head, in the treatment of the hair (no longer standardised by the wig) and above all in the face — the planes of brow and cheek, the curve of the lips and the brilliance of the eye. To achieve this brilliance the sculptor invented a special manner for the eyelids and pupils; he created protuberances and hollows to increase the play of light and to enliven the expression, thus endowing inert matter with vigorous life. In the same way he often employed materials which were easy to work (such as terra cotta and plaster) and which responded immediately to the caprice of his imagination or his hand. The sensitive and smoothly rounded modelling seized on the contrasts of lighting to interpret the mobility of feature and character of 18th-century man, his lively emotions and his responsiveness. Intellectualised naturalism lent itself to the portrayal of the great personalities of this period — Diderot (Pigalle), Montesquieu (Lemoyne), Mirabeau (Houdon), Moses 987, 991 Mendelssohn (Tassaert), Handel (Roubillac), Charles XI (Gaspar Schöder).

In the painted portrait we find this same desire to express the essential nature of the period. The rhythms are less violent and more restrained and introverted than in Baroque portraits; the violence is no longer contained in flying draperies but in the restless glance. Hogarth painting James Quin, the actor, Fra Galgario, the 'Painter' in the Brera Museum, Reynolds painting Dr Johnson and La Tour painting his self-portrait had all abandoned superficial lyricism and were seeking out the hidden depths in which the unique and solitary being develops his particular destiny. This destiny is expressed with a peculiar brilliance in such curious works as the *Cagliostro* by Houdon and the *Banished Lord* by Reynolds; and the insatiable, painful intensity with which La Tour delves into the enigma of each 894, 895 person transcends the limits of wisdom and reason and even borders on the insane in its fierce impatience to render the inexpressible.

Grace and unrest in Watteau

As this century was so rich in contrasts painting was able to pursue this psychological inquiry and at the same time to abandon itself to the worship of beauty for its own sake and to a delicate grace which merely brushed the surface of intelligence and feeling. More than any other period this century loved grace — a grace that was without problems and without unrest and which contained a facile harmony and a simple enjoyment. François Hubert Drouais, Mme Vigée-Lebrun, 1032, 1038 Rosalba Carriera and Gainsborough and Lawrence painted 1037, 1004 scenes of tranquil felicity and unclouded pleasure. On the other hand the study of character led to the exaggeration of some characteristic trait, either unconsciously or for a polemical purpose; indeed, caricature originated in the 18th century. This was, particularly among the English caricaturists (Gillray; Rowlandson; Hogarth), a kind of aggressive realism, a sadistic 1114, 1113 exaggeration of natural ugliness or absurdity; it was the counterpart, on the level of excessive and emotional expression, of the delight in grace which enhanced the beauty of reality and gave it a sort of poetic lyricism.

The desire to render a more graceful beauty and a more extreme ugliness than were consistent with reality was in keeping with the spirit of a period which, like all periods of transition from one cultural phase to another, suffered from malaise and

MASTERPIECES OF FRAGONARD
(1732–1806)

997. The High Priest Coresus sacrificing himself to save Callirrhoe. Picture presented to the Academy as admission piece. Salon of 1765. *Louvre*.

998. The Fountain of Love. *Wallace Collection, London*.

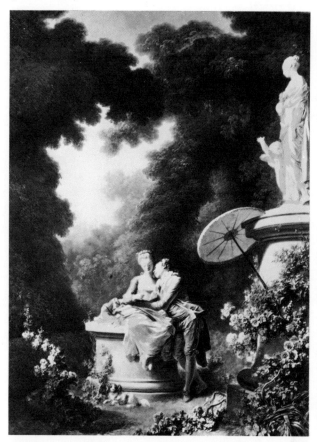

996. The Love Letters. One of four decorative panels ordered by Mme du Barry in 1771 for her pavilion, but later rejected by her. *Frick Collection, New York*.

unrest. The new ways of feeling and thinking which make up modern man freed themselves only with great effort from the intellectual and emotional habits in which and by which he had been formed. The most typical men of the 18th century were those restless spirits in whom the upheaval of ideas and society was reflected — either those whose task it was to fashion this new world and bring it into being or those who could merely observe the inevitable disruption and bear witness to it.

993 In the variety of his work with its infinite reflections of its
994 time Watteau was a perfect incarnation of this unrest. Unlike those of Lancret or Pater, his *fêtes galantes* (open-air festivities) are not mere scenes of untroubled gaiety or triumphant frivolity. Like Magnasco's *Company in a Garden* they represent the last performance, played to itself, of an era which felt its end approaching; the ground is cracking, the setting betrays its falsity and man, fearing menacing reality, takes refuge in a dream. The melancholy which pervades these gaieties is the sadness of advancing twilight, the presentiment of brutal destruction or of slow decline into old age. Watteau often borrowed forms and themes from the theatre, because the theatre is a way of denying reality and of raising up between man and real life the setting of fiction and phantasmagoria. The perspectives of trees disappearing into the distance and the people, their backs to the spectator, who are moving towards this distance are the evidence of aspirations — already Romantic — towards an infinity, an absolute quite out of reach, which a nostalgia sharpened by disillusion with reality pursues into a world of dreams and legends.

995 Even when he is intimate and realistic (as in the *Enseigne*

de Gersaint, the signboard for his friend Gersaint's shop) Watteau fills both figures and objects with a fragile beauty suggesting the precariousness of life. The total knowledge of the mysteries of the human being to which La Tour aspired, and the nostalgia for eternal happiness which Watteau gave to a natural world rarefied by dreams, were the fundamental characteristics of a period whose conscious aim was to be rationalist, hedonist, materialist and scientific. Watteau's drawing, nervous, tormented 980 and almost feverish when he is concerned with anxious looks and restless hands rather than the calm beauty of the flesh, is evident throughout the picture, often only brushing the canvas with a delicate touch as if to render it less material. As in the work of Magnasco, in which the supernatural is more evident, 922 the undertone of fantasy is near enough to the surface to shine through the transparent forms of reality.

Beginnings of Romanticism

Parallel with the various aspects of melancholy and fantasy represented in the works of Blake, Fuseli and the Piranesi of 1001, 1003 the *Prisons*, the engravings of Tiepolo and the *Caprichos* of Goya are an aspect of the Romantic spirit which, contrary to the usual belief, had its roots deep in the 18th century. Just as the Rococo was a joint product of the Baroque and classicism (perhaps one aspect or one facet of the Baroque and of classicism) so the psychological and emotional characteristics of the century of the *Encyclopedia* and of natural science, free-thinking and atheism prepared the way for both the spirit and the form of Romanticism. This century of reason was open to the wildest extremes of irrationality (Cagliostro; Mesmer; the Comte de

GRACE AND THE FANTASTIC

FRENCH

ITALIAN

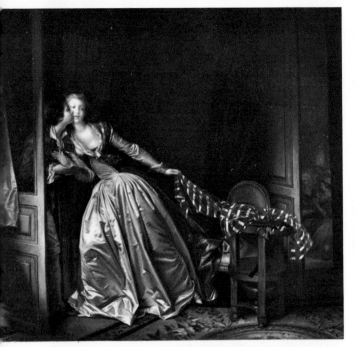

999. JEAN HONORE FRAGONARD (1732–1806).
The Stolen Kiss. *Hermitage, Leningrad.*

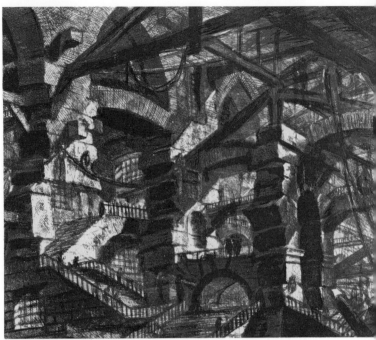

1001. GIOVANNI BATTISTA PIRANESI (1720–1778).
Engraving from the series of Prisons.
Series begun *c.* 1745 and reworked in 1761.

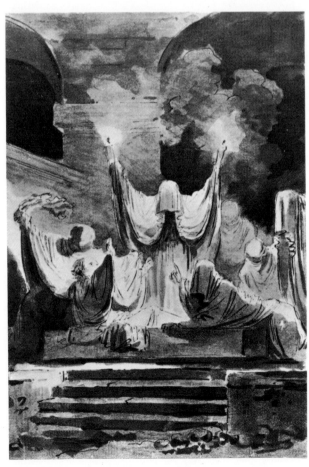

1000. JEAN HONORE FRAGONARD. Sketch for an
illustration for the Fables of La Fontaine. Wash drawing.

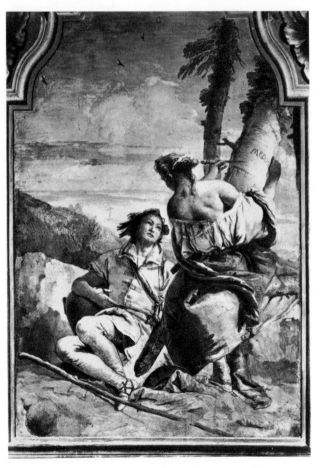

1002. GIOVANNI BATTISTA TIEPOLO (1696–1770).
Angelica and Medoro. 1757. *Villa Valmarana, Vicenza.*

1003. HENRY FUSELI (Zürich 1741 – London 1825).
The Nightmare. 1782. *British Museum*.

1005. FRENCH. JEAN BAPTISTE GREUZE (1725–1805).
The Village Bride. Salon of 1761. *Louvre*.

1004. THOMAS GAINSBOROUGH (1727–1788).
Musidora. 1780–1786. *Tate Gallery*.

Saint-Germain). Fragonard painted such works as the *Fountain* 996–100
of Love and also chronicled the naughty eroticism of *The Stolen
Shift*. Greuze spiced a fondness for innocence with all the tricks
of vice. Indeed, the art of this period evidently looked as kindly
on flights of the imagination as on the tranquil joys of intimacy.

Painting felt the influence of literature at this time; it took
its atmosphere from the theatre and its subject matter from
the novel either directly or indirectly. This passion in the 18th
century for the theatre was no longer satisfied by the dramatic
Baroque interpretation of a subject; a scene from the theatre
was preferred because it was both a refuge from the reality of
everyday life and a way of sublimating this reality by investing
it with a radiant poetry. The century which saw the blossoming
of the opera (created in the 17th century) transposed opera into
life and into the plastic arts. The *comédie larmoyante* (a sentimental
domestic drama) had a place in the sentimental compositions of 1005
Greuze; Highmore painted episodes from Richardson's *Pamela*; 1006
Chodowiecki illustrated the plays of Lessing. The different forms
of artistic expression exchanged media and sometimes confused
them. Abbé de Saint-Non takes on the stance of an actor when
he is painted by Fragonard, and the numerous portraits of
actors of this time prove that the man of the theatre was no
longer a despised mountebank and an outcast. Cornelis Troost 1007
portrays in his pastels the especially piquant moments in fashion-
able plays. At this time the landscape gardener endeavoured
to reproduce famous descriptions in best-selling novels, whence
the term Romantic (from *roman* [novel]), which appeared now
for the first time, to define this type of garden.

The 18th-century garden, influenced by landscape painting
and influencing it in its turn, was both an aesthetic and a
psychological phenomenon. It was suited to melancholy and
unrest; its twisting paths and false ruins and its buildings in
the antique manner (or upon occasion in a Gothic style) were
in keeping with the prevailing melancholy. In the classic French
garden of the 17th century a fan of rectilinear avenues radiated
from the centre, forming a sort of Louis XIV sun which
banished shade and mystery. Whether it was embodied in the
design of the so-called English garden or whether it was expressed
in a painted landscape this new feeling for nature was in tune
with the emotions of man. We see this in the work of such
painters as Watteau and Joseph Anton Koch. We have to go
back as far as that study, the *Valley of the Seine* by François
Desportes, for the first Romantic landscape; and this tendency
to treat the world of nature from an emotional point of view
which has its source in the subjective feelings of the artist can
be seen in the Italian landscapes of Fragonard, Hubert Robert,

1006. ENGLISH. JOSEPH HIGHMORE (1692–1780). Scene from Richardson's Pamela. c. 1745. *Tate Gallery*.

1019
1107

Johann Thiele, Old Crome and Richard Wilson and in the poetic landscapes of Gainsborough.

18th-century landscape painting was unrelated to the progress made in the natural sciences at this period and was based on an emotional conception of space. It was no longer a décor, more or less conforming to reality, but, as in the landscapes of the great Dutch school, it implied a unity between the observer and the observed — a kind of sentimental association of man and things. At this time the object entered (probably for the first time) into the circle of human feeling. It became yet another recipient of that sympathetic attitude which now caused the individual to endow everything with the passion which classicism had reserved for the human and the Baroque had guided towards the divine.

The concern with everyday life

The artist of the 18th century acquainted himself with things. He introduced them into the intimate scenes of that everyday life which he portrayed so frequently, giving them the value and prominence accorded the human figure. The human figure in the paintings of Chardin is reduced to the quiet and discreet simplicity of an object, whereas objects in Chardin's still lifes are raised to the powerful, autonomous and subjective dignity of human beings. Henri Roland de la Porte also respected this fidelity to the object and loved the play of coloured light over the rounded surface of a fruit.

The art of Chardin in its devotion to the real had something 1020–1023 in it of a rebellion against formalist art; by glorifying the dignity and purity of the object and by clothing it in a radiant beauty he glorified matter and pointed up the beauty that lies in the object itself. This was neither naturalism nor pantheism but was a vindication of what classicism had considered inanimate. The structure of Chardin's compositions is based on a subtle architectural feeling for form which at times anticipates Cézanne. The modest nature of the elements which go to form these compositions does not make Chardin's faithful rendering of nature any less moving, any less spiritual in character than a painting of a religious subject. Chardin's gift lay in the combination of the architectural structure, the richness of the painting and the festive visual and tactile exploitation of the unique quality of the material, such as the bloom on fruit or the soft slightly granular smoothness of porcelain.

We should take note at this point of the degree to which the religious art of the 18th century also tended towards this intimacy. Giuseppe Maria Crespi's St John Nepomuk hears the

1008. JEAN BAPTISTE PATER (1695–1736). The Bath. *Wallace Collection, London*.

1009. JOSHUA REYNOLDS (1723–1792). Lady Cockburn and her Children. 1773. *National Gallery, London*.

1010. GIOVANNI ANTONIO GUARDI (1698–1760). The Nuns' Parlour. Detail. *Palazzo Rezzonico, Venice*.

1011. ETIENNE JEAURAT (1699–1789). Interior. *Private Collection*.

1012. HENRY RAEBURN (1756–1823). John Tait and his Grandson. *National Gallery, Washington*.

1013. PIETRO LONGHI (1702–1785). The Nurse. *Museo Correr, Venice*.

1014. NICOLAS LANCRET (1690–1743). The Cook. c. 1738. *Wallace Collection, London*.

1015. WILLIAM HOGARTH (1697–1764). The Shrimp Girl. c. 1760. *National Gallery, London (on loan to Tate Gallery)*.

1016. GIUSEPPE MARIA CRESPI (1665–1747). Homely Scene. *Pisa Museum*.

1007. DUTCH. CORNELIS TROOST (1697–1750). The Declaration. *Mauritshuis, The Hague*.

INTIMATE LIFE

FRENCH **ENGLISH** **ITALIAN**

THE ARISTOCRACY

1008

1009

1010

THE BOURGEOISIE

1011

1012

1013

THE PEOPLE

1014

1015

1016

1017. ITALIAN. CANALETTO (1697–1768).
Campo di SS. Giovanni e Paolo. 1725–1726.
Pillow Collection, Montreal.

1018. FRENCH. FRANCOIS DESPORTES (1661–1743).
Landscape. Sketch. *Compiègne Museum.*

1019. ENGLISH. RICHARD WILSON (1713–1782).
Llyn-y-Cau, Cader Idris. *c.* 1774. *Tate Gallery.*

queen of Bohemia in a rough village confessional. In a famous bas-relief by Georg Raphael Donner Hagar's suffering in the desert is transformed into a scene of idyllic grace which might have been inspired by a pastorale of Salomon Gessner's rather than by the Bible. We can see here the logical evolution of the Baroque attempt, which dated from Caravaggio, to make the sacred subject natural. But even more we see a connection with the general emotional climate of a period in which mystical fervour itself was becoming humanised and was turning to the everyday world. Just as the men of the 17th century made a point of being portrayed as public characters in full dress, so the men of the 18th century wished to return to the tranquil pleasures of family life. The idyllic sentiment of the family, of meals and pleasures taken in intimacy, governs pictures of this kind. Children are loved and appear everywhere. They romp on the balustrades of Viennese staircases; they replace the nymphs of Renaissance and Baroque art on the bas-reliefs of public fountains; and the portraits of children by Michel Lepicié, Falconet, Pigalle, Drouais and Chardin are innumerable. These descendants of the putti of the Renaissance and the Erotes or Cupids of antiquity lend an air of eternal youth to the art of the 18th century. The family portrait, given its important place by the painters of the Netherlands, was more popular than ever. Zoffany, Januarius Zick, Pietro Longhi and Chodowiecki made it their favourite subject, and social gatherings themselves, now that simplicity and informality were the order of the day, became enlarged family circles. The studies of intimate social life by Moreau the Younger have a charming air of informality, as do the lamplit evening scenes with each person conversing, drawing or reading as he pleases which are portrayed by Georg Melchior Kraus, who was in the entourage of Goethe at the Weimar court.

This intimacy which now surrounded the individual, the object and the landscape was extended to mythological figures, which were transformed to suit the new sensibility. The Egyptian sphinx, used in garden statuary, acquired the forequarters of a smiling woman clothed in the latest fashion with a ribbon round her neck and flowers in her hair. In the parks classical allegory gave way to surprising or droll figures, caricatured or deformed; Moors, dwarfs, gardeners and shepherdesses introduced an element of jeering comedy into the princely gardens. This was less a taste for parody and caricature than a childish preference for what shocks or amuses, a desire for what was counter to the niceties of etiquette and for personal preference, even if puerile or in bad taste, rather than conformity.

The evolution of taste

The porcelain factories of France and Germany thus turned to the production of a new genre of small fancifully elegant polychrome sculpture. P. F. Lejeune at Ludwigsburg, F. A. Bustelli at Nymphenburg and J. F. Kändler and J. F. Eberlein at Meissen turned out quantities of picturesque fashionable figures and groups, giving personal style full rein. In Nevers miniature garden-table centres of spun glass were made which had the same freedom of fantasy. The Italian and Austrian *presepio* was part of the same taste, with its richly clothed minute figures which were so extraordinarily naturalistic in gesture and expression. Their tradition appeared again in the famous figurines by

1139

1032, 1023

1131

1041

1116

1082

ENGLISH. WILLIAM HOGARTH (1697–1764).
Chairing the Member. From the 'Election' series. *c.* 1754. Soane Museum, London.
Photo: Michael Holford.

ENGLISH. THOMAS GAINSBOROUGH (1727–1788).
Mr and Mrs Andrews. 1750. National Gallery, London.
Photo: Michael Holford.

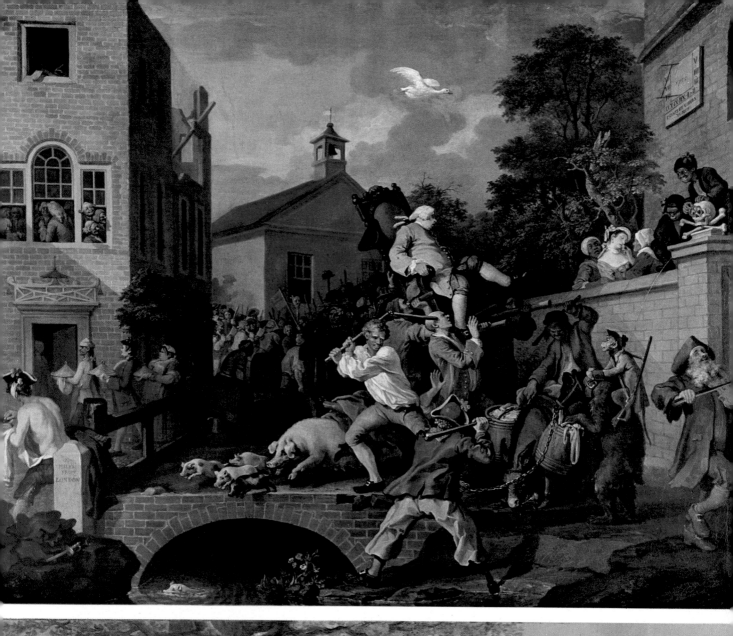

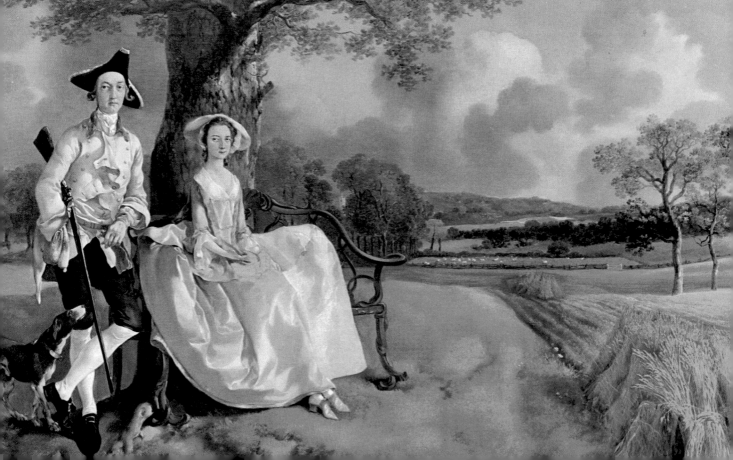

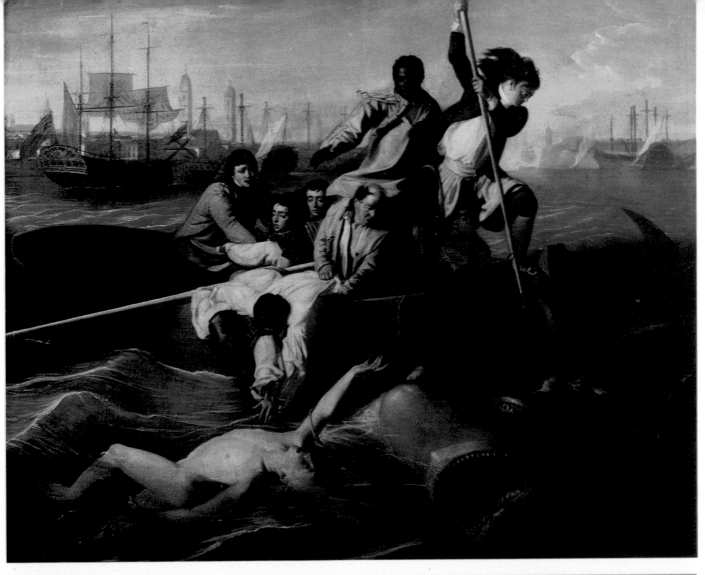

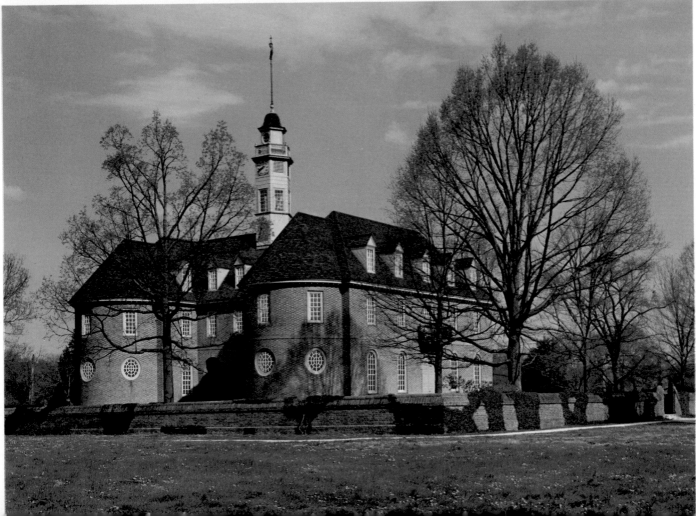

Salzillo in Spain and Portugal. Few applied arts acquired so much charm and value through individual taste and fantasy as did porcelain. Interest in the Far East came to Europe through porcelain; it grew into the craze for chinoiserie. Whole rooms in the palaces of princes were decorated with Chinese porcelain — *Lachine*, as it was called — whimsically ranged on tiers of lacquer panelling; and lacquer itself, either Chinese and Japanese or European imitations, was used to create impossible perspectives and exotic landscapes peopled with droll figures, accustoming the new sensibility to strange distances and to an unusual range of real or imaginary creations.

1115 While Wedgwood turned to 'Etruscan' classicism the continental manufacturers devised new and elegant forms and coloured decoration for porcelain, making it, together with pastels and miniatures, a characteristic expression of the taste and aestheticism of the 18th century. In the design of furniture light woods now took the place of ebony, and metal inlay was replaced by porcelain, both of them harmonising with Chinese lacquer. In keeping with the new demand for intimacy, the palette lightened at the same time as furniture and became more comfortable, more elegant and more welcoming, gaining in grace what it lost in splendour.

The spread of this taste was assisted by the increase in illustrated books, almanacs, theatre programmes, etc., which gave engravers scope for depicting daily life in its most elegant and appealing aspects. Public demand led to the appearance of a number of minor masters who were among the most representative artists of their time, both in their choice of subject and in the way in which these subjects were treated. Excellent engravers such as Charles Nicolas Cochin, Gabriel de Saint-

1041 Aubin, Hubert Gravelot, Charles Eisen, Moreau the Younger, gave a true reflection of the various and complex trends of the spirit of this century. Carmontelle's watercolours are strikingly exact renderings of the faces and attitudes of his contemporaries. Watercolour and pastel are the media which best lend themselves to conveying the rapidity of the imagination and the spontaneity of fancy. There is something of the minia-

1067 turist in Carmontelle, but he is also a raconteur, an interpreter of the fashions and manners of the time. He is true to life without displaying any satirical or laudatory intention; his work has the same veracity as those Italian and German painted wax models whose authors somehow contrived to add something outré and macabre to naturalism. We can discern in the latter the extreme attenuation of an art that was derived from those solemn funeral processions in which a life-size effigy of the dead sovereign was paraded — an effigy of painted wax, dressed in the ruler's own clothes. (This custom continued in England long after it had disappeared on the continent.)

The painted wax figures aimed at a perfect representation of life; this was also the aim of coloured engraving, a medium

840 practised by Herkules Seghers in the previous century and perfected by Christof Le Blon at the beginning of the 18th

1039 century. Stipple and crayon engraving were perfected at the same time as the colour engraving of Le Blon; the artists in all these media claimed to reproduce pictures more faithfully than could be done by etching, engraving or mezzotint. Coloured engraving and colour printing soon freed themselves from the limitation of being mere reproductions of painting and became independent art forms which reflected the spirit of the period with great success.

AMERICAN. JOHN SINGLETON COPLEY (1738–1815). Brook Watson and the Shark. 1778. Museum of Fine Arts, Boston. *Museum photograph.*

U.S.A. The Capitol, Williamsburg, Virginia. 1701–1705. *Photo: Freelance Photographers Guild.*

MASTERPIECES OF CHARDIN (1699–1779)

1020. Self-portrait, called Chardin with Spectacles. Pastel. 1778. *Louvre.*

1021. Kitchen Maid. 1739. *National Gallery, Washington.*

1022. The Ray. One of the diploma pieces for the Academy. 1728. *Louvre.*

1023. Child with a Top. Portrait of Auguste Gabriel Godefroy, son of the jeweller. 1737. *Louvre.*

History. Enlightened despotism was the ideal of nearly all the rulers. Frederick II, Catherine II, Joseph II, Joseph I of Portugal (assisted by his dictatorial minister the Marquis of Pombal), Charles III of Spain and Archduke Leopold of Tuscany all tried to improve the economic condition of their lands. They built roads and canals, encouraged agriculture and weakened the role of the Church by secularising some of the sources of revenue of the clergy and, in particular, by attacking the Society of Jesus, first suppressed by Pombal in Portugal in in 1759, then by Louis XV, then by the Bourbons in Spain, Naples and Parma. When the Society was abolished by papal decree the Jesuits took refuge in Prussia and Russia.

The emergence of new and powerful countries — Russia, Prussia and, towards the end of the century, the new United States of America — brought about changes in international relations and inaugurated modern politics.

The widespread interest in ideas, science and philosophy, the fame of such a man as Voltaire, the taste for art and for history which led to the founding of museums (British Museum, 1753) and which increased the number of collections (great collections open to the public, such as that of the king in the Luxembourg palace and that of the American Charles Willson Peale in Philadelphia), all heralded the modern era. The rise of the press and of academies and the passion for everything concerning antiquity, inspired by the discovery of the buried cities of Herculaneum and Pompeii (1748) and the Neoclassical theories of J. J. Winckelmann, Gotthold Ephraim Lessing and Anton Raphael Mengs (which had such an effect on German

19th-century thought), were all part of the new spirit.

The latter part of the century witnessed the rise of the proletariat. In 1776 the corporations were abolished in France, and in the same year the first workmen's syndicate was formed in England. Cosmopolitanism was a fundamental characteristic of the 18th century. Princes and nobles travelled all over Europe (Peter the Great, Joseph II, etc., and the Prince de Ligne who declared he had six or seven mother countries). Writers also travelled widely; Vittorio Alfieri, who was from Piedmont, explored all Europe as far as Russia and Scandinavia. Artists, especially French and Italian musicians, travelled over the entire world. Bartolommeo Rastrelli built the Winter Palace (1754–1762) for Elisabeth of Russia in St Petersburg; J. B. M. Vallin de la Mothe built the ' Little Hermitage ' (1764–1767) for Catherine the Great, which, joined to the Great Hermitage where the empress installed her collections, was to form the basis of the Russian museum.

Houdon went as far as America to make a portrait bust of George Washington; the American Gilbert Stuart, visiting Paris, painted a portrait of Louis XVI.

The art market was organised in Amsterdam and in Paris where Gersaint, the friend of Watteau, introduced auctions (at which Denis Diderot was the buyer for Catherine the Great).

This period saw the beginnings of aesthetics (*Aesthetica* by Alexander Gottlieb Baumgarten, 1750). Kant's theories of aesthetics were expounded in the *Critique of Judgment* (1790). Art history was now dissociated from the biographies of artists in the manner of Vasari. Art criticism made its appearance (Diderot's salon).

FRANCE

History. At the death of Louis XIV in 1715 Philip of Orléans, his nephew, became regent. The Scottish economist John Law was put in charge of finance. To fill the sadly depleted exchequer Law established the use of paper money, which turned out to be a disastrous experiment (1720). The Polish Succession War (Treaty of Vienna, 1735–1738, through which the French crown ultimately acquired the Duchy of Lorraine), the War of the Austrian Succession (Treaty of Aachen, 1748) and the Seven Years' War (Treaty of Paris, 1763, confirming the ruin of the French colonial empire to the benefit of England) were less onerous than the wars of the 17th century, but financial difficulties in a rapidly expanding economy made reforms necessary.

Louis XV tried in 1749 to institute equal taxation for all by exacting a twentieth. This resulted in a revolt of the privileged, the ' tax war ', and the dissolution of the parlement.

The accession of Louis XVI (1774) roused hopes that the reforms would be carried out under the ministry of Turgot (Baron de Laune), a champion of liberalism and a friend of the physiocrats and philosophers of the time. After the failure first of Turgot and then of Jacques Necker, Louis was obliged to summon the States General at Versailles on 5th May 1789. The distressed condition of the populace, particularly in Paris, the ineptitude of king and court, the symbolic capture of the Bastille and the unrest in the provinces made the role of the National Constituent Assembly pre-eminent. The Assembly issued the *Declaration of the Rights of Man* (1789), and by the Constitution of 1791 absolute monarchy was abolished and legislative power was invested in an assembly. The National Convention (September 1792 – October 1795) founded the Republic, condemned Louis XVI to death, legislated public instruction, imposed the metric system, standardised weights and measures and united the five academies to form the Institute. Popular revolutionary vandalism, however, could not be checked. The Terror raged until the execution of Robespierre on 28th July (10th Thermidor) 1794. The Directory (October 1795 – November 1799) was beset with financial and internal difficulties, but it triumphed at the Treaty of Campo Formio thanks to the military genius of General Napoleon Bonaparte (Italian campaign). Returning from the Egyptian campaign Bonaparte took power by the coup d'état of 18th Brumaire (9th November) 1799.

The growth in overall population (18,000,000 in 1715; 26,000,000 in 1789), the beginnings of industrialised production and of modern finance, the introduction of English techniques into metallurgy, the foundation of Creusot, centre of heavy industry, the establishing of the Bourse (Stock Exchange) in 1724 and the backward state of agriculture contributed to the growth of urban population.

Religion was no longer pre-eminent; the bad example of the Regency, the libertinage of the court, the mockery of Voltaire and the materialistic scepticism of the encyclopedists led up to the fanatical atheism of the revolutionaries.

Language. French replaced Latin as the language of diplomacy (the Treaty of Rastatt, 1714, was drawn up in French) and became the language of science (memoirs of the Berlin Acad-

1024. FRANCE. Place de la Concorde, by Jacques Ange Gabriel. 1754. Engraving by François Denis Née. 1781.

1025. GUILLAUME COSTOU (1677–1746). One of the Marly horses. 1740–1745. *Place de la Concorde, Paris.*

1026. NICOLAS SÉBASTIEN ADAM (1705–1778). Mausoleum of Queen Catherine Opalinska. Detail. 1749. *Church of Bonsecours, Nancy.*

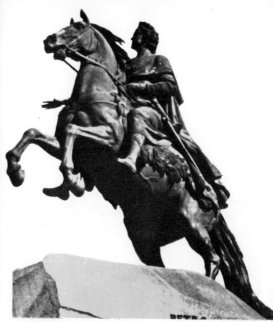

1027. ETIENNE FALCONET (1716–1791). Equestrian statue of Peter the Great. 1766–1778. *Admiralty Square, Leningrad.*

emy of Sciences published in French), of literature (*Mémoires* of Casanova and *Théodicée* and *Monadologie* by Leibnitz were published in French) and of the social world and the salons. (Frederick II of Prussia wrote in French.)

Literature. The first half of the century was the period of reason in literature (Voltaire and the encyclopedists) and of sensualism in philosophy (Etienne Condillac and his *Traité des Sensations*, 1754), but after 1760 or thereabouts literature discovered the enjoyment of sentiment (Jean Jacques Rousseau) and a wave of Anglomania followed (success of Samuel Richardson, translated by Abbé Prévost, of Macpherson-Ossian, translated between 1760 and 1774, and of the actor David Garrick who came to play Shakespeare in the salons after 1751; translation of Shakespeare by Le Tourneur, 1776–1782). The greatest French lyric poet of the century was André Chénier (1762–1794).

Writers and artists often travelled throughout Europe. Voltaire went to Prussia; Diderot and Bernardin de Saint-Pierre travelled as far as Russia. They learnt foreign languages. Foreigners came to Paris (Leibnitz, Hume, Horace Walpole, Benjamin Franklin, Hogarth, Sir Joshua Reynolds and others). Cosmopolitanism and encyclopedism became the characteristics of French intellectuals, who preached an ideal of lucid, tolerant humanism which was expressed in the *Declaration of the Rights of Man* in 1789. Both Montesquieu (*Lettres Persanes*, 1721; *L'Esprit des Lois*, 1748) and Voltaire (*Lettres Philosophiques sur les Anglais*, 1734; *Siècle de Louis XIV*, 1750–1753; *Essai sur les Mœurs*; *Dictionnaire Philosophique*) breathe this spirit; Voltaire settled in Ferney after 1754 and exer-

1028. JEAN BAPTISTE PIGALLE (1714–1785). Mme de Pompadour as the Goddess of Friendship. Terra cotta. 1753. *J. P. Polaillon Collection.*

1030. JEAN JACQUES CAFFIERI (1725–1792). Bust of Canon Pingré. 1789. *Louvre.*

1029. ROBERT LE LORRAIN (1666–1743). The Horses of the Sun at the Drinking Trough. *c.* 1740. Detail from the entrance to the mews. *Hôtel de Rohan, Paris.*

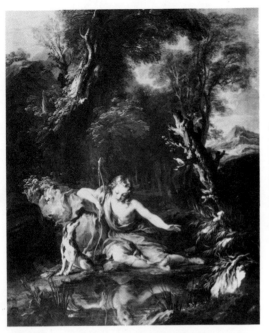

1031. FRANÇOIS LEMOINE (1688–1737). Narcissus. *Kunsthalle, Hamburg.*

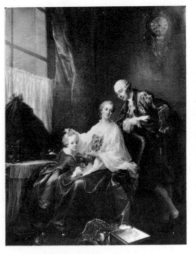

1032. FRANÇOIS HUBERT DROUAIS (1727–1775). Family Portrait. *Private Collection.*

1033. JEAN BAPTISTE OUDRY (1686–1755). The Wolf Hunt. *Nantes Museum.*

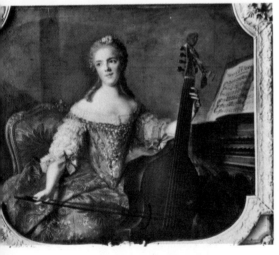

1034. JEAN MARC NATTIER (1685–1766). Mme Henriette. *Versailles Museum.*

1035. JOSEPH VERNET (1714–1789). The Neapolitan Gondola. *Private Collection.*

cised a literary dictatorship by means of his letters. Diderot and others published the *Encyclopedia* between 1751 and 1765. Rousseau (*Discours sur l'Inégalité*, 1755; *Nouvelle Héloïse*, 1761; *Emile* and the *Contrat Social* [*Social Contract*], 1762; the *Confessions*, 1781) brought about a virtual revolution in the realm of ideas.

Science. The passion for learning was general. Scientists wrote in clear and elegant French (Bernard Fontenelle, *Entretiens sur la Pluralité des Mondes*; R. Réaumur; the Comte de Buffon, *Natural History*; J. L. Lagrange, mathematician; Pierre Maupertuis, mathematician and astronomer; Antoine Lavoisier, creator of modern chemistry [1771, experiment on the composition of air]; the brothers Montgolfier — 1783, ascent of their balloon). In 1793 the metric system was adopted.

Music. French music maintained its originality in the earlier part of the century in spite of the Italian influence which dominated Europe. After 1760, however, it was swept along in the Italo-Germanic current. It was mainly religious and above all vocal. French opera after Jean Baptiste Lully (André Campra; André Destouches) reached a new peak with Jean Philippe Rameau, 1683–1764 (*Indes Galantes*; *Castor et Pollux*), who also revised the theory of harmony (*Traité de l'Harmonie*, 1722).

Artistic climate. Academies were all-powerful in the arts, and unity of purpose was provided by the director, whose power and long term of service ensured the best use of artistic resources despite financial difficulties. The academies were copied abroad (Academy

of Berlin) and the directors were often French (Louis Lagrenée in St Petersburg). The Académie des Beaux-Arts welcomed artists from other countries (Sebastiano Ricci; Rosalba Carriera; Gustaf Lundberg; A. Roslin).

After 1750 a part of the royal collection was on exhibition in the Luxembourg palace. Diderot, in the *Encyclopedia*, proposed a museum plan for the Louvre. D'Angivillier organised a museum in 1774 for the Grande Galerie of the Louvre; he bought pictures for the royal collection (especially Dutch paintings). The Grande Galerie opened in 1793 and closed shortly afterwards.

The Convention was responsible for the Museum of Natural History, the Museum of French Monuments and the Museum of Arts and Crafts; the Consulate opened fifteen departmental museums, among them the ones in Brussels, Geneva and Mainz.

Salons were numerous and influential and the art-lovers (Pierre Crozat; the Comte de Caylus) had become more discriminating; these two factors created a need for art criticism, which became a literary genre. Diderot was a leading critic (*Essai sur la Peinture*, 1765; salons of 1759–1771, 1775 and 1781). Abbé du Bos (1670–1742) wrote his *Réflexions sur la Poésie et la Peinture*, in which he demanded that art should 'touch'.

Architecture. *Theory.* Academic discussion hinged on the quarrel between the moderns and the ancients, between Perrault on the one hand, who maintained that beauty has its foundation in habit and who came out in favour of technical progress (a notion dear to the 18th century), and Blondel, enamoured of Platonic beauty, on the other. The Academy preserved Blondel's rule

1036. SWISS. ANGELICA KAUFFMANN (1741–1807). Self-portrait as a Sibyl. *Gemäldegalerie, Dresden.*

1037. ITALIAN. ROSALBA CARRIERA (1675–1757). Self-portrait. Pastel. *Academy, Venice.*

1038. FRENCH. ELISABETH VIGÉE-LEBRUN (1755–1842). Portrait of Marie Antoinette with a Rose. *Versailles Museum.*

of proportions and always classified decoration as being on a lower level of importance. The taste for the noble and formal gave way to elegance and fantasy. The new function of decoration was but to amuse and please rather than to impress. Flowers, imaginary foliage, fantastic animals, rock-work, bergeries (scenes of shepherds and shepherdesses), chinoiseries, singeries (scenes with monkeys) [**1055**], carved or painted, provided a decorative vocabulary of unique invention and richness. The second half of the century turned resolutely away from the Rococo, which was so opposed to the French love of symmetry and balance, and returned to the antique, the classical. This was due to the influence of Germain Soufflot of the French Academy in Rome, who sent young architects to Paestum (influence of Piranesi), Herculaneum and Pompeii, and of the theoreticians (P. Laugier). 'Everything in Paris is in the Greek style,' said Grimm in 1763. Peristyles, pediments and Doric columns abounded, and decoration was a pastiche of the antique. However, in 1771 J. F. Blondel drew attention to the fact that some architects were preoccupied with Gothic art and were studying Gothic buildings.

The long battle between the architects (J. F. Blondel maintained in 1737 that 'architecture must always be superior to ornament') and the Rococo decorators, the efforts of Charles Cochin and of art-lovers such as Lalive de Jully and in particular the Comte de Caylus — a scholar and collector of antiques — all of whom sought a model of simplicity and purity in antiquity, resulted in the development of the Louis XVI style. This style

was a perfect blending of proportion, balance and comfort, with none of the coldness of the Neoclassicism of the early 19th century. Anglomania accentuated the antiquarian tendency by introducing the Palladian style then fashionable in London.

Architects. As in the time of Louis XIV, there were families of architects who handed down from father to son or son-in-law the taste for tradition but who concentrated now on convenience and comfort. After Robert de Cotte [**717, 735**], a brother-in-law of Mansart, Gabriel Boffrand (1667–1754), a pupil of Mansart, was the most creative architect of the Regency (St Jacques at Lunéville [**932**]). Jacques Gabriel III (1667–1742), a relative of Hardouin Mansart (hôtel de Peyrenc de Moras-Biron [**725**]), J. M. Chevotet (château of Champlâtreux) and J. Aubert (Chantilly; abbey of Châalis) were all good architects. Juste Aurèle Meissonier (1695–1750), of Italian origin, and Gilles Marie Oppenort (1672–1742), of Dutch origin, whose decorative inventions were spread by engravings [**886, 920**], gave a strong impetus to the Rococo. Jean François de Cuvilliés (1698–1768) made a brief stay in Paris. Jean Nicolas Servandoni (1695–1766), born in Florence, a designer of sets for opera, was a Rococo decorator and a classical architect (façade of St Sulpice, Paris, 1732–1737).

The greatest architect under Louis XV was Jacques Ange Gabriel (1698–1782), a pupil of his father Jacques, whom he succeeded as chief architect in 1742; he had never been to Italy, and he developed a purely French style which established the continuity between the

art of Mansart and Neoclassicism. His two masterpieces were the Place de la Concorde in Paris [**1024**] and the Petit Trianon at Versailles (1762–1764) [**715**]. His numerous buildings include the Ecole Militaire, Paris (1751–1775), and the Versailles Opéra (1753–1770). His contemporaries included Pierre Contant d'Ivry (Arras cathedral), Jacques Germain Soufflot (1713–1780), who was influenced by Italy and the antique [**730**], J. F. Blondel, Vallin de la Mothe and La Guêpière [**732, 734**], all of whom made important contributions to French architecture.

There followed a generation which was extremely classicistic, working in the style introduced by Soufflot at Ste Geneviève (today the Panthéon) [**730**]. Among them were Victor Louis who worked in the provinces at Besançon and at Bordeaux, where his masterpiece the Grand Théâtre [**726**] is, and also Claude Nicolas Ledoux (1736–1806) — a powerful imaginative genius, influenced by Palladio and the antique as seen through the eyes of Piranesi — few of whose works survive (hôtel d'Hallwyl, Paris; château of Benouville; the salt works of Arc et Senans [**727-729**].

Churches. Few new churches were built in Paris but many were built in the provinces. St Sulpice (Paris), begun in the 17th century by Le Vau and Gittard and continued by Oppenort who worked on the nave and on the two lateral portals, was completed by J. N. Servandoni, who added the façade with two towers and a colonnade which contrasted with the interior decoration of Rococo wood work. Ste Geneviève, today the Panthéon [**730**], is typical of the antiquarian taste

FRENCH ENGRAVING

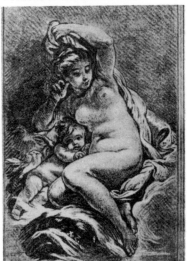

1039. Nymph, by Boucher. Stipple engraving by Louis Marin Bonnet.

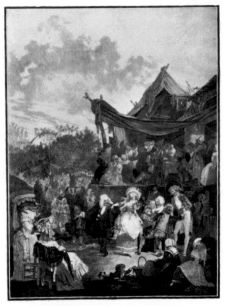

1040. The Bride's Minuet. Painted and engraved by Philibert Louis Debucourt. 1786.
Bibliothèque Nationale, Paris.

1041. The Game of Whist, by Moreau the Younger. Engraved by Jean Dambrun. 1783.

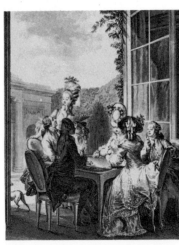

of the last quarter of the 18th century. Soufflot tried to resolve the problem of lightening the dome, which rose above a ground plan in the shape of a Greek cross treated like a basilican plan. At the church of the Madeleine, incomplete at the time of the Revolution, Contant d'Ivry and later G. M. Couture were purely imitative. The cathedrals of Versailles (1743–1754), La Rochelle and Montauban are in the typical Baroque style of Louis XV. Rococo taste and the linear light style of Louis XVI are particularly evident in interior decoration, in the wood work [**1052, 1058, 1059**], choir stalls, grilles, altars and baldachini, and organs. These redecorating activities were often regrettably accompanied by the destruction of what had preceded them.

An exception of some curiosity is Ste Croix at Orléans, which was reconstructed in the Gothic style.

Secular architecture. Versailles was abandoned at the death of Louis XIV. Louis XV when a baby lived at the Tuileries and did not return to Versailles until 1722. His main concern was to make pleasant apartments out of the ceremonial palaces. Mme de Pompadour was responsible for a number of buildings. She had Louis XV commission J. A. Gabriel to build the Ecole Militaire. Gabriel worked at the Louvre and at Versailles, where fortunately financial difficulties interrupted the project for the architectural reconstruction of the palace. Under Louis XVI the alterations at Versailles and the Temple of Love and the hamlet at the Petit Trianon, created for the queen by Mique, continued the work of Gabriel.

The crisis of austerity at the end of the reign of Louis XIV did not prevent the princes of the blood and powerful nobles from building or improving residences in Paris and Versailles, as well as their châteaux, with rich decoration in the style of Bérain. The Duke of Orléans employed Oppenort at the Palais Royal from 1712 onwards; Chantilly was redecorated and Aubert built the stables there (1721–1736; one of the finest monuments of the period). The Duchess of Maine had a menagerie built at Sceaux by La Guêpière. Magnificent work was done at the hôtel de La Vrillière (Banque de France) [**1052**]. Pierre Alexis Delamair built the hôtel de Rohan and the hôtel de Soubise (Archives) for the Soubise family. The social centre of Paris changed during the century; the old Marais went out of fashion and was replaced by the faubourg St Germain, which grew rapidly (hôtels Matignon, Lassay and Salm by P. Rousseau; hôtel Monaco by A. T. Brongniart). At the same time the faubourg St Honoré, the rich neighbourhood of the financiers, and the Chaussée d'Antin, were created. Outside in the country (Passy; Chaillot;

FRENCH MINOR ARTS

1042. FRENCH. Dish with polychrome decoration of double cornucopia. Rouen. Rococo. 1740–1770. *Musée de la Céramique, Rouen.*

1043. FRENCH. Dish in pink monochrome decoration, with gold (Fouque). Moustiers. Low fired. 1759–1790. *Akas Collection.*

1044. FRENCH. Tureen by François Thomas Germain. Silver. 1757. *Lisbon Museum.*

1045. FRENCH. Pygmalion and Galatea. Sèvres biscuit by Falconet. 1763. *Musée des Arts Décoratifs, Paris.*

1048. FRENCH. Book binding in morocco leather by the Derôme family. *c.* 1750. *Bibliothèque Méjanes, Aix en Provence.*

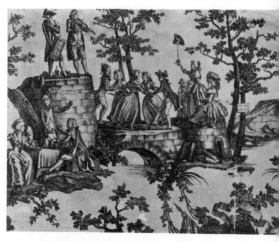

1049. FRENCH. The Dance in front of the Bastille. Jouy cloth. End of the 18th century.

1046. FRENCH. Portière showing Juno. One of a set of eight portière panels of the Triumph of the Gods, designed by Claude Audran III. Gobelins. Series in high warp with gold ground and border. c. 1699.

1047. FRENCH. Louis XV. Obverse of the commemorative medal of the union of Corsica with France (1770). Engraved by Roëttiers. *Cabinet des Médailles, Bibliothèque Nationale, Paris.*

Auteuil) there grew up towards the end of the century a taste for princely hermitages and charming luxurious follies. Mme Du Barry's pavilion at Louveciennes, built by Ledoux (1771), and Bagatelle by F. J. Bélanger, built for the Count of Artois, were the finest examples.

In Paris the number of houses built for letting was growing apace, and this contributed to the growth of speculative building. (The architects participated: R. de Cotte, Boffrand, Brongniart.) It was an important period of town planning, of light and commodious ensembles having perfect proportions and showing great technical skill. The Place de la Concorde (1754) by Gabriel was the masterpiece of all royal squares [1024]. In the provinces commercial riches and emulation of the capital led to frantic building activity. Rennes was rebuilt after the fire of 1720 by Robelin and J. Gabriel. Châteaudun, Nantes, Dijon, Tours and Orléans were all planned round their main roads or bridges. At Lyon, where Soufflot worked, and at Montpellier and the Provençal cities promenades, fountains, theatres, great squares and town halls were built. Nancy was given an admirable Rococo ensemble (the work of Emmanuel Héré) which is enhanced by the splendid wrought-iron work of a native of Nancy, Jean Lamour [772]. Bordeaux was the prototype of fine 18th-century towns with its Bourse (J. A. Gabriel), its quays, its Grand Théâtre [726] and its town hall and bishop's palace.

Gardens. The garden *à la française* in the style of Le Nôtre continued to be laid out until about 1750. Its design included sheets of water and decorative parterres, but this type of garden was now condemned by Dezallier d'Argenville and J. F. Blondel, who advocated the 'beautiful simplicity of nature'. Flowerbeds, baskets of flowers, wooden trellises (designed by Roubo), winding paths and 'English lawns' heralded the beginning of the new style. The most beautiful gardens were Bellevue (for Mme de Pompadour), Champs, Brunoy, and those in Provence (Barbantane, Entrecasteaux, Bouc, Tourves, etc.), where the use of statues and buildings was in the classical tradition.

The general climate of ideas (Rousseau, in the *Nouvelle Héloïse*, criticised the French garden) together with the growing Anglomania combined to bring the English garden or 'natural garden' into fashion (to which Chinese fantasy was added to make those 'never-never lands' of 'every age and every place' which were already completely Romantic). Watelet published his *Observations sur le Jardinage Moderne* in 1771; it contained a standard theory of building an English garden, advising the addition of a cemetery in a park and ornamental farms, thereby paving the way for the 'hamlet'. Examples of this type of garden are: Raincy; the Parc Monceau in Paris, laid out by Carmontelle (1779); Ermenonville; the garden of Marie Antoinette and the hamlet of Trianon; Bagatelle; Méréville, by Hubert Robert, the loveliest park of all.

Sculpture. Baroque influence is more apparent in sculpture than in painting and can be seen in the three members of the Coustou family who worked at Trianon and Marly. The sons and grandson of François Coustou and the nephews and pupils of Antoine Coysevox, they were: Nicolas (1658–1733), Guillaume (1677–1746; Marly horses [1025]), and Guillaume's son Guillaume the Younger (1716–1777). Baroque influence can also be seen in Robert Le Lorrain (1666–1743), a pupil of Girardon (choir stalls at Orléans; work on the hôtel de Soubise and the hôtel de Rohan: the *Horses of the Sun* [1029]). The Lemoyne family

FRENCH STYLES
REGENCY **LOUIS XV** **LOUIS XVI**

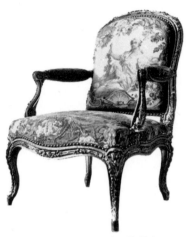

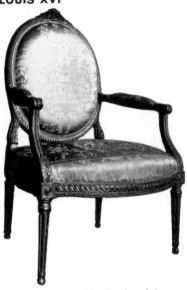

1050. Armchair. *c.* 1725. *Musée des Arts Décoratifs, Paris.*

1053. Armchair, by the Foliots. *c.* 1770. *Louvre.*

1056. Armchair. *Musée des Arts Décoratifs, Paris.*

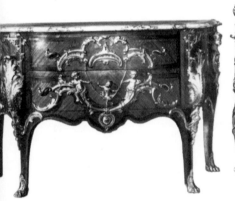

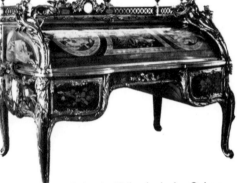

1051. Commode, by Charles Cressent. *c.* 1745. *Wallace Collection, London.*

1054. Louis XV's desk, by Oeben, Riesener, Duplessis, Winant and Hervieux. 1760–1769. *Louvre.*

1057. Commode, by Carlin. *Louvre.*

1052. Doorway of the Golden Gallery (restored in the 19th century). *Hôtel de La Vrillière (Banque de France), Paris.*

1055. Panel of the Grande Singerie at Chantilly, by Christophe Huet.

1058. Door of the boudoir of Marie Antoinette at Fontainebleau. Decorated by the brothers Rousseau. *c.* 1785.

FURNITURE IN FRANCE
IN THE 18TH CENTURY

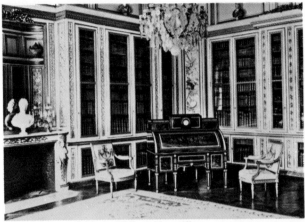

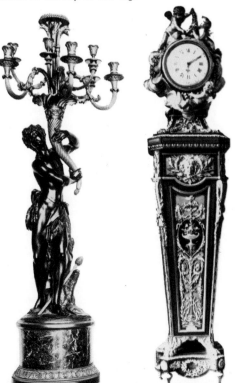

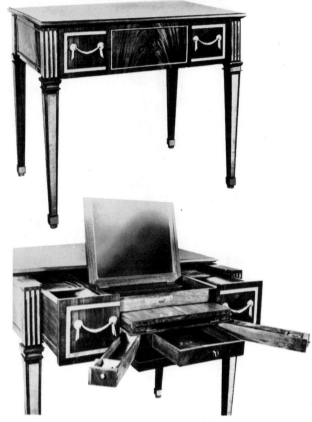

1059. Library of Louis XVI at Versailles.
Planned by Gabriel in 1774; decorated by the
brothers Rousseau; mantelpiece in white marble with
caryatids by Boizot and bronzes by Gouthière.
Bust of Marie Antoinette by Gross.

A: Louis XIV; B: transitional; C, D, E: Louis XV;
F: transitional; G, H: Louis XVI

1060. Evolution of style of the chair leg (drawing after
Le XVIIIe Siècle, published by Hachette).
The 18th-century curved chair leg appeared between the
ornamented straight chair leg of the Louis XIV style and the
plain straight chair leg of the Louis XVI style;
the curved leg corresponded to the substitution of foliage
decoration with its living forms for geometric themes.
The curve developed into a double S-curve which
continued for a long period; the decoration gradually
receded to the top of the leg.

1063, 1064. Convertible furniture. Toilet table by
David Roentgen. *Formerly in the Marquis de Ganay Collection*.

1065, 1066. *Above*. Design and completed piece.
Commode by Gaudreaux, with bronzes by
Jacques Caffieri, for the bedroom of Louis XV at Versailles.
Design by the brothers Slodtz. *Wallace Collection, London*.

1061. *Far left*. Candelabrum with a bacchante
in bronze, after Clodion. Louis XVI style. *Louvre*.

1062. *Left*. Regulator clock, by Carlin and Gouthière.
Louis XVI style. *Louvre*.

1067. Costume of a nobleman, 1760. Drawing by Carmontelle. *Musée Condé, Chantilly.*

1068. *Right.* Gentleman, 1671. Detail from an engraving by Lagniet. *Bibliothèque Nationale, Paris.*

Male costume evolved from ostentatious luxury (Louis XIV) towards greater simplicity.

1069. ITALY. The Spanish Steps, Rome. 1721–1725. Begun by Alessandro Specchi (1668–1729) and completed by Francesco de Sanctis (1693–1740).

1070. ITALY. The Fontana di Trevi. 1732–1762. Begun by Niccolò Salvi (1697–1751).

worked as portraitists. They were Jean Louis Lemoyne (1665–1755), a pupil of Coysevox, and his son Jean Baptiste (1704–1778), official sculptor to Louis XV (equestrian statues for Bordeaux, Rennes and the Ecole Militaire) [**987**]. Even more Baroque in style were the Slodtz family, originally from Antwerp; they were Sébastien (1655–1726) and his three sons: Antoine Sébastien (1695–1754), Paul Ambroise (1702–1758) and Michel-Ange (1705–1764); tombs of the archbishops of Vienne in the cathedral; tomb of Languet de Gergy at St Sulpice). The portrait busts by this family show genuine talent. Similar tendencies can be seen in the work of the Adam brothers, natives of Lorraine. They were Lambert Sigisbert, called Adam the Elder (1700–1759; *Triumph of Neptune*), Nicolas Sébastien, called Adam the Younger (1705–1778), who worked on the hôtel de Soubise and at Nancy (mausoleum of Queen Catherine Opalinska, 1749 [**1026**]), and François Gaspard (1710–1761), who had Frederick the Great as his patron and worked at Sans Souci.

The classical reaction had its beginnings quite early in the 18th century with Edmé Bouchardon (1698–1762), who worked in a cold style and who admired the antique (Fountain of the Seasons, rue de Grenelle, Paris). Jean Baptiste Pigalle (1714–1785), a pupil of R. Le Lorrain and of the Lemoynes, executed an allegorical statue, *Mme de Pompadour as the Goddess of Friendship* [**1028**]; but his monument for the Maréchal de Saxe (in St Thomas, Strasbourg), a masterpiece of French monumental sculpture, was closer to the Baroque than to the antique, and

the same is true of his nude *Voltaire*, which is strongly realist. His sensibility made Pigalle an admirable portraitist. Etienne Falconet (1716–1791), a pupil of J. B. Lemoyne, was director of the Sèvres porcelain factory (1757–1766) and worked for Mme de Pompadour at Bellevue and Crécy; he executed the equestrian statue of Peter the Great in St Petersburg (1766–1778) [**1027**].

Jean Baptiste Defernex (1729–1783) executed models of Boucher for Sèvres, and in his terra-cotta busts (*Mme Favart*, Louvre) he continued the Louis XV style, as did Jacques Caffieri (1678–1755) and his son Jean Jacques (1725–1792) who worked in this style until the very end of the Ancien Régime (*Canon Pingré*, Louvre [**1030**]). Augustin Pajou (1730–1809) was unrivalled in decorative sculpture, particularly in his work at the Opéra at Versailles, but he lacked the greatness of Jean Antoine Houdon (1741–1828), who was interested in the antique and in nature. Houdon, who was a pupil of Lemoyne and Pigalle, worked successfully in Italy (*St Bruno*). He was a portraitist of genius (*Diderot*, 1771; *Gluck*, 1775; *Voltaire* and *Benjamin Franklin*, 1778). He travelled widely; on his return from Germany he executed a *Diana* (1780) for Catherine the Great of Russia. In 1785 he went to America with a commission for a statue of George Washington. His style deteriorated after the Revolution [**896, 978, 991**].

Finally we may mention Simon Louis Boizot (1743–1809), who was the director at Sèvres [**1059**], and Claude Michel known as Clodion (1738–1814), a pupil of L. S. Adam and the son-in-law of Pajou, famous for his statuettes and bas-reliefs in terra cotta.

Painting. *From academic art to Louis XV (1690–1725).* There was less painting as decoration and more easel painting, which explains the vogue for collecting. Colour triumphed; the quarrel between the Poussin faction and the Rubens faction was settled by the victory of Rubens.

Religious painting was still produced in great quantity, but it lacked true inspiration. Among these painters were: J. B. Santerre (1658–1717); Pierre Subleyras (1699–1749), who settled in Rome, where he continued the academicism of the 17th century (*Mass of St Basil*, Sta Maria degli Angeli, Rome); Gabriel François Doyen (1726–1806), a pupil of Carle van Loo, who was summoned to Russia by Catherine the Great in 1789. Jean Restout (1692–1768), who came of a family of painters and did many religious and mythological pictures, worked for a time for Frederick the Great.

In decorative and historical painting nobility was rejected in favour of grace and piquancy. Antoine Coypel (1661–1722) worked for the Versailles chapel; his easel paintings (*Democritus*, Louvre

1071. ITALY. ALESSANDRO GALILEI (1691–1737). Façade of S. Giovanni in Laterano, Rome. 1733–1736.

1072. ITALIAN. ROMAN. CARLO RUSCONI (1658–1728). Monument to Gregory XIII. St Peter's, Rome.

1073. ITALIAN. ROMAN. FILIPPO DELLA VALLE (1696–1770). The Annunciation. Relief. S. Ignazio, Rome.

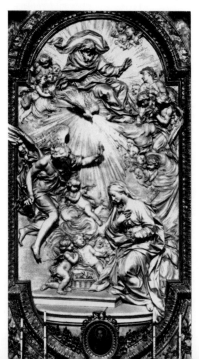

[720]) show a lively talent. Charles de La Fosse (1636–1716), an outstanding pupil of Lebrun and a follower of Rubens, painted large decorative ensembles (Montagu House, London) [721]. Claude Audran III (1658–1734) was the best painter of grotesques, but unfortunately his exotic decorations and monkey compositions for the menagerie at Versailles have been lost. Christophe Huet (d. 1759) did painted decorations at Chantilly [1055].

Portraiture flourished during the 18th century. Two artists whose work is transitional make a brilliant opening to the period. Hyacinthe Rigaud (1659–1743), court portrait painter to Louis XIV, belonged to the 17th century in his nobility of conception (Bossuet and Louis XIV, Louvre), but his depth of psychology (Mignard, Louvre), his charm (Louis XV as a Child, Versailles; the Young Lesdiguières, Louvre), his mastery of technique (portrait of the artist's mother, Louvre) and his colour and use of glazes belonged to the 18th century [982]. His nephew Jean Ranc (1674–1735) took his influence to Spain. Nicolas de Largillierre (1656–1746) belonged even more fully to the 18th century. He was trained in Antwerp and later by Lely in London, and he showed great skill in the use of transparent glazes; his sense of real life gave charm to his portraits of middle class people (the Belle Strasbourgeoise; the Painter and his Family, Louvre [984]).

In addition to these two outstanding portrait painters a few names worth mentioning are: Robert Levrac de Tournières (1667–1752), who was also a genre painter and who was influenced by Gerard Dou [981], François de Troy (1645–1730) and his son Jean François de Troy (1679–1752). The latter was much in demand as a decorator and as a painter of flattering portraits of ladies. Joseph Vivien (1657–1734), who worked in pastels, brought the influence of the French portrait into Germany (portrait of Fénelon, Munich).

Claude Gillot (1673–1721), a painter of scenes from Italian comedy (the Drum of Maître André, Louvre), had as his pupil Jean Antoine Watteau (1684–1721) [980, 993–995; see colour plate p. 365]. Watteau was born in Valenciennes; he came to Paris about 1702, where he worked for the dealer Gersaint; he became acquainted with fashionable engravers in Mariette's print shop. From 1704 to 1708 he worked for Gillot, then in 1708–1709 under Claude Audran III, curator at the Luxembourg palace. Here he learnt to admire the works of Rubens, which had a great influence on his fêtes galantes. He returned to Valenciennes in 1709, where he painted some military scenes. He was accepted by the Academy in 1712 but entered only in 1717 with the Embarkation for Cythera (Louvre) [994]. Connoisseurs such as Jean de Jullienne and Crozat took an interest in him. Ill with tuberculosis, Watteau went to London in 1719, perhaps for treatment, but returned to France in 1720. One of his last paintings was the Enseigne de Gersaint (the signboard for his friend Gersaint's shop), now in Berlin. Both his vibrant and nervous style and his subjects were imitated by his followers. The works of two of these, Jean Baptiste Pater (1695–1736), who had a facile technique [1008], and Nicolas Lancret (1690–1743) [1014], painter of fêtes galantes, are no more than pale reflections of Watteau's genius. Philippe Mercier (1689–1760) spread the influence of Watteau to England, Pierre Antoine Quillard (1711–1753) to Portugal, and Michel-Ange Houasse (1680–1740) to Spain (where he was court painter to Philip V).

Painting under Louis XV and Louis XVI (1725–1789). There was an increase in the number of collectors; the growth of criticism and the reappearance of salons after 1737 had a great influence on painting.

Decorative painters flourished at this time. Jean Baptiste van Loo (1684–1745), decorator and portrait painter, trained his young brother Carle (Charles André) van Loo (1705–1765), who worked in Turin for the king of Sardinia. Chief painter to the king of France in 1762, Carle van Loo was regarded as the head of the French school and enjoyed a great vogue (paintings for Bellevue and for St Sulpice) [934]. Jean Baptiste's sons spread the influence of French art abroad — Louis Michel van Loo (1707–1771) in Spain, and Charles Amédée (1719–1795) in Prussia. François Lemoine (1688–1737) was a more experienced decorator; he worked at St Thomas d'Aquin and at St Sulpice in Paris, and at Versailles (Salon d'Hercule). Lemoine combined grace with forcefulness in accomplished foreshortenings [1031]. His pupil Charles Natoire (1700–1777), a member of the Academy and director of the French Academy in Rome, collaborated with François Boucher (1703–1770) on the hôtel de Soubise in 1737–1740. Boucher, a pupil of Lemoine, was a member of the Academy, teacher of Mme de Pompadour, director of the Gobelins tapestry factory and chief painter to the king. He set the fashion in interior decoration. From 1727 to 1731 he was in Rome. Among his works were: 1732, Venus ordering Arms from Vulcan for Aeneas; 1734, illustrations of Molière and work for the queen at Versailles; 1750, The Mill (Louvre); 1752, decorations for Fontainebleau [924–926, 985; see colour plate p. 365]. His sons-in-law Pierre Antoine Baudoin (1723–1769) and Jean Baptiste Deshayes (1729–1765) exploited his style, often in a rather licentious manner.

In portraiture the most distinguished

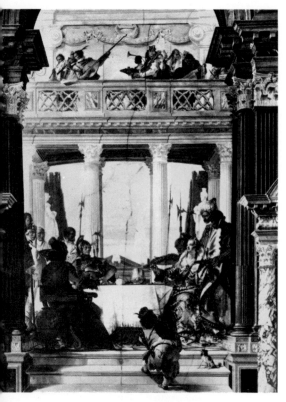

1074. ITALIAN. VENETIAN.
GIOVANNI BATTISTA TIEPOLO
(1696–1770). The Banquet of Antony
and Cleopatra. c. 1750.
Palazzo Labia, Venice.

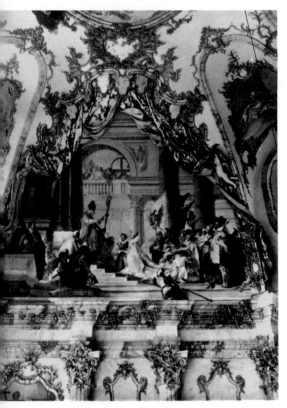

1075. ITALIAN. VENETIAN.
GIOVANNI BATTISTA TIEPOLO.
The Marriage of Frederick Barbarossa
and Beatrice of Burgundy.
Fresco in the Kaisersaal. 1750–1753.
Residenz, Würzburg.

talent was Maurice Quentin de La Tour (1704–1788), who specialised in pastels and painted the philosophes (portraits of d'Alembert and Rousseau), the court (*Louis XV*, Louvre) and the nobility (*Mme de Pompadour*, Louvre); the museum at St Quentin, his native town, has a large proportion of his work [**894, 895**]. Jean Baptiste Perronneau (1715–1783) was less brilliant; he created delicate portrayals of provincial society (*Mme de Sorquainville*, Louvre), usually in pastels [**986**]. Other portrait painters were Joseph Ducreux (1737–1802) and Joseph Boze (1744–1826), whose fine portrait of Mirabeau survives.

Mythological portraits were much in favour; their best exponent was Jean Marc Nattier (1685–1766) [**1034**]. His son-in-law Louis Tocqué (1696–1772) was more realistic. Tocqué worked in Russia, Sweden and Denmark [**893**]. Jacques André Aved (1702–1766), who trained in Amsterdam and was a friend of Chardin (*Mme Crozat*, Montpellier [**988**]), was equally true to nature, as was Henri Pierre Danloux (1753–1809) [**992**]. The work of Danloux, and that of Antoine Vestier (1740–1810) [**990**], marks the end of the Ancien Régime. The worldly portrait had its partisans, who were flattered by the cleverness of François Hubert Drouais (1727–1775) [**1032**], a pupil of Boucher and a specialist in child portraits. Elisabeth Vigée-Lebrun (1755–1842), a highly talented portrait painter, worked at the court of Louis XVI (many portraits of Marie Antoinette [**1038**]); she emigrated in 1790 to Italy and Russia.

Among the still life and genre painters was François Desportes (1661–1743), who was much influenced by the Flemish painters; he specialised in the portrayal of animals, living or dead, and also painted landscapes in the neighbourhood of Paris [**782, 1018**]. Jean Baptiste Oudry (1686–1755) painted with great virtuosity (*The White Duck*, formerly in the Sassoon Collection, London) [**1033**] but was overshadowed by Jean Baptiste Siméon Chardin (1699–1779). Chardin, who was influenced by Flemish and Dutch art, painted the finest still lifes of any French painter of the 18th century (the *Ray* and the *Brioche*, in the Louvre), as well as inspired genre scenes (*Boy blowing Soap-bubbles*, Metropolitan Museum of Art; *Child with a Top*, Louvre, [**1021-1023**]) and decorations for Bellevue and Choisy (1765). From 1771 to 1775 he did portraits in pastels (*Self-portrait* [**1020**], *Mme Chardin*, Louvre). The most popular genre painter was Jean Baptiste Greuze (1725–1805), whose ' morality in paint ' was praised by Diderot (the *Village Bride* [**1005**], *The Broken Pitcher*, the *Return of the Prodigal Son*, all in the Louvre); his best works, and the least moralistic, were his portraits (the engraver *Georges*

Wille); he was a competent technician but his talent was hampered by his moralising.

Jean Honoré Fragonard (1732–1806) [**996-1000**] was a pupil of Chardin and of Boucher. He spent several years at the Ecole des Elèves Protégés directed by Carle van Loo. In 1756 he left for Rome. He became acquainted with Hubert Robert and with Abbé de Saint-Non (portrait of Abbé de Saint-Non). Returning to Paris in 1761, he was accepted by the Academy in 1765 *Coresus and Callirrhoe*). From about this time until 1769 he painted his amorous and erotic works (*The Swing*, Wallace Collection, London; the *Sleeping Bacchante*; *The Stolen Shift*); after his marriage in 1769 he turned to paintings of children and family scenes (*Dites donc, s'il vous Plaît*; the *Jealousies of Childhood*). He received commissions from the dancer La Guimard and from Mme de Pompadour and Mme Du Barry (*The Progress of Love*, Frick Collection, New York). In 1773 he made his second journey to Italy. In 1794 he became a member of the administration of the Museum. In his entourage were Gabriel de Saint-Aubin (1724–1780), an excellent etcher, and Michel Barthélemy Ollivier (1712–1784).

Landscape was much in vogue among the painters of ruins, of whom the best was Hubert Robert (1733–1808) [**360**], a chronicler of some charm (the *Pont du Gard*). It was also popular with marine painters such as Joseph Vernet (1714–1789) [**1035**], who also managed to catch the Italian light admirably in his paintings (*Ponte Rotto*, Louvre; the *Port of Toulon*). Among landscape painters of the late 18th century Louis Gabriel Moreau (1739–1805) deserves mention as one of the best of his generation in his delicacy and sincerity (*View of the Bellevue Hillside* [**989**]).

Stained glass. As in the previous century, it was a frequent practice to destroy early stained glass and replace it with plain glass for greater light. Guillaume Le Vieil (1676–1731) did some windows in grisaille for the chapels at Versailles and at the Invalides; his sons Pierre and Jean repaired the windows of Notre Dame and of many churches in Paris.

Tapestry. Tapestry was used mainly for decoration; the size was smaller than previously and the subject matter imitated painting. The vogue for ' sets ' continued.

At the Gobelins factory both low- and high-warp tapestry was practised. Mansart commissioned the *Grotesque Months* from Claude Audran III [**1046**]. Exoticism was fashionable; the cartoons of Boucher were used. J. B. Oudry, who became director of the factory at Beauvais in 1734, supervised a *History of Don Quixote* after Natoire. At Au-

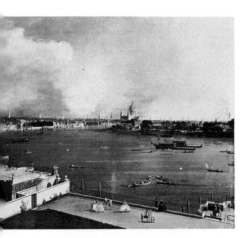

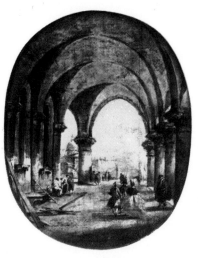

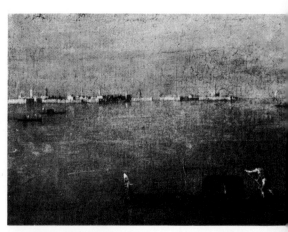

1076. ITALIAN. VENETIAN. CANALETTO (1697–1768). View of London from Richmond House. 1746. *Duke of Richmond and Gordon Collection, Goodwood.*

1077. ITALIAN. VENETIAN. FRANCESCO GUARDI (1712–1793). A Vaulted Arcade of the Doges' Palace. *Wallace Collection, London.*

1078. ITALIAN. VENETIAN. FRANCESCO GUARDI. View of the Lagoon looking towards the Islands. *Poldi Pezzoli Museum, Milan.*

busson only low-warp tapestries were made; these were copied from already existing sets and interpreted fashionable engravings or landscapes. During the reign of Louis XVI the Beauvais factory copied Boucher's pastoral scenes and Vernet's marine pictures, adding a border of beads.

Carpets. In 1712 the Savonnerie (soap works) became the royal factory for furniture and Persian and Levantine style carpets. These carpets differed from Oriental carpets and were adapted to Western taste by an ornament of acanthus leaves and flowered medallions. The long-pile 'savonneries' were imitated at Aubusson in short pile with simplified motifs.

Textiles. Embossed cloth was invented in Paris about 1680 and exported to Holland, where it became Utrecht velvet; in the 18th century there was competition from Amiens velvet. Watered cloths were made at Lyon; *lampas*, or flowered silk, was fashionable and *indienne* (printed calico or chintz) was imported by the Compagnie des Indes until Oberkampf set up a factory for Jouy cloth at Jouy en Josas at the end of the century [**1049**].

Engraving. Copper plate was the current technique, and the majority of subjects were genre. Families of engravers were still found in the 18th century (Audran, Tardieu, Aveline, Baron, Duvivier and Tournay). Large studios were formed under J. P. Le Bas and J. G. Wille. Prints were sold in the rue St Jacques, and dealers published catalogues of their stock.

Large albums of prints were published (Crozat album, 1732 and 1742, reproducing the finest drawings and pictures preserved in France, with notes by J. P. Mariette). The Jullienne album, after the paintings of Watteau,

was finished in 1735. Chardin's work was engraved by Cochin the Elder (1688–1754), who was also a brilliant engraver of Watteau, Lancret, Coypel and others [**919**]. Cochin the Younger (1715–1790) made engravings showing the ceremonies and festivities of the court [**884**]. Boucher was copied for half a century by all engravers [**1039**].

Small-scale engraving came into its own after 1750 with book vignettes, and this transformed technique was better suited to the paintings of Greuze and the drawings of Moreau the Younger [**1041**]. Stipple engravings [**1039**] and engravings in the 'pastel' or 'wash manner' were popular in the second half of the 18th century. J. F. Janinet and Philibert Louis Debucourt [**1040**] employed colour printing. About 1780 stippling was used by N. H. Regnault for his transcriptions of Fragonard (hand colouring was reserved almost exclusively for fashion plates). A number of engravers of portraits, landscapes and ornament were active at this time. P. P. Choffard was the best ornamentalist in small-scale engraving.

Books. The finest books were produced between 1755 and 1785. The four great artists working between 1757 and 1780 were: Gravelot, who illustrated Boccaccio (1757) in collaboration with Boucher; Eisen, who illustrated La Fontaine; Marillier, dubbed the 'miniaturist of the vignette'; Moreau the Younger (1741–1814), the brilliant illustrator of Rousseau.

Between 1780 and 1800 the taste for travel albums grew (Abbé de Saint-Non's *Voyage Pittoresque ou Description de Naples et de Sicile*, illustrated by Fragonard, Hubert Robert and Vernet). Colour printing was used in books from about 1790. The Derôme family were leading book binders for three generations [**1048**].

The minor arts. Medallists were numerous at this time (Dassier from Switzerland; Nini from Urbino; the Duviviers). Charles Norbert Roëttiers belonged to a family of medallists who worked all over Europe [**1047**].

Goldsmiths' work was affected by the political vicissitudes of the 18th century. The luxury of Louis XIV's time continued into the following reign, and the courts of Europe were supplied from France (especially that of Portugal). On the other hand the increasing number of meltings down destroyed the richest pieces. From the time of the Regency the middle classes possessed metal ware for daily use; table ware assumed increasing importance, and silver became functional as well as elegant. C. Ballin, N. Delaunay and François Thomas Germain [**1044**] influenced the form and decoration of metalwork in the 18th century. At first dominated by architecture, it was more decorative at the beginning of the Regency, and became asymmetrical with very free contours during the reign of Louis XV. The sculptural trend evident before 1750 gave way after that date to a new balance of form which inaugurated the Louis XVI style.

The use of boxes increased considerably in the 18th century; extremely varied collections were formed.

In ceramics, fine faience which imitated English ware was manufactured in France before 1750. Imported porcelains from the Far East had a great influence. In 1769 after the discovery of kaolin France was able to produce hard-paste porcelain. Soft-paste porcelains were made at Rouen and St Cloud (decoration in blue camaieu or monochrome painting; embroideries; Bérain arabesques); these also copied Oriental motifs (Tê-hua Chinese; blue sun mark). These porcelains were also made at Chantilly,

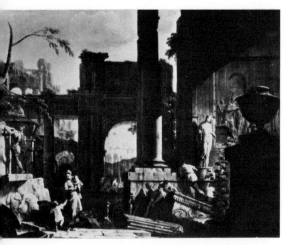

1079. ITALIAN. VENETIAN. SEBASTIANO RICCI (1659–1734) and MARCO RICCI (1676–1730). Figures among Ruins. *Vicenza Museum.*

1080. ITALIAN. GIUSEPPE ZAIS (1709–1784). Landscape. *Vicenza Museum.*

1081. ITALIAN. GIOVANNI BATTISTA TIEPOLO (1696–1770). Engraving from the series of Capricii.

where inspiration was drawn from Japanese Imari porcelains. About 1740 there was a modification in design; motifs appeared inset on cross-hatched or stippled backgrounds (mark: hunting horn). Very close to that of St Cloud and Chantilly, the soft-paste ware of Mennecy imitated blue and Japanese decoration but specialised in polychrome floral decoration, which was made fashionable by the factory at Vincennes. From 1738 to about 1750 Vincennes (mark: two interlaced Ls) produced soft-paste porcelain in Far Eastern style (blanc de Chine; polychrome). From 1750 to 1800 the French taste predominated (monochrome; polychrome; white and gold; paintings on porcelain; sculptures). Boucher, Pigalle and Falconet [1045] worked for Sèvres, which began the manufacture of hard-paste ware after 1772. This technique was also used at Strasbourg and Niderviller (1765–1827).

Nevers faiences were in the Chinese taste (1700–1769), on blue or white grounds. Those of Rouen were in the *style rayonnant* (with radiating decoration; 1700–1760), or were Oriental (1725–1750) or Rococo (1740–1770) [1042]. Strasbourg used 'Indian flower' (in fact Japanese Kakiemon or Arita) and Strasbourg flower designs, as well as Chinese backgrounds for exotic themes which were unrelated to the East (chinoiserie). Popular products (patriotic subjects, pitchers in the form of figures, etc.) came from Nevers, Rouen and Sinceny.

Furniture and interior decoration were influenced by the same factors which influenced architecture. S-curves and rounded angles replaced straight lines; furniture was less heavy, more comfortable and more suited to everyday life. The Far East was much in vogue.

The extremes of the ornate and tortuous style characteristic of interiors during the Regency and until about 1760 were mainly due to decorators such as Oppenort, Meissonier and Antoine Sébastien Slodtz, whose designs were fortunately somewhat modified by the French cabinet-makers and decorators [1065, 1066].

Undulating forms were especially suited to iron work; this reached its greatest perfection in balustrades for staircases and grilles for railings and gates (Palais de Justice, Paris; Place Stanislas, Nancy [772]).

After 1760 forms and ornament became more sober; the Louis XVI style showed the greatest originality and invention. The Louis XV and Louis XVI styles were taken over in the furniture designs of most of the other European countries.

There was a great diversity in kinds of furniture; beds were no longer four posters but were French, Duchess, Italian or Chinese style; game and bedside tables came into use. Furniture was designed to be practical, and chairs had to be convenient for the voluminous skirts and also comfortable. Armchairs and S-shaped cabriolet chairs and oval chairs were replaced under Louis XVI by small geometric chairs with straight fluted legs and with backs decorated with lyres, monograms, baskets or balloons.

The choicest woods were used in the 18th century — mahogany, amaranth, citron, purple wood and rosewood; lacquering of furniture was part of the taste for chinoiserie, and the brothers Martin imitated Chinese black-and-gold or red-and-gold lacquers. The greatest cabinet-makers were active in this century (the Foliots [1053]; Pierre Migeon II, 1701–1758; Antoine Robert Gaudreaux, c. 1680–1751 [1066]; Charles Cressent, 1685–1768 [1051]; Johann Franz Oeben, c. 1720–1763, of German origin, and his pupil and collaborator Johann Heinrich Riesener, 1734–1806) · [1054]. The work of Georges Jacob (1739–1814) reflects all the trends of his period, from Rococo to Neoclassical.

Extremely varied bronze decoration was added to furniture. Among the specialists Jacques Caffieri (1678–1755), sculptor and decorator to the king, followed Meissonier.

ITALY

History. With the exception of the Papal States, Modena, Venice and Genoa, Italy was divided between the houses of Savoy and Lorraine (successors to the Medici in Tuscany) and the Bourbons (Kingdom of the Two Sicilies).

Fighting against Austria and the Bourbons, Revolutionary France invaded northern Italy. Bonaparte, at the Treaty of Campo Formio (1797), created the republic of Liguria (Genoa) and the Cisalpine republic (Lombardy, Modena and Romagna).

In 1798 Rome was occupied by the French, who dominated all of Italy after the Treaty of Lunéville. In 1798 an exhibition of works of art from Italy was held at the Louvre. The old and powerful republic of Venice lost its independence.

The 'enlightened despots' such as Charles IV of Bourbon (1734–1759), later king of Spain, Charles VI, who had Pompeii excavated, and Archduke Leopold (1747–1792), brother of Joseph II, resisted the power of the Church. The powerful and learned popes took an interest in archaeology, protected antiquities and founded museums (edicts forbidding the export of antiquities, 1701–1704; founding of the Vatican Museum). Indeed, Benedict XIV protected the Colosseum and stopped its being used as a quarry; he also founded the Capitoline Museum.

Rome remained the artistic centre, but it was visited only in an anti-

quarian spirit. Naples was near Herculaneum, Pompeii and Paestum — where the beauty of the Doric was rediscovered. Venice entered a period of political decline, masked, however, by the brilliance of its social and artistic life.

Cultural background. Although the authorities were strict and vigilant, new ideas were in ferment throughout Italy and national feeling developed through the unifying medium of cultural life. This spirit was expressed by the historians (Ludovico Muratori and his *Annals of Italy*; the Neapolitan Giovanni Battista Vico [1668–1744], who can be called the father of the philosophy of history), the critics (Zeno and S. Maffei with their *Journal for the Litterati*) and such thinkers as the gentle and generous Cesare Beccaria (*Treatise on Crime and Punishment*, 1764), who introduced the French philosophes to Italy. After the 'Roman Arcadian' movement which restricted poetry to pastoral themes (Carlo Frugoni, 1699–1768), A. Varano (1705–1788), the scholar Melchiore Cesarotti (1730–1808), translator of 'Ossian', and Giuseppe Parini (1729–1799) were the most notable authors. Vittorio Alfieri (1749–1803), the great tragic dramatist, gave new life to the language; he stands out through his tragic and epic sense as the only great poet of this time. Verri was an elegant and imaginative prose writer who was perhaps too much influenced by antiquity.

The theatre, with Zeno and Metastasio (1698–1782), Riccoboni, Carlo Gozzi, and the malicious racy Carlo Goldoni (1707–1793), together with Alfieri attested to the renewed vitality of Italian literature.

But above all Italy possessed in Rome the natural cradle of Neoclassicism, the movement which put an end to the Rococo and proclaimed the absolute superiority of the classical world and of Greek art. Carlo Lodoli, who spread the idea of functional beauty, Francesco Milizia (*Memorie degli Architetti Antichi e Moderni*, 1781) and in particular the Germanic writers (the painter-philosopher Anton Raphael Mengs; the archaeologist Johann Joachim Winckelmann, 1717–1768, with his *History of Ancient Art* in 1764; Lessing with his *Laokoon* in 1766), were the theoreticians of this movement which rapidly took Europe by storm. It was propagated by the works of Piranesi, the lyrical engraver-architect.

Italian musicians were regarded as supreme in the 18th century throughout Europe (Spontini and Cherubini in France; Paisiello and Cimarosa in Russia). Composers of sacred music were: B. Marcello (1686–1739), with his *Psalms of David*; F. Durante; N. A. Porpora (1686–1766); Pergolesi (1710–1736), who wrote the famous opera buffa *La Serva Padrona* but also wrote a *Stabat Mater* and a *Salve*

Regina which are admirable. Opera buffa was a light lyrical genre in which the Italians excelled (Pergolesi, Paisiello, D. Cimarosa). Composers of opera seria were Porpora, Caldara and Leo, and of instrumental music Torelli, Antonio Vivaldi (d. 1741), who invented the symphony and the concerto, Giuseppe Tartini (1692–1770; violin) and Alessandro Scarlatti (1659–1725; harpsichord). Sammartini, who composed symphonic music, influenced Gluck and J. C. Bach.

Scientific interest was no less remarkable, particularly in physics (Luigi Galvani, 1731–1798; Alessandro Volta, 1745–1827; Beccaria; the Cassini family).

Architecture. The evolution from the Baroque to the Rococo was continuous. Both painted and carved decoration encroached more and more until they were supreme (Serpotta's work at Sta Cita at Palermo). Overabundance of decoration was due in the Kingdom of the Two Sicilies to the influence of the Spanish Churrigueresque (Lecce; Sicily). A taste for illusionism and trompe l'oeil and for strange perspectives in churches and palaces ended, with the Bibiena family, in the apotheosis of the theatrical. (This family, who were architects and theatrical designers [**921**], travelled all over Europe.) Use was made of large staircases of fantastic design in both palaces and churches (Trinità de' Monti, Rome; royal palace, Caserta), of vistas and perspectives and of voids which increase the feeling of space (ceilings by Pozzo and Tiepolo). Horizontals or verticals were sometimes emphasised almost to excess (Vanvitelli at Caserta; Juvarra at the royal palace, Madrid); great use was made of polychrome materials (coloured marbles in Sta Maria dei Gesuiti, Venice, by D. Rossi), which gave the effect of a riot of colour (silks; gilded and silvered wood; mother-of-pearl inlays; mirrors; porcelains).

In Rome two characteristic monuments were built at the beginning of the century: the stairs (Spanish Steps, 1721–1725 [**1069**]) joining Trinità de' Monti with the Piazza di Spagna, and the Fontana di Trevi (1732–1762 [**1070**]), which was begun by Niccolò Salvi. The façade of S. Giovanni in Laterano (1733–1736) [**1071**], by Galilei, is reminiscent of St Peter's. At Sta Maria Maggiore, Fuga disposed his statues in pyramids. The Neoclassical buildings were mainly derivative.

In Venice the architects preserved the Baroque traditions of the city. Decoration was Rococo; much use was made on ceilings of the effects of empty spaces, in the manner of Tiepolo (Giorgio Massari, 1686–1766: Church of I Gesuati, begun *c.* 1726; Palazzo Grassi, 1705–1745, with its immense staircase). The next generation was

1082. ITALIAN. Detail of a Neapolitan crèche (presepio). 18th century. *S. Martino Monastery Museum, Naples.*

1083. ITALIAN. Commode in wood, painted in green with design picked out in gold. Venice. *c.* 1760. *Karl Fischer Böhler Collection, Munich.*

1084. SPAIN. View of the palace of La Granja, showing the gardens. The latter were laid out by French landscape gardeners.

399

influenced by Neoclassicism (M. Lecchesi, T. Temanza and A. Selva). In Venetia and at Vicenza there was a revival of Palladian style.

At Bologna, F. Dotti (church of the Madonna di S. Luca) and A. Torregiani (oratory of S. Filippo Neri) were the best architects, but the Bibiena family [921] were the most imaginatively creative.

In Milan B. Bolli (d. 1761), C. G. Merli and G. Piermarini (1734–1808) were active. The last named built La Scala.

In Genoa the influence of France prevailed in Rococo decoration (Palazzo Cataldi).

The kingdom of Naples and Sicily had a great patron of architecture in the person of Charles IV; he was responsible for the palaces at Caserta and Capodimonte, the Albergo dei Poveri and the Teatro S. Carlo. Francesco Solimena and A. Vaccaro were typical of the Neapolitan style but were less gifted than Fernando Fuga and Luigi Vanvitelli (1700–1773), a Neapolitan of Dutch extraction who designed the huge palace at Caserta [972], begun in 1752 (where the staircases were very dramatic in effect, in the manner of Piranesi). Lecce was a Rococo town. In Sicily Palermo was the only town that was not destroyed by earthquakes (G. Amato and G. Biagio Amico; A. Giganti). At Catania (G. B. Vaccarini, 1702–1768) local traditions were combined with a Borrominesque style.

Piedmont, with Turin, was the region richest in great buildings of the 18th century, owing to the work of Filippo Juvarra (1676–1736), a pupil of Fontana and influenced by Guarini; Juvarra's churches are highly imaginative in conception (Sta Cristina, S. Filippo, and the Superga, 1717–1731, which is his masterpiece [871] — all at Turin). He also built the façade of the royal palace at Turin. B. Vittone (c. 1705–1770) marks the transition from Guarini to Juvarra.

Gardens remained traditional. The influence of the English garden was not felt until the end of the century.

Sculpture. In Rome the Baroque taste for movement and for the grandiose gave way to grace and lightness. Giuseppe Mazzuoli (1644–1725), a pupil of Ferrata, evolved from a Berninesque style towards a melancholy grace (Laura Carpegna, Altieri chapel in Sta Maria in Campitelli, Rome. He worked from designs of Maratta on statues of Apostles in S. Giovanni in Laterano, as did Carlo Rusconi (1658–1728); monument to Gregory XIII, St Peter's [1072], whose restrained manner is at times reminiscent of Algardi. Filippo della Valle (1696–1770) produced works of greater charm (Annunciation in S. Ignazio [1073], which is one of his finest pieces). Pietro Bracci (1700–1773), a pupil of Rusconi, carved a number of tombs. His 'angels' in

S. Ignazio are famous.

Innocenzo Spinazzi (c. 1720–1795) was the most representative sculptor of 18th-century Florence (monument to Machiavelli, Sta Croce). In Naples sculpture tended to virtuosity with Giuseppe Sammartino (1720–1793; Dead Christ, Sansevero chapel, Naples) and Francesco Queirolo (Disillusion, Sansevero chapel [930]). Sicily had one of the most original sculptors of the century in Giacomo Serpotta (1656–1732) [976]. He is known also for his exquisitely skilful stucco decoration (oratory of S. Lorenzo, Palermo). Domenico Parodi (1668–1740), Bernardo Schiaffino (1680–1725) and Francesco Maria Schiaffino (1691–1765) worked in Genoa. In Turin there were a number of foreign sculptors, as well as a local school whose most notable members were Ignazio Secondo and Filippo Collino (1724–1793). In Venice one of the best known sculptors was Antonio Corradini (1668–1752), who was born at Este and trained in Venice, and who died in Naples where he did the greater part of his work. He excelled in veiled statues (Modesty, Sansevero chapel, Naples); he was not so fine an artist as Gian Maria Morlaiter (1699–1781), who also worked in Saxony and in Russia. His bas-reliefs, in a very pictorial style, are extremely delicate (Venice, Gesuati).

Painting. Rome remained the artistic centre to which painters were drawn. From Gaeta came Sebastiano Conca (1679–1764), who trained in Naples under Solimena. He lived in Rome from 1706 to 1750, and founded a famous workshop. His frescoes (Sta Cecilia, Rome; Sta Maria della Scala, Siena) are Baroque in style but are modified by a symmetry of studied elegance and by light colours.

The painting of ruins, made fashionable by Flemish and Dutch artists, was revived by Giovanni Paolo Pannini (1691–1765) [881]; he was born at Piacenza but lived in Rome, where he acquired great fame. His sense of light and of pictorial values lends charm to his architectural fantasies and to his chronicles (Charles III visiting Benedict XIV, Naples).

The Roman painter Marco Benefial (1684–1764) and the French painter Pierre Subleyras (1699–1749), who worked in Italy from 1728 until his death, foreshadowed the Neoclassical reaction, whose most important representative was Pompeo Batoni (1708–1787). He was the rival of Mengs in Rome, though less Neoclassical in spirit in spite of his enthusiasm for Raphael and the antique. His delicacy of handling attracted foreign patronage and the greater part of his output consisted of portraits of princes and Grand Tourists (Watkin Williams Wynn, 1768, Cardiff; David Garrick, 1764, Ashmolean). From 1735 he pro-

duced religious and mythological works (altarpiece in St Peter's, 1760). The German artist Anton Raphael Mengs (1728–1779) was called the finest painter in Europe and had a considerable influence through his writings, in which he expounded the dogma of Neoclassicism; his work, apart from his portraits, is often mediocre. Another Roman painter was Gregorio Guglielmi (1714–1773), who did much work outside Italy and who seems to have impressed Goya.

Naples was an extremely lively artistic centre. Francesco Solimena [974] (1657–1747), the most important painter of his day in Naples, was influenced by Lanfranco, Mattia Preti and Luca Giordano; he decorated many Neapolitan churches (S. Paolo Maggiore; Gesù Nuovo) and trained many pupils who perpetuated his Baroque style. Francesco de Mura (1692–1782), with his lighter palette and his taste for elegance, was clearly Rococo in style in the work he did in Naples, Monte Cassino and Turin (frescoes in SS. Severino e Sosio, Naples, 1740).

Corrado Giaquinto (1699–1765) was a pupil of Solimena and collaborated with Conca. He had an eventful career, working in Turin and Rome (S. Lorenzo in Damaso and Sta Croce in Gerusalemme). He was called to Madrid, where he succeeded the Venetian Jacopo Amigoni.

Genre painting also flourished in Naples, with Giuseppe Bonito (1707–1789) and Gaspare Traversi (d. 1769).

Tuscany produced only second-rate painters in the 18th century, but Bologna produced an excellent painter as well as an interesting local school. In Bologna the arts of scenography and perspective were brilliantly represented by the Bibiena family (Giovanni Maria, 1619–1665; Ferdinando, 1657–1743; Antonio, 1700–1774), who were architects and painters [921], and also by the Haffner family (Enrico, 1640–1702; Anton Maria, 1654–1732). The decorators, brilliantly represented at Forlì (dome of the cathedral) by Carlo Cignani (1628–1719), included Marcantonio Franceschini (1648–1729; Corpus Domini church, Bologna) and the Gandolfi brothers — Gaetano (1734–1802), the better of the two, who was influenced by Tiepolo, and Ubaldo (1728–1781) who is often confused with him.

The leading Bolognese painter of this time, Giuseppe Maria Crespi (1665–1747), was influenced mainly by the Carracci and Guercino and by his visits to Venice, Parma, Pesaro and Urbino. His chiaroscuro and warm palette enhance a very personal sense of form and a frequently popular treatment of subject (series of the Sacraments, Dresden; Fiesta at Poggio di Caiano, Uffizi) [1016].

In Emilia Giuseppe Bazzani (1690–1769), born in Reggio, was influenced

by the Venetians and Rubens.

In Genoa Alessandro Magnasco (1667–1749) dominated painting with his strange personality, his nervous technique and his exaggerated chiaroscuro; his expressionistic distortions created a fantastic world reminiscent of Jacques Callot, Salvator Rosa, Marco Ricci and Guardi (the *Refectory*, Bassano) [922].

In Lombardy the realist trend was upheld by genre painters such as Giacomo Ceruti (probably a native of Brescia); active during the first half of the century, he was also a powerful portraitist (*Young Girl with a Fan*, Carrara Academy, Bergamo) with a very individual palette. Another fine colourist was the portrait painter Vittore Ghislandi (1665–1743), called Fra Galgario [897]. Among portrait painters who became famous abroad were Pietro Rotari (Vienna, Dresden and St Petersburg) and Giambattista Lampi (Vienna; also Poland and Russia).

In Piedmont a local school appeared which was influenced by Venice; one of its leaders was Claudio Francesco Beaumont (1694–1766).

In the 18th century Venice again became a great centre of painting, of importance throughout Europe. Transitional artists, still faithful to 17th-century techniques or aestheticism (Antonio Zanchi, 1631–1722; Gregorio Lazzarini, 1655–1730), were followed by Sebastiano Ricci (1659–1734), who first studied the Emilian masters and the Baroque decorators and was later influenced by Magnasco and Veronese. He inaugurated true 18th-century Venetian art with his light luminous palette and quick rhythmic drawing (*St Gregory freeing the Souls in Purgatory*, S. Alessandro della Croce, Bergamo) [1079]. While Sebastiano Ricci and his nephew Marco often worked outside Venice, Giovanni Battista Piazzetta (1683–1754) [931], a pupil of Giuseppe Maria Crespi, remained in Venice. He painted both religious and genre subjects; he employed contrasts of chiaroscuro, and his decorative painting had an influence on Tiepolo (SS. Giovanni e Paolo, Venice). One of his followers was the Dalmatian artist Federico Bencovich (1677–1753) who in 1733 was appointed painter to the court of Frederick Charles at Schönbrunn in Vienna.

Giovanni Battista Tiepolo (1696–1770), the supreme exponent of the Italian Rococo and the last of the great Venetian decorators, enjoyed a European reputation through his work at Würzburg and Madrid [see colour plate p. 366]. He was first influenced by Piazzetta and Bencovich, and then by .Veronese and Sebastiano Ricci; he developed a daring decorative style and a dazzlingly clear palette (Archbishop's palace at Udine, 1725–1728; Colleoni chapel in Bergamo, 1731–1732; Scuola dei Carmini and Chiesa delle Scalzi in Venice, 1740–1743; Antony and Cleo-

1085. PORTUGUESE. JACINTO VIEIRA. St Gertrude. Statue in the monastery of Arouca. 1723–1725.

1086. SPANISH. LUIS PARET Y ALCAZAR. Shop Interior. 1772. *Museo Lázaro Galdiano, Madrid*.

1087. SPANISH. The Village Wedding. Tapestry designed by Goya. 1787. *Prado*.

patra series, Palazzo Labia, Venice, [1074]; frescoes in the Residenz at Würzburg, 1750–1753 [1075] — the most important of his career; staircase in the Residenz, Würzburg [*Olympus with the Four Quarters of the Earth*]; mythological and romantic subjects for the Palazzo Valmarana in Vicenza, 1757 [1002], and the Palazzo Pisani at Strà, 1761–1762 [880]). From 1762 until his death he lived in Spain (*Apotheosis of Spain*, throne room, royal palace, Madrid). Among his sons, who worked with him, Giovanni Domenico (1727–1804) showed an individual talent in his genre paintings and in the frescoes in the Palazzo Valmarana in Vicenza.

Among the artists who spread Tiepolo's influence abroad were Rosalba Carriera (1675–1757), a portrait painter, pastellist and miniaturist who was popular in the courts of Europe [1037], Antonio Pellegrini (1675–1741), who worked in France, Holland, Germany, Austria and England, and Jacopo Amigoni (1675–1752), who worked in London and Paris and in Madrid, where he died.

Pietro Longhi (1702–1785) was an

indifferent historical painter who, however, became the chronicler of his time with delightful genre scenes rendered with an exquisite palette (the *Rhinoceros*, Palazzo Rezzonico, Venice) [1013]. His son Alessandro (1733–1813) was an excellent portrait painter; his *Compendio della Vita dei Pittori Veneziani* is an interesting source of 18th-century art history.

Venice also had a brilliant school of landscape painting. The painting of 'views' in the traditional objective manner (under Flemish and Dutch influence), of which Luca Carlevaris (1665–1731) is a good representative, was transformed by Antonio Canaletto (1697–1768) through his majestic rigour of composition and his fine sensitivity to light and atmosphere [see colour plate p. 366]. The son of a scene painter, he was influenced by Pannini in Rome in 1719. He was working for the English market by 1726. His finest works before 1730 were: *Campo di SS. Giovanni e Paolo* (Montreal, 1725–1726) [1017]; *Stonemason's Yard*, National Gallery, London. In 1746–1756 he was in England (*View of London*

1088. HOLLAND. Kabinet. Rosewood, walnut and oak. *c.* 1750. *Rijksmuseum, Amsterdam.*

who was French and then by Pietro Ferloni. The Turin factory (1737–1832) wove from designs by Claude Beaumont, and the Naples workshop (which closed in 1793) brought out a series of *Don Quixote* in the Gobelins manner.

Textiles. Textiles were still extremely fine in the 18th century, and silk was in great favour. Milan specialised in embroidery and Bologna in ribbons. Lace-making deteriorated, and Venice imitated French or Flemish products (workshop for counterfeits started by Ranieri and Gabrielli in 1751).

Engraving. A number of painters were also engravers, as was Giovanni Battista Tiepolo [1081]; his son Giovanni Domenico also showed a very individual talent in his twenty-seven variations on the theme of the *Flight into Egypt*. Carlevaris, Bellotto and Canaletto all made fine engravings. Marco Pitteri engraved the works of Piazzetta. Francesco Bartolozzi (1727–1815) had an original technique; he worked in London and made engravings after Reynolds and Lawrence. There were a number of famous albums of views. The greatest engraver of the century, however, was Giovanni Battista Piranesi (1720–1778), a Venetian architect who was in Rome by 1740; his feeling for the poetry of ruins and for romantic archaeology and dramatic light had a great influence on 18th-century architecture. He is famous for his *vedute*, or views (1748, *Roman Antiquities*; 1750, *Views of Rome*). His most original works were the series of *Prisons* (*c.* 1760) [1001]. Giuseppe Tocchi (1711–1767) was more classical. He engraved views of Tuscany. The Zucchi family engraved views of Venice.

The minor arts. Metalwork drew its inspiration from nature or from Baroque motifs.

In ceramics there were Carlo Antonio Grue (1655–1723), who set up a workshop in Castelli, and his sons who continued the undertaking and perfected it; his grandson Filippo Saverio started a porcelain factory in Naples by order of Ferdinand I. In the north the workshops of Savona and Genoa prospered thanks to the skilful decoration of Domenico Salomoni (1670–1746). Near Modena, Andrea Ferrari installed kilns at Sassuolo towards the middle of the century which were active until 1799. On the island of Murano the brothers Bertolini opened ceramics workshops about 1758.

In furniture and interior decoration motifs were borrowed from the Near East (Palazzo Valmarana at Vicenza; Turkish room in the Palazzo Colonna, Rome) and China (Palazzo Barbarigo, Venice). In Venice stucco was also popular (Palazzo Widman), as was polychrome decoration with inlays of

1089. FLEMISH. LAURENT DELVAUX (1695–1778). The Theological Virtues. *Musée du Cinquantenaire, Brussels.*

from Richmond House, 1746 [1076]). He influenced Hogarth and Samuel Scott. His later work became harder and tighter, losing its breadth and freedom of handling. Canaletto's nephew and pupil Bernardo Bellotto (1720–1780) was more realistic and precise, and showed his individuality in his paintings of Dresden, Vienna and Warsaw.

Francesco Guardi (1712–1793) studied with his brother Giovanni Antonio [1010], who was famous. He was influenced by him and also by Ricci and Magnasco. He painted figures and landscapes and he loved to recreate them in a fantastic manner, dissolving form with light. The ' view' became for him a pretext for poetic evocation. Guardi was one of the best interpreters of changing light and atmospheric effect (*View of the Lagoon*, Poldi Pezzoli Museum, Milan) and the most modern of Venetian painters (*Story of Tobias*, *c.* 1747, Venice; *Concert for the Counts of the North*, 1782, Munich) [1077, 1078].

Other landscape painters working in Venice and Venetia included Marco Ricci (1676–1730) — nephew of Sebastiano — Giuseppe Zais (1709–1784) [1080] and Francesco Zuccarelli (1702–1788), a Tuscan by birth.

Tapestry. The Florence factory closed its doors at the beginning of the 18th century. In Rome Pope Clement XI founded the factory of the St Michael Hospital, directed first by Simonet

1090. DUTCH. ADRIAEN VAN DER WERFF (1659–1722). Self-portrait. 1699. *Rijksmuseum, Amsterdam.*

stones, precious woods and wallpapers. Furniture, as in the previous century, followed the French fashion which was particularly influential in southern Italy and in Turin, the birthplace of Meissonier. Pietro Piffetti (1700–1777) worked in Turin as court cabinet-maker. Gian Maria Banzanico (1744–1820) decorated the royal palaces in Turin. In Venice taste was dictated by André Brustolon (d. 1732) in the first half of the century; the Chinese influence was predominant in the second half of the century.

Church decoration displayed the same characteristics as decoration in the palaces, and tended to grace and elegance (organs at Sta Maria Maddalena, Rome, 1735).

SPAIN

History. The influence of the French court and French art was introduced into Spain by the Bourbons — particularly by Philip V (1701–1746), who was a grandson of Louis XIV and who remembered Versailles. His second wife Elisabeth Farnese and his son Ferdinand VI (1746–1759), and later Charles III (1759–1788) who had been king of Naples, brought Italian taste to Spain. Outside the court, however, in the provinces and among the people, Spanish life and art were unchanged.

Cultural background. Literature experienced a long period of decline which began towards the end of the 17th century. Padre José Francisco de Isla (1703–1781) showed a lively and biting wit in his satirical novel on the clergy, *Fray Gerundio*. The fashionable theatre presented translations of Corneille and Racine or of Italian operas. The plays of Leandro Fernandez de Moratín (1760–1828), though showing 18th-century French influence, are decidedly Spanish in character and foreshadow the spirit of 19th-century literature.

Popular music and drama alone remained untouched by Italian influence. The dances, *zarzuelas* (musical comedies) and *autos sacramentales* (allegorical religious plays) continued in the 18th century. Domenico Scarlatti was at the court from 1729 to 1754. Luigi Boccherini (1743–1805) had great success in Madrid, where he came under the influence of popular Iberian music.

Architecture. Court architecture was subject to the usual cosmopolitan taste which prevailed among the European monarchies, in which French and Italian influence was strong; it developed independently of religious and provincial architecture in which the Baroque of excessive ornamentation and of movement persisted. The Churrigueresque style was the most striking manifestation of this Baroque,

and the Transparente chapel in Toledo cathedral, by Narciso Tomé, was its most typical example [967].

The Bourbon kings were builders. The royal palace of La Granja near Segovia, begun by the German architect Teodoro Ardemáns, was continued after 1726 by the Italian architect Giovanni Battista Sacchetti; it shows the influence of Versailles and the Escorial [1084]. In 1734 the royal palace in Madrid was destroyed by fire; a new palace, based on Versailles, was designed by Filippo Juvarra and built by Sacchetti [958]. Italian and French architects worked on the palace at Aranjuez during the 18th century. While official and royal art preserved a kind of clarity and simplicity both of plan and of decoration (yet without losing its splendour), Churrigueresque architecture (neither begun nor practised with particular excess by the Churriguera family) neglected structure, drowning it in a superabundance of vertiginous decoration which evokes Hispano-Moorish art, and often adding the play of colours to the phantasmagoria of light and shadow (colours and effects of light in the stucco work in the sacristy [1727–1764] built by Luis de Arévalo in the Carthusian monastery [Cartuja] at Granada).

The Churriguera family, despite its fame, is little documented. José Benito (1665–1725), the head of the family, executed the altar [808] in the church of S. Esteban at Salamanca; he worked in Madrid with his sons Matías, Jerónimo and Nicolás (façade of the Goyeneche palace, now the Academia de Bellas Artes). Joaquín and Alberto de Churriguera worked at Salamanca on the new cathedral from 1713 to 1738; at Salamanca, too, Joaquín worked on the colegio de Calatrava and Alberto on the Plaza Mayor.

Pedro de Ribera worked in Madrid (Hospicio de S. Fernando, 1722–1726; Puente de Toledo [Toledo bridge], completed 1732 [968]) and Narciso and Antonio Tomé in Toledo (Narciso's famous Transparente chapel [967]). Leonardo and Matías de Figueroa worked on the Palacio de Santelmo at Seville, a town rich in Baroque monuments. The above works all bear witness to the vitality of the style. At Valencia the palace of the Marqués de Dos Aguas, the tower of Sta Catalina and the Baroque façade of the cathedral, begun in 1703 by the German architect Konrad Rudolf (called Rodolfo), a pupil of Bernini, and finished by Spanish architects, are examples of Baroque influences from outside the peninsula, as is the fine façade of the cathedral at Murcia by Jaime Bort Miliá. The work done on the cathedral of Santiago de Compostela by Fernando de Casas y Novoa (Pilar chapel; Obradoiro [965]), and Sta María at S. Sebastián are the finest Baroque works in north-western Spain.

After the foundation of the official Academia de Bellas Artes in 1752 and through Charles III, who had acquired in Naples a passion for the antique, court taste triumphed and Neoclassicism prevailed. Representative of this trend were: the Italian architect Sabatini (1722–1797), who worked on the royal palace, the Puerta de Alcalá (1778) and the Prado in Madrid, and at Aranjuez; Ventura Rodriguez (1717–1785), whose best work is the façade of the Liria palace; Juan de Villanueva (1739–1811), who built the Prado Museum; Padre Francisco de las Cabezas (1709–1773), who built the church of S. Francisco el Grande, in Madrid. The best works of this period were the small châteaux built on the outskirts of Madrid by the nobility.

Gardens. The influence of Versailles is seen in the gardens of La Granja, which remain intact today [1084]. They were designed by René Carlier and executed by Etienne Boutelou, both French, who sent for their compatriots to decorate the gardens with sculpture. The vast elaborate gardens of Aranjuez had been famous from the time of Philip II. They still were partly influenced by the Petit Trianon and by English landscape gardens.

Sculpture. The sculpture on the large altars in the churches belongs more to architecture than to sculpture, the exuberant effect of the whole being more important than the sculptural or expressive quality of any individual statue. Thus the 18th century was not a great period of sculpture in Spain, despite the fame of the altar [808] by José Benito Churriguera (catafalque of Queen María Luisa, Church of the Incarnation, Madrid, the work which made him famous). Antonio Tomé and his son Narciso adapted to the Gothic of Toledo cathedral the extraordinary hybrid combination of cherubs, saints, clouds and coloured light which makes the Transparente a unique work, celebrated in 1732 as one of the marvels of Spain [967].

The same delirious profusion of ornament is found on the Carthusian monastery of El Paular. At Valencia the Vergara family, Francisco (1681–1753) and, in particular, his son Ignacio (1715–1776), who executed the portal of the palace of the Marqués de Dos Aguas [876], were subject to German influence through Konrad Rudolf.

Remarkable statues were still produced in polychrome wood, a traditional medium of the Iberian Baroque. These were extremely realistic and were often articulated (even to mechanisms for bending the head), had hair, and were sumptuously clothed and adorned with jewels (*Virgen de los Reyes*, Seville); *pasos* (Virgins, saints, scenes of the Passion) were carried during feasts and processions by the

1091. ENGLAND. JOHN VANBRUGH
(1664–1726). Blenheim palace,
Oxfordshire. 1705–1724.

1092. ENGLAND. JAMES GIBBS
(1682–1754). St Mary le Strand,
London. 1714–1717.

1093. *Left*. ENGLAND. NICHOLAS
HAWKSMOOR (1661–1736).
Church of St Anne, Limehouse,
London. 1714–1724.

fraternities; these have an important place in the art of southern Spain.

The Baroque style of Alonso Cano, Pedro de Mena and José de Mora was perpetuated at Granada by José Risueño (1665–1732) and Ruiz del Peral (1708–1773), who carved several fine Virgins.

Duque Cornejo (1677–1757), a pupil of Pedro Roldán, worked after 1748 on the choir of Cordova cathedral (*Magdalen* in Granada cathedral). The most famous sculptor of *pasos* in Murcia was Francisco Salzillo (1707–1783) [975], of Neapolitan origin. He was inexhaustible in his production of religious scenes (the *Agony in the Garden*, Salzillo Museum). Together with his brothers, he perpetuated in a sentimental and spirited style the naive and charming tradition of the presepios of Neapolitan origin [1082].

Stone was used for royal and official sculpture and myth and allegory were introduced into this religious art. The French pupils of Coustou, brought to Spain to adorn the royal parks in the manner of Versailles, influenced the sculptors of Madrid. Michel Verdiguier was a Marseillais who settled in Cordova (reliefs for the cathedral of Granada).

Alonso de Villabrille, Luis Salvador Carmona (1709–1767) and his pupil Francisco Gutierrez (1727–1782) were notable sculptors working in the Baroque style.

The foundation of the Academia de Bellas Artes, soon followed by provincial academies at Valencia, Barcelona, Valladolid, Salamanca, Cadiz and Saragossa, transformed Spanish art. Henceforth official European art pre-

vailed. The Italian sculptor Olivieri and Felipe de Castro (allegorical bas-relief of the foundation of the Academy) were early directors of the Academy.

Painting. French influence was dominant under Philip V with the portrait painter Jean Ranc (1674–1735), a nephew of Rigaud, who worked in Spain from 1724 onwards, Michel-Ange Houasse (1680–1730), called to Madrid in 1715, and Louis Michel van Loo (1707–1771), who worked for Philip V from 1737 to 1746.

Ferdinand VI called in Italian decorators (Jacopo Amigoni; Corrado Giaquinto). Charles III entrusted the artistic direction of the royal enterprises to Giovanni Battista Tiepolo, whose influence was very great, and to the German painter Anton Raphael Mengs [**1129**], a theoretician who was very influential in Madrid.

José Cobos y Guzmán (1666–1746) did many paintings for monasteries in Cordova. His works and those of Antonio Viladomat (1678–1755) in Catalonia continued at the beginning of the 18th century the taste for a genre treatment of religious subjects.

Local painters were often mediocre when compared to foreign artists. The most remarkable academic painter was Mariano Maella (1739–1819) and the best were Francisco Bayeu (1734–1795), brother-in-law of Goya, who was more portrait painter than decorator, and his brother Ramón (1746–1793). Luis Egidio Melendez (1716–1780), the 'Spanish Chardin', had a naive sincerity and tended towards trompe l'oeil (*Self-portrait*, Louvre).

Luis Paret y Alcazar (1746–1799), dubbed the 'Spanish Watteau', was a witty chronicler of the period (the *Masked Ball*; *Shop Interior*, Madrid [**1086**]). There were a number of flower painters in Valencia and in Barcelona.

Tapestry. In 1720 Philip V founded the factory of Sta Barbara at Madrid. Goya supplied forty-five cartoons to the workshops between 1776 and 1791 [**1087**].

Textiles. In 1720 the new royal factory of silks was under French management. Barcelona produced mantillas with floral decoration. Ferdinand VI opened a factory for gold and silver cloth at Talavera.

The minor arts. Charles III founded a goldsmiths' workshop. One of its two leading goldsmiths was French. In both table ware and ecclesiastical objects the influence either of Churriguera or of French artists is evident.

Under the direction of Luis Calisto the now reopened Toledo armour factory regained its old prosperity.

Charles III introduced the manufacture of porcelain into Spain in 1759

1094. ENGLAND. JAMES GIBBS. St Martin in the Fields, London. 1721–1726.

1095. ENGLAND. WILLIAM KENT (1685–1748). Entrance hall, Holkham Hall, Norfolk. From 1734.

and founded a factory at Buen Retiro near Madrid which produced decorative porcelain plaques for cabinet walls (royal palace, Madrid [**951**]; palace at Aranjuez). Another centre, at Alcora, produced table ware, vases, statuettes and clocks. The manufacture of *azulejos* was continued at Valencia, but at Talavera the industry was declining.

Cut and engraved glasses were made at S. Ildefonso; glassware continued to be produced at Mataró.

In furniture and interiors French influence was very strong; models derived from Meissonier, Caffieri and Duvaux were adapted. Decoration passed from the Louis XV style to the Neoclassical, but in the reign of Charles IV it was influenced by English styles.

PORTUGAL

History. Portugal made a slow recovery from the Spanish occupation. After 1703 (with the Methuen Treaty) Portuguese commerce suffered, to the benefit of England. The rich gold and diamond mines of Brazil enabled John V (1706–1750) to attract foreign artists such as Pierre Antoine Quillard (a pupil of Watteau) and Jean Ranc to his court and to build up fine collections (particularly of German silver ware) which were continued after the earthquake of 1755 by Joseph I (1750–1777) who, with his minister the terrible Marquis of Pombal, rebuilt Lisbon.

Cultural background. There was an attempt to recapture the great Portuguese tradition of the 16th century. A. Diniz da Cruz (1730–1811), Correa Garção and M. de Nascimento (1734–1821) mark the renaissance in poetry. The Academy of Sciences was founded in 1778. In music Italian influence was predominant (Domenico Scarlatti made a long visit to Lisbon).

Architecture. At the end of the 17th and the beginning of the 18th centuries the great architect was João Antunes (active 1683–1734), who built the church and monastery of Louriçal, the sacristy of the cathedral at Braga, and the octagonal church at Barcelos, which heralds the studied elegance of the period of John V. This king wished to construct a palace-monastery at Mafra [**957**] which would rival the Escorial. He sent for João Frederico Ludovice (Ludwig), a German artist trained in Rome. The palace-monastery was begun in 1717 and completed in the 1730s.

The Tuscan architect Niccolò Nasoni brought the Baroque to Oporto (São Pedro dos Clérigos [**949**]; Freixo palace [**964**]). At Oporto the combination of dark granite structures with *azulejos* (which both inside and out form great religious or profane pictures) gives an original harmony of cool tones. The

1096. ENGLAND. Chiswick Villa, Chiswick, Middlesex, by the Earl of Burlington and William Kent. From 1725.

traditional use of these tiles was general in churches, palaces and houses; they give Portuguese architecture its special flavour. A fine example is the charming royal palace of Queluz, and the same charm is evident in the rebuilding of Lisbon after the earthquake of 1755 (rebuilding plans by Manuel da Maia, executed by Eugenio dos Santos); the new Lisbon was a fine urban ensemble, the best part being the Praça do Commercio. At Braga the style has its own particular fantastic character.

Sculpture. Despite foreign influences there were original sculptors who interpreted a truly national art. The French sculptor Claude Laprade (active 1699–1730) decorated the university of Coimbra with allegorical figures and carved the tomb of Bishop Moura at Vista Alegre near Aveiro. Italian influence is noticeable at Mafra where the Roman Alessandro Giusti founded a school of sculpture where he trained such artists as Joaquim Machado de Castro (1731–1822), the best sculptor of the period, who collaborated with Giusti at Mafra. Machado's masterpiece is the equestrian statue of Joseph I (*c.* 1772), in the Terreiro do Paço in Lisbon. The influence of the Mafra school can be seen at Évora, in busts for the high altar of the cathedral, and the influence of Bernini's art is evident at Braga in the Evangelists in the Jesuitas church.

The Evangelists in São Miguel de Alfama at Lisbon are more typically Portuguese, as are the angels of the convent at Aveiro and, in particular, the statues of saints and nuns at the monastery of Arouca (Aveiro), carved by Jacinto Vieira from Braga in 1723–1725 [**1085**]. The most beautiful ensemble is the Bom Jesus shrine in

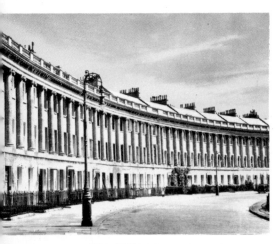

1097. ENGLAND. JOHN WOOD THE YOUNGER (d. 1782). The Royal Crescent, Bath. 1767-1775.

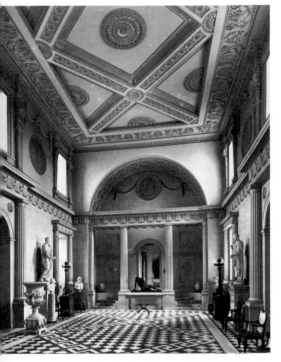

1098. ENGLAND. ROBERT ADAM (1728-1792). Entrance hall at Syon House, Isleworth, Middlesex.

1099. ENGLAND. ROBERT ADAM. Detail of a ceiling from Adelphi Terrace. 1768-1772. *Victoria and Albert Museum.*

Braga (c. 1730-1774 [956]; the statues of the staircase date from the second half of the 18th century). Crèche art (the *presepio*) should not be forgotten. It was executed by the best artists, most of them trained at Mafra (Antonio Ferreira; Machado de Castro).

Altars of carved wood developed under Italian influence. Wood sculpture reached perfection in all realms, from coaches (that of John V by João de Almeida) to church furniture (organs at Lisbon and Braga cathedrals; pulpit at São Salvador, Braga) [952].

In the second half of the century Rococo ornament was introduced; often this style maintained its vigour (high altar of the Benedictine monastery at Tibães) up to the Neoclassical reaction at the end of the century.

Painting. French influence was maintained by Pierre Antoine Quillard, Antoine Noël and Jean Pillement. Italian influence entered Portuguese painting through Francisco Vieira de Matos (1699-1783), called Vieira Lusitano, a renowned portrait painter and an excellent engraver. One of his most important pupils was André Gonçalves (1699-1763). Vieira Portuense (1765-1805) was also an excellent draughtsman and an engraver and was influenced by Italian and English art. Domingos Sequeira (1768-1837), the leading painter at the end of the century, is at times reminiscent of Goya.

The minor arts. The abundance of foreign works of art (English, French and Italian) gave a stimulus to the art of faience tiles, or *azulejos*, which had its principal centre in Lisbon. In furniture a Portuguese version of Chippendale existed. English influence was particularly strong around Oporto. John V and Joseph I ordered from France the finest ensemble of silversmiths' work in the world today [1044]; Portugal itself produced some beautiful pieces of silversmiths' work.

Sylvie Béguin, Lydie Huyghe and Gisèle Polaillon-Kerven

FLANDERS

History. Under Austrian rule the country was relatively peaceful. Commissions for architecture were numerous and the activities of the clergy and religious Orders were felt as much in the arts as socially. Contacts with the art of other countries were frequent, owing to visits of Flemish artists to France and Italy and to foreign artists who worked in Flanders.

Architecture. The clergy and the religious Orders exercised a great influence. Italian Baroque architecture influenced the style of the cathedral of Namur, built in 1751 by the Italian Pizzoni, and of the church of St Pierre

at Ghent, completed by Henri Mathis. French influence can be seen in the Benedictine church at Liége; it was even stronger towards the end of the century at St Jacques sur Coudenberg in Brussels, built by the French architect François Guimard in 1776 in a classical style, and in the buildings by Laurent Dewez (1731-1812), trained in Italy by Vanvitelli, who built the abbeys of Orval, Florival, Vlierbeek and Andenne.

Smaller domestic buildings continued to be constructed in the local Baroque style, which often retained the ornate gables of the 17th century, but following the French example the great nobles built their houses and palaces in the classical style (château at Laeken, 1782; hôtel Herrera at Ghent). In Brussels Claude Fisco built the Place St Michel (now Place des Martyrs); the palace of Charles of Lorraine (now the Royal Library) was built by Jan Faulte. Along the north side of the park G. B. Guimard and L. Montoyer built the hôtel of the Council of Brabant (Palais de la Nation, destroyed by fire in 1884 and then rebuilt) and the ministries.

Sculpture. The Flemish sculptors remained faithful to local traditions, whereas the Walloons, influenced by French and Italian sculpture, became academic. Jacques Bergé (1693-1756) worked with Coustou (*Conversion of St Norbert*, pulpit for the abbey church at Ninove; *Adoration of the Magi*, Brussels Museum). Theodoor Verhaeghen (1700-1759) executed some complex works (pulpit at Notre Dame d'Hanswyk, Mechelen; panelling at Ninove). Laurent Delvaux (1695-1778) was born in Ghent; he visited Italy and came under the influence of Rubens and Bernini, and he also worked in England (*Time discovering Truth*, cathedral of St Bavon, Ghent, 1739; *The Theological Virtues*, Brussels [1089]; bust of Maurice of Saxony, 1748). Delvaux's style marked the beginning of the classical reaction deriving from France (influence of Bouchardon), seen also in the work of Pieter Verschaffelt (1710-1793), who carved the tomb of Bishop Maximilien van der Noot at St Bavon, Ghent, and also carved other tombs.

Painting. Historical painting in the 17th-century style was continued in the 18th century with Guillaume Herricx (1682-1745), Jacques van Roore (1686-1747), Maarten Geeraerts (1707-1791) and Pieter Verhaeghen (1728-1811), painter of the *Feast of Belshazzar* (Brussels) and the *Presentation in the Temple* (Ghent Museum, 1767).

Historical painting was also part of the repertory of classical artists such as Andreas Cornelis Lens (1739-1822) of Antwerp, who visited Rome, was much taken with the ideas of Mengs and

Winckelmann and returned to become the leader of a school (*Ariadne on Naxos*, Brussels Museum). Flemish painting lost its originality and became thoroughly cosmopolitan.

Among the landscape painters and animal painters were Jean Demarne (1754–1829) and Balthasar Ommeganck (1755–1826). Among genre painters were B. van den Bossche (1681–1715), J. J. Horemans the Elder (1682–1759) and his son J. J. Horemans the Younger (1700–1776), who continued the tradition of interiors.

Tapestry. The workshops of Audenarde, Tournai and Brussels suffered from French competition. The *Loves of Venus*, by Jos de Vos, *Don Quixote* by Pieter van Hecke and the *Triumphs of the Gods* by D. Leyniers were the last productions of the Brussels workshops, which closed in 1794.

Textiles. Points de Flandres and Valenciennes lace were made in Bruges, Courtrai, Ypres and Ghent (which produced particularly splendid lace). The technique was perfected at the end of the century with the very fine square mesh of diaphanous toile.

There were also laces made *à fond de neige* (snow ground) and pillow lace with flowers called *bloemwerck*; *quilles de dentelle*, laces with gold, silver or silk thread, were introduced into Flanders during the Spanish rule.

HOLLAND

History. In 1713 the Treaty of Utrecht ended the war between France and the United Provinces. Holland was in a state of decline, despite the prosperity of the Dutch East India Company. The re-establishment of the Stadtholderate in 1747 did not succeed in arresting the decline but merely maintained the traditions of the past. The house of Orange limited its artistic activities to the maintenance of its innumerable châteaux.

Architecture. The Reformation put a stop to the development of religious architecture, and buildings remained faithful to the earlier traditions (bricks and high gables). The only buildings of any originality were the stock exchange in Rotterdam (plans by the painter van der Werff, *c.* 1721), the Amsterdam stock exchange (Italian inspired) and the Haarlem pavilion where Lucien Bonaparte later resided.

Sculpture. The only sculptor was J. B. Xavery, who carved the allegories for the façade of the town hall in The Hague; he lacked originality, and his busts are mediocre (*William IV*, 1733).

Painting. Gérard de Lairesse (1640–1711), from Liége, was well known in The Hague (*Mars, Venus and Cupid*,

Amsterdam) and inaugurated the classical reaction, and Adriaen van der Werff (1659–1722) [**1090**], Willem van Mieris (1662–1747), son of Frans van Mieris, and Constantin Netscher (1668–1722), son of Caspar Netscher, painted historical and mythological compositions. Jan Maurits Quinkhard (1688–1722) painted portraits in the 17th-century manner. Cornelis Troost (1697–1750) is reminiscent of Jan Steen and was a competent engraver [**1007**]. Julius Quinkhard (1736–1776) painted portraits and Thierry Langendyk specialised in battle scenes. The landscape painters were J. Kompe, Jan Ekels the Elder, Isaak Ouwater and Dirk Jan van der Laer. Still life was represented by Jan van Huysum.

Engraving. At the beginning of the 18th century Gérard de Lairesse gave impetus to the technique of mezzotint. Etching took a new lease of life with the French artist Bernard Picart. Jan Punt, van der Schley and especially Jakob Houbraken imitated the best French artists.

The minor arts. The Delft ceramics industry was killed by the competition of Far Eastern porcelain and English faience; this pottery ceased to be a luxury art in the middle of the century, and its European imitations are only interesting as curiosities. The workshops at Weesp, Arnhem and The Hague, founded in the second half of the 18th century, were short lived.

Glass engravers were extremely skilful; Aat Schouman and Wolf engraved scenes in the manner of Boucher and Watteau.

Around 1750 Dutch furniture abandoned the English style for the French style; about 1780 a more original style borrowed its motifs from Louis XVI. The settle and the kabinet (linen cupboard) were typically Dutch [**1088**]. Panelling followed the Parisian style, and Louis XIV motifs remained in favour until the middle of the century.

ENGLAND

History. Queen Anne (1702–1714), daughter of James II, succeeded William III; she waged war against France and acquired Gibraltar, and she saw Scotland and England united to form Great Britain (Act of Union, 1707). George I (1714–1727) succeeded her, and was succeeded by George II (1727–1760) who took part in the War of the Austrian Succession, ended by the Treaty of Aachen (1748). George III (1760–1820) was opposed to the French Revolution; war with France began in 1793. During the reigns of the three Georges internal affairs were characterised by the growing importance of Parliament and the office of Prime Minister (Robert Walpole, 1721–1742; William Pitt the

1100. ENGLAND. ROBERT ADAM. Houses in Portland Place, London. From 1773.

1101. ENGLAND. Landscape garden at Stourhead, Wiltshire.

1102. ENGLAND. ROBERT ADAM. Staircase of Home House (Courtauld Institute of Art), London. 1775–1777.

1103. ANGLO-FRENCH. LOUIS FRANÇOIS ROUBILLAC (c. 1705–1762). Bust of Alexander Pope, *Victoria and Albert Museum.*

1104. ENGLISH. WILLIAM HOGARTH (1697–1764). Captain Coram. 1740. *Thomas Coram Foundation for Children, London.*

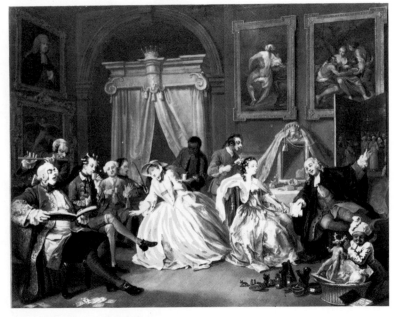

1105. ENGLISH. WILLIAM HOGARTH. Marriage à la Mode: the Countess's Morning Levée. 1745. *National Gallery, London.*

Elder, 1757–1761; William Pitt the Younger, 1784–1801), by economic changes which culminated in large estates where new methods of agriculture were adopted which transformed the countryside (gentlemen farmers) and by the development of trade and mechanised industry (particularly in textiles and metallurgy), which made England the strongest economic power in Europe in the 18th century (Adam Smith's treatise on the *Wealth of Nations*).

The religious revival was brought about by Wesley and the Methodists.

The Treaty of Utrecht confirmed England's possession of Minorca, Nova Scotia and Newfoundland. Between 1757 and 1759 Lord Clive founded the British Empire in India. North America became a vast British colony; by the Peace of Paris (1763) she obtained Canada. When, however, Britain tried to make the American colonists bear the burden of the public debt they revolted and Britain was forced to recognise the independence of the United States in 1783.

Cultural background. The early part of the century was a classical period (Alexander Pope, 1688–1744). Daniel Defoe (c. 1660–1731) glorified the spirit of adventure in his *Robinson Crusoe* (1719). Jonathan Swift (1667–1745) supported the Whig party until about 1710 and then became violently anti-Whig. He wrote biting satire on English society in the *Tale of a Tub* and *Gulliver's Travels.*

Samuel Richardson (1689–1761) was the father of the modern English novel (*Pamela*; *Clarissa Harlowe*); he had some influence on Diderot and Rousseau. Other leading novelists were: Henry Fielding (1707–1754), whose best known works are *Tom Jones* and *Amelia*; Lawrence Sterne (1713–1768), author of *Tristram Shandy*; Tobias Smollett (1721–1771), whose best known work is *Humphrey Clinker*; Oliver Goldsmith (1728–1774), novelist, poet and dramatist, author of the popular *Vicar of Wakefield.*

Journalism flourished with Richard Steele (1672–1729) and Joseph Addison (1672–1719) and their publications the *Tatler* and the *Spectator*. Samuel Johnson (1709–1784), critic, essayist and lexicographer, wrote his *Dictionary of the English Language*, and Johnson's life was brilliantly chronicled by his friend and biographer James Boswell.

Pope was the leading poet of the earlier part of the century, and was a witty and biting satirist (*Essay on Criticism*; *Essay on Man*; *Rape of the Lock*). After 1730 a pre-Romantic movement began with James Thomson (1700–1748) and his writing on nature (*The Seasons*, 1730, translated into French in 1759), and others, including ' Ossian ' (Macpherson), who had a widespread influence on the continent. Later in the century leading poets were Thomas Gray (1716–1771), whose outstanding poem was his *Elegy written in a Country Churchyard*, the youthful Thomas Chatterton (1752–1770) and William Cowper (1731–1800). One of the outstanding lyric poets, the Scotsman Robert Burns (1759–1796), was active towards the end of the century.

William Congreve (1670–1729), the writer of brilliant comedies of manners (*The Way of the World*; *Love for Love*), was active at the beginning of the century. The leading dramatist of the latter part of the century was Richard Brinsley Sheridan (*The Rivals*; *School for Scandal*).

In philosophy David Hume introduced a new scepticism opposed to the idealism of George Berkeley.

In science the beginnings of mechanisation stimulated invention. Darby treated iron ore with coal and obtained a good quality casting; G. D. Fahrenheit constructed a mercury thermometer in the first quarter of the century; Joseph Priestley (1733–1804) isolated oxygen; James Watt (1736–1819) produced a steam engine (c. 1760s) — an

1106. ENGLISH. JOSHUA
REYNOLDS (1723–1792).
Anne, Countess of Albemarle. 1759.
National Gallery, London.

invention which contributed greatly to
the industrial revolution.

In music George Frederick Handel
(1685–1759), a German by origin,
found favour with Queen Anne and
was naturalised in 1726. He composed
a *Te Deum* for the Peace of Utrecht
and tried to introduce Italian opera
into London, but without success;
later he turned to oratorio (*Messiah*,
Dublin 1742) with such success that
this form dominated English music for
a century and a half.

Architecture. The interdependence
of John Vanbrugh (1664–1726) and
Nicholas Hawksmoor (1661–1736) at
the turn of the century produced a
new grandeur, the nearest to Baroque
in England in its emphasis on mass and
the relationship of volumes (Castle
Howard, 1699–1712; Blenheim, 1705–
1724 [1091]; Seaton Delaval, 1710–
1719). Hawksmoor's independent work
after 1710 included: Easton Neston
(1713); London churches of St Anne,
Limehouse [1093]; St George, Blooms-
bury; St Mary Woolnoth. At All
Souls' College, Oxford (completed
1734), he adapted a Gothic design. The
third architect associated with English
Baroque is Thomas Archer (1668–
1743); the strong influence of Borro-
mini is seen in St Philip's (now the
cathedral), Birmingham (1709–1715).
James Gibbs (1682–1754) was unique
in having studied in Rome, under
Carlo Fontana; among his leading
works are: St Mary le Strand (1714–
1717) [1092]; St Martin in the Fields

(1721–1726), adopted as the type of
Anglican parish church [1094]; Senate
House, Cambridge (1722–1730); Rad-
cliffe Camera, Oxford (1739–1749).

The reaction from Baroque to clas-
sicism, interpreted through Palladio
and Inigo Jones, was marked by two
important architectural books (pub-
lished 1715–1717), Colen Campbell's
Vitruvius Britannicus and G. Leoni's
translation of Palladio's *I Quattro Libri*
(followed in 1727 by Kent's *Designs of
Inigo Jones*). Campbell remodelled
Burlington House (1717–1719) and
based Mereworth, Kent (1725), on
Palladio's Villa Capra (Rotonda). An
important part was played by the
Earl of Burlington, whose enthusiasm
for architecture was confirmed by his
Italian journeys in 1714–1719 and
culminated in Chiswick Villa (from
1725) [1096]. In 1719 he brought back
from Italy William Kent (1685–1748),
who started as a painter (Kensington
Palace, 1721–1727) and made the
transition to architecture and landscape
gardening at Chiswick. Holkham Hall,
Norfolk (from 1734), is his most
representative work [1095]. Other Pal-
ladians included Henry Flitcroft (1697–
1769) and Isaac Ware (d. 1766), author
of *A Complete Body of Architecture*
(1756). Of the second generation,
James Paine (1725–1789) was chiefly
associated with large houses in the
midlands and north, for example:
Mansion House, Doncaster (1745–
1748); Worksop Manor; Kedleston
(1761; completed by Adam). His rival
in this field was John Carr (1727–1807)
of York (Harewood House, York-
shire, 1760; Tabley House, Cheshire,
1762–1769).

The finest example of 18th-century
town planning is by John Wood the
Elder (1705–1754) and his son at Bath.
Queen Square is the direct outcome of
early Palladian experiments in London.
His aim was to re-endow Bath with
Roman monuments, for example:
South Parade (1743); Circus, com-
pleted by his son John, whose two
major additions were the Assembly
Rooms and the Royal Crescent (1767–
1775) [1097], a new type of urban
composition, repeated well into the
19th century (Buxton, Brighton, Edin-
burgh, Clifton).

Around 1750, with the growth of
the concept of archaeology, there came
a new spirit of Neoclassicism influenced
by Piranesi's architectural etchings.
English contributions to archaeological
scholarship included: Robert Wood's
Ruins of Palmyra (1753) and *Ruins of
Baalbec* (1757); Stuart and Revett's
Antiquities af Athens (1762); Robert
Adam's *Palace of Diocletian at Spalato*
(1764). Chambers and Adam dominated
the period 1760–1790, Chambers as the
greatest official architect of his time,
Adam as an influential innovator.
William Chambers (1728–1796), born
in Sweden, went in the service of the

1107. ENGLISH. THOMAS
GAINSBOROUGH (1727–1788). The
Harvest Wagon. 1771. *Barber
Institute of Fine Arts, Birmingham.*

1108. ENGLISH. JOSHUA
REYNOLDS. Lord Heathfield. 1788.
National Gallery, London.

409

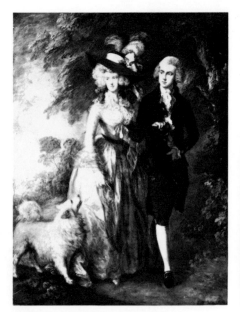

1109. ENGLISH. THOMAS
GAINSBOROUGH (1727–1788). The
Morning Walk. 1785.
National Gallery, London.

1110. ENGLISH. THOMAS
LAWRENCE (1769–1830). Queen
Charlotte. 1789.
National Gallery, London.

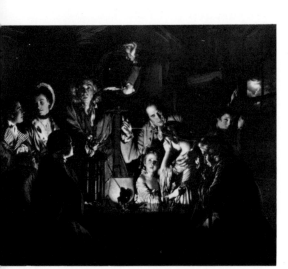

1111. ENGLISH. JOSEPH WRIGHT
(1734–1797). Experiment with an
Air Pump. 1768. *Tate Gallery.*

1112. ENGLISH. GEORGE ROMNEY
(1734–1802). Emma Hamilton
as a Spinstress. *Kenwood, London.*

East India Company to China after study in Paris and Italy (1750–1755). He settled in England in 1755; in 1759 he wrote his *Treatise on Civil Architecture.* His most famous works are Somerset House (1776–1786) and the Casino, Marino, near Dublin (1769). His pupil James Gandon (1743–1823) designed the custom house, Dublin (1781–1789). Robert Adam (1728–1792) was the second son of William Adam, the leading architect in Scotland before 1750. In 1754–1758 he travelled with his three brothers in France and Italy and visited Spalato, where he could study at first hand the art of antiquity and of the Renaissance. He was influenced by Piranesi and the architectural draughtsman C. L. Clérisseau. In his treatment of interior decoration lay the revolution in design for which he became famous, a personal revision of the antique in its combination of painted medallions and low-relief stucco. His work included: the completion of Harewood House, Kedleston Hall, Bowood and Osterley Park; recasting of the interior of Syon House (1762) [1098]; additions to Kenwood, Hampstead (1767–1768); speculative ventures in Adelphi Terrace (1768–1772) [1099] and Portland Place (from 1773) [1100]. His town houses included: Lansdowne House, Berkeley Square (1762–1765); Wynn House, St James's Square (1772–1773); Home House, Portman Square (1775–1777) [1102]. Eight thousand drawings in the Soane Museum testify to his capacity and fertility of invention.

Gardens. The landscape garden, perhaps the most influential English innovation in the visual arts, was the antithesis of the classical Palladian

building. Formal alleys, clipped hedges, etc., were replaced by the irregularity of winding paths, serpentine lakes and clumped trees, while sunk fences allowed the garden to merge into the park beyond. William Kent the architect was the first to use water, woods, meadows and temples to evoke the pictorial ideal of Claude le Lorrain and Gaspard Poussin (Burlington House; Chiswick Villa; Carlton House; Claremont, Esher; Rousham; Stowe). About 1730–1740 England was virtually covered with landscape gardens; all that might remain of regular parks was destroyed, and the leading figures of the time interested themselves in this new art (Charles Hamilton at Pains Hill, Philip Southcote at Woburn Farm, William Shenstone at The Leasowes and Lord Lyttelton at Hagley).

Lancelot (Capability) Brown (1716–1783) dominated the second generation. He was kitchen gardener at Stowe by 1739, and he turned it into a 'landscape' which set the fashion in Europe for the English garden. His most celebrated work is at Blenheim, where he swept away Henry Wise's formal garden and dammed the Glyme to form a great lake in keeping with the scale of the house. The most beautiful example of this period is probably Stourhead, with its colonnaded temples, grass-paved bridge, grotto and lake fed from the Stour [1101]. The danger of monotony in the repetition of boundary ride, serpentine river, undulating lawns and clumps of trees was stressed by Chambers in his *Dissertation on Oriental Gardening* (1772); at Kew (1759–1763) he implemented his plea for more variety with several ornamental buildings, including a ten-storey pagoda.

The ideal of 'the picturesque', sponsored by Sir Uvedale Price (*On the Picturesque*, 1794) and Richard Payne Knight, was opposed by Humphrey Repton in his series of *Red Books*. With the rise of Romanticism the relationship between house and garden was neglected; there was a concentration on carpet-bedding at the expense of lay-out and an import of exotics demanding conservatories.

Sculpture. Pieter Scheemaker (1691–1770) of Antwerp, Laurent Delvaux of Ghent [1089] and John Michael Rysbrack (1696–1770) of Antwerp carved a number of tombs in Westminster abbey, but the finest sculpture in England during the 18th century was done by the French sculptor Louis François Roubillac (*c.* 1705–1762), who settled in London around 1732. In 1737 he made his reputation with his statue of Handel for Vauxhall Gardens; towards 1750 he worked as a modeller at the Chelsea china factory (fine terra-cotta busts of Alexander Pope, Colly Cibber and Hogarth, and Martin

Folkes (1749) [1103]. His tombs in Westminster abbey include those of the 2nd Duke of Argyll (1748) and Lady Elizabeth Nightingale (1761) [928].

At the end of the century there was a return to the antique and a number of English sculptors went to Rome; among these Joseph Wilton (1722–1803), a pupil of Roubillac (monuments for General Wolfe, Stephen Hales and Admiral Holmes), showed originality. Thomas Banks (1735–1805) was more uneven (*Thetis and her Nymphs*, tomb of Sir Eyre Coote, 1783). Joseph Nollekens (1737–1823) produced competent portrait busts (bust of Dr Johnson in Westminster abbey) and executed a number of tombs of classical inspiration. The elder John Bacon (1740–1799) executed the Chatham monument in Westminster abbey and that of Dr Johnson in St Paul's. John Flaxman (1755–1826) enjoyed a European reputation in his own day as the finest sculptor after Canova. In 1775–1787 he worked for Wedgwood, who was popularising Neoclassical designs in his new 'Etruscan' ware. Funerary sculpture formed the majority of his later work (*Lord Mansfield*, 1795, Westminster abbey).

Painting. In the early 18th century there was a new freedom of design and an ambitious draughtsmanship under the influence of French conversation pieces by Philippe Mercier, Hubert Gravelot, J. B. van Loo and others and of visiting Italian decorators (Verrio, Pellegrini, Bellucci, Sebastiano Ricci). The results are evident in the work of Joseph Highmore [1006] (1692–1780), best remembered for his series of twelve scenes from Richardson's *Pamela* (c. 1745), and of Francis Hayman (1708–1776), whose small portrait groups influenced the young Gainsborough (*Mr and Mrs Kirby*, National Portrait Gallery). Hayman's most famous works were the decorations for Vauxhall Gardens (1740s).

William Hogarth (1697–1764), the outstanding figure in English painting before Reynolds and Gainsborough, after an apprenticeship to a silversmith began as an engraver of satirical prints for publishers [1113] (*South Sea Bubble*, c. 1721). By 1725 he was painting small conversation pieces; these he extended to full-scale portraits in *Captain Coram* (1740) [1104], the *Painter's Servants* (c. 1760), *Self-portrait* (1745), the *Shrimp Girl* (c. 1760) [1015] and *The Actor Garrick and his Wife* (1757). The *Beggar's Opera* (Tate Gallery) marked the transition from portraiture to his best known works, the series of moral subjects, influenced by Dutch models, in which he satirised the follies of the age: the *Harlot's Progress* (1732; burnt); the *Rake's Progress* (1735, Soane Museum, London); *Marriage à la Mode* (1745, National Gallery, London

[1105]); *Election* series (1754, Soane Museum [see colour plate p. 383]). In 1748 he went to France with Roubillac (*Calais Gate*, Tate Gallery). After Hogarth, the finest draughtsman and caricaturist of the manners of his time was Thomas Rowlandson (1756–1827). Robust humour, exuberance and flowing line are combined in his work, much of which was for the publisher of prints Ackermann [1114].

Allan Ramsay (1713–1784) and Thomas Hudson (1701–1779) were both superseded in popularity by Joshua Reynolds (1723–1792), historically the most important figure in British painting. He was a close friend of Johnson, Goldsmith, Burke and Garrick and was the first president of the Royal Academy and the author of *Discourses on the Fine Arts*, given to Royal Academy students (1769–1790); the essence of his portraiture is the appeal to the educated eye, above the needs of mere likeness. Born in Devon, he was a pupil of Hudson in London in 1740; he studied in Rome in 1750–1752, with the aim of reconciling the 'grand style' and portrait painting. His portraits include *Augustus Keppel* (1753–1754, Greenwich); *Anne, Countess of Albemarle* (1759, National Gallery, London [1106]); *Nelly O'Brien* (1760–1762); *Lady Elizabeth Keppel* (1761–1762, Duke of Bedford Collection); *Lady Cockburn and her Children* (1773) [1009]; the *Duke of Marlborough and his Family* (1778); *Mrs Siddons as the Tragic Muse* (1784). In 1781 he visited the Low Countries; the influence of Rubens can be seen in the *Duchess of Devonshire and her Daughter* (1786) and in *Lord Heathfield* (1788) [1108].

Thomas Gainsborough (1727–1788), with his quality of rhythmic line, his gift of seizing a likeness and his love of landscape painting and music, was the opposite of Reynolds [1004]. Born in Suffolk, he worked under Hubert Gravelot in London in 1740; from Hayman he adopted the type of small portrait group in a realistic landscape as in the *Artist with his Wife and Child* (c. 1751). His early landscapes reflect the influence of Wynants and Ruisdael (the *Charterhouse*; *Cornard Wood*). About 1750 he moved to Ipswich (*Mr and Mrs Andrews*, National Gallery, London [see colour plate p. 383]; the *Painter's Daughters with a Cat*, National Gallery, London [unfinished]). In 1759–1774, in Bath, his works took on a larger scale and a new sense of fashionable elegance under the influence of the van Dycks he saw in the neighbouring country houses; examples of this period are: *Countess Howe* (c. 1760, Kenwood, London); *Blue Boy* (c. 1779, San Marino, California). Under the influence of Rubens' work he painted landscapes which were more Arcadian in mood and were composed rather than observed: the *Harvest Wagon* (1771, Barber Institute, Birmingham

1113. ENGLISH. WILLIAM HOGARTH (1697–1764). Bathos. *Bibliothèque Nationale, Paris.*

1114. ENGLISH. THOMAS ROWLANDSON (1756–1827). A Little Tighter. Caricature. 1791.

[1107]); *Watering Place* (1777, National Gallery, London). In 1774–1788 he was in London, in a rivalry with Reynolds, but he was the favourite painter of the Royal Family. His best works have a poetic quality combined with rhythmic line and a personal technique, for example: *Mrs Siddons* (1785, National Gallery, London); the *Morning Walk* (1785, National Gallery, London [1109]). His late popular pictures are an extension of his interest in landscape (*Girl feeding Pigs*, 1782; the *Cottage Door*.) This aspect of picturesque rustic genre was carried on by George Morland (1763–1804), whose works were popularised through engravings.

Apart from Reynolds and Gainsborough, the most famous portrait painter before Lawrence was George Romney (1734–1802). Born in Lanca-

1115. ENGLISH. Wedgwood pottery with Adam decoration. *Private Collection.*

1116. *Right.* ITALO-GERMAN. Figure from the Italian theatre (Pantaloon), by F. A. Bustelli, Nymphenburg. *Bavarian National Museum, Munich.*

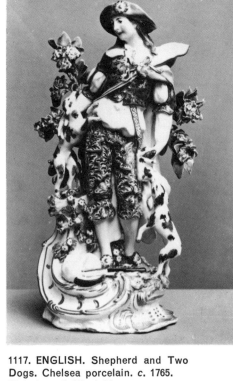

1117. ENGLISH. Shepherd and Two Dogs. Chelsea porcelain. *c.* 1765. *Victoria and Albert Museum.*

shire, he was in London by 1762 (*Peter and James Romney*, 1766; *Sir George Warren and his Family*, 1769; *Mrs Carwardine and her Child*, 1771). In 1773–1775 he was in Italy, where his admiration for the antique resulted in aspirations towards the 'grand style', for which he was ill equipped. He is best known for his studies of Lady Hamilton (as Circe, as a spinstress [1112] and as a bacchante).

Painting outside London were Joseph Wright and Raeburn. Joseph Wright of Derby (1734–1797) shows, in his candlelight pictures, affinities with the Utrecht school. His moonlit landscapes recall Vernet. Patronage by Wedgwood and Arkwright, pioneers of science allied to industry, resulted in new subjects (*Orrery*, 1766; *Experiment with an Air Pump*, 1768 [1111]). Henry Raeburn (1756–1823) was the painter of the personalities of the great age of his native Edinburgh [1012]. In 1784 in London he came under the influence of Reynolds. In 1785–1787 he was in Italy. His best works are marked by a vigorous and virtuoso handling of paint.

Thomas Lawrence (1769–1830), born in Bristol, was a child prodigy and enjoyed a lifetime of success. In 1792 he was successor to Reynolds as court painter. He was in London after 1786 (*Queen Charlotte*, 1789 [1110]; *Nellie Farren*, 1790). His European reputation came about through the Prince Regent's commission to paint the personalities of the struggle against Napoleon (Waterloo Chamber, Windsor, 1814–

1820); the finest of these anticipate Delacroix (*Archduke Charles of Austria*; *Pius VII*). Empty flashiness increasingly marred his later work (*Calmady Children*, 1824).

English landscape painting had its beginnings in the 18th century. Ultimately it was to have considerable influence on the Barbizon school and on the Impressionists. Samuel Scott (1700–1772) painted views along the Thames at London (*Old London Bridge*; *Old Westminster Bridge*); Richard Wilson (1713–1782) idealised the Roman countryside and painted evocative landscapes in England (*Valley in Wales*; *Cader Idris* [1019]). Alexander Nasmyth, and George Barret also expressed the charm of the English countryside; John Crome (1768–1821), also known as Old Crome, exalted the sense of space and was a precursor of Romantic art.

Henry Fuseli (1741–1825), who was born in Zürich, settled in London in 1763; he was a professor at the Royal Academy (1799) and had considerable influence on Romantic painting; he anticipated Surrealism (*The Nightmare*, 1782 [1003]; the *Corpse Thief*; the *King of Fire*).

Miniatures. Miniatures were much in vogue in the 18th century. The best miniaturist was John Smart (*c.* 1741–1811), and the most famous, Richard Cosway (1742–1821).

Tapestry. The factory at Mortlake closed in 1703. A new factory was

established in Soho (tapestries with Chinese subjects by Vanderbank; Oriental figures by Saunders). At Paddington and Fulham tapestry was woven mainly for chairs, etc.

Textiles. At the end of the 18th century the Adam style influenced printed cottons, which were very popular. The taste for floral sprays of Oriental inspiration persisted on black or brown grounds. Lace was made at Honiton (Brussels type) and in Buckinghamshire (English Lille).

Engraving. In his lifetime Hogarth, who made etchings and engravings of the majority of his own satirical paintings, was more admired as an engraver than as a painter (*Beer Street*; *Gin Lane*) [1113]. The mezzotint, once introduced into England, was used by John Smith (1652–1742) in his portraits in a manner which established its use for the future.

J. McArdell (*c.* 1710–1765) reproduced Reynolds, as did the more talented Valentine Green (1739–1813), Thomas Watson (1750–1781) and J. R. Smith (1752–1812). Lastly Richard Earlom (1743–1823) did exquisite flower pieces and landscapes after the Dutch painters. At the end of the century stippling was introduced into England by the Italian Bartolozzi.

The minor arts. Metalwork was much influenced by the French style of Pierre Platel and Paul Lamerie. Elongated forms characterise the pieces in the Adam style, which evolved in con-

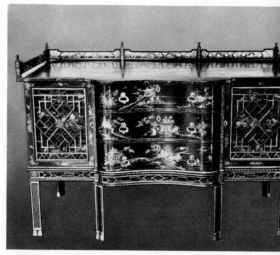

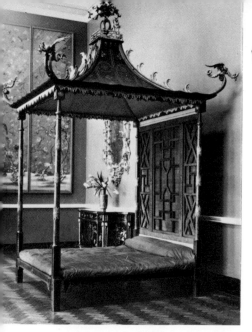

1118. ENGLISH. Bedstead, showing the vogue for chinoiserie. Chippendale. *Victoria and Albert Museum.*

1119. ENGLISH. Chair. Adam. *Victoria and Albert Museum.*

1120. ENGLISH. Commode, showing the vogue for chinoiserie. Chippendale. *Victoria and Albert Museum.*

1121. ENGLISH. Cabinet. Adam. *Victoria and Albert Museum.*

1122. ENGLISH. Chair. Sheraton. *Geffrye Museum, London.*

1123. ENGLISH. Chair. Hepplewhite. *Geffrye Museum, London.*

nection with the development of the new techniques of Sheffield plate (1743).

In glassware Lambeth spread the use of crystal and competed with Bohemian glass.

In ceramics about 1730 moulded salt-glazed pottery was introduced, followed by enamelled and transfer-printed wares and a blue-glazed type associated with William Littler of Longton Hall. In 1740 Thomas Whieldon started a factory at Fenton Lord (agate and tortoise-shell ware): in 1754–1759 he was in partnership with Josiah Wedgwood (1730–1795) who in 1769 opened the new factory called Etruria. Apart from the development of the white creamware known as

Queen's Ware (Frog service for Catherine the Great) he experimented with ornamented stoneware; two of the most important were 'jasper' (copy of the Portland Vase) and 'basalt'. Flaxman was one of the modellers (1775–1787) who designed reliefs and portrait medallions for these bodies. Jasper was to be used extensively for cheap pottery in the 19th century. English porcelain appeared about 1745, and was initially under the influence of Meissen. It was almost exclusively bone-ash soft-paste **[1115, 1117]**.

Furniture was very much influenced by Holland in the Queen Anne period (1689 – *c.* 1727). The Chippendale period (1740–1760) **[1118, 1120]** saw a spread of the Rococo, with Chinese

and Gothic elements; the cabinet-makers John Bradburn and Benjamin Goodison worked in this style, and Thomas Chippendale (1718 –1779) published in 1754 a collection of designs for furniture, but at the beginning of the reign of George III a classical reaction set in and he had to adapt his designs to the Graeco-Roman taste. The Adam brothers dominated taste in decoration in the latter part of the century **[1119, 1121]**. At this time ceilings were treated as domes; decorations were often executed by Angelica Kauffmann or the Italians Zucchi and Cipriani; glazed marquetry was inlaid in mahogany furniture. At the end of the century furniture became lighter, mahogany and bronzes disappeared,

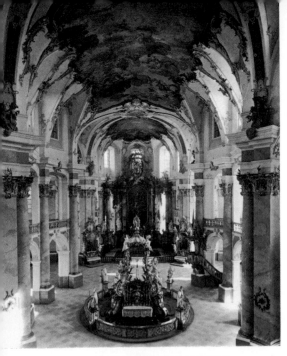

1124. GERMANY. JOHANN BALTHASAR NEUMANN (1687–1753). Interior of the church of Vierzehnheiligen. 1743–1772.

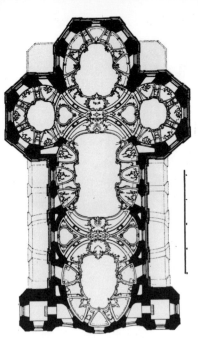

1125. Plan of Vierzehnheiligen.

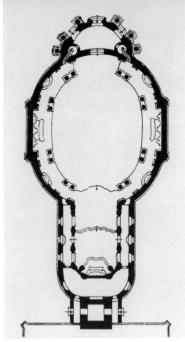

1126. GERMANY. Plan of the church of Die Wies, by Dominikus Zimmermann. (See 900 and 943.)

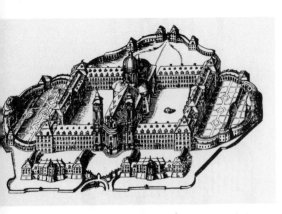

1127. GERMANY. Project for the monastery of Weingarten. Woodcut.

and Thomas Sheraton (1751–1806) and George Hepplewhite (d. 1786) gave their names to leading styles [**1122, 1123**]; this furniture was light and graceful, in pale woods and sometimes painted (citrus wood with garlands of flowers or bacchant medallions); seats were often of cane.

GERMANY

History. The Hohenzollerns in Germany became dangerous rivals of the Habsburgs. The son of the Great Elector proclaimed himself king of Prussia in 1701 as Frederick I; he was succeeded by Frederick William I (1713–1740) and Frederick II (the Great; 1740–1786). While Austria grew weaker between 1715 and 1740, Prussia's power was increasing. Following the War of the Austrian Succession Maria Theresa of Austria (1740–1780) had her husband Francis of Lorraine elected Emperor and struggled in vain to destroy the Prussian

forces. Her son Joseph II (1780–1790), imbued with the spirit of the French philosophes, opposed the policy of Vergennes and attempted to annex Bavaria by exchanging it for the Netherlands (1784). Meanwhile Frederick II was securing the greatness of Prussia; he reorganised the administration and seized Silesia. As a sceptical and realist politician he took part in the first partition of Poland (1772); he attracted many French scholars and artists, including Voltaire, to Sans Souci. Their influence became dominant in Germany and in Austria (where it found a rival in Italy); it was prolonged by the arrival of the many royalist emigrants from the Revolution.

The middle class ceased to be the dominant class; the princes, installed in great palaces outside the towns, influenced the arts. Versailles became the chief model for the princely courts.

Cultural background. The imitation of foreign literature, particularly French, had almost denationalised German literature. However, at the end of the 18th century the national spirit was awakened in the *Sturm und Drang* (storm and stress) generation animated by the philosopher and poet J. G. von Herder (1744–1803) and the poet G. A. Bürger (1748–1794). Johann Wolfgang von Goethe (1749–1832) published his *Werther* in 1774; until 1786 he lived at court, where he took an enthusiastic interest in science. Friedrich Schiller (1759–1805) was a disciple of Rousseau; his revolutionary play *The Robbers* (1781) was translated into French in 1792.

The archaeologist J. J. Winckelmann (1717–1768) dogmatised his love for antiquity by publishing his works on antique art. The original and pas-

sionate critic G. E. Lessing (1729–1781) published his *Laokoon* in 1766, in which he delimited the sphere proper to each art. Lastly the Swiss poet and landscape painter Salomon Gessner (1730–1788), a native of Zürich, achieved great success among the admirers of Rousseau.

The universities of Berlin and Basle attracted many foreign scientists. The Swiss mathematician Euler (1707–1782) published a *New Theory of the Moon*; the German Herschel (1738–1822), living in England, discovered the planet Uranus (1781).

Johann Sebastian Bach (1685–1750), a master of counterpoint, was the most influential composer of his time. His sons were composers of repute (Wilhelm Friedemann, 1710–1784; Carl Philipp Emmanuel, 1714–1788, musician to Frederick II; Johann Christian, 1735–1782, who anticipated the style of Mozart). Christoph Willibald Gluck (1714–1787) reformed opera by simplifying it (*Orpheus*; *Alceste*); he lived in Paris, where he was under the protection of Marie Antoinette.

In Austria Franz Joseph Haydn (1732–1809) fixed the rules of symphonic writing with his balanced and graceful style. Wolfgang Amadeus Mozart (1756–1791), one of the greatest masters of dramatic art and of rhythm, achieved greatness through simplicity (production of *Don Giovanni* in Prague, 1787). The precocious Ludwig van Beethoven (1770–1827) was active before 1800, with his twenty-four piano sonatas (1792–1804) and his First Symphony (1799).

Architecture. Until about 1780 German architecture followed two trends — the Italian influence, mainly in religious architecture (the Church of

the Gesù and St Peter's), and the French influence, mainly in domestic architecture (Versailles and Marly). However, the Germanic spirit affected the foreign styles with its own quality and gave rise to the German Rococo which followed the German Baroque. After 1780 an antiquarian reaction set in. Local architects showed their originality, especially in circular or elliptical plans in religious buildings, in low pavilions in palaces, which were joined to the main body by galleries, and in monumental staircases and an abundance of decoration.

Bavaria. In the beginning Bavaria continued to follow Italian taste, and Italian influence can be seen in the work of the Asam brothers (Cosmas Damian, 1689–1739; Egid Quirin, 1692–1750), who were Bavarian but were trained in Rome; both were architects, plaster workers and painters, and Egid Quirin was also a sculptor [936]. They worked on the church of St John Nepomuk in Munich (1733–1735). French influence became evident under Maximilian Emmanuel, about 1714, and was dominant under Charles Albert (1726–1745) and Maximilian Joseph III. The German Josef Effner (1687–1745), a pupil of Boffrand, worked at Schloss Schleissheim (1701–1719) where he followed the Italian Zuccalli; Cuvilliés (1698–1768) [1130] made a very original adaptation of French Rococo for the German taste (Amalienburg pavilion at Nymphenburg, 1734–1739; Residenz Theater in Munich, 1751–1753).

Large monasteries were built throughout southern Germany (Weingarten, by Georg Beer, 1715–1722 [1127]; Ottobeuren, built by Johann Michael Fischer [948]; Wiblingen, 1772–1781). Pilgrimage churches were built: Steinhausen, Günzburg, Die Wies, by the brothers Zimmermann who designed plans with lighting effects of great ingenuity and who worked also on the chapel at Buxheim [900, 942, 943, 1126]. (See colour plate p. 316.)

Saxony. This region owed little to France in its architecture. M. D. Pöppelmann (1662–1736), a native of Westphalia, built the masterpiece of German Rococo, the Zwinger in Dresden (1711–1722) [939, 940], as well as the Fleming palace (1715), which was later transformed into the Japanisches Palais by the French architect Longuelune. Georg Baehr (1666–1738) built the Frauenkirche in Dresden (1726–1738; burnt down in 1945), a Protestant church having seven rows of galleries inside and a high stone dome. Many country houses were also built (Pillnitz, with Japanese style pavilions; Gross Sedlitz).

Swabia and the upper Rhine. The dukes of Württemberg first called on

1128. GERMAN. ANTOINE PESNE (1683–1757). The Dancer Barbarina. c. 1745. *Charlottenburg Palace, Berlin.*

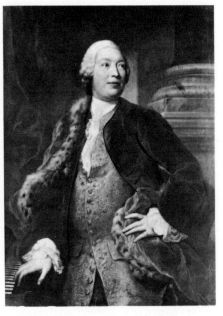

1129. GERMAN. ANTON RAPHAEL MENGS (1728–1779). Portrait of the Singer Domenico Annibali. 1750–1752. *Brera, Milan.*

Johann Friedrich Netṭe (d. 1714) for the Residenz of Ludwigsburg, and then on the Italian architect D. Frisoni (1683–1735). His compatriot L. Retti (1705–1751), born in Vienna and living in Paris, drew the plans for the new Residenz at Stuttgart. It was completed by the French architect La Guêpière [732, 734], who also built Monrepos and Schloss Solitude (1760–1763) in the Stuttgart district.

In the Palatinate the Catholic Electors settled at Mannheim, where work on the palace was directed by the French architect Jean Clément de Froimont (1720–1726). Nicolas de Pigage (1723–1796), from Lorraine, built Schloss Benrath near Düsseldorf.

The margraves of Baden–Durlach appointed A. F. von Kesslau as architect for Schloss Karlsruhe.

The middle Rhine and Franconia. Johann Balthasar Neumann (1687–1753), who first specialised in military architecture, worked in the service of the prince-bishops of Würzburg from 1714, and then went to Paris in 1723 to submit his projects for the Residenz at Würzburg (1719–1744) to de Cotte and Boffrand. He also built the palace at Werneck (1733–1737) and the church of Vierzehnheiligen (1743–1772) in Franconia [1124, 1125].

The palace of Pommersfelden, Bamberg, was designed by Johann Dientzenhofer (d. 1707) and completed by Maximilian von Welsch (1671–1745) [935]. In the second half of the 18th century French influence was dominant in Mainz through Charles Mangin (1721–1807), who built the charming palace of Mon Aise near Trier.

1130. GERMANY. JEAN FRANÇOIS DE CUVILLIÉS (1698–1768). Detail of the ballroom in the Amalienburg pavilion at Nymphenburg. 1734–1739.

The lower Rhine. In Cologne French architects were much in demand; Robert de Cotte succeeded Zuccalli at the Residenz at Bonn. The gardens of Brühl were designed by a pupil of Le Nôtre. The German architect Konrad Schlaun (1695–1773), who lived in France, designed Schloss Münster (begun in 1767).

Hesse-Cassel. In the Protestant town of Cassel the Du Ry, a French family driven out by the Edict of Nantes, worked. Paul (1640–1714) built the Orangery (1701–1711); Charles (1692–1757) built the old picture gallery. But the gardens of the Residenz of Wilhelmshöhe were the work of the Italian G. F. Guernieri at the beginning

1131. GERMAN. JANUARIUS ZICK
(1732–1797). Scene outside an Inn.
Stuttgart Museum.

1132. GERMAN. ANTON GRAFF
(1736–1813). Self-portrait. 1795.
Gemäldegalerie, Dresden.

1133. GERMAN. DANIEL NIKOLAUS
CHODOWIECKI (1726–1801). The
Game. *Bibliothèque Nationale, Paris.*

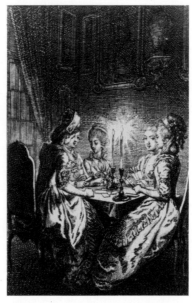

of the 18th century and were a copy of the gardens of the Villa d'Este.

Prussia. The artistic development of Prussia followed its political evolution. Frederick I employed the French architect Jean de Bodt (1670–1745) and the sculptor-architect Andreas Schlüter (1664–1714), one of the best representatives of German Baroque, who had travelled in Italy and in France and had worked with the Swedish architect J. F. Eosander on the reconstruction of Schloss Berlin (1698–1706). Frederick the Great had his own ideas about architecture and collaborated with Georg Wenceslaus von Knobelsdorff (1699–1753), who had visited the Latin countries before building Potsdam as a Rococo ensemble (the Stadtschloss and the palace of Sans Souci, 1743–1748, inspired by the Grand Trianon [**944**]). He also built the Berlin Opera (1743). The New

Palace was the work of K. von Gontard and Le Geay; and the latter built, to the king's design, the church of St Hedwig (1747). This has a central plan with a low dome over it. Gontard completed the two churches of the Gendarmenmarkt (1780). The Brandenburg Gate in Berlin, by Langhans (1732–1808), opened the period of classicism.

Sculpture. The 18th century was an important period for sculpture in Germany.

Pieter Verschaffelt (1710–1793) from Ghent, who was trained in Paris, did sculpture for the park of Schwetzingen; Antoine Tassaert (1729–1788) of Antwerp directed the Academy and taught Gottfried Schadow (1764–1850). Balthasar Permoser (1651–1732) of Salzburg played an important part in the decoration of the Zwinger in Dresden. Among his best known works are the *Apotheosis of Augustus the Strong*

and the *Apotheosis of Prince Eugene* (Vienna [**938**]).

Leading sculptors in Munich were Straub and his pupils Ignaz Günther (1725–1775) [**947**] and Franz Xaver Messerschmidt [**979**].

Painting. Both the Italian and French influences were important. In the south painting was influenced by Tiepolo's magnificent decorative frescoes at Würzburg (1750) [**1075**]. French influence was stronger in Dresden. Antoine Pesne (1683–1757) [**1128**] and Amédée van Loo emigrated to Berlin. The portrait was even more in vogue than in the preceding century. Johann Daniel Preissler (1666–1737), director of the Nuremberg Academy, and Jan Kupecky (of Bohemia) taught a number of painters, among them Georg Desmarées (1697–1776), a descendant of French émigrés who was born in Stockholm and who lived in Munich (portrait of the Count of Preysing). J. G. Edlinger (1741–1819), an Austrian by birth, also lived in Munich (*The Bookseller Strobe and his Children*, Munich). In the north J. G. Dathan (1703 – after 1748) was influenced by French painting; J. G. Ziesenis, of Polish origin, who settled in Berlin, was influenced by Tocqué and F. H. Drouais. The painting of Daniel Chodowiecki, a Polish artist educated in France, was more objective (the *Calas Family*).

Ismael Mengs (*c.* 1688–1764) worked at the Saxon court, as did his son Anton Raphael Mengs [**1129**] who painted portraits in Dresden about 1744–1745 and between 1749 and 1751 (*Self-portrait*, 1744, Dresden). Anton Graff (1736–1813) [**1132**], of Swiss origin, painted the outstanding personalities of the period in Germany (portrait of Chodowiecki, Munich). There was also the Tischbein family (Johann Heinrich the Elder, 1722–1789, his nephew Friedrich August, 1750–1812, and his cousin Johann Heinrich Wilhelm, 1751–1829, who spent a long time in Italy [portrait of Goethe in the Roman Campagna, Frankfurt] and was a disciple of Johann Joachim Winckelmann).

Among the genre painters the Bavarian Januarius Zick [**1131**] recalls Goya.

At the end of the century painting was dominated by the theories of Winckelmann, whose greatest German follower was Mengs [**1129**]. Mengs settled in Rome in 1751; he was a Jew converted to Catholicism and he painted great religious and mythological compositions. He did a pastiche of Raphael's *Parnassus* on the ceiling of the Villa Albani (1756); after 1761 he divided his time between Italy and Spain, whither he was summoned by Charles III to collaborate on the decoration of the Escorial. In 1762 his

Reflections on Beauty was published. Among his followers were J. A. Carstens (1754–1798), who marks the beginning of monochrome painting, and the landscapist Jakob Philipp Hackert (1737–1807).

Tapestry. The factories of Berlin and Munich were still active at the beginning of the 18th century and were attempting to imitate and compete with the Gobelins.

Engraving. German engraving was influenced by France in the 18th century. J. G. Wille (1715–1807) who settled in France and G. F. Schmidt (1712–1775) who worked in Paris were competent if monotonous engravers. Wille taught Preissler, Schmutzer and Bause. Of a higher quality were the etchings by J. E. Ridinger (1695–1767), C. Dietrich (1712–1774) and Weirotter (1720–1773). Chodowiecki (1726–1801) showed a superior talent in his witty vignettes (*Minna von Barnhelm*) [1133].

The minor arts. Extraordinary preciosity was shown in metalwork; forms were often extravagant (ostrich eggs mounted as vases). Dinglinger made miniature altars packed with figures.

The Bavarian Kraebenberger and Simon Troger of Nuremberg carved ivory statuettes of great virtuosity.

In ceramics Boettcher discovered kaolin about 1709; a factory was immediately started at Meissen, first influenced by the Far East and later producing work with Rococo decoration and with a decoration of small pictures cleverly painted. In the second half of the 18th century the style was influenced by Sèvres. Soon the secret of porcelain spread throughout Germany and other factories were started, at Hoechst near Frankfurt (1746), at Frankenthal in the Palatinate, at Ludwigsburg and Nymphenburg and in Berlin (1750). All these centres produced utility wares and delicate statuettes known as Saxe in France and Dresden in England. The two greatest modellers were Johann Kändler at Meissen (1731–1774) and F. A. Bustelli at Nymphenburg (1754–1763) [1116]. Nuremberg continued to make faience stoves.

Cuvilliés [1134] published a collection of designs in 1738 which spread the Louis XV style of furniture and decoration throughout Germany; it also influenced Melchior Kambly, of Swiss origin, and the Bavarian Spindler, who both worked in Berlin. The Germans excelled in marquetry which reached a rare degree of perfection in the work of David Roentgen (1743–1807; bureau for Louis XVI at Versailles; bureau for Catherine the Great in the Louvre [1063, 1064]). A number of German cabinet-makers worked in Paris.

1134. GERMANY. Balcony, by Jean François de Cuvilliés.

AUSTRIA

Architecture. After 1683 (the date of the siege of Vienna and the second retreat of the Turks) the Austrian Baroque reached its peak in the reigns of the Emperors Leopold I (1657–1705), Joseph I (1705–1711) and Charles VI (1711–1740), owing to two exceptionally gifted artists. The first was Johann Bernhard Fischer von Erlach (1656–1723), who built the Kollegienkirche in Salzburg (1696–1707), designed the plans for Schönbrunn (1695), built by his son, built the palace of Schwarzenberg (1697–1705) and did the plans for the Karlskirche in Vienna [1135]. The other great architect, Johann Lukas von Hildebrandt (1668–1745), built the Kinsky palace (1713–1716), the Vienna Belvedere, for which he began the designing of the gardens in 1700 (Lower Belvedere 1714–1715; Upper Belvedere, 1721–1722 [1136]); he also built Schloss Mirabell in Salzburg (1721). Splendid monasteries were built in upper and lower Austria (Klosterneuburg, 1729; Altenburg; and above all Melk, on the Danube, by Jakob Prandtauer, 1702–1736 [1137]).

Sculpture. Georg Raphael Donner (1693–1741) [1139] executed statues and decorations for Schloss Mirabell at Salzburg and did the Neuemarkt fountain in Vienna (1739). At Bratislava he executed the group in lead of *St Martin on Horseback* (1734) and the praying statue of the Prince-Archbishop for St Martin's cathedral. Josef Anton Feuchtmayer (1696–1770), member of a family of plaster workers, was active mostly in the region of Constance [946].

Painting. In 1702 Andrea Pozzo was called to Vienna to decorate the university church and the Liechtenstein palace. Under his influence there grew up a group of decorative painters whose illusionist perspective is extremely interesting (Lower Belvedere by Martin Altomonte; ceiling of the great hall of the Vienna National Library by D. Gran, 1694–1757; dome of the Karlskirche, by J. M. Rottmayr, 1660–

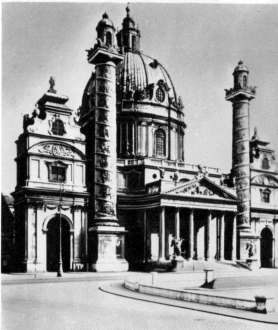

1135. AUSTRIA. JOHANN BERNHARD FISCHER VON ERLACH (1656–1723). Karlskirche (church of St Charles Borromeo), Vienna. 1716–1737.

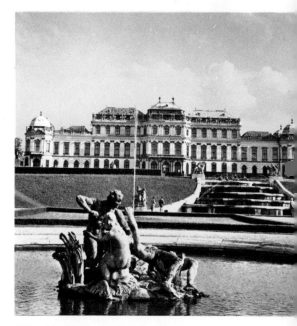

1136. AUSTRIA. JOHANN LUKAS VON HILDEBRANDT (1668–1745). The Upper Belvedere, Vienna. 1721–1722.

1137. AUSTRIA. JAKOB PRANDTAUER. Melk monastery. 1702-1736.

1138. BOHEMIAN. JAN KUPECKY (1667-1740). Self-portrait. 1735. *Stuttgart Museum.*

1730; and, most important of all, the decorations for the monasteries of Göttweig, Melk, Altenburg and Zwettl, by Paul Troger, 1698-1762, whose work influenced Anton Franz Maulpertsch, 1724-1796, the most gifted of all, who did the frescoes in the library of the Strahov monastery in Prague and the ceiling of the hall of investiture in the archiepiscopal palace at Kroměříž in Moravia [937]). J. G. Platzer (*c.* 1702-1761) was the master of Viennese Rococo. There were also the excellent portrait painter Heinrich Füger (1751-1818), and Josef Kreutzinger (1757-1829), painter of attractive miniatures.

The minor arts. The Vienna ceramics factory, founded in 1718, was directed by Sorgenthal and produced vases, luxury table services and statuettes in biscuit.

BOHEMIA

Architecture. Like Vienna, Prague is extremely rich in Baroque monuments. The Mala Strana quarter has retained great unity of style. Christoph and Kilian Ignaz Dientzenhofer built the church of St Nicholas (1703-1752), perhaps from the plans of Hildebrandt. The palace of Clam Gallas, with its fine doorways, is by Fischer von Erlach.

Sculpture. The Charles IV bridge in Prague has fine statues, showing the influence of Bernini, by the Brokoffs and Matthias Braun.

Painting. Decoration is primarily represented by the Austrian artist Maulpertsch (Strahov monastery library). Carl Skreta and Peter Brandl painted religious pictures and some excellent portraits. Jan Kupecky worked mostly in Vienna (portraits of Joseph I and Charles IV) and in St Petersburg

[1138]. The landscapes of Norbert Grund (1717-1767) are reminiscent of Guardi.

The minor arts. Bohemian glass met with competition from England. In the 18th century the industry specialised in the production of cut and engraved coloured crystal.

SWITZERLAND

Architecture. In Geneva secular architecture showed strong French influence (hôtel Lullin by Joseph Abeille; Maison Mallet from plans by J. F. Blondel), as it did in Berne (hôtel de Musique; old police station; plans of the new town hall and of the mint by J. D. Antoine). Religious architecture was influenced by Italy or by Austria (Einsiedeln monastery, by the brothers Moosbrugger, 1734-1770).

Sculpture. Sculpture played a very minor role at this time. Johann August Nahl of Berlin executed the tomb of Mme de Langhans in Berne; Valentin Sonnenschein of Stuttgart was professor at the newly founded Academy of Berne. Alexandre Trippel (1744-1793) of Schaffhausen lived in London and Paris and died in Rome (bust of Goethe; monument for Salomon Gessner at Zürich). Funk the Younger (1745-1811) did excellent busts.

Painting. Joseph Werner (1637-1710), who worked in Berne, was an outstanding miniaturist. J. Huber (1721-1786) of Basle is known for his sketches of Voltaire. Robert Gardelle (1682-1766) was a follower of Largillierre. Although competent portrait painters they are overshadowed by the technical skill of the famous pastel artist Jean Etienne Liotard (1702-1789), who lived successively in every country in Europe and also in Constantinople (*Empress Maria Theresa*, Geneva; *La Belle Chocolatière*, Dresden; *Madame d'Epinay*, Geneva); he also did a number of engravings. The portrait painter J. M. Wyrsch (1732-1798) settled in Besançon. Angelica Kauffmann (1741-1807) was a disciple of Winckelmann and a follower of Mengs; the latter part of her life was spent in Rome, where her studio was famous (portrait of the Baronne de Krudener, Louvre [1036]).

At the end of the century a number of painters of delicate landscapes were active (owing to the return to nature encouraged by Rousseau and Haller). Among them were J. L. Aberli, S. Freudenberger and Salomon Gessner, who was also a good engraver.

The minor arts. Faience factories were started at Zürich, Winterthur, Lenzburg, Schoren and Nyon, but these were short lived. Production

1139. AUSTRIAN. GEORG RAPHAEL DONNER (1693-1741). Hagar in the Desert. Marble. *Österreichische Galerie, Vienna.*

was continued of large stoves with Baroque or Rococo decoration.

Jean Jacquet (1765–1839), a pupil of Pajou, specialised in interior decoration.

SCANDINAVIA

History. At the death of Charles XII (1718) his sister Ulrica Leonora came to the throne. Her reign is remembered for the dispute between the 'Cap' and 'Hat' parties, and for the Russian conquests (loss of Estonia, Karelia and a part of Finland). Count Tessin, a great diplomat and patron of the arts, was ambassador to Paris from 1739 to 1742 and was interested in French art.

Cultural background. The Swedish theosophist and visionary Emanuel Swedenborg (1688–1772) wrote *Arcana Coelestia* in 1749. Ludwig Holberg (1684–1754) was dubbed the 'Plautus of Denmark' (*Voyage of Niels Klim*).

In Sweden the astronomer and physicist Anders Celsius (1701–1744) invented the centigrade scale (1742); Scheele (1742–1786) discovered chlorine, and the naturalist Linnaeus (1707–1778) invented the system of the classification of plants and animals.

Architecture. *Denmark.* Everything points to French influence (palace of Christianborg, 1733–1740, much damaged by fire in 1794; the new district of Amalienborg, with the marble church, begun in 1749 by Jardin [**1142**]). Harsdorf (1735–1799), who was influenced by Soufflot, was active in Copenhagen.

Sweden. French influence replaced that of Holland and Germany during the 18th century. The transition can be seen in Riddarhuset palace by Simon de La Vallée and his son Jean. Both the royal palaces of Skokloster and the castle of Drottningholm (by N. Tessin the Elder and N. Tessin the Younger) were inspired by French architecture. The latter's son, the famous diplomat Carl Gustaf Tessin (1695–1771), undertook the greatest project of the period — the reconstruction of the royal palace at Stockholm, which was based on Versailles. Versailles was also the inspiration for the palace of Haga by Louis Deprez (1743–1804). Erik Palmstedt (1741–1803) was influenced by antiquity (stock exchange, Stockholm).

Sculpture. *Denmark.* French sculptors were in demand from the end of the 17th century. J. F. Saly, a French sculptor, designed the equestrian statue of Frederick V for Amalienborg Square. Johann Wiedewelt, who worked in Rome, was influenced by Winckelmann and appears to have been the precursor of Thorvaldsen.

Sweden. The German and Dutch influences (pulpit in Uppsala cathedral

1140. DANISH. CARL GUSTAV PILO (1711–1793). The Coronation of Gustavus III. *Stockholm Museum.*

1141. SWEDISH. ALEXANDER ROSLIN (1718–1793). Portrait of the Artist's Wife. 1768. *Stockholm Museum.*

1142. DENMARK. The Amalienborg quarter, Copenhagen. The palace was built by Nicolas Eigtved (1701–1754).

by Burchard Precht; *Apollo and the Muses* by Nicolas Millich, pupil of Rombout Verhulst) were followed by the French, with Jacques Philippe Bouchardon (1711–1753), who carved an *Agony in the Garden* and a bust of Charles XII, and with P. H. Larchevêque, who became court sculptor in 1760 (statue of Gustavus Vasa, 1773; equestrian statue of Gustavus Adolphus, 1791). His pupil J. T. Sergel (1740–1814) worked in Paris and Rome and was influenced by the ideas of Winckelmann (*Sleeping Faun*, Stockholm; commemorative monument to Descartes).

Painting. *Denmark.* Nicolai A. Abilgaard (1743–1809) broke away from the Dutch and French influences. He painted portraits of Gustavus III (1771) and of Queen Louisa Ulrica (Drottningholm). The same influences helped to form Jens Juel (1745–1802). Carl Gustav Pilo (1711–1793) was a powerful and daring portrait painter [**1140**].

Sweden. Count Tessin's stay in France

was partly responsible for the arrival in Paris of a number of Swedish artists such as Alexander Roslin (1718–1793) [**1141**] and Nicolas Lafrensen, called Lavreince (1737–1807), a pupil of Baudouin and Largillierre, whose light subjects were engraved (*The Comparison*; *The Difficult Confession*).

The minor arts. The porcelain factory at Copenhagen, founded in 1772, soon acquired a world-wide reputation. Those at Rostrand and Marienberg (Sweden) opened in 1726 and 1756.

In Denmark Abilgaard designed furniture of a very pure line and with a distinct local accent [**1143**].

POLAND

History. The great families (Czartoryski, Radziwill, Potocki) quarrelled over the tutelage of the monarchy. Catherine the Great imposed Stanislas Poniatowski as king. The conference of Bar (1768) ended in the first parti-

1143. DANISH. Gold and enamel box. Stamped Copenhagen (1758) and J. Henriksen. *Museum of Decorative Arts, Copenhagen.*

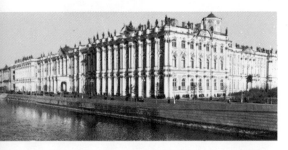

1144. RUSSIA. BARTOLOMMEO RASTRELLI (1700–1771). The Winter Palace, St Petersburg (Leningrad). 1754–1762.

tion of Poland (1772) between Russia, Prussia and Austria. The civil war of 1792 gave Russia the opportunity to intervene; Poland, abandoned by Prussia, was subjected to a second dismemberment (1793), and then a third partition (1794) after the fall of Warsaw erased the country from the map of Europe.

Architecture. Under Stanislas Poniatowski French influence was stronger than Italian. The king called in Victor Louis [726] to do work on the royal palace at Warsaw. The summer palace of the Lazienki was built by the German architect J. C. Kamsetzer, a friend of Clérisseau. Religious architecture produced some perfect examples of Baroque (Dominican churches at Tarnopol and Lvov).

Sculpture. French influence was dominant in sculpture after the arrival in Warsaw of André Lebrun, a pupil of Pigalle, who was summoned by Stanislas Augustus to decorate the royal palace.

Painting. Many French painters came to Poland in the last third of the 18th century. Mme Vigée-Lebrun and Marteau painted portraits of the nobility. Norblin de la Gourdaine was the head of the national school of painting and taught Orlowski and Plonski. In addition to French and Italian painters, Swedish and German artists were active. Chodowiecki was famous in Germany and Kucharski (1736–1826) worked in Paris; he was the last to paint the portrait of Marie Antoinette. Czehowicz and Konicz were influenced by the Baroque art of Rome.

The minor arts. There were numerous tapestry and carpet factories; the main ones were those of Lancut and Biezdziatka. Belts woven in gold were made at Sluck (founded *c.* 1750).

Famous ceramics factories were founded at Belveder (1770), Korzec (1791) and Baranovka (1797).

RUSSIA

History. After the death of Peter the Great (1725) the power was in the hands of four successive empresses: Catherine I (1725–1727), Anna Ivanovna (1730–1740), Elisabeth Petrovna (1741–1762) and Catherine II, the Great (1762–1796). These feminine governments were favourable to French influence. Catherine the Great corresponded with Voltaire, Diderot, Buffon and Mme Geoffrin, despite her antipathy to the French monarchy and, later, her hatred of the French Revolution. During the first two reigns Russia was almost continually at war with the Turks; under Catherine II there took place after the Seven Years' War the three partitions of Poland.

Cultural background. An Academy of Fine Arts was founded on the model of the one in Paris; Russian writers were subject to French influences (Trediakovski translated and imitated Boileau). Poetry took a new lease of life with Lomonosov. True Russian theatre appeared in 1756 with the troupe of Volkov.

Architecture. The first architects of St Petersburg were the Italian Domenico Tressini, who was trained in Holland (cathedral church of SS. Peter and Paul), and the Germans Andreas Schlüter, Theodor Schwertfeger and Gottfried Schädel (Menshikov palace at Oranienbaum), who introduced the ideas of modern Baroque into Russia. Under Elisabeth French influence prevailed and adapted itself to national traditions in a highly original style. The Italian Count Bartolommeo Rastrelli (1700–1771), who had studied in France and who worked at St Petersburg, built the Winter Palace (1754–1762) [1144], the Summer Palace (destroyed), the palace at Tsarskoe Selo (1752), the Stroganov palace (1750–1754), the Anitchkov palace and the Vorontsov palace, and designed and began the cathedral of the Smolny convent [927]. His pupil and assistant Sava Chevakinski designed the pretty campanile of St Nicholas of the Sea. Under Catherine II the return to antiquity became more pronounced (first Hermitage and St Petersburg markets by Vallin de la Mothe; palace of Pavlovsk by the Scottish architect Charles Cameron (*c.* 1750–1811); colonnade of the Alexander palace at Tsarkoe Selo, 1795; gateway of the English Palace at Peterhof;

Hermitage theatre by the Italian architect G. Quarenghi, a follower of Palladio.

Among the young architects trained at the Academy there were: Ivan Yegorovich Starov (Taurid palace for Potemkin, 1783); V. I. Bazhenov (project for a gigantic palace to replace the Kremlin); Matvei Feodorovich Kazakov, who built the Pachkov and Rasumovski palaces.

Sculpture. During the first half of the 18th century sculpture was represented by foreign artists (Konrad Osner; Andreas Schlüter; Count Carlo Rastrelli; Nicolas Pineau; Nicolas Gillet, who became professor at the St Petersburg Academy and wielded great influence). Among the Russian pupils of Gillet were Chubin (1740–1805), a good carver of busts (*Potemkin*; *Lomonosov*), M. I. Kozlovski (1753–1802; statue of General Suvarov, 1801) and F. F. Shchedrin (1751–1825), a decorative sculptor (gateway of the Admiralty). Ivan Martos (1752–1835) was trained in Rome.

Painting. The modern school of Russian painting was formed in the middle of the 18th century. At the beginning of the century painting was done mainly by foreign artists, and many well known painters from all over Europe taught at the Imperial Academy (including Claude le Lorrain).

The national school distinguished itself particularly in portraits. Leading painters were: A. P. Antropov (1716–1795); F. S. Rokotov (1738–1812); and, most important of all, D. G. Levitski (1735–1822; portrait of Diderot; series of *Pensioners of the Smolny Institute*).

Engraving. Chmesov and Utkin were pupils of the etcher Schmidt of Berlin and of the French etcher Radigues. Skorodumov studied stippling technique in London with Bartolozzi. Popular tradition survived in the very characteristic bright colour prints carried all over Russia by pedlars.

The minor arts. The imperial tapestry factory, founded under Peter the Great, imitated the Gobelins. High warp was introduced by weavers from Brussels.

The St Petersburg ceramics factory, founded in 1741, was greatly enlarged under Catherine II.

LATIN AMERICA

History. The Spanish colonies in the New World were much dominated by a harsh administration based on the Inquisition. But in spite of commercial and political domination they began gradually to form an American civilisation. The new riches of gold and diamond mines discovered in the region

of Minas Gerais in Brazil gave a stimulus to the Portuguese colony which built new towns, churches and convents.

Architecture and sculpture. The 18th century was the great age of the 'ultra-Baroque' which flourished in Latin America and in which the genius of native craftsmen added its peculiar ornamental flavour to the Baroque structure. The most ornate work, typical of this art, is at Tepotzotlán in Mexico.

Strangely enough an Oriental influence, brought by trade between American colonies and Far Eastern colonies by way of the Philippines or by the Goa-Macao-Portugal route, is a characteristic of Iberian Baroque. This can be seen in the ruins of the church of Paoy in the Philippines and in the great cathedral of Goa.

Mexico. The Trinidad church in Mexico City (1755–1783) was completed by the Spanish architect Lorenzo Rodriguez; the Indian sculptor P. Patino Ixtolinque worked on it. The cathedral of Zacatecas and the monasteries of Churubusco, Chalma and Querétaro are all fine examples of Mexican Baroque [**969**]. In Puebla local characteristics are dominant on the façade of S. Francisco at Acatepec and inside Sto Domingo. [**960, 970**]. At Ocotlan, with its totally indigenous decoration [**953**], and at Guadalupe, with its *azulejos*, the builders sought effects of colour, as did the builders of the small rural churches in which these popular tiles were also found.

Secular architecture provided fine squares, splendid palaces, which were based on Andalusian palaces and were adorned with *azulejos*, and fine aqueducts and fountains.

Guatemala. Despite influences from Mexico and Peru Guatemala had an original art (Santiago de los Caballeros, Antigua).

Peru. A fine architecture was built up from a valuable local contribution. At Lima [**961, 962**] the cathedral was reconstructed to resist earthquakes. Trujillo was another Baroque centre. Cuzco kept its ancient primacy and had fine 18th-century churches. Arequipa, which was also an important capital, influenced the architecture of the region of Lake Titicaca (Puno cathedral).

Bolivia. Bolivia shared the Peruvian style. Examples are: S. Francisco and Sto Domingo, and houses of Villaverde and of Don José de Araña, at La Paz; the cathedral at Potosí, which is rich in Baroque work.

Venezuela. Fine domestic architecture was built at Caracas.

Chile. The building of the Jesuit missions introduced German influences (Santiago cathedral, begun 1748).

Argentina. Córdoba cathedral, reconstructed after the end of the 17th century, combines Andalusian, Italian and indigenous influences.

Brazil. Missionary architects came from Portugal (1700–1730); the style of these mission churches remained rather severe (Madre de Deus at Recife, 1706–1730). The Baroque was established about 1690; it began to evolve towards Rococo after 1760. At first the region of Bahia was most important, but after 1740 the mining region of Minas Gerais superseded it. At Ouro Preto [**966**] the typical churches of Manuel Francisco Lisboa (active 1728–1764) are the best known, together with those of his mulatto son Antonio Francisco Lisboa (1738–1814), who built the church of São Francisco but who was first of all a famous sculptor, known as Aleijadinho; his Prophets from the Bom Jesus de Matozinhos at Congonhas do Campo is a masterpiece of powerful lyricism [**977**]. Another sculptor of the same generation at Rio was Valentim da Fonseca Silva who turned to Neoclassicism. Sculptors of polychrome statues were inspired by Sapnish models.

Painting. The influence of Murillo was considerable in Mexico, where José Ibarra (1688–1756) and Miguel Cabrera (1695–1768) painted religious scenes. The only original painter was Gregorio Vazquez (1638–1711) in Colombia.

The minor arts. The same exuberance and decorative proliferation that prevailed in architecture and sculpture were found in furniture and metalwork, which was sumptuous and heavy [**955**].

CANADA

History. Quebec, the capital of New France, was founded in 1608 and was followed by Montreal in 1641. The region of the St Lawrence prospered until the Seven Years' War, which ended after the fall of Quebec (1759) with the Treaty of Paris (1763); this gave Canada to England. The political constitution was fixed by the Act of Quebec in 1774 and the Constitution of 1791, which divided the country into two provinces — Upper Canada and Lower Canada — each administered by a governor and a council dependent on England and by an assembly elected by the Canadians.

Architecture. The French provincial tradition of modest, plain, but well proportioned architecture was continued in simple churches throughout the 17th century; these became a little

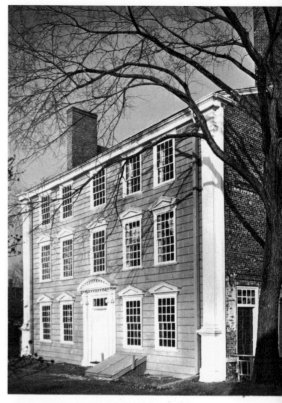

1145. U.S.A. Isaac Royall house, Medford, Massachusetts. West façade. 1747–1750.

1146. U.S.A. Vassall-Longfellow house, Cambridge, Massachusetts. 1759. The façade has full length pilasters.

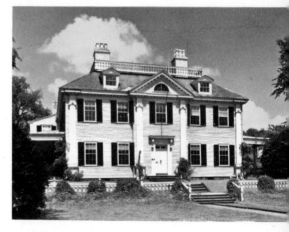

more ornate during the most prosperous period (1730–1745). The finest churches of the 18th century were those at Cap de la Madeleine (1715) and St Pierre (island of Orléans, 1716) and (in the more refined style of the middle of the century) the churches of Ste Famille (1743), Cap Santé (1754), Varennes (1780) and Baie St Paul. Ramesay castle in Montreal (1705) is typical of the great patrician dwellings.

Sculpture. A tradition of religious wood sculpture prevailed from the 17th century (altarpiece of the Ursulines in Quebec).

Painting. Painting was mainly religious; *ex votos* were naive and dramatic. Some 17th-century portraits remain.

Lilianne Brion-Guerry, Lydie Huyghe and Gisèle Polaillon-Kerven

THE UNITED STATES

History. The prosperity of the American colonies increased with the steady growth of trade and industry in the north and the tobacco plantations in the south. The colonies aided England in the Seven Years' ('French and Indian') War, which resulted in England acquiring a part of the French territories between the Mississippi and the eastern colonies. Much dissatisfaction and several disputes over taxation of the colonies by England culminated in the first Continental Congress in 1774, which sent a Declaration of Rights to England protesting against taxation and declaring a boycott of English goods. War broke out in 1775. On 4th July 1776 the Declaration of Independence was adopted. In 1778 France entered into an alliance with the United States. The war ended in 1781, and the Treaty of Paris in 1783 placed the western boundary of the new United States at the Mississippi. The Constitution was ratified in June 1788.

Cultural background. Harvard University and William and Mary College, established in the 17th century, were followed in the 18th by Yale in Connecticut, Princeton in New Jersey and King's College (now Columbia University) in New York. Learned societies and libraries flourished. Newspapers helped to spread ideas throughout the colonies. Scientist, writer and diplomat, Benjamin Franklin was the perfect type of cultivated American. Towards the end of the century a number of talented writers were active — Philip Freneau the poet, Charles Brockden Brown, writer of 'gothic' novels, and Royall Tyler whose witty play *The Contrast* is reminiscent of Sheridan.

Architecture. The new élite, rich merchants in the north and planters in the south, looked to England for an architecture befitting their position and adopted the established fashions of court and aristocracy. The result was a rapid transition from the Middle Ages to Georgian in building style. Wren's influence was great, particularly via the work of his anonymous followers. English architectural handbooks were used by the colonists in building their houses — in particular in the treatment of architectural detail. Regional differences became less important with the advent of Georgian.

Georgian, a Renaissance style, was balanced and symmetrical, consciously

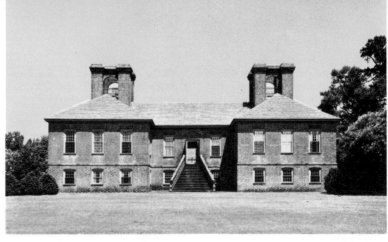

1147. U.S.A. Stratford, Westmoreland County, Virginia. *c.* 1725–1730. The plan is H-shaped.

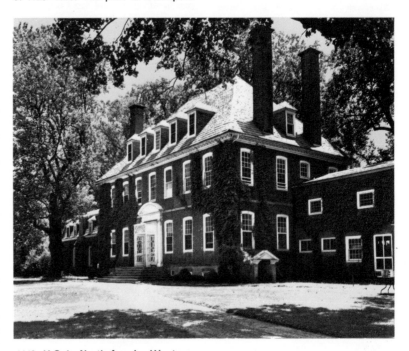

1148. U.S.A. North façade, Westover, Charles City County, Virginia. *c.* 1730–1740.

1149. U.S.A. The entrance hall, Carter's Grove, James City County, Virginia. 1750–1753.

1150. U.S.A. Street façade, showing portico,
Miles Brewton house, Charleston, South Carolina. 1765–1769.

1151. U.S.A. Ludwell-Paradise house,
Williamsburg, Virginia. c. 1717.

ordered and classical — in direct contrast to Colonial 17th-century architecture. Typical house plans had a central hall with two rooms on either side — each with a fireplace, generally on the outside wall — and with four chimneys. In the northern colonies the kitchen was frequently in an attached extension; in the south, with its many servants, the kitchen was in a separate building and might be a distance from the house. Roofs were low pitched and sometimes had dormers, and the hipped roof was popular — often with a balustrade round the upper part. Under the eaves was a classical cornice, and earlier in the century there were sometimes quoins at the corners of the façades. A horizontal moulding often marked the line between first and second storeys. Sash windows replaced casements; doors were panelled, often with a rectangular window, or later in the century a fanlight, above, and might be flanked by classical Orders and topped by a pediment. Paint and plaster had transformed the insides of houses. Walls were panelled and painted, and wallpaper was common after the middle of the century. Stairways and fireplaces became increasingly refined.

About the middle of the century certain changes are evident in Georgian architecture. The roof pitch became lower and the balustrade more common. A projecting pavilion in the centre of the façade was often seen. Sometimes there was an entrance portico (two storey in the south), and full length pilasters might run the height of the façade. The pediment over the door might be segmental, and the

1152. *Above*. U.S.A. Doorway, Mount Pleasant, Philadelphia.

1153. *Above, right*. U.S.A. Mount Pleasant, Philadelphia. 1761–1762. Brick quoins are used at the angles of the building.

1154. *Right*. U.S.A. Grumblethorpe, Germantown, Pennsylvania. 1744.

1155. U.S.A. Christ Church (Old North Church), Boston. 1723. The steeple is reminiscent of Wren.

1157. U.S.A. S. José at San Antonio, Texas, a building showing the influence of Spanish Baroque. 1720–1731.

1156. U.S.A. St Michael's, Charleston, South Carolina. 1752–1761. The influence of Gibbs can be seen.

dormer windows arched. The Palladian window over the doorway dates from this period [1153].

Although brick was the popular Georgian building material, New England houses were still generally clapboard or perhaps shingled. The hipped roof was less common here than in the south, but roof balustrades and pilasters on the façade were largely New England features. Among many fine Georgian houses of this area are: Isaac Royall house, Medford, Massachusetts (east façade 1733–1737; west façade 1747–1750 [1145]; Vassall-Longfellow house, Cambridge, Massachusetts (1759) [1146]; Wentworth-Gardner house, Portsmouth, New Hampshire (1760); Jeremiah Lee house, Marblehead, Massachusetts (1673); Samuel Cowles house, Litchfield, Connecticut (c. 1780).

Southern Georgian domestic architecture was distinguished by its handsome great houses of beautiful proportions and simple design — often with outbuildings in symmetrical wings — set in large grounds with formal gardens. There were fine town houses in the cities. Examples of southern great houses are: Stratford, Westmoreland County, Virginia (c. 1725–1730) [1147]; Westover, Charles City County, Virginia (c. 1730–1740) [1148]; Carter's Grove, James City County, Virginia [1149]; Tulip Hill, Anne Arundel County, Maryland (c. 1756); Mount Airy, Richmond County, Virginia (1758–1762). Examples of town houses

are: Ludwell-Paradise house, Williamsburg, Virginia (c. 1717) [1151]; Miles Brewton house, Charleston, South Carolina (1765–1769) [1150]; Hammond-Harwood house, Annapolis, Maryland (1773–1774). Charleston, with its diversity of influences (among them French and West Indian), produced a distinctive town house, having its gable end to the street and its long side, with its porches and galleries, facing the gardens. Charleston houses were sometimes covered with coloured stucco.

Georgian in the middle colonies in the early part of the century was fairly plain as regards decoration. A feature sometimes seen is a sloping roof-like projection between the first and second storeys [1154]. Stone or brick were the materials in this area; stone might be covered with stucco. Examples are: Steelman house, Pennsauken Township, New Jersey (1728–1749); Grumblethorpe, Germantown, Pennsylvania (1744) [1154]; Mount Pleasant, Philadelphia (1761–1762) [1152, 1153]; Cliveden, Germantown, Pennsylvania (1763–1764).

18th-century churches were Georgian in style, based on English churches (the influence of Gibbs was strong) with their varied spires, but were usually adapted to a wood construction. The emphasis on pulpit rather than altar was marked, even in the southern Anglican churches (Christ Church [Old North], Boston, 1723 [1155]; Christ Church, Cambridge, Massachusetts, 1759–1761; First Baptist Meet-

424

1158. U.S.A. Window in the baptistery, S. José at San Antonio. Texas.

1159. U.S.A. S. Xavier del Bac, Tucson, Arizona. 1784–1797.

ing-house, Providence, Rhode Island, 1774–1775; Bruton Parish Church, Williamsburg, Virginia, 1711–1715; St Michael's, Charleston, 1752–1761 [**1156**]).

There was substantial public building, particularly in Boston (Old State House, 1712–1713; Harvard University halls; Faneuil Hall, 1740–1742) and also in Providence. Independence Hall was built in Philadelphia between 1731 and 1745. Georgian civic architecture came early to Williamsburg, which was made the capital of Virginia in 1699 (William and Mary College, 1695–1702; Capitol, 1701–1705 [see colour plate p. 384]; Governor's Palace, 1706–1720).

At the end of the century the new republic saw the Georgian supplanted by a very different classical style which we call Federal today. The influence came partly from England and the work of the brothers Adam, partly from the French Louis XVI style, and partly from the new attention given to archaeology. It continued into the 19th century and can be considered in spirit more a part of 19th-century art than 18th.

Farther west on the continent, in the area colonised by the French, little remains from the 18th century. One surviving house, however, typical of its period, is Parlange in Pointe Coupée Parish, Louisiana (1750). A rectangular three-storey building with a hipped roof and dormers, it is encircled by a two-storey colonnaded gallery which foreshadows Louisiana

plantation houses of a later date.

In the south-west in New Mexico adobe churches in the Indian tradition, with little external decoration, continued to be built in the 18th century (S. José at Laguna, 1699–1706; S. Francisco at Rancho de Taos, 1772). In Texas (S. José at San Antonio, 1720–1731 [**1157, 1158**]), Arizona (S. Xavier del Bac, Tucson, 1784–1797 [**1159**]) and California (S. Carlos Borromeo, Carmel, 1793–1797), where the Pueblo tradition was less widespread or was absent, mission churches showed many more Spanish Baroque characteristics.

Sculpture. As in the previous century, sculpture consisted of wood-carving. Among the best known of the wood-carvers were Samuel McIntire of Salem and the Skillin family of Boston.

Painting. The 18th century in the colonies was a period of portraiture in painting. In the first half of the century the trends were a late Baroque style brought from Europe by immigrant painters and also by European engraving, and a local trend stemming from straightforward, realistic portraits by native-born artists (most of whom remain anonymous). Foremost among the immigrant painters were: Charles Bridges from England, who was active in Virginia from 1735 to about 1740 (portrait of Maria Taylor Byrd, Metropolitan Museum of Art); John Smibert (1688–1751), a Scot who came to New England in 1729 (*Dean George Berkeley*

and his Family [**1160**], which influenced a number of colonial painters); Gustavus Hesselius (1682–1755) from Sweden, who in his later years in America did impressive realistic portraits of the Indian chiefs Tishcohan and Lapowinska; John Wollaston; Joseph Blackburn (*Isaac Winslow Family*, c. 1755, Museum of Fine Arts, Boston); William Williams (portrait of Deborah Hall, 1766, Brooklyn Museum). Among the leading native-born painters were Joseph Badger (1708–1765) and in particular Robert Feke (c. 1706/10–before 1767) of Rhode Island (*Isaac Royall and Family*, 1741 [**1161**], a work which shows the influence of Smibert; *General Samuel Waldo*, c. 1748, Bowdoin College Museum of Fine Arts).

The more gifted and ambitious painters of the second half of the century studied or worked in England at some time in their careers. John Singleton Copley (1738–1815), a painter of powerful, sensitive, vividly realistic portraits, was the outstanding painter of this period (*Mrs Sylvanus Bourne* [**1162**]; *Colonel William Montresor*, c. 1772, Detroit Institute of Arts; *Copley Family*, Washington); he went abroad in 1774 and soon settled in England, where he painted his gripping study of a contemporary subject *Brook Watson and the Shark* (see colour plate p. 384). Among his later works, in the Neoclassical style, is the *Death of the Earl of Chatham* (1779–1780; Tate Gallery). Benjamin West (1738–1820) went abroad in 1759 and settled per-

1160. AMERICAN. JOHN SMIBERT (1688–1751).
Dean George Berkeley and his Family. 1729.
*Yale University Art Gallery, New Haven. Gift of
Isaac Lathrop.*

1161. AMERICAN. ROBERT FEKE (*c.* 1706/10 – before 1767).
Isaac Royall and Family. 1741.
Fogg Art Museum, Cambridge, Massachusetts.

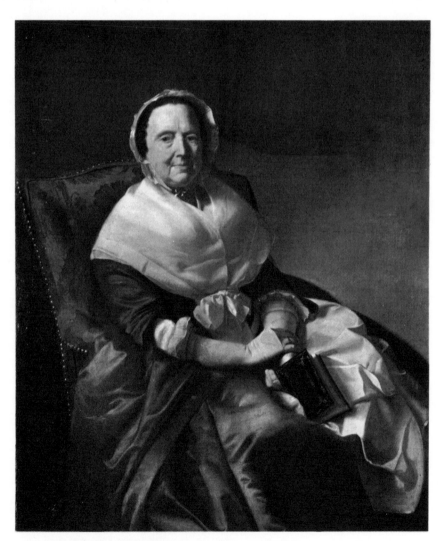

1162. AMERICAN. JOHN SINGLETON COPLEY (1738–1815).
Mrs Sylvanus Bourne. 1766.
Metropolitan Museum of Art.

manently in England, becoming a successful historical painter (*Death of General Wolfe*, *c.* 1770 [**1163**], National Gallery, Canada). A number of American painters studied with him in England; among these were: Ralph Earl (1751–1801), a New England portrait painter with a severe, realistic style (*Roger Sherman*, *c.* 1777, Yale University Art Gallery; *Mrs William Moseley and her Son Charles* [**1165**]); Matthew Pratt (1734–1805; *The American Academy*, 1765, Metropolitan Museum of Art); John Trumbull (1756–1843), an admirer of Rubens and a painter of historical pictures (*Death of General Montgomery at Quebec* [**1164**]); Gilbert Stuart (1755–1828), influenced by Reynolds and Gainsborough, who is best known for his studies of George Washington; Charles Willson Peale (1741–1827), a fine portrait painter and a man of great knowledge and intellectual curiosity who in the 1780s opened first an art museum and then a natural history museum in his native Philadelphia. He also started the first art school in the country. An interesting painting by him is the *Staircase Group* (*c.* 1795; Philadelphia Museum of Art), a trompe l'oeil study of his two sons ascending a staircase [**1166**].

The minor arts. Furniture in the bigger homes took on a new elegance with the 18th century. Some furniture was imported from England, but local cabinet-makers produced fine works in the Queen Anne, Sheraton, Hepplewhite and Chippendale styles. Imported mahogany was used as well as local walnut, maple and cherry.

Emily Evershed

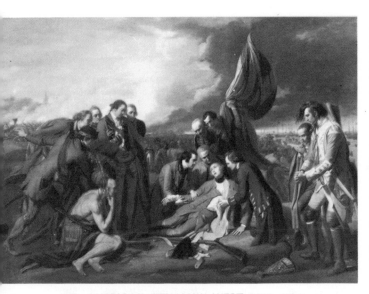

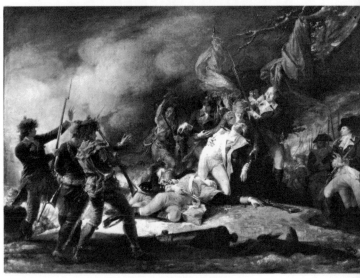

1163. AMERICAN. BENJAMIN WEST (1738–1820).
Death of General Wolfe. c. 1770.
National Gallery of Canada.

1164. AMERICAN. JOHN TRUMBULL (1756–1843).
Death of General Montgomery at Quebec. 1775.
Yale University Art Gallery, New Haven.

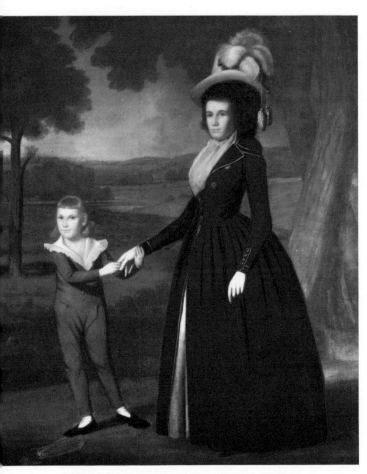

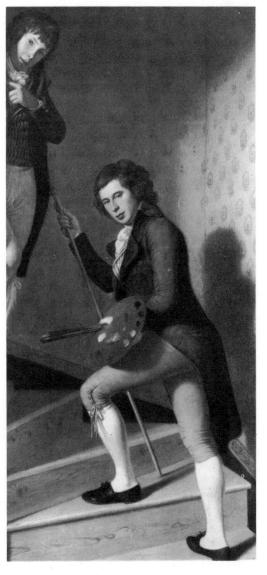

1165. AMERICAN. RALPH EARL (1751–1801).
Mrs William Moseley and her Son Charles.
Yale University Art Gallery, New Haven.
Bequest of Mrs Katherine Rankin Wolcott Verplanck.

1166. AMERICAN. CHARLES WILLSON PEALE
(1741–1827). Staircase Group. c. 1795.
Philadelphia Museum of Art.

ACKNOWLEDGEMENTS

Reproduced by Gracious Permission of Her Majesty the Queen: 261.

The Publishers also wish to thank the following for supplying photographs: A.C.I., Brussels: 95, 118, 477. — A.C.L., Brussels: 159, 178, 344, 347, 480, 493, 497, 567, 568, 569, 579, 594, 595, 596, 599, 604, 605, 1089. — Albertina: 498, 582. — Alinari: 31, 33, 34, 39, 40, 41, 45, 46, 50, 52, 53, 54, 56, 59, 60, 63, 70, 161, 170, 172, 176, 177, 181, 191, 206, 207, 210, 211, 215, 217, 220, 221, 224, 226, 227, 229, 231, 237, 239, 240, 241, 242, 243, 254, 258, 262, 263, 265, 266, 270, 273, 274, 275, 281, 291, 298, 300, 301, 304, 307, 310, 313, 315, 317, 318, 319, 467, 485, 507, 508, 516, 520, 522, 524, 526, 529, 530, 531, 561, 740, 741, 742, 745, 754, 755, 871, 875, 880, 887, 902, 904, 906, 907, 908, 911, 930, 933, 972, 973, 974, 1016, 1071, 1072, 1073, 1074. — Alinari-Brogi-Giraudon: 302, 746. — Alinari-Giraudon: 37, 42, 43, 47, 49, 138, 157, 169, 199, 311, 739. — Ambrosiana Library, Milan: 61. — Anderson: 72, 201, 233, 244, 269, 271, 277, 278, 280, 295, 303, 314, 316, 513, 548, 558, 563, 564, 877, 910, 1069, 1070. — Anderson-Giraudon: 35, 38, 48, 50, 51, 57, 58, 109, 114, 171, 180, 186, 193, 194, 195, 196, 197, 198, 256, 264, 295, 303, 345, 555, 748, 817, 882, 899. — Charles André: 1026. — Wayne Andrews: 859, 860, 862, 863, 867, 1146, 1147, 1148, 1150, 1156, 1157, 1158. — Archaeological Museum, Granada: 541. — Archives Photographiques: 84, 87, 102, 104, 111, 125, 145, 148, 149, 151, 152, 160, 168, 184, 209, 223, 249, 252, 257, 259, 283, 286, 287, 305, 328, 346, 468, 469, 477, 543, 571, 581, 591, 597, 607, 613, 625, 653, 699, 712, 719, 720, 722, 730, 731, 758, 762, 769, 777, 780, 781, 793, 800, 806, 814, 881, 893, 894, 896, 924, 978, 984, 989, 997, 1005, 1020, 1022, 1023, 1030, 1046, 1053, 1054, 1062. — Art Gallery of Atheneum: 624. — Art Institute of Chicago: 82. — Ashmolean Museum, Oxford: 790. — Austrian State Tourist Department: 1136. — Barber Institute, Birmingham, 1107. — Bayerisches Nationalmuseum: 1083. — Bayerische Staatsgemäldesammlungen, Munich: 285, 288, 334, 343, 572, 692, 872. — Becker: 574. — A. de Belder: 585. — Beleza: 956. — Besançon Museum: 470, 985. — Biblio-

thèque Nationale, Paris: 61, 650. — Bildarchiv Foto Marburg: 2, 32, 501, 503, 614, 1075, 1124, 1125, 1130. — R. Blanc: 320. — Jean Bottin: 968. — Boudot-Lamotte: 297, 717, 726, 727, 738, 744, 901, 905, 942, 954, 1025. — Boymans van Beuningen Museum, Rotterdam: 350, 601. — British Museum: 13, 20, 678, 835, 838, 839. — Brogi: 188, 205, 213, 216, 245, 272. — Brogi-Giraudon: 246. — Henri Bron, Montpellier: 988. — Bulloz: 93, 107, 110, 122, 143, 166, 487, 592, 700, 761, 763, 764, 785, 823, 1032, 1040. — Cabinet des Estampes, Brussels: 570, 827. — Camera Press: 861, 866, 868, 1154. — J. Camponogara: 783. — Carvajal: 352, 353. — Cas Oorthuys: 609. — Castelvecchio Museum, Verona: 71. — Photo Causse: 121. — Centraal Museum, Utrecht: 488. — Chapelle de l'Hôtel-Dieu, Troyes: 321. — Chapelle St Sebastien, Cadiz Cathedral: 538. — Cincinnati Art Museum: 185. — Colmar Museum: 332. — Colonial Williamsburg: 1151. — Comune di Genova: 222. — Conservation du Musée National de Fontainebleau: 1058. — Thomas Coram Foundation for Children, London: 1104. — Corsiniani Library, Rome: 139. — Cortlandt V.D. Hubbard: 869. — Courtauld Institute, London: 580, 1102. — George M. Cushing, Boston: 1145. — Dalmas: 775. — Darmstadt: 338. — Daspet: 116. — Deutsche Fotothek, Dresden: 630, 657, 687, 939, 940, 944, 1036, 1132. — A. Dingjan: 621, 636, 658, 659, 1007. — Doeser Fotos: 617. — Draeger Photos: 1052. — Echte: 331. — Editions Tel: 703, 704. — Ellebe: 721, 1042. — Faillé Giraudon: 918. — Fogg Art Museum, Harvard University: 1161. — Fondazione Artistica Poldi Pezzoli, Milan: 897, 1078. — Frick Collection, New York: 559, 651, 996. — Gabinetto Fotografico Nazionale, Italy: 158, 212, 230, 499, 525, 532, 632, 747, 786, 879. — Gasparini: 590. — Geffrye Museum: 1122, 1123. — Gemäldegalerie, Vienna: 834. — Germanisches National-Museum, Nuremberg: 12. — Foto Ghilardi, Lucca: 200. — Foto Gino: 976. — Foto Giovetti: 292, 878. — Giraudon: 1, 28, 65, 66, 67, 68, 69, 89, 92, 96, 97, 119, 120, 162, 163, 164, 204, 236, 267, 296, 299, 323, 471, 472, 476, 478, 481, 492, 500, 527, 578, 584, 587, 603, 645, 665, 669, 672, 675, 680, 681, 682,

685, 686, 688, 689, 691, 695, 705, 706, 709, 713, 715, 716, 723, 724, 765, 912, 929, 983, 994, 1001, 1018, 1035, 1055, 1056, 1057, 1061. — Hanfstaengl-Giraudon: 486. — Hauptampt für Hochbauwesen, Nuremberg: 147. — Hermitage Museum: 855, 986, 993, 999, 1139. — Michael Holford: 512. — Francis Howard Collection: 633. — Inga Aistrup Foto, Denmark: 1142. Iveagh Bequest, Kenwood: 647, 655, 1112. — Kaiser Friedrich Museum, Berlin: 666. — A. F. Kersting: 137, 505, 506, 847, 1093, 1095, 1098, 1101. — Kress Foundation, National Gallery of Art, Washington: 333, 528. — Kulturhistorisches Museum, Stralsund: 88. — Kunsthalle, Hamburg: 77, 1031. — Kunsthistorisches Museum, Vienna: 108, 294, 312, 495, 496, 514, 660. — Kunstsammlung, Basle: 183, 339, 340, 341. — Mansell Collection: 336, 482, 828. — Mansell-Alinari: 75. — Mas: 535, 553, 753, 809, 811, 816, 876, 951, 967, 1086. — T. Mead: 153, 608, 610, 797, 798, 1094, 1096, 1100. — Metropolitan Museum of Art: 549, 690, 696, 1162. — Musée des Arts Décoratifs, Paris: 154, 1045. — Musée des Augustins, Toulouse: 677, 778. — Musée des Beaux-Arts, Bordeaux: 619, 631, 987. — Musée de Dijon: 676. — Museo Civico, Padua: 931. — Museum of Fine Arts, Boston: 551. — Museum of Fine Arts, Budapest: 260. — Mustograph Agency: 846, 1097. — Národní Galerie, Prague: 74, 639, 856. — Nationalbibliothek, Vienna: 937, 938. — National Gallery, London: 90, 94, 103, 112, 124, 173, 228, 251, 289, 290, 294, 583, 586, 626, 638, 693, 694, 837, 921, 1009, 1015, 1076, 1105, 1106, 1108, 1109, 1110. — National Gallery of Art, Washington: 113, 1012, 1021, 1163. — National Museum of Ancient Art, Lisbon: 106, 326, 1044. — National Museum of Coaches, Lisbon: 952. — Nationalmuseum, Stockholm: 533, 673, 782, 925, 1140, 1141. — National Museum of Sculpture, Valladolid: 547. — National Portrait Gallery: 479. — Sydney W. Newbery: 618, 848. — Hugh Newbury: 849, 850, 851, 852, 1092. — New Mexico Department of Development: 858. — Niedersachsische Landesgalerie, Hanover: 606. — Nordisk Pressefoto-Sven Thoby: 611. — Novosti Press Agency: 1027,

1144. — Omaggio, Ferrara: 225. — Österreichische Galerie, Vienna: 979. — Peruvian Embassy: 961. — Philadelphia Museum of Art: 1152, 1153, 1166. — Plus Foto: 234. — Portuguese State Office: 957. — Prado Museum: 101, 327, 351, 519, 539, 552, 554, 557, 560, 562, 565, 598, 600, 812, 813, 815. — Radio Times Hulton Picture Library: 928, 1091. — Rheinisches Bildarchiv, Cologne: 105, 641, 750. — Rijksmuseum, Amsterdam: 615, 616, 627, 643, 644, 646, 649, 656, 759, 829, 841, 842, 843, 844, 845, 1088, 1090. — Foto Rossi: 247, 284, 1037. — Jean Roubier: 466, 489, 509, 510, 511, 517, 671, 707, 710, 711, 736, 771, 773, 774, 776. — San Roque Museum, Lisbon: 819. — Bildergalerie, Sanssouci, Potsdam: 824. — J. Scheerboom: 136. — Service de Documentation Photographique, Château de Versailles: 697, 701, 708, 807, 991, 1034, 1038. — Service Photographique des Archives Nationales: 1029. — Society for the Preservation of New England Antiquities: 1155. — Soprintendenza alle Gallerie, Naples: 1082. — Spanish National Tourist Office: 534, 537, 540. — Staatliche Museen, Berlin: 36, 115, 165, 232, 349, 589. — Staatsgalerie, Stuttgart: 1131, 1138. — Staatsgemäldesammlungen, Munich: 78. — Städelsches Kunstinstitut, Frankfurt: 75, 99, 833. — Statens Museum for Kunst, Copenhagen: 309, 593. — Walter Steinkopf: 995. — Studio Piccardy: 494, 684. — Tate Gallery: 662, 1004, 1006, 1019, 1111. — Robert W. Tebbs: 870, 1149. — Toledo Museum of Art: 895. — Toulouse Lautrec Museum, Albi: 779. — Turin Museum: 174. — Uffizi Gallery: 629. — Valetta Cathedral, Malta: 523. — Valmarana, Vicenza: 1002. — Vatican Museum: 31, 268. — Vernacci: 500, 545, 1084. — Marcel Viaud: 667, 981, 1033. — Victoria and Albert Museum (Crown Copyright reserved): 144, 490, 556, 853, 909, 1099, 1103, 1117, 1118, 1119, 1120, 1121. — Villeri e Figli, Bologna: 235. — Roger-Viollet: 150, 711, 960. — Wallace Collection (Crown Copyright reserved): 760, 998, 1008, 1014, 1066, 1077. — Worcester Art Museum: 250, 864, 865. — Yale University Art Gallery: 1160, 1164, 1165. — Yan: 146, 544, 546. — Joseph Ziolo - André Held: 749.

Burgundy 12, 16, 20, 39, 42, 45, 47, 51, 57, 66, 68, 76, 82, 83, 84, 92, 97 (map), 168, 171
Burgundy, dukes of 47, 48, 66, 76, 81, 82, 92, 117, 146, 149
Burke, E. 411
Burlington, Earl of 13, 409, **1096**
Burlington House 322, 409, 410
Burnacini 324
Burns, Robert 408
Busby monument 322
Buschetto 28
Bushnell, John 253
Bussola, Dionigi 292
Bustelli, F. A. 382, 417, **1116**
Bust-reliquaries 78, 80, 83, 311
Butter Tower, Rouen cathedral 81
Buxheim 357, 415
Buxton 409
Buysleden 170
Buyster, Philippe de 248, 303
Byrd, William 173
Byzantine art 22, 26, 27, 28, 29, 32–3, 37, 40, 41, 42, 43, 45, 88, 90, 145, 177, 180, 229, 363
Byzantine Empire 18, 26, 76, 94, 96, 177

C

Ca d'Oro, Venice 114, **297**
Cabbalism 184
Cabezas, Francisco de las 403
Cabezon, A. 168
Cabral, Pedro Alvares 85
Cabrera, Miguel 421
Cabrieli (family) 158
Caccia, Guglielmo (il Moncalvo) 294
Cachoeira 360
Cadiz 168, 310, 404
Caen 166, 290 (map)
Caffa, Melchiore 292, 312
Caffagiolo 165
Caffarelli, Palazzo, Rome **874**
Caffieri, Jacques 394, 398, 405, **1065–6**
Caffieri, Jean Jacques 394, **1030**
Cagliari 28
Cagliostro 377
Cajamarca 312
Calandria (Bibbiena) 158
Calatrava, Colegio de, Salamanca 403
Calcutta 321
Caldara 399
Calderón 233, 308
Calendrier des Bergiers 83
California 425
Calisto, Luis 404
Calixtus III 84
Callot, Jacques 270, 272, 274, 289, 295, 307, 401, **423, 679, 792**
Calvaert, Denys 210
Calvin, John 179, 184, 332, 340
Calvinism 170, 236, 317
Camaieu 176, 397, 398
Camaino, Tino di 31, 40
Camarín 367
Cambiaso, Luca 164, 182, 190, 216, 219, 231, **455, 457, 546**
Cambiaso, Palazzo, Genoa 161
Cambio, Arnolfo di 29, 30, 31, 40, 113, **46**
Cambrai 290 (map), 348, **918**
Cambridge 78, 79, 173, 321, 409
Cambridge, Massachusetts 424, **1146**
Cameron, Charles 420
Camoëns 168
Campagnola, Domenico 117
Campana, Pedro de 231, 232, **555**
Campanella, Tommaso 219
Campania 28, 29
Campanile 31, 40, 158
Campbell, Colen 409
Camphuysen, Rafel 259
Campi 186, 216, 219, **515**
Campin, Robert (Master of Flémalle) 12, 47, 57, 58, 59, 60–2, 64, 65, 66, 67, 76, 77, 79, **98–9**
Campion, R. 321
Campo Formio, Treaty of 386, 398
Campo Santo, Pisa 24, 40, 41

Campra, André 388
Canada 326, 327, 408, 421–2
Canaletto 349, 401–2, **1017, 1076**, *colour plate p.* 366
Canary Islands 84
Candelabras 165, 295
Candida, Giovanni 117
Candido, Pieter 155, 176
Cano, Alonso 228, 308, 309, 310, 371, 404, **541–2, 809**
Canons' Church, Erfurt 79
Canova, Antonio 13, 411
Cantarini, Simone 293, 295
Canterbury 78, 290 (map), 322
Canzoni (Lorenzo de' Medici) 113
Cap de la Madeleine 421
Cap Santé 421
Caparola, Cola de 158
Capen house, Topsfield, Massachusetts 327, **860**
Capilla de los Reyes, Mexico City cathedral 312, 368
Capilla Real, Granada 85
Capitol, Williamsburg 425, *colour plate p.* 384
Capitoline Museum, Rome 398
Capodimonte 360, 400
Cappella del Crocifisso, Monreale 364
Cappella per la Ciambretta, S. Gregorio, Messina 364
Cappellano, Andrea 98
Cappuccino, il, *see* Strozzi, Bernardo
Capra, Villa (Rotonda) 145, 161, 409, **319**
Caprarola 131, 161, 164, 292
Caprioli 334
Capua 98
Capuchins 158, 291
Caracas 421
Caracciolo, Giovanni Battista 294
Caraglio, G. J. 165
Caravaggesque 192, 244, 247, 253, 270, 272, 292, 293, 294, 310
Caravaggio 13, 164, 182, 186, .190–2, 216, 219–21, 223, 224, 232, 240, 242, 244, 270, 275, 292, 293, 295, 304, 310, 314, 319, 336, 338, 341, 342, 382, 520–1, **523–6**, *colour plate p.* 211
Carbonell, Alonso 308
Carcel de la Corte, Madrid 224
Cardi, Lodovico (Cigoli) 293
Carducho, Vincento 310
Cariani 153, 163
Caribbean 168, 318
Caricature 25, 290, 376
Caridad, Madrid 368
Caridad hospital, Seville 309
Carignano, Palazzo, Turin 291
Carlevaris, Luca 401, 402
Carlier, J. W. 243
Carlier, René 359, 403
Carlone 356
Carlos, Frei 170
Carlton House, London 410
Carmel, California 425
Carmelite church, Paris 345
Carmine Altarpiece 41
Carmona, Luis Salvador 404
Carmontelle 385, 391
Carnelivari, Matteo 114
Carnevali 250
Carolingian 42, 43
Caron, Antoine 167, **374**
Carpaccio, Vittore 116, 134, **247**
Carpenter's Shop (C. van der Passe) 320
Carpets 295, 397, **806**
Carpi, Girolamo da 202
Carpi, Ugo da 165, 217, **518**
Carpintería de lo Blanco 367
Carr, John 409
Carracci (family) 131, 186, 195, 219, 221–2, 240, 242, 276, 290, 292, 293, 295, 332, 400
Carracci, Agostino 241, 292, 293
Carracci, Annibale 13, 186, 190, 219, 221–2, 223, 292–3, 295, 329, **425, 527–8**
Carracci, Ludovico 221–2, 292
Carreño de Miranda, Juan 233, 311, **812**
Carretto, Ilaria del 100, 115, **200**
Carriera, Rosalba 376, 388, 401, **1037**
Carstens, J. A. 417
Carter's Grove, Virginia 424, **1149**

Cartesian 268
Cartouches 304
Cartuja, Granada 403
Casa Professa, Palermo 364
Casanova 387
Casas y Novoa, Fernando 359, 368, 403, **965**
Caserta 362, 363, 399, 400, **954, 972**
Casino, Marino, Dublin 410
Casino Rospigliosi–Pallavicini, Rome 293
Casole d'Elsa 31
Cassel 355
Casserius 290
Cassini 296, 399
Cassoni 101, 117, 165
Castagno, Andrea del 59, 92, 103, 104, 115, **186, 213**
Castel del Monte, Andria 29
Castel Durante 165, 172
Castelfranco Madonna 163
Castelgandolfo 291
Castelli, G. D. 291
Castelli 402
Castello 161
Castello, Valerio 294
Castello Branco 362
Castello delle Torri 29
Castello di Corte, Mantua 117
Castelseprio 42
Castiglione 111
Castiglione, Baldassarre 158, 190
Castiglione, Giovanni 29
Castiglione d'Olona 115
Castile 65, 74, 84, 85, 86, 97 (map), 155, 169, 228, 309
Castillo, Antonio del 310
Castillo, Juan de 169, 310
Castle Howard 249, 322, 409
Castro, Felipe de 404
Castro, Joaquim Machado de 405, 406
Cataldi, Palazzo, Genoa 400
Catalonia 49, 65, 73, 85, 86, 169, 309, 311, 404
Catania 370, 400
Catherine I of Russia 420
Catherine II of Russia 177, 386, 394, 413, 417, 419, 420
Catherine Opalinska 394
Catholic League 323
Catholicism 177, 179, 180, 204, 323, 329, 340, 345, 355
Cattaneo, Danese 145, **314**
Cattaneo, G. A. 81, 162
Caus, Salomon de 323
Cavagna, Giovanni Paolo 294
Cavalli 290
Cavallini, Pietro 32, 33, 40, 88, **49**
Cavallino, Bernardo 294, **754**
Caxés, Eugenio 312
Caylus, Comte de 388, 389
Ceán-Bermudez, A. 368
Cellini, Benvenuto 131, 158, 161, 165, 167, 199, 206, 217, **382, 449–50**
Celma 311
Celsius, Anders 419
Celtes, C. 174
Cennini, Cennino 37, 94
Ceramics, Austrian 418; Chinese 360; Danish 419; Dutch 320, 360, 407, **843**; English 323, 385, 411, 412, **1115, 1117**; Flemish 172; French 168, 351, 382, 397–8, **373, 805, 1042–3, 1045**; German 177, 324, 382, 417; Italian 117, 128, 165, 295, 402, **151**; Polish 420; Portuguese 170, 312, 360, 385; Russian 420; Spanish 86, 311, 359, 360, 385, 404–5, **153**
Cerano 294, 336
Ceresa, Carlo 294
Cerezo, Matteo 311
Cerquozzi, Michelangelo 221, 293
Certosa, Pavia 115, 117
Certosa di Val d'Ema 164, 198
Ceruti 186, 401
Cervantes 308
Cesari, G., *see* Arpino, Cavaliere d'
Cesarini, Cardinal, 179
Cesarotti, Melchiore, 399
Céspedes 231
Cesti 290
Ceylon 318

Cézanne, Paul 58, 66, 190, 276, 380
Châalis 389
Chaillot 390
Chaldean oracles 184
Chalices 78
Chalma 421
Châlons sur Marne 168
Chambers, William 409–10
Chambiges, P. 165, 166
Chambord 97 (map) 166, 173, **359, 801**
Chambray 306
Champagne 67, 81, 97 (map), 147
Champaigne, Philippe de 192, 244, 248, 270, 279, 305, 307, 346, **434, 697**
Champlâtreux 389
Champmol 48, **68, 86**
Champs 299, 391, **436**
Chancillería, Granada 169
Changenet, Jean 68
Chanson de Roland 20
Chantelle 82
Chantelou 306
Chantilly 57, 167, 303, 389, 390, 395, 397, 398
Chapel of the Sindone, Turin 291, 344, **913**
Chapelle du Grand Séminaire, Cambrai 348, **918**
Chardin, Jean Baptiste Siméon 244, 340, 380, 382, 396, 397, **1020–3**
Charité 296
Charlemagne 42
Charles V, Emperor 84, 150, 155, 158, 162, 163, 168, 169, 170, 174, 182, 184, 209, 227, 234
Charles IV of Bohemia 16, 90, 92
Charles IV of Bourbon 398, 400
Charles VI of Bourbon 398
Charles I of England 242, 243, 291, 314, 320, 322
Charles II of England 321, 322
Charles V of France 16
Charles VI of France 48
Charles VII of France 20, 81, 83
Charles VIII of France 81, 82, 83, 84, 113, 146, 179, 206
Charles IX of France 165, 168
Charles of Lorraine 234, 406
Charles of Orléans 52, 81
Charles II of Spain 233, 308
Charles III of Spain 358, 360, 386, 403, 404, 416
Charles IV of Spain 405
Charles XI of Sweden 324
Charles XII of Sweden 324, 419
Charles Albert 415
Charles the Bold, Duke of Burgundy 76, 77
Charles Bridge, Prague 253, 418
Charleston, South Carolina 424, 425, **1150, 1156**
Charleval 167
Charolais 97 (map)
Charonton, Enguerrand 67, 68, 82, 116
Chartier, Alain 52
Chartres 16
Chastellain, Georges 76
Châteaudun 82, 391
Châteaux 166, 299, *see under individual names*
Chatham tomb, Westminster abbey, London 411
Chatranez, Nicolas 169
Chatsworth 322
Chatterton, Thomas 408
Chaucer 49
Chaussée d'Antin 390
Chelles, Pierre de **16**
Chelsea china 410, **1117**
Chelsea Hospital 321
Chénier, André 387
Chenonceaux 97 (map), 166
Cherubini 399
Chevakinski, Sava 420
Chevotet, J. M. 389
Chevreuse, Madame de 296
Chiari, Giuseppe 293
Chiaroscuro 120, 125, 131, 137, 140, 143, 165, 180, 202, 213, 217, 232, 233, 242, 257, 267, 342, 400, 401
Chiaveri, Romano 355
Chiericati, Palazzo, Vicenza 161
Chiesa Nuova, Rome 186
Chieze 250

Chigi, Agostino 158
Chigi chapel, Sta Maria del Popolo, Rome 158
Chile 168, 421
Chimenti, Jacopo 293
Chimney pieces, monumental 173
China and Chinese art 168, 170, 312, 318, 360, 385, 402, 410
Chinoiserie 360, 385, 389, 398, **1118, 1120**
Chinon 97 (map)
Chippendale, Thomas 360, 406, 413, 426, **1118, 1120**
Chiswick Villa 409, 410, **1096**
Chmesov 420
Chodowiecki, D. 379, 382, 416, 417, 420, **1133**
Choffard, P. P. 397
Choisy 396
Cholula 367
Christ Church, Boston, Massachusetts 424, **1155**
Christ Church, Cambridge, Massachussetts 424
Christ Church, Oxford 249
Christian III of Denmark 177
Christian IV of Denmark 251, 324
Christianborg 419
Christina of Sweden 304, 324
Christus, Petrus 24, 59, 77, **1**
Chrysoloras, Manuel 94, 96
Chubin 420
Church of the Apparition of the Virgin, Dubrovitsy 326
Church of the Assumption, Paris 352
Church of the Capuchins, Seville 310
Church of the Holy Apostles, Florence 99
Church of the Incarnation, Madrid 403
Church of the Incoronata, Lodi 114
Church of the Observance, Siena 114
Church of the Scalzi, Florence 131
Church of the Sisters of the Visitation, Fribourg 324
Church of the Theatines, Munich 323
Church of the Ursulines, Fribourg 324
Church of the Virgin of Georgia, Moscow 326
Church of the Visitation, Avignon 301
Church of the Visitation, Nevers 345
Churriguera, José Benito de 308, 309, 367, 368, 403, 404, **808**
Churrigueresque 291, 311, 313, 338, 361, 363, 364, 367, 399, 403
Churubusco 421
Cibber, Caius Gabriel 252, 322
Ciboria 86
Cicero 334
Cid (Corneille) 296
Cifrondi 186
Cignani, Carlo 400
Cigoli 293
Cima da Conegliano 116, **305, 402**
Cimabue 33, 40, 88, **54**
Cimarosa 399
Cimborio 169, 371
Cincinnato, Romulo 231
Cino, Giuseppe 370
Cinquecento 116, 133, 134, 199
Cipriani 413
Cisalpine republic 398
Cistercian Order 25, 85
Ciudad Real 170
Ciudad Rodrigo 85
Civil War 322
Civitali, Matteo 115
Claesz, Pieter 320
Clagny 284, 288, **718**
Clairo, Francesco del 294
Clapboard 327
Claremont, Esher 410
Clarendon House, London 321
Classicism 118, 140, 143, 145, 157, 192, 219, 222, 223, 249, 250, 251, 254, 268, 275, 276–82, 309, 323, 338, 340, 377, 409, 416
Clement VII 158, 161

abbey 173
Henry II of France 165, 166, 167, 168, 209, 268
Henry III of France 165, 167
Henry IV of France 165, 167, 168, 268, 295, 320
Henry of Valois 177
Henry the Navigator 84
Hepplewhite, George 414, 426, **1123**
Herculaneum 13, 386, 389, 399
Herder, J. G. von 414
Héré, Emmanuel 391, **772**
Hereford 78
Herlin, Friedrich 70, 80
Hermes Trismegistus 184
Hermitage, St Petersburg 420
Hernandez, Gregorio *see* Fernandez, Gregorio
Herrera, F., the Elder 310
Herrera, F., the Younger '233, 308
Herrera, Juan de 169, 186, 224, 227, 233, 308, 332, 362, 364, **534, 544, 565**
Herrera, hôtel, Ghent 406
Herrera Barnuevo, S. de 308
Herreraesque 308
Herricx, Guillaume 406
Herschel 414
Hertogenbosch, 's 76, 77, 97 (map)
Hesius, Willem 235, 238, 313, **568**
Hesse-Cassel 415
Hesselius, Gustavus 425
Hickes, Richard 173
Highmore, Joseph 379, 411, **1106**
Hildebrandt, J. L. von 355, 417, 418, **1136**
Hildesheim 175, 290 (map)
Hilliard, Nicholas 173, 182, 265, **490**
Hingham, Massachusetts 327, **863**
Hirschvogel 176
Hirtz, H. 79
Hispano-Flemish 65, 74, 86
Hispano-Indian 313
Hispano-Moorish 74, 86, 117, 403
Hobbema, M. 259, 320, **625**
Hochzeithaus, Hameln 250
Hoechst 417
Hoeimaker, H. 236
Hofkirche, Dresden 355
Hogarth, W. 13, 322, 376, 387, 402, 411, 412, **1015, 1104–5, 1113,** *colour plate* p. 383
Hohenstaufen court 29
Hohenzollern (family) 414
Hokusai 46
Holanda, F. de 168
Holanda, G. de 169
Holbein, Hans, the Elder 70, 151, 154, 175, 265, **343**
Holbein, Hans, the Younger 12, 154–5, 173, 174, 175–6, **338–42, 349,** 479, *colour plate* p. 159
Holberg, Ludwig 419
Holkham Hall 409, **1095**
Holl, Elias 174, 250, 323, **503**
Holland 13, 51, 66, 67, 74, 76, 149, 150, 157, 170, 171, 247, 249, 253–65, 267, 296, 317–20, 321, 322, 324, 360, 397, 401, 407, 419; *see also* Dutch school
Hollar, Wenceslaus 324
Holy Cross hospital, Toledo 169
Holy Trinity, Brussels 238
Holy Trinity, Kristiánstad 324
Holzer 357
Home House, London 410, **1102**
Hondecoeter 265
Honduras 312
Honiton lace 412
Hooch, Pieter de 13, 262, 319, **656**
Horemans, J. J., the Elder 407
Horemans, J. J., the Younger 407
Horn 252
Hoskins, John 265, 322
Hortus Deliciarum 42
Hortus Palatinus, Heidelberg 323
Hospicio de S. Fernando, Madrid 367, 368
Hospital de Venerables Sacerdotes, Seville 368
Hospital Real, Santiago de Compostela 85
Houasse, Michel-Ange 358, 398, 404
Houbraken, Jakob 407
Houckgeest 320

Houdin, Léonor 268
Houdon, Jean Antoine 376, 386, 394, **896, 978, 992**
Hours of Baltimore 49
Hours of Etienne Chevalier 83
Howard, Henry 173
Huber, J. 418
Huber, W. 154, 175, 176
Hübner, Paul 177
Hudson, Thomas 411
Hudson River 327
Huerta, Juan de la 82
Huet, Christophe 395, **1055**
Hugo, Victor 238
Huguenots 320
Huguet, Jaime 65, 73, 86, 92, **123**
Huizinga, J. 24
Humanism 12, 76, 79, 96, 113, 115, 122, 125, 151, 154, 158, 165, 167, 168, 170, 172, 173, 174, 175, 179, 184, 205, 210–13, 249, 313, 329
Hume, David 387, 408
Hundred Years' War 51, 66, 76, 81, 82, 146
Hungary 80–1, 115, 177, 182, 323
Hurtado, D. 168
Huss, John 76
Hutten, Ulrich von 151, 174, 204
Huys, P. 172
Huysmans, Cornelis 314
Huysmans, Jacob 322
Huysmans, Jan Baptist 314
Huyssens, Pieter 235, 236, 238, 313

I

Ibarra, José 421
Iberia, *see* Portugal; Spain
Iconologia (Ripa) 332
Icons 40, 177, 326
Ignudi 149
Ikonopis 326
Ile-de-France 27, 30, 81, 97 (map), 166, 167, 168
Illuminated manuscripts 24, 37, 42, 90; English 43, 49; French 43, 45, 48, 67, 90, 206; Hungarian 81; Italian 47, 92, 164, **175**; Persian 49; Polish 177
Illuminism 186
Imago Mundi (P. d'Ailly) 57
Imari porcelains 398
Imitation of Christ (Thomas à Kempis) 22, 57, 76
Impressionism 145, 224, 233, 311, 412
In Calumniatorem Platonis (Bessarion) 96
In Praise of Folly (Erasmus) 96, 173
Indaco, Francesco del 169
Indaco, Jacopo del 163, 169
Independence Hall, Philadelphia 425
India 85, 168, 338, 360, 408
Indienne 397
Indo-Portuguese 170, 323
Infantado palace, Guadalajara 74, 85, 169, **149**
Ingelheim 42
Ingeniosa Comparación (de Villalon) 168
Inglés, Jorge 65, 86
Ingres, Jean Auguste Dominique 198, 268
Innocent III 18
Innocent VIII 114
Innocent X 290, 311
Innocent XI, tomb of 355
Innsbruck 151, 250, 290 (map)
Inquisition 84, 168, 170, 180, 186, 421
Institutes of the Christian Religion 179
Intaglio engraving 117, 317
Intarsia 28, 117
International Gothic 12, 41, 42–56, 57, 62, 65, 66, 73, 82, 86, 88, 91, 92, 104, 115, 182
Invalides, Paris 283, 286, 287, 299, 301, 396, **674, 716–17**
Ionic Order 165
Ipswich, Massachusetts 327
Ireland 90
Iron work, *see* Wrought-iron work
Isabella, Archduchess 234, 235, 313

Isabella of Castile 59, 74, 75, 84, 85, 155, 169
Isabelline style 16, '85, 169, 367, **149**
Isemann, Antoine 324
Isenbrandt, A. 77, 149
Isenheim 175
Isenheim Altarpiece 12, 152, **332**
Isenmann, Kaspar 70, 80
Isla, José Francisco de 403
Islamic art 85, 362
Italianism 146–7, 150, 151, 169, 171, 173, 175, 235
Italy 16, 18, 20, 22, 24, 26–41, 51, 66, 67, 68, 73, 76, 79, 81, 84, 85, 87–145, 146, 150, 151, 158–65, 170, 172, 179, 180–2, 186, 192, 197–202, 216–23, 224, 243, 249, 253, 268, 288, 290–5, 311, 324, 332, 345, 348–9, 355, 360, 363, 364, 370, 371, 396, 398–403, 406, 414; architecture 26, 56, 95, 99–100, 101, 113–14, 118, 122–5, 128, 130, 131, 134, 135, 137, 143–5, 158–61, 180, 202, 216, 219, 290–1, 336, 341–2, 344, 348, 349, 355, 363, 364, 370, 372, 399–400, **188–9, 195, 215, 218, 221, 239–43, 253, 262, 297–8, 300–1, 303, 310, 313, 316, 319, 354–7, 407–8, 499–501, 507–8, 517, 736–44, 874–5, 899, 902–4, 916, 921, 929, 963, 972–3, 1069–71**; painting 32–9, 40, 42, 44–6, 47, 57, 58, 59, 86, 88, 90, 92, 94, 95, 98, 101–12, 113, 115–17, 118–22, 125–9, 131–43, 145, 162–4, 180–2, 184, 186, 190, 197–202, 216, 219–23, 292–4, 334, 336, 341, 342, 343, 348, 349, 370, 371, 400–2, **48, 49, 51–63, 70–2, 125, 170–3, 175–81, 185–6, 191–2, 194, 201, 204, 207–13, 216, 220, 223, 225–32, 234, 246–50, 251, 254–9, 263–9, 275, 277–82, 283–96, 299, 301–2, 305–7, 309, 312, 315, 318, 362–7, 383, 396, 399–401, 404, 409–10, 422, 425, 443–8, 454, 457–8, 462, 463, 513–15, 519–33, 745–57, 872, 877–80, 897, 931, 1001–2, 1010, 1013, 1016, 1017, 1037, 1074–83,** *colour plates* pp. 35, 36, 105, 106, 124, 141, 142, 211, 366 *frontispiece*; sculpture 26–31, 33, 37, 40, 45, 88, 92, 100–1, 114–15, 118, 130–1, 134, 145, 161–2, 165, 180, 199, 216, 219, 291–2, 323, 341, 342, 343, 344, 347, 348, 370, 400, 406, **23, 25, 27, 29, 31–46, 169, 187, 196–200, 202, 206, 219, 222, 233, 235, 237–8, 244–5, 252, 260, 270–2, 274, 304, 311, 314, 317, 411–12, 437–9, 441–2, 449–50, 516, 753, 901, 910, 930, 954, 1072–3,** *colour plate* p. 123
Ivan III, Grand Duke of Moscow 76, 177
Ivan IV the Terrible 177
Ivories, Flemish 248, 313; French 30, 40, 43, **779**; German 253, 417
Ivory, engraved and inlaid 165, 170, 177, 307, 317, 320, 324
Ivry, Pierre Contant d' 389, 390
Ixtolinque, P. Patino 421
Izbienski tomb, Poznan 177

J

Jackson, Gilbert 265
Jacob, George 398
Jacobson, Jurian 324
Jacobsz, Dirck 172, 254
Jacomart 65, 73, 86
Jacquemart de Hesdin 46, 47, 48, **65**
Jacquerie 18
Jacquet, Jean 419
Jaén 162, 371
Jagellonka, Anna 177
Jain 169
Jamaica 321
James I of England 173, 320, 321
James II of England 321, 407
Jamestown, Virginia 326

Jamnitzer, Christoph 177, 253
Jamnitzer, W. 154, 176
Janinet, J. F. 397
Jansen, Cornelius 192
Jansen, Hans 235
Jansenism 192, 279, 296
Janssen, Pieter 262
Janssens, Abraham 210, 242
Japan and Japanese art 168, 186, 312, 318, 360, 385, 398
Japanisches Palais 415
Jardin, N. H. 419
Jardin des Carmes, Paris 347
Jardin des Pins, Fontainebleau 166
Jasper 413
Java 318
Jean d'Arbois 47
Jean de Beaumetz 48, **73**
Jean de Bruges 46
Jean de Cambrai 82
Jean de Meung 18, 24
Jean de Rouen 169
Jean le Maire 170
Jeaurat, Etienne **1011**
Jecher, Christopher **827**
Jeronymite monastery, Belem 85, 169, **378**
Jerusalem 308, 342
Jesuit church, Fribourg 324
Jesuit Guaranían style 313
Jesuitas church, Braga 405
Jesuits 158, 174, 186, 192, 195, 235, 236, 238, 290, 291, 296, 312, 313, 332, 334, 336, 386
Jewellery, French 307; Italian 131, 165, 217; Spanish 360
Jivopis 326
Joan of Arc 76
Joanna (the Mad) of Castile 76, 84
João, M. 311
João de Castilho 85
Joey, Jean de 168
John VIII 94
John XXIII, anti-Pope 114
John Palaeologos 113
John of Antwerp 174
John of Bavaria 77
John II of Castile 85
John II (the Good) of France 90, 92
John of Jandun 18
John of Luxemburg 90
John I of Portugal 84, 86
John II of Portugal 84, 85, 86
John III of Portugal 168, 169
John IV of Portugal 311, 312
John V of Portugal 358, 359, 362, 405, 406
John of Salisbury 25
John III of Sweden 251, 324
John Maurice 249
John the Baptist church, Yaroslavl 326
John the Fearless 82
Johnson, Cornelius 322
Johnson, Samuel 408, 411
Joly, Gabriel 169
Jones, Inigo 13, 173, 249, 250, 321, 322, 409, **608, 846–7**
Jones, Robert 321
Jonghelinck, Jacques 172
Jordaens, Jacob 236, 244, 248, 314, 317, **593**
Jordan, Esteban **535**
Joseph I of Austria 417
Joseph II of Austria 386, 398, 414
Joseph I of Portugal 386, 405, 406
Joshua Roll 45
Josquin des Prés 76, 81
Jouvenet, Jean 287, **435**
Jouvenet, Noël 305
Jouy cloth 397, **1049**
Jouy en Josas 397
Juan de Flandes 74, 169
Juanes, Juan de 155, 169, 229, **536**
Juel, Jens 419
Julius II 12, 88, 158, 204, 205; tomb 130, 161
Julius III 216
Jullienne, Jean de 395
Jullienne album 397
Jully, Lalive de 389
Juni, Juan de 157, 169, 227, 309, 311, **353**
Juste (family) 147, 167
Justus of Allamagna 59, 267
Justus of Ghent 65, 77, 147, 213
Juvarra, Filippo 349, 355, 358, 363, 372, 399, 400, 403, **871, 958**
Juvénal des Ursins 83

K

Kahriyeh Djiami, Constantinople 52
Kakiemon 398
Kalf, Willem 262, 320
Kalmar 177
Kambly, Melchior 417
Kampen 171
Kamsetzer, J. C. 420
Kamyn, Erasmus 177
Kändler, J. F. 382, 417
Kant, Immanuel 386
Karcher 164
Karelia 419
Karlskirche, Vienna 417, **1135**
Karlsruhe 97 (map); Schloss 415
Kauffmann, Angelica 413, 418, **1036**
Kazakov, M. F. 420
Kedleston 409, 410
Keiser, Reinhard 323
Kempeneer, Peter de 157, 169
Kempten 344
Kensington Palace 409
Kent, William 13, 409, 410
Kenwood, Hampstead 410
Kepler, Johann 174, 323
Kern, Leonard 253
Kerricx, Guillelmus 313
Kessler, A. F. von 415
Ketel, Cornelis 172, 173, 254, 265
Kew Gardens, Surrey 410
Key, Adrian 172
Key, Lieven de 249, 318
Key, Willem 172
Keyser, Hendrik de 249, 252, 318, **617**
Keyser, Thomas de 249, 256, 257, 258, 318, **620**
Keyser, Willem de 252
Khludov Psalter 22
Kilian, P. A. **891**
Kimbolton 322
Kindt, David 324
King's College, New York 422
King's College chapel, Cambridge 78, 173
Kingston, New York 327
Kinsky palace 417
Kirby 173
Kircher, Balthasar 250
Kircher, P. 290
Klauber, J. **873**
Klosterneuburg 417
Kneller, Godfrey 13, 265
Knieper, H. 177
Knight, Richard Payne 410
Knobelsdorff, G. W. von 416, **944**
Knole 173
Knüpfer, Nikolaus 254
Kobenhaupt, G. 177
Koch, B. **389**
Koch, Joseph Anton 379
Koedijck, I. 319
Kokoshniki 326
Kokoshnikirche, Salzburg 417
Kollegienkirche, Salzburg 417
Kolomenskoe palace 177
Kompe, J. 407
Konicz 420
Koninck, P. de 319, 320
Konrad of Soest 48, **76**
Korovniki 326
Korzec 420
Kossovo 76
Koster, Laurens 76
Kostroma 326
Kozlovski, M. I. 420
Kraebenberger 417
Krafft, Adam 70, 79, 152, **147**
Krafft, David von 324
Kraus, Georg Melchior 382
Kremlin, Moscow 177, 420
Kremlin, Yaroslavl 326
Kreutzinger, Josef 418
Kristianstad 324
Kromeriz 418
Kronberg 177
Krumper, Hans 175
Kucharski 420
Kulmbach, Hans von 175, 177
Kupecky, Jan 416, 418, **1138**

L

La Bruyère, Jean de 296
La Chaise Dieu **19**
La Chambre, Abbé de 347

435

R

Rabelais 165, 204
Rabutin, H. de 68
Racine, Jean 244, 268, 270, 274, 283, 296, 347, 403
Radcliffe Camera, Oxford 409
Radigues 420
Radziwill (family) 419
Raeburn, Henry 412, **1012**
Raefen 177
Ragghianti 100
Raggi, Antonio 292, 346
Ragione, Palazzo della, Vicenza 161, **408**
Ragusa 370
Raimondi, Marcantonio 165, 168, **386, 403**
Rainaldi, Carlo 291, 347
Rainaldi, Girolamo 291
Raincy, 391
Raleigh, Walter 172
Rambouillet, Madame de 296
Rameau, Jean Philippe 388
Ramesay castle, Montreal 421
Ramsay, Allan 411
Ranc, Jean 358, 359, 395, 404, 405
Rancho de Taos 425
Ranieri 402
Raphael 12, 55, 95, 97, 111, 116, 120, 122, 125–8, 129, 130, 131, 133, 135, 140, 150, 155, 158, 161, 162, 163, 164, 165, 169, 171, 172, 179, 184, 190, 198, 199, 202, 216, 219, 220, 221, 222, 254, 276, 278, 287, 293, 295, 306, 322, 329, 400, 416, **194, 263–6, 268–9, 383, 396,** colour plate p. 142
Raray 269
Rastatt, Treaty of 386
Rastrelli, Bartolommeo 354, 386, 420, **927, 1144**
Rastrelli, Carlo 420
Rasumovski palace 420
Ratgeb, Jorg 175
Ratio Studiorum 334
Rattenfängerhaus, Hameln 323
Rauchmüller, Matthias 253
Ravello 29, **37**
Ravenna 41, 290 (map)
Ravenscroft, George 323
Ravesteyn 257, 318
Realism 12, 20, 22, 26–39, 46, 52, 55, 57, 70, 75, 76, 78, 79, 80, 82, 88, 92, 115, 116, 146, 167, 192, 219, 253, 254, 257, 292, 294, 309, 310, 340
Réaumur, R. 388
Rebelo, Avelar 312
Recco, Giuseppe 294
Recife 421
Redentore, Venice 161, 288
Reformed churches 250, 318
Reformation 12, 65, 76, 79, 81, 151, 158, 164, 165, 171, 173, 174, 175, 176, 179, 180, 184, 186, 192, 204, 252, 253, 267, 323, 329, 336, 364, 407
Regensburg 80, 97 (map), 175, 290 (map)
Reggimento, Palazzo del, Bologna 293
Reggio, Raffaellino da 216
Regiomontanus 79
Regnault, G. 147, 167
Regnault, N. H. 397
Regulae (F. Bacon) 195
Reichle, Hans 175
Reimer, Hans 177
Reims 83, 168
Reinoso, André 311
Reixach, Joan 65, 86
Reliquaries 40, 83, **159**; see also Bust-reliquaries
Rembrandt 13, 65, 90, 182, 192, 234, 241, 254, 257, 258, 260–2, 267, 275, 304, 318–19, 320, 340, **421, 643–7, 649–51, 835–6, 838–9, 898,** colour plate p. 263
Renaissance 12, 16, 25, 26, 34, 56, 57, 65, 66, 74, 85, 88–271, 329, 332, 334, 360, 362, 363
Renaissance und Barock (Wölfflin) 329
René of Anjou, King of Sicily 59, 66, 78, 81, 82, 113, 117, 146
Renée of France 158
Reni, Guido 210, 222–3, 243, 293, 295, **530**

Rennes 56, 290 (map), 391, 394
Renoir, Pierre Auguste 240, 260
Rensselaer, New York 327, **469**
Repton, Humphrey 410
Residenz, Bonn 415
Residenz, Ludwigsburg 415
Residenz, Munich 323
Residenz, Stuttgart 415, **732, 734**
Residenz, Wilhelmshöhe, 415
Residenz, Würzburg 336, 349, 356, 401, 415, **733**
Restoration 321, 322
Restout, Jean 394
Retables 308, 311
Retti, L. 415
Reuchlin 174
Reverdy, G. 168
Revolution, French 289, 386, 394, 414, 420
Reynolds, Joshua 13, 243, 376, 387, 402, 411, 412, 426, **1009, 1106, 1108**
Rezzonico, Palazzo, Venice 343, 401, **742**
Rhenish art 22, 28, 41, 43, 48–9, 65, 70, 79, 80, **75**
Rhenish mysticism 22, 96, 152, 180, 184, 186
Rhine 22, 62, 79, 97 (map), 154, 177, 415
Rhode Island 425
Rhône 97 (map), 146
Rhynne, Sir J. 173
Ribalta, Francisco 232, 310, **539**
Ribalta, Juan 232
Ribera, José de 186, 232, 294, 310, **552**
Ribera, Pedro de 367, 368, 403, **968**
Riccardi, Palazzo, Florence 113, 294, **210**
Ricchinio, F. M. 291
Ricci, F. J. 308
Ricci, Marco 401, 402, **1079**
Ricci, Sebastiano 322, 336, 349, 388, 401, 402, 411, **1079**
Riccio, Andrea 162, 165
Ricciboni 399
Richard II of England 90
Richardson, S. 379, 387, 408, 411
Richelieu, Cardinal 192, 234, 248, 295, 299, 301, 306; château 299, **713**
Riddarhuset palace 419
Ridinger, J. E. 417
Ridolfi 137, 143, 145
Riedinger, Georg 323
Riesener, Johann Heinrich 398
Rigaud, Hyacinthe 287, 359, 395, 404, **982**
Riley, John 322
Rimini 12, 41, 45, 97 (map), 113, 114, 116, **180, 195**
Rinaldi, Antonio 363
Rio de Janeiro 372
Riom 82, 83, 97 (map)
Ripa, Cesare 332
Ripon 78
Risueño, José 371, 404
Rizi, Francisco 233, 311
Rizi, Juan Andrés 311, **815**
Rizzo, Antonio 114, 115, **301**
Robbia, Girolamo della 166
Robbia, Luca della 114, 149, **238**
Robelin 391
Robert of Anjou 40, 45
Robert, Hubert 379, 391, 396, 397, **708**
Roberti, Ercole de' 92, 107, 117
Roberval 296
Robespierre 386
Robetta, C. 117
Rocca Paolina 158
Roche, Alain de la 76
Rock crystal 165, 217, **758–9**
Rococo 13, 202, 224, 269, 287, 340, 354, 359, 360, 367, 371, 377, 389, 399; English 413; French 350, 351, 352, 389, 390, 391, 398, 415; German 342, 355, 356–7, 415, 416, 417; Italian 399, 400, 401; Luso-Brazilian 372, 421; Portuguese 372, 406
Rodez 167
Rodriguez, B. 311
Rodriguez, Lorenzo 368, 421
Rodriguez, Ventura 372, 403
Roeghman 320
Roelas, Juan de 310
Roemer, C. 324
Roentgen, David 417, **1063–4**

Roëttiers, Charles Norbert 397
Rohan Master 51, 52, 57, 60, **83**
Rohan, hôtel de, Strasbourg 288, 290
Rohr 356
Rojas, Pablo de 309
Rokotov, F.S. 420
Roldán, Luisa 309
Roldán, Pedro 309, 371, 404, **971**
Romagna 398
Roman de la Rose 18, 24, 43, 98, **13**
Roman de Renart 18, 43
Roman Empire, art of 28, 45, 57, 113
Romanelli, G. F. 275, 293, 294, 346
Romanesque 16, 25, 26, 27, 28, 29, 32, 33, 42, 43, 99, 113, 166, 284, 364, 367, 371
Romanino, G. 163
Romanism 140, 149, 157, 169, 171, 172, 176, 210, 235, 253–4, 265, 274, 310, 319, 323
Romano, Cristoforo 115
Romano, Giulio 12, 128, 140, 143, 158, 162, 163, 164, 166, 202, 276, 329, **354–5, 878**
Romanov, Michael 324
Romanov-Borisoglebsk 326
Romanticism 247, 330, 340, 373, 377–80, 391, 410, 412
Romar 168, 169
Rombouts, Theodoor 242, 247, **599**
Rome 16, 24, 26, 27, 33, 40, 52, 82, 88, 97, 97 (map), 101, 113, 115, 117, 122, 125, 137, 143, 145, 146, 149, 158, 161, 163, 172, 179, 180, 186, 195, 198, 199, 202, 210, 216, 219, 235, 240, 243, 248, 270, 272, 276, 287, 290–1, 292, 293, 294, 299, 304, 306, 307, 311, 312, 313, 314, 319, 322, 324, 332, 338, 341, 345, 348–9, 359, 360, 363, 364, 370, 398, 399, 400; Baths of Diocletian 161; Baths of Titus 158; Capitoline Museum 398; Casino Rospigliosi-Pallavicini 293; Chiesa Nuova 186; Collegio di Propaganda Fide 291; Colosseum 398; Conservatori palace 292; Cortile della Pigna 158; Cortile di S. Damaso 158; Fontana di Trevi 348, 352, 399, **1070**; Gesù 131, 161, 175, 216, 290, 291, 293, 296, 323, 324, 332, 336, 344, 348, 415, **499–501**; Golden House of Nero 158; Palazzo Barberini 291, 293, **741**; Palazzo Colonna 402; Palazzo Farnese 158, 190, 221, 222, 293, 329, **356**; Palazzo Massimi alle Colonne 158; Palazzo Mattei 291; Palazzo Spada 291; Palazzo Venezia 113; Piazza del Popolo 291; Piazza della Minerva 343; Piazza di Spagna 399; Piazza Navona 291, 295, 343; Sta Agnese 291; S. Alessio 349; S. Andrea al Quirinale 291; S. Andrea della Frate 291; S. Andrea della Valle 291, 293, 323, 341; S. Carlo ai Catinari 341; S. Carlo al Corso 291; S. Carlo alle Quattro Fontane 291, 342, **875, 904**; Sta Casa in Loreto 158; Sta Cecilia in Trastevere 33, 40, 291, 400, **49**; S. Clemente 32, **48**; Sta Croce in Gerusalemme 400; S. Filippo Neri 291; S. Francesco a Ripa 305; S. Giorgio in Velabro 40; S. Giovanni in Laterano 40, 98, 291, 292, 342, 348, 399, 400, **1071**; S. Ignazio 293, 348, 400; S. Ivo della Sapienza 291, 342, **902–3**; S. Lorenzo fuori le Mura 40; S. Lorenzo in Damaso 400; S. Luigi dei Francesi 220, 222, 292, 293; Sta Maria degli Angeli 161, 394; Sta Maria del Popolo 158, 164, 220, 292, **414**; Sta Maria della Pace 122, 158, 291, 341, **407, 740**; Sta Maria della Vittoria 291; Sta Maria di Loreto 248; Sta Maria in Campitelli 291, 400; Sta Maria in Trastevere 32, 33, 40, **47**; Sta Maria in Vallicella 341; Sta Maria in Via Lata 391; Sta Maria Mad-

dalena 348, 403; Sta Maria Maggiore 40, 45, 292, 341, 368, 399; Sta Martina e S. Luca 291, 341; St Peter's 12, 13, 40, 114, 125, 128, 130, 131, 158, 161, 179, 224, 248, 290, 291, 292, 296, 308, 313, 342, 343, 345, 364, 397, 355, 367, 399, 400, 415, **221, 736–8, 905**; S. Pietro in Montorio 125, 158, **262**; S. Pietro in Vincoli 161; Sta Prassede 292; S. Sebastiano fuori le Mura 342; S. Silvestro 40; Sta Susanna 291; SS. Vincenzo ed Anastasia 291; Scala Regia 291; Sistine chapel 12, 129, 130, 133, 209, 240; Spanish Steps 399, **1069**; Trinità de' Monti, 399; Vatican 12, 113, 115, 116, 125, 127, 128, 129, 130, 131, 133, 158, 161, 162, 164, 165, 184, 240, 291, 398; Villa Albani 416; Villa Borghese 342; Villa Farnesina 158, 162, 329; Villa Giulia 131, 161, **507**; Villa Ludovisi 223, 293; Villa Madama 158, 161; Villa Medici, 161, 311, 324
Rome, school of 13, 33, 40, 88, 162, 163, 199, 216, 219–21, 292, 293, 294, 346, 348, 350, 400, **365–7, 400, 411, 440, 520–6, 749, 878–9, 881, 878–9, 881, 910, 1072–3,** colour plate p.211; see also Baroque, Roman
Römische Historie 267
Romney, George 411–12, **1112**
Roncalli 292
Rondanini Pietà 101, 131, 199, **271**
Ronsard, Pierre de 165
Roos, Peter 324
Rora, Cypriano da 158
Rosa, Salvator 295, 401, **757**
Rosaries 76
Rose windows 16
Rosenborg castle 324
Roskilde 177, 324
Roslin, A. 388, 419, **1141**
Rospigliosi-Pallavicini, Casino, Rome 293
Rosselli, Matteo 293
Rossellino, Antonio 114, 118
Rossellino, Bernardo 99, 113, 114, **205**
Rosseter, P. 321
Rossetti, Biagio 114, **242**
Rossi, D. 399
Rossi, Vincenzo de' 199
Rosso, G. B. 47, 131, 147, 164, 166, 167, 168, 182, 198, 199, 206, **448**
Rosso, Palazzo, Genoa 294
Rost, Jan 164
Rostov 326
Rostrand 419
Rotari, Pietro 401
Rotonda, Villa (Villa Capra), Vicenza 145, 161, **319**
Rottenbuch colour plate p. 316
Rottenhammer, J. 182, 267
Rotterdam 252, 318, 407
Rottmayr, J. M. 417
Roubiliac, Louis François 354, 376, 410, 411, **928, 1103**
Roubo 391
Rouen 97 (map), 168, 169, 173, 290 (map), 305, 397, 398; cathedral 81, 167; St Maclou 81; St Ouen 83; St Vincent 168; town hall 82
Rousham 410
Rousseau, Jean Jacques 13, 387, 388, 391, 397, 408, 414
Rousseau, P. 390
Roussillon 296
Rovere, Francesco Maria della 158
Rovezzano, Benedetto da 161
Rovira Brocandel, Hipólito 369
Rowlandson, Thomas 376, 411, **1114**
Royal Academy, London 411, 412
Royal Naval Hospital, Greenwich 321
Royall house, Medford, Massachusetts 424, **1145**
Rubens 13, 90, 134, 163, 172, 182, 190, 192, 209, 210, 234, 235, 238–42, 243, 244, 247, 248, 265, 270, 275, 287, 294, 310, 313–14, 317, 332, 336, 338, 341, 345,

394, 395, 401, 406, 411, 426, **571–2, 578, 582–7, 603,** colour plate p. 245
Rucellai, Palazzo, Florence 113, **205**
Rucellai Madonna 40
Rudolf, Konrad 359, 403
Rudolph II 155, 174, 177, 182, 184, 197, 267, 323
Rue, Pierre de la 76
Ruisdael, J. 13, 192, 259, 260, 320, 340, 411, **642, 648,** colour plate p. 264
Ruisdael, S. 320
Rule of the Five Orders of Architecture (Vignola) 116
Rules of Architecture (Bullant) 166
Ruoppolo, Giovanni Battista 294
Rupert, Prince 324
Rurik 324
Rusconi 113, 400, **1072**
Rusnati, Giuseppe 292
Russia and Russian art 76, 177, 324–6, 386, 387, 394, 396, 399, 400, 401, 420; architecture 177, 324–6, 354, 363, 420, **1144**; painting 177, 326, 420, **857**; sculpture 326, 420
Rustici, G. F. 161
Rutebeuf 22
Ruysbroeck, Jan van 18
Ruyter tomb 318
Ryckaert, David 314
Ryckere, Abraham de 210
Rysbrack, John Michael 410

S

Sabatini 403
Sable, Madame de 296
Sacchetti, G. B. 372, 403, **958**
Sacchi, Andrea 223, 293
Sachs, Hans 174
Sackville monument, Withyham 322
Sacra Conversazione altarpieces 116
Sacro Speco, Subiaco 40
Sadeler 172
Saenredam, Pieter 262, 320, **661**
Sagrada Forma, Escorial 311, **817**
Sagrario chapel, Toledo cathedral 308, **971**
Sagredo, E. Diego de 168
Sahagún 86
St Afra, Augsburg 253
Sta Agnese, Rome 291
S. Alessandro, Milan 291
S. Alessandro della Croce, Bergamo 401
S. Alessio, Rome 349
St Aloysius 348
St Amand 269, 349
Sto Ambrogio, Milan 122
Sta Anastasia, Verona 72
S. Andrea, Mantua 113, **241**
S. Andrea, Pistoia 31, 40, **40**
S. Andrea al Quirinale, Rome 291, 342
S. Andrea della Valle, Rome 291, 293, 323, 341
S. Andrea delle Frate, Rome 291, 342
S. Andrés, Madrid 227, 308
St Andrew, Düsseldorf 349
St Anne, Augsburg 151, 174
St Anne, Limehouse, London 409, **1093**
St Anselm 94
St Anthony, Bertoldshofen 357
St Anthony, Partenkirchen 357
S. Antonio, Padua 114, colour plate p. 123
San Antonio, Texas 425, **1157–8**
Sta Apollonia, Florence 92, 104, 115, **213**
Saint-Aubin, Gabriel de 385, 396
St Augustine 20, 40, 98
St Augustine, Antwerp 238
St Augustine, Florida 326
S. Bartolomeo, Bergamo 163
St Bavon, Ghent 313, 406
S. Benito, Valladolid **413**
São Bento, Oporto 311, **818**
St Bernard 16, 18
St Bernardino of Siena 113
S. Bernardino Oratory, Perugia 113, **208**
St Bertin Altarpiece 68, 82, **165**
S. Biagio, Montepulciano 114

Thoroughgood house, Virginia 327, **866**
Thorpe, John 249
Thorvaldsen 419
Tiarini, Alessandro 293
Tibães 406
Tibaldi, D. 164, 231 292, **546**
Tiber River 107, 161
Ticino 355
Tickhill 173
Tiefenbronn 79
Tiepolo, Giovanni Battista 13, 336, 340, 343, 349, 358, 371, 377, 399, 400, 401, 402, 404, 416, **880, 1002, 1074-5, 1081,** *colour plate p. 366*
Tiepolo, Giovanni Domenico 401, 402
Tiercerons 81
Tiles, English 323; Flemish 172; French 168; Portuguese 311, 312, 360, 361, 364, 406; Spanish 86, 170, 368, 369, 405, **155-6;** *see also Azulejos*
Tinelli, Giuliano 292
Tinoco, João Nunes 227, 311
Tinoco, P. Nunes 311
Tintoretto 12, 137-40, 143, 145, 163, 164, 210, 221, 243, 294, 310, **291, 293-6, 318, 410**
Tirso de Molina 308
Tischbein (family) 416
Titian 12, 116, 135, 137, 140, 143, 145, 163, 164, 172, 176, 180, 182, 209, 213, 219, 221, 223, 240, 242, 243, 275, 276, 294, 305, **286-90, 315, 399, 409, 467,** *colour plate p. 124*
Titicaca, Lake 421
Titus, Baths of 158
Tivoli 161, **357**
Tlaxcala 368, 421, **953**
Tocchi, Giuseppe 402
Tocqué, Louis 396, 416, **893**
Todeschini 186
Todi 158
Toft, Thomas 323
Toledo 85, 97 (map), 145, 168, 169, 184, 197, 232, 290 (map), 311, 368, 404; Alcazar 155, 169, 170,308; Bernardine church308; cathedral 86, 169, 228, 233, 308, 309, 310, 368, 403, **967, 971**; Holy Cross hospital 169; Sto Domingo el Antiguo 229, 310; S. Juan Bautista 224; S. Juan de los Reyes 74, 85, 169; Sto Tomé 310, *colour plate p. 193*
Toledo bridge (Puente de Toledo), Madrid 301, **968**
Toltchkovo 326
Tombs, *see* Funerary sculpture
Tomé, Antonio 403
Tomé, Narciso 368, 403, **967**
Tomicki Gospels 177
Tommaso da Modena 41, 47
Tongeren 76
Topsfield, Massachusetts 327, **860**
Torchères 295
Torelli, Giacomo Cavalein 346
Torelli, Giuseppe 399
Tornabuoni (family) 113
Toro, Bernard 304, 350, 351, **919**
Torre de la Parada 311
Torregiani, A. 400
Torrigiano, Pietro 150, 169, 173
Torriti, Jacopo 40, 45
Tory, Geoffrey 168
Toulon 304
Toulouse 97 (map), 167, 272, 290 (map)
Tour de la Garde-Robe, Palace of the Popes, Avignon 20, 44
Touraine 97 (map), 167, 206
Tournai 60, 62, 64, 76, 77, 92, 97 (map), 172, 236, 407, **573**
Tournay (family) 397
Tournier 192, 272, **677**
Tournières, Robert Levrac de 395, **981**
Tours 67, 82, 83, 84, 97 (map), 147, 167, 391
Tourves 391
Toussaint-Dubreuil 167, 168, 210
Traini, Francesco 41
Transparente chapel, Toledo cathedral 368, 403, **967**
Traversi, Gaspare 400
Treatise on Astronomy (Copernicus) 174
Treatise on Cosmography (Müns-

ter) 174
Treatise on Painting (L. da Vinci) 158, 209
Treatise on Perspective (Vignola) 161
Treatise on Sybils and Prophets (Barbieri) 113
Treatise on the Five Orders (Dietterlin) 174
Třeboň Altarpiece 48, **74**
Trecento 107, 146
Trediakovski 420
Tremignon, A. 291
Trent, council of 158, 161, 186, 217, 241, 290, 313, 329, 332
Trentino 104
Trento, Antonio da 217
Très Riches Heures 45, 46, 55, 57, 60, 64, **65-7**
Tresseno, Oldrado da 27
Tressini, Domenico 420
Trevano, Giovanni 324
Trevisani (family) 113
Treviso 41
Trianon, Versailles 391; Grand 286, 301, 416, **710-11**; Petit 288, 389, 390, 403, **715**
Triboli 161
Trier 96, 97 (map), 290 (map), 415
Trinidad church, Mexico City 421
Trinità de' Monti, Rome 399
Trinity church, Molsheim 250
Trinity College, Cambridge 321
Trinqueau 147
Triple Alliance 296
Trippel, Alexandre 418
Triptychs 49, 60, 62, 67, 68, 77, 169, 175, 240, 314
Trissino 143, 161
Tristán, Luis 232, 310
Troger, Paul 418
Troger, Simon 417
Trois Dames de Paris 18
Troja palace, Prague 324
Tromp, Admiral 318
Trompe l'oeil 42, 45, 57, 59, 60, 68, 88, 92, 117, 285, 301, 336, 338, 341, 399, 426
Troost, Cornelis 379, 407, **1007**
Troubadours 18, 26, 39, 42, 56
Troy, François de 395
Troy, Jean François de 395
Troyes 82, 97 (map)
Trujillo, Peru 421
Trumbull, John 426, **1164**
Tsarskoe Selo 420
Tuby, J. B. **675**
Tubeuf, hôtel de, Paris **668**
Tucher Haus, Nuremberg 174
Tucson 425, **1159**
Tudor dynasty 78
Tudor style 150
Tuileries 166, 167, 299, 346, 390
Tulip Hill, Maryland 424
Tura, Cosimo 92, 107, 117, **125, 225**
Turenne 296
Turgot 386
Turin 26, 288, 290 (map), 291, 344, 349, 350, 395, 400, 402, 403, **871, 913**
Turin Hours 45, 57, 61, 64, **76-7**
Turin 97 (map)
Turkey, Turks 18, 56, 76, 324, 417, 420
Turmel, Father 299
Turner, J. M. W. 265
Turriano brothers 227
Tuscan Order 165
Tuscany and Tuscan art 27-39, 40, 41, 90, 92, 97 (map), 104, 112, 113, 114, 115, 130, 131, 134, 145, 146, 162, 197, 198, 291, 398, 400, 402, **446-7, 458**
Two Sicilies, Kingdom of the 84, 398, 399
Tyler, Royall 422
Tyrol 80, 97 (map), 371

U

Überlingen 344, **914**
Uccello, Paolo 47, 58, 59, 97, 103, 104, 115, 117, **192, 211,** *colour plate p. 106*
Udarte, Felipe 169
Udine, Giovanni da, *see* Giovanni da Udine

Udine 401
Uffenbach 267
Uffizi palace, Florence 216, **517**
Uglitch 326
Ukraine 326
Ulm 70, 79, 80, 97 (map), 175
Ulrica Leonora of Sweden 419
Ulysses Gallery, Fontainebleau 209, 210
Umbria and Umbrian art 104, 116, **230, 232, 872,** *colour plate p. 105*
United States 422-7; *see also* America, North
Uppsala 177, 290 (map), 324, 419
Urban VIII 13, 248, 290, 291, 292, 342
Urbino 12, 41, 74, 77, 96, 97 (map), 107, 111, 113, 114, 115, 116, 117, 125, 128, 147, 158, 162, 165, 400
Ushakov, Simon 326, **857**
Utkin 321
Utrecht 49, 76, 170, 171, 172, 249, 253, 254, 317, 320, 324; Treaty of 358, 407, 408
Utrecht, school of 192, 270, 304, 319, 412
Utrecht Psalter 42
Utrecht velvet 397
Uytewael, J. 172, 254, **633**

V

Vaccarini, Giovan Battista 370, 400
Vaccaro, Andrea 294, 400
Vaccaro, Domenico 294, 400
Vadder, Lodewijk de 247
Vadstena 252
Vaga, Pierino del 128, 163
Val de Grâce, Paris 299, 301, 303
Valavez 238
Valckenborgh (family) 172
Valdés Leal, Juan 233, 310, **563**
Valençay 166
Valencia 50, 51, 65, 74, 85, 86, 97 (map), 155, 169, 229, 290 (map), 309, 310, 359, 369, 403, 404, 405; Lonja de la Seda 85; Sta Catalina 309, 403; Stos Juanes 367, 309
Valenciana, Guanajuato 369
Valencienne 68, 77, 82, 317, 395, 407
Valentin 270, 272
Valentina of Milan 47
Valero tomb 343
Valla, L. 112, 113
Valladolid 74, 85, 97 (map), 169, 290 (map), 309, 368, 371, 404, **148, 413, 535**
Valle, Filippo della 400, **1073**
Vallée, Jean de la 251, 419
Vallée, Simon de la 251, 419
Vallery **361**
Vallin de la Mothe, J. B. M. 288, 386, 389, 420
Valloires 352
Valmarana, Palazzo, Vicenza 161, 401, 402
Valois (family) 168, 204, 206, 209
Valois 97 (map)
Van Aelst, P. 172
Van Alsloot, Denis 247, 314
Van Balen, H. 314
Van Beijeren, Abraham 320, **654**
Van Bentheim, Luder 250, 323
Van Boghem, L. 171
Van de Cappelle, J. 320, **837**
Van Cleve, Joos 150, **330**
Van Coninxloo, G. 172, **459**
Van Craesbeeck, Jos 314
Van de Velde (family) 320
Van Delem, Dirck 320
Van den Bogaert, Martin 248
Van den Bossche, B. 407
Van der Goes, Hugo 12, 65, 66, 68, 74, 77, 92, **109, 114**
Van der Helst, B. 256, 257, 258, 318, **623**
Van der Heyden, J. 320, **607**
Van der Hoecke, Jan 314
Van der Laer, Dirk Jan 407
Van der Meulen, Adam Frans 247, 314, **676**
Van der Neer 320
Van der Noot, Maximilien, tomb 406
Van der Passe, Crispin 249, 320

Van der Schley 407
Van der Steen, Jan 313
Van der Stock, Ignatius 314
Van der Valckert, Werner 254
Van der Veken 313
Van der Voort, Cornelis 254, 318
Van der Werff, Adriaen 407, **1090**
Van der Weyden, Rogier 12, 59, 62, 64, 65, 66, 67, 68, 70, 73, 74, 77, 78, 79, 88, 92, 210, 213, **100-1,** *colour plate p. 54*
Van Dyck, Anthony 13, 163, 234, 242, 243-4, 265, 294, 310, 314, 317, 322, 411, **590-2, 828**
Van Egmont, Justus 314
Van Es, Jacob 247
Van Everdingen, Alaert 259, **622**
Van Eyck (family) 24, 47, 49, 55, 58, 59
Van Eyck, Hubert 76
Van Eyck, Jan 12, 57, 58-9, 60-2, 64, 65, 66, 67, 75, 76-7, 86, 88, 92, 210, **90-7, 174,** *colour plate p. 54*
Van Frytom 320
Van Geeraerts, Maarten 406
Van Goyen, Jan 259, 320, **619**
Van Hecke, Pieter 407
Van Heemskerck, M. 172
Van Heil 314
Van Helmont, M. 235, 314
Van Hemessen, J. 24, 172
Van Herp, Willem 314
Van Herwijk, Steven 172
Van Honthorst, Gerard 254, 304, 319, 322, **629**
Van Huysum, Jan 407
Van Kampen, Jacob 249
Van Kessel, Jan 247
Van Keyser, Hendrik 171
Van Laer, Pieter (Bamboccio) 221, 254, 258, 293, **632**
Van Langerveld, Rudger 251
Van Leyden, Lucas 150, 165, 168, 171, 172, 213, 254, **329, 384**
Van Loo, Carle 350, 352, 394, 395, 396, **934**
Van Loo, Charles Amédée 395, 416
Van Loo, Jean Baptiste 395, 411
Van Loo, Louis Michel 358, 395, 404
Van Loon, Theodoor 242
Van Mander, Carel 170, 256, 318, 324
Van Meert, Pieter 244
Van Mieris, Frans 319, 407, **627**
Van Mieris, Willem 407
Van Mol, Pieter 314
Van Noort, Adam 213, 244, 314
Van Obbergen, Anton 250, 323, 324
Van Obstal 303
Van Oost (family) 242
Van Orley, Barent 150, 171, 172, 213
Van Ostade, Adriaen 257, 258, 319, **637**
Van Ostade, Isaac 320
Van Ouwater, Albert 65, 77
Van Panderen, Egbert 242
Van Papenhoven, Alexander 313
Van Plattenberg 247
Van Reymerswaele, M. 24, 172
Van Roore, Jacques 406
Van Santvoort, D. 257, 318
Van Schoor, Ludwig 317
Van Scorel, Jan 254, 350, **488**
Van 's Gravensande, Arent 249
Van Siegen, Ludwig 267
Van Somer, Paul 322
Van Steenwinkel, Hans 324
Van Steenwinkel, Laurens 250, 251
Van Stenwijck, Hendrick 248
Van Swanenburg 319
Van Thienen, Renier 78
Van Thulden, Theodoor 242, 314, 317, **824**
Van Tilborch, Egidius 314
Van Uden, Lucas 247, 314, **826**
Van Uylenborch, Saskia 319
Van Veen, Otto 172, 210, 213, 240, 314
Van Vianem, Adam 320, **842**
Van Vianen, Paulus 172, 177
Van Vliet 320
Van Vriendt, Cornelis 177
Van Zerroen, Anton 253
Vanbrugh, John 249, 409, **1091**

Vanderbank 412
Vanvitelli, Luigi 363, 370, 399, 400, 406, **972**
Varano, A. 399
Varennes 421
Vargas, Luis de 157, 169
Varin, Jean 248, 279, 303, **803**
Varin, Quentin 305
Vasa dynasty 324
Vasari, G. 33, 103, 131, 158, 161, 164, 176, 182, 184, 192, 198, 199, 216, 217, 324, 332, 386, **517**
Vasconcelos, Constantino de 359
Vassall-Longfellow house, Cambridge, Massachusetts 424, **1146**
Vassilacchi, Antonio 294
Vatican 12, 113, 115, 116, 125, 127, 128, 129, 130, 131, 133, 158, 161, 162, 164, 165, 184, 209, 240, 291, 398
Vauban 286, 296, **768, 770**
Vaux le Vicomte 268, 282, 285, 299, **664**
Vauxhall Gardens, London 410
Vaz, Gaspar 170
Vazquez, Gregorio 421
Vazquez, J. B. 227
Vazquez Ceballos, Gregorio 233, **821**
Vecchietta, L. 115
Vecchio, Palazzo, Florence 161, 162, 164, 216
Vega, Garcilaso de la 168
Vega y Verdugo, José de 368
Velasquez, Diego 13, 134, 157, 182, 224, 231, 232-3, 242, 260, 275, 310-11, 334, **426, 556-62,** *colour plate p. 212*
Velatura 107
Vellert, D. 172
Velvet 397
Vendôme **3**
Vendramin (family) 113
Vendramin Calergi, Palazzo, Venice, 114, **300**
Venetia 27, 41, 47, 104, 115, 116, 145, 163, 165, 400
Venetian glass 324
Venezia, Palazzo, Rome 113
Veneziano, Domenico 107, 115, 116, 165
Veneziano, Paolo 41
Venezuela 308, 421
Venice, 16, 40, 51, 90, 92, 94, 97 (map), 113, 114, 115, 116, 117, 151, 152, 158, 161, 162, 163-4, 165, 169, 174, 175, 179, 180, 184, 198, 199, 229, 240, 291, 295, 314, 323, 324, 334, 336, 343, 345, 398, 399-400, 402, 403; Accademia della Fama 113; Ca d'Oro 114, **297**; Doges' Palace 40, 41, 114, 163, 164, 209, **308**; Fondaco dei Tedeschi 135; Gesuati 399, 400; Libreria 137, 161; Loggetta of the Campanile 161, 162; Palazzo Barbarigo 402; Palazzo Corner 161; Palazzo Dario 114; Palazzo Dolfini 161; Palazzo Grassi 399; Palazzo Grimani 161; Palazzo Labia 401; Palazzo Pesaro 291; Palazzo Rezzonico 343, 401, **742**; Palazzo Vendramin Calergi 114, **300**; Procuratie Nuove, Piazza S. Marco 161; Redentore 161, 288; Sta Elena 117; S. Fantino 310; S. Francesco della Vigna 161; S. Giorgio Maggiore 161, 163, **316**; SS. Giovanni e Paolo 117, 401; Sta Maria dei Gesuiti 399; Sta Maria dei Miracoli 114, **303**; Sta Maria del Giglio o Zobenigo 291; Sta Maria della Salute 163, 291, 343, **743-4**; Sta Maria dell'Orto 163; Sta Maria Formosa 114; St Mark's 27, 32, 40, 41, 113, 158, **33, 34, 313**; S. Moisè 291; S. Sebastiano 163; S. Zaccaria 114; Scala dei Giganti 114; Scalzi church 291, 401; Scuola dei Carmini 301; Scuola della Misericordia **298**; Scuola di S. Marco 114; Scuola di S. Rocco 163, 240; Zecca 161
Venice, school of 12, 27, 32, 41, 70, 111, 116, 131, 133, 134-45, 151, 155, 162, 163, 164, 180, 190, 210, 219, 221, 243, 294,

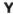